The Handbook of
Visual Culture

THE HA

OF

CUL

NDBOOK VISUAL TURE

Edited by
Ian Heywood and Barry Sandywell

with
Michael Gardiner, Gunalan Nadarajan and
Catherine Soussloff

BERG

London • New York

English edition
First published in 2012 by

Berg

Editorial offices:
50 Bedford Square, London W1CB 3DP, UK
175 Fifth Avenue, New York, NY 10010, USA

© Ian Heywood and Barry Sandywell 2012

Berg is an imprint of Bloomsbury Publishing Plc

Library of Congress Cataloging-in-Publication Data

A catalogue record for this book is available from the Library of Congress.

British Library Cataloguing-in-Publication Data

A catalogue record for this book is available from the British Library.

ISBN 978 1 84788 573 9 (Cloth)
e-ISBN 978 1 84788 575 3 (individual)

Typeset by Apex CoVantage, LLC.

Printed in the UK by the MPG Books Group

www.bergpublishers.com

For Emma and Isabel
and
Emily, Gerard, Miriam and Phoebe

CONTENTS

ILLUSTRATIONS XI

ACKNOWLEDGMENTS XIII

CONTRIBUTORS XV

Critical Approaches to the Study of Visual Culture:
 An Introduction to the Handbook 1
 Barry Sandywell and Ian Heywood

PART ONE: HISTORICAL AND THEORETICAL PERSPECTIVES

Editorial Introduction 59

1 Major Theoretical Frameworks in Visual Culture 68
 Margaret Dikovitskaya

2 Towards a New Visual Studies and Aesthetics: Theorizing the Turns 90
 Catherine M. Soussloff

3 Scopic Regimes of Modernity Revisited 102
 Martin Jay

4 Phenomenology and Its Shadow: Visuality in the Late Work of Merleau-Ponty 115
 Michael E. Gardiner

5 Hermeneutical Aesthetics and an Ontogeny of the Visual 131
 Nicholas Davey

PART TWO: ART AND VISUALITY

Editorial Introduction 155

6 Visual Culture and Contemporary Art: Reframing the Picture,
 Recasting the Object? 164
 Robin Marriner

7 Beyond Museology: Reframing the Sensorium 184
 Donald Preziosi

8 Cubism and the Iconic Turn: A Climate of Practice,
 the Object and Representation 200
 Ian Heywood

9 Reframing Nature: The Visual Experience of Early Mountaineering 220
 Simon Bainbridge

10 The Work on the Street: Street Art and Visual Culture 235
 Martin Irvine

PART THREE: AESTHETICS, POLITICS AND VISUAL CULTURE

Editorial Introduction 281

11 Sociology of the Spectacle: Politics, Terror, Desire 290
 Roy Boyne

12 Art, Feminism and Visual Culture 310
 Lisa Cartwright

13 Visual Consciousness: The Impact of New Media on Literate Culture 326
 Nancy Roth

14 The 'Dictatorship of the Eye': Henri Lefebvre on Vision, Space and Modernity 342
 Michael E. Gardiner

15 Cubist Collage and Visual Culture: Representation and Politics 361
 Ian Heywood

PART FOUR: PRACTICES AND INSTITUTIONS OF VISUAL CULTURE

Editorial Introduction 389

16 Looking Sharp: Fashion Studies 405
 Malcolm Barnard

17 Seeing Things: Apprehending Material Culture 426
 Tim Dant

18 Photography and Visual Culture 445
 Fiona Summers

19 Television as a Global Visual Medium 464
 Kristyn Gorton

20 Film and Visual Culture 480
 Andrew Spicer

21 Pragmatic Vision: Connecting Aesthetics, Materiality and Culture in
 Landscape Architectural Practice 499
 Kathryn Moore

22 Images and Information in Cultures of Consumption 516
 Martin Hand

PART FIVE: DEVELOPMENTS IN THE FIELD OF VISUAL CULTURE

 Editorial Introduction 535

23 The Question of Method: Practice, Reflexivity and Critique in Visual
 Culture Studies 542
 Gillian Rose

24 Digital Art and Visual Culture 559
 Charlie Gere

25 Digitalization, Visualization and the 'Descriptive Turn' in Contemporary
 Sociology 572
 Roger Burrows

26 Action-based Visual and Creative Methods in Social Research 589
 David Gauntlett and Fatimah Awan

27 Neuroscience and the Nature of Visual Culture 607
 John Onians, with Helen Anderson and Kajsa Berg

28 Re-visualizing Anthropology through the Lens of *The Ethnographer's Eye* 628
 David Howes

29 Seven Theses on Visual Culture: Towards a Critical-Reflexive Paradigm for
 the New Visual Studies 648
 Barry Sandywell

30 Mapping the Visual Field: A Bibliographical Guide 674
 Barry Sandywell

 NAME INDEX 765

 SUBJECT INDEX 775

ILLUSTRATIONS

6.1	Robert Longo, *Love Police and the Golden Children*, 1982-83	171
8.1	Gerhard Richter, *Annunciation after Titian*, 1973	204
8.2	Pablo Picasso, *Still Life With Chair Caning*, Spring 1912	208
10.1	Gaia and palimpsest with other street artists (1), New York City (i), 2008	257
10.2	Swoon (left), Gaia (right) and other artists, New York City, 2008	257
10.3	Swoon, New York City, 2008	258
10.4	Multiple artists, Soho, New York City, 2008	258
10.5	Shepard Fairey and multiple artists, New York City, 2008	259
10.6	Gaia and palimpsest with other street artists (2), New York City (ii), 2008	259
10.7	Herakut and multiple artists, New York City, 2009	260
10.8	WK Interact, New York City, 2005	260
10.9	Judith Supine, New York City, 2007	261
10.10	Advertising, New York City, 2010	261
10.11	Advertising, Barcelona, 2010	262
10.12	Shepard Fairey, Washington, DC, 2008	262
10.13	Shepard Fairey and EVOL, Washington, DC, 2009	263
10.14	Shepard Fairey, Washington, DC, 2008	263
10.15	Shepard Fairey, Washington, DC, 2008	264

10.16	Os Gemeos, New York City, 2009	264
10.17	Os Gemeos, New York City, 2009	265
10.18	Banksy, San Francisco, 2010	265
10.19	Banksy, San Francisco, 2010	266
10.20	Multiple artists, Berlin, 2007	266
10.21	Multiple artists, Berlin, 2007	267
10.22	Invader, Ron English, Shepard Fairey and others, Paris, 2009	267
10.23	Shepard Fairey, Venice, 2009	268
10.24	Shepard Fairey, Venice, 2009	268
10.25	Shepard Fairey, Venice, 2009	269
10.26	Shepard Fairey, Venice, 2009	269
10.27	Multiple artists, Barcelona, 2010	270
10.28	Btoy and other artists, Barcelona, 2010	270
11.1	Auguste Maquet, *Maximilien Robespierre and His Followers on Their Way to the Scaffold on 28 July 1794*, 1845	291
11.2	Arnold Böcklin, *Odysseus and Calypso*, 1883	298
11.3	Viaduc de Millau, France, 2004	303
11.4	D-Tower, Doetinchem, 2003	304
11.5	Richard Serra, *Monumenta*, 2008	306
15.1	Pablo Picasso, *Glass and Bottle of Bass*, Spring 1914	368
15.2	Pablo Picasso, *L'etat durada*, 1902	375
16.1	Irena Sedlecká, *Beau Brummell*, 2002	408
16.2	*Blackspot Sneaker*, 2009	420
17.1	*Glass of Water (light)*, 2010	432
17.2	*Glass of Water (dark)*, 2010	432
17.3	Michael Craig-Martin, *An Oak Tree*, 1973	433
18.1	Willie Doherty, *The Other Side*, 1988	446

ACKNOWLEDGMENTS

The editors would like to thank the following for their help and support:

Adbusters, Tony Carter, Michael Craig-Martin, Professor Willie Doherty, David Fitzgerald, Mark Francis, Chris Jenks, Robert Longo, Robert Longo Studio, Museu Picasso, Kevin O'Brien, Professor Christine Poggi, Ms E. R. Pulitzer and Helene Rundell, Gerhard Richter, Atelier Richter, Chris Rojek, Andreas Schmitt, Mike Smith, Matthias Wascheck.

We would also like to than Tristan Palmer for supporting this project throughout its lengthy gestation and Emily Johnston for guiding the book through its final production stages.

CONTRIBUTORS

Helen Anderson is a Tutor in the Archaeology of Art in the School of World Art Studies at the University of East Anglia, Norwich, UK. She has presented research papers in both South Africa and the United States. Her thesis examined the origin and development of art from Middle Stone Age Africa to Upper Palaeolithic Europe, using neuroscience and in particular neural plasticity to understand the earliest art especially the interrelationship between the brain, the environment and cultural production. Her research interests centre on the origin and development of art in Africa and the development of, and the neural correlates for, symbolic thought.

Fatimah Awan is a Research Fellow in Media Users and Creative Methodologies at the University of Westminster, London. She taught media studies for a number of years at Southampton Solent University and undertook her PhD at Bournemouth University (see www.artlab.org.uk). Her research interests include the sociology of young people and contemporary media, and new qualitative methods which use visual/creative techniques.

Simon Bainbridge is Professor of Romantic Studies at Lancaster University. He is the author of the monographs *Napoleon and English Romanticism* (Cambridge University Press, 1995) and *British Poetry and the Revolutionary and Napoleonic Wars: Visions of Conflict* (Oxford University Press, 2003) and the editor of *Romanticism: A Sourcebook* (Palgrave, 2008). Among his current research projects is a study of the literature and culture of mountaineering in the Romantic period.

Malcolm Barnard is Lecturer in Visual Culture in the School of Art and Design at Loughborough University. He has degrees in philosophy and the philosophical aspects of sociology and has published in the areas of fashion, graphic design and visual culture. His main publications include *Fashion as Communication* (Routledge,

1996), *Approaches to Understanding Visual Culture* (Palgrave, 2001), *Graphic Design as Communication* (Routledge, 2005) and *Fashion Theory* (Routledge, 2007).

Kajsa Berg is a neuroarthistorian who completed a PhD in Art History at the University of East Anglia in 2010. Her thesis seeks to demonstrate that neuroscience is helpful in the context of specific art-historical queries. In her thesis, 'Caravaggio and a neuroarthistory of engagement', she uses neuroscience to explore artists', patrons' and other spectators' responses to Caravaggio's paintings. Her specialty is the culturally specific emotional engagement with early seventeenth-century painting and sculpture in Rome. More widely she is developing Baxandall's concept of the 'period eye', replacing it with the 'contextual brain', which allows a recognition of both the cognitive skills and the emotional factors involved in spectatorship. She has taught at the University of East Anglia and the Norwich University College of the Arts on a variety of topics.

Roy Boyne has published books on French philosophy, the sociology of art and cinema, and cultures of risk. He is a member of the executive editorial board of *Theory, Culture and Society*, and a board member of the recent journal, *Creative Industries*. He was guest-editor for the 2007 edition, devoted to cinema, of *Symbolism: A Journal of Critical Aesthetics*. He was Vice-Chair of the Board of Culture North East (until its demise in April 2009). He is writing a book for Sage on regional and international cultural strategy, based in part on research he did whilst visiting professor at the University of Strasbourg in 2007. As part of the research into questions of cultural strategy, he has become especially interested in the idea of 'impact', with particular reference to evaluation methodology, and to indirect impacts and externalities.

Roger Burrows is a Professor of Sociology at the University of York, UK. His main research interests are in the areas of social informatics, urban studies and the sociology of health and illness. He has published numerous articles, chapters and books in the fields of sociology, social policy, social geography and research methods. His recent work with Mike Savage on the 'coming crisis of empirical sociology', discussed in Chapter 25, has generated considerable debate in UK sociology in recent years.

Lisa Cartwright is a Professor at the University of California, San Diego, where she is appointed in the Department of Communication and affiliated with the graduate Science Studies Program and the undergraduate program in Critical Gender Studies. She works across visual studies; gender and sexuality studies; science, technology, information and medicine studies; and disability studies. Her most recent book is *Moral Spectatorship: Technologies of Voice and Affect in Postwar Representations of the Child* (Duke University Press, 2008). She is coauthor, with Marita Sturken, of *Practices of Looking: An Introduction to Visual Culture* (2nd edn, Oxford University Press, 2008). That book can be found in Czech, Korean and Mandarin. Her early work on motion picture film and medicine is contained in *Screening the Body: Tracing Medicine's Visual Culture* (University of Minnesota Press, 1995). With Paula Treichler and Constance Penley, she co-edited the volume *The Visible Woman: Imaging Technologies, Gender and Science* (New York University Press, 1998). A book about the visual culture

of transnational adoption is in process. She is currently working on three small visual culture book projects about animation and embodiment; biomedical citizenship, public art and landscape; and wind power and the transformation of the American heartland.

Tim Dant is Head of Department and Reader in Sociology at the University of Lancaster. He has written two books on sociological aspects of materiality (*Material Culture in the Social World*, 1999 and *Materiality and Society*, 2005) and has published a number of articles on different aspects of material interaction. His research interests include the sociology of the image and he is currently writing a book on the moral consequences of television.

Nicholas Davey was educated at the Universities of York, Sussex and Tübingen. He has lectured at the City University London (1976–9), at the University of Manchester (1979–80), the University of Wales Institute Cardiff Institute (1981–96) and is presently Professor of Philosophy and Dean of Humanities at the University of Dundee. His principal teaching and research interests are in aesthetics and hermeneutics. At the University of Wales and at the University of Dundee he has established new graduate and postgraduate courses in art and philosophy. He has published widely in the field of Continental philosophy, aesthetics and hermeneutic theory. His book, *Unquiet Understanding: Gadamer and Philosophical Hermeneutics* (2006), is published with the State University Press of New York. He is currently completing a monograph *Gadamer, Aesthetics and Hermeneutics: Seeing Otherwise.*

Margaret Dikovitskaya obtained her PhD degree from Columbia University in New York. She has directed three Summer Institutes in Visual Culture at the Central European University, Soros Foundation, Budapest. Her first book, *Visual Culture: The Study of the Visual after the Cultural Turn* was published by the MIT Press in 2005 (Korean edition, 2009). Currently she is writing on the image of Central Asia in early Russian colour photography (researching materials from the Library of Congress, Washington, DC).

Michael E. Gardiner is a Professor in Sociology at the University of Western Ontario, Canada. His books include the edited four-volume collection *Mikhail Bakhtin: Masters of Modern Social Thought* (Sage, 2003), *Critiques of Everyday Life* (Routledge, 2000), *Bakhtin and the Human Sciences: No Last Words* (Sage, 1998, co-edited with Michael M. Bell) and *The Dialogics of Critique: M. M. Bakhtin and the Theory of Ideology* (Routledge, 1992), as well as numerous articles dedicated to dialogical social theory, ethics, everyday life and utopianism in such journals as *History of the Human Sciences, Theory, Culture and Society, Theory and Society,* and *Utopian Studies.* Recently he has co-edited (with Gregory J. Seigworth) a special double issue of the journal *Cultural Studies,* with the title 'Rethinking Everyday Life: And Nothing Turned Itself Inside Out' (Routledge, 2004).

David Gauntlett is Professor of Media and Communications in the School of Media, Arts and Design at the University of Westminster, London. He is the author of several

books, including *Moving Experiences* (1995, 2005), *Media, Gender and Identity* (2002, 2008) and *Creative Explorations: New Approaches to Identities and Audiences* (2007). He produces the popular website about media and identities, Theory.org.uk, and the hub for creative and visual research methods, www. artlab.org.uk.

Charlie Gere is Head of Department and Reader in New Media Research in the Department of Media, Film and Cultural Studies, Lancaster University. He is the author of *Digital Culture* (Reaktion Books, 2002, 2008), *Art, Time and Technology* (Berg, 2006), *Non-Relational Aesthetics: Transmission, the Rules of Engagement 13* (*Artworlds*, 2008) with Michael Corris, and co-editor of *White Heat Cold Technology* (MIT Press, 2009), as well as many papers on questions of technology, media and art. In 2007 he co-curated *Feedback*, a major exhibition on art responsive to its instructions, input, or its environment in Gijon, Northern Spain.

Kristyn Gorton is Lecturer in Television in the Department of Theatre, Film and Television at the University of York, UK. She is the author of *Media Audiences: Television, Meaning and Emotion* (Edinburgh University Press, 2009) and has written about television for several journals such as *Critical Studies in Television*, *Journal of British Cinema and Feminism* and *Feminism and Psychology*.

Martin Hand is Professor of Sociology at Queen's University, Canada. His research focuses on the consumption of technologies of varying kinds. He is currently researching the spread of wireless handheld devices in relation to mobile commercial applications, gaming, learning and social networking. He is the author of *Ubiquitous Photography* (Polity Press, forthcoming), *Making Digital Cultures: Access, Interactivity and Authenticity* (Ashgate, 2008) and co-author of *The Design of Everyday Life* (Berg, 2007).

Ian Heywood was trained initially as a painter. He went on to study sociology and social theory at Goldsmiths' College, London and York University. For many years he taught fine art at Leeds Polytechnic (later Leeds Metropolitan University). He is currently Research Fellow in the Institute for the Contemporary Arts at Lancaster University. He has written and published widely in the fields of art practice, theory and criticism, social theory and leisure studies. He is the co-editor, with Barry Sandywell, of *Interpreting Visual Culture: Explorations in the Hermeneutics of the Visual* (Routledge, 1999).

David Howes is Professor of Anthropology at Concordia University, Montreal, and the Director of the Concordia Sensoria Research Team (CONSERT). He holds two degrees in law and three degrees in anthropology. His research interests span the fields of law, commerce, consumption, cross-cultural psychology, the senses and aesthetics. He is the editor of *The Varieties of Sensory Experience* (Toronto, 1991), *Cross-Cultural Consumption* (Routledge, 1996) and *Empire of the Senses* (Berg, 2004), the co-author (with Constance Classen and Anthony Synnott) of *Aroma: The Cultural History of Smell* (Routledge, 1994), and the author of *Sensual Relations: Engaging the Senses in Culture and Social Theory* (University of Michigan, 2003). His latest book is *The Sixth*

Sense Reader (Berg, 2009). See generally www.david-howes.com. For more information on the activities of CONSERT see http://alcor.concordia.ca/~senses.

Martin Irvine is a Professor at Georgetown University and is the owner and director of Irvine Contemporary gallery in Washington, DC. He founded the Communication, Culture and Technology programme at Georgetown University in 1995, the first interdisciplinary post-Internet media and communication department at the graduate level, where he currently teaches graduate seminars on media theory, visual culture and contemporary art (www.georgetown.edu/irvinemj). In addition to his academic background in cultural history and theory, philosophy and art history, Martin Irvine has twenty years of experience with the Internet and digital media. Through Irvine Contemporary gallery, he has curated over twenty major exhibitions and has worked with many of the artists discussed in the essay in this book. He is currently writing a book on the contemporary art world from a broad interdisciplinary perspective.

Martin Jay is Sidney Hellman Ehrman Professor of History at the University of California, Berkeley. Among his works are *The Dialectical Imagination* (1973 and 1996), *Marxism and Totality* (1984), *Adorno* (1984), *Permanent Exiles* (1985), *Fin-de-Siècle Socialism* (1989), *Force Fields* (1993), *Downcast Eyes* (1993), *Cultural Semantics* (1998), *Refractions of Violence* (2003) and *Songs of Experience* (2004). *The Virtues of Mendacity: On Lying in Politics* (University of Virginia Press, 2010) is his latest work.

Robin Marriner is a Senior Lecturer in the Bath School of Art and Design, Bath Spa University, where he was the course director for the MA in Visual Culture for the duration of its life from 1990 to 2004. He teaches undergraduate and research fine art students; his own research explores the conditions of meaning of art objects and in particular the ways in which these are differently perceived within modernist and postmodernist art culture. His writings, which philosophically engage with the relationships between theory, criticism and contemporary art practice, particularly painting, photography and sculpture, have appeared in various British art journals and in several anthologies.

Kathryn Moore is a Past President of the Landscape Institute and 2008 Thomas Jefferson Visiting Chair at the University of Virginia. Her book *Overlooking the Visual: Demystifying the Art of Design* (2010) lifts the philosophical veil obscuring critical, artistic discourse. Crossing boundaries between philosophy, theory and practice it is an interdisciplinary analysis of consciousness and the creative process that is of considerable interest to those concerned with design quality in the built environment and to those striving to meet current global environmental challenges. Her research, having major pedagogical implications, also informs her consultancy. On behalf of IFLA she is advising UNESCO on the feasibility of an international landscape convention.

John Onians is Emeritus Professor in the School of World Art Studies at the University of East Anglia where he taught for thirty-five years. He was founding Director of Research and Academic Programs at the Clark Art Institute, founding editor

of the journal *Art History* and edited the first *Atlas of World Art*. His books include *Hellenistic Art: The Greek World View 350–133BC* (1979), *Bearers of Meaning: The Classical Orders in Antiquity, the Middle Ages and the Renaissance* (1988) and *Neuroarthistory: From Aristotle and Pliny to Baxandall and Zeki* (2007). He is currently writing a history of European art in the light of the latest neuroscience.

Donald Preziosi is Emeritus Professor of Art History and Critical Theory at UCLA and a former Slade Professor of Fine Art at Oxford. He received his PhD at Harvard, has taught at several American universities including MIT and Yale, and has lectured widely in Europe, North America, Australia and the Middle East. He is the author of twelve books on art and architectural history, critical theory and the historiography of cultural institutions, including *The Semiotics of the Built Environment*; *Architecture, Language and Meaning*; *Aegean Art and Architecture*; *Rethinking Art History*; and *The Art of Art History*, and is co-author with Claire Farago of *Grasping the World: The Idea of the Museum*. His newest book, *Enchanted Credulities: Art, Religion, and Amnesia*, is forthcoming in 2012.

Gillian Rose is Professor of Cultural Geography at the Open University in the UK. She is the author of *Visual Methodologies* (2nd edn, Sage, 2007), and has just completed a book about family photography in both domestic and public settings, entitled *Doing Family Photography: The Domestic, The Public, and The Politics of Sentiment* (Ashgate Press, 2010). She also has research interests in the everyday visualities of urban spaces, some of which can be found at www.urban-experience.net.

Nancy Roth is Joint Course Leader of the MA photography course at University College Falmouth, Cornwall, UK. She studied art history at the City University of New York, earning a PhD in 1996 with a study on the work of the German photomontage artist, John Heartfield (1891–1968), whose work combined writing, photography and theatrical elements in the mass circulation newspaper, the most technologically advanced medium of its time. The combination of interests—in writing, photography, art and new media—has made her an enthusiastic reader and translator of the work of Vilém Flusser.

Barry Sandywell is Honorary Research Fellow in Social Theory in the Department of Sociology at York, UK. He is the author of *Logological Investigations* (Routledge, 1996), a multi-volume work on the history of reflexivity, alterity and ethics in philosophy and the human sciences: *Reflexivity and the Crisis of Western Reason* (volume 1), *The Beginnings of European Theorizing: Reflexivity in the Archaic Age* (volume 2) and *Presocratic Reflexivity: The Construction of Philosophical Discourse* (volume 3). He is also the co-editor, with Ian Heywood, of *Interpreting Visual Culture: Explorations in the Hermeneutics of the Visual* (Routledge, 1999) and of essays on Baudrillard, Bakhtin and Benjamin and other theorists published in various journals and collections. Recent publications include essays on digitization, cyberspace, new media and global criminality as part of a continuing programme of research concerned to map the reflexive transformations of postmodern

societies and cultures. His most recent book, *Dictionary of Visual Discourse: A Dialectical Lexicon of Terms* was published in 2011 (Ashgate).

Catherine M. Soussloff teaches at the University of British Columbia, where she is currently Head of the Department of Art History, Visual Art and Theory. Her book publications include *The Subject in Art: Portraiture and the Birth of the Modern* (Duke University Press, 2006), *The Absolute Artist: The Historiography of a Concept* (Minnesota University Press, 1997), *Jewish Identity in Modern Art History* (California University Press, 1999) and *Editing the Image: Strategies in the Production and Reception of the Visual* (Toronto University Press, in press). She is the author of more than thirty essays that address the historiography of art history, aesthetics, early modern European art and theory, image theories, performance studies, photography and Jewish identity and visual culture. She is currently writing a book on Michel Foucault and late-twentieth-century visual studies.

Andrew Spicer is Reader in Cultural History and Director of the Visual Culture Research Group in the Department of Art and Design, University of the West of England. He has published widely on the construction of masculinities, British film history and *film noir*, including *Typical Men* (2003), *Sydney Box* (2006) and the *Historical Dictionary of Film Noir* (2010). He is currently directing an AHRC-funded research project on the film producer Michael Klinger.

Fiona Summers is a Lecturer in Sociology at Lancaster University. Prior to this she has taught Media, Film and Cultural Studies at Lancaster. Her research and publications focus on contemporary visual culture and she has recently published work on feminist visual art and haptic visuality in *Feminist Theory*. She is currently working on a book project on the relationship between the moving image in contemporary art gallery space and spectatorship as well as a further book on visual research methods.

Critical Approaches to the Study of Visual Culture: An Introduction to the Handbook

BARRY SANDYWELL AND IAN HEYWOOD

OVERVIEW OF CONTENTS

The collection of original papers forming this *Handbook* has been assembled to facilitate access to recent thought and research in the study of visual culture. The volume has been organized into five main sections, each prefaced by an introductory overview. This chapter provides background to the *Handbook of Visual Culture* and the field of visual culture as a whole.

The chapters are grouped as follows. In terms of content Part One, 'Historical and Theoretical Perspectives', contains chapters that primarily deal with the historical contexts and theoretical orientations in the study of visual culture. Part Two, 'Art and Visuality', focuses predominantly upon issues and questions linking art, aesthetics and visual culture; it also opens the exploration of diverse art practices and the transformations of public space and related topics. Part Three, 'Aesthetics, Politics and Visual Culture', explores the dialectical relationships that exist between aesthetic structures and everyday life, in particular the role of aesthetic formations in material culture, fashion and costume, the spectacular transformation of the political imagination and resistance to the aestheticization of daily life. Part Four, 'Practices and Institutions of Visual Culture', explores different 'regions' of visual culture, including photography, television, cinema, cultures of consumption and visual rhetoric. Finally, the chapters in Part Five, 'Developments in the Field of Visual Culture', deal with important issues of visual knowledge, method and methodology, the impact of the global digital revolution upon visual experience, the emergence of everyday 'reflexive sociologies' as a response to consumer-led capitalism, visuality in performative context, the prospects of alternative methods of visual research, and the emergence of new forms of transdisciplinary visual analysis. Of course

to some extent these clusterings are somewhat artificial as many individual chapters contain both descriptive, critical and, occasionally, polemical orientations (thus a reader does not have to wait until Part Five to gain a sense of future critical directions and changes that need to be made to the current theory and practice of visual studies).

The brief editorial introductions to each of these five parts locate the intellectual backgrounds that underwrite many of the individual chapters, pointing out the history and context of these engagements with seeing and visualization and how they have influenced and continue to influence research and theorizing carried out within these different traditions. Where appropriate each chapter also provides a 'Further Reading' section in addition to the references contained in the chapter. We have striven to identify the most theoretically relevant and up-to-date readings, without neglecting older traditions and texts where these offer valuable insights, in order to assist students of visual culture to orient themselves to broader questions and issues not directly discussed within the relevant chapter. We also include a comprehensive bibliographical chapter that maps the landscape of visual studies for readers new to this field.

THE RATIONALE AND APPROACH OF THE *HANDBOOK*: TOWARDS REFLEXIVE VISUAL STUDIES

The Handbook of Visual Culture has three primary aims. First, in its selection of contributions from a wide range of areas the book has been designed to reflect the diversity and creativity of visual culture research in the first decade of the twenty-first century. Second, by commissioning new chapters from very different perspectives it provides background knowledge for those who wish to understand the forces at work in the practices and institutions of contemporary visual culture. And third, the collection provides a guide and information resource to the main issues, themes and theoretical orientations within this rapidly expanding field. But even more important, we wish to encourage the reader to reflect upon the positions and arguments contained in these chapters and to question their theoretical and substantive claims about the place of images and visual experience in today's global society, politics and culture. The emphasis throughout is upon understanding visual experience as embodied in social and cultural practices. This might be called the 'institutional' turn in visual studies (prefigured by George Dickie's theory of the institutional context of art objects, 1974). Of course we are acutely aware that the all-but-neglected field of visual culture in the 1970s and 1980s has today become something of an intellectual industry (reflected in the explosion of journals, textbooks, academic programmes and conferences in this field). In fact the landscape of visual studies is now filled with a plethora of theoretical superstructures and interpretative positions. The rise of the new media and globalized visual culture in particular—we might also say hybridized and diasporic cultures—has become one of the driving force-fields of contemporary knowledge production and cultural change.

One manifest danger in this situation of exponential expansion is that the discredited logocentrism and textualism of previous cultural research in the 1970s and 1980s might be simply replaced by a one-sided ocularcentrism. To avoid this we need to reconsider

the social and cultural contexts that have led to the expansion of visual studies and to situate this development within a wider critique of contemporary society and intellectual life. We also need to provide a richer and more philosophically nuanced conception of 'the visual' that interfaces with the other senses as productive knowledge sites and critical interventions in social life. Finally we need to invent imaginative research agendas and discourses to advance a multi-sensorial conception of visual experience and visual understanding. All of these *desiderata* are part of a more general reflexive approach to social relations, social practices and institutions.

Traditional cultural theory has until quite recently been dominated by linguistic and verbally based semiotic models of 'meaning production and reproduction'. This situation is largely the outcome of the dominance of French social theory and philosophy in the 1970s and 1980s. Yet despite this linguistic bias even the most extreme forms of 'Theory' (we use this capitalized term as shorthand for 'Theory and Cultural Studies' and to mark its predominantly European philosophical provenance) have had a transformative effect on the study of things visual. In different ways the papers assembled in this collection all reflect the intended and unintended consequences of the Theory wars of the 1970s and 1980s and the legacies of more constructive research in the last two decades. In the light of this fluid situation we emphasize that any such *Handbook* needs to be complemented by other perspectives, other voices, conversations and experimental lines of thought that may not have found a place in the present collection. The inevitable partiality and selectivity of any such anthology should invite criticism and stimulate further thought (for example from the perspectives of the sociology of knowledge, psychology of perception, information and artificial intelligence theory, cognitive science, discourse theory, biomedical engineering and neuroscience).[1]

NEW VISUAL STUDIES

We also claim that this is a *Handbook* with a difference. We are not providing a textbook of instructions or a 'how-to-do-it' manual of methods (such guides are available and are often of great value as Sandywell's 'Bibliographical Guide' (Chapter 30) later in this volume argues). Rather than setting out canonical perspectives and methods that can be 'applied' or adopted uncritically, the *Handbook* has been expressly designed as a site of provocations and reflective dialogues in and around its main thematic sections. The recurrent theme of interdisciplinary exchange is reflected in the diverse intellectual origins of the contributions to this volume, which include Philosophy, Sociology, Social and Cultural Anthropology, Art History, Art Practice, Aesthetics, Cultural Studies, Semiotics, Education, Feminism, Geography, Theatre, Film and Television Studies and Literary Theory. The very plurality of perspectives should encourage reflection about the changing conditions and dynamics of the different forms of knowledge production within these intellectual settings and institutional spaces. This diversity is itself symptomatic of the transition from the relatively insular visual studies of the 1980s and 1990s to the interdisciplinary (and postdisciplinary) explorations of everyday visualities that characterize the past two decades of post-Theory inquiry and research. The exchange

of conceptual perspectives and methodological tools within and between these new knowledge formations promises to create new contexts of inquiry and theories bearing upon the institutional life of seeing in everyday life and the wider society. Contributors and research in the fields from which they come, are coming to terms with history and development of visual culture research and theory in very different ways. This is what one would expect, given that visual culture studies has taken different forms and had different impacts in, for example anthropology as opposed to art and design history, film studies as against sociology.

We have marked this difference by arguing that critical reflection within visual studies has moved from *inter*-disciplinary to *multi*-disciplinary and finally to *trans*-disciplinary—and perhaps *in*-disciplinary and *post*-disciplinary—research and theorizing. This questioning of disciplinary preconceptions and historical institutional boundaries is itself part of the larger social, economic and cultural processes that theorists express with the difficult concepts of *postmodernization* and *globalization* (Bauman 2000, 2007; Beynon and Dunkerley, 2001; Featherstone 1990; Giddens 2002; Hall et al. 2005; Nancy 2007; Rancière 2007; Sandywell 2009). Seen from the perspective of cultural change, the contested transition from modernism to postmodernism might be considered as the most recent form of the mass culture theories of the 1930s and 1940s that stimulated the study of popular culture and, latterly, of the detailed analysis of popular visual forms. Ultimately it is the socioeconomic and cultural impact of globalization over the past three decades that has 'scrambled' social relations and traditional disciplinary institutions along with the vast changes in economic and social circumstances of millions of people worldwide. And one of the key cultural mechanisms of the postmodernization of daily life is the emergence of the Internet and new communicative media as these have transformed visual experience and its analysis.

The passage from modernism to postmodernism that has witnessed the re-direction of Cultural Studies from traditional questions of economic determinism, ideology and representation towards the micro-analysis of everyday life, the vision-saturated cultures of material life, and the sociology of ordinary social practices and embodiments has had a significant impact upon the field of visual studies. However, this shift has not wholly negated an older framework, with a characteristic dichotomy. That is the grand historical narrative of the structural changes—the socioeconomic, political and technological 'mechanisms'—behind the shift from modernity to postmodernity remains intact, if only as a hugely powerful discursive feature of politics and policy, as well as that parallel story, at once 'complex' but also invoking the 'other', of micro phenomena at the level of our ever-mysterious everyday life, variously understood as effects, responses, spontaneous quotidian creative practices and so forth. Such post-Enlightenment struggles with subjects and objects—or freedom and spontaneity on one hand and self-imposed rules and forms of self-objectification on the other—are embedded in our 'modern' form of life, our cultural grammar (Pippin 1991, 1997, 2005).

On a theoretical level we have moved from a sometimes quasi-elitist theory of 'the culture industry' to a more demotic theory of the dynamics of global culture industries as these impact upon the configurations of everyday life. However, questions of

significance and value—once predominantly located in high culture, in aesthetics, ethics and criticism—are more relevant than ever, given the instrumental success and economic power of the culture industries in their penetration of the life world. It has become evident that in coming to terms with these seismic social, political and cultural changes we need to acquire new levels of sophistication and reflexivity in deconstructing the history, structure and dynamics of visuality and visual culture in contemporary life.

The new visual studies might also be called 'reflexive visual studies' given their aim not only to describe and analyse visual media and communication through visual imagery but to excavate and display the generative conditions, assumptions and implicit methods at work in visual analysis (and to use this knowledge of the interfaces between operative assumptions and visual worlds as a force of criticism and transformation in the wider society). One requirement of these new explorations is the imperative to resist defining visual studies *substantively* (or thematically in terms of phenomenal 'fields', 'domains' or 'regions')—a traditional analytical strategy that produces an impossibly wide realm of phenomenal objects—and instead to define visual studies *strategically* and *tactically* in terms of specific problems and questions—for example in exploring the existential, ethical, social and political *functions* of visual life, the blurring of distinctions between high and low culture, the wandering of visual signifiers within everyday materialities, and, perhaps even more important, of asking radical questions about the *transformative* dynamics at work in visual experience from the earlier 'urhistory' of visual media to the globalized digital worlds of cyberspace. However, any such acknowledgement of a shift in the conditions under which one can ask existential, ethical, aesthetic and politics questions does not entail the conclusion that they have become irrelevant or impossible. They remain as important and urgent as ever.

In this sense the questions that were traditionally posed by such modernist disciplines as aesthetics and art history now interface with the postmodern problematics of such perspectives as the study of power, gender and ideologically stratified 'differences', the implosion of aesthetics within everyday life, the diverse cultural functions of science and technology, postmodern geography and so on. Continuing in this vein, recent research has begun to pose explicitly reflexive questions about the relationships between seeing, social practices and knowledge production, vision and power, visual ways of thinking and wider aesthetic, ideological and cultural formations. We will return to this definitional problem later in the section 'The Visual Turn?'.

We might take the 'colonization' of everyday life by visual media as a specific example of new forms of visual space. The globalization of visual media—what some have called the global society of the spectacle or, more generically, the postmodernization of everyday life—has forced every academic programme in visual culture to resolve the paradox that to know the real world we have to examine the mediations and re-mediations of visual forms; indeed to gain any kind of knowledge requires something like a genealogy of the heterogeneous work of images and interpretive traditions that are more ancient than social life itself (the vicissitudes of the concept of *ideology* might be explored in this context). The resurgent interest in socially constructed institutional sites and cultural processes is again a prominent theme of such emerging problematics as global media

studies, mediology and new cultural studies (for example Hall et al. 2005; Hall and Bir-chall 2006; Longhurst et al. 2008; McGowan 2007; McRobbie 2005; Turner 1996).

Locating our bearings in the complex worlds of contemporary life is only possible through the mediations of image-saturated storytelling and narratives that make up the larger part of a living culture. What sociologists have called 'the practices of everyday life' have come to be overwhelmingly mediated by visual forms and the ways in which we discuss and analyse our visual experiences. Major social institutions—including systems of education, entertainment industries and political systems—have been reconfigured in response to the impact of new media. In turn this concern for the popular, the quotidian and the everyday has forced a general change of focus from a high-altitude concern with semiotic codes, generative structures and meta-languages to a more micrological and self-referential focus upon vernacular modes of embodiment, performances and social practices that involve all the senses in shaping what passes for experience and reality (cf. Howes 2006). In this sea-change exclusively linguistic concepts have proved inad-equate as a general model of mediated and re-mediated cultural processes (cf. Mitchell 1994a). Indeed the emergence of a range of transdisciplinary problematics in the last decade—including Media Studies, Internet Studies, Cyberculture Studies, Cognitive Science, Information Theory, Globalization research (Globalization studies), Cultural Geography, Consciousness Studies, Animation Studies, and Ecophilosophy—is symp-tomatic of deeper crises and changes within text-dominated university systems as these respond to global shifts in the larger information economy. In this context it is worth noting the resilience of the text, that is its capacity to re-territorialize and set itself in command, a power which stems from its abstraction, the insignificance of the signifier and its related promiscuity; set this against the stubborn 'this-ness' or 'haecceity' of the material image. The imperial text is highly resilient, particularly adept in reappearing in ways claimed to be contrary to purportedly conventional textual forms.

It has become clear that the task of working through these contradictory processes and implementing more transdisciplinary perspectives will have to inform the agen-das of future theorists and researchers. Whatever the ultimate shape of these emerging constellations we believe that future explorations will continue to be committed to the values of dialogue, critical debate, cross-disciplinary exploration and the willingness to create new conceptual formations, methodologies and philosophical alliances in return-ing to the things themselves. However, the conceptual and methodological flexibility advocated by this approach to visual studies is not at the expense of the important in-sights lodged within relatively separate disciplines and practices. Such visual phenom-ena, experiences and ideas—some related to sensory specialization and embodiment, some to conceptual frameworks that divide up the world in different ways, some to dif-ferent histories—frequently challenge or resist translation. Rather than the definitive es-tablishment of any post-disciplinary quasi-discipline of visual studies, the new situation is defined by the need to encounter visual and somatic phenomena creatively and sen-sitively, attentive to what disciplines and practices offer, but also what they obscure and limit. Post- or a-disciplinarity is improvising, not allowing interpretation to be 'settled', either by discipline or routinized indiscipline.

On a more practical level these new developments pose more immediate questions for those developing course programmes and curricula in the field of aesthetics, new media and new visual studies. If it is the case that we are moving from linear-verbal and writing-dominated paradigms to multidimensional hybrid paradigms based on digitalized audiovisual information (see Flusser 2004; Gitelman 2006; Johnson 1999; Kittler 2009; Levy 1997, 1998; Lister 1995; Manovich 2001; McLuhan 1989; Mitchell 1994a,b; Poster 1990, 1995, 2001, 2002; Robins 1996; Silver and Massanari 2006; Stephens 1998; Terranova 2004; Zielinski 2008) then the most urgent task is to construct transactional and interactional sites that facilitate dialogues *across* all the constituencies concerned with the vicissitudes of visual meaning and cultural formations in the emerging information society. Comprehensive programmes of visual studies must, in principle, be multidisciplinary, transcultural and global in design and delivery. Such programmes must be capable of theorizing the material dynamics embedded in *systems* and *institutions of meaning* as these are increasingly transformed through digitalization. We will need to pursue difficult forms of reflection by asking: What kind of syllabus, reading list, lecture series or library could accommodate the infinite and expanding realms of visual knowledge? How should we acquire the competences to interpret non-Western art? How can we keep track with the hybridized subcultures of the contemporary world?

Turning to the conditions for visual study and practice, in the UK visual art and design education and training evolved independently, initially in colleges of art and design, then in Polytechnic departments. With the conversion of Polytechnics into universities in 1992, these courses joined with other arts and humanities subjects in a unified university sector. Recent years have seen considerable pressure on creative visual and material practices to make themselves more 'academic', or at least to claim the conceptual and methodological rigour supposedly characteristic of 'research'. Yet the stimulus and benefits of visual sensibility and thinking to other largely text-based arts and humanities subjects are almost entirely unrecognized.[2] Where are the 'Creative Seeing' programmes that might complement well-established 'Creative Writing'? How should we develop the 'close *seeing*' of image-based cultural forms and digital media to parallel the task of close *readings* of literary texts commended by structuralist and poststructuralist paradigms? What analytical and synoptic competences would empower a teacher to provide explicit instruction in 'critical visual studies' within the mediascapes of a globalized society? What would be the visual equivalent of critical social theory? How can future students be trained to analyse the visual topographies created by cyberspace, to understand and intervene within the expanding universe of creative industries based upon electronic image processing? What philosophical and institutional changes would be necessary to create reflexive programmes of cultural criticism? And so on. Clearly one of the most urgent tasks for teachers and researchers is to create more strategic, holistic, critical, comparative, multisensorial frameworks and reflexive intercultural methodologies for visual inquiry (a 'route-map' of such strategic directions—what we then called the hermeneutics and politics of vision—is included in our earlier collection of chapters, see Heywood and Sandywell 1999, 'Appendix: The Original Project', pp. 238–50).

CRITICAL THEMES

> Ultimately, having an experience becomes identical with taking a photograph of it, and participating in a public event comes more and more to be equivalent to looking at it in photographed form. That most logical of nineteenth-century aesthetes, Mallarmé, said that everything in the world exists in order to end in a book. Today everything exists to end in a photograph. (Sontag 2002: 24)

We have suggested that one of the fundamental requirements of the new visual studies is to approach visual phenomena reflexively from *critical*, *culturally specific* and *historical* standpoints. But like the heteroglossial character of the contemporary academy, critical thinking about the visual forms a spectrum of interests distributed unevenly across existing disciplinary formations. Our starting point is the view that the new visual studies have no realistic alternative other than to build upon and exploit the energies released by the many forms of critical discourse and media theorizing of the last three decades. This is particularly true with respect to what has been called the postmodern turn and the wider impact of poststructuralist problematics in social theory (for example in the burgeoning research that has accumulated thanks to feminist theorizations of vision, social space and society).

Within a larger horizon and time-frame, programmes of visual enquiry will need to reconnect to perspectives that transcend the history of Cultural Studies and lead back into the deep-history of European institutional life. By deconstructing such postmodernist programmes we also need to problematize the exclusively 'Eurocentred' paradigms of traditional cultural/visual theory and be open to non-European and comparative accounts of image awareness and consciousness (for example Davis 1999). We are reminded that the concern for modes of signification and signifying practices is not a recent intellectual invention. John Berger in his path-breaking lectures *Ways of Seeing* had already pointed the way to more concrete studies of gendered power in understanding the visual field. Being 'shocked' by past theories of meaning and signification might help loosen the overwhelming textual orientation of critical studies. Here again how we break the grip of such text-centred disciplines like art history, museology and media studies will prove crucial to the development of a more robust social theory of visual forms, visual space and visual institutions.

To this end we have emphasized the importance of developing self-reflexive perspectives towards the current status of 'visual studies' and commend new configurations of the visual as complex, heterogeneous and dynamic sociocultural formations in their own right. However, by opening up traditional perspectives we do not claim to lay down rules or preempt the explorations of others. The promise of Reflexive Visual Studies converges on three recurrent themes: first, that we need to question and rethink many of the earlier formulations and implicit frameworks of visual studies programmes (Martin Jay's contribution to this volume, 'Scopic Regimes of Modernity Revisited' is exemplary in returning to and revising his earlier path-breaking essay (Jay 1992) on the historicity of 'regimes of seeing'), second, that we need to critically recover the history

and philosophical presuppositions of earlier forms of visual analysis *and* our commonsense understandings of audiovisual experience (exemplified in Barry Sandywell's programmatic chapter on the historicity of visual knowledge), and third, that we need to imagine and invent new forms of research and alternative methodologies—and perhaps even metadisciplines—in response to the transformational forces of digitalization and cyberspace as these are reconfiguring social relations and everyday life (for example to uncover both the aestheticizing and the de-aestheticizing forces at work in contemporary society). In all of these respects we claim that the 'pictorial' turn cannot simply replace the 'linguistic' turn of traditional cultural studies.

More than a decade ago, in an earlier collection of essays on interpretation and visual culture (Heywood and Sandywell 1999), we diagnosed the prospects of visual studies in the following way:

> The visual field has begun to be explored with a thoroughness and global understanding that is unique in the history of human self-reflection. Recent work on the work of seeing, vision, perception, and culture has taken explicitly historical and hermeneutic directions. Indeed, to borrow an expression from Martin Jay, the topic of 'visuality' presents itself as a radical discursive 'force field', 'a non-totalized juxtaposition of changing elements, a dynamic interplay of attractions and aversions, without a generative first principle, common denominator or inherent essence' (1993, 2). Recent work from sociology and social theory have been at the forefront of this revaluation of visual metaphors and ideas—witness the recent collection of essays edited by Chris Jenks (*Visual Culture*, 1995), David Lowe's *History of Bourgeois Perception* (1982), Elizabeth Chaplin's book *Sociology and Visual Representation* (1994), Paul Virilio's *Vision Machine* (1994) as well as major texts exploring 'the denigration of vision' in social thought (Jay's *Downcast Eyes*, the collection of essays edited by David Michael Levin, *Modernity and the Hegemony of Vision* (1993) and the more recent collection edited by Stephen Melville and Bill Readings, *Vision and Textuality* (1995)). From the contributions of these important interventions we are gradually realizing the extent to which the project of modernity has been saturated by the problematics of viewing and visualisation. We are also now fully aware that the latter are themselves open to sociocultural and historical analysis in their own right. (1999: ix–x).

Ten years of scholarship and critical reflection has seen a massive explosion of theoretical and empirical research on the material presence of imagery, artworks and visual culture in society. As a response to the globalization of media, the appearance of convergent and interactive media, and the digitization of culture we have become acutely aware of the 'specularization' of social life and with it the spread of new technologies that visibilize ever more spheres of private and public life (from the family, schooling, religion to the social organization of science and politics). Terms like 'surveillance', 'panopticon', 'society of the spectacle', 'gaze', 'image', 'screen culture', 'digital image processing', and 'ways of seeing' have become commonplace across the human sciences. What

earlier theorists somewhat innocently called 'the visual field'—we might think of the path-breaking explorations of John Berger, Svetlana Alpers, Michael Baxandall, Roland Barthes, Susan Sontag, Norman Bryson, Barbara Stafford, W.J.T. Mitchell and others— has today become a global space of material performances and practices. In the world of late-capitalist societies, visual culture has become one of the most dynamic global industries of the age. The fusion of the political economy of visuality and the emerging new media technologies has created the transinstitutional and transnational virtual topographies that we refer to as 'cyberspace'.

In the light of these unparalleled transformations it is no accident that the field of visual studies has itself moved beyond its exploratory and preparadigmatic stage influenced by traditional art history and cultural historiography to a more forthright acceptance of the material, neurobiological, cognitive, social-historical and cultural processes that mediate visual experience. The coming of cyberspace has forced many to rethink their assumptions about visuality as the new information technologies have produced qualitatively new forms of seeing and interactivity on a global scale. Where older theories of art and media sometimes tended to dematerialize the operations of visuality, today many researchers are acutely aware of the concrete effects and operations of visual apparatuses in the context of particular organizations of seeing, spectatorship and surveillance.[3] Older litigious disputes about disciplinary borders have given way to inter- and cross-disciplinary dialogues. In areas such as Art History, Film Studies, Culture and Media Studies explorations of the interstices and intersections of disciplinary perspectives have become much more significant and productive. And as we move into the first decades of the new millennium one of the recurrent motifs of work in this area— a theme as evident in the later writings of Stuart Hall as in the work of Slavoj Žižek, Gilles Deleuze, Friedrich Kittler, Nicholas Mirzoeff and Lisa Cartwright—is the shift away from interdisciplinary collaboration to more resolutely meta- and trans-disciplinary thinking and a growth of reflexive self-awareness with regard to methodological and epistemological issues that cut across the natural sciences, arts, social studies and philosophy. Today the emerging programmes of 'visual studies' are exerting an irresistible pressure for change upon all the arts, sciences and humanities.

The diversity of voices, emphases and theoretical strategies exemplified by this collection attests to the remarkable growth of the field of visual studies. Yet despite the manifest differences in approach and diversity of theoretical backgrounds there has emerged a remarkable set of overlapping concerns—philosophical, theoretical and thematic— running through the *Handbook*. Taken together we believe that this unique mosaic of themes forms a creative matrix of ideas that might act as conceptual markers for more radical experiments in visual research and teaching.

Among these distinctive features we would single out the following:

- The explicit concern with questioning the historical and philosophical traditions that inform the available paradigms of visual thinking across the arts, humanities and sciences. This concern for the genesis and genealogy of interpretive traditions is part of a broader philosophical effort to restore human

activities and practices to their sustaining experiential contexts and forms of life (a project that involves integrations of research agendas concerned with the senses in historical and comparative perspective). In this respect theorists like Constance Classen and David Howes have spoken of 'the sensual revolution' or 'sensory turn' in the humanities and social sciences (Howes 2006: 402; cf. Classen 1993 and Howes's contribution to this volume).

- The interdisciplinary nature of many of the chapters (exemplifying a desire to move beyond traditional disciplinary boundaries and frameworks that have tended to focus more or less exclusively upon painting and pictorial arts, performance arts, television, cinema and related visual media). This shift might also be understood as a loosening of the tie between particular visual forms and conventional, modish or authoritative ways of talking about them.[4] An active engagement with the visual field in explicitly self-reflective and deconstructive terms (an engagement that commends self-analyses of the guiding assumptions and methods of inquiry as integral to every form of visual and audiovisual research).

- A common concern to develop more reflexive frameworks of visual research and visual teaching that are both theoretically informed, historically specific and empirically concrete.[5]

- An emphasis upon the 'politics of the visual' that relates the organization of visual practices and visual subcultures to their concrete performative settings and material contexts in everyday social life.

- A commitment to diverse projects of imagining new ways of thinking about visual practices and institutions that articulate with the seismic changes in global society and culture, especially with force fields linked to 'new technologies' and emerging forms of information culture indexed by the problematics of 'globalization', 'digitalization', and 'cyberculture' (Sandywell 2009, 2011).

- In the context of the global turn, an emphasis upon theoretical openness, diversity and explicitly ethical and political concerns in imagining future developments in the rapidly changing world of visual identities and forms of life.

To summarize, despite differences of emphasis and diverse theoretical backgrounds, all of the voices in this collection concur that the field of visual culture and visual studies is one of the most creative and dynamic zones of contemporary intellectual life. The new visual studies promise to open the academy to other voices and practices intent upon transforming the landscape of everyday life. The challenge posed to the traditional university and text-based university curricula is to have the imagination and will to create structures that facilitate radical dialogue across the established disciplinary boundaries. Ultimately the success of these programmes will depend on macro- and micro-agencies—from governmental departments to individual scholarly enterprises—with the imagination to invest resources to encourage and sustain these new developments.

While we know a great deal about visuality and visual culture the 'field of the visual' is still one that invites new theories and intellectual perspectives. In what follows we wish

to conceptualize 'the visual' less as a discretely bounded domain of study—traditionally occupied by art history, media studies, film studies and the like—and more as an underlying problematic that informs the disciplinary concerns and research programmes of all the arts, sciences and philosophy. As an intersecting cluster of themes and problems—what we might call a *transverse problematic*—visual culture lends itself to a multiplicity of theoretical interventions and programmatic inquiries. Investigations into practices of seeing thus necessarily interface with wider frameworks of thought, among these aesthetics, the philosophy of culture, sociology, politics, anthropology, cognitive science, philosophy, the psychology and physiology of vision and neuroscience. By encouraging researchers to question disciplinary boundaries and traditional conceptual tools, the 'visual problematic' provides a rich resource of reflexivity and further attests to the vitality of existing work and the promise of future research.

SOME PRELIMINARY DISTINCTIONS

While terminology is often nebulous and ill-defined we need some operational clarity in locating the chapters in this collection. Bearing in mind that language itself is inevitably contested and subject to contextual determination, we might establish a number of conceptual issues that should prove useful to those wishing to work productively within the visual field. The following brief discussion has accented the operational and methodological implications of these conceptual tools.

The Visual

The visual (usually appearing in quotation marks as 'the visual') is the most generic term designating the entire multifaceted field of visual experience. Like the word 'culture', references to the visual, 'visual field/s' and visual experience are in one sense completely ordinary. If we denaturalize and historicize the concept of perception we generate the category of 'seeing' or, more simply, *visuality*. Visuality, then, refers to the presence and workings of image-mediated phenomenon operating in the organization of human experience. Today the field of vision would include the arts, the creative work of the media and the built environments—or as sociologists might say 'art-worlds', 'media-worlds' and 'architectural worlds'. But it would also include everyday or vernacular visual cultures—both mass popular culture and the routine organization of mundane ecologies for different societies and cultures, the spatiotemporal systems of domestic arrangements, the unnoticed visual spaces of everyday social interaction, the reconfiguration of urban space and the social processes this facilitates. Until quite recently the 'seeing' and analysis of the spatiotemporal structuring of quotidian life as a serious domain of research was all-but-nonexistent. Today we see the outline forms of more robust institutional theory and research focused upon the cultural practices that mediate everyday life and social space (Massey 1984, 1994, 2005; Rose 1993; Smith 1987; Sheringham 2006; Soja 1989, 1996).

To inhabit a culture is to belong to its orderings of visual space, its structuring of environments and meaningful sites as contexts of action and interaction. As with the

performances of routine conversation, fluency in these spatial domains is assessed imma-nently in terms of the operative capacities to negotiate these 'subworlds' and universes of meaning. In the activities of daily life praxis takes priority over theory. We move through different 'provinces' of social space. We listen to music, we are surrounded by images, we experience the virtual worlds of digital culture at particular times and in specific places. To function competently any society typically requires individuals to internal-ize the dominant audiovisual order as a taken-for-granted *field of action*. Individuals are 'socialized' into prescribed identities and roles 'tuned' to these spatiotemporal singulari-ties. In this way children engage in social activities and visual practices before they are capable of formulating anything like a theory or meta-theory of those activities. Visual competences—like linguistic competences—are acquired without deliberate thought or reflection. Here the concept 'field' also marks the everyday invisibility of routinized practices of seeing and identity. Visual worlds—think of domestic artefacts, public space and architectural structures—are, so to speak, constantly 'in play' as the vital horizon of identity-formations in ordinary life. But like many of the practices of everyday life the horizon of visuality is typically taken for granted. The complex origins and struc-turation of institutional space is ignored as an analytic concern. Institutional sites are encountered at the level of 'the lived' rather than 'the reflected' (thus the everydayness of visual perception remains silent about its underlying neurological, biological and psy-chological mechanisms). What we call 'the visual', then, signifies the vast and typically unremarked phenomenal orderings that configure and accompany every individual and social activity. If we can supplement traditional aesthetics focused primarily upon the analysis and evaluation of 'fine art'[6], the visual turn today discloses a remarkable field of everyday aesthetic concerns, singular judgements and practical experiences. Once we overcome the traditional condescension towards the everyday we reveal the unexplored landscapes of everyday aesthetics (Saito 2007). We reclaim the *aesthetics of everyday life* but only on the condition that we return what is called 'art' to the wider community, to an enlarged horizon of subjects and their diverse concerns, although not at the expense of types of experience and 'values' traditionally nurtured by the arts.

Visuality

The complex institutions of visuality come into focus when the unnoticed realms of the visual are seen as problematic or extraordinary. What is striking here, and what matters, is what we might call 'invisible visibility', that combination of the utterly obvious—on which our capacity to live a life necessarily depends—and the radical elusiveness of everyday life. In this context 'institution' is shorthand for the organized articulations of social practices and their sustaining material resources, personnel and interactional processes. In historical terms institutions of visuality have been mediated by relations and representations of class, gender, age, ethnicity and 'race' (here again we return to the theme of identity formations as a central focus of gender theory). Or, even more directly, by the transformative effect of such new visual technologies as photography, cinema and digitalized optics. Once this 'alienation effect' is set into motion we begin to notice the remarkable unremarkableness

of ordinary perception and visual practices. On a broader historical scale, the social organization of seeing is transformed into a problem, a cultural and historical puzzle: how do different cultures and subcultures organize and envision their worlds?, why did these societies come to view the world in these ways?, how do different subcultures envision everyday life, create art and interpret the visible?, how do we see the world?. Everyday practices of seeing—including the making of artefacts, visible signs and artworks—can then be revealed as 'anthropologically' strange and research-worthy.

Asking historical questions about institutional contexts functions like an ethnomethodological 'breaching experiment' enabling the analyst to appreciate the diverse and multifarious involvements human beings have with the visual surface in all their remarkable singularity and concreteness. Of course major advances in science and, especially, in the neurobiology of vision and cognitive processes has historically been decisive in this 'problematization' (indeed one of the earliest transdisciplinary sources of inquiry into the dynamics of vision is the experimental work of the physiologist Hermann von Helmholz (1821–94)). Even earlier we might mention the impact of microscopy in the work of the English scientist Robert Hooke (*Micrographia*, 1665) as an exemplary episode in the emergence of modern forms of descriptive 'seeing'. In terms of its influence, Hooke's work remained a paradigm case of the power of rigorous observation and descriptive imagery in early modern science. Many other examples of the transformative impact of optical media and instrumentation might be cited (Kittler 2009).

By approaching vernacular perception as problematic we experience a sudden *détournement*, a vertigo of disorientation and, hopefully, wonder (again, we might mention the reception of Hooke's *Micrographia* that more or less established the authority of the Royal Society and physical research in seventeenth-century Britain). What was previously an unnoticed resource—the visual field—now turns into a topic of thought and inquiry. Through the researches of a range of new sciences the familiar has been relativized and assumes the character of unfamiliarity, the ordinary assumes the appearance of the extraordinary. And, of course, this 'defamiliarizing' operation can take many forms and result in different 'seeings' (we should recall that like modern science one of the functions of artworks is to perform this 'transfiguration of the commonplace' (Danto 1981) by reordering our taken-for-granted assumptions and perceptions of the world).

We can also make analogous claims for the phenomenological tradition originating in the writings of Edmund Husserl and Martin Heidegger and the sociological traditions of ethnomethodology and reflexive social inquiry (Blum 1974; Garfinkel 1968; Sandywell et al. 1975). The historical predecessor of this kind of *aesthetic distanciation* that creates new techniques of observation and new forms of knowledge is the recurrent appearance of the carnivalesque and ludic episodes that turned everyday life 'upside down' (Bakhtin 1968). By means of such symbolic reversals we are, in Walter Benjamin's terminology, 'shocked' into new insights and profane illuminations (Benjamin 1969; also Benjamin 2008; cf. Bryson 2004; Foster 1987). In different ways and using different media the history of modern science and modern art is a continuous record of such transformative shocks to commonsense beliefs and assumptions. Any kind of critical theory of vision, social space or society presupposes some kind of operative

defamiliarization (in recent years these operative strategies have sheltered under the general rubric of 'postmodernism').

When visual experience is transformed into an explicit topic of inquiry the term 'visuality' can function both as a placeholder for the phenomenological qualities of seeing and visual phenomena more generally (qualities that tend to get occluded when expressed in the visual predicates that enter ordinary language and everyday judgements about visual experience) and, more analytically, as a concept that emphasizes the craft, techniques and processes of seeing (expressed more directly, the *practices of seeing* available to a given community, society or whole culture). The radical extension and transformation of practices of looking is, of course, one of the major functions of new art forms, new sciences and visual technologies (Crary 1990). The genealogy of photography reveals a reciprocal field that enfolds the discourse of science and photographic science (Wilder 2009). An analogous formation operates in the science/technology/cinematic constellation (Cartwright 1995). The coming of cinematic technologies not only created new forms of knowledge and expertise configured around cinematic art (set design, art direction, montage, special effects, colour technology, editing, film processing, management and distribution, image storage and archiving, film music and so on), but also revolutionized scientific medicine and therapeutic observation. For example those professionally concerned with the origins, structure and dynamics of visuality could assume a more 'disengaged', reflective and analytic attitude towards the visual phenomena (again photography's and film's complex and creative relationship with the conduct of modern scientific research is paradigmatic of these emergent configurations). Rather than 'living in' visual experience we experience estrangement and adopt an investigative orientation towards the conditions, mechanisms and structures of visual life.

Habituated forms of perception and commonsense assumptions are bracketed by the virtual spaces of screen imagery. Through the magical zones created by visual technologies we stop and wonder and in the space of this astonishment ask questions about previously hidden phenomenal orders. What appeared solid and universal now appears mutable and relative. Through such 'shocks' the visuality of everyday life is transformed into an analytical, scientific, aesthetic and reflexive topic (cf. Jacobsen 2009; Merleau-Ponty 1962; Onians 2007; Johnstone 2008; Saito 2007; Sheringham 2006). The invisible is made visible and we turn to the 'showing' of seeing (Mitchell 2002). This 'bracketing' of the visual field as a taken-for-granted attitude enables the inquirer to 'see that even something as broad as the image does not exhaust the field of visuality; that visual studies is not the same thing as image studies, and that the study of the visual image is just one component of the larger field' (Mitchell 2002: 178–9).

Visibilization

Visibilization designates the social and material conditions, machineries and processes that make different modalities of visuality possible. Research into social visibilization is particularly concerned with the activities, techniques and performative status of seeing, spectatorship and the technological expansions of visual experience through optical

media. As an analytical theme the concept of visibilization is inseparable from the so-ciological question as to who imagines, designs and transforms visual ideas and image 'blueprints' into real works, artefacts and technological apparatuses. Who is licensed to produce visibilizations as a routine operation of particular social activities and organi-zations (who has the responsibility and sanctionable power to reframe social objects, reconfigure categories of objects and process the products of visibilization)? Who is empowered to reproduce (or to contest) the dominant ways of seeing? In general we as-sume that powerful groups and institutions in a society prescribe the forms of empirical visibility—sites of vision—along with the operative practices of the wider culture. We also assume that every form of social interaction presupposes some type of observational scene (involving prototypes of actual or virtual surveillance). The simple fact of seeing others turns out to involve a complex set of constructive procedures and interpretive 'work'. Even ghosts require a spectral stage. Individuals and groups who control a so-ciety's 'visibility machines' also control the 'scenes of appearance' which can be linked to surveillance strategies, discourses and the mobilization of socio-symbolic power. But once in existence such scenarios constrain the kinds of interaction they facilitate. As Mitchell rightly observes, visual culture 'is the visual construction of the social, not just the social construction of vision' (2002: 170).

Mitchell's chiastic inversion becomes self-referential when we realize that every model of knowledge and every programme of education is itself a kind of seeing. The theoretician's ways of 'seeing vision'—by, for example asking after the visual construc-tion of the social—is itself a suitable topic for historical analysis. Cultural capital be-comes transformative when it is linked up to social apparatuses and 'vision machines' just as a society actualizes its values only when these are translated into spectacles and scenes of normative inscription. From this perspective a society is a grid of visual net-works composed—in Foucault's idiom—of normalized sites and heterotopias. Today these 'relations', 'link-ups' and 'externalizations' are carried out in ways that relate local cultures to events on a truly global scale.

But 'visibilization' may also be extended to the particular work of singular arts and cul-tural forms—the specialized forms of experience, subjective intentionalities and dialogical possibilities made possible by the available machineries of visual experience and practices of looking (Sturken and Cartwright 2001). It should also be extended to practices that contest and resist the dominant forms of visualization (Haraway 1991). We need to be reminded that subversive images, just like critical verbal acts, are potentially dangerous phenomena that can have serious implications for the wider social and political order. The story of modernist art and music is littered with such transgressive interventions. The iconic instance of Osip Mandelstam's fateful 'Ode to Stalin' might be taken as an object lesson in the dangerous consequences of audiovisual intervention (Mandelstam 2003).

Visual Technologies

Visual technologies refer to the apparatuses and mechanisms that provide the conditions of the possibility of visibilization/s (ranging from the 'biological apparatus' of neural

networks to the technological apparatuses that extend and transform human perception). With the transition to a global social order we move from an age of 'mechanical reproduction' to an age of 'electronic' and 'digital reproduction'. The shift from analogue technologies like lithographic reproduction and emulsion-based photography to digital technologies is one of the major changes that has revolutionized the rules governing the visual field. In general the focus upon the 'machineries' of visibilization opens new paths into the traditional research practices of art historians and art critics (cf. Onians 2007). We might cite recent research on the historical uses of the *camera obscura*, linear perspective techniques, photographic media, multimedia digital technology and the like. In general such apparatuses are 'composed of lines of visibility, utterances, lines of force, lines of subjectivation, lines of cracking, breaking and ruptures that all intertwine and mix together and where some augment the others or elicit others through variations and even mutations of the assemblage' (Deleuze, 'What Is a *Dispositif*?' (1989), in Deleuze 2007: 347).

Visibility Machines

Visibility (or aesthetic) machines are specific instruments and apparatuses that generate—or facilitate the generation of—visible displays, sites and scenes of optical interpretation:

> Visibility [Deleuze is discussing Foucault's analyses of visibilization processes] does not refer to a general light that would illuminate pre-existing objects; it is made up of lines of light that form variable figures inseparable from an apparatus. Each apparatus has its regimen of light, the way it falls, softens and spreads, distributing the visible and the invisible, generating or eliminating an object, which cannot exist without it. This is not only true of painting but of architecture as well: the 'prison apparatus' as an optical machine for seeing without being seen. If there is a historicity of apparatuses, it is the history of regimes of light but also of regimes of utterances. (Deleuze, 'What Is a *Dispositif*?' (1989), in Deleuze 2007: 344)

Aesthetic machines are artefacts, devices, instruments, apparatuses and technologies which extend (and in some cases transform) human awareness, perception and sensual consciousness through visual simulacra: from older and no less wonderful technology, like damp, dimly lit cave walls (Lascaux to Plato), a piece of paper and a pencil, the camera obscura, through to more recent light machines and artificial technical sensoria (magnifying lenses, spectacles, magic-lanterns, dioramas, the telescope, microscopes, cameras, x-ray technology (radiography), body scanners (Magnetic-Resonance Imaging), writing machines, lasers, magnetic resonators, televisual technologies, etc.), cognitive machines, recording machines, artificial intelligence machines, prosthetic devices, telegraph, typewriters, maps and so on. The transformative power of such machinery has frequently been described in 'magical' or 'dream-like' terms (photography capturing the ghosts of the past, cinema as an oneiric medium, etc.). While the idea has Darwinian

precedents and, more specifically, origins in the notebooks of his contemporary, Charles Babbage (1801–71), the model of machinic production might be considered as a generalization of Charles Baudelaire's thought-provoking maxim: 'A painting is a machine'. Postmodernists have taken the theme to heart in their notions of the *machine à écriture* and *vision machine* (cf. Virilio 1989, 1994). Paintings are *image* machines. Maps are *power* machines. Photography is an *evidence machine*. Cinema is a *dream machine*. This is the same idiom that permitted Walter Benjamin's well-known homology: 'The camera introduces us to unconscious optics as does psychoanalysis to unconscious impulses' ((1936) 1992: 230; cf. Sontag, 'Melancholy Objects', in 2002). Today we would invert Baudelaire's phrase in describing the digital machineries of telecommunications: 'Digital machines are painting the world'. Through digitization we revolutionize the relationship between the visible and the invisible, the real and the virtual, actuality and dream, self and other. Photography, as Susan Sontag observed, 'though not an art form in itself, has the peculiar capacity to turn all its subjects into works of art . . . Now all art aspires to the condition of photography' (2002: 149).

We are entirely comfortable with the synesthesia that enables us to 'see' with sound (as in ultrasound technologies) or to visualize the workings of the brain through magnetic waves. Today the conduct of modern science has become inseparable from the revelatory work of such prosthetic instruments. If the telescope is the paradigmatic aesthetic machine of the seventeenth century, perhaps the camera (including the more advanced machines of cinematography) will one day be considered as the paradigmatic aesthetic machine of the nineteenth century (Benjamin had already formulated the thesis in relation to photography and cinema in the 1930s) and the laser or digital light machine as the aesthetic machine of the twentieth century. Speaking generically, we might respecify the vast and heterogeneous universes of material culture, technology and telecommunications as not only information media, but as 'embodiments of mind' (cf. McCulloch 1989), extensions of human praxis (McLuhan 1989, 1994), and 'tools of living' (the eye itself being nature's great contribution to the development of infinitely extended aesthetic machinery). Thus the digital apparatuses of contemporary advertising, popular culture, film, architecture and the designed environment are all intensive domains of materialized aesthetics based upon the transformative powers of visual technology (an expanded concept of technological embodiment which demands the creation of a new cultural science of *Prosthetics*). Such a prosthetics would have as its central theme the sociocultural construction of embodied subjectivities and objectivities and their social, ethical and political consequences.

Visual Subjectivation/Objectivation

Subjectivation and objectivation refer to the processes and practices that construct 'subjectivities' and 'objectivities' in different historical regimes and social orders. Speaking of the library as a visibility machine, Alberto Manguel reflects: 'Entering a library, I am always struck by the way in which a certain vision of the world is imposed upon the reader through its categories and its order' (2008: 47). A physical organization like a

library or museum prescribes ways of seeing and acting upon its users. It is not merely a physical space but a grammar of social interaction. It is, in this sense, an image machine. But from this perspective all powerful social organizations and institutions create visual domains in which certain forms of selfhood are prescribed or proscribed.

The visual turn is thus also a turn towards a renewed interest in the self and conceptions of selfhood and 'modes of spectatorship' as these are correlated to the changing organizations of visual experience within larger political constellations. A library is thus both a mirror of the universe and a technology of the self. The central contention here is that different techniques and apparatuses of visibilization give rise to different forms of space, subjective orientation and self-experience. Just as texts always entail an 'implied reader' so visual artefacts always presume an 'implied spectator' (the library, in Manguel's sense, would project an 'implied browser', a *flâneur/flâneuse* both following and resisting the rules of its categorical systems). And these projected 'spectators/readers/listeners' vary in time and space. A melancholic eye thus elicits a melancholic glance from the objects in its visual field. As Irit Rogoff observes: 'Spectatorship as an investigative field understands that what the eye purportedly "sees" is dictated to it by an entire set of beliefs and desires and by a set of coded languages and generic apparatuses' (1998: 22). The 'spaces of seeing', 'practices of looking', and 'forms of selfhood' they facilitate are themselves products of particular modes of production (Benjamin (1936) 1992, 2008), socioeconomic formations of lived space and time (Gregory 1994; Lefebvre 1991; Soja 1989, 1996), gendered ways of seeing (Berger 1972; Haraway 1991; Pollock 1988) and 'scopic regimes' (Jay 1993). Acts of perception are both routine extensions and everyday expressions of a culture's obsessions and sensibilities.

As a general heuristic assumption we would hypothesize a complex relationship or internal 'dialectic' operating between discursive formations, visual structures and embodied forms of selfhood. The empirical exploration of the grammars of different visual regimes and subcultures—what Martin Jay has called the contested terrain of *scopic regimes*—opens paths to a more explicitly social and historical analysis of past and present visual practices and to the forms of material embodiment and differential selfhood these facilitate. Somewhat surprisingly the precise empirical analysis of the lived experiences of different visual life-worlds and historical cultures—the vast panorama of different forms of visual consciousness—is of quite recent provenance.

Visual Engagement

Visual engagement refers to the embodied encounters, dialogical transactions and interpretative adventures of visual life. Here the one-dimensional and monological concept of 'subjective constitution' to be found in modernist and postmodernist theory needs to be radically modified to accommodate the active appropriations of visual experience by self-reflective, interactive, embodied human agents. The contingencies of spectatorship and interpretation mean that what has been called the act of seeing is rarely passive and disinterested. Rather, practices of seeing are typically active and engaged (for example as the virtual sites of desire and pleasure located in different class, gender

and 'race'-based relationships). The term 'spectator' has unfortunate connotations that are themselves rooted in older positivist and reflectionist views of subjects encountering objects (for example where the traditional concept of the museum and of museum studies was premised on spectatorship, of disengaged subjects viewing curious artefacts and objects). Where older theoretical frameworks, particularly those seeking to exhibit quasi-scientific rigour, from Structural Marxism, Semiotics, Critical Theory, and early Feminism, postulated a relatively fixed mode of passive spectatorship, the new theorizations openly admit heterogeneity and multiplicity in modes of perception and correlated forms of subjectivity.[7]

From this perspective every modality of lived experience—perception, memory, anticipation, interpretation, judgement and so forth—is differentially embodied and historically contingent. A 'full-bodied' social phenomenology based on these insights would be one where the social forms of memory, perception, action and interaction are recovered together and integrated into a more encompassing account of incarnate awareness and situated knowledge drawn upon by individuals and collectivities in projects of self-understanding (if space permitted we would explore the implications of these constellations for concepts of memory, identity and cultural transmission). Where earlier visual research methodologies posited a passive 'spectator' and 'dominated' object, we now see realms of corporeal agency interwoven with complex vectors of affectivity and pleasure. The 'sensory-turn' in general epistemology entails a renewed focus upon the materiality and corporeality of vision.

A more existential and performative concept of 'material encounter' thus helps to transform the passive 'object' of visual experience into an active facilitator of concrete kinaesthetic practices and meanings. While no doubt spectators will continue to 'gaze' and 'watch', while museums and art galleries will predominantly remain archives of aesthetic objects, the possible modalities of empirical visuality are much more interactive, diverse and complex. Acts of seeing are precisely *actions*, modes of praxis bordered by contingencies and unanticipated consequences. Viewing 'seeing' in isolation from social action and interaction is precisely an 'abstraction' from the contexts of lived experience. In reality perception is interwoven with active world orientations, moral and ideological discourses. From this perspective every act of seeing—including the acts of seeing we call 'science' and 'knowledge'—is shot through with gendered, racialized and other cultural mediations. Thus the pictorial artwork, the photograph and cinematic image now appear more like grenades of possible meanings and interpretative openings upon possible worlds rather than inert planes of colours, lines and textures. By reactivating the gendered and racialized structures of ways of seeing we can return to the work of art history and art practice with renewed eyes.

We might then reclaim the polysemic word 'art' as a portmanteau term for every kind of act or instrument that engenders reflexive awareness of being in the world. What is called 'art' is not simply a passive medium of class ideologies or gendered power. It is more deeply an articulation and revelation of historical social relations. Moreover, as seeing is thoroughly socialized every act of seeing is acquired in relation to the wider fabric of education and learning in a particular culture. To see 'art' as an embodiment

of knowledge and learning provides new dialogues with traditional art history. We see things together; we 'read' the world by applying common interpretive repertoires. We view the world and talk about the world in shared idioms. Knowledge is always an anticipated outcome of dialogical pacts. This relational and dialogical reorientation also leads to systematic reappraisals of the diverse functions of older representational artworks, painting traditions, icon factories in the late medieval period, modes of representation in the Middle Ages, Renaissance painting schools, Enlightenment visual cultures, modern regimes of visual replication, modern science, museology, cinematic *flânerie* and so on. Art history, the epic story of modernism, the canonical works of the European avant-gardes become candidates for reappropriation in sociocultural terms as particular organs of societal reflexivity.

This paradigm shift towards models of active reception and processes of interpretative self-definition might be considered as part of a more radical integration of phenomenological hermeneutics and gendered inquiry that informs the reflexive turn in contemporary intellectual life.

Visual Performance

Of course, every such 'zone of encounter' presupposes a medium of material images and, typically, contested complexes of image repertoires and discourses. Visual performance indexes the concrete enactments of visual forms and practices as a dialogical work of situated, collaborative, signifying performances. Sensitized by the concept of *performance* we again underline the radical *sociality* of visual media. We now see that from its oldest origins 'art' has been a mode of *social engagement*, an *interrogation* rather than a *reflection* of the real. In general we not only *do things* with visual media, we *do things with others* to realize particular ends (and such acts and values are invariably conflictual). From the perspective of praxis, visible artefacts and artworks begin to assume a much more complex provenance and diverse functionality in the genesis of meaning. Recall, for example, that the Romantic image of the isolated painter is a product of an essentially modern conception of art and in no sense reflects the practices of earlier traditions of painting where the craft involved cooperative performances involving a number of different skilled practitioners and artisanal conventions. The 'finished product' was thus a kind of palimpsest of laminated inscriptions, each layer compiled like a trace of untrained and trained competences (art historians recognize this 'layering' by using the designation 'from the school of x'—that is that certain 'Titians' are actually in part the work of Titian's apprentices and collaborators).

It might be more fruitful to adopt the idea of collective inscription as a general model of art and culture. The emphasis on the trans-subjective dimensions of cultural production and interpretation restores the interplay between image, verbal media and active appropriations across the whole field of situated social interaction. By underlining the situated social character of visual 'events' we also underline the historical specifics of occasioned encounters—the partial and fractured transactions human beings have with visual objects and artefacts that are already framed and colonized by powerful material

systems and normative constraints. We see, in Michael Baxandall's terms, with 'period eyes' (1988). Perhaps every society produces the eyes it deserves. A culture insulated against movement and travel produces a static and timeless sense of things. Historically, aspects of the world seen from female standpoints have differed significantly from the world viewed through male eyes. Cultures that proscribe figural representation find compensatory release in worlds of labyrinthine geometrical designs and verbal imagery (Haldon and Brubaker 2010). The world seen from a moving train is radically different from the world viewed on foot (Schivelbusch 1986; Kern 1993).

In phenomenological terms, the zones of engagement mentioned above are cultural envelopes of embodied intentionality that are normatively linked with their experiential 'correlates' (for a phenomenology of lived-place and landscape in these visceral terms see Charles Tilley's *The Phenomenology of Landscape* (1994), Edward Relph's *Place and Placelessness* (1976) and Jeff Malpas's *Place and Experience* (1999)).

Visible Cultures/Cultures of Visibility

If Visual Studies defines its topic as the investigation of visual cultural practices we should immediately warn that there is no homogeneous 'object' indexed by the phrase 'visual culture'. What we see are always visual *cultures*. By highlighting the plural phrase 'cultures of visibility' we draw attention to the importance of investigating sociocultural differences and normative social multiplicities (these pluralized terms underlining heterogeneity, complexity, conflict and 'polyphony' as normal features of the ongoing particularities of cultural life).

The pluralized and modal concept of vision also reminds analysts to respect the singularity of different practices, technologies and media. Thus we should resist collapsing one medium into another or 'flattening' the diverse practices of seeing by translating them into some monological concept or theory. One example is the importance of defending the singularity of visual art and its resistance to facile appropriation and theoretical translation. It is the very ambivalence and singular 'spaceless spatiality'—the *punctum*—of the artwork that facilitates a range of determinate and indeterminate visual experiences and discourses. This in essence is the phenomenological teaching that what survives every reductive translation inhabits the sphere of singularity. In this respect we can learn a great deal from some of the more reflective practices of traditional art history with their intensive focus upon the material density and performative characteristics of singular artefacts and artworks.

Here we have in mind the 'immanent methodology' of approaches to the artwork where the task is not to describe the visual artefact or performance from afar—codifying and mapping the work from a high-altitude—but to 'enter into', to open a dialogue, to surrender to and be contested by the complexity, ambiguity and ambivalent experiences released by the work in question. From this perspective, artworks are provocations and interrogations of the world before they are reflections or representations of pre-formed experience. Before we search for meanings and construct interpretations we have to surrender to the disturbing 'embodied presence' of the artwork

and related aesthetic forms (Roland Barthes, for example identifies singularity as the essential feature of the photograph—suggesting a definition of photographic art as 'the impossible science of the unique being' (2000: 71)). In this context we also underline the importance of rethinking the *materiality* of art practices—the sheer *haecceity* of painterly works, for example—as a way of resisting and contesting dominant ways of reading the tradition of art history. Ian Heywood's reflections on the cubist moment in modern art in this *Handbook* analyses the materiality of early modernist art and suggests other ways of addressing the standard story of modernism in the arts. Merleau-Ponty's late reflections on the painterly work of Paul Cézanne interfaces with his own version of phenomenological thought to create an alternative form of embodied and participatory phenomenology (see Merleau-Ponty, *The Visible and the Invisible* (1968) and *The World of Perception* (2008)). An analogous appreciation of the material singularity of artworks can be found in the work of Theodor Adorno and the kind of close reading practices that Walter Benjamin undertook in his *Arcades* project (Benjamin 1999b, 2008; cf. Buck-Morss 1989). A recent exponent of a similarly image-pervaded literary art is the novelist and critic W. G. Sebald (1944–2001; the interplay of discourse and photography in Sebald's fictions is a central theme in Carolin Duttlinger's work (2006)).

The general 'ethnographic' task of entering into the occasioned particularity of a social practice or organization with the aim of recovering the meanings that practice has for participants is a commonplace in certain forms of reflexive sociology (for example de Certeau (1998) and Sandywell (1996)—the theme is also recovered and defended in Gillian Rose's chapter in the *Handbook*). For related empirical studies of the differential work of 'visibility machines' see the collection edited by Lynne Cooke and Peter Wollen, *Visual Display: Culture beyond Appearances* (1995). See also the references under 'Technoculture and visual technology' in the bibliographical chapter by Barry Sandywell in this volume. Sandywell's 'Seven Theses on Visual Culture' in this volume addresses some of these theoretical concerns.

THE VISUAL TURN?

> Reality has always been interpreted through the reports given by images; and philosophers since Plato have tried to loosen our dependence on images by evoking the standard of an image-free way of apprehending the real. (Sontag 2002: 153)

Sontag's neat formulation needs immediate qualification. Plato's work is of course as full of images and ideas that depend on vision as it is of compelling theatre, narrative and myth, the 'allegory of the cave' being the most famous example. Much the same could be said of the presence of visual ideas in Descartes, Hegel, Nietzsche, Wittgenstein, Husserl or Heidegger. Rather than the fact that certain key ideas gain explanatory and metaphoric power from vision, visual images are critical to their teaching. So while the prominence of the visual in older philosophy and theory cannot be denied, are we being unduly optimistic in anticipating a new phase in theorizing and empirical research in

the ever-expanding field of visual studies? Certainly there are signs that rigidities and assumptions in the way of this change are breaking down. What will emerge is partially historically contingent, and it is important to heed the warnings of Stafford (1996) and others about growing visual illiteracy, ironically amid a culture suffused by the image, but also one taking itself to be somehow naturally fluent and at ease with the visual. While some have spoken of a 'pictorial' or 'iconic' turn by analogy with what Richard Rorty famously called the 'linguistic turn' in modern philosophy, the general strategy advocated here is to move away from linguistic and text-based models centred upon the linguistic signifier towards image-based semiotic and intertextual models of visual experience and image life.[8]

Once we accept that every 'reality' or 'form of life' constructed by human beings is image-based we have a new incentive to focus intensively upon the ontology and sociology of image formations.

There are clearly dangers in thinking that this 'pictorial' turn has suddenly discovered visual experience and perceptual life. This is clearly not the case as even the briefest encounter with the writings of Husserl, Heidegger, Merleau-Ponty and others in the phenomenological tradition will confirm. Once we begin to 'read' the tradition of Western philosophy for these themes we find that visuality has been a constant concern from Plato and Aristotle down to Descartes, Kant, Hegel and beyond. Indeed we find that in many of the canonical writings of this tradition and against the general logocentrism of other perspectives, visual experience—particularly everyday perception—has been recurrently used as the paradigmatic model for other forms of human intentionality. Husserlian phenomenology is in some respects the culmination of a deep-rooted European ocularcentrism. Writers in the Marxist tradition such as Theodor Adorno, Walter Benjamin and Ernst Bloch were even more intensively concerned with the modern transformations of the visual field as were such modern art historians as Erwin Panofsky, Heinrich Wölfflin and E. H. Gombrich.[9] The self-interpretation of modernity as an age of 'enlightenment' and self-reflection betrays the same obsessive fascination with things visual. The institutional genealogy of Art History as a discipline in the eighteenth century and 'image science' and 'photographic science' in the nineteenth century offer further examples of the fascination with the image in European intellectual life. This 'specular' legacy lives on in the hegemonic grip of images and ideas centred upon *theoria*, *mimesis* and *representation* that continue to organize everyday life and intellectual culture to the present day (Sandywell 1996, 2011; cf. McNeill 1999; Thrift 2007). Yet while notions of seeing have been powerfully active in much of Western thought, a proposition denoted by the term 'occularcentrism', it is important to avoid a simplistic connecting of 'visual thinking' to the mechanics of ideology and the politics of domination. Careening from obliviousness to the visual to reflex suspicion or condemning it out of hand is precisely what a new visual culture studies would want to avoid.

In the many justified attempts to escape the framework of logocentric perspectives and verbal paradigms there is a danger of abstracting 'the visual' from larger patterns of human experience, of isolating acts of seeing from the complex range of sensory experience that is a normal condition for human beings and human praxis. Against this

tendency we emphasize that such distinctions are to be seen primarily in *analytical* and *strategic* terms. In reality visuality cannot be readily separated from other sensory and affective modalities and, as many of the chapters in this collection argue, we should begin thinking of the human sensorium in developmental, multidimensional and multisensorial terms (a rethinking of basic epistemological categories that transform what we understand by terms like 'knowledge' and 'understanding'). However, it is important not to neglect an important legacy of cultural and artistic forms that have been concerned to explore the senses in relative, but certainly never complete, isolation. A key topic for visual studies must be the particular but various modes of 'visual thinking' present in such forms.

Where we have traditionally carved up creative arts into pictorial arts, literature and music, today it is the crossings and 'synaesthesia' within and between these domains that have stimulated reflection and rethinking; the theme of synaesthesia is particularly evident in film studies where the concern for 'cinesthesia' and 'cinesthetic form' is relatively well developed, but is also present in reflections on the body and metaphor in painting (Wollheim 1987: 305–56). The currently popular idea of 'mixed media' and 'multimedia' experience woven from sound-image-text ensembles is in fact prefigured by the multisensorial nature of human intelligence in its endless quest to 'translate' the visual into the verbal and the verbal into the visual (we already recognize this interplay of 'showing' and 'telling' in the commonplace idea of 'visual music'—for example in the visually rich orchestration of Elgar, Mahler or Shostakovich or the visuality of the novel genre as a hybrid art of 'telling-showing'). Recent research on the neurophysiology of 'mirror neurons' has even suggested that the evolution of the human cortex has become hard-wired to carry out these intersubjective 'translations' between verbal and the visual experience. While recent research in neuroscience has revealed extraordinary sensory specialization, thus presenting the problem of how connections and networks operate, we might speculate that the networked multimodal organization of the brain is reflected (at several ontological removes) by the multimodal or synaesthetic functioning of perception. From contemporary neuroscience and the basic phenomenology of the human sensorium to the higher reaches of aesthetic practice and technoscience we increasingly find that we are dealing with complex *experimental* intersections and constellations of synaesthetic experience involving tactile, auditory, olfactory, haptic as well as visual information.

It becomes clear that the binary contrast between 'showing' and 'telling' is inadequate and misleading and that an adequate philosophy of the visual needs to deconstruct this opposition and explore spheres of experience where showing and telling—image and text—interact in productive ways. Perhaps even the most elementary human competences are always already experimental, dialogical and polyphonic. In 1948 Merleau-Ponty was already speaking of sensory qualities as emerging from 'the dialogue between me as an embodied subject and the external object which bears this quality' (2008: 47). As an experiential adventure such 'dialogues' can never be grasped as a pure transmission of information nor as a purely abstract verbal 'event'. To think otherwise is to allow a disciplinary classification to shape the transformative possibilities of concrete experience.

Indeed mandatory disciplinary commitments to autonomy and purity remain abstract ideals in the face of such nomadic and hybridized experiences. As Shohat and Stam argue, the visual:

> never comes 'pure', it is always 'contaminated' by the work of other senses (hearing, touch, smell), touched by other texts and discourses, and imbricated in a whole series of apparatuses—the museum, the academy, the art world, the publishing industry, even the nation state—which govern the production, dissemination, and legitimation of artistic productions . . . The visual, we would argue, is 'languaged', just as language itself has a visual dimension . . . The visual is simply one point of entry, and a very strategic one at this historical moment, into a multidimensional world of intertextual dialogism. (1998: 45)

The problem here, 'at this historical moment' but with its roots deep in modernity, is that the abstraction and consequent power of the text then tends to dominate in many analyses of this synthesis. As the history of both pragmatic thought and Heideggerian hermeneutics has argued the simplest visible thing is already a dialogical complex, a *concretum* of sensory qualities, a node of affectivity and desire, a congealed history that opens out upon a genealogy of human practices and forms of embodiment (here the investigation of material culture in its dense historical materiality is a more instructive paradigm for the new visual research). From this perspective 'the visual' is an open totality of sensory histories (for synaesthesia and the interaction of the senses see Richard Cytowic 2002, 2003 and David Howes 2006). Above all we need to avoid the temptation to reify 'the visual' by abstracting visual forms and experiences from the complex ecological, cultural, technological, historical and political contexts of human experience. In this respect William Mitchell is correct in claiming that 'there are no visual media. All media are mixed media, with varying ratios of senses and sign-types' (2002: 170). This suggests the need for phenomenological sensitivity to and respect for such 'varying ratios', not their levelling in the name of textual analysis or mutlimedia technology.

Literary practices—diverse modalities of *telling*—are thus also profoundly visual. The classical narrative forms of the novel not only involve 'techniques like ekphrasis and description' but 'more subtle strategies of formal arrangement' that involve 'virtual or imaginative experiences of space and vision that are no less real for being indirectly conveyed through language' (Mitchell 2002: 174). This, again, is a lesson that we can learn from the embodied phenomenology of lived experience: 'We are rediscovering in every object a certain style of being that makes it a mirror of human modes of behaviour' (Merleau-Ponty 2008: 53–4). From the auspices of these critical conceptions of sensory experience we may say that the visual studies of the future must be strategically intermodal, intermedial, and intertextual.

Of course we are already unknowing victims of a dualist mythology in even opposing 'the visual' and 'the verbal', the 'realms' of the visible and the sayable, what can be seen and shown and what can be heard and read (recall that *ekphrasis* is an ancient trope that promised to translate visual images into verbal representations, iconic experience

into textual meanings). Historically this hybridization is encoded in Horace's maxim *ut pictura poiesis*. The idea of embracing the visual by mortgaging the verbal is a prime example of undialectical thinking. In fact all such 'ecphratic' reductions simply avoid the complex problems associated with the dialectical texture of everyday experience, perceptual interaction and social knowledge. The theme of the crossing of the poetic and the visual dates back to Greek antiquity: the saying that painting was silent poetry and poetry speaking painting is attributed to the poet Simonides (c. 556 BC–468 BC).

This type of uncritical reduction and ontological 'flattening'—itself a product of our spontaneous representational ideology—is particularly misleading in restricting 'the visual' to 'the pictorial' or thinking of visuality as purely a question of the production, transmission, dissemination and appropriation of images, as though the 'image universe' stood diametrically opposed to a nonvisual realm of verbal culture or discourse. To counter this kind of reification we commend the idea of an image-saturated universe, a world of everyday life relations organized by definite social 'imaginaries' and visual practices. Here it might be more useful to think of the construction of the real in terms of interacting networks of sensory information (in parenthesis we might note that even the term 'intertextual' is inappropriate by retaining its overtly verbal resonances when analysing the interplay between music, poetry, painting, sculpture and prose). The most insistent of such intermodal networks are those that interlace diegetic and optical forms (where words 'carry' images and images are saturated by verbal materials). Ancient Graeco-Roman art forms contain endless examples of this interplay of audiovisual forms (cf. Squire 2009). And, of course, this intermixing of verbal and visual ideologies continues to the present day. Modern commercial iconography, for example is pervaded by this complex form of interwoven semiotics.

Against the Platonic tradition of reflectionism that posited a derivative relationship between thing and image, image formations and image processing need to be viewed as transformations of being, modes of existence and historicity. Although we do not have the space to defend the thesis we would claim that the basic building-blocks of social worlds are images (or as we have elaborated in later chapters in this volume, *image networks*).

While we should avoid Cartesian dualism and resolutely refuse to compartmentalize the verbal and the visual, we accept that the analysis of words and language remain fundamental for every visual inquiry. To this end we adopt a strong version of the reflexivity thesis that claims that visual worlds are partially constituted by the ways in which we speak and verbally articulate those phenomena. This, of course, does not remove the complexity, opaqueness and ambiguity of visible displays. To borrow an older terminology, visual forms are always-already theory-laden. In the light of this thesis we postulate a complex dialectical relationship between image and text, invoking the syncretic idea of *image configurations* or *intersensoriality* as a more useful metaphor for research in this field (the latter notion interfacing with the recent rediscovery of corporeality and performativity in social and cultural theory). Thus while not privileging linguistic and textual paradigms we would nevertheless underline the importance of exploring the cultural functions of visual rhetorics and visual narratives—visual

stories—as reflexively constitutive of phenomenal domains. This places emphasis upon the dynamic—and often contradictory—*transactions* between the worlds created by narrative and the worlds created by visual imagery (as we have already noted, the tradition of the European novel is itself a dialectical archive of such visual worlds).

Sontag suggests that the powers of photography have in effect de-Platonized our understanding of reality, making it less and less plausible to reflect upon our experience according to the distinction between images and things, between copies and originals.

> It suited Plato's derogatory attitude toward images to liken them to shadows— transitory, minimally informative, immaterial, impotent co-presences of the real things which cast them. But the force of photographic images comes from their being material realities in their own right, richly informative deposits left in the wake of whatever emitted them, potent means for turning the tables on reality—for turning *it* into a shadow. Images are more real than anyone could have supposed. And just because they are an unlimited resource, one that cannot be exhausted by consumerist waste, there is all the more reason to apply the conservationist remedy. If there can be a better way for the real world to include the one of images, it will require an ecology not only of real things but of images as well (2002: 179–80).

This passage floats a common misreading of Plato, related to another frequent misconception, his alleged opposition to all forms of art. Plato's attitude to images could not be entirely 'derogatory' when he makes clear that the 'intellectual intuition' through which we approach the Ideas is itself a kind of seeing. It is important not to confuse the possibility of mis-seeing with a condemnation of images as such. However, Sontag's emphasis upon the material force of images and the 'dialectics of seeing', of course, echoes questions and themes that were first explicitly defined by critical thinkers like Walter Benjamin, semiologists such as Roland Barthes, and the psychoanalytic tradition that traces its lineage from Freud's metapsychology to Jacques Lacan. Benjamin's materialist hermeneutics in particular stressed the socially embedded character of visual artefacts ('The uniqueness of a work of art is inseparable from its being imbedded in the fabric of tradition' ((1936) 1992: 217)). Here social and contextual considerations are constitutive of the meaning and function of acts of perception and visual objectivities. In some of his early writings in semiology Barthes was already tracing the etymology of the word image to the root *imitari*—suggesting the profound mimetic, rhetorical and narrative implications of images in human experience (for example his 'Rhetorique de l'image' (1964)). Benjamin is also well known for arguing for the formative functions of imagery in human experience and in particularly what he calls the 'mimetic faculty' and the 'optical unconscious' revealed by new forms of technological mimesis (1999c: 511–12). Similar considerations led the Russian writer Mikhail Bakhtin to foreground the heteroglossial nature of human activities (suggesting an even broader conceptualization of a future 'dialogics of seeing').

On the plane of theory we would also necessarily have to critically reassess the rhetorical presuppositions and design of major theoretical frameworks as these have sought to articulate and delimit the field of visual culture in reflective and mimetic

terms (for example the classical neglect of visual experience within traditional Marxist and Marxian theorizing—despite their erstwhile origins in the philosophical writings of G.W.F. Hegel, one of whose major works was his *Aesthetics: Lectures on the Fine Arts*). Indeed, Frederick Beiser (2005) has recently underlined how passionately interested and hugely well informed Hegel was about the arts, including the visual and material art forms, far more so than the vast majority of philosophers and theorists.

Once we have abandoned misleading mirror-imagery and the simplistic idea that culture is a 'reflection' of a more substantial and 'real' infrastructure we can recognize that there is a thoroughgoing interaction between the ideal and the material, the visible and the sayable (or, as we might say, between the *rhetorics* of the visible and the sayable). Yet visual studies needs to bear in mind that the notion of a rhetoric of the visible might easily put the sayable back in the driving seat. Moreover, this dialectic is not unique to the 'higher realms' of visual art, criticism or philosophy. The interpenetration of visual rhetorics and visual 'phenomena' in fact implicates the widest spectrum of human competencies as these are found in everyday 'imaginings' and 'interpretations' of experience. There is, in other words, an immanent 'aesthetics of everyday life' embodied in large stretches of human endeavours. The recognition of 'significant form' and playful experiments with visible configurations may well turn out to be generic features across a range of human experiences. Evidence is accumulating that the evolution of the human brain and the emergence of 'mind' are co-implicated in dynamic forms of pattern recognition and synaesthetic consciousness. Here the constitutive 'dialogue' between the deep structures of human cognition, visuality and discursivity opens up a range of historical inquiries into the ways in which experience has been semiotically networked and narratively organized by past societies and cultures. Such narrative-mediated enquiries also introduce a more radical sense of historicity as a precondition for the new visual studies.[10]

In the light of these reflections we need to openly admit and explicitly address the diversity and variability of the ways in which 'the visual' has been approached, defined and thematized in traditional and contemporary scholarship. The basic conceptual structures of these theories have been dominated by linear, progressive and Eurocentric presuppositions. Thus rather than being neutral instruments some of our major conceptual resources are themselves organized as particular ways of seeing the world—and in an unconscious sense, ways of seeing the world through 'Western' eyes. In fact critical knowledge of the workings of these different 'visual rhetorics' and culturally specific 'ways of understanding' presupposes a comprehensive *critique* of many of the theoretical movements that have organized debates and research in the social sciences, humanities and philosophy over the past two or three decades. Here the changing fate of philosophical ideas and philosophical debates are themselves both topics and resources for a more transdisciplinary review of intellectual cultures. Precisely how such frameworks as Husserlian phenomenology, Heideggerian and Gadamerian hermeneutics, Wittgenstein-inspired Analytical Philosophy, Structuralism, Post-Structuralism, Psychoanalysis, Marxism and Critical Theory, Cultural Studies, Semiology, New Science Studies, Deconstruction, Gender Studies, Cultural Geography have entered into the fabric of intellectual debate and more general public concerns becomes an important focus of inquiry.

We should also emphasize that our 'cognitive maps' in general, and more particularly with regard to what we mean by 'visual culture' or 'the visual' are *constitutive* and not simply passively *reflective* of our practices and forms of life (hence the tendency within traditional visual studies to think of these conceptual frameworks and the methodologies and narratives they sustain less as creative acts and interventions and more as secure categorical grids to be 'applied' to visual culture). Against this we maintain that *how* we conceptualize visual culture is itself a topic of considerable interest to reflexive inquiry. By thinking in terms of secure 'frameworks', established 'fields', and neutral 'applications' we miss a fundamental reflexive opportunity—to engage in a genealogical inquiry into the particular origins of our own 'ways of seeing' and their entanglements in forms of power and ideology that can be dated in centuries if not millennia. New visual techniques may transform how we see and act in the world. Moreover, how we have *objectified* 'the' visual—how we have produced the concept of the visual—is itself a topic requiring extensive genealogical investigations.

Our alternative models of self-implicating 'networks', 'formations' and 'configurations' suggest more fluid, temporal and historical ways of proceeding in the study of visual experience. For the new visual studies issues of method, methodology and philosophical self-understanding are to be viewed as historically specific ways of interpretatively framing and delineating experience for particular interests and purposes. Each intervention and form of self-reflection (sociological, art-historical, philosophical, iconological and so forth) has its own specific locus within a socio-historical network of practices, institutions and material contexts. Such networks are typically open-ended and hybrid-like interactional formations. The traditional blindness towards social differences and historical hybridity in the very formation of our concepts and models is the first obstacle to be overcome in moving into more productive zones. Each is a network of discourse that must be forced to account for its own possibility. In this context we can identify with the 'polycentric' approach to visual culture advocated by Ella Shohat and Robert Stam:

> For us, art is born *between* individuals and communities and cultures in the process of dialogic interaction. Creation takes place not within the suffocating confines of Cartesian egos or even between discrete bounded cultures but rather between permeable, changing communities. (1998: 46)

The project of a more pragmatic, strategic and reflexive dialogics of seeing is transdisciplinary in opening up 'the visual field' to a range of 'others'. Our justified scepticism towards high-altitude theorizing and disciplinary definitions of 'objects' and 'fields' extends to some of the major theoretical traditions and serves to underline the fundamental importance of 'terms', 'words' and vocabularies of the visual in the development of what we mean by 'visuality' and 'visual culture' (hence the difficulties of securing a watertight separation between the discursive and the experiential). In reality the cognitive, discursive and the experiential fuse into one another like interweaving layers of information.[11] So it is important that the specificity of visual thinking deposited in

historical and contemporary art and material culture is disclosed and understood, not carelessly consigned to hastily drawn 'Cartesian egos' or 'bounded cultures'.

These cautionary observations have led us to emphasize the importance of developing more reflexive concepts and theoretical frameworks when approaching the 'universe of the image' (image networks, image repertoires, image creation, image morphology, image politics, image epistemology, ontology, axiology and so forth) but also prompt more comprehensive or synoptic ways of thinking that can address the realm of 'word-images' as coeval with the politics of images in contemporary society and culture (see Sandywell 2011). In the light of this reorientation we might consider Benjamin's chiastic formulation of a 'dialectical optic' governing the mutations of 'art' and 'art worlds' as a particular path towards a new cultural science of imagineering: 'as soon as the criterion of authenticity ceases to be applied to artistic production, the whole social function of art is revolutionized. Instead of being founded on ritual, it is based on a different practice: politics' (2008: 25). However, since Benjamin's time, there has emerged another, and more ominous sense of 'imagineering', that is the explicit use of the social and natural and sciences—including neuroscience—combined with information technology and 'creativity', to design and market optimally effective commodities for a capitalist society of the spectacle. As Stafford has observed:

> The convergence of advanced information technology with cognitive science is, I fear, sidelining the effortful and deliberative aspects of thinking. One fall-out of the merger between automaticity and high-speed processing is that the making of cognitive meaning—emerging from acts of connecting of which we are *aware*—tends to get lost. (2007: 191)

There is growing need in the social sciences and humanities not only to understand the cultural impact of digital technology and cognitive science, but also to mount a thoroughly critical political economy of their applications.

WHAT IS 'VISUAL CULTURE'?

As might be anticipated there is no shortage of general conceptions of the field of visual culture and visual studies. The unprecedented expansion of courses and programmes concerned with visual experience over the past two decades has itself become part of the political landscape of modern educational systems and modern societies. On an even broader canvas, image creation, production and appropriation have become central to corporate imagineering industries. Creating and commodifying visual worlds is now inseparable from the transnational activities of the global cultural industries. It is not only the case, to extend Guy Debord's well-known thesis, that the universe of those societies in which the capitalist mode of production prevails now presents itself as an immense accumulation of spectacles (*Society of the Spectacle*, Thesis 1); rather the empire of the visible now reaches into the microscopically small and the unimaginably large (instruction in science now takes the form of guided tours through the subatomic world

disclosed by electronic microscopy and the cosmically violent galactic worlds revealed by radiotelescopy). We have moved from the society of the spectacle to the universe of the spectacle. In sum, every branch of knowledge, every social institution, every modern social system now relies upon visual image making.

In the context of this commercialization of the visual we need to be aware that many, if not all, of these definitions cast as much light on the purposes of their formulators as they do upon the nature of the visual field itself. They are, in other words, self-displaying conceptions—understandings and interpretations of visual culture produced in the context of particular economic, political and philosophical projects, theoretical paradigms and empirical concerns. In this way the 'politics of the visual' stretches from everyday popular media to the realms of higher education, art and cultural criticism. This ubiquity of the visual also stamps the concepts and frameworks of visual culture with an inescapable provisionality.

In the terminology of classical philosophy the visual field designates the world of sensuous images and perception, or in its older Greek sense *aisthesis*. In vernacular usage 'the visual' is an expansive, polysemous concept that includes everything linked with *aisthesis*—sensory appearances, embodied experience and acts of visual perception in particular (*aisthanomai*). In keeping with this polysemy we could, somewhat disingenuously, claim that 'visual studies' includes everything that is taught in 'visual studies programmes', in the creative arts, traditional art-historical research, film, photography, digital media, video game studies, design and cultural studies curricula. In this context the visual would include the whole spectrum of visual forms and their interpretation from painting, sculpture and design to advertising, fashion, costume, virtual imagining and digital media (forms that the ancients would no doubt categorize under the heading of *phantasia*). We might also be faulted if we left out such noncanonical visual forms as weaving, basket-making, quilting, domestic furnishing, jewellery, ornamentation, advertisements, movie posters, postcards, comics, junk culture and the like. Once we admit vernacular design and ornamentation we would also have to include the whole realm of quotidian aesthetics—the images, furnishings, ornaments and objects that decorate our domestic spaces and gardens (landscape gardening), the ubiquitous presence of visual displays, screens and Web sites, the stylization of writing and font making that accompanies all academic life today (cf. Saito 2007). Of course such an all-embracing, and somewhat promiscuous, definition threatens to admit every phenomenal domain explored by such programmes and activities. Once thematized, visuality expands into myriad streams of image making that mediate the practices and structures of everyday life. In other words 'visuality' begins to merge into the all-embracing category of 'culture' itself.

More cautiously, we might say that visual studies are those cultural inquiries that are typically designated by such disciplinary labels as 'the pictorial arts' (and in particular, painting and drawing), art practice and education, sculpture, architecture/architectural studies, photographic science, the designed world (including landscaping, gardening and related crafts), theatre, cinema, television, new visual media (digital arts, video, information arts, computer animation, 3-D modelling, Web art and so forth). This broad conception would then generate further 'chains' of signifiers linked with the terms

'culture', 'arts', 'visual', 'aesthetic', 'modernism' and their conjugates. It would provide a more critical incentive to reframe the question of the 'everydayness' of everyday artefacts deemed to be beautiful.

To place some limit upon this expanding galaxy we might qualify this generic formulation by defining the field through those particular inquiries that explicitly address, analyse, explain and interpret visual phenomena. 'Visual studies' would thus designate such areas as the history of art, aesthetics, the philosophy of art, cultural studies (cultural art history), design, media studies, film studies, technologies of the visual, advertising and media-based industries. Visual culture 'provides the visual articulation of the continuous displacement of meaning in the field of vision and the visible' (Rogoff 1998: 15).

Perhaps until recently the dominant perspective in contemporary visual studies is one that emphasizes the understanding of visual artefacts, forms and media as *social* and *cultural* formations (or in the idiom of this perspective, as *sociocultural* formations of *signifying practices*). This approach was historically linked to the British tradition of 'Cultural Studies' arising from the Birmingham Centre for Cultural Studies in the 1960s (itself a polyphonic formation derived from different theoretical traditions—such as Marxism, sociology, semiotics, structuralism and psychoanalysis but also a strand of political and aesthetic cultural criticism going back to the Romantic poets, John Ruskin, William Morris and F. R. Leavis, as well as the British Left's strong tradition of working-class social history). Of course the perspective of Cultural Studies has long since broken free from its origins in Anglophone debates about cultural production, semiotic mediation and meaning-making to form a transnational tradition of critical research into media-ted sociocultural practices and hybrid semiotic formations (see Hall and Birchall 2006). The broad paradigm of Cultural Studies has today blended with the equally comprehensive traditions of European critical social theory, Media theory and Communications studies.[12]

This generic sociocultural framework then provides both a *definition* of visual studies as the exploration of visual culture and a projective *sense* of the most appropriate *methods* of visual research (namely methods that emphasize investigations of the social-structural and cultural conditions of visual *representations*). This general approach to visual representations has been typically influenced by the idea of a general 'cultural studies' framework first explored in the context of debates within British Marxism in the 1970s and 1980s and associated with the writings of Stuart Hall and his colleagues working in the Birmingham Centre for Cultural Studies. And just as the post-Althusserian debates in British Marxism formed a creative intellectual and academic site for the importation of European theory—Gramscian 'cultural' Marxism, Saussurean structuralism, Lacanian psychoanalysis, Bakhtinian dialogical theory, Derridean deconstruction, Postmodernism, Genealogy and so forth—so the field of visual studies and research has been decisively shaped and reshaped by changing methodological commitments reflecting the shifting debates within and between the different currents of psychoanalysis, linguistics, deconstruction, genealogy, hermeneutics, feminism and so forth as these movements have structured the field of critical intellectual debate over the past thirty or forty years.

The 'cultural studies' approach to visual phenomena now reflects many different kinds of influence and interests. However, tensions persistently emerge between a postmodern

hankering for a transcendence of disciplines, defined object-domains and cognitive claims buttressed by rigorous methodology, along with social-structural 'narrative' history, on the one hand, and the practical, institutional imperative to suggest that just such things, including the narrative of narrative's demise, underpin visual cultural studies.

We come to the inevitable conclusion that in its genesis and academic institutionalization the field of visual studies is both contested in terms of its substantial definition and intrinsically plural with regard to an array of possible methods of analysis, theoretical approaches and interpretative frameworks. This is not a history that can be or needs to be repaired. This contested tradition remains as a notable characteristic of academic visual studies during the period of 'Theory wars' and still shapes many of the emerging transdisciplinary paradigms of visual culture. Rather than seeing this situation in negative terms as an obstacle to creative work we think of the open-textuality of visual research as a provocation for more creative interdisciplinary inventiveness and collaboration. In this respect it replicates many of the debates over the nature and meaning of art and the arts in society from the late 1960s to the present. It clearly underlines the importance of public debate and political context in the emergence and direction of academic research. However, as Readings's (1996) stimulating polemic suggests, the reflexive terms of any such debate may be uncomfortable for political pieties prevailing in the academy.

A similar cluster of questions, for example, arises with respect to the question as to whether there is a definition of the field of 'art' and 'aesthetics' that would be acceptable to partisan interests in the contested field of aesthetic criticism? 'Aesthetics' like 'culture' is also one of the most contested words in the intellectual lexicon. The past two decades have, for example, seen a shift from Eurocentred and 'contemporary' aesthetic questions to global and historical problematics. In this context we might broach the definitional problem by transforming the more traditional language of aesthetics and philosophical aesthetics. Thus what would be a 'useable' general definition for a philosopher of film studies (cf. Cavell 1971; Shaw 2008) would not necessarily be helpful for a semiologist or sociologist of culture, let alone a 'neuroart' historian (John Onians writes: 'Experiences are indeed "mediated", and the extent to which they are mediated by words, images and other forms of discourse can continue to be studied using semiotics, but primarily they are mediated by neurons, so it is on neurons that anyone interested in mediation should really concentrate' (2007: 2)).

It is clear that the field of visual studies—as with cultural studies more generally—reflects the common experiences of many of the human sciences—particularly sociology, anthropology and political science—as these have developed away from empiricist meta-theories and embraced more 'postmodern' and 'continental' styles of analysis and theorizing. The historical impact of cultural and media studies—what their critics condemned as 'culturalism'—within the Anglophone academy in the 1970s and 1980s retains its polemical significance for key contributors to the debate on visuality today. We might, for example cite the generous definition provided by Nicholas Mirzoeff:

Visual culture is concerned with visual events in which information, meaning, or pleasure is sought by the consumer in an interface with visual technology. By visual

technology, I mean any form of apparatus designed either to be looked at or to enhance natural vision, from oil painting to television and the Internet. (1998: 3)

Mirzoeff's deconstruction of the standard binaries—high and low culture, elite and popular culture, mass media and fine art, art and non-art and so forth—is wholly in keeping with the tradition of Cultural Studies. In a similar pluralistic spirit, Malcolm Barnard (2001) has explored approaches to the visual field from the social sciences—particularly sociology, Marxism, Semiology, Feminism and Cultural Studies, concluding his survey with an advocacy of a historically specific hermeneutics of visuality (a position that is also explored in the collection edited by Ian Heywood and Barry Sandywell (1999)). Barnard singles out the post-phenomenological French philosopher Paul Ricoeur as one example of a dialectical synthesis of structural and hermeneutic interpretations of cultural phenomena that might open lines of inquiry for future research. Adapting ideas from hermeneutics would reframe cultural studies as an attempt to disclose the meanings of visual forms in order to interpret and explain their functions in human life-worlds.

We should also point out that what orthodox media and cultural studies have traditionally sidelined has recently become central to accounts of the visual. One such 'domain' is the gendered character of visual phenomena and the relationships into which the visual is folded; this is not to neglect the fact that gender issues have been important for an earlier tradition of visual scholarship including Roland Barthes's *The Pleasure of the Text* (1975), Laura Mulvey's *Visual Pleasure and Narrative Cinema* (1975), Erving Goffman's *Gender Advertisements* (1979) and Judith Williamson's *Decoding Advertisements* (1978) among these (for a comprehensive sample of such positions see *The Feminism and Visual Culture Reader*, edited by Amelia Jones (2003)).

TOWARDS A RENEWAL OF VISUAL STUDIES: DIMENSIONS OF A NEW VISUAL STUDIES

By correcting these elisions and oversights recent work on visibilization, what we might call the new visual studies, would now include the sociology of visuality, the politics and ethics of visual cultures, the impact of technological transformations involved in 'new media', digital visibilities, new aesthetics and so on. More specific studies of everyday visualities have promoted alternative methodologies that avoid the generic positivism of the traditional social sciences by emphasizing the reflexive processes involved in the processes of meaning-making, performance and cultural interpretation throughout everyday life.[13]

Cultural Constellations

Of course, methodological reflection and epistemological reflexivity are only the beginning of a more radical understanding of the layers of experience and self-understanding involved in the intricacies of visual culture. Here the analogy between 'old media' studies and 'new media' studies (sociology of the Internet, digitalization, global mobile

communications, computer-mediated interaction, cyber-networked societies and so on) re-occurs in the secondary literature. If this analogy can be sustained, new visual studies would be postdisciplinary studies focusing upon the global impact of the new technologies and the spread of global visualities. Digital visualities are the new forms of inscription characterizing the electronic age. These visible 'writings' form the seeding grounds for new forms of cultural life and community (inscriptions that actively create virtual communities, new forms of communication, network sites, blog-culture and the like). The investigation of these technological inscriptions might find their common ground in an extended concept of 'information' or 'information arts' (see Wilson 2002).

In this rapidly changing arena we might bracket substantive and thematic definitions of visual culture and look for problematics and strategies: how do visual media and visual information *function* in a globalized world? What are the dynamic interfaces between visualizations in the arts, sciences and technology? How do different individuals and communities *use* visual artefacts? What forms of inscription and writing have emerged with the mobile digital media? How are different subjectivities (audiences, agents, agencies, etc.) constituted through their particular modes of visual appropriation?

It is no accident that the adjective 'new' or 'novel' has increasingly crept into attempts to revitalize more traditional and relatively unreflexive conceptions of aesthetics and art history (the new art history described in Harris 2001, 2006; Rees and Borzello 1986), new media studies (Taylor and Harris 2008), new cultural studies (Hall and Birchall 2006; Gunster 2004) and new humanities (Trifonas and Peters 2005). Here the qualifier 'new' functions as a signifier of both discontent and discontinuity within the academic traditions of art history, media and communication studies and cultural studies.[14] As an authentic marker for both anxiety and hope, it should resist all 'rebranding' opportunism, although this is very much part of a 'real world' of globalized capital into which universities are steadily dissolving.

Practices and Active Appropriation

We have suggested that one important step in imagining the shape of future conceptual frameworks and theoretical perspectives is to move away from definitions of visual studies couched in terms of their *substantive* focus and to shift to thinking of new visual studies in terms of the questions they ask, their strategic interventions in new visual space, their tactical dialogues with those who produce and consume new visualities in an increasing globalized world. This is where the 'new visibilities' of digital screen culture, global culture industries and the coming of cyberculture become the forcing ground of new conceptualizations and critical problematics.

The emergence of global *imagineering industries* has cast a revealing light upon the workings of earlier image cultures (would Barthes's definition of the essence of the photograph, for example in terms of the primacy of the referent—the photograph as a witness to the fact that *the thing has been there* (2000: 76–7)—need to be modified in the light of digital photography, citizen journalism and family-based photographic archiving?). The fact that today the target audiences of advertising and media communications

are acutely knowledgeable about the 'meaning of the message' and the 'rhetoric of the image' and modern image-repertoires already entail a different attitude towards reception and appropriation. Today most people live in worlds that are irreversibly mediated by multiple image rhetorics. If the idea of the passive 'receiver' or inert audience has long since lost its validity, we should also consign the idea of the passive 'object' or inert image to the grave. Images—indeed all objects and artefacts—are grenades of meaning, often with their own life and fortunes. This is Michell's point in restoring the 'voice' to images: 'the questions to ask about images are not just what do they mean, or what do they do? But what is the secret of their vitality—and what do they want?' (2002: 176). If the initial energy of cultural studies is to survive in the new information age it must be capable of transforming itself and moving beyond the traditional concepts of semiotic representation and signification.

The availability of affordable photographic equipment—today in the form of digital cameras and computers with sophisticated image-manipulating software—has both democratized image production and led to new levels of competence distributed across diverse constituencies and populations. Where Barthes could claim that 'in every society various techniques are developed intended to fix the floating chain of signified in such a way as to counter the terror of uncertain signs' ('Rhetoric of the Image', in *Image-Music-Text* (1977)), we are now aware that self-reflective audiences positively welcome and celebrate 'the terror of uncertain signs'. Audiences now search for images with 'something to say'—they ascribe agency to images in the face of a long tradition of voicelessness. Today the mass use of digital media actively encourages the production and circulation of 'uncertain signifiers'. Where Barthes believed that the photograph is 'literally an emanation of the referent' (2000: 80) advertising and other forms of visual media have moved through the phase of 'irony' to become acutely reflexive about message content and structure. The compartmentalized stability of the Referent and the Virtual no longer survives digitization. To stay ahead of the game advertising has to reflexively deconstruct its own history and forms.[15] Large sections of the populations of modern societies begin to think in terms of cybernetic analogies and network imagery. Faith in Representation gives way to the Play of Virtuality. Digitalization undermines Barthes's claim that every photograph is a certificate of presence (2000: 87). The 'what-has-been' of photography is not immune from difference and manipulation. Here, once again, we have come to realize that we are dealing with complex processes of *active reading*, situated *interpretation* and with much more structurally differential and 'self-selected' audiences acutely aware of the rhetorical work of mediated meaning. We move from *artworks* to heterogeneous art *works* (with a verbal inflection). From works framed by individual signatures to anonymous, collective, unnameable cultural performances and webworks (iconically the Web and Cyberspace provide semantic resources for self-reflection and self-understanding on a global scale). Yet while recent technology provides these opportunities, it remains to be seen how much difference they will eventually make to everyday photographic practices, for example whether they will transform it fundamentally or whether it will survive pretty much intact, but with additions (the widespread emailing and social network exposure of images, Flickr and so on).

Functions Not Essences, Tactics Not Structures

In stressing the 'productive', 'praxical' and 'reflexive' dimensions of visual experience—in thinking in terms of the organization, distribution and workings of visual practices in a given society—we might proceed pragmatically and sketch alternative forms of strategic conceptuality. Thus rather than asking after the essence or structure of 'the visual', we pursue the question of the *ontogeny*, situated *functions* and *operations* of visuality in the experience of individuals and communities: what are the origins and functions of artworks, photography, televisual media, advertising rhetorics, digital cinema, mobile computing? Here genesis displaces substance.

In this reorientation towards the history and social functions of *visual practices* and *image dialogues* we resist the reductive idea that these functions coincide or, even worse, that they can be conflated (for example painting is simply an older form of photographic representation or the idea that analysis is complete when the 'meaning' or 'interpretation' of the image has been secured). Even before we turn to the wandering signifiers of deconstruction we should attend to the fact of cultural hybridity, diversity and global appropriation (what the images from non-European space want still remains to be seen). Here we still lack detailed empirical and ethnographic knowledge of the diverse functions of images and, especially, of their participation in local cultures across the world. What event-sites, scenarios and contexts define the 'orders' of aesthetic or cinematic experience for different societies and subcultures? How have more traditional visual media been transformed through digitization? What kinds of societal *work* do the arts, photography, television, mainstream cinema, art cinema and so on *perform* for different groups, societies and cultures? How do audiences navigate the complex media-ted worlds of popular culture and everyday life, blending religious imagery with secular discourses? Here traditional metaphors and frameworks organized around the static categories of substance and predication need to be displaced by transactional ontologies of events, developmental processes and information networks.

As 'events' and 'processes' pay no respect to disciplinary borders the general directive would be to explore questions and problems that straddle disciplines, problems with a 'transverse' resonance and dynamic (for example the cross-disciplinary operations of imagination, image-formations and imagineering in different societies). In radically rethinking the 'being' of images, in restoring the immanent dialogics of visual life, in returning to the 'secret' life of signs we are only at the beginning of alternative conceptualizations. Indeed the expression 'new visual studies' is itself merely a provisional placeholder, a temporary site from where we might conduct skirmishes and mount campaigns against rigid barriers, boundaries and borders.

Systematic Reflexivity

We have argued that visual studies problematics are increasingly concerned with individuals and communities who are visually literate, who actively adopt positions with regard to their experience, who interpret and change the dominant messages and—with

new computer-based technologies—transform media and create their personalized media-ted life-worlds and communication networks. The ability to digitally produce, transform and circulate visual images plays a key role in these new forms of audience reflexivity and interpersonal communication. Here it is not so much the liberation of the signifieds of the image as the liberation of the 'means of image production' that is currently transforming visual culture on an increasingly transnational scale. We move, to borrow Benjamin's formula, from an age of mechanical reproducibility to an epoch of digital replication. And this transition has transformed how we think about images and how we imagine a world saturated by imaginary practices.

The basic theorem here is that there are indefinitely many modalities of visibility and forms of visual experience and in response to this situation we urgently need a much more historical and cultural phenomenology of these modes, media and forms of communication as they actually operate within the material and technological systems of the postmodern economy and in the interactional contexts of day-to-day life. The 'return of the Subject' in visual research needs to be complemented by the 'return of the Object', by the rematerialization of images with all their postontological reflexivities and complexities.

Visual Media as Instruments of Self-Understanding

In the light of this principle we need to look for strategic operations, procedures and tactics within everyday social action and interaction rather than continue to pursue non-contextual, eidetic and pseudo-universal definitions of 'the visual field'. Thus rather than asking the substantive 'what' (or 'whatness') it is more fruitful to ask after the origins, uses and appropriations of visual artefacts and media in the context of everyday life. How do individuals and communities communicate with visual media? The strategic question 'How' leads inevitably to the question of 'Who?'—who uses, appropriates, operates upon, interprets, transforms visual objects? Who produces and consumes images? Who engages and interacts with visual media? In turn the 'who' question is looped back into the 'why' question: why are visual media produced, used, reproduced, changed, circulated? Finally we are returned to the enigma of images themselves: what are images, what are their demands? And each of these questions leads back to the central question of 'subjectivation'—what forms of subjectivity, what forms of selfhood, are created in and by visual performances. Who—which individuals, groups and communities—take an interest in things visual? Inversely what types of 'subject' are created by different image orders and institutionally sanctioned spectacles? How do these interweaving processes of subjectivation and objectivation interact and transform one another in the everyday transactions of different visual worlds?

Visuality in/as Textuality

These programmatic agenda, of course, implicate even more complex philosophical questions and larger issues of social, political and cultural context—to what ends and

why do we live these kinds of media-ted life? What are the connections between textuality and visuality? How do the dominant metaphors of visual life—until recently dominated by verbal and textual conceits—actively shape and define our personal horizons? How do visual worlds come to be differentiated into 'everyday life', 'art worlds', 'advertising', 'popular media' and so on? What are the differences between private and public visual worlds? How are 'public spheres' dramatized through the interaction of verbal and visual means? How has the perception of visual artefacts and representations changed over time (do we look at photographs in 2010 as we did in 1910 or 1840?—how would we research and investigate the mutations undergone by these historical gazes?). In what way are the visual legacies of earlier civilizations also the history of visual barbarism?

At this point the question of delimiting the legitimate sphere of 'visual studies' opens out upon difficult empirical, theoretical and philosophical questions concerning the changing social, technological, cultural and ethico-political structures of modernity and postmodernity. The new agenda comes into play immediately in foregrounding the reflexive relationships that now exist between the visual field and the globalization of social relations in an increasingly multicultural and diasporic world.

This interwoven problematic of visuality, media and information systems prefigures more self-critical and reflexive paradigms of visual cultural studies where the orientations, attitudes and ideas towards the visual become as important as the forms of the visual themselves. We do well to remember that visual artefacts and media are first and foremost 'extensions' of the self (in McLuhan's sense) and, more problematically, 'technologies of the self' and 'arts of existence' (in Foucault's sense, 1978). But above all, they provide the tools and instruments of self-understanding and clues to how they were used by individuals and whole societies (Sandywell 1996, vol. 1; Sandywell 2011).

Traditional approaches have been forced to come to terms with the idea that individuals adopt stances and attitudes towards their lives, apply critical standards and criteria to their activities, espouse beliefs and hold opinions about their life-worlds. They are, in the sociological jargon, 'reflexively knowledgeable agents', they know 'for all practical purposes' what they are doing. In principle some of the forms of 'reading' or 'modes of appropriation' carried out by different individuals and communities need to be viewed as research 'objects' in their own right. Moreover such 'interpretations' may be critically aligned with the interpretative frames used by theorists and researchers. Here we see a realm of interaction rather than a hierarchical order where active researchers investigate the responses of passive research subjects. Without this 'dialectic' we lose a vast realm of researchable phenomena—precisely the realm where interpretations of the world—in this case, the world of the visible—are in conflict, where readings are not reducible to a shared account, where interpretations suggest fractures and lines of change in social and political arrangements.

Malcolm Barnard speaks to this conception in the following description:

> opinions concerning, and responses to, visual culture are part of what makes people the people they are and an understanding of these opinions and responses can generate a more sophisticated, self-reflexive and critical, understanding of the visual world and

one's place in it. Here, the study of visual culture performs the relatively sophisticated function of self-enlightenment through providing an understanding of one's own role and position in the process of understanding visual material. (2001: 4)

This helpful reminder underlines the way in which our images and representations of visual experience are themselves reflexively folded back into new orders of the visual as these become technically available to wider sections of the public (here again the globalization of media and new communications technologies has a direct bearing upon the transformation of visual space in contemporary life). Contemporaries are completely at ease with the idea of alternative, competing and contestatory scopic regimes. They no longer see the point in earlier debates as to whether the Benin bronzes could have been produced by a non-European culture; they are not shocked by Picasso's *Les Demoiselles d'Avignon* (1907); they are no longer troubled by the practices of a Damien Hirst or Tracey Emin. Yet, while many are no longer outraged by Picasso or Emin, particularly that someone can do 'this' and call it art, we might still be shocked by the frank sexual confrontation of *Demoiselles* or the nervy vulnerability of an Emin. 'Shock' demonstrates that we still care about art, life, good and evil. It would be worrying indeed were we never to feel annoyed, frustrated, disoriented, baffled, alienated, upset or bemused by new (or indeed old) art and visual culture.

CONCLUSION: THE FUTURE(S) OF TRANSDISCIPLINARY RESEARCH

We suggest that the new visual studies might be one of the first major efforts to transcend existing disciplinary domains and paradigms and produce something like a transdisciplinary research programme of critical sociocultural studies. In this respect Visual Studies represent something like a test-case for future cross-disciplinary dialogues and the generation of new 'knowledges'. As Irit Rogoff has conjectured: 'Perhaps then we are at long last approaching Roland Barthes's description of interdisciplinarity not as surrounding a chosen object with numerous modes of scientific inquiry, but rather as the constitution of a new object of knowledge' (Rogoff 1998: 15). This 'new object of knowledge' is most emphatic in explorations of the social life of the arts and visual media. This reinforces an argument formulated by Nicholas Mirzoeff:

To some, visual culture may seem to claim too broad a scope to be of practical use. It is true that visual culture will not sit comfortably in already existing university structures. It is part of an emerging body of post-disciplinary academic endeavours from cultural studies, gay and lesbian studies, to African-American studies, and so on, whose focus crosses the borders of traditional academic disciplines at will. In this sense, visual culture is a tactic, not an academic discipline. It is a fluid and interpretive structure, centered on understanding the response to visual media of both individuals and groups. Its definition comes from the questions it asks and issues it seeks to raise. (Mirzoeff 1999: 4; cf. Mirzoeff 1998: 11–12)

While Mirzoeff rightly emphasizes the need to cross arbitrary discipline boundaries when necessary, the vocabulary of 'tactics' has a military flavour, a particular way of describing the outlook of visual culture studies perhaps derived in Mirzoeff's case from the prevailing Gramscism of his time as a student of Stuart Hall at the Centre for Contemporary Cultural Studies at Birmingham. As set out here, the authentically reflexive politics of writing in the spirit of the 'new visual studies' is inseparable from particular substantive, interpretive and critical questions about visual culture. These kinds of substantives, plus the reflexive perplexities of writing more generally, are at the core of this approach to the study of visual culture. The reflexive political challenge, to which Barnard refers, is a highly indexical, singular effort that often runs against the grain, or powers, of the image-suffused language that modernity makes available.

If the term was not already appropriated by French poststructuralism we might think of the project of new visual studies in the plural as critical 'archaeologies of the visible' (Foucault 1973; cf. Gutting 1989; Shapiro 2003). Another name for this reorientation of cultural studies is 'cultural politics' (Jordan and Weedon 1995) or 'the politics of culture' (Lloyd and Thomas 1998) where the emphasis is placed upon the social and ethico-political contexts of research in the visual field. A more appropriate designation would be the genealogy of visibilities or *visual imagineering*.[16]

Initially many of the advocates of visual studies as a research field spoke of its 'interdisciplinarity' as a virtue. Others, however, see dangers of dispersion and vagueness in the promissory statements of visual studies programmes (the now-classical negative reaction to such programmes can be found in the responses to the 'Questionnaire on Visual Culture' (1996) circulated by the journal *October*). Yet a third position suggests that visual studies point the way towards more radical transdisciplinary formations as the older organization of university disciplines breaks down giving rise to new models of vision and new knowledge formations:

> It is one of the characteristic features of this problematic that there is no simple way of disentangling the social history of perception from the arts of observation and the technologies of visual culture. Indeed an adequate hermeneutics of the scopic regimes of modern European culture needs to 'triangulate' all three of these themes and to invent new forms of interpretive inquiry that advance this understanding on several fronts. (Heywood and Sandywell 1999: x)

By adopting the third position we see the 'field of visual culture' less as a discrete and bounded 'domain' of social research and more as a force-field that is in the process of changing the academic divisions of labour that organize the humanities, arts and social sciences. Thus where we traditionally focused upon national contexts ('national sociologies', 'art histories' and so on) we would now move towards globalized frameworks (where the traditional 'national traditions' are seen to have complex relationships with colonial and imperial powers). Where 'aesthetics' was profoundly Eurocentred we now must entertain the idea of *hybrid aesthetics*. Where social theory was 'nation-state' oriented we must now think in terms of global mobilities.

By opening the discourses of academic inquiry to broader public issues and to wider domains of social, ethical and political debate we introduce a greater sense of relevance and purpose to some of the arcane debates about the visual and the verbal. As many of the chapters in the *Handbook* suggest, the phenomena of visual culture are inextricably bound up with issues that are central to the idea of the public sphere and political life. Whatever our ultimate theoretical destinations, research on the functions of images in society that has taken the postdisciplinary turn must enter this turbulent space and experience some of the vectors and dynamics of the field in its emergent complexity. The future holds out the promise not merely of a 'politics of aesthetics' but a more global 'politics of vision'. We anticipate that the next decades of creative inquiry will constitute unprecedented horizons and research agendas for the visual studies of the future.[17]

NOTES

1. For examples of work exploring the intersections between art and science, and in particular between art, aesthetics and neuroscience see Barbara Maria Stafford, *Echo Objects: The Cognitive Work of Images* (2007). For cross-disciplinary exchange between the arts, sciences and technology see Stephen Wilson's *Information Arts: Intersections of Art, Science, and Technology* (2002) and Jill Scott, ed., *Artists-in-Labs* (2010). For the dialogue between photography, cinema and neuroscience see Warren Neidich, *Blow-up* (2003). On the interaction of psychology, visual science and art see Richard L. Gregory's *Eye and Brain: The Psychology of Seeing* (1998). John Onians has elaborated a new discipline of art history from the convergence of research in art, biology and neuroscience, calling this, appropriately, *Neuroarthistory*, tracing its intellectual genealogy back to Aristotle, Pliny, Apollonius of Tyana, Ibn al-Haytham (Alhazen) and others (2007). Computation-based studies and cognitive science form a major research cluster with innovative ideas on the place of visual experience within a larger theory of mind and neural science (for example Robert L. Solso's *The Psychology of Art and the Evolution of the Conscious Brain*, 2005). For resources from cognitive science, philosophy and psychology see Alva Noë and Evan Thompson, eds., *Vision and Mind* (2002) and Alva Noë's account of visuality in terms of sensorimotor functions and kinaesthetic activity, *Action in Perception* (2004) (also Alva Noë and J. Kevin O'Regan, 2002). For the dialogue between aesthetics, social thought and hermeneutics see Heywood and Sandywell, *Interpreting Visual Culture* (1999). On the interplay between art and social theory see Ian Heywood, *Social Theories of Art* (1997) and Chris Jenks, *Visual Culture* (1995). For the confluence of philosophy, life sciences and cybernetics drawing upon post-metaphysical European philosophy see the writings of Gilles Deleuze, Manuel de Landa and Paul Virilio. The emergence of such transdisciplinary collaborative theory and research suggests a more radical 'dialogue' between visual formations and their material, biological and ecological conditions A brief list of explorers who have forged or are forging new forms of transdsciplinary inquiry would include Theodor Adorno, Giorgio Agamben, Arjun Appadurai, Alain Badiou, Mieke Bal, Jean Baudrillard, Walter Benjamin, Mikhail Bakhtin, Rosi Braidotti, Judith Butler, Pierre Bourdieu, Cornelius Castoriadis, Manuel Castells, Arthur Danto, Jacques Derrida, Gilles Deleuze, Michel Foucault, Vilém Flusser, Donna Haraway, Luce Iragaray, Martin Jay, Julia Kristeva, Bruno Latour, Michéle Le Doeuff, Henri Lefebvre, Jean-François Lyotard, Alberto

Manguel, Lev Manovich, Jacques Rancière, W. G. Sebald, Barbara Maria Stafford, Charles Taylor, Francisco J. Varela, Gianni Vattimo, Paul Virilio, Slavoj Žižek.

2. See Stafford 1996 on the situation in the USA.

3. However, even in art history preference for the immaterial was far from universal, with examples ranging from Aby Warburg's passion for a broad range of graphic forms to Michael Baxandall's careful interpretations of the cultural significance of the materials and processes of painting. The concrete nature of the medium of communication was, of course, at the centre of Marshall McLuhan's pioneering media theory.

4. For a striking and innovative example outwith the collection, see Michael Fried's interpretations of recent art photography (Wall, Gursky, Struth, the Bechers et al.) via ideas developed with respect of eighteenth- and nineteenth-century French painting and postwar modernism.

5. For example Kittler 2009.

6. The term 'aesthetics' is used enormously widely, from references to a specific Kantian and eventually analytical philosophical tradition to the much broader idea of values and experiences uniquely to do with 'art', and of course 'art' can mean virtually anything these days. Narrow descriptions of 'fine art' and 'aesthetic' struggle to make much sense of either contemporary art or the experiences and questions it raises. The possibility and significance of critically based definitions is, of course, a different matter entirely.

7. Subjects of study, disciplines, epistemes and the institutional edifices associated with them often involved passive spectatorship as part of an attempt to tidy up, organize and mobilize everyday, scholarly and avant-garde practices (both reproduction and experimentation). However, untidiness and heterogeneity are highly resilient, not only because materials and processes often refuse to behave as required, but also because the subjects ostensibly in charge of disciplines and quasipolitical ideologies often fail to discipline themselves.

8. The 'pictorial turn' has become associated with the work of W.J.T. Mitchell and the Chicago school of visual studies (see his *Iconology: Image, Text, Ideology* (1987); *Picture Theory* (1994); and *The Reconfigured Eye: Visual Truth in the Post-Photographic Era* (1994)) and with the intensive analysis of iconism in the writings of Gottfried Boehm (Boehm speaks more broadly of the 'iconic turn'; for the latter see Keith Moxley, 'Visual Studies and the Iconic Turn' (2008)). Mitchell derides this imputation as 'the fallacy of the pictorial turn' and rather links the contemporary interest in iconology and pictorialism with the closure of postmodernism and commends a renewed interest in 'pictures' and 'iconic' objects that fall outside the textualist framework of poststructuralist theory (see Mitchell 2002: 171–2). For caveats and cautions with regard to the expansionary claims of visual studies see James Elkins (2003), W.J.T. Mitchell (2002) and Mark Poster (2002). In 'Showing Seeing', Mitchell treats the pictorial turn as a rhetorical trope or 'narrative figure' rather than a social or metaphysical condition. At best it should be used as a heuristic or diagnostic tool 'to analyze specific moments when a new medium, a technical invention, or a cultural practice erupts in symptoms of panic or euphoria (usually both) about the visual' (2002: 173). Such commonplace schemas are 'beguiling, handy for the purposes of presentist polemics, and useless for the purposes of genuine historical criticism' (2002: 173).

9. For Benjamin's ocular interests see Susan Buck-Morss, *Dialectics of Seeing* (1989). For retranslations of Benjamin's writings on visual artefacts and media see Benjamin (2008). For classical art historians see Donald Preziosi, ed., *The Art of Art History: A Critical Anthology* (1998), chs. 3–5. For a comprehensive philosophical demonstration of the rich visual

resources within the phenomenological and hermeneutic tradition see David Levin's *The Opening of Vision: Nihilism and the Postmodern Situation* (1988); *The Philosopher's Gaze: Modernity in the Shadows of Enlightenment* (1999); and his edited collections *Modernity and the Hegemony of Vision* (1993) and *Sites of Vision: The Discursive Construction of Sight in the History of Philosophy* (1997).

10. Historicity also means recognizing and deconstructing the Eurocentric, phallocentric, and logocentric origins of our own theoretical frameworks and discourses. Here we might think of historicity as a mode of self-reflection created by modernity that problematizes the grounding presuppositions of traditional investigative projects and discursive formations. One of its recurrent features is an acute self-consciousness about the implicative order of social systems and modes of selfhood and self-reflective consciousness. On historicity with respect to visual studies see Sandywell's essay in this volume: 'Seven Theses on Visual Culture'. For a post-Eurocentric and 'polycentric' conception of aesthetics and visual culture see Shohat and Stam (1998). For deconstructions of the metaphysical models of mimesis, reflection and representation that have shaped Western European culture see Sandywell, *Logological Investigations* (1996), volume 1. The historicity of *all forms* and *modes* of image production and representation is another recurrent theme of recent research. For the older idea of 'the dialectics of seeing' see Susan Buck-Morss, *The Dialectics of Seeing: Walter Benjamin and the Arcades Project* (1989). For the 'theory-dependence' of 'artworks' see Arthur Danto's *Transfiguration of the Commonplace* (1981). Danto notes that to 'see something as art at all demands nothing less than this, an atmosphere of artistic theory, a knowledge of the history of art. Art is the kind of thing that depends for its existence upon theories . . . the artworld is logically dependant upon theory . . . there is an internal connection between the status of an artwork and the language with which artworks are identified as such, inasmuch as nothing is an artwork without an interpretation that constitutes it as such' (1981: 164; cf. Dickie 1974). In essence, it is the *mythos* or *interpretation* embodied in particular practices and institutions that constitutes an 'artwork' from a possible array of visual objects. Interestingly, the convention-bound interweaving of myth and narrative and the production of visual art works is one of the most established techniques of traditional art history (see Patrick de Rynck, *Understanding Paintings: Bible Stories and Classical Myths in Art* (2009) and Harris 2001, 2006).

11. The image of 'fusion' is, of course, Gadamerian. But the dialectical involvement of acts of reading and interpretive traditions of meaning might also be derived from the writings of Mikhail Bakhtin, Walter Benjamin, Emmanuel Levinas, Maurice Merleau-Ponty and others. For the remarkable parallels between Benjamin's materialist hermeneutics and Bakhtin's 'dialogics' see Sandywell, 'Memories of Nature in Bakhtin and Benjamin', in Craig Brandist and Galin Tihanov, eds., *Materializing Bakhtin: The Bakhtin Circle and Social Theory* (1999). From a more critical multicultural history the term 'fusion' might be replaced by a concern for transcultural transaction, intercultural dialogue and 'polycentric' hybridity (Shohat and Stam 1998). For a systematic defence of this kind of 'logological' reflection upon the discourses of reflection and representational theorizing see Sandywell, *Logological Investigations*, volume 1, *Reflexivity and the Crisis of Western Reason* (1996). Although this is not the place to defend the idea we would suggest that there is a critical mass of scholarship that suggests the construction of a comparative, post-logocentric, transdisciplinary science of 'image creation' (*iconpoiesis*) which might be called *social imagineering*, concerned with the creation of plural, hybridized and heterogeneous social alterities and intersubjective imaginaries. The

first reaction to such a transdisciplinary critique is shock and defensiveness on the part of established canons and traditions: 'The culturally empowered are not accustomed to being relativized; the world's institutions and representations are tailored to the measure of their narcissism. Thus a sudden relativization by a less flattering perspective is experienced as a shock, an outrage, giving rise to a hysterical discourse of besieged standards and desecrated icons. A polycentric approach, in our view, is a long-overdue gesture toward historical equity and lucidity, a way of re-envisioning the global politics of visual culture' (Shohat and Stam 1998: 47).

12. For standard accounts of Cultural Studies see Barker (2000); During (2005); Easthope and McGowan (1997); Gray and McGuigan (1993); Munns and Rajan (1995); Storey (2001). For imaginative and innovative reappraisals of this tradition see Connor (1989); Grossberg et al. (1992); Hall and Birchall (2006). On the complex relationships between art, aesthetics and the human sciences see Inglis and Herrero, eds. *Art and Aesthetics: Critical Concepts in the Social Sciences* (2009).

13. The general trend over the past two decades is towards methodologies that emphasize cultural difference, social complexity and discontinuous constellations of experience in the formation of cultural orders. After the work of Clifford Geertz this is usually referred to as the quest to establish 'thick descriptions' of cultural phenomena (Geertz 1973, 1983). As we shall later argue, the pervasive idea that runs through these redirections is the theme of historicity and with it a renewed interest in temporality, memory, dialogue and intersubjectivity. See, for example Sandywell, *Logological Investigations* (1996), Rose, *Visual Methodologies: An Introduction to the Interpretation of Visual Materials* (2001), and John A. Walker and Sarah Chaplin, *Visual Culture: An Introduction* (1997). On the horizon we foresee the larger hermeneutical project of exploring all the arts in performative terms and investigating the 'outcomes' of the different arts as different kinds of embodied performance. The emphasis on lived experience and creative embodiment in an expanded dramaturgy of art suggests new kinds of dramatic ontology and interactive strategies of appreciation and interpretation (a comprehensive philosophy of art might have to look towards the cultural work of ballet, theatrical and filmic performances rather than to the two-dimensional models of mimesis and representation that have traditionally informed discussions of art and culture). The key note was struck by Roland Barthes in his last work, *Camera Lucida* where he writes: 'Photography is a kind of primitive theatre, a kind of *Tableau Vivant*, a figuration of the motionless and made-up face beneath which we see the dead' (2000: 32). Hence like theatre artworks inevitably return to the themes of love and death. The polyphonic character of 'performance studies' might also be seen as another example of an essentially transdisciplinary problematic (see the essays in Erin Striff, ed. (2003) and Christopher Balme's overview (2008) for recent perspectives and statements in 'performance studies').

14. Nicholas Mirzoeff is quite explicit on this reorientation: 'Everyday life is the key terrain for visual culture, just as it has been for cultural studies. This represents an ethical choice to concentrate on the culture of the majority rather than the elite practices of a few, for everyday life is the mass experience of modernity' ('Introduction to Part Two', Mirzoeff 1998: 125). New forms of critical theory provide occasions where the interplay of art, media, science and technology become commonplace (Wilson 2002: 11). Another sign of the times is the revitalized interest in aesthetics and the philosophy of aesthetics, exemplified by Cambridge University Press's *Studies in New Art History and Criticism*, Blackwell's *New Directions in Aesthetics*, Routledge's series, *The Art Seminar*, and important collections of essays concerned

with the arts and aesthetic questions (for example Garry Hagberg's *Art and Ethical Criticism* (2008) and James Elkins's *Art History versus Aesthetics* (2006) and more recently Halsall, Jansen and O'Connor, *Rediscovering Aesthetics: Transdisciplinary Voices from Art History, Philosophy and Art Practice* (2009)).

15. There appears to be a new wave of spectacularly 'dumb' advertising (for example Burger King and Go Compare), although whether this is motivated by a conscious reaction against being 'smart' or just the need to cut costs is not clear.

16. Work that already moves within this general orientation includes the following: the historical investigation of scopic regimes (Crary (1990); Foucault (1971, 1977); Gregory (1994); Jay (1992, 1993); Kern (1993); Lefebvre (1991); Maillet (2004); Murphie and Potts (2003); Shapiro (2003); Soja (1989, 1996); Stafford (1996, 2007); Virilio (1983, 1986, 1989, 1991a, 1997)); the global economy of visualization exploring transnational class-based visibilities (visible and invisible classes, inequalities, social struggles, new forms of virtual space-time, urban formations and cityscapes): Amin and Thrift (2002); Cresswell (2004); de Certeau (1988); de Landa (1992, 1997, 2002); Hardt and Negri (2000); Rancière (2006, 2007); Sibley (1995); Thrift (2008); the exploration of gendered visibilities and feminist perspectives in visual studies: Berger (1972); Bernal (1987, 2001); Chaudhuri (2006); Fuller (1980); Haraway (1991); Jones (2003); McRobbie (1991); Mulvey (1989); Plant (1997). On race and racialized visibilities: Bernal (1987, 2001); Paul Gilroy (1987); Cornell West (1990); Gayatri Chakravorty Spivak (1987, 1988, 1990). For general background studies see Jessica Munns and Gita Rajan, eds., *A Cultural Studies Reader*, Section 6 'Race studies' (1995); Lisa Bloom, ed., *With Other Eyes: Looking at Race and Gender in Visual Culture* (1999). More broadly the intersecting areas of 'Afro-American studies' and 'postcolonial studies' have made important contributions to the role of visual representations in the constitution of racist attitudes, beliefs and institutional formations (Gregory (1994); Said (1985); Spivak (1987, 1988, 1990); West (1990)). Explicitly reflexive approaches to social visibility and visibilization can be found in the essays collected in Teresa Brennan and Martin Jay (1996); Chris Jenks (1995); Nicholas Mirzoeff (1998). Visual transformations through digitization and global multimedia: Bolter and Grusin (2002); Levy (1997, 1998); Lister (1995); Manovich (1993, 2001, 2003); Nichols (1995); Plant (1997); Terranova (2004); Turkle (1984, 1995); Wells (2004).

17. A local instance is the creation by the Department of Philosophy at the University of York (Spring 2009) of the Centre for Research into Imagination, Creativity and Knowledge (CRICK), with its mission statement that promises to 'focus on understanding the nature of creativity and innovation, their relation to the imagination, and their role in developing and extending the frontiers of human knowledge in the arts and humanities, the sciences, and business' (http://www.york.ac.uk/depts/phil/crick/ 14 May 2009). For more global examples of similar multidisciplinary projects crossing the arts, humanities and sciences see Stephen Wilson, *Information Arts: Intersections of Art, Science, and Technology* (2002), especially pp. 41–8 and pp. 850–73 for details of these projects (also the Web site http://mitpress.mit.edu/ Leonardo for Leonardo: The International Society for the Arts, Sciences, and Technology).

REFERENCES

Alpers, S. 1983. *The Art of Describing: Dutch Art in the Seventeenth Century*. Chicago: University of Chicago Press.

Amin, A. and N. Thrift. 2002. *Cities: Re-imagining the Urban*. Oxford: Polity Press.

Augé, M. 1995. *Non-Places: Introduction to an Anthropology of Supermodernity*, trans. J. Howe. Chicago: University of Chicago Press.

Bakhtin, M. M. 1968. *Rabelais and His World*, trans. Helene Iswolsky. Cambridge, MA: MIT Press.

Balme, C. B. 2008. *The Cambridge Introduction to Theatre Studies*. Cambridge: Cambridge University Press.

Barker, C. 2000. *Cultural Studies: Theory and Practice*. London and Thousand Oaks: Sage.

Barnard, M. 1998. *Art, Design and Visual Culture*. Basingstoke: Macmillan.

Barnard, M. 2001. *Approaches to Understanding Visual Culture*. Basingstoke: Palgrave.

Barthes, R. 1972. *Mythologies*, trans. Anne Lavers. London: Jonathan Cape.

Barthes, R. 1975. *The Pleasure of the Text*, trans. R. Miller. New York: Hill and Wang; London: Jonathan Cape.

Barthes, R. 1977. *Image-Music-Text*, trans. Stephen Heath. London: Fontana.

Barthes, R. 2000. *Camera Lucida: Reflections on Photography*, trans. Richard Howard. London: Vintage.

Bauman, Z. 2000. *Liquid Modernity*. Cambridge: Polity Press.

Bauman, Z. 2007. *Consuming Life*. Cambridge: Polity Press.

Baxandall, M. 1988. *Painting and Experience in Fifteenth Century Italy*, 2nd edn. Oxford: Oxford University Press.

Beiser, F. 2005. *Hegel*. London: Routledge.

Belting, H. 1994. *Likeness and Presence: A History of the Image before the Era of Art*, trans. Edmund Jephcott. Chicago: University of Chicago Press.

Benedikt, M., ed. 1991. *Cyberspace: First Steps*. Cambridge, MA: MIT Press.

Benjamin, W. (1936) 1992. 'The Work of Art in the Age of Mechanical Reproduction', in W. Benjamin, *Iluminations*. London: Fontana Press, 211–44.

Benjamin, W. 1969. 'On Some Motifs in Baudelaire', in *Illuminations: Essays and Reflections*, trans. Harry Zohn. New York: Schocken Books; also in *Illuminations*. 1992. London: Fontana Press.

Benjamin, W. 1999a. *Charles Baudelaire: A Lyric Poet in the Era of High Capitalism*, trans. H. Zohn. London and New York: Verso.

Benjamin, W. 1999b. *The Arcades Project*, trans. H. Eiland and K. McLaughlin. Cambridge, MA and London: The Belknap Press of Harvard University Press.

Benjamin, W. 1999c. 'Little History of Photography', in Walter Benjamin, *Selected Writings*, vol. 2, *1927–1934*, ed. Michael W. Jennings, Howard Eiland and Gary Smith, trans. Rodney Livingstone and others. Cambridge, MA: Harvard University Press, 507–30.

Benjamin, W. 2008. 'The Work of Art in the Age of Its Technological Reproducibility', in Walter Benjamin, *The Work of Art in the Age of Its Technological Reproducibility and Other Writings on Media*. Cambridge, MA: Harvard University Press, 19–55.

Berger, J. 1972. *Ways of Seeing*. London and Harmondsworth: BBC/Penguin Books.

Berger, K. 2000. *A Theory of Art*. Oxford: Oxford University Press.

Bernal, M. 1987. *The Fabrication of Ancient Greece 1785–1985*, vol.1 of *Black Athena: The Afroasiatic Roots of Classical Civilization*. London: Vintage Books.

Bernal, M. 2001. *Black Athena Writes Back*. Durham, NC and London: Duke University Press.

Beynon, J. and D. Dunkerley, eds. 2001. *Globalization: The Reader*. London: Routledge.

Blanchot, M. 1982. *The Space of Literature*, trans. A. Smock. Lincoln: University of Nebraska Press.

Bloom, L., ed. 1999. *With Other Eyes: Looking at Race and Gender in Visual Culture*. Minneapolis: University of Minnesota Press.

Blum, A. 1974. *Theorizing*. London: Heinemann.

Bolter, J. D. and R. Grusin, eds. 2002. *Remediation: Understanding New Media*. London and Cambridge, MA: MIT Press.

Brennan, T. and M. Jay, eds. 1996. *Vision in Context: Historical and Contemporary Perspectives on Sight*. London: Routledge.

Bryson, N. 2004. *Looking at the Overlooked: Four Essays on Still Life Painting*. London: Reaktion Books.

Buck-Morss, S. 1989. *The Dialectics of Seeing: Walter Benjamin and the Arcades Project*. Cambridge, MA: MIT Press.

Cartwright, L. 1995. *Screening the Body: Tracing Medicine's Visual Culture*. Minneapolis: University of Minnesota Press.

Cavell, S. 1971. *The World Viewed: Reflections on the Ontology of the Cinema*. Cambridge, MA: Harvard University Press.

Chaudhuri, S. 2006. *Feminist Film Theorists: Laura Mulvey, Kaja Silverman, Teresa de Lauretis, Barbara Creed*. London and New York: Routledge.

Classen, C. 1993. *Worlds of Sense: Exploring the Senses in History and across Cultures*. London and New York: Routledge.

Connor, S. 1989. *Postmodern Culture: An Introduction to Theories of the Contemporary*. Oxford: Blackwell.

Connor, S., ed. 2004. *The Cambridge Companion to Postmodernism*. Cambridge: Cambridge University Press.

Cooke, L. and P. Wollen, eds. 1995. *Visual Display: Culture beyond Appearances*. Seattle: Bay Press.

Crary, J. 1990. *Techniques of the Observer: On Vision and Modernity in the Nineteenth-Century*. Cambridge, MA: MIT Press.

Cresswell, T. 2004. *Place: A Short Introduction*. London: Blackwell.

Cytowic, R. E. 2002. *Synesthesia: A Union of the Senses*, 2nd edn. Cambridge, MA: MIT Press.

Cytowic, R. E. 2003. *The Man Who Tasted Shapes*. Cambridge, MA: MIT Press.

de Certeau, M. 1988. *The Practice of Everyday Life*. Berkeley: University of California Press.

de Certeau, M. 1998. *Culture in the Plural*, trans. T. Conley. Minneapolis: University of Minnesota Press.

de Landa, M. 1992. *War in the Age of Intelligent Machines*. New York: Zone Books.

de Landa, M. 1997. *A Thousand Years of Nonlinear History*. New York: Zone Books/Swerve Editions.

de Landa, M. 2002. *Intensive Science and Virtual Philosophy*. London and New York: Continuum.

de Rynck, P. 2009. *Understanding Paintings: Bible Stories and Classical Myths in Art*. London: Thames and Hudson.

Danto, A. 1981. *The Transfiguration of the Commonplace*. Cambridge, MA: Harvard University Press.

Davis, R. H. 1999. *Lives of Indian Images*. Princeton, NJ: Princeton University Press.

Debord, G. 1977. *The Society of the Spectacle*. Detroit: Black and Red Press.

Deleuze, G. 2007. *Two Regimes of Madness. Texts and Interviews 1975–1995*, trans. A. Hodges and M. Taormina, ed. D. Lapoujade. New York: Semiotext(e).

Dickie, G. 1974. *Art and the Aesthetic: An Institutional Analysis*. Ithaca, NY: Cornell University Press.

During, S. 2005. *Cultural Studies: A Critical Introduction*. London: Routledge.

Duttlinger, C. 2006. 'Traumatic Photographs: Remembrance and the Technical Media in W. G. Sebald's *Austerlitz*', in J. J. Long and Anne Whitehead (eds), *W. G. Sebald—A Critical Companion*. Edinburgh: Edinburgh University Press, 155–71.

Eagleton, T. 2000. *The Idea of Culture*. Oxford: Blackwell.

Eagleton, T. 2003. *After Theory*. London: Allen Lane.

Easthope, A. and K. McGowan. 1997. *A Critical and Cultural Theory Reader*. Buckingham: Open University Press.

Elkins, J. 2003. *Visual Studies: A Skeptical Introduction*. London and New York.

Elkins, J., ed. 2006. *Art History versus Aesthetics*. London and New York: Routledge.

Featherstone, M., ed. 1990. *Global Culture: Nationalism, Globalization and Modernity*. London: Sage.

Feenberg, A. 1991. *Critical Theory of Technology*. New York: Oxford University Press.

Flusser, V. 1999. *Shape of Things: A Philosophy of Design*. London: Reaktion Books.

Flusser, V. 2000. *Towards a Philosophy of Photography*. London: Reaktion Books.

Flusser, V. 2004. *Writings*, trans. Erik Eisel. Minneapolis: University of Minnesota Press.

Foster, H. 1985. *Recodings: Art, Spectacle, Cultural Politics*. Port Townsend, WA: Bay Press.

Foster, H., ed. 1987. *Vision and Visuality*. Seattle: Bay Press.

Foucault, M. 1971. *The Order of Things: An Archaeology of the Human Sciences*. New York: Vintage Press.

Foucault, M. 1973. *The Birth of the Clinic: An Archaeology of Medical Perception*, trans. Alan Sheridan-Smith. London: Pantheon.

Foucault, M. 1977. *Discipline and Punish: The Birth of the Prison*. Harmondsworth: Penguin.

Foucault, M. 1978. *The History of Sexuality, Volume 1: An Introduction*, trans. R. Hurley. Harmondsworth: Penguin.

Fuller, P. 1980. *Seeing Berger: A Revaluation of Ways of Seeing*. London: Writers and Readers Publishing Cooperative.

Gadamer, H.-G. 1975. *Truth and Method*, trans. J. Weinsheimer and D. G. Marshall. London: Sheed and Ward.

Gadamer, H.-G. 2004. *Truth and Method*, rev. trans. J. Weinsheimer and D. G. Marshall. London: Continuum.

Garfinkel, H. 1968. *Studies in Ethnomethodology*. Englewood Cliffs, NJ: Prentice-Hall.

Gauntlett, D. 2007. *Creative Explorations: New Approaches to Identities and Audiences*. Abingdon: Routledge.

Geertz, C. 1973. *The Interpretation of Cultures*. New York: Basic Books.

Geertz, C. 1983. *Local Knowledge*. New York: Basic Books.

Giddens, A. 2002. *Runaway World: How Globalisation Is Reshaping Our Lives*. London: Profile.

Gilroy, P. 1987. *There Ain't No Black in the Union Jack*. London: Hutchinson.

Gitelman, L. 2006. *Always Already New: Media, History and the Data of Culture*. Cambridge, MA: MIT Press.

Goffman, E. 1979. *Gender Advertisements*. New York: Harper and Row.

Gombrich, E. H. 1982. *The Image and the Eye*. Oxford: Phaidon Press.

Gray, A. and J. McGuigan, eds. 1993. *Studying Culture: An Introductory Reader*. London: Edward Arnold.

Gregory, D. 1994. *Geographical Imaginations*. Oxford: Blackwell.

Gregory, R. L. 1998. *Eye and Brain: The Psychology of Seeing*, 5th ed. Oxford and Tokyo: Oxford University Press.

Grossberg, L., C. Nelson and P. Treichler, eds. 1992. *Cultural Studies*. London and New York: Routledge.

Gunster, S. 2004. *Capitalizing on Culture: Critical Theory for Cultural Studies*. Toronto: University of Toronto Press.

Gutting, G. 1989. *Michel Foucault's Archaeology of Scientific Reason*. Cambridge: Cambridge University Press.

Hagberg, G. L., ed. 2008. *Art and Ethical Criticism*. Oxford: Blackwell.

Haldon, J. and L. Brubaker. 2010. *Byzantium in the Iconoclast Era, c. 680–850*. Cambridge: Cambridge University Press.

Hall, G. and C. Birchall, eds. 2006. *New Cultural Studies: Adventures in Theory*. Athens: University of Georgia Press; Edinburgh: University of Edinburgh Press.

Hall, J. R., B. Stimson and L. Tamiris Becker, eds. 2005. *Visual Worlds*. London: Routledge.

Halsall, F., J. Jansen and T. O'Connor, eds. 2009. *Rediscovering Aesthetics: Transdisciplinary Voices from Art History, Philosophy and Art Practice*. Stanford, CA: Stanford University Press.

Haraway, D. 1991. 'A Cyborg Manifesto: Science, Technology and Socialist-Feminism in the Late Twentieth Century', in *Simians, Cyborgs and Women: The Reinvention of Nature*. New York: Routledge and London: Free Association Books, 149–81.

Hardt, M. and A. Negri. 2000. *Empire*. Cambridge, MA: Harvard University Press.

Harris, J. 2001. *The New Art History: A Critical Introduction*. London and New York: Routledge.

Harris, J. 2006. *Art History: The Key Concepts*. London and New York: Routledge.

Hartley, J. 2003. *A Short History of Cultural Studies*. London: Sage.

Hemingway, A., ed. 2006. *Marxism and the History of Art: From William Morris to the New Left*. London: Pluto Press.

Heywood, I. 1997. *Social Theories of Art*. London: Macmillan.

Heywood, I. and B. Sandywell, eds. 1999. *Interpreting Visual Culture: Explorations in the Hermeneutics of the Visual*. London: Routledge.

Howes, D., ed. 2006. *Empire of the Senses. The Sensual Culture Reader*. Oxford and New York: Berg.

Inglis, D. and M. Herrero, eds. 2009. *Art and Aesthetics: Critical Concepts in the Social Sciences*, 4 vols. London: Routledge.

Jacobsen, M. H., ed. 2009. *Encountering the Everyday: An Introduction to the Sociologies of the Unnoticed*. London: Palgrave Macmillan.

Janicaud, D. 1994. *Powers of the Rational: Science, Technology, and the Future of Thought*, trans. P. Birmingham and E. Birmingham. Bloomington: Indiana University Press.

Jay, M. 1992. 'Scopic Regimes of Modernity', in Scott Lash and Jonathan Friedman (eds), *Modernity and Identity*. Oxford: Basil Blackwell, 178–95.

Jay, M. 1993. *Downcast Eyes: The Denigration of Vision in Twentieth-Century French Thought*. Berkeley: University of California Press.

Jay, M. 2004. *Songs of Experience: European and American Variations on a Universal Theme*. Berkeley: University of California Press.

Jenks, C., ed. 1995. *Visual Culture*. London: Routledge.

Johnson, S. A. 1999. *Interface Culture: How New Technology Transforms the Way We Create and Communicate*. New York: Basic Books.

Johnstone, S., ed. 2008. *The Everyday (Documents of Contemporary Art)*. Cambridge, MA: MIT Press.

Jonas, H. 1966. 'The Nobility of Sight: A Study in the Phenomenology of the Senses', in Hans Jonas, *Phenomenon of Life: Toward a Philosophical Biology*. New York: Harper and Row, 135–56.

Jones, A., ed. 2003. *The Feminism and Visual Culture Reader*. London and New York: Routledge.

Jordan, G. and C. Weedon, eds. 1995. *Cultural Politics: Class, Gender, Race and the Postmodern World*. Oxford: Blackwell.

Joseph, J. 2006. *Marxism and Social Theory*. Basingstoke: Palgrave Macmillan.

Kern, S. 1993. *The Culture of Time and Space 1880–1918*. Cambridge, MA: Harvard University Press.

Kittler, F. A. 2009. *Optical Media: Berlin Lectures 1999*, trans. Anthony Enns. Cambridge: Polity Press.

Lefebvre, H. 1991. *The Production of Space*, trans. D. Nicholson Smith. Oxford: Blackwell.

Levin, D. M. 1988. *The Opening of Vision: Nihilism and the Postmodern Situation*. London and New York: Routledge.

Levin, D. M., ed. 1993. *Modernity and the Hegemony of Vision*. Berkeley: University of California Press.

Levin, D. M., ed. 1997. *Sites of Vision: The Discursive Construction of Sight in the History of Philosophy*. Cambridge, MA: MIT Press.

Levin, D. M. 1999. *The Philosopher's Gaze: Modernity in the Shadows of Enlightenment*. Berkeley: University of California Press.

Levy, P. 1997. *Collective Intelligence: Mankind's Emerging World in Cyberspace*, trans. R. Bononno. New York: Plenum.

Levy, P. 1998. *Becoming Virtual: Reality in the Digital Age*, trans. R. Bononno. New York: Plenum.

Lister, M., ed. 1995. *The Photographic Image in Digital Culture*. London and New York: Routledge.

Lloyd, D. and P. Thomas, 1998. *Culture and the State*. London and New York: Routledge.

Longhurst, B., G. Smith, G. Bagnall, G. Crawford, M. Ogborn, E. Baldwin, and S. McCracken. 2008. *Introducing Cultural Studies*, 2nd edn. Harlow, Essex: Pearson Education.

Lowe, D. M. 1982. *History of Bourgeois Perception*. Chicago: University of Chicago Press/ Brighton: Harvester Press.

Lury, C. 1998. *Prosthetic Culture: Photography, Memory and Identity*. London: Routledge.

Maillet, A. 2004. *The Claude Glass: Use and Meaning of the Black Mirror in Western Art*, trans. J. Fort. New York: Zone Books.

Malpas, J. E. 1999. *Place and Experience: A Philosophical Topography*. Cambridge: Cambridge University Press.

Mandelstam, O. 2003. *The Moscow and Voronezh Notebooks. Poems 1930–1937*, trans. Richard and Elizabeth McKane. Tarset, Northumberland: Bloodaxe Books.

Manguel, A. 2008. *The Library at Night*. New Haven and London: Yale University Press.

Manovich, L. 1993. *Tekstura: Russian Essays on Visual Culture*. Chicago: University of Chicago Press.

Manovich, L. 2001. *The Language of New Media*. Cambridge, MA: MIT Press.

Manovich, L. 2003. 'New Media from Borges to HTML', in N. Wardrip-Fruin and N. Montfort (eds), *The New Media Reader*. Cambridge, MA: MIT Press, 13–25.

Massey, D. 1984. *Spatial Divisions of Labour*. Basingstoke: Macmillan.

Massey, D. 1994. *Space, Place and Gender*. Cambridge: Polity Press.

Massey, D. 2005. *For Space*. London: Sage.

McCulloch, W. S. 1989. *Embodiments of Mind*. Cambridge, MA: MIT Press.

McGowan, K. 2007. *Key Issues in Critical and Cultural Theory*. Maidenhead, Berkshire: Open University Press/McGraw-Hill Education.

McLuhan, M. 1967. *The Media Is the Message*. Harmondsworth: Penguin.

McLuhan, M. 1989. *The Global Village: Transformations in World and Media in the 21st Century*. New York: Oxford University Press.

McLuhan, M. 1994. *Understanding Media: The Extensions of Man*. Cambridge, MA: MIT Press.

McNeill, W. 1999. *The Glance of the Eye: Heidegger, Aristotle, and the Ends of Theory*. Albany, NY: State University of New York Press.

McRobbie, A. 1991. *Feminism and Youth Culture: From Jackie to Just Seventeen*. London: Macmillan.

McRobbie, A. 2005. *The Uses of Cultural Studies*. London: Sage.

Merleau-Ponty, M. 1945. *Phénoménologie de la perception*. Paris: Gallimard.

Merleau-Ponty, M. 1962. *Phenomenology of Perception*, trans. Colin Smith. London: Routledge and Kegan Paul.

Merleau-Ponty, M. 1964. *The Primacy of Perception*, trans. W. Cobb. Evanston, IL: Northwestern University Press, 1964.

Merleau-Ponty, M. 1968. *The Visible and the Invisible*. trans. Alphonso Lingis. Evanston, IL: Northwestern University Press.

Merleau-Ponty, M. 2008. *The World of Perception*, trans. Oliver Davis. London and New York: Routledge.

Mirzoeff, N. 1998. 'What Is Visual Culture?', in N. Mirzoeff (ed.), *The Visual Culture Reader*. London and New York: Routledge, 3–13.

Mirzoeff, N., ed. 1998. *The Visual Culture Reader*. London and New York: Routledge.

Mirzoeff, N. 1999. *An Introduction to Visual Culture*. London and New York: Routledge.

Mitchell, W.J.T. 1987. *Iconology: Image, Text, Ideology*. Chicago: University of Chicago Press.

Mitchell, W.J.T. 1994a. *Picture Theory*. Chicago: University of Chicago Press.

Mitchell, W.J.T. 1994b. *The Reconfigured Eye: Visual Truth in the Post-Photographic Era*. Cambridge, MA: MIT Press.

Mitchell, W.J.T. 1995. *The City of Bits: Space, Place, and the Infobahn*. Cambridge, MA: MIT Press.

Mitchell, W.J.T. 2002. 'Showing Seeing: A Critique of Visual Culture', *Journal of Visual Culture*, 1/2: 165–81.

Moxley, K. 2008. 'Visual Studies and the Iconic Turn', *Journal of Visual Culture*, 7/2: 131–46.

Mulvey, L. 1975. 'Visual Pleasure and Narrative Cinema', *Screen*, 16/3: 6–18.

Mulvey, L. 1989. *Visual and Other Pleasures*. Bloomington: Indiana University Press.

Munns, J. and G. Rajan, eds. 1995. *A Cultural Studies Reader: History, Theory, Practice*. London and New York: Longman.

Murphie, A. and J. Potts. 2003. *Culture and Technology*. London: Palgrave Macmillan.

Nancy, J.-L. 2007. *The Creation of the World or Globalization*, trans. F. Raffoul and D. Pettigrew. Albany, NY: State University of New York Press.

Neidich, W. 2003. *Blow-up: Photography, Cinema and the Brain*. New York: D.A.P./UCR/ California Museum of Photography.

Nichols, B. 1995. *Blurred Boundaries: Questions of Meaning in Contemporary Culture*. Bloomington: Indiana University Press.

Noë, A. 2004. *Action in Perception*. Cambridge, MA: MIT Press.

Noë, A. and J. K. O'Regan. 2002. 'On the Brain-Basis of Visual Consciousness: A Sensorimotor Account', in Alva Noë and Evan Thompson (eds), *Vision and Mind: Selected Readings in the Philosophy of Perception*. Cambridge, MA: MIT Press, 567–98.

Noë, A. and E. Thompson, eds. 2002. *Vision and Mind: Selected Readings in the Philosophy of Perception*. Cambridge, MA: MIT Press.

Onians, J. 2007. *Neuroarthistory: From Aristotle and Pliny to Baxandall and Zeki*. New Haven and London: Yale University Press.

Pippin, R. 1991. *Modernism as a Philosophical Problem*. Oxford: Blackwell.

Pippin, R. 1997. *Idealism as Modernism*. Cambridge: Cambridge University Press.

Pippin, R. 2005. *The Persistence of Subjectivity: On the Kantian Aftermath*. Cambridge: Cambridge University Press

Plant, S. 1997. *Zeroes and Ones: Digital Women and the New Technoculture*. New York: Doubleday.

Pollock, G. 1988. *Vision and Difference: Feminism, Femininity and the Histories of Art*. London and New York: Routledge.

Pooke G. and D. Newall. 2008. *Art History: The Basics*. London and New York: Routledge.

Poster, M. 1990. *The Mode of Information: Postmodenism and Social Contexts*. Cambridge: Polity Press.

Poster, M. 1995. *The Second Media Age*. Cambridge: Polity Press.

Poster, M. 2001. *What's Wrong with the Internet?*. Minneapolis: University of Minnesota Press.

Poster, M. 2002. 'Visual Studies as Media Studies', *Journal of Visual Culture*, 1/1: 67–70.

Preziosi, D., ed. 1998. *The Art of Art History: A Critical Anthology*. Oxford and New York: Oxford University Press.

'Questionnaire on Visual Culture'. 1996. *October*, 77 (Summer): 25–70.

Rancière, J. 2006. *The Politics of Aesthetics: The Distribution of the Sensible*, trans. G. Rockhill. London: Continuum.

Rancière, J. 2007. *The Future of the Image*. London: Verso.

Readings, B. 1996. *The University in Ruins*. Cambridge, MA: Harvard University Press.

Rees, A. L. and F. Borzello, eds. 1986. *The New Art History*. London: Camden Press.

Relph, E. 1976. *Place and Placelessness*. London: Pion.

Rheingold, H. 2002. *Smart Mobs: The Next Social Revolution*. New York: Basic Books.

Ricoeur, P. 1994. *Oneself as Another*, trans. K. Blamey. Chicago: University of Chicago Press.

Robins, K. 1996. *Into the Image: Culture and Politics in the Field of Vision*. London: Routledge.

Rogoff, I. 1998. 'Studying Visual Culture', in Nicholas Mirzoeff (ed.), *The Visual Culture Reader*. London and New York: Routledge, 14–26.

Rorty, R. 1979. *Philosophy and the Mirror of Nature*. Princeton, NJ: Princeton University Press.

Rose, G. 1993. *Feminism and Geography*. Cambridge: Polity Press.

Rose, G. 2001. *Visual Methodologies: An Introduction to the Interpretation of Visual Materials*. London: Sage.

Said, E. 1985. *Orientalism*. London: Random House; Harmondsworth: Penguin.

Saito, Y. 2007. *Everyday Aesthetics*. Oxford: Oxford University Press.

Sandywell, B. 1996. *Logological Investigations*, 3 vols. London; Routledge.

Sandywell, B. 2000. 'Memories of Nature in Bakhtin and Benjamin', in C. Brandist and G. Tihanov (eds), *Materializing Bakhtin: The Bakhtin Circle and Social Theory*. London and New York: Macmillan and St. Martin's Press, 94–118.

Sandywell, B. 2009. 'On the Globalization of Crime: The Internet and the New Criminality', in Yvonne Jewkes and Majid Yar (eds), *Handbook of Internet Crime*. Uffculme, Devon: Willan Publishing, 38–66.

Sandywell, B. 2011. *Dictionary of Visual Discourse: A Dialectical Lexicon of Terms*. Farnham, Surrey: Ashgate.

Sandywell, B., D. Silverman, M. Roche, P. Filmer, and M. Phillipson. 1975. *Problems of Reflexivity and Dialectics in Sociological Inquiry: Language Theorizing Difference*. London: Routledge and Kegan Paul.

Schivelbusch, W. 1986. *The Railway Journey: The Industrialization of Time and Space in the Nineteenth Century*. Berkeley: University of California Press.

Scott, J., ed. 2010. *Artists-in-Labs: Networking in the Margins*. Vienna: Springer.

Shapiro, G. 2003. *Archaeologies of Vision: Foucault and Nietzsche on Seeing and Saying*. London and Chicago: University of Chicago Press.

Shaw, D. 2008. *Film and Philosophy: Taking Movies Seriously*. London and New York: Wallflower.

Sheringham, M. 2006. *Everyday Life: Theories and Practices from Surrealism to the Present*. Oxford: Oxford University Press.

Shohat, E. and R. Stam. 1998. 'Narrativizing Visual Culture: Towards a Polycentric Aesthetics', in Nicholas Mirzoeff (ed.), *The Visual Culture Reader*. London and New York: Routledge, 27–49.

Sibley, D. 1995. *Geographies of Exclusion: Societies of Difference in the West*. London: Routledge.

Silver, D. and A. Massanari. 2006. *Critical Cyberculture Studies*. New York and London: New York University Press.

Smith, D. 1987. *The Everyday World as Problematic: A Feminist Sociology*. Boston: Northeastern University Press.

Soja, E. J. 1989. *Postmodern Geographies: The Reassertion of Space in Critical Social Theory*. London: Verso.

Soja, E. J. 1996. *Thirdspace: Journeys to Los Angeles and Other Real-and-Imagined Places*. Oxford: Blackwell.

Solso, R. L. 2005. *The Psychology of Art and the Evolution of the Conscious Brain*. Cambridge, MA: MIT/Bradford Books.

Sontag, S. 2002. *On Photography*. Harmondsworth: Penguin (Penguin Classics).

Spivak, G. C. 1987. *In Other Worlds: Essays in Cultural Politics*. New York: Methuen.

Spivak, G. C. 1988. 'Can the Subaltern Speak?', in C. Nelson and L. Grossberg (eds), *Marxism and the Interpretation of Culture*. London: Macmillan, 271–313.

Spivak, G. C. 1990. *The Post-Colonial Critic: Interviews, Strategies, Dialogues*. London: Routledge.

Squire, M. 2009. *Image and Text in Graeco-Roman Antiquity*. Cambridge: Cambridge University Press.

Stafford, B. M. 1996. *Good Looking: Essays on the Virtue of Images*. Cambridge, MA: MIT Press.

Stafford, B. M. 2007. *Echo Objects: The Cognitive Work of Images*. Chicago: University of Chicago Press.

Stephens, M. 1998. *The Rise of the Image, the Fall of the Word*. Oxford: Oxford University Press.

Storey, J. 2001. *Cultural Theory and Popular Culture*, 3rd ed. Edinburgh: Edinburgh University Press.

Striff, E., ed. 2003. *Performance Studies*. Basingstoke: Palgrave Macmillan.

Sturken, M. and L. Cartwright. 2001. *Practices of Looking: An Introduction to Visual Culture*. Oxford: Oxford University Press.

Taylor, P. A. and Jan L. Harris, eds. 2008. *Critical Theories of Mass Media: Then and Now*. Maidenhead, Berkshire: Open University Press/McGraw-Hill.

Terranova, T. 2004. *Network Culture: Politics for the Information Age*. London: Pluto Press.

Thrift, N. 1996. *Spatial Formations*. London: Sage.

Thrift, N. 2005. *Knowing Capitalism*. London: Sage.

Thrift, N. 2007. *Non-Representational Theory: Space/Politics/Affect*. London and New York: Routledge.

Tilley, C. 1994. *The Phenomenology of Landscape: Places, Paths and Monuments*. Oxford: Berg.

Trachtenberg, A., ed.1980. *Classic Essays on Photography*. New Haven, CT: Leet's Islands Books.

Trifonas, P. P. and M. A. Peters, eds. 2005. *Deconstructing Derrida: Tasks for the New Humanities*. Basingstoke: Palgrave Macmillan.

Turkle, S. 1984. *The Second Self: Computers and the Human Spirit*. New York: Simon & Schuster.

Turkle, S. 1995. *Life on the Screen: Identity in the Age of the Internet*. New York: Simon & Schuster.

Turner, G. 1996. *British Cultural Studies: An Introduction*, 2nd edn. London: Routledge.

Ulmer, G. 1989. *Teletheory: Grammatology in the Age of Video*. New York: Rouledge.

Virilio, P. 1983. *Pure War*. New York: Semiotext(e).

Virilio, P. 1986. *Speed and Politics*, trans. M. Polizzotti. New York: Semiotext(e).

Virilio, P. 1989. *War and Cinema: The Logistics of Perception*, trans. P. Camillier. London: Verso.

Virilio, P. 1991a. *The Aesthetics of Disappearance*, trans. P. Beitchman. New York: Semiotext(e).

Virilio, P. 1991b. *Lost Dimension*, trans. D. Moshenberg. New York: Semiotext(e).

Virilio, P. 1993. *L'art du moteur*. Paris: Galilée.

Virilio, P. 1994. *The Vision Machine*. Bloomington: Indiana University Press.

Virilio, P. 1997. *Open Sky*, trans. J. Rose. London: Verso.

Walker, J. A. and S. Chaplin. 1997. *Visual Culture: An Introduction*. Manchester and New York: Manchester University Press.

Wells, E., ed. 2004. *Photography: A Critical Introduction*. London and New York: Routledge.

West, C. 1990. 'The New Cultural Politics of Difference', in Russell Ferguson, et al. (eds), *Out There: Marginalization and Contemporary Cultures*. Cambridge, MA: MIT Press, 19–36.

Wilder, K. 2009. *Photography and Science*. London: Reaktion Books.

Williamson, J. 1978. *Decoding Advertisements: Ideology and Meaning in Advertising*. London: Marion Boyars.

Wilson, S. 2002. *Information Arts: Intersections of Art, Science, and Technology*. Cambridge, MA: MIT Press.

Wollheim, R. 1987. *Painting as an Art*. Cambridge, MA: Harvard University Press.

Zielinski, S. 2008. *Deep Time of the Media: Towards an Archaeology of Hearing and Seeing by Technical Means*. Cambridge, MA: MIT Press.

Zimmerman, M. 1990. *Heidegger's Confrontation with Modernity: Technology, Politics, Art*. Bloomington: Indiana University Press.

Historical and Theoretical Perspectives

Editorial Introduction

Margaret Dikovitskaya's chapter begins with what she regards as a decisive challenge to the development of visual culture studies: how to retain its legitimate ambition to breadth while avoiding the incoherence and confusion that failure to identify and embrace a suitable conceptual, methodological and disciplinary model might entail.

Setting the scene, Dikovitskaya argues that the 1980s cultural turn in the humanities and social sciences was related to both a dissatisfaction with 'positivist' and/or quantitative methods on the one hand, and a reawakened interest in subjectivity, consciousness or what in sociology were known as 'members' accounts' on the other. However, in the field of culture these developments soon succumbed to a new wave of objectifying theory and method in the forms of ideology critique and an obsession with codes, signs and structures. For Dikovitskaya what defines contemporary visual studies is a rejection of the supposedly 'privileged' position of visual high art coupled with a determined emphasis on the 'sensuous and semiotic particularity' of the cultural artefact.

In defending this perspective she identifies different approaches to the study of visual culture. In the USA the programme developed at the University of Rochester sought to combine art history with 'Theory', a mélange of predominantly French ideas based in linguistics and semiotics but reordered through a Nietzschean 'genealogical' approach to the more traditional critique of ideology and discourse formations. Concepts drawn from these theoretical perspectives proved both powerful and attractive, especially in the context of the study of culture and cultural change in the setting of the university world after 1968, convincing many of the need to abandon all existing forms of art history and traditional discourses drawn from the humanities, and to replace these with new programmes explicitly informed by Theory. After this turn towards Theory the special place granted to art and high-cultural critique could only be justified in terms of their 'socio-political' significance. The radically demotic impulses of late-modernity or postmodernity had thoroughly discredited the very idea of an exclusive concept of

high culture. Although castigated by some as reductive, in this new political context the notion of 'aesthetic value' became indistinguishable from an arbitrary assertion of local valuations or personal taste.

Dikovitskaya turns next to W.J.T. Mitchell's important attempt to introduce more precision and discrimination into the field of visual culture studies, in particular his distinction between the verbal, the visual and the pictorial. Mitchell treats word and image as two different ways of interpreting the world or creating meaning. The image, however, has often been thought of as 'natural', identifying something by simple resemblance rather than by participation in a system of codes and conventions. Yet Mitchell also insists that many of the canonical texts celebrated by Theory are thoroughly 'impure', not only supplemented by pictures of various kinds but also suffused with visual imagery and metaphor. For Mitchell the creation of meaning through language or images is firmly embedded in society, history and culture. Mitchell is careful to clearly distinguish between these terms. 'Society' refers to real relations between people, whereas 'culture' refers to representations of these relations, what they are, what they mean, and critically how they are enacted. This last step, however, has the unfortunate effect of emptying the notion of 'society' of any substantial content, a problem that we will see reappear elsewhere in this collection.

Turning to the influential approach of Nicholas Mirzoeff, Dikovitskaya focuses on his advocacy of the postmodern social condition, a relative of Guy Debord's 'society of the spectacle' and Jean Baudrillard's simulated hyperreality. Advanced information technology linked with structural and global changes in the capitalist economy towards hypercommodification characterized by the proliferation of powerfully persuasive images, meant that today's society experiences and understands itself as a globalized visual culture. Global technologies for producing, distributing and consuming images reflect and enhance relations of cultural power, hence the need for a visual political economy capable of analysing and intervening in such systems. For Mirzoeff, visual culture studies needs to resist narrow conceptions of the visible, if only because of the convergence of different sensory modalities engineered by the new media technologies.

Given the very different approaches outlined above, for Dikovitskaya the study of visual culture has transcended the attempt to synthesize a new discipline out of artefact-oriented approaches like art history, linguistics, film studies and anthropology.

Finally, Dikovitskaya returns to the place of art and art history in visual studies. Visual culture is not a separate kind of culture, but the result of a particular emphasis, whose approach is historical and social, and this must apply to art as well as other predominantly visual phenomena. Art is 'a human construct that functions in particular ways at particular times, and analyzes artistic production locally.' This is not to negate art and its history but to make these formations topics of historical and sociological enquiry. Popular and elite forms survive but represent different materials for analysis, not levels in a hierarchy of aesthetic or reflective ontology.

For **Catherine Soussloff**, popular assumptions about visual culture and visual studies have not aided the understanding of their intimately related histories. Soussloff identifies two such approaches during the last twenty years: the *admonitory* sensibility and the *redemptive* impulse.

The redemptive theme in the study of visual culture is often expressed in positive evaluations or expectations of new visual and communicative technologies, from Walter Benjamin's endorsement of photography and 'collage', which he associated with the onset of the mechanical reproduction of the image, through to more recent enthusiasm for digital media and the Internet. However, an admonitory or critical outlook has been behind powerful critiques of the 'society of the spectacle', and even of the visual image itself and its supposed predominance in late-modern or postmodern society.

As a way of making sense of such opposed positions within the study of visual culture, Soussloff proposes a 'historiography of visual culture and visual studies', culminating in a new idea of aesthetics based around a critique of the theoretical foundations of visual culture and its investigation.

The field of visual culture is usually taken to include the 'creation, production and interpretation of all visual artifacts and images'. Visual studies focuses on the centrality of the image to many cultural forms. The development and spread of image technologies has been particularly important to visual studies because of their obvious impact on popular culture and the attitudes and outlooks it shapes. Soussloff observes that the inherently inter- or cross-disciplinary character of visual studies springs from the variety of approaches, practices and media within visual culture itself. She notes different reactions to the heterogeneity and 'unruliness' of late-modern visual cultures, welcomed by some as inherently subversive of hierarchical high culture, but condemned by others as merely reflecting, or indeed being critically important to, the new epoch of globalized, disorganized capital.

Soussloff concurs with many others that theories of postmodernity that predate visual studies have strongly influenced its development. The confluence of visual culture, visual studies and postmodernism is an important part of her proposed historiography. Fredric Jameson advances the argument for postmodernity in a highly traditional Marxist way. Technological and economic developments in the capitalist mode of production underlie profound change in relations of production and products, specifically the shift towards 'aesthetically' activated commodities, this essentially to stave off a 'crisis of overproduction' by increasing turnover. For Jameson, the stylistics of postmodernism mean nothing unless rooted in its political economy, a strongly realist and critical idea that outcrops widely in visual culture and visual studies.

Soussloff also notes François Lyotard's view that the irrelevance of older disciplinary boundaries mirrors the new economic and political realities of global, postmodern capital. Interdisciplinarity as both a reality and a critical methodology thus offers a more effective range of performative applications.

Turning to art history, Soussloff recalls debates in 1990s about the appropriateness of art history's theories and methods to an 'expanded field' of visual culture. However, the traditional concern of art history and practice with 'aesthetics' reappears in a new form. Important here is Jacques Rancière's view that the aesthetic has fresh political and cultural significance as an imaginative attempt to 'remodel' the basic elements of sensory experience in the context of everyday life. This means that it cannot derive its justification or guiding interests from current political forces, arrangements and discourses. It is forced to take up once more the theme of emotion or feeling, and seeks to develop its

ethical implications. Soussloff compares Jameson to Rancière. Both seem to share a view of late-modernity in which older ideas of aesthetic autonomy and the freedom of the artist on the one side, but also the ideological functions performed by art for a dominant class, made only very limited sense. For Jameson, the result is the obsolescence or neutralization of the aesthetic, while for Rancière it suggests new positive possibilities and new forms of relevance for the arts. In particular a 'political aesthetics' promises to free art and cultural practice and reflection generally from the assumed opposition between the higher status of active intelligence and the lower faculty of passive sensibility.

Soussloff concludes by arguing that the aesthetic turn, and the retrieval of visual art's significance to the study of visual culture generally, requires a more critical historiography capable of establishing a social and historical context for art as a practice and art history and scholarly, critical discipline. The emergence of this kind of interdisciplinary work is inextricably linked to the central concerns of visual culture and visual studies.

Martin Jay sets out to examine what has happened to his earlier idea of a 'scopic regime' or historically predominant 'way of seeing' that takes root in and gives shape to certain general cultural forms and social practices at particular periods in history. The concept was given its current meaning in his paper 'Scopic Regimes of Modernity' in 1988, which both reformulates and critiques Martin Heidegger's essay 'The Age of the World Picture' (1938).

'World-picture', for Heidegger, does not simply mean a conventional representational image (of a world or cosmos) but a kind of active representing where being is indistinguishable from 'being able to be re-presented to a *subjectum*', and a situation he thinks of as 'the essence of the modern age' in mimetic or representational terms. According to Heidegger Classical Greece and Medieval Europe did not 'picture' being or understand human being as picturing in this representational fashion. Rather, beings (*seiende*) were taken as integral parts of Being (*Sein*), entities emerging from the world as an 'event of disclosure' (*aletheia*). Not only could human beings look at things but also things could look back at them. Modern science and technology, particularly technologies of vision, far from creating this situation, are rather its expressions, forms or consequences of a radically different conception of Being. At its core is 'representational enframing' and the 'primacy of subject over object'.

Jay identifies two central claims of Heidegger's essay. While this kind of picturing is uniquely characteristic of the modern age, 'Cartesian perspectivalism', technological instrumentality and modern science do not cause the violent subjection of Being, jeopardizing *Dasien*'s essential care for *Sein*; as Heidegger remarks, the essence of technology is nothing technological. However, Heidegger roots the origins of modernity in the classical period, specifically in Plato's identification of the appearance of *Sein* as *eidos* (the look or 'idea' of something). So pre- and non-modern cultures may not be exempt from ocularcentric tendencies.

Jay next examines the contention that modern culture is entirely dominated by 'vision', understood along Heidegger's lines. It has been widely argued that Cartesian perspectivalism was the predominant way of understanding and experiencing vision in the modern era. Some claim that post-Renaissance art, or at least the philosophical

system of 'aesthetics' that develops in order to understand it, is dominated by the same ideas, forcing art to understand itself exclusively in terms of the visual experience of the subject.

Sceptical of the view that modernity is best described as a single, hegemonic regime of seeing and visibility, Jay's original essay supplemented Cartesian perspectivalism with two other scopic regimes: Svetlana Alpers's 'art of describing' and Buci-Glucksmann's account of 'Baroque reason'.

Critical responses to Jay's thesis pointed out other attempted departures from and moments of crisis in the development of Cartesian perspectivalism, for example the break-up of coherent Albertian perspective or pictorial regimes of ordered spatial recession in the history of European painting, correlated with parallel critiques of 'integrated subjectivity' and realist and positivist epistemologies. Much later, the arrival of antinomian modernism and postmodernism dealt further blows to Cartesianism.

Other critics argued that Descartes's attitude to vision is much more complex than often supposed, often exhibiting considerable suspicion of vision, and that the Baroque era marks a crisis in early modern culture so profound as to make implausible the idea of the serene rule of a hegemonic perspectivalism.

In revisiting his earlier work Jay sums up his thoughts about the currency of the notion of a scopic regime as a 'tool of critical analysis' in visual studies. The initial examples of scopic regimes were always intended to be ideal types, tools of historical analysis, characterizing broad features of historical visual cultures, and were never intended to be absolutely accurate, exhaustive or definitive descriptive accounts. At a microscopic level, the idea has been fruitfully applied to a wide range of historical and contemporary phenomena, from visual aspects of the 'war on terror', the literature of Chaucer and John Ashbury, to the visual experience of shopping malls and consumer culture.

Jay supports the idea of reflecting on the relationship between ideal type constructs through detailed inspection of particular visual forms. For example to what extent do contemporary films or artworks, analysed under the notion of Baroque reason, conform to, qualify or deviate from this template? Also, like Mitchell, Jay insists on the need to think more broadly and critically about the 'visual', including not just optical phenomena and conventionally visual artefacts, but also the use of visual concepts and metaphors and visually articulated ways of apprehending and recording embodied in specific historical conjunctures and systems of social relations.

Beyond this, however, is the question of the idea of a 'regime' itself. For Jay the idea is holistic, broader than a type of government. He quotes the political theorist Leo Strauss: a regime is a particular way of life characteristic of a given society, which depends upon the 'predominance of human beings of a certain type'. As far back as Christian Metz's use of the term with regard to the cinema, and perhaps echoing French Jacobin attitudes to the *ancien régime*, the idea of a regime, throughout the history of visual culture studies, has been connected to the assumption of a deficit of legitimacy. Often, a regime of any kind is often taken as equivalent to a ruling ideology, and so fair game for critique and subversion. Jay, however, warns against both the fantastic belief in the transcendence of scopic regimes as such, and the hasty assumption that such regimes are always

repressive or regressive. Political and ethical outlooks which many might regard as cred-
itable and constructive may well depend upon an 'eye', a way of seeing or a kind of direct
ethical apprehension. While it is important to understand the multisensory character of
human experience, Jay believes that 'the most promising area of new enquiry remains
in visual culture.'

Michael Gardiner plots another, albeit closely related, route towards the funda-
mental concepts of visual studies. He begins by outlining some problems confronted by
much recent work in the area.

Intense interest in aspects of visual culture, and the popularity of the concept of
visual culture itself, over the past three decades has often been accompanied by a 'herme-
neutics of suspicion', a tendency to associate the visual with undesirable aspects of the
modern and contemporary world. Gardiner sets this against the more nuanced historical
analysis advocated by Peter de Bolla, which uncovers different, often competing notions
and practices of vision at work from early modernity onwards (if not before), hence 'het-
eroscopics', an awareness of scopic pluralism.

This outlook echoes Jay and Bruno Latour's critiques of simplistic, blanket con-
demnations of the baleful, unqualified power of the gaze. For Jay the belief that sight
is completely determined by its cultural context leads to the view that there can be
no meaningful translations between incommensurable groups. In fact cultures are not
'clearly delineated entities with distinct expressive qualities' but rather, 'impure and
heterodox constructions, amalgams of myriad discursive impulses and forms, and are
"always-already" complexly intertwined with natural processes.' Gardiner proposes as an
alternative, a 'relational or dialogical theory of vision', for which the richest resource is
the existential phenomenology of Maurice Merleau-Ponty.

Gardiner poses three questions to Merleau-Ponty's phenomenology: Do important
aspects of visual experience resist discursive construction? Do we need to question the
suspicion characteristic of reductive culturalism? Can there be a 'dialogical mode of see-
ing' that does not simply enact given power relations, but which is ethically open to dif-
ferent forms of insight and recognition?

Merleau-Ponty consistently criticized the 'philosophy of reflection' or 'high altitude
thinking', in which a solitary, seeing subject gazes out at the external world. The con-
tents of this passive apprehension are then submitted to an organizing intellect to pro-
duce 'knowledge'. For Merleau-Ponty, however, the underlying schema of subject/object
dualism distorts the mutual participation of self and other in a much more productive,
fluid and ambiguous historical and social reality. The philosophy of reflection makes the
observer debilitatingly abstract, seeking to defeat and possess the world by purifying and
objectifying it. The drive to omniscience—the God's-eye perspective—inevitably fails.
The world now appears to the subject utterly hostile and alien, stimulating even more
desperate efforts to apprehend, organize and control.

Merleau-Ponty's well-known alternative is a concrete 'philosophy of embodi-
ment'. Our embodied being, shared with others, operates prior to all reflective forms
of consciousness. We first inhabit the pre-predicative world of perception before we
engage in theory and systematic reflection. Further, the world exists only through our

embodiment within it. We are, in Heidegger's terms, beings already thrown into a world. He believed, along with Husserl, that this primary reality could be experienced 'pre-reflectively' and described in terms that would respect the 'nascent *logos*' of concrete visual experience. For Merleau-Ponty this was one of the fundamental tasks of a critical phenomenology.

Gardiner admits that some of this may sound like the ocularphobia he has earlier opposed, perhaps particularly when it comes to relations with the other, that is what seems like the paranoia and controlling impulses of the gazing subject. Yet Gardiner argues that at critical junctures Merleau-Ponty departs form this model, opening up the possibility of what Jay calls 'dialogic specularity'. This possibility rests on the ontology of embodiment proposed in Merleau-Ponty's later work. This emphasizes the changeability of the world, a process of constant, radically unpredictable 'becoming', which he sees positively in terms of fecundity, new life, new beginnings. This is our 'being-in-the-world'; this is the sense in which life—or living—is inherently open and hence dialogical, dialogue being the capacity to establish and reestablish connections, and to make something of these discontinuities and unexpected turns, to transform these into new possibilities of experience.

If the seer and seen are intertwined in the 'flesh of the world', how does the philosophy of reflection come about? One difficulty is that the flesh, as a 'general thing' at the junction of the finite individual and the other, cannot be described 'in general'. This is because the other is another opening of the world, which is not identical with the opening that is 'me'. This is not because we are two monads separated by different viewing positions, but because our difference is itself an expression, a coming into being, of an essential aspect of being itself, its incompleteness, its invisibility, its mystery. What, then, of the origins of 'dialogue' as a movement against, or at least a mitigation of, the openness and otherness of being? How can dialogue be both an instance of the otherness of being and an effort to palliate its inhuman rigors, by symbolic re-embedding, re-establishing a semblance of connection and continuity, or perhaps by mutually binding or ethical constructions of a world?

However, it is clear in Gardiner's account that Merleau-Ponty is rethinking a very influential idea about seeing, where what is purportedly obvious about the act of seeing is transferred to the act of thinking. To the philosophy of reflection he opposes an ontology of embodiment, in which the seer is a particular, finite expression of the flesh of the world, unfathomable even to itself. Among the 'things' seen are other such expressions, discontinuous with themselves in the flux of being. The openness of others, in which I share, has a special place in and claim on my experience of the world. Seeing, then, is dialogue, which seeks to interpret and make tangible the commonality of embodied being. This suggests that perceptual avenues, including vision, are in principle multiple, or we might say that when we view artefacts made in response to seeing they may also have this as a possibility, this reference to other ways of seeing not just as difference but as an attempt at connection, amplification, intensity. Merleau-Ponty tries to work out what this might mean concretely in his justly famous essays devoted to the paintings of Paul Cézanne.

Nicholas Davey is interested in the clarity with which the objects of visual studies are understood. He is particularly concerned with the place of works of art, or 'aesthetics' understood from the point of view of philosophical hermeneutics, which he believes offers the possibility of dialogue, a 'fusion of horizons' involving the artist, the work, its forms and its spectators. He is concerned about a tendency in visual studies to homogenize all cultural artefacts into 'signs and symptoms' of the time, place and circumstances of their production and consumption; this anxiety leads him to question certain prevalent analytical and methodological assumptions in influential approaches to the artwork.

Davey argues that a failure to acknowledge the ontogenetic difference between the artwork and the designed object imperils the veracity of visual studies and in particular undermines the possibility of critique within the experience of art. In this way the pleasure or judgement of the seeing subject, which form the basis of neo-Kantian aesthetics, are of reduced importance for both hermeneutics and visual studies, albeit for somewhat different reasons. However, the claim of hermeneutics that the work of art is ontologically distinctive raises problems for the inclusivity of visual studies.

More concretely, Davey asks whether a Tizio lamp and a painting by J.W.M. Turner can be treated as having the same cultural value? If not, can a distinction be maintained without falling back into outmoded 'bourgeois' aesthetics? Davey argues that equalizing the two misses an important ontological difference between artworks and designed objects, to the detriment of both cultural spheres and the common visual world in which they participate.

Davey approaches these questions through a discussion of the iconography of John the Baptist, who in Western art is usually presented as naked except for a sheepskin, a covering which declares his biblical purpose: the announcement of the coming of the Christ. This makes his sparse clothing the opposite of camouflage, whose purpose is disguise and deception. Davey suggests that the existence of camouflage, and the familiarity of its mechanisms to visual artists whose ostensible goal is visual truth, jolt our natural confidence in our capacity to judge what we have seen. Indeed, the question is raised as to whether a distinction possible between visual truth and convincing visual rhetoric is viable?

The purpose of camouflage is to hide from view, and Davey concedes that even the most successful work of art withholds the 'full totality of its subject matter'. However, in this second case, there is a connection or path leading from the visible appearance of the work to the subject it depicts. The 'how' of appearance must cohere with the truth of 'what' is shown. This is not the case with camouflage.

Culture as such is often understood as a set of different human practices, providing contexts in which questions of quality and value are meaningful. As practices with their own outlooks, methods and canons, each of which may in certain circumstances become questionable, producing an evolution in attitudes and canonical exemplars, fine art and design are very similar. However, the facts that expectations about subject matter and criteria of quality operate in broadly similar ways or even that typical examples can be analysed 'aesthetically' do not make these practices identical.

Davey points out that a painting like Brueghel's *Hunters in the Snow* both convinces us that it represents an actual or at least possibly actual scene, but also inaugurates a way of seeing the natural world as a 'landscape', that is in terms of a picture of a certain kind. In hermeneutical terms, it introduces a historically effective way of looking, a new dimension of the human world, and for Hans-Georg Gadamer such representations exist in intimate connection with the aspects of the world they reveal, such that violence to the work of art is also violence to what it depicts, and visa versa.

Not to look at an artwork, or not to look at it in such a way that the question it confronts, and which it poses to the viewer, about whether it brings something forth, is to 'miss' the artwork, not to encounter it at all. Conversely, it would be a mistake to 'look' at a designed object in such a way that prevented its consummation in use. Following the thinking of hermeneutic philosophers like Hans-Georg Gadamer and Paul Ricoeur, Davey summarizes the difference by saying that the artwork 'calls a world into being', whereas the designed object 'is called into existence by a world'. This difference in ontogenetic backgrounds is the main difficulty faced by the methodological inclusiveness of visual studies.

In his concluding section Davey analyses the kind of visual attention invited by the artwork, a kind of 'clearing the mind' so that the subject matter can be properly addressed, but only via attentiveness to the concrete way, the 'how', through which the subject matter appears at all. This openness may even invite shock, coming face to face with something unexpected or disturbing. For Davey's hermeneutical aesthetics it is the work that actively questions the viewer.

In much visual studies, however, the suspicious spectator interrogates the object, methodologically constructing it as yet another instance of ideology or political mechanisms underlying cultural practices. This effectively silences the work as a dialogical object, ironically reinstates the subject-dominated perspective of Cartesianism and neo-Kantianism, and thus negates an important way in which art and symbols generally can be a recurring basis for 'festive' gatherings in which communal bonds are both celebrated but may also be tested for vitality and relevance.

Major Theoretical Frameworks in Visual Culture

MARGARET DIKOVITSKAYA

Visual culture, also known as visual studies, is a research area and a curricular initiative that regards the visual image as the focal point in the processes through which meaning is made in a cultural context. An interdisciplinary field, visual culture came together in the late 1980s after the disciplines of art history, anthropology, film studies, linguistics and comparative literature encountered cultural studies and poststructuralist theory. The inclusive concept of culture as 'a whole way of life' (Raymond Williams) has been the object of inquiry of cultural studies, which encompassed the 'high' arts and literature without giving them any privileged status. Deconstructionist criticism showed that the academic humanities were as much artefacts of language as they were outcomes of the pursuit of truth. Although visual culture has enjoyed a proliferation in the Anglo-American academy in the past decade, there is no consensus among its adepts with regard to its scope and objectives, definitions and methods. Recent introductions to and readers of visual culture have spelled out a variety of conceptual perspectives. At the May 2001 Clark Art Institute Conference, 'Art History, Aesthetics, Visual Studies', the question was posed as to whether or not this new field has reached a state of inconsistency by subsuming everything related to the cultural and the visual. Some theorists are of the opinion that visual culture has no object of study since it commenced with a disapproval of the 'traditional histories of art, film, photography ... [and] their positivist attachment to their object as a discrete given' (Rampley 2002: 3). I envision my task to be to show how visual studies avoids these two ontological perils and negotiates between the Scylla—the lack of a specific object of study—and the Charybdis—the expansion of the field to the point of incoherence. In what follows I offer an overview of this new area of study in order to reconcile its diverse theoretical positions and understand its potential for further research.

THE VISUAL TURN

The term 'visual culture' first appeared on the covers of books whose topics were neither Western art nor—in the spirit of their time—art with a capital 'A': *Towards a Visual Culture: Educating through Television* (1969) by Caleb Gattegno, *Comics and Visual Culture: Research Studies from Ten Countries* (1986), edited by Alphons Silbermann and H.-D. Dyroff, and *The Way It Happened: A Visual Culture History of the Little Traverse Bay Bands of Odawa* (1991) by James McClurken. Before he acquired a black-and-white television set in 1966, Gattegno had studied the imagery of children's drawings and worked on films for teachers' education. Marvelling at the efficacy of knowing through sight, his book distinguished between 'the clumsiness of speech' as a means of expression and 'the powers of vision'. With sight, Gattegno states,

> infinities are given at once; wealth is its description. In contrast to the speed of light, we need *time* to talk and express what we want to say. The inertia of photons is nil compared to the inertia of our muscles and chains of bones. (Gattegno 1969: 4)

This position reflects a utopian spirit: Gattegno posits that television would make the greatest contribution in the area of education by 'casting away our preconceptions, our prejudices made explicit by the shock of the encounter of a true image and presumably true belief'. As such, it is obviously vulnerable to criticism from all quarters of contemporary scholarship: we need time *to see* what we gaze upon, and this meaning-making process is unthinkable without language, after all. But Gattegno's text was among the first that emphasized the formation of subjectivity: 'To talk of the medium of television is a way to talk of man the perceiver, the responder, the expander, and the processor of messages' (1969: 4).

Visuality at present is dominated by the speed, the logic and the ubiquity of the electronic screen: we have all become accustomed to scanning images instantaneously in an environment dominated by sensory overload. There is a much greater fluidity of transfer between the visual and other forms of knowledge, with more access to objects through the visual. The condition of our culture in which visuality is centrally important brought to the fore the new approaches to its academic study. The issues of visuality and vision[1] have been zealously explored across a broad range of the humanities and social sciences—the trend called the 'visual turn' (Jay 2002).

Since the term 'pictorial turn' was coined in the 1990s by W.J.T. Mitchell, it has served as a focus for the ongoing theoretical discussion on pictures whose status lies 'somewhere between what Thomas Kuhn called a "paradigm" and an "anomaly"' and which have emerged as a 'kind of model or figure for other things' in the human sciences (Mitchell 1994: 13). Mitchell (1995b) has further posited that a new interdiscipline of visual culture has surfaced around the pictorial turn that runs through critical theory and philosophy. I argue that if we are to accept Mitchell's thesis that visual studies was born to the marriage of art history (a discipline organized around a theoretical object) and cultural studies (an academic movement echoing social movements) we

should recognize that it is the 'cultural turn' that made visual studies possible in the first place.

THE CULTURAL TURN AND 'EMERGENCE' OF VISUAL CULTURE

From the early 1980s on, the study of culture became overwhelmingly significant in the humanities.[2] In general, we can distinguish between two research paradigms: one that organized the study of society on the model of natural sciences and another whose approach belongs to the interpretative and hermeneutic tradition that emphasizes human subjectivity and contextual meaning. Before the cultural turn, researchers did not much question the meaning or operation of social categories themselves, nor did they pay attention to individual motivation within social formations. Research projects based on a commonsense meaning of the social typically employed quantitative methods. In the end,

> multimillion-dollar studies of census records ... and thousands of individual case studies came up with contradictory rather than cumulative results. Social categories— artisans, merchants, women, Jews—turned out to vary from place to place and from epoch to epoch, sometimes from year to year. As a result, the quantitative methods that depended on social categories fell into disrepute. (Bonnell and Hunt 1999: 7)

The major theme needing revision was the status of the social. Historians began to explore cultural contexts in which groups or individuals acted and to emphasize the interpretation of symbols, rituals and discourses. The issue of subjectivity and the subjective side of social relations was given an important place on the research agenda. The investigation of culture demonstrated, among other things, that all our approaches are contaminated with ideological preconceptions. The previous paradigm, based on a belief in the objective nature of social scientific inquiry, was subsequently displaced by a standpoint that reveals culture—a representational, symbolic and linguistic system—to be an instigator of social, economic and political forces and processes rather than a mere reflection of them. Among the notable outcomes of these explorations was the forging of a common language that uses the same concepts and terms—such as 'culture', 'practice', 'discourse', and 'narrative'—across many disciplines that have become mutually intelligible.

The cultural turn brought to the study of images a reflection on the complex interrelationships between power and knowledge. Perception has come to be understood as a product of experience and acculturation. Representation began to be studied as a structure and process of ideology producing subject positions. In the light of Louis Althusser's (1971) broadened notion of ideology—that it covers all aspects of societal life and is analogous to systems of signs—the work of art came to be seen as a communicative exchange. As a result, the concept of autonomy of art was replaced by the concept of intertextuality. Art is now treated as a specific discursive system that during the modern period created the category of 'artwork' as a repository for values (noninstrumentality, creative labor, etc.) that had been suppressed within the dominant culture of

mass production. Contemporary scholarship has disclosed the ways in which the work of art has been traditionally presented as the object that rejects contingency and refuses or 'frustrates the grasp of discursive systems of knowledge through its relentless formal self-transformation' and has revealed how 'formal meaning becomes the emblem of an immanent, autonomous drive towards differentiation' (Kester 2000: 2). The scholarship that rejects the primacy of art in relation to other discursive practices and yet focuses on the sensuous and semiotic peculiarity of the visual can no longer be called art history—it deserves the name of visual studies.

FROM ART HISTORY TO A HISTORY OF IMAGES

The field of visual culture or visual studies is not the same thing for all of its theorists and practitioners. Moreover, one can speak of distinct schools of thought being formed at the different institutions of higher learning in which these people teach and do research. To start with, Michael Ann Holly, former chair of the Art and Art History Department at the University of Rochester (home to the first US graduate program in Visual Studies) and now director of research and academic program at the Clark Art Institute, thinks of visual culture as a hybrid term that describes a situation when one fuses works of art with contemporary theory imported from other disciplines and fields, particularly semiotics and feminism. For Holly, visual studies calls into question the role of all images in culture, from oil painting to twentieth-century TV. These images can be contrasted and compared on the basis of their working as visual representations in culture rather than through the use of such categories as 'masterpieces' and 'created by geniuses' versus 'low art' (Dikovitskaya 2005h: 194). As a historiographer interested in the intellectual history of art history, Holly has been concerned with how the practice of art history in the United States was turning into an empirical discipline, preoccupied solely with facts and frozen in place around the time of the Cold War. In the late 1980s, the influx of thinking that has fallen under the ubiquitous term 'theory' shook up those established procedures and protocols of the discipline. Stephen Melville of Ohio State University pointed to theory as the essential background for the origin of visual culture:

> Shortly after the Second World War, and depending very much on a complicated set of cultural and political developments through the 1960s, you have the emergence of a very powerful line of thinking in France that ultimately gives rise to what is called, briefly and mostly around the journal *Tel Quel* in France but much more sustainedly in the United States, 'theory.' The developments that drive the emergence of theory happened in a variety of fields—anthropology, literary criticism, psychoanalysis, intellectual history, philosophy. There is a large body of shared references that bind them together—to Saussure and linguistics, to the drift of post-Kantian European philosophy, to some stakes in or near Surrealism. One shared feature of this work is its claim to a thorough-going 'anti-humanism.' Some people think of it as a form of Marxist ideology critique with the modifier 'bourgeois' understood to be integral to what's meant by humanism here; others, including myself, will take its force to be better

caught by reference to Nietzsche or Heidegger. It seems natural to take this as entail-
ing also some kind of critique of 'the humanities.' Visual culture, more or less inherit-
ing all this, would be part of an unprivileging of the humanities and the central place
they traditionally occupy in the university, and of course art history would be one of
the things in need of such undoing. (Melville 2001: 3)

More recently, two summer institutes on theory and interpretation in the visual arts,
funded by the National Endowment for the Humanities and held at Hobart and Wil-
liam Smith Colleges in 1987 and at the University of Rochester in 1989, aimed to lo-
cate art history within the context of theoretical debates taking place in other fields. To
this end, they examined new interpretative strategies developed by semiotics, linguistics,
psychoanalysis, feminism, queer studies and cultural theory. These institutes resulted
in the publication of two books edited by Norman Bryson, Michael Ann Holly and
Keith Moxey: *Visual Theory: Painting and Interpretation* (1991) and *Visual Culture: Im-
ages and Interpretations* (1994), which brought 'theory' on board. In the introduction to
Visual Culture, the editors suggested that since the collected essays strove for 'a broader
understanding of their [artworks'] cultural significance for the historical circumstances
in which they were produced, as well as their potential meaning within the context of
our own historical situation,' they could be understood as contributions to a *history of
images* rather than a history of art (Bryson et al. 1994: xvi, emphasis added). In short,
visual studies—the study of representations—pays close attention to the image but uses
theories developed in the humanities and the social sciences to address the complex
ways in which meanings are produced and circulated in specific social contexts. Holly
is convinced that considering images in light of new theoretical perspectives provides
new answers to old questions about art. An example of the transition to a more theoreti-
cal model of visual studies can be found in Paul Duro's book *The Rhetoric of the Frame*
(1996). Duro, who in 2000 succeeded Holly at the University of Rochester, confessed
that the editing of this collection of essays on framing devices that condition the way we
view works of art enabled him 'to move away from the point of view that isolates period
and historical context, to instead look at things theoretically, across disciplines, but also
across instances within the fine arts' (Dikovitskaya 2005j: 146–7).

Holly and Moxey were especially interested in importing poststructuralist theory
widely employed in other humanities into the emerging field of visual studies. They saw
deconstruction not as an end in itself, but rather as a flexible mode leading to a reori-
entation, as opposed to the destruction, of art historical perspectives. In her response to
the 'Questionnaire on Visual Culture', Holly asserted that visual culture should study,
not objects, but 'subjects caught in the congeries of cultural meanings' (1996b: 40).[3]
She argued that while art history writing recognizes only linear time and aims at reveal-
ing the hidden 'truth', there is an awareness in the new field that all historical narratives
are invested with the values of the present. Self-reflexive visual studies preoccupies itself
with the way in which the objects under scrutiny reveal the ethical and political com-
mitments of those who study them (Moxey 1994, 2001). Visual studies makes it clear
that interpretation should be distinguished from the search for the meanings 'concealed'

within images; instead, this new field breaks down established systems of interpretation in order to find new meanings in the work of art.

Moxey charted two possibilities for the new research area: it could become the study of *all* images 'without making qualitative distinctions' between them, or, preferably, it might concern itself with 'all images for which distinguished cultural value has been or is being proposed' (1996: 57). The use of the past perfect tense along with the present tense in the last statement was not accidental: it spells out Moxey's idea that aesthetic criteria do not exist outside a specific historical context, and what was worth studying yesterday might not be considered so today. This consciousness helped to undermine the theory of universal response that has animated art history; indeed, it was the absence of this universal epistemological basis for art historical activity that made the new academic field of visual studies possible. Yet, while Moxey rejected the concept of immanent aesthetic value, he did not deny its existence as a social construct: aesthetic value had been ascribed to the work of art by the culture of the European Enlightenment and has been modified with the times. Far from supporting the canon, Moxey argues that visual studies should reenact a contestation between different forms, genres and mediums of visual production as the embodiments of different cultural values. Hence, this new field will have a selective focus, which will change over time.

There has been no unanimity among scholars about the relation of art history to the study of image. For instance, Moxey suggests that visual studies has revived the discipline of art history through the study and 'the recognition of [images'] heterogeneity, the different circumstances of their production, and the variety of cultural and social functions they serve' (Moxey 2001: 109). On the other hand, art historian Thomas Crow does not welcome visual culture claiming that 'a panicky, hastily considered substitution of image history for art history can only have the effect of ironing out differences' (quoted in Heller 1996: A8). For Crow, the study of art acknowledges that art is a social category, but asks that it cannot be equated with visual culture as a whole.[4]

THE VISUAL AND THE CULTURAL IN VISUAL STUDIES

To James D. Herbert of the University of California at Irvine, visual culture is a term encompassing all human products with a pronounced visual aspect including those that do not, as a matter of social practice, carry the imprimatur of art, whereas visual studies is a name for the academic discipline that takes visual culture as its object of study. Visual studies democratizes the community of visual artefacts by considering all objects—and not just those classified as art—as having aesthetic and ideological complexity. However, instead of leveling them or lumping them all together, visual studies embarks on the scrutiny of the hierarchy of objects that has imbued and continues to imbue some with a greater significance than others. I find a connection between this view on visual studies and the concept of 'World Art Studies' initially put forward by British art historian John Onians. When World Art Studies works against the art historical canon by 'taking the broadest view of what is visually interesting', it, like visual studies, involves 'acknowledging the variation of concentration on different forms of

art through time and across cultures' (Onians 1996: 206). As Onians notes, this should ultimately help us understand such phenomena as the European privileging of fine arts over decorative arts or the Chinese disregard of paintings not produced by the literati. Onians underlines the possibility of what he calls a 'natural' history of art, whose task would be to explore how the relationship of humans to their natural environment determines the diverse character of art throughout the world. Herbert's visual studies, however, suspends itself somewhere between an art history that uses evidence of human social practice to understand a work of art and an anthropology that regards material artefacts as evidence of such practice.

In this formulation, visual studies reflects the impact of cultural anthropology, which was responsible for the recent displacement of the elitist notion of culture based on absolute models of aesthetic value (which needs to be cultivated in everybody but is available to only a few) by another concept that considers material, folk and popular cultures as important signifying practices. This all-embracing and anthropologically more egalitarian notion of culture implies that all artefacts and practices are worthy of scholarly study. It also encourages the application of methods and procedures that were previously reserved for the study of 'high' culture to those artefacts that were thought to be outside of it but which are cultural nonetheless.

Herbert's desire for the expanded territory of visual studies also echoes somewhat the concept of material culture introduced to art history some twenty-five years ago by Jules David Prown, an art historian from Yale University where Herbert studied for his PhD. The object-based theory of material culture premises that artefacts are primary data for the study of culture and that they should be used as evidence rather than illustrations; it thus deals with objects such as Chippendale sideboards or furniture because they have symbolic meaning or symbolic capital in the antebellum United States. Through its attendance to both art objects and artefacts, visual studies in Herbert's formulation forges an important bridge with material culture studies and thus escapes the danger of being reduced to mere semiology of the visual sign.[5] Additionally, visual culture pays special attention to the study of modern manufactured goods (thus distinguishing itself from art history).

THE VERBAL AND THE VISUAL

W.J.T. Mitchell of the University of Chicago describes visual culture as analogous to linguistics: the former has the same relation to works of visual art as the latter has to literature. Art here plays the role of literature despite a fundamental difference between, on the one hand, visual imaging and picturing and, on the other, linguistic expression: language is based on a system (syntax, grammar, phonology) that can be scientifically described whereas pictures cannot. In addition, while literature forms a part of the study of language, visual art is just one area of visual culture: In 'What Is Visual Culture?' (1995a), Mitchell made the case for popular imagery.

Mitchell's understanding of the image stems from the general notion that the world is held together with figures of knowledge. In *Iconology: Image, Text, Ideology* (1986), he suggested that an image is not just a particular kind of sign, but a parent concept—image

as such. Mitchell treats textuality as a foil to imagery, a significant other or rival mode of representation. Within this framework, the history of culture is the story of the struggle between pictorial and linguistic signs, a history which reflects

> the relations we posit between symbols and the world, signs and their meanings. The image is the sign that pretends not to be a sign, masquerading as (or, for the believer, actually achieving) natural immediacy and presence. The word is its 'other,' the artificial, arbitrary production of human will that disrupts natural presence by introducing unnatural elements into the world—time, consciousness, history, and the alienating intervention of symbolic mediation. (Mitchell 1986: 43)

According to Mitchell, the word-image difference can be likened to the relation between two languages that have been interacting for a long time: an ongoing dialogue between verbal and pictorial representations. Mitchell condemns the current separation of the academic humanities into verbal and visual factions[6] and stresses that all media are mixed media.

For Mitchell, the emergence of visual culture is a challenge to traditional notions of reading and literacy. Because the literary text consists of visible signs, the alphabet and mode of inscription become issues: the researcher has to analyse writing as a system of images. The Chinese character system, Egyptian hieroglyphics and Aztec writing have very elaborate graphic conventions. All these symbols have historical origins; they become the proper domain of visual culture, which stimulates an interest in typography, graphology and calligraphy. Beyond this graphic level, there is a realm of what can be called 'virtual' visuality in literature implied by the text that contains images, inscriptions and projections of space. Traditional literary scholars, who are not interested in how the text represents itself, usually read through novels, plays and poems for something else (plot, meaning, etc.) and are not very mindful of descriptive literary texts where the projection of virtual spaces and places unfolds. Visual culture, on the other hand, refers to this world of internal visualization that appeals to imagination, memory and fantasy. Memory is encoded both visually and verbally and has a connection to rhetoric. The psychological notions of vision—interior vision, imagining, dreaming, remembering—are activated by both visual and literary means. Thus, the study of visual culture allows all these aspects to come into view: one begins to look at and actually examine the process of visualizing literary texts.

PRACTICES OF SEEING

The focus of visual culture analysis is shifted away from things viewed towards the process of seeing, insists Mitchell. In this light, visual representations are seen as part of an interlocking set of practices and discourses. Mitchell chose the title 'Visual Culture' instead of 'Visual Studies' for the first in the United States undergraduate course (in the early 1990s) because he was interested in the constructedness of vision:

> The name Visual Studies seemed to me too vague, since it could mean anything at all to do with vision, while Visual Culture … suggests something more like an

anthropological concept of vision as artifactual, conventional, and artificial—just like languages, in fact, which we call 'natural languages,' in the same breath we admit that they are constructed systems on the borderlines between nature and culture. By calling the field Visual Culture, I was trying to call attention to vision as itself prior to consideration of works of art or images, and to foreground the dialectics of what Donna Haraway calls 'nature/culture' in the formation of the visual field. Vision itself is a cultural construction. (Dikovitskaya 2005l: 243–4)

'Visual Culture: Signs, Bodies, Worlds', an academic course at the University of Chicago, generalized the institutional and technological conditions of the visible, including both the arts and the vernacular understanding of ordinary visual experience. One of the main questions which visual culture addresses is: what is it that you learn when you learn to see?

According to Mitchell, works of art do not set the boundaries of the new field, nor do images or representations. (For instance buildings and landscapes, which are neither images nor representations, are nevertheless objects that are looked at in the course of everyday life and are, therefore, legitimate objects of visual culture.) The way one sees the world is important, and the visual field is the place where social differences are inscribed. Researchers who adopted Mitchell's definition of visual culture as the study of the cultural construction of visual experience in everyday life, as well as in media, representations and visual arts (Barnard 1998; Mirzoeff 1999), use 'cultural' and 'social' interchangeably, and this calls for clarification. When asked during our interview, Mitchell posited that visual culture is about the social formation of the visual field, or visual sociality:

> Raymond Williams suggests we think of society as designating the whole realm of relations among persons, classes, groupings, i.e. so-called 'face to face relations,' or immediate relations. Culture is the structure of symbols, images, and mediations that make a society possible. The concepts are interdependent: you could not have a society that did not have a culture, and a culture is an expression of social relations. However, the culture is not the same thing as the society: society consists in the relations among people, culture the whole set of mediations that makes those relations possible—or (equally important) impossible. Visual culture is what makes possible a society of people with eyes. (Dikovitskaya 2005l: 245)

The epistemological centrality of culture does not imply that 'everything is culture' but means that every social practice depends on and relates to meaning, and culture is the constitutive condition of that practice. One can conclude that visual culture is a field for the study of both the social construction of the visual (visual images, visual experience) and the visual construction of the social, which apprehends the visual as a place for examining the social mechanisms of differentiation. The interesting questions that might be further asked here are, what is the absence of visual culture? and what is the absence of cultural vision?

In this light, Janet Wolff, former director of the Rochester Visual and Cultural Studies Program and now professor of Cultural Sociology and director of the Centre for Interdisciplinary Research in the Arts at the University of Manchester, has argued that the necessary project for the study of visual culture is an approach which combines textual analysis with sociological analysis of institutions. Such an approach emerged from her own frustration with two modes of analysis—what she described as a

> parallel experience and parallel dissatisfaction with two traditions: first, a sociological tradition that looks at cultural institutions and cultural processes but never pays attention to the text ... and which is agnostic about aesthetic questions; and second, textual analysis mainly in the humanities, which for the most part pays no attention to institutions and social processes, but concentrates on readings—however interesting but nonetheless just readings—of texts and images. My argument has been that the best kind of work in visual studies manages to do both of those things and to integrate them. (Dikovitskaya 2005e: 276–7)

Visual studies claims that the experience of the visual is contextual, ideological and political. Douglas Crimp posits that objects of study should be determined by the type of knowledge that one seeks to create and by the specific uses for that knowledge. When he began thinking about the subject of AIDS about twenty-five years ago, he was interested in how US artists and the art world as a social matrix were responding to the crisis brought on by the epidemic. Crimp became involved in a political movement fighting AIDS. He soon realized that the initial questions he had been asking were inadequate for the type of information he sought to produce:

> To limit myself to fairly narrowly defined notions of art practice or the art world would not suffice ... This didn't mean that I relinquished my interest in how art practices were dealing with AIDS, but it gave me a very different perspective on how people might deal with it: what kinds of information they would have to understand in order to deal with the subject adequately. (Dikovitskaya 2001c: 132)

Thus, Crimp began looking at wider ranges of cultural discourses, including popular culture and medical discourse, that were outside the purview of contemporary art. This is just one, albeit a vivid, example of how and why a researcher's orientation has changed from an art critical to a visual studies perspective.

The position of Douglas Crimp coincides with that of Gayatri Spivak and Irit Rogoff, according to whom it is the questions that they ask that produce the new field of inquiry (Rogoff 1998: 16). Rogoff's essay, 'Studying Visual Culture', appeared in *The Visual Culture Reader* (1998), edited by Nicholas Mirzoeff and aiming to trace how a critical examination of vision and the gaze over the preceding fifteen years had led to the development of visual studies. As she pointed out, what was being analysed by *The Reader* was a 'field of vision version of Derrida's concept of *differance*' organized around the following sets of queries: 'Whom we see and whom we do not see, who is privileged

within the regime of specularity, which aspects of the historical past actually have circu-
lating visual representations and which do not, whose fantasies of what are fed by which
visual images?' (Rogoff 1998: 15)

VISUAL CULTURE AND THE POSTMODERN

Mirzoeff, whose *Introduction to Visual Culture*[7] accompanied the reader, criticized those
art historians for whom 'visual culture is simply "the history of images" handled with a
semiotic notion of representation (Bryson et al. 1994: xvi)' as well as those for whom it
is 'a means of creating sociology of visual culture that will establish a "social theory of
visuality" (Jenks 1995: 1)' (1999: 4). According to him, visual culture was born in the
new art history[8] departments set up in the British universities but it has begun to have a
much wider range of possibilities in the last twenty years (Dikovitskaya 2005i). The re-
cent developments in digital technology caused the immense cultural changes through-
out the world that earned the visual a preeminent place in our everyday life. Accordingly,
visual culture should concern itself with 'events in which information, meaning, or plea-
sure is sought by the consumer in an interface with visual technology', embracing all ap-
paratuses designed either to be looked at or to enhance natural vision, from fine arts to
cinema and the Internet. On Mirzoeff's view, visual culture is both an approach to the
study of contemporary living from the standpoint of the consumer rather than producer
and a means of understanding the user's response to visual media. I understand Mirzo-
eff's concept to be based on the Marxian postulate that the process of consumption itself
creates both the producer and the consumer. Michel de Certeau elaborated on this issue:
he regarded viewing productive insofar as the viewer or reader, by taking an image and
recirculating it, is engaged in artistic production.

Mirzoeff is convinced that 'the disjunctured and fragmented culture that we call *post-
modernism* is best imagined and understood visually, just as the nineteenth century was
classically represented in the newspaper and the novel' (1999: 3–4, emphasis added). He
argues that the new academic field should address the gap between the wealth of visual ex-
perience in postmodern culture[9] and our inability to adequately analyse observations. This
field is new because of its focus on the visual as a place where meanings are created as op-
posed to the written word, which prevailed in nineteenth-century culture. In order not to
overestimate such a broad claim, however, I should like to refer to Mitchell's earlier words:

> Books have incorporated images into their pages since time immemorial, and televi-
> sion, far from being a purely 'visual' or 'imagistic' medium, is more aptly described
> as a medium in which images, sounds, and words 'flow' into one another … The in-
> teraction of pictures and texts is constitutive of representation as such … the impulse
> to purify media is one of the central utopian gestures of *modernism*. (Mitchell 1994:
> 3–5, emphasis added)

Today Mirzoeff claims that visual culture needs to position itself as a critical study of
the genealogy and condition of the global culture of visuality. Globalization in its various

forms—TV channels and programs, visual infrastructures such as cable and satellite and the World Wide Web—is one of the key features of our lives. Since the exploration of these forms does not fit the disciplinary boundaries of traditional academic courses, a post-disciplinary formation called visual culture comes to the fore. Mirzoeff calls visual culture the interface between all the disciplines dealing with the visuality of contemporary culture and studying the visual in the overlap between representation and cultural power. I argue that the thesis of visual culture as an *interface*, that is the point of interconnection between one network and another network (here between the disciplines), can be presented as *the* answer to a recent criticism of visual culture put forward by Mieke Bal, who lays blame on visual culture for 'visual essentialism' in its describing 'the *segment* of that culture that is visual, as if it could be isolated ... from the rest of that culture' (Bal 2003: 6, emphasis added). Neither Mirzoeff nor other theorists mentioned in this essay would have suggested such a narrow approach. Furthermore, stressed Mirzoeff, in talking about visuality

> one has in mind a much wider field than that concerned only with the media, one covering the present process of collapse of the media into each other, or convergence—particularly in the digital realm—so that it no longer makes sense to organize our study of visuality by medium. (Dikovitskaya 2005i: 227)

David N. Rodowick, a former professor at the Rochester Visual and Cultural Studies Program and now the director of Graduate Studies for Film and Visual Studies, is mostly interested in the critical theoretical study of the different visual and articulable regimes. Contrary to Mirzoeff, Rodowick argues that the notion of visual culture is not only a function of twentieth-century culture but needs to be applied historically. He based his concept of visual culture on Deleuze's (1988) understanding of Foucault's theory. Deleuze was able to see in Foucault what Foucault did not necessarily see clearly himself: namely, that he had a unique sense of how the occurrence of epistemic changes from early modern society and the industrialized era to the twentieth century took place. Foucault revealed not only changing notions of subjectivity but also how such notions of subjectivity themselves overlap different strategies of visualization and expression, which Deleuze called *le visible et l'énonçable*, or the visible and the utterable.

Deleuze developed a periodization of the history of power—from a sovereign, to a disciplinary, to what he calls a 'controlsociety'. While each of these periods is marked by different strategies of knowing and power, they are also articulated by means of distinctive mobilizations of the visible and the expressible. Rodowick states that the same set of concepts can be used to explain both cultural and epistemological changes taking place over long periods of time, and this is what visual culture 'is all about: how these different notions of power and knowledge change across different strategies of visualization and expression, and how they are imbricated with one another in different complex ways in different, relatively distinct, historical eras' (Dikovitskaya 2005b: 263). Visual culture embraces modes of being and experiencing within distinct regimes, modes such as subjectivities—subject positions that emerge through visual relations, the subject within the 'society of spectacle'—as well as industries of the visual.

Visual culture entails a meditation on blindness, the invisible, the unseen and the unseeable. Engagements with biomedicine and digital technology have allowed us to form new conceptions of contemporary bodies. Lisa Cartwright, a professor of communication and science studies at the University of California, San Diego, explores the optical virtuality of postvisual domains constituted by institutional discourses of science and medicine. These employ such techniques as endoscopy, where simulation reproduces not merely the image but also behaviors and functions. Telepresent surgery, which involves using virtual reality to perform surgery at a distance, is another example of a possible object of scrutiny for visual culture.

To summarize, some researchers use the term 'visual culture' or 'visual studies' to denote new theoretical approaches in art history (Holly, Moxey); some want to expand the professional territory of art studies to include artefacts from all historic periods and cultures (Herbert); others emphasize the process of seeing (Mitchell) across epochs (Rodowick); while still others think of the category of visual as encompassing nontraditional media—the visual cultures not only of television and digital media (Mirzoeff) but also of science, medicine and law (Cartwright). Objects of visual studies are not only visual objects but also modes of viewing and the conditions of the spectatorship and circulation of objects. One can conclude that visual studies goes far beyond its constituent object-oriented disciplines of art history, anthropology, film studies and linguistics.[10]

BETWEEN ART HISTORY AND CULTURAL STUDIES

The field of visual culture drew upon critical theory and cultural studies, the latter itself being a critique of the barriers between the humanities and the social sciences that had been constructed in the nineteenth century due to the refusal of art to be subsumed under scientific rationality.[11] Customarily, in addressing the quartet of art, culture, history and visuality, one sets up different hierarchies of knowledge that stem from the long debate about the relationships of their study: art and history are paired, as are the cultural and the visual. From the standpoint of visual studies, this stance solicits critical reflection: a difference between art and culture can only be posited if art is given an exceptional status, which would take us back to Kenneth Clark's *Civilisation* (1969), a work that conceived of art as the highest cultural achievement of European society. Research of the visual in art (Holly 1996a), in science and medicine (Cartwright 1995, 1998), among communities of the deaf (Mirzoeff 1995), and in surveillance practices (Rodowick 1991) bridged the exploration of the arts and cultural analysis. In visual studies, the relationship between the visual and the cultural (as two adjectives) is entirely meshed, and the visual can only be understood through cultural meaning-making processes. Therefore, visual studies makes use of the same social theories as cultural studies, social theories that hold that meaning is embedded not in objects but in human relations—poststructuralism, Marxist theory, semiotics and psychoanalysis. However, where the stress is placed will often be different: for instance spectatorship theory and such texts as Martin Jay's *Downcast Eyes* (1993) would be more relevant to a program

in Visual Studies than they are to someone from the English Department working in cultural studies.

Visual studies is neither a modernized art history nor cultural studies. Although both cultural studies and visual studies question the firm stance art history takes with regard to the authenticity of artistic expression at the level of high art, cultural studies begins from the assumption that cultural expression at the level of popular culture is an authentic expression of class or national identity, thus reversing the formula 'high art versus mass culture'. Visual studies, rather than making this reversal, historicizes the visual by promoting the view that the discipline of art history begs the fundamental question, What is art? This question could not have been asked within art history because the discipline itself—as its name presupposes—depends on the assumption that what is worthwhile is already present. Herbert, trained as a social historian of art,[12] had begun his research by posing the problem, 'Here's a painting of peasants, and there is some history about peasants; let's examine the connection'. In spite of the fact that social history was a radical movement at the time, however, this research question did not yield a radically different insight:

> If you study the social history of art, you end up measuring these 'artistic' things against something else, and similarly if you are doing a formal analysis, or carrying out an intertextual analysis of criticism. In each case, there seems to be this need for art or specific 'artistic' artifacts in order to justify the discipline … In writing my first book called *Fauve Painting: The Making of Cultural Politics*, I realized that by the very nature of the topic I would not be able to answer certain questions because I begin by saying, 'Let's start with Fauve painting' … In my second book, *Paris 1937: World on Exhibition*, I looked at six world exhibitions, taking place over an eight-month period in France; some of them were art exhibitions and some were not. The idea of the book was to find some way of holding all historical variables constant in order to see clearly what particular function and purpose the category of art has. At art exhibitions, the 'art' label is assumed valid. How different it is when the label is absent! (Dikovitskaya 2005d: 186)

The field of visual studies enables us to ask questions that are not asked in art history: What does art *do*? What are the social and formal advocacies for the category of art? Today, many scholars are convinced that the most socially effective aspect of painting is to be found in a scrutiny of the constructedness of 'art', when the notion of art itself takes precedence over the artwork in stipulating its reception. Visual studies has no interest in finding some platonic definition of art that would hold true once and forever. Instead, it views art as a human construct that functions in particular ways at particular times, and analyses artistic production locally. The proper question for visual studies is: How are the aesthetic categories in their various manifestations realizing themselves, being applied, appropriated and redeployed in this local circumstance? Hence, the first task of visual studies is to critique what has been historically valorized as art and to ruminate on the differences between notions of art and non-art that have been created during particular historic periods. Visual studies does not replace art history or aesthetics but supplements

and problematizes them both by making it possible to grasp some of the axioms and ide-ological presuppositions underlying the past and current methodology of art studies.

Visual studies works to supplant the reified history of art with other cultural dis-courses and covers a wider field of inquiry by embracing photography, film, media and the Internet. However, visual studies does not pursue the goals of redefining all cultural artefacts as art, expanding the canon, or erasing the 'high-low' distinction. The boundaries—high, low and middle—still exist but their definitions are determined by the type of materials (for example oil painting versus photography) rather than by the degree of aesthetic sophistication.[13] The discipline of art history, because it emerged alongside the museum, is structured around the categorization of individual objects, whereas visual studies is more interested in systems of visuality rather than singular ob-jects; thus the competencies of the latter are expanded. At the same time, visual studies is a narrower field than art history because the former uses a critical framework, a set of assumptions, through which one assesses the object under analysis. Because of this approach, visual studies is able to reevaluate the past and rediscover aspects of personali-ties and discursive practices. As W.J.T. Mitchell has noted, visual studies is an inside-out phenomenon in its relation to art history because the former is

> opening out the larger field of vernacular images, media, and everyday visual practices in which a 'visual art' tradition is situated, and raising the question of the differences between high and low culture, visual art versus visual culture. On the other hand, visual culture may look like a deep 'inside' to art history's traditional focus on the sen-suous and semiotic peculiarity of the visual. (Mitchell 1995b: 542–3)

The profound transformation of contemporary culture to which we are witnesses demands a new history of modernity. The alternative forms of visualization used in the nineteenth century were not much discussed in traditional histories because they did not seem to bear on canonical art and literature. Such things as Charles Babbage's in-ventions of the Difference Engine, a calculating machine, and the Analytical Engine, are now seen as precursors of the computer. Hence, a second task of visual studies is to chart new inventories and write local histories that deal with names, issues and tenden-cies from today's perspective. Moreover, the field of visual studies is relevant to the ex-ploration of culture of more distant eras in that it allows us to trace historic trends and interrelationships. Instead of creating grand narratives, however, visual studies generates situated and partial accounts of the past in which subjectivity is not hidden and authors no longer evince a Kantian and Baumgartian disinterest.

CONCLUSION

One can conclude that visual studies is becoming a new historiography. By examining the settings for spectatorship and working against the theory of the universal response, it dispels the illusion that 'art' corresponds to some eternal standards. Visual culture

stresses the importance of contemporary visual technologies. It sheds light on those things that were noticed only in passing in the standard histories of culture but which had an enormous impact on our current condition. This new historiography requires an interdisciplinary methodology, one which has developed through its reflection on objects falling between the cracks of compartmentalized academic disciplines and through its use of cross-fertilizing methodologies that originated in discrete research areas. Visual culture, by directing attention to the connection between what is seen and what is read, mobilizes written culture and creates new spaces. It is important to stress here that interdisciplinarity does not mean simplified comparative study, wherein differences between the genres of artistic production are eradicated. Students of visual culture may apply a methodology from literary criticism to a work of art, or from film studies to architecture, but they pay equal attention to the 'resistance' of the one to the other. In this regard, Paul Duro criticizes a model of cultural study that was based more on a nineteenth-century Burckhardian idea, whereby the concepts of a particular culture are made to cover both literature and art. He further explained, 'I am interested in locating this sort of resistance … to which end I approach the visual using a variety of different methodologies—not to find some ultimate meaning, since I have never believed in that, but to generate new meaning' (Dikovitskaya 2005j: 149). Jay calls productive

the tension between a work of art, a text, or philosophical argument, that is produced, and the enabling and disseminating of receptive contexts, a tension which should be retained rather than resolved either in favor of the atemporality of the object, making it transcendentally valuable for all time, or the utter reduction of the object to nothing but an exemplar of its context. (Dikovitskaya 2005g: 203–4)

There is yet another potential methodological pitfall: insofar as we analyse the visual, as opposed to language-based information, then what we are doing is aesthetic. Visual culture began with the rejection of Kantian aesthetics but it is now in danger of reification of sensual perceptions, and in the long run it may turn into aesthetics again, holds Laura U. Marks (Dikovitskaya 2005f). This paradoxical situation might be avoided, suggested Brian Goldfarb, if one takes into consideration semiotics along with the theories of vision and thinks about images through both absence and presence. In this way, such an object as the telephone, for instance can be seen as a major visual technology of the twentieth century for 'it allows for associations of vision via auditory presence much like the Panopticon' (Dikovitskaya, 2005a: 163). This version of a visual culture appeals to mental images rather than perceptible artefacts and prevents the regression to Kantian aesthetics. Another way around the aesthetics dilemma is being proposed by Rodowick who believes that cinema and the electronic arts—the realm of visual culture—are ahead of philosophy (Dikovitskaya 2005b :260). Because new images may have a conceptual basis not accessible via traditional aesthetical approaches, philosophical criticism has to find or invent new concepts as tools for understanding what is happening culturally.

FURTHER READING

Dikovitskaya, Margaret. 2005. *Visual Culture: The Study of the Visual after the Cultural Turn.* Cambridge, MA: MIT Press.

Herbert, James D. 2003. 'Visual Culture/Visual Studies', in Robert S. Nelson and Richard Shiff (eds), *Critical Terms for Art History*, 2nd edn. London and Chicago: University of Chicago Press.

Mirzoeff, Nicholas. 1998. 'What Is Visual Culture?', in Nicholas Mirzoeff (ed.), *The Visual Culture Reader*. London and New York: Routledge, 3–13.

Mitchell, W.J.T. 2002. 'Showing Seeing: A Critique of Visual Culture', *Journal of Visual Culture*, 1/1: 165–81.

Moxey, Keith. 2001. 'Nostalgia for the Real: The Troubled Relation of Art History to Visual Studies', in *The Practice of Persuasion: Paradox and Power in Art History*. Ithaca, NY and London: Cornell University Press, 103–23.

NOTES

1. In the academic literature, there are diverse opinions expressed about the privileging of vision. Thomas Gunning is convinced that separation of vision from a broader consideration of the senses, particularly of sound, is not desirable. Visuality should be thought about in terms of a matrix of experience that includes all of the five senses interwoven. Gunning is concerned that 'very often when people privilege [sight] they pick up on the old hierarchy of arts, which is not necessarily being true to the modern experience' (Dikovitskaya 2005k: 174). W.J.T. Mitchell responds to this criticism thusly:

 The reason for isolating [vision] is that one can then determine much more precisely the boundaries and interactions between the way we construct the world through sight and the way we construct the world through sound and touch, in fact through all of the senses other than sight. (Dikovitskaya 2005l: 246)

 According to Mitchell, visual studies' emphasis of vision allows the whole manifold of means of reception to become objects of study.

2. Among the reasons for this occurrence, Simon During suggested, is the increased importance of cultural industries to postindustrial national economies and the rise in 'the use of cultural heritages and cultural consumption to maintain or stabilize identities by nations, ethnic groups, and individuals (partly because socialism has been delegitimized, and people cease to identify with a class)' (1999: 26).

3. The 'Questionnaire on Visual Culture' was sent out to a number of art and architecture historians, film theorists, literary critics and artists, and then appeared, along with their responses, in the summer 1996 issue of the magazine *October*. This influential journal was concerned with the role of cultural production within the public sphere and focused on the intersections of cultural practices with institutional structures. The questionnaire was composed of four open-ended questions. In a manner openly unsympathetic to visual studies, the anonymous author (or authors) suggested that visual culture was organized on the model of anthropology with result that visual culture positioned itself as antagonistic to art history. Arguing that the precondition for visual culture is a 'conception of the visual as disembodied image', the questionnaire alarmed that visual studies is helping 'to produce subjects for the next stage of globalized capital' ('Questionnaire on Visual Culture' 1996: 25). The response

of academics varied greatly—from the condemnation of visual culture as being 'anamorphic, junk-tech aesthetics of cyber-visuality', through to a moderate resistance considering it to be a 'levelling of all cultural values', to the acceptance of visual culture as 'an updated way of talking about postmodernism.' Overall, three clusters of scholars were represented: the first saw visual studies as an appropriate expansion of art history; the second group viewed the new focus as independent of art history and more appropriately studied with technologies of vision related to the digital and virtual era; and, finally, the third cluster considered visual studies a field that threatens and self-consciously challenges the traditional discipline of art history. The questionnaire did not eliminate the increasing interest among its students but rather helped proponents of visual culture to articulate their positions and thus contributed to the theoretical growth of the new field. The experience also demonstrated that, since the issue of visual culture's relation to anthropology, history and postmodern theory has had very material effects on the perceived place of scholars of the visual in the university and publishing spheres, there was increasing pressure within visual studies to define itself as valuable, relevant and distinct from other fields.

4. Another question was, 'Where to look for the location of art in this new lunapark of visual culture?' (Sauerländer 1995: 391). Donald Preziosi condemns the very aspect of art history that Saurländer suggests is missing from visual culture, claiming that 'art', the object domain of art history, is

a *virtual space* populated by artifacts simultaneously historical and a-historical, documentary and monumental, semiotic and eucharistic, ethical and aesthetic, and never entirely reducible to the one or the other. It is precisely this *irreducibility* which renders the very idea of 'art' … so powerful, so seemingly natural, so apparently universal. (Preziosi 1999: 94)

5. In the introduction to *Visual Culture: The Reader*, editors Jessica Evans and Stuart Hall pointed to the reasons visual culture had been neglected: Mainly, 'the privileging of the linguistic model in the study of representation led to the assumption that visual artefacts are fundamentally the same, and function in just the same way, as any other cultural text' (Evans and Hall 1999: 2). It is doubtful, however, that the introduction and prevalence of a linguistic model and the textualization across the humanities and social sciences took as much of a toll on the study of visual imagery as Evans and Hall would have us believe. In fact, far from being lost in the endless chain of signification, artwork has come to be seen as a 'thing' (to use philosophical jargon) in its own right. I argue that this was *due to* the semiotic approach: for the first time in art studies, the work of art was talked about as having its own specificity; that is as being neither an autonomous entity nor a mere reflection of social and political processes but a maker of culture. As Keith Moxey put it,

The adoption of a socially and historically specific notion of the sign implies that the study of visual representations will approach visual signs as if they were contiguous to and continuous with the signifying systems that structure all other aspects of the historical horizon … There is no attempt to look through the network of signs in order to reify or fetishize the intentions of the artists involved in their production … A semiotic approach would attempt to define the ways in which works of art actively worked to generate meaning and thus to define the values of the society. (Moxey 1991: 991–5)

Indeed, the semiotic approach provides an analysis of the artwork's specificity based not on some questionable inherent qualities but on its performance, distinct from any other text's, in a social setting.

6. Mitchell has questioned the difference between images and words, while also questioning the systems of power and canons of value that underwrite the possible answers to these questions. Mitchell describes the difference between images and words as being 'linked to things like the difference between the (speaking) self and the (seen) other ... between words (heard, quoted, inscribed) and objects or actions (seen, depicted, described); between sensory channels, traditions of representation, and modes of experience' (1994: 5). He called a purist's desire to separate the two 'an ideology, a complex of desire and fear, power and interest' linked to particular institutions, histories and discourses (1994: 96). As a public intellectual, Mitchell addressed the tension between visual and verbal representations, suggesting this tension to be inseparable from struggles in cultural politics, and he also built a curriculum that emphasizes the importance of visual culture and literacy in its relation to language and literature.

7. The second edition of *Visual Culture* was published by Routledge in 2009.

8. The new art history in both the UK and the US paid close attention to three issues related to representation and centred around the relationship between individual subject (the artist, the art historian) and social and power relations: (1) ideology, (2) subjectivity and (3) the relationship between subjectivity and interpretation, specifically in reexamining the notions of artistic authority, uniqueness of the individual work and priority of painting.

9. Martin Jay sees a connection between the postmodern and the visual turn, but does not wish to reduce one to another. He contends that the study of visual culture did emerge out of the context of what Jean-Louis Comolli 'called the frenzy of the visible—the flood of images, the spectacle, and our interest in surveillance, all of which seem to be characteristic of the postmodern movement' (Dikovitskaya 2005g: 205–6). Nevertheless, because postmodernism is founded on the reflexive relationship between language as text and language as rhetoric, to the postmodern the linguistic and visual aspects of language are considered of equal value.

10. The question is also whether or not those disciplines visual culture negates are as firmly formulated today as these definitions might suggest. In order to do justice to these disciplines, we must look at how they are themselves undergoing significant transformations along similar lines as visual culture.

11. Political concerns about class, culture and identity are characteristic in cultural studies whose origins are associated with the names of Richard Hoggart (*The Uses of Literacy*, 1957) and Raymond Williams (*Culture and Society*, 1958). In the article 'Cultural Studies: Two Paradigms', Stuart Hall (1980) compared the early model, based on the study of popular culture as the articulation of the proletariat's experience, with a later model that studies mass culture as meanings imposed on society—an oppressive ideological arrangement. According to Jonathan Culler, the project consists in the negotiation of the tension between, on the one hand, the analyst's desire 'to analyze culture as a hegemonic imposition that alienates people from their interests and creates the desires that they come to have' and, on the other hand, the analyst's wish 'to find in popular culture an authentic expression of value' (Culler 1999: 338). As time went on, cultural studies broadened the range of its inquiry, so that in the last two decades it has developed a commitment 'to the study of the entire range of a society's arts, beliefs, institutions, and communicative practices' (Grossberg et al. 1992: 4). However, it is neither aesthetic nor humanist in emphasis, but political (Fiske 1996).

12. In the 1970s, the social history of art opposed the widespread tendency of scholars to isolate works of art from the broader cultural circumstances of their production and reception. This movement redirected the viewer's attention to political and ideological contexts of image creation. As a historical enterprise, it sought to restore the missing dimension of once existing social conditions and relations. Despite its desire to add to the standard canon, social history failed to revise the category of art—the foundation for the entire enterprise of art history.

13. In contemporary exhibitions these margins are continually being redefined: there are mixtures of the high and the low, and there are instances of border crossing in multimedia works. At the same time, when mass culture items are placed in a museum, the border is reset as much as erased because of the nature of the museum as an institution.

REFERENCES

Althusser, Louis. 1971. 'Ideology and the Ideological State Apparatus', in *Lenin and Philosophy and Other Essays*, trans. Ben Brewster. London: New Left Books.

Bal, Mieke. 2003. 'Visual Essentialism and the Object of Visual Culture', *Journal of Visual Culture*, 2/1: 5–32.

Barnard, Malcolm. 1998. *Art, Design and Visual Culture: An Introduction*. New York: St. Martin's Press.

Bennett, Tony. 1998. 'Cultural Studies: A Reluctant Discipline', *Cultural Studies*, 12/4: 528–45.

Bonnell, Victoria E. and Lynn Hunt. 1999. *Beyond the Cultural Turn: New Directions in the Study of Society and Culture*. Berkeley and Los Angeles: University of California Press.

Bryson, Norman, Michael Ann Holly and Keith Moxey, eds. 1991. *Visual Theory: Painting and Interpretation*. Cambridge: Polity Press and Blackwell.

Bryson, Norman, Michael Ann Holly and Keith Moxey, eds. 1994. *Visual Culture: Images and Interpretations*. Hanover and London: Wesleyan University Press.

Cartwright, Lisa. 1995. *Screening the Body: Tracing Medicine's Visual Culture*. Minneapolis: University of Minnesota Press.

Cartwright, Lisa. 1998. 'A Cultural Anatomy of the Visible Human Project', in Paula A. Treichler, Lisa Cartwright and Constance Penley (eds), *The Visible Woman: Imaging Technologies, Gender, and Science*. New York: New York University Press.

Clark, Kenneth. 1969. *Civilisation: A Personal View*. New York: Harper & Row.

Culler, Jonathan. 1999. 'What Is Cultural Studies?', in Mieke Bal (ed.), *The Practice of Cultural Analysis: Exposing Interdisciplinary Interpretation*. Stanford, CA: Stanford University Press, 335–47.

Deleuze, Gilles. 1988. *Foucault*. Minneapolis: University of Minnesota Press.

Dikovitskaya, Margaret. 2005a. 'Interview with Brian Goldfarb', in *Visual Culture: The Study of the Visual after the Cultural Turn*. Cambridge, MA and London: MIT Press, 162–72.

Dikovitskaya, Margaret. 2005b. 'Interview with David N. Rodowick', in *Visual Culture: The Study of the Visual after the Cultural Turn*. Cambridge, MA and London: MIT Press, 258–67.

Dikovitskaya, Margaret. 2005c. 'Interview with Douglas Crimp', in *Visual Culture: The Study of the Visual after the Cultural Turn*. Cambridge, MA and London: MIT Press, 131–41.

Dikovitskaya, Margaret. 2005d. 'Interview with James D. Herbert', in *Visual Culture: The Study of the Visual after the Cultural Turn*. Cambridge, MA and London: MIT Press, 181–92.

Dikovitskaya, Margaret. 2005e. 'Interview with Janet Wolff', in *Visual Culture: The Study of the Visual after the Cultural Turn*. Cambridge, MA and London: MIT Press, 276–84.

Dikovitskaya, Margaret. 2005f. 'Interview with Laura U. Marks', in *Visual Culture: The Study of the Visual after the Cultural Turn*. Cambridge, MA and London: MIT Press, 215–23.

Dikovitskaya, Margaret. 2005g. 'Interview with Martin Jay', in *Visual Culture: The Study of the Visual after the Cultural Turn*. Cambridge, MA and London: MIT Press, 203–9.

Dikovitskaya, Margaret. 2005h. 'Interview with Michael Ann Holly', in *Visual Culture: The Study of the Visual after the Cultural Turn*. Cambridge, MA and London: MIT Press, 193–202.

Dikovitskaya, Margaret. 2005i. 'Interview with Nicholas Mirzoeff', in *Visual Culture: The Study of the Visual after the Cultural Turn*. Cambridge, MA and London: MIT Press, 224–37.

Dikovitskaya, Margaret. 2005j. 'Interview with Paul Duro', in *Visual Culture: The Study of the Visual after the Cultural Turn*. Cambridge, MA and London: MIT Press, 146–53.

Dikovitskaya, Margaret. 2005k. 'Interview with Thomas Gunning', in *Visual Culture: The Study of the Visual after the Cultural Turn*. Cambridge, MA and London: MIT Press, 173–80.

Dikovitskaya, Margaret. 2005l. 'Interview with W.J.T. Mitchell', in *Visual Culture: The Study of the Visual after the Cultural Turn*. Cambridge, MA and London: MIT Press, 238–57.

During, Simon. 1999. 'Introduction', in Simon During (ed.), *The Cultural Studies Reader*. London and New York: Routledge, 1–28.

Duro, Paul.1996. *The Rhetoric of the Frame: Essays on the Boundaries of the Artwork*. Cambridge and New York: Cambridge University Press.

Evans, Jessica and Stuart Hall. 1999. *Visual Culture: The Reader*. London, Thousand Oaks and New Delhi: Sage.

Fiske, John. 1996. 'British Cultural Studies and Television', in John Storey (ed.), *What Is Cultural Studies? A Reader*. London and New York: Arnold, 115–46.

Gattegno, Caleb. 1969. *Towards a Visual Culture: Educating through Television*. New York: Outerbridge and Dienstfrey.

Grossberg, Lawrence, Cary Nelson and Paula A. Treichler, eds. 1992. *Cultural Studies*. New York: Routledge.

Hall, Stuart. 1980. 'Cultural Studies: Two Paradigms', *Media, Culture, and Society*, 2: 57–72.

Hall, Stuart. 1997. 'The Centrality of Culture', in Kenneth Thompson (ed.), *Media and Cultural Regulation*. London, Thousand Oaks and New Delhi: Sage, 207–38.

Heller, Scott. 1996. 'Visual Images Replace Text as Focal Point for Many Scholars', *The Chronicle of Higher Education* (July 19): A8, A9, A15.

Herbert, James D. 2003. 'Visual Culture/Visual Studies', in Robert S. Nelson and Richard Shiff (eds.), *Critical Terms for Art History*, 2nd edn. London and Chicago: University of Chicago Press.

Hoggart, Richard. 1957. *The Uses of Literacy*. London: Chatto and Windus.

Holly, Michael Ann. 1996a. *Past Looking: Historical Imagination and the Rhetoric of the Image*. Ithaca, NY and London: Cornell University Press.

Holly, Michael Ann. 1996b. 'Response to the Visual Culture Questionnaire', *October*, 77: 39–41.

Holly, Michael Ann, and Keith Moxey, eds. 2002. *Art History, Aesthetics, Visual Studies*. Williamstown, MA: Sterling and Francine Clark Institute.

Jay, Martin. 1993. *Downcast Eyes: The Denigration of Vision in Twentieth Century French Thought*. Berkeley: University of California Press.

Jay, Martin. 2002. 'That Visual Turn: The Advent of Visual Culture', *Journal of Visual Culture*, 1/1: 87–92.

Jenks, Chris, ed. 1995. Visual Culture. London: Routledge.

Kester, Grant. March 24, 2000. 'A Response to Tim Hodgkinson', Socially Engaged Practice Forum, message #25. <http://www.listbot.com.>

McClurken, James M. 1991. The Way It Happened: A Visual Culture History of the Little Traverse Bay Bands of Odawa. East Lansing: Michigan State University Museum.

Melville, Stephen W. 2001. Response to Margaret Dikovitskaya. Unpublished manuscript.

Mirzoeff, Nicholas. 1995. Silent Poetry: Deafness, Sign, and Visual Culture in Modern France. Princeton, NJ and Chichester, UK: Princeton University Press.

Mirzoeff, Nicholas, ed. 1998. The Visual Culture Reader. London and New York: Routledge.

Mirzoeff, Nicholas. 1999. An Introduction to Visual Culture. London and New York: Routledge.

Mitchell, W.J.T. 1986. Iconology: Image, Text, Ideology. Chicago and London: University of Chicago Press.

Mitchell, W.J.T. 1994. Picture Theory: Essays on Verbal and Visual Representation. Chicago: University of Chicago Press.

Mitchell, W.J.T. 1995a. 'What Is Visual Culture?', in Irving Lavin (ed.), Meaning in Visual Arts: Views from the Outside. Princeton, NJ: Institute for Advanced Study, 207–17.

Mitchell, W.J.T. 1995b. 'Interdisciplinarity and Visual Culture', The Art Bulletin, 77/4: 540–544.

Moxey, Keith. 1991. 'Semiotics and the Social History of Art', New Literary History, 22/4: 985–1000.

Moxey, Keith. 1994. The Practice of Theory: Poststructuralism, Cultural Politics, and Art History. Ithaca, NY and London: Cornell University Press.

Moxey, Keith. 1996. 'Animating Aesthetics: Response to the Visual Culture Questionnaire', October, 77: 56–59.

Moxey, Keith. 2001. 'Nostalgia for the Real: The Troubled Relation of Art History to Visual Studies', in The Practice of Persuasion: Paradox and Power in Art History. Ithaca, NY and London: Cornell University Press, 103–23.

Onians, John. 1996. 'World Art Studies and the Need for a New Natural History of Art', The Art Bulletin, 78/2: 206–9.

Preziosi, Donald. 1999. 'Virtual (Art) History', RACAR: Canadian Art Review, 26/1–2: 91–5.

'Questionnaire on Visual Culture', 1996. October, 77 (Summer): 25.

Rampley, Matthew. 2002. 'Whatever Happened to Material Culture?', Unpublished paper presented to Session on Theory and Pedagogy of Visual Culture at the Crossroads in Cultural Studies 4th International Conference, Tampere, Finland.

Rodowick, David N. 1991. The Difficulty of Difference: Psychoanalysis, Sexual Difference, and Film Theory. New York: Routledge.

Rogoff, Irit. 1998. 'Studying Visual Culture', in Nicholas Mirzoeff (ed.), The Visual Culture Reader. London and New York: Routledge, 14–26.

Sauerländer, Willibald. 1995. 'Struggling with a Deconstructed Panofsky', in Irving Lavin (ed.), Meaning in Visual Arts: Views from the Outside. Princeton, NJ: Institute for Advanced Study, 385–96.

Silbermann, Alphons and H.-D. Dyroff, eds. 1986. Comics and Visual Culture: Research Studies from Ten Countries. Munchen, New York, London and Paris: K. G. Saur.

Williams, Raymond. 1958. Culture and Society, 1780–1950. London: Chatto and Windus.

Towards a New Visual Studies and Aesthetics: Theorizing the Turns

CATHERINE M. SOUSSLOFF

I begin by proposing that the assumptions that have prevailed over the last twenty years in the scholarly literature on both visual culture—including concepts of the image—and visual studies—including its relationship to art history—have done little to further a useful understanding of their intertwined histories. In the main, approaches to this history have moved across a spectrum punctuated at one end by what I characterize as *the admonitory sensibility*—as in critiques of the spectacle of the image—and at the other by what I would call *the redemptive impulse*.[1] Numerous accounts of the redemptive value of visual culture may be found, from the recent elevation of social computing as a practice ideally suited to provide alternatives to the dominant uses of ideologized imagery and surveillance techniques by corporations and governments, to the contrarian idea that the speed with which images can be delivered via the Internet decreases our dependence on them, and therefore enhances our freedom from them, or at least re-invests in us a measure of control in a society apparently dominated by those same images. I will argue that a historiography of the intertwined histories of visual culture and visual studies suggests what might be gained by turning away from these sensibilities and impulses towards a new form of aesthetics founded on a critique of the theoretical foundations of visual culture and its attendant visual studies. Historiography refers us to both visual culture and to visual studies but it insists on neither. Perhaps the very possibility of a historiography of the two portends the end of an era of 'perceptual faith' announced by Maurice Merleau-Ponty in *The Visible and the Invisible*:

> We do not know what to see is and what to think is, whether this distinction is valid, and in what sense. For us, the perceptual faith includes everything that is given to the natural man in the original in an experience-source, with the force of what is inaugural and present in a person, according to a view that for him is ultimate and could not

conceivably be more perfect or closer—whether we are considering things perceived in the ordinary sense of the word, or his initiation into the past, the imaginary, language, the predicative truth of science, works of art, the others, or history. (Merleau-Ponty 1968: 158)

INTRODUCTION

If the term *visual culture* may be said to encompass the creation, production and interpretation of all visual artefacts and images, the significance of the field constituted by these actions and materials requires no justification. Indeed, over the past twenty years the ubiquity of *visual studies*, often understood as a loosely aligned grouping of fields and approaches used to study *visual culture*, became a characteristic feature of many disciplines. The two are separate, although often not perceived as such, resulting in a good deal of confusion in the assessments of each. Visual studies mirrors the perceived centrality of the image mediated by and through technology in the culture at large.[2] This perception of the centrality of the image should be considered the foundational historiographical presupposition of visual studies.[3] Image-technologies construct and serve virtually every aspect of society today: arts, entertainment, education, business, science, politics and medicine. Images produce and construct popular knowledge because they form the integral part of a global culture that both generates and monitors information. The technologically mediated image has been acknowledged in disciplines not previously focused on the visual, including cultural anthropology, sociology, community studies, communications, aesthetics, history, comparative literature, performance studies; in disciplines already constituted around the visual, preeminently art history and film studies; and in the newer disciplinary formations constituted partially as a result of this ubiquity, that is new media studies and the digital arts. The significance of visual culture has also been adduced over this same period in the sciences, particularly in the newer research in the areas of optics and cognitive sciences. These other fields overlap precisely because of visual culture and through the study of it, which accounts for the *interdisciplinary* character of visual studies and the variety of methods associated with it—ranging from critical theory, to ethnographic analysis, to phenomenology, to experimental psychology and linguistics. Just as the objects and technologies associated with visual culture do not belong to any one particular discipline or knowledge system, so too the attempts at understanding these and the turn to visual culture do not exhibit the characteristics of disciplinarity. First, in visual studies no distinction occurs according to traditional hierarchies of genre and media, meaning that the objects of study may not be fixed according to a commonly held type or using an agreed-upon method. Further, the singularity accorded or deemed necessary to visual artefacts and processes—to art making and art production—by art history no longer holds.[4] The nature and situation of visual culture today encourages the study of visualities and related performativities across media, time periods and geographies, that is without the usual separations found within each traditional discipline, according to a

doxa proper to it. One might claim at this point that visual studies has simply sought to remain open to the present and to a world to which the proliferation of visual culture gives us access. But this is too simple and prevents interpretations that seek an analysis of both visual culture and visual studies wherein the characteristic superficial or surface analogy between the two may be discerned as one of the perceptions that has prevented a deeper, historiographical understanding of their situation in the operations of contemporary culture.

Many scholars have considered the freedom from disciplinary conventions of discourse and methods of analysis claimed by visual studies to be liberatory, a granting of a sort of permission to 'respond to the new urgency of the visual' (Mirzoeff 2002: 6). According to this view, visual studies actually required inventing in order to cope with the unruliness of visual culture in the globalized world economy. These same so-called liberatory characteristics of visual culture have also been used as a criticism against it. In Hal Foster's view, the breakdown of media and generic distinctions and boundaries participates in and produces the procedures of the 'service economy', which then incorporates and aestheticizes unruly 'aesthetic objects' (Foster 2006: 195). In contrast, W.J.T. Mitchell wrote: 'The idea is to release the study of media from a misplaced emphasis on the material support (as when we call paint, or stone, or words, or numbers by the name of media) and move it towards a description of the social practices that constitute it' (2005: 204).[5] Here, again, a method of visual studies—the description of social practices—mirrors the unruly behavior or uncanonical status of the image itself. According to Mitchell, the technological image must also be released from perspectival space and, by inference, from the traditional methods of art history built upon the methods of depiction in place since the beginning of the Early Modern period. A perception of visual culture as transitory and unfixed, therefore, both engenders and justifies the characteristic of interdisciplinarity claimed for visual studies. Being not confined to the discussion of immanent objects or texts, such as those found in the disciplines of art history and literature, and not united by any particular theory or method, visual studies crosses cultural, historical, geographical and disciplinary boundaries. However, this situation and these approaches have led, as might be expected, to a rather eclectic assortment of conclusions regarding the functioning and meaning of the visual in contemporary culture.[6] Nicholas Mirzoeff's (2009) influential understanding of visual studies as a 'tactic' for negotiating the politics of visual culture implicitly admits of this move away from fixed objects of study and commonly held approaches.

However conflated in the scholarship and criticism, the separation of the two usually intertwined strands of visual culture and visual studies emerges as necessary for the historiographical analysis sought here. The relative maturity of the field of visual studies today indicates that a historiography that addresses the conflation of visual culture and visual studies may now be possible. Recently, Dikovitskaya asked whether a 'common ground for working in the field of the visual' is even possible or desirable (Dikovitskaya 2006: 2). Rather than using visual studies for certain ends, or assimilating it to visual culture, a critical historiography of it addresses the present historical situation in which it is found.

THE POSTMODERN TURN

We must first locate visual culture in the predominant theories of postmodernity, which, I argue here, have led to the intertwining of visual culture and visual studies in contemporary theoretical accounts and institutional contexts. Theories of or explanations about postmodernity predate the turn to visual studies (see, e.g., Huyssen 1984). They participate in the turn to visual culture.[7] Two aspects central to the earliest theorizations of the postmodern turn concern the intertwining of visual culture and visual studies: the emphasis on visual culture itself as a marker of the era *and* the use of a concept of interdisciplinarity as a means to understand knowledge production in this period. Significantly, for many visual studies came to be considered the paradigmatic field of or for interdisciplinarity in the university. Yet, the temporal correspondence of the ubiquity of visual culture and of the implementation of the idea of interdisciplinarity by the university has contributed to the difficulty of establishing a situated historiography of the visual during this time.

Interestingly, considering the difference of their conclusions on visual studies indicated here, both Foster and Mitchell view the predominance of visual culture in terms of a theory of postmodernity based on Frederic Jameson's (1984) seminal essay 'Postmodernism, or, the Cultural Logic of Late Capitalism'. In this essay Jameson begins with a list of visual and literary examples of the postmodern aesthetic. He goes on to argue that:

> What has happened is that aesthetic production today has become integrated into commodity production generally: the frantic economic urgency of producing fresh waves of ever more novel-seeming goods (from clothing to aeroplanes), at ever greater rates of turnover, now assigns an increasingly essential structural function and position to aesthetic innovation and experimentation. Such economic necessities then find recognition in the varied kinds of institutional support available for the newer art, from foundations and grants to museums and other forms of patronage. (Jameson 1984: 56)

Jameson explicitly states that his approach to postmodernism is historical and not to be confused with stylistics. That is, that visual culture, understood as the cultural objects and artefacts of postmodernism, may be historicized and periodized, just as, we could also say, the history of art historicized and periodized its objects in modernity. However, the signal and distinguishing mark of postmodernism lies not simply in the unruly cultural objects of contemporary visual culture—high, mass and commercial—but also in the point 'that every position on postmodernism in culture—whether apologia or stigmatisation—is also at one and the same time, and *necessarily*, an implicitly or explicitly political stance on the nature of multinational capitalism today' (Jameson 1984: 55). This is how, we might say with Jameson, that visual culture became political. Whether complicit in the countering of a 'true' aesthetics, as understood by Foster, or operational in revealing of the society that produced it, as Mitchell would have it, visual studies emerged in the academy in the mid-1990s, just as Jameson's critique of the ideology of

postmodernism gained ascendancy in the academy in the new field of cultural studies. Historiographically, then, the interdisciplines of visual studies and cultural studies may be said to have the same roots.

THE TURN TO INTERDISCIPLINARITY

In the university these roots go deep. In the late 1970s the French philosopher Jean-Francois Lyotard (1984) famously wrote about the effects of the 'postmodern condition' in the university as a destruction of knowledge. For Lyotard, the postmodern condition 'designates the state of our culture following the transformations which, since the end of the nineteenth century, have altered the game rules for science, literature, and the arts' (Lyotard 1984: xxiii). In his view, the changes in culture in these areas resulted in a crisis in the traditionally held view of the disciplines, which, in the postmodern era could no longer contain these newer forms of knowledge. Marking the end of disciplinarity, Lyotard understood interdisciplinarity as the preeminent 'performative' for the most economically viable models, or ends, of the university. These ends could only result in a destruction of knowledge production as the new and economically efficient model of the university prevailed. Lyotard's concept of the performativity of interdisciplinarity remains a major factor in any analysis of its use and practice in higher education, including research and scholarship, as Mark Franko and I have argued (Soussloff and Franko 2002). Institutional critiques of the university in the late twentieth and early-twenty-first centuries have recognized to a certain extent this parasitic action of interdisciplinarity. Nonetheless, its usage has continued unabated as the justification for changes in university structures related to academic programs and for the allocation and reallocation of resources in diminishing economic times proliferated, fulfilling Lyotard's prophecy.[8] Interdisciplinarity provides the university with an efficacious means of marketing and positioning itself in the larger global economy. The paradox may be articulated as follows: to the extent that interdisciplinarity presents a challenge to the authority of the faculty member's individual judgement, formerly guaranteed in the classroom and in research, it also challenges the actual possibilities available in new areas of study, such as visual studies, opened up only as a result of it.

The debates among art historians that surfaced in the 1990s over visual studies centred on the value of *interdisciplinary methods* found in early art history.[9] Perhaps it is useful here to understand visual studies as the product or proof of the significance of the debate about the *adequacy of the discipline of art history to interpret* the objects and events that had come to be known over the course of the last twenty years of the twentieth century as the visual art(s) and culture. These debates served to perpetuate the justification of the values that were assigned to disciplinarity in general in modernity—by Kant, most famously—and to art history, specifically, while the interdisciplinarity of visual studies could be maligned using this view (Kant 1979).[10] Arguments supporting interdisciplinarity in visual studies cannot be considered frivolous when viewed in the light of Lyotard's critique of postmodernism, even if many of the points made in its defense had already appeared earlier in art history's modernist methodologies.[11] In addition, the aesthetic values traditionally given to art, and essential to its concept of the freedom

of the artist, require us to understand these debates over interdisciplinarity as equally essential to what the art historian has done and continues to do.[12] So too, the aesthetic values practiced in art history give something significant to visual studies: its ability to be performatively interdisciplinary in the Lyotardian sense.

Most of the conclusions concerning visual studies that I have drawn here have been fed by arguments about the nature of culture in the postmodern era: broadly speaking, that the present situation of interdependent, globalized economies has helped, if not caused, both the constitution of visual studies as a field and the proliferation of visual culture, particularly images and performances (Hardt and Negri 2000; Retort 2005). As I suggested at the beginning of this chapter, when viewed across the range of the disciplinary *loci* in which they have been posited and from which they have been taken up, conclusions in regard to visual culture in a globalized postmodernity may be characterized in two ways: the admonitory, or the spectacular, and the redemptive.[13] The recent 'aesthetic turn' in art history and visual studies, which I will explore for the remainder of this chapter, helps to explain this situated historiography of visual culture. My view is that the aesthetic turn contributes an explanatory framework towards certain problematic aspects of the precedent historiography of visual studies, particularly its intertwined relationship with visual culture and the resulting history of its configuration with and in art history.[14] Jameson argued that: 'The problem of postmodernism ... is at one and the same time an aesthetic and a political one' (Jameson 1988: 103). Thus, given both Jameson and Lyotard, we say that the present aesthetic turn must be viewed not as unexpressed earlier, but as suppressed, until recently, in regard to its significance for the understanding of the visual turn and its previous intertwining of visual culture and visual studies.

THE AESTHETIC TURN

The aesthetic turn belongs to the present, 'post-metaphysical', moment in philosophy.[15] This sense of the exhaustion of metaphysics emerged potently in poststructural French philosophy in the last quarter of the twentieth century, particularly in the work of Michel Foucault, who, throughout his life sought a reconciliation of aesthetics and political theory, whether by studying the Western tradition of oil painting, as I have argued, or through an aesthetics of the self.[16] Recently, and most famously, Jacques Rancière has rearticulated what it means to have a politics of aesthetics:

> The politics of aesthetics would more accurately be named as a meta-politics: a politics without *demos*, an attempt to accomplish—better than politics, in the place of politics—the task of configuring a new community by leaving the superficial stage of democratic *dissensus* and reframing instead of the concrete forms of sensory experience and everyday life. (2009b: 326)

If we accept that traditional aesthetics, particularly in regard to the visual arts, addresses issues of value, judgement, beauty, the nature of perception and the affective, then the contemporary aesthetic turn is precisely towards the contradictions in the concept of aesthetics that have been uncovered by its presence in everyday life, or in what

Foucault termed existence. Rather than focusing on 'the waning of affect', as did Jameson in his formulation of the postmodern turn, the aesthetic turn regards affect as central to a politics of art and visual culture. Or, to take up a Foucauldian articulation, it is affect that leads us to the understanding of the ethics in art and visual culture.

The new concept of aesthetics that has emerged embraces contradictions inherent to it in order to understand the role of the political in art and culture. Some have argued that such contradictions have been present in the history of art since the eighteenth century. For example, Whitney Davis observed in his analysis of the first edition of *The Encyclopedia of Aesthetics* (1999) that the conceptual structure of art today contains both cultural/social/historical determinations together with 'a necessary dynamic of autonomous artistic identity' adhering both to the subject in and the object of aesthetic analysis. Indeed, the necessity of the dynamic of the absolute artist and the original art object has its corollary in the apparently contrary, and relativistic, methods of historical analysis employed by art historians. Davis called this 'the palimpsest', which he thought art history must simultaneously reveal and penetrate using both its archeological and critical-formal methods of analysis.[17] In art history, the archeological method mentioned by Davis pertains to the postmodern period and visual culture and the critical-formal methods to the modern and its art history. According to Jameson, the very forms and means of contradiction that had been present in modernity—including the action of reflection itself—had been consumed and naturalized in postmodernity.[18] The aesthetic turn may be considered a refutation of this theory of consumption and naturalization. Indeed, Rancière has suggested 'disorder' as another metaphor for the embracing of the contradictions that characterize contemporary aesthetics:

> Aesthetics is the thought of the new disorder. This disorder does not only imply that the hierarchy of subjects and of publics becomes blurred. It implies that artworks no longer refer to those who commissioned them, to those whose image they established and grandeur they celebrated. Artworks henceforth relate to the 'genius' of the peoples and present themselves, at least in principle, to the gaze of anyone at all. Human nature and social nature cease to be mutual guarantees. Inventive activity and sensible emotion encounter one another 'freely', as two aspects of a nature which no longer attest to any hierarchy of active intelligence over sensible passivity. (2009a: 13)

In such a view, cultural analysis cannot be separated from or privileged over an aesthetic one. So too, visual studies cannot be privileged over art history. Both form part of the creation and reception of the work of art today. However, the present aesthetic turn to both art and visual culture must do more than reflect their respective periods, it must be understood as productive of its own historiography, one that can simultaneously reveal the ideological levels of past turns and offer something more visible: an ethics of the interpretation of art and visual culture. I began this chapter with a long quotation from Merleau-Ponty, whose late work on visuality and art marks a change from an earlier modernist sensibility. With the aesthetic turn, Merleau-Ponty's faith in *seeing*, or the perception of the visual, that could be said to both initiate and be intrinsic to visual culture

in postmodernity, ideally transforms into an understanding of the visual as a form or medium of ethics. The efficacy of the ideal remains to be tested.

A historiographical method persists as the way that art history has of doing the kind of critical archaeology called for by Davis.[19] This approach allows a strategic intervention in the historical record and in the story that history has written about art in order to reveal the aesthetic investments that have been placed in art in the past. Some art historians have used the revelation of aesthetic investments in art to argue narrowly, and pessimistically, that they ultimately betray only the bad faith of the investor, that is the art historian (Preziosi 1998). Others have rejected the value of traditional aesthetics by arguing that the only ethical approach to the aesthetic in art would be to proclaim the 'anti-aesthetic'.[20] Coined over twenty years ago, the anti-aesthetic required the now outdated view of a noncontradictory aesthetics based primarily on the concept of aesthetic value. The turn to aesthetics, I would argue, cannot be resolved from the specific position of art history without the acknowledgement of the significance of the intertwining of its historiography with that of visual studies over the last generation. I suggest that without this prior turn in or away from the discipline of art history, the notion of an aesthetic turn today would also not be possible. In other words, without the prior turn to visual studies—in both its disciplinary and theoretical-temporal dimensions—the extra-art historical turn of aesthetics today would not be a matter of note. By extra-art historical I mean other disciplines named already in which the visual turn has been noted, and in which the essential historiography through visual studies of the turn has not been considered: ethics, law, sociology, political theory and philosophy. Whether this visual turn and its possible echo, the aesthetic turn, have been of value to art history as a discipline and to its audiences remains to be determined.

TOWARDS A DIALECTICAL TURN IN CONTEMPORARY VISUALITY

In conclusion, a dialectical model of contemporary visuality emerges from my interpretation here and the vacillation between visual culture and visual culture studies marks its beginnings. Signaled by a confusion between the interdisciplinary methods found in art history and the interdisciplinarity claimed for visual studies, the efficacy of this indeterminacy inherent to it supported structural changes in the university that sought to establish new programs and research devoted to visuality without acknowledging the older ones that it already inhabited. In addition, the efficacy of this indeterminacy has begun to bring about a reconceptualization of aesthetics, wherein the strength of the dialectic in contemporary visuality provokes a movement away from the absolute idea of art and towards the contingency of political actions, such that an aesthetics founded on the characteristics of contemporary visuality may now be thought as the ideal politics for the present. If this is so, we no longer live in the condition of postmodernity as defined by Lyotard and Jameson. Where the aesthetic turn in visual studies will take us in the future, of course, remains to be seen. For the present, we can but mark its actions and its significance for both visual studies and art history through a historiographical analysis that reveals a desire for ideal forms of history and visual culture in our globalized society.

NOTES

1. To cite the numerous theories of the image that insist on and warn about its danger would be impossible here, but their lineage in critiques coming out of the French Situationists must be acknowledged, if not explored here. See, most importantly, Roland Barthes (1973), *Mythologies*, first published in France in 1957; Berger (1972); and the texts assembled by Martin Jay (1993) in *Downcast Eyes*.

2. 'So, the real image revolution (if there was one) happened a long time ago, when images lost the transcendent power they used to have and were reduced to mere records, however expressive, of appearances' (Aumont [1990]1997: 241). Jacques Aumont's useful compilation of the history of images is singularly disciplinary in its focus on film and art history and Western oriented, thereby not addressing the ritualistic significance of images in local contexts, nor accepting the results of a global culture that has produced an 'image-world'. See Soussloff (2008: 145–70).

3. 'This little incident expressed the formal condition of contemporary visual culture that I call intervisuality, the simultaneous display and interaction of a variety of modes of visuality' (Mirzoeff 2002: 3). Susan Sontag was the first to attempt to understand the magnitude of the significance that the image in culture would have for society and for future studies: 'a widely agreed-on diagnosis: that a society becomes "modern" when one of its chief activities is producing and consuming images, when images that have extraordinary powers to determine our demands upon reality and are themselves covet substitutes for firsthand experience become indispensable to the health of the economy, the stability of the polity, and the pursuit of private happiness' (Sontag 1977: 153).

4. On this singularity, see above all the writings of art historian Hubert Damisch, as explained in 'Hubert Damisch and Stephen Bann' (2005: 155–81).

5. In this section of the book Mitchell makes an extended plea for a theory of media, and by extension of the image, that locates in the 'vernacular media themselves' (see p. 210).

6. I made an early attempt at explaining this turn, see Soussloff (1996).

7. Although some scholars have considered Habermas's views on postmodernity central to art history and visual studies, I disagree here. In Donald Preziosi's *The Art of Art History*, the author positions Habermas's 'Modernity versus Postmodernity' (also 'Modernity—An Incomplete Project') (1980 and 1981) and Jean-François Lyotard's *The Postmodern Condition* (1984) on the subject as the two key texts (Preziosi 1998: 280). Preziosi's view appears based on the appearance of Habermas's essay in the collection *The Anti-Aesthetic* (1998). First published in 1983 this collection appeared after the publication of the books on postmodernism published by Lyotard and Jameson, discussed here. Over the intervening years, while a number of these essays have proven exceptionally important for the field of visual studies, Habermas's is not among them. The reasons for this cannot be explored fully at this time, but can be determined from the historiography given here.

8. See Soussloff and Franko (2002). Of interest for my argument here, Frederic Jameson calls Lyotard's analysis of postmodernism 'prophetic': 'The ingenious twist or swerve in his own proposal involves the proposition that something called "postmodernism" does not *follow* high modernism proper, as the latter's waste product, but rather very precisely *precedes* and prepares it, so that the contemporary postmodernisms all around us may be seen as the promise of the return and the reinvention, the triumphant reappearance, of some new high modernism endowed with all its older power and with fresh life. This is a prophetic stance, whose analyses turn on the antirepresentational thrust of modernism and postmodernism' (Jameson 1988: 109).

9. See, 'Questionnaire on Visual Culture' (1996). See also, articles by Ginzburg et al. (1995).
10. This essay has been amplified and put into the context of discussions of the humanities disciplines in the late-twentieth century by Jacques Derrida (1992). Significant to the historiography I am developing here, the first version of the essay was presented in 1980 for the centenary of the founding of the Graduate School of Columbia University.
11. For a good discussion of modernist methodologies in art history, see the introduction by Kurt W. Forster to Aby Warburg (1999).
12. On the imbrications of the aesthetic value of art and the artist, see Soussloff (1997).
13. These terms differ from but are related to Jameson's antimodern/propostmodern and promodern/antipostmodern formulations of cultural theory articulated in Jameson (1988: 103–13).
14. See Foster (2006: 195): 'At times everything seems to be happy interactivity: among "aesthetic objects" Bourriaud counts "meetings, encounters, events, various types of collaboration between people, games, festivals and places of conviviality, in a word all manner of encounter and relational invention." To some readers such "relational aesthetics" will sound like a truly final end of art, to be celebrated or decried. For others it will seem to aestheticize the nicer procedures of our service economy.'
15. See Milchman and Rosenberg (2008: 106) quoting van Buren (1994: 7): 'Metaphysics strives for perfection, completion, in the sense of having thought in the actualization and presence of its end [*entelecheia, perfectio*], whereas the work [*ergon*] or text of postmetaphysical thinking puts itself forth as *energeia ateles*, i.e., being at work that never reaches its end and is thus imperfect.'
16. The acknowledgement of the significance of Foucault's thought for the aesthetic turn is recent and contested in its formulation, see Soussloff (2010) and Tanke (2009).
17. On this issue, see Summers (2003).
18. For the realism and Modernism thesis, see Jameson (1977).
19. See the introduction and essays in Holly and Moxey (2002).
20. As Foster and others seemed to argue in *The Anti-Aesthetic* (Habermas 1998).

REFERENCES

Aumont, Jacques. [1990]1997. *The Image*, trans. Claire Pajackowska. London: British Film Institute.

Barthes, Roland. 1973. *Mythologies*, trans. Annette Lavers. St. Albans: Paladin (repr. 1976).

Berger, John. 1972. *Ways of Seeing: Based on the BBC Television Series*. Middlesex: BBC and Penguin.

Davis, Whitney. 1999. 'Formalism in Art History', in M. Kelly (ed.), *The Encyclopaedia of Aesthetics*. Oxford: Oxford University Press, 2: 221–25.

Derrida, Jacques. 1992. 'Mochlos; or, The Conflict of the Faculties', trans. Richard Rand and Amy Wygant in Richard Rand (eds.), *Logomachia: The Conflict of the Faculties*. Lincoln: University of Nebraska Press: 3–34.

Dikovitskaya, Margaret. 2006. *Visual Culture after the Cultural Turn*. Cambridge, MA: MIT Press.

Foster, Hal. 2006. 'Chat Rooms//2004', in Claire Bishop (ed.), *Participation*. London: Whitechapel and the MIT Press.

Ginzburg, Carlo, James D. Herbert, W.J.T. Mitchell, Thomas F. Reese, and Ellen Handler Spitz. 1995. 'Inter/disciplinary', *Art Bulletin*, 77: 534–52.

Habermas, Jürgen. 1998. 'Modernity versus Postmodernity', in H. Foster, ed. *The Anti-Aesthetic: Essays on Postmodern Culture.* New York: The New Press.

Hardt, Michael, and Antonio Negri. 2000. *Empire.* Cambridge, MA: Harvard University Press.

Holly, Michael Ann, and Keith Moxey (eds.). 2002. *Art History, Aesthetics, Visual Studies.* Williamstown, MA: The Sterling and Francine Clark Art Institute.

'Hubert Damisch and Stephen Bann: A Conversation'. 2005. *Oxford Art Journal*, 28: 155–81.

Huyssen, Andreas. 1984. 'Mapping the Postmodern', *New German Critique*, 33: 47–52.

Jameson, Frederic. 1977. 'Reflections in Conclusion', in *Aesthetics and Politics.* London: Verso: 196–213.

Jameson, Frederic. 1984. 'Postmodernism, or, the Cultural Logic of Late Capitalism', *New Left Review*, 146: 53–92.

Jameson, Frederic. 1988. 'The Politics of Theory: Ideological Positions in the Postmodern Debate', in *The Ideologies of Theory: Essays 1971–1986,* vol. 2, *Syntax of History.* Minneapolis: University of Minnesota Press.

Jay, Martin. 1993. *Downcast Eyes: The Denigration of Vision in Twentieth-Century Thought.* Berkeley: University of California Press.

Kant, Immanuel. 1979. *The Conflict of the Faculties* (Der Streit der Fakultaten), trans. Mary J. Gregor. New York: Abaris.

Lyotard, Jean-François. 1984. *The Postmodern Condition: A Report on Knowledge*, trans. Geoff Bennington and Brian Massumi. Minneapolis: University of Minnesota Press.

Merleau-Ponty, Maurice. 1968. *The Visible and the Invisible*, trans. Alphonso Lingis and ed. Claude Lefort. Evanston, IL: Northwestern University Press.

Milchman, Alan, and Alan Rosenberg. 2008. 'Self-Fashioning as a Response to the Crisis of "Ethics": A Foucault/Heidegger *Auseinandersetzung*', in David Pettigrew and François Raffoul (eds.), *French Interpretations of Heidegger: An Exceptional Reception.* Albany: State University of New York Press.

Mirzoeff, Nicholas. 2002. *The Visual Culture Reader*, 2nd ed. London: Routledge.

Mirzoeff, Nicholas. 2009. *An Introduction to Visual Culture*, 2nd ed. London: Routledge.

Mitchell, W.J.T. 2005. *What Do Pictures Want?: The Lives and Loves of Images.* Chicago: University of Chicago Press.

Preziosi, Donald. 1998. *The Art of Art History: A Critical Anthology.* Oxford: Oxford University Press.

'Questionnaire on Visual Culture.' 1996. *October*, 77.

Rancière, Jacques. 2009a. *Aesthetics and Its Discontents*, trans. Steven Corcoran. Malden, MA: Polity Press.

Rancière, Jacques. 2009b. 'Afterword', in Gabriel Rockhill and Philip Watts (eds.), *Jacques Rancière: History, Politics, Aesthetics.* Durham, NC: Duke University Press: 326.

Retort. 2005. *Afflicted Powers: Capital and Spectacle in a New Age of War.* London: Verso.

Sontag, Susan. 1977. 'The Image-World', in *On Photography.* New York: Farrar, Straus, Giroux.

Soussloff, Catherine M. 1996. 'Review Article: The Turn to Visual Culture', *Visual Anthropology Review*, 12: 77–83.

Soussloff, Catherine M. 1997. *The Absolute Artist: The Historiography of a Concept.* Minneapolis: University of Minnesota Press.

Soussloff, Catherine M. 2008. 'Image-Times, Image-Histories, Image-Thinking', in Tyrus Miller (ed.), *Given World and Time: Temporalities in Context.* Budapest and New York: Central European University Press, 2008.

Soussloff, Catherine M. 2010. 'Michel Foucault and the Point of Painting', in Dana Arnold (ed.), *Art History: Contemporary Perspectives on Method*. West Sussex: Wiley-Blackwell: 78–98.

Soussloff, Catherine M., and Mark Franko. 2002. 'Visual and Performance Studies: A New History of Interdisciplinarity', *Social Text*, 73: 29–46.

Summers, David. 2003. *Real Spaces: World Art History and the Rise of Western Modernism*. London: Phaidon.

Tanke, Joseph. 2009. *Foucault's Philosophy of Art: A Genealogy of Modernity*. London: Continuum.

van Buren, John. 1994. *The Young Heidegger: Rumor of the Hidden King*. Bloomington: Indiana University Press.

Warburg, Aby 1999. *The Renewal of Pagan Antiquity: Contributions to the Cultural History of the European Renaissance*, trans. David Britt. Los Angeles: Getty Research Institute for the History of Art and the Humanities: 1–75.

Scopic Regimes of Modernity Revisited

MARTIN JAY

'What are scopic regimes?' recently asked a curious, unnamed Internet questioner on 'Photherel', an official European e-learning Web site dedicated to the 'conservation and dissemination of photographic heritage'.[1] Although noting that the now widely adopted term was first coined by the French film theorist Christian Metz, the no less anonymous site respondent ducked answering the question head on. He nonetheless could claim that 'the advantage of the concept of "scopic regime" is that it supersedes the traditional distinction between technological determinism ... and social construction ... In the case of scopic regimes, culture and technology interact.' And then to offer a 'simple example', he adduced the distinctions made by contemporary culture between fictional and documentary versions of reality, which are created by a number of different devices, such as the greater narrative coherence of fiction over the 'possible fragmentation' of documentary. Other differences between scopic regimes, he continued, include the effects of gender—for example the 'male gaze'—and class, which he defined in terms of an opposition between the formalist look of bourgeois culture and the more politically infused variant betraying the scopic regime of dominated classes. The remainder of the entry stressed the important role played by photography in the generation of different scopic regimes.

As this episode in random Internet knowledge dissemination demonstrates, there are at least two things that can confidently be said about the concept of 'scopic regime': first that it has begun to enter popular discourse, arousing curiosity on the part of people who have heard about it, but are puzzled by its meaning, and second, that that meaning is by no means yet settled. In 1988, when I first composed an essay entitled 'Scopic Regimes of Modernity' for a conference at the Dia Art Foundation in New York, which produced the widely read collection *Vision and Visuality* edited by Hal Foster (1997), only the second of these conditions obtained, as the term was familiar, if at all,

to devotees of esoteric French film theory. When Metz had introduced it in 1975 in *The Imaginary Signifier*, he had, in fact, used it in a precise and circumscribed sense, solely to distinguish the cinema from the theatre: 'what defines the specifically cinematic *scopic regime*', he wrote, 'is not so much the distance kept ... as the absence of the object seen'. Because of the cinematic apparatus's construction of an imaginary object, its scopic regime is unhinged from its 'real' referent. Representation is independent of what is represented, at least as a present stimulus, both spatially and temporally.

Metz's distinction was suggestive, but it's fair to say, if a bit of self-congratulation can be excused, that 'scopic regime' remained only a restricted and obscure term until the publication of 'Scopic Regimes of Modernity' two decades ago. Inflating its meaning and expanding its range, the essay suggested that there were three competing regimes characterizing the era of history that has come to be called, with more or less precision, modernity. The audacity—or was it foolhardiness?—to do so came largely from the inspiration of a seminal essay by Martin Heidegger, which was at once the stimulus to my argument and its target. In 'The Age of the World Picture' of 1938, Heidegger had taken the German word *Weltbild*, which had been a close synonym of the more familiar term *Weltanschauung* or 'worldview', and given it a more than merely metaphorical meaning (Heidegger 1977).[2] 'Worldview', a term popularized by Wilhelm Dilthey and developed by later philosophers like Karl Jaspers, had pretty much lost its connection with vision (still faintly audible in the *Schau* in *Anschauung*), and become a synonym for a philosophy of life. Freud, for example could define it in an essay of 1933 as 'an intellectual construction which solves all the problems of our existence uniformly on the basis of one overriding hypothesis, which, accordingly, leaves no question unanswered and in which everything that interests us finds its fixed place' (1964: 158).

Paying more attention to the expressly visual nature of *Bild* (image or picture in German), Heidegger explored the meanings of both 'world' and 'picture', at least as he understood them. And then he posed the question, does every age have a world picture? Or is it only characteristic of the age we call 'modern'? Mobilizing his special vocabulary, Heidegger explained that *Welt* is 'a name for what is, in its entirety. The name is not limited to the cosmos, to nature. History also belongs to it. Yet even nature and history, and both interpenetrating in their underlying and transcending of one another, do not exhaust the world.' (Heidegger 1977: 129).[3] This somewhat cryptic statement was clarified in the appendix to the essay in which he linked 'world' to the ontological question of Being, which was of course the fundamental theme of his entire philosophy. What it did not mean, Heidegger contended, was the reduction of everything that exists to objects standing opposed to subjects viewing them from afar. This distortion was accomplished, much to his dismay, only with the introduction of the modern 'world picture', when 'the world' became primarily a visual phenomenon, available to the allegedly disinterested gaze of the curious subject.

As for 'picture', Heidegger made it clear that he did not mean a copy of something, an image of the world. Instead, he wrote, it suggests 'the world conceived and grasped as picture'. Crucially, Heidegger continued, not every age grasps the world in this way. It is only a function of the metaphysical biases and impoverished cultural practices of the

modern era, in which the broader reality he called *Dasein*, whose major trait was its concern for the question of Being, had shriveled into a *subjectum*, a punctual subject with all the myriad connotations of that word. Correspondingly, 'the world' was reduced to mere objects standing opposed to that subject, objects understood solely in ontic rather than ontological terms, as objects to be represented in a frame, as if through a window. Thus, Heidegger emphasized, 'the world picture does not change from an earlier medieval one into a modern one, but rather the fact that the world becomes picture at all is what distinguishes the essence of the modern age (*Neuzeit*)'. (Heidegger 1977: 130).

Strictly speaking, according to Heidegger, neither the ancient nor the medieval worlds had a picture of themselves in this sense. Neither of them posited a punctual viewing subject outside of a welter of discrete objects in its visual field. For their inhabitants, still immersed in a richly meaningful world before the split between subject and object, the mode of representing the world as if it were in a picture to be viewed through a window-like canvas was not yet prevalent. The vice of curiosity for its own sake, an expression of voyeuristic inquisitiveness distracting us from attending to more important matters, was still kept under control. Only with the rise of modern technology, in which the world was reduced to a standing reserve for human domination, did a true *Weltbild* arise. Only with the fateful advent of Descartes's dualist metaphysics did the radical opposition of viewing subject and viewed object supplant earlier ontological ways of being immersed in the world. 'The fundamental event of the modern age is the conquest of the world as picture,' Heidegger boldly asserted. 'The word "picture" (*Bild*) now means the structured image (*Gebild*) that is the creature of man's producing which represents and sets before' (Heidegger 1977: 134). In the terminology he would adopt elsewhere, it meant putting the world in a frame (*Gestell*), an act of 'enframing' that turns the world into a 'standing reserve' for human exploitation.

Heidegger, in short, made two very broad claims in 'The Age of the World Picture', both of which inspired my own attempt to conceptualize the scopic regimes of modernity and yet seemed to me at the same time problematic. The first was his assertion that only the modern age could be understood to have possessed a true 'world picture' in the sense he gave those terms. Modernity was radically different from what had preceded it, at least in terms of the domination of representational enframing and the primacy of the subject over the object. Cartesian philosophy, the technological domination of nature and the rise of modern science were all factors in the creation of that outcome, or at least symptoms of the change, which involved the forgetting of Being and the privileging of the *subjectum* over *Dasein*, whose mode of relating to *Sein* had been care, not domination.

Heidegger, however, himself provided a clue to the inadequacy of this conclusion, which too categorically differentiated historical epochs. Although insisting that 'in the age of the Greeks the world cannot become picture', he acknowledged nonetheless, 'that the beingness of whatever is, as defined for Plato as *eidos* [aspect, view] is the presupposition, destined far in advance and long ruling indirectly in concealment, for the world's having to become picture' (Heidegger 1977: 131). That is in the Platonic system of Ideas, visible to at least the mind's eye, there is already the kernel of the world as a picture, which anticipates in some sense the radical departure that was the modern age.

Premodern cultures could therefore be understood in part to possess inchoate 'world pictures', even if they were not yet fully hegemonic.

As I tried to show in the book that followed a few years after the Dia Foundation conference, *Downcast Eyes*, Hellenic attitudes towards vision had been in fact often ocularcentric, even if not uniformly so (Jay 1993a: 21–33). The Platonic *eidos* was not as idiosyncratic a concept in classical Greece as Heidegger suggested. What exists 'in concealment' in a culture can, in fact, often disrupt the apparent coherence of that culture, even perhaps, to repeat Heidegger's own phrase, 'long ruling indirectly'. So although Heidegger may well have been right to stress the uniqueness of the modern era in terms of its clear-cut privileging of the world picture, it would be wrong to ignore the anticipations and manifestations in premodern cultures, both in the West and elsewhere, of that outcome. And, in fact, a good deal of subsequent scholarship on scopic regimes, as we will see, was to investigate precisely these prior historical instances.

The second bold conclusion of Heidegger's essay which seemed questionable was his characterization of the modern era entirely in terms of one dominant visual culture, that which he identified with Cartesian dualism, the technological domination of nature and the punctual subject representing a world of objects at the other end of a visual field. To be sure, what might be called 'Cartesian perspectivalism' was arguably the most prevalent model of visual experience in the modern era, as Richard Rorty had also contended in his influential *Philosophy and the Mirror of Nature* (Rorty 1979). In fact, Heidegger's case would be strengthened if we add post-Albertian perspective in the visual arts to the philosophical and scientific/technological evidence he provided. Although in 'The Age of the World Picture', Heidegger did not focus on aesthetic issues, elsewhere he indicated that treating works of art as objects for the aesthetic experience (*Erlebnis*) of a subject rather than as vehicles for the disclosure of Being also characterize the modern *Weltbild* (Heidegger 2008). The revolution in painting during the Renaissance associated with the invention or discovery of perspective can be understood, among many other ways, as supporting this general conclusion. And perhaps we might also add, as Jacqueline Rose has urged, the development of the bourgeois subject in the early modern era, which from a certain political perspective might even be understood to underlie the entire epochal shift that Heidegger described (Foster 1997: 24).

But however persuasive Heidegger's critique of the hegemonic Cartesian perspectivalist *Weltbild* or scopic regime of the modern era might be—and, of course, there are many critics sceptical of the underlying premise of his argument about the alleged 'forgetting of Being' in the West—a closer analysis of the complexities of the era we call modernity suggest that it was not quite as all-pervasive as he implied. As a result, 'Scopic Regimes of Modernity' sought to pluralize his monolithic argument and bring attention to two other less prominent, but still important scopic regimes of modernity. This is not the place to rehearse the argument in all its details, but suffice it to say that they were characterized as the Dutch 'art of describing', a term taken from an important book of that name by the art historian Svetlana Alpers, and that of 'baroque reason', whose characteristics had been developed by the French philosopher and cultural critic Christine Buci-Glucksmann (Alpers 1983; Buci-Glucksmann 1994). Each of these was a manifestation of what Jacqueline Rose had called the 'moment of unease' in the dominant

scopic regime of an era (Rose 1986: 233). Each manifested a different combination of philosophical, aesthetic and technological assumptions and practices. Indeed, as a later, expanded version of my initial essay tried to argue, each might also be extended to the competing urban design patterns of modern cityscapes (Jay 1993b).[4] And perhaps, as I sought to show in a still later effort dealing with the threatened transformation of St. Petersburg's skyline, they might even be helpful in our understanding of the different skyscapes of modern cities as well (Jay 2008: 158–9).

It would, of course, have been possible to multiply other examples of plausible candidates for modern scopic regimes, and in fact in several responses to the essay, a number were quickly suggested. One commentator, for example pointed to the importance of the 'criticisms of Cartesian perspectivalism offered by twentieth-century art and artists' (Green et al. 1989: 37)[5] thus drawing our attention to late-modern rather than early-modern visual cultures, those informed by that crisis of integrated subjectivity, representation, three-dimensional perspective and realism we identify broadly with aesthetic modernism. It would be easy to locate philosophical correlates in twentieth-century thought, such as phenomenology or the later Wittgenstein's theory of language games, for this plausible fourth modern scopic regime. And with the emergence of postmodernism still later in the twentieth century, it would be possible to posit a new scopic regime expressing its major traits, such as the triumph of simulacra over reality abetted by the digital revolution, which correlates with the philosophy of figures like Jean-François Lyotard or Gilles Deleuze, although some might argue that it really was better understood as a revival of the 'baroque reason' of the early-modern period.

It would also be worth pausing to consider objections that have been made to the characterizations of the three scopic regimes or their relative importance in the original essay. For example the philosopher Margaret Atherton has questioned the elevation of Descartes by Heidegger and Rorty, which I then appropriated, into the philosophical inspiration for the dominant ocularcentric regime of the modern era. Doing so, she argues, 'often results in a dual oversimplification: it reduces the highly complex thought of Descartes to a caricature, and it removes attention from events that do not fit neatly the Cartesian mold. In discussions of vision, what can often get ignored is the alternative account of George Berkeley' (1997: 140).[6] She goes on to claim that the camera obscura model of vision, in which the corporeal intervention of the spectator is bracketed out in the service of a formal, geometric model of visual experience, does not accurately describe either Descartes or Berkeley, as recent commentators like Jonathan Crary have also mistakenly assumed. 'For all of Descartes' praise of vision of (*sic*) the beginning of the *Optics*, what he produced was an account that encouraged a distrust of vision, which was continued by later Cartesians like Malebranche' (148). Thus, using his name as a shorthand way to label the perspectivalist regime akin to Heidegger's notion of the modern 'world picture' is to do Descartes a disservice.

Focusing instead on the implications of the alternative modern scopic regime called 'baroque reason', Christopher Braider, a scholar of comparative literature, accepts Buci-Glucksmann's general description of its characteristics, but questions its allegedly subordinate status in comparison to the dominant one associated—rightly or

wrongly—with Cartesian perspectivalism. 'The baroque', he claims, 'marks indeed at once the apogee and crisis of early modern visual experience, simultaneously magnifying and deprecating human sight and the modes of depiction calculated to model and enhance it' (2004: 42). By focusing on the gender relations enacted in baroque visuality, violent and disruptive, he suggested that even Baconian science is characterized by a self-undermining of the claims it makes on the surface to visual mastery. 'Perhaps the essential point is just the difficulty of saying or showing as such. The Naked Lady that images both nature and truth is an *idea* in Kant's strict sense, a principle that guides us precisely because it can never be realized in the realm of representable experience' (67). It is therefore a mistake, he concludes, to date the terminal crisis of the dominant Cartesian perspectivalist scopic regime to the advent of Impressionism in painting and Bergson in philosophy, as I had done in *Downcast Eyes*, for it was already in crisis at the outset (69).

Rather, however, than speculate on the alternative candidates for scopic regimes of modernity or try to fine-tune the ideal types presented in the original essay, I want to use this opportunity to think a bit more reflectively on the larger issues raised by the concept itself. That is what can we now say about 'scopic regime' as a tool of critical analysis some two decades after its introduction into visual culture studies? How has it been used and what are the implications of that usage? Luckily, Internet search engines make it possible to canvas a wide variety of different cases, which might otherwise have slipped through the cracks, to arrive at a tentative answer. These include not only publications, but also university courses, academic conferences and even artistic production inspired by the concept, or at least illuminated by it.[7]

What first becomes apparent after such a search is the range of applications in terms of scale. We might for shorthand purposes speak of a division into 'macroscopic' and 'microscopic' regimes. At one end are attempts to characterize epochal configurations, inevitably coarse-grained and bold in the manner of Heidegger's critique of the *Neuzeit*'s 'world picture'. Such were the three scopic regimes of modernity introduced in my 1988 essay. They should be understood, it bears repeating, as heuristic devices or ideal types, which allow many exceptions to whatever rules or patterns they claim to discern. The temporal and spatial boundaries of these macroscopic regimes are, of course, impossible to limit with any rigour, as is the case with all period categories used by historians.[8] But attempts to provide large-scale generalizations about the visual cultures of a period, however imprecisely defined, provide at least benchmarks against which deviations and variations can be measured. They alert us to the ways in which untheorized and often unconsciously adopted background practices may inform a wide variety of phenomena during a period, from urban design and the conventions of painting to philosophical and theological doctrines to interpersonal interactions and self-images. How uniformly they may follow the patterns established is, of course, difficult to say, nor is it likely that the same pattern permeates every aspect of a regime. As is the case with all ideal types, there will always be refinements that will modify original characterizations, which are never to be understood as adequate to the reality they can only approximate.[9] But enough rough coherence may characterize an epoch in ways that still allow us to speak

with heuristic value of a macroscopic regime, such as 'Cartesian perspectivalism', 'the art of describing' or 'baroque reason'.

At the other end of the spectrum are those usages that focus on a very narrow and circumscribed set of visual practices and designate them as a scopic regime. To take some examples at random, the term has been used to describe visual dimensions of 'the war on terror' and the horrors of the Khmer Rouge in Cambodia (Darts et al. 2008; Stanbury 1997; Ly 2003). It has been mobilized to investigate landscape styles under the rubric 'land-scopic regimes' (Getch Clarke 2005) and to describe the erotic imagery of early-modern Japanese prints called *Shunga* (Screech 2004). It has been compared with the 'spectro-scopic domains' within the rarefied science of spectrochemistry and identified with the visual experience of shopping malls (Falk 1997; Hentschel 2002: 434). It has been introduced to make sense of orientalist encounters with the colonial other in Egypt, postcolonial photography in Mali and the antihegemonic, 'subaltern' novels of Bolivia (Sanjinés 2000; Pinney 2003; Gregory 2003: 224). It has been employed to understand Chaucer's *Clerk's Tale* in the fourteenth century and the poetry of John Ashbury in the twentieth (Stanbury 1997; Dimakopoulou 2004). And the list could easily be extended in a way that would make Borges's heteroclite Chinese encyclopedia, made famous by Foucault in *The Order of Things*, seem coherent by comparison.

It would be tempting to condemn these motley uses as a misapplication of the term, which ought to be restricted only to the most extensive macroscopic regimes, such as those postulated in 'Scopic Regimes of Modernity'. They are certainly less fleshed out in terms of all the possible elements in a force field, nonvisual as well as visual, metaphoric as well as literal. But insofar as no culture is homogeneous and consistent, allowing many different subcultures to flourish or compete, it would be healthier to learn from the wider and less rigorous use of the term, which, after all, has no strong claim to intrinsic, objective validity on any scale. What might be profitably explored are the congruences or lack thereof between macro and microscopic regimes. Do they reinforce or challenge the more expansive fields in which they are situated? Are they the moments of unease on a micro-level of which Jacqueline Rose spoke? Can, for example there be a comfortable fit between the historical regime identified by Christine Buci-Glucksmann as 'baroque reason' and certain representatives of contemporary, postmodernist art, as exemplified by a recent gallery show in London with that very title?[10] Can films like Sally Potter's *Orlando* or Peter Greenaway's *The Draughtman's Contract*, *The Belly of an Architect*, *A Zed and Two Noughts*, *The Cook, the Thief, His Wife and Her Lover*, *The Baby of Mâcon* and *The Pillow Book* be understood according to the same template, as one critic has suggested (Degli-Eposti 1996a,b)? Are the visual protocols of postcolonial photographers in Mali best understood as an 'art of describing' challenge to Cartesian perspectivalism, a vernacular modernist 'surfacism' (Pinney 2003)? Can the new media as a whole be reckoned as inclining towards a resurrection of the baroque scopic regime (Manovich 2001)? Or are there aspects of these contemporary phenomena that may escape or even contradict some of the traits Buci-Glucksmann attributed to the Baroque in its original form?

It also may be worth addressing the issue of what elements need to be present to construct a complex of visual practices and habits that constitute what might justifiably be

called a full-fledged scopic regime, macro or micro. In visual culture studies, we have learned to expand our focus beyond images, whether traditional easel paintings, devotional icons, printed illustrations, photographs or the like, which were for so long the primary preoccupation of canonical art historical discourse, to more complex, historically variable force fields of visuality. What Rosalind Krauss called in her classic essay of 1979, the 'expanded field' of sculpture, which emerged with installations and site specificity, has been extended to all visual artefacts. Within those force fields of relational elements, we have learned to question the protocols of seeing and the techniques of observation, the power of those who have the gaze, the right to look, as well as the status of those who are its objects, the obligation to be on view. The latter we have come to understand not only in terms of weakness and vulnerability, but also at times as the privilege to exhibit, to attract, solicit or demand the gaze of others in a struggle for recognition and attention. We have also learned to ask what is visible and what is invisible in a particular culture and to different members of the culture. We have explored what Walter Benjamin famously called the 'optical unconscious' revealed by new technologies, registering the expansion, augmentation and/or distortion produced by prosthetic devices enhancing the natural powers of the eye. We have learned to situate those technological innovations in more complicated apparatuses and practices of visuality that include cultural, political, religious, economic and other components. All of these meanings are folded into the notion of the 'scopic', which thus extends beyond more limited concepts such as a 'regime of perception'. (Singy 2006: 57).

But what precisely is added to the more generic notion of visual cultures or subcultures by the terminology of a 'regime'? As the etymology of the term itself suggests—it is derived from the Latin *regimen*, which means rule or guidance—it implies a relatively coherent order in which protocols of behaviour are more or less binding. As such, it fits well with what can be called the political turn in visual culture studies, in which relations of power are understood to be expressed in or reinforced by visual interactions. 'Regime' suggests, however, more than just a governmental form with norms and rules, regulating behavior, enforcing conformity and setting limits. To cite one eminent observer, the political theorist Leo Strauss,

regime is the order, the form, which gives society its character. Regime is therefore a specific manner of life. Regime is the form of life as living together, the manner of living of society and in society, since this manner depends decisively on the predominance of human beings of a certain type, on the manifest domination of society by human beings of a certain type. Regime means that whole, which we are today in the habit of viewing primarily in a fragmentized form: regime means simultaneously the form of a life of a society, its style of life, its moral taste, form or society, form of state, form of government, spirit of laws. (1959: 34)

Strauss's remark about the 'manifest domination of society by human beings of a certain type' gives away something important about the inevitable connotation of the word 'regime'. Implying coercive or disciplinary constraint, it may tacitly suggest the lack of full legitimacy based on the absent or manipulated consent of the governed. Because

of the long-standing habit of calling prerevolutionary France, the France of the late Valois and Bourbon dynasties, the *ancien régime*, it may connote an autocratic, unjust and unpopular order, which constrains and exploits those under its control. We rarely talk of a democratic government based on popular sovereignty as a regime. As a result, it may also inspire thoughts about deliberately subverting and discrediting it, extrapolating from the recently fashionable idea of 'regime change'. Indeed, merely exposing what had hitherto been an unconsciously followed regime may be seen as a step on the road to subverting it. Take, for example the usage in an essay on the painter Paul Klee whose 'private visual language' is said to have 'offered a "scopic regime" that challenged National Socialism's mimetic reproduction of mimetic myths' (Kramer 1996: 182).

Although Metz's original use of the term to describe the cinema may not seem explicitly intended to discredit it, it is worth recalling nonetheless that he coined it at the very same time that he and his colleagues at the *Cahiers du Cinéma* were developing what became known as 'apparatus theory' to criticize the ideological function of film as a whole.[11] Typically, as two of their number, Marcelin Pleynet and Jean Thibaudeau put it, 'the film camera is an ideological instrument ... [which] produces a directly inherited code of perspective, built on the model of the scientific perspective of the Quattrocento' (1969: 10). In other words, it is complicit with the Cartesian perspectivalist worldview, which was so much a target of the anti-ocularcentric discourse of the era.

It is thus not surprising to see the very idea of a dominant or hegemonic scopic regime, no matter what its actual content, employed as a frequent target of critique, as much ethical as political. For example in 2008, a blogger named Y. H. Lee suggested that tagging and graffiti can be understood as a way of 'resisting the (*sic*) scopic regime by taking control over the visual landscape'.[12] Similarly, in a recent book on Marcel Duchamp and John Cage, Jonathan D. Katz wrote:

> From the perspective of postwar gay (that is to say, closeted) culture, there is something deeply, resonantly queer here: this sense of interrupted or blocked desire; this unwavering, implacable self-control; this persona staged for public consumption; and most of all this consuming awareness of audience, of a life lived under a scopic regime. (Roth 1998: 58)

In a comparable vein, a University of Kansas literary critic, Kathryn Conrad, delivered a paper at a Canadian Association for Irish Studies conference in Toronto in 2008 on 'Queering the Scopic Regime in Northern Ireland'.[13] In all of these uses, the very existence of a regime suggests that subversion or resistance will have progressive implications. With a kind of implicit anarchistic distaste for regimes of any kinds, commentators like these advocate subverting whichever one is in place. A regime becomes equivalent to an ideology, whose exposure and subversion are sought in the name of something truer or more just.

But insofar as the fantasy of living outside of a scopic regime at all is posited as the unstated alternative to being coerced by the present dominant one, the project of subversion or resistance loses, I would argue, its plausibility. For as in the parallel case of

Foucault's concept of a discursive regime, a pervasive 'episteme' defining an age, the only alternative is another regime, another more or less coherent form of visual life with its own internal tensions and coercive as well as liberating implications. There may never be an 'outside' beyond a cultural filter, allowing us to regain a 'savage' or 'innocent' eye, a pristine visual experience unmediated by the partial perspective implied by the very term 'scopic'.[14] Nor is it always clear that the politics of a specific scopic regime are predominantly sinister with, say, surveillance and the spectacle serving the domination of those who are victimized by them, as Chris Otter has prudently argued in his detailed exploration of the liberal implications of 'the Victorian eye' (Otter 2008).

The inherent parallel with ideology critique thus falters. Some rules may be challenged and new ones introduced, although the effort may itself be less easy to realize than is the case when the rules are explicitly legislated, as in the political arena. But it is hard to imagine living with no rules at all. Heidegger to the contrary notwithstanding, the hope of ending the age of the world picture, *all* world pictures, and somehow forging a new or restoring an old nonvisual order of interaction between humans and their environment would be very difficult to achieve. There may well be an ineluctable modality of the visual, to borrow Joyce's familiar phrase, even though the dominance of specific modalities can vary. The culturally and technologically abetted hegemony of the eye may, of course, be challenged by other senses, or at least the balance tilted back away from its domination. But it difficult to imagine that another sense can ever become dominant enough to allow us to talk of a hegemonic haptic, vocative, gustatory or olfactory regime with the same plausibility we can assume for scopic regimes. Or at least no compelling cases have emerged so far, at least to my knowledge.

The example of multiple, competing scopic regimes does, to be sure, suggest that seeking other patterns in the relationship between the different senses and larger cultural wholes may well be fruitful.[15] But for the moment, the most promising area of new inquiry remains in visual culture, where major questions about the coherence and integration of practices and protocols of interaction remain to be resolved. Although we are still groping around in the dark for ways to articulate the relationships between micro and macroscopic regimes and have by no means exhausted all the possible coherent regimes that might plausibly be found, we have certainly come a long way since Christian Metz first floated the idea that we might distinguish between the cinema and the theatre according to the absence or presence of the object seen and defined each in terms of a unique scopic regime.

FURTHER READING

Brennan, Teresa and Martin Jay, eds. 1996. *Vision in Context: Historical and Contemporary Perspectives on Sight*. London: Routledge

Buci-Glucksmann, Christine. 1994. *Baroque Reason. The Aesthetics of Modernity*, trans. Patrick Camiller. New York: Sage.

Jay, Martin. 1993a. *Downcast Eyes: The Denigration of Vision in Twentieth-Century French Thought*. Cambridge, MA.: Harvard University Press.

Jay, Martin. 1993b. *Force Fields: Between Intellectual History and Cultural Critique* (New York and London: Routledge, 1993b)

Melville, Stephen and Bill Readings, eds. 1995. *Vision and Textuality.* London: Macmillan.

NOTES

1. See http://www.photherel.net/notes/relationships/ideas/re19aiii. When the same question was asked of Yahoo! Answers on 9 November 2008, by a student who needed to know for a class in cultural studies, the answer was the same example. http://answers.yah.com/question/index?qid=20081109202323AAW0eaJ.

2. *Weltbild* implied more of a scientific view of the world, whereas *Weltanschauung* can also refer to prescientific intuitions. The term had been introduced by Wilhelm Dilthey. See the discussion in Makkreel (1975: 349–54). He thought it was more strictly cognitive than a *Weltanschauung.*

3. For an account of Heidegger's use of the word, see the entry on it in Inwood (1999).

4. It was first published in Scott Lash and Jonathan Friedman eds., (1992) and then in my collection (Jay 1993b).

5. For an attempt to do just that, see Jacobs (2001).

6. In an essay in the same volume, 'Discourse of Vision in 17th-century Metaphysics', Catherine Wilson also argues that seventeenth-century metaphysicians had a more nuanced understanding of vision than is implied by the term 'Cartesian perspectivalism'.

7. At the 2003 annual meeting of the American Society for Information Science and Technology, there was a panel on 'Visual Containment of Cultural Forms: An Examination of Epistemologies and Scopic Regimes'. In September 2007, the 24th International Conference of the Society of Architectural Historians Australia and New Zealand was devoted to the theme of 'Paradise: Scopic Regimes in Architectural and Urban History and Theory'. At the University of Amsterdam in 2008–2009, there was an MA theme seminar on the topic 'Scopic Regimes of Virtuality'.

8. For an attempt to wrestle with the vexed question of historical periodization in general, see Jay (2008/2009: 160–1).

9. It has, however, been noted that perspective in the early-modern period was itself ambiguous, sometimes implying a single transcendental subject, sometimes a plurality of different subjects. See Somaini (2005–2006: 38).

10. The show at the Keith Talent Gallery in London from February to April 2009 was entitled 'Baroque Reason', which it explained in these terms: 'This is a neo-baroque reflecting the dynamics of hybridity and difference. These artists celebrate the dazzling, the disorientating, and revel in baroque's fascination with opacity, unreadability and the indecipherability of the reality they depict. This collection of paintings present a conception of reality in which the instability of forms in movement creates a duality; an enchanted illusion and a disenchanted world. The title of the exhibition is taken from the French philosopher Christine Buci-Glucksmann's book on the aesthetics of modernity. Buci-Glucksmann claims "If one had to single out a scopic regime that has finally come into its own in our time, it would be the madness of vision identified with the baroque."' (http://www.re-title.com/exhibitions/KeithTalentGallery.asp).

11. For an account, see my *Downcast Eyes*, chapter 8.

12. See http://leeyh85.blogspot.com/2008/03/scopic-regimes-graffit.html.

13. See http://people.ku.edu/~kconrad/.

14. As Hans-Georg Gadamer notes, *scopi* or perspective was a metaphor implying partial knowledge in rhetoric ever since the time of Melanchthon. See *Reason in the Age of Science*, translated by Frederick G. Lawrence (1983: 125).
15. See, for example, Classen (1993).

REFERENCES

Alpers, Svetlana. 1983. *The Dutch Art of Describing: Dutch Art in the Seventeenth Century*. Chicago: University of Chicago Press.

Atherton, Margaret. 1997. 'How to Write the History of Vision: Understanding the Relationship between Berkeley and Descartes', in David Michael Levin (ed.), *Sites of Vision: The Discursive Construction of Sight in the History of Philosophy*. Cambridge, MA: MIT Press, 139–166.

Braider, Christopher. 2004. *Baroque Self-Invention and Historical Truth: Hercules at the Crossroads*. Aldershot: Ashgate.

Buci-Glucksmann, Christine. 1994. *Baroque Reason: The Aesthetics of Modernity*, trans. Patrick Camiller. New York: Sage.

Classen, Constance. 1993. *Worlds of Sense: Exploring the Senses in History and across Cultures*. London: Routledge.

Darts, David, Kevin Tavin, Robert W. Sweeny and John Derby. 2008. 'Scopic Regime Change: The War on Terror, Visual Culture, and Art Education', *Studies in Art Education*, 49(3): 200–17.

Degli-Eposti, Christina. 1996a. 'Sally Potter's *Orlando* and the Neo-Baroque Scopic Regime', *Cinema Journal*, 36(Autumn): 75–93.

Degli-Eposti, Christina. 1996b. 'The Neo-Baroque Scopic Regime in Postmodern Cinema: Metamorphoses and Morphogeneses: The Case of Peter Greenaway's Encyclopedic Cinema', *Cinefocus*, 34–45.

Dimakopoulou, Stamatina. 2004. 'The Poetics of Vision and the Redemption of the Subject in John Ashbery's *Self-Portrait in a Convex Mirror*', *Poetics of the Subject*, 2: 2.

Falk, Pasi. 1997. 'The Scopic Regimes of Shopping', in Pasi Falk and Colin B. Campbell (eds), *The Shopping Experience*. New York: Sage, 177–83.

Foster, Hal, ed. 1997. *Vision and Visuality*. New York: The New Press.

Freud, Sigmund. 1964. *New Introductory Lectures on Psychoanalysis*, trans. James Strachey. New York: W. W. Norton.

Gadamer, Hans-Georg. 1983. *Reason in the Age of Science*, trans. Frederick G. Lawrence. Cambridge, MA: MIT Press.

Getch Clarke, Holly A. 2005. 'Land-scopic Regimes: Exploring Perspectival Representation beyond the "Pictorial" Project', *Landscape Journal*, 21: 24(1): 50-68.

Green, Tony. May 1989. Review of *Vision and Visuality* and Steven Benson, *Blue Book* in M/E/A/N/I/N/G, 37.

Gregory, Derek. 2003. 'Emperors of the Gaze: Photographic Practices and Productions of Space in Egypt, 1839–1914', in Joan M. Schwartz and James R. Ryan (eds), *Picturing Place: Photography and the Geographical Imagination*. London: I. B. Tauris, 195–225.

Heidegger, Martin. 1977. 'The Age of the World Picture', in *The Question Concerning Technology and Other Essays*, trans. William Lovitt. New York: Harper and Row, 143–187.

Heidegger, Martin. 2008. 'The Origin of the Work of Art', in David Farrell Krell (ed.), *Basic Writings*. New York: Harper and Row, 193–212.

Hentschel, Klaus. 2002. *Mapping the Spectrum: Techniques of Visual Representation in Research and Teaching*. Oxford: Oxford University Press.

Inwood, Michael. 1999. *A Heidegger Dictionary.* Oxford: Blackwell.

Jacobs, Karen. 2001. *The Mind's Eye: Literary Modernism and Visual Culture.* Ithaca, NY: Cornell University Press.

Jay, Martin. 1993a. *Downcast Eyes: The Denigration of Vision in 20th-Century French Thought.* Berkeley: University of California Press.

Jay, Martin. 1993b. *Force Fields: Between Intellectual History and Cultural Critique.* New York: Routledge.

Jay, Martin. 2008. 'Skyscapes of Modernity', *Salmagundi* (Spring/Summer): 158–9.

Jay, Martin. 2008/2009. '1990: Straddling a Watershed?', *Salmagundi*, 160–1.

Kramer, Kathryn E. 1996. 'Myth, Invisibility, and Politics in the Late Work of Paul Klee', in Beate Allert (ed.), *Languages of Visuality: Crossings between Science, Art, Politics, and Literature.* Detroit: Wayne State University Press, 174–85.

Krauss, Rosalind. 1979. 'Sculpture in the Expanded Field', *October*, 8: 30-44.

Lash, Scott and Jonathan Friedman, eds. 1992. *Modernity and Identity.* London: Blackwell.

Ly, Boreth. 2003. 'Devastated Vision(s): The Khmer Rouge Scopic Regime in Cambodia', *Art Journal* 62(1): 66-81.

Makkreel, Rudolf A. 1975. *Dilthey: Philosopher of the Human Sciences.* Princeton, NJ: Princeton University Press.

Manovich, Lev. 2001. *The Language of New Media.* Cambridge, MA: MIT Press.

Otter, Chris. 2008. *The Victorian Eye: A Political History of Light and Vision in Britain 1800–1910.* Chicago: University of Chicago Press.

Pinney, Christopher. 2003. 'Notes from the Surface of the Image: Photographic Postcolonialism and Vernacular Modernism', in Christopher Pinney and Nicolas Peterson (eds), *Photography's Other Histories.* Durham, NC: Duke University Press, 202-20.

Pleynet, Marcelin and Jean Thibaudeau. 1969. 'Economique, idéologique, formel', *Cinéthique*, 3:10.

Rorty, Richard. 1979. *Philosophy and the Mirror of Nature.* Princeton, NJ: Princeton University Press.

Rose, Jacqueline. 1986. *Sexuality in the Field of Vision.* London: Verso.

Roth, Moira with commentary by Jonathan D. Katz. 1998. *Difference/Indifference: Musings on Postmodernism, Marcel Duchamp and John Cage.* London: Routledge.

Sanjinés, Javier. 2000. 'Subalternity within the "Mestizaje Ideal": Negotiating the "Lettered Project" with the Visual Arts', *Nepantla: Views from the South*, 1: 2.

Screech, Timon. 2004. *Sex and the Floating World: Erotic Images in Japan 1700–1820.* Honolulu: University of Hawaii Press.

Singy, Patrick. 2006. 'Huber's Eyes: The Art of Scientific Observation before the Emergence of Positivism', *Representations*, 95: 54–75.

Somaini, Antonio. 2005–2006. 'On the "Scopic Regime" ', *Leitmotif*, 5: 38.

Stanbury, Sarah. 1997. 'Regimes of the Visual in Premodern England: Gaze, Body, and Chaucer's *Clerk's Tale*', *New Literary History*, 28: 2.

Strauss, Leo. 1959. *What Is Political Philosophy?.* Chicago: University of Chicago Press.

Wilson, Catherine. 1997. 'Discourse of Vision in 17th-century Metaphysics', in David Michael Levin (ed.), *Sites of Vision: The Discursive Construction of Sight in the History of Philosophy.* Cambridge, MA: MIT Press, 117–38.

Phenomenology and Its Shadow: Visuality in the Late Work of Merleau-Ponty

MICHAEL E. GARDINER

Courage consists in being reliant on oneself and others to the extent that, irrespective of differences in physical and social circumstance, all manifest in their behaviour and their relationship that very spark which makes us recognize them, which makes us crave their assent or criticism, the spark which means we share a common fate.

—*Maurice Merleau-Ponty (2004: 88–9)*

The very existence of the present *Handbook of Visual Culture* confirms the widespread impression that the explosion of scholarly interest in vision and visuality over the last twenty-odd years shows no signs of slowing down. Yet, at the same time, there has still been an influential tendency, at least in the more critically engaged literature, to foster a scopic 'hermeneutics of suspicion' that regards the visual register as linked inextricably to an abstract, totalizing and decontextualized form of power/knowledge that denigrates and undermines the bodily, affective and intersubjective qualities of contemporary sociocultural life. This occurs through such phenomena as the technological mediation and manipulation of sight, and the overdetermination of vision by the commodity form, as registered in such familiar tropes as Debord's 'society of the spectacle' or Baudrillard's 'simulacrum'. Typically, such a diagnosis is accompanied by a call to 'de-throne' sight as a privileged sense—which, in the feminist literature, often takes the form of a masculinist prerogative that seeks to contain or vanquish women's differential embodiment and agency—and to explore alternatives to what Martin Jay has, in a series of important works (1993a,b), usefully termed 'ocularcentrism'.

More recently, there have emerged a number of important criticisms of such ocularphobic accounts that address the implications of the sort raised by Fredric Jameson when he writes: 'the visual is *essentially* pornographic' (1990: 1; my italics). For instance,

Peter de Bolla (1996) makes the effective point that the Enlightenment is all too often and easily pegged as the *Ur*-ground of modern hegemonic conceptions and operations of the visual. But what is lacking in such narratives, which rely far too much on abstract, sweeping generalizations, is a more nuanced and specifically *historical* sense of the relationship between the Enlightenment, modernity and vision, especially the various countertendencies that inform all of these. De Bolla argues that if we can historicize successfully the organization of visual perception, we typically discover that there are multiple, often antagonistic paradigms about vision (or any sensory regime) operating at any given point in time/space. This is not to deny that there might well be dominant or hegemonic perceptual forms in effect during any historical period. But it does mean that, insofar as vision is always inflected by such factors as socioeconomic class, gender or locale, we should instead strive to develop a 'heterotopics' that is aware of scopic pluralism, one that pays sufficient attention to relevant historical details.

There are other, equally salient concerns vis-à-vis such ocularphobic approaches. In particular, whilst it is important to uphold a critical orientation, what is problematic about assuming that the 'gaze' always, and inextricably, ensnares the Other in a matrix of subjectifying power is that such approaches cannot uphold the possibility of a conceptual and normative space of contrast or difference, wherein there might be a *relative* suspension of power imbalances in the dialogical interchanges of an 'ideal community of embodied subjects' (Merleau-Ponty 1970: 82). In combating 'visual essentialism' (Bal 2003), which supposes that seeing is a 'pure' and transparently unmediated experience that is not influenced by wider discursive factors, it is important not to move too far in the opposite direction, and embrace uncritically a kind of cultural reductionism which says there is nothing primordially 'given' or experiential about sight. For, as Jay (2002) argues convincingly in his recent essay 'Cultural Relativism and the Visual Turn', the assumption that sight is determined unilaterally by the specific cultural or discursive situation in which given visual events occur, and that there can be no possibility of fostering the conceptual reinscription or translation of meanings across existing cultural boundaries, is deeply suspect. For one thing, it falls prey to the Romanticist (or 'left-Herderian') notion that the human world consists of utterly distinctive and discrete groups and cultures—whether of nationalities, as in the older counter-Enlightenment account, or multiple and dispersed 'neo-tribes' and subcultures, as in the updated Postmodernist version. Each such cultural formation, according to this account, has a quasi-organic, tightly integrated character, and they foster meanings that are essentially incommensurable vis-à-vis other groups.

The key objection here is that cultures are not, and never have been, clearly delineated entities with distinct expressive qualities. Jay draws on the work of Bruno Latour to develop an alternative position: that cultures are always impure and heterodox constructions, amalgams of myriad discursive impulses and forms, and are 'always-already' complexly intertwined with natural processes. Instead of the absolute relativism of Lyotard's brand of Postmodernism, which is in reality a simple reversal of the Enlightenment belief in a natural universalism, Latour promotes a 'relational relativism'. The goal of the latter is to conceptualize human sociocultural formations as hybridized, 'quasi-objects'

that always strive to translate localized codes into meta-codes (regardless of whether they are ultimately 'successful' in doing so), move constantly beyond established symbolic boundaries, initiate novel conceptual and practical connections with other processes and entities and so forth. In the view of Latour and Jay, the subject is always imbricated with the object, the material with the immaterial, nature with culture. Although sight might seem to alienate us from the world, provide a simulacrum of 'distance', it is part and parcel of a compound, hybridized world no less than any other sense or human activity. In questioning such a cultural relativism, concludes Jay, we don't have to fall back on an earlier transcendental naturalism, but we do have jettison the notion that 'culture goes all the way down'. As he writes:

> [T]he persistent disruption of the organic, holistic concept of culture by visual expe-
> rience reveals, we can do without choosing between extremes and live comfortably
> within the negative dialectic of culture and nature, knowing that neither term can
> suffice without the other. Relativism, cognitive and normative, may not be overcome,
> but the assumption that cultural difference is its source cannot be plausibly sustained.
> (Jay 2002: 276; also Latour 1993)

For our purposes, what is most germane about these sort of counter- or post-ocularphobic arguments is that they raise the possibility of a more relational or *dialogical* theory of vision. Which brings me to the central argument of this chapter: that we can locate the rudiments of such a dialogical account of sight most fruitfully in the work of Maurice Merleau-Ponty. The sort of questions to be pursued here include the following: does Merleau-Ponty provide us with some of the conceptual tools to avoid visual essentialism, but without falling prey to the errors of cultural reductionism? Are there aspects of visual experience that are not determined completely by discursive factors, and that suture bodies, natural processes and sociocultural factors together into complex, hybridized, multilayered wholes favoured by Latour et al.? Should we be 'suspicious', as it were, of the supposition that the hermeneutics of suspicion must always, and everywhere, 'go all the way down', analogous to the manner in which culture is treated in the theoretical narratives Jay calls to account? And, aligned closely with the latter, can there be a specifically *dialogical* mode of seeing that does not isolate the visual or insert the subject into a prevailing system of power and domination, but carries with it instead the possibility of an ethically charged moment of mutual recognition that is at least potentially enriching for all participants?

THE 'PHILOSOPHY OF REFLECTION' AND ITS DISCONTENTS

By way of addressing these sorts of queries, I will attempt to sketch out the basic elements of a dialogical theory of vision through an examination of Merleau-Ponty's writings of the late 1950s and early 1960s, especially his final, unfinished text *The Visible and the Invisible* (1968). Despite shifts in thinking over the course of his career, Merleau-Ponty's chief adversary was remarkably consistent. He referred to it variously

as 'high-altitude thinking', Cartesian dualism and objectivism—or, perhaps most commonly, the 'philosophy of reflection'. What he meant by such appellations was the position, so well-entrenched in Western thought, that the production of knowledge involved a solitary subject gazing on an external world of discrete things or 'facts', which are then reflected or 'possessed' in thought by a sovereign act of cognition. In so doing, we understand the world as externalized projections of our own ideations. Our capacity for abstract, rational thought is, in this schema, considered to be the 'highest' and most admirable human faculty, one that is facilitated by the 'noblest' of the senses: namely, sight. What the philosophy of reflection strives for is a kind of magical transcription: to substitute a rigorous and irrefutable system of crystalline logic and conceptual rigour for a 'messy', inconstant and ambiguous reality, to 'take out an insurance against doubt', as Merleau-Ponty puts it, although he is quick to add that the premiums that must be paid to secure such a clarity 'are more onerous than the loss for which it is to indemnify us' (1968: 36).

For Merleau-Ponty, the translation of the world into an algorithm is a move fraught with immense repercussions. In the philosophy of reflection, the subject that grasps the world in a solely cognitive manner, so as to generate timeless and universal truths, is effectively a disembodied entity, a 'pure' observer with no real or constitutive connection to the world around him. The egological self 'makes itself "indifferent", pure "knower", in order to grasp all things without remainder—to spread all things out before itself—and to "objectify" and gain intellectual possession of them'. The world lies prostrate before this omniscient subject's purview, like captured booty and slaves paraded before an victorious warrior-potentate. Nothing is hidden from its gaze: 'He [*sic*, and *passim*] always was, he is everywhere, he is king on his desert island' (Merleau-Ponty 1964b: 162, 14). The external world *in toto* presents itself as a collection of inert facts that is wholly Other, completely exoteric vis-à-vis my existence—and indeed, it represents a distinct *threat* to my self, unless I can master it and transform it into something that I can use. Consequently, we are encouraged to relate to others and to the world in an *instrumental* fashion: the world becomes a kind of blank screen upon which the interests and desires of the egological, transcendental self are projected. The logical *terminus* of such an attitude is the rapaciously domineering project of modern scientific rationalism and the cult of high technology that accompanies it.

Yet, Merleau-Ponty suggests (if somewhat optimistically) that 'the philosophy of God-like survey was only an episode' (1964b: 14). In the wake of its hoped-for demise, he strives to jettison the epistemological fetish of modern Western thought, which relies on a peculiarly atrophied and fetishized notion of vision, in order to make the passage back to what he terms an 'intra-ontology'. In so doing, we do not strive to possess and dominate the world through the exercise of abstract Reason, but rather attempt to 'understand from within' our embodiment *in* and *of* the world, so as to foster 'communication with a way of being' (Merleau-Ponty 1974: 168). Merleau-Ponty's work of the 1940s, especially his monumental study *The Phenomenology of Perception*, was intended to inaugurate this move towards such a 'philosophy of the concrete', and to offer a decisive challenge to the logic and methods of high-altitude reasoning. In pursuing such

a strategy, he was not suggesting that all the achievements of Western science, philosophy and aesthetics were wholly illusory. However, he did want to say that the philosophy of reflection offered us only a narrow and often destructive template for thinking and acting, especially because it failed to realize that the ultimate well-spring of genuine understanding lay in grasping the world of 'raw', prereflective experience and primordial sociality, in the context of what Husserl designated as the *Lebenswelt*, or lifeworld. The phenomenological method that Merleau-Ponty envisaged as a replacement for the paradigm of reflection is a 'search for a philosophy which shall be a "rigorous science", but [that] also offers an account of time, space, and the world as we "live" them' (1962: vii). The false clarity engendered by objectivist epistemologies must be countered by a phenomenology of the body that emphasizes our somatic 'openness' on to the lived environment. We must, in short, 'plunge into the world instead of surveying it, it must descend toward it such as it is instead of working its way back up toward a prior possibility of thinking it—which would impose upon the world in advance the conditions for our control over it' (Merleau-Ponty 1968: 38–9).

Thus far in my account, it might seem that Merleau-Ponty is participating fully in the critique of ocularcentrism sketched out above. It is certainly true that he set out to challenge a particular manifestation of 'specular consciousness', which supposes that vision is a pure and 'ubiquitous' presence that captures and objectifies the entire world at a glance. This is the seeing of the absolute spectator, an 'eagle-eye view' in which 'there can be no encounter with another: for [this] look dominates; it can dominate only things, and if it falls upon men it transforms them into puppets which move only by strings'. If we espouse a philosophy of pure vision and abstract reflection, then the relation between self and other can only be one of contestation, a struggle for supremacy, whereby the 'other can enter into the universe of the seer only by assault, as a pain and a catastrophe' (Merleau-Ponty 1968: 77–8). However, his approach departs, albeit subtly at times, from the central axioms of the ocularphobic theories of Bataille, Foucault and others, mainly because his phenomenology of embodied perception opens up the distinct possibility of what Jay (1993a: 169) calls 'dialogic specularity'. In such an account, the look of the Other, Sartre's *l'regard*, is not out of necessity an act of entrapment or containment, but can be an invitation to reciprocal exchange, an inherently ethical attunement and receptiveness to others that encourages a radical questioning of the egological self.

VISION, REVERSIBILITY AND 'PERSPECTIVALISM'

To understand more fully the dialogical properties and potentialities of vision, however, it is necessary to take a closer look at Merleau-Ponty's attempt to rethink the nature of the human perceptual apparatus and how it manifests itself in the world. In developing alternatives to 'high-altitude thinking', Merleau-Ponty argues that what we require is an intensified awareness of our carnality, our situatedness in actual time and space, and our introjection into the material and sociocultural worlds. For it is only through our bodily connection to the world and to others that we construct a meaningful whole, a *gestalt*, out of our lived experience. This is a theme he pursued in many of his investigations; for

instance as he put it in *The Primacy of Perception*, 'the body is much more than an instrument or means; it is our expression in the world, the visible form of our intentions' (1964a: 5). However, it is in *The Visible and the Invisible* that Merleau-Ponty effects his most decisive break from the phenomenology of consciousness, inherited from Brentano and Husserl, that arguably hobbled his earlier work (see Dillon 1988: 85). At this late stage in his career, Merleau-Ponty's thinking is grounded more thoroughly in process philosophy, and he proffers an image of the world that is always in a state of Heraclitean change and flux, birth and death, transformation and 'becoming'—but in a utterly unpredetermined manner, lacking any sort of overarching Hegelian *telos* or dialectically driven necessity (see Gardiner 2000). The lived world, unlike the idealized world postulated in egological philosophies, is 'unfinished', pregnant, fecund, literally erupting with new life and novel potentialities. Moreover, this insight equally applies to us: 'the perceiving subject undergoes continued birth; at each instant it is something new. Every incarnated subject is like an open notebook in which we do not yet know what will be written' (Merleau-Ponty 1964a: 6). Because the world is a living and constantly developing whole, and hence inherently responsive and interactive, our 'Being-in-the-world' is, to Merleau-Ponty's way of thinking, constitutively interrogative or dialogical in nature.

It is also important to note, following Merleau-Ponty, that vision in inescapably 'synaesthetic'—that is to say, 'always-already' entangled with other sensory modalities, the social world of interacting bodies, communicative impulses (especially language) and natural events and processes. The incarnate subject partakes of the overarching 'becoming' of the world because it is radically intertwined rather than separate from it, as the dominant modes of Western philosophy have always maintained: '*we are* at the junction of Nature, body, soul, and philosophical consciousness' (Merleau-Ponty 1964b: 177). There can be no hierarchy of sense domains; to isolate vision and treat it as the 'highest' or 'noblest' sense implies precisely that. Through the apertures of our perceptual apparatus we open on to the widest possible range of sensations, sights, sounds and smells—but this sensory system is also the avenue through which the world simultaneously enters into our body in transverse fashion. Inasmuch as 'the world is made of the same stuff as our body' (1964a: 163), we are part of the 'flesh of the world', to evoke one of Merleau-Ponty's most provocative metaphors. He intends this to be much more than a useful analogy: it is a genuinely novel way to (re-)conceptualize our lived embodiment, our reciprocal connection to the natural world and other selves through the vehicle of the human sensorium. This flesh is a '*general thing*, midway between the spatio-temporal individual and the thing … a sort of incarnate principle … an "element" of Being'. It constitutes the inescapable horizon of our existence: a milieu that envelops us and sustains us, much as aquatic life is surrounded by and lives within the medium of water. My body, he writes, is 'shared by the world, the world *reflects* it, encroaches upon it and it encroaches upon the world … they are in a relation of transgression or of overlapping' (1968: 139, 248).

World and body overlap in a most peculiar way, however. Again, I do not surveil the world around me from an Olympian height through vision alone, and passively register in my consciousness the colours, shapes and sounds of this world, like images

formed automatically on a photographic plate when it is momentarily exposed to light. My body, my senses reach out to the world, respond to it, actively engage with it, shape and configure it—just as the world, at the same time, reaches into the depths of my sensory being. Merleau-Ponty implores us to cultivate a sharper awareness of the 'perceptible world's explosion within us' (1964a: 20). Hence, the human perceptual system is not a quasi-mechanical apparatus that exists only to facilitate representational thinking, to produce reified 'concepts' and 'ideas' that mimetically copy inert things and objects in the world; it is, in a very real and profound sense, enmeshed with the world itself. Furthermore, my bodily and perceptual introjection into the world makes possible a *self-perception*, a mode of reflexivity that is not merely cognitive but corporeal, what Merleau-Ponty refers to as *reversibility*. As I view and experience the world around me, I am simultaneously an entity in the world: the seer is also the seen, I can touch myself touching, hear myself speaking and so forth. Seen, heard and touched by myself, certainly; but also by other subjects, and by the world in general, a 'universal Being' that is simultaneously active and passive, proactive and reactive, and that ruptures the imaginary boundaries separating the egological subject from the world:

> [When] I touch myself touching … my body accomplishes 'a sort of reflection'. In it, through it, there is not just the unidirectional relationship of the one who perceives to what he perceives. The relationship is reversed, the touched hand becomes the touching hand, and I am obliged to say that the sense of touch here is diffused into the body—that the body is a 'perceiving thing', a 'subject-object'. (Merleau-Ponty 1964b: 166–7)

If such an account is accurate, suggests Merleau-Ponty, we are compelled to engage in an 'ontological rehabilitation of the sensible'. But the world is not experienced by me alone, even if in an reversible or reciprocal manner, and therefore any such attempt at rehabilitation must also address what he terms the 'problem of other people' (1982–1983: 34). (As it is not a 'problem' in the Sartrean sense, Merleau-Ponty's tone here is probably at least somewhat ironic.) The crux is that my point of view is not the only possible opening on to the flesh of the world, and hence we must supplement our perspective with a 'second openness'—that of other selves. However, to grasp the significance of this, we must backtrack a little. For Merleau-Ponty, the world is presented to me in a strangely 'deformed' manner—that is my perspective is always inflected by the precise situation I occupy at a particular point in time/space, the idiosyncrasies of my personal psychosocial development, relevant sociocultural factors and so forth. Insofar as I am 'thrown' into a universe lacking intrinsic significance—the world does not simply consist of self-evident 'things-in-themselves'—the existential task that confronts me is to make the world meaningful, to create, in architectonic terms, coherent patterns out of the chaotic rhythms, events and fluctuations of lived experience. 'The world', he says, 'is something to be constructed' (1982–1983: 39). But the accomplishment of this task is necessarily a limited, partial and perennially unfinished one. Reality, as it is available to a given body-subject, is therefore full of gaps and invisibilities, lacunae and

blind-spots; it is filtered through my concrete particularity, the precise aperture through which I open on to the world. Hence, to utilize Merleau-Ponty's terminology, the world is an admixture of immanence and transcendence. It is immanent because I am onto-logically part of the world that I inhabit, perceive and ultimately reflect upon. But it is simultaneously transcendent, because there is always an aspect of the world that escapes my sensory exploration of the world and *post-facto* cognition of it. There is a vast, invis-ible world that lies beyond my sensory and ideational grasp. The conclusion Merleau-Ponty draws from this is that no two individuals will experience the world in exactly the same way: I perceive and experience things in a manner that another cannot fully duplicate or re-experience, and the reverse is equally true. The following quotation from *The Primacy of Perception* expresses this point very well:

> [The] subject, which takes a point of view, is my body as the field of perception and action [*pratique*]—in so far as my gestures have a certain reach and circumscribe as my domain the whole group of objects familiar to me. Perception is here understood as a reference to a whole which can be grasped, in principle, only through certain of its parts or aspects. The perceived thing is not an ideal unity in the possession of the intellect, like a geometrical notion. (1964a: 16)

One might be tempted to think that Merleau-Ponty's position here merely recapitu-lates Nietzsche's famous argument regarding perspectivalism. But this would be a pre-mature conclusion. Although both thinkers are adamant that our access to the world is always mediated by our lived body, and that our situatedness in concrete time and space makes each of our perceptual openings on to the world singular and irreplaceable, the crux of Nietzsche's argument is that the world is qualitatively distinct for each observer, because it is determined solely by the interpretative strategies brought to bear on the world by each and every individual. In other words, Nietzsche's untrammelled individu-alism precludes him from accepting that there is a *common* world shared by a multiplic-ity of persons outside the perspective of any given subject-position. This is precisely the conclusion that Merleau-Ponty would want to avoid. While Nietzsche's 'Dionysian ma-terialism' (Sloterdijk 1989) is a definite improvement on Cartesian dualism, because it affirms the embodied character of the subject, in the final analysis it constitutes yet an-other version of dogmatic solipsism, and hence does not accomplish the decisive break from the long history of Western metaphysics of the sort Nietzsche himself envisaged. For Merleau-Ponty, the decisive issue is this: although the meaning of the world for each of us is constructed from the vantage-point of our embodied point of view, and hence irreducibly pluralistic, in an important sense we continue to inhabit the same world— that is we are *co-participants* in a universe that ultimately transcends any particularistic perspective (see McCreary 1995: 9; also Schenck 1985). As he puts it, the world can best be understood as 'a totality open to a horizon of an indefinite number of perspectival views which blend with one another according to a given style, which defines the ob-ject in question' (1964a: 16). This emphasis on 'blending' or inter-individual synthesis, this intertwining and overlapping of human bodies and sensoriums through which we

collectively participate in and create a shared sociocultural and physical environment, implies that the world has the ontological status of an 'in-itself-for-others', and not simply an 'in-itself-for-us'. Merleau-Ponty's desire to think through the many ramifications of the principle of a fully lived unity-in-diversity (as opposed to pure, abstract 'difference' as such), and to supersede the solipsistic tendencies of Western thought, is what marks his thought as distinctive and fundamentally at odds with those Postmodernist and Poststructuralist thinkers who find in Nietzsche a fundamental source of inspiration, no less than the debilitating nostrums of scientific positivism.

ALTERITY AND 'PRIMORDIAL BEING'

What the preceding discussion indicates is that I do, in actuality, have access to a world that others perceive and experience: '*What* I see is not mine in the sense of being a private world' (Merleau-Ponty 1968: 57). This is the central conundrum that he tries to think through in his late writings: that although my placement in the world is unique and not shared identically by another person, this is no absolute barrier to a reciprocal, mutually enriching relationship between self and other and the world at large. For him, the very presence of another self in my perceptual horizon forces me to reassess my relationship to the world, invites me to question the supposition that I alone have the capacity and the right to arrogate to myself a privileged access to Being, and to realize that the boundaries of my self are not rigid and sacrosanct. The very proximity of the other in my field of activity is akin to a calling, an invitation to co-participate in primordial Being and to short-circuit our egocentric insularity, inasmuch as the sensory extension of our bodily presence into the world intersects, cross-cuts, and is ensnared by the same objects and processes in the same world as other people. Merleau-Ponty believed firmly this is a summons that we can ignore only at our own peril:

> The gaze of the other men on the things is being which claims its due and which enjoins me to admit that my relationship with it passes through them. ... The other's gaze on the things is a second openness. ... I as it were do everything that depends on me in order that the world lived by me be open to participation by others ... since I put into the arena of the world my body, my representations, my very thoughts qua mine, and since everything that one calls me is in principle open to a foreign gaze, should it but be willing to appear. (1968: 58–9)

Because we are so habituated to thinking in accordance with the tenets of Cartesian dualism, it is difficult for us to grasp this crucial point: that we are in ourselves and in others and in the world simultaneously, and vice versa. This, for Merleau-Ponty, implies that such perceptual openings on to the world have multiple points of entry, 'effected at the crossing of avenues' (1968: 160), not a singular, monocular one. It is important to realize that this reciprocal and transgressive encounter between self, other and world does not 'annihilate' the self, or dissolve each of us into some kind of undifferentiated, homogeneous 'substance'. Rather, this transivity promotes a decentring, a heightened

awareness of the presence of the other in ourselves, and, *inter alia*, ourselves in others, an 'intercorporeality'. It is this eternal confrontation with a radical and irreducible otherness that allows us to surmount egocentricity, to escape the gravitational pull of solipsism: 'the experience of the other is necessarily an alienating one, in the sense that it tears me away from my lone self and instead creates a mixture of myself and the other' (Merleau-Ponty 1964a: 154–5). Or, as he puts it succinctly in *The Prose of the World*, 'Myself and the other are like two *nearly* concentric circles which can be distinguished only by a slight and mysterious slippage' (1973: 134). Again, our co-participation in the flesh of the world does not take place solely (or even primarily) at the level of abstract, reflective cognition—I cannot 'flatter myself' that I think the same thoughts as another, that I have some sort of privileged access into another's inner, psychic life, and the reverse is equally true. Rather, this common enfolding into the world's flesh is something that I sense or intuit at the level of 'wild being', whereby I come to realize that my perceptual opening on to the world has not only an inner, subjective dimension, but a visible 'exterior'. I cannot fully 'inhabit' another body, for this would only create another myself, a 'second dwelling for me', which is, needless say, impossible. The key lies in the 'inbetweenness' of the ontological linkage between self and other, an 'interhuman' realm where there is a perpetual exchange and reciprocity of perspectives, an endless, circular transcendence and returning to self, which always occurs on the border between two or more interacting subjects. 'It is in the very depths of myself that this strange articulation with the other is fashioned', writes Merleau-Ponty.

> The mystery of the other is nothing but the mystery of myself. A second spectator upon the world can be born from me. I make this possible myself if I take account at all of my own paradoxes. That which makes me unique, my fundamental capacity for self-feeling, tends paradoxically to diffuse itself. It is because I am a totality that I am capable of giving birth to another and of seeing myself limited by him. For the miracle of the perception of another lies first of all in that everything which qualifies as a being to my eyes does so only by coming, whether directly or not, within my range, by reckoning in my experience, entering my world. (1973: 135)

My embodied perceptions are therefore the means through which I gain entry to a world shared by other selves. The body-subject, as Merleau-Ponty puts it, is a 'vehicle of a relation to Being in which third parties, witnesses can intervene'. I enter into the totality of the world, its flesh, but only occupy a part of this totality, because my situation, my thoughts and my body are all delimited by time and space, by the physical arrangement of my perceptual apparatus, my subjective idiosyncrasies and so forth. The arrogance of the philosophy of reflection lies in its tacit refusal of the right of others to gain access to this universal, primordial Being, and to suppose that a monocular, God's-eye view on the world is infinitely superior and preferable to a multiplicity of overlapping perspectives. Such a stance cannot 'comprehend how a constitutive consciousness can pose another that would be its equal, and hence also constitutive' (Merleau-Ponty 1968: 62). What must be affirmed strenuously is that the world is not

merely an object-world; it is a domain filled with other subjects, each with his or her own unique experiences, perspectives and life-projects. Modern Western societies have been marked by a desperate and ultimately self-defeating desire to insulate themselves from the world that surrounds us, except through our capacity for abstract cognition and instrumental control. We refuse to answer the invitation to open ourselves to primordial Being, to plunge into its rich, complex and ambiguous depths, and respond to its solicitation with our body and soul. Yet, Merleau-Ponty reminds us, there are always moments when our connection to the flesh of the world is revealed starkly to us, which might conceivably jolt us out of our inward-looking complacency, force us to confront the inherently ethical responsiveness of the human condition, and envisage the possibility of an entirely different way of relating to the world and to other selves. We can come to the realization that the other is not an object, nor another 'me', an extension of my own consciousness, but rather another body-subject with equal rights to myself with respect to the constitution of the world and the creation of existential meaning. This is because, ultimately, the 'other is born *from my side*, by a sort of propagation by cuttings or by subdivision, as the first other, says Genesis, was made from a part of Adam's body' (Merleau-Ponty 1968: 58–9). Since the mind is incarnate, and all human beings co-participate in the material world, the 'problem of other selves' ceases to be the conundrum that has bedevilled philosophers for centuries.

> It is … indeed true that the 'private worlds' communicate, that each of them is given to its incumbent as a variant of one common world. The communication makes us the witnesses of one sole world, as the synergy of our eyes suspends them on one unique thing … And it is this unjustifiable certitude of a sensible world common to us that is the seat of truth within. (Merleau Ponty 1968: 11)

The cultivation of openness to a shared, primordial Being requires that we partially transcend our egocentric situation, to live in the interstices between self, other and world, including that of the inorganic—or, as Merleau-Ponty puts it, on the 'margin of non-being' (1968: 74). Again, however, the operative notion here is 'partial' transcendence: there is no question of a complete *fusion* or identity between self and other, regardless of the fact that we co-participate in the same world. 'We should', writes Merleau-Ponty, 'return to this idea of proximity through distance, of intuition as auscultation or palpation in depth, of a view which is a view of self, a torsion of self upon self, and which calls "coincidence" in question' (1968: 128). The dialogical relation between self and other is a synthesis, albeit a tensile one, of communion and distance. Our respective viewpoints descend on the same world, it is true, but always from dissimilar angles. There is no possibility of abandoning arbitrarily my embodied location in concrete time/space through an act of sovereign will; the body-subject and its environs constitute the inescapable horizon of my life. My vision is inscribed in the world, and the world upon my vision; the perceiver is not alienated from the world he or she gazes upon. However, the vision of the other does not necessarily threaten this reversibility; on the contrary, it complements it, 'doubles' my vision by supplementing it with another perspective, a

'second openness'. The cross-cutting and overlapping gazes that emanate simultaneously from self and other 'announce an open and indefinite series of complementary perceptions which we would be able to fulfill if we were to change our vantage point. Perception is the synthesis of all the possible perceptions', writes Merleau-Ponty (1982–1983: 36–7). The other is my mirror, as I am of them; the images are reversible, and they are not two distinct images, but rather 'one sole image in which we are both involved'. The other sees what is invisible to me, things that I can never witness directly, but the reverse is also true—and therefore our respective gazes are not necessarily antagonistic but at least potentially complementary. They overlap, intertwine and together give each of us a more complete opening on to the world: 'Since the total visible is always behind, or after, or between the aspects we see of it, there is access to it only through an experience which, like it, is wholly outside of itself' (Merleau-Ponty 1968: 82, 136). As an aside, it might be asked legitimately at this stage whether Merleau-Ponty breaks as decisively with Cartesianism's subject-object ontology and the 'philosophy of reflection' that underpins it as he might have liked. After all, much of the preceding discussion still relies on the conventional metaphorics of reflection, the 'mirror' and so forth. The lived body certainly mediates between subject and object, but perhaps does not dissolve them entirely. This is a complex issue that cannot be resolved here. Suffice to say that although he may not have articulated a full-blown 'post-Cartesian' paradigm (although in fairness it should be noted that *The Visible and the Invisible* was, after all, an unfinished work), Merleau-Ponty was certainly acutely aware of the issue, and my sense is that he identifies so forcefully the crucial issues at hand, and assembles so many of the key conceptual building-blocks, that his work lies on the cusp of such a transition—and, indeed, is difficult to imagine without. This conceptual exploration is witnessed most directly in such characteristically Merleau-Pontyian notions as 'intertwining', 'chiasm', 'reversibility' and, most provocatively, the 'flesh of the world'. All such tropes and metaphors point to a posthumanism, or at least a 'relational' humanism, in which self, other and world are conceived of as overlapping parts of a complexly differentiated and meaningfully patterned whole that Merleau-Ponty labels the 'Gestalt'.

In any event, Merleau-Ponty's conclusion after reviewing the nature of alterity is that we *need* the other, in a profoundly ontological and ethical sense, to be able to answer the solicitation of the world, to imagine ourselves as coherent and meaningful entities capable of responsible actions, and to be able to gain access to primordial Being. As he bluntly puts it: I 'borrow myself from others' (1964b: 159). This is a debt that we must continually repay. Without access to the other's point of view, we remain 'flat', one-dimensional creatures lacking depth, more object than active subject. Yet again, there is no overarching fusion, no finalizing synthesis or coincidence between self and other in such encounters; there can be no 'arbitrary intrusion of a miraculous power transporting me into the space of another person' (Merleau-Ponty 1982–1983: 44). Difference in alterity is preserved in this schema, but otherness is not an inherently hostile or incomprehensible force, as such Poststructuralist thinkers as Derrida, Foucault or Lyotard tend to suggest (see Gardiner 1996; Kearney 1993). Again, the body-subject has a 'double reference': it is a thing in the world yet simultaneously what sees and touches this thing.

I cannot literally see behind my back; but it is 'seen' nonetheless, by the generalized vision of Being that is part of the sensible world. Accordingly, our own being is 'a means to participate in the other, because each of the two beings is an archetype for the other because the body belongs to the order of the things as the world is universal flesh'. It is only in encountering another self that I have access to an external viewpoint, and can visualize myself as a meaningful whole, as a *gestalt*: 'for the first time I appear to myself completely turned inside out under my own eyes' (Merleau-Ponty 1968: 137, 143).

The upshot is that reversibility, visual or otherwise, is never realized in some sort of totalizing or all-encompassing way for Merleau-Ponty. As expressed earlier, self and other form concentric circles that *nearly* overlap, but can never completely usurp each other's situated existence. Although intercorporeality facilitates a communicative transivity between myself, another and the world, there is no possibility of an absolute transcendence from my own unique embeddedness in concrete space/time. On the contrary: dialogue (in all of its manifestations) presupposes a radical difference between interlocutors, because there would be no point in communicating at all if myself and another were not uniquely embodied and located in the world, each with divergent but overlapping experiences, perspectives and so on. There would nothing of value to exchange, no possibility of a communicative reversal of perspectives, without difference. 'We will arrive at the universal not by abandoning our particularity but by turning it into a way of reaching others, by virtue of that mysterious affinity which makes situations mutually understandable', as Merleau-Ponty puts it. 'It is our very difference, the uniqueness of our experience, that attests to our strange ability to enter into another' (1974: 168). As such, there is always exchange, transversal contact and reciprocity between different body-subjects as they interrelate. In Merleau-Ponty's opinion, an enhanced awareness of this primordial connectivity, or 'hinge', signals the emergence of a new, post-Cartesian form of being, one marked by 'porosity, pregnancy, or generality [...] before whom the horizon opens is caught up, included within it. His body and the distances participate in one same corporeity or visibility in general, which reigns between them and it, and even beyond the horizon, beneath his skin, unto the depths of being' (1968: 149).

CONCLUSION

By way of conclusion, I'll return briefly to Martin Jay's critique of cultural reductionism. Again, his key point is that the object or image is never fully reducible to the discursive, because any visual experience is always synergetically and simultaneously materially embodied, symbolic and natural. Indeed, there seem to be certain images or visual modalities that are able to cross cultural barriers with relative ease, which indicates that however much images 'are filtered through such a [discursive] screen, however much they are connotatively deflected by the magnetic field of culture, they remain in excess of it' (Jay 2002: 275). The world-wide visceral reaction to the now infamous Abu Graib photographs might be such an example of such a excess or surplus, one that taps into a specularity that generates identification and empathy in part because it is dialogical, taking the interrogative form of 'question and response' (Merleau-Ponty 1968: 131), rather

than a distanciated, quasi-pornographic titillation and seduction of the sort Jameson and others have fixated on. But such a surplus, as I have taken pains to argue here, does not have to negate difference or erase the situated particularity of individual and group experiences. Insofar as any properly dialogical account of specularity must vouchsafe 'unity-in-diversity' for Merleau-Ponty, it echoes Agnes Heller's concept of 'radical tolerance', whereby we open ourselves up to the possibility of self-transformation through contact with the other, and vice versa, rather than simply 'put up' with difference, as liberal forms of tolerance are prone to do (Heller 1987). Expressed differently, the recognition of otherness does not inevitably entail subjection (see Melville 1996), but can be an invitation, however hesitant, contingent and open-ended, to collaborate on exploring the rich possibilities of 'wild being'. As Merleau-Ponty himself noted in a radio address to the French nation in 1949, shortly after the horrors of the Second World War, the ethical and ontological onus always remains on us to seek out and cultivate 'those rare and precious moments at which human beings come to recognize, to find, one another' (2004: 90).

In *The Visible and the Invisible* and related works, we are sensitized to certain commonalities of vision that enfold all of us into the world's flesh, and provides the semblance of a shared experiential ground that connects, rather than divides, by virtue of our being humanly embodied entities. Nonhuman species, with their differently organized sensoriums and cognitive capacities, have primordial relations to the world that undoubtedly depart significantly from ours—although not in utterly incommensurate ways, Merleau-Ponty might be quick to add, inasmuch as the presence, experiences and activities of animals (and other organic forms) overlap with our own. Again, we are all part of the flesh of the world. In this sense, our perceptual apparatus is something of an a priori, the necessary means by which we gain access to, engage with, and come to understand our lived environment and other selves. Technological advances can extend or mediate our senses, but can never completely negate or supplant them. The instrumental rationality and 'high-altitude thinking' promoted by the central tendencies of modernity does bolster a rarified 'specular consciousness' that abstracts from and seeks to dominate the world. But this is not an essential feature of vision per se, and, as de Bolla reminds us, there are always multiple sensory regimes at play in any given historical period, and an enhanced awareness to this might well encourage what Helga Geyer-Ryan calls a 'theory of polyscopy' (1996: 123). In challenging the monocular, abstract and disengaged 'seeing' of Cartesian perspectivalism, Merleau-Ponty holds out the possibility of just such a 'polyscopic' perceptual system, one that teases out and encourages rather than suppresses the 'multiple, even contradictory potentials' of vision, evoking a 'plural metaphoricity that resists reduction to a univocal master trope' (Jay 1993a: 104, 511). Merleau-Ponty suggests that we can aspire to an embodied, intersubjective form of reason that engages all of the human senses, but without denigrating the visual register, in a manner that privileges an open, mutually enriching and ethically responsible relationship between self and other and between society and the natural world. This has profound implications for the study of visuality: amongst other things, it forces us to consider the relationally situated, ethical and embodied character of seeing; sensitizes us to the necessarily

mediational role of the human–nature connection in any visual experience (see Cataldi and Hamrick 2007); and, finally, prompts us to develop a much more nuanced and complex account of power and domination as it relates to scopic practices. The ultimate goal would be the full efflorescence of what Herbert Marcuse once called a 'new sensibility'; that is a perceptual and experiential regime that 'instead of being guided and permeated by the rationality of domination, would be guided by the imagination, mediating between rational faculties and the sensuous needs' (Marcuse 1969: 30).

FURTHER READING

Heywood, Ian and Barry Sandywell, eds. 1999. *Interpreting Visual Culture: Explorations in the Hermeneutics of the Visual*. London and New York: Routledge.

Jay, Martin. 1993. *Downcast Eyes: The Denigration of Vision in Twentieth-Century French Thought*. Berkeley: University of California Press.

Merleau-Ponty, Maurice. 1962. *The Phenomenology of Perception*. London and New York: Routledge and Kegan Paul.

Merleau-Ponty, Maurice. 1968. *The Visible and the Invisible*. Evanston, IL: Northwestern University Press.

REFERENCES

Bal, Mieke. 2003. 'Visual Essentialism and the Object of Visual Culture', *Journal of Visual Culture*, 2/1: 5–32.

Bolla, Peter de. 1996. 'The Visibility of Visuality', in Martin Jay and Teresa Brennan (eds), *Vision in Context: Historical and Contemporary Perspectives on Sight*. London and New York: Routledge, 65–79.

Cataldi, Suzanne L. and William S. Hamrick, eds. 2007. *Merleau-Ponty and Environmental Philosophy: Dwelling on the Landscapes of Thought*. Albany: State University of New York Press.

Dillon, M. C. 1988. *Merleau-Ponty's Ontology*. Bloomington: Indiana University Press.

Gardiner, Michael. 1996. 'Foucault, Ethics and Dialogue', *History of the Human Sciences*, 9/3: 27–46.

Gardiner, Michael. 1999. 'Bakhtin and the Metaphorics of Perception', in Ian Heywood and Barry Sandywell (eds), *Interpreting Visual Culture: Explorations in the Hermeneutics of the Visual*. London and New York: Routledge, 57–73.

Gardiner, Michael. 2000. ' "A Very Understandable Horror of Dialectics": Bakhtin and Marxist Phenomenology', in Craig Brandist and Galin Tihanov (eds), *Materialising Bakhtin: The Bakhtin Circle and Social Theory*. Basingstoke and New York: Macmillan and St. Martin's Press, 119–41.

Geyer-Ryan, Helga. 1996. 'Imaginary Identity: Space, Gender, Nation', in Martin Jay and Teresa Brennan (eds), *Vision in Context: Historical and Contemporary Perspectives on Sight*. London and New York: Routledge, 117–25.

Heller, Agnes. 1987. *Beyond Justice*. New York: Blackwell.

Jameson, Fredric. 1990. *Signatures of the Visible*. London and New York: Routledge.

Jay, Martin. 1993a. *Downcast Eyes: The Denigration of Vision in Twentieth-Century French Thought*. Berkeley: University of California Press.

Jay, Martin. 1993b. *Force Fields: Between Intellectual History and Cultural Critique*. New York and London: Routledge, 99–113.

Jay, Martin. 2002. 'Cultural Relativism and the Visual Turn', *Journal of Visual Culture*, 1/3: 267–78.

Kearney, Richard. 1993. 'Derrida and the Ethics of Dialogue', *Philosophy and Social Criticism*, 1/19: 1–14.

Latour, Bruno. 1993. *We Have Never Been Modern*. Cambridge, MA: Harvard University Press.

Marcuse, Herbert. 1969. *An Essay on Liberation*. Boston: Beacon Press.

McCreary, Mark. 1995. 'Merleau-Ponty and Nietzsche: Perspectivism in Perception', *Metaphysical Review*, 2/3: 1–11.

Melville, Stephen. 1996. 'Division of the Gaze, or, Remarks on the Color and Tenor of Contemporary "Theory" ', in Martin Jay and Teresa Brennan (eds), *Vision in Context: Historical and Contemporary Perspectives on Sight*. London and New York: Routledge, 101–16.

Merleau-Ponty, Maurice. 1962. *The Phenomenology of Perception*. London and New York: Routledge and Kegan Paul.

Merleau-Ponty, Maurice. 1964a. *The Primacy of Perception*. Evanston, IL: Northwestern University Press.

Merleau-Ponty, Maurice. 1964b. *Signs*. Evanston, IL: Northwestern University Press.

Merleau-Ponty, Maurice. 1968. *The Visible and the Invisible*. Evanston, IL: Northwestern University Press.

Merleau-Ponty, Maurice. 1970. *Themes from the Lectures at the College de France 1952–1960*. Evanston, IL: Northwestern University Press.

Merleau-Ponty, Maurice. 1973. *The Prose of the World*. Evanston, IL: Northwestern University Press.

Merleau-Ponty, Maurice. 1974. *Phenomenology, Language and Sociology: Selected Essays of Merleau-Ponty*. London: Heinemann.

Merleau-Ponty, Maurice. 1982–1983. 'The Experience of Others (1951–1952)', *Review of Existential Psychology and Psychiatry*, 28/1–3: 33–63.

Merleau-Ponty, Maurice. 2004. *The World of Perception*. London and New York: Routledge.

Schenck, David. 1985. 'Merleau-Ponty on Perspectivalism, with Reference to Nietzsche', *Philosophy and Phenomenological Research*, 46/2: 307–14.

Sloterdijk, Peter. 1989. *Thinker on Stage: Nietzsche's Materialism*. Minnesota: University of Minnesota Press.

Hermeneutical Aesthetics and an Ontogeny of the Visual

NICHOLAS DAVEY

INTRODUCTION: ON CLARITY AND DISTINCTIVENESS

Do we have a clear and distinct understanding of objects at the centre of attention within visual studies? Over the recent decade the academic expansion of visual studies has been extensive. Courses in design, film, visual culture, art history and aesthetics abound. Compared to forty years ago, awareness of the sheer variety of visual languages is now acute and sophisticated. The rapidity of this almost universal shift has led some to proclaim the demise of literary culture. More vocal, however, have been those who assert that it is both conceptually correct and culturally appropriate that the traditional studies of art history and fine art are subsumed within the more broadly envisioned disciplines associated with visual studies. The assertion has the useful consequence of demythologizing the status of the artwork stripping it for the most part of its association with elitist attitudes and educational privilege.

Despite notable detractors, such shifts in intellectual perspective have initiated major alterations in how aesthetics and its relation to the study of art is understood (Elkins 2007: 171–8). Discussions of the nature of taste and the character of beauty have been displaced in favour of debates devoted to the social construction of aesthetic attitudes and the cultural formation of art discourses. My own work in aesthetics has made its contribution. In the essay, 'The Hermeneutics of Seeing', I argued that hermeneutic aesthetics exemplifies how philosophical and existential determinants configure themselves in our perceptions of art (Davey 1999). What addresses us in art is not what *we* come to see but *what* shows itself to us. What displays itself is not reducible to subjectivity alone but depends upon historical and cultural forms (*Sachen*) which transcend the subjective and yet achieve personal perceptual instantiation within individual aesthetic experience (Davey 1999). Aesthetics understood within the framework of philosophical

hermeneutics is no isolated monologue on personal pleasure but a complex dialogical achievement involving the fusion of horizons surrounding the artist, the work, its subject-matter and its spectators (Davey 1999). Hermeneutical aesthetics presents the artwork as a dialogical space and sounds a critical note concerning the tendency of visual studies to reduce artworks to being mere objects of analysis, to signs and symptoms of the circumstances of their production. We will reflect on this criticism below.

Hermeneutical aesthetics shares with visual studies a decentring of traditional subjectivist aesthetics. It does so by reminding us that an artwork is in itself a dialogical response to a subject-matter and demands too that the spectator responds to its answering of that subject-matter. The spectator is reminded that an artwork can never exhaust its subject-matter and is thereby constantly exposed to possibilities of thinking and seeing other than those that he or she is accustomed to. Self-criticism and review of response is integral to a dialogical conception of the artwork. A clear strength of visual studies is that through its demystification of the artwork it both widens the participatory franchise of dialogical interaction with the artwork, and through its own analytical methods strives towards greater rational inclusivity and a wider consensus of judgemental norms.[1]

In summary, one of the most powerful reasons for supporting a more inclusive approach to the visual arts is that it escapes from the subject-based aesthetics of neo-Kantian thought that tended to privilege individual responses to the artwork. Hermeneutical aesthetics steers thought about art in another direction, emphasizing aesthetic experience as a space of dialogical interaction in which priority is given to the address of the artwork. Hermeneutical aesthetics achieves this by emphasizing the ontological basis of dialogical interaction. It is this turn to the ontological which causes problems for the methodological inclusivity of visual studies. The ontological basis of hermeneutical aesthetics poses a telling question to the broad aspiration of visual studies. Can the claim within critical visual discourse that designed objects *and* artworks should be treated in the same way be profitably sustained? Has the new discourse of visual studies overlooked significant differences of ontogenesis in the objects of its world? This chapter will argue that visual studies has neglected a fundamental distinction between the ontogenetic characteristics of the designed object and the artwork and that this failure not only threatens the variety of study within visual culture but also disrupts the possibility of radical critique within aesthetic experience. The implicit issues are weighty. Nicholas Mirzoeff argues that visual studies promotes the 'ability to become critical viewers' (cited in Dikovitskaya 2006: 89). Hans-Georg Gadamer is sanguine about the educative and political significance of teaching and research in the arts.

> We should have no illusions. Bureaucratized teaching and learning systems dominate the scene, but nevertheless it is everyone's task to find his free space. The task of our human life in general is to find free spaces and learn to move therein. In research this means finding the question, the genuine question. (Misgeld and Nicholson 1992: 59)

This chapter will contend that hermeneutical aesthetics is of strategic importance for bringing to light what is at stake within the study of visual culture. It offers a way of

understanding the social application of visualized meaning, of appreciating why subject-centred theories of the aesthetic cannot appropriately work in the case of what is delimited as visual culture and why critique, reflective space, hermeneutical movement and the visual are all interlocked in a mutually determining way. At the same time, hermeneutical aesthetics insists on making an important ontological distinction within visual discourse between a designed object and an artwork. This does not involve a retreat into either obscurantist or socially privileged accounts of art. To the contrary, hermeneutical aesthetics offers an important methodological qualification to modern visual studies which must be recognized if the latter are to remain true to their aspiration of widening the critical community within the visual arts. Having established the strategic ambition of this chapter, let us now turn to the pivotal questions of our debate.

1. Over-rigid conceptual boundaries can hinder fruitful interdisciplinary cooperation. An advantage of deploying philosophy in the realm of the visual arts is its ability to probe conservative assumptions about the nature of art. On the other hand, if conceptual borders become too porous, does such elasticity hinder the formation of identities, weaken the honing of clear distinctions and inhibit the very process of definition and clarification upon which provocative dialogue and exchange depend?

2. The development of visual studies over the last twenty years has challenged the relevance and tractability of Kantian and neo-Kantian aesthetics to contemporary visual culture. Contemporary theorists of visual culture have questioned the range and extent of art history arguing that the latter offers far too narrow a conception of what the discipline should include. Why are Porsche designs excluded from the history of sculptural art? Is not the silver tail fin of a Boeing 727 as aesthetically pleasing as the steely geometry of David Smith's sculptures? Why should the Mont Blanc pen, the Olivetti typewriter or the angle-poise lamp not be treated as art? The tolerant catholicism of visual studies promotes a ready interchangeability of aesthetic and design perspectives and, plausibly, since the aesthetic form of motorways, bridges, railway stations and building gantries celebrates the sheer visuality of both our environment and our existence in it. Has this new inclusiveness become too loose in conceptual terms? Can the composition of Turner's seascapes be negotiated hermeneutically in the same way as the Tizio angle-poise desk lamp? In Gadamer's terms, are the two objects equally *historically effective* in terms of their transformative educational and cultural power?

It would surely seem counterintuitive to object to a Turner canvass and an angle-poise lamp being treated differently but, as we shall see, our argument will take some surprising turns. There is much within hermeneutic analysis to suggest that a work of Turner and a designed object can indeed be treated in the same way aesthetically. In terms of symbolic function, both objects render inwardly visible to aesthetic reflection the cultural horizons that nurture them. This, however, makes our principal question even more urgent and, indeed, generates a second important issue. Can the Turner painting

and the Tizio lamp actually be treated as visual objects of comparable cultural and edu-
cative value? If not, is there an articulable and defensible distinction between them that
does not fall back on to customary bourgeois characterizations of fine art objects? The
second issue is whether there is a serious misconception within any equalization of the
artwork and the designed object. Does the fact that the angle-poise lamp can be analy-
sed hermenetically in exactly the same way as can a Turner canvass render the lamp an
artwork? There is a tendency in recent cultural theory that reaches back to Nietzsche
which supposes that discourses are power practises: the mode of analytic predetermines
the mode of the analysed. Visual studies has good methodological reasons to dissolve the
distinction between the designed object and the artwork but does this suffice to dissolve
the distinction? The reasons against such dissolution are offered below.

We shall argue that the tolerant inclusiveness of visual studies overlooks a key on-
tological difference concerning the specificity of the designed object and the artwork.
Conflating the two as beings of equal value in a unifying methodological field has two
negative consequences. (1) The equalization ignores a central claim of philosophical
hermeneutics that an artwork is a participatory event and not an object for detached
methodological analysis. Visual studies threatens an injustice to the speculative charge
of the artwork. (2) The methodological equalization obscures what, arguably, is of value
i.e. an understanding of how the designed object and the artwork are complementa-
ries. Understanding the extent to which a designed object is not an artwork and vice
versa does not re-establish arcane exclusionary distinctions between artworks and other
visual phenomena but allows for the articulation of a difference which enriches the vi-
sual world and its philosophical and cultural significance. This will demand, unavoid-
ably, a reflection on the most canonical question in hermeneutical aesthetics: *what is
an artwork*?

Questioning the range and extent of traditional art history and aesthetics leads to
our central question: 'Did John the Baptist wear camouflage?' If visual studies has the
elastic conceptual tolerance claimed for it, it is not absurd to ask whether the arts of
camouflage can be considered as a distinct visual regime as aesthetically potent as the
arts pictorial presentation. The question is intentionally mischievous but philosophical
and intellectual probity require that it be asked, not least to the end of seeking to ar-
ticulate a strategic differentiation between the designed object and the artwork which
if successfully made will enrich an understanding of the visual world. However, let us
first contextualize the methodological issues which govern the framing of our central
question.

THE REVOLUTIONARY ROAD

My earlier essay 'The Hermeneutics of Seeing' formed part of a collection which under
the guiding eyes of Ian Heywood and Barry Sandywell made a notable contribution to
the evolution of what has now become known as the discipline of visual culture. Mar-
garet Dikovitskaya in her book *Visual Culture: The Study of the Visual after the Cultural
Turn*, a historical review of the research field, comments that 'Heywood's and Sandywell's

book makes a genuine effort to move away from (the) … staple feature of the literature presenting visual culture'. It is not a series of negations of traditional art history, sociology and so on. *Interpreting Visual Culture* is a success because it makes an attempt to ground the new field by showing the persistent philosophical interest in the visual throughout history (Dikovitskaya 2006: 29). She argues that 'the cultural turn brought to the study of images is a reflection on the complex interrelations between power and knowledge. Representation began to be studied as a structure and process of ideology that produced subject positions' (Dikovitskaya 2006: 28). Thus, the scholarship that rejects the primacy of art in relation to other discursive practices and yet focuses on the sensuous and semiotic peculiarity of the visual can (seemingly) no longer be called art history. Visual studies, Dikovitskaya argues, questions the role of all images in culture. It suspends reverence for masterpieces and deals with the analysis of images as the organizational vehicles of different visual regimes. This, it must be noted, is a distinctly analytic move: the object of the enquiry is treated as a semiotic element within larger social functions. The image is no longer an object of taste or discernment but an ideological product in need of deconstruction. Visual studies necessarily involves a critique of the humanities though Dikovitskaya too readily judges them as zones of uncritical institutionalized privilege, of elite if not *effete* views of art and literature. Dikovitskaya claims that visual studies has not so much replaced art history or aesthetics as supplemented and problematized them by exposing their axioms and ideological presuppositions.[2] Instead of creating grand narratives, visual studies is charged with generating situated and partial accounts of the art historical past in which subjectivity is not hidden and authors no longer evince a Baumgarten-like disinterest (Dikovitskaya 2006). The educational importance of this shift is well noted.

An eloquent case for expanding conventional art history into the broader pedagogical remit of visual studies is put forth by Nicholas Mirzoeff whose work explores the role of the visual image in fine art, advertising, television, writing and film. Deploying specific art historical examples, he introduces students to the practices of reading visual images in the everyday seeking to train students to acquire the 'ability to become critical viewers'.

> Given that our culture is now so intensely visualised, if students don't get this ability from universities then they're going to regard universities as not providing them with the tools they need. (cited in Dikovitskaya 2006: 89)

The levelling of the elitist and canonical prejudices of fine art, traditional aesthetics and art history is in many respects commendable. A certain educational inclusivity is achieved. Permitting the boundaries of art history a greater porosity allows a wider range of visual phenomena to become legitimate objects of study. The subject-centred tradition of aesthetic preference is by-passed allowing images to be analysed not in terms of their capacity to induce individual responses but with regard to their objective status as signifying elements within socially constructed visual discourses. Individual powers of subjective discernment are displaced by a universal instrumentality of analytic method

which locates the effectiveness of a work not in the consciousness of the spectator but in the cultural structure out of which it operates. However, the logic of such inclusiveness forces the return of our defining question: 'Did John the Baptist wear Camouflage?' Do the visual attributes of this biblical figure's iconography have the same pedagogic status as the elements of camouflage? For those who oppose the assimilation of fine art by visual studies, the considerations will initially prove disarming.

SMOKE GETS IN YOUR EYES

'Camouflage' is a term which emerged during the First World War and denotes the disguising of military equipment and personnel with painted patterns and patterned clothing so as to either make them indistinguishable from their surroundings or, as in the use of visually disruptive patterns, to confuse an opponent as to the size and character of the deployments under observation. The word derives from the French verb *camoufler* meaning to disguise, to deceive or to confuse by using such theatrical effects as blowing smoke into the eyes of the spectator. Such principles of deception operate similarly in nature where fauna disguise themselves to hide, hunt and hound. Nevertheless medieval and renaissance depictions of John the Baptist as a wild man of the desert, naked but for a sheep skin, have no associations with wolves hunting in sheep's clothing. His sparse attributes are a prescient symbol of Christian discipleship and the future coming of *agnus dei*. Whereas camouflage clothing has the purpose of rendering its wearer either indistinct or less distinct within her surroundings, the function of John the Baptist's sartorial wooliness is not to hide but to reveal precisely who he is. The task of one is to dissemble, the purpose of the other is to announce.

Art is indissociable from the production of appearances. Plato may have fretted over the ability of art (poetry) to convince us that the objects of its representation are convincingly real but military defenders know that life can depend on the success of such deceptions. Decoy military installations must be convincing in their deception in order to be effective. The Luftwaffe once complimented a not-so-successful Allied decoy depot in North Africa by dropping a wooden bomb on it. The practices of camouflage reveal something here about the disciplines of visual representation. Both the artist and military engineer require the imaginative capacity to mentally construct what they anticipate the visual expectations of their respective opponents to be. The evolution of camouflage practices is inseparable from the development of visual technologies deployed by the opposing observers. 'Hiders' must anticipate what, where and how 'seekers' look. 'Hiders' need to imagine how a disguised object might appear within the parameters of an observing visual regime.[3] Much First World War military equipment was painted in startling colours and violently angular patterns. When photographed from a distance, however, the patterns when duplicated in black and white became surprisingly less distinct. The stark patterns appealed to the modernist sensibilities of such artists as Franz Marc, Marcel Bain, Paul Nash, Georges Braque. Timothy Newark notes how Roland Penrose, artist and *camoufleur* of the Second World War, recounted a conversation between Pablo Picasso and Jean Cocteau over camouflage in the Great War.

'If they want to make an army invisible at a distance', said Picasso, 'they have only to dress their men as harlequins'. Penrose understood immediately what Picasso meant by this seemingly ridiculous idea. 'Harlequin, Cubism and military camouflage had joined hands,' Penrose concluded. 'The point they had in common was the disruption of their exterior form in a desire to change their too easily recognised identity.' (Newark 2007: 72)

A sign of painterly maturity lies in the skill of anticipating how a work will 'look' in the eye of its beholders. Just as painters acquire a practical knowledge of how assemblages of pigment and various brush strokes configure themselves as flower petals in the eye of the beholder from a certain distance, so Frans Marc, the Blaue Reiter painter and First World War military *camoufleur*, remarked,

> The business has a totally practical purpose ... to hide artillery emplacements from airborne spotters and photography by covering them with tarpaulins painted in roughly pointillist designs in the manner of bright natural camouflage. The distances one has to reckon with are enormous—from an average height of 2000 metres—your enemy aircraft never flies much lower than that ... I am curious what effect the Kandinskys will have at 2000 metres. (Newark 2007: 68)

During the Second World War, Roland Penrose brought a painter's understanding of surface and texture to the discipline of camouflage.

> In order to obtain concealment ... it would appear at first sight that resemblance in colour is the most important factor. Actually this is not the case ... a smooth surface reflects more light than a rough surface. In consequence, supposing we have a smooth board and a rough piece of bath towel, both painted with exactly the same colour, the smooth board will inevitably look light in tone. (Newark 2007: 92)

Penrose understood that it was more important to match the texture of the background than its colour (Newark 2007: 92). Thus, paradoxically, when seen against contrasting backgrounds, many aircraft camouflage patterns actually confirmed the type and provenance of the aeroplane. Penrose, himself a surrealist artist though less well known than his partner, the photographer Lee Miller, understood the inverted principle well. The disruptive pattern painted on his wartime car made it as distinctive and conspicuous a vehicle parked on a London street as any Rolls Royce (Newark 2007: 92).

If art works upon what Nietzsche describes as a science of effects, then a grasp of the arts of camouflage is as central to the achieving of convincing effects in painting as an understanding of painting is to the ability of camouflage artists to produce effective deceptions (Nietzsche 1986: 145–6). Considerations from Heidegger's later aesthetics make this parallelism even more convincing: part of the function of the artwork for Heidegger is, indeed, to withhold something from the viewer. Furthermore, from Gadamer's perspective the shock of an artistic revelation is of the same order as the dismay

caused by the revelation that camouflage has successfully deceived us. It is curious that he actually speaks of aesthetic experience as an instance of becoming undeceived (Gadamer 1989: 356). In both instances, belief in our ability to judge what we have actually seen is seriously challenged. The effects of camouflage and pictorial art offer ethical caution against the rush to judgement. As Nietzsche remarks, it is not the senses that deceive us: 'it is what we make of their evidence that introduces the lie into it' (Nietzsche 1968: 36). There is, in summary, considerable merit to the suggestion that the study of camouflage and other visual regimes whether film or fashion should be considered as having equal merit with the study of painting. However, there is a philosophical objection to this equation and two other related concerns about the philosophical foundations of the methodological inclusiveness of visual studies that demand attention.

NOW YOU SEE IT, NOW YOU DON'T

It can be conceded that both the camouflaged surface and the painted canvass withhold something from view: the camouflaged surface intends to hide something and the painted canvass hides, metaphorically speaking, the full totality of its subject-matter. However, this is where the analogy fails. Whereas in the case of camouflage, what is hidden is completely inconsistent with what hides it (the self-propelled howitzer is in no sense comparable to the netted surface that disguises it as part of a hillside), what is withheld from view by the painted canvass must, when revealed, remain consistent with the visual logic of that canvass. Otto Dix's painting *Jüdenfriedhof in Randegg* (1935) announces itself superficially as a traditional landscape which would have conformed to the narrow nationalistic horizons of National Socialist aesthetics but it also utilizes another and not-so-hidden visual code which allows it to be read as a romantic allegory for rebirth, renewal and stoic German individualism (Löffler 1960: illus. 150). The visual logic of the hidden code must be consistent with that of the surface code or else the implicit meaning cannot announce itself from within the explicit meaning. This is to the advantage of the satirical or ironic artist. For the political censor to demonstrate that unpalatable meanings are 'within' the painting would be to concede that the explicit view of politically acceptable meaning actually contained unacceptable meanings. Ian Hamilton Finlay's image *Arcadia* exemplifies the need for a consistent visual logic to bind both the disclosed and the withheld meaning.

The camouflage pattern on the *Panzer* in Ian Hamilton Finlay's *Arcadia* (1973) is neither to hide the vehicle nor to visually confuse us about its presence: it serves as an attribute of origin revealing that this war machine also is a child of *arcadia*, an exile from a lost or broken order. The leaf pattern displayed on the vehicle is explicitly appropriate for an engine of war but is also implicitly to be read as a reference to the leaves of *arcadia*'s gardens. Hamilton Finlay's work relies on the logical compatibility of two visual regimes, one referring to the military and the other invoking paradise. The work of the military *camoufleur*, however, seeks to conceal the logical incompatibility of two visual regimes. Probing the question 'Did John the Baptist wear Camouflage?' may not lead to a substantive definition of what an artwork is, but it at least enables us to achieve a

better grasp of the different visual dynamics in the logics of disclosure and withholding operating in the visual world. In this respect, the disciplines of camouflage and painting may not be treated in the same way. They clearly do complement and inform one another in ways that support the claim for a greater academic inclusivity of content within the visual studies but logically they cannot be treated as the same.

CULTURAL ARCHETYPES

One of the strongest arguments in favour of dissolving the distinction between fine art and designed objects concerns the subsumption of the different modes of practice under the general term 'culture'. Alasdair MacIntyre and Hans-Georg Gadamer are philosophers who defend the view that human culture is constituted by a series of related practices (MacIntyre 1993: ch. 15; Gadamer 1989: 9–19, 81–8; see also Davey 2006: ch. 2). Practices very loosely defined as 'ways of doing things' generate their own historical narratives and criteria of excellence. An artistic community like an education community establishes through its own activity benchmark levels of what it regards as excellent performance. The pursuit of excellence is always controversial: it engenders a dynamic of expectation, criticism and aspiration. A practice will hold up certain ways of performing a task or producing a work as exemplary. The status of a canonical work is by no means arbitrarily established. A community of practitioners will develop through trial and error a sense of its best practice. Thinkers and artists will gravitate to such 'centres of learning' where the values of a practice are regarded as best as applied. As such practices establish themselves historically, certain of their creations achieve the status of masterpieces. Works become canonical because they come to be regarded by practitioners as almost defining the practices that produce them. It would, for example, be almost impossible to think of the history of Western drama without reference to Greek tragedy, to Shakespeare or indeed to Anton Chekov. Practices, like cultures, are self-forming historically constituted productive processes which understand and judge themselves according to their own creations. However, some would argue and with good reason, that there is a productive instability inherent in the pursuit of excellence. For a work to be judged as canonical, it has to be seen to fulfil much of what a practice community esteems as exemplary practice. This suggests that the community already has an ideal sense of a 'virtuous' practice. Goethe's quip that the work of genius is one which hits a target which no one knew was there does not contradict the point: the target has to have been implicitly recognized if it was known *post factum* to have been hit. The canonical work does not to have be judged 'ideal' or perfect in every respect. It may have recognized shortcomings. Not all of Shakespeare's plots are convincing, not all of Mozart's libretti are coherent. Excellence is divisive in that good practice within a discipline will be contested and, at the same time, it will also set a benchmark for future performance. The differential between ideal and questionable performance drives subsequent performance (Iser 2000: ch. 6). Each cultural practice will have its own self-generating *Bildungsformen*. In this respect, there is indeed little to distinguish between fine art and design history. This is where the subsumption is indeed at its strongest.

If poetry, philosophy and art have their canonical works, design practices too have their archetypes. In the 'Golden Age' of piston-driven aircraft, the Mitchell 'Spitfire' and the North American P51 Mustang became icons of excellence in aerial engineering. Both had the same Merlin engines and both came to serve as an icon for two nations. These aircraft did not so much emerge from aeronautical design history as redefined it until the appearance of the jet engine. Both aircraft became practice archetypes with technical parameters that subsequent designers found difficult to better. A change of parameter can, however, prove inspiring for other designers. A military example concerns the Mauser General Purpose Machine Gun (MG 34) or *Spandau*, which was built to escape the prohibition of Maxim Guns in post–First World War Germany. It is a weapon still acceptable to contemporary armies because of its lightness, rate of fire and ease of barrel maintenance. The small superfluities in the *Spandau*'s design were removed in the MG 42, a weapon that went on as the MG 1A3 in Pakistan, the MG 3 in Persia and the Sarac M53 in Yugoslavia. The MG 34 is the model for Ian Hamilton Finlay's bronze *Flute* (1991) and the many variants of that image.

The emergence of archetypes with design history is where the subsumption argument concerning design objects and fine art objects is most convincing. The evolution of archetypal forms in painting and poetry follows a similar developmental logic. Whether a sonnet form or an engine type, both evolve in response to questions and challenges to the limitations of their respective idiom. On this basis, the argument in favour of treating artworks and design works as the same is almost persuasive. Each area of reflection involves the evolution of practices and dialogical exchange over standards and that evolution is in ontological terms discipline constituting.

WHAT IS THAT ALL ABOUT?

The case for a less exclusive approach to fine art and design objects can be put if we consider the question of visual language. Why are the sculptural features of a designed object such as Marcel Breuer's Wassily chair excluded from the history of sculpture? Why should the Mont Blanc pen, the Olivetti typewriter or the angle-poise lamp all not be treated as artworks? Are they not all visual archetypes which have come to define their genre in exactly the same way as a Schubert sonata or a painting by Egon Schiele have? Those who reject such an equation might insist that the artwork has a clear language of convention, expectation, canonical reference and symbolic syntax. But, in his instructive essay *The Language of Things*, Deyan Sudjic has cogently argued that the designed object is no different from the artwork in this respect.[4] It too is very much an articulation of a language: the object can be read. The language evolves and changes its meaning as rapidly as any other, 'it can be manipulated with subtlety and wit or with heavy handed obviousness' (Sudjic 2008: 51).

> If you question the premise that objects mean anything beyond the utilitarian, just think for a moment about all the emotional content so far beyond legibility that we can read into the minute nuances that shape a typeface and give it personality. The fact

that it is called a face at all is certainly not a coincidence. Type is fully capable of show-
ing the character and personality of the human face. (Sudjic 2008: 37)

There is an interesting asymmetry of conceptual languages here. Kant and Colling-
wood have accustomed us to a principle beloved of many Marxist critics of art, namely,
that art is utterly useless. A Brancusi bronze might serve as a handsome cudgel but in
itself it has no practical value: art may be utilized for secondary ends but it is not a pri-
mary utility. What can be asked of it is *what is it about* rather than what it is for? This
asymmetry used by many who would preserve a difference between the artwork and the
designed object is not as stark as it seems. One asks for the function of a designed object
certainly but one can also ask of it: 'What is that all about?' What do Gucci handbags
or Rolex watches communicate when carried or worn? Like an artwork, they are meant
to be read. They display a clear hermeneutic stratagem: the wearing of such objects re-
veals assumptions about how others will read the wearing of such accessories. The wearer
may regard these items as signs of a luxurious life hoping, perhaps pretentiously, that the
wearing of them will lead onlookers to see the wearer as being of such an opulent world.
The designed object insofar as it has a specific hermeneutic resonance speaks of and to its
world. It embraces both the language of expressive intention and the language of origi-
nating purpose. How far can the equation of designed objects and artworks be taken?

As we argued the desire within much contemporary visual studies to transcend the
exclusivity of traditional approaches to art is in many ways laudable but, philosophically
speaking, can the attempt at greater inclusivity work? Can or should the discipline of
camouflage be treated on the same level as the productive activities which generate an
artwork? The quick answer to this is, 'Yes, of course'. Camouflage, as other objects of
human artifice, lends itself to aesthetic analysis in exactly the way that L. Campbell Tay-
lor's painting of a dazzle ship *Herculaneum Dock* (1918) does. Any product of human
artifice articulates the hermeneutical horizons of meaning from which its meaning and
intelligibility derives. A camouflaged building and a painting by Eric Ravillious of a
camouflaged installation both address and express a world of distinct meaning albeit
a rather anxious one. There are many virtues of reading designed objects aesthetically.
They are as hermeneutically articulate as the paintings of Paul Nash. They offer a huge
amount to learn but the question remains: does the fact that an object can be read aes-
thetically make it art? We shall answer in the negative.

That we are comparing the designed object with the artwork already speaks of a
common sense differentiation. I may relish the opportunity of visiting the Duxford Air
Museum in order to admire the ingenuity of Clarence Johnson's design for the Lock-
heed Lightning. I do not go to Duxford to view Van Dyck's astonishing rendition of
lace work. But even here the common sense differentiation is not informative. Are not
both items worthy of equal admiration as instances of real ingenuity and creativity in
overcoming a whole range of technical and visual issues? Do not both objects equally
represent 'the effort and intelligence that have been brought to bear in their creation'
(Sudjic 2008: 173)? What does it matter that one is an aeroplane and another is a can-
vas? What makes one an artwork and the other not? Is the distinction as indefensible as

many advocates of visual studies claim? This is the point in the argument where defence is more difficult than attack for to successfully defend the distinction between art and design, the question of 'what is an artwork?' can no longer be avoided.

Were I an essentialist, getting the answer to this right would be a heavy responsibility. Hermeneutical thought emphasizes that, sometimes, the posing of a question is more useful for what subsequent reflection on it produces rather than because it achieves what can only ever be, historically speaking, a tentative answer. In this respect, considering the artwork along side the designed object is useful as it deploys an Aristotelian tactic of debating what something is (in this case the artwork) against what it is most likely not (i.e. the designed object). To proceed with the argument involves the tactic of going back to some aspects of recent hermeneutic thought and Kantian aesthetics. As Nietzsche might have observed, the bricks of one philosophical argument often bear more weight when reassembled in another. We shall see that though the text of philosophical hermeneutics is visibly opposed to Kant's aesthetics in one key respect, it actually serves to strengthen the contentious notion of disinterestedness.

USE IT OR LOSE IT

Jürgen Habermas argues that, 'Interest in general is the pleasure that we connect with the idea of the existence of an object or action. Interest aims at existence, because it expresses a relation of the object of interest to our faculty of desire' (1978: 198). Kant's argument concerning disinterestedness suggests that the existence of the object represented in a painting is inconsequential aesthetically since what matters is the pleasure we take in the representation per se, that is not as a copy of a real object but as a composition in its own right (Kant 1978: 62–5). The landscape shown in Brueghel's painting *Hunters in the Snow* does not exist. The painting is not a representation of an actual place but a visualization of a setting more likely described in a traveller's tale. Though Brueghel's landscape does not indicate a known geographical location, there is another sense in which what the painting indicates i.e. a mental phenomenon, certainly does exist. The painting informs the development of the existent visual regime 'landscape'. Indeed, the historical evolution of this artistic genre allows us to look at a geographical environment *as if* it were a landscape, i.e. something picturesque. Brueghel plays a part in the development of this culturally transmitted visual regime which has inscribed itself in our way of seeing to such an extent that we now talk about the physical environment as if it were composed as a painting. This historical development is a practical exemplification of Heidegger's argument that the artwork brings a world-into-being: it inaugurates a history, initiates a historically effective way of seeing, so much so that we forget that we are not looking at actual objects rather than deploying a very distinct 'way of looking'.

Before we turn back to the question of designed objects, we should note a crucial distinction between Kant and Gadamer on the ontological consequences of disinterestedness. For Kant the destruction of the represented object is of no consequence. Aesthetic pleasure derives not from the actual *object* (the original) represented but from the nature of the representation (copy) itself. The destruction of the representation would have no

bearing upon the being of the actual object represented: it would remain unaffected by the disappearance of the painting. However, the outcome of this argument in Gadamer's thinking is tellingly different: the destruction of the artwork has the consequence of diminishing the reality of the artwork's objective correlative i.e. what it is about, its subject-matter. To destroy Brueghel's painting would be to destroy an element of the form *landscape*. It would do violence to the reality (the world of landscape) which that painting brought into being. That world—the world of landscape—would be diminished by the loss of the painting through which that world comes into being.

The different ontological consequences of Kant's and Gadamer's aesthetics impact on the differentiation between the designed object and the artwork in the following way. This point can be negotiated via two related questions: (1) What is the worst insult you can offer an artwork? (2) What is the worst harm you can do to a designed object?

The answer to the first question is not to attend to the work, to prevent it from working on one, and to pass it by with a cursory glance. If we take Heidegger's and Gadamer's eventual account of the artwork seriously, its task is to bring something forth. It therefore demands that the spectator tarries (*verweilen*) with and attends to its epiphany. Not to 'watch with' the work is effectively to betray its nature. If, as Heidegger and Gadamer argue, the task of the artwork is to bring forth a world and set it into play, the artwork can be ontologically effective only if it is allowed to operate as a window of epiphany or, in other words, if it is looked at. The being of the artwork and the being of what it discloses are interdependent: the artwork functions only insofar as it brings forth a world and insofar as that which is brought forth is invariably larger than the work, its existence is also partially dependent on that of the work. There is an ontological reciprocity between the being of a work and what it brings forward such that to harm the existence of the painting is to do violence to the being of what comes forward. This clarifies why Gadamer is so deeply interested in the symbol. The materially constructed symbol brings forth a world which is not reducible to the nature of its construction and yet it is made present by that construction. The symbol relies on its materiality for its manifestation in the world though its nature or content is not describable in terms of its materiality alone.

The second answer is the reverse of the first and reveals a most telling point. The worse you can, arguably, do to a designed object is to look at it as if it were an artwork, that is to look at it and not use it. To look at the designed object as if it were an artwork instead of using it is to prevent it from exercising the purpose for which it was designed. Of course, it does the object no good if it is destroyed but the world of purposes that brought it into being would remain unaffected. This gives rise to a critical distinction. Quite unlike the artwork, the designed object has to be taken up by and subsumed within the world that calls it forth. There is a parallel between the ontological characteristics of the sign and the designed object. The being of the road sign is fulfilled in the execution of its designated task: it must point beyond itself to the anticipated danger or place of arrival. The sign that drew attention only to itself would be a potential hazard. There is, it would seem, something tragic about a designed object: if it succeeds in fulfilling its designated task, it must self-negate. Like a tool or piece of equipment, it

must be completely absorbed within the performance of the task it was brought into being to address. The artwork, however, calls a world into being. It is not called into existence by a world. The artwork simply cannot be absorbed into a preexistent world of purposes without contradicting its disclosive nature. In contrast to the self-effacing nature of good design, artworks are indisputable show-offs wishing to be the centre of attention all the time. Of course, both the artwork and the designed object can be seen as dialogical objects. Both forms of object instantiate answers to questions. The designed object embodies a response to challenging operational difficulties. The artwork too replies to a question raised by a certain content or subject-matter. Indeed, both types of response can transform our understanding of the question they address. Nevertheless, a fundamental difference in ontogenesis remains. The world of technical needs and purposes calls the designed object into being and it is that world which subsumes the tool in the pursuit of its purpose. The artwork, however, does not disappear into the world that it and it alone brings into being. To revert to a former point: the destruction of the designed object does not affect the being of the world of purposes that brought it into being. The destruction of the artwork, however, has a direct impact upon the effectiveness and influence of the world that it brings into being. The very different ontogenetic backgrounds of the designed object and the artwork constitute a major objection to the inclusiveness of visual studies.

There are without doubt many cooking utensils that are a delight to look at and a pleasure to use, knives with handles that perfectly match the curvature of the palm in which they are held. Their visual qualities can excite and attract, drawing their user into the execution of the tasks the equipment is intended to fulfil. However, a kitchen utensil cannot be so beautiful so as to become a distraction, possibly, a dangerous one. Of course, the better the design, the more effortless and graceful the performance of the task. However, like the function of a sign, the designed object fulfils its objective by disappearing into the task it was intended to fulfil. The road sign which does not point beyond itself but only to itself would cause chaos on the motorways. Furthermore, unlike the art object which for it to hermeneutically function has to maintain itself at the centre of the spectator's gaze, the designed object no matter how aesthetically pleasing it might be has to disappear within the performance of its function. The exquisite kitchen utensil may indeed be glorious to look at. It may indeed also be hermeneutically charged in that in the act of looking at it, a whole world of associations may come to mind. We may indeed be greatly excited by the transformative possibilities that are brought to consciousness. Nevertheless, the *raison d'être* of the utensil is that it has to be *used* whilst the *raison d'être* of the artwork is that it has to be contemplated. There is, then, something almost religious about the designed utensil: it has to sacrifice itself entirely to the purposes it addresses. The Leica camera must, in a certain sense, disappear into its photographs in the same way that a Stradivarius violin disappears into being played. We do not mean that the camera literally disappears in spatio-temporal terms. In being used the equipment might be said to fulfil itself by withdrawing from the focus of attention. The well-designed tool may indeed attract us to the task it is designed to undertake but to perform the designated task it must not

distract from that task and withdraw from being an object of aesthetic attention. Ga-damer makes an analogous observation about writing. Writing, though beautiful, does not try and be understood or noticed as such. Its role consists in drawing the reader into a course of thought. It is not an end-in-itself but a means of bringing something to mind. If a writing style is an obstacle to such an occurrence it is in effect bad writing (Gadamer 1989: 394).

In contradistinction to the ontological quality of purposeful disappearance intrinsic to the exercise of the designed object, an artwork that is self-negating or whose *raison d'être* is affirmed in its purposeful disappearance seems a contradiction in terms. Like Purcell's song title 'Music for a While', the majority of artworks demand that we 'tarry' with them. In order for the artwork to operate hermeneutically, it has to command at-tention. The properties of diversion and distraction are, however, potentially disastrous for a piece of equipment. Of course an artwork may be used as propaganda but such a deployment is incidental to its primary *raison d'être*, which is to work as a bringing forth—to be an annunciation. The artwork cannot disappear into itself but to rather an-nounce itself and what it brings forth ever more fully.

J. M. W. Turner's *Fishing Boat with Hucksters Bargaining* brings forth an aspect of the subject-matter 'seascape' (1837/38). It is not meant primarily to depict a scene but in Gadamer's language to bring an aspect of the sea to the picture. This it does exquisitely well. The work not only translates into painterly form the heaving liquid power of the sea but by unsettling the eye it allows the massive welling of the sea to come forth. For this and other paintings to work, there can be no disappearing into the exterior world. The work must command attention as a painting and if it works it does so because it brings forth its world and manages to hold it in place. As we argued above, in the case of the artwork, the work and its subject-matter are indistinguishable. Destroy the work and you destroy something of our understanding of seascape. By way of contrast, however, destroying the tool does not destroy the world of purposes that brought it into being in the first place. In conclusion, the argument within visual studies for treating art and de-sign as the same visual studies overlooks what is a crucial ontogenetic difference between the two types of object.

HERMENEUTICAL AESTHETICS AND A KIND OF LOOKING

Hermeneutical aesthetics and visual studies share an antipathy towards subject-centred aesthetics. Both regard the visual object as hermeneutically charged in that it can speak of and speak to the horizons of meaning which form the circumstances of their being. Both approaches esteem the artwork and the designed object as a 'dialogical response' to questions of content and subject-matter. Here the parallels between these two ways of seeing cease. Once the ontogenetic differences between artwork and designed object are recognized, other differences become apparent. To turn a visual item into an object of visual study is to subordinate it to methodological presuppositions which are quite different from those which apply to any approach to the object as the focus of a visual contemplation. In the case of the artwork, the spectator is subject to its address. In

contrast, the designed object if treated as a sign or symptom of visual culture is subject to the methodological regime of the spectator. The question then arises as to how critical of reflexive methodology can visual studies can be? Let us first consider Gadamer's account of aesthetic contemplation.

Hermeneutical aesthetics appeals to a form of contemplative attentiveness. It regards the artwork as a space of world-emergence. Gadamer argues,

> In the puzzling miracle of mental wakefulness lies the fact that *seeing something and thinking something are a kind of motion*, but not the kind that leads from something to its end. Rather, *when someone is looking at something, this is when he or she truly sees it*, and when one is directing one's thinking at something, this is when one is truly pondering it. So motion is also a holding oneself in being, and through this motion of human wakefulness (*Wachseins*) there blows the whole breath of the life-process, a process that ever and again allows a new perception of something to open up. (Palmer 2007: 367)

The object of attention for Gadamer is the subject-matter invoked by the work. It is not a question of the artwork being a neutral object on to which several interpretations can be projected. To the contrary, the artwork addresses the spectator. Hermeneutical aesthetics presents aesthetic attention as a form of *kenosis*, the practice of clearing one's mind and stilling one's will in order to become receptive to what comes forth from within a subject-matter. Clearing the mind is not understood in Cartesian fashion as an emptying. Following Heidegger, Gadamer is committed to the view that there is no such thing as pure consciousness or a mind equivalent to a *tabula rasa*. Consciousness is always awareness of *something* and in as much as consciousness is aware of an object actual or virtual, the latter will always be given within a linguistic and a cultural horizon. Clearing the mind is, then, not a question of emptying it of its contents but of preparing it to be attentive. It is more a question of 'clearing the (mental) decks' for immanent action. Everyday issues and immediate projects are suspended so that the mind can become receptive to what emerges before it. Like certain spiritual practices, aesthetic contemplation releases the observer from inattentive entanglements in the world not in order to escape it but rather to achieve a cultural space for developing an enlarged sense of the subject-matters that shape our cultural being (Wright 1998: 187). Plainly, this is not a return to Kantian disinterestedness. Becoming open to the movement within a subject-matter is to give the dialogical initiative to the artwork allowing it to question the assumptions of the spectator. This is why Gadamer occasionally describes the aesthetic impact of a work as a real shock. The procedure is somewhat different with visual analysis.

Nicholas Mirzoeff claims that visual studies promotes the 'ability to become critical viewers' (cited in Dikovitskaya 2006: 89). This is not in dispute. What remains problematic is the philosophical structure of methodic visual analysis. If its aim is to relate the visual object to the social circumstances that produced it or if it endeavours to account for the construction of a painting by referring to a specific scopic regime, the

visual is explained by reference to determinants that exist independently of the object under scrutiny. The visual object is exemplified as an instance of a political ideology or of a specific social practice. In such cases the object is subjected to a methodological engine that interprets it according to a designer's or artist's intentions, according to archaeo-logical or genealogical assumptions or with reference to other ideological determinants. In other words, the object of analysis serves as a vehicle for demonstrating something beyond itself. Insofar as the visual object is subjected to a method of analysis, it is not accorded any autonomy of address. It is, in effect, silenced. It is not allowed, therefore, or cannot force the spectator to review his or her assumptions.

The dynamic which governs the relationship between the visual object and the spec-tator is quite distinct in the cases of hermeneutical contemplation and visual analysis. In the case of hermeneutic aesthetic reflection, the spectator is subject to the interrogative address of the artwork. Where visual studies operates, it is the visual object that is sub-ject to the interrogation of the spectator. If so, how critical can visual studies be? Recent protagonists for visual studies celebrate the discipline's ability to nurture critical social and cultural responses to visual objects. This is commendable but how reflexive can the discipline be? If the methodological terms of a visual analysis are never brought into question by its object, how critical can visual studies be? What is gained if the blindness attached to subject-centred accounts of aesthetic response is only replaced by the reflex-ive blindness of culturally based forms of visual analysis?

Gadamer's hermeneutical aesthetics seeks 'free spaces' and the ability to move therein (Misgeld and Nicholson 1992: 59). There is a real question as to whether method in the visual studies promotes either. There is no doubt that reductive analyses of artworks and designed objects can be extremely illuminating. The work of a brilliant visual critic can transform one's view of art and literature offering an innovative paradigm of interpreta-tion. However, having *one's view* of the visual changed is not the same as *being changed* by the visual object. If different methods generate different views, then, 'bureaucratized teaching and learning systems dominate' (Misgeld and Nicholson 1992: 59). If so, the hermeneutic practice of attentive looking which allows a space for the artwork and its subject-matter to come forth is much better suited to challenge that domination. A fur-ther irony remains.

The emergence of visual studies has been in part inspired by the conviction that fine art and elite aesthetic attitudes estranged the less educated or socially privileged. To counter such alienation, critical methods of analysis have sought to deconstruct and de-mythologize the artwork. Unfortunately, a cure can be as troublesome as the malady. A potent argument within *Truth and Method* concerns the thesis that a 'methodological at-titude' entails a form of Cartesian alienation: the cognitive subject is always at a distance from the object of investigation. The methodological attitude prises the art object out of its world and treats it as an isolated phenomenon subject to analysis. This approach effectively silences a work's address. Analysing the work and its properties in this way disrupts any dialogical exchange value within the work. The work is effectively treated as a symptom or expression of cultural and political forces. This subsumption to a world of analytic purposes fragments the artwork by treating it as an instance or example of

a wider social movement. The capacity of a work to serve as a dialogical partner in the unfolding of a spectator's life is lost. Worst of all, the Cartesian model assumes that the methodological subject is detached from and unaffected by the lived world of meaning and value. Paradoxically, the very alienation concerning the elite if not remote status of 'high art' which the deconstructive and demythologizing methods of critique analysis were meant to overcome is reinstated at another level. Relating the artwork to a wider nexus of ideological determinants may place the artwork back into an identifiable world of social practices but it nevertheless dissolves the dialogical status of the work by removing the spectator from the very hermeneutical networks of meaning and value capable of embracing and transforming the spectator's understanding. Gadamer's criticisms of the analytic approach to aesthetic experience have a further disconcerting critical twist. The methodological attitude tears the artwork out of its existential context and converts it into an object of consumption.

In *Art and Social Theory*, Austin Harrington (2004: 178–80) suggests that for Gadamer there are three features of art's existential significance: (1) art enables 'play'; it involves spectators in acts of imagination that contribute to its inexhaustible meaningfulness, (2) art functions in the manner of a symbol releasing meanings that can never be captured in their entirety, and (3) art is essentially 'festive' in that each perception or performance of a work creates a community of responsive spectator members who are drawn into communication. For philosophical hermeneutics, these moments articulate the temporal structure in which a work is experienced. These, Gadamer suggests, are qualities characteristic of the way ancient festivals not only occurred in time but defined it. In their regular sequence, festivals define a community's calendar. The Venice Biennale or the Berlin Film Festival create occasions not only in which practitioners of a discipline gather, exchange and confer but also establish the rhythm of their productivity as they prepare their submissions. It is noteworthy that for Gadamer contemporary commercialism has a corrosive effect on the communicative time-structuring feature of aesthetic experience. Harrington observes that commercial culture tends to isolate members of a cultural practice from one another breaking the regularity and continuity of socially experienced time into disconnected instants (Harrington 2004). These observations have a cautionary relevance for the cultural impact of visual studies. They pose four questions.

1. By silencing the artwork as a dialogical object, does not visual studies ignore a central claim of philosophical hermeneutics—that the artwork is a participatory event and not an object for detached methodological analysis alone?
2. Though it endeavours to counteract the alienating effects of high art and culture, does not visual studies create another form of alienation—the artwork is regarded not as a dialogical agent but as one of many other socially produced objects?
3. Does treating artworks as symptoms of certain ideological groupings actually lead to certain works or objects becoming even more fetishisized precisely as expressions of that lifestyle?

4. If so, then far from achieving a critique of subject-centred aesthetics (which hermeneutical aesthetics succeeds in achieving), does not contemporary visual studies reinstate that perspective by attempting to treat designed objects as artworks, that is not as dialogical objects which bring forth a world of distinct meanings but as objects with pleasurable aesthetic features in their own right?

Let us conclude.

When contemplated aesthetically, the designed object can equally be seen as a potent bearer of a framework of meanings and values. Like any object in the visual world it will belong to a distinct realm of defining structures and purposes. To a certain degree, it will embody that world exactly in the same way as the various cutting edges of different ploughs exhibit long-established knowledge about soil types and densities. The designed object can equally transform the practical world whose needs inspired it: The Douglas Dakota DC-3 designed by Donald Douglas and which entered service in 1935 transformed the world of long-distance civil flying. More recently Braun's hand-held calculator has a deck-layout the design of which may now be found in nearly every mobile phone. The range of visual studies has been appropriately extended to include the social dynamics of visual objects. The enormous relevance of hermeneutical structures of thought to the understanding of both art and design is manifest and perhaps still underestimated. The art of 'reading' designed objects and more conventional artworks is much the same. Without doubt, visual studies has become hugely important within the evolution of critical visual thinking. However, the very hermeneutic characteristics that are sympathetic to the culturally inclusive ambitions of visual studies also give pause to wonder whether all visual phenomena can be meaningfully treated as art and if not why not. The vital ontological distinctions which concern the inseparable link between an artwork and the world it brings forth and the asymmetry of this argument with the designed object whose tragedy is that it must disappear into the realizations of the purposes that brought it into being indicate that within visual studies all visual objects are not and cannot be treated as the same. Because a designed object can be read as an artwork does not turn it into an artwork. In summary, our principal concerns are as follows.

If visual studies is understood solely in terms of a methodological analysis and critique of the logic and social genesis of images, it falls into a double trap. (1) In attempting to overcome the subjective preferences and obscurantist elitism which often accompany high art objects, the application of analytic rigour threatens to detach the subject from any cultural involvement in the image. This only succeeds in displacing one form of cultural alienation with another. (2) Tracing visual images back to the circumstances of their social production is to be guilty of the genetic fallacy. It is in the nature of visual and verbal images that their meaning always transcends the circumstances of their genesis. The origin of the popular wearing of wrist watches lies for the most part in the First World War when field officers found the pocket watch too unwieldy for battlefield easy use. Wearing a wrist watch, however, does not turn one into a twentieth-century military imperialist. (3) As a dialogical interlocutor, an artwork

can challenge the viewer's presuppositions about the subject-matter being contemplated, subject the viewer to critique. To treat an artwork solely as an object of visual study is to silence it and disregard it as a participatory event. Without qualification by hermeneutic aesthetics, visual studies weakens the speculative charge of artworks, diminishes their transformative power and impoverishes the pedagogical and existential significance of visual education. This might be avoided if the implications of recognizing the quite different ontogenesis of the artwork on the one hand and the designed object on the other are recognized, understood and assimilated throughout aesthetic education. Visual studies would be the richer and more diverse as a consequence of that recognition.

In conclusion, hermeneneutical aesthetics is openly hostile to the subjectivist doctrine of taste informing Kantian aesthetics. In this, it shares common ground with those who would dissolve the distinction between art and design within the visual arts. However, hermeneutical aesthetics both reinvents and relocates Kant's distinction between the aesthetic and the nonaesthetic. Abjuring the epistemological basis of Kant's distinction between the disinterested and the interested, philosophical hermeneutics differentiation between (a) disclosive phenomena and (b) phenomena subsumed within utilitarian frameworks of interpretation nevertheless reestablishes Kant's nonaesthetic/aesthetic distinction on the basis of an ontological differentiation between those things which come into being spontaneously (such as aesthetic *Sachen*) and those called into being by an anterior world of purposes (designed objects). It is this difference of ontogenesis which leads philosophical hermeneutics to insist on the aesthetic/nonaesthetic (the art and design) distinction but on grounds which are far from Kantian. Furthermore, from the perspective of philosophical hermeneutics it is a distinction that is worth preserving. Collapsing the categories of design and art into one needlessly impoverishes the experience of the visual world. Such a reduction amounts to either fear or awe of the status accorded to high art. However, to recognize a fundamental difference of ontogenesis concerning the artwork and the designed object is neither to rank or evaluate the difference. Recognizing the difference amounts to what should be recognized: the rich diversity of objects within the world of the visual. A misguided sense of political correctness which would see art objects and designed objects as the same should not be allowed to impoverish visual culture in the way which philosophical hermeneutics suggests that it might.

NOTES

1. Jürgen Habermas (1972: 176) refers to this as the knowledge constituitive interest of the cultural sciences.
2. A dialogical conception of the artwork places critique at the centre of aesthetic experience. Thinkers such as Habermas, Gadamer and Iser see the humanities disciplines as being constituted by on-going reflection and critique. It is a fundamental misconception of the practices occurring within humanities disciplines that leads to the false conception of the humanities as 'zones of uncritical institutionalised privilege'.

3. For an account of how different lens types pick out different aspects of a terrain, see McGrath (2007).
4. The argument here to be expanded is that the function of language is not just statemental but revelatory.

REFERENCES

Davey, Nicholas. 1999. 'The Hermeneutics of Seeing', in Ian Heywood and Barry Sandwell (eds.), *Interpreting Visual Culture*. London: Routledge, 3–29.

Davey, Nicholas. 2006. *Unquiet Understanding*. Albany: State University of New York Press.

Dikovitskaya, Margaret. 2006. *Visual Culture: The Study of the Visual after the Cultural Turn*. Cambridge, MA: MIT Press.

Elkins, James, ed. 2007. *Visual Practices across the University*. München: Wilhelm Fink.

Gadamer, Hans-Georg. 1989. *Truth and Method*. London: Sheed and Ward.

Habermans, Jürgen. 1972. *Knowledge and Human Interests*. London: Heineman.

Harrington, Austin. 2004. *Art and Social Theory, Sociological Arguments in Aesthetics*. London: Polity Press.

Iser, Wolfgang. 2000. *The Range of Interpretation*. New York: Columbia University Press.

Kant, Immanuel. 1978. *The Critique of Judgement*. Oxford: Clarendon Press.

Löffler, Fritz. 1960. *Otto Dix, Leben und Werk*. Dresden: VEB Verlag der Kunst.

MacIntyre, Alasdair. 1993. *After Virtue*. London: Duckworth.

McGrath, Jim. 2007. 'A High Resolution Multi-Channel Photograph', in James Elkins (ed.), *Visual Practices across the University*. Munchen: Wilhelm Fink, 171–8.

Misgeld, Dieter and Graeme Nicholson, eds. 1992. *Hans-Georg Gadamer on Education, Poetry and History: Applied Hermeneutics*. Albany: State University of New York Press.

Newark, Tim. 2007. *Camouflage*. London: Thames and Hudson.

Nietzsche, Friedrich. 1968. *Twilight of the Idols*, trans. R. J. Hollingdale. London: Penguin.

Nietzsche, Friedrich. 1986. *Human All Too Human*. Cambridge: Cambridge University Press.

Palmer, Richard E., ed. 2007. *The Gadamer Reader*. Evanston: Illinois University Press.

Sudjic, Deyan. 2008. *The Language of Things*. London: Allen Lane.

Wright, Dale S. 1998. *Philosophical Meditations on Zen Buddhism*. Cambridge: Cambridge University Press.

Art and Visuality

Editorial Introduction

Robin Marriner's chapter explores the complex relationships between visual culture and modern art. He follows an earlier sociological precedent by approaching contemporary art as a specific 'artworld' conceptualized as 'the objects and network of social and discursive institutions and practices'. He examines two claims familiar in visual culture studies: that recent art has been borrowed from and been stimulated by popular or mass culture, and that popular culture is a threat to contemporary or late-modern art. These questions have become more pressing and more complex as a result of the different critical and theoretical approaches that have explored these positions in recent cultural studies. As an example, Marriner mentions two exhibitions on the subject. While *The Forest of Signs: Art in the Crisis of Representation* (1989), which took pains to be 'informed', was criticized for being obscurantist and politically correct, the second *High and Low: Modern Art and Popular Culture* (1990), which took a more straightforward line, was widely attacked for being uninformed by recent theory.

Marriner next discusses the well-known opposition between high and low culture, particularly in the context of industrialized modernity, articulated theoretically, historically and politically by critics of both the Right and Left. Theodor Adorno's view of the spread of the 'culture industry' as both mass entertainment and as a vehicle for the 'dominant ideology' underwriting late capitalism has been particularly influential. However, Marriner argues that recent developments in both theories of visual culture and in the artworld have forced us to change this predominantly negative view of the media and cultural representations.

The rise of semiotics and structuralist 'Theory' in the 1970s, initially in relation to film, provided a basis for criticism of 'aesthetic autonomy' and key tenets of formalist modernism. This new critical climate has been reflected and mediated in a variety of ways in the practice and production of contemporary art from the 1980s to the present; Marriner in particular mentions the work of David Salle, Sigmar Polke,

Gerhardt Richter, Richard Deacon and Jeff Koons. Taking Robert Longo as an example of a pervasive 'postmodern' outlook in art practice, he discusses the widespread use of self-conscious 'appropriations' or reflexive borrowings from popular culture, which to some degree call into question the difference between high and low art.

For both supporters and critics of the new postmodern sensibility, Andy Warhol is a crucial figure, with apologists arguing that his photographic silk-screen images of celebrities and sensational newspaper images enable the viewer to explicitly confront an image *as* image, and thus reflect upon the potency of images in an increasingly visually mediated culture. Using Christian Metz's semiotics of the photographic image, Marriner analyses a work by Robert Frank, showing how the manipulation of various 'codes' enables its real subject matter to be the phenomenon of the 'fan'. Frank relies upon the interpretive work of the viewer, prompted by a foregrounding of photographic conventions, to create this specific aesthetic meaning.

This question of the conditions favouring an active spectator has been widespread in visual culture studies. While accepting the judgement that much of the popular culture is complicit with or complementary to the social and political needs of capitalism, visual studies has learned to be critical of the suggestion that the spectator is simply duped, drawing attention to the range of different 'readings' across different groups and 'subject positions'. The works of Koons and Haim Steinbach are seen as dissolving any simple distinction between objects, particularly between consumer goods and aesthetic signs. Moreover, these artists continue to claim that what they are presenting are works of 'art'.

Marriner interprets Roland Barthes's influential notion of the 'death of the author' as a reminder to artists that they are producers rather than creators, and that they necessarily drawn upon the work of other artworld members, including active, competent viewers, to bring their work into being.

In conclusion, Marriner argues that many of the ideas and theories embraced by visual culture studies have succeeded in unseating a Greenbergian formalist outlook predominant through the 1950s and 1960s. For art practice, the result has not been a new critical or philosophical consensus, but a range of responses from anxiety and uncertainty on the one hand to energetic pluralism on the other. However, there is today widespread scepticism about any aspiration to purity, diversity aplenty, and a new interest in relationality, which finds theoretical expression in the work of Nicolas Bourriaud. While finding these new 'demotic' and critical impulses to be unsettling and productive Marriner concludes by rejecting simplistic claims to 'radicalism' and 'critique' once made by and on behalf of the avant-garde. Popular media and demotic visual culture remain a tremendous force for contention and change in the modern world.

The concept of visuality is manifestly a fundamental idea for visual studies. **Donald Preziosi** is concerned to explain not only its meaning, but also what it reveals about the development of the study of visual culture, and in particular what he discerns as its 'current impasse'. While being an occasion to reflect on his own intellectual odyssey, his chapter situates the idea of visuality as a separate mode of knowing in the context of modernism, art history and museology. More specifically, Preziosi poses the question, Who benefits from the currency of the idea of visuality?

Preziosi is preoccupied by the idea that art history, visual studies and museums must present their objects within contexts or scenes of interpretation. Inevitably, this creates a tension between the material and textual devices of presentation and the question of the inherent legibility or meaning of these artefacts. This 'fabrication' or 'staging' of knowledge is always ethical and political, generating questions about the wider social and historical context to which it belongs. For Preziosi, the artifices of art history, visual studies and museums 'render their own legibilities moot and problematic'.

Lighting on the simile of the pantograph, a device for magnifying drawings or conveying electrical power, Preziosi suggests that the way in which artefacts are presented in museums is meant to transport the viewer and enhance the object. He wonders how far this goes, whether it lends the mute object an aura of agency or an empowering voice? Does it extend to a relationship with the artist, mediated by the work, through which both the artist and spectator live more fully in the spirit, or is this a merging with the object, a diminishing idolatry?

Tendencies to iconophilia on the one hand and iconoclasm on the other are intrinsic to Western philosophical and religious thought. This is the problem not so much of interpretation but of the eventual self-consciousness of the artifice on which interpretation depends. Iconophilia aims to palliate its anxiety by forgetting itself, by fusing with the object, while iconoclasm seeks release by destroying the object and hence its consciousness of artifice. Yet Preziosi insists that maintaining the difference, and so experiencing an emotional tension, between the idea and object, the immaterial and the material, form and content, is itself problematic, or perhaps creatively ambiguous. Refraining from either fusion or destruction enables the viewer to prolong a condition that may, after all, be a kind of narcissism; the viewer only finds in the work the meaning that interpretation places there. This seems to be one of the insoluble problems with which art and the modern idea of the self confront us, and which Preziosi believes the disciplines of art history, philosophy, sociology and visual studies are systematically engineered to evade. Disciplinarity risks eliding 'difference and heterogeneity' in the name of knowledge and control.

Making this point in another way, Preziosi suggests that there is an 'irresolvable ambivalence' about the constitutive powers of the self, which extend to self-constitution, and its relationship to objects, in particular its sustaining life-world. Proliferation of irreconcilable theories is a sign not of a commitment to overcome the problem, but rather of a desire for the power its aporias sustain. That is if 'aesthetic significance' is a ghostly 'residue' lingering in artefacts of a certain kind once superstitious, instrumental, commercial or everyday purposes have been removed, the collection and display of such objects in museums can be represented as their liberation, an act of preservation that may also be appropriated by powerful commercial interests and state powers.

Preziosi insists that the concept of visuality in art history, art theory and visual culture studies is dogged by similar dilemmas. For example the unending conflict between formal and contextual properties serves the ends of political expediency by ensuring that there is no alternative to 'overwriting' the object, giving it 'voice', making it 'legible'. The alternative, for Preziosi, is a 'multi-sensorial approach to cultural behavior' or

'artisinal anthropology', which requires a difficult recognition of the multimodal practices of doing and knowing in everyday life. Museums, like disciplines, art and language are both the means to confront artifice and 'dangerous' ways of evading it.

The problematic topic of the preservation and presentation of categories of 'art objects' is also critical to **Ian Heywood**'s chapter. He is centrally concerned with the relationship between visual art practice and the ways in which visual art has been represented by theories that have become important to influential versions of visual culture studies, in particular those shaped by the outlook of cultural studies. Taking up the example of Cubism and Cubist collage, he argues that Cubist collage need not be seen as a damaging auto-critique of painting in the name of popular visual culture but might be more usefully viewed as a risky, often ambiguous but ultimately successful reinvigoration of painting practice.

Cubism's historical connection to France's emerging visual culture has been widely discussed, but its formal and semantic complexities and puzzles make this relationship difficult, if not impossible, to decipher. Yet the drive of Pablo Picasso and George Braque to represent modern, everyday urban life in a modern way is unmistakable. No account of Cubism can evade this social-historical-aesthetic problem.

Heywood suggests that what makes visual art important in visual culture studies is not just its sociological or historical importance, but the kind of thinking that goes on within it and which it makes apparent.

Cubism is often presented in terms of a response to or symptom of crisis, specifically a crisis in French painting at the end of the nineteenth century. A view of one such crisis, made popular within visual culture studies (although usually applied to the 1960s onset of pop art or postmodernism a decade or so later), suggests a collapse of formalist high art into a newly visual or 'aesthetic' popular culture. It has been accompanied by a socio-political critique of all high art on the grounds of its supposed complicity with an unequal distribution of 'cultural capital' underpinning iniquities in the distribution of economic and political power. These and related arguments have contributed to a problematic climate of practice for visual art, aspects of which Heywood examines through the work and opinions of the leading German artist Gerhard Richter. Richter seems to accept an unavoidable, irremediable 'inadequacy' of available means and methods, and hence a kind of debility at the core of contemporary art practices.

However, there have been recent revivals of interest in both the object and the aesthetic, suggesting to some the possibility of a more positive outlook on both the artwork and art practice. As an example, Heywood reviews remarks by Keith Moxey, proposing a 'pictorial' or 'iconic' turn, views that encourage a fresh look at Cubism and its relationship with the emerging realms of quotidian visual culture.

Heywood identifies three practical terms necessary for an adequate discussion of Cubism: the object characteristics of the work, the picture plane and the surface. Using the example of Picasso's *Still Life with Chair Caning* (1912), he tries to show how Cubist collage engages in new ways with each of these features, as well as with puns, word play and jokes. He examines the tendency of the quasi-linguistic interpretations of culture to result in a judgement, that the heightened self-consciousness about the devices and methods of art displayed in Cubist work is tantamount to irony about the possibilities

of painting or visual art as such. In the work of Braque and Picasso at this time there is certainly a rejection of many aspects of traditional art and the vigorous testing of others, but the intense scrutiny of the particularities of everyday visual experience does not suggest the detachment and abstraction implied by the linguistic abstractions of poststructuralism.

While T. J. Clark judges Cubism a tragic failure, it was, nevertheless, enormously influential in understanding something important and pervasive about the cultural possibilities of capitalist modernity. Its obsession with the means of devices of representation—a structural feature of its distinctively and radically modern form of artistic reflexivity—prevents it from achieving its ultimate end, the truthful representation of the experience of modern life. Its very modernity frustrates its desire to represent modern life.

Heywood argues that what Clark misses in his critique is the ghostly doubling of experience in modernity. Cubist collage needs to be understood in terms of a tension between the drive to represent modern experience faithfully, which involved coming to grips with its sensory presence and in particular its look, and a commitment to reveal and explore the consequences of acute self-consciousness of the artifice involved, the artistic modernity of its way of seeing. As Poggi suggests, this is pushed to the point where the play of devices and signs seems almost an end in itself, promoting imagination over recognition.

This can be interpreted as a response to a wider anxiety that pervades modern experience about what to believe, how to act and who to be, an instability in modern culture sometimes framed as the outcome of a tension between the ideal of spontaneity and effective freedom on the one hand and on the other, the remorseless objectification of life, specifically its transformation through technical discourses and methods. That is, this feature of Cubism reflects the ways in which modernity raises difficulties with knowing, ethical behaviour and cultural value, due not to deficient self-consciousness about outlooks and methods of painting practice and their typical results, but to a grasp of their constitutive power and the consequent uncertainty about the grounds or reasons for choosing one kind of approach over another.

A similar problem dogs ordinary life and reflection outside the rarefied cultural laboratory of avant-garde art. Feelings of not living fully or authentically, problems of identity and anomie, spring not from a lack of rules, prescriptions, roles or techniques of living and acting but from their prevalence and necessity. Adorno and Horkheimer suggest that capitalist modernity exacerbates the problem by requiring the elimination of personal history and connectivity as a condition of the individual's market value. As has been often observed, the emerging visual culture of modern France was the outcome of relentless objectifying and commodifying forces, weakening the boundary between art and life. This did not, however, of itself entail a negation of art by popular culture, but rather enabled artists like Braque, Picasso and others to both employ and confront urban experience in broader, more radical ways.

These factors suggest a bifurcation of experience in everyday life, two ways of experiencing being a subject of modernity: on the one side what we might call spontaneous or singular life, its vitality, locality, affectivity and receptivity, and on the other constructed life, consciousness of the abstraction, power and determining character of ways

of enacting spontaneity. Cubism's will-to-representation and its ferociously inventive play with the means and methods of painting do not so much 'fail' as detect and replay fundamental tensions within modern experience.

Like Heywood, **Simon Bainbridge** is concerned to recover an even earlier moment of modern visual experience, one that marked the very beginning of a modern 'romantic' conception of seeing and transformative visual experience. Bainbridge draws attention to the intensely visual, pictorial descriptions of a natural, albeit cultivated, landscape at the heart of English Romantic literature and in the origins of what we have subsequently come to see as a certain, important kind of tourist experience.

In triangulating new forms of seeing, new practices with regard to the natural environment (walking, personal exploration and so on), and the emergence of romantic-literary language he examines the first phase of a major cultural revolution with regard to how subjects envisage and appropriate the natural landscape, a change that still underwrites the world of mass tourism and what John Urry has called the *tourist gaze*.

More specifically, he explores and advances recent research in the development of this aspect of visual culture, concentrating on the 'envisioning of landscape and the relationship between viewing subjects and the world around them'. Here the 'visionary' writings of the English Romantics prove to be of seminal importance. The poet William Wordsworth is explicit about the delight, the 'substantial pleasure', which comes from elevated viewing of the mountains and valleys of the English Lakes. The pleasure of this seeing comes from both the beauty of the scene but also from a 'fuller and truer understanding'. Visual motivation, the desire to access a view or prospect, would also become critically important in the early history of mountaineering (and, in Britain, with hiking and fell or hill walking), one that made worthwhile the physical effort involved in 'accessing' monumental natural sights. This paradigm shift towards the natural landscape and its popularization was very rapid, clearly discernable in the 1760s, but already well established in tourist literature by the 1830s.

The visual culture of early mountaineering is bound up with two concepts of eighteenth-century aesthetics: the *sublime* and the *picturesque*. The idea of the sublime, elaborated by the so-called pseudo-Longinus, Joseph Addison, Edmund Burke, Immanuel Kant and others, links a certain type of emotional excitement, sometimes verging on fear, to natural landscape features that exhibit 'vastness, obscurity and infinity'. An opportunity to view such 'terrors' from a position of safety converted anxiety into stimulation and pleasure. Here the calm 'aesthetic' of neo-classicism was effectively displaced by the 'wild aesthetic' of Romantic *experience*.

The picturesque, introduced into aesthetic discourse in the eighteenth century, referred explicitly to a comparison between views of landscape and paintings, particularly those of Claude Lorraine and Salvator Rosa. It originally aspired to differentiate a kind of 'rough' or 'rugged' beauty, an objective correlate that perfectly fitted the landscape of unexplored mountains and wilderness. In many senses these Romantic reformulations of 'the natural' in terms of the sublime and the picturesque actively created the modern concept of *wilderness*. The texts of the Romantic celebrants of wild nature in effect constituted what we now understand as wilderness experience.

Bainbridge discusses early guides and contemporary accounts of ascents to popular English, Welsh and Scottish peaks, and the rapid growth of a tourist infrastructure inspired by this literature. Observers vividly reported disorientation, astonishment and delight at the views disclosed by upward movement through the mountain landscape as they ascended towards the summit. What was seen from the summit was often described as exceptional, even incomparable, to the extent of causing physical symptoms like vertigo and giddiness.

One way of coming to terms with—and to some extent, domesticating—this novel, disorienting experience was by linking it to the idea of maps and mapping. Again Bainbridge breaks new ground in reminding his readers that the modern vogue for maps as both orientational devices and aesthetic objects is a primary *visual* phenomenon. To look down from a high peak was similar to occupying the imaginary viewing position of the cartographer, and this suggestion links naturally to an aspiration to recognize and even name other peaks and features, leading to a demand that such features be given unique, identifying names should they not posses them already. The 're-seeing' and 're-naming' of the environment are correlative features of these cultural practices. Interest in topographical panoramas is widespread by the nineteenth century, and is an important feature of visual representations of summit views even today.

Bainbridge discusses various ways in which the excitement of vertiginous views could be heightened by approaching the edges of precipices, but also by atmospheric conditions, in particular the dynamic play of sunlight and clouds, sometimes comparing them not to the familiar example of painting but to theatrical effects and an emerging nineteenth-century technology of projection shows and visual 'spectacles'.

In conclusion, Bainbridge suggests that the desire for a particular kind or intensification of visual experience was central to the early development of mountaineering, mountain literature and tourism. John Keats's description of an ascent of Ben Nevis brings out the possibility of a new or at least unfamiliar way of looking, which displaces the need for naming features and fixing positions, relishing the dissolution of the fixed and known into fleeting, mutable impressions and unexpected changes of scale.

The discovery of wilderness, the ascent of mountain peaks and the exploration of hitherto 'unknown' domains offered to the emerging visual culture of modernity not simply new things to see, prospects that defied the capacities of prosaic description, but new ways of seeing and being.

The theme of visual transformation as a medium of new ways of seeing and being is continued in Martin Irvine's chapter on contemporary street culture. **Martin Irvine** succinctly describes his subject 'street art' as:

a paradigm of hybridity in global visual culture, a post-postmodern genre being defined more by real-time practice than by any sense of unified theory, movement or message . . . a form at once local and global, post-photographic, post-Internet and post-medium, intentionally ephemeral but now documented almost obsessively with digital photography for the Web, constantly appropriating and remixing imagery, styles and techniques from all possible sources.

Street art is an instance of an ambivalent visual space, straddling the worlds of everyday urban life and the commercial art world. In recent years street art has become a familiar part of the artworld, appearing in art events, exhibitions, catalogues and collections, and enjoying extensive media coverage. This phenomenon raises for visual culture studies questions about globalized visual art, creative uses of remix and hybridization and the function of public urban spaces in developing communities of practice and counterpractice.

Irvine emphasizes that street artists have from the first used the city not only as a canvas but also as a collaborator, an active and changing source of codes, topics and creative opportunities. It also rematerializes, rehistoricizes and resocializes an increasingly pervasive disembodied, transmedia visual environment, and often deliberately contests the corporate and government monopoly on visual events within the urban environments. The space with which it is concerned and seeks to reclaim, making a claim to 'place', is urban space as lived out in the visceral movements and mobile activities of the people who use them, forging a public aesthetic of reappearance and dematerialization.

Irvine notes the increasing sophistication and prominence of street artists since 2000, with many moving from underground graffiti to commissioned public murals and exhibitions. He notes an extension of the logic of Pop art, a move out of the studio and gallery to convert the urban environment into a means and scene of art production, for some continuous with Situationist techniques of 'wandering', repetition, dialogue and disruptive deviation in highly controlled visual regimes of regulated, commoditized space.

For Irvine, contemporary street art is a product of the 'network society' and the 'global' or 'postmodern' city. That is there is an oscillation between the material city of places and the immaterial, fragmented city of 'flows', particularly the digital imagery of the Web. While they challenge the homogenous virtual space of the postmodern city, many street artists use the Web to distribute and achieve a more permanent visibility. The synamic interaction between the traditional 'immediacy' of street graffiti and the relative permanence of Web-mediated art and artworld installations becomes an important site of future research and investigation.

Street art is necessarily engaged with walls and vertical surfaces generally, which are often prominent and valuable in the modern city, particularly for advertising and commercial display. For the artworld, the typically internal white wall of the gallery has been important, even for art movements that wanted to challenge the commodity form and the 'white cube'. For street art, the exterior wall both narrows or eliminates the gap between art and life and enables the conversation about the work to occur outside the confines of the gallery.

Irvine outlines some precedents for the concerns and methods of current street artists in the history of avant-garde visual art, but suggests a reversal of interest; not a 'reduction' of painting to basic or nonart gestures, street murals exhibited unrestrained mixtures of codes and styles already present within the city's visual environment. However, for many artists, some of them known for their 'street' work, the old distinctions between inside and outside, wall and canvas, no longer apply.

Mentioning Michel de Certeau's emphasis on the creative borrowing, reuse or rewriting characteristic of everyday life, and at odds with ideas of simple consumption, Irvine argues that street art 'lives at the read-write intersection of the city as geo-political territory and the global city of bits'. Street art both constitutes and exemplifies a new form of 'remix culture', a phenomenon that other analysts of new technologies and visual media have called 're-mediated culture'.

Street art contests two 'regimes of visibility': that of government and legally authorized display (usually commercial) on one side and of the artworld on the other. Its 'semiocracy' works against advertising for example by asserting the possibility of subjects other than the consumers projected by advertisers, and 'scrambling' or 'jamming' the messages implicit in designed and managed urban space. It is in these oppositions that something like a postmodern politics of street aesthetics might be located.

Irvine concludes by suggesting that the term 'street art' may have become redundant, simply a 'short-hand term for multiple ways of doing art in dialogue with a city in a continuity of practice that spans street, studio, gallery, museum and the Internet'. As a polemical term, however, it remains useful to indicate a group of concerns and approaches to new forms of visual practice and experience. Street art seeks to 'answer back', to reassert demotic presence in the controlled, dematerialized visuality of the city, to rematerialize and resocialize urban public spaces. It contests the orders imposed by both legal display and artworld institutions, demonstrating that art can appear in nonart public spaces. It also contests an impasse in postmodern art and art theory, the continual reinstitutionalization of cultural transgression and its 'consensual disunity'. We might also underline the thought that street art and self-conscious urban graffiti are the first products of a generation of creative individuals fully at home with the Internet and digital technology, and as such a model for post-Internet practices of remix and hybridization.

Irvine concludes that street artists have come to terms with the idea of culture—and especially visual culture—already being hybrid, impure and dialogical, and is working with this insight more successfully than much gallery- and museum-based art. In this context he notes the importance of a recent case brought against a prominent street artist for copyright infringement, the significance of which is the difficulties faced by legally sanctioned regimes of visibility in coming to terms with the realities of postmodern and post-postmodern global culture.

Visual Culture and Contemporary Art: Reframing the Picture, Recasting the Object?

ROBIN MARRINER

The phrase 'visual culture' has, at least within the context of contemporary art culture, been understood to have a double aspect. On the one hand it has been perceived as referring to a hybrid or multi- and inter-disciplinary intellectual field that has emerged in the last twenty years or so which has as its focus of study the objects, practices and institutions of those aspects of culture which are considered primarily visual.[1] That is, a field that takes as its object of study cultural phenomena, which would include contemporary fine art itself, and aspires to theorize how such cultural phenomena mean.

On the other hand visual culture is taken not to designate the intellectual field but rather that which is claimed to be the object of the field's study. Within this meaning art culture is itself a subclass of the phenomena that is constitutive of visual culture, along with for example advertising, television, cinema, photography, fashion, the Internet and so forth, but in much art world writing visual culture is used as a shorthand to reference those visual phenomena other than art itself. Visual culture is taken as synonymous with 'popular culture' or 'mass culture' or 'nonart culture' and what is usually under discussion is the relations between the two.

In this chapter 'art culture' or 'contemporary art' as in the art world itself is being used not to reference all artworks being made or forms of artistic production being presently or recently engaged but rather that fraction which, in virtue of its preoccupations and values locates itself or is locatable in relation to (1) notions of the history of Modern Art as constructed in innumerable academic texts, as locatable in relation to (2) 'already' significant modern artworks (as embodied/celebrated in e.g. those art historical texts, and the collections of museums of modern and contemporary art), in relation to (3) the kind of work and critical debates that are presented in contemporary and recent art journals such as for example *Artforum, Artscribe International, Frieze, Art in America, October, Parkett, Flash Art, Modern Painters, Art Monthly* and in relation to

(4) works shown in the network of dealers' galleries of international standing in New York, Frankfurt, Cologne, Berlin, London and so forth, or in the international art fairs that they now attend. That is by contemporary art what is being referenced are the objects and network of social and discursive institutions and practices which in conjunction are productive of present artworks and art culture, constitutive of 'the artworld' (see Bourdieu 1993: 78).

In what follows it will be suggested that for most of the twentieth century the relations between art and visual culture (i.e. as understood as mass or popular culture) have within the art world been understood essentially in terms of two narratives: one, that art feeds upon and is reinvigorated by popular culture, two, that popular/mass culture and art culture are antagonistic and a threat to each other. The latter to the former by way of critique or exposure of the former's ideology, the former to the latter by way of recuperation and erasure. Both of these narratives carry certain epistemological allegiances or assumptions and values within them, epistemological allegiances and values that are alignable with the differing versions of the model through which during this period culture has been widely pictured and understood, namely modernism (Jameson 1984). What complicates the task of mapping the relations between contemporary art and visual culture now is that in the latter part of the twentieth century, in what in a stricter sense might be thought of as the contemporary, is that the above perceptions of the relations have been interrogated and problematized across several different areas of theorizing and disciplines (e.g. philosophy, film and photographic theory, sociology, cultural studies, feminist theory), disciplines which have been brought together to form visual culture as an intellectual field. At the same time many of the allegiances and (epistemological) assumptions of modernism that have underpinned art and critical practice in the art world in the twentieth century have themselves come under scrutiny and their persuasiveness challenged by drawing from the same sources: for example as will be explored below, the idea of the autonomy of artworks, of how the production of their meaning is to be understood, and of how they and how mass or popular culture are consumed and so forth.

What is being suggested here is that what makes the mapping of the relations between contemporary art and visual culture particularly complicated is that though the relations between visual culture (mass culture/popular culture) and art culture have been contentious and debated from early within modernism, from way before the time the term' visual culture' became well circulated, in the latter part of the twentieth century the grounds of those debates have been challenged in such a way that for some people at least their terms have been reconfigured: the ontological nature and conditions of meaning of for example pictures, paintings, sculptures have been retheorized (as part of debates about modernism and postmodernism), not least by those disciplines that have come to be designated as making up the intellectual field of visual culture. It will be argued below that the disciplines that make up this intellectual field have had real effects on the territory—both 'nonart culture' and 'art culture'—that is the object of their analysis and theorization, in the case of the art culture to the degree that our idea of pictures has been reframed and of sculpture recast. Additional to the complexity this creates

any mapping offered is inevitably going to be viewed as contentious since the relations under consideration here have been and are still themselves sites of contention within contemporary art culture itself.

REINVIGORATION

Despite the disclaimers to the contrary within the rigorously articulated formalism of the 1960s and 1970s (e.g. Fried 1965: 7) it is evident that art is a social phenomenon and as was said above, has had relations to nonart culture even before the term 'visual culture' was coined to so designate it. From the representation in late-nineteenth-century painting of aspects of popular culture, e.g. by Seurat and Manet, and the physical inclusion of elements of it by Picasso and Braque in their cubists 'papiers colles' of 1911/12 as a means to signal 'modernity', through much work of the twentieth century (for example most conspicuously but far from exclusively, Pop) there are many instances of art culture drawing from popular culture for its subject of representation, its materials and processes and its aesthetics. A narrative of the 'key exchanges through which artists have expanded the languages of art by taking up styles and forms found outside the usual precincts of the museum' was fairly comprehensibly, though not unproblematically, presented in the 1990 exhibition at MOMA New York entitled 'High and Low: Modern Art and Popular Culture'. Through a series of divisions used to categorize the popular, words, graffiti, caricature, comics, advertising, the exhibition clustered the art in terms of its perceived beholdenness to each of the categories. But as the title of Roberta Smith's review of the exhibition in the *New York Times* suggested, 'High and Low Culture Meet on a One-Way Street' (1990) the organization of the show acknowledged nothing of the purported interchange between art and the popular nor other than a very traditional notion of the way in which the popular entered into art. Not unconnectedly and more profoundly Smith and others, e.g. Paoletti (1990) critiqued the show for its lack of any acknowledgement of the theory or (art) practice of the prior decade that had interrogated and in some cases rejected the validity of the grounds for the very hierarchy on which the exhibition had been premised and through its omissions seemed to be sustaining. In effect what was omitted and ignored, the theorizing of meaning offered by structuralist and poststructuralist philosophers, the challenge to the art world's perception of consumption presented by the analysis of consumption offered by cultural studies, the theorizing of representation with reference to film and photography drawing from semiotics, and the theorizing of notions of selfhood and identity developed by feminism and so forth, all of which had gained a degree of currency and circulation in the more general culture by the late 1980s as well as with emerging artists, was the very material which by 1990 was being drawn together to constitute the field of visual culture itself. Perhaps it is here worth noting, as signalling the complexity of the terrain for which a map is being sought, that in the year previous the exhibition 'The Forest of Signs: Art in the Crisis of Representation' at the Museum of Contemporary Art, Los Angeles, which drew heavily on the art and theoretical material that High and Low ignored, was itself criticized for doing just that: being too theoretically driven and politically correct (see e.g. Gilbert-Rolfe (1989) 1996).

THREAT AND ANTAGONISM

The other major and recurrent narrative within contemporary art culture in relation to visual culture (popular or mass culture) is the one of threat and antagonism. Originating in a range of nineteenth-century responses to the development of industrial capitalism and concerns about the quality of life, (for example Mathew Arnold, John Ruskin, Karl Marx) but in its contemporary formation more dependent on Marx and later Marxist theoreticians' development, for example on the early 'marxist/trotskyist' writings of Greenberg ((1939) 1961, (1940) 1985), on the Frankfurt School and in particular and recurrently Adorno and Horkheimer ((1944) 1969), Adorno ((1970) 1984) and in the late 1970s on Althusser (1971), the art world has sustained a view of itself and its objects as transcending social determination and in opposition to the ideologically permeated and socially 'complicit' objects of mass (commercial) popular culture. With varying degrees of complexity and supportive argumentation Greenberg and Frankfurt School thinkers (particularly, Adorno and Horkheimer ((1944) 1969) and Marcuse (1979)) and those who would claim them as influences (e.g. Fuller (1980), Gablik (1981, 1984), Kuspit (1988, 1993), the writers of the journal *October* (Foster et al. 2004) have propounded the thesis that kitsch (all of culture excepting high culture for Greenberg) or mass culture or commodity culture is essentially ersatz or inauthentic and within capitalism is used to orchestrate and choreograph our desires and pleasures in a manner that makes them compatible with the system. Though some distance from uniform in their conception of the nature of art and how it is oppositional to its other, Greenberg arguing the need for art to pursue autonomy, disengage from the social/political in order to avoid 'contamination' by its values and thus render itself more open to recuperation by the system, Adorno ((1970) 1984) more complexly arguing that art has a double status that is at once 'social' and 'autonomous' and it is in the contradiction of these two positions within capitalism that the development of modernism is to be understood:

> the history of modernism is, at base, the history of those aesthetic strategies through which the work of art (the commodity as fetish) has resisted its own social form (the commodity as exchange) in order to be able to reveal, through its difference from it, the true meaning of the social order of which it is a part, as a form of un-freedom. (Osborne 1989: 40)

What Greenberg and Adorno do have in common that it is through art's existence/presence as in some sense autonomous rather than through overt political engagement in critique that its oppositionality is provided. The presence of the real aesthetic in the world indicts and discloses the inauthenticity of the rest of culture (albeit, if only briefly according to Adorno). The reconsideration of Marx in the late 1960s by Althusser, particularly Althusser's writings on ideology and the construction of ourselves as 'subjects' which began to circulate in the cultural debates of the 1970s (Althusser 1971), provided at least in some circles a shift through offering a rationale/licence for a more overt concern with the political in art making, one that enabled to a degree a reconciliation between politics and the self-referential concern with the language of art that had been central to

the (late modernist) concern with autonomy by harnessing the latter to a deconstruction of how that language was itself instrumental or productive in giving us a sense of self, 'interpellating' subjects in the image/text text work of Victor Burgin and Barbara Kruger (see New Museum of Contemporary Art 1985). For the most part though the narrative drawn upon and shared within the art world—even by those whose positions were in many respects antithetical to each other, either from the right in wanting to characterize and emphasize the threat that commercial culture and its values provided to high culture (see e.g. Fuller, Gablik, Kuspit on Warhol) or from the left in trying to defend and sustain the possibility of art having critical or radical potential (e.g. editorial contributors to *October*)—was that provided by Adorno et al. A narrative that in effect says that popular/mass culture is produced under capitalism to support and sustain present social arrangements is (therefore) permeated by and the carrier of the dominant ideology, and has its meanings unproblematically consumed by those to whom it is presented.

It is these very elements that are here drawn upon and used in art culture's construction of its other and of itself and on the basis of which its narratives about its relations to that other, whether reinvigorating or antagonistic, have been based that in more recent history have been challenged, and depending upon one's persuasion, seen to have been reconfigured.

THE CHALLENGE TO AUTONOMY

Though in circulation since the eighteenth century, as has already been mooted, one of the concepts most central to an understanding of the nature of the art of the dominant tendency of the twentieth century and of its perceived relations to its other is autonomy. Not only in philosophical aesthetics, in art criticism and narratives of art history has the notion been fundamental but as the twentieth century progressed it became so in the thinking and practice of artists themselves. The latter reached its apogee in the 1960s and 1970s, particularly in the USA, where notions of subject matter and quality in both painting and sculpture came to be understood in terms of a progression towards a concern with the nature or 'essence' of the media themselves to the exclusion of anything else, for example in the painting of Kenneth Noland or Jules Olitski, or in the sculpture of Don Judd. Despite the combative stance taken at the time by the advocates of 'Modernist Painting' and 'Literalist Sculpture' (in effect 'Minimalist Sculpture'): the distance from and disavowal of Modernism claimed by Judd ((1965) 1975), the denying of art status to Minimalist work by Fried ((1967) 1968), subsequently there has been a substantive body of opinion (see Foster 1985; Krauss 1977) that both were working within the same (modernist) paradigm. Fried's notion of 'presentness'—that the best painting of the period is about its own nature *qua* painting and discloses its meaning instantaneously at the moment of our encounter, and Judd's notion of 'literalness', that the best objects are nonillusionistic, and obdurately and literally themselves—both (despite their mutual recriminations) subscribe to the idea of art's autonomy. Both are propounding the idea of there being objects in the world which are totally nonrelational, totally self-referential and meaningfully able to declare that.

Despite their eminence, problems could have been found internal to both Fried's and Judd's writing from the outset. Fried, for example both wanting to claim that the meaning of modernist works e.g. Olitski's paintings was disclosed in their first moment of perception and at the same time that if all one saw when encountering a painting such as *Pink Shush* or *Comprehensive Dream* 1965,[2] was the colour then 'one had not seen them as paintings' (Fried 1966: fn 8) and Judd slipping from characterizing 'specific objects' through a series of negative relations, e.g. nonillusionistic, nonreferential, and so forth to such objects having 'no relations' but being 'obdurately and literally themselves' (Judd (1965) 1975), see *Untitled* 1967 & 1976.[3] That is, in both cases it could be said that our assent to and understanding of the claim that the meaning of the art is inherent, immanent, is sought through a series of arguments which evoke and put into play notions of relations that in their conclusions they disavow or deny. Perhaps not surprisingly then, it is when theories that articulate meaning in terms of relations and challenge the theories that underpin modernism start to circulate and eventually penetrate the art world that the notion of autonomy and immanence begin to loose their credibility.

Initial circulation in English-speaking culture of what somewhat disparagingly in some quarters became designated as 'French Theory' (and in so doing giving it a homogeneity that it does not have) in relation to the visual took place initially for the most part in journals concerned with film (and to a lesser extent photography) such as *Screen* and *Screen Education* in the 1970s. It was there that structuralist and semiotic works were both presented (e.g. Levi-Strauss and Barthes) and drawn upon in debates about the nature of cinematic (and later in the decade, photographic) language and of the ideological/political position they had within the culture. (This began to ripple out towards the end of the 1970s and the early 1980s into the art world through 'small/independent' magazines like *Real Life* and *ZG*.) Whilst not wishing to underplay the differences between the work of individual (French) thinkers or between those designated structuralist or poststructuralist of more importance here is what they share and have taken from de Saussure's *Course in General Linguistics*. In this text Saussure offers an account of how linguistic signs mean that has provided a model for approaching and understanding how any sign system means. A 'sign' for Saussure comprises two elements: a signifier and a signified. The former is the sound or image or letter forms (word) and so forth that is used in acts of communication, the latter the concept to which it refers, its meaning. For example the letters form 'd-o-g', the sound 'dog' is the signifier which in English refers to the concept of a four-legged domestic animal. In elaborating how a sign means Saussure introduces two propositions which, despite subsequent reevaluation of some aspects of his theory, have become and remain of fundamental and central importance to both structuralism and poststructuralism: (a) that a sign is differential, part of a system of meaning where it gains significance in virtue of and in relation to what it is not. (In itself the sound/letter form 'dog' means nothing but comes to mean in virtue of its difference from 'log', 'dig' and other signs which it is not.) Or as Saussure says systems of meanings have no positive terms, they do not mean as former theories of meaning have claimed in virtue of a concept or object that they 'label' or name; (b) that the meaning of a sign is arbitrary (unmotivated): that a particular sound/image, word signifies a

particular concept, e.g. 'dog' a 'four-legged domestic animal etc' is not a natural but a cultural connection. Saussure's account introduces a distinction between the 'system' of language (*langue*) and individual utterances or iterations (*parole*) that comprise its use. For Saussure and for the structuralists it is to the workings of the former that we have to look to grasp how meaning works. The difference between poststructuralism and structuralism can be understood in terms of the different weight given to the system and to the individual iterations or contexts of its use in explaining meaning. As was said above what is of central significance here despite their differences is what they share, namely that something only takes on the status of a sign, becomes meaningful within a system, that meaning is *relational and conditional*. Assenting to whichever version of the way this has been drawn out, e.g. whether Barthes, as articulated through notions of intertextuality in 'The Death of the Author' and 'From Work to Text' ((1968) 1977) or Derrida's challenge to our understanding of the mutual exclusivity of the concepts of interiority and exteriority in *The Truth in Painting* (1978), casts claims that meaning can be inherent, immanent, or present in/to the sign as untenable because they have misconstrued the logical conditions under which meaning can transpire.

The growing circulation of theory that challenged the epistemological allegiances of modernism enabled the critical rereading of the meaning and significance of work that (late) modernism had marginalized (e.g. Robert Rauschenberg (Crimp 1993), Ed Kienholz (Whitney Museum of American Art 1996)) (which in turn themselves impacted on art practice), at the same time new work emerged in practice that appeared either as retrograde and vastly inadequate by modernist criteria or as itself challenging or critiquing or rejecting the values on which those criteria were grounded. Works such as the paintings of David Salle, Sigmar Polke, Gerhardt Richter, and later Glenn Brown which overtly acknowledge their source material and their interconnectedness (intertextuality) both at the level of image and facture with other culture, art and nonart; works such as the sculpture of Richard Deacon, Grenville Davey and Robert Gober which offer ostensibly abstract and minimalist forms that at the same time reference their relations with the wider culture (whether anatomical/organic, functional and symbolic, coke/pill bottle tops, or urinals or hand basins), that minimalism disavows, or the sculpture of for example Jeff Koons and Haim Steinbach which challenges the very grounding for the modernist distinctions between sculpture and nonsculpture (see below); or work such as that of Robert Longo which in its 'dated' 'devalued' and 'appropriated' conventions of representations (graphite photo-illustrational drawing, reliefs, bronze figurative memorial-type sculpture) and its hybrid form, seems wilfully (or with an incredulous degree of ignorance) systematically to transgress every late-modernist edict on art making, see Figure 6.1 *Love Police and the Golden Children*, 1982/83. Through theoretical critiques of the epistemological underpinnings of late-modernist art practice and through the impact that reformulated ideas of meaning had on practitioners' concepts of the nature of objects and practice the writings of visual culture directly and indirectly might be seen to have had marked effects on the practice of criticism and the practice of art making itself. Effects that are not perhaps separable from the shift from the modern to postmodern.

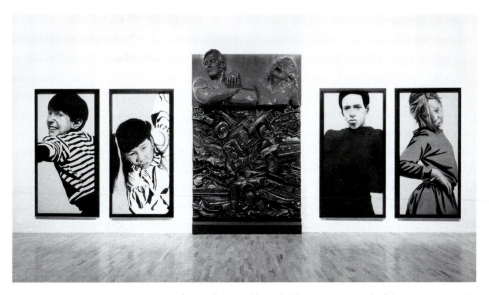

FIGURE 6.1 Robert Longo, *Love Police and the Golden Children,* 1982-83, relief: lacquer on cast aluminium and cast bronze. Courtesy of the artist, © Robert Longo. Photograph: Robert Longo Studio.

RETHINKING THE RELATIONS OF ART AND ITS OTHER

In a lecture given at the Whitney Museum of American Art towards the end of 1981 Frederick Jameson (Foster 1985), in an attempt to characterize the postmodern, declared (not without a degree of ambivalence) that the distinction between high culture and so-called mass or popular culture had been eroded:

> The second feature of this list of postmodernism is the effacement in it of some key boundaries or separations, most noticeably the erosion of the older distinction between high culture and so-called mass or popular culture. This is perhaps the most distressing development of all from an academic standpoint. (Jameson (1981) 1985: 112)

This will be discussed below. The threat to art from mass culture as was said earlier has been a long-running narrative in the art world, and its embodiment most correspondent with Jameson's utterance was seen to come from Pop. From its outset in some quarters (e.g. Kozloff (1962) 1970) Pop had been perceived as bringing the 'vulgar' into the realm of high culture, over time it became Warhol who was perceived as the main offender (Fuller 1980; Gablik 1981; Kuspit 1993). In the same year as Jameson's lecture was published for example Gablik slammed both Warhol and his work as offering an uncritical celebration of popular culture and an unashamed embrace of capitalistic values, and in the subsequent book followed up with:

> Does truth lie, for instance in the lonely defiance of Van Gogh, bruised by poverty and pain, who claimed that the only lesson we have to learn from life is how to stand up to suffering, or does someone like Warhol provide us with a model image for the artist of our time, with his social bravura and celebrity life, playing it straight to a world in

which everyone can be famous for fifteen minutes? (According to Warhol fame is what makes life liveable.) No one is likely to dispute the extent to which these conflicting images of power and personality are totally at odds with each other. (1984: 84)

This was a criticism repeated but with even more vitriol later by Kuspit in *The Cult of the Avant-Garde Artist*. There was however a different perception of Warhol's work already in circulation, albeit limitedly and initially somewhat slowly, namely that offered in a remark by Steinberg (1972) in his essay on Rauschenberg to the effect that though both Rauschenberg's and Warhol's work could be said to give the viewer an image of the world through their use of silk screens, more accurately it is an image of an image of the world that we are given to look at. In presenting us with images of images, ones from the public domain, for example of Marilyn Monroe (*Marilyn Diptych* 1963) or a car crash (*Orange Disaster* 1963), but separated from our normal context of encounter, e.g. a newspaper or magazine, and in their half-toned printing and colouration underscoring their flatness, it is the image itself that is drawn to our attention rather than or as much as Marilyn. One might see the work as concerned with the ways in which images contribute to and are constructive of our views of for example glamour and celebrity and tragedy, of our views of the world and not merely copies of it. The reading of Warhol's work as exploring the nature of media representation and the effects of media representation on our perception and conception of the real (rather than as either a failed critique or celebration of commercial culture) gained circulation and acceptance amongst certain artists and critics perhaps not surprisingly as theory which itself to a degree had the same preoccupations was better disseminated (Lawson 1981). The purchase that semiotics enables both practitioners and theorists to get on how (initially photographic) images mean (e.g. Barthes (1961) 1977; Metz 1973; Burgin (1977) 1983), to get beyond the language of form and content (see thinking entrapped and trying to break out in Sontag (1966)), where content or meaning is (problematically) written of as somehow identifiable in separation from its mode of presentation, and instead, through notions of signifier, signified and code, show that what something means, what is it, is inseparable from how it is what it is, undermines the concept of a photographic image being a mirror or window on the world.

To make this more concrete, using ideas from Barthes and Metz we can approach Robert Frank's image *Movie Premier—Hollywood* 1958, (Frank 1958: 141).[4] This black-and-white photograph has centrally placed and occupying about two-thirds of the picture plane an image of a glamorous blond starlet, head and shoulders. Not just the caption but her clothes, hair style, jewellery and so forth suggest that it is the 1950s and America or do so if one already has certain knowledge that allows that detail of recognition. Behind her at a distance, between her shoulders and the photo's edges, at the opposite side of the (unseen) red carpet to the photographer are a line of women, in appearance much less glamorous or expensively dressed. The initially odd thing about the photograph given the then rules of good composition and clear subject matter is that the centrally placed woman who occupies most of the picture, and therefore one expects to be the subject, is (slightly) out of focus, the women beyond are sharply in. In effect this

is a photograph about fandom not about the movie starlet and that it is so is because of the 'how' of its imaging. Metz writes about what he designates as 'specific' and 'nonspecific' codes that combine in an image: the former being those elements that contribute to the meaning of the image that are specific to the medium, e.g. in the case of photography, framing, depth of field, tonal values, angle of shot, the latter codes that are at work in and that we have learnt from more general social experience, e.g. facial expressions, body postures, hair styles, clothes/fashion, interior design, architectural features and so forth. The Frank photograph draws upon and puts all these codes into play but what makes it have the particular meaning that is being claimed here, as opposed to other possible photographs that could have been taken at the same moment from the same spot is its focus and depth of field. The same event (what Barthes calls the 'pro-photo' event, the event/scene before the camera (Barthes (1961) 1977)) could have been shot using the same depth of field but with the actress in focus and the spectators out in which case it would have become a more orthodox image of her with blurred background, it could also have been shot with a greater depth of field in which case both she and the spectators would have been in focus. The point being that in each of these alternatives the event before the camera would have been the same, what gives the actual photograph its particular meaning as being a study of fandom is how it was photographed: how it is what is it is makes it what it is. An image is always a combination of a pro-photo event and its manner of recording, though common sense tells us otherwise (and many forms of photography, e.g. advertising, fashion, pornography play on that), the pro-photo event is not in itself retrievable from the image. Metz's writing at this point is focused on 'signifiers' internal to the 'text'/image, as is mooted above and will be discussed further below, how one reads a signifier or even recognizes a signifier as such is dependent upon knowledge that one brings to the 'text' and the context of one's encounter.

What is exemplified here and of particular importance to the overall concerns of this paper is that the work drawn off of semiotics in relation to the visual demonstrates that engaging with images is *active*, involves an act of reading or decoding. This it is suggested is true of all images not especially art images, that in reading certain knowledges and competences are drawn on. What marks the difference on this account between high and 'low', 'mass', 'popular' culture is not that one is engaged with actively and the other passively but the different knowledges that are drawn on in those engagements. The binaries art/mass culture, active/passive consumption become uncoupled.

Despite a long history subscribing to the ideas that (visual) art can 'get to the parts of you other culture can't', (Tolstoy (1898) 1969: 178; Bell (1913) 1958: 28), and more recently the idea that we can 'directly' perceive/experience art (Fried, Judd, Krauss), contemporary art culture has taken within itself theorists who explore and debate the conditions of art being experienced and what they would argue is the knowledge only in relation to which artworks become intelligible: for example from philosophy Danto has argued that what makes something a work of art is a body of theory, a knowledge of art history and an art world (1981), Derrida has interrogated the ostensible mutual exclusivity assumed to apply to the fundamental notions of art theorizing, for example object and context, interior and exterior and shown their logic of mutual interdependence

((1978) 1987; also see Marriner 2002). And from sociology Bourdieu has examined the ground of the distinction between high and low culture and challenged the idea of the pure aesthetic (1993).

The serious consideration of the knowledges at work in the engagement with and reading of mass/popular culture has been developed through both theoretical and empirical work that has come to constitute the field of cultural studies. Not only has this provided a massive body of material testifying to the active engagement and knowledge demanded in the consumption of popular culture (e.g. Fiske 1989; Hebdige 1988; Strinati 1995), but also the complex modes that engagement can take. For example Hall (1993) categorized three positions that viewers can take in engaging with cultural images and artefacts: one where we align ourselves with the hegemonic position and read the dominant message of an image or text in an unquestioning manner; two, where we negotiate a meaning from the image and its 'dominant' meanings, i.e. struggle to make the image meaningful through some form of 'reconciling' what we take the image to bring with it with what we bring to it (our own memories, knowledge and cultural frameworks); three, where we disagree with the values, ideological position we see to be embodied in the image and oppose the proffered meaning through contestation, critique or rejection/ignoring it (see Baudrillard 1983).

Even if one admits part of the received art world narrative on its other, that the culture produced under capitalism is the carrier of meanings supportive of or at least consistent with the maintenance and perpetuation of the system—which much cultural studies theory would in some form or other accept—what culture studies has done is radically to critique the other part of the narrative, that unquestioningly repeated from the Frankfurt School, namely, that the 'masses' are duped. Not just within the literature on subcultures (Gelder and Thornton 1997) but in that around consumption (Lury 1996) and material culture (Miller 1987) and that arising from feminism in the 1980s and 1990s (e.g. Attfield and Kirkham 1989) complex relations between cultural products, artefacts, institutions and persons are mapped out and elaborated that show how few viewers' experiences comply with Hall's first category above (historically, the art world's preferred option). Category one assumes a congruence between the meaning of a cultural product aimed at a mass and the specific (individual) experiences and memories and desires of a mass of people. What cultural studies research has shown is that cultural products with a mass audience have very different meaning to the different (interest) groups that are counted collectively to make up that mass (e.g. the audience for a television 'soap').

Though far from universally acknowledged or accepted throughout contemporary art culture (e.g. Foster et al., or Kuspit), the literature from culture studies that has been taken into visual culture as an intellectual field has opened up and provided justification for a 'post-Warhol' practice, i.e. art making that addresses and explores our lived experience of popular culture, of mass media, of an image-saturated world—most conspicuously perhaps in the work of Cindy Sherman, Richard Prince, Andreas Gursky and the painters included in *The Painting of Modern Life* (Rugoff 2007)—rather than condemning that experience or excluding it from art as beyond the pale.

The study of peoples' lived relations with objects, of the meanings generated at their moment of consumption, and the idea that meaning is relational can be seen to have implications in other areas of contemporary art too. Here there is space to only touch on two of these.

THE SHIFT FROM OBJECT TO SIGN

Perhaps with the cultural studies and anthropological examination of the lived relation between people and objects and the questioning of autonomy it is not surprising, given that for most of the twentieth century sculpture has been designated and demarcated through the use of the concept 'object' (that it is a class of object marked off from other objects because of its nonfunctionality) (e.g. Tucker 1974; Krauss 1977), sculpture theorizing and practice becomes a territory of contestation in the 1980s. Though in many eyes Minimalism was seen as still the dominant paradigm (Cooke 1987) aspects of objects that in minimalism and late-modernist accounts had been excluded or repressed began to reappear. For example, as mentioned above in the works of Deacon and Davey and Gober and Cragg where play was made of both the work as object and as a signifier and image, and increasingly within theorizing where the idea that not just images but objects are (never just objects but) also always signifiers gained circulation (Baudrillard (1968) 2005). Perhaps, though, the sharpest challenge to the modernist narrative about sculpture and the epistemology that underpinned it can be seen in the works drawing on and using mundane or nonart objects of Jeff Koons and Haim Steinbach. Koons's show 'The New' for example presented a series of sealed Plexiglas vitrines that contained brand-new (physically unmodified) vacuum cleaners seated on shelves which were underlayed with fluorescent tubes. In their presentational form (cubes, frontality, use of Plexiglas, fluorescent tubes, etc) they can be read to reference aspects of minimalism but in their presentation of new consumer objects par excellence in a gallery it is not difficult to see them as asking questions about the difference (if any) between the way in which 'newness' is fetishized both in the consumer world and that of modernist art. Subsequent shows, for example 'Equivalence' using flotation/swimming devices in conjunction with basket balls and reproduced images of street basket balls teams, or those drawing on romance and pornography with la Cicciolina, 'Made in Heaven', seem centrally to be concerned with examining the grounds for marking difference between objects. In Steinbach's work too there is an initial reference to minimalism through his use of the hand-constructed laminate shelf-like forms on which he displays and juxtaposes (ready-made and often mass-produced) objects. At the same time as alluding to Judd's work the units also have a resemblance to particular shop display units (e.g Habitat) and to 1980s designer domestic shelves (they are 'Memphis' like). Each of these different references puts into play knowledges of different kinds of social spaces, different expectations of the kind of objects we are going to encounter, and different concepts of appropriate ways of 'looking'. They draw attention to and destabilize or unfix relations we normally take for granted. Given the context of our encounter with them, i.e. an art gallery, the works in their presentation of 'nonart' objects in this particular presentational

and equivocal form can be seen as a meditation on where the meaning of objects reside. In both cases, Koons and Steinbach in their works seem to cross the borders between high and low culture and as such provide confirmatory instances of Jameson's contention about the nature of the postmodern that the distinction between high and popular culture has been eroded. Though their work might be seen to challenge Modernism in that it challenges the epistemology on which modernist ideas of art are founded, it seems to me to present itself very much as art. Its postmodernism is not tied to the erosion of difference between high and low/popular, but in where it locates that difference to be grounded: not as inherent qualities of the objects but in their relations with the social, institutional and discursive realms within which they circulate and are encountered. Koons and Steinbach could be said to make the sign value of objects they use the language of their work, the works' meaning is dependent on exactly that which minimalism and late-modernism banished from practice (Marriner 1990, 2002). It is only for example in the late 1990s that sculptors who have been marginalized through that banishment and might be seen as precedents for using sign value begin to get revalued, e.g. Edward Kienholz with a retrospective at the Whitney Museum (Whitney Museum of American Art 1996).

INTERTEXUALITY AND AUTHORSHIP

In terms of traceable direct consequences, one of the pieces of theory that has had the most potent effects on the contemporary art world must be Barthes's essay 'The Death of the Author' ((1968) 1977). This essay and its companion piece, 'From Work to Text' both underscore the way in which the meaning of 'texts' are dependent upon the interrelations between rather than the 'autonomous' 'isolation' from one another, and put emphasis on the moment of consumption as a moment of meaning making. Though taken somewhat literally in some circles (e.g. Belsey 1980) read calmly despite its attention-grabbing title Bathes seems less concerned with ridding the world of authors/artists than in undermining a particular notion of maker as promoted by modernism, 'the author god'. In part there is something of Benjamin's exhortation for the writer/'artist' to reflect on his position in the production process and for his practice to draw the reader/spectator as collaborators into that process of production (Benjamin (1934) 1983); in part there is something of Machery's insistence, published a couple of years before the Barthes's essay in France, of the author as 'producer' rather than creator, of Machery's emphasis on the author's/artist's relationships to material of one kind and another from which the work is constructed in opposition to its being brought into being from nothing on the model of a creation by God (Machery (1966) 1978). Barthes's position could also perhaps be understood as a salutary kind of social anthropological or epistemological reminder of just how much has to be in place, what practices, institutions, concepts, values, knowledges, in order that an impulse, desire, thought, act can be an artistic one either to ourselves or to another. And how none of that which has to be in place originates from within ourselves. A reminder of just what, were we to be asked say by a person from outside of our culture about the significance of smearing pigment on a piece of

cloth would have to be narrated in order that the meanings to us of that could become intelligible to that person. That we should remember with respect to what contributes to something being significant, meaningful—as opposed to being 'noise'—that what we normally focus on is merely the tip of the iceberg.

For anyone who subscribes to a notion of artistic agency based on a model of the creativity of God, this claim is perhaps sufficiently deflationary (especially if one also suggests that the artist/maker himself is encultured) to amount to the artist's/author's death. To anyone else it could be seen to offer a humbler, less mystificatory idea of the ways in which things come to have meaning for us and of the 'personal' contribution one can make to its production.

Responses to these ideas in the art world, in both criticism and practice have been quite extreme: from on the one hand dismissal and a reassertion of 'subjectivity', for example in the writings of Kuspit (1988) where these ideas are seen cynically to promote/exploit the demise of originality, imagination, authenticity and require an antidote of subjectivism as exemplified in the artworks of Neo-Expressionism, to on the other hand (initially at least) total acceptance: for example in Jameson's account of postmodern 'authorship' and Sherrie Levine's rehearsal of Bathes's argument through practice in her display of (overtly) appropriated images of 'Master' photographers or the (re)-painting of Picasso's paintings by Mike Bidlo, or the overt recycling of imagery by Salle (touched on above). Because Barthes's essays offer more by way of critique than by way of plausible alternatives—having argued that the condition of meaning in a text is its interrelations with other texts, and critiqued realism for effacing its own workings, the few examples given of what he seems to approve of and advocate by way of acceptable are texts that adopt established modernist and avant-garde strategies of referencing themselves and their own (internal) textual organization—it is perhaps not surprising that for a period art practice that takes the writing seriously gets locked into a reiteration of 'the critique of authorship'. The more significant legacy, at least among those who believe Barthes's criticism of received notions of authorship has a validity, has been not a repetition of its utterance but an acceptance amongst practitioners not of the death of originality and agency but of the idea that disclosing the real conditions of meaning of their work and their part in it necessitates their acknowledging the work's beholdenness to other work. Across most areas of contemporary art practice it is possible to see significant work where this is done.

CONCLUSION

Though in its entirety Modernist Art is far from uniform and monolithic in its philosophy, in its models for artworks or in their values, that moment of it, usually designated as Late-Modernism, that falls within the direct remit of this chapter could perhaps be said to be an exception. 'Modernist Criticism' as articulated by Greenberg and his acolytes between the late 1940s and late 1970s gained a sufficiently ubiquitous degree of ascendancy in both art-making and art-exhibiting circles to constitute the 'dominant' paradigm for 'serious' art (Jameson 1984; Foster 1993). The idea that each art form has

qualities unique and specific to itself, and that modernism in art can be understood as the gradual movement of each of those art forms towards its own essence—in the case of painting for example to the acknowledgement of flatness—provided a model for art making and criteria for both quality and (which was not unconnected) progress in art during that time (Greenberg (1965) 1982). 'Greenbergian Modernism' generated the underpinning rationale for and the frame within which works deemed significant by 'significant' critics (Greenberg himself, Fried, Krauss, Rose), by 'successful' artists and 'major' curators (for example at MOMA and the Metropolitan Museum of New York) were to be understood (e.g. Rubin 1970; Geldzahler 1969), and furnished a degree of shared certainty about quality (for exceptions/dissent see e.g. Rosenberg 1972; Steinberg 1972). One of the consequences of the challenges described in this chapter to this version of modernist ideas has been to unsettle that notion of certainty. Much of the work of the 1980s as we have seen created anxieties about loss of quality (e.g. Cooke, Kuspit), and subsequently debates about whether art culture was embroiled in its demise or redefinition. Twenty or so years of the lack of a dominant paradigm and the acknowledgement of areas of art making as involving contestation over what constitutes quality are no longer seen as grounds for defensive apprehension but embraced as distinguishing characteristics of what makes the field contemporary, for example in the large-scale survey books Vitamin P, and Vitamin 3-D (Schwabsky 2002/2004 and Ellegood 2009, respectively).

But of at least as fundamental importance to the nature of the contemporary and the challenge to Greenbergian modernism of the above has been that which interrogated the idea that art forms (or anything else for that matter) can be defined in terms of an essence. The rejection of essentialist theories of meaning in favour of relational theories not only undermines the claim that each art form can be demarcated in virtue of a specific property but also that quality of works can be assessed in relation to their acknowledgement of and progressive movement towards that specific property. Progress, or 'advancedness', and quality are on the Late-Modernist view tied to a process of purification of the medium, and importantly therefore quality can only be understood in relation to and as belonging within specific definable art forms, e.g. painting or sculpture. With the undermining of 'essence', the persuasiveness of the medium specificity of quality collapses too. One of the conspicuous differences between the contemporary art world and that of for example the 1960s and 1970s is the enormous quantity of work that is produced and exhibited now that ruptures the boundaries of or exists between the boundaries of what in the earlier period would have been deemed an art form, work that on late-modernist criteria would be 'impure' (e.g. the subtitle of the book Vitamin 3-D above is '*New Perspectives in Sculpture and Instillation*' not just sculpture). Such 'impure' work can vary from the three-dimensional which sees itself as and as interrogating the nature of painting, for example Jessica Stockholder's, or two-dimensional work using paint that interrogates the nature of real space e.g Katharina Grosse, through to huge immersive, technically sophisticated and theatrical environments such as Olafur Eliasson's *Weather Project* (2003/2004) in the Turbine Hall of Tate Modern, or Christian Boltanski's *Personnes* (2010), Grand Palais, Paris, the primary visual aspect of which (not for

the first time in Boltanski's work) are mounds of used old clothes. Given that photography and film only entered into art galleries initially primarily through conceptual art in the 1960s and 1970s there is now widespread and very diverse uses of photography, analogue and digital, and video in art contexts: the rephotographed photographs of Richard Prince, the ostensibly unstaged 'documentary' images of Nan Goldin, the huge digitally worked immaculate prints of Andreas Gursky, and the technically unmanicured prints of Richard Billingham all sit within the art world, as do the video works of Douglas Gordon and Bill Viola but are so different in kind that they collectively raise issues about the ontology of photography and video rather than proffer a notion of photography's nature or video's nature that could aid in determining their quality. Across other areas, for example performance art or instillation art similar lists and similar diversities can be pointed to (see e.g. Bishop 2005) which, unless such issues are to be relinquished exclusively to the determination of the art market signal a need for urgent and ongoing theoretical investigations into ontology and value/quality within the field.

The other area where the shift in the concept of meaning from immanent to relation and conditional outlined above can be seen to be having ongoing consequences is with reference to the nature of debates about the political. Whilst meaning was understood to be in the signifier it was possible to define a work as radical in virtue of certain (more often than not formal) properties, properties that were seen to guarantee its radicalness e.g. Victor Burgin and Barbara Kruger's work was argued to 'decentre' the viewer through its juxtapositions of text with image and by so doing disrupt and expose the normal viewing space into which the photographic image would recruit us (see Tickner 1985), or for example that some of Cindy Sherman's photographs through their 'glister and gleam' disorientate and subvert our location as viewers (Krauss 1993). In both these cases the claims are made through the bringing in of extensive bodies of theory in relation to which the designated signifiers are being read, but nowhere is it acknowledged that it is in those relations rather than in the characteristics of the work that the political critique is being generated. During the same period it was often asked of work, particularly that which engaged with consumption, for example Koons or Steinbach, Barbara Bloom or Sylvie Fleury, was it complicit or critical? And again from a position which assumed a fixedness between signifier and meaning, i.e. from an assumption that seemed to be the very thing that was at issue in the work.

More recently, politics concerns have been given a different direction and flavour through the curatorial and theoretical efforts of Bourriaud's *Relational Aesthetics* ((1998) 2002) with reference to artists such as Carsten Holler, Rirkrit Tiravanija, and Pierre Huygne and others. Bourriaud proselytizes on behalf what he sees as a nonutopian, more 'humble', more democratic and 'interactive' (he borrows terminology from the vocabulary of the Internet and video games) tendency in art, one which (to varying degrees) places the artist as facilitator or MC: the artwork, though it may make use of objects (e.g. Holler's slides at Tate Modern 2006/2007) is less an object than an event. In its most abstract formulation the artwork is the creation of a social environment in which people come together to participate in a shared activity e.g. Tiravanija setting up a kitchen, cooking and serving curry to visitors in various art galleries in the art capitals of

Western culture (e.g. Paris, New York and London). What Bourriaud suggests is being relinquished or eschewed is the 'role of artworks . . . to form imaginary and utopian realities' in favour of offering ways of living and acting within the existing real, 'on whatever scale chosen by the artist' ((1998) 2002: 13). Though at a time when 'the grand narratives' and their respective idealisms have been said to have lost their credibility (Lyotard (1979) 1984) and the more 'realistic', 'modest', and 'democratic' characterization of art that Bourriaud is advocating seems to have a particular appropriateness, his formulation has proven far from unproblematic (see particularly: Bishop 2004). Given the particularly of the event sites claims about participation and inclusiveness and democratic begin themselves, at least with respect to the world outside of the art world, to appear virtual. The unresolved debates in respect of video games about the nature of interactivity and levels of relative self-determination of participants as compared with the game's designer is something that seems equally apposite to ask of the audience and artist in this scenario. And in respect of the claim to the mantle of politics, the nonutopian, nonidealistic can without much difficulty be read as an accommodation of art to the present, a kind of resignation as much as modesty.

No less than of the 'formal' radicalism discussed above (and of much other twentieth-century 'radical' work) does it seem appropriate to ask of Relational Art a series of questions: for whom is this work radical? to whom does it mean what is claimed for it? what knowledge is needed to so read it? No more than that earlier radicalism does its persuasiveness sustain itself before those questions despite its emergence post the shifts in the ideas about the nature of meaning which makes such questions necessary. Whether radicalism is still possible in art is something that has been recurrently debated in the art world, particularly in the journal *October*, what in the light of changing concepts of meaning has been exceedingly underdiscussed and cries out for discussion is what 'radicalism' might now mean (as opposed to what it is taken to mean by *October* from before that moment). If meaning is relational and conditional and not located in the signifier (or artwork) per se, radicalism surely has to be looked for not in the work itself but in terms of the work's effects under certain conditions; that is, there should not be an expectation of a singular answer to what radical work looks like. Participants in popular culture seem to have had an awareness of this way in advance of the art world, signs of dissidence or oppositionality have recurrently undergone abandonment, and change, and renewal in relation to their fading effectivity (witness, for example, the career of subcultural styles). This is perhaps another territory in which art culture might learn from and be 'reinvigorated' by its other.

FURTHER READING

Costello, Diarmuid & Vickery, Jonathan J. 2007. *Art: Key contemporary thinkers.* Oxford: Berg.

Graw, Isabelle, 2009. *High Price: Art Between the Market and Celebrity Culture.* Berlin: Sternberg Press.

Sandler, Irving. 1996. *Art of the Postmodern Era.* New York: Harper Collins.

NOTES

1. The first university sector course in the UK with the designation Visual Culture was validated in 1990 at Bath College of Higher Education (now, Bath Spa University): MA Visual Culture.
2. Jules Olitski, *Comprehensive Dream*, acrylic on canvas, 1965. http://www.abstract-art.com/abstraction/12_Grnfthrs_fldr/g115_olitski_compr.html, accessed 5 November 2010.
3. Don Judd, *Untitled*, plywood cube, 1967 & 1976. http://www.artinfo.com/news/story/35918/art-dealer-david-zwirner-lands-donald-judd-foundation/, accessed 25 September 2010.
4. Robert Frank, *Movie Premier—Hollywood* 1955. http://www.nga.gov/podcasts/fullscreen/020309lect01.shtm, accessed 24 September 2010.

REFERENCES

Adorno, T. (1970) 1984. *Aesthetic Theory*, trans. C. Lenhardt. London: RKP.

Adorno, T. and M. Horkheimer. (1944) 1969. 'The Culture Industry: Enlightenment as Mass Deception', in *The Dialectics of Enlightenment*, trans. J. Cumming. London: Verso NLB: 120–67.

Althusser, L. 1971. 'Ideology and Ideological State Apparatuses', in *Lenin and Philosophy*, trans. B. Brewster. London: Monthly Review Press, 27–69.

Attfield, J. and P. Kirkham. 1989. *A View from the Interior: Women and Design*. London: Women's Press.

Barthes, R. (1961) 1977. 'The Photographic Message', in *Image-Music-Text*, trans. S. Heath. London: Fontana.

Barthes, R. (1968) 1977. 'The Death of the Author' and 'From Work to Text', in *Image-Music-Text*, trans. S. Heath. London: Fontana.

Baudrillard, J. (1968) 2005. *The System of Objects*. London: Verso.

Baudrillard, J. 1983. *In the Shadow of the Silent Majorities*. New York: Semiotext(e).

Bell, C. (1913) 1958. *Art*. New York: Capricorn Books.

Belsey, C. 1980. *Critical Practice*. London: Methuen.

Benjamin, W. (1934) 1983. 'The Author as Producer', in *Understanding Brecht*. London: New Left Books, 85–103.

Bishop, C. 2004. 'Antagonism and Relational Aesthetics', *October*, 110 (Fall): 51–79.

Bishop, C. 2005. *Instillation Art: A Critical History*. London: Routledge,

Bourdieu, P. 1993. *The Field of Cultural Production*. London: Polity Press.

Bourriaud, N. (1998) 2002. *Relational Aesthetics*. Paris: Les Presse du Reel.

Burgin, V. (1977) 1983. 'Looking at Photographs', in V. Burgin (ed.), *Thinking Photography*. London: Macmillan, 142–53.

Cooke, L. 1987. 'Object Lessons', *Artscribe International* (September/October): 55–9.

Crimp, D. 1993. *On the Museum's Ruins*. Cambridge, MA: MIT Press.

Danto, A. 1981. *The Transfiguration of the Common Place*. Cambridge, MA: Harvard University Press.

Derrida, J. (1978) 1987. *The Truth in Painting*, trans. G. Bennington and I. McLeod. Chicago and London: University of Chicago Press.

De Saussure, F. (1916) 1974. *Course in General Linguistics*, trans. W. Baskins. London: Fontana.

Ellegood, A. 2009. *Vitamin 3-D: New Perspectives in Sculpture and Instillation.* London: Phaidon Press.

Fiske, J. 1989. *Understanding Popular Culture.* London: Routledge.

Foster, H. 1985. 'The Crux of Minimalism', in H. Singerman (ed.), *Individuals: A Selected History of Contemporary Art 1945–1986.* Los Angeles: MOCA/Abbeville Press, 162–83.

Foster, H. 1993. 'Postmodernism in Parallax', *October*, 63 (Winter): 3–20.

Foster, H., R. E. Krauss, Y. Bois, and B. Buchloh. 2004. *Art since 1900: Modernism, Anti-modernism, Postmodernism.* London: Thames and Hudson.

Frank, R. 1958. *The Americans.* New York: Grove Press.

Fried, M. 1965. *Three American Painters.* Cambridge, MA: Fogg Art Museum/Harvard University Press.

Fried, M. 1966. 'Shape as Form: Frank Stella's New Paintings', *Artforum* (November): 17–32.

Fried, M. (1967) 1968. 'Art and Objecthood', in G. Battcock (ed.), *Minimal Art: A Critical Reader.* New York: E. P. Dutton, 116–47.

Fuller, P. 1980. *Beyond the Crisis in Art.* London: Writers and Readers Co-operative.

Gablik, S. 1981. 'Art under the Dollar Sign', *Art in America* (December): 13–19.

Gablik, S. 1984. *Has Modernism Failed?* London: Thames and Hudson.

Gelder, K. and S. Thornton, eds. 1997. *The Subcultures Reader.* London: Routledge.

Geldzahler, H. 1969. *New York Painting and Sculpture: 1940–1970.* London: Pall Mall Press.

Gilbert-Rolfe, G. (1989) 1996. 'A Forest of Signs: The Price of Goodness', in *Beyond Piety.* New York and Cambridge: Cambridge University Press, 205–17.

Goldstein, A. and M. J. Jacob. 1989. *A Forest of Signs: Art in the Crisis of Representation.* Los Angeles and Cambridge, MA: MOCA Los Angeles.

Greenberg, C. (1965) 1993. *In The Collected Essays and Criticism: Modernism With a Vengence, 1957-1969.* Chicago: University of Chicago Press, 85-93.

Greenberg, C. (1940) 1985. 'Towards a Newer Laocoon', in F. Frascina (ed.), *Pollock and After.* London: Harper & Row.

Greenberg, C. (1965) 1982. 'Modernist Painting', in F. Frascina and C. Harrison (eds), *Modern Art and Modernism: A Critical Anthology.* London: Harper & Row.

Hall, S. 1993. 'Encoding, Decoding', in S. During (ed.), *The Cultural Studies Reader.* London: Routledge, 477–87.

Hebdige, D. 1988. *Hiding in the Light: On Images and Things.* London: Routledge.

Jameson, F. (1981) 1985. 'Postmodernism and Consumer Society', in H. Foster (ed.), *Postmodern Culture.* London: Pluto Press, 111–25.

Jameson, F. 1984. 'Postmodernism, or the Cultural Logic of Late Capitalism', *New Left Review* (July/August): 53–92.

Judd, D. (1965) 1975. *Complete Writings 1959–1975.* Halifax and New York: Press of Nova Scotia College of Art and Design, New York University Press.

Kozloff, M. (1962) 1970. 'Pop Culture, Metaphysical Disgust, and the New Vulgarians', in *Renderings.* London: Studio Vista, 216–22.

Krauss, R. 1977. *Passages in Modern Sculpture.* Cambridge MA: MIT Press.

Krauss, R. 1993. *Cindy Sherman 1975–1993.* New York: Rizzoli.

Kuspit, D. 1988. *The New Subjectivism: Art in the 1980s.* Ann Arbor, MI: UMI Research Press.

Kuspit, D. 1993. *The Cult of the Avant-Garde Artist.* Cambridge and New York: Cambridge University Press.

Lawson, T. 1981. 'Last Exit Painting', *Artforum*, 20 (October): 40–7.

Lury, C. 1996. *Consumer Culture*. London: Polity Press.

Lyotard, J.-F. (1979) 1984. *The Postmodern Condition: A Report on Knowledge*. London: Manchester University Press.

Machery, P. (1966) 1978. *A Theory of Literary Production*, trans. G. Wall. London: Routledge and Kegan Paul.

Marcuse, H. 1979. *The Aesthetic Dimension: Towards a Critique of Marxist Aesthetics*. London: Macmillan.

Marriner, R. 1990. 'Signs of the Times: Sculpture as Non-Specific Objects: The Works of Koons and Steinbach', *Art Monthly*, no. 138 (July/August): 13–18.

Marriner, R. 2002. 'Derrida and the Parergon', in P. Smith and C. Wilde (eds), *A Companion to Art Theory*. Oxford: Blackwell Publishers, 349–59.

Metz, C. 1973. 'Methodological Propositions for the Analysis of Films', *Screen* (Spring/Summer): 89–101.

Miller, D. 1987. *Material Culture and Consumption*. Oxford: Blackwell Publishers.

New Museum of Contemporary Art. 1985. *Difference: On Representation and Sexuality*. New York: New Museum of Contemporary Art.

Osborne, P. 1989. 'Aesthetic Autonomy and the Crisis of Theory: Greenberg, Adorno, and the Problem of Postmodernism in the Visual Arts', *New Formations*, no. 9 (Winter): 31–50.

Paoletti, J. T. 1990. 'High and Low: Modern Art and Popular Culture', *Art Monthly* (November): 3–9.

Rosenberg, H. 1972. *The De-Definition of Art*. London: Secker and Warburg.

Rubin, W. 1970. *Frank Stella*. New York: Museum of Modern Art.

Rugoff, R. 2007. *The Painting of Modern Life: 1960s to Now*. London: Hayward Publishing.

Schwabsky, B. 2002/2004. *Vitamin P: New Perspectives in Painting*. London: Phaidon Press.

Smith, R. 1990. 'High and Low Culture Meet on a One-Way Street', *New York Times*, 5 October, Section C, 1.

Sontag, S. 1966. 'Against Interpretation', in *Against Interpretation*. New York: Delta Books.

Steinberg, L. 1972. 'Other Criteria', in *Other Criteria*. London: Oxford University Press.

Strinati, D. 1995. *An Introduction to Theories of Popular Culture*. London: Routledge.

Tickner, L. 1985. 'Sexuality and/in Representation: Five British Artists', in K. Linker (ed.), *Difference: On Representation and Sexuality*. New York: New Museum of Contemporary Art, 19–39.

Tolstoy, L. (1898) 1969. *What Is Art?* London: Oxford University Press.

Tucker, W. 1974. *The Language of Sculpture*. London: Thames and Hudson.

Varnedoe, K. and A. Gopnik. 1990. *Hi and Low Modern Art and Popular Culture*. New York: Museum of Modern Art.

Whitney Museum of American Art. 1996. *Kienholz: A Retrospective*. New York: DPA/Whitney Museum of American Art.

Beyond Museology: Reframing the Sensorium

DONALD PREZIOSI

[I]deology, roughly speaking, is about what we think we see when we aren't really looking.

—Homi Bhabha

Magnificat anima mea Dominum.

—Luke 1:46

It has not gone unremarked that a fair amount of contemporary visual culture studies seems to have proceeded in curious detachment not only from the social, political and ethical circumstances of their actual practices but from engagements with the actual histories and historiographies of premodern and extra–Euro-American artistries. One of the reasons for this has been its academic institutionalization on the western side of the Atlantic as a specific reaction to certain parochial debates within New York City art criticism by a small group of modernist art historians—a situation rather different on the eastern side of the Atlantic.[1] The resultant interrelations between visual studies and art history were reduced either to the former being staged as astronomy to a discarded and dismissable astrology, or as a cure (perhaps, more exactly, a *pharmakon*)[2] to the latter's parochial ethnocentrism. What follows examines the problem of visuality in its (still mostly occluded) relationship to *museology*—the commonly overlooked third term in contemporary discourse on visuality—art history, visual culture studies and museology.

REFRAMING VISUALITY

The following follows upon and reframes for this volume a circuitous and not easily diagrammed personal/professional trajectory of my engagements with the critical and

theoretical grounds of contemporary disciplinary practice, in particular those that take as their domain of study 'visuality' or the 'visual culture' of peoples, times and places. It takes a critical stance regarding its aims and claims, engaging with a long-standing disquiet within that field that in fact is coterminous with its quarter-century history. I will try to make clear what has bothered me (and not a few others) about the academic marketing endeavour of visual culture studies, and about not a few disciplinary turns or re-turns over the past academic generation (towards culture, history, politics, visuality, theory, (new) media, religion, the object, etc). Scepticism about these and similar 'turns' may be an inevitable artefact of having seen so many turns, re-turns, evasions, diversions and about-faces in the academic fields amongst which I've been working, and about many of which I've had a few things to say historiographically, and methodologically, as well as about various ethical and political problems raised by various disciplinary turnings. This chapter, then, will attempt to outline the reasons for my position(s) on these and related issues, and along the way will suggest approaches to resolving the current impasse in visual culture studies and related academic endeavours.

The invitation to contribute to this volume comes at a time when my attention is divided between two partly overlapping research projects, the first dealing with the perennial conundrum of the antitheses between what are conventionally distinguished as art and religion, the second with the problem of writing a polemical manifesto on 'the idea of art' today.[3] Both of these projects, as well as the writing of the present chapter, also come after a long and circuitous history of my own engagements with a number of disciplinary and cross-disciplinary developments.

What follows here is a marking of several *standpoints* that by hindsight may be linked together to suggest an intellectual and philosophical trajectory to my account of current disciplinary impasses. Starting with an old student fascination with the problem of interpreting the labyrinthine ruins of ancient Minoan/Cretan architecture and settlement planning, interests morphed thereafter into a fascination with the artifice of knowledge production itself and the interrelations between diverse sensory modes of understanding and signification. All of that evolved against the backdrop of long trying to negotiate or reconcile the artistic passions of a visual artist father with those of a (dead just before my birth) poet/journalist grandfather, both of whom in their work were intensely mesmerized (visually, verbally) by the modernist romance of antiquity and various manifestations of otherness. The latter (for them) apparently inherited from memories of an earlier ancestor who made his livelihood as a mid-nineteenth-century European orientalist painter living and working in Istanbul, partly employed for a time by the Ottoman court cataloguing the many ethnic customs and costumes of peoples of the Empire in Turkey, Palestine, the Balkans and Egypt. My own professional oscillations ('turns') between investigating visual and verbal modes of knowledge production (through disciplinary formations such as classical philology, art history, visual semiology and anthropology, linguistics, archaeology, architectural history) are equally explained by this background and simultaneously not at all explicable.

At any rate, the following begins where that past continues; futurity, as Benjamin argued, being most lucidly recognizable in the past:[4] a future anterior of what we shall have

been in what we were in the process of becoming. But most recently, this paper comes soon after several months spent on a residential research fellowship in Australia investigating the fabrication and global marketing of 'aboriginal art' as a (visual) *abstraction out of* (and thereby the commodification of) the intensely multimodal, multidimensional and multifunctional cultural practices of indigenous communities in that country, and in particular those of the central western desert. In the latter research, partly undertaken in connection with the aforementioned joint volume on 'the idea of art' commissioned by the Blackwell 'Manifestoes' series of books, the disciplinary singling out and isolating for analysis of 'the visual' in fields such as visual culture studies and art history became more palpably problematic than ever.

This in turn deeply challenged the task of co-producing a book on 'the idea of' (indeed, any aspect of) cultural practice,[5] given the epistemological, philosophical and semiological conundrums surrounding the Western opposition between an idea and its purported manifestation; between 'meaning' and 'form'; oppositions cogently argued long ago as serving to perpetuate a metaphysical ideology of signification (Derrida 1981b), rooted in monotheist religiosities.

This chapter addresses that conundrum as specifically articulated in the Western modernist tradition of separating visuality from other modes of understanding and knowledge-production, as with visual culture studies and related academic disciplines such as art history and museology, as if it had a life of its own. My concern in what follows also addresses the ethical implications and political effects of this and related reductionisms: aside from the globalized market in commodities, who and what is benefitted by the 'turn' towards the visual?[6]

MARY IN THE MUSEUM

A clear awareness of the reality of our own finitude being a source of some anxiety, we may at times be tempted to actually believe in our own immortality. Aesthetic, historical, biographical and museographical possibilities for after-lives may seduce us into imagining the constraints of the real being eliminated if we keep a tense yet measured distance—a coy similitude or even a pantographic relationship—towards our (self) image. As epistemological technologies of virtual/heterotopic space, museums and collections keep the real at a manageable distance in the face of anxieties. The ego's habitation in museological space opened up by its mirror image, however, is yet more complicated and tense. On the one hand, the duplication of the self and the distance it presupposes is a necessary condition for reflection and autonomy. Yet on the other hand, the ego, driven by the will to converge with its image, might be tempted (like the ancient patron saint/avatar of the museumgoer, Narcissus) to annihilate that distance. Hence the efficacy of aesthetic institutions such as museums or religions (or of artefacts such as visuality) depends precisely on the *maintenance* of that tension; the maintenance, that is of a consciousness of the artifice of our realities *as* artifice. Even as we masquerade its denial in our theologies, and even, indeed, in most of our visual studies, art histories and museologies.

In what follows, I would like to consider the inextricability of the aims and claims of 'visual culture' in modernity and those of museums and museology: the obscure romance of the twin siblings of the Enlightenment, visuality and museology (mediated by their mid-wife aesthetics). This is a subject that in my experience has been too little attended to in contemporary visual studies, in particular the problem of the uncanny relationship; the ambivalent juxtapositions between the individual and the museologized object. On a fundamental level, this interrelationship is the core conundrum haunting these and related modernist discursive practices since their early-modern elaborations. I won't attempt to give an overview of the many ways in which that question has been or could be viewed historically or thematically, including a direct problematizing of the rhetorical/onto-theological distinction itself between 'subjects and objects'—although what follows does in fact bear very much indeed upon that issue.[7]

The hagiographic uses and effects of art museums have long overshadowed their essentially ethical functions as instruments for modeling, mimicking and modifying individual and collective behaviour. As modes of interpretation and social discipline, museums stage *parallactic* relations between diverse domains of the sensible (such as objects and their framings in whatever medium, including verbal glossing) whilst simultaneously fixing in place those embeddings and juxtapositions as if they were tamely and mutely *stereoscopic*. Beyond their modern social status as architectonic phenomena, museums are more fundamentally a staging of occasions for relating sets of appropriated or invented phenomena, using diverse materials and methods. However, this invariably confers an *ambivalent legibility* to the visible entities ostensibly foregrounded by their framing—a situation paradoxically rendering any museological legibility itself moot, which of course drives fundamentalist believers in the literalness of representation up (and indeed over) the wall, as we saw in the sectarian lunacy spawned a few years ago by the 'Mohammed cartoon' controversies, which continues unabated.

As an epistemological technology, a method of fabricating knowledge, interpretation is essentially ethical and political in that its manifestations, palpably impinging upon the perceptions of individuals, invariably have potentially unpredictable consequences for individual and social behaviour. Moreover, the very palpability of the artifice of its own stagecraft renders museological effects potentially construable otherwise than as (presumably) intended. In this respect, museological practice shares the core conundrum of all artistry or artifice as such. In rendering the visible legible, art history and visual studies, for example render their own legibilities moot and problematic, bringing to light the (often covert) *agency* of those who would claim a given interpretation as true or faithful to its alleged intentions. This is a key issue widely occluded in the earliest stagings of and claims for visual culture studies a quarter-century ago, although within the then-current critiques of art historicism such issues were indeed quite prominent.[8] In effect, interpretation's own artistry renders its productions moot: a situation with fundamental political, philosophical and theological consequences, few of which continue to engage contemporary visual studies except on its disciplinary margins.

While some commentators—recently, for example Rancière—have claimed that the supposedly mute palpability of artworks renders them not only 'democratically available'

to audiences but also available as models (simulacra) of empowerment, not only is its supposed opposite in fact equally probable, but the antithesis as such is palpably problematic. As indeed is the customary distinction between a staged artefact and its written or verbal inflections.

I want to contextualize recent critical museological practices by drawing attention to the nature and functions of interpretation ('reading') as a practice *always ambivalently sanctioned and proscribed*, linking it to long-standing political and cultural conflicts and impasses regarding the proper social roles of artistic (re)presentation—a dilemma as old at Plato's (not unconflicted) attempt to banish the mimetic arts from his ideal city, and as recent as violent religious conflicts over the proper uses and interpretations of artistry, where the paradoxical ambiguity of signification has quite rightly unhinged true believers in literalism.

I would like to reckon with these fraught interconnections using a no doubt rather odd and seemingly counterintuitive image, that of the *pantograph*, a term which is familiar in two principal ways. It commonly refers to (a) an instrument for copying a drawing or plan at a different and usually larger scale by a system of linked and jointed rods, and (b) a jointed metal framework for conveying a current to a train, tram or other electrical vehicle from overhead wires. An image made with a pantograph enlarges or magnifies the original. And a pantograph is a conveyer of power to mobile machinery.

I am reminded here of how, on the occasion of visiting her cousin Elizabeth, the pregnant Mary described her feelings *pantographically*, as follows:

> My soul doth magnify the Lord and my spirit hath rejoiced in God my saviour.
> For he hath regarded the lowliness of his handmaiden.
> For behold, from henceforth all generations shall call me blessed.
> For he that is mighty hath magnified me and holy is his Name.[9]

This is an extraordinary declaration, for (as with our encounter with museum images and objects) what is portrayed was no simple one-way encounter between the immortal and the mortal, but rather in fact a claim of *mutual magnification*. The text literally says that Mary's soul (*psyche; anima*) enlarges (*megalunei; magnificat*) a divine spirit that in turn *magnifies her*. She becomes a vessel for the divine spirit (her 'saviour') so that, in *conveying* that spirit, channeling it, it in turn enlarges her own soul or spirit. By becoming a divine conveyance, she is no longer a mere 'handmaiden' of that spirit, for she will give birth to its announced *embodiment*, a mortal or corporeal manifestation of that spirit. From being herself the issue of mere mortals, her own *issue* is to be an embodied divinity.

What is encountered with an object, image or artefact in the museum is similarly of course no simple or direct confrontation, but the mooting of a possible *conveyance* in which encountering subjects are enriched and transformed, and, following the analogy, in that encounter the 'spirit' of the object is itself magnified.

Does this make idolatrous the individual's relationship to museological (or other artefactual) material? In acceding to the power (spirit, soul . . .) of the object, is the viewing/using subject in fact attributing agency to it, or attributing a simulacrum of

agency; mooting an agency?[10] Also, in doing one or the other, magnifying its assumed spirit, are we (is it) magnifying (or mooting the magnification of) our own spirit(s)? Did T. S. Eliot's words in *The Wasteland*, 'In the room the women come and go, speaking of Michelangelo' give a hint that *magnification* has just taken place; that the *speaking* constitutes a magnifying and extension of the spirit of the artist?

Interpretation or verbal articulation, then, might appear to be a recasting of the ancient *ars longa, vita brevis* as *ars longa, ergo vita longa* (or even *longissima*)? Interpretation or critique as ceremonial incantation revivifying a palpably mute artefact? Following the analogy may raise some not-so-easily articulated mootings of relations between artistic and theological agency, if staged (museological) encountering positions the encounterer as an echo chamber amplifying the spirit of the artificer.

It begins to sound like an echo of the architectonic stagecraft of the ancient Greek theatre, where you may recall were strategically sited amongst several ascending semicircular rows of stone seats, a series of (harmonically calculated) hollow urns which acoustically amplified and passed on the voices of the actors down below on the small circular speaking, singing and dancing stage (*khoros*), so that those on the uppermost tiers of the theatre could hear the performers as if they were physically closer to the drama's action.

In the quotation from Luke, Mary's *soul* (*psyche; anima*) magnified the Lord, yet her *spirit* (*pneuma; spiritus*)—an analogous but not exactly the same entity—(her breath) rejoiced in her saviour-impregnator. Magnifying and rejoicing from the same individual. Magnifying *as* rejoicing perhaps. There is a window here into confronting the perennial problem of the fetish, or the aesthetic/theological conundrum of idolatry (that rabbit-hole into which all true believers may fall), and by extension the nature of museological staging and encountering.

Shall I then be a vessel for the soul/spirit of (say) Picasso in my encounter with *Guernica*, and is my bodily encounter with it a vicarious involvement in what is re-presented? Are we not here confronted with the (essentially problematic) nature of museological aims and functions in relation to the expectations and desires for resolution and fixity of sense on the part of the visitor? The establishment of a field of expectations; of the anticipation of interpretation; of a palpable sense of fixing in place a measured/measureable relationship between subjects and objects. A tense space-time of mutual confrontation, solicitation and seduction. As one of the most widely distributed Anglophone museum bookstore guides to viewing art so aptly put it, 'Do your best at all times to let the work of art *speak directly to you* with a minimum of interference or distraction' (Finn 1985). We are entreated, are we not, to believe in the efficacy of this encountering, in anticipation of (spiritual) magnification?

I walked into this gallery a (mere) citizen, perhaps a mere anonymous handmaiden of a great immaterial Spirit dwelling in a sidereal realm presumably 'outside' the museum (if sidereal realms can be situated by GPS-location concretely relative to other realms). But right there, confronted with the *Guernica*, I become an echoing urn for Picasso's spirit—Pablo not only *living on* as echoed in and by me, but being truly aggrandized by my encounter with what breathed 'life' into the effects of his artistry. My soul (*psyche*) doth magnify Picasso, and, what's more, my spirit's breath or voice (*pneuma*) rejoices in

him. I am indeed bettered by the encounter, by becoming (wilfully or circumstantially) an instrument of the transmission and dissemination and magnification of Pablo's sprit. Of the artistry or artifice of that spirit.

Was Mary bettered by her gossip with her cousin, re-announcing her own annunciation by articulating her recent experience? Was Elizabeth herself (like second-hand smoke) duly affected (magnified) as a result? Was Mary's transformed state the origin or product of her conversation with Elizabeth? Or ambivalently both: sometimes, after all, conversations may indeed be quite literally productive of what is being pronounced. What exactly was John Soane doing in writing a 'history of my house' in Lincoln's Inn Fields in 1812, prior to its full habitation and transformation into a museum, and seeing it in ruins as if discovered by antiquarians of the future trying to make sense of what this artefact might have been? (arguably the first 'science fiction' autobiographic novella, as I argued in my Slade Lectures at Oxford a few years ago).[11]

NARCISSUS IN THE GALLERY

Is my ingestion of Pablo's spirit an instance of techno-lust, or even a case of *technophagism*?[12] The story of Narcissus reminds us that merging with one's (or any) image is not so much an ultimate autobiographic act, perhaps, but anti-autobiographic. Self-ingestion would seem to defeat the purpose of ingestion, namely to maintain or magnify (grow) oneself by assimilating raw material. Narcissus's aims were evidently no more nor less gastronomic than those of other lovers. I devour you with my eyes: what of lovers of imagery? Consumers of museological materials? We are (decorously) entreated to keep such materials at arm's length; but what of biographical matter? Is that a different matter after all? Does being confronted with (auto) biographical material change the nature of the relationship?

We are perhaps inevitably returned to Hegel's definition of art (indebted in all respects to Plato, lest we forget) as the sensible presentation of *Idea*—a definition, as Jean-Luc Nancy (1996) nicely put it a decade and a half ago, yet not without a certain (perhaps unappreciated) irony, that *haunts* philosophy—not to speak of all those disciplinary discourses swirling in its wake (museology, art history, aesthetics, archaeology, visual culture studies) which have been instituted in modern times to make the invisible (Idea) visible, and henceforth *legible*. Legibility, that is as translation; as embodiment. A thoroughly theological problem, of course—or more specifically the key problem of (monotheist) theologies in the wake of Plato (not to speak of Moses confronted by those (no doubt famished) wasteland worshippers of that gilded bovine, that exquisitely apt idol of wish-fulfillment; Moses didn't quite get it, or maybe he really did realize the real, terrifying danger of (the hunger for) art)—all permanently confounded by the perennially irresolvable war between iconophilia and iconoclasm, from (well before) Byzantium up to or down to the present.[13]

The West's problem with 'art' (its own invention, after all) *as* a key problem in philosophy/theology: perhaps the central problem. Plato's own ambivalence about this even in the wake of a need to banish (mimetic) art from the city; to insulate and close

the eyes of the ordinary citizen from the semiotic indeterminacy (framed as promiscuity) and interpretative ambiguities of artifice.[14] The (Christian, Muslim, Jewish) monotheist's worst nightmare.

Let us perhaps understand Mary's *issue*, then, as a party to, perhaps even an uncanny mooting of a resolution of that unresolvable conversation; a mooting as *mediating* the rhetorical/extra-rhetorical distinction between matter and spirit; between the material and immaterial; the visible and invisible; form and content; signifier and signified? The *Magnificat* if you will as the philosopher's stone of artistry where the Platonic/ontotheological juxtaposition between invisible and visible, between Idea and artifice, endures as the necessary condition for reflection on the singularity of the autonomous ego. The Christ as an embodiment of the philosophical conundrum of visual artifice itself: the field of forces that is precisely mooted in museological space-time. The museum not as a what but as a fielding of relations: an articulation of stage directions putting actor-agents in place relative to what, precisely by their relative positioning, evokes and conjures up a stage which perforce becomes the backdrop or screen to action.

As epistemological technologies of virtual space-time, museums, collections, exhibitions and expositions do indeed expose this relationship as a distance tensely maintained between the ego of the viewing subject and the viewed object, image or artefact. A distance that needs no external electronic sensing device for alarms to ring if contracted too much: the pantographic maintenance of the socialized ego is sufficient for the distance to be maintained so that the magnifying process may proceed. Yet the effect of this 'accession to the Symbolic'[15] is to keep in place the rhetorical syntax of content, signification, meaning: the very artifice of the opposed poles of 'subjects-and-objects'.

It was Samuel Weber who observed, in his 1996 book *Mass Mediauras,* a study commissioned by the Australian Commission on the Reform of Higher Education in a 'multicultural' or 'postcolonial' environment (a veritable Antipodean Lyotardian 'postmodernism' moment (Lyotard 1979)), that

> If the institutionalization of the subject/object relation—the matrix of representational thinking [I should add here, a supremely parochial, Eurocentrist division of labour]—is the result of the *emplacement* that goes on in and as modern technology, then those same goings-on undermine the objectivity upon which the matrix depends. By determining reality as standing stock, representational thinking treats objects as calculable 'data,' as 'information' to be taken into account or accounted for. Thus, whether in economic practice or in modern art, objects are de-objectified by becoming increasingly subject to the calculations of a subjective will struggling to realize its *representations* and thereby to place itself in security.

He then went on to say:

> But . . . there are no secure places. Emplacement itself remains *tributary to that movement of unsecuring that it ostensibly seeks to escape or to ignore.* (Weber 1996: 73, my emphasis)

I'd like to juxtapose this with Derrida's assertion, some twenty years ago, that 'a divine teleology secures the political economy of the Fine-Arts' (Derrida 1981a). You may well ask of Derrida what exactly, then, was that 'political economy'? or for that matter that 'divine teleology'—isn't art history after all, and from when it was but a gleam in the eyes of its Enlightenment progenitors, if not for some of its Renaissance humanist precursors, a *divine* teleology, with visual culture, as art history's latter-day wake, its after-math, even its *after-mathesis*. I'd also like us to think these two things together with Emmanuel Levinas's equally implacable insistence, repeated one might say all during the rises and wanes of the modernist history of art history and postmodernist visual culture (and indeed alluded to in Derrida's own tribute to Levinas that he read at the latter's burial), that there is a form of truth that is totally alien to us, that we do not discover within ourselves, but that calls on us from beyond us, requiring of us the need to leave the realms of the known and the same; the recognition of otherness—of *otherness* as such, which is what, he insisted, in fact actually *constitutes us as ethical beings*? You don't need to boil down the epistemological broth of aesthetics to find ethics at the bottom of the pot, all you have to do is smell and taste the broth itself.

On which, of course, hinges the fate of visual studies.

The situation might seem to be too complex to successfully articulate, but in reality it's quite stunningly simple: *Narcissus is held in check by the (unquenchable) desire to prolong and maintain his own narcissism, which is precisely what would be drowned if not drawn out and perpetuated in a semi-idolatrous state of suspension.* Maintaining the tension, suspending dis-belief, keeping the real at a manageable distance in the face of anxiety about the fragility of the ego's mirror imagery—a fragility (like that of the Catholic *eucharist*) that nonetheless makes possible imagining (imaging) its non-fragility and apparent permanence (its avatar) in virtual museological (and ecclesiastical) space-time. (Auto) biographical museological matter (perhaps there's no other completely distinct kind, really) is a mooting or reckoning with the question of embodiment, of magnification, of transmission and dissemination, of interpretation. Of the artifice of interpretation. The dream of science and the dream of meaning: the dream of the science of meaning, as someone (Derrida no doubt) once put it in another but not unrelated context.

MAKING THE LEGIBLE VISIBLE

Let me backtrack one more time and lay a fresh deck of cards on the table. I began a series of lectures I gave a few years ago in Oxford with the following words, which I'll repeat here, since it has been haunting me ever since and remains a kind of conundrum, or even a Borromean knot (to speak through Lacan for a moment) which I've been trying to untie, and if not actually disentangle (to disentangle a Borromean knot you have to cut one of the four strands, leaving you with three unattached strands (art history, visual culture, museology, perhaps?)), and which continues to call out to me to rotate it and peer at it from many directions. This is what I said:

At the heart of that two-century-old practice of the modern self we call art, the 'science' of which we might once have liked to have called art history (or perhaps museology,

art history's chief allomorph, or even 'visual culture', that other highly commodified method of avoiding the impossibilities of representation), and the 'theory' of which we may still wish to call aesthetics, or sociology, or even philosophy, [at the heart of all this] lie a series of knots and conundrums, the denial of which constitutes the very relationship between 'subjects and objects' naturalized in circular fashion and kept in perpetual play by the 'disciplinary' machinery; the epistemological technology, of art history.

It is precisely this denial that has grounded, legitimized, and institutionalized that shadow discourse of aesthetic philosophy or 'theory' which the art historical imagination, in varying ways over these two centuries, has continued to project as a 'transcendence' of its own (simultaneously co-constructed) disciplinary abjection. We need not be surprised that a discipline can be grounded in denial, since disciplinarity as such (as I said at the beginning above) is founded upon the occlusion of difference and heterogeneity; on explicit fragmentings and channelings of vision. (Preziosi 2003: 1)

The academic discipline(s) of art history and visual culture studies, from one perspective the most rigorous and encyclopedic 'institutionalization(s) of the subject/object relation' as such, to borrow Weber's words, has evolved historically by living on the horizon of a virtual future, in a curious space-time of the future perfect tense—*as if* (as professions) *they shall have been* the 'practice' of a philosophy (or a concept or theory which some may continue to call aesthetics), and in so doing, in approaching (whilst never quite reaching) its (their) asymptotic point or horizon of completion, it/they perpetually reconstitute(s) and reiterate(s) the problematic of its/their irresolvable foundational dilemma. This is part of what may be meant by the idea that the only compelling vision of the future being the failure of the present: one of the conundrums wrestled with by Benjamin and alluded to at the beginning of this chapter.

The dilemma I'm referring to is, precisely, *an irresolvable ambivalence about the constitution of the self in its relation to and seemingly inextricable entailment with objects; with its object-world; its Lebenswelt.* This repetition-compulsion is played out as attempts to keep in play contrary theories of that relationship, as I've noted earlier, much like the endless and irresolvable oscillations of an optical illusion (the form of your stuff—the stuff you either produce or consume or both—either *is* the 'figure' (emblem, symbol, character, etc) of your truth; and/or *it is not*).

Keeping that ambivalence in play is, of course, a strategy of power. I am reminded of the controversies surrounding the fielding of the essentially and deliberately ambiguous notion of 'terrorism', which one cannot either rationally interrogate (as what in the mind of some would constitute 'appeasement' of an ill-defined enemy) or ever finally defeat (which would lead to admitting that we and the 'terrorist' live in the same moral universe). That this political display of power is itself grounded in a religionist discourse is quite clear: moral equivalences are abhorrent also because they question the 'exceptionalism' of America (or Europe, or the West) in relation to ('terrorist') Islam.[16]

It is consequently no mean task—as the past two centuries of art history and of the 'philosophy of art' and as the past quarter-century of 'visual culture' have dramatically

demonstrated—to conceive of articulating a critically adroit historiography of a discourse built around such doubly compounded phantasms, let alone project for it (them) a better institutional future. It has certainly been not a little problematic to articulate the evolutionary development of an academic field as if it were some singular evolution of concepts or 'theories' of 'art'. That is the simulacrum of the idea that 'art' itself was historically the evolution of a certain *residue in all things*—once you subtract the instrumental and utilitarian (and for some the sectarian and social-historical) 'meanings' of things, as so clearly and explicitly articulated in connection with the founding of (but not only) the Louvre Museum. That is 'residues' linked together (as a visual or aesthetic 'history' one might say) to serve ethical and political functions in the present in the practice of critical and museological apologists and ideologues of the new modern nation-state.

In the latter case it should be recalled that Napoleon justified his plundering of the treasures of Europe on behalf of Parisian institutions such as the Louvre as not a capture but rather a *liberation* of the aesthetic qualities of works once held captive (by private individuals, institutions, monasteries, churches, etc) on behalf of citizens of the Republic.[17] A freeing up of aesthetic properties formerly held 'captive' by being embedded in the multifunctional contexts of their original production and use (Deotte 2004). Like a *visuality* abstracted out of its (multimodal, multidimensional and multifunctional) cultural praxis (visual culture studies as a *Napoleonic* practice?). Is it any wonder that the critical/historical *extraction of a residue* from the object-world—whether you call that the aesthetic dimension of a thing; the visual culture of a people; the mentality of a person or people; or indeed anything from the 'spirit of a Folk' to the 'gayness of an artist' purportedly 'legible' in an object—is always already foreclosed?

This is deeply problematic; which is why I would suggest that our disciplines have been virtually indistinguishable, historically, from that prefabricated secular theologism, that desire for a magisterial voice and Archimedean leveraged position, in which mastery is conceived of as the control over material seen as its *domain*; its 'data' (yet another allomorph of the program of imperialism (and not only Eurocentric))—in contrast to whatever our craft might be modeled upon (queerness?). It would behoove us to step back and try and reconstruct the conditions that led to the invention and naturalization of this remarkable *practice* of the modern subject; of the modern 'citizen', we call 'art'.

The pantograph of the vanities (indeed, the afterlife of vanity itself) is the crux of the issue of the poetic artifice of the museum, of the endeavour to make the visible legible; to make an object 'speak', as David Finn (1985) once notoriously argued. At the end of the day—better yet, let us rather say at the end of the *night* (the night of the soul, indeed)—*museums permit us to see fiction as fiction, to see the fictiveness or contingency of our world*. In that respect, and not so coincidentally, museums render distinctions between the sacred and the secular deeply and intensely problematic. Visual studies if it has a viable and responsible future will need to begin attending to such complexities.

THE EXIT TO THE MUSEUM IS JUST ANOTHER
PICTURE ON THE WALL?

To recapitulate: Every mode of disciplinarity is by definition blind or deaf to what in its purview has been obscured so as to render more effectively lucid or tellingly powerful what it desires to socially, politically and culturally privilege. This is no less the case not only with visual culture studies or with the history, theory and criticism of art, but also—and more fundamentally—with *visuality* itself as conventionally understood not only in Western modernity and its allomorphs and aftermaths, but also in its antecedents or anticipations in Europe and elsewhere, as commonly projected by disciplinary hindsight. In the current disquiet over the parochial nature of visual culture studies themselves, I would like to open up here at the end of my chapter the question of what an ethically responsible practice of cultural studies might be today which *begins* with a notion of synaesthesia rather than with a framing of (multimodal) social and cultural behaviour as an *addition* of already-reified sensory modes of knowledge-production and behaviour. And, to ask a not-entirely-unrelated question, Can (or should) the still academically isolated epistemological technologies of art history or visual culture studies be effectively (re)integrated into a multisensorial approach to cultural behaviour? Can the academic glass walls still separating art history, visual studies, anthropology, ethnography, aesthetics (etc) be shattered in the service of a genuine ethics of practice? Could the *ruins* of those practices form the ground for changes that are more than mere reupholstery?

Reductionism in any guise renders up only impoverished accounts of how individuals come to know and do what they appear to know and do. Such impoverishments are not without danger, and not only abstractly. In the discursive formation of art history, for example the academically enshrined opposition between formal and contextual 'readings' of artefacts and imagery is inherently irresolvable, and has effectively fixed in place a tension that consequently serves to maintain political and ethical positions *vis-à-vis* the object's signification or, in the words of one art historian, evidently unaware of contemporary cross-cultural debates regarding the agency of (natural and humanly made) objects, its 'intelligence' (Crow 1999). The oscillation of temporarily cogent modes of modeling knowledge about artefacts may be likened to the oscillation of alternative electrical charges ('turns', anyone?) generating electricity as a palpable phenomenon.

Knowledge is formed in everyday activities and knowing is coterminous with our movement through the world.[18] It is not 'built up' from data acquired at static positions or from selected vantage points, but grows and changes with human subjects and the world through which they move. But the challenges to fabricating such a holistic analytic practice are very great, as current debates in a number of academic fields have clearly shown: an 'artisanal anthropology' of multimodal cultural behaviour—from which our own practices would learn a very great deal—remains in its own infancy.[19] And, frankly, at present, art historians and students of visual culture have not been formally trained to even recognize the problems that need to be faced, let alone reckon effectively with what needs to be done to address them. What is needed is to literally make what is still invisible palpably legible, and, indeed, unavoidable.

For those committed to the critical study of culture and its histories, current states and possible futures, thinking in and about museums may be one way to appreciate, even perhaps to actually *envision* artifice as artifice, with all that may entail ethically and politically, including the possibility to change what we think we see or thought we saw. This is no simple or innocent task. But we have always known, have we not, that museums, like all forms of human artifice, including sciences, histories and religions, are very dangerous things indeed, not to be taken lightly in any age, least of all our own.

FURTHER READING

Marchand, Trevor H. J. 2010. Making Knowledge: Explorations of the Indissoluble Relations between Minds, Bodies, and Environment', *Journal of the Royal Anthropological Institute*, 16/1. http:www3.interscience.wiley.com/cgi-bin/fulltext/1233338948.

Preziosi, Donald. 2003. *Brain of the Earth's Body: Art, Museums, and the Phantasms of Modernity*. Minneapolis and London: University of Minnesota Press.

Preziosi, Donald. 2009. *The Art of Art History*, 2nd edn. Oxford: Oxford University Press.

Preziosi, Donald and Claire Farago. 2004. *Grasping the World: The Idea of the Museum*. London: Ashgate.

Preziosi, Donald and Claire Farago. 2011. *The Idea of Art*. Oxford: Blackwell.

NOTES

The first chapter epigraph is from Homi Bhabha, 'Dance This Diss Around', in Maurice Berger, ed., *The Crisis of Criticism* (New York: The New Press, 1998), 48.

1. A perusal of one of the foundational Anglophone texts of postmodern visual studies, Foster (1983), as well as publications such as the New York City art journal *October* (1979–) (founded by disaffected *Art Forum* magazine critics such as Foster), and especially the latter's notorious 'Questionnaire on Visual Culture' (*October*, Summer 1996), makes this quite clear. The latter contributed to remarkably agonistic 'pro- and anti-visuality' tracts in the emerging field of visual culture studies and the latter's relationship to art historical theory and criticism, in particular that field's commitment to aesthetic formalism. It seemed very apparent at the time (a feeling undiminished by hindsight) that many of the disputes of the period were generationally grounded, occluding instrumentalist pro- and anti-Greenbergian approaches to art criticism, in particular the enduring problem of how to rescue professional art criticism from the devastating implications of the European (and especially Francophone) 'theory', which ironically some of the *October* magazine contributors had a role in translating for audiences west of the Atlantic. The notable lack (or marginalization) of social-historical and gender-attentive discourse in these and many subsequent texts was not unremarked at the time: for a typical reaction to the *Anti-Aesthetic* volume see Aronowitz (1983). Not a few of the anthologies of visual studies that appeared in the USA in the wake of these events perpetuated the instrumentalisms and parochial disciplinary interests of that period, a trend still evident in some recent American anthologies, notoriously the recent *Visual Culture: The Study of the Visual after the Cultural Turn* (Dikovitskaya 2005), whose editor explicitly takes up a 'pro-visual' (in that case more precisely a pro-formalist art historical) slant.

2. On which see Derrida ((1972) 1981), on the *pharmakon* as cure and poison. Visual studies as art history's *pharmakon*. The point to consider and reckon with here is whether as a 'cure' of art history's Eurocentrism, in reifying visuality as an abstraction out of the multi-modality and multifunctionality of actual sociocultural praxis, visual culture studies may in fact have 'poisoned' the latter precisely by its abstract reductionisms. The issue is taken up further below.

3. The first book, tentatively titled *Enchanted Credulities: Art, Religion, and Amnesia*, was contracted with Routledge, and builds upon a long-standing interest in the connections between artistry and religiosity, most recently enlivened by controversies surrounding the infamous 'Mohammed cartoon' controversy in Europe and ancient, enduring and seemingly irresolvable disputes on the aims and functions of representation in various monotheist traditions. The second book project is a jointly authored volume (with Claire Farago) commissioned by Blackwell for its 'Manifestoes' series of books in various fields, the first in that series being Terry Eagleton's 2000 manifesto *The Idea of Culture*. Our book, on 'The Idea of Art', interrogates the premises of the idea of the series itself.

4. Among many discussions of this Benjaminian perspective see Krapp (2004), especially chapter 2, 'Future Interior: Walter Benjamin's Envelope', 31–52.

5. The volume, co-authored with Claire Farago, is currently in production (Oxford: Blackwell, 2011). The first volume in that series was Terry Eagleton's *The Idea of Culture* (Oxford: Blackwell, 2000). Our volume opens with a critique of the idea of the series itself, and considers what it might mean ethically and politically today to write a 'manifesto' on art.

6. As remarked about throughout the present volume, the literature on visuality and visual culture is quite immense, and even more so as it bleeds into, extends and follows on its own paths in the wake of the evolution of the academic discipline of art history. This chapter will not deal with that tradition except at certain critical points. A useful introduction to what has been at stake, and an important landmark in attending to these issues, and especially as a questioning of tacit assumptions about the universality of visuality, is Brennan and Jay (1996).

7. A subject taken up at length in my forthcoming Routledge volume *Enchanted Credulities: Art, Religion and Amnesia*, synopsized in an article of the same name (Preziosi 2009b).

8. Among these, see the following, which also include extensive references to these debates: Preziosi (1989, 2003, 2004, 2009a).

9. English Book of Common Prayer, Luke 1:46–9. In the original Greek, *megalunei he psyche mou ton Kurion, kai hegalliasen to pneuma mou epi to Theo to soteri mou . . . oti epoiesen moi megala ho dunatos, kai hagion to onoma autou.*

10. The situation here hinges on distinguishing between equation and adequation or approximation (*aequatio* vs. *adaequatio*), echoing the sixteenth-century dispute over the interpretation of the reality of the *eucharist*. When the priest intones the words *hoc est corpus meum* (this is my body), at and for that very moment is this piece of bread *literally* (Catholic) Christ's body, or is it symbolically and metaphorically, 'representation' (Protestant) of that body?

11. Described in detail *passim* in Preziosi (2003), especially chapter four, 'The Astrolabe of the Enlightenment'.

12. I'll make this a technical term for art (*tekhne*)-consumption, beyond the mere eating of the menu.

13. See above, n. 4. The cited work continues a discussion on the issue of iconophobia and art as inciting contemporary sectarian violence, especially in the wake of the infamous 'Mohammed cartoon' controversy in Denmark and Europe, which was taken up in my

keynote address to the international conference on the critique of religion (*Gudløs! Religionskritk i dag*) at the University of Copenhagen, 29–30 January 2007. The conference papers were published in 2008 (Preziosi 2008); my talk appeared (in Danish) as 'Fortryllet lettroenhed—kunst, religion og hukommelestab' (Art, Religion, and Amnesia).

14. As made quite clear by Agamben (1999), 4; see also Preziosi (2009b). Simon Critchley (2005) makes similar points in his book *Things Merely Are*, through an extended meditation on the poetry of Wallace Stevens.

15. The Lacanian reference is important here; see the recent study by Nusselder (2009), especially chapter 4, 'The Body in Space', 83–97, and in particular part 4.2.3, 'Affective Avatars', p. 93, where the author notes 'The (spatial) differentiation between the body as organism and the body as image constitutes the ego as a necessary alienation from the direct sensory sensations . . . The imaginary ego retains strong elements of illusion and lure, but it has powerful effects. It "virtualizes" our direct sensations by making our awareness of them an effect of the imaginary.'

16. A useful discussion of this may be found in Kandutsch (2010).

17. One thinks of course of Lord Elgin's marbles: Elgin, perhaps, being once thought of as liberating the Parthenon sculptures from their Ottoman owners on behalf of (some) future Greek Republic, subsequently held 'in trust' (captive) by the British Museum, which of course continues to refuse to give them back to Athens because of its own wider obligation to humankind (Cuno 2004; Kimmelman 2010).

18. On which see Ingold (2001).

19. See the excellent review of current literature by Marchand (2010).

REFERENCES

Agamben, Giorgio. 1999. *The Man without Content*, trans. Georgia Albert. Stanford, CA: Stanford University Press; original ed. *l'uomo senza contenuto*. Milan: Quodlibet, 1994.

Aronowitz, Stanley. 1983. So What's New? The Postmodern Paradox', *Voice Literary Supplement* (October): 14–15.

Brennan, Teresa and Martin Jay, eds. 1996. *Vision in Context: Historical and Contemporary Perspectives on Sight*. New York and London: Routledge.

Critchley, Simon. 2005. *Things Merely Are*. London: Routledge.

Crow, Thomas. 1999. *The Intelligence of Art*. Chapel Hill: University of North Carolina Press.

Cuno, James, ed. 2004. *Whose Muse? Art Museums and the Public Trust*. Cambridge, MA: Harvard University Press.

Deotte, Jean-Louis. 2004. 'Rome, The Archetypical Museum, and the Louvre: The Negation of Division', in Donald Preziosi and Claire Farago (eds), *Grasping the World: The Idea of the Museum*. London: Ashgate.

Derrida, Jacques. (1972) 1981. 'Plato's Pharmacy', *Dissemination*. Paris: Minuit; Chicago: University of Chicago Press, 61–172.

Derrida, Jacques. 1981a. 'Economimesis', *Diacritics*, 11/2: 3–25.

Derrida, Jacques. 1981b. 'Semiology and Grammatology: Interview with Julia Kristeva', in Jacques Derrida, *Positions*. Chicago: University of Chicago Press, 15–36.

Dikovitskaya, Margaret, ed. 2005. *Visual Culture: The Study of the Visual after the Cultural Turn*. Cambridge, MA: MIT Press.

Finn, David. 1985. *How to Visit a Museum*. New York: Abrams, 10.

Foster, Hal, ed. 1983. *The Anti-Aesthetic: Essays on Postmodern Culture*. Seattle: Bay Press.

Ingold, Tim. 2001. 'From the Transmission of Representations to the Education of Attention', in H. Whitehouse (ed.), *The Debated Mind: Evolutionary Psychology versus Ethnography*. Oxford: Berg.

Kandutsch, Carl. 2010. 'Mechanisms of Power in the Age of Terrorism', *CTheory. Resetting Theory*. http://www.ctheory.net/articles.aspx?id=646.

Kimmelman, Michael. 2010. 'Who Draws the Borders of Culture?', *New York Times*, 9 May, Arts and Leisure, 1–18.

Krapp, Peter. 2004. *Déjà vu: Aberrations of Cultural Memory*. Minneapolis and London: University of Minnesota Press.

Lyotard, Jean-Francois. 1979. *La Condition postmoderne: rapport sur le savoir*. Paris: Minuit.

Marchand, Trevor H. J. 2010. Making Knowledge: Explorations of the Indissoluble Relation between Minds, Bodies, and Environment', *Journal of the Royal Anthropological Institute*, 16/1. http://www3.interscience.wiley.com/cgi-bin/fulltext/123338948.

Nancy, Jean-Luc. 1996. *The Muses*, trans. Peggy Kamuf. Stanford, CA: Stanford University Press, 88 f.; original ed. *Les Muses*, Galilee, 1994.

Nusselder, Andre. 2009. *Interface Fantasy: A Lacanian Cyborg Ontology*. Cambridge, MA: MIT Press.

Preziosi, Donald. 1989. *Rethinking Art History: Meditations on a Coy Science*. New Haven, CT and London: Yale University Press.

Preziosi, Donald. 2003. *Brain of the Earth's Body: Art, Museums, and the Phantasms of Modernity*. The 2001 Slade Lectures in the Fine Arts at Oxford. Minneapolis and London: University of Minnesota Press.

Preziosi, Donald. 2004. *In the Aftermath of Art: Ethics, Aesthetics, Politics. With a Commentary by Johanne Lamoureux*. London: Routledge.

Preziosi, Donald. 2008. 'Fortryllet lettroenhed—kunst, religion og hukommelestab' (Art, Religion, and Amnesia), in Malene Busk and Ida Crone (eds), *Gudløs! Religionskritk i dag*. Copenhagen: Tiderne Skrifter, 203–18.

Preziosi, Donald. 2009a. *The Art of Art History*, 2nd edn. Oxford: Oxford University Press.

Preziosi, Donald. 2009b. 'Enchanted Credulities: Art, Religion and Amnesia', *X-Tra. Contemporary Art Quarterly*, 11/1: 18–25.

Weber, Samuel. 1996. *Mass Mediauras. Form. Technics. Media*. Stanford, CA: Stanford University Press.

Cubism and the Iconic Turn: A Climate of Practice, the Object and Representation

IAN HEYWOOD

Why does Cubism matter to the contemporary study of visual culture? It's hardly new, dating back to the early years of the twentieth century, it has been much written about, and many Cubist works have settled seamlessly into international collections of modern art and the history they document. Having long ago ceased to provoke shock and anger, hasn't it also been pretty well understood as just another episode in the development of modernism, significant only to the history of visual art?

Cubism, and in particular Cubist collage (sometimes called 'synthetic cubism'), marks an early and decisive contact between modernist high art and everyday visual culture.[1] This chapter will maintain that it continues to raise many important issues for art practice and history, and visual culture studies. For example it would be easy to think of Cubist collage as a critically destructive attack on traditional painting, a denial of its integrity and distinctiveness, the knowledge and skills it requires and its purported elite cultural status. In the case of collage, the supposedly disruptive materials were derived largely from the popular visual culture of the day. Was it, then, an attack on the pretensions of painting and high art somehow motivated or authorized by the artefacts and spirit of popular visual culture? Was it the ironical, ambiguous display of the material and practical mechanisms of painterly likeness, or perhaps an early discovery of the utterly arbitrary character of the painterly sign? Or was it a reflexive critique of certain limitations, contingent rigidities or, to put it bluntly, decadence in the tradition of painting conducted by a progressive avant-garde, a critique which, despite being in some ways located within high art, undermined art's capacity to produce signs of cultural distinction, to generate the cultural underpinning for supposed qualitative differences between social and political strata? In this chapter we examine the view that Cubist collage was an attack on painting using weapons forged by fine de siècle visual culture. For some, the

result of this assault was a renewed, invigorated approach to painting, while for others it demonstrated that the era of painting was over.

Yet it is possible to question this narrative, reversing a pattern of negative judgement. I shall argue that Cubism is a supreme demonstration of the resilience of painting, its capacity to take into itself alien materials and processes, some derived from popular visual culture, using them in ways that change what its very success demonstrates to be merely contingent codes and conventions. This radical act, revolutionary but not solely destructive, gives rise to collage and construction, new forms of art that revitalize and expand the deeper structures of methods and values embedded in painting.

Cubist collage also has something to say at the level of content through its novel embrace of fragments of an emerging mass market in visual commodities. These bits and pieces allude strongly to scenes of public amusement—cafes, food and drink, conversation, flirtation, music, news and gossip—and to the enjoyment of private life, in particular the comforts and visual pleasures of everyday domestic life then being developed and more widely distributed by innovations in home decorations and furnishing. The look of everyday life was changing rapidly, as new products, new visual technologies and visual events appeared in urban settings. The visual environment of everyday life, which included many images and signs referring to, exploiting and undercutting the history of painting, drawing and other craft occupations, was being mobilized as never before.[2] Yet it does not follow from any of this that Cubist collage was designed either to subvert painting and high art through an alignment with the purportedly antagonistic or levelling instincts of popular culture, or conversely to reject out of hand the new, commoditized forms of leisure in the name of elite culture.

Crow (1996) argues that at the core of modern culture is the tension in capitalism between destruction and creation, a phenomenon sharply visible in modernist art, and in particular in the repeated taming and accommodating of avant-garde transgressions by the dynamic, integrating force of capitalist mass culture. The approach adopted here maintains, however, that visual art is important to the study of visual culture in all its forms, providing a uniquely concentrated, rigorous practical enquiry into vision itself, and what it is like to see the modern world in a modern way.

The influence of postmodernism, semiology, poststructuralism and what will be discussed below as 'visual cultural studies' is waning, with new theories and outlooks jostling for position.[3] This interregnum is a propitious moment for treating visual culture studies as a forum for different interests and approaches to social and cultural phenomena possessing a significant visual dimension to meet and exchange insights and ideas. It is a moment not only for thinking about the visual, but also attempting to understand the thinking embedded in visual things, particular kinds of reflection that resist capture in words, numbers, concepts and categories. The visual arts, particularly painting and drawing, have a long tradition not only of looking carefully at and recording the visible world, but also scrutinizing vision. Paul Cézanne's influence on modern painters was profound precisely because of his practical reflexivity, particularly his worry about being able to 'fix' perception in an authentic way, his dogged struggle to reconcile the act of

recording with the event of seeing (Merleau-Ponty 1993: 59–75). If nothing else, the longevity and intensity of the scrutiny embedded in painting and drawing make them critical to any visual culture studies to which reflexivity about seeing is important.

ART'S CRISES, CULTURAL THEORY AND HYPOCHONDRIACAL REFLECTION

Had painting in France, in the early years of the twentieth century, entered a crisis, either by its own logic or because of innovations by leading practitioners? This is a common way of seeing not only Cubism, but also other important moments in the history of modern art. While the tropes of an unfolding inner logic on the one hand and crisis on the other, with in some versions the former directly leading to the latter, haunt the history of modern art, their nature, extent and gravity often seem elusive. For example do we mean by crisis the onset of a profound but temporary turbulence, with modernism representing a return to a kind of aesthetic normality, albeit one marked fundamentally by the preceding trauma? Or is art's history during this period a series of related but different crises, which contribute to the transgressive and increasingly divergent paths of different media and practices? Or again, is there one, chronic underlying crisis, from which art has yet to recover?

These questions highlight the idea of crisis itself, incorporating at its root a medical meaning, that of a turning point in the course of an illness leading to either recovery or death. While this image may seem exaggerated or far-fetched, from Hegel onwards writers have pointed out the ways in which visual art has been troubled by anxiety about its health, even the suspicion that it is undergoing its own death (Hegel 1975 (*Lectures on Aesthetics* 1820s), Kermode 1963, Heidegger 1971, Adorno 1984, Lang 1984, Bois 1990, Danto 1987, Pippin 2005b, Geulen 2006).[4]

This is not the place for a full discussion of these often-complex lines of thought. However, a popular approach to visual culture studies, let's call it visual cultural studies, has provided the theoretical framework behind an influential interpretation of the crisis of art, one that links art to culture and society in a specific way.[5] On this view we should see in Cubist collage early signs of dedifferentiation, a flattening of cultural topography caused by the disappearance of visual high art into popular visual culture, a transformation often represented as involving two motions: the collapse of supposedly elite culture meeting the upwards thrust of popular culture. Turning to popular, consumer forms first, the advent and growth of a form of capitalism geared to the symbolic dimension of products meant that ordinary, useful artefacts were designed to operate as signs. Artefacts had practical functions to perform but also possessed an increasingly important 'aesthetic' dimension.[6] Their purchase and consumption were best seen as the expressive assertion, in a minority of cases contestation, of existing or new life-style identities, which were beginning to replace the older social classes rooted in production. Lending theoretical weight and a particular interpretation to art's alleged crisis, visual cultural studies sees works of art as essentially no different. Hence the only significant contrast between art and popular culture is the 'honesty' of accessible, commercial mass culture as opposed to the deceitfulness of inaccessible, elite culture.[7]

In visual cultural studies, then, art is often represented as having lost its aura of taste and elevated value on the one hand and confidence in its cultural and political potential on the other, where the latter can range all the way from cultural formations underpinning nation states to 'progressive' forms of cultural intervention. Demystification, driven by auto-critique, advanced theoretical criticism or technological or historical obsolescence, reveals modern visual art of every kind to be a niche product whose signs of distinction are consumed by an elite expressing and reinforcing its cultural, and hence ultimately political, power (Bourdieu 1986). The influence of semiotics from the 1970s onwards encouraged the reconceptualization of works of art as coded, ultimately linguistic messages that naturalize or justify contingent social facts operating in the interests of the powerful and wealthy. Even supposedly 'oppositional' art must fall under the same suspicion. The knowledge claims of cultural studies rest on the contention that it provides theories and methods enabling images and artefacts to be 'read' or decoded for ideological content and political effect.[8] This climate has encouraged many to treat works of art as texts, which when decoded testify monotonously to their role in the residual political reality of deceptive cultural processes.

It is important not to exaggerate the direct influence on art practice of the crisis story told by visual cultural studies and other theorists and critics. Yet by the close of the 1970s the view had been widely accepted that modernity and modernism—its supposed official culture—had reached an impasse. Eventually a good deal of academic and popular criticism, influenced by postmodernism, poststructuralism, the new art history and the linguistic, class and gender theories of cultural studies, and in particular by the syncretic assembly of critical assumptions, concepts and themes devised by visual cultural studies, both reflected and contributed to concrete, practical manifestations of what we might call hypochondriacal reflection.[9]

For example in the 1970s the German artist Gerhard Richter, for many a key postmodern artist, decided to paint large, religious oil paintings (based on an Annunciation by Titian; see Figure 8.1), but what he discovered was the impossibility not only of this kind of religious imagery but also of great painting with profound spiritual or philosophical aspirations. He reports just wanting a copy of a 'beautiful painting'. Eventually he realized that 'it just can't be done any more, not even by way of a copy' (Richter 1995: 226). Giving Richter the benefit of any doubt, let's say he tries to summon up the conditions, both internal to himself as an artist and external in the sense of referring to what seems valid or honest once expressed (criteria evidently important to Richter), necessary to engage authentically with this primary form of painting. In the final analysis the specifically Christian content is neither here nor there. What is important is the possibility of visualizing and presenting a scene in which something of extraordinary importance and beauty occurs, where this is inextricably connected to the importance and beauty of the image and the act of seeing which reveals its significance. If we are to believe Richter, or see his case as paradigmatic, art practice now seems doomed to disappointment with respect to traditional and modern aspirations for its wider cultural significance, at least aspirations that might connect its historical achievements with the goals of contemporary practice.[10]

FIGURE 8.1 Gerhard Richter, *Annunciation after Titian/Verkündigung nach Tizian*, 1973, oil on canvas. Courtesy of the artist, © Gerhard Richter 2010. Photograph: Atelier Richter.

Yet, paradoxically, Richter insists on his 'daily practice of painting', on carrying on with art as if it were still a going concern. He is well known for engaging seriously and rigorously with a variety of styles—heroic modernist abstraction, Romantic depiction, political engagement and so forth—but in light of some his self-reflections what results seems critically indistinguishable from a series of exemplary failures. An exchange with critic Jonas Storsve in 1991 makes the point clearly. Storsve formulates what Richter is doing in terms of a contradiction between something that can 'really be kept alive' and 'an empty pose', a contradiction that cannot be evaded and so must be continually repeated. Richter rejects 'contradiction', forcing Storsve to redefine it as 'knowing full well that the means you are using won't achieve what you aim for, and at the same time not being prepared to change those means'. Richter's reply, again denying contradiction, is that what Storsve is talking about is 'a perfectly normal state of affairs . . . the normal mess if you like'. Nothing would be achieved by 'different means and methods', not because all are of the same value but because all are 'similarly inadequate' (Richter 1995: 158). Richter's case is exemplary for Storsve and others precisely because he recognizes this inescapable inadequacy and yet continues his dogged, daily practice.[11]

Sophisticated artists like Richter may have reached the conclusion that the 'normal' state of affairs for practice is the 'inadequacy' of available means and methods either via theory or the experience of practice itself.[12] Most likely, the two are connected, with views on the health of practice being shaped by the rising influence of theory from the 1970s onwards, not only in the education of artists but also setting the ideological climate for curators and critics. Recently, however, key tenets of the theory conducive to the hypochondriacal assessment of contemporary practice have been questioned, in particular its evaluation of the significance of the sensory, material

singularity of works of art. I cite as evidence an essay by the prominent US art historian and theorist Keith Moxey.

Most people would associate Moxey with a critical theory and method, which, having learned from semiotics and poststructuralism, saw itself as finally being able to free art history from privilege and elitism, positivism and idealism. Moxey has never been, as far as I am aware, opposed in principle to traditional art practices like painting, nor has he advocated abandoning art history in favour of cultural studies. Rather he stands here as a representative figure in what seemed to many a theoretical and critical consensus about art and culture, influenced on the one hand by semiotics and poststructuralism and on the other by cultural studies. His essay is very useful in setting out some aspects of a shift in outlook. Two quotations give the flavour of what he proposes:

> Bored with the 'linguistic turn' and the idea that experience is filtered through the medium of language, many scholars are now convinced that we have unmediated access to the world around us, that the subject/object distinction, so long a hallmark of the epistemological enterprise, is no longer valid. In the rush to make sense of the circumstances in which we find ourselves, our tendency in the past was to ignore and forget 'presence' in favour of 'meaning'. Interpretations were hurled at objects in order to tame them, to bring them under control. (Moxey 2008: 131)

However, a new generation of scholars believes that

> the physical properties of images are as important as their social function. In art history and visual studies, the terms 'pictorial' and 'iconic turn' currently refer to an approach to visual artefacts that recognises their ontological demands. Paying heed to that which cannot be read, to that which exceeds the possibilities of a semiotic interpretation, to that which defies understanding on the basis of convention, and to that which we can never define, offers a striking contrast to the dominant disciplinary paradigms of the recent past: social history in the case of art history, and identity politics and cultural studies on the case of visual studies. (132)

According to Moxey, then, the 'pictorial' or 'iconic' turn is a shift from representation to presentation, from reading the function of images as moments in a process of ideological reproduction to the more complex recognition of what we might call the rights and agency of the object, the wholeness of its material, sensory, ideational being in its singularity, and the ways in which these characteristics influence its meaning, aesthetic presence and history.[13]

It is not possible to evaluate the strength of Moxey's argument here, or speculate on the consequences for visual culture studies should the 'iconic turn' prove influential. Of direct concern is the connection between the prevalence of crisis talk in contemporary art practice and criticism, leading to the kind of hypochondriacal reflection outlined in our discussion of Richter, and an image of a modernist cultural crisis circulated by visual cultural studies. On this view, with the onset of modernism and the rise to prominence and power of visual culture the arts are on a journey that leads inexorably

to postmodernism, a condition of practice premised upon the failure of modern art's means, methods and most profound aspirations.

Emboldened by the iconic turn we shall examine this view by considering a key episode in the development of modern art in terms of both its artistic significance and its relationship with everyday life and culture. We want to look more closely at Cubism and Cubist collage, and the ways in which it has been recently interpreted, in light of its relationship with vernacular visual culture. These are of course the old questions: what is the nature and significance of the work of art (or other cultural artefact) 'in itself' or at least in terms of the specific kind of practice to which it belongs, and how does this practice, together with its artefacts, relate to its society? They reappear not only when we are confronted by a new work successfully estranging itself from public expectations, but also when we return to older art, like Cubism, that remains, for some of us at least, enigmatic, elusive and, despite its embrace of popular cultural forms, sometimes defiantly obscure, but also intriguing and oddly beautiful.

No one thinks that the history of modern art is one of serene, unbroken continuity with tradition. Far more common is the view that Cubist collage is an early moment in modern art's unfolding turbulence, perhaps partially inflicted by art upon itself, but also precipitated by developments in the wider culture. But how adequate is our grasp of Cubism and the theories of visual culture that frame its contact with selected bits and pieces of the *fin de siècle* urban environment? There is a lot at stake here, not just the relative importance of a local event in the history of modern art, but modern art itself and its relationship to modern visual culture. Assuming that we take modern art to be an important element of modern visual culture, then it is worth recalling T. J. Clark's observation: the idiom that resulted from Cubism's intense preoccupation with its devices and goals became '*the* idiom of visual art in the twentieth century . . . Therefore all those who wish to secure an account of modernism as a line of art, or tradition, or canon, have had to confront Cubism pre-eminently—to spell out its purposes, and show why and how it gave rise to such rich variations' (Clark 1999: 175).[14] The story of modern visual culture cannot be told without something being said about Cubism.

The studies by Poggi (1992) and Clark (1999) discussed below have important, enlightening things to say about Cubism or Cubist collage. While both writers are art historians, they draw on and refer to ideas and themes that outcrop widely in visual cultural studies. They will assist our discussion of significant aspects of Cubist painting and collage—without 'writing off' the object in the ways we have seen Moxey criticize—and help us to assess and review a range of different interpretations of the meaning of Cubist painting and collage, and different views on the relationship between Cubism and modern vernacular visual culture.

OBJET/TABLE, IMAGE/*TABLEAU*

In order to take the object seriously we should establish some terms in which a discussion of Cubist paintings and collages can be carried out. In particular, we need to identify three pictorial elements as they were taken up and modified by Cubism,

initially in the context of painting and drawing: the *object characteristics* of the work, the opaque ground to which painted, pigmented marks are traditionally applied and the usually shallow-box construction of the framed canvas; the *picture plane*, the illusory 'front' or transparent face of the painting perpendicular to a horizontal projection from the principal motif or topic of interest, the boundary between pictorial illusion and the surrounding world; and the *surface*, a key distinguishing phenomenon of painting, the outcome of the relationship devised and presented by the artist and his or her materials and processes, between ground and picture plane. It should be noted that the surface is simultaneously sensuously visible and tangible, but also imaginary or virtual.

Cubism is a good example of modernist works in which the artist establishes as a surface a particularly overt, dynamic relationship between ground, which in collage includes the work's enhanced object characteristics, and the illusory order of representation, in the case of still life tables, bottles, glasses and so forth in a familiar horizontal, intimate, quotidian spatial arrangement.[15] To think of this as a simple preference in modernist painting for shallow space misses much of the complexity. Rather, it should be understood as the relationship between the possibility of illusory or pictorial space, the flatness of the ground, and the real depth of the painting-as-object, the material, physical space it occupies. This creates the possibility of an active relationship between a surface, an image and an object dynamically charged by tensions between different degrees of illusory depth. The viewer is assertively confronted by the tangible flatness of the support, the material, spatial and optical presence of the artwork as an object, the mundane physical things depicted in still life, and in Cubist collage, by the unadorned, almost brutal appearance of the profane artefactual world of everyday life in the form of fragments torn out of their ordinary context, and so deprived of their original use and meaning. Collage can thus be seen to enhance a kind of uncompromising materialism already present in Braque's innovative emphasis on painting materials and process, for example mixing in sand and the use of combs as spreaders. Braque and Picasso set these dimensions to work, but do not allow any of them to dominate the logic of the image as a whole. Picasso is peculiarly insistent on keeping all these balls in the air at the same time[16].

Cubist works of this period operate vigorously upon the difference between the picture place—the facing, vertical plane of illusory pictorial space, which can be thought of as a transparent surface through which one sees everything the painting depicts in a receding spatial order[17]—and two horizontal worlds of objects, the illusory space of the still life that structures the picture and, in a new twist, the space of real objects applied to the work, thus foregrounding the object characteristics of the painting itself. In this kind of still life ordinary, everyday things arranged on a table or against a wall dominate the horizontal world of observed objects. Moreover, through the scenes and settings they represent and evoke, these works play with ideas of leisure, escape, the pleasures of everyday intercourse in the midst of the products of a capitalism gearing up to market and exploit consumption, leisure and what we have subsequently come to know as life-style, vigorously energizing visual and tactile pleasures in the process. The inert, stubborn materiality of things is emphasized, along with their capacity to mobilize desire.

Given these and other complexities, Cubism has provoked many explanatory and aesthetic theories, two of which are important here.[18] In the first, it is said to achieve a higher conceptual realism by abandoning a single, fixed viewing position of largely opaque objects in order to see through or show all round the object, thus offering a fuller view and more complete knowledge.[19] In the second, Cubism exemplifies a typical modernist preoccupation with the self-contained, nonreferential object: the significance of the modern work is said to lie in its material, optical presence, not its literary message or what or how it depicts. For some who take this view, Cubism is a significant step towards full-blown abstraction.[20] Yet if Cubism aspires to present the art object shorn of reference and meaning, how are we to understand Braque and Picasso's tenacity about representation, not only the display of its elementary constitutive forms, but also of everyday objects, scenes, settings and themes? But then again, if clarity and realism are the goal, how are we to understand Cubism's delight in ambiguities and paradoxes?[21]

Poggi discusses some of these puzzles in terms of a relationship between table and tableau. The table is a 'sign for the modernist aspiration for the literal object', whereas the tableau is 'a sign of traditional illusion' (1992: 86). She reports documentary evidence that the Cubist circle discussed the Symbolist insistence on the independent existence or autonomy of the work of art in terms of the *tableau-objet*. Moreover, Picasso's group was well known for its love of puns and paradoxes, for which *tableau* proved a

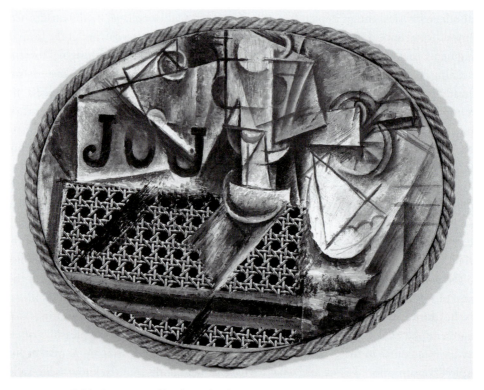

FIGURE 8.2 Pablo Picasso, *Still Life With Chair Caning*, Spring 1912, oil and oilcloth on canvas, Museé Picasso, Paris. © Succession Picasso/DACS, London 2010. Photograph: Bridgeman Art Library.

rich source. The word derives from the Latin *tabula* for wooden board or plank, but was eventually extended to apply to a table or any smooth, flat surface suitable for writing or drawing on. In France *tableau* eventually came to refer to a painting on a wooden panel, and finally portable easel paintings. Thus *tabula* encompasses both tables and traditional paintings (*tableau*).

Inspection of the chair caning in Picasso's *Still Life with Chair Caning*, supposedly the 'first collage', reveals it not to be hand-painted but a mass-produced, printed image on oilcloth, crudely cut and stuck onto the canvas surface, shifting the work vigorously towards the table or object (see Figure 8.2). Is this, then, the disruptive placing of a piece of mundane reality—an ordinary thing—into the illusory, sacred space of an otherwise conventional still life oil painting? The paradox is immediately apparent: this particular fragment of the object world is designed to create an illusion, while the painting into which it is inserted cannot in any way be described as conventionally illusionistic. Is it possible that it was somehow meant to function as *trompe l'oeil*, even if only locally within a section of the image? Yet Picasso seems to go out of his way to prevent this, crudely painting a grey bar across the oilcloth, and making no attempt to hide the cut edges. In other words, he ensures that we simultaneously have the illusion and see it shattered. But again, even this interpretation needs qualification. Its colour and sharpness of detail makes the chair caning jut forward, a vertical plane in front of what might be a second, more distant picture plane located close to the painted objects, becoming almost a *repoussoir*, a painted framing device like a curtain, which pushes back the illusion. But Picasso offsets this effect, making the chair caning recede by means of the overlaid grey bar, what may be diagonal shadows and the base of a glass.[22]

Poggi has many illuminating things to say about Cubism and Cubist collage derived from both her historical research and direct observation, but her interpretation is also strongly influenced by linguistic and poststructuralist theories prominent in some approaches to visual culture, notably visual cultural studies.[23] It is their effect on her analysis that interests us here. Visual cultural studies has often had a tendency to write off the art object by textualizing it, making its whole significance something to be read-off from its optical and material features. For the eclectic and reflexive visual culture studies proposed here, however, visual works of art constitute a test case. Simply put, we need to acknowledge and understand their optical and material features, as well as their historical character, how they belong or do not belong to their times. Neither task is easy, nor is the question of their relationship.

In a section tellingly called 'The Play of Identity and Difference' Poggi begins by dismissing all claims for 'realism'. Such is the profound ambiguity or impossibility of the ways in which these objects and scenes are represented that there can be no question of conventional cognitive or conceptual advance as their aim. At one level this seems reasonable enough; it is tricky indeed to say just how Cubism helps us to see better or know more. However, is it adequate to conclude that the unwavering insistence on representation, or at least its simulation, and the refusal to step fully into abstraction, paradoxically signal Braque and Picasso's negative attitude to the whole of painting up to that point and even painting as such? Cubism does cleave to representation, and it is far from obvious that Braque and Picasso depart fundamentally from a tradition of practice premised

on the belief that painting as an art could refer to, and make something of value from, a common human experience of life, via some kind of metaphoric transformation of ordinary visual appearances. The difficulty is coming to terms with how this works out in practice.

Poggi accurately describes these works as composed of contrasts, a 'play of differentiated signifiers: the straight edged versus the curved, the modelled versus the flat, the transparent versus the opaque, the handcrafted versus the machine-made, the literal versus the figurative' (1992: 78). She claims that Braque and Picasso are practically proposing 'the artificiality of art and the arbitrary, diacritical nature of its signs' (78). The basic argument is as follows: the whole tradition of painting as an art is about illusion; Cubism is sophisticated, self-aware art that rigorously rejects mimesis (while toying with the devices upon which it depends); hence Cubism negates, or is ironical about, painting as an art. Put in poststructuralist terms, Cubism rejects the task of imitating the look of the 'organic object', the solid, opaque, self-identical object available for imitation, in favour of a collection of discrete formal units, a bit like letters or words. These units may be combined to create the effect of reference or meaning, but in this case at least, do not tell us anything substantial or new, even by way of metaphor, through the look of the objects they allude to. Indeed, by employing these elements in paradoxical and contradictory ways Braque and Picasso do not give the viewer more information about the visible world but seek to 'undermine the traditional conventions of illusion by isolating them and setting them in opposition' (Poggi 1992: 46).

Do Braque and Picasso espouse some kind of literary-theoretical irony about the very possibility of reference by resemblance, a view that calls into question the possibility of their work being 'about' anything other than a grammatical play of signifiers? The plausibility of this view is contradicted by the ferocity of Braque and Picasso's concern for particulars—not only the structure and details of the works, but also the visual presence of the subject matter, a glass, lemon-squeezer, half a lemon, a little pot with drinking straws and the rest—evident throughout their work.[24] Also, a conscious grasp of the power of visual contrasts, explicitly modernized by Signac and Leger, is as old as art itself. As radicalized by Picasso in particular, the exploitation of contrast, and reflexive awareness of devices and procedures found in the history of painting, do not entail the kind of scepticism about art's capacity to represent aspects of embodied experience that Poggi sees as Cubism's animating spirit. Braque and Picasso are simply not quasi-poststructuralists *avant la lettre*.

In sum, Poggi finds in the table-tableau theme a 'critique' of the modernist idea of the *tableau-objet* and traditional, illusionistic easel painting. It is undeniable that Cubism uses elements of both approaches, allowing neither to dominate, but of itself this does not amount to either an active negation of painting or an ironical demonstration of its contemporary impossibility. It is certainly true that Picasso and Braque reject the authority of historical convention, the received regime of pictorial resemblance and illusion, and that they place before their audience images that result from a vigorous play with the elements of both pictorial illusion and the modernist *tableau-objet*, almost, but not quite, to the point of destruction. It is also possible to argue, on the basis of the quality of the

work produced between 1908 and 1916, that in sailing so close to the wind, in taking such risks, Cubism forged an image-making practice of exceptional vitality.

REPRESENTATION, METAPHOR AND APPARITIONS

T. J. Clark has argued that Braque and Picasso were determined that Cubism should represent the visible world, not just in some vague, general way but with the high degree of particularity traditionally achieved by the best painting and drawing. His conclusion, however, is that ultimately it fails, managing only schematic allusion. Cubism is thus 'pretence'.[25] It professes to offer fresh knowledge about a new, modern world, knowledge that has been gained by looking hard into the visible face of everyday life, then organizing, articulating and making visible this unfamiliar way of seeing through meeting the demands intrinsic to making a successful painting. However, for Clark, Cubism falls short of this goal because of its very radicalism, its insistence on presenting the means of representation as such.

As a preliminary to considering this claim we should summarize, as plausibly as possible, Cubist intentions: first, to foreground not only the formal or technical machinery, but also the brute materials of painterly representation more starkly than ever before; second, to make an image rich and complex in different ways, encompassing both a visual or aesthetic dimension that is fresh, bold, arresting, challenging and inventive, and also what we might call a 'discursive' aspect using puns, jokes and word play; third, to forge, through the act of seeing, an image that represented truthfully how the world is. The difficulties with which we have been preoccupied belong largely to this third ambition.

For Braque and Picasso, the painterly image was rooted in the representation and recognition of particularities, the conviction that what we see, represented in drawing, painting or collage, has to have the standing and authority of a recognizable, particular visible thing, in both what it represents and what it is. If the image is incapable of convincing the viewer that he or she is looking at the likeness of a particular, as opposed to something that brings to mind a generalized look or idea, then a metaphorical transformation of one particular into another cannot take place. That is, in order to achieve metaphorical transformation, a shape recognizable as the likeness of a visible thing must be modified, lending it new significance and intensity. Without the likeness there is nothing for metaphor to work on.[26]

Clark judges that Cubism fails in this basic task. The machinery of representation, and the adventitious details and motifs (all those moustaches, buttons, pipes and so on), almost pushed into the face of the viewer, announce the arrival of something that should be recognizable and particular, able to disclose something important in its singularity. However, in refusing unambiguous representation, the appearance of a substantial particular anchored in everyday appearances and experience, the ground floor of metaphorical transformation, and by insisting instead on the priority of the play of representational devices, Cubism offers the viewer only schematic allusion, something equivalent to a sketch or diagram.

Clark's underlying idea seems to be as follows. In the early years of the twentieth century a new social order, a new reality for human being-in-the-world, is emerging. For some modernists, grasping the new reality required seeing it for what it was—because seeing is a primary way of knowing—and that meant seeing it through modern eyes. However, the radical reflexivity inherent in modernity entails recognition that ways of seeing are both historically relative and constructive; as constructive interpretations they are a constituent, formative part of the orders to which they belong. Modernity has revolutionary consequences not only for what Marxists like Clark refer to as the means and relations of production, but also for modes of sensory apprehension. It would follow, therefore, that the new way of seeing, which would reveal the reality of modernity, is embedded in emerging ways of life, and unless it is disembedded, dug out and grasped as such, we will fail to release the full promise of the new world.

If we are unable to see the life around us properly it is because we cling to old ways of seeing. The modern way of seeing does not present itself as something novel to look at, like a locomotive, a shopping arcade or the Eiffel Tower. Rather, it has to be worked out, brought fully into the world, and Braque and Picasso believed visual art capable of achieving this. You begin by looking hard, not only at ordinary visible things, but also at *how* one looks and represents what there is to be seen. The way of seeing embedded in older life and art, its formal structure or grammar, must be isolated, appraised, rejected or augmented as necessary, and set to work. The problem for Clark is simply that isolating the visual means of production from their product leaves the Cubist image adrift, arbitrary, and the inevitable alternatives, relentlessly and often anxiously explored by Picasso, are a slide into what Clark sees as the elegant vacuity of grids or, now bereft of any defence against fantasy and idiosyncrasy, a kind of manic inventiveness.[27] Put in somewhat different terms, the modern tendency to objectify the senses and mechanize meaning leads to confusion between seeing and making. In this case, the intense reflexivity of Cubist seeing leads to the techniques and devices or praxis of image making monopolizing the field of vision and the occluding of the visible world.

Clark misses something here: the ghostly reappearance of visible things. Certainly the best Cubist pieces are inseparable from the questions and paradoxes they pose. These marks, lines and surfaces could perhaps be that jug, bottle and glass arranged in that way, something we might have seen in an artists' café on an April evening in Paris, but does the image convince sufficiently for metaphor to take hold? The talent, skill and inventiveness of Braque and Picasso persuade the spectator that Cubism has the capacity to achieve whatever kind of representation is wanted. Hence, if there are indeed real difficulties with Cubist mimesis this might suggest either that it has in some way repudiated representation or that the viewer is at fault for not cottoning on. As we have seen, popular alternative interpretations try to resolve this difficulty through their proposals of higher conceptualism realism, progress towards complete abstraction, or a kind of reflexive self-disenchantment, irony and the open play of signifiers. If none of these satisfy, we are left to question the image by looking hard and long at its facets, edges, shadows, impasto, collaged fragments and so forth, searching for a solid presence that will not leave our imagination roaming and unsettled. Put more positively, the Cubist image

seems to demand from the viewer that imagination precedes recognition.[27] Braque and Picasso's fierce engagement with quotidian things, the will to representation evident in their relentless exploration of the means and materials of art, leads to the everyday, visible world's spectral reappearance. These ghostly entities are not of the past, but belong to the present or the future. While they seem to be what they appear to be, they also lack something: substance, full corporeal life, the capacity to participate.

Yet ghosts often have a message or secret to impart, revealed to their intended recipient only through anxious interrogation. The various theories prompted by Cubism seem to be just this. However, Braque and Picasso did not intend Cubism to 'pose questions'. On the contrary, they were after answers. Nor is it being suggested that this ghostly reappearance of everyday experience, of life at the point where it is at its most substantial, material and embodied, but also at its most ephemeral and subjective, has an immediate, neat application to other aspects of visual culture. It is a disclosure specific to art of this kind.

The spectral visibility Cubism lends to everyday life suggests a theme that outcrops elsewhere in twentieth-century art, literature and philosophy, a suspicion that moderns are not fully what they seem to be, that there is a widespread falseness and debility because modern societies fail to provide sufficiently convincing guidance about what to believe, how to go on, what to do.[29] This is not due to a failure to regulate life; there are instructions, scripts, rules and norms aplenty, behind which lie the division of labour, highly rationalized institutional roles, the replacement of ascribed by achieved identity and sophisticated procedural reasoning, or more recently under the 'new capitalism' the direct application of power unfiltered by bureaucratic structures. Formulae, prescriptions, procedures and directives on the one hand, and on the other guidance for self-help, DIY identity, cognitive therapy, techniques of 'positive thinking', and scripts and choreographies for successful living are not enough, however, failing to vanquish the danger of meaninglessness and leaving unsatisfied longings for freedom, autonomy and morally based communities (Giddens 1991: 70–108, 181–208).

In addition to the refinement of institutional and organizational frameworks for action designed to ensure transparency, intelligibility and efficiency, whether enshrined in bureaucratic structures or actively pushed out to the institutional periphery—for example by the kind of de-layered, 'flexible organisations' discussed by Sennett (2006)—there is also the progressive impact of technical and theoretical discourses, in particular the interpretive constructions of psychology, sociology and cultural theory on the ways in which human beings understand their ordinary, everyday lives and practices. The impact of technical discourses of various kinds on the self-interpretation of everyday life merits a longer discussion than is possible here.[30] However, it is perhaps useful to think about the significance of Cubism from the point of view of how attempts to theorize everyday life and experience, or make it amenable to technical control, contribute not to its disappearance but its bifurcation. On the one hand there is the continued substantiality, vitality and urgency of everyday experience—accompanied of course by its fleeting, highly local character—but also, as late-modernity takes hold, its ghostly, denatured reappearance, the effect of its objectification, either as subject to techniques of living or

more philosophically, the formal apparatus of constitutive interpretation, ultimately the 'grammar' of discourse.[31]

CONCLUSION

In a historical period characterized by an intentionally activated visual and sensory environment, amplified and diversified by new communicative technologies, the encounter between visual art and visual culture may seem of marginal importance. The prominence of visual artefacts in the modern period, in particular the obvious reach, power and glamour of popular, commoditized, mass cultural forms, has led some theorists to claim that this kind of visuality has become the dominant cultural form, with visual art sidelined as a minority, elite preoccupation. The interpretation provided by visual cultural studies suggests that at the root of cultural artefacts and processes is a covert distribution and legitimating of quasi-political power, and that underlying and disguised by visual and sensory appearances is language, in the shape of arbitrary, coded signs which make meaning, and therefore author the world. Understood properly, language rivals number as a human technology, the power of both derived from their capacity for abstraction. The result, as Barbara Stafford has observed, is a postdisciplinary academy 'haunted by the paradoxical ubiquity and degradation of images; everywhere transmitted, universally viewed, but as a category generally despised' (Stafford 1992: 11).

Against this, however, should be set the need not only fully to understand the consequences of changes in the traditional cultural hierarchies, including the significance of visual art, brought about by modernity, but also the fact that within two- and three-dimensional art visual sensibility and visual thinking have undergone exploration and refinement of unrivalled depth. Both aspects are of critical significance to visual culture studies.

Those who have never been totally satisfied with visual cultural studies should be heartened to receive Moxey's news of the 'iconic turn', which seems to offer if nothing else a chance to take the object, embodied experience and work of art *as art* more seriously. In order to discuss Cubism and Cubist collage properly it has been necessary to have available terms that identify key formal features of this kind of artefact, and this requires examining and evaluating the usefulness of various descriptive and critical ideas by looking carefully at works. The notions of object-features, picture plane and surface, as well as Poggi's *objet*/table and image/*tableau*, touch on recurrent themes in Cubist criticism, specifically the tension between the modernist material object on the one hand and the representation of quotidian modern life on the other. In the case of Cubism, the modernist object attains its peculiar autonomous presence by being on the one hand deprived of its embeddedness in familiar contexts of use and meaning, triggering imagination by forcibly propelling the senses into an interpretive role, but also by being perceptibly organized as if for the kind of representation characteristic of visual art. The ferocity of Braque and Picasso's will to representation, together with their radical experiments with the constitutive conventions of visual mimesis, simultaneously ironical and in deadly earnest, lead to the ghostly reappearance of familiar everyday scenes and

things. Although probably not intentional, there is here an envisaging how modern life can appear both real and substantial and yet also reflectively spectral, that is insubstantial when reframed by technical discourses and procedures. In the field of cultural theory this reframing has often been particularly pronounced, with interpretive practices transformed into highly technical procedures and discourses. The prestige and rhetorical power of such discourses is derived largely from their capacity for reflexive and abstract self-formulation, that is so to speak, the will to disembodiment of those who use them.

NOTES

1. For an influential account of links between avant-garde art and modern mass culture see Crow (1996).
2. A growing class of entrepreneurs realized the economic potential of leisure. New forms of commoditized recreation included music and dance halls, organized sports, cinemas, cafes and restaurants, newspapers and magazines and gambling, while the spread of paid holidays from work encouraged the growth of tourism and holiday resorts. Paris also gained notoriety for its hundreds of brothels, as well as revues and risqué cabarets, such as the Moulin Rouge. Its metro system opened in 1990. For an outline of social history of leisure see Rojek (1985).
3. See for example the rise of iconology or picture theory outlined below; also of note is Norman Bryson's recent conversion to neuroaesthetics, see his introduction to Neidich (2003).
4. In the famous Epilogue to his essay 'The Origin of the Work of Art' Martin Heidegger quotes three passages from Hegel's *Aesthetics* (1828/29). Heidegger remarks that while the ultimate truth of the judgement that 'art is and remains for us, on the side of its highest vocation, something past' has yet to be decided, but until then 'the judgement remains in force' (Heidegger 1971: 80).

 Frederick Beiser reminds us that Hegel does not use the phrase 'the death of art', the attribution probably coming from a paraphrase in Croce's *Aesthetica*. He also remarks that an early translation of the *Aesthetics* rendered *Kunst sich selbst aufhebt* as 'art commits an act of suicide' (Beiser 2005: 340).
5. Dikovitskaya (2005: 64–84). See also her distinction between cultural studies and visual culture studies.
6. For Fredric Jameson 'aesthetic production today has become integrated into commodity production generally: the frantic economic urgency of producing fresh waves of ever more novel-seeming goods (from clothing to aeroplanes), at ever greater rates of turnover, now assigns an increasingly essential structural function and position to aesthetic innovation and experimentation'. However, lest we blithely welcome the democratizing, or at least commoditizing, of the aesthetic, Jameson sternly reminds us that 'this whole global, yet American, postmodern culture is the internal and superstructural expression of a whole new wave of American military and economic domination throughout the world: in this sense, as throughout class history, the underside of culture is blood, torture, death, and terror' (Jameson 1992: 56).
7. An art historical-critical version of this cycle is often said to begin with Marcel Duchamp and reach its culmination in Andy Warhol, who then opens the way to a fully postmodern art (Danto 1986, 1987, 1992; see also Shusterman in Rollins 1993). It's worth recalling that Duchamp went through a Cubist phase, and the introduction of what he calls 'readymades',

that is the direct use of manufactured artefacts in works of art (usually dated to the signed bottle rack of 1914), had already been pioneered by Braque and Picasso. See Pierre Caban (1971: 26).

8. The influence of poststructuralism on visual culture studies is another story, but the emphasis on language, albeit denied the possibility of reference and hence of ideology critique, both radicalizes the constructive character of theory and connects it inextricably to written texts.

9. The point is not that difficulties, problems and challenges confront practice, but that reflection is hypochondriacal when an unbalanced judgement of possible symptoms has become habitual or compulsive. For the related omnivorous appetite of cultural studies and the connection with a regime of 'excellence' characterizing the late-modern university see Readings (1996).

10. See also Heywood: 'An Art of Scholars' in Jenks (1995) and 'Richter's Reflexivity' in Whiteley (2001).

11. This view, or something like it, would be shared in my opinion by influential curator-critics like Benjamin Buchloh and Hans-Ulrich Obrist.

12. It is tempting to compare this apparently bleak outlook with what Nietzsche calls the 'ascetic ideal' (Nietzsche (1887) 1969: 159–61), an 'unconditional honest atheism', the origins of which lie in the Christian conscience 'sublimated' into scientific conscience, becoming eventually an ethic of 'intellectual cleanliness at any price'. Oddly, the conviction behind Richter's 'honesty' may rest in a certain self-inflicted cruelty, in essence the working out of a moral stance towards the practice of art.

13. Moxey summarizes the areas and major figures contributing to the iconic or pictorial turn:

Philosophy: Deleuze and Guattari, Alain Badiou
Art History: Georges Didi-Huberman
Visual Studies: W.J.T. (Tom) Mitchell, James Elkins
New Science Studies/Actor Network Theory: Bruno Latour
German *Bildwissenschaft/Bildanthropologie*: Gottfried Boehm, Hans Belting, Horst Bredekamp

14. For John Golding, Cubism represents 'the most important and certainly the most complete and radical artistic revolution since the Renaissance . . . [Nothing] has so altered the principles, so shaken the foundations of Western painting as did Cubism' (Golding 1988: 15). Of collage, Clement Greenberg writes: 'Collage was a major turning point in the evolution of Cubism, and therefore a major turning point in the whole evolution of modernist art in this century' (Greenberg 1961: 70).

15. Although the relationship between ground and picture plane enacted by surface becomes a common preoccupation in the modern period, it is a characteristic of what Wollheim calls 'painting as an art' (Wollheim 1987). One of the effects of modernism is to give the premodern history of this defining feature greater prominence.

16. See Clark (1999: 204).

17. It should be noted that the picture plane can seem to coincide with the actual material surface (ground) of the painting, to recede behind it, or even to be in front of the ground. We should also note the use of *repoussoir* or painted framing devices like curtains, which push back the illusion, but then sometimes raise questions about their spatial position. See also Poggi (1992: 62).

18. There are important contemporary accounts of Cubism by Albert Gleizes and Jean Metzinger, Fernand Leger, Juan Gris, Guillaume Apollinaire, Andrè Salmon and Daniel-Henry Kahnweiler. The best source of information on this literature in English is Antliff and Leighten (2008). See also more recent work by T. J. Clark (1999), Rosalind Krauss (1985) and Yves-Alain Bois (1990).

19. Kahnweiler, not only a businessman but also an able critic, was one of the first to interpret Cubism along these lines. He claimed that Picasso, after years of research, had 'pierced the closed form'. His defence of Cubism combines claims about the ways in which it overcomes 'distortions' of colour and form present in all previous painting, and its advanced method of distinguishing between Locke's primary and secondary qualities, presenting and organizing the former and only 'suggesting' the latter. He also remarks that Cubism gives to painting 'unprecedented freedom'. See Kahnweiler in McCully (1996: 69–73).

20. See Clement Greenberg's important essay 'Collage' (Greenberg 1961: 70–83). He writes: 'There is no question but that Braque and Picasso were concerned, in their Cubism, with holding on to painting as an art of representation and illusion.' Elaborating the point, he says that 'Painting had to spell out, rather than pretend to deny, the physical fact that it was flat, even though at the same time it had to overcome this proclaimed flatness as an aesthetic fact and continue to report nature' (70–1).

21. See also Clark's brisk dismissal of the idea that Cubism offers more knowledge of the object by releasing the eye to 'wander' (Clark 1999: 204).

22. In *Violin Hanging on a Wall* (1912) wood grain wallpaper suggests both a vertical surface (although not close to the picture plane) and the horizontal space of a table supporting the display of objects. We also see this play of vertical and horizontal planes in *Construction with Guitar* (1913).

23. In this she follows what are perhaps the best-known semiotic interpretations of Cubism offered by Rosalind Krauss and Yves-Alain Bois.

24. See Clark (1999: 183).

25. A loaded word, seeming to imply that Braque and Picasso knew that they had failed, but pretended—in what they said and perhaps in loading up their works with adventitious details—that they hadn't. This is a peculiar accusation, not only because conscience is difficult to get at, but also because it seems at odds with what Clark rightly wants us to see as the utter seriousness and integrity of Cubist practice.

26. See also Clark's helpful comparison with a painting of olive trees by Van Gogh (Clark 1999: 216).

27. The pictures organized as 'elegant grids' belong to the summer of 1910 spent at Cadaqués, for example *Female Nude* in the National Gallery of Art, Washington, DC, and *The Guitarist* in the Musée National d'Art Modern, Paris. For paintings that for Clark show manic activity and a 'failure to conclude' see *(Wo)man with a Mandolin*, 1912, Musée de Picasso, Paris (Clark 1999: 188–91).

28. For interesting remarks about how viewers must combine in their minds an undistorted 'scheme of forms' with secondary qualities like 'colour and tactile quality' if they are to appreciate the full pictorial effect of Cubism see Kahnweiler in McCully (1981: 71).

29. These ideas can be found in works by Nietzsche, Kierkegaard, Adorno, Heidegger, Jean Paul Sartre, T. S. Eliot, D. H. Lawrence, George Orwell, David Riesman, Erving Goffman and Richard Sennett among many others. See also Geoffrey H. Hartman's (1997) connection of culture to 'abstract life'. He provides many literary examples of the 'feeling of being an outsider to life'.

30. For two illuminating philosophical discussions see Cavell (1988) and Rosen (2002).
31. Semiotics, structuralism and poststructuralism pursue this idea, but have different views on its significance.

REFERENCES

Adorno, Theodor. 1984. *Aesthetic Theory*, trans. C. Lenhardt. London: Routledge.

Antliff, Mark, and Leighten, Patricia, eds. 2008. *A Cubism Reader: Documents and Criticism 1906–1914*. Chicago: University of Chicago Press.

Beiser, Frederick. 2005. *Hegel*. London: Routledge.

Bois, Yves-Alain. 1990. *Painting as Model*. Cambridge, MA: MIT Press.

Bourdieu, Pierre. 1986. *Distinction: A Social Critique of the Judgement of Taste*, trans. Richard Nice. London: Routledge.

Caban, Pierre. 1971. *Dialogues with Marcel Duchamp*. New York: Da Capo.

Cavell, Stanley. 1988. *In Quest of the Ordinary*. Chicago: University of Chicago Press.

Clark, T. J. 1999. *Farewell to an Idea: Episodes from a History of Modernism*. New Haven, CT: Yale University Press.

Cottingham, David. 2004. *Cubism and Its Histories*. Manchester: Manchester University Press.

Crow, Thomas. 1996. *Modern Art in the Common Culture*. New Haven, CT: Yale University Press.

Danto, Arthur. 1986. *The Philosophical Disenfranchisement of Art*. New York: Columbia University Press.

Danto, Arthur. 1987. *The State of the Art*. New York: Prentice Hall Press.

Danto, Arthur. 1992. *Beyond the Brillo Box: The Visual Arts in Post-Historical Perspective*. New York: Farrar, Straus, Giroux.

Dikovitskaya, Margaret. 2005. *Visual Culture: The Study of the Visual After the Visual Turn*. Cambridge, MA: MIT Press.

Geulen, Eva. 2006. *The End of Art: Readings in a Rumour after Hegel*, trans. J. McFarland. Stanford, CA: Stanford University Press.

Giddens, Anthony. 1991. *Modernity and Self Identity in the Late-Modern Age*. Cambridge: Polity.

Gleizes, Albert and Jean Metzinger. (1912) 2003. *Du Cubism*. Paris: Presence.

Golding, John. 1988. *Cubism: A History and an Analysis*. London: Harper Collins.

Greenberg, Clement. 1961. *Art and Culture*. Boston: Beacon Press.

Hartman, Geoffrey H. 1997. *The Fateful Question of Culture*. New York: Columbia University Press.

Heidegger, Martin. 1971. *Poetry, Language, Thought*, trans. Albert Hofstadter. New York: Harper & Row.

Hegel, G.W.F. 1975. *Aesthetics: Lectures on Fine Art*, trans. T. M. Knox, 2 vols. Oxford: Clarendon Press.

Jameson, Frederic. 1992. *Postmodernism, or the Cultural Logic of Late Capitalism*. London: Verso.

Jenks, Chris, ed. 1995. *Visual Culture*. London: Routledge.

Krauss, Rosalind. 1985. *The Originality of the Avant-Garde and Other Modernist Myths*. Cambridge, MA: MIT Press.

Lang, Berel, ed. 1984. *The Death of Art*. New York: Haven.

McCully, Marilyn, ed. 1996. *A Picasso Anthology: Documents, Criticism, and Reminiscences*. Princeton, NJ: Princeton University Press.

Merleau-Ponty, Maurice. 1993. *The Merleau-Ponty Aesthetics Reader: Philosophy and Painting*, ed. Galen A. Johnson. Evanston, IL: Northwestern University Press.

Moxey, Keith. 2008. 'Visual Culture and the Iconic Turn', *Journal of Visual Culture*, 7/2 (August): 131–46.

Neidich, Warren. 2003. *Blow-up: Photography, Cinema and the Brain*. New York: Distributed Art Publishers.

Nietzsche, Friedrich. (1887) 1969. *On the Genealogy of Morals* and *Ecce Homo*, trans. W. Kaufmann. New York: Vintage Books.

Pippin, Robert. 2005a. 'Authenticity in Painting: Remarks on Michael Fried's Art History', in *Critical Inquiry*, 31 (Spring): 575–98.

Pippin, Robert. 2005b. *The Persistence of Subjectivity*. Cambridge: Cambridge University Press.

Poggi, Christine. 1992. *In Defiance of Painting: Cubism, Futurism and the Invention of Collage*. New Haven, CT: Yale University Press.

Readings, Bill. 1996. *The University in Ruins*. Cambridge, MA: Yale University Press.

Richter, Gerhard. 1995. *The Daily Practice of Painting*. London: Thames and Hudson.

Rojek, Chris. 1985. *Capitalism and Leisure Theory*. London: Routledge.

Rollins, Mark, ed. 1993. *Danto and His Critics*. Oxford: Blackwell.

Rosen, Stanley. 2002. *The Elusiveness of the Ordinary*. New Haven, CT: Yale University Press.

Sennett, Richard. 2006. *The Culture of the New Capitalism*. New Haven, CT: Yale University Press.

Stafford, Barbara. 1992. *Good Looking: Essays on the Virtue of Images*. Cambridge, MA: MIT Press.

Whiteley, Nigel, ed. 2001. *De-Traditionalisation and Art: Aesthetics, Authority, Authenticity*. London: Middlesex University Press.

Wollheim, Richard. 1987. *Painting as an Art*. London: Thames and Hudson.

Reframing Nature: The Visual Experience of Early Mountaineering

SIMON BAINBRIDGE

In the opening of his popular *Guide to the Lakes* ((1810) 1975), the poet William Wordsworth introduces his readers to the Lake District landscape by asking them to imagine themselves in a particular viewing position:

> To begin, then, with the main outlines of the country;—I know not how to give the reader a distinct image of these more readily, than by requesting him to place himself with me, in imagination, upon some given point; let it be the top of either of the mountains, Great Gavel, or Skiddaw; or, rather, let us suppose our station to be a cloud hanging midway between those two mountains, at not more than half a mile's distance from the summit of each, and not many yards above their highest elevation; we shall then see stretched at our feet a number of valleys, not fewer than eight, diverging from the point, on which we are supposed to stand, like spokes from the nave of a wheel. (Wordsworth (1810) 1975: 41–2)

For Wordsworth's readers, this cloud-based viewing position was one that could only be realized in the imagination, though as an idea it might have been influenced by the age's experiments in balloon travel (see Holmes 2008: 125–62). As the paragraph makes clear, however, this impossible position was actually only an imaginative extension of what was a relatively new but rapidly developing way of viewing landscape, seeing it from the summit of a mountain. By ascending to a summit, the poet suggests, the reader will be able to gain a fuller and truer understanding of the world around him. Drawing an analogy for his *Guide* with a scale-model of the Alps, Wordsworth writes that an elevated perspective over a miniaturized landscape supplies a 'substantial pleasure: for the sublime and beautiful region, with all its hidden treasures, and their bearings and relations to each other, is thereby comprehended and understood at once' (Wordsworth (1810) 1975: 41).

Wordsworth, an experienced mountaineer who had climbed Snowdon and the major Lake District peaks and had walked through the Swiss Alps, published his *Guide* in the middle of a period which saw the initial development in Great Britain of what now would be termed 'hill-walking', 'fell-walking' or 'mountaineering'; the latter word was first coined in 1802 by Wordsworth's friend and fellow poet Samuel Taylor Coleridge to describe his own exploits in the Lake District (Coleridge 1956: 452). While many early mountain ascents were undertaken for scientific, military or other practical purposes, from the 1760s onwards people increasingly began to climb mountains for a specifically visual experience. Though ascending fells is a highly physical activity and appeals to the senses of touch, smell and hearing, in the period of its early development it was very much understood as visually motivated; as Jonathan Otley commented in his *A Concise Description of the English Lakes*, 'an extensive prospect [is] the principal motive for ascending a mountain' (Otley (1823) 1825: 43). Indeed, while many hill-walkers would now see exercise as a major reason for undertaking the activity, in its early history the physical effort required to reach a high point was very much regarded as the cost which it was hoped would bring the reward of a summit view. For example after describing the 'laborious ascent' required to reach the top of Skiddaw in 1773, William Hutchinson remarked that 'the prospect which we gained from this eminence very well rewarded our fatigue' (Hutchinson 1774: 156).

The early history of mountaineering, then, represents an important development in visual culture, particularly in terms of the envisioning of landscape and the relationship between viewing subjects and the world around them. In this chapter, I want to trace the origins of this new way of seeing and experiencing the world and examine what it was about the visual experience of climbing mountains that led to the remarkable development of the activity in the period from the 1760s to the 1830s, by which decade the desire to reach summits had been fully incorporated into the general literature of tourism. Though there is now much debate about what precisely constitutes mountaineering as opposed to fell and hill-walking, during this period there were no such distinctions and I use the different terms interchangeably to describe the activities of those tourists who deliberately set out to climb or ascend what they called 'mountains' (a term they often used to refer to peaks much lower than the height of 3,000 feet which has since become one of the most common definitions of a mountain in Great Britain). The broader context for this study is provided by two excellent book-length accounts of the shifting cultural response to mountains: Marjorie Hope Nicolson's *Mountain Gloom and Mountain Glory* (1959) and Robert Macfarlane's *Mountains of the Mind* (2004). Nicolson provides a wonderfully informative account of the aesthetic revaluing of mountains in the seventeenth and eighteenth centuries, though her study is much more focused on looking at peaks than looking from them. Macfarlane gives a terrifically wide-ranging and stimulating analysis of the culture of mountains and mountaineering (including a chapter on 'Altitude: The Summit and the View'), though the very scope of his study make it impossible for him to look in any detail at the rapidly expanding field of travel writing from the late-eighteenth and

early-nineteenth centuries in which we can trace the development of this new visual experience.

THE SUBLIME, THE PICTURESQUE AND THE DEVELOPMENT OF MOUNTAINEERING IN BRITAIN

The visual culture of early mountaineering represents a development of two of the major concepts of eighteenth-century aesthetics, the sublime and the picturesque. The concept of the sublime can be traced back to the Greek writer Longinus whose first-century essay 'On the Sublime' was concerned with the uplifting effect of elevated language. Though this meaning was still current in the eighteenth century, the sublime came increasingly to be used to describe certain kinds of landscapes and natural features which produced powerful emotional reactions from those who saw them. Early examples of such reactions to sublime landscapes include the dramatist John Dennis's description of his feelings of 'a delightful horror [and] a terrible Joy' when ascending a perilous Alpine pass in 1688, and Joseph Addison's account of how mountain landscapes and 'unbounded views' produced 'a pleasing Astonishment' in his 'Essay on the Pleasures of the Imagination' of 1712 (Addison 1712: 540; Dennis in Thorpe 1935: 465). It was Edmund Burke in his *A Philosophical Enquiry into the Origins of Our Ideas of the Sublime and Beautiful* of 1757 who most influentially associated this sense of excitement bordering on fear with the sublime, writing that 'whatever is fitted in any sort to excite the ideas of pain, and danger, that is to say, whatever is in any sort terrible, or is conversant about terrible objects, or operates in a manner analogous to terror, is a source of the *sublime*; that is, it is productive of the strongest emotion which the mind is capable of feeling' (Burke (1757) 1998: 13). However, Burke argues that for this powerful emotion to be pleasurable it needs to be experienced from a position of safety: 'When danger or pain press too nearly, they are incapable of giving any delight, and are simply terrible; but at certain distances, and with certain modifications, they may be, and they are delightful' (Burke (1757) 1998: 13–14). Mountainous landscapes offered a key source of the sublime and an important way of understanding the relationship between visual experience and psychological reaction. It was in terms of the sublime that Wordsworth's friend Thomas Wilkinson justified a lifetime of mountain climbing, opening his memoir *Tours to the British Mountains* of 1824 by stating 'From early life I have been an admirer of the sublime in Nature. Mountains and their accompaniments are amongst the finest specimens of the sublime. Hence, when circumstances allowed, I availed myself of the opportunity of exploring their recesses and ascending their summits' (Wilkinson 1824: v).

Burke clarified previous theories of the sublime by defining it against beauty. For him the beautiful was characterized by smallness, smoothness, roundness and delicacy, and produced feelings of love. The sublime was defined by vastness, obscurity and infinity, and produced feelings of astonishment and, as we have seen, terror. As the eighteenth century progressed, a third term was introduced that overlapped with, and mediated between, these opposing conceptions of landscape—the 'picturesque'. The clergyman William Gilpin, one of the earliest and most important theorists of the picturesque, defined

it as 'that particular kind of beauty, which is agreeable in a picture' (Gilpin 1768: 2), finding in the works of painters such as Claude Lorraine and Salvator Rosa the models for an appreciation of landscape. For Gilpin, the distinguishing quality of such paintings and landscapes was their 'roughness', which defined them against the regularity and smoothness of nonpicturesque beauty. 'Roughness' and 'ruggedness' produced variety, richness and contrast—desirable qualities in art and landscape for Gilpin. Though the nature of the picturesque was much debated in the closing decades of the eighteenth century, it provided a valuable aesthetic for appreciating the British landscape, and particularly the increasingly popular tourist destinations of the mountainous regions of the Lake District in north-western England, Snowdonia in Wales and the Highlands of Scotland which, while certainly rough and rugged, were sometimes seen to lack the scale and magnificence of the Alps.

Though the cult of the picturesque and the picturesque tour have often been characterized as only interested in low-level views, the possibility of ascending to summits was inherent within them from their origins. In his *Guide to the Lakes* of 1778, a founding text of the picturesque tour, Thomas West advocated the Lake District over the Alps as a travel destination because, though 'the tops of the highest Alps are inaccessible, being covered with everlasting snow', the Lake District mountains 'are all accessible to the summit' and 'furnish prospects no less surprising [and] with more variety than the Alps themselves' (West 1778: 6). West offers no advice on how to ascend to these summits, but the famous 'stations' which he identified as the ideal locations from which to view the landscape were sometimes surprisingly elevated. For example his fourth station on Derwentwater is Castle Crag, a very steep peak in the so-called Jaws of Borrowdale, which is just under 1,000 feet high and requires quite a demanding climb to gain what West describes as 'a most astonishing view' (West 1778: 97).

West's *Guide* was only one early literary encouragement to climb mountains, and the search for the sublime or picturesque experience produced a large number of summit narratives as well as a developing infrastructure of guides and accommodation that supported the increasing demand to ascend for the sake of a view. In the Lake District, Skiddaw near Penrith in the northern part of the district became the most popular site for ascents to a mountain summit, due to its accessibility, its relative separation from other peaks and the fact that it was possible to get close to the top on horseback. Ascents of 'lofty Skiddaw' were described in a number of the most popular travel accounts, including those made by William Hutchinson in 1774, Adam Walker in 1791, Joseph Budworth in 1792 and Ann Radcliffe in 1794. As early as 1798 this nascent summit fever had become a target for satire. In the comic parody of picturesque tourism *The Lakers*, the heroine Veronica's plans to climb Skiddaw are frustrated by bad weather, but she comments 'I must go up whether it is fine or not. My tour would be absolutely incomplete without an account of a ride up Skiddaw' (Plumptre 1798: 27). Semi-organized mountain trips of the sort a real-life Veronica would have taken were often rather sociable events. Led by a local guide, often a farmer, shepherd, innkeeper or one of their family, many people climbed as part of a group or small party. These trips often began very early in the morning and seem to have involved drinking fairly copious amounts

of brandy, rum and whisky, supplied by the guide (an issue frequently discussed in the accounts). Exploring summits beyond the most popular ones of Skiddaw, Helvellyn and Coniston Old Man remained rare in the eighteenth century, and the desire to do so could disconcert even the local guides. Joseph Budworth, who made pioneering ascents for pleasure of Helm Crag in 1792 and the Langdale Pikes in 1797, recounts how having scrambled over the rocks to reach the summit of Pike O' Stickle in Langdale, his guide Paul Postlethwaite turned to him and said, in a broad Cumbrian accent, 'Ith neome oh fackins, wot a broughtin you here?' To which Budworth replied: 'Curiosity, Paul'. Postlethwaite responded: 'I think you mun be curious enuff: I neor cum here but after runaway sheop, an I'me then so vext at um, I cud throa um deawn th' Poike' (Budworth 1810: 269). The canon of climbable Lake District mountains expanded rapidly in the opening decades of the nineteenth century. In his *A Companion to the Lakes*, first published in 1829, Edward Baines offered 'a particular account of the ascents of Skiddaw, Helvellyn, Scawfell Pikes, Great Gavel, Bowfell, Langdale Pikes, High Bell, High Street, and several other mountains' (Baines 1834: v).

There was a comparable expansion in the number of visitors who sought to reach the summits of the Scottish Highlands and Snowdonia in Wales, though the greater scale and difficulty of the Highland mountains meant that activity focused initially on Ben Lomond, the most southerly of the Scottish peaks over 3,000 feet, where guides were 'at hand to conduct you, by the best and readiest track, to the summit' (Denholm 1804: 39). Though Ben Nevis was recognized as the highest mountain in Britain, as late as 1824 one guidebook could still describe it as 'not often visited' due to the 'considerable … distance to the top' and the 'laborious' accent (MacCulloch 1824: 323). Even the adventurous Samuel Taylor Coleridge was rather overawed by the wildness of the Highlands, compared to the Lakes. In Wales, Thomas Pennant ascended Cadair Idris and Snowdon (the highest mountain in Wales) as early as 1773. He failed to gain a view on the former, and his hope that 'another traveller' would be able to 'make a more satisfactory relation of this mountain, than I have been able to do' indicates how pioneering this venture was (Pennant 1778: 89). However, following Pennant's ascents, Cadair Idris and Snowdon became established as the two most popular Welsh summits, with an infrastructure of guides, ponies, new roads and accommodation growing up around them. By the time of the Reverend William Bingley's *A Tour Round North Wales, 1798*, seven main routes had been established up Snowdon, 'the most celebrated mountain in Great Britain', all of which Bingley explored and described in detail (Bingley climbed several other Welsh mountains including Tryfan, though his account of the dangers of this peak served to discourage others from attempting it) (Bingley 1800: I.239). By 1803, William Hutton, who commented that it is 'unfashionable not to visit the Lakes of Llanberis, but chiefly Snowdon', was assessing the economic benefit of the developments in mountaineering to Wales, reporting that 'there is already … more than thirty thousand [pounds] a year spent by the English mountain-hunters' (Hutton 1803: 54). Towards the end of the period covered by this essay, Snowdon (like Scafell and Ben Nevis) started to become a target for those motivated by a desire to climb the highest peak in the region. M. R. of Liverpool wrote to *The Kaleidoscope* in 1828 that 'From the time I landed in North

Wales I had looked upon the ascent of Snowdon as a kind of achievement I should like to perform. It would be, I thought, a feat without which all my other excursions would be incomplete' (M. R. 1828: 102). However, for the vast majority of visitors the reason for reaching a summit was the view it facilitated, and many writers saw their expeditions as failures if they were unable to obtain a view despite having reached the summit (see, for example Fisher 1818: 36).

THE VIEW FROM THE TOP

The power of the extraordinary and unprecedented visual experience of a summit view in this early age of mountaineering is illustrated by the frequent invocation of the idea of 'astonishment', a term central to Addison's and Burke's accounts of the sublime (and that we have already seen in West's description of the prospect from Castle Crag). For Edward Baines the view from the summit of Skiddaw was an 'astonishing prospect' while Richard Warner described how the 'vast unbounded prospect' seen from Cadair Idris impressed 'the astonished and delighted eye' (Baines (1829) 1834: 146; Warner 1798: 97). It was this idea of being stunned, bewildered or even terrified as a result of climbing up and looking down that Dr John Brown invoked in his A *Description of the Lake at Keswick*, an account first published in 1766 and one of the earliest appreciative descriptions of the Lake District's mountain scenery. In what appears to have initially been a private letter of the 1750s, Brown wrote to his friend Lord Lyttleton:

> I will now carry you to the top of a cliff, where if you dare approach the ridge, a new scene of astonishment presents itself, where the valley, lake and islands, seem laying at your feet; where this expanse of water appears diminished to a little pool amidst the vast immeasurable objects that surround it; for here the summits of more distant hills appear before those you had already seen; and rising behind each other in successive ranges and azure groups of craggy and broken steeps, form an immense and awful picture, which can only be expressed by the image of a tempestuous sea of mountains. (Brown 1771: 8)

Brown skilfully captures the sense of visual defamiliarization that ascent produces through a combination of distance, changes of perspective and the shifting relations of objects within the landscape: valleys, lakes and islands shrink while mountains arise as if from nowhere, dwarfing all around them. As his description illustrates, mountain climbing creates a compelling visual fusion of the familiar and the strange, enabling the viewer to see new objects, or to identify known places but to see them in novel ways. Brown's account would become well known and it was frequently invoked by other writers when seeking to describe the visual experience resulting from a position of eminence. Writer after writer would repeat Brown's observations that ascent appeared to cause the world to diminish, to become a miniature version of itself, while simultaneously revealing a series of mountainous prospects that could only be observed from such an elevated position. Unlike the picturesque tour, with its emphasis on fixed stations,

mountaineering involves movement through landscape, and though some writers describe a summit as if it were a station *par excellence*, others emphasize the sense of a constantly changing visual experience as the viewer ascends, descends or traverses. Jonathan Otley, for example particularly recommended climbing Skiddaw because, though other mountains rivalled it for the grandeur of its summit view, 'in no other ascent, are the prospects equalled, which unfold themselves in the *ascent*' (Otley (1823) 1825: 47). Similarly, the novelist Ann Radcliffe took pleasure in her descent of the same mountain as a result of the series of visual effects it produced: 'it was interesting to observe each mountain below gradually re-assuming its dignity, the two lakes expanding into spacious surfaces, the many little vallies that sloped upwards from their margins, recovering their variegated tints of cultivation, the cattle again appearing in the meadows, and the wooded promontories changing from smooth patches of shades into richly tufted summits' (Radcliffe 1795: 460).

Brown's account of his elevated experience helped establish some of the tropes of mountaineering writing. Hutchinson, for example referred to 'the image of a tempestuous sea of mountains' in his *An Excursion to the Lakes* (Hutchinson 1774: 156). But also repeated throughout the period is the sense that the visual experience resulting from standing on a summit was unprecedented and exceeded anything with which it might be compared. Edward Baines, for example describes how a 'young friend' who had not climbed a peak before had thought the ascent of 'Bell' in Kentmere 'the most wearisome thing in the world, but the view from the summit repaid all, being beyond comparison the most novel, interesting, and wonderful prospect he had ever beheld' (Baines (1829) 1834: 277). Indeed, so new was the visual experience of mountaineering that it could disconcert those who undertook it for the first time, and not only when there was real danger of falling. The German tourist Charles P. Moritz recounts in his *Travels . . . through Several Parts of England, in 1782* how he set out to 'climb an high hill', clambering up a 'pretty steep . . . green mountain'. Reaching halfway without having once looked back, Moritz found himself nearly paralyzed when he did turn to take in the prospect:

> when I looked round, I found my eye had not been trained to view, unmoved, so prodigious an height; Castleton, with the surrounding country, lay below me, like a map; the roofs of the houses seemed almost close to the ground, and the mountain, with the ruins itself, seemed to be lying at my feet. I grew giddy at the prospect, and it required all my reason to convince me that I was in no danger, and that, at all events, I could only scramble down the green turf, in the same manner as I had got up. At length I seemed to grow accustomed to this view, till it really gave me pleasure; and I now climbed quite to the summit. (Moritz 1795: 233–4)

Moritz's reaction reminds us just how extraordinary and novel an elevated view would have been for these early climbers, unfamiliar with air-travel, aerial photography or even the high-rise buildings that have made the sensations of altitude more familiar in the centuries since. But it also illustrates the process of an individual teaching himself to

appreciate this novel visual experience, educating himself in the aesthetics of a new way of seeing until vertiginous viewing starts to become pleasurable rather than petrifying.

BECOMING MASTER OF THE PROSPECT

Moritz's initial reaction to his elevated position also illustrates one of the key ways in which early climbers responded to the visual experience such a location afforded them, comprehending the defamiliarized landscape through analogy with a map. Summiting a mountain came close to replicating the omniscient viewpoint created by cartography, the viewer seeming to hang above the landscape and look down with a 'bird's eye view' (an idea invoked by Budworth and Green, and that developed into Wordsworth's cloud-based viewing station with which this chapter began). As Joseph Hucks observed in *A Pedestrian Tour through North Wales* of 1795, from the top of the Welsh Mountain Cadair Idris the view is 'grand and magnificent. Ireland, the Isle of Man, North and South Wales, lie extended before the eye like a level map' (Hucks 1795: 114). Thinking of summit views as maps provided ways of engaging with what was being seen. In *A Companion to the Lakes*, Edward Baines describes how, on the summit of Helvellyn, 'we found it most interesting to behold again Skiddaw and Saddleback, Scawfell, and Langdale Pikes, and to trace with the eye, as on a map, all the journeys we had been making since we entered Westmoreland' (Baines (1829) 1834: 220). *An Account of the Principal Pleasure Tours in Scotland* went beyond this analogous relationship of summit view and map, commenting of the view from the top of Ben Nevis as follows:

> To enumerate all the objects in this view is impossible; if the tourist take the Map of Scotland in the Pleasure Tours, and spread it in a horizontal position, he can then take the range of one hundred miles around, and the objects to be seen will be distinctly laid before him. For instance, let him take an object on the east, west, south, or north; then turn leisurely round, and he will have it pointed out to him by name on the map as he comes to it. This appears to us better than inserting a mere catalogue of names, without pointing out their positions. (Anon. 1821: 74)

The *Pleasure Tour*'s practical advice indicates how written guidebooks were gradually taking the place on summits of actual mountain guides, whose roles normally included identifying key features in the prospect for their clients. Common expectations about the guides' role are indicated by Hutton's disappointed comments about his own guide on Snowdon, whom he thought 'inadequate to his office. He made no observations, nor spoke but when spoken to, and *then* I could barely understand his English. He ought to have been master of the prospect, and, like a showman, pointed out the various objects' (Hutton 1803: 152). Printed guides increasingly sought to take on this position of mastery of the prospect, enabling their readers to locate themselves within a comprehensible location and to identify surrounding features. Travel writing from the early part of this period often resorted to the simple counting of natural features observable from a summit, as when Thomas Pennant writes that from the top of Snowdon 'I counted this time

between twenty and thirty lakes' (Pennant 1778: 164). And a sense of exploration was
sometimes accompanied by a willingness to confess ignorance, Joseph Budworth com-
menting that he had journeyed over many 'noble mountains' between Buttermere and
Patterdale in the Lake District but admitting that 'for want of a guide I cannot distin-
guish their names' (Budworth 1792: 213). However, as accounts of climbing mountains
became increasingly part of the growing genre of travel guides, they sought to express
a stronger sense of knowledge about summit views and to provide their readers with
different aids to understanding and appreciating what they were seeing (such as the
Pleasure Tour's map). In his *A Companion to the Lakes*, Edward Baines names forty-six
individual mountains and several more mountain ranges 'visible in the grand panoramic
view from the summit of Skiddaw', detailing their positions so that the viewer can note
them by rotating in a clockwise direction (Baines (1829) 1834: 147–8). Even more spe-
cific in the aids he offers for identification of objects visible from a summit is Jonathan
Otley, who in his *A Concise Description of the English Lakes* provides distances and com-
pass bearings for the sights that can be seen from his four mountain 'Stations' (Scafell
Pike, Skiddaw, Helvellyn and the Old Man of Coniston). In works such as these, we can
see an anticipation of the most popular of all guides to the Lake District Mountains,
Alfred Wainwright's ((1955–1966) 2003) seven-volume *A Pictorial Guide to the Lake-
land Fells* published between 1955 and 1966, which uses a range of methods to illustrate
the views from the summits of the fells. Like Wainwright, these early mountain guides
enable those on a summit to gratify the desire to identify and name the prominent ele-
ments of the surrounding view.

 One way in which summit views were often assessed in the period was in terms of
how distant were the objects that could be identified. In 1792, Adam Walker describes
how, from the top of Skiddaw, 'with a Refracting Telescope we saw the sheep on Mount
Creffel on the coast of Galloway, and some of our company believed they saw the moun-
tains of Mourn in Ireland' (Walker 1792: 98), some 124 miles distant. However, other
writers were scornful of what they dismissed as a rather naive approach to the apprecia-
tion of mountain prospects. While Jonathan Otley discussed in detail when to ascend a
mountain to gain 'an extensive prospect', carefully considering issues of time of day and
weather conditions, he was forceful about the reasons for doing so:

> The value of a prospect of this kind, consists not in straining the eye to see what (ac-
> cording to the strength of the imagination) may be either mountains of Ireland, or a
> fog bank—a distant gleam of sunshine, or the reflections from the German Ocean—a
> speck of condensed vapour, or a ship on the glittering sea: it consists rather in be-
> holding a country richly variegated, with fields of corn fit for the sickle—meadows,
> green as an emerald—hills, clad with purple heath—lakes, with winding shores, and
> beautiful islands—rivers, shining like silver, as they shape their serpentine courses
> towards the sea;—and in tracing the effects of light and shade upon mountains, ris-
> ing behind mountains, in every imaginable diversity of form: in short, it consists in
> viewing such objects as can be distinctly known, and properly appreciated. (Otley
> (1823) 1825: 46)

First published in 1818, Otley's *Guide* illustrates the growing sophistication and indeed familiarity with which summit views started to be assessed. His aesthetic strictures reject the sense of astonishment characteristic of those seeing a mountain prospect for the first time and he pokes fun at the desire of others to identify distant objects. Instead Otley considers the view as if he were appreciating a landscape painting, indicating the extent to which some climbers had indeed mastered the mountain prospect in the period.

MOUNTAIN SPECTACLE

While an 'extensive prospect' was the primary motivation that drove the development of mountain climbing in this period, it was not the only new or engaging visual sensation offered by this nascent activity. The summits of the higher mountains in Britain were themselves unexplored spaces which looked to early climbers like nowhere they had ever been before. In 1778, Thomas Pennant gave a frequently quoted description of the summit of Glyder Bach in Wales:

> The area was covered with groupes of columnar stones, of vast size, from ten to thirty feet long, lying in all directions: most of them were in columnar form, often piled on one another: in other places, half erect, sloping down, and supported by others, which lie without any order at their bases. The tops are frequently crowned in the strangest manner with other stones, lying on them horizontally. (Pennant 1778: 151)

Pennant described this extraordinary scene as 'a sort of wreck of nature, formed and flung up by some mighty internal convulsion' (Pennant 1778: 152), and for other writers the sense of ruination they felt on a summit often led to thoughts of the earth's creation and its eventual destruction. John MacCulloch described the summit of Ben Nevis as 'utterly bare' and presenting 'a most extraordinary and unexpected sight', adding 'if any one is desirous to see how the world looked on the first day of creation, let him come hither' (MacCulloch 1824: 325). Yet MacCulloch also saw the summit's 'black and dreary ruins' as testimony to the destructive power of Nature, exciting 'surprise at the agencies that could thus, unaided by the usual force of gravity, have ploughed up and broken into atoms, so wide and so level a surface of the toughest and most tenacious of rocks' (MacCulloch 1824: 326). The sense of discovery on the top of mountains was not limited to these grand and terrifying scenes, however, but was also produced by the exquisitely beautiful. At the culmination of a description of Scafell Pike's summit, published in her brother's *Guide to the Lakes*, Dorothy Wordsworth identifies a visual sensation available to only the very few who reach that remote spot, writing that 'flowers, the most brilliant feathers, and even gems, scarcely surpass in colouring some of these masses of stone, which no human eye beholds, except the shepherd or traveller be led thither by curiosity: and how seldom must this happen!' (Wordsworth (1810) 1975: 110).

Climbing mountains gave individuals plenty of opportunities to indulge and develop their taste for the pleasurable terrors of the sublime. Summits provided an excellent grandstand for looking at other peaks and experiencing what one novice climber described as a 'compound of wonder, grandeur, and terror' (Hutton 1803: 154). But these feelings could be made all the more intense by adding an element of what in modern mountaineering parlance is called 'exposure'—the sense of personal vulnerability to great height. We can see such an intensification of sublime emotion in James Denholm's description of his experience on the summit of Ben Lomond in 1804. Initially, Denholm gives an account of the view from a position of personal safety, writing that 'The prospect to the north is . . . the most awfully grand: Immense mountains, piled, as it were, above each other [and forming] a prospect, which may in some degree be conceived, but cannot be properly described' (Denholm 1804: 41–2). However, as Denholm explores the summit itself, he becomes aware of a different kind of visual experience available:

> Ben Lomond . . . appears as an immense cone, detached or insulated from the surrounding mountains. Towards the north, however, this figure is broken by an immense precipice of 2000 feet in height, conjectured by some to be the remains of an imperfect crater, with one side forcibly torn off. To look down this fearful steep requires a considerable resolution: you approach it with cautious step and a trembling nerve, clinging firm to the surface of the mountain, which even appears insecure; the view is terrific and grandly sublime. (Denholm 1804: 42)

For some writers, peering down precipices took them to the limits of vision and experience. Joseph Hucks, standing on the edge of a precipice on Cadair Idris and looking into the 'frightful abyss', was put 'in mind of the chaos, or void space of darkness, so finely described in Milton, when the fallen archangel stood at the gates of hell, pondering the scene before him, and viewing, with horror, the profound expanse of silence and eternal night' (Hucks 1795: 113–4). Others, however, adopted a more light-hearted if no less intrepid approach to the dangers of mountain landscapes. After quoting a fellow writer's account of the 'numerous narrow openings' on the route to Skiddaw—'Chasms of enormous depth in the bowels of the mountain forming steeps of slaty shiver yawn upwards with frightful grin'—William Green comments that 'it is an amusing sort of exercise to tramp along the edges of these grinning fissures' (Green 1819: 2.340). As well as staring down and walking alongside precipices, the period also saw individuals such as William Bingley and Samuel Taylor Coleridge beginning to scramble up and down them, signalling the birth of rock climbing as a pursuit in Britain, an activity closely related to mountain climbing but one with a very different visual aesthetic.

Weather and atmospheric conditions had a considerable impact on the visual experience of mountaineering. While cloud, mist or rain could ruin the hoped-for prospect, they could also contribute to what William Hutchinson terms the 'grand spectacle of nature', a phrase he uses to describe a temperature inversion when he and his party find themselves above the clouds on the summit of Skiddaw, looking 'down upon an angry and impetuous sea, heaving its billows, as if boiling from the bottom' (Hutchinson

1774: 159). Jonathan Otley gives a fuller account of this phenomenon, again adopting something of the role of a connoisseur of visual effects whose sophisticated response is defined against that of the novice mountaineer:

> Sometimes when clouds have formed below the summit, the country as viewed from above, resembles a sea of mist; a few of the highest peaks having the appearance of islands, on which the sun seems to shine with unusual splendour. To such as are acquainted with it under other circumstances, this may be considered a magnificent spectacle; but a stranger will naturally wish to behold the features of the country in a more distinct kind of view. (Otley (1823) 1825: 44)

Hutchinson and Otley both describe a striking but relatively static phenomenon. However, changes in weather and atmospheric conditions can make the visual experience of mountaineering compellingly dramatic and dynamic, rapidly transforming not only what can be seen but also the conditions of vision themselves. Early mountaineering literature is full of detailed descriptions of the various visual effects caused by different combinations of light and vapour. More surprisingly, when writers were looking for an art form with which to compare the visual experience of mountaineering, they often turned not to landscape painting as we might expect but to the theatre or to one of the many forms of visual 'spectacle' that developed in the nineteenth century. Otley illustrates this sense of observing Nature's performance when he comments that those who are fortunate enough to be upon a summit 'at the very time of the cloud's departure, will experience a gratification of no common kind—when, like the rising of the curtain in a theatre, the country in a moment burst upon the eye' (Otley (1823) 1825: 43–4). William Green, who remarks that 'floating vapours are frequently the sources of supreme amusement', presents the changing conditions on mountains as creating a series of rather tantalizing revealed and veiled tableaux:

> In their playful humours these immense curtains in openings of every shape and feature, when contrasted with the azure of a beautiful distance appear as brown frames, through which, like scenes of enchantment, momentary glimpses are caught of the far removed country, which lost, the anxious spectator may be as suddenly saluted from another quarter, perhaps displaying a scene more grateful than the former, and with which the capacious elements may either feast him, or as suddenly as the former veil it from his view. Thus by an ever shifting exhibition, the eye is kept in a perpetual play and the sense alternately delighted, vexed, or agitated into extacy. (Green 1819: 2.341)

The perceived link between the natural spectacle gained through mountaineering and the technological spectacle that was developing in this period is illustrated by Edward Baines's comparison of the 'continual shifting of light and shadow' seen from Harrison Stickle in Langdale to the popular projection show called 'a phantasmagoria' (Baines (1829) 1834: 309). As this comparison would suggest, though the visual culture

of mountaineering developed out of the eighteenth-century aesthetic theories of the sublime and picturesque, as it developed it also had much in common with the emerging technologies of spectacle that have been seen as embodying the start of the modern visual age.

CONCLUSION

This chapter has sought to examine the visual culture of early mountaineering, arguing that what has become a highly popular activity was initially motivated by the desire for a specifically visual experience—the 'extensive prospect'. Ascending to the summits of mountains frequently did more than gratify this desire, however, granting many individuals what they claimed to be the most powerful and memorable visual experiences of their lives. It enabled the curious and the adventurous to see new things, previously unimagined, and it enabled them to see in new ways. By way of brief conclusion, I want to trace the short mountaineering career of the poet John Keats which succinctly encapsulates this set of visual experiences.

As a young man living in London, Keats dreamed of climbing mountains:

> I will clamber through the Clouds and exist. I will get such an accumulation of stupendous recollections that as I walk through the suburbs of London I may not see them—I will stand upon Mount Blanc and remember this coming Summer when I intend to straddle ben Lomond—with my Soul! (Keats 1970: 83)

While Keats never made it to Mont Blanc, his pedestrian tour through Northern England and Scotland in 1818 took him to the Lake District, where he climbed Skiddaw, having earlier been frustrated by mist in an attempt to climb Hellvelyn. Describing his Skiddaw experience, Keats captures the sense of the economy of physical expenditure and visual reward dominant in the period: 'we had fagged & tugged nearly to the top, when at half past six there came a mist upon us & shut out the view; we did not however lose anything by it, we were high enough without mist, to see the coast of Scotland; the Irish sea; the hills beyond Lancaster; & nearly all the large ones of Cumberland and Westmoreland, particularly Helvellyn & Scawfell' (Keats 1970: 108). Keats here expresses no interest in summiting Skiddaw or disappointment at having failed to do so; the achievement of the view provides the culmination of his efforts. Travelling north to Scotland, the high price of a guide deterred Keats from tackling Ben Lomond, but he did climb Ben Nevis. For Keats, the visual experience of climbing the mountain was unprecedented and unrivalled—he described the chasms on Ben Nevis as 'the most tremendous places I have ever seen'—and his comment in a letter to his brother Tom that 'I do not know whether I can give you an Idea of the prospect from a large Mountain top' reminds us that this was an entirely new visual experience and one that was difficult to capture in language (Keats 1970: 146–7). Yet it was not the hoped-for prospect that had most impact on Keats; indeed, it seemed at first that he would be unlucky with weather conditions, as the clouds formed 'as it appeard large dome curtains which kept sailing

about, opening and shutting at intervals here and there and everywhere' (Keats 1970: 146). But the poet was not disappointed by these conditions, finding in them an *alternative way of seeing*. He continues: 'so that although we did not see one vast wide extent of prospect all round we saw something perhaps finer—these cloud-veils opening with a dissolving motion and showing us the mountainous region beneath as through a loop hole—these Mouldy [*probably for* cloudy] loop holes ever varrying and discovering fresh prospect east, west north and South' (Keats 1970: 146–7). Keats takes pleasure in the way his vision is shaped by atmospheric conditions, feeling no need to assert the power of his own eye or self over nature. As he says later in the same letter, on a mountain 'the most new thing of all is the sudden leap of the eye from the extremity of what appears a plain into so vast a distance' (Keats 1970: 147). Of the many novel visual sensations inspired by reaching the summit of a mountain, for Keats the most striking is that it creates a new way of seeing. Such a revelation provides a fitting final example of the importance of the development of mountaineering to the history of visual studies.

FURTHER READING

Andrews, Malcolm. 1989. *The Search for the Picturesque: Landscape Aesthetics and Tourism in Britain, 1760–1800*. Stanford, CA: Stanford University Press.

Macfarlane, Robert. 2004. *Mountains of the Mind: A History of a Fascination*. London: Granta Books.

Nicolson, Marjorie Hope. 1959. *Mountain Gloom and Mountain Glory: The Development of the Aesthetics of the Infinite*. Ithaca, NY: Cornell University Press.

Nicholson, Norman. (1955) 1995. *The Lakers: The Adventures of the First Tourists*. Milnthorpe, Cumbria: Cicerone Press.

REFERENCES

Addison, Joseph. 1712. 'Essay on the Pleasure of the Imagination', *The Spectator*, 412: 540.

Anon. 1821. *An Account of the Principal Pleasure Tours in Scotland*. Edinburgh: John Thomson.

Baines, Edward. (1829) 1834. *A Companion to the Lakes*, 3rd ed. London: Simpkin and Marshall.

Bingley, William. 1800. *A Tour Round North Wales, 1798*, 2 vols. London: E. Williams.

Brown, John. 1771. *A Description of the Lake at Keswick*. Kendal: W. Pennington.

Budworth, Joseph. 1792. *A Fortnight's Ramble to the Lakes*. London: Hookham and Carpenter.

Budworth, Joseph. 1810. *A Fortnight's Ramble to the Lakes*, 3rd edn. London: Joseph Palmer.

Burke, Edmund. (1757) 1998. *A Philosophical Investigation into the Origin of Our Ideas of the Sublime and the Beautiful*, ed. A. Phillips. Oxford: Oxford University Press.

Coleridge, Samuel Taylor. 1956. *Collected Letters*, vol. 2, ed. Earl Leslie Griggs. Oxford: Clarendon Press.

Denholm, James. 1804. *A Tour to the Principal Scotch and English Lakes*. Glasgow: A. MacGoun.

Fisher, Paul Hawkins. 1818. *A Three Weeks Tour into Wales, in the Year 1817*. Stroud: F. Vigurs.

Gilpin, William. 1768. *An Essay upon Prints*. London: J. Robson.

Green, William. 1819. *The Tourist's New Guide, Containing a Description of the Lakes*, 2 vols. Kendal: R Lough.

Holmes, Richard. 2008. *The Age of Wonder: How the Romantic Generation Discovered the Beauty and Terror of Science*. London: Harper Press.

Hucks, Joseph. 1795. *A Pedestrian Tour through North Wales*. London: J. Debrett.

Hutchinson, William. 1774. *An Excursion to the Lakes, in Westmoreland and Cumberland, in August 1773*. London: J. Wilkie.

Hutton, William. 1803. *Remarks upon North Wales*. Birmingham: Knott and Lloyd.

Keats, John. 1970. *Letters: A New Selection*, ed. Robert Gittings. Oxford: Oxford University Press.

MacCulloch, John. 1824. *The Highlands and Western Isles of Scotland*. London: Longman.

Macfarlane, Robert. 2004. *Mountains of the Mind: A History of a Fascination*. London: Granta Books.

Moritz, Charles P. 1795. *Travels, Chiefly on Foot, through Several Parts of England, in 1782*. London: G. G. and J. Robinson.

Nicolson, Marjorie Hope. 1959. *Mountain Gloom and Mountain Glory: The Development of the Aesthetics of the Infinite*. Ithaca, NY: Cornell University Press.

Otley, Jonathan. (1823) 1825. *A Concise Description of the English Lakes, and Adjacent Mountains*, 2nd edn. Keswick: Jonathan Otley.

Pennant, Thomas. 1778. *A Tour in Wales, 1773*. London: Henry Hughes.

Plumptre, James. 1798. *The Lakers: A Comic Opera, in Three Acts*. London: W. Clarke.

R., M. 1828. 'Four Days' Ramble in the Neighbourhood of Bangor, North Wales', *The Kaleidoscope*, 9/431: 102–3.

Radcliffe, Ann. 1795. *A Journey Made in the Summer of 1794*. Dublin: William Porter.

Thorpe, Clarence DeWitt. 1935. 'Two Augustans Crossing the Alps', *Studies in Philology*, 32: 463–82.

Wainwright, Alfred. (1955–1966) 2003. *Pictorial Guide to the Lakeland Fells: 50th Anniversary Edition*. London: Taylor & Frances.

Walker, Adam. 1792. *Remarks Made in a Tour . . . to the Lakes in 1791*. London: G. Nicol.

Warner, Richard. 1798. *A Walk through Wales in August 1797*. London: C. Dilly.

West, Thomas. 1778. *A Guide to the Lakes*. London: Richardson and Urquhart.

Wilkinson, Thomas. 1824. *Tours to the British Mountains*. London: Taylor and Hessey.

Wordsworth, William. (1810) 1975. *Guide to the Lakes*, ed. Ernest de Sélincourt with a preface by Stephen Gill. London: Frances Lincoln.

The Work on the Street: Street Art and Visual Culture

MARTIN IRVINE

THE SIGNIFICANCE OF STREET ART IN CONTEMPORARY VISUAL CULTURE

Street art, c. 2010, is a paradigm of hybrid art in global visual culture, a post-postmodern genre being defined more by real-time practice than by any sense of unified theory, movement or message. Many artists associated with the 'urban art movement' do not consider themselves 'street' or 'graffiti' artists, but as artists who consider the city their necessary working environment. It's a form at once local and global, post-photographic, post-Internet and post-medium, intentionally ephemeral but now documented almost obsessively with digital photography for the Web, constantly appropriating and remixing imagery, styles and techniques from all possible sources. It's a community of practice with its own learned codes, rules, hierarchies of prestige and means of communication. Street art began as an underground, anarchic, in-your-face appropriation of public visual surfaces, and has now become a major part of visual space in many cities and a recognized art movement crossing over into the museum and gallery system.[1] This chapter outlines a synthetic view of this hybrid art category that comes from my own mix of experiences and roles—as an art and media theorist in the university, as an owner of a contemporary gallery that has featured many street artists and as a colleague of many of the artists, curators, art dealers and art collectors who have contributed to defining street art in the past two decades.[2]

The street artists who have been defining the practice since the 1990s are now a major part of the larger story of contemporary art and visual culture. Street art synthesizes and circulates a visual vocabulary and set of stylistic registers that have become instantly recognizable throughout mass culture. Museum and gallery exhibitions and international media coverage have taken Shepard Fairey, Banksy, Swoon and many others to levels

of recognition unknown in the institutionally authorized art world. Street art has also achieved a substantial bibliography, securing it as a well-documented genre and institutionalized object of study.[3] This globalized art form represents a cultural turning point as significant, permanent and irreversible as the reception of Pop art in the early 1960s.

For contemporary visual culture, street art is a major connecting node for multiple disciplinary and institutional domains that seldom intersect with this heightened state of visibility. The clash of intersecting forces that surround street art exposes often suppressed questions about regimes of visibility and public space, the constitutive locations and spaces of art, the role of communities of practice and cultural institutions, competing arguments about the nature of art and its relation to a public, and the generative logic of appropriation and remix culture (just to name a few).

Street art subcultures embody amazingly inventive and improvisational counterpractices, exemplifying Michel de Certeau's description of urban navigators in *The Practice of Everyday Life* (de Certeau 1984) and Henri Lefebvre's analyses of appropriations of public visual space in cities (Lefebvre 1991, 2003, 1996). Street artists exemplify the contest for visibility described by Jacques Rancière in his analysis of the 'distribution of the perceptible', the social-political regimes of visibility: the regulation of visibility in public spaces and the regime of art, which polices the boundaries of art and artists' legitimacy (Rancière 2004a, 2006a,b, 2009a,b). However the reception of street art continues to play out, many artists and their supporters have successfully negotiated positions in the two major visibility regimes—the nonart urban public space regime and the highly encoded spaces of art world institutions. Street art continues to develop with a resistance to reductionist categories: the most notable works represent surprising hybrid forms produced with the generative logic of remix and hybridization, allowing street artists to be several steps ahead of the cultural police hailing from any jurisdiction.

By the early 1990s, street art was the ghost in the urban machine becoming self-aware and projecting its repressed dreams and fantasies onto walls and vertical architecture, as if the visible city were the skin or exoskeleton of something experienced like a life form in need of aesthetic CPR. A visually aware street art cohort in New York, Los Angeles, San Francisco, Paris and London began to see the city as the real teacher, providing a daily instruction manual for the visual codes and semiotic systems in which we live and move and have our being. A call went out to hack the visually predatory codes of advertising, the rules of the attention economy and the control of visibility itself. A new generation of art school–educated artists heard the call and joined the ranks of those already on the ground; they combined punk and hip-hop attitude with learned skills and knowledge of recent art movements. By 2000, street artists had formed a global urban network of knowledge and practice disseminated by proliferating Web sites, publications and collective nomadic projects.

Whether the street works seem utopian or anarchic, aggressive or sympathetic, stunningly well-executed or juvenile, original or derivative, most street artists seriously working in the genre begin with a deep identification and empathy with the city: they are compelled to state something *in* and *with* the city, whether as forms of protest, critique, irony, humor, beauty, subversion, clever prank or all of the above. The pieces can be

ephemeral, gratuitous acts of beauty or forms of counter-iconography, inhabiting spaces of abandonment and decay, or signal jams in a zone of hyper-commercial messaging. A well-placed street piece will reveal the meaning of its material context, making the invisible visible again, a city re-imaged and re-imagined. A street work can be an intervention, a collaboration, a commentary, a dialogic critique, an individual or collective manifesto, an assertion of existence, aesthetic therapy for the *dysaesthetics* of urban controlled, commercialized visibility and a Whitmanian hymn with the raw energy of pent-up democratic desires for expression and self-assertion. Whatever the medium and motives of the work, the city is the assumed interlocutor, framework and essential precondition for making the artwork *work*. (See especially the examples in Figures 10.1–10.7, 10.9, 10.14–10.22, and 10.27, 10.28.)

In the context of art theory in the institutional art world, street art and artists seem made-to-order for a time when there is no acknowledged 'period' identity for contemporary art and no consensus on a possible role for an avant-garde.[4] Yet the reception of street art in the institutional art world remains problematic and caught in a generational shift: the street art movement embodies many of the anti-institutional arguments elaborated in the art world over the past fifty years, but it hasn't been adopted as a category for advancing art-institutional replication, the prime objective of the art professions. Art world institutions prefer their avant-garde arguments and institutional critiques to be conducted intramurally within established disciplinary practices. Even though no art student today experiences art and visual culture without a knowledge of street art, most art school programs continue an academic platform invested in playing out some remaining possibilities in a postmodern remix of Performance Art, Conceptual Art, Appropriation Art, Institutional Critique and conceptual directions in photography, film and digital media. Critics, curators and academic theorists now routinely discuss art forms that are 'post-medium', 'post-studio' and 'post-institutional', precisely the starting point of street art.

Street art is also a valuable case for the ongoing debate about the material and historical conditions of visual culture, and whether the concept of 'visual culture', as constructed in recent visual culture studies, dematerializes visual experience into an ahistorical, trans-media abstraction.[5] The pan-digital media platforms that we experience daily on computer and TV screens and on every conceivable device create the illusion of a disembodied, abstract, transmedia and dematerialized visual environment, where images, video, graphics and text converge and coexist in the field of the flat-panel frame. Street artists are making statements about visual culture and the effects of controlled visibility in the lived environment of the city, where walls and screens are increasingly intermingled. Shepard Fairey frequently remarks that one of his main motivations was inserting images in urban space that challenged the corporate-government monopoly of visible expression, creating a disturbance where 'there can be other images coexisting with advertising' (Fairey 2009: 94). Street art inserts itself in the material city as an argument about *visuality*, the social and political structure of *being visible*. Street art works by being confrontationally material and location-specific while also participating in the global, networked, Web-distributable cultural encyclopedia.

The social meaning of street art is a function of material locations with all their already structured symbolic values. The city location is an inseparable substrate for the work, and street art is explicitly an engagement with a city, often a specific neighborhood. Street artists are adept masters of the semiotics of space, and engage with the city itself as a collage or assemblage of visual environments and source material (Ellin 1999: 280–8; Rowe and Koetter 1979; see Figures 10.7, 10.8, 10.19, 10.21, 10.22, and 10.27). A specific site, street, wall or building in London, New York, Paris or Washington, DC, is already encoded as a symbolic place, the dialogic context for the placement of the piece by the artist. The practice is grounded in urban 'operational space', the 'practiced place' as described by de Certeau (de Certeau 1984)—not the abstract space of geometry, urban planning or the virtual space of the screen, but the space created by lived experience, defined by people mapping their own movements and daily relationships to perceived centres of power through the streets, neighborhoods and transit networks of the city. Street art provides an intuitive break from the accelerated 'aesthetics of disappearance', in Paul Virilio's terms, a signal-hack in a mass-mediated environment where what we see in the regime of screen visibility is always the *absence* of material objects (Virilio 2009; Armitage and Virilio 1999). The placement of works is often a call to *place*, marking locations with awareness, over against the proliferating urban 'non-places' of anonymous transit and commerce—the mall, the airport, Starbucks, big box stores—as described by Marc Augé (Augé 2009). Street art is driven by the aesthetics of material *reappearance*.

CONTEXTS OF STREET ART 1990–2010: RECEPTION, THEORY AND PRACTICE

The genealogy of street art is now well documented.[6] Every art movement has its own myths of origin and foundational moments, but the main continuity from the early graffiti movements of the 1970s and 1980s to the diverse group of cross-over artists and urban interventionists recognized in the 1990s (Blek le Rat, Barry McGee, Shepard Fairey, Ron English, Banksy, WK Interact, José Parlá, Swoon) and the new cohort of artists recognized since 2000 (for example Os Gemeos, Judith Supine, Blu, Vhils, JR, Gaia) is the audacity of the *act* itself. The energy and conceptual force of the work often relies on the act of 'getting up'—the work as performance, an event, undertaken with a gamble and a risk, taking on the uncertain safety of neighborhoods, the conditions of buildings and the policing of property (see Castleman 1984). As ephemeral and contingent performance, the action is the message: the marks and images appear as traces, signs and records of the act, and are as immediately persuasive as they are recognizable.

The history and reception of street art, including what the category means, is a casebook of political, social and legal conflicts, as well as disputes in the artists' own subcultures. Political tensions remain extreme over graffiti, and urban communities worldwide are conflicted about the reception of street art in the context of the graffiti and 'broken windows' debates,[7] and whether there can be any social differentiation among kinds of street works. Many street artists working now have 'graduated' from simple graffiti as

name or slogan writing to a focused practice involving many kinds of image and graphic techniques.[8] By 2000, most street artists saw their work as an art practice subsuming mixed methods and hybrid genres, executed and produced both on and off the street. The 'street' is now simply assumed and subsumed wherever the work is done.

A useful differentiator for street artists is the use of walls as mural space. By the early 1990s, the mass media had disseminated the graffiti styles in New York and Los Angeles, and some of the most visually striking images of the fall of the Berlin Wall in 1989 were its miles of graffiti and mural art. Throughout the 1990s, street art as city mural art was spreading across Europe and to South America, especially Brazil, home of the Os Gemeos brothers, who combined influences from hip-hop, Brazilian folk culture and artistic friendships with Barry McGee and other artists from Europe and the USA (Nguyen and Mackenzie 2010: 358–63). In the past fifteen years, many street artists have gone from underground, usually anonymous, hit and run, provocateurs pushing the boundaries of vandalism and toleration of private property trespass to highly recognized art stars invited to create legal, commissioned wall murals and museum installations (see Figures 10.12–10.17 and 10.23–10.26). Banksy, though by no means a paradigm case, went from merry prankster, vandal and nuisance to an art world showman and post-Warholian career manager with works now protected on the streets and studio objects in high demand by collectors, auction houses and museum curators. The global community of artists is now a network of nonlinear relationships that grow and cluster nodally by city identity, techniques and philosophy of art practice.

While artists as diverse as Blek le Rat, Barry McGee, Dan Witz, Ron English, Shepard Fairey, Swoon, José Parlá, David Ellis, Os Gemeos and Gaia have developed important conceptual arguments for their work (whether explicit or implicit), street artists mainly work intuitively in a community of practice with multiple sources of cultural history, not through formalized theory. But the levels of sophistication in their work reveal conceptual affinities and sometimes direct, intentional alliances with prior art movements. Where Pop opened a new conceptual space anticipated by Duchamp and Dada, inaugurating new arguments for what art could be, street artists took those arguments as already made (and over with), and ran with them out the institutional doors and into the streets. Street art became the next step in transformative logic of Pop: a redirected act of transubstantiation that converts the raw and non-art-differentiated space of public streets into new territories of visual engagement, anti-art performative acts that result in a new art category. Like Pop, street art de-aestheticizes 'high art' as one of many types of source material, and goes further by aestheticizing zones formerly outside culturally recognized art space. The 'extramural' zones of non-art space and the logic of the art container are now turned inside out: what was once banished from the walls of the art institutions (schools, museums, galleries) is reflected back on the walls of the city. Street art thrives on the paradox of being the mural art of the *extramuros*, outside the institutional walls.

Street artists are also being discussed as inheritors of earlier art movements, especially the ideas that emerged within Dada and Situationism: viewing art as act, event, performance, and intervention, a *détournement*—a hijacking, rerouting, displacement

and misappropriation of received culture for other ends.[9] Street artists reenact the play and spontaneity envisioned by Debord and described by de Certeau, escaping the functionalism and purposiveness of urban order by deviation and wandering (*derivé*) across multiple zones, rejecting and modifying the prescribed uses of the urban environment (Knabb 2006). Parallel with some forms of performance and conceptual art, street artists are at home with the fragment, the ephemeral mark and images that engage the public in time-bound situations. Street art extends several important post-Pop and postmodern strategies that are now the common vocabulary of contemporary art: photoreproduction, repetition, the grid, serial imagery, appropriation and inversions of high and low cultural codes. Repetition and serial forms are now embedded in the visible grid of the city.

Street artists take the logic of appropriation, remix and hybridity in every direction: arguments, ideas, actions, performances, interventions, inversions and subversions are always being extended into new spaces, remixed for contexts and forms never anticipated in earlier postmodern arguments. Street art also assumes a foundational dialogism in which each new act of making a work and inserting it into a street context is a response, a reply, an engagement with prior works and the ongoing debate about the public visual surface of a city. As dialogue-in-progress, it anticipates a response, public discourse, commentary, new works. The city is seen as a living historical palimpsest open for new inscription, re-write culture in practice (see Figures 10.1, 10.4–10.7, 10.20, 10.27, 10.28).

Street art continually reveals that no urban space is neutral: walls and street topography are boundaries for socially constructed zones and territories, and vertical space is regulated by regimes of visibility. Leaving a visual mark in public urban space is usually technically illegal and often performed as an act of nonviolent civil disobedience. The artists understand that publically viewable space, normally regulated by property and commercial regimes for controlling visibility, can be appropriated for unconstrained, uncontainable, antagonist acts. From the most recent stencil works and paste-ups on a city building in publically viewable space to formal objects made in artists' studios or site-specific projects in galleries and museums, each location is framed by institutions, legal regimes, public policies, cultural categories—frequently overlapping and cooperating, often contradictory in a nonharmonizing coexistence.

Several techniques, mediums and styles now converge in practice: stylized spray-can graphics and spray drawings from graffiti conventions; found and appropriated imagery from popular culture, advertising and mass photographic images re-produced in stencil imagery or other printing techniques; design, graphics and illustration styles merging everything from punk and underground subcultures to high culture design and typography traditions; many forms of print-making techniques from Xerox and screen printing to hand-cut woodblocks and linocuts; direct wall painting, both free-hand and from projected images; and many forms of stencil techniques ranging from rough hand-cuts to multiple layers of elaborate machine-cut imagery. A wall piece in New York, Los Angeles, London or Paris can combine stencil imagery with spray paint, pre-printed artist-designed paste-ups, photocopy blow-ups and collage imagery, and all imaginable

hybrids of print making, drawing and direct wall painting. Unifying practices are montage and collage, shifting scale (up or down) and using the power of serial imagery and repetition in multiple contexts. The photographic and digital photographic sources of images are taken for granted.

Many artists associated with the movement are beyond category, and experiment with installations, material interventions and many hybrid genres. Vhils carves imagery into walls and buildings, recalling some of Gordon Matta-Clark's deconstructions of built spaces. José Parlá creates wall murals and multilayered panels and canvases as visual memory devices, palimpsests of urban mark-making, material history, graffiti morphed into calligraphy and a direct confrontation of AbEx action painting with the decay of the streets and the life of city walls. David Ellis makes films of extended action painting performances and creates kinetic sculptures programmed to make found materials and instruments dance in a call and response with the rhythms of the city. Shepard Fairey channels popular culture images through multiple stylistic registers, including Socialist Realism, constructivist and modernist graphic design, rock poster designs and Pop styles all merged and output as posters and screen prints for street paste-ups, murals and hand-cut stencil and collage works on canvas, panel and fine art papers. While there is no easy unifying term for all these practices, concepts and material implementations, theory and practice are as tightly worked out in street art as in any art movement already institutionalized in art history.

STREET ART AND THE GLOBAL CITY: ALL-CITY TO ALL-CITIES

Society has been completely urbanized . . . The street is a place to play and learn. The street is disorder . . . This disorder is alive. It informs. It surprises . . . The urban space of the street is a place for talk, given over as much to the exchange of words and signs as it is to the exchange of things. A place where speech becomes writing. A place where speech can become 'savage' and, by escaping rules and institutions, inscribe itself on walls.
—*Henri Lefebvre,* The Urban Revolution, *1970 (Lefebvre (1970) 2003: 19)*

Street art is truly the first global art movement fuelled by the Internet.
—*Marc and Sara Schiller, Wooster Collective, 2010*
(Nguyen and Mackenzie 2010: 141)

More than 75 per cent of the developed world now lives in cities and urban agglomerations; lesser developed regions are moving in the same direction.[10] The future is the global networked world city. Although the globalization of the 'network society' is unevenly distributed, globalization is primarily enacted through a network of cities.[11] One of its effects is a change in the idea of the city itself, a regional site incorporating vast amounts of population mobility, flows of intellectual and material capital, expanding

beyond historic and local identity politics. All art movements have developed in cities, but street art is distinctive in having emerged as a direct engagement with the postmodern city: the artists and the works presuppose a dialogic relationship, a necessary entailment, with the material and symbolic world of the city.

Though closely tied to locations and the temporal performative act, the practices of street art as well as the works themselves vacillate between the specific materiality of urban space, street locations, local contexts, and the exhibition, distribution and communication platform of the Internet and Web. Street artists since around 2000 continually code-switch back and forth between the city as a material structure and the 'city of bits',[12] the city as information node, the virtual 'space of flows' (Castells 2000, 1989), networked and renderable in multiple digital visualizations. With proliferating Web sites and popular media coverage, most street artists are not only aware of being seen on a global stage, speaking locally and globally, but they actively contribute to the global Web museum without walls, documenting their work digitally as it is executed. First and foremost, there is the material moment, the physical act of *doing* the art in a specific location and with specific materials (spray paint, stencils, print and poster paste-ups, direct painting and every conceivable variation). But more and more, street art is being made and performed to be captured in digital form for distribution on Web sites and YouTube—the work of art in the age of instant digital dissemination.[13]

Street art has emerged in this moment of accelerated and interconnected urbanization, and it's no surprise that street art is most visible in global world cities where concentrations of people, capital, built infrastructure and flows of information are the densest. In many ways, street art is a response to this concentrated infrastructure with its unequal distribution of resources, property and visibility. Street art reflects globalization while resisting being absorbed into its convenient categories. Street artists interrupt the totalizing sense of space produced in modern cities with a local, place-bound gesture, an act that says 'we're here with this message now'. Street artist are also known for travelling to specific locations to do their work in as many contexts as possible, documenting the work for Web sites as they go. The work is fundamentally nomadic and ephemeral, destabilizing in its instability.

For New York graffiti writers in the 1970s, having your name seen 'all-city' (the trains traversing every borough) was 'the *faith* of graffiti' (Mailer and Naar 2010). This faith has now been transferred to visibility 'all-cities' through the many Web sites and blogs that document and archive street art, most of which are organized by city. Since the late 1990s, the imagery and practices of street artists have been spreading around the world at Internet speed, artists tracking each others' work, styles, techniques, walls and sites. The Art Crimes Web site, the first graffiti site in the Internet, launched in 1995, and the Wooster Collective, now a leading aggregator of all categories of street art, started in 2001 (Art Crimes Collective 1995; Wooster Collective 2001; Howze 2002). Through individual and collective artists' Web sites, Flickr image galleries, Google Maps tagging and blogs, the faith of street art has migrated to the digital city, achieving visibility all-cities.

EXTRAMUROS/INTRAMUROS: STREETS, CITIES, WALLS

I've always paid a great deal of attention to what happens on walls. When I was young,
I often even copied graffiti.

—*Picasso (Brassaï 1999: 254)*

[Modern paintings] are like so many interpretations, if not imitations, of a wall.

—*Brassaï (Brassaï 2002: 13)*

A good city is a city with graffiti.

—*Miss Van, 2007 (Neelon 2007)*

De Certeau cites a statement by Erasmus, 'the city is a huge monastery' (de Certeau
1984: 93), a reference to the premodern image of the walled city and the walled mon-
astery as boundaries of inclusion and exclusion. The metaphors of *intramuros* and *ex-
tramuros*, inside and outside the walls, run deep in Western culture. They name both
material and symbolic spaces, zones of authority and hierarchies of identity (Brighenti
2009a,b). The premodern metaphors remain in many institutions—schools, colleges
and universities, and urban space itself. Paris, arguably the home of the modern idea
of the city, still retains the idea of metropolitan expansion zones *extramuros*, the *ban-
lieues*, outside the historic, and once walled, city centre. In modern cities without the
internalized history of the classical and medieval defensive walls, the structure of streets
and buildings, highways and train yards creates marked boundaries, territories, zones
and demarcations of hierarchical space, a psychogeography of spaces. Street artists have
a well-developed practice for placing works in this structured space, where the well-
chosen placement of a work often builds more credit than the work itself.

Surfaces that form the visible city are vertical: visibility becomes a contest for using
and regulating vertical space. The wall is a metaphor for verticality—buildings, street
layout and boundary walls form the topography of the visible in public space, or more
appropriately, *publically viewable*, space (see Brighenti 2009a,b). Vertical space is highly
valuable in modern cities, driving the value of 'air rights' above a property and the verti-
cal surfaces which can be leased for advertising. When concentrated in spaces like Times
Square in New York, Potsdamer Platz in Berlin and Shibuya Crossing in Tokyo, advertis-
ing surfaces achieve the status of totalizing spectacles, walled enclaves of manufactured
and regulated visuality.

One of the major obsessions of modern art theory has been the cultural wall: the
problem of institutional walls, the over-determined modernist 'white cube' of four gal-
lery walls (O'Doherty 1999), the bourgeois commoditization of wall-mountable works
representing symbolic capital in domestic space, the conceptual use of art institution
walls as an abstract surface for ephemeral works requiring no permanent or durable

material form, walls as boundaries, limits, enclosures, territories, zones and concepts of art on, off or outside the walls. This theorizing is enacted as a series of arguments that presuppose, and only make sense within, the intramural art world. For many avant-gardes, the bourgeois domestic gallery or museum interior, a wall system for objects, provides the scene for irony and subversions precisely because it is everywhere stable, entailed, presupposed, always-already there. For conceptual art, it was the question of the objecthood of the work, its independence from wall space other than as a structure of verticality to be used, or not, in the installation of a work. Performance art challenged everything except the presupposition of the constitutive intramural art space for the recognition, reception and visibility of the art act as *art*.[14]

In a recent essay, Mel Bochner reflected on the move in the 1970s and 1980s to draw and paint directly on walls, redirecting the question of art as object to one of concept on surface (Bochner 2009). It was still a question of intramural art institution walls, and one that had been already raised in Andy Warhol's famous show at Leo Castelli's in 1966 when he covered every wall in the gallery with Pop-coloured cow wallpaper, using actual printed wallpaper, and taking object-less flatness all the way. Bochner reflects that Warhol's move combined with the impact of the graffiti written in the May 1968 Paris student uprising signalled a new awareness of direct encounters with the inscribed surface of a wall: it is immediate and temporal. 'These works cannot be "held"; they can only be seen.' Bochner's concluding observation could easily be expressed by a street artist: 'By collapsing the space between the artwork and the viewer, a wall painting negates the gap between lived time and pictorial time, permitting the work to engage larger philosophical, social, and political issues' (Bochner 2009: 140). OK, the street artist would say, but reverse the orientation of the walls: what was formerly a debate about work done in institutional art space has now been turned outward into public space, or, more fully, let's erase the zones and demarcations and acknowledge a continuum between art-institutional space and the public space surrounding everyday life.

Let's consider a few routes through which street art wall practices were anticipated but not fulfilled by avant-garde attempts to break the wall system. I'm not interested in developing myths of origin or a genealogy of practices that could legitimize street art in an art historical narrative, as if street art were a long-repressed, internalized 'other' finally bursting out on its own. Rather, when read dialogically, the moves, strategies and arguments being restated in street art practice become visible as intuitive and conceptual acts with equal sophistication and awareness of consequences.

We can trace a nonlinear cluster of concepts and practices extending from postwar neo-Dadaist artists down to the 1980s and the art world reception of Basquiat, Jenny Holzer and Barbara Kruger, whose works, as different as they are in medium and concepts, presuppose the *intramuros/extramuros* symbolic system. Conceptual and strategic connections to recent street art practice are found in Robert Rauschenberg's image transfers and assemblage works, Cy Twombly's large mural paintings of writing and graffiti gestures, the works of the *décollage* artists begun in the late 1940s, especially by Jacques Villeglé in Paris, and the 'matter' and wall paintings by Antoni Tàpies in Barcelona in the 1950s–1980s. An ur-text for the tradition is Brassaï's *Graffiti*, photographs of

the paint marks, image scratches and writings on Paris walls from the 1930s–1950s, the first collection of which was published in 1961 with an introduction by Picasso (Brassaï 2002). Known as the photographer of the Paris streets, Brassaï made photographing graffiti a life-long project. The Museum of Modern Art presented an exhibition of Brassaï's graffiti photographs in 1956 and the Bibliothèque Nationale organized a Brassaï retrospective in Paris in 1964, both of which had a major influence on artists and the modernist discourse about primitivism, outsider art and the unselfconscious expression of the untrained savant. The art world debate about walls, graffiti and the authentic outsider provided one context for the reception of Basquiat and Haring in the post-Pop 1980s. Also beginning in the 1980s, Barbara Kruger extended the debate about walls and appropriated images for a feminist conceptual critique that both crossed the wall boundaries and disrupted the white cube of gallery space by presenting all walls, ceilings and floors as a continuous surface of image and text.

Artists in the Abstract Expressionist and Neo-Dadaist traditions quoted or appropriated the *look* or the Romantic *myth* of graffiti as a gesture to be incorporated in large, mural paintings. The appropriation made sense only as a move in a specific kind of argument about painting that involved breaking down the pictorial surface with graphism, writing and symbols, usually with a down-skilling or deskilling of mark-marking and other nonpictorial elements. Cy Twombly's works in the 1950s show the transference of street wall acts and gestures, 'surrogate graffiti', 'like anonymous drawings on walls'.[15] Twombly's 'allusions' to writing on walls and blackboards were a means to smuggle graffiti gestures into painting as a sign of the primitive, raw, spontaneous and pre-formal, writing overtaking pictorial space.[16] Rauschenberg, who initially appeared in shows with Twombly, constructed combine and collage works incorporating nearly all possible graphic gestures and image appropriations in wall-like systems (Mattison 2003: 41–104). Rauschenberg's deconstructed image- and sign-bearing materials were the escape hatch that launched appropriation art as an ongoing encounter with what is found in the city. As Leo Steinberg noted, 'Rauschenberg's picture plane is for the consciousness immersed in the brain of the city' (Steinberg 1972). At the time, a similar move inside painting was developed by Antoni Tàpies in Barcelona, whose paintings appropriated the materiality of the city wall with its codes for communal inscription and palimpsest history.

What emerged in the 1950s–1960s as a formal argument *about* painting 'degree-zero', a reduction of means to the baseline materiality of surfaces, a reduction down to the bare walls as a minimal signifying unit of plane space, was converted into a material practice by street artists in the 1980s–1990s. Instead of smuggling in nonart acts on walls as a disruptive move within the grand narrative of painting, street art starts from the reversed wall, the interchange and promiscuous mix of cultures *intra-* and *extra-muros*, as the now always-already state of the world's imaging system. The reversal reveals the urban wall as we've already known it, though often occluded in misrecognition: the wall as the primary signifying space of the human built environment, the picturing plane *par excellence*, a kind of deep structure in the generative grammar of visuality, part of a centuries-long cultural unconscious. We can't get over the wall.

This awareness of the signifying materiality of the urban wall was explored persuasively by two other artists in the 1950s–1960s, Jacques Villeglé and Antoni Tàpies, artists who have continued their practice to the present day. Villeglé's works are made of, or from, torn street posters, a move that both scaled up and reversed the process of Dadist collage and redirected the anonymity of posters pasted and torn away by the hands of passersby.[17] Villeglé usually named his *decollage* pieces by the streets, squares or metro stations from which he extracted the found and torn posters, many of which had graffiti and other paste-up additions added by others. He 'deglued' the street-scale posters and papers and then reapplied them to canvas and paper supports to be mounted on exhibition walls, thus reversing nonart/art wall spaces and allowing the extramural realm of anonymous, layered public walls to penetrate the intramural space of the gallery, museum and art collection. It was a move that inserted a *sign* of the ephemeral, public street experience without engaging in its practice. This technique is now used by many street artists who create studio-produced canvases and wood panel works using various collage techniques with found and prepared papers.

Antoni Tàpies, the Catalonian artist known for his interpretation of Dada, *art brut* and *art informel* (formlessness), transposed the function of city walls onto his canvases, often marking them with raw graffiti gestures, crosses, Xs, and ritual and territorial marks.[18] His appropriation of the city wall went back to growing up in Barcelona and experiencing the city walls as both a cultural identity and a tableau on which the daily violence of fascist oppression was inscribed and memorialized in the 1930s–1940s. For him, the direct marks in matter were signs of the undeniable presence of human action, the traces of history and memory imposed materially and directly, and not through illusionistic images which can only be signifiers of absence. He turned the external inscribed surface of walls *inward*, into interior space and the inward space of symbols and meditation. In the 1950s he discovered Brassaï's photographs of graffiti and the theories accompanying the reception of Brassaï's work, further motivating his move to making paintings as quotations from walls.

Tàpies inserted the materiality of old, marked city walls into painting, using marble dust, sand and clay; he marked the materials like territory identity signs, but limited to the demarcated surface of a painting. In his essay 'Communication on the Wall' (1969), he recalled a turning point in the 1950s: 'the most sensational surprise was to discover one day, suddenly, that my paintings . . . had turned into walls'.[19] Reversing exterior walls to interior reflection, Tàpies represents walls not simply as material barriers but as the medium for public marks of human struggle, presence, mortality and collective memory. The secular extramural ritual of adding human presence to the palimpsest wall in nonart space has been turned around to present itself in the intramural art space of the studio, museum, gallery and art collection. *Mutatis mutandis*, street artists in Barcelona have extended Tàpies's project by executing some of the most striking street mural art in the world (see Figures 10.27 and 10.28).[20]

Around 1980, Basquiat made the transition from graffiti and his SAMO street identity to working out his famous street/studio fusion with lessons learned from the early Pollock, Dubuffet, Twombly, Rauschenberg and Picasso (Marshall 1992; Mercurio

2007; Cortez et al. 2007). He reversed the walls again, eagerly joining the prestige system of the art world, and was at home with large-scale mural paintings, creating paintings that were walls of brut imagery, graphics and writing. When Basquiat abandoned his street work for the intramural art world, there was an enthusiastic embrace of his outsider cross-over status, as if he came from a curatorial central casting agency. He emerged at a moment when 'outsider' and 'primitive' art were established as art market and curatorial categories, and when the first wave of graffiti art had crossed over into the gallery system. Basquiat's and Keith Haring's works were also received as viable moves within a post-Pop continuum, both artists benefitting from art world and popular culture myths of the Romantic outsider artist. The next generation of street artists moved beyond the wall problematic of the art world, and energetically embraced working as outsiders. The nonart space of city walls remained open for intervention, and the rest is now history.

Jenny Holzer and Barbara Kruger, important wall-breakers in other directions, should be cited as concluding examples of artists who intervened in the mediated city and the urban wall messaging system. Both artists rose to international attention in the 1980s simultaneously with Basquiat and Haring, and both began by responding to the cultural messaging system of New York City. Jenny Holzer began her LED aphorism and posters in the late 1970s as interventions in public space, and she then developed her signature style of large-scale text projections on city buildings and messages on appropriated billboards.[21] Barbara Kruger has produced a large body of work that combines collaged or photomontaged appropriated images from mass media with slogans in the Futura Bold type font directed towards a feminist critique of consumer culture. Her works are like scaled-up magazine advertising spreads, and she often installs her work like walls of posters and billboards, at times covering entire floors and ceilings of gallery rooms.[22] She has also produced works installed in public spaces, including billboards, posters, bus stops and exterior museum installations.[23] Shepard Fairey and others have acknowledged Holzer and Kruger as major influences for using text messages and appropriated, stylistically encoded mass media imagery in works created for multiple spaces of reception (Fairey 2009: 34; Spears 2010; Revelli and Fairey 2010: 44–55).

Street artists have broken the wall system even further by including the social *intramuros*/*extramuros* partitions as part of their subject matter. Public spaces and city walls have become a heuristics laboratory for experimentation and discovery, the results of which are brought back into studio art making, and vice versa. For many artists today, making new art is not only about negotiating with 'art history', but about engaging with the history of every mark, sign and image left in the vast, global, encyclopedic memory machine of the city. The street, studio and gallery installation spaces now continually intersect and presuppose one another; artworks are made for the spaces that frame them. As Alexandre Farto (Vhils) explains, 'I don't discriminate between outside and inside. I think it's more about the way you embrace a particular space and what you want to question with it' (Nguyen and Mackenzie 2010: 10). Likewise, José Parlá 'never saw the difference' between doing his illegal street work and his experiments on canvas when he started painting in the late 1980s: 'my generation grew

up seeing . . . Jean-Michel Basquiat, Futura and Phase2 and their gallery exhibitions around the world . . . Regardless of the surface, for me it was all just art—and that's it' (Nguyen and Mackenzie 2010: 27).

The cultural wall system is capable of many reversals and inversions precisely because the major art and property regimes are defined by secular extensions of the rule of *intramuros* and *extramuros*. Within the institutional boundaries of the art world system, we learn what the category of art is, what is excluded and excludable (the *extramuros*) and what is included and includable. Visibility regimes remain embedded in our material and symbolic wall systems like resident software always functioning as a background process. The art world had a dream of art forms that subverted the received structures and boundaries, but never imagined that outsiders would actually be doing it. Dada didn't overturn the intramural idea of art; it required and presupposed it. Dada was the theory; street art is the practice.

STREET ART AND REWRITING THE CITY

The way I look at the landscape is forever changed because of street art.
—*Shepard Fairey, 2010*[24]

Much of street art practice follows the logic of transgressions, appropriations and tactics described in Michel de Certeau's *The Practice of Everyday Life*.[25] De Certeau describes how ordinary urban citizens navigate and negotiate their positions in power systems that mark up city space. Breaking up the totalizing notion of those dominated by power as passive consumers, de Certeau shows that daily life is *made*, a creative production, constantly appropriating and reappropriating the products, messages, spaces for expression and territories of others. For de Certeau, the term 'consumer' is a useless, reductionist euphemism that obscures the complexities of daily practice. Consumers are more appropriately users and re-producers. 'Everyday life invents itself by *poaching* in countless ways on the property of others' (de Certeau 1984: xii). Street art and urban artist collectives are acts of engagement and reorganization, a therapeutics based on reappropriations and redeployments of the dominant image economy and hierarchical distribution of space experienced in metropolitan environments.

De Certeau described the strategy of city dwellers in their 'reading' of received culture with its normative messages and the active 'writing' back of new and oppositional uses that become community identity positions (de Certeau 1984: xxi). He anticipated the idea of 'read-write' culture, the post-Internet context of all art practice, which involves 'reading' transmitted information and 'rewriting' it back to the cultural archive, reusing it by interpretation and new context, the remix of the received and the re-produced.[26] Street art lives at the read-write intersection of the city as geopolitical territory and the global city of bits. Not only are the material surfaces of buildings and walls rewritten, but street art presupposes the global remix and reappropriation of imagery and ideas transferred or created in digital form and distributable on the

Internet. Remix culture scans the received culture encyclopedia for what can be reinterpreted, rewritten and reimaged now. Displacements, dislocations and relocations are normative generative practices.

Many street artists are nomads, moving around when possible in this connected and rapidly continuous *intermural* global city. This is a very new kind of art practice, doing works in multiple cities and documenting them in real time on the Web. Nomadic street artists are now imagining the global city as a distributed surface on which to mark and inscribe visual interventions that function both locally and globally. The act and gesture performed in one location can now be viewed from any other city location, and documented, archived, compared, imitated, remixed, with any kind of dialogic response. Banksy's stencil works have appeared on Palestinian border walls as well as on the walls and buildings of most major cities, instantly viewable through a Google image search. Reading and rewriting the city has been globalized; the post-Internet generations of artists navigate material and digital cities in an experiential continuum. The art of the extramural world has reconceived both material and conceptual walls and spaces: the extramural has become post-mural.

THE CONTEST OF VISIBILITY

The future of art is not artistic, but urban.

—*Henri Lefebvre (Lefebvre 1996: 173)*

New York, London, San Francisco, Los Angeles, Paris, Melbourne, Rio and Sao Paulo are palimpsests of visual information in the consumerist attention economy, every visual signifier discharged in a real-time competition and rivalry for observers' attention. World cities have known territories and hierarchies, peripheries and zones for industry or marginalized classes, all of which are assumed and exploited in street art. For street artists, a city is an information engine: the daily flows of people for work, leisure and consumption are information; the invisible communications network infrastructure not only transmits information but its very density is itself information; streets, alleys, the built environment is information; the presence or absence of buildings are information; the commercial messaging systems in signs, advertising, logos, billboards and giant light panels both transmit and are themselves information. Some of the information becomes communication, addressable messages to passersby, advertising hailing us all to look and receive. Ubiquitous, street-level, vertical advertising spaces are a normative experience in every city, a protected zone of visuality now nearly inseparable from urban life itself (see Figures 10.10 and 10.11).

Street art is thus always an assertion, a competition, for *visibility*; urban public space is always a competition for power by managing the power of visibility (See Brighenti 2007, 2009a; Brighenti and Mattiucci 2009). To be visible is to be known, to be recognized, to exist. Recognition is both an internal code within the community of practice of street artists, and the larger social effect sought by the works as acts in public,

or publically viewable, space (see Figures 10.15–10.26). The acts of visibility, separable from the anonymity of many streets artists, become part of the social symbolic world, and finally, of urban ritual, repetitions that instantiate communal beliefs and bonds of identity.

Street art contests two main regimes of visibility—legal and governmental on one side, and art world or social aesthetic on the other—which creates the conditions within which it must compete for visibility. Street art works against the regimes of government, law and aesthetics as accepted, self-evident systems that normalize a common world by unconscious rules of visibility and recognition. In each regime, there are rules and codes for what can be made visible or perceptible, who has the legitimacy to be seen and heard where, and who can be rendered invisible as merely the background noise of urban life. Jacques Rancière has noted how politics is enacted by 'the partition of the perceptible' (French, *partage du sensible*), how the regulation, division or distribution of visibility itself distributes power: 'Politics is first of all a way of framing, among sensory data, a specific sphere of experience. It is a partition of the sensible, of the visible and the sayable, which allows (or does not allow) some specific data to appear; which allows or does not allow some specific subjects to designate them and speak about them' (Rancière 2004b: 10). Advertising and commercial messaging space are made to appear as a guaranteed, normalized partition of the visible in the legal regime. Street artists intuitively contest this rationing or apportioning out of visibility by intervening in a publically visible way. Street art thus appears at the intersection of two regimes, two ways of distributing visibility—the governmental regime (politics, law, property) and the aesthetic regime (the art world and the boundary maintenance between art and nonart).

The contest of visibility is clearly marked in the visual regimes for commercial communication. As de Certeau observed, 'from TV to newspapers, from advertising to all sorts of mercantile epiphanies, our society is characterized by a cancerous growth of vision, measuring everything by its ability to show or be shown and transmuting communication into a visual journey. It is a sort of epic of the eye and of the impulse to read' (de Certeau 1984: xxi). Every day, we consume more visual messages than products. Street advertising has to be instantly recognizable, but with image saturation, it's also instantly disengageable, a contest between meaning and noise. All advertising messages are constructed to *interpellate* us, calling us out to take up the position of the advertising addressee—the consumer, the passive receiver.[27] Street art pushes back with alternative subject positions for inhabitants and citizens, confusing the message system by offering the alternative subjectivity of gift-receiver, and blurring the lines between producers and receivers.

Street artists often talk about their work as a reaction to the domination of urban visual space by advertising in a closed property regime. Street art is a response to experiencing public spaces as being implicitly, structurally, forms of advertising, embodying the codes for socialization in the political economy. In attempts to maximize the commercial appeal of city centres, many cities have government-sponsored urban projects that turn urban zones into theme parks with carefully controlled visual information necessary for sustaining a tourist simulacrum. As Baudrillard noted, 'today what we

are experiencing is the absorption of all virtual modes of expression into that of ad-
vertising' (Baudrillard 1995: 87). Not merely messages for products and services, but
a social messaging system, 'vaguely seductive, vaguely consensual', that replaces lived
social experience with a fantasy of a consumerist community. The code of advertising
is socialization to the message system: 'a sociality everywhere present, an absolute so-
ciality finally realized in absolute advertising . . . a vestige of sociality hallucinated on
all the walls in the simplified form of a demand of the social that is immediately met
by the echo of advertising. The social as a script, whose bewildered audience we are'
(Baudrillard 1995: 88).

Street art works to scramble this script, jam the communiqué, or expose its falsely
transparent operation, allowing viewers to adopt different positions, no longer simply
subjects of a message. Street art is a direct engagement with a city's messaging system, a
direct hit on the unconscious, accepted, seemingly natural spaces in which visual mes-
sages can appear. Street artists intervene with a counter-imagery, acts of displacement
in an ongoing generative 'semeiocracy', the politics of meaning-making through images
and writing in contexts that bring the contest over visibility into the open. Walls and
structures can be de-purposed, repurposed, de-faced, refaced, de-made, remade.

Ron English, Shepard Fairey, Banksy and many others have made explicit subversion
of advertising space one of their main tactics. Ron English has high-jacked more than
1,000 billboards with his Pop 'subvertisements', becoming the exemplar of the culture-
jamming potential of street art.[28] This approach has been the main motivation for Shep-
ard Fairey's long-running 'Obey' campaign: images and slogans that provoke awareness
about public messages and advertising (Fairey 2009: ii–v and passim). Though criticized
for being simplistic, Fairey's message targets the consumer subject directly: 'keep your
eyes and mind open, and question everything' (Fairey 2009: xvi). Swoon takes a subtler
but still pointed approach: 'Lately I have wanted to give all of my attention to reflecting
our humanness, our fragility and strength, back out at us from our city walls in a way
that makes all of these fake images screaming at us from billboards seem irrelevant and
cruel, which is what they are' (in Ganz and MacDonald 2006: 204).

In terms of visual communication space, privatized commercial messages are end-
lessly displayed on industrial scale on billboards, street posters and kiosks, and huge
lighted signs. The visual space of many cities is given over to advertising in protected
spaces rented from property owners. As de Certeau observed in 'The Imaginary of the
City', an 'imaginary discourse of commerce is pasted over every square inch of public
walls'. The visible spaces of inscription for commerce, of course, can reveal precisely
where artists' interventions will be most visible as a counter-imaginary language:

> [Commercial imagery] is a *mural language* with the repertory of its immediate objects
> of happiness. It conceals the buildings in which labor is confined; it covers over the
> closed universe of everyday life; it sets in place artificial forms that follow the paths of
> labor in order to juxtapose their passageways to the successive moments of pleasure.
> A city that is a real 'imaginary museum' forms the counterpoint of the city at work.
> (de Certeau 1997: 20)

This view is precisely what motivates many street artists: the city as a competitive space of mural messaging, walls and nonneutral spaces with a potential for bearing messages. Street artists seize the spaces of visibility for the messaging system. As Swoon stated in 2003 on the methods of her Brooklyn collective, 'we scour the city for the ways that we are spoken to, and we speak back . . . Once you start listening, the walls don't shut up.'[29]

Street art also exemplifies the kind of cultural reproduction that de Certeau discovered in actions that transgress not only the spaces where messaging can appear, but in its obvious noncommercial, ephemeral and gratuitous form. It takes on the politics of the gift, in direct opposition to most legal messaging on city walls and vertical spaces. His description of popular culture tactics is parallel to the logic of street art:

> [O]rder is tricked by an art . . . , that is, an economy of the 'gift' (generosities for which one expects a return), an esthetics of 'tricks' (artists' operations) and an ethics of tenacity (countless ways of refusing to accord the established order the status of a law, a meaning, or a fatality) . . . [T]he politics of the 'gift' also becomes a diversionary tactic. In the same way, the loss that was voluntary in a gift economy is transformed into a transgression in a profit economy: it appears as an excess (a waste), a challenge (a rejection of profit), or a crime (an attack on property). (de Certeau 1984: 26, 27)

For the generation of artists in the 1990s, the walls became found materials to work *with*, turning attention to what is normally, intentionally, unnoticed, visually suppressed. The public gift of the street work, even if declined or disavowed, would always be a mark of presence. As Barry McGee stated in 1995, graffiti was all about showing 'signs of life. People are alive. Someone was here at that time.'[30] Visibility is presence; to exist is to be seen.

A clear statement of public intervention in city space is summed up in Swoon's description of her Indivisible Cities project that she organized with artists in Berlin in 2003. '[T]here is a struggle going on for the physical surfaces of our cities.'

> Indivisible Cities is a visual and cultural exchange focusing on artistic interventions in the urban landscape. Creating itself out of the margins of our cities is a community of people, more precisely it is a community of actions, a floating world of ephemera and physical markings made by people who have decided to become active citizens in creating their visual landscape. Every time someone reappropriates a billboard for his or her own needs, scrawls their alias across a highway overpass, or uses city walls as a sounding board for their thoughts and images for messages that need realization, they are participating in this community. They are circumscribing a link to every other person who believes that the vitality of our public spaces is directly related to the *public* participating in the incessant creation and re-creation of those spaces. [Street art is] a form of active citizenship that resists attempts at containment . . . I think that the persistence of graffiti and street art in cities all over the world is evidence of a common need for citizens to take a role in their environments.[31]

Street art provides ongoing signs of environmental reclamation, marking out zones for an alternative visibility. Both regimes of visibility are disturbed, a disturbance that also renders their falsely transparent operations visible as the social and political constructions they are.

CONCLUSIONS AND CONSEQUENCES: STREET ART IN THE DIALOGICAL FIELD OF ART

In providing an overview of the larger contexts of street art for visual culture, I'm painfully aware of the omissions and generalizations one must commit to fulfill the task. I can only provide some conclusions and consequences in a brief form here. Like all cultural terms, 'street art' names and constructs a category useful in various kinds of arguments, but is easily deconstructible as riddled with internal contradictions and contestable assumptions. And like Pop after the 1960s, some critics are already declaring an 'end' to street art as a viable movement: street art, as the argument goes, has now received art institutional recognition along with trivializing by media exposure and dilution by imitators and co-option by celebrity culture. For most artists today, street art is simply a short-hand term for multiple ways of doing art in dialogue with a city in a continuity of practice that spans street, studio, gallery, museum and the Internet. This continuum of practice was unknown to artists in any prior cultural position. The term does useful cultural work when street art is viewed as a practice that subsumes many forms of visual culture and postmodern art movements, but played out in conflicting ways across the visibility regimes and constitutive spaces of the city and art institutions.

Summing up, let's retrace the network array of forces within which street art has become a connecting node:

1. Street art reveals a new kind of attention to the phenomenology of the city, the experience of material spaces and places in daily life, and has reintroduced play and the gift in public exchange. Well-executed and well-placed street art reanchors us in the here and now, countering the forces of disappearance in the city as a frictionless commerce machine neutralizing time and presence and claiming all zones of visuality for itself. Street art rematerializes the visual, an aesthetics of reappearance in an era of continual re-mediation and disappearance (see Bolter and Grusin 2000).

2. Street art thwarts attempts to maintain unified, normalized visibility regimes, the legal and policy regime for controlling public, 'nonart' space and the institutional regime controlling the visibility of art. It exposes the contest for visibility being played out in multiple dimensions, and the internal contractions which must be repressed for the regimes to function. Street art will remain an institutional antinomy because it depends on the extramural tensions of working outside art spaces that are commonly understood as 'deactivating' art. Art space, the heterotopia of museum, gallery and academic institutional space, is well recognized in its constitutive function as part of learned and shared

cultural capital.[32] Public space, on the other hand, is understood as precisely that space in which art does not and cannot appear, where we've learned that art cannot be made visible as such. The spaces have been, and continue to be, reconfigured, but the visibility regimes remain deeply embedded in our social, economic and political order.

3. By subverting the cultural wall system and championing the ephemeral act of art, street art reveals internal contradictions and crises in the parallel universe of the art world. In the institutional art world, we only find unity in a consensual disunity about the state of contemporary art, the institutional response to popular visual culture, and the ongoing dissatisfaction with dehistoricizing, dislocating, institutional containers. There seems to be no escape from the intramural self-reflexive authentication operations, no 'outside the wall'. Hal Foster aptly describes the effect of monumental institutional spaces like Dia:Beacon and the Tate Modern: 'we wander through museum spaces as if after the end of time' (Foster et al. 2004: 679). The art world isn't dancing on the museum's ruins (as in Crimp 1993), but keeps the 'museum without walls' installed within the institution.

4. Street art since the late 1990s is the first truly post-Internet art movement, equally at home in real and digital spaces as an ongoing continuum, interimplicated, inter-referenced, the real and the virtual mutually presupposed. This phenomenon is partly generational and partly a function of ubiquitous and accessible technology in cities. Inexpensive digital cameras and laptops join the Web's architecture for do-it-yourself publishing and social networking in a highly compatible way. Street art as a global movement has grown unconstrained through Web image-sharing and multiple ways of capturing and archiving ephemeral art.

5. Street art since the 1990s is a kind of manifesto-in-practice for the complex forms of globalization, cultural hybridity and remix which are increasingly the norm for life in global, networked cities. Street art's embrace of multiple mediums, techniques, materials and styles makes it an exemplar of hybridity, remix and post-appropriation practices now seen to be a defining principle of 'contemporary' culture. I'd like to expand on this issue to explore some wider implications of street art and cultural hybridity.

STREET ART AND CONTEMPORARY HYBRIDITY, REMIX AND APPROPRIATION: THE IMPLICATIONS OF READ-WRITE VISUAL CULTURE

To riff on a police term, street artists have 'known associations' with hip-hop and post-punk cultures, a trans-urban 'mash-up is the message' aesthetic that values a living, performative, reinterpretation and recontextualization of received materials in real-time practice. If collage is arguably the major aesthetic force in twentieth-century art forms,[33]

then hybridity, appropriation and remix have clearly become the forces for the early-twenty-first.[34] The key issue, which I will develop further in a forthcoming book, is understanding hybridity, remix and appropriation as surface forms of a deeper generative grammar of culture, as visible or explicit instances of a structurally necessary dialogic principle underlying all forms of human expression and meaning-making.[35] The appropriative or dialogic principle in creative production is part of the source code of living cultures. As part of the internalized, generative grammar of culture, the dialogic principle is ordinarily invisible to members of a culture because it is not a unit of content to be expressed, but makes possible the expression of any new content per se.

In street art, appropriation and remix of styles and imagery extend the prior practices of Pop and Conceptual Art genres,[36] but street artists take the conditions of postmodernity for granted, as something *already* in the past, already accounted for and in the mix. The state of art-making today is no longer burdened with the curriculum of postmodernism—mourning over the museum's ruins and the dehistoricized mash-ups of popular culture,[37] cataloguing the collapse of high and low culture boundaries, and finding uses for anxieties about postcolonial global hybridization and identity politics. Remix is now coming into view as one of the main engines of culture, though long shut up and hidden in a black box of ideologies. Behind so much creative work in art, music, literature and design today is the sense of culture as being always-already hybrid, a mix of 'impure', promiscuous, and often unacknowledged or suppressed sources, local and global, and kept alive in an ongoing dialogic call and response.

Nicolas Bourriaud has argued that the cluster of concepts related to remix and appropriation can be described as *postproduction*: recent art practices function as an alternative editing table for remixing the montage we call reality into the cultural fictions we call art (see Bourriaud 2005, 2009b: 177–88). The editing table or mixing board (terms from audio-visual postproduction) are apt metaphors for a time when so much new cultural production is expressed as postproduction, received cultural materials selected, quoted, collaged, remixed, edited and positioned in new conceptual or material contexts. By making visible the reuse of materials already in circulation in the common culture, much street art has affinities with constantly evolving global hybrid music cultures, which have subsumed earlier DJ, Dub, sampling and electronic/digital remix composition practices.[38]

Street art is visual dub, extracting sources and styles from a cultural encyclopedia of images and message styles, editing out some transmitted features and reappropriating others, inserting the new mix into the visual multitrack platform of the city.[39] The urban platform is assumed to be read-write, renewable, and never a zero-sum game: you only 'take' when in the process of creating something that gives back.

The cultural logic of remix and appropriation has collided with the intellectual property regime in the high-profile copyright case of Associated Press v. Shepard Fairey, which hangs on the interpretation of Fair Use in the transformation of a digital news photograph in Fairey's iconic Obama poster portrait in 2008. The lawsuit has been settled out of court with neither side conceding its point of law, which means that the macro legal issues remain unsettled and with no change in legal philosophy going forward.[40] The

case is not simply a matter for theory and practice in the arts and the publishing industries, but for the legal regimes now at a crisis point in adjusting to contemporary cultural practices and digital mediation.[41] Artists, writers, musicians, fashion designers, advertising creatives and architects all know that the active principle named by 'appropriation' is part of the generative grammar of the creative process. Appropriation is not imitation, copying or theft. It's conversation, interpretation, dialogue, a sign of participating in a *tradition* (lit., 'what is handed down'), regardless of whether the tradition is a dominant form or an outsider subculture, or whether the artist takes an adversarial, affirmative or conflicted position within the tradition.

Of course, neither street art nor Fairey's post-Pop practices are special cases for art or legal theory. But since the AP case is based on the practice of a street artist known for appropriation and remix, it represents a 'perfect storm' of issues that can be redirected to expose collective misrecognitions about artworks that lost sustainability decades ago. The misrecognitions are maintained through our enormous social investment in the ideologies of single authorship, originality, property and ownership. Misrecognitions about production are further maintained by the positivist, atomistic logic of legal philosophy on copyright and IP in which surface similarities between works are taken as the bases for causal arguments about copy or derivation. Specifically for visual culture, Fairey's Obama images rely on a logic of remediation, recontextualization and stylized iconicity that extends back to Rauschenberg and other Pop artists. Through the strategy of the 'demake' or down-skilled 'remake', a strategy observable in a wide array of twentieth-century works prior to recent street art, generic portrait features present in a digital photograph have been rendered as a hand-made screenprint image.[42] Of course, the uses of the remake in Fairey's and other artists' practices are only one instance of multiple kinds of expressions produced every day in the dialogic grammar of culture. The AP v. Fairey case can generate a larger public awareness of these urgent issues and make it possible to ask precisely those questions that cannot be asked when collective misrecognitions are at stake. Artists producing works in all media and the public receiving them now live in a culture with a legal-economic regime requiring a resyncing with reality that will be as unsettling as the Copernican revolution.

With its ability to embrace multiple urban subcultures and visual styles in a globally distributed practice, street art provides a new dialogic configuration, a post-postmodern hybridity that will continue to generate many new kinds of works and genres. Now working in a continuum of practice spanning street, studio, gallery, installation spaces, digital production and the Internet, street artists expose how an artwork is a momentary node of relationships, a position in a network of affiliations, configured into a contingent and interdependent order. The node may have collective authorship, may have affiliations with media, images or concepts from other points in the network, near or far, contemporary or archival, may take form in an ephemeral, material location and live on through global digital distribution. The important thing for the artists is to keep moving and keep proving themselves for their mentor and interlocutor, the city. The artists are mapping out in real time one possible and promising future for a post-postmodern visual culture.

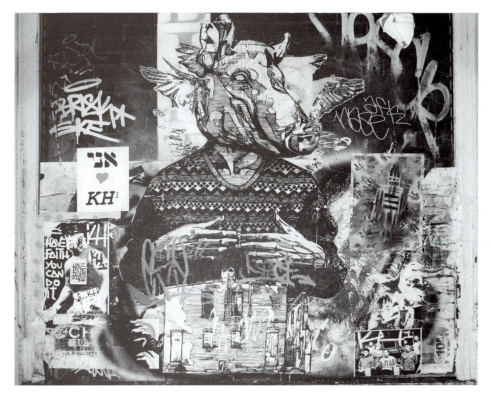

FIGURE 10.1 Gaia and palimpsest with other street artists (1), Soho, New York City, 8/2008. Photograph by Martin Irvine, © Martin Irvine, 2010.

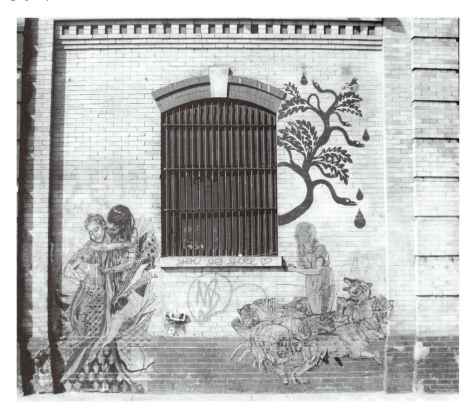

FIGURE 10.2 Swoon (left), Gaia (right) and other artists, woodblock and linocut prints on paper and acrylic on wall, W. 21st St., New York City, 7/2008. Photograph by Martin Irvine, © Martin Irvine, 2010.

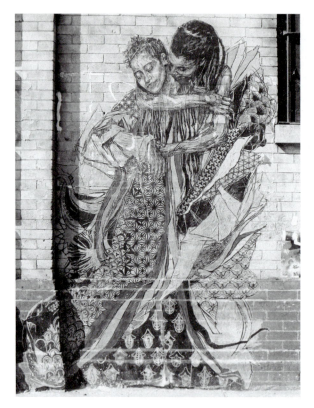

FIGURE 10.3 Swoon, W. 21st St., New York City, 7/2008. Detail. Photograph by Martin Irvine, ©
Martin Irvine, 2010.

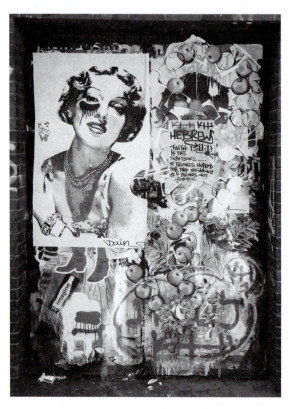

FIGURE 10.4 Multiple artists, Soho, New York City, 8/2008. Photograph by Martin Irvine, © Martin Irvine, 2010.

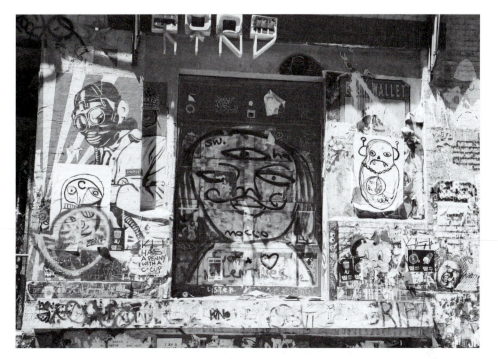

FIGURE 10.5 Shepard Fairey and multiple artists, Candy Factory Building, Soho, New York City, 8/2008. Photograph by Martin Irvine, © Martin Irvine, 2010.

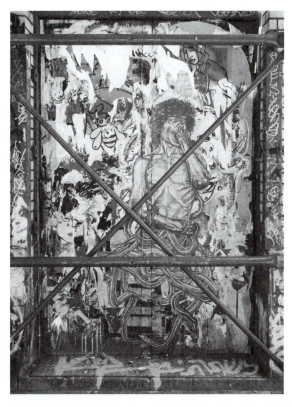

FIGURE 10.6 Gaia and palimpsest with other street artists (2), Soho, New York City, 8/2008. Photograph by Martin Irvine, © Martin Irvine, 2010.

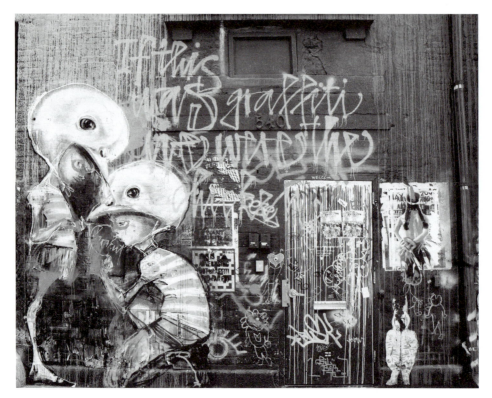

FIGURE 10.7 Herakut and multiple artists, W. 22nd St., Chelsea, New York City, 6/2009. Photograph by Martin Irvine, © Martin Irvine, 2010.

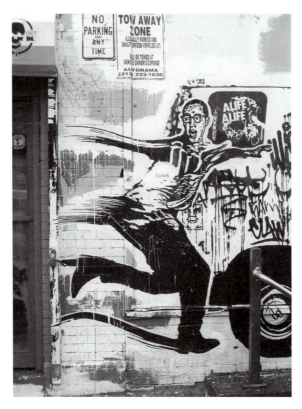

FIGURE 10.8 WK Interact, Houston St. and 1st Ave., New York City, 8/2005. Photograph by Martin Irvine, © Martin Irvine, 2010.

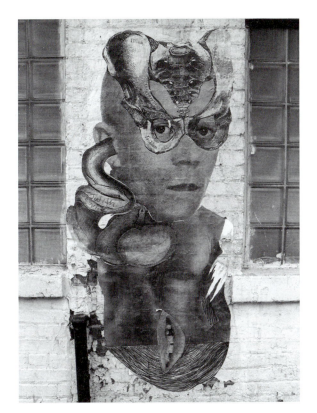

FIGURE 10.9 Judith Supine, printed collage on wall, Chelsea, New York City, 7/2007. Photograph by Martin Irvine, © Martin Irvine, 2010.

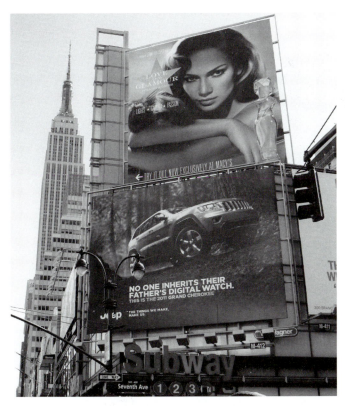

FIGURE 10.10 7th Ave., New York City, vertical advertising space, with Empire State Building in background. 10/2010. Photograph by Martin Irvine, © Martin Irvine, 2010.

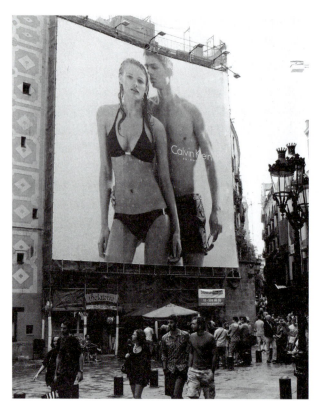

FIGURE 10.11 Plaça de Santa Maria del Mar, Barcelona, vertical advertising space, 6/2010. Photograph by Martin Irvine, © Martin Irvine, 2010.

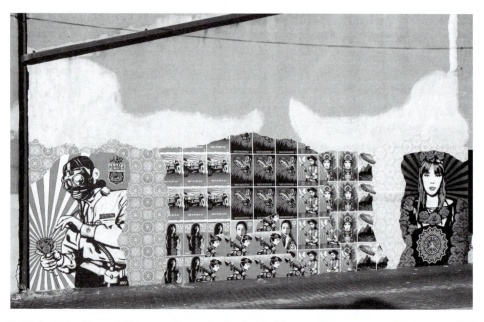

FIGURE 10.12 Shepard Fairey, wall mural, alley behind Irvine Contemporary, Washington, DC, 10/2008. Photograph by Martin Irvine, © Martin Irvine, 2010.

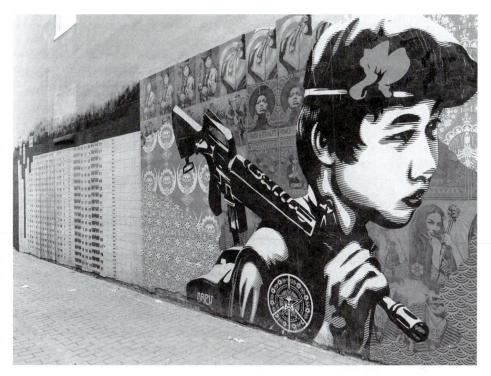

FIGURE 10.13 Shepard Fairey and EVOL, wall murals, alley behind Irvine Contemporary, Washington, DC, 6/2009. Photograph by Martin Irvine, © Martin Irvine, 2010.

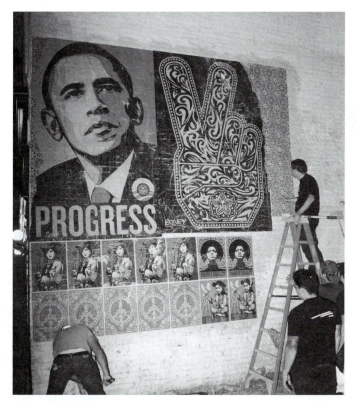

FIGURE 10.14 Shepard Fairey and crew installing 'Obama Progress' mural at 14th and U Streets, Washington, DC, 10/2008. Photograph by Martin Irvine, © Martin Irvine, 2010.

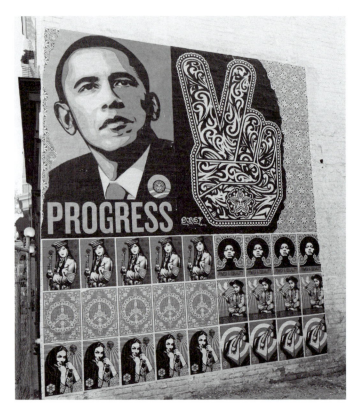

FIGURE 10.15 Shepard Fairey, 'Obama Progress', completed mural, 10/2008. Photograph by Martin Irvine, © Martin Irvine, 2010.

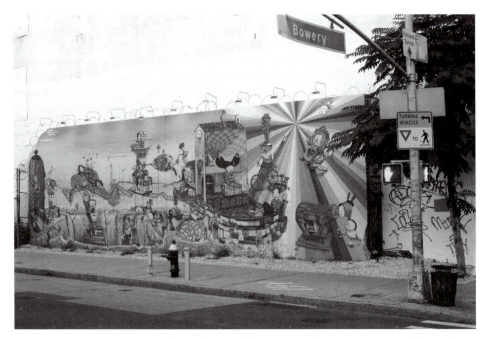

FIGURE 10.16 Os Gemeos, mural, acrylic on wall, Houston and Bowery, New York City, 8/2009. Photograph by Martin Irvine, © Martin Irvine, 2010.

FIGURE 10.17 Os Gemeos, mural, Houston and Bowery, New York City, 8/2009. Detail. Photograph by Martin Irvine, © Martin Irvine, 2010.

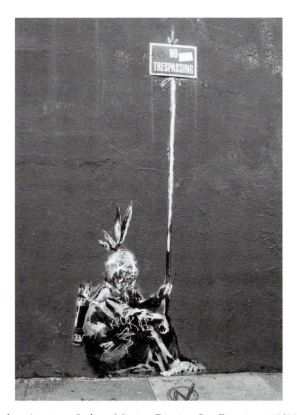

FIGURE 10.18 Banksy, American Indian, Mission District, San Francisco, 10/2010. Photograph by Martin Irvine, © Martin Irvine, 2010.

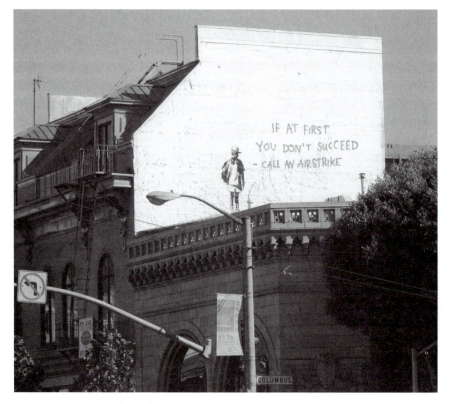

FIGURE 10.19 Banksy, wall mural, Columbus Ave., San Francisco, 10/2010. Photograph by Martin Irvine, © Martin Irvine, 2010.

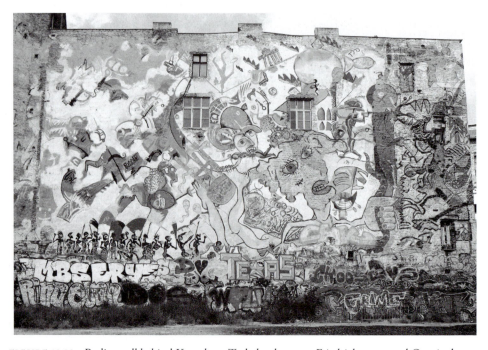

FIGURE 10.20 Berlin, wall behind Kunsthaus Tacheles, between Friedrichstrasse and Oranienburger Strasse, 6/2007. Photograph by Martin Irvine, © Martin Irvine, 2010.

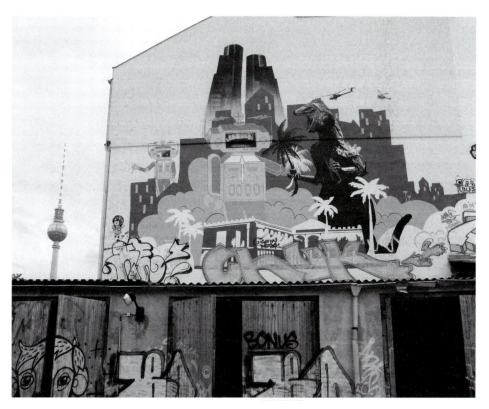

FIGURE 10.21 Berlin, urban intervention and placement, off Alte Schönhauser Strasse, with the Fernsehturm ('television tower') in background, 6/2007. Photograph by Martin Irvine, © Martin Irvine, 2010.

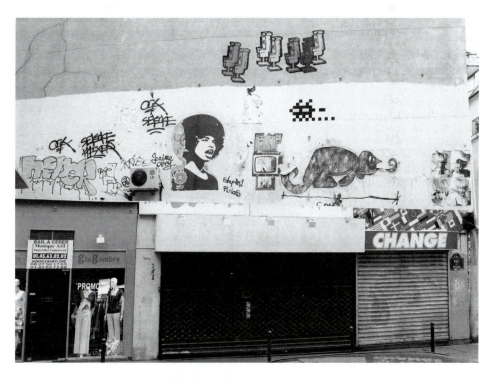

FIGURE 10.22 Invader, Ron English, Shepard Fairey and others. Paris, Rue du Four, 7/2009. Photograph by Martin Irvine, © Martin Irvine, 2010.

FIGURE 10.23 Shepard Fairey, Peace Goddess collage, collage and acrylic on canvas, Grand Canal, Venice. Venice Biennale, 6/2009. Photograph by Martin Irvine, © Martin Irvine, 2010.

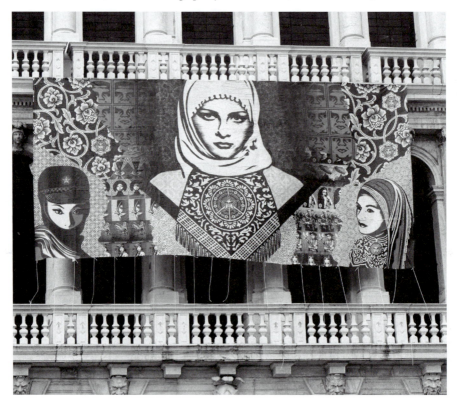

FIGURE 10.24 Shepard Fairey, Peace Goddess collage, Grand Canal, Venice, 6/2009. Close up. Photograph by Martin Irvine, © Martin Irvine, 2010.

FIGURE 10.25 Shepard Fairey, collage on canvas, St. Mark's Square, Venice. Venice Biennale, 6/2009. Photograph by Martin Irvine, © Martin Irvine, 2010.

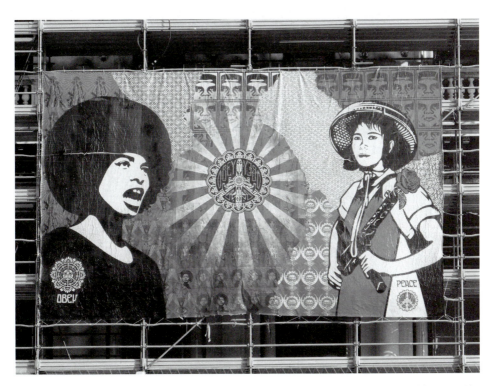

FIGURE 10.26 Shepard Fairey, collage on canvas, St. Mark's Square, Venice, 6/2009. Close up. Photograph by Martin Irvine, © Martin Irvine, 2010.

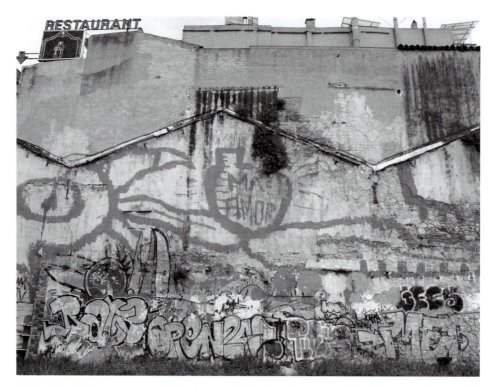

FIGURE 10.27 Barcelona, multiple artists, wall behind the Mercado St. José, 6/2010. Photograph by Martin Irvine, © Martin Irvine, 2010.

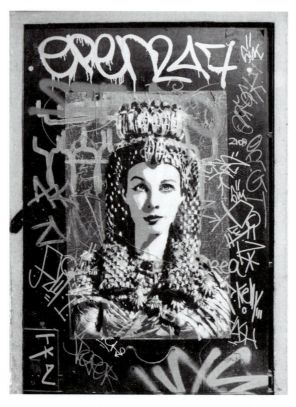

FIGURE 10.28 Barcelona, Btoy and other artists, stencil on paper and paint on door, Barri Gòtic, 6/2010. Photograph by Martin Irvine, © Martin Irvine, 2010.

FURTHER READING

Alonzo, Pedro and Alex Baker. 2011. *Viva La Revolucion: A Dialogue with the Urban Landscape*. Berkeley, CA: Museum of Contemporary Art, San Diego, and Gingko Press.

de Certeau, Michel. 1984. *The Practice of Everyday Life*. Berkeley: University of California Press.

Fairey, Shepard. 2009. *OBEY: Supply & Demand: The Art of Shepard Fairey, 20th Anniversary Edition*. Berkeley, CA: Gingko Press.

Lessig, Lawrence. 2008. *Remix: Making Art and Commerce Thrive in the Hybrid Economy*. New York: Penguin Press.

McCormick, Carlo, Marc Schiller and Sara Schiller. 2010. *Trespass: A History of Uncommissioned Urban Art*. Köln: Taschen.

Nguyen, Patrick and Stuart Mackenzie, eds. 2010. *Beyond the Street: With the 100 Most Important Players in Urban Art*. Berlin: Die Gestalten Verlag.

Rose, Aaron and Christian Strike, eds. 2005. *Beautiful Losers*, 2nd edn. New York: Iconoclast and Distributed Art Publishers.

Wooster Collective. 2001–2010. http://www.woostercollective.com/.

NOTES

1. Arguments for this transition are appearing at an accelerated pace; see especially Nguyen and Mackenzie 2010; Klanten, Hellige and Ehmann 2008; Chandès 2009; McCormick, Marc Schiller and Sara Schiller 2010.

2. It would be impossible to recognize all the friends, colleagues and artists that have been part of an ongoing dialogue that informs many of the ideas in this chapter, but I would especially like to thank Shepard Fairey, Swoon, Roger Gastman, Pedro Alonzo and Jeffrey Deitch for their dedication and commitment to boundary-crossing art forms.

3. Notable books include Gastman, Neelon and Smyrski 2007; Klanten et al. 2008; Lazarides 2009; Lewisohn 2008; Mathieson and Tápies 2009; Rose and Strike 2005; Shove 2009a,b; Banksy 2007; Fairey 2008, 2009; Ganz 2004; Ganz and MacDonald 2006; Rojo and Harrington 2010; Swoon 2010; Nguyen and Mackenzie 2010; McCormick et al. 2010.

4. A highly perceptive description of the current scene of contemporary art is Terry Smith 2009 and 2006; see especially chap. 13, pp. 241–71; see the recent dialogue in *October*: Foster 2009; also telling is the Roundtable discussion on 'The Predicament of Contemporary Art' in Foster et al. 2004: 671–9.

5. This is a central question approached in various ways in Marquard Smith 2008; see also the now-famous volume of *October* devoted to the issue: Alpers et al. 1996; Foster 1996; and the 2005 issue of the *Journal of Visual Culture*, Jay 2005.

6. See especially Gastman et al. 2007; Gastman and Neelon 2010; Ganz 2004; Mathieson and Tápies 2009; Nguyen and Mackenzie 2010.

7. The seminal argument about 'disorder' (also taken to be symbolized in graffiti) and crime was stated in Kelling and Wilson 1982; further developed in Kelling and Coles 1996; the application of this theory on graffiti policy in New York City has been well examined by Joe Austin in Austin 2001.

8. The transitions and hybridizations across the variety of street art and graffiti art practices are well documented in Nguyen and Mackenzie 2010 and McCormick, Marc Schiller and Sara Schiller 2010.

9. The historical context for these theories is beyond the scope of this chapter, but see especially Klanten and Huebner 2010: 4–5; Burger 1984; Krauss 1986: 151–70; questions of relational art in global cities is also usefully explored in Nicolas Bourriaud's essays; see Bourriaud 2002, 2009b; on the Situationist theory of *detournement*, see the key texts by Debord in Knabb 2006 and the overview by Sadler in Sadler 1998.

10. See the World Urbanization Prospects, United Nations Department of Economic and Social Affairs: http://esa.un.org/unpd/wup/index.htm.

11. For the conceptual models here, I am especially indebted to the research by Manuel Castells and Saskia Sassen on the global city; see especially Castells 1989, 2000 and Sassen 2001, 2002, 2006, 1998.

12. See the works of William J. Mitchell: Mitchell 1996, 2000, 2005; and the Web site for his 'Smart Cities' project at MIT: http://cities.media.mit.edu/.

13. For example, from May 2008 to October 2010, the street art animation MUTO by BLU was viewed 8.2 million times on YouTube: BLU 2008. A simple search on 'street art' and 'graffiti' in YouTube yields more than 5,000 videos with millions of aggregate total views. A search on the tag 'street art' in Flickr in November 2010 yielded more than one million photos, appearing in many collective and group collections (see www.fllicker.com).

14. This is affirmed in the recent exhibition of performance art at the Whitney Museum; in the curator's view, performance played out 'the end game of Modernism in their various rupturings of the autonomous space of painting and its primary location—the vertical plane of the gallery wall' (Whitney Museum of American Art 2010).

15. The first quotation is from an essay by Robert Pincus-Witten in 1968, the second from a review in 1953 by Lawrence Campell, in Del Roscio and Twombly 2003: 65, 25; see also Bird 2007.

16. Twombly's 'allusions' to writing were famously described by Roland Barthes in 'The Wisdom of Art' (1979); in Barthes 1984; reprinted in Del Roscio and Twombly 2003: 102–13.

17. The Pomidou Center in Paris organized a Retrospective of Villeglé's work, *Jacques Villeglé, La comédie urbaine*, September 2008–January 2009. Other important exhibitions include *L'informe, mode d'emploi*, Centre Georges-Pompidou, Paris, 1996 and *Le Nouveau réalisme*, Galeries nationales du Grand Palais, Paris, 2007. The artist has his own official Web site: http://www.villegle.fr.

18. A good overview of Tàpies's career is on the Web site for the Dia:Beacon exhibition in 2009: *Antoni Tàpies: The Resources of Rhetoric*, http://www.diaart.org/exhibitions/introduction/9.

19. Tàpies 2007: 117; also reprinted in Bozal and Guilbaut 2005.

20. During a visit to Barcelona in June 2010, I was struck by the historical layers of street mural art visible in central zones around the city, including the walls on streets opposite the Museum of Contemporary Art, Barcelona, which has an extensive collection of Tàpies's works. The street art was still securely *extramuros* in relation to the museum, and the artists' awareness of this binary relationship is clearly marked in their placement strategies.

21. See especially Holzer and Creative Time 2005; Holzer's Web site, 'Projections', http://www.jennyholzer.com/ (Holzer n.d.); Waldman and Holzer 1997; and Elizabeth A. T. Smith and Holzer 2008.

22. Kruger's recent exhibition at Sprüth Magers gallery in Berlin was entitled *Paste Up* (November 21, 2009–January 23, 2010), indicating affinities with billboards and street art. See http://spruethmagers.net/exhibitions/248.

23. Kruger designed a city-block-long installation on the façade of the Ontario Museum of Art in 2010; see http://www.ago.net/barbara-kruger, and the installation video: http://artmatters. ca/wp/2010/05/barbara-kruger-installation-video/. She also recently created a location site-specific work in lower Manhattan as part of the Whitney Museum's 'On Site' series; see http://whitney.org/WhitneyOnSite/Kruger.

24. Interview in Redmon 2010.

25. First published in French in1980 as *L'invention du quotidian*; English translation, 1984 (de Certeau 1984).

26. See Lessig 2008, 2005. The creative foundations of read-write and remix are explored in Miller (DJ Spooky) 2004 and 2008, and Miller and Iyer 2009.

27. I'm extrapolating here from the standard model of the interpellation of the subject in Althusser's 'Ideology and Ideological State Apparatuses' (1970) (in Althusser 2001) and the tradition of message-addressee analysis and reception theory.

28. See Ron English's Web site: http://www.popaganda.com/index.shtml, and Nguyen and Mackenzie 2010: 100–7.

29. From Swoon 2004. Some projects of Swoon and Toyshop from 2003–2004 are archived at the collective's Web site: http://toyshopcollective.org/.

30. *Juxtapoz* (Spring 1995): 69.

31. Statement: Swoon 2003; additional description of the project: http://toyshopcollective. org/.

32. These concepts have been extensively developed by Pierre Bourdieu: see Bourdieu 1992, 1990, 1979.

33. One version of the often-cited comment by Donald Barthelme, 'the principle of collage is the central principle of all art in the 20th century', was from 'A Symposium on Fiction' (1975), included in his collected essays, Barthelme 1999: 58.

34. See, inter alia, Letham 2007; Hebdige 1987; Miller (DJ Spooky) 2008; Lessig 2008; Bourriaud 2005.

35. The literature on this topic from multiple disciplines is huge, but my view draws from semiotics, linguistics, Bakhtin, reception theory and theories of appropriation; see Holquist 1990; Bakhtin 1992; Petrilli and Ponzio 2005; Evans 2009.

36. For a useful compendium of sources and arguments, see Evans 2009.

37. As expressed in the now-canonical statements by Douglas Crimp (1993) and Fredric Jameson (1991).

38. Bourriaud expands on the question of hybridity and postproduction as part of global, nomadic culture in Bourriaud 2009a,b.

39. The dub concept, derived from Jamaican reggae studio production, is excellently explored by Veal 2007; see also Paul D. Miller, Miller (DJ Spooky) 2004, 2008 and Miller (DJ Spooky) and Iyer 2009.

40. By way of disclosure, I negotiated the acquisition of Fairey's hand-stenciled Obama HOPE portrait for the Smithsonian National Portrait Gallery in Washington, DC, and I was a consultant for the legal firm representing Fairey in the AP lawsuit. It is difficult to find a noncontentious summary of events in the AP v. Fairey case, but see *The New York Times* archive of coverage (http://topics.nytimes.com/top/reference/timestopics/ people/f/shepard_fairey/index.html). A special issue of the *Journal of Visual Culture*, 8/2 (August 2009) was devoted to the topic of Obama in visual culture and political iconography.

41. This is one of the most urgent issues of our time, which I will treat more fully in a forthcoming book. For background, see Lessig 2008; Patry 2009; Vaidhyanathan 2001; Boyle 1996.
42. This point is persuasively argued by Cartwright and Mandiberg (2009); see also Sturken 2009.

REFERENCES

Alonzo, Pedro and Alex Baker. 2011. *Viva La Revolucion: A Dialogue with the Urban Landscape.* Berkeley, CA: Museum of Contemporary Art, San Diego, and Gingko Press.

Alpers, Svetlana et al. 1996. 'Questionnaire on Visual Culture', *October*, 77: 25–70.

Althusser, Louis. 2001. *Lenin and Philosophy and Other Essays.* New York: Monthly Review Press.

Armitage, John and Paul Virilio. 1999. 'From Modernism to Hypermodernism and Beyond: An Interview with Paul Virilio', *Theory, Culture & Society*, 25–55.

Art Crimes Collective. 1995–2010. http://www.artcrimes.org/.

Augé, Marc. 2009. *Non-Places: Introduction to an Anthropology of Supermodernity*, 2nd edn. London: Verso.

Austin, Joe. 2001. *Taking the Train: How Graffiti Art Became an Urban Crisis in New York City.* New York: Columbia University Press.

Bakhtin, Mikhail. 1992. *The Dialogic Imagination: Four Essays.* Austin: University of Texas Press.

Banksy. 2007. *Wall and Piece.* London: Random House.

Barthelme, Donald. 1999. *Not-Knowing: The Essays and Interviews of Donald Barthelme.* New York: Vintage.

Barthes, Roland. 1984. *The Responsibility of Forms: Critical Essays on Music, Art, and Representation.* New York: Hill & Wang.

Baudrillard, Jean. 1995. *Simulacra and Simulation.* Ann Arbor: University of Michigan Press.

Bird, Jon. 2007. 'Indeterminacy and (Dis)order in the Work of Cy Twombly', *Oxford Art Journal*, 30: 484–504.

BLU. 2008. *MUTO: A Wall-painted Animation by BLU.* http://www.youtube.com/watch?v=uuGaqLT-gO4.

Bochner, Mel. 2009. 'Why Would Anyone Want to Draw on the Wall?', *October*, 130: 135–40.

Bolter, Jay David and Richard Grusin. 2000. *Remediation: Understanding New Media.* Cambridge, MA: MIT Press.

Bourdieu, Pierre. 1979. *Distinction: A Social Critique of the Judgement of Taste.* London: Routledge & Kegan Paul.

Bourdieu, Pierre. 1990. 'Social Space and Symbolic Power', in *In Other Words: Essays Towards a Reflexive Sociology.* Trans. M. Adamson. Stanford, CA: Stanford University Press, 122–39.

Bourdieu, Pierre. 1992. *The Field of Cultural Production: Essays on Art and Literature.* Cambridge: Polity Press.

Bourriaud, Nicolas. 2002. *Relational Aesthetics.* Dijon: Les Presses du réel.

Bourriaud, Nicolas. 2005. *Postproduction: Culture as Screenplay: How Art Reprograms the World*, 2nd edn. New York: Lukas & Sternberg.

Bourriaud, Nicolas. 2009a. *Altermodern: Tate Triennial.* London; New York: Tate Publications and Harry Abrams.

Bourriaud, Nicolas. 2009b. *The Radicant.* New York: Lukas & Sternberg.

Boyle, James. 1996. *Shamans, Software, and Spleens: Law and the Construction of the Information Society*. Cambridge, MA: Harvard University Press.

Bozal, Valeriano and Serge Guilbaut, eds. 2005. *Tàpies: In Perspective*. Barcelona: Actar/MACBA.

Brassaï. 1999. *Conversations with Picasso*. Chicago: University of Chicago Press.

Brassaï. 2002. *Brassaï Graffiti*. Paris: Flammarion.

Brighenti, Andrea. 2007. 'Visibility: A Category for the Social Sciences', *Current Sociology*, 55: 323–42.

Brighenti, Andrea and Cristina Mattiucci. 2009. 'Editing Urban Environments: Territories, Prolongations, Visibilities', in *Mediacity*. Berlin: Frank & Timme. http://eprints.biblio.unitn.it/archive/00001481/.

Brighenti, Andrea Mubi, ed. 2009a. *The Wall and the City*. Trento, Italy: Professional Dreamers' Press.

Brighenti, Andrea Mubi, ed. 2009b. 'Walled Urbs to Urban Walls—and Return? On the Social Life of Walls', in *The Wall and the City*. Trento, Italy: Professional Dreamers' Press, 63–71.

Burger, Peter. 1984. *Theory of the Avant-Garde*. Minneapolis: University of Minnesota Press.

Cartwright, Lisa and Stephen Mandiberg. 2009. 'Obama and Shepard Fairey: The Copy and Political Iconography in the Age of the Demake', *Journal of Visual Culture*, 8: 172–6.

Castells, Manuel. 1989. *The Informational City: Economic Restructuring and Urban Development*. Oxford, UK; Cambridge, MA: Blackwell.

Castells, Manuel. 2000. *The Rise of the Network Society (New Edition) (The Information Age: Economy, Society and Culture, Volume 1)*, 2nd edn. Oxford: Wiley-Blackwell.

Castleman, Craig. 1984. *Getting Up: Subway Graffitti in New York*. Cambridge, MA: MIT Press.

de Certeau, Michel. 1984. *The Practice of Everyday Life*. Berkeley: University of California Press.

de Certeau, Michel. 1997. 'The Imaginary of the City', in *Culture in the Plural*. Edited by Luce Giard, trans. Tom Conley. Minneapolis: University of Minnesota Press, 17–27.

Chandès, Hervé, ed. 2009. *Born in the Streets: Graffiti*. London: Thames & Hudson.

Cortez, Diego, Glenn O'Brien, Gerard Basquiat, Franklin Sirmans and Arto Lindsay. 2007. *Jean-Michel Basquiat: 1981, The Studio of the Street*. New York: Charta/Deitch Projects.

Crimp, Douglas. 1993. *On the Museum's Ruins*. Cambridge, MA: MIT Press.

Del Roscio, Nicola, and Cy Twombly , eds. 2003. *Writings on Cy Twombly*. Munich: Schirmer/Mosel.

Ellin, Nan. 1999. *Postmodern Urbanism*. 1st edn. Princeton, NJ: Princeton Architectural Press.

Evans, David, ed. 2009. *Appropriation*. London: Whitechapel; Cambridge, MA: MIT Press.

Fairey, Shepard. 2008. *E Pluribus Venom*. Berkeley, CA: Gingko Press.

Fairey, Shepard. 2009. *OBEY: Supply & Demand: The Art of Shepard Fairey, 20th Anniversary Edition*. Berkeley, CA: Gingko Press.

Foster, Hal. 1996. 'The Archive without Museums', *October*, 77: 97–119.

Foster, Hal. 2009. 'Questionnaire on 'The Contemporary'', *October*, 130: 3–124.

Foster, Hal, Rosalind Krauss, Yves-Alain Bois and Benjamin H. D. Buchloh. 2004. *Art since 1900: Modernism, Antimodernism, Postmodernism*. New York: Thames & Hudson.

Ganz, Nicholas. 2004. *Graffiti World: Street Art from Five Continents*. New York: Harry N. Abrams.

Ganz, Nicholas and Nancy MacDonald. 2006. *Graffiti Women: Street Art from Five Continents*. New York: Harry N. Abrams.

Gastman, Roger and Caleb Neelon. 2010. *The History of American Graffiti*. New York: Collins Design.

Gastman, Roger, Caleb Neelon and Anthony Smyrski. 2007. *Street World: Urban Culture and Art from Five Continents*. New York: Abrams Books.

Hebdige, Dick. 1987. *Cut 'n' Mix: Culture, Identity, and Caribbean Music*. London; New York: Methuen.

Holquist, Michael. 1990. *Dialogism: Bakhtin and His World*. London; New York: Routledge.

Holzer, Jenny. n.d. 'Jenny Holzer: Projections', *Jenny Holzer, Projections*. http://www.jennyholzer.com/.

Holzer, Jenny and Creative Time. 2005. 'Jenny Holzer: For the City', *Jenny Holzer: For the City*. http://www.creativetime.org/programs/archive/2005/holzer/index1.html.

Howze, Russell. 2002. 'Stencil Archive'. http://stencilarchive.org/, accessed 10 May 2010.

Jameson, Fredric. 1991. *Postmodernism, or, The Cultural Logic of Late Capitalism*. Durham, NC: Duke University Press.

Jay, Martin. 2005. 'Introduction to Show and Tell', *Journal of Visual Culture*, 4: 139–43.

Kelling, George L. and Catherine M. Coles. 1996. *Fixing Broken Windows: Restoring Order & Reducing Crime in Our Communities*. New York: Free Press.

Kelling, George L. and James Q. Wilson. 1982. 'Broken Windows: The Police and Neighborhood Safety', *The Atlantic* (March). http://www.theatlantic.com/magazine/archive/1982/03/broken-windows/4465/.

Klanten, R., H. Hellige and S. Ehmann, eds. 2008. *The Upset: Young Contemporary Art*. Berlin: Die Gestalten Verlag.

Klanten, R. and M. Huebner, eds. 2010. *Urban Interventions: Personal Projects in Public Places*. Berlin: Die Gestalten Verlag.

Knabb, Ken, ed. 2006. *Situationist International Anthology*. Revised and Expanded. Berkeley, CA: Bureau of Public Secrets. http://www.bopsecrets.org/SI/index.htm.

Krauss, Rosalind. 1986. *The Originality of the Avant-garde and Other Modernist Myths*. Cambridge, MA: MIT Press.

Lazarides, Steve. 2009. *Outsiders: Art by People*. London: Random House.

Lefebvre, Henri. 1991. *The Production of Space*. Oxford: Blackwell Publishers.

Lefebvre, Henri. 1996. *Writings on Cities*. Oxford; Malden, MA: Wiley-Blackwell.

Lefebvre, Henri. (1970) 2003. *The Urban Revolution*. Minneapolis: University of Minnesota Press.

Lessig, Lawrence. 2005. *Free Culture: The Nature and Future of Creativity*. New York: Penguin Press.

Lessig, Lawrence. 2008. *Remix: Making Art and Commerce Thrive in the Hybrid Economy*. New York: Penguin Press.

Lessig, Lawrence. n.d. 'Free Culture', *Free Culture—Free Content*. http://free-culture.org/freecontent/, accessed 12 October 2009.

Letham, Jonathan. 2007. 'The Ecstasy of Influence: A Plagiarism', *Harper's Magazine*, 59–71. http://www.harpers.org/archive/2007/02/0081387.

Lewisohn, Cedar. 2008. *Street Art: The Graffiti Revolution*. New York: Abrams; London: Tate Publishing.

Mailer, Norman and Jon Naar. 2010. *The Faith of Graffiti*, new edn. New York: It Books.

Marshall, Richard, ed. 1992. *Jean-Michel Basquiat*. New York: Whitney Museum of American Art.

Mathieson, Eleanor and Xavier A. Tàpies, eds. 2009. *Street Artists: The Complete Guide*. London: Korero Books.

Mattison, Robert Saltonstall. 2003. *Robert Rauschenberg: Breaking Boundaries*. New Haven, CT: Yale University Press.

McCormick, Carlo, Marc Schiller and Sara Schiller. 2010. *Trespass: A History of Uncommissioned Urban Art*. Köln: Taschen.

Mercurio, Gianni, ed. 2007. *The Jean-Michel Basquiat Show*. Milan: Skira.

Miller (DJ Spooky), Paul D. 2004. *Rhythm Science*. Cambridge, MA: Mediawork/MIT Press.

Miller (DJ Spooky), Paul D., ed. 2008. *Sound Unbound: Sampling Digital Music and Culture*. Cambridge, MA: MIT Press.

Miller (DJ Spooky), Paul D. and Vijay Iyer. 2009. 'Improvising Digital Culture: A Conversation', *Critical Studies in Improvisation* 5. http://www.criticalimprov.com/index.php/csieci/article/viewArticle/1017/1636.

Mitchell, William J. 1996. *City of Bits: Space, Place, and the Infobahn*. Cambridge, MA: MIT Press.

Mitchell, William J. 2000. *e-topia*. Cambridge, MA: MIT Press.

Mitchell, William J. 2005. *Placing Words: Symbols, Space, and the City*. Cambridge, MA: MIT Press.

Mitchell, William J. n.d. *Smart Cities*. http://cities.media.mit.edu/.

Neelon, Caleb. 2007. 'Miss Van', *Swindle 9: Miss Van*, February 15. http://swindlemagazine.com/issue09/miss-van/.

Nguyen, Patrick and Stuart Mackenzie, eds. 2010. *Beyond the Street: With the 100 Most Important Players in Urban Art*. Berlin: Die Gestalten Verlag.

O'Doherty, Brian. 1999. *Inside the White Cube: The Ideology of the Gallery Space*, expanded edn. Berkeley: University of California Press.

Patry, William. 2009. *Moral Panics and the Copyright Wars*. New York: Oxford University Press.

Petrilli, Susan and Augusto Ponzio. 2005. *Semiotics Unbounded: Interpretive Routes through the Open Network of Signs*. Toronto: University of Toronto Press.

Rancière, Jacques. 2004a. *The Politics of Aesthetics: The Distribution of the Sensible*. London and New York: Continuum.

Rancière, Jacques. 2004b. 'The Politics of Literature', *SubStance*, 33: 10–24. http://0-muse.jhu.edu.library.lausys.georgetown.edu/journals/substance/v033/33.1ranciere01.html.

Rancière, Jacques. 2006a. 'Aesthetic Separation, Aesthetic Community: Scenes from the Aesthetic Regime of Art', *Art & Research*, 2. http://www.artandresearch.org.uk/v2n1/ranciere.html.

Rancière, Jacques. 2006b. 'Thinking between Disciplines: An Aesthetics of Knowledge', *Parrhesia*, 1: 1–12. http://www.parrhesiajournal.org/parrhesia01/parrhesia01_ranciere.pdf.

Rancière, Jacques. 2009a. *Aesthetics and Its Discontents*. Cambridge: Polity Press.

Rancière, Jacques. 2009b. 'The Aesthetic Dimension: Aesthetics, Politics, Knowledge', *Critical Inquiry*, 36: 1–19.

Redmon, Kevin Charles. 2010. 'Shepard Fairey's American Graffiti, The Future of the City', *The Atlantic* (20 May). http://www.theatlantic.com/special-report/the-future-of-the-city/archive/2010/05/shepard-faireys-american-graffiti/56924/.

Revelli, M. and Shepard Fairey. 2010. 'Barbara Kruger', *Juxtapoz* (November): 44–55.

Rojo, Jaime and Steven P. Harrington, eds. 2010. *Street Art New York*. New York: Prestel.

Rose, Aaron and Christian Strike, eds. 2005. *Beautiful Losers*, 2nd edn. New York: Iconoclast and Distributed Art Publishers.

Rowe, Colin and Fred Koetter. 1979. *Collage City*. Cambridge, MA: MIT Press.

Sadler, Simon. 1998. *The Situationist City*. Cambridge, MA: MIT Press.

Sassen, Saskia. 1998. *Globalization and Its Discontents*. New York: The New Press.

Sassen, Saskia. 2001. *The Global City: New York, London, Tokyo*, 2nd edn. Princeton, NJ: Princeton University Press.

Sassen, Saskia. 2002. *Global Networks, Linked Cities*. New York; London: Routledge.

Sassen, Saskia. 2006. *Cities in a World Economy*, 3rd edn. Thousand Oaks, CA: Pine Forge Press.

Shove, Gary. 2009a. *Untitled II. The Beautiful Renaissance: Street Art and Graffiti*. Berkeley, CA: Gingko Press.

Shove, Gary. 2009b. *Untitled: Street Art in the Counter Culture*. Berkeley, CA: Gingko Press and Pro-Actif Communications.

Smith, Elizabeth A. T. and Jenny Holzer. 2008. *Jenny Holzer*. Ostfildern, Germany: Hatje Cantz.

Smith, Marquard. 2008. *Visual Culture Studies: Interviews with Key Thinkers*. Los Angeles; London: Sage.

Smith, Terry. 2006. 'Contemporary Art and Contemporaneity', *Critical Inquiry*, 32: 681–707.

Smith, Terry. 2009. *What Is Contemporary Art?* Chicago: University of Chicago Press.

Spears, Dorothy. 2010. 'Barbara Kruger in Europe, Toronto and the Hamptons: Resurgent Agitprop in Capital Letters', *The New York Times*, August 24. http://www.nytimes.com/2010/08/29/arts/design/29kruger.html.

Steinberg, Leo. 1972. 'Reflections on the State of Criticism', *Artforum* (March): 37–49.

Sturken, Marita. 2009. 'The New Aesthetics of Patriotism', *Journal of Visual Culture*, 8: 168–72.

Swoon. 2003. 'Toyshop Collective: Indivisible Cities'. http://www.toyshopcollective.org/indivisible.html.

Swoon. 2004. 'Swoon Union'. http://www.fingerweb.org/html/finger/finger8_12/finger11/swoon.html.

Swoon. 2010. *Swoon*. New York: Abrams.

Swoon. n.d. 'Newtopia Magazine: Indivisible Cities, by Caledonia Curry', *Newtopia*. http://www.newtopiamagazine.org/issue11/newart/indivisiblecities.php.

Swoon. n.d. 'TOYSHOP'. http://toyshopcollective.org/.

Tàpies, Antoni. 2007. 'Communication on the Wall', in *Antoni Tàpies: Works, Writings, Interviews*, ed. Youssef Ishaghpour. Barcelona: Poligrafa, 115–17.

Vaidhyanathan, Siva. 2001. *Copyrights and Copywrongs: The Rise of Intellectual Property and How It Threatens Creativity*. New York: New York University Press.

Veal, Michael. 2007. *Dub: Soundscapes and Shattered Songs in Jamaican Reggae*. Middletown, CT: Wesleyan University Press.

Virilio, Paul. 2009. *The Aesthetics of Disappearance, New Edition*. New York: Semiotext(e).

Waldman, Diane and Jenny Holzer. 1997. *Jenny Holzer*. New York: Solomon R. Guggenheim Museum.

Whitney Museum of American Art. 2010. 'Off the Wall: Part 1—Thirty Performative Actions'. http://whitney.org/file_columns/0001/8996/off_the_wall_press_release.pdf.

Wooster Collective. 2001–2010. http://www.woostercollective.com/.

Aesthetics, Politics and Visual Culture

Editorial Introduction

All the essays in this part of the collection consider the relationships between aspects of visual culture, particularly those shaped by recording and communicating technologies, as well as those with specifically aesthetic dimensions, and their wider social and political setting. Also, in this context, the essays by Roth and Gardiner cast light on works by two writers who, they maintain, should be better known to visual culture studies: respectively Vilém Flusser and Henri Lefebvre.

Roy Boyne explores a tradition of public spectacle that has persisted throughout the modern period. Both Futurism and Situationism contributed not only to the theory of spectacle but also its practice, or in some respects its 'counter-practice'. Here the power of spectacle is discussed in relation to two aesthetic ideas: the *sublime* and *aura*. Following Walter Benjamin, these need to be considered in the light of changes in the technology of image reproduction and distribution. More concretely, Boyne considers the cinematic spectacle, architecture and large public artworks.

The Futurist Filippo Marinetti famously celebrated the naturally spectacular public phenomena of industrial modernity. Marinetti seems to suggest that the role of avant-garde art was to prepare in the public mind a positive, exciting image of the creative destruction integral to unending modernization. Both Left and Right eventually came to exploit the idea that spectacle could create mass enthusiasm for their policies, and from the twentieth century onwards, 'bureaucracy and spectacle zigzag alongside each other as two dominant abiding features of the Western world'.

Situationism and Guy Debord's *Society of the Spectacle* have been very influential as diagnoses of contemporary visual culture and the devising of critical, oppositional strategies. Up-dating Marx's early theory of alienation, Debord argued that modern life is no longer lived 'directly', but through representations, often fragmentary images that are brought together by those who wield representational power, usually through the mass media and entertainment industries, into 'pseudoworlds'. Any resistance to this power

must include everyday acts of disruption of these 'regimes of representation', the transgression in particular situations of habitual, passive or normal ways of visualizing, speaking and thinking. Techniques and practices like psychogeography and the *dérive* (aimless urban wandering or 'drifting') deliberately repudiated instrumental mobility, seeking out the emancipatory potential of chance encounters and unpremeditated discoveries. With *détournemont* the Situationist sought unexpected connections and novel experiences. This de-familiarizing process was felt to be most applicable to the work of the cinema.

Repudiating a rationalized revolutionary strategy led and executed by a centralized party in favour of spontaneity and disruptive cultural tactics, Situationism is often seen as reaching a kind of consummation in the student movements of 1968. Arguably, Debord's critical theory of the spectacle failed politically, perhaps because it was insufficiently spectacular.

Boyne argues that spectacle is a compound of the natural, the human and the technological. Not only Futurism, but also other important forms of modernism displayed enthusiasm for technology and the modernization process embodied in the energy of collective spectacles. Walter Benjamin famously argued the mechanical reproduction of images led to a loss of a sense of the 'distance' and 'singularity' of 'aura' and auratic experience. Instead of 'sacred' art modernity and mass society has 'profane' visual culture. Benjamin, like Martin Heidegger, saw behind the elimination of aura a desire for 'closeness'. Works of art in particular, cut loose from ritual and place, became free to circulate, leading to a proliferation of hybrid forms on the one side and the elaboration and amplification of their commercial and political possibilities on the other. Boyne reviews Miriam Hansen's recent analysis, which suggests that Benjamin's conception of aura was much more complex and useful than is usually assumed.

Boyne summarizes the history of the idea of the sublime, concentrating on Edmund Burke, Immanuel Kant and Friedrich Schiller. Turning to David Nye's political economy of the modern sublime, he draws attention to the development of the United States' railway system in the nineteenth century as a staged, spectacular demonstration of the technological sublime and nationhood. Similar celebratory presentations of the constructed worlds of bridges, dams and skyscrapers persisted throughout the first half of the twentieth century.

The modern sublime that is inextricably connected with technological information and image systems brings with it a suggestion of 'surrender' to the new, or of 'terror' before something of overwhelming power. Viewed on screen, it is domesticated, and so, as Burke observed, able to be enjoyed and consumed.

Turning to cinematic spectacle, Boyne summarizes recent research into the history not only of cinema technology but also of the skills of viewing and interpretation needed by the cinema audience. Focusing on a series of 'blockbuster' films, he discusses the total marketing of cinematic spectacle, suggesting the pertinence of Debord's thesis that these are 'irresistible', ultimately reassuring moments of commodified pleasure.

For some commentators, the attack on the World Trade Centre in 2001 inaugurated the 'terror spectacle'. Boyne discusses responses to an exhibition curated by Paul Virilio which takes up the themes of man-made disaster and the modern visual media, linking

technology, speed and spectacle. He also notes Rebecca Adelman's remark that 'zero visibility' seems to be the preferred response to spectacular terror.

Turning finally to public art and architecture, Boyne discusses spectacle in relation to aesthetics, functionality and in particular the 'liberal democratization' of urban space. As case studies of different modes of 'interactivity'—in design, conception or response—he cites the Viaduc de Millau in Southern France, the sculptural D-tower in the Dutch city of Doetinchem, Antony Gormley's 'fourth plinth' project in Trafalgar Square, London, and the BMW car plant building in Leipzig designed by Zaha Hadid. He suggests that interactive spectacle may well be one of the dominant functions of new architecture and large-scale public art.

In conclusion, Boyne takes up the theme of spectacular public art, exemplified by the Turbine Hall of Tate Modern in London and the Grand Palais in Paris. Such works seek to activate an experience of spectacle and scale, memory and allusion in the fabric of the building itself, but also raise difficult questions about the means and purpose of such events.

For **Lisa Cartwright,** feminism as a theoretical perspective has been one of the most important contributors to the study of visual culture as it has developed and expanded over the past forty years. Among its leading themes have been its 'critique of discourses of mastery and universal value', its 'emphasis on embodied experience', and its interest in 'subjugated and situated forms of knowledge, experience and pleasure as legitimate and important areas of focus'. Feminists have also emphasized the gaze, meaning by this acts of looking which contribute to determining someone's identity and supposed social attributes, and the organization of things, spaces and social relations through practices, which include ways of seeing.

Cartwright reviews the place of feminism in the institutional development of visual culture studies during the 1980s and 1990s, initially in departments of fine art, art history and film, but eventually embracing anthropology, history and sociology. Debates continue as to the subject matter or field of visual studies, as well as theory and method, and the place of feminism in this field. Cartwright suggests that feminist theory's appropriation and use of psychoanalytic, Marxist and semiotic ideas has made a unique contribution to the development of visual culture studies.

Cartwright charts the evolution of notions of ideology in feminist approaches to visual studies, from a concentration on 'negative' stereotypes to an analysis of structural features of representations that shape reception and audience appropriation. She notes how Mary Kelly's artworks brought psychoanalytical ideas into conceptualism, while the theorist Jacqueline Rose pioneered a theory of vision applying to the gendered politics of everyday life.

In the context of art history, feminism is often linked to the 'cultural turn' and the 'new art history', both of which gave prominence to political, institutional and economic factors. In the 1970s Linda Nochlin made the point that it was not enough to promote a few women artists to the canon of critical esteem but that what was required was a much more radical critique of the very notion of 'great art' and the institutions that sustained this male-dominated canon. The only truly radical solution to the 'structural absence of

women' was a fundamental revision of what counted as art and its history. Slightly later, Griselda Pollock analysed the symbolic and institutional structures forming the conditions for women's aesthetic practice. Cartwright also discusses the sociological contributions of Janet Wolff and the semiotic and poststructuralist approaches of Michael Ann Holly, Keith Moxey, Norman Bryson and Mieke Bal.

Cartwright returns to the influence exerted by the idea of the 'feminine gaze', in which 'being looked at' is contrasted with a supposedly male position of active looking, as well as to critiques and modifications of the original formulation, many of which are being published in *Camera Obscura*. In the collection *How Do I Look?* feminist theory and politics were applied to pornography, provoking a controversy about the 'perceived prudery' of older feminist attitudes, with wider repercussion in the conduct and thematics of visual culture studies.

In the area of art practice, feminism has also influential, for example Cindy Sherman's gently ironical photographs of herself in scenes from various Hollywood genres, Catherine Opie's portraits of lesbians influenced by Lacanian notions, Barbara Kruger's use of familiar iconography, graphic techniques and sometimes sardonic captions, and the Guerilla Girls' performance interventions emphasizing art's social context. More recently, Kimiko Yoshida has used photography for critical comment on the emerging global visual culture, while other artists have given a combination of theory and practice a stronger presence in visual culture studies.

Scholars like Anne Friedberg and Lisa Nakamura have extended feminist approaches into new media studies, analysing the role of the screen, mobile phone and the Internet. The works of others, like Vivian Sobchack, have raised interest in embodied experience in visual culture studies, while Donna Haraway has compared cross-media forms with fluid identity construction. Other women artists and theorists have explored connections between feminism, technology and science studies, sexuality and visual culture.

Finally, Cartwright cites useful overviews of visual culture studies that emphasize the continuing role of feminism in advancing research in this field.

Nancy Roth explores the contribution of the Czech-born philosopher Vilém Flusser (1920–1991) to the study of visual culture. She is particularly interested in Flusser's ideas about the relationship between images or, more broadly, the visual, in a culture 'overpowered by written language'. Like the media historian and theorist Marshall McLuhan, Flusser speculates about the transition from a 'linear' writing culture to a visual one, a new universe of 'technical images'. Flusser is distinctive, however, in his grasp of the connection between new visual media and pictorial or historical consciousness.

Roth initially reviews Flusser's understanding of the conflicted relationship between image and text. Two key events in this history are the invention of writing in the third millennium BCE and the invention of photography in the nineteenth century. He sees writing as linear, serious and directed towards a goal, characteristics that eventually come to structure a distinctive form of human consciousness. By the eighteenth century writing had pushed images to the margins of Western culture. Yet because of its growth in volume and complexity literate consciousness was faced with a growing crisis: dealing with 'unbearable' demands of written texts, a failure to convey information clearly and

quickly, and thus to serve human needs. The eagerness with which photography—the first 'post-historic' medium—was seized upon demonstrates the severity of this impasse. The proliferation of technical images means that the linear character of consciousness is replaced by simultaneity and a kind of permanent stasis.

Uprooted from Europe by the Nazis, Flusser settled in Brazil, becoming a university professor in the 1960s. Loss of his first cultural home, however, helped free him from prejudices and assumptions, enabling fresh thinking about the emerging new media of representation and communication. Although valuing profoundly the heritage of writing, Flusser raised the question as to whether writing had a future.

At the centre of his theory of communication, still unfinished at his death in 1991, were the concepts of discourse and dialectic. Discourse is a set of 'formal ideals and history', typically stored in print. Dialogue is open, exploratory and ephemeral, and a source of new information. In principle cultures should be woven from both modes, but Flusser feared that in much of the modern world discourse would be the dominant force. Giving Martin Buber's ideas a secular and existential twist, Flusser believed that dialogue establishes and maintains an identity within a life worth living, and his hopes and anxiety for new media were that 'a profound change in the medium of communication inevitably means a profound change in the potential for dialogue, for making meaningful creative contact with another human being'. For Flusser speech and writing were fundamentally acoustic, but new media were ushering in a radically new visual consciousness. In order not to lose the cultural heritage stored in writing, Flusser called for 'envisioners', those capable of translating between word and image.

Flusser was an admirer of the phenomenologist Edmund Husserl, whose method of phenomenological 'reduction' or *epoché* he adapted and applied in a series of essays with 'gesture' in the title. Gestures are 'movements of the body or tool' that have no causal significance, but which do encode intentions. In painting for example Flusser wants to emphasize the organic wholeness of gesture, a kind of dynamic unity between canvas, materials, tools and painter. However, Flusser suggests that in photography, the phenomenon visibly impresses itself on a surface, almost along the lines laid down by empiricist philosophy. Roth explains how Flusser proceeded to analyse the photographic gesture phenomenologically.

Photography enjoys a fundamental place in Flusser's culture of technical images, as a basic form of 'apparatus'. All technical images are mediated by apparatus of some kind, which entails an abstraction of consciousness from an immediate or purely sensory engagement with the life-world (*Lebenswelt*). The apparatus of technical images deals with particles too small to be perceived normally, selects and orders them through a programme, transfers them to a surface, and stores them for as long as necessary. From the first, photography displayed these characteristics. This is a very different idea of photography from conventional ideas of 'index' or 'trace'. Like the more sophisticated technology that followed it, photography has always been a way of constructing images, 'fictions' or 'projections', out of particles devoid of intrinsic meaning. This insight is difficult to grasp, argues Flusser, because of the predominance of assumptions that characterize a literate culture still oriented to a world in need of representation. Flusser

highlighted the key difference between those who understand how new technologies work to construct images, sounds and so on, and mere users who, as a consequence, cleave to the older idea of *mimesis* or representation. The wider cultural danger here is not only a failure to interact creatively with technology, but also the ways in which convictions about representation buttress discourse and impede dialogue.

Finally, Roth turns to Flusser's approach to visual art. Somewhat impatient with institutional aspects of art, he continually emphasized the importance of creative activity with technical images, which follows from the overriding importance of communication, or what Roth calls 'real, creative contact or dialogue'. At the root of dialogue is an exchange between memories, within the memory of the individual, between those of different individuals or between people and 'artificial memory' of some kind, where this may go as far as demanding of an apparatus unprecedented uses and results, a practice of '*einbilden*', which Roth translates as 'imagine' or 'envision'. At this point, traditional distinctions between creative artists and scientists dominated by methodological and cognitive values become less useful, damaging even. Flusser's call is for a culture of 'envisioners', restlessly dissatisfied with known codes and communicative habits, but convinced that 'surprise, invention, creative human dialogue can and should flourish in the new universe of technical images'.

The phenomenology of Husserl and his students (Heidegger, Merleau-Ponty and Sartre in particular) have also been extremely influential upon the work of the unorthodox French Marxist Henri Lefebvre. During the past decade the influence of Lefebvre on the study of culture has grown considerably. However, **Michael Gardiner** argues that his ideas about vision have still to receive the attention they merit. Gardiner sets out to show that while critical of some aspects of modern visual culture, in particular what he calls 'abstract space', Lefebvre is not simply hostile to so-called ocularcentrism. His more complex, nuanced position involved rethinking 'decorporealized' ideas of vision and the development of alternatives in which a prelinguistic, multisensory engagement with the world was prominent.

Gardiner begins by discussing Lefebvre's criticism of Surrealism for being fixated on disruptive but static and decontextualized images that belong to the 'abstract space' of exchange value rather than the concrete space of lived experience, use value and 'dialectical reason'. This notion of a reductive and destructive relation to space and the natural world, to which a certain modality of vision is critical, is one of the recurrent themes of much of Lefebvre's work.

Lefebvre contrasts modern space with premodern or 'absolute' space, for him a natural landscape established primarily by the symbolic mobility of the human body. This kinaesthetic space is experienced and understood by being 'lived' rather than appropriated abstractly and intellectually. Eventually the growing power of urban centres saw the growth of a more quantitative, homogenous space, measurable and readable. Abstract space is characterized by hierarchical proscription, control and quantitative changes, the elimination of qualitative differences, and ultimately the 'commodified space' that has been globalized by neocapitalism. What makes all this possible, Lefebvre argues, is ultimately 'language' as a means to distance ourselves from embodied life. Yet Lefebvre

insists that all such linguistic codes and ideologies necessarily still operate in particular historical and local circumstances.

Gardiner outlines three key factors in Lefebvre's account of the emergence of abstract space—the geometric, the visual and the phallic—and the possible origins of a kind of abstracting gaze in Renaissance perspective. He notes connections between Lefebvre's critique of modern space and criticisms developed earlier by Nietzsche and Heidegger.

In setting out his utopian alternative, Lefebvre concentrates on the democratic potential inherent in modern urban life. It is important to understand the history and contemporary working of abstract space in order to overcome it. Yet abstract space is not as controlled and organized as it may appear, but rather uneven, folded, discontinuous, features that appear to and through the lived body in its actions. In fact, the reality of space is the body and its movements and gestures, the life of the prodigal, energetic erotic body, a 'practico-sensory totality'. In a style that influenced Situationism, Lefebvre advocates a 'revolt of the body', rooted in the 'cryptic opacity' of a corporeality capable of resisting the mapping and codification of analytic, linguistic reason.

Gardiner notes Lefebvre's phenomenological insistence on multisensory perception, in particular the virtual elimination from modern public life of an extended range of olfactory experiences. However, hearing—the primary sense of the premodern era—is central to Lefebvre's argument, and he develops a detailed phenomenology of hearing in the context of embodied everyday life. Lefebvre's ultimate goal is to restore the senses, including vision, to their proper interplay, richness and creative potential, to create a philosophy of the concrete that can resist the dominance of abstract seeing.

In conclusion, Gardiner suggests that Lefebvre did not think that vision was intrinsically abstract and hegemonic; however, its modern deformation could be overcome by restoring its relationship with the other senses. This led Lefebvre to advocate forms of art not set apart from, but in intimate contact with, everyday, natural embodied life, and capable of affirming the spontaneity and creativity of mundane experience.

The study of visual culture cannot evade questions about its own values and politics. **Ian Heywood** suggests that the topic of Cubist collage raises immediate and unavoidable questions about the politics of experimental art and, necessarily, about the critical and ethical standpoint of visual culture studies.

The context of Cubist collage in France in the early years of the twentieth century is the process of modernization, widely theorized by historians, philosophers and social and cultural theorists. Heywood notes a shift in ideas about what culture consists in, as well as its relationship to other social, economic and political forces. He reviews a growing emphasis on the autonomous or prior structuring force of culture, and the impact of ideas of textuality, emphasizing the indeterminacy of interpretation.

Heywood next discusses the values and politics of the quasi-discipline of visual culture studies in the context of its history and Bill Readings's polemical analysis of humanities in the late-modern university. He agrees with Readings that a demand for 'participation' for those classes and groups largely excluded from national life was at the core of early British cultural studies.

In the USA there was a related, although less class dominated, demand for participation and inclusivity, which, however understandable, led eventually a lack of clarity about the object of study and incoherence of critical and political values on the one hand, and an ultimately timid assertion of 'political pieties' on the other.

The strengths of Pierre Bourdieu's reflexive sociology of culture offset for many the weaknesses of cultural studies. However, Readings argues that Bourdieu's ideas are now critically limited, crucially because national cultures aligned to national economics and politics have been replaced by the global circulation of capital, leaving behind an empty, impotent centre. This new situation makes questionable some of the founding assumptions of visual culture studies. Universities, as institutions that have to adapt to new circumstances, can no longer see themselves as places for the articulation and criticism of national cultures. In the new millennium, with neither an authentic legitimating role nor any defined object, culture is 'over', yet ironically it is at just this point that cultural studies comes into being, typically seeking an uneasy accommodation between a tradition of 'criticism' and a sociological or historical account of the complicity of all high culture, including critique—an *impasse* that we have come to call *postmodernism*.

While the Cubist collages made by Braque and Picasso between 1912 and 1914 are not overtly or conventionally political, they do seem to be pictures of modern life, or perhaps works in which an emerging vernacular visual culture meets highly self-aware, experimental, ambitious art prepared to take dramatic risks.

Informed by the recent work of Christine Poggi, Heywood outlines some of Cubist collage's formal and substantive innovations, initially the use of frames and framing devices within the work, and then the use of *tromp l'oeil* chair caning printed on oil cloth in Picasso's famous *Still Life with Chair Caning* (1912). He suggests that the collages do not reject the ideal of perceivable pictorial coherence but reassert it with new ferocity, embracing and arranging 'profane' materials and surfaces to suggest the work's self-structuring, lending the work an aura of independence or authenticity.

T. J. Clark observes that Cubism shares a basic conviction of modernism: that truth to the world in painting depends on truth to what painting consists of. What is peculiar about it is its determination not to abandon or even tone down either demand. It follows that if the painting is to enter fully embodied life it must be rid of its merely 'objective' characteristics. Self-structuring in the context of 'rough' materials and 'brutal' techniques does not turn the collage into a 'subject', but it does suggest a certain awkward, assertive autonomy among other mobilized visual objects of vernacular modernity.

Heywood turns to Cubism's relations with newspapers, wallpaper and Symbolist poetics. He outlines the arrival of cheap newspapers and paper wall decoration during the nineteenth century, and some of the critical conclusions that have been drawn from the ways Cubism takes up and manipulates materials and devices drawn from this new visual and literate culture. Negative assessments, sometimes inspired by Bourdieu, need to be reexamined in light of a more plausible account of the politics of Cubist practice. Although Patricia Leighten's account of the political and aesthetic radicalism of Picasso's early years contains much of interest, Heywood suggests that it oversimplifies Cubism's

formal challenge, and in particular its practical criticism of aspects of existing painting practice. The underlying, unavoidable question is that of the work's real subject matter.

Returning to images and theories of modernity and modernization, Heywood highlights not only the familiar theme of rapid and sometimes violently disruptive social change, but also ongoing bottom-up efforts to reestablish orderly, reliable, legitimate forms of life, the possibility of an everyday life worth living. In this larger cultural context, Cubism may be seen as a highly paradoxical self-modernization, fused with an energetic, stressful re-embedding of painting practice.

Sociology of the Spectacle: Politics, Terror, Desire

ROY BOYNE

Machiavelli implies that the inseparability of spectacle and politics is demonstrated when the warrior-king publicly slaughters his triumphant and loyal second-in-command: an extreme form of the political imperative that control must be demonstrated. During the course of European history, this relation between power and spectacle became less important. Michel Foucault (1976) described the public spectacle of an execution in a manner reminiscent (although Foucault is more lascivious and less situated) of Christ carrying the cross to Golgotha. In both cases these ritual events served, in part, to affirm the power of the ruling order. Eighty years after the execution of Damiens, with the public execution of Robespierre in 1794, with Paris still fresh in living memories (see Figure 11.1), a new form of strategic political security had taken shape, exemplified by the timetabled administration of the reformatory, presented in *Discipline and Punish*. The movement that Foucault described, from rule through permanent fear and intermittent spectacle to administration, measurement and routine, was clearly substantial. It was not definitive, however, and the second half of the twentieth century is effectively a new age of spectacle, now permanent rather than intermittent.

The following chapter explores some of the main elements of spectacle. Futurism and Situationism contributed significantly to the development of its forms in the first half of the twentieth century, invoking questions of propaganda and resistance respectively. The contribution of political ideologies is not dealt with to a great extent, but we should note the use of spectacle as a key tool of political propaganda during the twentieth century (Doob 1950). Following the discussion of Futurism and Situationism, the sources of the power of spectacle are considered through the debates on aura and the sublime. The complex connection between them is important not least because many people engage with spectacle at a distance through visual media. The commentary on Benjamin's argument that technological reproduction destroys aura is set alongside an account of the technological sublime. The nineteenth century may have been the start of the age of

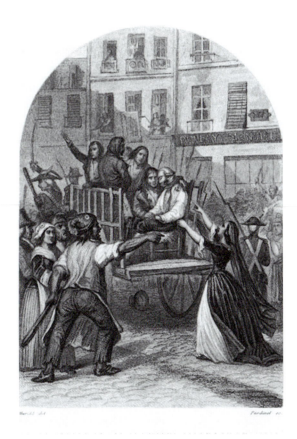

FIGURE 11.1 *Maximilien Robespierre and His Followers on Their Way to the Scaffold on 28 July 1794.* From Auguste Maquet and Jules Edouard Alboise du Pujol, Les Prisons de l'Europe, Paris: Administration de librairie, 1845 (public domain, see http://en.wikipedia.org/wiki/File:Robespierre Execution.jpg).

sublime engineering of and between cities, but then the twentieth can be seen as the time of the screen, as illustrated through the discussion of cinematic spectacle which follows. This discussion of spectacle closes with an engagement with architecture and large works of public art.

FUTURISM AND THE SHOCK OF THE NEW

The contemporary history of politics, culture and spectacle may be said to begin in 1909, with Marinetti's first *Manifesto of Futurism*. Its eleventh thesis opens as follows:

We will sing of great crowds excited by work, by pleasure, and by riot; we will sing of the multicoloured, polyphonic tides of revolution in the modern capitals; we will sing of the vibrant nightly fervour of arsenals and shipyards blazing with violent electric moons; greedy railway stations that devour smoke-plumed serpents; factories hung on clouds by the crooked lines of their smoke; bridges that stride the rivers like giant gymnasts, flashing in the sun with a glitter of knives. (Apollonio 2009: 22)

Walter Benjamin, first analyst of the seductions of the arcade form, and aware of the contradictions of Futurism, which appealed to both fascist and communist, wrote that 'Fascism, as Marinetti admits, expects war to supply the artistic gratification of a sense perception that has been changed by technology' and goes on to say that 'Fascism aestheticises politics, while communism politicizes art' (quoted in Perloff 2003: 30). Which perspective did Marinetti take? The answer is indeterminate. He was driven by the future, and thought that it had to be realized by engineers, scientists and politicians, and anticipated on the aesthetic plane by artists. He could not see—for he was in the middle of things, and emotionally embroiled—that both communism and fascism engaged with Futurism and sipped from its energies, in order to appropriate the visual and put it into the service of a utopia. From Futurism forwards, the relation between power and spectacle—once occasional, violent and cautionary, then submerged or modulated by the emergence, growth and orderly timetabling of the great social institutions: transport, employment, education, civil service, armed services, hospital, prison, church, entertainment and the arts—became primary. However, this was not just a return of occasional carnivalesque events, of intermittent transcendent and time-stopping episodes of beauty, horror or both. From the early twentieth century, bureaucracy and spectacle zigzag alongside each other as two dominant abiding features of the Western world.

These are areas that must be explored, but before we get to them, we should point at two further lines into and, thickening, out of Futurism which concern the human component of spectacle; we can do little more here than specify an example reference or two. The first concerns the multitude (Boyne 2006) as crowd (Schnapp and Tiews 2006), and the permanent link between mass presence/action and spectacle (Buur 2009; Newman 2007; Kohn 2008); the second is involved with the multitude as market (Arnoldi and Borch 2007; Borch 2007; Kozinets et al. 2008). Crowd as target and as spectacle come together for the suicide bomber, and we will return to this below.

As Christine Poggi (2002) points out Marinetti and his colleagues wanted to change the will of the masses, to turn them from tradition towards the future. Their art, politics and performances—unreflective and naïve much of the time—present this as their constant motivation. Recent reassessments of Futurism (Adamson 2007; Fogu 2008) have broadened out from the concern with fascism and aesthetics that dominated earlier discussions (Melograni 1976; Ghirardo 1996) in which scholars of fascist spectacle often ignored the Futurists altogether. It was the association with fascism, but also its history of disaggregation (Fogu), as well as the larger but fractured profile of surrealism (Bernard 2009), that prevented Debord, the founder of Situationism, from recognizing that Futurism had much to teach about spectacle.

SITUATIONISM AND THE SOCIETY OF THE SPECTACLE

Situationism was largely a Paris-based alliance of European avant-garde artists, writers and poets which came together in 1957. It arose from a collection of small artistic movements, including Lettrist International and the International Union for a Pictorial Bauhaus. The leading figure was Guy Debord. The well-known CoBrA painter, Asger Jorn,

was also an adherent. Its most significant output was Debord's *Society of the Spectacle*, published ten years after the initial gathering. Only five years after this, the movement dissolved itself. Debord's book remains important, and the methodology of resistance, designed by the Situationists to combat the social perversion they diagnosed, remains a significant source of aesthetic and social inspiration even today. The opening statement, in the 1973 film which Debord made of his text, is a clear expression of his basic thesis:

> In societies dominated by modern conditions of production, life appears as an immense accumulation of spectacles. Everything that was directly lived has receded into representation. The images detached from each aspect of life merge into a common stream, yet the unity of that life can no longer be recovered. Fragmented views of reality regroup themselves into imaginary unities, separate pseudoworlds that can only be looked at . . . even the deceivers deceive themselves. The spectacle is a concrete inversion of life.

Debord's *Society of the Spectacle* recognized the double subjugation of the individual, not just by everyday bureaucratic micro-surveillance, but—in some ways more fundamentally—by the routinely emollient and controlling permanence of the regime of representation. He called this 'the spectacle'. His text is heavily imprinted by Marx's (1844) writings on alienation. The young Marx, under the influence of Hegel and Feuerbach, said that capitalism fetishized commodities, and alienated people in three ways. Their conditions of work were outside their control. What they produced did not belong to them. Their connections to those they worked with were prescribed by others. In sum, they were disconnected from their 'natural' human condition. Debord updated this position to account for conditions in the second half of the twentieth century. He changed the focus from the production of goods to the reproduction of the capitalist social order. The prime locus of his analysis moved from the factory to the city (Leach 1999). He switched the source of revolution from the class struggle of the proletariat to the possibilities of general individual transcendence of everyday routines. He imagined a replacement of Marx's double emphasis on history and destiny, of the history of class struggle and its eventual resolution into an egalitarian regime of freedom and equality, by the understanding that social life consists only of situations in the present, and that these can be actively and creatively made, rather than passively and repetitively reproduced. Debord wanted, then, to liberate the individual from compliant spectatorship, and he believed that resistance to this 'society of the spectacle' had to take place in everyday life. As the debate within the Retort group suggests, the recognition that 'forms of recreation, patterns of speech, idioms of local solidarity' are subjected to 'the deadly solicitations (the lifeless bright sameness) of the market' (Retort 2005: 19) requires some form of strategic response.

Strategies of resistance were not obvious. The general regime of spectacle is powerful. The capitalist form had created the mass media, advertising and the emerging consumerism already positioned to equate happiness with material wealth. The rational

development of cities, exemplified in Haussman's nineteenth-century destruction of Parisian neighbourhoods to make way for the '*grands boulevards*', had continued with the alliance between urban planners and the marketing of the motor car (Debord 1955). Functionalism in architecture had developed as style. Overall, the passive reproduction of everyday life was being secured through an increasingly visual culture which created mass desires. For Debord, the need for resistance was obvious, but how?

One foundation of Situationist resistance methods was psychogeography. Debord (1955) defined this as 'the study of the precise laws and specific effects of the geographical environment, consciously organized or not, on the emotions and behaviour of individuals'. His understanding was indebted to Ivan Chtcheglov (1953), who had created the *dérive*—drifting—as disoriented urban engagement. Chtcheglov spoke of this as a method of overcoming stale and stereotyped assumptions about the character of different parts of the urban environment. Drifting was seen to be subversive. As if a motorway were built, yet the drivers chose not to use it, and cycled without dominant purpose through the villages, meeting with and reflecting on unfamiliar places and people.

> In a *dérive* one or more persons during a certain period drop their usual motives for movement and action, their relations, their work and leisure activities, and let themselves be drawn by the attractions of the terrain and the encounters they find there . . . the *dérive* includes both this letting go and its necessary contradiction: the domination of psychogeographical variations by the knowledge and calculation of their possibilities. (Debord 1958)

The other source of resistance was *détournement*: the making of unexpected connections. Debord's discussion (with Wolman) in 1956 is itself a *dérive*. Looking back, a more developed theory of resistance through *détournement* might have emerged in the next year, when a manifesto document (Debord 1957) appeared, and led to the founding of the Situationist International. What happened, however, was that the practice of *détournement* became focused on the arts, especially cinema, and then linked to the conceptual *dérive* that became the stock in trade of advertising. The following example from Debord reveals not only a projected example of *détournement*, but shows the potential significance of the technique within the 'society of the spectacle' which is subverted by means of its own techniques, and points to propaganda and counter-propaganda strategies (already well-understood by Goebbels and others):

> It is obviously in the realm of the cinema that *détournement* can attain its greatest effectiveness . . . we can observe that Griffith's *Birth of a Nation* is one of the most important films in the history of the cinema because of its wealth of innovations. On the other hand, it is a racist film . . . But its total prohibition could be seen as regrettable . . . It would be better to detourn it as a whole, without necessarily even altering the montage, by adding a soundtrack that made a powerful denunciation of the horrors of imperialist war and of the activities of the Ku Klux Klan. (Debord and Wolman 1956)

The Situationist International did not have an overall strategy within which the tactics of *dérive* and *détournement* would be purposefully employed. Their politics were gestural, and their hope was for spontaneous break-out from spectacle. From a distance it might seem as if the May events in 1968 Paris to some extent vindicate this resolute refusal of instrumental reason. From 1966 forwards there had been signs of student unrest, and when it did erupt in May 1968, slogans from Debord's work appeared on the streets: 'Down with spectacular-commodity society!' (Merrifield 2005: 68). However, far from presenting the spontaneous coalition between workers and students as a Situationist success story, Debord seemed more concerned with purifying the Situationist core, breaking from his longstanding friend Henri Lefebvre (whom he accused of plagiarism), and eventually moving to Italy, to purvey advice on the edges of the *Brigato Rosso*. His attempt to conceptualize spectacle as the negative core and target of a humanist-Marxist critique of society failed. Ironically, this failure is explained in part by his inability to present his vision in a spectacular way. It was something he could have taken from the Italian Futurists, but did not.

In his brief reflections on Debord's *Commentaries*—an underlying theme of which was the coming together of the two world systems in 1989—Giorgio Agamben (1990: 7) drew the lesson from the very exaggerated claims of massacre at Timisoara, in the final days of the Ceausescu regime in Romania:

> Timisoara, Romania, represents the extreme point . . . the secret police had conspired against itself in order to overthrow the old concentrated-spectacle regime while television showed . . . Auschwitz and the Reichstag fire together in one monstrous event . . . corpses that had just been buried or lined up on the morgue's tables were hastily exhumed and tortured in order to simulate . . . the genocide that legitimized the new regime. What the entire world was watching live on television, thinking it was the real truth, was in reality the absolute non-truth . . . In this way, truth and falsity became indistinguishable from each other and the spectacle legitimized itself.

The analysis from Debord, as Baudrillard (1994a) was also explaining it, was that the relation between spectacle and reality is an internal one. If that relation is to be dismantled, the entire system of which it is part must be transcended.

AURA AND SUBLIME

If we share neither the position of the Italian Futurists that spectacle is both instrument and aesthetic expression, nor the Situationist position that spectacle is systemically deceitful, how are we to understand it? We might begin by saying that spectacle as a fundamental phenomenon is compound: natural, human, technological. The Futurists were enthralled by technology, as their first manifesto salute to speed and war, and much of the work thereafter demonstrates. This enthusiasm permeated modernism, from Duchamp to Joyce (Henderson 2007). Unsurprisingly, the connection between modernism and spectacle has led towards the positive and negative recognition of the technological sublime

(Nye 1996). Furthermore, accelerating practices of environmental self-mutilation display a sense of the human corruptibility of the natural sublime of Schiller, Casper David Friedrich and other romantics. At the very heart of this is a dialectic of presence and absence which we can expose by considering the distinction between aura and sublime.

Walter Benjamin made his position crystal clear in 1936. Spectacle is simultaneous collective experience. It has been expanded through mechanical (and now digital) reproduction; and something has been lost from such seemingly egalitarian encounters, whether with art, landscape, artefact or particular people. Aura is lost. Aura required distance, difficulty of access, and the loyalty and exclusion practices of *cognoscenti*. For Benjamin, aura and mass society seemed to be incompatible:

> Technical reproduction . . . enables the original to meet the beholder halfway . . . in the form of a photograph or a phonograph record . . . The situations into which the product of mechanical reproduction can be brought may not touch the actual work of art, yet the quality of its presence is always depreciated. This holds not only for the art work, but also, for instance, for a landscape which passes in review before a spectator in a movie. (Benjamin (1936) 1973: 222–3)

Loss of authenticity is a consequence of mass-produced art calendars, museum marketing, television documentaries on architecture, Shakespeare films and Beethoven on CD. Multiple copies substitute for singular phenomena in special locations. Wide facsimile distribution eliminates aura though separation from context, history, performance and expert knowledge proudly but parsimoniously shared. For Benjamin, this process of dilution and erasure of aura arises from 'the desire of the contemporary masses to bring things "closer" . . . as offered by picture magazines and newsreels' (225). As theatrical performances are increasingly outnumbered by cinematic productions, the coherent involvement of the spectator and actor with role and performance in the auratic recreation of characters and theatre becomes far less defining of the modern era than the marketing of film stars, whose staged performances of themselves—compare the mimed performances of their own recordings by singers on television—elicit the entitled opinions of all and sundry. In the case of art, works formerly were set apart, and had 'cult' and ritual value. Now such work has become secular, made for use and circulation, available for the politics of propaganda and spectacle. Their form of value has changed from the ritually specific to the generally exhibited. Benjamin tells us that 'photography and film are the most serviceable functions of this new function' (227) and that the shrivelling of aura leads to the cult of personality. Thus begins the era of Warhol's invitation to all for a few minutes of fame, extending into the universal public appearance of daily lives on Facebook and through Twitter.

Miriam Hansen (2004, 2008) shows this account of aura to be partial. It is well understood that aura engages with distance: 'a strange weave of space and time: the unique appearance of a distance, however near it may be' (Benjamin 1999: 519). Hansen goes beyond this already complex view, to look at the other sources for Benjamin's thought, in three ways. First, she opens the possibility of intergenerational aura. Second, she

discusses aura as a form of perception which invests phenomena with 'the ability to look back at us' (Hansen 2008: 351). Third, she considers the theological and mystical roots of aura in ideas of individual halo and presence. Her discussion of old photographs expands the relation of aura and distance by adding temporality to spatiality. The photograph of a dead man already contains the line into the future, and this can sometimes be seen more clearly as time passes. Ludwig Klages, a key source for Hansen, thought that souls could return; and much of the culture through which Benjamin passed as a young man was suffused with archaic and Gnostic memories. Thus it was that, finding that Benjamin cited Novalis, in his dissertation of 1919, to the effect that inanimate objects can return the gaze upon them, Hansen wrote: 'The reflexivity of this mode of perception, its reciprocity across eons, seems to both hinge upon and bring to fleeting consciousness an archaic element in our present selves, a forgotten trace of our material bond with nonhuman nature' (2008: 346). However, Benjamin lived when connections to the past were being broken apart. He wrote just before the outbreak of the Second World War,

> The replacement of [] narration by information, of information by sensation, reflects the increasing atrophy of experience . . . It is not the object of the story to convey a happening *per se*, which is the purpose of information; rather it embeds it in the life of the storyteller in order to pass it on as experience. (161)

He lamented the changing times, and it seems likely that Hansen's recovery of a progressive logic from his thought, through which aura is placed under protective erasure through the 1936 essay—defined as attacking auratic simulation—leaving authentic aura ready to re-imagine collective experience at some point in the future, owes more to Benjamin's schooled instincts than to his refined cognition.

While it may be too early to come to a judgement on aura, this may not be true for the sublime. As a concept, the sublime has a clear modern history. From the seventeenth century, the term came to be used by Milton, Dryden and others to refer to things or people at the highest level. By the eighteenth century, 'the sublime' had come to refer to exalted things in art, nature and human affairs. In 1757 Edmund Burke published a treatise on the sublime, in which he sought to connect the core of the concept of the sublime to terror and amazement, but by the time of Kant, the link to terror—though still understandable—had weakened. What remained from Burke's formulation was, however, the link between the sublime and the *'strongest emotion which the mind is capable of feeling'* (Burke 1757: part 1, ch. 7) Kant (1790) further developed the idea in that part of his *Critique of Judgement*, which concerned aesthetics. Kant asked what are judgements of beauty, and how are they different from judgements of the sublime. He wrote that the former are disinterested: the judgement comes first, and then we may take pleasure in what we have judged to be beautiful. He thought that such judgements were universal, so that all would agree with them. He added that they were necessary. He concluded that beauty might be seen as motivated to display itself. Against the idea of beauty, Kant set that of the sublime. The sublime refers to overwhelming experience

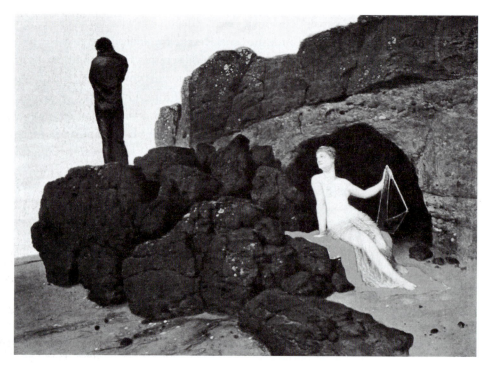

FIGURE 11.2 Arnold Böklin, *Odysseus and Calypso*, 1883, Wikimedia commons, GNU Free Documentation License (http://commons.wikimedia.org/wiki/File:Arnold_B%C%B6cklin_008.jpg)

like encountering a violent storm or confrontation with an extraordinarily huge building. The former, he referred to as 'dynamic'—relating to its immense force—the latter, he spoke of as mathematical, indicating that our response was a reaction to sheer scale. In both types, he noted that the encounter could be pleasurable.

Not long after, Friedrich Schiller set things out dramatically. He used the story of Calypso and Odysseus (pictured here in Figure 11.2 by Arnold Böcklin, 1883), and showed that while Odysseus could remain with Calypso for some time, there would come a point at which he was called back to engage with the world. Calypso's beauty could not triumph over the call of the world, and its varied component challenges. Schiller (1801: n.p.) concluded

> The sublime affords us an egress from the sensuous world in which the beautiful would gladly hold us forever captive. Not gradually (for there is no transition from dependence to freedom), but suddenly and with a shock it tears the independent spirit out of the net in which a refined sensuousness has entoiled it.

Schiller's story illustrates some of the elements in the feminist debates about the sublime. The main line, from Longinus to the present, is that recognition of the sublime is evidence of subjective achievement, of resistance and survival in the face of inexpressible forces. On the island, Odysseus was charmed by beauty and ease (as Christine Battersby (1998) compellingly and critically explains, female beauty and charm become increasing

self-defining from the Enlightenment forwards). Once returned to the mainland, he would show himself a man by holding firm against opposing forces. Barbara Claire Freeman (1997: 4) explained that the self is supposed to discover its own sublimity as it achieves emotional and intellectual mastery over the sublime through confrontation with it. In critiquing this formulation, she saw a subordination of difference which appropriated 'rather than identifying with that which presents itself as other . . . functioning not to explicate but to neutralize excess'. She goes on to argue that the foundation of this strategy of neutralization is an implicit engagement of the sublime in the mode of spectacle. Odysseus does not dive into the volcano, but masters his fear as he skirts its edge, always as an onlooker. The essence of the sublime (both in its direct experience, and then in its retelling) is that the line between spectator and spectacle is crossed, that the man (and it is almost always a man) is tested and triumphs. Thus she argues (1997: 8) that a deceitful (because the man flirts but does not fully engage) and 'dominant ideology of misogyny haunts canonical theories of the sublime', a position she sustains whether discussing the celebration of selfhood in Wordsworth's 'egotistical sublime' or its abjection in Keats and Coleridge.

The feminist critique of the sublime is not the only negative voice to be heard. In addition to the Heideggerian critique of technology, which can be easily turned towards a critique of the work of David Nye, whom we shall shortly discuss, the concept of the 'false sublime' deserves some attention. The term was coined in 1850 by the American poet and painter Washington Allston, who drew a distinction between the moral sublime and the false sublime. He spoke of horror and pity when faced with a victim of the Inquisition on the rack, and suggested that some might see this as an example of the sublime, as confrontation with something awe-ful. But he refused the idea that the sublime be separated from the moral order entirely, writing that 'Sympathy alone is insufficient as a cause of sublimity', and refusing the solely horrific and frightful as belonging to the sublime:

> If we ascend . . . into the moral, we shall find its influence diminish in the same ratio with our upward progress . . . Elegance . . . Majesty . . . Grandeur; in the next, it seems almost to vanish, and a new form rises before us, so mysterious, so undefined and elusive to the senses, that we turn, as if for its more distinct image, within ourselves, and there, with wonder, amazement, awe, we see it filling, distending, stretching every faculty, till, like the Giant of Otranto, it seems almost to burst the imagination: under this strange confluence of opposite emotions, this terrible pleasure, we call the awful form Sublimity. (Allston 1850: n.p.)

As we turn to the material development of the world in North America, a new era was coming: the time of the railroad. Between 1828 and 1869, Americans 'integrated the railroad into the national economy and enfolded it within the sublime' (Nye 1996: 45). The nineteenth century development of technology in the United States produced machines and structures that strengthened the sense of national belonging among the working, middle and upper classes. In 1828, to celebrate the agreement to build a railroad between Maryland and Ohio, thousands of people paraded in celebration of a

development which had barely started. They did so in a way that affirmed their membership of American society, by showcasing their occupations. David Nye documents this general relation between technology and national hope. When the two approaching ends of the transcontinental rail tracks met in 1869, a golden spike was driven into the ground to mark the occasion. Every blow of the hammer was telegraphed across the United States, sparking 'a celebration of the technological sublime from coast to coast' (74). Yet, only eighteen years later most of the rail system of the United States had been stilled by striking workers, and the technological sublime had become instantiated by the building of bridges, followed by the erection of skyscrapers. In the years between the building of the Niagara Suspension Bridge in 1855, and the erection of the Empire State Building, completed in 1931, the dominant form of the technological sublime became architectural. Each major architectural achievement during this time became a moment for celebrating the essential relation between nationhood and technology.

It is, however, part of the technological sublime that its condition is transient, since there will come a larger building or a greater machine, and even a new modality. The replacement of architecture by military technology may even signal the end of sublimity. The nuclear bomb was created in secret, and even if it was tested in public for a short time—in front of large crowds in Nevada—it could not create the sublime reflex once its legacy of death and radiation was understood. It replaced Burke's sublime formula of terror and awe with the much more forbidding connection between death and disease, as the movement towards the safe use of nuclear energy faltered from the 1970s through to the present day.

What this exploration of the technological sublime against the shimmering of aura reveals is a part of the power of spectacle. If aura means the preservation of enchantment but always at a distance, and the sublime demands surrender to what is newly arrived or has been an overwhelming presence for as long as any can remember, both forms of affect will be at play, for those in the forefront and those watching safely in their homes. It may be true that a remote screen cannot convey what it is truly like to be at a Cape Canaveral launch, or in the midst of an earthquake. It can, however, create the desire to be there—or the relief at being safe.

CINEMATIC SPECTACLE

The first demonstration of the impact of cinematic spectacle might have occurred when some of the audience in 1896 found themselves moving out of the way as the Lumières' cinematic train pulled into Marseille station. The train was moving on-screen, of course, but the audience had not experienced such moving pictures before, and may have been uncertain how to behave. Tom Gunning argued that cinema took some time to develop story-telling, and was first of all engaged in showing things. He developed the idea that early cinema was, what he called, 'a cinema of attractions'. The narrative instinct was not long in coming, but Gunning thought that the cinematic function of revelation was always available:

[despite] the introduction of editing and more complex narratives, the aesthetic of at-
tractions can still be sensed in periodic doses of non-narrative spectacle given to audi-
ences . . . The cinema of attractions persists in later cinema, even if it rarely dominates
the form of a feature film as a whole. It provides an underground current flowing be-
neath narrative logic. (1989: 38)

Over time, film audiences and critics developed their skills and understanding, sur-
viving and adapting to sound, colour, and then screen size. The history of filmic screen
technology has not, however, been consistently linear. Cinemascope was criticized when
first developed, as unsuitable for serious drama (Barr 1963: 5). It took nearly a decade
to become fully accepted, by which time an even bigger format (70mm) had arrived.
Subsequent developments have taken place culminating in IMAX films, and new-
generation 3-D films from 2009. Such movement has been seen as following a line
begun with the mediaeval and early modern cathedrals (Griffiths 2006): locations which
were developed to capture the soul.

Geoff King relates his 2005 collection, which contrasts Hollywood spectacle with
reality TV, to the destruction of the World Trade Centre. It is an irresistible move, but
we should go back a little, to note a series of films from 1977 through to 1999: *Star
Wars*, *Close Encounters of the Third Kind*, *Alien*, *Raiders of the Lost Ark*, *E.T.*, *Termina-
tor 2: Judgment Day*, *The Matrix*. These seven Hollywood productions are at the core
of the 'blockbuster' phenomenon (Bordwell 2006: 1–12), which concerns the total
marketing of cinematic spectacle; now co-ordinated worldwide: to reduce the impact
of piracy. It is more than coincidence that all of these films can be placed within the
genre of fantasy—widely defined. They illustrate Debord's thesis that spectacle is a
fabulous and irresistible creation. As he put it in paragraph 153 of *The Society of the
Spectacle*:

the social image of the consumption of time is exclusively dominated by leisure . . .
moments portrayed, like all spectacular commodities, *at a distance* and as desirable
by definition. These commodified moments are explicitly presented as moments of
real life whose cyclical return we are supposed to look forward to. But all that is really
happening is that the spectacle is displaying and reproducing itself at a higher level of
intensity.

This passage from Guy Debord could almost have been paraphrased into Robert
Kolker's statement in 2000:

The ideological structures of Spielberg's films 'hail' the spectator into a world of the
obvious that affirms the viewer's presence (even while dissolving it), affirms that what
the viewer has always believed or hoped is (obviously) right and accessible, and as-
sures the viewer excitement and comfort in the process. The films offer nothing new
beyond their spectacle, nothing the viewer does not already want, does not immedi-
ately accept. (257)

As we now return to consider 9/11, the inauguration of terror spectacle (as Douglas Kellner has intimated), we must ask if terrorism has come to be defined by the principal aim of rolling back globalization, yet through the use of its science, technology and communication networks. This may be ironic, but it is not contradictory. Paul Virilio (1994) linked cinema, security and surveillance in the 1990s, and then after 9/11 began to work on the idea of the accident as a general category for man-made disasters, and called for a museum of such events to alert the world's populations of what might be to come:

> it is the whole of history that comes out of cinematic acceleration, out of this movement in cinema and television . . . this constant pile-up of dramatic scenes from everyday life on the evening news . . . catastrophes of all kinds—not to mention wars . . . Where the broadcasting of horror is concerned, television has . . . provided us with an instantaneous transmission of cataclysms and incidents that have broadly anticipated disaster movies. (2003: 63–4)

The exhibition which Virilio mounted at the Cartier Foundation in Paris (November 2002—March 2003) was not generally acclaimed. The negative reviews criticized it for opposite reasons. On the one hand, Hyland (2003) drew attention to the way that an intimate focus on those directly affected by an 'accident' will lead away from the critical questions of actual responsibility; on the other hand, Nechvatal (2002) asserted that the approach 'failed by submitting to an abstract aesthetic of the Romantic Sublime'. Even though Virilio's approach is epochal, and his critique of the alliance between technology, speed and spectacle makes him resist stopping the chain of causation too early, his exhibition was seen to draw a general lesson that had already been learned.

To illustrate the impossibility of totally certain protection, however, is another matter. It takes us to the idea of societies of control (Deleuze 1992), and to the connection between screens as spectacular media and as surveillance media. Looking again to the legacy of 9/11, Rebecca Adelman has noted that, beyond the technology of airport screening, ID systems and high-visibility policing:

> The US, in its current anti-terror campaign, has charted a divergent relation to the visual, a tactically flexible subversive relation to the spectacle . . . First among [their strategies] is the proliferation of surveillance . . . faith that sufficient panopticism will prevent terrorism . . . like surveillance, secrecy balances sight and the unseen in a calculation aimed at preventing future spectacular defeats . . . The creation of the category of 'enemy combatants' and the use of infinite detention . . . are not glamorous, but they are crucial . . . zero visibility . . . as a rejoinder to the spectacle. (Adelman 2009: 152–3)

It is a further irony, that while spectacle is a major weapon of terror, a key modality of response will be silence.

TOWARDS THE INTERACTIVE SPECTACLE: TRENDS IN PUBLIC ART AND ARCHITECTURE

Traditional large-scale architecture is still important. It has been defined by its use, its image and its history. From classical antiquity through the early European cathedrals, then later castles and palaces, and on to factory development and skyscraper office space, built for leasing, function has always been prime. The purpose of permanent structures usually outlives the impact created by the first viewings, even if that might not be the case for a work such as Richard Serra's *Tilted Arc*, erected in 1981 and destroyed in 1989 (Serra 1990). Aesthetic and public impact, however, are generally valued in themselves, and sometimes can enhance functionality. Thus, for example, the Viaduc de Millau (see Figure 11.3) has become not only a source of pride for the inhabitants of the Southern Aveyron in France, that pride was also a prerequisite for the level of local energies achieved in the area's initiative to maximize the regional economic impact of the bridge.

The planning of a bridge over the immediate Millau conurbation, which would keep the traffic at the level of *les grands causses*, limestone bluffs which characterize the area, was begun in the 1990s. It took quite some time for the political and economic actors in the Southern Aveyron to work out that they needed to actively respond to this item on the national agenda. Perhaps a little late, but nevertheless, an innovative research project, extending over 2003–2006, was funded by both the state and the regional prefecture. Researchers and students (from the Ecole Normale for rural society in Clermont-Ferrand), local actors, and national actors worked together in an action research and development project for one year. The core principles of the research development project illustrate that this wonderful bridge became an interactive spectacle: as it was being built it was surrounded by a continual public-private

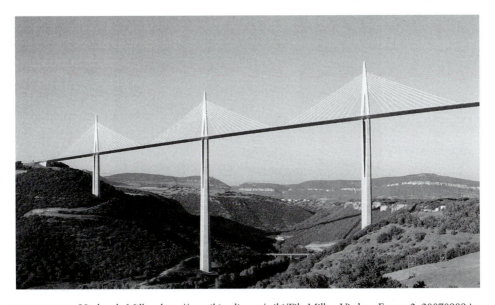

FIGURE 11.3 Viaduc de Millau. http://en.wikipedia.org/wiki/File:Millau-Viaduct-France-2–20070909.jpg.

dialogue, based on principles of permeable frontiers across all interests, primacy of network creation, recognition of ineluctable spatial transformation, and essential cross-territorial synergies (Lardon et al. 2007). A second, different but perhaps clearer, example of an interactive spectacle is that of D-Tower in the Dutch city of Doetinchem (see Figure 11.4). It was completed in 2005, and records happiness, love, fear and hate daily using different questions, answered every other day by a substantial group of e-respondents. The 12 metre tower changes colour to illustrate where in the city there is the most love (pink), happiness (blue), fear (yellow) and hate (green).

The 2,400 people who occupied the fourth Trafalgar Square plinth for an hour each over 100 days in the summer of 2009—under Antony Gormley's caretakership—might also be seen as interaction between event and context. Was this art? Antony Gormley passed on the question, indicating it was for others to categorize what he brought into being. Did the plinth fall into the development of public art which has marked the last twenty years? As a public art creator himself, it would have been hard for him to say that this work was not in some way related to the remainder of his oeuvre. He was not, however, asked this question. The critics nevertheless answered it. Jonathan

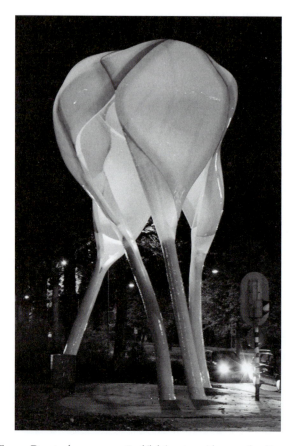

FIGURE 11.4 D-Tower, Doetinchem. www.v2.nl/lab/projects/d-tower/leadImage_preview.

Jones (2009) (not a member of the Anthony Gormley fan club) said that the work was designed to be an exercise in failed communication, with the plinth's occupants 'trying desperately to communicate against obstacles imposed by Gormley'. Adrian Searle (2009), in the same newspaper, three months earlier, placed the scheme in the tradition of living sculpture which goes back one hundred years, and thought it might be Anthony Gormley's best work. On balance one might argue that it was another moment in the possible dissolution of spectacle. As contrasted with *The Angel of the North* (undemocratic, spectacular and soon loved), the implied request to 2,400 people, individually, to hold our attention for one hour, and to make, even if only in one case, the front page of the newspaper, or the first item on the TV news—against the constraints of the context—was resoundingly rejected. The liberal democratization of performance art is anti-spectacle.

A final example of interactive spectacle is worth considering. The BMW car plant in Leipzig, with its central building designed by Zaha Hadid, opened in 2005. It is presented as a site of production, of architecture and of education: as spectacle within the modern global economy. It is a place where tours are not merely possible, but where they are part of the design of the plant, which is—in May 2010—fully booked for group tours (under the title of 'Architektur trifft Produktion' or 'Architecture Meets Production') every day of the week for the next three months and beyond. It is factory as spectacle, both internally and externally.

What can we conclude about the interactive spectacle? Perhaps not that it is a new form, but the best newer developments are adapting to multifunctional realities as creatively as they can, without losing sight of their main purpose(s), and extending those purposes where possible. We are perhaps entering a new age of multifunctionality, with spectacle being one of those functions.

CONCLUSION

Spectacular public art has been on display at Tate Modern for ten years now. The Turbine Hall is the site of an annual commission from Unilever, beginning with the giant egg-carrying spider, titled *Maman*, by Louise Bourgeois. In 2003, Olafur Eliasson installed *The Weather Project*, a huge sun at the end of the Hall. Four years later Doris Salcedo made a crack in the floor of the Hall. In 2009, Miroslav Balka was commissioned to build his huge steel box there. None of these examples of public art remain in the Hall, but each new commission, for as long as Unilever can stand this, will speak to its predecessors in different ways. Wonder and warnings come together variously. Just as they emanated also from Richard Serra's five megalithic structures beneath the glazed roof of the Grand Palais in Paris (see Figure 11.5), following Anselm Kiefer's *Falling Stars* in 2007. The Grand Palais and Serra's structures worked together in a way that would not have happened in the darker space of the Turbine Hall, inclining the viewer to conclude that space and spectacle interact, affecting the experience, the memory and the impact, perhaps as much as the event or structure in itself.

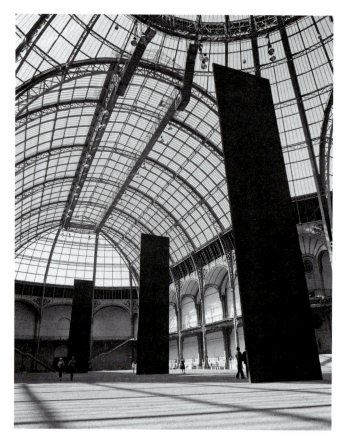

FIGURE 11.5 Richard Serra, *Monumenta* 2008, Grand Palais, Paris. © ARS, NY and DACS, London 2010

As for the intended functions of spectacle—whether aesthetic, historic, economic, ideological, celebratory or some combination—each planned event or structure will see the prior questions posed: why are we doing this? How are we doing this? With whom are we doing this? Then as soon as the work is finished in creating the spectacle, questions of its impact (Boyne 2006), its prior justifications, and its part in fashioning the future, cannot be avoided, even though they may be answered fully only—if ever—after many years. There is more public curiosity now about what such work does than was the case when Adorno wrote, 'it is self-evident that nothing concerning art is self-evident any more, not its inner life, not its relation to the world, not even its right to exist' (Adorno 1997: 1).

FURTHER READING

Debord, Guy. 1995. *The Society of the Spectacle*. New York: Zone. http://www.cddc.vt.edu/sionline/.

Hall, S. and S. Neale. 2010. *Epics, Spectacles, and Blockbusters: A Hollywood History*. Detroit: Wayne State University Press.

Mau, B. and D. Rockwell. 2006. *Spectacle: An Optimist's Handbook*. London: Phaidon Press.

Shaw, P. 2006. *The Sublime*. London: Routledge.

Vidler, A., ed. 2008. *Architecture between Spectacle and Use*. New Haven, CT: Yale University Press.

See also Adamson (2007), Benjamin ((1936) 1973, (1939) 1973), Nye (1996), Perloff (2003), Retort (2005), Schnapp and Tiews (2006).

REFERENCES

Adamson, Walter L. 2007. *Embattled Avant-Gardes: Modernism's Resistance to Commodity Culture in Europe*. Berkeley: University of California Press.

Adelman, Rebecca. 2009. 'Reconfiguring the Spectacle: State Flexibility in Response to Imaged Terror', in Marianne Vardalos et al. (eds), *Engaging Terror: A Critical and Interdisciplinary Approach*. Boca Raton, FL: Brown Walker Press, 149–58.

Adorno, T. 1997. *Aesthetic Theory*. Minneapolis: University of Minnesota Press.

Agamben, G. 1990. 'Marginal Notes on Comments on The Society of the Spectacle'. http://zinelibrary.info/files/.

Allston, Washington. 1850. *Lectures on Art*. http://www.gutenberg.org/ebooks/11391.

Apollonio, U. 2009. *Futurist Manifestos*. Boston: MFA Publications.

Arnoldi, J. and C. Borch. 2007. 'Market Crowds between Imitation and Control', *Theory Culture and Society*, 24/7-8: 164–80.

Barr, C. 1963. 'CinemaScope: Before and After', *Film Quarterly*, 16/4 (Summer): 4–24.

Battersby, C. 1998. 'Stages on Kant's Way: Aesthetics, Morality and the Gendered Sublime', in Naomi Zack, Laurie Shrage and Crispin Sartwell (eds), *Race, Class, Gender, and Sexuality: The Big Questions*. Oxford: Blackwell, 227–44.

Baudrillard, J. 1994a. *Illusion of the End*. Stanford, CA: Stanford University Press.

Baudrillard, J. 1994b. *Simulacra and Simulation*. Ann Arbor: University of Michigan Press.

Benjamin, W. (1936) 1973. 'The Work of Art in the Age of Mechanical Reproduction', in *Illuminations*. Glasgow: Collins.

Benjamin, W. (1939) 1973. 'On Some Motifs in Baudelaire', in *Illuminations*. Glasgow: Collins.

Benjamin, Walter. 1999. *The Arcades Project*, trans. H. Eiland, ed. R. Tiedemann. Cambridge, MA: Harvard University Press.

Bernard, Émilien. (Lémi). 2009. 'De l'exclusion en avant-garde: Breton vs Debord, le combat des papes', *Article XI*, lundi 12 octobre 2009. http://www.article11.info.

Borch, C. 2007. 'Crowds and Economic Life: Bringing an Old Figure Back In', *Economy and Society*, 36/4: 549–73.

Bordwell, D. 2006. *The Way Hollywood Tells It*. Berkeley: University of California Press.

Boyne, R. 2006. 'Methodology and Ideology in the Evaluation of Cultural Investments', in Christiane Eisenberg, Rita Gerlach and Christian Handke (eds), *Cultural Industries: The British Experience in International Perspective*. Berlin: Humboldt University. http://edoc.hu-berlin.de).

Boyne, R. 2007. 'Cinema and Multitude', *Symbolism: A Journal of Critical Aesthetics*, 7: Symbolism and Cinema: 61–98.

Burke, E. 1757. *A Philosophical Inquiry into the Origin of Our Ideas of the Sublime and Beautiful*. http://www.bartleby.com/24/2/.

Buur, l. 2009. 'The Horror of the Mob: The Violence of Imagination in South Africa', *Critique of Anthropology*, 29/1: 27–46.

Chtcheglov, Ivan. 1953. 'Formulary for a New Urbanism'. www.bopsecrets.org/SI/Chtcheglov. htm.

Debord, G. 1955. 'Introduction to a Critique of Urban Geography'. http://library.nothingness. org/articles/SI/en/display/2.

Debord, G. 1957. 'Report on the Construction of Situations and on the International Situationist Tendency's Conditions of Organization and Action'. www.bopsecrets.org/SI/report.htm.

Debord, G. 1958. 'Theory of the *dérive*'. http://library.nothingness.org/articles/all/all/ display/314.

Debord, G. 1973. *The Society of the Spectacle*, Film Soundtrack (audio transcription into English by Roy Boyne, on the basis of Ken Knabb's prior translation). www.bopsecrets.org/SI/ debord.films/spectacle.htm.

Debord, G. and G. J. Wolman. 1956. 'A User's Guide to *Détournement*'. www.bopsecrets.org/ SI/detourn.htm.

Deleuze, G. 1992. 'Postscript on the Societies of Control', *October*, 59 (Winter): 3–7.

Doob, L. W. 1950. 'Goebbels Principles of Propaganda', *Public Opinion Quarterly*, 14/3: 419–42.

Fogu, Claudio. 2008. 'Futurist *mediterraneità* between *Emporium* and *Imperium*', *Modernism/ Modernity*, 15/1: 25–43.

Foucault, M. 1976. *Surveillir et punir*. Paris: Gallimard.

Freeman, Barbara Claire. 1997. *The Feminine Sublime: Gender and Excess in Women's Fiction*. Berkeley: University of California Press.

Ghirardo, D. 1996. 'Citta *fascista*: Surveillance and Spectacle', *Journal of Contemporary History* (April): 347–72.

Griffiths, A. 2006. "Time Travelling IMAX Style: Tales from the Giant Screen," in Jeffrey Ruoff (ed.), *Virtual Voyage: Cinema and Travel*. Durham, NC: Duke University Press.

Gunning, Tom. 1989. 'An Aesthetic of Astonishment: Early Film and the (In)Credulous Spectator', *Art and Text*, No. 34 (Spring): 31–45.

Hansen, M. B. 2004. "Room-for-Play': Benjamin's Gamble with Cinema', *October*, 109 (Summer): 3–45.

Hansen, M. B. 2008. 'Benjamin's Aura', *Critical Inquiry*, 34/2 (Winter): 336–75.

Henderson, L. M. 2007. 'Modernism and Science', in Astradur Eysteinsson and Vivian Liskapp (eds), *Modernism* (vol. 1 of 2): Volume XXI of *The Comparative History of Literatures in European Languages*, 383–404.

Hyland, M. 2003. 'Say Fear Is a Man's Best Friend', *Mute*, July 8. http://www.metamute.org/en/ subject/theory_philosophy/chaos.

Jones, J. 2009. 'The Fourth Plinth: It Was Just *Big Brother* All Over Again', *The Guardian*, October 9. http://www.guardian.co.uk/artanddesign/2009/oct/09/fourth-plinth-gormley-trafalgar-square, accessed June 30, 2011.

Kant, E. 1790. *Critique of Judgement*. http://philosophy.eserver.org/kant/critique-of-judgment.txt.

King, G., ed. 2005. *The Spectacle of the Real: From Hollywood to Reality TV and Beyond*. Bristol: Intellect Press.

Kohn, Margaret. 2008. 'Homo Spectator: Public Space in the Age of the Spectacle', *Philosophy and Social Criticism*, 34/5: 467–86.

Kolker, R. 2000. *A Cinema of Loneliness*, 3rd edn. Oxford: Oxford University Press.

Kozinets, Robert V., Andrea Hemetsberger and Hope Jensen Schau. 2008. 'The Wisdom of Consumer Crowds: Collective Innovation in the Age of Networked Marketing', *Journal of Macromarketing*, 28/4: 339–54.

Lardon, Sylvie, Patrick Mocquay and Yves Poss. 2007. *Développement territorial et diagnostic prospectif: réflexions autour du viaduc de Millau*. La Tour d'Aigues: Editions de l'aube.

Leach, N. 1999. *The Anaesthetics of Architecture*. Cambridge, MA: MIT Press.

Marx, K. 1844. *The Economic and Philosophical Manuscripts*. Various editions.

Melograni, P. 1976. 'The Cult of the Duce in Mussolini's Italy', *Journal of Contemporary History*, 11/4: 221–37.

Merrifield, A. 2005. *Guy Debord*. London: Reaktion Books.

Nechvatal, Joseph. 2002. 'Review of Paul Virilio's "Ce qui arrive"/"Unknown Quantity"', *Film-Philosophy*, 6/47 (November): http://www.guardian.co.uk/artanddesign/2009/oct/09/fourth-plinth-gormley-trafalgar-square, accessed June 30, 2011.

Newman, Joshua. 2007. 'A Detour through "Nascar Nation": Ethnographic Articulations of a Neoliberal Sporting Spectacle', *International Review for the Sociology of Sport*, 42: 289–308.

Nye, D. 1996. *American Technological Sublime*. Cambridge, MA: MIT Press.

Perloff, M. 2003. *The Futurist Moment: Avant-Garde, Avant Guerre, and the Language of Rupture*, 2nd edn. Chicago: University of Chicago Press.

Poggi, C. 2002. 'Folla/Follia: Futurism and the Crowd', *Critical Inquiry*, 28 (Spring): 709–48.

Retort (I. Boal, T. J. Clark, J. Matthews and M. Watts). 2005. *Afflicted Powers: Capital and Spectacle in a New Age of War*. London: Verso.

Schiller, F. 1801. *On the Sublime*. http://www.studiocleo.com/librarie/schiller/essay.html.

Schnapp, J. T. and M. Tiews. 2006. *Crowds*. Stanford, CA: Stanford University Press.

Searle, A. 2009. 'Antony Gormley's Fourth Plinth Is His Best Artwork Yet', *The Guardian*, July 6. http://www.guardian.co.uk/artanddesign/2009/jul/06/antony-gormley-living-sculpture, accessed June 30, 2011.

Serra, Richard. 1990. 'Introduction' to Clara Weyergraf-Serra and Martha Buskirk (eds), *The Destruction of Tilted Arc: Documents*. Cambridge, MA: MIT Press, 3–17.

Virilio, P. 1994. *The Vision Machine*. Bloomington: Indiana University Press.

Virilio, P. 2003. 'The Museum of Accidents', in *Unknown Quantity*. New York: Thames and Hudson, 58–65.

Art, Feminism and Visual Culture

LISA CARTWRIGHT

As art historian Amelia Jones notes, feminism is one of the most important theoretical perspectives from which visual culture has been theorized over the past forty years (Jones 2010). The field of visual culture studies centres on the analysis of practices of looking and visual representation in a wide range of arenas: art, film, television and architecture; new, popular and alternative media forms and entertainment cultures; and everyday institutional contexts such as law, religion, science, medicine, information and education. Feminism has influenced this expansion of the field from its former and more conventional focus on works of art and film in a number of ways: through its critique of discourses of mastery and universal value; through its emphasis on embodied experience; and through its attention to subjugated and situated forms of knowledge, experience and pleasure as legitimate and important areas of focus. The field of visual studies continues to encompass the study of fine art, however there is not the assumption of its higher merit. Professional, institutional, everyday, popular, private, banal, diasporic and subculture image and design cultures and visual practices are approached with equal seriousness across the field, in keeping with the feminist viewpoint that regards situated and subjugated forms of human practice as equally important to the canon of scholarly analysis as highly valued, broadly recognized forms of imaging and visual practice. Work in the field ranges widely across forms of visual or audiovisual expression and everyday ways of seeing. The objects of visual culture study range from works of fine art to popular, sub-, and independent image cultures and to images and imaging technologies in science, technology, medicine and health. Importantly, visual studies has been innovative in emphasizing the study of practice in institutions and with technologies through which visual culture is organized and looking is practiced, covering settings that range from art galleries, museums and malls to laboratories, kitchens and the streets. Feminism's contribution to this turn to diverse sites of visuality and visual practice has been

considerable, beginning with the feminist theory concept of the gaze as an important feature of the constitution of the human subject in its discursive context. The terms 'practice' (which emphasizes embodied social activity) and the 'human subject', understood as a socially situated and constituted entity, derive directly from feminist theory. These are among the core concepts in visual studies work as distinct from art history and some areas of cultural analysis in which practice, the constitution of subjectivity, and the gaze are not primary organizing features. The study of collecting, curating and displaying has extended from its earlier focus on works of art and objects of ritual and science to everyday objects and the instruments and technologies used in the organization of things and the organization of spaces of practice in everyday work, study and leisure. Ways of seeing or practices of looking as they are organized around subject positions based in identity and realms of discourse has been a key aspect of work in the field. In some cases the key organizing terms of work in visual studies draw from the familiar intersectional nexus of gender, sexuality, race, class and ability; however, to these terms have also been added subcultures and other intersectional identity groupings, as well as professional and institutional categories of identities such as that of the scientist or doctor. Associated with the latter sort of designation of identity is the idea that discursive fields constitute provisional and intersectional subject positions inflected by ways of seeing and ways of conducting one's practice that are deeply situated in history, geography, nationality, political context and so forth.

The relationship of feminism to visual culture's field formation is important to note. Visual culture studies became institutionalized through college and university programmes in the late 1980s and 1990s during the height of critical theory and continental philosophy's influence in the humanities, and its influence was felt primarily through and across departments of fine art, art history and film studies. However, the focus on aspects of life beyond the arts and entertainment brought visual studies into currency in other disciplines, most notably anthropology, history and sociology. A scholarly journal (*The Journal of Visual Culture*) was launched in 2002, and an international association (Visual Culture International) was formally inaugurated in 2010. These two entities are marked by their interdisciplinarity and by lively controversy about such field-building questions as these: what is, and what should be, the place of art history (one of the foundational fields of visual culture study) and work on periods prior to the twentieth century in visual studies? This question is motivated by the fact that the field has tended to be concentrated around more recent periods and forms, though this is also increasingly the trend in art history, where attention to more recent periods outstrips work on earlier periods. Globalization, diaspoic cultural changes, and new media in relationship to art practice, collecting and display are all aspects of visual studies that have been influenced by feminist theory's emphases on intersectionality and subjective practice. Another key field question concerns methods and theories around which the field coheres, and where feminism continues to stand in this context. These are questions that arise as the field's international network grows, and as scholarship identified as visual studies or visual culture studies proliferated throughout the humanities in the 1990s and made headway in the social sciences in the 2000s. There has been significantly more work identified

as being in visual studies coming from the fields of communication, anthropology and sociology journals and departments during the first decade of the 2000s as compared to the 1990s.

Feminism has been an important approach in visual studies from the inception of the field, providing key methodological frameworks to the field in all of its aspects ranging from methodology to subject matter. Unlike other new disciplines emphasizing visuality in the late 1900s such as film and media studies and cultural studies, visual culture studies emerged after second-wave feminist theory had already established a presence in more established academic disciplines such as art and art history, literature and history, and after the turn to Marxism, psychoanalysis and semiotics were brought together in feminist theory work within the women's studies field, bringing into question the empirical designation of its key term ('women') and prompting some departments to change the key term to 'sexuality' and/or 'gender', terms that allowed for the inclusion of masculinity and femininity as fluid terms of identification not fixed subject positions, and incorporating queer studies into the field. In this regard the relationship of feminist theory to visual culture studies is unique in that feminism—specifically, feminist theory through the psychoanalytic, Marxist and semiotic turn of the early 1980s—has had a formative influence on visual studies from the ground up. Whereas film studies, cultural studies, ethnic studies, black studies and women's studies programmes emerged as disciplines at about the same time (from the 1970s forwards), visual culture studies emerged as a discipline designated by a name and programmes devoted to it about a decade after the institutionalization of these prior fields, and was significantly shaped by methods, theories and ideas about disciplinarity already at work in them—and particularly in feminist theory engaged in a semiotic theory of sexual psychology and identity. Interestingly, though science and technology studies emerged as a disciplinary area during roughly the same period as film studies and has consistently generated work on representation in scientific practice, that field has remained relatively less open to the paradigms and approaches that moved from film studies to visual studies, deriving instead more directly from social science–based information studies and, less strongly, through engagement with art history (though this engagement has more commonly been comparative rather than methodological).

FEMINIST FILM THEORY AND PRACTICE

Two works out of the British context are now legendary foundations for a kind of feminist visual theory that countered the empiricism of the American liberal feminist approach: Claire Johnston's 1973 essay drawing on Roland Barthes's idea of myth to examine, through an approach adapted from semiology, the concept of woman in classical Hollywood cinema; and 'Visual Pleasure and Narrative Cinema' (1975) in which Laura Mulvey introduced psychoanalysis as a means through which to analyse male pleasure in looking and the representation of the female body as the passive object of the male look. Whereas Johnston's essay introduced the framework of semiotics to feminist analysis of film, Mulvey introduced key concepts from Freudian psychoanalysis to consider the

relationship between sexuality and the gaze as a relational practice—an idea that remains in use currently, though with significant revisions and variations. At the same time, 1970s second-wave feminist scholarship in the USA included widely read, now iconic critiques of gendered stereotype focusing on film (Haskell (1973) 1987; Rosen 1973). The empirical and sociological approach represented in those works was the backdrop against which emerged the US feminist theory that would contribute to the grounding of visual studies. In the early 1980s, US scholars Constance Penley, Janet Walker, Elizabeth Lyons and Janet Bergstrom launched *Camera Obscura*, a journal of film and feminism to present an alternative to the empirical and sociologically based US feminist film scholarship that was beginning to organize around the critique of stereotype and gender roles. They had studied with or participated in dialogues with those engaged in the circles around Johnston and Mulvey's works, some of them had trained in the semiotic, psychoanalytic and Marxist approaches developed in Paris through the seminars of film theorists Christian Metz and Raymond Bellour, and they were engaged with ideas generated in the writings of the London-based *m/f* collective (a journal devoted to psychoanalytic feminist theory with which film theorist E. Anne Kaplan was involved) and *Screen* (a film theory journal with which Mulvey was involved). An important aspect of the visual studies paradigm launched with *Camera Obscura* is the role of the feminist visual theorist as curator of ideas and theories—a role occupied by this journal throughout the three decades of the field's existence. Journal founder Contance Penley has played a major role in shaping the field not only through her own writing on feminism and film theory, science, popular culture and new media, but also through her curator-like role as editor of contributions to a journal that has remained at the centre of the visual culture studies field. Penley also was a founding member of the first graduate programme in the United States devoted to the field: the Program in Visual and Cultural Studies at the University of Rochester.

Another important aspect of film theory in its relationship to visual studies is the innovation there of the idea of the filmmaker as theorist. In her classic essay, which is widely reviewed in numerous sources, Mulvey, who is a filmmaker as well as a theorist, introduced the idea of a feminist counter-cinema and, importantly, she herself was in fact a key practitioner in that mode. She identified feminist counter-cinema as being within the tradition of the avant-garde—a cinema that would 'free the look of the camera in its materiality in time and space' as well as offering the spectator a Brechtian stance of 'passionate detachment' as against the seductive masculine position of scopophilia offered in conventional mainstream narrative film. Feminist counter-cinema, which included the filmwork of Mulvey and her then collaborator Peter Wollen, presented an important model for the tradition in visual studies of production (or art, film and media) as a form of critical theory practice. Mulvey's article made important contributions to the theory of the gaze as noted below, however, it also served as a kind of visual theory call to practice, suggesting formally new ways to work the field aside from the tradition of critical writing and speaking. It is important to note that although Mulvey's essay is typically noted as her foundational work in the field, in fact it was a theory that accompanied a vital film practice through which many of her ideas were articulated. 'Visual Pleasure'

was bracketed by the release of her films *Penthesilea: Queen of the Amazons* (produced with Wollen in 1974) and *Riddles of the Sphinx* (also produced with Wollen, 1977). Both represent a kind of theory through practice, a way of working that would become key in art and film practice from the 1980s onwards due in part to Mulvey's founding influence on a generation of would-be scholars to become visual producers of critical theory works of art and film.

FEMINISM AND THE THEORY OF THE GAZE

The working concept of ideology in visual culture studies initially drew on the writings of the political philosopher Louis Althusser, whose understanding of ideology derived from Lacanian psychoanalysis the idea that ideology cannot adequately be understood as false consciousness or as existing within a moral framework of right and wrong beliefs and good and bad representations or practices. Feminist writing in film studies of the 1970s offered models of critique that followed older paradigms including the pre-Althusserian Marxist understanding of ideology, the practice of deriding negative stereotypes, and the Frankfort School critique of mass culture. Althusserian notions of the subject and ideology were taken up widely by feminist theorists of visual culture in the late 1970s and early 1980s interested in addressing the place of sexuality not simply as it is reflected in the contents of works of art and cinema (in projects arguing for 'positive' and against 'negative' representations of women, as in the works of 1973 by Rosen and Haskell, for example), but as structuring principles that shape a work of art or film, or that shape the reception of works in context and over time. Sexual difference is understood to be enacted or articulated through these works at the formal level and in their reception context, rather than simply standing as ideology-generative themes or representations in the work. In the projects that centred around the journal *m/f* in Britain, for example discussions shifted away from critique of images of women (or their absence in representations) to developing theories about desire and looking in the discursive field of the gaze. The artist Mary Kelly was very much engaged in this dialogue when she produced her groundbreaking serial process artwork titled *Post-Partum Document* between 1973 and 1979 (Kelly 1999). Entering the familiar 'female' subject matter of the mother-child relationship so familiar through the work of earlier women artists such as Berthe Morisot and Mary Cassatt, this subject matter was a radical challenge to conceptual art which during the period was still engaged in a pointed evacuation of content and culture in favour of form and structure. The subject matter provided Kelly with a framework through which to stage questions raised in the feminist collective's working through of concepts of female subjectivity and agency in Freudian and Lacanian writing. Rather than documenting the process of separation and development in her child, Kelly used the piece to stage key questions about intersubjectivity, the work of the mother, and the nature of marking (with framed dirty diapers as an interesting textual contribution to the then sterile field of conceptual art and to the then current range of familiar marking implements). Coming out of the same collective context regarding the field of the gaze, *Sexuality in the Field of Vision* (1986)

is a theory book by Jacqueline Rose, the noted British feminist theorist of literature and visual culture, who was also among this British network of feminists engaged in close reading of psychoanalytic theory of sexuality. Rose developed a theory of visuality and the gaze as concepts that pertain not just to visual images and media texts, but also to relationships of looking in the subject's negotiation of the world. In the early 1980s the French writer Michel de Certeau wrote about the quotidian practices of looking in everyday life (de Certeau 1984), however, his account never directly and analytically engaged the dynamics of seeing or the role of the visual in constructing the world encountered by the subject. Rose simultaneously delved into visuality and the psychic life of the subject engaged in a networks of looks and looking practices, drawing on the psychoanalytic concept that the gaze is a constitutive aspect of human subjectivity, that sexual difference is a structuring aspect of the subject's emergence into the social order, and developing a theory of psychic interiority relative to the external world of looking—all aspects of looking practices missing from the account of everyday life offered by de Certeau at about the same time. Rose developed a concept of the gaze not as the looking practice of an individual, but as relational field in which subjects perform and interact with others and with objects, whether we are aware or not of our place within the dynamic. Drawing on Lacan, she described the field of vision as one that is always structured around and through desire and sexual difference. Understanding the ways in which desire and sexuality are not simply reflected in the content of images or appearances, but also structure looking practices as a nexus of power, agency and the human subject's psychic life has been a fundamental aspect of visual culture studies since the beginning of the field, and the model of power in looking is well theorized in Rose and other foundational texts from this period.

THE CULTURAL TURN AND FEMINIST ART HISTORY

In art history, visual culture studies emerged as a discipline most directly in conjunction with changes that art historians described variously as a 'cultural turn' (Dikovitskaya 2005) and a 'new art history' (Harris 2001). The 'cultural turn' refers to a shift among art historians towards an examination of the place of art in its broader national, institutional, political, economic or material cultures. This approach drew from feminist methodology for models of thinking about culture in an interdisciplinary analytic framework. An important early contribution was the 1971 essay by the feminist art historian Linda Nochlin ironically titled 'Why have there been no great women artists?' Nochlin's title was ironic in that it repeated and reframed a question then being asked by art historians newly concerned with the status of women in the fine arts following the influence of second-wave feminists. Throughout the history of art, the studio system through which artists train had been largely a domain of men. Even in cases in which women were able to receive training, work by women was rarely exhibited and sold by major galleries. Dramatically under-represented in museum exhibitions and collections, art by women was largely ignored, dismissed as minor or derivative, or embraced in a patronizing manner by art critics and historians.

Nochlin wrote that to resuscitate the handful of under-considered female artists, as some art historians had begun to do, was a worthy task, however, this project tacitly reinforced a problem inherent in the very way in which the question was framed. The problem is that the question failed to address the issue of the social conditions required for what counted as 'greatness'. Instead of resuscitating and elevating women artists to the status of their male counterparts, she proposed that we analyse and critique the social and institutional conditions that made possible the production of what counts as 'great art'. Nochlin noted that this approach has been dismissed for being too much in the domain of sociology and not art history. But it was exactly this kind of interdisciplinary, sociological approach to art history that she called for. Deriding the sort of art history that casts artistic greatness as a matter of genius, as 'miraculous, nondetermined, [and] asocial', she argued in favour of an art history that is 'dispassionate, impersonal, sociological, and institutionally oriented'; that takes into account the 'total range of [art's] social and institutional structures'. Her challenge to the core of art history was bold and direct: She aimed to 'reveal the entire romantic, elitist, individual-glorifying, and monograph-producing substructure upon which the profession of art history is based' (Nochlin 1971).

Nochlin's essay was published during the early years of second-wave feminism, a time when Marxist feminist analyses of labour and the economy were widely embraced by scholars in a range of fields. Even art historians who were not inclined to work within the Marxist critique of the economy took up this approach, because it posed an alternative to the romantic view of individual artistic genius. The lack of 'great women artists' was understood as a structural absence or absenting of women in art training, social networks and institutions. This was a set of conditions no simple 'opening of the institutional doors' could change. Rather, what counted as art—its forms, its concerns, its media—needed to change.

The idea that women constituted a structural absence from the field opened the door to a range of approaches that allowed scholars to develop a more nuanced understanding of the paradox that whereas women were under-represented in art practice, they were over-represented as objects depicted in art by men. Writing shortly after Nochlin, the art historian Griselda Pollock considered among other things the social circumstances through which female artists such as Mary Cassatt and Berthe Morisot painted and drew the sorts of scenes representing female subjects in the home, as against their male counterparts who painted the landscapes and architecture of the public sphere. What distinguished the work of Pollock from art historians engaged in the reclamation of great women artists from the past was her sustained use of psychoanalytically informed Marxist feminist theories and her direct engagement with feminist film theories of the male and female gaze. Rather than valourizing the women artists she wrote about for working with distinction in a male-dominated field, and rather than arguing solely in favour of celebrating the overlooked importance of a female point of view reflected in these artists' works, Pollock drew on the Marxist-feminist-deconstructionist theory of the Indian literary critic Gayatri Chakravorty Spivak to ask her now-classic question,

'can the subaltern [woman] speak?' in order to address the sexual, racial and colonial structures of modernity in which these female artists practiced (Spivak 1988; Pollock 1997). She interpreted their work as being engaged in a critical dialogue with that milieu, expressed through the compositional forms of drawing and painting rather than strictly in representational iconography or literal meanings. Her analysis of the formal and esthetic aspects of the work suggested that we should consider elements such as framing and composition and the relationships of the male and female gaze both represented, implied and invited in spectators as structural expressions and interventions in a discursive cultural sphere articulated at the level of the image. The concept of the gaze at play in Pollock's essay was very much tied to developments of the concept to feminist film theory, as discussed below.

Janet Wolff's *Feminine Sentences: Essays on Women and Culture* (1990) was another major contribution to feminist visual culture studies. She introduced an approach that offered sociological methods as means to addressing the gendering of culture as a structuring principle rather than as an added feature to the interpretation of art. Wolff trained in sociology at the Centre for Contemporary Cultural Studies at Birmingham, one of the key programmes in the foundation of cultural studies, with Stuart Hall (the programme was started in 1964). She combined British cultural studies and visual studies in the early 1990s when she joined the faculty in art and art history at the University of Rochester, where she helped to found one of the first graduate programmes in the field. After her groundbreaking *The Social Production of Art* was published, she consistently addressed issues of gender as well as class and culture in considering art from a sociological standpoint informed by British cultural studies methods, along the lines called for by Nochlin in her classic essay described above.

Semiotics must be mentioned as an important component of feminist theory informing visual studies, and it cannot rightly be folded into a discussion of the cultural turn. Michael Ann Holly, Keith Moxey and Norman Bryson (1991) and Bryson and Mieke Bal (1991), writing in the USA, brought semiotic theory from literary theory to art history, opening up approaches to the work of art as a text open to semiotic interpretation. Rather than reading the work of art in linguistic terms they adapted semiotics to the study of the visual image, specifically painting in its historical context. Among this group, Mieke Bal brought the technique of close analytic to the study of the visual image in a manner informed by a feminist psychoanalytic view. The introduction of semiotics as a core component of visual studies, however, was also from film studies, dating back to the feminists who trained with Metz and the foundational essay of Johnston discussed above. Whereas in art history semiotics was adapted to the analysis of the static text and the nature of the gaze figured in it and in relation to it, in film studies semiotics was adapted to the analysis of serial frames, sequences and shots. The analysis of meaning in narrative became an important aspect filtering into visual studies through the generation of film scholars trained through the *Screen* theory tradition and *Camera Obscura*, where works of narrative cinema tended to be featured more frequently than works of experimental or nonnarrative cinema.

THE GAZE IN ART HISTORY AND FILM STUDIES

Nochlin introduced the concept of a 'feminine gaze' as a counterpoint to the concept of a dominant 'male gaze' that organized the esthetic and formal aspects of the field. The concept of the gaze was under discussion among feminists engaged in psychoanalytic theory in Britain, France and the United States during this period. It would become a cornerstone of both feminist film and art theory following from Nochlin's essay and an influential essay given as a paper at about the same time by the British filmmaker Laura Mulvey (1975). Mulvey introduced her highly influential critique of visual pleasure and narrative cinema in 1975, discussing not only the content of classical film representations of women, but also formal elements such as framing, shot duration and camera position. She showed how formal elements organized the way spectators look, setting up a sexual dynamic of the gaze in which looking is associated with the active, masculine position and being looked at (being the object of the gaze) is the feminine position, typically occupied by women. This formulation: women as object of the look, men as the subjects who look, has since held a central place in the field of visual culture studies, though often as a source that is critiqued (including by Mulvey herself), adapted and appropriated. The binary formula of the male spectator as an active figure who controls the look and the female body as the object of the look has been subject to extensive discussion. Theorists of the1980s and 1990s introduced the provisos that we can also speak of a female gaze (Doane 1987; Stacey 1987, 1994); that masculinity and femininity are fluid social and psychical positions which are not always attached to one's biological status as either male or female and are complex and subject to oscillation, making any singular identity position relatively untenable (Sedgwick 1990; Rodowick 1991); that the female position should be understood as one that can be maintained across all points of identification (de Lauretis 1984, 1987); that we must account for masculine, gay and lesbian subject positions among spectators and performers (Silverman 1992; White 1999); and that we must account for race and ethnicity as well as sexuality in discussing the female spectator (hooks 1992; Bobo 1995). Central to all of this work was the film journal *Camera Obscura*, which was the first English-language periodical devoted to feminist visual culture theory. Starting as a film journal, *Camera Obscura* evolved into a journal of media and culture. The book *How Do I Look? Queer Film and Video* (1991), edited by the Bad Object-Choices reading group, was an important collection of works introducing key issues in queer visual studies, including sociologist Cindy Patton's proposal of pornography as part of safe-sex vernacular in the first decade of the AIDS epidemic, Kobena Mercer on racial difference and the homoerotic imaginary, and Judith Mayne on female authorship in film, focusing on the US director Dorothy Arzner.

How Do I Look? originated in a conference in 1989 focused upon the study of pornography, until then an under-considered area of popular and subcultural visual media. In the same year, Linda Williams published the classic *Hard Core: Power, Pleasure and the Frenzy of the Visible* (1989). The book was a milestone in visual culture studies not only for applying the psychoanalytic, semiotic approach to the film genre

of pornography, but also because it challenged some of the tenets of feminist critique by refusing to take a negative critical stance on a genre and a sector of the film industry that was heavily under fire from anti-pornography feminists for its depictions of women as passive objects of the gaze. The book grew out of an early moment in feminist politics, the so-called feminist sex wars famously associated with a 1983 Barnard conference at which feminists against pornography were faced with the critique from sex-positive feminists across the straight, lesbian, trans and S&M communities who argued that the feminist position against porn foreclosed on women's pleasure in images of women and desire in relation to fantasy, and ruled out consideration of women as workers in the sex industry, confining feminists to a position of moral conservatism and mistakenly equating representation with violence. The launching of *On Our Backs* (1984–1994), the first women-run sex tabloid for a lesbian audience, was a direct response to the perceived prudery of the anti-porn stance embodied in the feminist newspaper *Off Our Backs* (1970–2008), which generally avoided discussion of sexuality to focus on politics and other aspects of lesbian feminist culture. Although the feminist sex wars were not a chapter in visual culture studies per se, they informed the field's scholarship by playing out a public debate about representations of women and the place of lesbian desire in that issue in a way that profoundly influenced feminist scholarship in the field. The sex wars also launched decades of work studying pornography with colleagues and students, generating studies of women in the industry and gay and lesbian subcultures—topics that upended the characterization of the field as solely exploitative and demeaning. This aspect of visual studies has been a critical area through which the field has gravitated away from the model of critique towards other modes of analytic practice.

ART PRACTICE AND FEMINISM

During the period that feminist film theory was emerging as a major aspect of intellectual work, a number of feminist photographers produced work that engaged with some similar ideas about visual culture and sexuality. Cindy Sherman's black-and-white photographic series 'Untitled Film Stills' (1977–1980) famously articulated a critical theory of the gaze through photographic form. In her self-portraits of the 1980s Sherman dressed and posed in settings evoking classical mid-century cinema to make ironic commentary about a period of visual culture known for its relegation of women to the position of object of the look. Sherman posed in clothing and sets reminiscent of and modeled on stills from films of the classical Hollywood cinema of the 1940s and 1950s, evoking scenes of female beauty and domesticity with subtle and ironic twists. Viewers could hardly fail to note the critique in these send-ups of the classical Hollywood cinema. Her work was never heavy-handed and condemning but rather came off as a wry critical embrace, allowing for a kind of double-edged appreciation of the culture of the 'male' gaze while making the viewer uncomfortably aware of the power dynamic behind the role of the woman who held and returned the look from the image or screen. Whereas old photographs of mid-century movie

stars appropriated and reused can make us appreciate the same ironies, the fact that Sherman herself appropriated, authored and also performed these roles in such stilted, highly mannered compositions lent a sharp, funny and smart edge to the critique. Photographer Catherine Opie's large and colourful 1991 portraits of butch dykes were given a title that explicitly drew on Lacan's notion of the phallus in relationship to power: 'Being and Having'. Opie's butch subjects use dress, pose and composition to perform types in a tongue-in-cheek and campy manner, confronting the camera face-on. Barbara Kruger, a commercial artist, used her graphic techniques and type-face to construct collage and print pieces commenting explicitly on ironies of sexuality and power, drawing on formats and themes of mass media concern and making ironic text statements in juxtaposition to the familiar iconography of magazine and newspapers advertisements. These are just a few of the artists of the period 1977 through the 1990s who were widely cited by visual studies scholars, and who also engaged in art practice as theory.

The concern raised in the 1970s by Nochlin about the exclusion of women artists from the canon continues to be brought to our attention through the work of the Guerrilla Girls, a feminist performance group of anonymous women who since 1985 have taken the name of dead artists (Frida Kahlo and Kathe Kollwitz, for example; see Guerrilla Girls 1998) to appear in public wearing masks and making interventions at museum and gallery functions. Their interventions draw attention to sexism in the arts, mostly through humor. Do women have to be naked to get into the Met museum?, one of their posters asks—and in their interventions at museums in person they have posed the same sorts of questions. Less than 5 per cent of the artists in the modern art section are women, the poster notes—but 85 per cent of the nudes are female. Although the Guerrilla Girls do not work in the theoretically dense frameworks of visual theory, they do engage in the sociological tradition of emphasizing that art is always in social context. In this they are very much within the field of visual culture, as well as in the tradition of institutional critique, an area of art practice in which artists' work in installation and performance foregrounds questions about the institutional politics and policies of museums, galleries, collecting and display. This performative tradition of critical theory was engaged in early on by Coco Fusco and Guillermo Gomez-Peña (1995), whose 'Couple in the Cage' performance of 1997 was a hilarious and biting send-up of the colonial gaze and romantic notions of natives expounded in museums of man and art. The artists dressed as a 'native' couple housed in a cage for museum display, a living diaroma of racialized display and a reference back to the tradition of human displays in museums of man and in circus and freak shows. That their preposterous performance as members of a lost tribe was received at face value by museum and gallery visitors in 1997 was a frightening reflection on the place of critical thinking in the public sphere. Fusco was and remains an important contributor to visual culture studies as a figure who has consistently worked as a curator, a writer, and a performance artist in her practice. With Jennifer Gonzalez, Fusco is among a small but growing group of visual culture studies scholars working on questions of racial difference and postcolonialism in feminist visual culture.

FEMINIST CRITICAL ART PRACTICE AND VISUAL CULTURE IN THE 2000S

The photographer Kimiko Yoshida, like Opie and Sherman, uses portraiture as a means of making critical political commentary about visual culture in a manner that is informed by visual culture theory. In a series that spanned seven years during the 2000s, Yoshida transformed herself into the brides of the world, making ironic commentary about globalization and the culture of femininity. Graduate programmes in visual culture studies such as the one at the University of Rochester have tended to promote the strategy of combining practice and theory, resulting in the ability of practitioners to have careers such as that of Tina Takemoto, the San Francisco–based performance artist who works on questions of embodiment and illness and who also writes criticism and theory of visual culture, racial identity, the body and illness. Combined practice-theory has had a much stronger presence in visual culture studies since 2000, and work such as Takemoto's that spans feminist, queer theory, critical race theory and disability studies across writing and performance is increasingly visible in the field.

NEW MEDIA, FEMINISM AND VISUAL CULTURE

New media studies has been a key area for the expansion of work in feminist visual culture studies. One of the key scholars in this area is Anne Friedberg, one of the founders of an early graduate programme in visual studies (at the University of California at Irvine) and a film studies scholar whose work on the cinematic gaze in the context of window shopping (1993) was one of the most influential books on the postmodern in visual culture studies. Her 2006 book *The Virtual Window: From Alberti to Microsoft* synthesized thinking about visual culture in a world in which screens have proliferated, from the drawing devices of the Renaissance to the present-day world of computer, cell phone and GPS screens. In her book *Digitizing Race*, Lisa Nakahara (2007) extends ideas about visual culture into the domain of new media, taking into account the ways in which the Internet is structured through notions of racial difference even as it is touted for bridging racial boundaries. Rather than condemning or bemoaning this fact, Nakamura uses visual culture studies methods to analyse and uncover the mechanisms through which racial identity is forged in the virtual space of the Web.

EMBODIMENT

Because the emphasis in visual studies remains with the human subject understood as a complex materially situated being, questions of embodiment and phenomenology of experience have been important theoretical and methodological threads in the field, with a turn to emphasis in the 2000s on intersubjective experience (a topic raised explicitly by Mary Kelly in her Post-Partum document but not widely investigated until recently) rather than the subject in the singular. Vivian Sobchack has made major contributions to theories of embodiment in film and new media visual culture with her *Address of the*

Eye (1991) and her contribution to the study of embodiment and moving image culture, the book *Carnal Thoughts* (2004). The latter book brings to the fore the role of embodied experience in sense-making as a neglected concern in the previous decades of visual theory, during which work on knowledge and visuality tended to be centred in the concepts of mind and thought without adequate attention to the body and embodied experience. Recent work in feminist affect studies has moved in this direction, following Eve Kosofsky Sedgwick and Adam Frank's introduction to the writings of Silvan Tomkins (Sedgwick and Frank 1995) and Sedgwick's book *Touching Feeling* (2004), in which Sedgwick writes about how people embody linguistic and nonlinguistic concepts through the concept of performativity. Though not a central figure in visual studies, Sedgwick has nonetheless been an important influence there in shaping fundamental approaches and theories of the relationship of the body to linguistic practice in the fields of practice and the gaze conceived as a multisensory space.

ART, TECHNOLOGY AND VISUAL CULTURE

Feminist science and technology studies has offered some important new work in visual culture studies. At about the same time that art historians took the cultural turn, science and technology studies scholars were raising questions about women's standpoint and issues of race and cultural identity in science and technology studies. Donna Haraway, in her classic *Cyborg Manifesto*, offered an 'ironic dream of a common language for women in the integrated circuit'—a configuration of a network that emphasized a kind of crossing of media forms as well as borders between identities and fields (Haraway 1991). Anthropologist Rosalind Petchesky, using a different set of methods, proposed that we consider the sonogram and fetal imaging in terms of power and politics of the visual (Petchesky 1987). Her method is very much in keeping with the Althusserian turn towards seeing culture and medicine as integral to the workings of the political economy. Scholars trained in an interdisciplinary framework across film and media studies and science and technology studies took up these concerns about scientific and medical imaging to produce critical accounts of representation that addressed sexuality and gender (see for example van Dijck 1995, 2005; Cartwright 1995). An early collection reflecting this convergence of science and technology studies with visual studies through feminism can be found in the collection edited by Lisa Cartwright, Constance Penley and Paula A. Treichler (1998). A number of women artists working in the paradigms and practices of the scientific laboratory have taken up questions of visual culture from within this context. Notable among these artists are Kathy High, the New York–based media artist who since the 1980s has produced video and new media work raising critical questions at the intersection of science, sexuality and visual culture; Beatriz da Costa, the southern California–based bioartist who works directly in tissue culture; and Natalie Jeremijenko, the New York–based performance artist who has included engineering technologies of vision and surveillance to track toxic chemicals and to re-engineer the environmental landscapes of the everyday.

OVERVIEWS OF THE VISUAL CULTURE FIELD THAT EMPHASIZE FEMINISM AND ART

Useful overviews of visual culture studies include Mirzoeff (1999, 2000); Dikovitskaya (2005); and Sturken and Cartwright (2008). Mirzoeff, Sturken and Cartwright all give significant attention to feminist contributions to the field. Useful overviews of feminism and visual culture are Jones (2010) and Carson and Pajaczkowska (2001). Carson and Pajaczkowska frame the subject through the categories of fine art, design and mass media. Jones, who is an art historian, traces theoretical and historical aspects of feminism and visual culture study across a diverse range of fields and topics that closely map the fields and topics that informed the history of the field, with articles representing most of the key foundational work of feminist visual studies. Fields covered include art history, art practice, and science and technology studies. The volume includes work by activists and artists as well as scholars, highlighting questions of race, class, nationality and sexuality, and includes a very useful introduction that traces the development of the field. Jones's book is a key text for anyone wishing to understand feminism's place in the foundation of visual culture studies.

FURTHER READING

Fusco, Coco and Brian Wallis. 2003. *Only Skin Deep: Changing Visions of the American Self.* New York: Harry N. Abrams.

Guerrilla Girls. 1998. *The Guerrilla Girls' Bedside Companion to the History of Art.* New York: Penguin.

Jones, Amelia. 2010. *Feminism and Visual Culture Reader*, 2nd edn. London: Routledge.

Nakahara, Lisa. 2007. *Digitizing Race: Visual Cultures of the Internet.* Minneapolis: University of Minnesota Press.

Sturken, Marita and Lisa Cartwright. 2008. *Practices of Looking: An Introduction to Visual Culture*, 2nd edn. Oxford: Oxford University Press.

REFERENCES

Bal, Mieke and Norman Bryson. 1991. 'Semiotics and Art History', *The Art Bulletin*, 73/2 (June): 174–208.

Bobo, Jacqueline. 1995. *Black Women as Cultural Readers.* New York: Columbia University Press.

Bryson, Norman, Michael Ann Holly and Keith Moxey. 1991. *Visual Theory: Painting and Interpretation.* New York: HarperCollins.

Carson, Fiona and Claire Pajaczkowska. 2001. *Feminist Visual Culture.* London: Routledge.

Cartwright, Lisa. 1995. *Screening the Body: Tracing Medicine's Visual Culture.* Minneapolis: University of Minnesota Press.

Cartwright, Lisa, Paula A. Treichler and Constance Penley. 1998. *The Visible Woman: Imaging Technologies, Gender, and Science.* New York: New York University Press.

De Certeau, Michel. 1984. *The Practice of Everyday Life.* Berkeley: University of California Press.

De Lauretis, Teresa. 1984. *Alice Doesn't. Feminism. Semiotics. Cinema*. Bloomington: Indiana University Press.

De Lauretis, Teresa. 1987. *Technologies of Gender: Essays on Theory, Film, and Fiction*. Bloomington: Indiana University Press.

De Lauretis, Teresa. 1991. 'Film and the Visible', in Bad Object-Choices (eds), *How Do I Look? Queer Film and Video*. Seattle: Bay Press, 223–64.

Dikovitskaya, Margaret. 2005. *Visual Culture: The Study of the Visual after the Cultural Turn*. Cambridge, MA: MIT Press.

Doane, Mary Ann. 1987. *The Desire to Desire: The Woman's Film of the 1940s*. Bloomington: Indiana University Press.

Friedberg, Anne. 1993. *Window Shopping: Cinema and the Postmodern*. Berkeley: University of California Press.

Friedberg, Anne. 2006. *The Virtual Window: From Alberti to Microsoft*. Cambridge, MA: MIT Press.

Fusco, Coco and Guillermo Gomez-Peña. 1995. *English Is Broken Here: Notes on Cultural Fusion in the Americas*. New York: New Press.

Guerrilla Girls. 1998. *The Guerrilla Girls' Bedside Companion to the History of Art*. New York: Penguin.

Haraway, Donna. 1991. 'A Cyborg Manifesto: Science, Technology, and Socialist-Feminism in the Late Twentieth Century', in *Simians, Cyborgs and Women: The Reinvention of Nature*. New York: Routledge, 49–181.

Harris, Jonathan. 2001. *The New Art History: A Critical Introduction*. New York: Routledge.

Haskell, Molly. (1973) 1987. *From Reverence to Rape: The Treatment of Women in the Movies*, rev. ed. Chicago and London: University of Chicago Press.

hooks, bell. 1992. *Black Looks: Race and Representation*. Boston: South End Press.

Johnston, Claire. 1991. 'Women's Cinema as Counter-Cinema', Notes on Women's Cinema (1973), Glasgow: *Screen* Reprint: 24–31.

Jones, Amelia. 2010. *Feminism and Visual Culture Reader*, 2nd edn. Routledge.

Kelly, Mary. 1999. *Post-Partum Document*. Berkeley: University of California Press.

Mirzoeff, Nicholas. 1999. *An Introduction to Visual Culture*. London: Routledge.

Mirzoeff, Nicholas, ed. 2002. *The Visual Culture Reader*, 2nd edn. London: Routledge.

Mulvey, Laura. 1975. 'Visual Pleasure and Narrative Cinema', *Screen* 16/3: 6–18. Reprinted in *Visual and Other Pleasures*. London: Macmillan, 1989, 14–26.

Nakahara, Lisa. 2007. *Digitizing Race: Visual Cultures of the Internet*. Minneapolis: University of Minnesota Press.

Nochlin, Linda. 1971. 'Why Have There Been No Great Women Artists?', *Art News*, 69. Reprinted in Linda Nochlin, *Women, Art and Power and Other Essays*. Boulder, CO: Westview Press, 1988. Quotes are from this volume, pp. 147–58.

Petchesky, Rosalind Pollack. 1987. 'Fetal Images: The Power of Visual Culture in the Politics of Reproduction', *Feminist Studies*, 13/2: 263–92.

Pollock, Griselda. 1997. *Differencing the Canon: Feminism and the Writing of Art's Histories*. London: Routledge.

Rodowick, David N. 1991. *The Difficulty of Difference: Psychoanalysis, Sexual Difference, and Film Theory*. London: Routledge.

Rose, Jacqueline. 1986. *Sexuality in the Field of Vision*. London: Verso.

Rosen, M. 1973. *Popcorn Venus: Women, Movies and the American Dream*. New York: Avon.

Sedgwick, Eve Kosofsky. 1990. 'Introduction: Axiomatic', in *Epistemology of the Closet*. Berkeley: University of California Press, 1–65.

Sedgwick, Eve Kosofsky. 2004. *Touching Feeling: Affect, Pedagogy, Performativity*. Durham, NC: Duke University Press.

Sedgwick, Eve Kosofsky, and Adam Frank, eds. 1995. *Shame and Its Sisters*. Durham, NC: Duke University Press.

Silverman, Kaja. 1992. *Male Subjectivity at the Margins*. New York and London: Routledge.

Sobchack, Vivian. 1991. *The Address of the Eye: A Phenomenology of Film Experience*. Princeton, NJ: Princeton University Press.

Sobchack, Vivian. 2004. *Carnal Thoughts: Embodiment and Moving Image Culture*. Berkeley: University of California Press.

Spivak, Gayatri. 1988. 'Can the Subaltern Speak?', in Lawrence Grossberg, Cary Nelson and Paula Treichler (eds), *Marxism and the Interpretation of Culture*. New York and London: Routledge, 271–313.

Stacey, Jackie. 1987. 'Desperately Seeking Difference', *Screen*, 28/1: 48–61.

Stacey, Jackie. 1994. *Star Gazing: Hollywood Cinema and Female Spectatorship*. London: Routledge.

Sturken, Marita and Lisa Cartwright. 2008. *Practices of Looking: An Introduction to Visual Culture*, 2nd edn. Oxford: Oxford University Press.

Van Dijck, Jose. 1995. *ImagEnation: Popular Images of Genetics*. New York: New York University Press.

Van Dijck, Jose. 2005. *The Transparent Body: A Cultural Analysis of Medical Imaging*. Seattle: University of Washington Press.

White, Patricia. 1999. *Uninvited: Classical Cinema and Hollywood Representability*. Bloomington: Indiana University Press.

Williams, Linda. 1989. *Hard Core: Pleasure and the Frenzy of the Visible*. Berkeley: University of California Press.

Wolff, Janet. 1990. *Feminine Sentences: Essays on Women and Culture*. Berkeley: University of California Press.

Visual Consciousness: The Impact of New Media on Literate Culture

NANCY ROTH

The shape and scope of visual culture crucially depends on how 'visual' is related to another kind or level of culture, often inexplicitly understood to be linguistic or literary. In the most familiar understandings of this relationship, 'visual' is a mode of perception distinguished from 'acoustic', so that the edge between them appears between speech (acoustic) and written text (visual). The meanings of images are then enmeshed with, discussable through, or, as Flusser might propose, overpowered by written language. Barthes's celebrated discussion of the Panzani advertisement shot through with verbal associations in 'The Rhetoric of the Image' (Barthes 1977), Benjamin's well-known observation about a caption effectively anchoring the meaning of a photograph (Benjamin 1991), Foucault's scopic regimes, set forth in detail in written texts (Foucault 1999), are among the most familiar examples.

Vilém Flusser (1920–1991) may in fact be unique in his grasp of the 'visual', first, as a form of consciousness rather than a mode of perception, and second, as profoundly antagonistic towards writing—or more exactly towards the form of consciousness writing sustains. Marshall McLuhan (1911–1980), like Flusser, projected the possibility of writing becoming obsolete, and began to think about some of the implications: 'Historic man may turn out to have been literate man. An episode.' (McLuhan 1997: 127). There are striking similarities in the way both define their objects of study, and despite McLuhan's reputation as an exuberant technophile, he and Flusser shared a sense of profound loss at the prospect of writing's demise. Yet the differences are crucial. In the present context, they help to appreciate Flusser's unique grasp of new media as actually mediating a new universe, of 'technical images' as the form this mediation takes, of writing as a cognitively acoustic rather than a visual medium, and of contemporary culture as increasingly rewarding and developing pictorial—as opposed to linear or, as he prefers to call it, historical consciousness.

Because only a small fraction of Flusser's writing is currently available in English, and very little of that is specifically concerned with the rise of a new visual culture, I would like to introduce some elements of his perspective here. Whether his specific predictions prove to be accurate or not, his view of our current cultural situation as a struggle between literate and visual consciousness is productively unsettling, promising to stimulate genuinely new questions, models and insights into the communicative context we share.

The following chapter begins with 'Image to Text—and Back Again', a brief account of technical images, underscoring their intractable opposition to writing. *Bodenlos*—a German word meaning 'without grounding' or 'rootless' and the main title of Flusser's autobiography (Flusser 1992)—then sets Flusser's sense of a new visual consciousness in the context of his own biography. The next section, 'Gestures', takes a closer look at Flusser's largely phenomenological approach to media, focussing on his own experience of the antagonism between text and image as the basis for his contention that new media are visual. 'Apparatus' then considers some implications of visual automation. The final section, 'Art', moves into the hopes and fears Flusser expressed as a witness to the rise of the new visual consciousness, along with some notes about the challenges he has left to us.

IMAGE TO TEXT—AND BACK AGAIN

The Moving Finger writes; and having writ
Moves on. Nor all your piety nor wit
Can lure it back to cancel half a line,
Nor all your tears wash out a word of it.

—Omar Kayyám (trans. Edward FitzGerald)

In a series of books first published in German in the mid-1980s, Flusser outlined a history of media in which images and linear writing are in constant conflict (2000, 2011a, 2011b). The narrative is shaped by two key events. The first is the invention of writing in roughly the third millennium BC, transforming societies that had until then relied on human memory and images (oral transmission) as their primary means of storing and transmitting information, ancient Greece in the time of Socrates and Plato being the prime example. The second is the invention of photography. Flusser credits the invention of writing to a slow-burning intolerance of the sort of 'woolly', circular, unproductive thinking supported and recorded through images and speech. His favoured image is Moses descending the mountain to confront the worshippers of an image—the Golden Calf—with the Law, a serious, respectable, clear, and above all *written* document, constructed in lines that go in one direction, towards a goal.

Over centuries, through ancient inscription and medieval scriptoria to Gutenberg's moveable type, the thoughts and deeds of historical, linear consciousness were

preserved, debated and distributed in writing. This form of consciousness came to dominate magical, image-based thinking, and to support, as Flusser claimed, 'everything we value in the Western inheritance (2011b: 53). But writing did not obliterate the force of images: 'Only in the eighteenth century, after a three-thousand year struggle, did texts succeed in pushing images, with their magic and myth, into such corners as museums and the unconscious' (2011b: 147). A restless, literate, linear consciousness that always moves forwards, pictured as a Moving Finger in the famous quatrain cited above, makes harsh, ultimately unsustainable demands on those who read and write—Flusser says bluntly that historical consciousness has shown itself to be 'murderous and mad' (2011b: 35). The poem crystallizes the pain and regret of at least two highly literate consciousnesses—that of both writer and translator, with such grace and economy as to resonate with many generations of readers. For as written texts branched and proliferated, they became so complex as to often be incomprehensible, and as the consciousness they support penetrated further and further into minds, bodies, molecules and galaxies, the demands—to keep moving, to push further—became unbearable. Flusser proposes, that is that photography was invented at the point of—and because of—writing's failure to convey enough information comprehensibly, quickly enough to serve the needs of human beings who were beginning to glimpse the limits of linear, literate thought. The early-nineteenth-century consciousness that was 'burning with desire' to photograph (Batchen 1997: 52) was one that had, in Flusser's framework, become dissatisfied with writing—or better, with the universe as it appears to linear, historical consciousness. This makes photography—the first automated image—at once a descendant of writing, indebted to innumerable texts in the fields of physics, chemistry and representation, and a force for overturning writing's dominance of the way we think, see, hope and fear.

Contemporary photography, having subsequently evolved into a vast array of what he calls 'technical images', or 'sounding surfaces' (terms embracing photography and the related media of film, video and digital image synthesis), appears just this side of a historical watershed. If the term 'pre-historic' quite literally means 'before writing', photography is, Flusser claimed, 'the first post-historic medium' (2002: 129). People who rely primarily on technical images to communicate with one another no longer think in terms of cause and effect, of events moving in one direction towards a goal or conclusion, of historical sequences or grammatically ordered sentences. 'Photographs are dams placed in the way of the stream of history, jamming historical happenings' he wrote (2002: 128). The Moving Finger has stopped writing, it would seem; it trips a shutter instead.

BODENLOS

Born in Prague in 1920, Flusser had just begun to study philosophy at the Charles University there when, at age 19, he realized that the Nazi occupation of Czechoslovakia was threatening to destroy not only the German language he loved (he grew up speaking both Czech and German, as well as the Hebrew he learned as part of his religious

training), but also his life. Unable to persuade his family of the danger, he left Prague with his fiancé, and eventually, after a brief stay in England, emigrated to Brazil. There, separated from everything familiar—people, language, geography, values—he learned that all of his family and friends—Czech, German and Jewish—had been murdered. In the following years, he was sometimes suicidal. But he married, raised three children, continued to study philosophy independently, learned Portuguese, and began to earn a living as a writer of commentary on current affairs for newspapers and magazines—in the new language. By the early 1960s he had become a university professor, first in the philosophy of science and then in the philosophy of communications, a field he called 'communicology'. Fluent at this point in five languages, English and French, in addition to his native Czech and the German, Flusser developed a pattern of translating texts from one language to another, in order, as he said, to exhaust their possibilities. Translation would remain a central concept in his thought (Guldin 2005), and communication, exchange, connection to others would emerge as itself the means of generating meaning, of continuing to live even with no access to one's roots. To be *bodenlos* was still to suffer, but it was also to be free as few can ever be, unbounded by the assumptions, prejudices, obligations that accompany any concept of 'home' (2003).

Flusser's sustained engagement with photography, and by extension with new media, seems to have begun after his return to Europe in 1973, a move precipitated by strong friendships, publication opportunities, and a deep disappointment with the political situation in Brazil. The Flussers settled in Robion, in southern France.

The last two decades of his life brought both an unprecedented level of conventional success—more publication and speaking engagements than ever before—and also a renewed struggle. He still sought routes into the unfamiliar, but now, rather than a new language, geography or history, he was encountering new media, with their characteristic ways of structuring thought, perception, time and space. This migrant from the 'land' of writing and history felt his hard-won skills threatened with obsolescence. Having mastered some five natural languages, he was now faced with the prospect of learning the visual and mathematical codes in which photographs, television, video were 'written'—of going, as he put it, 'back to kindergarten'. In the Afterword to the second edition of *Writing: Does Writing Have a Future?* (2011b), he expressed a painful awareness of having written a book about breaking out of the old codes, something he himself didn't have the mathematical competence to do very well, but which would be of no interest to those who could do it well, because they have no need to break out of anything: 'they've already set [writing] aside in contempt' (2011b: 164).

Flusser was killed in a car accident in 1991, his theory of communication still 'under construction'. At its centre of this theory are two interrelated concepts, discourse and dialogue: discourse is fixed and official, the formal ideals or history shared by a group of people—the most familiar forms today would be in print and broadcast—and held in storage indefinitely; dialogue is exploratory, experimental and usually ephemeral—and the only source of genuinely new information. Ideally, a society has a balance of both modes of communication, but in his own situations—both in Brazil and in Europe—Flusser saw discourse, probably with the image of network radio and television

prominently in mind, as the overwhelmingly dominant force, so powerful as to all but exclude the very possibility of meaningful dialogue, and so the possibility of creative social change. For he understood dialogue as essential to any sort of life that could justly be called 'human'.

Flusser drew his concept of dialogue from the theologian Martin Buber (1878–1965), but transformed it from a religious concept into a secular one (Ströhl 2002: xv): dialogue emerges as the means by which any of us establishes and maintains an identity, is remembered, overcomes the loneliness and absurdity of our own inevitable death. Flusser's hopes and fears with respect to media revolve fundamentally, that is around his sense that a profound change in the medium of communication inevitably means a profound change in the potential for dialogue, for making meaningful creative contact with another human being.

Flusser's contemporary, the media theorist Marshall McLuhan, seems never to have sensed any such unbridgeable difference between old and new, and so never felt himself on the 'wrong', that is the old side of the change. He tended to position himself as someone who could see shifts in the use and effects of media, could diagnose the perceptual shortcomings of his critics by being just a bit 'ahead' of them (1997). In fact he seemed to possess just the sort of sensitivity to the perceptual 'climate' of any given time and place he repeatedly attributed to artists. Among the remarkable points of agreement between McLuhan and Flusser, in fact, is a keen concern with clarifying and revaluing what might count as 'creativity' under changing conditions. But unlike McLuhan, Flusser saw himself on the outside, describing, calling for a new form of creativity without himself being able to participate very effectively in it.

It surely matters that Flusser, unlike McLuhan, was speaking as a migrant, as someone who had negotiated a completely unfamiliar situation, language, landscape and culture more than once in his life. Again unlike McLuhan, Flusser witnessed the advent of personal computing, early image synthesis software and the Internet. But none of this accounts for the neat reversal of their understanding of the perceptual difference between writing and new media. For McLuhan understood writing to be visual, new media to be acoustic, and himself—committed to oral over literary communication—a harbinger of the new. Flusser, committed to oral communication yet deeply committed to writing as well, understood writing to be bound to speech in a way that rendered both fundamentally acoustic. The consciousness he associated with new media was, by contrast, so resolutely visual as to put his own skills, beliefs, assumptions—his consciousness—under threat of obsolescence. Without definitively deciding whether computer code is 'language', or programming a form of 'writing', he calls urgently for translators, 'envisioners' who can make at least some aspects of the vast cultural memory stored in writing accessible to a new consciousness.

GESTURES

It seems clearer in retrospect than it was at the height of his fame in the 1960s, then, that McLuhan modelled new media—particularly film and television—on speech, with its immediacy and perceptual richness, its simultaneous engagement of tactile and acoustic

as well as visual senses (Moos 1997). Flusser, by contrast, although he imagined the universe of technical images as rather noisy—everyone, even machines, having learned to speak—thought speech was already losing precision and subtlety, the power to operate as collective memory it had acquired over centuries under the 'discipline' of writing. Both he and McLuhan read contemporary media shifts against the radical perceptual changes known to have accompanied the invention of writing some three millennia ago (Ong 1982). But Flusser looked more soberly at the persistent gap—spanning most of writing's history well into the nineteenth century—between the very few who were actually able to read and write and the many who could not. For Flusser, this gap translates into the contemporary situation roughly as one between those who can, and those who cannot 'write' computer code.

The respective disciplinary commitments of the two men do seem to have bearing on the issue. McLuhan's professional academic 'home' was in the history and criticism of literature. Flusser's central intellectual commitment, and this in spite of a radically truncated formal education, was always to philosophy, to a rethinking of inherited questions and categories—logic, epistemology, metaphysics and ethics—under changed conditions. More particularly, Flusser's early and lasting commitment to a phenomenological method of inquiry seems to have enabled him to think past language, to project a visual mode of thought quite completely different from the literate, or historical thought he called his own.

From his earliest study of philosophy, Flusser admired the thought of Edmund Husserl (1859–1938), widely regarded as the founder of phenomenology. And although there were other thinkers who affected him deeply, Flusser's approach to media old and new relies on the phenomenological 'reduction', Husserl's method of 'bracketing out' logical and causal assumptions in order to gain insight into the phenomenon under consideration. He applied this method explicitly in a series of essays whose titles begin with the word 'Geste', or 'gesture', among them 'The Gesture of Writing', 'The Gesture of Painting' and 'The Gesture of Photographing' (1991). Gestures are 'movements of the body or a tool linked to the body that have no satisfactory causal explanation' (1991: 8). They encode intentions, starting from the inside—from thinking or reflection—and moving towards the outside, towards other people. Within this framework Flusser developed many of his most remarkable insights into specific communications media.

In the essay entitled 'The Gesture of Painting' (1991: 109–26), Flusser almost literally 'walks' his readers through a phenomenological reduction, pointing out the advantages of such an approach. He asks us to consider the phenomenon of a painter at work, a human body with a brush attached, a pattern of movements between an assortment of coloured pigments and a canvas, alternating with moments of rest. We, as observers, are particularly cautioned to avoid any preconceptions about why these movements may be occurring, or even any assumptions about the relationships between parts of the scene, for example body, pigments, brush, canvas, activity and rest. In this way, Flusser presents the situation as a seamless integration between painter, paint, brush and painting, a perception inaccessible to anyone approaching the phenomenon with 'commonsense' knowledge about the causally related entities involved in the gesture. Observed in this way, the

canvas seems to be controlling the whole gesture, since everything seems to be directed towards it, to *mean* it. But ultimately, the gesture of painting presents us with an enigma, a puzzle that forces itself on us. This allows us to identify it as a *free* movement (1991: 115). The gesture of painting contains its own criticism, he says, which can actually be observed in certain phases of the movement, such as a stepping back from the canvas or looking at it in a particular way. In order to resolve the enigma it presents to an observer, the gesture of painting actually requires that the observer in some sense participate in it. The goal of such an analysis is not to enumerate causes and so to explain the phenomenon away, but to press more deeply into the enigma, to experience it more fully.

'The Gesture of Photographing' approaches photography in a similar way inasmuch as we are invited to analyse a photographer at work, and suspend all preconceptions about causes of this activity. But Flusser points out a crucial difference at the outset:

> The subject is the *cause* of the photograph and the *meaning* of the painting [italic in original]. The photographic revolution turns the traditional relationship between the concrete phenomenon and our idea of the phenomenon around. In painting, according to this tradition, we ourselves form an 'idea' of the phenomenon in order to fix it on a surface. In photography, by contrast, the phenomenon forms its own idea, for us, on a surface. In fact the invention of photography is a delayed technical solution to the theoretical debate between rational and empirical idealism.
>
> The English empiricists of the seventeenth century thought that ideas impressed themselves on us like photographs, while their rationalist contemporaries believed that ideas, like paintings, were formed by us. (1991: 127)

This presentation of photography as a sort of materialization of philosophical possibility, an alternative means of observing, reflecting, exchanging views about the world, turns out to be the central goal of Flusser's essay. Photography offers a means of philosophizing without writing—in fact without language:

> The gesture of photographing is a philosophical gesture, or to put it differently: since photography was invented, it is possible to practice philosophy not only in the medium of words, but also in that of photographs. The reason is that the gesture of photography is a gesture of seeing, of that which the antique thinkers called 'theory', and from which an image is produced they called an 'idea'. Unlike most gestures, the gesture of photographing is not directly concerned with changing the world or with communicating to others, but is aimed at observing something and fixing the seeing, making it 'formal'. The much-quoted Marxist argument that philosophers have tried to explain the world (which is to say, observe and chat about it), when the point is to change it— this argument is not very persuasive when it comes to the gesture of photographing. Photography is something new, the result of looking at and changing the world at the same time. The same is the case for traditional philosophy, although the resulting ideas are less easily grasped. Its intelligibility is indisputably a moment of photography's advantage over the results of traditional methods of philosophy. (1991: 134–5)

Flusser goes on to analyse a particular instance of photographing: we are asked to observe a gathering of people among whom a man is sitting in a chair smoking a pipe. He is the photographer's subject, and both the photographer and the other people move around him. The analysis divides the 'gesture' into three parts: the movement of the photographer around the subject in search of the best standpoint, the manipulation of the subject, and the judging—the photographer's self-critical, reflexive gesture of selecting the appropriate distance between the two. There is a fourth aspect, he admits, namely the tripping of the shutter, but that, along with all the developing, sizing, printing of a final image, lies beyond the gesture itself and so beyond the framework of the essay. In the deft and persuasive, if complex analysis that follows, each of the three enumerated aspects of the gesture of photographing is linked to aspects of traditional philosophy, emphasizing the impossibility of confirming a clear traditional distinction between observer and observed, and identifying still photography as the philosophic gesture *par excellence*. At the end, the essay opens a host of questions, such as whether the difference between art and philosophy has not been eroded, or what impact photography has had on scientific thought. At length it returns to the recognition of photography as a gesture of seeing, 'theoria'.

By contrast, 'The Gesture of Writing' (1991: 39–50) emphasized the orderly flow of lines on a page, and the sustained force required to achieve such order. Appearing more often in the first person than in many of his other essays, Flusser frequently resorts to the word *vergewaltigen*, meaning to violate or to rape, when accounting for, first, the 'translation' of ideas—images—into the sounds of a spoken language, and then again when those sounds are forced to obey the rules of letters, lines, sentences, grammar and punctuation—in a word, the rules of orthography. In order to communicate in writing, that is both writer and reader must command the codes of one or another spoken language, to in some sense 'hear' those acoustic codes. Photography, on the other hand, requires no such detour through spoken language.

It is easy to misunderstand the distinction he is drawing between writing and technical images in terms of the traditional break between images and texts, as they appear in, say, books illustrated with drawings or photographs. For both drawings and photographs usually function as traditional images in such contexts, which is to say they serve linear texts, reflecting the very old struggle between linear, historical consciousness overpowering magical, image-based thinking. At one point Flusser helpfully introduced the example of a scientific text composed of lines of alphabetic code and mathematical symbols, comparing it to an illustrated storybook (2011b: 24). In such a text, he suggested, complex equations sit like visual islands, stubbornly refusing to enter the directional flow of linear text, demanding instead a visual, mathematical consciousness to decode them. The break he sees opening now between writing and *technical* images is located between alphabetic (acoustic) codes, and mathematical (visual) ones. That is whether we are looking at video clips or listening to music or even reading a text online, the transmission depends on mathematical, which is to say, visual, thought. This is better observed from a standpoint other than the analysis of gestures. It opens at that point in 'The Gesture of Photographing' where reference is made to an apparatus.

APPARATUS

Photography is just one of many media that support the universe of technical images, the universe after writing. But for Flusser it appears as a kind of common denominator, something like the most basic form of the many image technologies that followed. At one point he set out to define 'technical images' as those that involve an apparatus. He never exactly retreated from this definition, but did feel the need to explain how the use of an 'apparatus' involves a very high level of abstraction, a consciousness at several removes—four, to be exact—from any immediate engagement with the life-world (first speech, then traditional images, then writing, then technical images). An apparatus is in some respects a machine, but greatly refined, unprecedented in its capacity to reach into a universe of particles far too small, moving too quickly for human beings to actually see or grasp, select them according to a program, register them on a surface far faster than a human hand ever could, and store them indefinitely. Even at its inception, that is photography possessed the basic characteristics that mark communication in the universe of technical images: it used an apparatus fitted with keys, it 'worked' with particles—initially with light-sensitive molecules—at a speed and scale inaccessible to sense perception, it was 'programmed' to do certain things and not others.

This account breaks sharply with the far more familiar understanding of photography as an 'index' or 'trace' of the world—and photography serves here as a kind of model, or first instance of all the apparatus that soon join in the bidding to 'record' phenomenon, for example film and video and sound recording. Although Flusser does not deny the apparatus's potential to function indexically, and in fact confirms, in 'The Gesture of Photographing' that the technology permits subjects to imprint themselves on a surface, 'like a fingerprint', he does not see this as being, or as ever having been its most characteristic or most significant function. As he discusses it in 'The Gesture of Photographing', photography is characterized both by the subject's manipulation of the photographer and the photographer's manipulation of the situation.

> The objectivity of an image (an idea) can be nothing but the result of manipulation (observation) of any situation. Any idea is false inasmuch as it manipulates that which it comprehends, and is in this sense 'art', which is to say, fiction. Yet in another sense ideas may be true, namely if they truly comprehend that which they observe. This may have been what Nietzsche intended in saying that art is better than truth. (Flusser 1991: 145)

For Flusser, then, digital photographic technology does not introduce a new medium, but allows us to see clearly for the first time what photography always was, namely a means of constructing images out of inherently meaningless particles. Photographs are and always were fictions, projections. In a passage distinguishing photographs from electronically synthesized images, he contends that both are projections, but that this is more difficult to understand with photographs for two reasons: first, because photographs seem to be copies, rather than projections, and second, because photographs

seem to be made by someone—a photographer—rather than calculated using software designed by so many as to have become anonymous: 'At first glance, a photo of an airplane does not reveal that, just like a synthetic computer image, it signifies a possible airplane rather than a given one' (2002: 131).

The reason this has become clear only recently and only to some people, or probably only to some people part of the time, is that 'most of us (including most photographers) are still caught up in historical, progressive, enlightened consciousness. Thus photographs are received with a different consciousness from the one that produces photo apparatuses' (2002: 131). That is the consciousness that receives photographs (and that, to a large extent, makes them) understands, appreciates, categorizes them in relation to a still-dominant, writing-based system of values, in a world understood to be meaningful, real, and so worth representing. The consciousness that designs cameras, film, chemistry and software understands the world to be the end result of an inconceivably vast play of chance. It sets about engaging in that game, playing with probabilities, using apparatus to compute tiny, meaningless bits of it into images that project a conception of the world, that confer meaning. Post-historic images (and this embraces the whole range of electronic communication technology, including sound reproduction) do not 'represent' things in Flusser's formal vocabulary, but more exactly calculate and compute them—and always did.

Flusser's hopes and fears for a future in which technical images gradually erode the functions, the values and assumptions of literate thought are therefore unrelated to any threat to the camera's—or any other apparatus's—perceived special relationship to 'truth'. He would not deny the possibility of such relationship, but he would insist that it always depended on a particular configuration of people, apparatus, time and place. His hopes and fears are rather bound up with the disjunction in consciousness between makers and users of apparatus, the gap between those who are able to operate humanely within the apparatus, and those who engage with it as a kind of 'black box', opaque and impenetrable. It is, approximately, a disjunction between those who believe they are taking pictures, recording meaningful information, and those who understand that they are making pictures—conferring meaning. Or, to put it another way, it is a disjunction between a belief that it is possible to distinguish definitively between 'real' and 'fictional' images (a belief of literate, historical consciousness), and a belief that fictions may be more or less comprehensive, satisfying or inspiring, depending on the clarity, depth and intensity of engagement between senders and receivers of those images.

This disjunction looms large in Flusser's structure of thought because it threatens to effectively block the use of technical images for genuine dialogue. Flusser fears, that is the tendency of users to understand technical pictures as in some sense reliable, or 'true', to reinforce discursive structures of communication, that is those structures that deliver a kind of general consensus, a shared meaning about a particular group of people (discursive structures embrace the ancient model of the Roman amphitheatre and the contemporary one of centralized broadcast). For in reinforcing discourse, they simultaneously threaten to impede the development of genuinely dialogic structures, opportunities for playful, creative exchange.

Flusser's view may be clearer in contrast to that of John Szarkowski, the highly influential curator of photography at New York's Museum of Modern Art between 1962 and 1991, and certainly among the most articulate of users of photographic apparatus.

> Our faith in the truth of a photograph rests on our belief that the lens is impartial, and will draw the subject as it is, neither nobler nor meaner. This faith may be naïve and illusory (for though the lens draws the subject, the photographer defines it), but it persists. The photographer's vision convinces us to the degree that the photographer hides his hand. (Szarkowski 1966: 12)

Szarkowski himself suggests that the 'faith' in photographic truth may be naïve and illusory, but still speaks approvingly of the photograph's detachment from the photographer (or at least the appearance of detachment) as the medium's identifying feature; Flusser would deny such detachment, and perhaps Szarkowski would not disagree. But Flusser would also see the 'hiding of the hand' itself as potentially dangerous. For to the extent that the image seems to appear without human intervention, it begins to exclude human decisions, the possibility of generating new, unexpected, surprising information. It begins to locate human beings within a 'black box', as functionaries who are effectively controlled by the apparatus. If by 'apparatus' we understand a structure of 'automated' transactions that extend beyond the immediate design, manufacture, marketing and sale of a particular camera, if we imagine automated decisions that reach back from the photographer to those who may have commissioned him or her, to descriptions of 'need' generated by automated market surveys, to a proliferation of concepts of 'new' and 'advanced', or even 'acceptable' that seem under the control of no one in particular, the fear becomes real and present. In light of such pressures, Flusser is emphatically opposed to the hiding of hands. Rather he sees our longer-term well-being resting on the generation and shared celebration of surprises, improvisations, improbable communication never anticipated by hardware, software, chemical or corporate designers, for only in this way can truly new information be generated.

Flusser displayed an almost even balance between optimism and pessimism regarding the rising universe of technical images, grasped in relation to the first promise of the Internet. In many ways he welcomed the proliferating automation of human labour—including mental labour—but feared that it would itself become automatic, making everything more and more predicable, less and less informative, excluding the possibility of creative dialogue to the point where human life would become unbearable. He also projected the possibility that the universe of technical images would be the first truly human culture exactly because automation would free human beings from the need to work, and allow them the leisure, along with the speed and flexibility of communication, to lead a life of joyous, playful celebration. But in order for this to happen, sterile, conventional unidirectional communication models, ostensibly inherited from the hierarchical patterns characteristic of writing and print culture, must give way to an open exchange among human beings who mutually acknowledge one another's distinctive skills, tastes and potentials and limitations. He is disparaging in his judgement of

cultural criticism that tries to identify ideological causes or malicious villains as a means of intervening in an increasingly automated process. He calls instead for a closing of the gap between those who design and those who use the apparatus, for users who can surprise themselves and one another. Users must, in short, learn to use, to creatively manipulate the new codes.

ART

McLuhan, borrowing the phrase from Ezra Pound, famously referred to artists as 'the antennae of the race' (1964: xi), people who could, by virtue of an exceptionally acute awareness of their own sense perception, appear to predict the future, alerting the rest of us to imminent changes in perceptual conditions. McLuhan further recognized the broad potential of 'obsolete' media to serve as platforms for gaining valuable critical insights into the contemporary communications, for example that painting might be in a strong position to criticize, say, television. The ideas seem to be related, at least indirectly, to his more general contention that techniques or processes that have been superseded—replaced partially or entirely by faster or more efficient ones—tend to take on a heightened aesthetic value (1964: ix, 32). Etching, lithography or, more recently, film-based photography, for example retire from commercial employment to an 'afterlife' in art colleges and artists' studios. There, they are subject to a very different structure of appreciation and valuation. Had McLuhan ever considered the range of media available at contemporary art colleges—from painting, drawing, modelling and casting, through many print processes including photography, to film, video and computer image synthesis—he would presumably have accepted them all, as most students as well as lecturers do, as potential means of innovative communication in the present.

Flusser seems to have had little patience with 'art' as he found it defined institutionally. He once dismissed 'the ridiculous isolation of an avant-garde' (1996: 240) as something completely alien to contemporary communication. With some hesitation, he supported the incorporation of schools devoted to the study of specific arts—conservatories and art schools—under the more general category of 'communication' colleges (1996: 239). Nor did Flusser ever extend anything like McLuhan's blanket recognition of 'old' media as potential means of communicating meaningfully in the present, although he clearly did recognize at least painting as a meaningful contemporary medium. Perhaps if he had considered the art college's temporal 'collapsing' of media, it would have presented an example of what is happening to history, an instance of considerable ambiguity about moving 'forwards' in time, and a clear sense of the past pooling up around us—techniques, texts, biographies all being available simultaneously in no inherently meaningful order.

But for all his seeming ambivalence towards institutionally identified 'art', Flusser repeatedly stressed the urgency of a particular type of visual practice, the need to claim—or reclaim—the inventive, creative potential of technical images. 'Art and *human* are synonymous, and they both mean that we deny the fullness of the world (its being such). They both mean that we are not animals governed by habit, but human beings, meaning artists'

(2002: 56). For Flusser grounds the whole purpose of human life in communication—in the possibility of making real, creative contact—dialogue—with other people, and in having that creative moment remembered past the point of any one person's death.

Flusser defines dialogue as an exchange of information between at least two memories. These memories may be human or artificial; the critical thing is that the exchange be open—there can be no prescription, no sanctity of established categories, no unidirectional flows. He accounts for one common model of creativity, the lonely genius alone in study or studio, as a dialogue between different aspects of the same memory, as Newton, for example making the connection between celestial mechanics and the fall of an apple to the ground. But exchange between memories is invariably a far faster, more exciting process. One memorable example he gives of creative dialogue involves a hypothetical chess game. The rules of the game are complex enough to provide nearly infinite possibilities and so considerable scope in themselves for creative, absorbing engagement; but the moment of genuine creativity—of 'connection', or dialogue—would come when both players look up from the game and decide—together—to change the rules, to really 'play' (1985: 109–10).

Flusser is convinced that the requisite technology is already largely in place, but that we ourselves, our habits of thinking and behaviour, our inherited convictions stand in the way of using technical images in playful, creative exchange. In his more optimistic passages, he describes a kind of practice that engages in such play, that forces the apparatus—whether literally boxes with control buttons or more generally automated processes that engage human beings—to produce what they were never programmed to produce, namely, new, improbable, surprising information. This would be a fundamentally visual practice inasmuch as it would involve the 'writing' of algorithms, rather than of linear text, whatever the mode in which anyone might ultimately communicate: visual, acoustic, tactile, olfactory or all of the above. He designated such practice with the German word *einbilden*, which may be translated as 'imagine', yet has additional resonances with 'envision' or 'visualize' or even 'hallucinate'; he kept the term neatly distinguished from *darstellen*, to represent or depict, which is what traditional images do, namely painting and drawing—whether they are depicting 'real' objects or imaginary ones.

Flusser looks to envisioners, in any case, to ensure that the new technologies do not become completely automated, that they are used to generate new information, to put creative human intelligences in touch with one another and with artificial intelligences, to generate surprising, unpredictable images, sounds, situations and events. It is Flusser's hope that such people, who may as well be students of science or engineering or marketing as of art, will find ways of 'writing' innovative code, of resisting a persistent tendency towards sameness and predictability, and of turning the vast potential of technical images into meaningful dialogue.

> A scientific text differs from a Bach fugue and a Mondrian image primarily in that it raises the expectation of meaning something 'out there', for example atomic particles. It seeks to be 'true', adequate to what is out there. And here aesthetic perception is

faced with a potentially perplexing question: what in the text is actually adequate to what is out there? Letters or numbers? The auditory or the visual? Is it the literal thinking that describes things, or the pictorial that counts things? Are there things that want to be described and others that want to be counted? And are there things that can be neither described nor counted—and for which science is therefore not adequate? Or are letters and numbers something like nets that we throw out in order to fish for things, leaving all indescribable and uncountable things to disappear? Or even: Do the letter and number nets themselves actually form describable and countable things out of a formless mass? This last question suggests that science is not fundamentally so different from art. Letters and numbers function as chisels do in sculpture, and external reality is like the block of marble from which science carves an image of the world. (2011b: 25).

In the universe of technical images, then, art can no longer claim either 'the visual' or 'creativity' as its particular province. Nor, conversely, can science make a special claim to knowledge. In fact Flusser sees a conventional concept of 'art' as largely obstructing a clear apprehension of the new technical possibilities:

We speak of 'computer art' when we are looking at the new images on monitors, as if we were concerned only with a new technique for producing images. By using the category 'art' we block our own access to these images. Computer keys simulate mental processes. These glowing images are nearly unmediated—if 'unmediated' means anything to such estranged creatures as human beings are—images drawn from the brain outward. It is therefore misleading to call these published and particularized dreams 'art' without adding that all previous art is only a hesitant approach to these images. Even understood in this way, however, the concept of art is a category that bypasses these images. Most computer images produced so far have been fabricated in laboratories, not in artists' ateliers transfigured by Benjamin's aura. Images produced in laboratories make at least as strong an aesthetic impact as those produced by 'computer artists'. Such images disregard the boundary between the category 'art' and the category 'science and technology'. Science presents itself as an art form and art as a source of scientific knowledge. (2011b: 28–29)

The conceptual category of art itself, then, is seen to be bound up with historical consciousness, linear thinking—and ultimately with writing. 'Envisioners', seeing the world as a massive play of probabilities, become accustomed to sharing memory with others, to using apparatus developed by others; 'artists', by contrast, ostensibly belong to the universe of writing, the universe that recognizes, reveres originality. Linear consciousness, he contends, seeks a beginning, an author—a founder of a city, an author of a text (2011a: 96). Writing made a world of authors and authorities. When the faith wears thin, when no textual 'frame' or context seems strong enough, persuasive enough to contain them, images no longer necessarily have an author, a founder, a beginning, a direction or an end.

Could the quatrain that opened this chapter be 'translated' into a technical image? Could there be a recording or a film of the smooth, unstoppable forwards flow of time, past the breaks in the lines, the piety and the tears, to the end of 'it', of history, of writing? In his admirable short study of the pioneer of motion pictures, Eadweard Muybridge, the filmmaker Hollis Frampton left us with a rare insight into the way a technical image maker might regard the flow of history. Near the end of an elegant account of Muybridge's life, showing how its various threads could be understood to converge on a single moment, Frampton rewrote a quotation from the sculptor August Rodin with which he had introduced his essay. Rodin's observation, made at the time Muybridge was working, contended that artists tell the truth and photographers lie, for in fact time does not stop. In Frampton's rewriting, 'It is the photograph which is truthful, and the artist who lies, for in reality time *does* stop' (1983).

Flusser seems to credit any one of us with the potential to be differently conscious in different contexts and situations—older codes coexist with newer ones. He makes no pronouncement of inevitable disaster or probable triumph. But specifically as a writer, addressing readers of alphanumeric code, he admonishes us not to languish in complacency with respect to the codes we know and value, but rather to be translators, envisioners, writers of algorithms who resist a comfortable automation of our communicative relationships, who insist that surprise, invention, creative human dialogue can and should flourish in the new universe of technical images.

FURTHER READING

Flusser, Vilém. 2002. *Writings*, ed. Andreas Ströhl, trans. Erik Eisel. Minneapolis and London: University of Minnesota Press.

Kittler, Friedrich. 1999. *Gramophone, Film, Typewriter*, trans., with an Introduction by Geoffrey Winthrop-Young and Michael Wutz. Stanford, CA: Stanford University Press.

McLuhan, Marshall. 1997. *Media Research: Technology, Art, Communication*, ed. Michel A. Moos. Amsterdam: G&B Arts International.

Wiesing, Lambert. 'Aesthetic Forms of Philosophizing', in C. v. Eck, J. McAllister and R. v. de Vall (eds), *The Question of Style in Philosophy and the Arts*. Cambridge, MA: Cambridge University Press, 108–23.

REFERENCES

Texts quoted from the German volumes are my translations.

Barthes, Roland. 1977. 'The Rhetoric of the Image', *Image-Music-Text*. New York: The Noonday Press, 32–51.

Batchen, Geoffrey. 1997. *Burning with Desire: The Conception of Photography*. Cambridge, MA and London: MIT Press.

Benjamin, Walter. 1991. 'Kleine Geschichte der Photographie', *Gesammelte Schriften* Vol II:1, ed. Rolf Tiedemann and Hermann Schweppenhauser. Frankfurt a.M: Surkamp Taschenbuch, 368–85.

Flusser, Vilém. 1983. *Für eine Philosophie der Photographie*. Göttingen: European Photography. Translated as *Towards a Philosophy of Photography* (2000). London: Reaktion.

Flusser, Vilém. 1991. *Gesten: Versuch einer Phänomenologie*. Düsseldorf and Bensheim: Bollmann Verlag.

Flusser, Vilém. 1992. *Bodenlos: Eine Philosophische Autobiographie*. Düsseldorf and Bensheim: Bollmann Verlag.

Flusser, Vilém. 1996. *Kommunikologie*. Mannheim: Bollmann Verlag.

Flusser, Vilém. 2000. *Towards a Philosophy of Photography*. Introduction by Hubertus von Amelunxen. Translated by Martin Chalmers. London: Reaktion. First published as *An eine Philosophie der Photographie*. Göttingen: European Photography. 1983.

Flusser, Vilém. 2002. 'Photography and History', in Writings, ed. Andreas Ströhl, trans. Erik Eisel. Minneapolis and London: University of Minnesota Press, 126–31.

Flusser, Vilém. 2003. *The Freedom of the Migrant: Objections to Nationalism*, ed. Anke Finger, trans. Kenneth Kronenberg. Indianapolis: University of Indiana Press.

Flusser, Vilém. 2011a. *Into the Universe of Technical Images*. Introduction by Mark Poster, translated by Nancy Ann Roth. Minnesota: University of Minnesota Press. First published as *Ins Universum der technischen Bilder*, Göttingen: European Photography, 1985.

Flusser, Vilém. 2011b. *Does Writing Have a Future?*. Introduction by Mark Poster, translated by Nancy Ann Roth. Minnesota: University of Minnesota Press. First published as *Die Schrift: Hat Schreiben Zukunft?* Göttingen: European Photography, 1987.

Foucault, Michel. 1999. 'Panopticism', in Jessica Evans and Stuart Hall (eds), *Visual Culture: The Reader*. London: Sage and the Open University, 61–71.

Frampton, Hollis. 1983. 'Eadweard Muybridge: Fragments of a Tesseract', in *Circles of Confusion*. Rochester, NY: Visual Studies Workshop, 69–80.

Guldin, Rainer. 2005. *Philsophieren zwischen den Sprachen: Vilém Flussers Werk*. Munich: Wilhelm Fink Verlag.

McLuhan, Marshall. 1964. *Understanding Media*. New York: Mentor. Reprinted with an Introduction by L. Lapham. Cambridge, MA: MIT Press, 1994.

McLuhan, Marshall. 1997. 'Culture without Literacy', in *Media Research: Technology, Art, Communication*, edited with commentary by Michel A. Moos. Amsterdam: G&B Arts International, 126–38.

Moos, Michel. 1997. 'McLuhan's Language for Awareness under Electronic Conditions', in Marshall McLuhan, *Media Research: Technology, Art, Communication*, edited with commentary by Michel A. Moos, Amsterdam: G&B Arts International, 140–66.

Ong, Walter. 1982. *Orality and Literacy: The Technologizing of the Word*. London and New York: Routledge.

Ströhl, Andreas. 2002. 'Introduction', in Vilém Flusser, *Writings*, ed. Andreas Ströhl, trans. Erik Eisel. Minneapolis and London: University of Minnesota Press, ix–xxxvii.

Szarkowski, John. 1966. *The Photographer's Eye*. New York: The Museum of Modern Art.

The 'Dictatorship of the Eye': Henri Lefebvre on Vision, Space and Modernity

MICHAEL E. GARDINER

One cannot look the philosophical sun in the face.
—*Maurice Blanchot (1997: 87)*

Despite his status as (in the words of long-time admirer Fredric Jameson) 'the last great classic philosopher', for a lengthy period the ideas of the heterodox (and heretical) French thinker Henri Lefebvre (1901–1991) were greatly neglected in the English-speaking world. The last ten years or so have witnessed a remarkable reversal of this situation, however, with a flood of new translations, monographs and other publications. These have been instrumental in kick-starting something of a renaissance in Lefebvre studies, through which we are beginning to grasp the full range, fecundity and philosophical depth of his work. Inevitably in any such process of critical reappraisal and reconstruction, however, there are gaps and oversights. Lefebvre's treatment of vision, which can be primarily (though not exclusively) found in his sprawling 1974 masterwork *The Production of Space* is arguably one of these (Lefebvre 1991a). Although his interest in this topic has not gone entirely unnoticed, it has generally been relegated to something of an aside within wider analyses of Lefebvre's work on space, particularly in the wake of the English translation of *The Production of Space*. As such, it has not usually been regarded as an issue worthy of independent examination, and nor has much effort been made to locate Lefebvre's account of visual phenomena vis-à-vis the wider spectrum of his work and interests. Furthermore, there has been little commentary on the philosophical roots of Lefebvre's construal of vision, apart from scattered references to Lacanian psychoanalysis or Nietzsche and Debord, and virtually no attempt to relate Lefebvre's position on this question to the burgeoning literature on visual theory and culture. For instance, such major works as David Michael Levin's *The Opening of Vision: Nihilism and the Postmodern*

Situation (1988) and Martin Jay's *Downcast Eyes: The Denigration of Vision in Twentieth-century French Thought* (1993) each contain only a brief mention of Lefebvre.

The central goal of this chapter will be to address at least some of these oversights, and to affirm that Lefebvre can add substantive value to the current debate over vision. Oftentimes, commentators have interpreted Lefebvre's argument about the close affinity between the dominance of vision in the post-Renaissance era and the creation of a specifically modern form of what he calls 'abstract' space, and the deleterious effects that flow from this, as a straightforward species of 'ocularcentrism' (see Dimendberg 1998: 24; 42, n26). Lefebvre undoubtedly *is* critical of a particular mode of visuality, one that he associates, through a series of complex arguments, with modernity. However, via a careful reading of *The Production of Space*, and by relating the core themes of this book to other of his major works and ideas, it is possible to tease out a more nuanced, and certainly more defensible position on vision. I will proceed, firstly, through a consideration of Lefebvre's account of the historical emergence of abstract space and the role played by a certain 'decorporealized' way of seeing in this process. Next, I will outline his critique of this 'logic of visualization' through Lefebvre's understanding of human embodiment, with reference to his main philosophical influences on this issue, especially Heidegger and Nietzsche. Crucial to this task will be to reconstruct his (admittedly fragmentary) suggestions as to alternative modalities of perception, which is an integral part of his clarion call in support of 'the right to difference'. In seeking to subvert the hegemonic aspect of the modern form of visuality and the role it plays in the domination of space, Lefebvre promotes a multisensorial, synesthetic engagement with the world that, arguably, has its roots in a key idea of ancient Greek philosophy: *aisthesis*. This concept, the origin of the modern term 'aesthetics', refers to a prelinguistic world of shared perceptual experience, involving all the senses, wherein the workings of the body are fully enmeshed with the world. It is through this corporeal disclosure of the sensible world that notions of meaning and value are actively formulated. In later Western thinking, however, the human perceptual realm and its co-extensiveness with the physical world became increasingly divorced from more abstract knowledge-claims, in which truth is equated with representation (see Kane 2007; Sandywell 2011). The conclusion of this chapter will focus more directly on this question of a reconstituted aesthetics in connection with Lefebvre's understanding of visual phenomena.

THE PRODUCTION OF 'ABSTRACT SPACE'

A useful *point de repère* might be to linger briefly on a curious, almost offhand comment Lefebvre makes about the Surrealists in the opening chapter of *The Production of Space*. Although initially fascinated by Surrealism's avant-garde iconoclasm and preoccupation with the textures of everyday life, Lefebvre eventually faulted their tendency to posit such fleeting nonrational experiences as *amour fou* ('mad love') or the 'marvellous' as techniques for escaping from the perceived banality of the everyday. In cultivating the irrational and the 'bizarre' as ends to themselves, the Surrealists expressed a 'transcendental contempt for the real' (Lefebvre 1991b: 29). In *The Production of Space*, Lefebvre

takes this further, suggesting that the aesthetic techniques of Surrealism privilege the re-ified *visual image* over a more processual *act of seeing*. That is in making a fetish of decon-textualized, static imagery, designed to disrupt the observer's habitualized perceptions and jolt him or her into a transfigured state of awareness—such as the apple-faced busi-nessman in Magritte, or Dali's lobster telephone—Surrealism fails to adopt 'a "listen-ing" posture, and curiously neglects the musical both in its mode of expression and, even more, in *its* central "vision"' (Lefebvre 1991a: 19). In the flash of 'profane illumination' that accompanies the Surrealist image, the world stands revealed as 'total transparency', thereby deranging the senses, arresting time, and immobilizing the viewer in a 'sort of ecstasy' (Breton 1990: 133; see also Jay 1993: 236–62). Through such purely aesthetic gestures, in which the object is overwhelmed by a superfluity of meaning, Surrealism promotes an 'immobile space' that is in reality, a projection of abstract Reason. Accord-ingly, despite its intentions, Surrealism reinforces instead of supercedes the perennial bourgeois separation between spirit and matter, mind and body, ideal and reality, time and space. For Lefebvre, the key point is this: Surrealist images are phantasmic echoes of the rarefied logic of exchange-value, rather than an expression of the embodied, practical appropriation of use-value, the latter unfolding according to the temporal rhythms of lived experience and the sensual needs of what he referred to as the 'total man' [*sic*, and passim], something that must be grasped (if always tentatively and incompletely) by the operations of what he called 'dialectical reason' (see Collinge 2008).

In unpacking this somewhat cryptic pronouncement on Surrealism, it is possible to glimpse the central argument of *The Production of Space* and related texts: that the practi-cal and symbolic symbiosis humankind had built up vis-à-vis the natural landscape over eons, including the deep encrustations of collective memory, is now in acute danger of being supplanted by an alienated, hyper-rational, and ultimately destructive relation to space, wherein the natural world is 'reduced to materials on which society's forces oper-ate' (Lefebvre 2009: 187). Crucial to this development is the promotion of a reified and disembodied way of seeing, which denigrates the other senses and renders problematic the connection between space and time. Yet, at the same time, the present conjuncture also harbours distinct possibilities for genuine human fulfilment, plenitude and the re-alization of a truly global 'community of difference'. To grasp this provocative formula-tion, however, we need to backtrack through a discussion of Lefebvre's historical schema regarding space, which is not without its controversies (see Kouvelakis 2008).

In its most basic formulation, Lefebvre argues that space is not a mere backdrop or 'container' in which human interests and activities unfold. Rather, every society produces a distinctive space—each *appropriates* the spatial realm in a particular way through its practical activity and mode of production. In premodern societies, space was appropri-ated through the immediate human dimension, in tandem with the idiosyncrasies of the local culture, such as its methods of establishing duration or distance. In the context of what Lefebvre terms 'absolute space', we relate to the natural landscape primarily through analogical extension of the human body itself, and hence there was a distinct symme-try between the microcosm of the body and the wider universe (Lefebvre 1991a: 111). Important spatial points (natural springs, salt licks, mountain passes), as well as the

aleatory paths that link them, are opened up and invested symbolically and ritually with magical, affective and sacred properties. For Lefebvre, these sensual meanings are not so much 'texts' as three-dimensional 'textures', marked with the traces of on-going physical and symbolic human contact, or what he terms 'archi-texture' (Lefebvre 1991a: 118). We make sense of this landscape not through a mode of 'reading' akin to linguistic comprehension, but by way of 'living in that space, of understanding it, and of producing it', via a 'scrawling hand' that has both verbal and nonverbal elements (sounds, touch and so on) (Lefebvre 1991a: 47). Moreover, there are always 'blank', which is to say 'unreadable' (and hence 'cursed') spaces that remain dark, threatening and beyond human control or comprehension, relegated to the category of *terra incognito*. Even after populations grew and congregated in emerging city-states, political systems became more formalized, and human constructions more elaborate, references to nature continued to be incorporated into architectural and urban design and associated with the rituals enacted within such spaces, which were intended to establish an equilibrium between the Logos of humanity and the cosmos of nature (Lefebvre 1991a: 48).

Lefebvre is careful not to present absolute space as a homogeneous, generic form of spatial production. For instance, he takes note of the many political and economic differences between ancient Greek, Roman and early Medieval societies, as well as their divergent conceptions of the body and corresponding modes of analogical reasoning. But one thing they share is a milieu where time and space are inseparably linked, in which humans relate to the world in a manner that is not conceived abstractly but lived '*immediately* (i.e. without intellectual mediation)' (Lefebvre 1991a: 241). In any event, for a series of complex reasons that Lefebvre only hints at in *The Production of Space*, this localized nature eventually recedes, and the trend of human societies is increasingly 'towards the quantitative, towards homogeneity, and towards the elimination of the body' (Lefebvre 1991a: 111). What really shifted this process into high gear was the transfer of power from the rural to the burgeoning urban areas, and from agricultural to artisanal (and eventually commodity) production, in Western Europe beginning around the twelfth century. By this time, asserts Lefebvre, absolute space was ebbing away, along with the vision of a pan-European ecclesiastical order dominated by Catholicism. What emerged instead was the 'space of a secular life, freed from politico-religious space . . . a benevolent and luminous utopia where knowledge would be independent, and instead of serving an oppressive power would contribute to the strengthening of an authority grounded in reason' (Lefebvre 1991a: 256). Interestingly, Lefebvre observes that in the overwhelming spectacle that the massive cathedrals of this period presented to the illiterate masses, we see the glimmerings of a specific 'visual logic' that eventually dominated the modern era, as well as the triumph of the phallus over the procreative female organs. Whereas the Medieval church was obsessed with subterranean cultic spaces, with its saint's bones and catacombs, a rapidly consolidating abstract space would disinter these musty relics and fetishes, literally 'decrypt' by exposing them to the withering glare of Logos, logic and the law.

These dark, enchanted and sacred spaces were gravely weakened, but did not cease to exist entirely. They were transformed into what Lefebvre calls "'heterotopical' places,

places of sorcery and madness, places inhabited by demonic forces—places which were fascinating but tabooed' (Lefebvre 1991a: 263). Whilst this 'heterotopy' suggests a veiled reference to Foucault's well-known 'Of Other Spaces' (1986), Tom McDonough argues that Lefebvre derives this concept, not from the root word 'utopia', but rather 'isotopy'. Heterotopy refers, then, to places that are not only 'other' in relation to abstract space, but also 'of' the other, where the marginalized and excluded dwell, and 'what remains disjointed, fragmented, uncontrollable, excluded, or dissociated' (McDonough 2008: 316). Traces of absolute space also survive in the perennial bourgeois nostalgia for the 'home' (Lefebvre mentions the work of Bachelard and Heidegger in this respect), and also in certain artistic forms and practices. Although such countervailing tendencies should not be underestimated, due to the relentless pressure of capital accumulation and urbanization, rapid scientific and technological advances, and the consolidation of new, interlocking systems of power, surveillance and control, abstract space came to dominate, firstly in Western Europe, and eventually the globe. Abstract space tightly regulates the uses to which spatiality can be put, and hence must be understood as the site of proscription, control and the forcible repression of heterotopical spaces. If we are unable to think and act outside such limitations, the realm of possibility vis-à-vis abstract space is restricted to merely quantitative extensions and 'improvements'—faster motorways, more retail outlets, speedier broadband access—as opposed to any qualitative transformation in our collective way of living.

For Lefebvre, abstract space is a 'bulldozer or tank' that rides roughshod over all qualitative differences, especially embodied and natural ones. It strives to project the world as transparent, homogeneous and depthless, proffering a set of meanings that are fully legible and self-evident. Examples are hardly difficult to find in our world of identikit strip-malls and bland suburban vistas. As Lefebvre himself notes in his *Introduction to Modernity*, the concretized, grid-locked monstrosity of the postwar 'new town', which exists on the very 'threshold of sociability', is a place where everything is 'clear and intelligible. Everything is trivial. Everything is closure and materialized system. The text of the town is totally legible, as impoverished as it is clear' (Lefebvre 1995: 119). There is a kind of 'flattening out' of spatial complexity and the depth of human experience occurring here, a reduction of the world to a single logic or plan—for example the driver is only concerned about getting to his destination, the city is a mere conduit for that end, and hence 'speed, readability [and] facility' trump all other considerations (Lefebvre 1991a: 313). Abstract space is an extension of the strategy of state bureaucratic control, and operates according to the dictates of the '"world of commodities", its "logic" and its worldwide strategies, as well as the power of money and that of the political state[,] the vast network of banks, business centres and major productive entities, [and of] motorways, airports and information lattices' (Lefebvre 1991a: 53). As has been widely noted, the commodified space of neo-capitalism is produced with visual comprehension uppermost in mind; in an average day we are exposed to literally thousands of images exhorting us to buy and consume specific brands and lifestyles (see Barnard 1995). These images stimulate desire, but, because there is no concrete referent, the result is frustrated enervation. This dominance of the visual obscures the stultifying repetitiveness involved

in the production of abstract space, wherein we identify life's rich pageant with the fleeting image: 'We buy on the basis of images. Sight and seeing, which in the Western tradition once epitomized intelligibility, have turned into a trap: the means whereby, in social space, diversity may be stimulated and a travesty of enlightenment and intelligibility ensconced under the sign of transparency' (Lefebvre 1991a: 76).

THE 'LOGIC OF VISUALIZATION'

As the preceding discussion indicates, what is crucial to grasp is the close connection Lefebvre posits between a particular form of subjectivity, new technologies of power and surveillance, and a uniquely modern conception of knowledge. More specifically, abstract space could only be produced via the reifications of linguistic representation at considerable remove from our tangible, embodied engagement with the world. It is language that makes possible the 'ever-growing hegemony of vision, of the visible and the legible (of the written, and of writing)' (Lefebvre 1991a: 140). What, then, is the precise role of the visual in the formation of abstract space, according to Lefebvre? Ever the Marxist, albeit a highly unorthodox one, he makes it clear that the modern production of space, as per the imperatives of capital accumulation and the reproduction of existing social relations, is not straightforwardly reducible to some sort of underlying scopic logic. The decisive factors are never simply 'codes' or ideologies in isolation, which is the conceit of an idealist textualism like semiotics, but rather 'modes of production [understood] as generalities covering specific societies with their particular histories and institutions' (Lefebvre 1991a: 47). This helps to explain why he identifies not one, but three central factors with respect to the emergence of abstract space: the visual, geometric and phallic. Tellingly, Lefebvre refers to each of these elements as 'formants', a musical term that refers to the acoustic resonance of the human voice.

1. The geometric—this is a purely mental space represented by Euclidean geometry, Descartes's mathematics, or a priori Kantian categories of time/space, all of which are divorced from the experiential world. The reduction of three-dimensional realities to two-dimensional plans and schemata results in an impoverishment and homogenization that clearly lends itself to the instrumentalized needs of technocrats, architects and urban planners. This abstract and infinite space, Descartes's *res extensa*, finds its representational form in 'blank sheets of paper, drawing-boards, plans, sections, elevations, scale models, geometrical projections, and the like' (Lefebvre 1991a: 200; see also Elden 2004a: 187–8).
2. The optical or visual—in modernity, the 'logic of visualization' (a term Lefebvre borrows from German art historian Erwin Panofsky) prefigured in Medieval cathedrals now dominates all social practice. It is marked by a fusion between the power of the written word and what Guy Debord popularly referred to as the 'spectacle' (although Lefebvre used the term before him, in the first volume of *Critique of Everyday Life*). There are two key components of this scopic regime: the metaphoric (the linguistic or visual images produced via textual inscription

supplant what is written about), and metonymy (the gaze of power transforms discrete, often hidden things into a unified, visible totality, as in the metonymic sequence 'driver-car-roadways').

3. The phallic—abstract space cannot be completely empty, so it is filled with something that symbolizes male power and virility and that holds sway over the generative feminine principle. In stressing the perpendicular, it proclaims 'phallocracy as the orientation of space, as the goal of the process' (Lefebvre 1991a: 287; see also Blum and Nast 1996; Stewart 1995).

Kirsten Ross has plausibly suggested that, in positing the triad geometrical-visual-phallic, Lefebvre is implicitly addressing what he takes to be the shortcomings of Debord's theory of the spectacle, which works on a purely optical basis; thus, the 'logic of visualization' as Lefebvre understands it is more complex than mere 'spectacularization' (see Ross 1999). What is apparent is that Lefebvre's 'formants' are intimately intertwined and mutually reinforcing: to conceive of the world geometrically relies exclusively on sight; the gigantic skyscraper only awes and intimidates if it is manifestly visible and dominates the urban skyline; and the supposed virility of the masculine principle works through the auspices of a 'penetrative' gaze. The cumulative effect is to alienate and reify, to negate the manifold qualities and potentialities of the human body and its mode of engagement with the material world, and to justify the relentless exploitation of natural space as per the dictates of capitalist accumulation. Such a visual logic has myriad deleterious effects, not only in terms of the formation of abstract space, but vis-à-vis the body itself. Chief amongst these is 'scotomization', an obscure term borrowed originally from nineteenth-century ophthalmology (referring to blind-spots), and later imported into French psychoanalysis, where it came to mean a kind of mental lacunae whereby we are seemingly unaware of the presence of others and indeed our own body. As Kirsten Simonsen puts it, in Lefebvre's usage scotomization 'signal[s] a historical process of abstraction of the body through an overlapping of the visual and the linguistic' (Simonsen 2005: 2). Another area where the violence of abstraction leaves its mark concerns the fragmentation and commodification of the body—especially the female body, of course, in the fetishistic, immature sexuality expressed in advertising or pornography. Just as space is fragmented, so the body is torn apart; abstract space becomes the place where 'nature is replaced by cold abstraction and by the absence of pleasure' (Lefebvre 1991a: 309).

Lefebvre suggests that the hegemonic visuality characteristic of modern abstract space can be traced ultimately to certain artistic techniques worked out in the Renaissance (Lefebvre 1991a: 79, 361). This thesis finds considerable support in Robert D. Romanyshyn's fascinating essay 'The Despotic Eye'. Here, Romanyshyn argues that the system of linear perspective and the 'vanishing point' (*punto di fuga*), as developed by such Renaissance artists as Leon Battista Alberti and Filippo Brunelleschi, is rooted in two key assumptions: first, that the world is 'infinite and homogeneous'; and second, that the further one removes oneself from multisensorial contact with the world, except through the abstracted gaze, the better one can understand and capture external reality

pictorially. Fifteenth-century Renaissance art, then, 'installs in place of the body a de-
tached eye, a disincarnated eye, as the vehicle of relation' (Romanyshyn 1984: 89). It
is worth nothing that the linear perspective was most efficaciously reproduced on the
painted or imprinted surface of the artwork through the use of a *velo*. This was a wooden
frame with cross-cutting lines through which the artist looked onto the landscape or
portrait, which allowed the outside world to be divided up into mathematically precise
horizontal and vertical vectors. It is not that this device mediates between the artist and
the world so much as it *becomes* the world itself as presented to the viewer, because to be
effective, the eye of the artist had to fixate exclusively on the thin screen stretched tightly
across the frame. (Interestingly, Alberti experimented with the *camera obscura* as well, and
was rumoured to have invented it.) In this way, the world is reduced to a set of numerical
values and the purely spatial relationships between imaged objects. It privileges a mon-
ocular, decorporealized and static mode of vision, in which dispassionate contemplation
supplants a fully embodied, affectual engagement with the world. Hence, the Italian
artist Lucantonio degli Uberti might well have been able to surveil imperiously the en-
tire Florentine landscape at a glance in his famous 1482 woodcut *Map with a Chain*—
significantly, the artist himself is clearly visible in the lower right-hand corner, peering at
the city from a hill-top through the lens of his *velo*—but he can never know first-hand
its tangible sounds, smells, tastes and rhythms (Romanyshyn 1984: 98). However primi-
tive a device it might seem at first glance, the role of the *velo* in Renaissance painting
would seem to conform neatly to Lefebvre's supposition that the modern domination
of space necessitates the mediation of a 'visionary' technology, one that 'introduces a
new form into a pre-existing space—generally a rectilinear or rectangular form such as
a meshwork or chequerwork' (Lefebvre 1991a: 165; also Kirsch 1995). One might fur-
ther speculate that the literal enframing of the world made possible by the Renaissance
velo evokes Heidegger's more metaphorical notion of *Gestell*. The latter refers to his argu-
ment in 'The Question Concerning Technology' that the essence of modern technology
is to contain or 'enframe' the world in an all-encompassing sense. The modern world has
value and significance only through its 'gathering together' as a visible 'presence' through
the aperture of specific technologies. In *Gestell* or enframing, the world is disclosed in-
strumentally 'in conformity with which the work of modern technology reveals the real
as standing-reserve', which negates the possibility of dwelling in the world aesthetically
(in the original Greek sense of *aisthesis*) (Heidegger 1977a: 302).

For Lefebvre, then, there is no 'neutral' gaze that brushes lightly over the surface of
things without leaving a trace; *how* we see has a considerable impact on the manner in
which we engage with, cognitively structure and shape in the world in practical ways.
This critique of the 'logic of visualization' clearly owes a large debt to Nietzsche (see
Merrifield 1995). In one of the few explicit references to his influences, *The Production
of Space* finds Lefebvre mentioning Nietzsche's belief that the abstract ideas perfected
in the modern era and their legal-rational instantiation impose themselves violently
on the fleshy reality of human bodies and their desires. In his earlier, 'Enlightenment'
phase, usually identified with *Human, All Too Human*, Nietzsche gives a favourable cast

to at least some ocular images and metaphors. But, in the bulk of his written work, Nietzsche identifies the visual register as the primary vehicle for an abstract, disembodied form of thought, especially through the distanciated images and circumlocutionary tropes of language. Regardless of the actual complexities of Nietzsche's presumptive anti-ocularcentrism (see Shapiro 1995), Lefebvre's position here is clear enough:

> Nietzsche stresses the visual aspect predominant in the metaphors and metonyms that constitute abstract thought: idea, vision, clarity, enlightenment and obscurity, the veil, perspective, the mind's eye, mental scrutiny, the 'sun of intelligibility', and so on. This is one of Nietzsche's great discoveries (to use another visual metaphor). He points out how over the course of history the visual has increasingly taken precedence over elements of thought and action deriving from the other senses (the faculty of hearing and the act of listening, for instance, or the hand and the voluntary acts of 'grasping', 'holding', and so on). So far has this trend gone that the senses of smell, taste, and touch have been almost completely annexed and absorbed by sight. (Lefebvre 1991a: 139)

To the 'holy trinity' of Marx, Nietzsche and Hegel, which by his own admission are Lefebvre's central influences, we could add Heidegger, for, as Stuart Elden convincingly argues, the latter's influence on Lefebvre has been woefully underappreciated (Elden 2004b; see also Waite 2008). In this context, we might single out Heidegger's famous 1938 essay 'The Age of the World Picture'. Although Lefebvre doesn't cite this piece directly, there are clear parallels with his own suppositions regarding the link between vision, domination and modernity, and we also know he was on intimate terms with the entire corpus of the controversial German philosopher. In 'The Age of the World Picture', Heidegger suggests that what characterizes modern science is its method of knowing the external world solely through an objectified representation of it, as reflected in the unblinking gaze and abstract cognition of a disembodied, egological subject. It is not that we grasp the world pictorially so much as it *becomes* a picture, with nothing else left over. This operation facilitates the transformation of the natural world into a 'standing reserve', which exists, according to the logic of such a 'metaphysics of presence', only insofar as we have specific, instrumentalized uses for it. 'In the planetary imperialism of technologically organized man', writes Heidegger, 'the subjectivism of man attains its acme, from which point it will descend to the level of organized uniformity and there firmly establish itself. This uniformity becomes the surest instrument of total, i.e., technological, rule over the earth' (Heidegger 1977b: 152). As David Michael Levin astutely points out, however, this attack on representational thinking cannot be equated with a straightforward equation of vision with nihilism per se on Heidegger's part. Rather, it is indicative of the latter's belief that there exists a close connection, but not necessarily a simple identity, between seeing and the modern 'will to power'. As such, it is possible to imagine an alternative mode of visualization, to foster a 'gaze that would hold itself open to the interplay of the visible and the invisible, the present and the absent—an interplay that is also made visible as the gift of the ontological difference, opening up a field of illumination for the enactment of human vision' (Levin 1995: 212).

THE REVOLT OF THE (MULTISENSORY) BODY

Heidegger's 'openness' to the solicitation of the world, his desire to cock a real and metaphorical ear towards its often muted rhythms, cadences and vibrations, is arguably closely aligned with Lefebvre's way of thinking. But against Heidegger's nostalgic pastoralism, not to mention his questionable political sympathies, Lefebvre locates the realm of utopian possibility firmly in the present, in the radically democratic potentialities to be found in the sphere of contemporary urban life (see Lefebvre 1996, 2003). More specifically, he believes that any history of space charged with emancipatory tasks must grasp the internal, constitutive relationship between the scopic regime of modernity and the increasing abstraction of the world, highlight their strategic interaction, and understand the crucial role they have in the conceptualization and practical realization of abstract space. Such an exercise will help us to comprehend how societies have produced space-time historically, including the manner in which they have been perceived, conceived and lived, and how their existing valances might be reconfigured. This 'retrospective-prospective' method might help us to envision an alternative space-time, and hence of a different ('impossible-possible') society. As Neil Maycroft puts it, throughout his long career Lefebvre was committed fully to 'romanticism, utopianism and a political philosophy of possibility' (Maycroft 2001: 125).

Again, Lefebvre is adamant that space is not a 'text' that can be 'read' by visual means alone. The social world is certainly steeped in communicative exchange and the superabundant production of signs, but it does not follow that space is a 'blank page' inscribed by real or metaphorical 'writing', in which unambiguous messages are passed back and forth between disembodied consciousnesses. Following Bataille and Nietzsche, Lefebvre argues that if we are sensitive to the full range of human action and experience, we come to understand there are clear limits to language and the forms of knowledge it makes possible. He concurs with Goethe's famous dictum: 'I cannot grant the word such sovereign merit' (cited in Lefebvre 1991a: 134). To mediate on the question of space provides us with an excellent vindication of this insight: it is not polished, completed 'text', but rather a 'rough draft, jumbled and self-contradictory', a mix of injunctions and prohibitions but also open possibilities—which he describes, well before Giddens, as a form of 'structuration'—all of which is anchored firmly in the prevailing matrix of spatial and institutional organization and power. Space might well 'speak', but it also has its gaps, silences and occulations: it is *produced* before it is read. It cannot be 'decoded' by linguistic or discursive means only, but must be lived in and through. The type of body we generate in our tangible encounter with the world is a function of how space is actually *used* within the terrain of our lived experience, involving a myriad of gestures, traces and marks. 'Prior to knowledge, and beyond it, are the body and the actions of the body: suffering, desire, pleasure', says Lefebvre. As such, the disengaged spectator, much less the sociological positivist or urban planner, cannot hope to grasp more than a 'pale shadow' of this complex, multilayered reality; they forget that space 'does not arise from a visible-readable realm, but that it is first of all *heard* (listened to) and *enacted* (through physical gestures and movements)' (Lefebvre 1991a: 135, 137, 200).

We cannot fully appreciate Lefebvre's attempt to locate alternative sensory modalities vis-à-vis the ocularcentric bias of modernity without reference to his more general account of the body. In Cartesian terms, the body is a mere container for the information recording machine that is the brain. Obviously, Lefebvre has little time for this conception, but equally rejects the Deleuzean notion of the body (without organs) as a 'desiring machine'. Albeit in very different ways, such images reflect the evisceration and fragmentation of the body that occurs in abstract space; they are '*ex post facto* projections of an accomplished intellect, against the reductionism to which knowledge is prone' (Lefebvre 1991a: 201). In repudiating the twin abstractions of the 'body-machine' and an empty and infinite space, both of which dominate Western philosophy, Lefebvre argues for a space that is 'always-already' occupied, always embodied. What occupies space is 'not bodies in general, nor corporeality, but a specific body, a body capable of indicating direction by a gesture, of defining rotation by turning round, of demarcating and orienting space' (Lefebvre 1991a: 170). Such a body is shaped by the qualities of this space, but equally creates its own space through the manner in which it deploys its capacities and vital energies. Preferring organic to mechanistic metaphors, Lefebvre posits a dynamic, vitalistic body, one that, much like Mikhail Bakhtin's 'grotesque body', joyfully transgresses proffered boundaries and thresholds, whether physical or symbolic, eroding the supposedly rigid barriers between knowledge and action, head and genitals, inner and outer, even human and nonhuman (see Bakhtin 1984; Gardiner 1993). The Lefebvrean body is not one of quiet repose or equilibrium; rather than imbued with a Weberian asceticism and concerned only for the pallid attractions of one's bank balance or the afterlife, it is invested with prodigalities of 'waste, play, struggle, art, festival—in short, Eros' (Lefebvre 1991a: 177). The key for Lefebvre is to not hierarchize different aspects of our embodied being-in-the-world, to privilege the head and the eyes, and hence abstract cognition—which is the default position of Western philosophy at least since Descartes. Rather, we should affirm the 'dialectical' or 'practico-sensory totality' of the body, which occupies a dense space where 'bodies and objects, sense organs and products all cohabit in "objectality"' (Lefebvre 1991a: 62, 164).

For Lefebvre, moreover, the body is the real source of genuine difference in the world: it is capable of generating novelty out of its seemingly repetitive gestures and actions, combining materials (things used in the construction of mental or physical things) and *matériels* (tools, techniques, instructions for use) in a manner that modifies nature in creatively unpredictable ways. Machines, by contrast, are only capable of a 'serial' form of repetition in which each discrete action is interchangeable and nothing new is ever created. Against all the odds, then, the body has its 'secrets' and its hiding places, its 'underground', even 'labyrinthine' qualities (such as those found in the hidden folds and openings of the female body); it is simultaneously 'present' and 'absent', existing *in potentia*, or *virtually*. Corporeality is therefore imbued with a 'cryptic opacity' that can never, in Lefebvre's opinion, be fully 'decoded' by analytic reason. Indeed, he longs for a 'revolt of the body', and believes there are glimmerings of such an uprising in the marginalized spaces of daily life. If we play close attention to the less rationalized and commodified spaces of users in the course of their daily activities, as opposed to the workings of the

Foucaultian panopticon, we can begin to detect the manner in which space is actively perceived and lived in a direct, embodied way, rather than merely conceived of abstractly. It is precisely here where meaningful social change has to occur, in a 'differential' space-time that abstract space unwittingly harbours, and that might well prove to be its gravedigger. 'Space is no longer defined exclusively in optical, geometrical and quantitative fashion', he writes. 'It is becoming—or once again becoming—a flesh-and-blood space, occupied by the body (by bodies). Judging from certain readily observable symptoms, daily life is tending to become, or once again become, multi-sensory' (Lefebvre 2002: 102).

Insofar as the organism can only be grasped *in situ*, through its location in concrete space, the full spectrum of the human sensory apparatus is relevant to Lefebvrean thinking. Experiential space is grounded in all the senses; when we arrive in a new city or country, Lefebvre notes, we experience it through smell and taste, through the soles of our feet, the vibrations that resonate in our body, at least as much as our seeing. What attenuates such a multisensory engagement with the world are the abstractions induced by modern abstract space, and especially the technological mediation of our relation to that space. With reference to the burgeoning steam-train networks of nineteenth-century Europe and North America, for instance, Wolfgang Schivelbusch observes that sight 'became the only qualities that the railroad traveler was able to observe in the landscape he traveled through. Smells and sounds, not to mention the synesthetic perceptions that were part of travel in Goethe's time simply disappeared' (Schivelbusch 1986: 5). In an unusual article, J. Nicholas Entrikin and Vincent Berdoulay focus on certain biographical details about Lefebvre (his long association with the Pyrenees region of France and Spain), as well as his popularly written 1965 book on the same area, and present him as something of a philosophically informed travel writer that might be construed as the very antithesis of Schivelbusch's imaginary nineteenth-century railway passenger: 'The words used by Lefebvre for speaking about "his land" (*pays*) demonstrate a deep affection and a sense of reconnection. In spite of his reticence to talk about nature without man, he momentarily adopts this unbalanced perspective in order to express his affection: "These lands. I savor them on my lips and the breath in their smells and perfumes"' (Entrikin and Berdoulay 2005: 139). Another example of Lefebvre's appreciation for the multisensory body can be found in his assertion that, in the monumental space of the Medieval cathedral, each visitor must 'become aware of their own footsteps, and listen to the noises, the singing; they must breathe the incense-laden air, and plunge into a particular world, that of sin and redemption; they will partake of an ideology; they will contemplate and decipher the symbols around them; and they will thus, on the basis of their own bodies, experience a total being in a total space' (Lefebvre 1991a: 221). Notwithstanding the fact that, as discussed above, the cathedral anticipated the hegemonic visuality of modernity, it successfully engages all the senses, and links each person's intimate gestures (prayers, genuflections) to the wider cosmos, thereby acknowledging the integrity of the total body. This is quite unlike modern architecture, which is designed for purely visual contemplation, dominated as it is by the very different monumentality of the external façade, which narcissistically refers only to its own power and reduces the individual to the insignificance of a dust-mote.

Numerous passages of *The Production of Space* are devoted to often minute analyses of the different senses and how they overlap and work syncretically, and it is instructive to focus on some of these observations. For instance, Lefebvre suggests here that experiential space-time is grounded in the olfactory at least as much as the visual. Perhaps in part because it works through direct chemical contact, the sense of smell is the most intimate linkage between 'subject' and 'object', to the point where it blurs the distinction between them. Although fast disappearing under the modern onslaught against smells, fair and foul alike, and their substitution by purely visual signs and spectacles, the olfactory persists in marginalized peripheral spaces (the cooking in ethnic neighbourhoods, in fairgrounds or farmyards), displaying a vestigial connection to the erotic in particular (Lefebvre 1991a: 197; see also Corbin 1986). Odours are raw and immediate, and often spontaneously evoke strong and irrepressible emotional reactions; their primal connection to the reptilian parts of the brain render them difficult to translate into abstract linguistic terms. This is why we lack a fully worked out metaphorical vocabulary for odours; to describe a smell as 'fishy' merely refers us back to the source, whereas the use of terms like 'acrid' or 'fresh' are really only *categories* that can never get beyond vague generalization. Smells for Lefebvre are therefore directly 'expressive', not metaphorical; they can be itemized, but not 'decoded' semiotically. Taste occupies a sightly different realm—underdeveloped in the human sensory apparatus, it is difficult to delineate from smell, or the tactility of the tongue and lips. Because taste tends to work through simple oppositions, such as sour/sweet, it is more amenable to cultural encoding and systematization—witness Lévi-Strauss's *The Raw and the Cooked*. Yet even here there are exceptions, according to Lefebvre: in nature, tastes are much more complexly intertwined, as in the bittersweet of unprocessed chocolate, and it would seem that it is culture that separates out and contrasts discrete flavours.

But it is hearing that is most central to Lefebvre's style of thinking. He regards it as the primary sense of the premodern era, and his works are peppered with innumerable musical and auditory references and metaphors. Lefebvre's lengthy study *Introduction to Modernity* was even conceived of as a 'musical' work composed of twelve 'preludes', designed to be 'understood in the mind's ear, to be a cry, a song, a sigh, and not simply to be read as a theoretical and discursive statement' (Lefebvre 1995: 4). Lefebvre is not just speaking metaphorically here. For instance, he points out that hearing is vital to the lateralization of space and allows us to chart its intimate topography, at least as much as seeing. Indeed, he notes that if space was completely homogeneous and simultaneously 'present', it would be literally 'imperceptible', and hence impossible to navigate and orient oneself in. Within the realm of lived space, there must be a mixture of presence/absence, visible/invisible, sound/silence, and innumerable gradations in between. These ideas about the acoustical resonances of life come to fruition in his last work, on the body and 'rhythmanalysis'. *In nuce*, Lefebvre believed that the body was animated by a 'bouquet' of vibrations or rhythms pitched at many different levels (molecular, cellular, communal, climatic and geographical), in which there was harmonic overlapping and partial fusion between natural and socially and historically shaped forces, especially between the linear and the cyclical. In this intersection, profound differences can be

created: 'If there is difference and distinction, there is neither separation nor an abyss between so-called material bodies, living bodies, social bodies and representations, ideologies, traditions, projects and utopias. They are all composed of (reciprocally influential) rhythms in interaction' (Lefebvre 2004: 43).

Whereas the hegemonic visuality Lefebvre associates with modernity has a highly problematic relationship to time, for reasons already discussed, the senses of smell, touch and taste retain a more organic, constitutive relation to embodied memory and historicity. Proust's famous Madeleine cake comes to mind, and it is worth noting that Proustian notions of involuntary, corporeal remembrance had more than a passing influence over Lefebvre's ideas about the potentially transformative 'moment' and our inherently affective relation to space (see Elden 2004a: 180). The overarching point, however, is that the body evinces a 'kernel' that resists the systematization of discursive processing and instrumental reason. In the blending and overlapping of the senses that occurs in the total body, what Juhani Pallasmaa calls the 'haptic continuum of the self' (Pallasmaa 2005: 11), there is a ' "something" which is not truly differential but which is nevertheless neither irrelevant nor completely undifferentiated: it is within this primitive space that the intimate link persists between [the senses]' (Lefebvre 1991a: 199). When an abstract opticality dominates, not only do the other senses lose their former richness and vitality, when they are utilized, they are consigned to the role of mere 'understudy' in the service of superordinate visual phenomena: 'Any non-optical impression—a tactile one, for example, or a muscular (rhythmic) one—is no longer anything more than a symbolic form of, or a transitional step towards, the visual' (Lefebvre 1991a: 286). Vision is essential to the logic of abstract space because it seems to 'freeze' the dialectic, to render dynamic movements as static objects within a well-ordered tableau. But, for Lefebvre, time and space form a synergetic 'knot' that cannot be arbitrarily disentangled. If we are to successfully detach seeing from this illusion of temporal stasis, what we have to do, in effect, is to learn to 'hear with our eyes'. An illustration of this can be located in Bakhtin's essay on the *Bildungsroman* in European literature, which contains a brief discussion of Goethe. Here, Bakhtin argues that vision for Goethe was not a passive, quasi-mechanical device (a 'crude primitive sensualism') for registering preconstructed objects in the world, or a mere conduit for rarefied thoughts and ideas. Goethe knew that vision, properly grasped in all its expressive richness, facilitated an embodied connectedness to the world, not an abstracted distanciation from it. Goethe's world pulsates rhythmically: even the most apparently immobile and monumental things—mountains, for instance—are alive, moving, changing. Hence, seeing is always entwined with a process of ceaseless becoming, with the open-ended vitality and dynamism of the world; space that 'appeared to be a stable and immutable background for all movements and changes became for Goethe a part of emergence, saturated through and through with time' (Bakhtin 1986: 30).

There is arguably much Lefebvre would find favour with here, especially the Goethean insight that space and time are inseparable, and that our sensory apparatus does not passively and mimetically reproduce the external world. Rather, spaces and the bodies that inhabit them are simultaneously immediate and mediator, subject and object,

transmitter and recipient, visible and opaque. Self, other and world are imbricated and interrelate reciprocally in a shared, 'primordial' realm of endless exchanges of matter and energy, flow and coexistence. Analytical reason cannot fully grasp this mobile and 'open' synthesis, which is structured in difference and not subject to ultimate closure, because it can only imagine discrete elements in fixed combination. In a fascinating couple of paragraphs from *The Production of Space*, which demonstrate his (rarely acknowledged) indebtedness to the late work of Maurice Merleau-Ponty (see Gardiner, chapter 4), Lefebvre spells out this insight:

> Objects touch one another, feel, smell and hear one another. Then they contemplate one another with eye and gaze. One truly gets the impression that every shape in space, every spatial plane, constitutes a mirror and produces a mirage effect; that within each body the rest of the world is reflected, and referred back to, in an ever-renewed to-and-fro of reciprocal reflection, an interplay of shifting colours, lights and forms. A mere change of position, or a change in a place's surroundings, is enough to precipitate an object's passage into the light: what was covert becomes overt, what was cryptic becomes limpidly clear. A movement of the body may have a similar goal. Here is the point of intersection of the two sensory fields. [Here we find a] shifting intersection between that which touches, penetrates, threatens or benefits my body on the one hand, and all other bodies on the other. Thus we are concerned, once again, with gaps and tensions, contacts and separations. Yet, through and beyond these various effects of meaning, space is actually experienced, *in its depths*, as duplications, echoes and reverberations, redundancies and doublings-up which engender—and are engendered by—the strangest of contrasts: face and arse, eye and flesh, viscera and excrement, lips and teeth, orifices and phallus, clenched fists and open hands. (Lefebvre 1991a: 183–4)

There is much to unravel in this dense but rewarding passage, but perhaps we can focus on the following: that the body represents an opening on to the world, and the entry of the world into the body, but in a manner that goes beyond the implied passivity of a Heideggerian 'receptiveness', so as to embrace a more dynamic, mutually constituting model of spatial bodies. Without being fully aware of it, yet not 'unconsciously', the human subject 'draws from the heart of the universe movements that correspond to its own movements. The ear, the eyes and the gaze and the hands are in no way passive instruments that merely gaze and the hands are in no way passive instruments that merely register and record. What is fashioned, formed and produced is stabilised on . . . the scale of the earth, of accidents on the earth's surface and the cycles that unfurl there' (Lefebvre 2004: 83). This implies two main things: first, all the senses, *including* vision, are active and shape the entire world in myriad ways; and second, that 'production' is not just a matter of 're-producing' objects given in nature, but something that 'exceeds or transfigures' the world through a mutually constitutive and transformative process, creating a 'surplus', a newness or 'maximal' difference, that did not exist previously. This affirmation of the senses as dynamic and transformative finds considerable support in the first volume of *Critique of Everyday Life*, where Lefebvre suggests that the eye does not simply register the external

world, but rather can be 'trained' through an on-going engagement with the object, as mediated by specific techniques. This is most clearly seen in painting: here, the realization that we *invent* rather than simply *observe* through our perceptual opening on to the world is cast into sharp relief. As Lefebvre suggests, it is in painting where 'the human eye has found the appropriate object; the human eye has formed and transformed itself first through practical and then through aesthetic activity, and by knowledge: it has become something other than a mere organ; for the painter [it means] truly prefiguring the realm of freedom, and producing the work of art' (Lefebvre 1991b: 174).

CONCLUSION

These brief comments on painting are significant because they raise the distinct possibility of *different modalities* of vision. Lefebvre, by his own admission, is a deliberately anti-systematic thinker, and his treatment of sight, as with many of his other topics, is not without ambiguity and contradictoriness. Admittedly, at times Lefebvre does seem to subscribe to a straightforward anti-ocularcentrism, such as when he suggests that 'the image kills', or that sight reduces things to 'an icy coldness', and at one point implies that the gaze is innately *masculine* (Lefebvre 1991a: 97, 286). But the overarching impression one gets in reading across Lefebvre's *oeuvre* is that he believed vision was not *inherently* domineering or hegemonic, although it certainly can be in specific socio-historical contexts. This leaves open our ability to disengage discrete perceptual fields from existing systems of power and domination, of exploring alternatives to the ocularcentric bias of contemporary Western (and 'Westernizing') societies, thereby nurturing 'wider and more far-reaching ways of seeing' (Lefebvre 1991b: 189–90). In taking this stance, Lefebvre offers contemporary analyses of visual culture a number of key insights that they would do well to heed: he counsels us to avoid the extremes of either biological or cultural reductionism; sensitizes us to the role played by the social and technological mediation of sight; and, perhaps most important, makes us realize that visual phenomena cannot be analysed in isolation, but only in relation to the 'total body', including the human affective and gestural registers (see Anderson 2006; Thrift 2008). Indeed, Lefebvre's call for a multisensorial engagement with space has already been reflected in a number of attempts to understand the fabric of urban life along such lines, which includes but goes well beyond purely visual experience (see Cronin 2006; Wunderlich 2008).

Carolyn Lee Kane has written that 'The cost aesthetic philosophy pays for severing its connection to the concrete and material world is immeasurable', wherein the status of the visual is 'not even neutral, but fiercely corrosive' (Kane 2007: 88, 86). Lefebvre's work on space can be seen as an attempt to undo this millennia-old damage. If he associates the hegemonic visuality of modernity with 'false consciousness, quasi-knowledge and non-participation', Lefebvre believes there still remains the chance that we can learn to look on the world 'with cultivated eyes, and love with senses formed by the *art of living*' (Lefebvre 2002: 90; 1995: 355, emphasis added). This would be a celebratory, 'socialized' type of vision, rather than an individuated and privatized one, and it would help effect the transition to a genuinely 'differential' or heterotopic space,

rather than the endless reproduction of the same. The true repository of the beauty of the world, as the ancients understood very well, is not to be found in rarefied ideas or formal stylistic properties grasped through solitary intellectual contemplation, but in embodied, communal participation: in the ecstatic dances of Dionysian revelry, the hoots and belly-laughs that accompany comic theatre, and the sensual pleasures of the feast (Lefebvre 2005: 135; see also Ehrenreich 2006). This again underscores the role played by the aesthetic vis-à-vis any such utopian transfiguration of the senses, but specifically in the original Greek meaning of *aisthesis*, as touched on above. Lefebvre firmly believed that a viable model of social change must involve a radical critique of the alienated conception of art as the nonsocial and essentially representational activity of the individual genius, as something external and in every way superior to the realm of the everyday (see Léger 2006). Rather, art must ultimately fulfill and supercede itself, along with philosophy; it needs to be fully reintegrated into a revivified everyday life, where it will become the touchstone of a multifarious existence understood and lived as an artwork. It seems fitting to conclude this chapter with a quotation from the second volume of Lefebvre's *Critique of Everyday Life*, where, in evoking Marx's famous passage from *The German Ideology*, he affirms the original vision of communism as a world in which 'everyone would rediscover the spontaneity of natural life and its initial creative drive, and perceive the world through the eyes of an artist, enjoy the sensuous through the eyes of a painter, the ears of a musician and the language of a poet' (Lefebvre 2002: 37).

FURTHER READING

Gardiner, Michael E. 2000. *Critiques of Everyday Life*. London and New York: Routledge.
Lefebvre, Henri, 1991. *The Production of Space*. Oxford: Basil Blackwell.
Lefebvre, Henri, 1991. *Critique of Everyday Life*, volume 1, Introduction, trans. John Moore. London and New York: Verso.
Lefebvre, Henri, 2004. *Rhythmanalysis: Space, Time and Everyday Life*. New York and London: Continuum.

REFERENCES

Anderson, Ben. 2006. 'Becoming and Being Hopeful: Towards a Theory of Affect', *Environment and Planning D: Society and Space*, 24: 733–52.
Bakhtin, Mikhail M. 1984. *Rabelais and His World*. Bloomington: Indiana University Press.
Bakhtin, Mikhail M. 1986. *Speech Genres and Other Late Essays*. Austin: University of Texas Press.
Barnard, Malcolm. 1995. 'Advertising: The Rhetorical Imperative', in Chris Jenks (ed.), *Visual Culture*. London and New York: Routledge, 26–41.
Blanchot, Maurice. 1997. *Friendship*. Stanford, CA: Stanford University Press.
Blum, Virginia and Heidi Nast. 1996. 'Where's the Difference? The Heterosexualization of Alterity in Henri Lefebvre and Jacques Lacan', *Environment and Planning D: Society and Space*, 14: 559–81.
Breton, André. 1990. *Communicating Vessels*. Lincoln: University of Nebraska Press.

Collinge, Chris. 2008. 'Positions without Negations? Dialectical Reason and the Contingencies of Space', *Environment and Planning A*, 40/11: 2613–22.

Corbin, Alain. 1986. *The Foul and the Fragrant: Odor and the French Social Imagination*. Cambridge, MA: Harvard University Press.

Cronin, Anne M. 2006. 'Advertising and the Metabolism of the City: Urban Space, Commodity Rhythms', *Environment and Planning D: Society and Space*, 24: 615–32.

Dimendberg, Edward. 1998. 'Henri Lefebvre on Abstract Space', in Andrew Light and Jonathan M. Smith (eds), *The Production of Public Space: Philosophy and Geography II*. Lanham, MD: Rowman & Littlefield, 17–47.

Ehrenreich, Barbara. 2006. *Dancing in the Streets: A History of Collective Joy*. New York: Metropolitan Books.

Elden, Stuart. 2004a. *Understanding Henri Lefebvre: Theory and the Possible*. London and New York: Continuum.

Elden, Stuart. 2004b. 'Between Marx and Heidegger: Politics, Philosophy and Lefebvre's *The Production of Space*', *Antipode*, 36/1: 86–105.

Entrikin, J. Nicholas and Vincent Berdoulay. 2005. 'The Pyrenees as Place: Lefebvre as Guide', *Progress in Human Geography*, 29/2: 129–47.

Foucault, Michel. 1986. 'Of Other Spaces', *Diacritics*, 16/1: 22–27.

Gardiner, Michael. 1993. 'Ecology and Carnival: Traces of a "Green" Social Theory in the Writings of M. M. Bakhtin', *Theory and Society*, 22/6: 765–812.

Heidegger, Martin. 1977a. *Martin Heidegger: Basic Writings*. New York: HarperCollins.

Heidegger, Martin. 1977b. *The Question Concerning Technology and Other Essays*. London and New York: Garland.

Jay, Martin. 1993. *Downcast Eyes: The Denigration of Vision in Twentieth-century French Thought*. Berkeley: University of California Press.

Kane, Carolyn Lee. 2007. 'Aisthesis and the Myth of Representation', *Minerva: An Internet Journal of Philosophy*, 11: 83–100.

Kirsch, Scott. 1995. 'The Incredible Shrinking World? Technology and the Production of Space', *Environment and Planning D: Society and Space*, 13: 529–55.

Kouvelakis, Stathis. 2008. 'Henri Lefebvre, Thinker of Urban Modernity', in Jacques Bidet and Stathis Kouvelakis (eds), *Critical Companion to Contemporary Marxism*. Leiden and Boston: Brill, 711–27.

Lefebvre, Henri. 1991a. *The Production of Space*. Oxford: Basil Blackwell.

Lefebvre, Henri. 1991b. *Critique of Everyday Life, Vol. I*. London and New York: Verso.

Lefebvre, Henri. 1995. *Introduction to Modernity: Twelve Preludes, September 1959–May 1961*. London and New York: Verso.

Lefebvre, Henri. 1996. *Writings on Cities*. Oxford: Basil Blackwell.

Lefebvre, Henri. 2002. *Critique of Everyday Life, Vol. II: Foundations for a Sociology of the Everyday*. London and New York: Verso.

Lefebvre, Henri. 2003. *The Urban Revolution*. Minneapolis: University of Minnesota Press.

Lefebvre, Henri. 2004. *Rhythmanalysis: Space, Time and Everyday Life*. New York and London: Continuum.

Lefebvre, Henri. 2005. *Critique of Everyday Life, Vol. III: From Modernity to Modernism*. London and New York: Verso.

Lefebvre, Henri. 2009. *State, Space, World: Selected Essays*. Minneapolis: University of Minnesota Press.

Léger, Marc James. 2006. 'Henri Lefebvre and the Moment of the Aesthetic', in Andrew Heming-way (ed.), *Marxism and the History of Art from William Morris to the New Left*. London and Ann Arbor, MI: Pluto Press, 143–60.

Levin, David Michael. 1988. *The Opening of Vision: Nihilism and the Postmodern Situation*. London and New York: Routledge.

Levin, David Michael. 1995. 'Decline and Fall: Ocularcentrism in Heidegger's Reading of the History of Metaphysics', in David Michael Levin (ed.), *Modernity and the Hegemony of Vision*. Berkeley and London: University of California Press, 186–217.

Maycroft, Neil. 2001. 'Henri Lefebvre: Alienation and the Ethics of Bodily Reappropriation', in Lawrence Wilde (ed.), *Marxism's Ethical Thinkers*. Basingstoke: Palgrave, 116–43.

McDonough, Tom. 2008. 'Invisible Cities: On Henri Lefebvre's *The Explosion*', *Art Forum* (May): 315–22.

Merrifield, Andrew. 1995. 'Lefebvre, Anti-logos and Nietzsche: An Alternative Reading of *The Production of Space*', *Antipode*, 27/3: 294–303.

Pallasmaa, Juhani. 2005. *The Eyes of the Skin: Architecture and the Senses*. Chichester: John Wiley & Sons.

Romanyshyn, Robert D. 1984. 'The Despotic Eye: An Illustration of Metabletic Phenomenology and Its Implications', in D. Kruger (ed.), *The Changing Reality of Modern Man: Essays in Honor of Jan Hendrik Van Den Berg*. Pittsburgh: Duquesne University Press, 87–125.

Ross, Kirsten. 1999. Review of Henri Lefebvre's *The Production of Space, Not Bored*, 30. http://www.notbored.org/space.html.

Sandywell, Barry. 2011. *Dictionary of Visual Discourse: A Dialectical Lexicon of Terms*. Farnham: Ashgate.

Schivelbusch, Wolfgang. 1986. *The Railway Journey: the Industrialization of Time and Space in the 19th Century*. Berkeley and Los Angeles: University of California Press.

Shapiro, Gary. 1995. 'In the Shadows of Philosophy: Nietzsche and the Question of Vision', in David Michael Levin (ed.), *Modernity and the Hegemony of Vision*. Berkeley and London: University of California Press, 124–42.

Simonsen, Kirsten. 2005. 'Bodies, Sensations, Space and Time: The Contribution from Henri Lefebvre', *Geografiska Annaler*, 87/1: 1–14.

Stewart, Lynn. 1995. 'Bodies, Visions, and Spatial Politics: A Review Essay on Henri Lefebvre's *The Production of Space*', *Environment and Planning D: Society and Space*, 13: 609–18.

Thrift, Nigel. 2008. *Non-Representational Theory: Space, Politics, Affect*. London and New York: Routledge.

Waite, Geoffrey. 2008. 'Lefebvre without Heidegger: "Left-Heideggerianism" *Qua Contradictio in Adiecto*', in Kanishka Goonewardena, Stefan Kipfer, Richard Milgrom, and Christian Schmid (eds.), *Space, Difference, Everyday Life: Reading Henri Lefebvre*. London and New York: Routledge, 94–114.

Wunderlich, Filipa Matos. 2008. 'Walking and Rhythmicity: Sensing Urban Space', *Urban Design*, 13/1: 125–39.

Cubist Collage and Visual Culture: Representation and Politics

IAN HEYWOOD

VISUAL CULTURE STUDIES AND POSTMODERNITY

It has long been a commonplace that the study of visual culture, and of culture in general, cannot evade questions of value and politics. Certainly the quasi-discipline of cultural studies, sometimes defined as the general study of signifying practices, which has exercised considerable influence on the study of visual features of culture in recent years, rarely claims to offer a detached or neutral study of values and politics as they surface in and structure cultural practices. Cultural theorists usually insist on their obligation to 'intervene' in on-going culturally expressed political processes.

The influence of theories of postmodernism and postmodernity on visual culture studies is too complex to be fully discussed here. However, in their useful and influential primer, Cartwright and Sturken (2001) illuminate a connection between postmodernism and the value stance of visual culture studies. They suggest that in practice visual culture studies has incorporated key insights and assumptions of postmodernism. In particular, they present postmodernism as 'complicating' the relationship between high and popular culture, thus making a 'critical viewpoint on culture from outside or above it' impossible.[1]

If there is no 'outside' to culture, we are left to examine the possibility of a vantage point within it. The stakes here are high. If an immanent 'critical viewpoint on culture' cannot be rationally articulated and defended then criticism is indistinguishable from the reflex expression of local tastes. Certainly the postmodern cultural theorist could not raise his or her particular tastes or values above anyone else's, nor use them just as they are as a basis for argument about quality. The vantage point on which criticism relies seems to entail something like a 'ladder', usually in the form of discrimination or taste, either in-born or learned. However, this idea is usually rejected as 'elitist'. Alternative ladders have been traditionally supplied by a theory or methodology, a conceptual

structure or cognitive procedure. Theory or method should lead, if not to elevation, at least to a cultural location different from other locations in ways relevant to the possibility of genuine, defensible criticism.

The ideal of a critical stance capable of legitimating itself through theory and method and evaluating a wide variety of cultural phenomena resembles the position formerly occupied by high culture, even if the means of attaining it are different.[2] Unfortunately, theory seems to many to be inaccessible, even elitist, as poetry or opera, its distribution generally reflecting that of economic and social capital. Equally, while methodology has plausible 'democratic' credentials, if it does not lead out of common opinion towards superior knowledge, it serves only as spin.[3]

In sum, questions of value, and in particular how particular values are arrived at and woven into the everyday lives and cultural activities of groups and individuals, are integral to visual culture studies. This must apply also to any form of cultural study itself, that is, the selection of research topics, as well as choice of methods, is inevitably strongly value-related. This leads unavoidably to difficult questions regarding the possibility and desirability of reasoned argument about choices and values, leading ultimately to defensible critical discriminations.[4] The usual alternative to the notion of in-born taste, commonly attributed to modernists and snobs, is theory or method, but both can appear problematic from points of view influenced by postmodernism. It seems that as a quasi-discipline visual cultural studies needs theory and method, but remains unsettled about their character and foundation.

CULTURE AND MODERNITY

The example of Cubist collage enables us to consider a key 'revolutionary' moment in modern visual art and the part played by a complex encounter with the emerging vernacular visual culture of the twentieth century.[5] More important, it also requires discussion of the values and politics in play at this point in the appearance of visual modernity, or stated in a different way, the relationship between the modernization of painting and the modernization of everyday life. However, enquiry into modernization has to include questions about the possibility of and context for critical reflection in the form of visual culture studies itself.

The relationship between art, culture in a broad sense, and modernization has been an explicit concern for historians, philosophers, critics and social scientists since the nineteenth century. The tradition of social theory, an early and important crucible for the formation of models and images of modernity, emphasized causal relationships between supra-individual conditions and forces: for example the development of industrial technology and its application to the production and distribution of goods, the legal framework of property ownership, the internationalization of money and markets, and the means through which political power is legitimated, distributed and exercised.[6] Essentially to do with representations, ideas and beliefs, either embedded in everyday practices or explicitly expressed in the arts, culture was initially understood as largely reflective or reactive with respect to other powerful structuring forces. Eventually, however, arguments

confining culture to the social superstructure began to seem less convincing, and it became common to think of culture as another active, structuring force. For example cultural factors could not only slow or accelerate the pace and depth of modernization but were seen as an essential, active feature of the self-construction of modernity.

Along with the cultural turn, definitional problems began to emerge: the meaning of 'culture' diversified, embracing from high art and criticism, through a huge variety of burgeoning popular forms, to a broad, holistic 'anthropological' sense of a complete 'way of life'. Eventually, however, the emphasis on culture gave rise to a new perspective, which threatened the coherence of social-structural theories. The key step is the idea that human experience comes to have shape and meaning only by virtue of 'signifying practices'. That is, coherent human experience only exists to the extent that perceptions, thoughts and feelings are stabilized, organized and structured. This is achieved through access to systems or processes of representing, symbolizing and referring, broadly 'languages'. This seemed to suggest to many that signifying practices were more fundamental than their products, and indeed that the brute presence of their products disguised complex, subtle, fluid interpretational processes—theorized linguistically—on which they depended. Clearly the notion of products would have to include the special 'object domains', the institutions and forces, critical constituents of social-structural theory itself, suggesting that such theory had in some ways a secondary or dependent status with regard to predominantly linguistic theories of interpretation; it should be noted that signifying practices too only become objects of knowledge through processes of interpretation.

At this point culture can appear as either a particular object domain (with its various semi-autonomous, self-differentiating fields of human thought and action) available for knowledge, or as textuality, a complex idea about how language as text gives rise to meaning (or *différance*), but also resists determinacy or identity, and hence all theory and method organized around the idea of 'knowledge'. From the point of view of textuality, theory—in the sense of the conceptual or formal structures necessary for human cognitive activity aimed at convincing representation, solving problems and achieving mastery—is inadmissible. Textual theory is the paradoxical expression of this impossibility.

Now, instead of being merely superstructure, a reflection or effect, culture is everything. Yet cognitive and analytical accounts of structures and forces, including culture itself, are easy to subvert because in the final analysis, to undermine something said about objects, specifically to make visible the perspectival projection of the subject, the process of reification of which they are the result, it is only necessary to say something else. Thus postmodern visual cultural studies often oscillates between carving out from within culture a particular object domain for analysis, interpretation and critique, and invocation of the 'indecidables' of textuality, sometimes even attempting both at once.

FROM CULTURAL STUDIES TO CULTURE IN RUINS

During its early years cultural studies shared with approaches located in sociology and history a belief that it is essential to set cultural phenomena in an appropriate social and historical context. Eventually, however, a broadening in the concept of culture and the

influence of French theory made this linkage much more problematic. Does Hegel's ((1820s) 2008: 16) famous insight into the relationship between intellectual endeavour and history apply here too? Is it possible that cultural studies, along with visual culture studies as a specific subtopic, emerges as an institutional force within the humanities at just that historical moment when culture has become a meaningless term? This is the radical argument of Bill Readings (1996), which we will briefly outline and review in order further to explore some questions about values and politics in respect of visual culture and its study.

Our focus here is on the values, politics and changing institutional context of recent cultural studies, the outlook of which, to repeat, informs a lot of work in visual culture studies. The initial British phase of 'cultural studies', pioneered by Raymond Williams and E. P. Thompson (and one might add Richard Hoggart), was fundamentally animated by a critique of cultural exclusion and a demand for participation, echoes of which still ring in the activist rhetoric of today's cultural studies. All three writers brought from their work in history and literature, and in the cases of Hoggart and Williams a working-class upbringing, care for the particulars of working-class life and culture, which they saw as unfairly overlooked, castigated or patronized by the English ruling classes and their spokesmen. This was neither 'workerism' nor sentimental ruralism, but did reflect dissatisfaction with standard European Marxist suspicion of the 'real' working class, and the related, damaging impulse to conceptualize and idealize it as the 'proletariat'.[7]

The political vision of British cultural studies maintained that all had the right to participate fully in their society, effectively taken to be that of the relevant nation state.[8] Four obstacles to participation were identified: the underlying economic and political infrastructure of modern capitalist societies; socially exclusive high culture, often in part at least an institution of snobbery; the debased, popular, mass culture produced and sold by a burgeoning capitalist entertainment industry; the abstractions and idealizations of European Marxist theory and political rhetoric. In Williams's famous anthropological view of culture as a 'whole way of life', authentic representations and transformations of experience, whether fashioned in speech, writing, pictures and material forms, song or dance were rooted in a multifaceted, everyday production of life, not just material survival but a resourceful, bottom-up making of a liveable existence, a life worth living, in the face of the turbulence and destruction experienced by millions during the process of industrial modernization. This culture was authentic and organic because it sprang from the life praxis of the working class, labour or making of many kinds that in reality created and sustained the whole of society. The full participation of this excluded or neglected way of life would transform the political, economic and cultural structures and processes of society as a whole.

Turning to the politics of contemporary cultural studies in the USA, which had become by the 1990s the leading approach in the humanities, Readings notes with approval the widespread rejection of arbitrary exclusions and boundaries. However, although laudable, this inclusiveness leads to a decisive weakness: a failure to identify a class of objects of study and, given the nature of these objects and of human cognitive

capacities, a distinctive and appropriate method of analysing and investigating them. An emphasis on process rather than outcome, more specifically the proposal of a general study of signifying practices, drawing its conceptual structure and systematizing rhetoric from theories of spoken and written language, have led to what Readings identifies as cultural studies' 'political piety'.

Insistence that 'everything is culture', and that language-like signifying practices are at the root of every identity, is reductive and distorting, particularly when it comes to primarily visual phenomena. For Readings, it also exposes cultural studies and visual culture studies to anomic anxiety; the refusal to exclude is also a refusal to identify, and without an object of study, method is transformed into a means of universal negation, the dispersing of 'things' into the ineffable textuality of which they are an effect. The prevalence of political piety, the basing of a stance or orientation on what is ultimately a decision to observe locally acceptable norms, results from the fact that cultural studies can find nothing in its object or its context capable of anchoring its interventions, except 'refusal of exclusion' (Readings 1996: 102).

The cultural sociology of Pierre Bourdieu has been influential because it seems strong where cultural studies is weak, that is by defining its object, and devising and deploying appropriate methods of enquiry, setting it firmly in an explanatory context. Bourdieu's sociology of culture claims to be a rigorously social scientific account, in which accurate knowledge of the social world is based on sound structural theory and rigorous empirical research.

While Bourdieu's outlook has been criticized for its relativist view of culture, and its inability to account for itself and explain social change (Gartman 1991; Alexander 1995), for Readings its principal difficulty comes from its anachronistic attachment to an idea of culture inseparable from the nation state. That is although Bourdieu is rightly keen to avoid economic-political reductionism, he clings to a concept of a stratified society or 'social space' located around a centre of power, wealth and prestige, structural inequalities articulated in parallel ways by the fields of politics, economics and culture. While, under certain circumstances, cultural capital can be turned into social capital, there is in Bourdieu's theory only one, closed 'game' of culture. However, for Readings the nation state 'which embodied capital and expressed it as a culture that radiated across the field of the social' has been superseded by globalized capital, which 'circulates around the circumference, behind the backs of those who keep their eyes firmly fixed on the centre' (Readings 1996: 111). This represents the ruination of the modern idea of a national culture as a bulwark against or remedy for the destructive or destabilizing moral and aesthetic effects of liberal, industrial modernization. The new situation leads not only to the possibility of multiple, heterogeneous 'games of culture', but also produces a widespread feeling that everyone is somehow culturally excluded, albeit from an 'impotent centre'. More sombrely, it also underlines the fact that culture no longer functions socially to bind together or edify, to exclude or command. As 'anything', a thoroughly instrumentalized culture's primary purpose is hedonism, although it may also serve as a means for the formation of flexible, ephemeral, consumption-friendly life-style identities that have in common only particular tastes.

Cultural studies, incorporating visual cultural studies, establishes a potent presence in the humanities at just the point when modern ideas of culture had become largely meaningless, emptied of substantive content. In what Readings calls 'the university of culture', by which he means the leading self-understanding of a university in the nineteenth and early-twentieth centuries, canonical artistic (usually literary) and sometimes philosophical works were seen as an essential ethical and aesthetic or spiritual counterweight to the growing dominance of science, technology and industrial capitalism.[9] Through them, comprehensive, critical self-reflection could be nourished and communicated, a process pivotal to the university of culture, the aim of which was the shaping and expression of a worthy national culture as a whole. However, once culture is emptied and 'delegitimized', that is understood as all signifying practices together with their outcomes without possibility of discrimination—except perhaps in terms of their relative power—it loses determinacy, and with it the possibility of being either an object of knowledge or critique, a means of edification, or a politically potent expression of organic community on the one hand or national identity on the other.[10]

Readings may be overstating the case for the total dominance of global capital, the complete dependence of a coherent, critical idea of culture on the existence of the nation state, and the disastrous plight of culture and the humanities in postmodernity. Nevertheless, many of his observations about cultural studies as a quasi-discipline are worth taking seriously, opening up a broader range of questions about values and politics than are encouraged by prevailing assumptions and political pieties. Putting the underlying issue in a preliminary way, it will be suggested that what an avant-garde art practice like Cubism shares with the study of culture in the late-modern period is an acute self-consciousness of constitutive powers. This degree of self-consciousness leads towards an awareness that mastery of signifying capacities manifests itself in the representations or constructions of the contemporary historical world characteristic of that practice, here with special emphasis on visual appearances. However, by the same token it makes problematic the capacity to root representations and values in this world in such a way that they escape arbitrariness, repetition and self-parody. Below we will look at Cubist collage in light of its particular struggle for authenticity and significance.

CUBISM: MAKING A START

Cubism and Cubist collage long ago ceased to present a fundamental challenge to accepted ideas about visual art or a shocking, wholly novel interaction between avant-garde art and vernacular visual and material culture. Cubism has become not only an accepted part of the modernist mainstream, but is widely seen to have exerted an important influence on what that mainstream eventually became. Yet, even if no longer controversial, a lot of Cubism, and the collages in particular, still seem awkward, austere, recondite, perhaps too much of their own times to mean much in ours. Despite this, for some of us at least, many of these works are strikingly and strangely beautiful, and demand to be understood.

Cubism was always at risk from collapsing into a style, something that Picasso worried about constantly. The peculiar intensity of the pieces that resist self-pastiche seems

to have something to do with the tensions they embrace, and whose explosive force they can barely contain; for example the appearance of both sophistication and rawness, and an insistence on representation, yet of a kind which is defiantly puzzling. In 1893, trying to get at what it meant to be modern, Hugo von Hofmannstall offered, as a matter of simple fact, 'the analysis of life and the flight from life', the detailed, almost obsessive 'anatomy' of inner life, but also a 'somnambulistic surrender' (*somnambule Hingabe*) to the revelations, seductions and harmonies of sensation.[11] This seems to capture another tension integral to Cubism.

We begin, then, from a specific experience of some Cubist works, which involves recognition of and submission to their distinctive, intense physical and visual presence, specifically their obdurate materiality, and their resistance to meaning, their calculated illegibility. However, this immediately needs to be set against the ways in which these works belong to and explicitly reference everyday life, an ordinary life world of people and things, historically remote and mysterious, yet also familiar. It is this connection to recognizable, intelligible life world features that provides for the possibility of metaphoric and symbolic transformations, and our capacity to know when norms, expectations and assumptions are observed, elaborated or transgressed.

The collages produced by Braque and Picasso between 1912 and 1914 are not overtly political works. They do not directly represent political or historical events (at least visually), nor do they exhort the beholder to think or act in specific ways, or express political or moral judgements. Yet they are, or seem to be, pictures of modern life, and hence may display an outlook or evaluation relevant to the nature and quality of contemporary individual and collective life. Cubist collage introduced into two-dimensional visual art not only references to vernacular, mass culture—for example lettering that mimicked advertising and brand logos and typography, brief excerpts from the lyrics of popular songs, techniques and materials used by commercial painters and decorators—but also real fragments of this new visual milieu, for example pieces of oilcloth, wallpaper and newspaper cuttings. If there is a broadly political, evaluative or rhetorical dimension to Cubist collage its natural place would be at the interface with popular visual culture.

It will be argued below that Cubism dramatically reconfigured the relationship between purity and danger (Douglas (1996) 2002) in the sphere of visual art, specifically by dicing with the logic of picture making via an engagement with vernacular visual culture. Collage strives to develop new ways in which the art image may actively confront modern life, not by shunning its visible surfaces but incorporating them. It works to establish its integrity not only by defying given tastes and conventional legibility, but also by forcefully establishing pictorial coherence out of dramatically heterogeneous elements, at the risky margins between image and object, and original and derived meanings. Braque and Picasso's ferocious energy and formidable self-confidence notwithstanding, the result of their struggle for and with Cubism even now does not suggest something resolved once and for all, but a precarious, often ungainly, anxious accommodation of heterogeneous elements, held together by intensity of vision and strength of will. It is never far from failure and chaos, the failure and chaos inherent in the process of modernization itself.[12]

FRAMES, FRAMING AND AUTHENTICITY

We need now to supply some details of Cubist collage's formal and substantive innovations and the tensions they set up. In Picasso's *Glass and Bottle of Bass* (1914) the support is cardboard, on which has been pasted various bits of cut-out paper. A simple still life arrangement of a bottle and glass is to be seen in a rough oval of cut paper in the centre. The work is without a conventional frame, but around the edges strips of wallpaper motif represent or allude to a frame. Picasso has gone out of his way to make the illusion apparent; the frame is not a regular square, but a strip of paper wonkily applied to the rectangular edges of the image, and with a bit missing in the top right-hand corner, which Picasso draws in, adding a shadow. Inside this faux frame, operating almost as a ground, is a piece of stuck-on wallpaper. In the lower left-hand corner is a blue number sticker of the kind used by Picasso's dealer, Kahnweiler, and in the lower centre of the wallpaper frame a small, glued paper nameplate, on which, in uneven printed capitals, is the artist's name. The central still life motif, which gives the work its title, looked at in one way has no frame, but in another is framed by the wallpaper mount and the edging strips (see Figure 15.1).[13]

In her perceptive account of Cubist and Futurist collage, Christine Poggi (1992: 61–73) notes that frames establish a boundary between the 'illusory inside' and the 'real

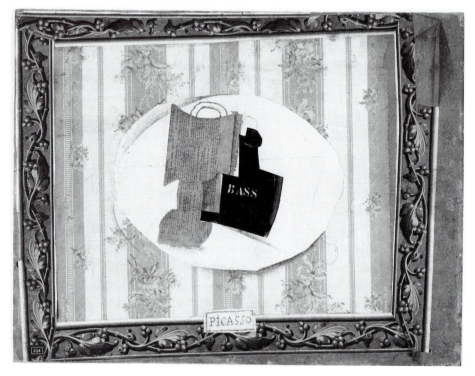

FIGURE 15.1 Pablo Picasso, *Glass and Bottle of Bass,* Spring 1914, charcoal, pencil, India ink, white gouache, newspaper, and woodblock printed papers pasted on wood pulp board, 51.6 x 67.7 cm, Private Collection. © Succession Picasso/DACS, London 2010. Photograph: Bob Kolbrener.

outside', but also mark the edges of an image that is an internally coherent aesthetic event. In these collages frames or frame motifs are parts of the work itself, thus complementing other 'real' materials, fragments of the ordinary world of everyday things, like wallpaper, oilcloth, newspaper clippings, musical scores and so forth out of which much Cubist work is made.[14] The materials used for the painted and drawn features—canvass, wood, pencil, charcoal, pigments—had become, by the start of the twentieth century, mundane and relatively cheap, but by the same token it was well understood that the skills and imagination of the artist were required to invest them with significance, longevity and value. Picasso seems to go out of his way to underscore their humble materiality by handling and presenting them roughly, with scant observance of the rituals and etiquette required for transfiguration by art. Yet of course, to achieve the transfiguration of not only ordinary materials but also profane fragments of inferior art, and in such a seemingly casual way, would testify loudly to this artist's unprecedented powers, one indication, perhaps, of Picasso's Nietzschean ambitions (see Clark 1999: 173–4).

The appearance of the frame, and allusions to frames and framing, within the picture suggest that the frame must form part of the logic of pictorial coherence instead of marking its boundary. Poggi reports an observation by Picasso's dealer Kahnweiler, to the effect that Cubism adheres to the basic task of painting, which is 'to represent three dimensions and colour on a flat surface, and to comprehend them in the unity of that surface'. However, this was achieved with 'no pleasant "composition" but uncompromising organically articulated structure'. For Kahnweiler the achievement of Cubism was reconciling fidelity to the representational goal of painting with a new kind of pictorial unity, a principle that makes these works 'finished and autonomous organisms' (cited by Poggi: 60).

Looking again at *Still Life with Chair Caning* (1912) we confront at one level a picture of everyday objects arranged on a table. There is a glass, a bottle, perhaps a plate, and a newspaper (the JOU from Journal), none of which are rendered to create an illusion, although we can see partial outlines, edges, modelling of form and shadows. The support is stretched canvas, to which has been applied oil paint, but also a large, irregular piece of commercially produced oilcloth with the preprinted image of facsimile chair caning. The chair caning oilcloth is machine-made, although it suggests the illusion of actual cane forming the seat or back of a chair; recognition of the skill involved in both real chair caning and its *trompe l'oeil* imitation is contrasted with the apparent clumsiness with which the piece is cut out and stuck onto the surface.

The painting comes along with its own 'frame', a piece of bristly rope, alluding to natural materials used for mundane tasks, but also at this point in the history of industrial technology, machine-made. There is another implied contrast here, between the 'sacredness' of the oil painting and a 'profane' material commodity, the rope suggesting a cheap memento of a seaside holiday. Does the rope also function as a frame, which conventionally separates the painted world of illusion from the real world around it, or is it part of the picture, linking in some way with the prefabricated oilcloth, and pushing the work as a whole away from being a pure, representational painting and towards the independent, sculptural object?[15]

The key idea behind Kahnweiler's claim for Cubism's contribution to a development in the general principle of pictorial coherence is that of a visibly necessary structure perceptibly arising from the demands of the image itself, not imposed and articulated by contingencies of taste or the rationalized purposes of others. Such a work does not need a frame, a corset that secures order from outside, and indeed the frame can be pulled into the picture, operating as one of its constitutive elements. Bits and pieces of frames become—along with other materials and devices, some two-dimensional, some with real volume, and others fragments of an urban visual culture—pictorial components from which new images can be made. The composition of these elements reasserts the traditional principle of pictorial coherence, but with an important new emphasis. Framing elements within the picture and the absence of an actual frame, together with 'alien', prefabricated, mundane surfaces and objects, radicalize the question of overall pictorial coherence, but in no sense negate it completely. The structure of the picture, the perceptible, intentional relationship between its now very heterogeneous elements, must appear to arise from within the work itself, not be imposed on it according to externally conceived rules of taste or commodity design, ensuring that the work is immediately pleasing and comprehensible. This gesture marks an important continuity with Symbolist poetics. The work is understood to need its own 'freedom', an evident capacity to self-structure, and the artist's obligation to the work consists in enabling it to achieve and exercise this autonomy.

Referring to the genuinely experimental work leading up to the high Cubism of the Cadaqués period, T. J. Clark astutely observes that:

> Somewhere woven into this practical reasoning—in a way that the best early commentators on Cubism did glimpse, I think—is a peculiar new version of the old modernist saw about truth to the world in painting depending on truth to what painting consists of. What is peculiar (what marks off Picasso's version of modernism from that of the Fauves and the Nabis, say) is once again the degree of insistence on both sides of the equation. (Clark 1999: 204)

We might then see Cubism presenting to the viewer, as something primarily disclosed by sight, a truth about our relationship with objects, or more broadly, the embodied, material, finite life we share with objects and others. If the object, in this case the painting-as-object, is fully to enter the human world it must, paradoxically, partially offset its contemporary, merely 'objective' being. The manoeuvres examined above, including the playful use of frames, are attempts to promote the object not to a kind of subject status, but to set it and the viewer back into the profound commonality of embodied life.[16] The uncompromising rawness, the almost brutal materialism with which these compositions are assembled, the stubborn insistence on representation and its material machinery, together with a logic visible in the image as a whole, provide a presence that conveys a sense of a living complexity and integrity. It is also perhaps a practical critique of the abstraction of modern life, reflected not only in the 'anatomizing' or rationalization engulfing it, but also in its organized and newly mobilized visible surfaces.

COLLAGE AND THE POLITICS OF FORM: NEWSPAPERS, WALLPAPER AND SYMBOLISM

At the end of the nineteenth century the object world of everyday life was becoming increasingly colonized by artefacts whose visual appearance had been designed and fabricated to serve particular purposes, to give pleasure or information, or to influence attitudes and behaviour. In order to have an adequate grasp of the relationship between Cubist collage and this emerging visual culture we need to understand the history of some of the items chosen for inclusion. Two of the most prominent were wallpaper and newspaper, which have a related history in France, strongly shaped by industrialization, printing and photographic technologies, and techniques of mass marketing.

Poggi (141-154) reminds us that before 1830 newspapers circulated to a largely urban elite. In 1836 *La Presse* appeared, the first cheap, large circulation daily. It was half the price of previous papers, derived income from advertising, and attracted new readers with such innovations as the *roman-feuilleton* or serial novel, in which writers like Alexander Dumas and Eugène Sue pioneered the composition of dramatic episodes adjusted to available word length, cliff-hanger endings, and stories of intrigue, violence, sentimentality, sensation and shocking revelations of urban low life, with crime and prostitution prominent. Further expansion of the newspaper market was fuelled by better and faster regional and national transport, rising wages and the spread of literacy. *Le Petit Journal* of 1863 was the first newspaper cheap enough to be affordable by virtually everyone.

The dramatic arrival of the mass circulation newspaper shook up the cultural landscape of reading and writing. Literacy and access to news were no longer markers of a simple division between the educated gentry and the unlettered working classes. A new distinction began to appear between readers of newspapers and readers of literature, particularly poetry. Symbolist poets aimed to develop a kind of writing that would resist commercial rationalization and the commodity form, which they believed reduced the relationship between writer and reader to that of an exchange of tokens, tired, over-familiar signs of a spiritually debased reality on sale for cash. They were acutely aware of the marginalization of writers and artists in a society increasingly regimented and disfigured by money, newspapers and posters exemplifying the commoditization of language, its poetic value as symbol replaced by its exchange value (see Poggi 1992: 143).

Up until the arrival of industrial technology, fabric or tapestry wall decoration were enormously expensive. Developments in block-printing during the early-nineteenth century increased supply and brought down the price of paper wall decoration, but it was only the introduction of steam-powered, raised surface printing cylinders that brought wallpaper within reach of the middle class. A preference developed for small, repeated pattern motifs that could be matched up on standard width rolls, but also for the close imitation of different surfaces and materials (*faux bois*, fabric, marble etc), which seem to function to give pleasure to the eye rather than delude it.

Wallpaper was eventually seen to offer a ground for further decorative objects (curtains, pictures, plaques, furniture), and that if used in this way the framing of these

additional decorative objects was important, insulating and setting them off from their surroundings. A whole section of wall could be a single display surface, framed by decorative borders; frames could nest within frames. Traditional craftsmen and many critics of modern culture decried what they saw as the supplanting of real artistic skill and sensibility by fake materials, insensitive mass production and ersatz tastes. Yet we can see Cubist collages enthusiastically taking up, exploring and elaborating, and commenting wryly on many of these features.[17]

The wallpaper in Picasso's collages is for the most part cheap and ordinary, often in a poor state, suggesting that he had only fragments at his disposal. It was also applied in quite rudimentary ways. Shapes were roughly cut out and simply glued to the base layer. The overall appearance seems temporary, ephemeral, almost throwaway. Taken together with Picasso's introduction of newspaper, this is for Poggi further evidence of a 'critique' of painting. Their use deprived the work of art of the value, legitimacy and longevity connected to craft skills, and the authenticity and meaning derived from the spontaneous, autographic mark. The irony conveyed by the words *J'aime Eva* when scrawled on a biscuit and glued to the canvas (*Guitar: L'aime Eva* 1912), and the kitschy allusion to a popular love song in *Ma Jolie* (1914), underscore a departure from the very idea that artists should invest their work with feelings and meanings that are authentic, unusual, articulate or fresh. While acknowledging a certain convergence with Mallarmé, who also emphasized the impersonality of pure poetry, Poggi argues that Picasso did not aspire to purity. Rather, the collages herald the 'obsolescence of contemporary critical hierarchies and theories of representation in an age when artefacts had become commodities' (153).

Arguments linking form and politics often end up undermining the practice of visual art as such. For example Poggi mentions Paul Cottingham's (2004) Bourdieu-inspired assessment of Cubism. Maintaining that if art has any importance or meaning whatsoever it is because of its political effects, Cottingham sees in Cubism only a visual 'discourse' containing political messages coded as form, often tricky to decipher because addressed to the highly wrought but self-serving tastes of elite groups. So, for example modernism's vaunted formal innovations, of which Cubism is said to be an example, while lacking overt social or political reference, can be shown to belong to the machinations of cultural distinction, the signs by which gradations of cultural value are inscribed on stratifications of social class. Such work is said to be 'elitist' precisely because of its lack of reference, or even ordinary intelligibility.

Poggi rightly rejects this reductive levelling of both the historical record and the aesthetic challenge of Cubist collage, rightly giving full weight to its 'ironic refusals and negations' with respect to both vernacular visual culture and the traditions and conventions of visual art, historical and contemporary (see Poggi 1992: 128–9). Yet if the main point is 'political effects' then Cottingham's point is stronger. Intrinsic, even quasipolitical complexity does not necessarily give an item of culture the capacity to effect substantial social and political change. If avant-garde artworks are unlikely to influence popular political opinion, then all that remains appears to be their possible effects on the interpretation and judgement of cultural forms, yet another kind of 'elite' preoccupation, characteristic of the art world or academe.

In sum, since the coming of modernism, many artists and intellectuals that what ultimately makes a work of art important is its 'critique' of a previous form of practice. In many cases, however, it has proved difficult or impossible to prevent this limited, local criticism sliding into a negation of the entire art form in question, thus normalizing what I have referred to elsewhere as hypochondriacal reflection and the erasure of the distinction between art and visual culture. The alternative is to look more closely at what we might still want to call Cubism's politics.

COLLAGE AND POLITICS

To recap, we have seen above how Cubism's struggle for authenticity in painting was waged not only in the face of a visually mobilized urban culture but also in the context of the danger of arbitrariness, aimlessness and style, eminently practical problems for avant-garde artists consequent upon a growing awareness of the autonomous signifying powers lodged in the modernized practice of visual art. However, we also want to pursue the question of the wider social and historical significance of modern painting, where 'significance' refers to a visible, intended feature of the work, something 'meant' by the artists concerned. It is clear that with Cubist collage its broadly political or social significance resides neither in the depiction of conventional political events, nor in the supposed disruption of political processes by cultural transgression. However, this does not make Cubist collage inherently complicit with a given political order. The issue is not so much the politics of form as 'coded statements' but the political significance of the self-enactment of the work visible in its form.

Patricia Leighten (1989) provides a straightforward historical and political account of Picasso's development prior to the outbreak of war in 1914, bringing to light other important aspects of the use of newspaper cuttings.[18] She emphasizes their deliberate, purposeful character, many culled from *Le Journal*, a mass circulation Republican daily, which covered political events, as well as prurient or gory human-interest stories.[19] Picasso cut carefully round the edges of columns, never up the centre, preserving whole passages of text so that the reader can make out their meaning. This content is largely to do with political news, in particular what we now see as events leading up to the Great War, for example the three Balkan Wars, which revealed Europe's political instability, and the diplomatic and military rivalry between the great powers, France, Britain, Russia and Germany. There are also stories about industrial unrest, strikes, strike breaking and demonstrations, as well as news from the Bourse, stock market prices, the data of speculation, boom and bust.[20] Finally, and increasingly, the cuttings contain sensationalist 'human interest' stories, often with bizarre, macabre, absurd overtones, the material of black humour, perhaps appealing to Picasso's sardonic eye.[21]

She emphasizes the collages' café references, revealed by the still life ingredients and other allusions, an important aspect of Braque and Picasso's social milieu. 'With their settings of bottles, glasses, café tables, and newspapers, these works not only depict the physical setting of artistic bohemia, where political arguments were part of the daily fare, but also suggest the contents of such arguments by importing the news itself into that heady atmosphere' (130). In particular, the political contents pertain to events that

Picasso's avant-garde 'anarcho-symbolist' circle would have discussed in cafés and apartments in an intensifying atmosphere of war preparation and appeals to patriotism on the one hand, and strident left-wing protest against militarism, capitalism and nationalism on the other.[22]

For Leighten the inclusion of text was a way of 'pulling Cubism back from the brink of total abstraction . . . And no more democratic way could be found for the project of subverting the high art of oil painting than that of introducing such easily readable articles on such universally engaging subjects' (Leighten 1986: 125).[23] But she also remarks that the effect of the clippings was to introduce 'anxieties' that 'seem to threaten the fragile pleasures of a civilized peace: wine and music in a wallpapered room' (126).

How successful is Leighten in relating the aesthetics of Cubism to either its overt content (café life, portraits of friends, still life) or to what she supposes to have been Braque's and Picasso's politics? Rejecting any simple divorce of form and content—with form being 'technical elements' and content 'those elements which make statements'—she traces the precedence of form in the interpretation of Cubism in modernist theory and practice following the First World War, and then sets this against what she sees as a more plausible emphasis on content.[24]

For the purposes of this chapter, form and content are taken to be discernibly different aspects of the work of art, which it is often useful to identify and discuss separately, while at the same time recognizing that they may be related in complex ways, and even 'fuse' in the final presence of the work. The problem is to understand both in their independence and integrity, the connections between them, and the 'third dimension' of the work their relationship can create. This task often gets lost once form is reduced to the arbitrary machinery of language-like coded statements. The encounter with art is dramatically simplified when it is taken to be axiomatic that there is nothing else really going on in most visual works, no other significance or meaning, than the concealed statements demanded by some purported dominant culture, that is rhetoric confirming its distinctiveness, legitimacy and predominance. Once the constitutive practices of an art form are treated in this way, the whole art form stands condemned, with well-known practical consequences. The post-visual, post-avant-garde artist seems to risk serious injury by sawing off the branch on which he or she sits, only to rise again as a disciple of Andy Warhol, the last artist and first high priest of celebrity culture. My point is that while it is very useful to understand Braque's and Picasso's political and aesthetic antipathy to many aspects of contemporary painting and bourgeois culture in general, it is a serious mistake to interpret Cubist collage as an attack on painting or visual art *tout court*. For Braque and Picasso, while the bourgeoisie might buy paintings, they did not own painting. It may be true that Picasso enjoyed 'cannibalizing' the history of art for his own purposes (see Richardson 2009: 77), yet he also wanted his achievement to be judged against its highest standards and so needed the possibility of a tradition and a canon.[25]

Some critics contemporary with Cubism accused it of being anti-rational and anti-art, purely destructive and dehumanizing. A defence in terms of the politics of form has generally conceded destructiveness, but then sought to legitimate it by revealing the discursive meanings concealed by the work's visible features. There is certainly a

critical or even destructive side to Picasso's output before the outbreak of war, evident in his manifest desire to shock the bourgeoisie (recalling the anarchist 'propaganda of the deed'), break the rules observed by lesser artists, and experiment rigorously with forms and conventions, testing them to the point of destruction. There was also his relentlessly sardonic wit.[26] However, if the positive element disappears from acts of creative destruction all that remains is the work of the negative, in this case the purported attack on painting and ultimately all art. While Cubism's transgressions and negations are obvious, the complementary question of its constructive side is posed less often. What, for example, of the anarchist and avant-garde's fervent desire to reconstruct the consciousness and society of the future, to 'reorder the universe' in Guillaume Apollinaire's words? Along with the destructiveness of Cubism went complete conviction in the validity of art, which for many avant-gardists entailed belief—at times, somewhat desperate or anguished—in its capacity to change the way people thought, accelerating and strengthening the movement of history towards social revolution.

From Ambrogio Lorenzetti up until Matisse and Cubism itself visual artists had tried to represent quite directly what a good human life might look like. Even the young Picasso contributed to this long tradition of the utopian imagination with what Leighten calls his 'pastoralism', images of peasants living in harmony with one another, the land and nature (see Richardson 2009: 42–3). For Picasso and other radical Spanish artists this was not a conservative celebration of the good old days, but a picturing of the last surviving expression of free, cooperative life and labour, and of the spirit and principles of the new age that their politics would bring about. A good example is *L'edat durada* (*The Age of Gold*), a drawing completed in Paris in 1902 (see Figure 15.2).[27]

FIGURE 15.2 Pablo Picasso *L'etat durada (The Age of Gold),* 1902, pen and ink, Museu Picasso, Barcelona. © Succession Picasso/DACS, London 2010. Photograph: Museu Picasso.

It is important to note the centrality of cooperative, collective labour to anarchist po-
litical philosophy. Leighten also reminds us that Picasso's most politically critical subject
matter in the first decade of the century concerns the depiction of poor, destitute indi-
viduals and small family groups in urban settings, in particular the semi-industrialized
suburbs, the *afueras, banlieu* or 'zones' that had sprung up around Madrid, Barcelona
and Paris. Picasso does not seem to have been able to imagine political scenes in an
urban setting except by representing the victims of industrialization, poverty, displace-
ment and exploitation.

While it would be quite wrong to see Picasso's entire creative output as dominated
by conventional political ideas and motives, it seems equally mistaken to deny alto-
gether the seriousness and continuity of the Cubists' anarcho-symbolist poetics. If so,
the next question is how such an outlook might have informed Cubist innovations
in form and content? Certainly there are no obvious signs of pastoralism in the col-
lages. Has the pastoral been replaced by another image, one more modern and urban
in character? The obvious difficulty here is not so much that Picasso tries to devise
and present a new likeness of some yearned for human flourishing, this time set in the
modern city, which we may or may not find convincing, but that he does not pres-
ent a conventional picture at all. If there is such an image in Cubist collage it's one
we struggle to see, given our interpretive habits and expectations. However, in order
to orient thought, fire the imagination and strengthen resolve in ways conducive to
political activity this new image of a good human life would first have to be recogniz-
able as such.

It is important to insist that these are pictures of *something*. In Leighten's words,
'Picasso precisely wanted to pursue a formal radicalism without abandoning allusion
and subject matter' (1989: 84). Cubism was surely meant to be a full response to the
contemporary experience of Braque, Picasso and his circle, including the utopianism
embedded in their political outlook. As John Richardson suggests, Picasso at this time
seems to have thought of his aims as similar to Baudelaire's 'painter of modern life', an
artist capable of conveying not only its depravity and ugliness but also its dynamism and
heroism (Richardson 2009: 11–27). The challenge remains that of seeing the collages'
true subjects, not just the look and feel of contemporary experience, but also the human
good, improbably conveyed by highly deliberate arrangements of bits and pieces culled
from the material and visual fabric of everyday Parisian life, the enactment of the collage
form. Put slightly differently, why do these formal innovations in which intrusions of
urban visual culture feature so prominently matter?

COLLAGE AND IMAGES OF MODERNITY

The visually, materially and semantically charged objects of French urban culture were
fast becoming prominent, active, communicative features of social life, importuning the
viewer in different ways. This mobilization of the visual occurs in the familiar context
of the rapid changes and developments in urban life particularly associated with aggres-
sive modernization.[28] Accounts of the 'creative destructiveness' of modernization have

been prominent in social theory since the middle of the nineteenth century, and it is this tradition of enquiry—stretching from Karl Marx and Max Weber to Ulrich Beck and Zygmund Bauman—that will be applied here.

Perhaps the best account of cultural responses to the peculiar dynamism of modernity is that of Marshall Berman (1983). Attempting to sketch the whole context of modernism in all its forms, he writes:

> The maelstrom of modern life has been fed by many sources: great discoveries in the physical sciences, changing our images of the universe and our place in it; the industrialization of production, which transforms scientific knowledge into technology, creates new human environments and destroys old ones, speeds up the whole tempo of life, generates new forms of corporate power and class struggle; immense demographic upheavals, severing millions of people from their ancestral habitats, hurtling them halfway across the world into new lives; rapid and often cataclysmic urban growth; systems of mass communication, dynamic in their development, enveloping and binding together the most diverse people and societies, increasingly powerful national states, bureaucratically structured and operated, constantly striving to expand their powers; mass social movements of people and peoples, challenging their political and economic rulers, striving to gain some control over their lives; finally, bearing and driving all these people and institutions along, an ever-expanding, dramatically fluctuating capitalist world market. (16)

The social, political and historical environment of modernity is thus a direct, powerful challenge to both traditional or premodern cultural forms and whatever temporary, fragile cultural stability can be improvised and pieced together by individuals and groups in the grip of modernization.

More recently, in Anthony Giddens's (1990, 1991) efforts to renew the tradition of classical social theory, modernity's 'extreme dynamism', a matter not only of the pace of change but also its scope and depth, is due to three factors: the separation and reorganization of time and space, institutional reflexivity, and disembedding mechanisms (or abstract systems).[29] The notion of disembedding, the '"lifting out" of social relations from local contexts of interaction and their restructuring across indefinite spans of space-time' (Giddens 1990: 21) refers to social theory's familiar theme of modernity's continuing assault on traditional forms of life. For Giddens, disembedding is a necessary prelude to rational restructuring, or at least restructuring in accord with technical knowledge and expertise, which he calls 'social reflexivity'. For the individual what we might term modernized or enlightened reembedding consists of a willingness pragmatically to change one's identity, by which we mean something like a self-conception or ego ideal, according to changing circumstances.[30]

The disembedding of everyday life provokes symbolic, local, routine efforts to reembed, to re-establish its intelligibility, coherence, reliability and normative legitimacy.[31] Behind the obvious reasons for improving the conditions of life for individuals and groups, for example mitigating hardship or increasing social equity—through

philanthropy, economic cooperatives, voluntary welfare and educational associations, trade unions, church and chapel groups, leisure and sports clubs, as well as individual actions often in the context of the family—was the constant, urgent need for symbolic restructuring, an effort to confront the threat of meaninglessness that sprang from the historical nihilism of capitalism itself.[32]

The reembedding enmeshed in everyday social practices in part takes shape through, and is made manifest in, visual and material culture. As a response to profound so-cial and cultural turbulence, it may include institutional attempts to resuscitate social and cultural traditions, but more important here are quotidian, creative cultural acts that seek to reconfigure everyday life so that it becomes sufficiently intelligible, reliable, benign and normatively defensible as to answer fundamental existential questions, an activity critical to *homo symbolicus*. Within this complex, multitudinous field of local restructurings, from the decoration and furnishing of the home, the adding of 'personal touches' to workshops and offices, the preparing and serving food and drink, to clothing and gardening, the visual is typically part of a multisensory awareness of things and set-tings, inflected by mood and memory (Seremetakis 1994; Attfield 2000; Vannini 2009). Perhaps because of the capacity of visual perception to range readily from the scanning of generalities to close inspection of detail, even when another sense seems to predomi-nate, specifically visual aspects are often of great importance.

The idea with which we conclude is that Cubist collage may be understood as a particular endeavour within painting—paradoxically involving both self-modernizing and reembedding—against the background of the paradoxical effects of global instabil-ity, rationalization, and ordinary, local, everyday acts of symbolic reconstruction.[33] Of course, this is not to ascribe to Braque and Picasso these precise socio-theoretical inten-tions, but rather to outline a context that helps make sense of some of the more puzzling features of Cubist collage. Needless to say, the reembedding undertaken by the mod-ernist avant-garde was not about reproducing a tradition by imitating its appearance, although there are important, deeper continuities with some aspects of the historically extended practical and critical tradition of painting. Modernization here means both a heightened awareness of the signifying powers of painting practice but also a free self-relation. As we have seen above, collage structure, the perceptible relationship between very heterogeneous elements, must appear to arise from within the work itself, not be imposed on it according to externally conceived rules of taste or commodity design, or ultimately, absurdly even, those conventions and expectations established in the course of this developing 'experiment'. The artist's obligation to the work is to help it achieve this 'freedom', an evident capacity not only to give itself a rule, to become itself , but also to depart from that rule.

In sum, Cubist collage displays not only a kind of self-directed, radical disembedding with respect to certain kinds of traditional art, specifically unadventurous, submissive art that sets out to please and flatter, but also a fierce engagement with how the visible and material features of the new urban environment, a setting in which complex disem-bedding and reembedding processes were being played out, may be picked up, modified and reused in new ways, but nevertheless in accord with the fundamental character of

painting practice. This is avant-garde, self-modernizing art's version of reembedding, in the final analysis the ideal of a chosen self-relation. Cubism sought to re-establish the integrity of painting by engaging fully with destruction *and* reconstruction, and by enacting destruction and reconstruction in its own terms. In the context of highly traditional subject matter and an austere formal structure derived from still life, Cubism sought to discover how its methods and results could be anchored in 'the truth to what painting consists of', a visible necessity specific to painting, while simultaneously engaging with what traditionalists took to be the most unsympathetic, even dangerous, 'impure' elements of everyday visual experience, those spawned by the new urban visual culture. Success in this task would unambiguously demonstrate also, of course, an artist's unrivalled creative powers.

In what sense is any of this political? It is true that much of Cubist collage represents a shift to what has been called the 'politics of form', but it is inadequate to see this as a self-deluding and self-serving capitulation to elite tastes. It is facile to reduce a serious struggle to make visual and material forms matter to 'statements'. What needs to be recognized, in its complexities and enigmas, is Cubist collage as a particular engagement— enacted with humble, profane materials through extravagantly embodied gestures— with the general social and historical phenomenon of modernization and reembedding, specifically a reembedding that was paradoxically ruled by the need visibly to establish, or at any rate assert, the integrity of painting itself.

CONCLUSION

Georg Simmel's famous essay 'The Metropolis and Mental Life' begins:

> The deepest problems of modern life derive from the claim of the individual to preserve the autonomy and individuality of his existence in the face of overwhelming social forces, of historical heritage, of external culture, and of the technique of life. (Simmel 1997: 174–5)

He goes on to say that the person 'resists being levelled down and worn out by a social-technological mechanism' (175). Let us suppose that this is true not only of the person but also for the art object. That is, if the object is to resist levelling down or chaotic disorganization it must achieve authenticity, it must have a perceivable structure or character which has been freely arrived at, and its appearance must assert the character it struggles to become.[34] Symbolist poetics gave Cubism a clue to understanding this requirement and carrying it out practically. The experiments with frames, materials, and profane visual signs and general detritus of contemporary visual culture, and the profound risks taken with representation are, then, best understood as ways in which Braque and Picasso asserted, and then tested, the possible integrity of the art object.

In a historical period characterized by an intentionally activated visual and sensory environment, amplified and diversified by industrial and commercial techniques and new communicative technology, the encounter between visual art and visual culture

may seem of marginal importance. The prominence of visual artefacts in the modern period has led some theorists to claim that the visual has become the dominant cultural form, and with visual art sidelined as a minority, elite preoccupation, the obvious reach, power and glamour of popular, mass cultural forms seemed to establish their unchallengeable preeminence. The particular interpretation given by visual cultural studies suggests that at the root of cultural artefacts and processes is a covert distribution and legitimating of quasi-political power, and that underlying and disguised by the visual is language, in the shape of arbitrary, coded signs which make meaning and therefore author the world. It is easy to believe that understood properly language rivals number as a human technology, the power of both derived from their capacity for abstraction.

Against this, however, should be set the need fully to understand the consequences of changes in the traditional cultural hierarchies, including the significance of visual art, brought about by modernity, and the fact that within two- and three-dimensional art visual sensibility and visual thinking have undertaken exploration and refinement of unrivalled depth. It has been suggested above that both are of critical importance to visual culture studies.

The employment of frames and allusions to framing in Cubist collage, and the introduction of materials and surfaces that were the products of the new visual, aural and tactile urban environment, might suggest that Braque and Picasso were trying to make painting practice appear ridiculous, an intuition that the peculiar hyper-visibility of the modern world defied the capacity of painting to represent it. A more plausible suggestion is that they set themselves the enormously difficult task of freely taking apart painting practice, but then demonstrating its vigour and integrity by making successful work out of its most rudimentary conventions and unlikely or profane ingredients. After reducing itself to the elementary components of painting method, where these are to be clearly distinguished from familiar picture-making techniques, it then displays strength and potency by reinventing pictorial coherence in entirely concrete, visible terms out of the anonymous, ephemeral, profane bits and pieces of a urban environment, not so much by imitation but by physically absorbing and transforming them.

The recreation of pictorial coherence out of the most unpromising materials gets close to their achievement, but does not explain why these arduous, uncertain, risky experiments were necessary. The connection between access to the truth about modern life, more specifically about its mode of visibility, and what Clark calls 'truth to what painting consists of' is critical here, but takes us beyond art and into theory or philosophy.

The chapter juxtaposes Cubist practice with wider social and cultural processes, specifically the destructive and creative dynamic of capitalist modernity, itself a long-term preoccupation for social theory. In some ways Cubism is a paradigmatic example of modern disembedding, seeking first to destroy local, historical, contingent or derivative forms of painting, and then reconstruct it, piece by piece, according to a principle of visible necessity, the traditional criterion of pictorial coherence made concrete under very different circumstances and in a new form. By doing so, Cubist images and artists sought to demonstrate their ingenuity and powers, their independence and integrity.

This is not to suggest, however, that Cubist practice does or could present itself as a lesson for everyday reembedding. There is an uncompromising singularity and simplicity about the aims and responsibilities of the artist that does not apply to everyday life. In confining its ambitions to making a visual and material image that extends and intensifies the visually mediated experience of modern life, Cubism belongs decisively to art.

FURTHER READING

Antliff, Mark and Patricia Leighten, eds. 2008. *A Cubism Reader: Documents and Criticism, 1906–1914*. Chicago: University of Chicago Press.

For illuminating discussions of some of the theoretical and aesthetic background issues see:

Phillipson, Michael. 2001. 'From Tradition to Hypertradition: Art's Mutation under the Decline of Modernity', in Nigel Whiteley (ed.), *Detraditionalisation and Art*. London: University of Middlesex Press, 107–27.
'What Was Abstract Art? (From the Point of View of Hegel)'. In Robert Pippin. 2005b. *The Persistence of Subjectivity: On the Kantian Aftermath*. Cambridge: Cambridge University Press.

NOTES

1. Cartwright and Sturken (2001: 239). In fact, defenders of high culture are usually prepared to concede that the 'entertainment', 'kitsch' or thoroughly 'conceptual' commodities of the culture industries they condemn are indeed cultural artefacts, just not very good ones.
2. Thus, clarifying what they mean by postmodernism, Cartwright and Sturken (2001) offer a contrast with modernism:

 Whereas modernity was based on the idea that the truth can be discovered by accessing the right channels of knowledge, the postmodernist is distinguished by the idea that there is not one but many truths. (251)

 However, postmodernism aims

 to put all assumptions under scrutiny in order to reveal the values that underlie all systems of thought, and thus to question the ideologies within them that seem natural. (252)

 Put this way, postmodernism offers 'knowledge' of ideologies by way of more intensive 'scrutiny', which it is difficult not to interpret as implying privileged access to something like appropriate theories and methods. At this point postmodernism sounds not very different from modernism, with its idea of the 'right channels of knowledge'.
3. Sophisticated postmodernists like Lyotard (1984, but see also Readings below) have sought strenuously to find a way of articulating the new situation critically and politically, in particular with respect to the discourse of justice.
4. Of course, none of this is new. For a particularly instructive account of how Max Weber sought to square an unflinching aspiration to knowledge of 'actuality' with the unavoidability

of 'values' which could not be 'scientifically' legitimated, including the value of science itself, see Scaff (1989).

5. Modernist art movements are rarely a major topic for visual culture studies. For example a search of the *Journal of Visual Culture* produces only three passing references to Cubism.

6. For important recent attempts to develop this kind of explanatory social theory, see Beck (1992); Giddens (1990).

7. The proletariat, an indispensable artefact of Marxist theory, was conceptualized as the oppressed class brought to correspond with its destined role and self-consciousness within the historical process of class struggle by means of the insights of historical materialism and the political leadership of the Party. As anointed agent of class struggle, the proletariat would eventually achieve a modern humanist utopia, transcending class divisions and the state along the way.

8. Emphasis on national culture is sometimes offset by the Left's internationalist outlook.

9. Matthew Arnold and Friedrich Schiller through to T. S. Eliot, F. R. Leavis and C. P. Snow.

10. Readings argues that what supersedes the university of culture is the 'university of excellence'. The ideal of excellence, which outcrops widely in the jargon of late-modern organizations, including the universities, purports to be an inclusive, objective measure of quality. 'Excellence' expresses how the university now understands itself, and as an 'integrating principle, excellence has the singular advantage of being entirely meaningless, or to put it more precisely, non-referential' (1996: 22).

11. Passage quoted by James McFarlane in Bradbury and McFarlane (1976: 71).

12. In other words, part of Cubism's social and cultural context is the fragility of everyday life under modern conditions.

13. Another good example of an innovative use of frame and framing is *Glass, Die and Newspaper* (1914), which includes a real frame, but painted the same dark green as the ground, and overlapped physically along the top edge by the folded metal from a tin can that makes up the glass, and the paper which forms a roughly rendered newspaper at the right.

14. See also Poggi's illuminating discussion (66-68).

15. See also Rudenstine (1988: 809-820).

16. Cf. Merleau-Ponty's treatment of Cézanne, who remained of immense significance to Picasso:

We live in the midst of man-made objects, among tools, in houses, streets, cities, and most of the time we see them through the human actions which put them to use. We become used to thinking that all of this exists necessarily and unshakeably. Cézanne's painting suspends these habits of thought and reveals the base of inhuman nature upon which man has installed himself. (Merleau-Ponty in Johnson 1993: 66)

17. Compare Poggi (124-163).

18. The relevant chapter is called 'The Insurrectionary Painter', a rather odd title as it is largely about the collages. It suggests, however, that Leighten shares Poggi's view that the 'negative' aspects of the collages are an 'insurrection' against painting.

19. Picasso never used material from anarchist or radical newspapers.

20. Between 1912 and 1913 Picasso produced around 80 collages, 52 with material about the Balkan Wars and the economic and political state of Europe. Tabloid stories constitute around a quarter of the clippings used between 1912–1914. After 1912 Picasso also included more 'personal' content (health matters, theatre listings, tonic wine advertisements).

21. Leighten argues far less convincingly that sensationalist stories should be seen 'politically', as evidence of Picasso's opinion of the madness and depravity of bourgeois society.

22. Unlike virtually all his friends and fellow avant-gardists, even those who were not French nationals and under no obligation to join up, Picasso did not succumb to war fever in 1914.

23. If one bears in mind Picasso's career as a whole, his character and artistic ambitions, surely 'total abstraction' was never really on the cards. It is worth noting that in the autumn and winter of 1912 Picasso did virtually nothing but collages, but by 1914 he had returned overwhelmingly to painting (see Leighten 1989: 128–9). If Leighten is correct about the importance of news content between 1912–1913, it is surprising that there is no sign of what must have been heated debates and difficult changes of view to the pacifist and antinationalist ideology of his circle leading up to the outbreak of war in 1914.

24. It should also be emphasized that with the most interesting early-modernist artists this connection does not simply consist in the fact that the latent content of form was some political 'statement' or other. She rightly observes that in the aesthetic ideas of many of the artists concerned there was explicit connection between form and content—examples being the Symbolists and Neo-Impressionists like Camille Pissarro—but not one that came down to 'statements'.

25. The recent exhibition *Picasso: Challenging the Past* (National Gallery, London, 2009) was illuminating on this point. Also Cowling et al. (2010).

26. Richardson thinks that Leighten makes too much of Braque's and Picasso's 'dormant social conscience'. The combat preoccupying Picasso was the controversy stirred up by Cubism, and the challenge issued by his papier collé to Braque and Matisse, the only living artists he regarded as his peers. See Richardson (2009: 250–2.)

27. See Leighten (42-43). The title she gives is *Pastoral Scene.*

28. The locus classicus is Marx and Engels's *Communist Manifesto*:

> Constant revolutionising of production, uninterrupted disturbance of all social conditions, everlasting uncertainty and agitation distinguish the bourgeois epoch from all earlier ones. All fixed, fast-frozen relations, with their train of ancient and venerable prejudices and opinions, are swept away, all new-formed ones become antiquated before they can ossify. All that is solid melts into air, all that is holy is profaned, and man is at last compelled to face with sober senses his real conditions of life, and his relations with his kind. (Marx and Engels (1848) 1969: 16)

For some important recent revisions, elaborations and extensions of social theory's idea of modernity see also Beck (1992), Beck, Giddens and Lash (1994), Bauman (2000).

29. For modernity and space-time see Giddens (1991: 16–18) and for expertise (18–21).

30. See Giddens 1992. The experience of disembedding, the disruption of the taken-for-granted continuity of everyday life, carries a real threat of meaninglessness and anomie.

> On the other side of what might appear to be quite trivial aspects of day-to-day action and discourse, chaos lurks. And this chaos is not just disorganisation, but a loss of the sense of the very reality of things and of other persons. (Giddens 1991: 36)

> The need to reembed—an attempt to reframe the conditions for minimum 'ontological security' (see Giddens 1991: 35–69)—confronts all, but most dramatically faces those directly

subject to the turbulence of industrial and later postindustrial modernization. The collective groupings encouraged by industrialization blunted the edge of this threat both psychologically and socially. In late-modernity, however, while individuals are released from 'ascribed identity', they are by the same token far more exposed to profound anxieties. Hence the need for 'expertise' (counselling, psychotherapy, life coaching etc).

31. There is no space here to discuss local, routine practices of everyday life in the context of de Certeau's well-known distinction between strategy and tactics. However, it's worth recalling his remark that local tactics may be all that the powerless have available (1984: 38).

32. See also classic social histories of working-class life, which are also chronicles of spontaneous reembedding: E. P. Thompson (1963, 1967) and Rose (2002). Ethnomethodology approaches this level of everyday practice as consisting of 'haecceities of familiar society', the 'worldly and real Work of making Things . . . Things of immortal, ordinary society' (Garfinkel 2002: 67).

33. Giddens's 'social reflexivity' is essentially a development of the concept of rationalization introduced into social theory by Max Weber (1978, 1985). While Giddens (like Beck) emphasizes that the 're-entry of knowledge' may have unintended consequences, the remedy seems to be yet more knowledge.

34. See also Pippin (2005a), in which he discusses Michael Fried's historical narrative of eighteenth- and nineteenth-century French painting as a continuing struggle against 'theatricality', falseness to the very practice of painting. Theatricality is not understood as a problem confined to painting but as a widespread, profound modern phenomenon. Pippin's claim is that 'the problem of genuine and false "modes of being" of the art work itself', as worked in painting, can contribute to a

more general understanding of meaning-responsive beings at work in a social world in historical time. Paintings thereby might be said to teach us how to appreciate their 'ontological status' and the historical fate of such embodied self-understanding. (Pippin: 578)

However, while Pippin would want to separate this 'ontological' dimension of painting from 'working out problems in perception, mimesis, iconography, formal organization, and the like' (578), I have tried to insist on their connection.

REFERENCES

Alexander, Jeffrey. 1995. *Fin de Siècle Social Theory: Relativism, Reduction, and the Problem of Reason*. London: Verso.

Attfield, Judy. 2000. *Wild Things: The Material Culture of Everyday Life*. Oxford: Berg.

Bauman, Zygmund. 2000. *Liquid Modernity*. Cambridge: Polity Press.

Beck, Ulrich. 1992. *Risk Society*, trans. M. Ritter. London: Sage.

Beck, Ulrich, Anthony Giddens, and Scott Lash. 1994. *Reflexive Modernization: Politics, Tradition and Aesthetics in the Modern Social Order*. Cambridge: Polity Press.

Berman, Marshall. 1983. *All That Is Solid Melts into Air: The Experience of Modernity*. London: Verso.

Bradbury, Malcolm, and James McFarlane (eds.). 1976. *Modernism: A Guide to European Literature 1890–1930*. Harmondsworth: Penguin Books.

Cartwright, Lisa and Marita Sturken. 2001. *Practices of Looking: An Introduction to Visual Culture*. Oxford: Oxford University Press.

Clark, T. J. 1999. *Farewell to an Idea: Episodes from a History of Modernism*. New Haven, CT: Yale University Press.

Cottingham, Paul. 2004. *Cubism and Its Histories*. Manchester: Manchester University Press.

Cowling, Elizabeth, Neil Cox, Simonetta Fraquelli, Susan Grace Galassi, Christopher Riopelli and Anne Robbins. 2010. *Picasso: Challenging the Tradition*. London: National Gallery.

De Certeau, Michel. 1984. *The Practice of Everyday Life*, trans. S. F. Rendall. Berkeley: University of California Press.

Douglas, Mary. (1966) 2002. *Purity and Danger*. Abingdon, Oxon: Routledge.

Garfinkcl, Harold. 2002. *Ethnomethodology's Programme: Working out Durkheim's Aphorism*. Lanham, MD: Rowan and Littlefield.

Gartman, David. 1991. 'Culture as Class Symbolization or Mass Reification: A Critique of Bourdieu's Distinction', *American Journal of Sociology*, 97: 421–47.

Giddens, Anthony. 1990. *The Consequences of Modernity*. Cambridge: Polity Press.

Giddens, Anthony. 1991. *Modernity and Self-Identity: Self and Society in the Late Modern Age*. Cambridge: Polity Press.

Giddens, Anthony. 1992. *The Transformation of Intimacy: Sexuality, Love and Eroticism in Modern Societies*. Cambridge: Polity Press.

Hegel, G.W.F. (1820s) 2008. *Outlines of the Philosophy of Right*, trans. T. M. Knox. Oxford: Oxford University Press.

Johnson, Galen A., ed. 1993. *The Merleau-Ponty Aesthetics Reader*. Evanston, IL: Northwestern University Press.

Leighten, Patricia. 1989. *Re-ordering the Universe: Picasso and Anarchism 1897–1914*. Princeton, NJ: Princeton University Press.

Lyotard, Jean-Francois. 1984. *The Postmodern Condition: A Report on Knowledge*, trans. G. Bennington and B. Massumi. Manchester: University of Manchester Press.

Marx, Karl and Friedrich Engels. (1848) 1969. *Selected Works*, trans. S. Moore. Moscow: Progress Publishers.

Pippin, Robert. 2005a. 'Authenticity in Painting: Remarks on Michael Fried's Art History', in *Critical Inquiry*, 31 (Spring): 575–98.

Pippin, Robert. 2005b. *The Persistence of Subjectivity*. Cambridge: Cambridge University Press.

Poggi, Christine. 1992. *In Defiance of Painting: Cubism, Futurism and the Invention of Collage*. New Haven, CT: Yale University Press.

Readings, Bill. 1996. *The University in Ruins*. Cambridge, MA: Harvard University Press.

Richardson, John. 2009. *A Life of Picasso, Volume II 1907–1917: The Painter of Modern Life*. London: Pimlico.

Rose, Jonathan. 2002. *The Intellectual Life the British Working Classes*. New Haven, CT: Yale University Press.

Rudenstine, Angelica. 1988. *Modern Painting, Drawing, and Sculpture Collected by Emily and Joseph Pulitzer Jnr*. Volumes 1-4. Cambridge: Harvard University Art Museums.

Scaff, Lawrence A. 1989. *Fleeing the Iron Cage: Culture, Politics and Modernity in the Thought of Max Weber*. Berkeley: University of California Press.

Seremetakis, Nadia, ed. 1994. *The Senses Still*. Chicago: University of Chicago Press.

Simmel, Georg. 1997. *Simmel on Culture*, ed. D. Frisby and M. Featherstone. London: Sage.

Thompson, E. P. 1963. *The Making of the English Working Classes*. London: Gollanz.

Thompson, E. P. 1967. 'Time, Work-Discipline and Industrial Capitalism', *Past and Present*, 38: 56–97.

Vannini, Phillip, ed. 2009, *Material Culture and Technology in Everyday Life: Ethnographic Approaches*. New York: Peter Lang.

Weber, Max. 1978. *Economy and Society*. Berkeley: University of California Press.

Weber, Max. 1985. *The Protestant Ethic and the Spirit of Capitalism*, trans. Talcott Parsons. London: Unwin.

Practices and Institutions of Visual Culture

Editorial Introduction

The essays in this part of the *Handbook* deal with recent thinking, debate and research in important, substantive areas of modern visual culture. A number of these research areas are both well established in their own right but also known and discussed as topics in visual culture studies—fashion, photography, television, and film—while others, like the perceptual basis of material culture, practices of landscape architecture and the recent digitization of consumption, will seem to some readers less familiar.

Many of the classic social theorists of cultural change—including Georg Simmel, Max Weber, and Thorstein Veblen among these—have considered the phenomenon of modern fashion as an exemplary sphere both of visual culture and of modern social life. The very idea of fashion's *obsolescence* and its association with the volatility of *style* and *life-style* makes it a central topic for visual studies. In more contemporary terms, fashion is perhaps the engine of change in a consumer culture or what has been called postmodern culture.

Malcolm Barnard is thus prescient in underlining the ways in which questions of identity—social, gender, ethnic and so on—have been absolutely central to theories of fashion as a particularly important area of visual culture. This is especially evident in the manifold ways in which clothing styles or *dress* functions to form and communicate the meaning of appearances and personal identity. While the term 'fashion' embraces a range of phenomena where taste or style are at issue, Barnard narrows his focus to the significance of what people *wear* largely in the context of everyday life, drawing on recent forms of fashion studies, which includes the history, sociology, anthropology, cultural study of fashion, as well as design history, psychoanalysis, gender and queer studies. He provides a useful outline of the history of fashion studies, the approaches prevailing over the last two decades, and finally a summary of its current preoccupations.

In his brief history of fashion theory and fashion culture Barnard notes the early influence of art history on thought about dress and fashion with its characteristic emphasis

upon taste, beauty and provenance. During the nineteenth and twentieth centuries, however, anthropologists began to take an interest in dress, especially in its nonfunctional characteristics as decoration, personal adornment and ritual. Sociologists like Thorstein Veblen and Georg Simmel began to pay more attention to the role of fashion and 'conspicuous consumption' as mechanisms to establish social standing and status distinctions. Status distinctions indexed by cultural markers like dress became as significant as class distinctions marked by ownership and authority relations. The early days of fashion studies still showed the influence of sociology and anthropology. More recently, however, the impact of cultural studies has been increasingly prominent, both as a label for a liberal, multidisciplinary outlook and as a quasi-discipline in its own right.

Perspectives that concentrate on the object have been linked to the outlook of predominantly female academics and curators, who argue that the material details of fabric and dress are vital to understanding their social and cultural meanings. Other approaches have sketched a social history of clothing styles, to which prominent historians like Fernand Braudel and Anne Hollander have contributed. Hollander explores how the meanings of clothed and unclothed bodies are expressed and mediated by both visual art and the cultural values of artists and spectators. Others, like Ann Rosalind Jones and Peter Stallybrass, have stressed that modern expectations and assumptions can be misleading in the interpretation of Renaissance dress codes.

Turning to the question of identity, the contention that dress contributes to the social construction of identity has become a commonplace in cultural studies. Identity can be expressed in terms of class position, and Barnard describes several relevant studies by Adrian Forty, Angela Partington and Diana Crane. There is also an enormous literature on fashion and gendered identities, from which Barnard singles out works by Adolf Loos, Lisa Tickner, Lee Wright, Elizabeth Wilson and Jennifer Craik. Other accounts by Shaun Cole and Katrina Rolley link dress codes with masculine and gay identities. All of these phenomena continue to attract much interest among theorists and researchers.

One influential theory of fashion and social subcultures can be found in Dick Hebdige's *Subculture: The Meaning of Style*, with its themes of resistance and incorporation. David Muggleton has recently provided an up-date to this study of subcultural styles by introducing ideas from postmodernism, while Emil Wilbekin has explored related issues in the context of a black presence in fashion and cultural life-styles. Barnard observes that age-related identities are somewhat under-represented in fashion studies, the exceptions being works by Alison Lurie, Cheryl Buckley and Lee Wright.

Turning next to theoretical and methodological issues, Barnard outlines the importance of semiological approaches to fashion, and the varied ways in which dress codes can be interpreted as 'language' or at least 'language like', with rather differing contributions from Roland Barthes, Alison Lurie, Ruth P. Rubinstein and Colin Campbell.

The specifically visual aspects of fashion are unexpectedly neglected in fashion studies. While work has recently appeared on the cultural and social significance of fashion photographers like Helmut Newton and Guy Bourdin, Barnard argues that this whole

area, particularly the relationship between 'high end' fashion, its dissemination and photography, is in need of greater analytical and critical attention. Something similar could be said of the complex relationships between fashion and the body, although as Barnard notes there are important differences between the relative intractability of the body and the facility with which clothes may be chosen or rejected. He outlines related arguments about whether tattoos for example should be treated as fashion.

Concern with globalization is often related to anxieties about the role of fashion in stoking up wasteful, unsustainable overconsumption and more generally environmentalist politics. In this context, Barnard mentions recent studies by Margaret Maynard, Colin Gale and Jasbir Kaur, and Sandy Black (for example the work *Eco-Chic*). The work of Kate Fletcher and the campaigning groups like 'Adbusters' seek to raise awareness of the sustainability and ethical problems relating to the production and use of clothing. Margaret Maynard's *Dress and Globalisation* (2004) represents an important development in more sociologically reflexive accounts of fashion as a global phenomenon.

Barnard warns against facile assumptions about the homogenizing effects of globalization in fashion. While companies like *Gap* and *Nike* may be everywhere, their products are not necessarily uniform or homogeneous. The overpowering of the periphery by the centre cannot be simply assumed. As Margaret Maynard argues, important different local uses and stylistic contexts for global products spring up continually and should not be ignored in either theory or research. Jose Tuenissen and Ted Polhemus have contributed to what Barnard calls the 'nonbinary account of globalization'.

In concluding, Barnard provides suggestions as to likely future avenues of research for fashion studies, proposing the topics of globalization, business and marketing, and 'green' and sustainability issues. Methodologically, Barnard advocates empirical, ethnographic research into the relationship between fashion and subcultures, combined with more conceptually and hermeneutically sophisticated interpretations of the complex links and mediations between visual presence and constructed meanings.

Like Barnard, **Tim Dant** is concerned with how we see 'things', particularly 'material objects', as the stuff of material culture. Ways of seeing—practices of looking—are embedded firmly within the everyday life-contexts of human beings. The objective of his chapter is to emphasize how the 'biomechanics of vision' needs to be supplemented by an account of the contribution of society and culture to seeing understood as the phenomenological 'apprehending' of everyday things. To this end he challenges the 'semiological' approach that has become widely influential in visual culture studies, a perspective that insists on understanding seeing as the 'reading' of discrete signs. For Dant, seeing things is not reducible to a 'system of language', but rather is a 'dynamic, embodied process, where things disclosed by the senses exist only in networks of other things with which our cultural experience has acquainted us. Dant commends a productive philosophical resource for understanding what happens in concrete perception in the tradition of phenomenology, from William James, Edmund Husserl and Maurice Merleau-Ponty to Alfred Schutz, Don Ihde and Paul Verbeek.

Dant usefully contrasts this phenomenological approach with the kind of semiotics readings that are current in the literature of visual culture studies. These kinds of linguistic models would, for example frame dress codes as ways of formulating sociological and ideological 'statements'. Dant notes, however, that in his later writing, the semiologist Roland Barthes moved away from treating things as *language* to the analysis of things as concrete sensory formations, moving in other words from structuralism to an early form of poststructuralism.

Barthes's application of linguistic and structuralist modes of thought to cultural phenomena—for example his *Mythologies*—has been enormously influential. Ultimately, however, the linguistic model does not stand up to scrutiny. There are both common sense and logical differences between meaning in language and meaning in our encounters with material culture. He notes that the anthropological approach thinks of material culture as 'co-constitutive of social groups along with other cultural processes that include language, economy, religion and consumption'. How something comes to be 'seen' depends on a dialectical interplay of social and cultural forces (rituals, social relations, discourse and so on). The complexity of seeing has led theorists to pay more attention to specifically *visual* techniques such as drawings, photographs, sound recording and films in sense-making activities. Dant suggests that anthropology both 'naturalizes' the seeing of its subjects, and routinely makes problematic its own practices of seeing. The latter reflexivity points towards a more emphatic concern with the 'mundane' process of seeing things.

Dant analyses aspects of everyday seeing, comparing these complex performances with the accounts provided by different theories of visual perception. The notion of an 'array' or compositional whole is useful as it suggests the ability of perception to shift from the 'outline' of a discrete item to a holistic view in which it is possible to look for contextual clues of various kinds. Michael Craig-Martin's *An Oak Tree* (1973) provides an example of a dramatic shift from a straightforward quotidian interpretation of the sight of a glass of water on a shelf to having to confront the possibility of an extraordinary interpretation.

From the perspective of Merleau-Ponty's phenomenology of embodiment, seeing things is not the result of a synthesis of relatively discrete parts but a single 'apprehension' of a body that sees, hears, smells, touches and moves through space. The kinaesthetic 'coherence of the body', and the ways in which we live our needs and interests, are the ultimate root of both the coherence and rich complexity of things seen.

Turning to the theme of 'apperception', identified in different ways by Edmund Husserl, William James, Alfred Schutz and others, Dant emphasizes the intertwining of 'thematic relevance', the ways in which memories, 'stocks of knowledge' and our current profile of interests and concerns shape perceptual acts. For the social phenomenolgist Alfred Schutz, perception also includes a sense of 'reach' or differential zones of actual or possible attainment with respect to an object or state.

Schutz's idea of 'appresentation' refers to the ways in which something not directly present in immediate perception may—through horizontal awareness or empathy—be indirectly presented. Following ideas from Husserl's transcendental phenomenology,

empathy and a conviction that the other's perception of the world is roughly like our own make possible not only a philosophical theory of the objective world but also a shared cultural world, specifically a world of shared and meaningful artefacts. From sharedness, rooted in sedimented layers of apperceptions, arise the possibilities of intersubjectivity and the phenomenon of 'co-presence', a belief that we are looking at the 'same thing'. These kinaesthetic reciprocities also enables the ego to imagine how another ego might react to the sight of a particular thing. Husserl makes clear that appresentation is not a step-by-step cognitive process but 'happens in a glance', and he calls the connection between the self's perception and that of the other 'pairing', something which depends to a large extent on a common stock of knowledge or 'co-perception'.

By creatively extending Husserl's ideas about apperception and appresentation Schutz created tools to explain mediated cultural experience, a 'communicative common environment' of meaningful artefacts, including predominantly 'visual' ones. Schutz's distinctive notion of the 'symbol' is that it forms part of a pairing with a realm of meaning beyond the everyday, for example in such 'provinces of meaning' as science and religious belief.

Dant concludes by noting important revisions to phenomenological theory by Ihde and Verbeek, suggesting a more active role for things in their relationships with people. Dant defends a position that points beyond the work of Merleau-Ponty and Schutz by stressing the role of holistic embodiment and an enhanced sensitivity to 'mediated and symbolic sub-universes' in their relationship with the orienting reality of everyday life. While critics have argued that early phenomenology paid insufficient attention to differences in power, Dant suggests that phenomenology has the advantage of explicitly addressing the question of a shared world in which such differences exist, and in which they might be challenged. Taken together, the descriptive accounts of the meaning and perception of things provided by the phenomenological tradition are more plausible and richer than those of semiotics and other language-based approaches.

If phenomenology tries to defamiliarize everyday experience and to uncover its complex meaning 'genesis', so technologies like photography and film may also function as 'bracketing' techniques. For example a black-and-white landscape photograph by the artist Willie Doherty, on which captions have been superimposed, might call into question the ways in which we usually make sense of photographs. For **Fiona Summers** this image highlights how the interpretation of photographs, rather than being obvious or unproblematic, is always undertaken from a point of view with particular perceptual and ideological dimensions. The appearance of digital photographic technology notwithstanding, work on photography within visual culture studies, by for example Susan Sontag, Roland Barthes, Victor Burgin, John Tagg and Stuart Hall, has thus continually emphasized the artefactuality and conventionality of the photographic image, and, more especially, its social or political meanings and uses.

Summers points out that the introduction of digital photography has not seriously threatened the 'mimetic' aura of photography generally. The conventions of analogue photography remain in force, despite the superseding powers of digital coding; indeed these conventions might be self-consciously used to introduce 'imperfections' or

'graininess' to the digital image to enhance its documentary connotations. Conversely, 'perfect' digital imagery has come to be associated with notions of hyper-reality. The role of ubiquitous photography as a medium for the production of circulation of visual images has shaped the culture of modern life. Ranging from public displays (advertising displays, journalism, photo-sharing Web sites) through to intimate family snaps, we find a complex set of relationships and connections between photography and everyday life. As Vivian Sobchack and others have pointed out, 'the way in which we see and make sense of ourselves as subjects is fundamentally transformed by photographic visuality'. Through photographs we present ourselves to others and ourselves in a variety of different ways, all of which may be reviewed in terms of the veracity or desirability of what is shown. Much of visual culture studies is about the role of photography in recognition and misrecognition, the power of the gaze, and the influence of photography on visual presentations of self. Unlike film, photographs arrest movement and freeze time, producing an 'object of vision', and thus lending an uncanny aura of veracity to the image. Yet as Roland Barthes points out, there can be no coincidence between a photograph and the 'real self'.

With family photography, the image captures the active presentation of 'being a family', of bringing out and strengthening real and/or imagined ties. Digital technology and image-sharing Web sites have continued the traditions of family analogue photography. Danish ethnographer Jonas Larsen argues that as family structures become more complex and fluid, family photography may evolve to emphasize longevity and consistency. He further points out that holiday, leisure and cultural locations, together with cameras, draw people together into enactments of 'familyness'.

Turning to the new phenomenon of digital sharing, Summers reports the view of Jose van Dijk that the digital camera is being used not just to record important events in the context of everyday life but much more casually, often as a means or enhancement of mundane social interaction. Communal photographic exchange via Web sites like *Flickr* does not so much displace the contribution to memory as to provide new patterns and opportunities for its distribution. Novel aesthetic and 'interest' communities may be the result.

The 'rhizomatic' effects of the causal, multiple 'labelling' of images on *Flickr* has produced what Daniel Rubinstein and Katrina Sluis call 'folksonomy', a shifting, flexible, collaborative organization of content. In the context of *Flickr*, labelling is important in that it creates finite collections of images among multiplicity of images too vast to be seen. These collections are typically viewed in sequence, thus departing from the largely static imagery familiar to earlier writers on photography. Digital technology also erodes the 'aura' of analogue images, replacing it with a sense of 'disposability and immediacy'. Summers argues, however, that the placing of photographs in online archives lends them importance and permanence.

Turning to the documentary uses of photography, Summers suggests that despite widespread scepticism about the veracity of such images the recording or memorializing functions of photography continue to matter immensely. As an example, she turns to Alison's Young's work on photography and the terrorist attacks on the World Trade

Centre in 2001, which shows how personal photographs of absent people and the build-ings operated in sites of mourning. Summers suggests that photographic imagery still attracts a conflation of seeing with knowing, perhaps as a response to an event that was difficult to comprehend. David Campany interprets the plate photographs of Ground Zero by Joel Meyerowitz as almost an attempt to 'rescue' memory, and the memorial functions of photography itself, from a welter of images and information.

This point connects to the use of photography in the context of archiving and mu-seums. Susan Sontag had already noted that photographs of particular events are often taken to encapsulate an entire historical event or even period, and that museums of vari-ous kinds are heavily reliant on photography. As an example, Summers cites Darren New-bury's work on the role of photography in two South African museums, showing how particular documentary images associated with violent episodes in the struggle against apartheid have shaped postapartheid national memory. However, Newbury's work also raises questions about the power of the photographic cliché 'congealing' around a prob-lem, sometimes obstructing more complex and constructive insights.

Rachel Hughes has drawn attention to the use of photographs to represent nations or historical episodes in the particular case of Cambodia's S-21 prison during the genocide of the 1970s. Portraits of incoming prisoners have been used worldwide to document and encapsulate Pol Pot's Kampuchea, largely as a result of the cataloguing and conser-vation work of the American Photo Archive Group. Yet even in the case of grotesque atrocities, the preservation and distribution of the material images does not eliminate questions about the formation and uses of historical memory.

In conclusion, Summers argues that the advent of digital technologies has not re-duced the importance of photography, but 'activated and built on photography's ability to mutate . . . in order to become crucial to the networked societies in which it is ar-gued we (as global citizens) live, work and connect'. She notes the continued power of individual images to elicit a range of powerful feeling, articulated in public and private settings. Digital technology has done nothing to change the capacity of photographs to be both transient and enduring. As Walter Benjamin observed, the camera can record what might have been seen, causing us to look at the photograph not only for what was 'there' but unobserved, but also for what was 'yet to come'. Amid the complexity, pro-fusion and chaos of a digital visual culture, photography still offers this hope of 'seeing better' or even seeing at all.

With the appearance of new media technologies like permanently streamed digital photography and film (especially through social networking sites and multimedia plat-forms), a whole new range of issues becomes researchable. Here the configuration of topics not only includes traditional issues of the content and structure of the medium but also its social production, dissemination and appropriation in social and cultural terms. **Kristyn Gorton** explores television as one such global visual medium, emphasiz-ing not just 'what appears on screen' but also the more intangible practices that occur around and through this global medium.

The new era for television, sometimes called 'TV 3', dating from around the mid-1990s, is one in which digital-satellite broadcasting bypasses national boundaries and

confronts a global environment, with radical consequences for older national institutional and organizational structures. Television has become part of the background of people's lives, but this does not necessarily mean that its influence on ideas and outlooks is continuous and emphatic. There are times when viewers actively engage with the visual message, and others when they allow the flow of meanings to wash over them as a kind of ubiquitous background to their normal activities and lives.

Plurality of screen technologies and convergence between the Internet, television and film have led to new patterns of viewing, raising the larger question of whether television is more or less central to modern life. Anna McCarthy is concerned with the public presence of television, what human acts it reinforces or interprets. For example is 'waiting' integral to its structure, and what feeling and needs does 'passing the time' address? The availability and placing of screens in public spaces like bars and restaurants are important to understanding what viewing practices are taking place.

John Sinclair, Elizabeth Jacka and Stuart Cunningham argue that signs of the coming globalized media future began to appear in the 1970s, accompanied by trade liberalization, increased international competition and the declining power of the national state. Satellite broadcasting, they say, acted as a 'Trojan Horse' for media deregulation. Burgeoning private programming led not only to more dependence on American imports but also new 'geolinguistic regions', often based around common languages, for example the popularity of South American 'telenovellas' in Spain and Southern Europe.

Reviewing the development of the debate, initiated in the 1960s by Herbert Schiller about media and cultural 'imperialism', Gorton suggests that there has been a recent resurgence of interest within global television studies, despite two decades of critique and revision. However, the ways immigrant groups and travellers actually use globalized content for their own, often unexpected, purposes has been increasingly researched. American cultural products cannot be assumed to make their consumers think like Americans. For example Lisa Parks has studied the use of satellite dishes by Aboriginal Australians, discovering that the selection and viewing of programmes are strategically restructured to give them shape and relevance for an indigenous audience.

In thinking about media globalization, the idea of 'flow' has become more important, a more plausible alternative to the older notion of a radiating centre dominating a periphery. Reviewing Raymond Williams's early work with the notion of flow, Lynn Spigel draws attention to the way it highlights a continuity of form and emotional tone in American television running across different programmes and advertisements. Albert Moran suggests that 'flow' is the unity of 'carriage and content', a more accurate way of thinking about global television than separating medium from message.

Different researchers have noted the power of television executives to decide what programmes to purchase for large national and international communities, and hence to influence production. Edward S. Herman and Robert McChesney focus on the emergence of transnational media corporations, while Michael Curtin argues that the growth of 'media capitals' like Bombay, Cairo and Hong Kong, dominating production, finance and distribution, is more important to the new global configuration than national

constraints. In some ways this makes branded content more important in attracting and retaining audiences than control of distribution. This means that consolidated media corporations must focus more on a broadening of emotionally compelling content within an overall brand image.

Toby Miller has suggested that in a neo-liberal globalized world questions of belonging become more urgent and more difficult. For Gorton, this raises the question of how audiences become emotionally engaged with what they watch. Henry Jenkins identifies a new 'convergence culture' in which content flows across different media, accompanied by migratory audiences in search of their desired entertainment experiences. Coining the term 'affective economics', he argues that production and distribution increasingly cater for specialist tastes via different media platforms, evidence of the exploitation of the emotional involvement of audiences with particular programmes.

Other researchers, influenced by the 'theory of reflexive modernization' of Anthony Giddens, Ulrich Beck and Elisabeth Beck-Gernscheim, have investigated television culture in the light of a 'new individualism', which stresses 'choosing, changing and transforming'. Lauren Berlant describes the arrival of an 'intimate public sphere', saturating television with scenes and techniques of intimacy, from the 'confessional' to therapy and self-help. Rachel Moseley argues that 'makeover', talent shows and 'reality television' generally have eroded the distinction between public and private. Researchers like Anita Biressi, Heather Nunn and Charlotte Brunsdon demonstrate how reality programmes supplement a 'didactic' element with a crucial moment of 'revelation', bearing on a display of the protagonist succeeding or failing in his or her transformational efforts. Many such programmes stress the obligation of choice and change, the designing and execution of a life.

The emphasis on 'choice' affects both what is watched and how it is watched. David Jay Bolter and Richard Grusin argue that, because of the structure of financing, television is even more oriented to the immediate gratification of audiences than film, relentlessly pursuing as a consequence proven formulae for positive emotional response. Derek Johnson has studied the 'interactive' involvement of enthusiastic viewers in programme design, arguing that producers enjoy 'free labour' but also keep firm control over what gets made.

Gorton notes the ambivalence in audiences who are both reflexively critical but also emotionally engaged; 'critical knowledge' does not inevitably negate 'viewing pleasures'. As Helen Piper has pointed out, much reality and life-style programming both invites empathic identification with participants, but also elicits judgement. For Gorton, such judgement is another expression of 'choosing, changing and transforming' with respect to a social role or identity.

Finally, Gorton summarizes recent television research focussed around debates over 'carriage' and 'content'. The 'culture of production' is as important as the 'production of culture'. In particular, new research has changed our understanding of 'how television is made and received in one culture and understood in another' or the flows between makers, sellers, buyers and watchers of television. In a complex, plural marketplace the capacity of programmes, under certain viewing conditions, to evoke emotions has become

critical to the formation and retention of audiences, hence the importance of 'content streaming' and 'aesthetics' to further research. Gorton concludes by arguing that the 'liveliness and immediacy' of television imagery, often watched in intimate, domestic settings, provides many people with a sense of the world in which they live and influences life-styles and identities, and as such research into television will remain important to the study of contemporary visual culture.

Andrew Spicer explores a related area of contemporary visual culture. He begins by noting that the appearance of new visual media and global forms of digitalization have threatened a crisis for film studies as a disciplinary research area within visual culture studies, heralding a new era of 'post-cinema', or a 'cinema of interactions' in which films are still made and watched, but in new forms and more actively in a variety of locations. Hollywood—the Hollywood industrial system—no longer prevails over an integrated system of production, distribution and exhibition.

In a similar vein, researchers like Christine Gledhill and Linda Williams endorse a 're-invention' of film studies, revising it fundamentally in the light of this new postmodern, globalized environment. For David Rodowick, digital technology means that film is no longer the 'pre-eminent modern medium'. For other film theorists, this new situation provides additional opportunities for revising the history of film as one episode in a longer, more diverse history of audiovisual 'moving images'. Focusing selectively on key accounts of the perceived 'crisis', Andrew Spicer sets out to explore debates about the 'nature of film itself', film's relationship with other practices of looking, and finally with visual culture.

Recent film history has examined film's contribution to the social and cultural changes associated with the rise of modernity. New visual technology, restless movement and urban spectacle were combined by early cinema, and regarded as quintessentially modern. Indeed the appearance of regulated 'industrialized time' and capitalist work practices formed the background to the cinema's capacity to capture and organize the ephemeral and the quotidian.

Studies by Tom Gunning, Vanessa Schwartz and Ben Singer locate early cinema amidst the emerging 'society of the spectacle' and a newly mobilized sensory environment of 'shocks, fragmentation and superabundance of sensation.' Miriam Hansen points out both the specificity of classical Hollywood film, and its success as the first 'global sensory vernacular', an aesthetic counterpoint to the experience of mass industrial society. Anne Friedberg sets cinema in the context of a 'mobilized virtual gaze', a characteristic perceptual form of modernity and ultimately of postmodernity.

Replacing an earlier unqualified enthusiasm for new media, recent studies have stressed the complex interplay between analogue and digital technologies. Both mainstream and experimental films have been made using digital formats, for reasons of both cost and aesthetic potential, with the latter often focussed on post-production editing. While the Hollywood blockbusters, characterized by expensive action sequences and special effects, are still globally important, other forms of cinema have arisen, hence the interest of film studies in a new, decentred multinational system for film. Hamid Naficy notes the rise to prominence of 'accented cinema', produced by displaced or diasporic communities and circulated across national boundaries.

The ways in which movies are seen and appropriated have also changed. Cinema going remains popular, but is just one way of viewing, displaced by a variety of screen formats and forms in which a film might exist, from DVD to the Internet. 'Home cinema' may well become a predominant form of film consumption, catering for new ways of being a fan or a connoisseur. Some observers argue that the interactive potential of digital technology is leading to the empowerment of audiences, or at least to a greater market voice.

Laura Mulvey has suggested that the ease with which moving images may now be frozen restores to film the 'weighty presence of passing time' that André Bazin and Roland Barthes associated with the epistemology of the photograph.

Turning to the aesthetic impact of digital film technology, Spicer discusses Lev Manovich's analysis of the changing ontology of the moving image. Situated at the confluence of computing and media technologies, digital film should be understood as an 'expressive, graphic medium', akin to painting, or 'a particular case of animation that uses live-action footage as one of its many elements'. Analogue film's technique of montage and cut has been replaced by digitalized composition and morphing.

Spicer suggests that the surface detail made possible by digitalization and the combination of computer-generated imagery (CGI) and live action have been exploited to blur the difference between 'immediacy' and 'hyper-mediacy', the 'real' and spectacle in an aesthetics of 'surface play and immersive spectacle rather than intelligibility'.

More radical experiments with digital aesthetics are conducted by avant-garde practices bringing together different cultural locations: filmmaking, music, video, street art, club events and video installations in galleries. Digital technologies lend themselves to eclectic hybridization and the forging of new connections. Among the better-known directors creating new work across different platforms are David Lynch and Peter Greenaway, but Spicer also points to the success of 'The Matrix' franchise, not so much a film genre as an 'evolving cultural entity', an instance of 'metacinema'. What this demonstrates, according to Spicer, is that while a particular form of cinema may be over, in its new, multiple forms film 'continues to be a crucial component of art and popular culture in the digital age'.

Digital visual images may be as important to the visual experience of postmodernity as analogue cinema was to the representation of modernity. However, do changes in moving image technology and practices of viewing amount to the end of film as a coherent cultural form, offering to the spectator distinctive features and qualities, as David Rodowick has suggested? As digital images seem more remote and are less dependent on the prior existence of material, temporal things, they may discourage the 'sensuous exploration of the physical world and the material structure of everyday life' that were important to photography and film. However the 'crisis' of film is mirrored by related crises elsewhere in the wider culture; indeed the very term 'digital' often seem a designation of 'crisis and transition'. Arguments about the integrity of film studies or its submergence in a new visual culture studies giving precedence to digital visuality are another expression of current uncertainties. For Spicer, the opening of film studies to a broader, more inclusive historical, technical and aesthetic context is

important for research into film specifically, but also to the quality of a dynamic, interdisciplinary visual culture.

In conclusion, Spicer argues that film and film studies are experiencing a 'threshold moment', with researchers having to confront and question fundamental presuppositions. Some of the most useful work is examining in empirical and experiential detail how new technologies operate and what practices of viewing they stimulate. In light of the declining centrality of the Hollywood system, we should also expect new studies of transnational or global cinema, as well as work on film as one component of complex, multiple and rapidly changing forms and networks made possible by digital media.

Connecting directly with the practice and theory of landscape architecture, as well as more broadly addressing the social and aesthetic impact of the built environment, **Kathryn Moore** argues for a need to change prevailing approaches to perception itself, particularly with respect to traditional assumptions about the role of visual perception in social life.

In the context of design practice, Moore suggests that there has been a growing awareness that the natural and built environment has a profound effect upon economic growth and upon many aspects of the quality of life. This recognition is also evidenced in the policies of governments internationally, with Moore citing as examples enlightened housing and landscape projects in the Netherlands, the Midlands area of the UK and Costa Rica. It also informs projects that cut across the conventional divide between the artistic and ecological, as well as democratic political initiatives furthering the idea of 'landscape rights'. Here the traditional separation of environment, architecture, aesthetics and human experience has become blurred.

Moore argues that by neglecting landscape, landscape architecture and architectural practice overlook an important dimension of modern life, its experiential value or 'lived' quality. In coming to terms with these complexities visual culture studies can learn from the emergent holistic strategies addressing the challenges of 'industrialization, urbanization, energy, demographic shifts and changing patterns of work and habitation, as well as climate change, the depletion of natural resources, de/forestation, problems relating to food production, biodiversity, heritage, a host of issues relating to the quality of life and other aspects of land use change and development'.

Blocking such changes, in Moore's view, reflects weaknesses in the philosophical basis of design practice, and more particularly a misunderstanding of the centrality of perception and lived experience in architectural praxis. The individual and collective factors involved in the making of good design have been subject to a misleading dichotomy, between ineffable subjectivity on the one hand and techno-scientific problem solving on the other. Moore's critique from the point of view of design practice raises questions about ideas of perception prevailing in visual studies. Moore thus recommends a 'pragmatic, holistic approach to consciousness and perception'.

Moore argues that sense perception, or the kind of organized awareness and reflection that takes place at least partly through the medium of seeing and looking, has been subject to contradictory assessments. In some accounts it is seen as primitive, instinctive

and unpredictable when compared with, say, the cool rationalism of verbal thinking. Often this view is connected to the idea of sensory specialization, which Moore argues is obviously fallacious when it comes to unified character of everyday perception. As the American pragmatist philosopher John Dewey observes, to think of 'sensory inputs' as 'synthesized' is already to have made a fundamental mistake. For Moore, the isolation of the senses encourages not only an overestimation of the 'sovereign' powers of vision, but eventually also 'ocularphobia', in which vision is accused of a wide variety of cognitive and ethical failures.

The underlying problem of the aesthetic, according to Moore, is the inevitable failure of the aspiration to 'see' beauty directly and without presuppositions, and the consequent descent of critical judgement into forms of subjective preference. This has many harmful implications for art and design pedagogy, which Moore describes.

Following the American neo-pragmatist Richard Rorty and others, Moore argues that mistakes, problems and disputes about the visual and so-called visual thinking can be simply removed by refusing to divide consciousness into different modes or conceptual spheres: 'all thinking, whether in the arts or sciences is therefore interpretative and metaphorical', and hence 'linguistic'. Presumably, however, the notion of 'language' at work here would privilege neither oral speech nor written text along the lines of received understandings of language. Moore suggests that refusing to separate awareness of the world into insular spheres of consciousness solves many intractable problems and helps secure a more robust, common-sense realism.

Moore outlines some of the consequences of rethinking perception, discussing in particular truth, visual skills, aesthetics and objectivity. Turning to the design process, she reviews the implications for theory and the generation of form (a key design skill) and the basis of design discourse.

In conclusion, Moore emphasizes how theorists can learn from practice, specifically a practice that avoids compartmentalizing its different aspects. The ambition of design practice should be to bring to bear all aspects of the social and cultural context for landscape and architecture. However, the resources offered by current discourse may well be deficient. Certainly Moore thinks that the language available for talking about public spaces needs a more 'differentiated vocabulary'. Abandoning current ideas about perception will improve design teaching and practice, enabling designers to 'connect special strategies to real places' through the development and application of new ideas.

The research theme that **Martin Hand** sets out to explore rests on the view that we live in an increasingly visualized culture, not simply because of the ubiquity and power of images and imaging technology but because of the use of images and visual artefacts in the production and mobilization of commodities. Consumer culture is thus thoroughly pervaded by social relations of design, marketing and branding.

With the coming of modern consumer culture there is an increasingly more emphatic connection between visual culture and the consumption of commodities. In very general terms, 'consumerism' has replaced 'productionism' in the logic of contemporary capitalism, and as a consequence, social-cultural life has been 'aestheticised'. Not surprisingly most work focussing on consumption in visual culture has been preoccupied

by advertising, and this relates to what Hand sees as the central question of all social-scientific studies of consumer culture: the capacity of consumers to act as agents. He suggests that studies of consumer culture and visual culture have much to offer one another, although both confront new theoretical and methodological challenges emerging from processes of global digitalization.

The idea that contemporary culture is a 'consumer culture' has become a commonplace of modern sociology. Application of semiotics encouraged the idea that the consumption of things was secondary to the consumption of images built into products by sophisticated designers, marketeers and advertisers, and that such consumption patterns had become indispensable to the formation and projection of identities. The result of this sociological and cultural turn was that the empirical study of consumption has tended to be predominantly culturalist. More recent consumer theory is the result of three shifts. First, commodities are now visualized in new ways. This is particularly evident in the exponential growth of the advertising industry. Second, changes in marketing and branding have to some extent undermined the priority of the visual. Third, digitalization has affected consumption profoundly, for some even threatening the 'death' of advertising.

Hand argues that analyses of 'visual consumption' and approaches to consumption generally within visual studies have overemphasized the importance of the visual and the symbolic, to the detriment of a more nuanced account in which visuality is treated as one element among other material and sensory features and practices. As with Dant's argument about the challenges faced by material culture, Hand suggests that we need new ways of thinking in dealing with the materiality of everyday life.

To this end he turns to well-known critiques of consumer culture, typically decrying its supposed visual emphasis through which anxious, avaricious consumers are created, and a shallow culture of images frustrates the promise of a society based on authentic human values. For Hand, research in visual consumption remains dominated by a monolithic idea of the technologically or economically determined disappearance of 'reality' into 'spectacle'.

Researchers have recognized the changing social significance of the commodity-sign. While the capacity of consumers to interpret the class and status connotations of commodities seems to have become more important, the bewildering array of choices and messages makes competence problematic, resulting in what Zygmunt Bauman has called a world of 'flawed consumers'.

The advent of digitalization, particularly the digital photograph and the proliferation of 'virtual' images whose relationship with their objects is uncertain, is taken to widen the gap between viewer and the world. A key idea here is the notion that goods have a predominantly 'visual face', the presentation of which has been primarily photographic. Hence, photography has been the most important visualizing tool employed by advertisers and marketeers. It has also been argued that the image of a commodity now often precedes its production, with brand management seeking to orchestrate product identities and meanings.

Hand reviews changes in advertising research, with more recent accounts stressing the active consumer, the possibility of different consumption practices, and the inescapable

problems of choice and possible error, with consequences for the construction and presentation of consuming selves. While much visual advertising invokes an active, rational agent as its addressee, critics suggest that the range of choices on offer is narrow and predetermined according to corporate interests. While there are well-known theoretical and methodological difficulties in proving the direct power of advertising over consumer behaviour, nevertheless Hand concludes that advertising shapes the 'visual terrain of consumption by encouraging consumers to identify with particular images of lifestyle'.

The history of advertising formats provided by William Leiss, Stephen Klein and Sut Jhally usefully charts the development of advertising in relation to socioeconomic change. While early advertisers stressed the self-evident value of the product or its progressive, modern characteristics, 'totemic' or 'narcissistic' life-style connotations pervade later commodity images. The late-twentieth century saw the rise of global branding where product-imagery and personalized life-style formulae combine to constitute the more differentiated (or perhaps fragmented) 'postmodern consumer'. Advertisers reflectively acknowledge and incorporate what consumers 'know', their cultural and aesthetic competencies in the context of a highly fluid and rapidly changing field that branding tries to 'manage'. As Celia Lury has pointed out, brands become not only 'practices' but also 'new media objects', replacing products and consumers. In this context visual appearances become one dimension of an array of sensory and textual features, including material qualities and characteristics, to create identities, presence and the experiential effects of life-style and 'authenticity'.

Hand turns next to the relationship between visual aspects of consumption and digitalization. Much research concerned with the impact of digital technology appears to accept that contemporary society has become pervasively cultural and 'visual'. Modern and postmodern life has been thoroughly *aestheticized*. The image has become not only the means but also the end of consumption. With economic globalization the commercial penetration of an increasingly visual culture has been accelerated and deepened through the new digital technologies. However, while some theorists stress the 'dematerialized' image, others propose the appearance of 'lively' and interactive media formats.

Global digitalization facilitates the 'voluntaristic production of visual culture by consumers', with blogging Web sites, *YouTube* and user-generated photographic archives like *Flickr* being prominent platforms. Researchers have drawn attention to the erosion of the boundary between amateur and professional image-making, the development of 'user-friendly' creative software, and the potential of digital equipment for a growing 'craft' orientation among ordinary, nonspecialist image practitioners.

These changes produce contradictory phenomena. On the one hand the new geo-ecology of proliferating, mutating images makes it difficult to know 'who' produces, distributes or owns an image. On the other hand image rights have become critical for maintaining older producer-consumer relations and profit margins. Digital imaging as an instance of mobile and convergent media combine with other digitalized data flows and raise profound theoretical, practical, ethical and commercial problems, prompting a radical questioning of visual culture as a 'field of representation'. Hand also notes the paradox of increasing consumer participation on the one hand alongside the commercial use of software that sorts, classifies and codes behaviour into different life-style categories on the other.

Hand concludes his survey by arguing that theory and research in the field of visual culture has hitherto elided the diversity and specificity of consumption practices. Faced with the inadequacy of these models we need more realistic accounts of actual consumption patterns, especially 'a more nuanced consideration of the ways in which images are acquired, interpreted, used, and increasingly co-created by situated consumers, in relation to historically and socioeconomically defined contexts'. In moving away from traditional models of representation and commoditization, and towards emergent forms of co-production or 'prosumption', theory is simply responding to the changing practices of consumers, or what Hand refers to as the 'rematerialization of culture in digital terms'.

Looking Sharp: Fashion Studies

MALCOLM BARNARD

Fashion and clothing construct, reproduce and challenge all kinds of identity and they do so visually and immediately. The meanings of the visual here, the meanings of what people are wearing, are quickly learned and readily understood by all members of all cultures: learning and understanding those meanings may even be said to be the conditions for membership of those cultures. So, for example within seconds of seeing or meeting someone we make a series of judgements concerning identity and culture, about who they are and whether we will have anything in common with them, on the basis of what they are wearing. Rarely, if ever, do we wonder what people mean by the things they wear or dismiss garments as meaningless: meaning and identity are constructed, negotiated and understood constantly in visual fashion. The centrality of fashion and clothing to the concerns of this collection (the concern with visuality, meaning, identity, society and culture), should not need emphasizing. Social and cultural identity and social and cultural status, including those identities and statuses that are to do with gender, class, sexuality and ethnicity, are constructed, negotiated and challenged visually, in and through what we wear. Similarly, our sense of self, and our understandings of our own bodies, are also produced and tested visually by the things with which we adorn, decorate, display, hide and protect our bodies—fashion and clothing. In raising concerns such as these, fashion is at once an extremely ancient, a completely modern and a thoroughly postmodern phenomenon. What people wear has always constructed and indicated social and cultural status and what people wear is now part of a postmodern and globalizing economy in which the relation of identity to consumption is readily or functionally understood by almost everyone, even if not everyone is ready to critically analyse and explain that relation.

This chapter will include everyday clothing, or dress, as well as fashion in its account of fashion studies. It is possible to argue, as Adam Smith argued in the eighteenth century,

that the term 'fashion' includes everything to which the concept of taste is relevant or may be applied and that it therefore includes music, poetry, architecture and furniture (Smith 2006: 194). It is also possible to argue, with Baudrillard in the twentieth century, that fashion includes all consumer goods and our own bodies, as well as the things that we wear (Baudrillard 1993: 87). Following Fernand Braudel (Braudel 1981: 328), Lars Svendsen goes so far as to wonder whether philosophy and even thought itself are ruled by the cycles of fashion and one does not have to be very cynical to begin to agree with him when he suggests that academics have their 'in' subjects and their 'sexy' approaches (Svendsen 2006: 15). And it would be possible to concentrate on what some people think of as 'high fashion', expensive or exclusive items of clothing that are produced by high-status, high-profile and famously named designers. Such a version of fashion would include, but not be exhausted by, haute couture production and the production centred around places such as Savile Row in London or the Garment District in Manhattan, New York. However, this chapter will side with those who argue (Hollander 1994: 11; Barnard 2007: 3) that fashion also and most interestingly includes 'what people wear'; fashion is also what everyone wears to go about their everyday lives at work, at leisure and at rest. A concern for the everyday and for what everyone does every day is itself a significant product of the processes that led to the establishment of fashion studies in the first place and that concern is hardly to be ignored. Finally, we should consider the argument that it is impossible to buy clothes (or any other products), for everyday use that are not fashion in the sense of being fashionable: this is because everything in the shops is new and of its time and to that extent everything is fashionable. Consequently, this chapter will use fashion to refer to the garments and other things that people all over the world wear every day and it will include catwalk and haute couture creations as well as the items on every High Street and in every mall and catalogue.

This chapter will call the collection of disciplines and approaches that make up the study of fashion 'fashion studies' and we shall see that that collection of disciplines and approaches will include fashion history, the sociology of fashion, anthropology, cultural studies, history, art history, design history, psychology, psychoanalysis, gender studies and queer studies.

There will be three main sections to this chapter. The first will identify and explain the origins of scholarly and other interests in what we wear and it will chart the early history and development of those interests. Early descriptions and explanations of fashion were coloured by the interests of other forms of visual analysis: art history and visual anthropology, in particular, informed nineteenth- and early-twentieth-century accounts of what people wore. The second section will be the main section and it will account for the approaches and perspectives that have been most prevalent over the last ten to twenty years. Art historical preoccupations with visual style and anthropological interests in non-Western cultures developed via cultural studies and feminism into a series of concerns with identity and meaning. The role of the visual, fashion, in constructing and negotiating meaning and identity became central to fashion studies while, oddly, the visual itself was pushed to the sideline. The third section will consider some of the interests that have occupied fashion studies more recently and which look set to continue to hold

our attention. This section will indicate how the specifically visual in fashion has become subordinate to another set of themes and concerns. These concerns are predominantly to do with the environment and globalization but they also include the unapologetically economic: the business and commercial sides of the fashion and clothing industries are increasingly the object of fashion studies.

HISTORY AND ORIGINS

This section will give some indication of the history and origins of modern interests in fashion by charting the contributions of art history, sociology and anthropology to the analysis of what people wear.

The art historian Rudoph Wittkower was in no doubt that art history is the 'mother discipline' of all other fields of study (Weinshenker 2008) and we may be less than surprised to find that early fashion studies do indeed owe much to certain strands of art history. Those strands are concerned with connoisseurship and style and they are both the product and the reproduction of a popular conception of fashion as 'art'. It is clear that one of the many pseudonyms for fashion is style and it is natural that fashion studies should look to art history for an account of style and for the concerns of art history to permeate early fashion studies in this way. The relation to connoisseurship derives from the need of fashion historians to be able to date items of clothing. Often their only source would be the paintings the clothes appeared in and the experts in dating paintings were, of course, art historians (see Breward 1995: 1–3). There is also the relation to beauty and the attempt to define or explain it that unites early fashion studies and art history. Writing about both art and fashion in 1859, Charles Baudelaire argues that there is a double aspect to beauty. There is an 'eternal invariable element' and there is a 'relative circumstantial element'. The latter is ephemeral and fashion, but without it the former eternal element is impossible to appreciate (Baudelaire 1995: 3).

Charles Baudelaire provides a commentary on the French version of Dandyism in his 1863 essay 'The Painter of Modern Life', suggesting that it is aristocratic, cold and founded on a 'personal originality' to make a 'cult of the self' (Baudelaire 1995: 27). Fashion itself is described as 'a symptom of the taste for the ideal which floats on the surface of all the crude, terrestrial and loathsome bric-a-brac' (1995: 33). His account can be compared with that of Thomas Carlyle, who describes the Dandy (see Figure 16.1) as someone who 'lives to dress' and who dresses in order that the public 'recognise his existence' (Carlyle 1987: 207). Baudelaire's account of fashion may be compared with that of H. G. Wells, who has one of his characters say that fashion is 'the foam on the ocean of vulgarity' (Wells 1895: 17).

Nineteenth- and early-twentieth-century anthropology took an early interest in what people wore, describing the dress of non-Western cultures in the search for answers to the questions surrounding why people wear clothes. Around the beginning of the twentieth century, the functionalist anthropologist Bronislaw Malinowsky was arguing that protection from the elements was the reason for clothing in humans (see Rouse 1989: 2–3). The anthropologists Ernest Crawley and Hilaire Hiler, writing in the 1920s and

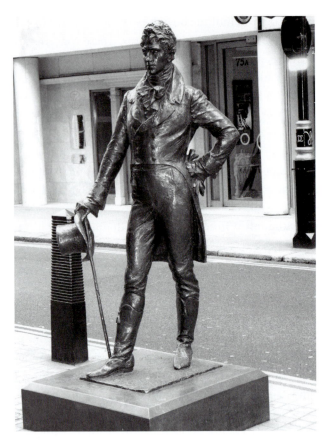

FIGURE 16.1 Irena Sedlecká, *Beau Brummell*, 2002, bronze, Jermyn Street, London. Photograph: Mike Smith.

1930s, also studied what they called 'primitive' cultures in order to understand why they wore what they wore in terms of decoration and adornment (see Laver 1969: 1–4). These interests are reproduced today in Justine Cordwell and Ronald Schwartz's (1979) edited collection *The Fabrics of Culture: The Anthropology of Clothing and Adornment*, in which they comprehensively enumerate and describe the various functions of fashion and dress. These writings lead to Judith Barnes and Joanne Eicher's (1993) collection *Dress and Gender*, which takes an anthropological interest in the ways that different, non-Western cultures organize and communicate gender roles by means of what is worn. And Ted Polhemus and Lynn Proctor's work, in their (1978) *Fashion and Anti-Fashion: An Anthropology of Clothing and Adornment*, provides a slight change in disciplinary approach in that it tries to provide anthropological explanations of what Western people wear as fashion.

The sociologist Rene Koenig actually takes something of a psychoanalytic approach in parts of his (1973) *The Restless Image*, explaining the impulses driving fashion as scopophilia and exhibitionism (1973: 81–3). Thorstein Veblen's (2007) *The Theory of the Leisure Class*, written in 1899, is the classic source for the sociological idea that fashion, in the form of conspicuous consumption (1992: 60), is used by the highest social classes

to indicate that they have no need to work and that they can afford to wear items that actually render them incapable of productive labour (1992: 118). This theory has been enormously influential and much subsequent writing may be seen as either a development or a diversion from it. Indeed, Quentin Bell's *On Human Finery*, written in 1939, opens with a large quote from Veblen and the assertion that it is 'the most valuable contribution yet made to the philosophy of clothes' (Bell 1976: 15). Writing a few years after Veblen in 1904, Georg Simmel differs slightly in his account when he says that, while fashion is the preserve of the upper classes, the lower classes are left to copy those fashions: having done this, the upper classes must find some novel way of distinguishing themselves in what they wear and as Simmel says, 'the game goes merrily on' (Levine 1971: 299). The so-called trickle-down theory of fashion is also found in Polhemus (1994) and McCracken (1985).

MAIN PERSPECTIVES AND APPROACHES

Many of the early concerns of fashion studies were informed by a curious mix of 'old school' art history and anthropology. More recently, many of the main perspectives and approaches have come from cultural studies, which itself may be viewed as a form of anthropology, and art history has in turn changed to take on many of the concerns of cultural studies.

It is largely agreed that the study of fashion and clothing is or should be interdisciplinary. The historian Fernand Braudel, the art historian Lisa Tickner and Elizabeth Wilson, who adopts a wide-ranging cultural studies type approach to fashion, are all agreed that there is a range of disciplines in terms of which fashion and clothing may be studied. Braudel tends towards the economic in the following quote but insists that 'the study of costume is less anecdotal than it would appear. It touches on every issue: raw materials, production processes, manufacturing costs, cultural stability, fashion and social hierarchy' (Braudel 1981: 311). To the economics of production and manufacture he adds important social, cultural and political themes. In her groundbreaking 1977 essay on women and trousers, which deals with gender as well as social and cultural history, Tickner lists many disciplines without which fashion studies would be incomplete. She says that fashion studies is a 'rich and multidisciplinary subject and a point at which history, economics, anthropology, sociology and psychology could be said to meet' (Tickner 1977: 56). And, although it would be easy to argue that she adopts and makes use of many more approaches than she lists, Wilson says that aesthetics, social theory and politics are some of the approaches we must adopt when studying fashion and clothing (Wilson (1985) 2003: 11).

The history of fashion studies begins in the 1960s, when cultural studies and feminism collided and began to transform the humanities and social sciences. Of course, people had noticed fashion and clothing before then and they had written about them before then (see McNeil 2008; Purdy 2004, for example), but the serious, analytical and, most important, critical study of fashion and clothing really only took off in a sustained and institutionally sanctioned manner in the late 1960s and early 1970s. This new approach

to fashion studies as such can be outlined under the topic headings it developed: object-based studies, history and fashion, identity, semiology and meaning, the visual aspects of fashion, consumption and production, and the body.

Object-based Studies

There are probably two ways of approaching object-based studies of clothing and fashion. The first is through a methodological and almost ideological commitment to 'the object', where 'the object' is conceived as a legitimate and even unfairly neglected aspect of such studies. Such an approach is perhaps best represented by the work of Lou Taylor in dress and costume history. The second is where an object is concentrated upon, but with no commitment to it as a methodologically privileged item. Such approaches are seen in the work of Valerie Steele (2001) and David Kunzle (2006) on the corset, and in that of Daniel Miller on the Little Black Dress (Miller 2004).

In her (1998) reassessment of object-based dress history, for example Taylor notes the 'hostility' of the male curators of the museum which went on to become the Victoria and Albert Museum towards collections of dress and suggests that such 'prejudice' became enshrined within the museum's collecting policies in the nineteenth century (1998: 337–8). She describes a division between (predominantly male) academics and museum curators on the one hand and (largely female) devotees of object-based research on the other (1998: 339). Taylor notes the way in which the economists Ben Fine and Ellen Leopold (1993) 'dismiss' the work of a series of women dress historians who rely on the detailed description of dress and clothing. She defends the historians' approach by arguing that the cultural, social and economic readings of Fine and Leopold are only made possible on the basis of the 'information' gained through the 'meticulous study' of these details (Taylor 1998: 348). The argument has to be, of course, that the descriptions and the 'information' are always-already culturally loaded; they are themselves the products of social, economic and cultural positions and not some neutral and objective descriptions or 'information'. It is not so much a gendered hostility and prejudice that disposes many against object-based studies as the idea that the empiricist belief in objective observations and descriptions of facts has no answer to the argument that facts and observations are the products of theories and as such not objective descriptions.

For what it is worth, Steele (1998) presents her own version of object-based studies in the same edition of *Fashion Theory* and, although she adds a positivist belief in the difference between facts and hypotheses, she makes essentially the same move as Taylor makes by presupposing that neutral and objective observations are possible, and the basis for theoretical explanations.

History

Chronological versions of fashion and dress history, where the only tale being told takes the form of a time-line, are not as prevalent as might be feared. James Laver's (1969) *Costume and Fashion: A Concise History*, is probably as near as one will get. He begins

his ostensibly descriptive history of what people wear with the loin-cloth worn by the Venus of Lespugue, a figurine dating from around 2800 BC and ends it with Donna Karan's 1994 sportswear collection. Cultural identities along with political positions and values are regularly to be found in this account. The Teddy Boys of the 1950s precede Hippies, who appeared in the 1960s, and who are in turn succeeded by Punks in the 1970s. They are not united in a conscious account of fashion and class, for example, but the politics and cultural values of these groups are inevitably hinted at: the Teddy Boys' style is explained in terms of the new affluence of working-class men and their increasingly confident visual presence (1969: 260); Hippies are said to 'reject' Western consumerism (268) and Punks are anarchic and shocking (270). Any idea that what is being presented as a commonsense history of dress and fashion here is not a constructed bourgeois consensus is completely avoided.

It may strike some as odd that Fernand Braudel, who was quoted above in support of interdisciplinarity, appears in the same section as Laver. Braudel was a member of the French Annales School of history writing, which deals with very long periods of time and the persistence of deep structures over those long periods, rather than the relatively short periods, changes and differences dealt with by other historical approaches. However, there is an entire chapter in volume 1 of Braudel's major work *Civilisation and Capitalism* that is devoted to the conditions for the possibility of fashion and to the ways that it changes. Braudel says, for example that in stable societies and among the poor, there is and can be no fashion (1981: 312–3). Tellingly, perhaps, Braudel spends some time himself charting the social and economic conditions for the possibility of fashion and describing some societies in which fashion either does not exist or in which what people wear changes infinitesimally and very slowly before turning to Europe. 'We can now', he says, 'approach the Europe of the rich and of changing fashions without risk of losing ourselves in its caprices' (1981: 315); only then can fashion in the Europe of between around 1350 and the end of the eighteenth century be analysed and explained.

Anne Hollander's approach in her (1993) *Seeing through Clothes*, like those of Laver and Braudel, is also to cover a long period of time. She begins with the clothed statues of ancient Greece and Rome and ends with advertisements, photographs and shop windows from the 1970s. Her approach, however, is not chronological. Rather the relation between visual representation (in sculpture, painting and photography, for example), the body and the clothes the body wears is analysed into different categories: the representation of the clothed and unclothed body in statues and sculpture is covered as 'drapery', before 'nudity' is distinguished from 'undress' and theatrical 'costume' is distinguished from 'dress'. Finally, the various forms of mirroring and mirrored representation are covered.

In her account of the effects of changing cultural values on the representation of women's legs in paintings, Hollander points out that Rembrandt's women, who have never learned how to display their bare legs elegantly in seventeenth-century Dutch public life, are unselfconscious and inelegant. Goya's naked Maja of 1800, however, knows exactly how to display her legs to best erotic effect, having worn lightweight and narrow skirts in public life. And the women in William Bailey's twentieth-century

paintings, who are most accustomed to wearing trousers, borrow a '"natural" sprawl' from men, with 'knees at angles and noticeable feet' (Hollander 1993: 91–3). Where Steele and Taylor deny the role of cultural values and 'perspectives' on the perception and understanding of dress and fashion, Hollander explicitly identifies the different cultures, along with their values and practices, and explains how the latter mediate the former. The meanings of the bodies of the clothed and unclothed people appearing in the sculptures, paintings and photographs that Hollander describes are explained as being produced by the cultural values and locations of artists and spectators.

Ann Rosalind Jones and Peter Stallybrass consciously move these hermeneutic concerns to centre stage when they consider the history of Renaissance dress and fashion. They say that, in order to 'understand the significance of clothes in the Renaissance, we need to undo our own social categories' (2000: 2). The beliefs and values that modern readers hold, simply as a result of being modern readers, from a different cultural time and place, are here conceived as a problem, an obstacle in the way of understanding what fashion meant to fifteenth-century Europeans. One of the ideas that modern readers may have trouble with is the idea, found in Shakespeare's *Henry IV* Part 2, that fashion may be worn 'deeply'. When Hal sees and understands his brothers' sadness at the death of their father, they point out that he assumes or takes on that sorrow as though it were a garment: 'I will deeply put the fashion on, / And weare it in my heart', he says. This is, as Jones and Stallybrass put it, 'challenging' to a modern audience who will be used to thinking about fashion as a superficial, surface effect: to a fifteenth-century audience it will indicate the idea that clothes 'permeate the wearer' making them what they are (Jones and Stallybrass 2000). In this case, even the meaning of the word 'fashion', with its Old Testament undertones of God's hands 'fashioning' mankind, is different for modern readers from what it is for Renaissance readers. There is, then, a wide range of historical approaches to the study of fashion and dress, from the naively empiricist to the reflexively sophisticated hermeneutic.

Identity

The ways in which what people wear construct and communicate identity through the things that they wear are absolutely central to a lot of work in fashion studies. As Diana Crane says, 'fashion . . . performs a major role in the social construction of identity' (Crane 2000: 1). Fred Davis (1992) complicates the ways in which fashion and dress relate to identity by exploring the ways in which cultural, gender and class identities are in fact ambivalences; he argues that it is these ambivalences that drive fashion. A comprehensive introduction to most aspects of fashion, dress and identity can be found in Mary Ellen Roach-Higgins et al.'s (1995) *Dress and Identity*. This huge collection covers fashion and identity from the perspectives of the individual and the psychological, the social and cultural as well as from those of time and place. The present section will survey the main categories: class, gender, sexuality, race/ethnicity and age.

Given that many people argue that fashion is only possible in the sorts of societies that have social classes and social hierarchies, it is not surprising that class is an important

part of fashion studies (see Baudrillard 1993: 89; Barnard (1996) 2003: 102ff). Adrian Forty explains fashionable change in terms of class in his *Objects of Desire*. He describes how the higher social classes in the late-eighteenth century would wear printed cottons, because at this time machine production and colour technologies were costly and time-consuming and printed cottons were expensive to produce. The higher classes could therefore use them, in good Veblenian style, to distinguish themselves from the lower orders. As the industrial revolution progressed, however, print and colour technologies got cheaper and quicker and the lower orders found that they too could afford printed cottons. The higher classes therefore went back to wearing plain cottons, loftily dismissing printed cottons as 'vulgar' and 'common' (Forty 1986: 73–5).

In her essay on working-class affluence and the New Look, Angela Partington describes the ways in which women of her own mother's generation and social class adapted and adopted Christian Dior's New Look of 1947. These women would use less material and less expensive materials, they would tone down the sexiness of the look and they would incorporate elements of the earlier shirt-waister dresses, but they created for themselves an unofficial and class-specific version of the New Look that satisfied their needs (Partington 1992). Diana Crane's (2000) *Fashion and Its Social Agendas* explains the origins of class as something to be signalled by what people wear in the industrial revolution, when new social classes were created and what they wore became significant. Crane distances herself from Veblen and Simmel's 'top-down' theories of fashion and complicates the account by adding gender to the mix; she also suggests that modernity and globalization involve a move from class to consumer fashions.

There is an enormous literature on gender and fashion. Adolf Loos's (1998) explanations of men's and women's fashion, written around the end of the nineteenth century and the beginning of the twentieth century, are definitely gendered. In 'Men's Fashion', he says that changes in men's fashions are driven by the desire for aristocratic elegance, and comes close to echoing Veblen's account, in which the lower orders strive to emulate their social betters by wearing what they are wearing. In his essay 'Women's Fashion', however, he takes an almost Rudofskian approach. Rudofsky is well known for explaining the changes in what women wear in terms of biology and natural selection, arguing that they are a product of a biological need to attract and keep a sexual partner (see Rouse 1989: 11).

Lisa Tickner takes an interdisciplinary approach to gender and dress in her (1977) essay 'Women and Trousers'. In this essay Tickner is interested in what different cultural and gender groups of people think about women wearing trousers and to that extent she is writing a cultural history of the garment. However, she is also interested in women's social roles in the twentieth century and the ways in which women's work and leisure habits changed: to that extent she is writing a social history of the garment. Lee Wright's (1989) essay on stiletto heels concentrates on the meanings that the shoes had for the women who wore them and for the army of disapproving male 'experts' who saw fit to comment on the heels. To the young, independent women wearing them, they meant dissatisfaction with existing gender roles, glamour and rebellion (1989: 14). To the male 'experts' they represented a different sort of challenge; pavements and aircraft floors had

to be reinforced against the damage the heels were doing and medical doctors warned of the damage wearing them would do to tender female bones.

Chapter 6 of Elizabeth Wilson's ((1985) 2003) *Adorned in Dreams* is devoted to gender and identity. She surveys the history of fashion from around the seventeenth century, when gender was not so strongly marked as it is today, to modern times and argues that fashion is obsessed with gender and with drawing and redrawing the shifting boundaries of gender in what people wear. While subtitled 'Cultural Studies in Fashion', Jennifer Craik's (1994) *The Face of Fashion* is mostly about gender. Femininity is central to most of the chapters, and especially those on fashioning women and fashion models, but masculinity is also covered. It is made very clear that fashion, modelling and fashion photography are powerful ways in which women are made feminine and men are made masculine. Tim Edwards's (1997) *Men in the Mirror* is concerned with the construction of masculinity in fashion and dress. He looks at the ways in which masculinities, including the so-called New Man of the 1980s, are constructed, consumed and reproduced in and through men's magazines, advertising, and men's experiences of shopping. Anne Hollander's (1994) *Sex and Suits* is also actually mostly about gender. Within what has become known as 'queer studies', Shaun Cole's (2000) *Don We Now Our Gay Apparel* is probably the best source for a cultural historical account of gay men's dress. This book explains various effeminate and masculine gay male stereotypes as well as gay men's relations to subcultures such as hippies, bikers and punks. The use of dress in gay women's relationships is introduced by Katrina Rolley's (1992) essay 'Love, Desire and the Pursuit of the Whole'. The use of masculine dress to signify lesbian identity and the development of 'butch/femme' identities through clothing are covered.

The most influential text dealing with subculture and fashion is undoubtedly Dick Hebdige's (1979) *Subculture: The Meaning of Style*, which defines and exemplifies a powerful cultural studies approach to youth culture. Hebdige explains the origins of youth subcultures like the skinheads of the 1970s in terms of their borrowing the styles, dances and music of Jamaican and African traditions introduced to Britain in the 1970s and in terms of an aping of supposedly working-class white values of the time. He also uses terms such as 'hegemony' and 'bricolage', borrowed from Marxist cultural studies and French semiology respectively, to begin to explain the meaning of white youth subcultures as resistance and communication. The title of David Muggleton's (2000) *Inside Subculture: The Postmodern Meaning of Style* gives it away as a conscious theoretical retake and updating on Hebdige's work. The themes of resistance and incorporation are explicitly present here, as a critique of 'hegemony' but they have been joined by (or they are now viewed through the prism of) the postmodern. Consequently, there is now a concern for postmodern subcultures and for the self. The work of Baudrillard and Frederic Jameson has explored the disjunction between style, meaning and identity and there are now postmodern codes, differences and consumptions.

The cultural critic Emil Wilbekin analyses black hip-hop styles and the relation of different black communities to the higher end of fashion production in his article in (1999) *Vibe History of Hip-Hop*. More recently, he has noted the appearance of black

models and people in fashion places where they are not often observed: in a piece on Be-
yoncé's cover shoot for American *Vogue* in April 2009, he reminds us that Italian *Vogue*
devoted a whole issue to black women in 2008 and he recalls that Michelle Obama ap-
peared on the cover of the March 2009 American *Vogue* (accessed at http://giant.black
planet.com/style/beyonce-in-vogue/ April 2009). Wilbekin's approach is from a black
history perspective, charting the place and roles of black people where they have been
underrepresented since Beverley Johnson's first appearance on *Vogue*'s cover in 1974.
There are some interesting essays, from the likes of Susan Bordo and Neil Bernstein on
subjects such as Gangsta and Cool-Cat style in Mary Lynn Damhorst et al.'s (1999) *The
Meanings of Dress*. Edna Nahshon's (2008) *Jews and Shoes* is an edited collection of es-
says that discuss shoes in terms of religious and cultural identity and look at the different
meanings that footwear has and has had for Jews.

The construction and reproduction of appropriate age-related identities is curiously
neglected in fashion studies, although there is a range of social-psychological approaches
collected in Chapters 8 and 9 of Mary Lynn Damhorst et al.'s (1999) *The Meanings of
Dress*. Alison Lurie devotes a chapter to the subject and points out that it was only to-
wards the end of the eighteenth century, with the work of Rousseau, that Europeans
began to see children as being very different from adults; before then, they had been seen
and treated as undersized adults and dressed accordingly. She surveys various 'looks': the
Kate Greenaway look, the Lord Fauntleroy look and the Sailor look, for example and
explains the phrase 'mutton dressed as lamb' (Lurie 1992). Lee Wright explores an in-
teresting take on adults wearing clothes that are 'too small', discussing them in relation
to the idea of being young and of 'conjuring up' the child's experience of growing out of
things and to the adult's experience of power (Wright 1992). Children's clothes are dis-
cussed in terms of gender in Cheryl Buckley's (1996) essay. She looks at the catalogues
and advertisements and argues that while the very young are shown alone, the slightly
older are shown in company, happily replicating the gender-appropriate poses and roles
of adults. Nevertheless, she says that the patterns and the sizes of patterns used in clothes
for the very young are distinctly gendered, with the smaller and floral prints being used
in girls' clothes and describes her own attempts as a parent to challenge and resist domi-
nant gender identities.

Semiology and Meaning

Semiological and meaning-based approaches sometimes get criticized for reducing fash-
ion and dress to meaning, but such criticisms inevitably propose a meaning themselves,
be it the body or some other experience of what is worn, and meaning is once again what
stands in need of explanation. There is a range of approaches to the explanation of mean-
ing of dress and fashion and a lot of them, including social-psychological approaches to
nonverbal communication, are surveyed and exemplified in Mary Lynn Damhorst et al.'s
The Meanings of Dress. This is a massive collection of essays and papers from a range
of perspectives. Alison Lurie (1992) takes the view that clothing is literally a language.
On this account, items of clothing are one's vocabulary and one has a large or a small

vocabulary (1992: 4–6). Lurie also thinks that items of clothing, like words, are meaningful in, or by, themselves independently of what people think of them. Meaning resides in, or is a property of, the object itself on her account.

Ruth P. Rubinstein (1995) offers a slightly more sophisticated account of meaning. Like Lurie, she thinks that clothing is a language and that there is a vocabulary of both. Unlike Lurie she thinks that social context generates the meaning of clothing: one needs to know the social and cultural codes in order to decode the meaning of the clothing (1995: 7). The French semiologist Roland Barthes is also misled somewhat by the idea that fashion is like a language. In his astonishing (1990) *The Fashion System*, he attempts to provide a rigorously semiological and scientific account of how meaning in fashion is created in fashion journalism. Colin Campbell (1997) takes rigorous, and correct, philosophical issue with the whole idea that fashion might be a series of messages that are sent and received. My own essay (2007a) also argues against the sender/receiver model and tries to reinstate a version of Barthes's connotation to bring culture back into the explanation of meaning in fashion.

The Visual

Bizarrely, the visual has remained relatively neglected in fashion studies, while being held responsible in the popular press and public opinion for creating an entire generation of young women suffering from anorexia, bulimia and other eating disorders. There are too many picture books, coffee-table books and uncritical celebrations of designers and their beautiful productions to list, of course, but the critical analysis of the visual in fashion, whether through drawings and illustration or photography remains curiously underrepresented. Carol Di Grappa edited a fascinating and utterly forgotten book on fashion photography entitled *Fashion: Theory*, in which fashion photographers such as David Bailey, Chris von Wangenheim and Arthur Elgort wrote about the relations between the technical and the aesthetic in their works (Di Grappa 1980). The essays and images collected here begin the task of analysing the ways in which the visual, what fashion looks like and how it works on bodies, is mediated through different kinds of photographic practices.

E. Sue Atkinson presented what she called a 'short survey' of fashion photography in her 1981 essay for the *British Journal of Photography*. In this essay she notes the illustrative function of fashion photography around the beginning of the twentieth century before moving on to begin an explanation of the rhetorical function of fashion photography as it manifests itself in advertising from the 1930s through to the 1960s and 1970s. The work of people such as Cecil Beaton in *Vogue*, Baron de Meyer in *Vogue* and *Harper's* and Edward Steichen for J. Walter Thompson and Condé Nast in the 1930s is explained with reference to the culture and technology of their times. Bert Stern's development of the all-American outdoors girl for American *Vogue* in the 1950s and the ways in which David Bailey promoted a slightly different kind of girl for *Vogue* in the 1960s are discussed in terms of gender and culture. The different gender identities of the American and British versions of femininity are explained by saying that they are the products of different cultural values.

A decade or so later Rosetta Brookes (1992) and Teal Triggs (1992) contributed es-
says on fashion photography to Juliet Ash and Elizabeth Wilson's collection of essays,
Chic Thrills. Brookes wonders whether Guy Bourdin's and Helmut Newton's 'strange'
settings of accidents and suicides represent the 'intrusion of a "real world" into fashion
photography' or are 'distanced' by it (Brookes 1992: 19). She also notes that, if Bour-
din and Newton know they are manipulating stereotypes of femininity, then Deborah
Turbeville's work communicates the 'strangeness' of the female image and its failure to
reduce to the identity of the 'image presented by the model' or the 'image presented
by the picture' (Brookes 1992: 23). Rebecca Arnold's essay, 'Heroin Chic' appeared
in the September 1999 edition of *Fashion Theory*. Bourdin, Lang and Newton reappear in
this essay, which describes and analyses the development of a photographic and fashion
aesthetic, the 'heroin chic' of the title, through the 1980s and 1990s. Also published
in 1999, Paul Jobling's *Fashion Spreads* also looks at fashion photography since 1980.
Kate Moss, who was one of the models associated with the 'heroin chic' aesthetic,
reappears in Jobling's book when he compares the treatment of her and of the girl in the
'Alex Eats' series of images produced by Anthony Gordon in the late 1980s. The book
uses Lacanian psychoanalytic concepts, including those developed by Julia Kristeva, as
well as methods and concepts from gender studies.

In 2002 Berg published a special edition of its journal, *Fashion Theory*, on fashion
and photography. In the guest editor's introduction, Carol Tulloch reminds us that there
is not much theoretical work written on the subject of fashion photography and says
that the collection is intended to be part of a much larger and developing body of work
pitted against the minority who still believe that fashion photography is about 'selling
the accoutrements of dress through pretty pictures' (Tulloch 2002: 1–2).

Consumption/Production

It would not be unreasonable to suggest that the appearance and development of fashion
studies is itself at least partly a product of intellectual interest moving from production
to consumption in the 1970s (see Styles 1998: 387). It is also not unreasonable to see
a connection between a shift in analytical and critical interest from production to con-
sumption in gender terms. Breward, for example, makes just such a connection when
he suggests that design history's roots in 'masculine' and production-oriented industrial
design and architecture led to the *marginalization* of 'feminine' areas of interest such as
dress, fashion and consumption (Breward 1998: 303).

The Body

The body is at once the most and the least obvious thing to think about when thinking
about fashion and what people wear. On the one hand, it is true but trivial to say that
fashion is worn on the body and that adorning, colouring, shaping and adapting the
body are what fashion does. As Baudrillard says, fashion includes our bodies along with
all consumed commodities and what is worn (1993: 87). The idea that the fashionable

things we wear enable and constrain our movements and poses and that those bodily phenomena are therefore fashionable is a familiar one. On the other hand, the body itself is not at all a fashionable item: one does not choose it and one does not change it every season. It is not immediately clear that the tattooing, cicatrization, scarring, surgery, piercings and the many other body modifications that are undergone in the name of this season's ideas of beauty and fashion are in fact fashion. Once undertaken, many of these practices and processes are either difficult or impossible to reverse or un-perform.

In the book *Streetstyle*, Ted Polhemus suggests that tattoos are not fashion (1994: 13). Rather, he says, they are style and style is 'inherently conservative and traditional'; this is why tribal styles often take permanent forms such as tattoos and scarification. Reporting from what some would consider the wilder shores of fashion, hinted at in the work of Foucault on the body and sexuality, Paul Sweetman argues that, while some see tattooing and piercing as 'little more than a fashionable trend' and others see them as antifashion, they are in fact postmodern body-projects, 'corporeal expressions of the self' in which a 'coherent and viable sense of self-identity' is constructed and communicated (Sweetman 1999: 2–3). Joanne Entwistle's (2000) *The Fashioned Body* is a Foucauldian and sociological account of the body and fashion. After surveying a huge range of accounts of fashion, she concentrates on how fashion and dress relate to power, gender and class identity before looking at fashion and sexuality.

CONCLUSION: NEW AGENDAS/FURTHER RESEARCH

This section will offer a few hostages to fortune by describing some of the more recent agendas of fashion studies, and then indicate which are most likely to hold the interest of fashion studies in the future. It will start by suggesting that globalization will become an increasingly significant area in fashion studies in the future. The prevalence of business and marketing-related studies, initiated some thirty or so years ago by the likes of Gordon Wills and David Midgley in their (1973) *Fashion Marketing*, also looks as though it will develop and be welcomed in some quarters in the future. And, on slightly safer if metaphorically more threatened ground, green issues and sustainability will surely come to dominate the critical and analytic agendas of fashion studies. More methodologically, I would like to see Caroline Evans's (1997: 185) suggestion that the nature and role of fashion and clothing in contemporary subcultures be studied in more serious and empirical ways get taken up and developed. As she says, the way that British academic life is organized at present means that it is cheaper and easier to produce theoretical accounts of what cultures and subcultures are doing than it is to produce 'ethnography'. Consequently, more 'armchair' analysis and explanation than primary research and 'field work' gets done. What fashion studies may need and what it may provide in the future is a marriage of more conceptually and hermeneutically sophisticated accounts of what contemporary cultural and subcultural groups are doing visually with what they wear. If the theoretically and methodologically uncomplicated concerns of 'object studies' were to meet the insensitive and abstracted concerns of more semiological cultural studies, then fashion studies would undoubtedly benefit.

There is increasing interest in the idea of fashion as a business and as a marketing opportunity. Critical interest in fashion and textiles as industries with an interest in marketing and image has been stoked for a while, since Angela McRobbie's (1998) *British Fashion Design: Rag Trade or Image Industry?* but there are more 'how to do it' books around. Michele Granger's (2007) *Fashion: The Industry and Its Careers* and Leslie Davis Burns and Nancy O'Bryant's (2007) *The Business of Fashion* are just two of the publications put out by Fairchild Books in recent years that provide a student's guide to fashion as an industry or as a global business. This sort of book tends towards the descriptive and the explanatory: providing definitions of marketing phrases such as 'supply chain management' and explaining what qualifications are required for certain positions within the industry. Recent publications, such as Jennifer Craik's (2008) *Fashion: The Key Concepts*, continue to uphold a more critical and analytical interest, including chapters on fashion as a business and as a cultural industry.

Up until around 2007, when what journalists started to call the 'credit crunch' began to steal newspaper headlines and colonized the op-ed pages, sustainability was becoming the most fashionable issue in fashion and fashion studies. At the time of writing, it remains to be seen what the ultimate effects of the economic crisis will be on fashion and whether it will negate or accelerate any progress that had been made in terms of sustainability and a green agenda. As early as 1971, Victor Papanek (1971) was arguing against the way in which fashion (in the broader sense noted above in the introduction) entails the endless production of expensive and unsustainable novelty in all consumer goods, from motorcars and refrigerators to furniture and stiletto heels.

The final chapter of Margaret Maynard's (2004) *Dress and Globalisation* turns to 'responsible' design. 'Corporate' responses to green challenges are outlined and the contribution of new, 'smart' clothing is assessed. Given Maynard's arguments, noted below, it is not surprising to see her deal with the problem of second-hand Western clothing turning up in less developed areas such as India and Africa (2004: 150), although she does not deal with it in the detail found in Black (2008). Colin Gale and Jasbir Kaur's (2002) *The Textile Book* includes a useful chapter on ecology. They place ecological concerns in historical, political, social and theoretical contexts before scrutinizing the roles of governments, global corporations and other agencies and organizations in the debates and actions taking place around these concerns. Sandy Black's (2008) *Eco-Chic: The Fashion Paradox* outlines a number of 'paradoxes', or problems, generated by recent speculation on the combined futures of fashion and the earth. It may appear to be a good thing for Western and non-Western environments that wealthy Western consumers 'recycle' clothing by sending it to underdeveloped countries in Africa, but local textiles and fashion industries inevitably suffer because there is no local production. Kate Fletcher's (2008) book *Sustainable Fashion and Textiles* is supported by a Web site and a sustainability blog (go to http://www.katefletcher.com/index.shtml). The book covers the production (cultivation and growing of cotton and wool, for example), and consumption (the use and refuse of clothing) of fashion before discussing more speculative proposals concerning local production, sharing and 'slow' clothing. She is concerned to alert us to the many problems involved in materials such as cotton, polyester and wool. Cotton production

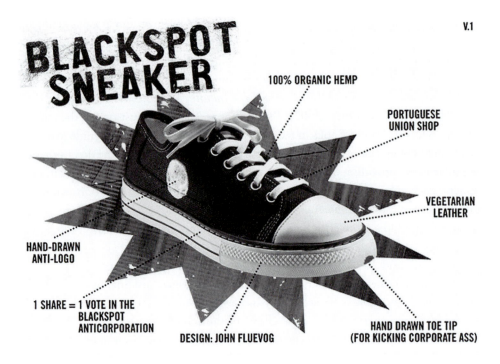

FIGURE 16.2 Adbusters, *Blackspot Sneaker*, 2009 (http://www.adbusters.org/campaigns/blackspot).

uses many chemicals as pesticides and fertilizers, for example which contaminate water and leave animals and humans with health problems. The anticonsumerist group behind the Adbusters Web site has recently launched a couple of anti-global anti-branded sneakers, the 'Blackspot' and the 'unswoosher' (available from http://www.adbusters.org/campaigns/blackspot in April 2009) (see Figure 16.2). They have, of course, also been accused of selling out and of un-green activities by their opponents.

 If it has become a commonplace to say that globalization is the sense that, wherever one goes in the world, one is always in the same place (Arnason 1990: 220; Giddens 1990: 77), then it is tempting to suggest that globalization in fashion and clothing is the sense that, wherever one goes in the world, everyone is wearing the same things. This temptation should be resisted, however, because while it is clear that there may be a Nike and a Gap store in every city (Klein 2000), people are not in fact wearing the same things wherever one goes. There is evidence that what some analysts call the centre-margin model of globalization, where the values and styles of the central and dominant culture overpower themselves into the markets and life-styles of peripheral and subordinate cultures is not sufficient to the task of explaining what globalization is and does. Arjun Appadurai, for example argues that a global cultural economy must be understood as a 'complex, overlapping and disjunctive order' (1990: 296), where simple economic or cultural binaries do not work. It may also and even be the case that the weaknesses of the centre-margin models are more clearly and obviously seen in relation to consumption in general and fashion and dress in particular than in other areas.

This insight is one of many arrived at by Margaret Maynard in her (2004) *Dress and Globalisation*, in which she unites economics and politics in her account of the cultural construction and communication of meaning through what people wear. Maynard adopts a version of the 'single place' definition of globalization, saying it is the experience of being part of a 'single, interwoven macro-culture', and allies it to an aspect of du Gay et al.'s account (1997), where it is also described as the processes by means of which commodities 'move across the world' (Maynard 2004: 3). Maynard argues that what is common to many cultures in a globalized world is the self-awareness and self-consciousness of consumers, who know very well how best to 'express their identity' (2004: 1). What requires explanation, on this account, is how it is that members of different cultures will wear a mix of locally available dress and globally available dress. Her examples of this include the crowd of Muslim 'pilgrims' in Bangladesh, who are wearing a complicated mixture of 'western style jeans . . . and baseball caps, but also customary knee-length *shirvani* coats and *tupa* (caps) and wrapped *lungi*, or perhaps *dhoti*' (2004: 1) as well as young Australians wearing Rastafarian dreadlocks and jeans (2004: 131). In all of these cases the problem concerns politics, economics and the negotiation of meaning, how it is that local cultural identities are constructed and reproduced in the face of powerful global brands and identities and economics.

In their discussion of the cultural place of textiles, Colin Gale and Jasbir Kaur locate globalization under the heading of 'lifestyle' and include references to industry bodies. Also following the 'single place' definition, they suggest that 'consumer trends, aspirations and products are becoming increasingly similar around the world' (Gale and Kaur 2002: 17). Also driving what they present as an increasing uniformity in demand for textiles is a decrease in free time, and a need for smart/casual, versatile and good value clothing. Hermes Lab and the Associazione Tessile Italiana, as well as the Woolmark Company and Tradepartners UK, have all noticed these trends and taken appropriate action (2002: 18). This approach links industry bodies to an account of life-style and consumption.

Jose Teunissen (2005) is also concerned with a nonsimple and nonbinary account of globalization in fashion. She points out that fashion is based on communication and that it has always been international (2005: 9); it is not difficult to understand how it becomes global very quickly. She also explores a number of examples of the different relations that are possible between the global, the local and the exotic. In India, for example Ritu Kumar designs for modern Indian women who want to dress in Western style but who do not want to abandon the traditional *sari* or *salwaar kameez* (2005: 11). Other examples are taken from Japan and Africa. In the collection of essays edited by Brand and Teunissen (2005), Ted Polhemus provides another variant of the nonbinary account of globalization. He points out that talk of 'the west' is inaccurate and he says that the idea of the west, or 'us' as some monolithic and unified identity is mistaken. Even within the European Union, fashionable differences and the resulting regional identities continue to exist and even thrive, despite the significant cultural, economic and political merging that the EU represents (Polhemus 2005: 83).

Gosewijn van Beek's essay in the Brand and Teunissen (2005) collection is a fascinating mixture of early anthropology, ethnography, photography, collecting policy and

of the ways in which they relate to what people wear, the local and globalization. The essay concentrates on the Asmat people of Southern Papua and investigates the ways in which the Western t-shirts and dresses that they wear construct them as citizens of a global world: it is also one of the few essays that refers critically to 'our reaction' (the reaction of Western audiences) to seeing what Western anthropologists once called tribal cultures dressed in this way, as one of disappointment and shame (van Beek 2005: 140).

FURTHER READING

Barnard, Malcolm, ed. 2007. *Fashion Theory*. London: Routledge.

Bruzzi, Stella and Pamela Church-Gibson, eds. 2000. *Fashion Cultures: Theories, Explorations and Analysis*. London: Routledge.

Laver, James. 1969. *Costume and Fashion: A Concise History*. London: Thames and Hudson.

Svendsen, Lars. 2006. *Fashion: A Philosophy*. London: Reaktion Books.

Wilson, Elizabeth. (1985) 2003. *Adorned in Dreams: Women and Modernity*. London: I. B. Tauris.

REFERENCES

Appadurai, A. 1990. 'Disjunction and Difference in the Global Cultural Economy', in M. Featherstone (ed.), *Global Culture: Nationalism, Globalization and Modernity*. London: Sage, 295–310.

Arnason, Johann P. 1990. 'Nationalism, Globalization and Modernity', in Mike Featherstone (ed.), *Global Culture: Nationalism, Globalization and Modernity*. London: Sage, 207–36.

Arnold, R. 1999. 'Heroin Chic', *Fashion Theory*, 3/3: 279–96.

Atkinson, E. Sue. 1981. 'Advertising and Fashion Photography: A Short Survey', *British Journal of Photography* (20 March): 300–13.

Barnard, Malcolm. (1996) 2003. *Fashion as Communication*. London: Routledge.

Barnard, Malcolm. 2007a. 'Fashion Statements: Communication and Culture', in Malcolm Barnard (ed.), *Fashion Theory*. London: Routledge, 170–81.

Barnard, Malcolm, ed. 2007b. *Fashion Theory*. London: Routledge.

Barnes, Judith and Joanne Eicher. 1993. *Dress and Gender*. Oxford: Berg.

Barthes, Roland. 1990. *The Fashion System*. Berkeley: University of California Press.

Baudelaire, Charles. 1995. 'The Painter of Modern Life', in *The Painter of Modern Life and Other Essays*. Phaidon: London, 1–41.

Baudrillard, Jean. 1993. *Symbolic Exchange and Death*. London: Sage.

Bell, Quentin. (1939) 1976. *On Human Finery*, 2nd edn. London: Alison and Busby.

Black, Sandy. 2008. *Eco-Chic: The Fashion Paradox*. London: Black Dog Publishing.

Brand, Jan and Jose Teunissen, eds. 2005. *Global Fashion Local Tradition: On the Globalisation of Fashion*. Arnhem: Terra.

Braudel, Fernand. 1981. *Civilisation and Capitalism 15th–18th Century. Volume One: The Structures of Everyday Life*. London: Collins.

Breward, Christopher. 1995. *The Culture of Fashion*. Manchester: Manchester University Press.

Breward, Christopher. 1998. 'Cultures, Identities, Histories: Fashioning a Cultural Approach to Dress', *Fashion Theory*, 2/4: 301–14.

Brookes, Rosetta. 1992. 'Fashion Photography: The Double Page Spread: Helmut Newton, Guy Bourdin and Deborah Turbeville', in Juliet Ash and Elizabeth Wilson (eds), *Chic Thrills: A Fashion Reader*. London: Pandora, 17–24.

Buckley, Cheryl. 1996. 'Children's Clothes: Design and Promotion', in Pat Kirkham (ed.), *The Gendered Object*. Manchester: Manchester University Press, 103–11.

Burns, Leslie Davis and Nancy O'Bryant. 2007. *The Business of Fashion*, 3rd edn. Oxford: Fairchild.

Campbell, Colin. 1997. 'When the Meaning Is Not a Message', in Mica Nava, Andrew Blake, Iain MacRury and Barry Richards (eds), *Buy This Book: Studies in Advertising and Consumption*. London: Routledge, 340–51.

Carlyle, Thomas. 1987. *Sartor Resartus*. Oxford: Oxford University Press.

Cole, S. 2000. *Don We Now Our Gay Apparel*. London: Berg.

Cordwell, Justine M. and Ronald A. Schwartz, eds. 1979. *The Fabrics of Culture: The Anthropology of Clothing and Adornment*. The Hague: Mouton.

Craik, J. 1994. *The Face of Fashion*. London: Routledge.

Craik, Jennifer. 2008. *Fashion: The Key Concepts*. Oxford: Berg.

Crane, Diana. 2000. *Fashion and Its Social Agendas: Class, Gender and Identity in Clothing*. Chicago: University of Chicago Press.

Damhorst, Mary Lynn, Kimberley A. Miller and Susan O. Michelman, eds. 1999. *The Meanings of Dress*. New York: Fairchild.

Davis, Fred. 1992. *Fashion, Culture and Identity*. Chicago: University of Chicago Press.

Di Grappa, Carol. 1980. *Fashion: Theory*. New York: Lustrum Press.

du Gay, P., S. Hall, L. James, H. Mackay, and K. Negus. 1997. *Doing Cultural Studies: The Story of the Sony Walkman*. London: Sage.

Edwards, Tim. 1997. *Men in the Mirror: Men's Fashion, Masculinity and Consumer Society*. London: Cassell.

Entwistle, Joanne. 2000. *The Fashioned Body*. London: Polity Press.

Evans, Caroline. 1997. 'Dreams That Only Money Can Buy . . . or, The Shy Tribe in Flight from Discourse', *Fashion Theory*, 1/2: 169–88.

Fine, Ben and Ellen Leopold. 1993. *The World of Consumption*. London: Routledge.

Fletcher, Kate. 2008. *Sustainable Fashion and Textiles*. London: Earthscan Publications.

Forty, A. 1986. *Objects of Desire*. London: Thames and Hudson.

Gale, Colin and Jasbir Kaur. 2002. *The Textile Book*. Oxford: Berg.

Giddens. Anthony. 1990. *The Consequences of Modernity*. Cambridge: Polity Press.

Granger, Michele. 2007. *Fashion: The Industry and Its Careers*. Oxford: Fairchild.

Hebdige, Dick. 1979. *Subculture: The Meaning of Style*. London: Routledge.

Hollander, Anne. 1993. *Seeing through Clothes*. Berkeley: University of California Press.

Hollander, Anne. 1994. *Sex and Suits*. New York: Kodansha International.

Jobling, Paul. 1999. *Fashion Spreads: Word and Image in Fashion Photography since 1980*. Oxford: Berg.

Jones, Ann Rosalind, and Stallybrass, Peter. 2000. *Renaissance Clothing and the Materials of Memory*. Cambridge: Cambridge University Press.

Klein, N. 2000. *No Logo*. London: Flamingo.

Koenig, Rene. 1973. *The Restless Image: A Sociology of Fashion*. London: Allen and Unwin.

Kunzle, David. 2006. *Fashion and Fetishism: Corsets, Tight-Lacing and Other Forms of Body-Sculpture*. Sutton: Stroud Publishers.

Levine, Donald, ed. 1971. *Simmel: On Individuality and Social Forms*. Chicago: University of Chicago Press.

Loos, Adolf. 1998. 'Men's Fashion', 39–44, 'Women's Fashion', 106–11, 'Underwear', 112–18, 'Footwear', 94–99, 'Short Hair' 190 and 'Gentlemen's Hats' 89–93, in *Ornament and Crime: Selected Essays*. Riverside, CA: Ariadne Press.

Lurie, A. 1992. *The Language of Clothes*. London: Bloomsbury.

Maynard, Margaret. 2004. *Dress and Globalization*. Manchester: Manchester University Press.

McCracken, Grant. 1985. 'The Trickle-down Theory Rehabilitated', in M. R. Solomon (ed.), *The Psychology of Fashion*. Lexington, MA: Lexington Books, 39–54.

McNeil, Peter. 2008. *Fashion: Critical and Primary Sources*. Oxford: Berg.

McRobbie, A. 1998. *British Fashion Design: Rag Trade or Image Industry?* London: Routledge.

Miller, Daniel. 2004. 'The Little Black Dress Is the Solution but What Is the Problem?', in Karin M. Ekstrom and Helene Brembeck (eds), *Elusive Consumption*. Oxford: Berg, 113–28.

Muggleton, David. 2000. *Inside Subculture: The Postmodern Meaning of Style*. Oxford: Berg.

Nahshon, Edna. 2008. *Jews and Shoes*. Oxford: Berg.

Papanek, Victor. 1971. *Design for the Real World*. New York: Pantheon Books.

Partington, Angela. 1992. 'Popular Fashion and Working Class Affluence', in J. Ash and E. Wilson (eds), *Chic Thrills: A Fashion Reader*. London: Pandora, 145–61.

Polhemus, Ted. 1994. *Streetstyle: From Sidewalk to Catwalk*. London: Thames and Hudson.

Polhemus, Ted. 2005. 'What to Wear in the Global Village?', in J. Brand and J. Teunissen (eds), *Global Fashion Local Tradition: On the Globalisation of Fashion*. Arnhem: Terra, 82–95.

Polhemus, Ted and Lynn Proctor. 1978. *Fashion and Anti-Fashion: An Anthropology of Clothing and Adornment*. London: Thames and Hudson.

Purdy, Daniel L., ed. 2004. *The Rise of Fashion*. Minneapolis: University of Minnesota Press.

Roach-Higgins, Mary Ellen, Joanne B. Eicher and Kim K. P. Johnson, eds. 1995. *Dress and Identity*. New York: Fairchild.

Rolley, Katrina. 1992. 'Love, Desire and the Pursuit of the Whole: Dress and the Lesbian Couple', in J. Ash and E. Wilson (eds), *Chic Thrills: A Fashion Reader*. London: Pandora, 30–9.

Rouse, Elizabeth. 1989. *Understanding Fashion*. Oxford: Blackwell Scientific.

Rubinstein, Ruth P. 1995. *Dress Codes: Meanings and Messages in American Culture*. Boulder, CO: Westview Press.

Simmel, Georg. 1904. 'Fashion', chapter 19 in Donald Levine, ed. 1971, *Georg Simmel on Individuality and Social Forms*. Chicago: University of Chicago Press, 294–323.

Smith, Adam. 2006. *The Theory of Moral Sentiments*. Mineola, NY: Dover Publications.

Steele, V. 1998. 'A Museum of Fashion Is More Than a Clothes-Bag', *Fashion Theory*, 2/4: 327–36.

Steele, Valerie. 2001. *The Corset: A Cultural History*. New Haven, CT: Yale University Press.

Styles, John. 1998. 'Dress in History: Reflections on a Contested Terrain', *Fashion Theory*, 2/4: 383–90.

Sweetman, Paul. 1999. 'Anchoring the (Postmodern) Self? Body Modification, Fashion and Identity', *Body and Society*, 5/2–3: 51–76.

Taylor, Lou. 1998. 'Doing the Laundry? A Reassessment of Object-based Dress History', *Fashion Theory*, 2/4: 337–58.

Teunissen, Jose. 2005. 'Global Fashion Local Tradition', in J. Brand and J. Teunissen (eds), *Global Fashion Local Tradition: On the Globalisation of Fashion*. Arnhem: Terra, 8–23.

Tickner, Lisa. 1977. 'Women and Trousers', in *Leisure in the Twentieth Century*. London: Design Council Publications.

Triggs, Teal. 1992. 'Framing Masculinity: Herb Ritts, Bruce Weber and the Body Perfect', in
J. Ash and E. Wilson (eds), *Chic Thrills: A Fashion Reader*. London: Pandora, 25–29.

Tulloch, Carol. 2002. 'Letter from the Editor', *Fashion Theory*, 6/1: 1–2.

Van Beek, Gosewijn. 2005. 'Culture in Shreds', in Jan Brand and Jose Teunissen (eds), *Global Fashion Local Tradition: On the Globalisation of Fashion*. Arnhem: Terra, 134–55.

Veblen, Thorstein. 2007. *The Theory of the Leisure Class*. Teddington: The Echo Library.

Weinshenker, Anne B. 2008. http://www.montclair.edu/Arts/dept/artdesign/ad03.html, accessed March 2009.

Wells, H. G. 1895. *Select Conversations with an Uncle Now Extinct*. New York: Merriam.

Wilbekin, Emil. 1999. 'Great Aspirations: Hip Hop and Fashion Dress for Success and Excess', in A. Light (ed.), *The Vibe History of Hip Hop*. New York: Three Rivers Press, 280–4.

Wills, Gordon and David Midgley. 1973. *Fashion Marketing: An Anthology of Viewpoints and Perspectives*. London: Allen and Unwin.

Wilson, Elizabeth. (1985) 2003. *Adorned in Dreams: Women and Modernity*. London: I. B. Tauris.

Wright, Lee. 1989. 'Objectifying Gender', in J. Attfield and P. Kirkham (eds), *A View from the Interior: Feminism, Women and Design*. London: The Women's Press, 7–19.

Wright, Lee. 1992. 'Outgrown Clothes for Grown-up People', in J. Ash and E. Wilson (eds), *Chic Thrills: A Fashion Reader*. London: Pandora, 49–60.

Seeing Things: Apprehending Material Culture

TIM DANT

Most humans largely take for granted their capacity to see things—apart from those who have a sight impairment, human beings see things just about all the time they are awake without noticing or thinking about it. Making sense of what we see is seldom a problem because it is part of the flow of action that may become more or less intense but is virtually continuous as we move from one thing to another in everyday life. Even in those most inactive periods of our waking life we are often using our visual capacity to look at things as we read or look at pictures, sometimes moving pictures displayed on a screen. Through these media we continue to look at 'things', identifying, recognizing and making sense of them, much as we do in the immediate life-world. Most of the problems with seeing the world around us arise with the seeing apparatus of our bodies; eyes become tired, their acuity fades with age in a number of ways and for some, the apparatus of sight is irreparably damaged either before birth or at some time later in life. The visual capacity that humans take for granted in everyday life is a major field of academic interest and concern but I want to focus here on one particular aspect, the way we see 'things'—by which I mean material objects, the stuff of material culture. And in a perverse way I want to undo much of the scholarly and scientific work on vision because I think the concern with the biomechanics of vision—no doubt enormously valuable for some purposes—tends to overlook the role of culture and society in contributing to how we see things. How the eyes work—the saccades or the rapid unconscious movements that human eyes make, the role of the retina, the fovea and the resolution of what is seen—are all fascinating because they are part of a process that we all take for granted in everyday life. But I want to develop a less biomechanical version of how we *apprehend* things visually which takes central highly focussed (foveal) sight in its context of broader, less focussed peripheral vision.

As well as challenging a biomechanical account of sight, I also want to counter a cultural approach to seeing that treats it as 'semiological' by understanding what is in our visual field as a combination of signs that together make a particular sense. Again, this has been an enormously fruitful line of investigation in visual culture and one that I want to deviate from in what may seem a rather pedantic way. The semiological approach has tended to translate the way we see things into a process of 'reading' discrete signs, a process that even has its own 'grammar' and lends itself to a systematic analysis of a process that parallels that of linguistic analysis (Kress and van Leeuwen 1996). I want to argue that seeing things is not reducible to anything like a system of language. Our visual perception is a dynamic, embodied process that occurs in the moment in which what is made present to the senses is recognized in its specific but complex relation to things that are familiar from within our cultural experience. The process is best understood by reference to the phenomenological tradition from William James, via the gestalt psychologists, Husserl, Merleau-Ponty to the social phenomenology of Schutz, Ihde and Verbeek. Instead of the conceptual tools of signifiers and signifieds, the phenomenological approach uses the concepts of 'apperception' and 'appresentation' to explain how the thing that is present in front of us is related to other things that we have experience of either directly or vicariously. The prefix 'ap-' means 'formed from' or 'derived from' and points to the biographical and cultural origins of how we see things. To 'apprehend' can mean to arrest someone for a crime but it also means to understand or perceive with connotations of 'taking hold' of something in the sense of grasping, discerning, making out, realizing, comprehending or recognizing it, and that is the sense I wish to evoke here.

THE METAPHOR OF LANGUAGE

A popular approach to the material world is to think of it as making sense in the same way as language makes sense. This method identifies visible components in the material world that are the equivalents of words so that, when combined, they make a particular sense. A classic example is the 'reading' of a clothing ensemble, such as that of punk or 'power dressing', as a statement by the wearer about his or her values and situation in society (Hebdige 1979; Davis 1992; Polhemus 1994). The individual clothing items are treated as 'signs' that are 'structured' like a language in that their form reveals a particular set of relationships that by convention make sense—the 'language of clothes' (Lurie 1981). A ripped T-shirt, when worn with bondage trousers, spiky dyed hair and large boots, signified, in 1970s United Kingdom, membership of a particular subcultural group and not simply the lack of resources to replace a damaged item of clothing. In the same society, in the 1980s, a suit of a subdued colour with padded shoulders, combined with solid high heels and carefully shaped hair, signified membership (or at least aspiration) by a woman of the decision-making classes of government and business. The two 'dress-codes' are quite different and work as a response to each other and it is through the precise combination of clothing signs that each is distinguished from other clothing combinations that are not intended to make a statement.

The semiological approach to visual and material culture is often traced to the work of Roland Barthes ((1957b) 1993; (1957a) 1979) whose inspired vignettes of material culture, written in the 1950s, were read as a decoding that showed how signs were combined for ideological effect. His essays on images and photographs ((1961) 1977; (1964b) 1977) did draw a parallel between the visual and linguistic systems and Barthes's own statements on semiology in the essay 'Myth Today' (1972) and in *Elements of Semiology* ((1964a) 1967) referenced the writing of Hjelmslev, Trubetzkoy and Saussure and promised a structural and systematic approach to visual and material culture. However, by the time of the detailed and systematic account of *The Fashion System* ((1967) 1990), his most sustained attempt at a semiological method, what he produces is an analysis of how clothes are *written* about and its codes (the 'vestimentary code'; the 'rhetorical system') are those of the language used to refer to clothes. He does not analyse the signs visible in the clothes themselves, nor even in their visual representation in images. There was then a moment when Barthes appears to have been convinced that visual and material culture was amenable to a systematic quasi-linguistic analysis of the origins of meaning in the ideological values of a capitalist system. But this structuralist phase of his work was short-lived; by 1970 he was still using the jargon of signs and codes but in a poststructuralist way, largely to draw out the instability of meaning in written language and its irreducibility to any origin of meaning (Barthes (1970b) 1975, (1970a) 1982).

Despite his relatively brief and equivocal interest in it, Barthes's use of semiology and its origins in linguistics has had an enormous impact on the methods for analysis of visual and material culture that echoes well into the twenty-first century (e.g. Burgin 1982; Hodge and Kress 1988; Thwaites et al. 1994; Kress and van Leewen 1996; Bignell 1997; Emmison and Smith 2000; Rose 2001; Pink 2001). The metaphor of what we look at as being amenable to 'de-coding' as if it was imbued with meaning in the same way as an utterance or statement in a language has persisted, especially in the analysis of the visual culture of photographs, advertisements, graphic art, television, movies and even fine art. The metaphor of language has also persisted in attempts to grasp the meanings of modern material culture works (e.g. Riggins 1994; Gottdiener 1995; Dittmar 1992; Schiffer 1999), though not necessarily drawing on a semiological model. But what is problematic about using the metaphor of language for understanding the visual perception of things, both as materially present and in pictorial images, is that neither the form nor the structure is consistent or conventional. Written language is perceived through a very particular process as the eyes gather detailed orthographic information that is made sense of according to a specific, learnt system. The eyes progressively scan the symbols, running across the words and sentences, accumulating information in a linearly ordered spatial and temporal sequence at a fixed focal length. Meaning is derived from the consistent orthographic and structural conventions of the particular language. I can read English but while I can recognize written Danish as writing because it largely shares the same orthographic conventions, apart from the odd word with a similar origin, writing in Danish is meaningless to me.

In contrast I have no difficulty in understanding the material culture of Danes and indeed that of most cultures in the world. There will be differences in architecture and

design that I will notice and perhaps take pleasure in but they will seldom make it difficult for me to visually apprehend the things that I see. Sometimes what I see has a symbolic or quasi-linguistic quality (an emblem or insignia for instance) that I find obscure and sometimes there is a distinctive technological variation that is unfamiliar and often fascinating (for example the Danish trikes with bins on the front for carrying children or stuff). But meaning in the material world is not dependent on language and no formal structural properties need to be learnt for the visual world to make sense. Very young children begin to look at the world before they have language and make distinctions between things as is evident from the feelings they express through noises, gestures and facial expressions. Indeed, language is often taught and acquired through the shared visual field of the material world of parent and child. This suggests that the shared visual field—of people, pets, toys, clothes and food—is constituted by a process that is prelinguistic and not dependent on the conventional structuring of language.

Although there was a 'structuralist' moment in material cultural studies (e.g. Tilley 1989; Llamazares 1989; Pearce 1992) that explored semiology, the largely anthropological tradition of material culture resists any reduction to language or its structure. Instead, the material world of humans is seen as co-constitutive of social groups along with other cultural processes that include language, economy, religion and consumption (e.g. Mauss 1990; Miller 1987). The approach of material culture does not usually treat 'seeing things', that is how human beings make visual sense of the material world around them, as a distinct issue. Material objects are interpreted through analysis that includes a description and perhaps a representation that specifies the cultural situation in theoretically informed language, that refers to speech, rituals, money, human relations, movement, actions and so on (Gell 1998; Appadurai 1986). Any problem of 'seeing' is here the anthropologists'; they are trying to grasp both what it is that the native of the culture sees and also how it relates to other cultural contexts, especially those from which the anthropologist's descriptive language is drawn. Visual culture is itself a topic within the study of material culture and it is noticeable that photographic images have increasingly become part of the attempt to describe material culture, often replacing the more traditional line drawings that effectively extract the object from its visual context, often to enable textual annotation (see the contributions in Buchli 2002 and Tilley et al. 2006). The materiality of images, especially photographs, is becoming part of the understanding of their cultural significance (Edwards and Hart 2004) and phenomenology has begun to play a role in understanding the relation between image and object (Pinney 2002). In anthropology (Ingold 2000) and other disciplines that try to understand material culture (Attfield 2000; Molotch 2003; Riggins 1994; Gregson and Crewe 2003), objects are usually analysed within the patterns and practices of ordinary lives. It is how things are taken up in use that is the focus of concern and the analytical problem is one of making the meaning for the user available to a wider audience in a wider context. But the tendency of the material culture tradition is to naturalize the seeing of things to the user so that meaning is only a problem for the analyst or ethnographer; it is taken for granted that the person or social group being studied see things in a consistent and unproblematic way. In this paper it is the mundane process of looking at things that I want to explore.

LOOKING AT THINGS

When the view is unobstructed lookers may choose to follow whatever path they wish as they scan a visual field, focussing on whatever thing and whatever aspect of that thing attracts their attention. What is more, since central and peripheral vision work simultaneously, even while lookers have their eyes directed at one point of an array, they can also see much of the rest of the array. The thing in front of us is perceived not through systematic gathering of information by the senses but through a process of perception that involves directing the eyes at particular features of the object with the central, sharp, foveal image being focussed on salient features while at the same time peripheral vision is situating those salient features (Hochberg 1972: 60). There is no predetermined sequence of 'looking' but there are patterns in that humans will tend to pay more early attention to some things than others—the eyes in a face, the face on a body, the figure in a landscape. The patterning is of course also likely to vary from person to person, according to their particular interests in the field of things (Hochberg 1972: 61–5)—a point I will return to below.

Sartre argues that the difference between the perception of things and imagination is that there is a superabundance of visual information such that there is an '*overflowing* in the world of "things": there is always, at each and every moment, infinitely *more* than we see; to exhaust the wealth of my actual perception would require infinite time' (Sartre 1991: 11). Apprehending a thing visually has a cumulative temporality; the quick glance can be followed up with a serious and sustained inspection. Attention can more or less consciously and intentionally move across the array of objects to look for specific things and Hochberg asserts that '*most or all visual perception involves highly skilled sequential purposive behaviors,* and that some large component of the perceptual process in the adult is best understood in terms of the "expectations" and "maps" that underlie these skilled behaviors' (Hochberg 1972: 63—emphasis in the original). This is a very strong claim and difficult to reconcile with the coincidental nature of the flow of the life-world through which we move. But some ways of looking at things are clearly planned and particular impressions are sought out in the visual field. Technicians servicing cars follow sequential practices of looking at components, sometimes guided by checklists or service manuals. But they also develop ways of looking that go beyond the issued instructions to involve fine detail in the way they orient their body to certain objects (Dant 2005, 2010). Even when following a sequence, how they look at things is never quite the same; it always develops in the situated context of what it is they see.

The shape of things is identifiable by the lines of edges and boundaries that are revealed by the contrast of solidity between a thing and the air around it—the absence of thing. This is cued by colour difference and perspective but the continuity of the line around a thing gives it a 'form' or shape. The 'Gestalt psychologists' recognized this human capacity to identify the form of a thing as a figure, or entity in itself; Köhler describes the order of the visual field in which 'particular areas "belong together" as circumscribed units from which their surroundings are excluded'

(1947: 137). The 'thing' is perceived as a whole, a discrete entity distinct from its background not as a series of bits of information. Gestalt psychology argues that these sensory units of form and figure are richly symbolic and meaningful but it also argues that the whole that is perceived precedes its recognition as a particular thing. Famously, this approach also argues that objects are perceived in groups; the similarity between items connects them, as does their spatial orientation in an array. The Gestalt psychologists also argue that in most instances the perception of a thing is, however, stable and that it is seen as 'solid' with 'figure quality' against the looseness of the 'ground character' of the environment that surrounds it (Köhler 1947: 202–3). But this makes it difficult to explain the illusions that those interested in visual perception are always fascinated by—where visual stimuli create a mistaken perception or perhaps an alternating perception when there are two ways of 'seeing' something (e.g. the Necker cube, the duck/rabbit, the vase/profiles, the crone/demoiselle). The Gestaltists believed that the external field of what was seen corresponded to an internal field of the brain but as Hochberg argues, the changing relation of central to peripheral vision and the serial attention to different components in a visual field does not support this idea (Hochberg 1972: 60–1).

The word 'array' is useful because it suggests that distinctions are made between the material components of an impression and that the composition of the array is part of what is involved in looking at things. Making distinctions between the things we see treats the material world as ordered and the entities within it as meaningful in themselves as well as in relation to each other. There are occasions when we look and we cannot make sense of what we see but usually when we are looking at things that are familiar, we can take in the array and without any noticeable passage of time apprehend what we see. The visual apprehension of things can involve a slow continuous looking that lingers on items or roams across the array gathering a more detailed impression of objects and even the identity of particular items within the array. A visual field that contains a glass of water on a table is taken in as a scene, a set of things situated in relation to each other that is the same whichever way and for however long the eyes travel over the array or rest on particular items (Figure 17.1). Even if seen from a different angle with very different lighting, the same scene is made sense of in the same way; it is still a glass of water on a table (Figure 17.2). Of course features of the situation may give particular meaning to the array and stop it being simply a glass of water and this is precisely the point of Michael Craig-Martin's famous 1973 artwork, *An Oak Tree* (see Figure 17.3) in which a glass of water sits on a glass shelf above head height in an art gallery. Craig-Martin provides the viewer with an explanatory text (Figure 17.3) at eye-height, below and to the left in a location that information about an artwork is often presented. Some viewers will see the artwork first and then move closer to read the text, others will read the text first and then move back to see the artwork. The text plays precisely on the role of art practice as a means of changing the perception of objects; what is familiar as a glass of water may be transformed through the cultural alchemy of the work of an artist in collaboration with curators, a label and an exhibition space.

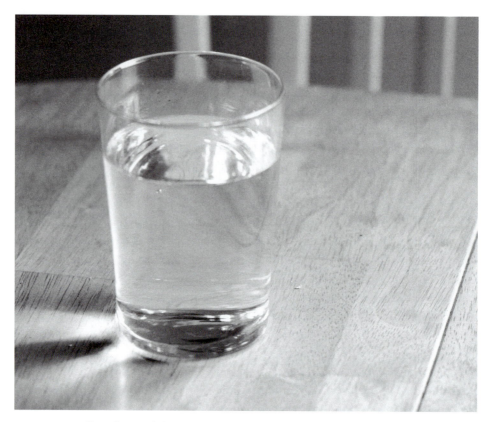

FIGURE 17.1 *Glass of Water (light)*, 2010, photograph by author.

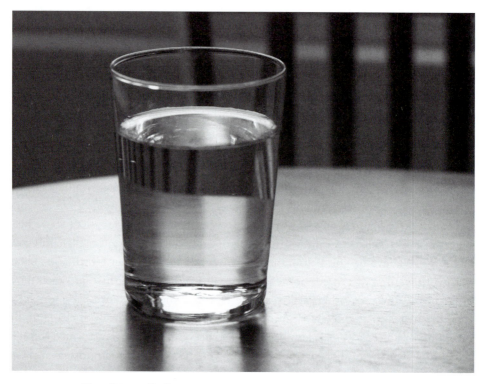

FIGURE 17.2 *Glass of Water (dark)*, 2010, photograph by author.

Q: To begin with, could you describe this work?

A: Yes, of course. What I've done is change a glass of water into a full-grown oak tree without altering the accidents of the glass of water.

Q: The accidents?

A: Yes. The colour, feel, weight, size ...

Q: Do you mean that the glass of water is a symbol of an oak tree?

A: No. It's not a symbol. I've changed the physical substance of the glass of water into that of an oak tree.

Q: It looks like a glass of water ...

A: Of course it does. I didn't change its appearance. But it's not a glass of water. It's an oak tree.

Q: Can you prove what you claim to have done?

A: Well, yes and no. I claim to have maintained the physical form of the glass of water and, as you can see, I have. However, as one normally looks for evidence of physical change in terms of altered form, no such proof exists.

Q: Haven't you simply called this glass of water an oak tree?

A: Absolutely not. It is not a glass of water any more. I have changed its actual substance. It would no longer be accurate to call it a glass of water. One could call it anything one wished but that would not alter the fact that it is an oak tree.

Q: Isn't this just a case of the emperor's new clothes?

A: No. With the emperor's new clothes people claimed to see something which wasn't there because they felt they should. I would be very surprised if anyone told me they saw an oak tree.

Q: Was it difficult to effect the change?

A: No effort at all. But it took me years of work before I realized I could do it.

Q: When precisely did the glass of water become an oak tree?

A: When I put water in the glass.

Q: Does this happen every time you fill a glass with water?

A: No, of course not. Only when I intend to change it into an oak tree.

Q: Then intention causes the change?

A: I would say it precipitates the change.

Q: You don't know how you do it?

A: It contradicts what I feel I know about cause and effect.

Q: It seems to me you're claiming to have worked a miracle. Isn't that the case?

A: I'm flattered that you think so.

Q: But aren't you the only person who can do something like this?

A: How could I know?

Q: Could you teach others to do it?

A: No. It's not something one can teach.

Q: Do you consider that changing the glass of water into an oak tree constitutes an artwork?

A: Yes.

Q: What precisely is the artwork? The glass of water?

A: There is no glass of water any more.

Q: The process of change?

A: There is no process involved in the change.

Q: The oak tree?

A: Yes. the oak tree.

Q: But the oak tree only exists in the mind.

A: No. The actual oak tree is physically present but in the form of the glass of water. As the glass of water was a particular glass of water, the oak tree is also particular. To conceive the category 'oak tree' or to picture a particular oak tree is not to understand and experience what appears to be a glass of water as an oak tree. Just as it is imperceivable, it is also inconceivable.

Q: Did the particular oak tree exist somewhere else before it took the form of the glass of water?

A: No. This particular oak tree did not exist previously. I should also point out that it does not and will not ever have any other form but that of a glass of water.

Q: How long will it continue to be an oak tree?

A: Until I change it.

FIGURE 17.3 Michael Craig-Martin, *An Oak Tree*, 1973, glass, water and printed text, Tate Collection, lent from private collection 2000. Courtesy of the artist, © Michael Craig-Martin 2010.

The approach of psychology to how we see things usually treats it as a cognitive problem and theorizes those systems by which percepts could be generated (Gordon 2004; Gregory 1998; Findlay and Gilchrist 2003). Experimental psychology has played with structures and modular components—such as cones, blocks, cylinders and other 'geons' (geometric icons)—as the building blocks underlying object recognition (see for example Bruce et al. 2003: 265–98). This approach has contributed to the design of computer programmes that it is hoped might 'see' in a way analogous to how humans see things but it is not clear that it tells us much about how *people* actually perceive objects. Features of perception, such as how a visual system deals with the relative distance of an object and consequent variation in its apparent size, are tricky for disembodied systems that have no experience of the world. But if sight is treated as one part of a body, situated and mobile within a familiar world, such as the embodied person described by phenomenology, it is not so difficult. Despite the similarity of approach and the historical links with phenomenology, Merleau-Ponty distinguishes Gestalt psychology as retaining the naturalism characteristic of psychology (1962: 47). Its proposal of the category of 'form' as something prior to and of a higher order than the flow of experience of the world is for Merleau-Ponty both unnecessary and unjustified ((1945) 1962: 46). A particular problem is the tendency for Gestalt psychology to treat 'form' as correlated with physical structures in the body (Merleau-Ponty (1945) 1962: 151).

Perception is a part of the way that a human body lives and moves through the space it shares with other objects; there is an optimum distance for viewing different objects that is determined by the relative size of the object and us. Objects that are too far away or too close are not amenable to perception so a mountain is impossible to see if you are on its side and a friend is difficult to recognize on the horizon. As Merleau-Ponty puts it, 'our body as a point of view upon things, and things as abstract elements of one single world, form a system in which each moment is immediately expressive of every other' ((1945) 1962: 301). An object should not be confused with its appearance and there need be no underlying law or formula by which I judge the object because it is through having a body with a specific but changing kinaesthetic situation that 'I am at grips with the world' (Merleau-Ponty (1945) 1962: 303). Rather than approach perception as a systematic problem that must be broken into its component parts, Merleau-Ponty proposes that perception is an expansion of the field of presence of the body in which all perceptual experiences hang together. The qualities of things are not reducible to those components that can be measured by instruments but how they fit into the sense or impression of the thing. Looking is done from a body that moves, hears, touches and smells. The movement of the eyes, of the head, of the torso and ultimately of the whole body are part of an act of looking.

As we look at things we are used to identifying their colour as if it is a property of the thing itself. But Merleau-Ponty says that colour is a 'non-sensory presence' ((1945) 1962: 305) by which he means that we identify a colour despite the way our visual senses receive information from different surfaces, in differing blocks, adjacent to other colours and above all in different degrees and directions of light (Figure 17.2 is the same glass as Figure 17.1 viewed from a different direction). Light itself can have a colour (daylight, candlelight, tungsten lamps, fluorescent lamps) and can alter the colour of

what it falls on. The phenomenological approach treats colour not as a property of things or of the perceptual apparatus of vision but as a quality of the thing within a field, which includes lighting and the proximity to the person seeing it. Lighting leads our eyes and attention and it is often designed to do so in interior spaces; especially in the theatre or in a window display ('We perceive in conformity with the light, as we think in conformity with other people in verbal communication'—Merleau-Ponty (1945) 1962: 310). Lighting provides a level or an atmosphere in the context of which an object is perceived. Yet in everyday life we seldom notice light and treat it as neutral, a background that we assimilate as we or the object moves between different qualities of light.

An impression of a thing involves not simply sight but a whole bodily engagement; when I see a glass of water my body can remember what it is to hold one; to feel the smoothness of glass, its cool hard surface, the weight of the water that is fluid and moves, the hardness of the glass as it touches my lips and the smooth, cool flow of the liquid as it enters my mouth. These memories do not need to crowd my conscious, reflective mind for them to be entailed in what it is to recognize a glass of water—it is the coherence of the body rather than a function of the brain that brings these qualities of perception together. When we perceive, we not only grasp the thing with our understanding, we situate ourselves in relation to it and so can grasp our selves in the world. Nonetheless we perceive the thing as '*in-itself-for us*' in that as we direct our attention towards it, we regard it in relation to us and our projects (Merleau-Ponty (1945) 1962: 322). Is the car I am looking at one I want to buy? Or, is it in my parking space? Is the glass of water fresh, am I thirsty and so on? What comes into our field of attention we don't approach scientifically, systematically or objectively but in the context of our everyday concerns— 'In order to perceive things, we need to live them' (Merleau-Ponty (1945) 1962: 325). The thing we see is not simply given in perception, it is taken up by us, experienced and reconstituted within the context of our body and its existing relation with the world. And the nature of human behaviour is that it has a movement towards the world, a primordial attachment to the world; it is 'thrown' into a natural world. The unity of the world remains a constant presence to my being; it is always there, as a field to which my senses respond rather than being a product of consciousness or cognition. My point of view is a way of my 'infiltrating into the world in its entirety' rather than an act of thought (Merleau-Ponty (1945) 1962: 329). This is in contrast to the exclusive experience of a hallucination that does not offer a continuous world that can be shared with others. The certainty of perception can be undermined or cancelled—as with the revelation of an illusion or *trompe l'oeil*—but only by being replaced with another perception that fits even better with the rest of the world we experience.

APPERCEPTION

If Merleau-Ponty's phenomenology emphasizes the embodied character of how we see things, an earlier phenomenological approach emphasizes that perception is based on what we already know of the world. Writing in 1890 on the 'perception of things', William James suggested that what he had been calling perception was more properly

an 'apperceptive process' in which 'incoming ideas or sensations are said to be "apperceived" by "masses" of ideas already in the mind' including 'habits, memory, education, previous experience and momentary mood' ((1890) 1950: 107). He later clarified this idea of apperception:

> we never get an experience that remains for us completely nondescript: it always *reminds* of something similar in quality, or of some context . . . drawn, of course, from the mind's ready-made stock. We *conceive* the impression . . . according to our acquired possibilities, be they few or many, in the way of 'ideas.' This way of taking in the object is the process of apperception. (James (1899) 1927: 158)

How we see things entails apperception; our apprehension is in terms of what we have already seen and what we already know of how things in the world look. Even 'the new' is always interpreted according to 'the old' and as a person ages so he becomes resistant to his stock of ideas being disturbed or expanded.

Alfred Schutz (1971) develops the concept of apperception drawing on both James's and Husserl's use of the term but it is best understood in terms of his ideas about 'relevance', 'reach' and 'typification' set out in his major work *Structures of the Life-World* (1974). Perception is not random or irrelevant but is structured according to our ongoing motives, interests and actions as we interact with the life-world. 'Thematic relevance' is the flow of attention, usually below the level of conscious awareness, that connects one action to another, directing the attention of visual perceptions to what we are doing. It may sustain a connected sequence of actions but it can be redirected to focus on something new in the environment or it can turn inwards to connect musings and thoughts. Thematic relevance may arise from personality and biography and be concerned with motives, wants and projects, or it can be imposed from beyond the person by the actions of others or the contingencies of the environment. If imposed relevance is when I find a car parked in the space outside my house where I hoped to park, motivational relevance shapes perception and action when I go in search of a second-hand car that will serve my purposes at a price I can afford. The material stuff of the world is encountered in this way and attention is not determined by some quality in it (such as its 'affordance') but is directed by its relevance to our continuing interests. We can easily ignore or overlook that which is *ir*relevant to us and we pay little attention to most of what passes in front of our eyes. Some things have an 'interpretational relevance' because they cannot simply be incorporated into continuing action and we need to stop and make sense of them. Interpretation is not scientific or objective but is motivated by what is relevant to the person (Schutz and Luckmann 1974: 211). Interpretational relevance structures how we look at an old car and wonder what it is worth or what it would take to fix it. Thematic relevance blends into interpretational relevance when there is an interruption in the flow of experience that demands reflection on something, a conscious and willed thought that addresses the significance of meaning of something.

If 'relevance' structures how we see things, so does 'reach'. For Schutz (1974), there are zones of 'actual', 'restorable' and 'attainable' reach in the life-world that refer to the

zones in which a human body orients itself to things. The zone of actual reach refers to the spatial and temporal location of a person in the world and what they can reach with their hands and eyes. It constitutes the 'paramount reality' of lived experience that is present for a person who is wide-awake. Restorable reach includes those things that have been experienced before and could be returned to, and attainable reach includes those things that might be brought within the zone of actual reach at some point in the future. If the zone of restorable reach recalls things from biographical experience, the zone of attainable reach is formed by the mediated experiences of other people who tell me, for example that India is a beautiful country to visit. Both relevance and reach structure how I experience things in the world that I know about. For Schutz knowledge is stored as 'typifications' that arise from a 'situationally adequate solution to a problematic situation through the new determination of an experience that could not be mastered with the aid of the stock of knowledge already on hand' (Schutz and Luckmann 1974: 231). That is the stock of knowledge drawn on to apprehend things that we see is organized according to practical interests and experiences, not as a 'code' or abstract system. The availability of typifications (rather like James's 'masses of ideas') means that perception is always apperception; nothing is ever looked at with completely fresh eyes working simply as organs of sight. Put like this, the process of perception sounds personal and idiosyncratic, but our stocks of knowledge are built up through the cultural context in which we live. The typifications that we draw on to apprehend what we see for example draw on shared and mediated experiences (e.g. images of all types) that have been framed and given value through talk or text.

APPRESENTATION

In the context of Schutz's phenomenology 'apperception' points to the importance of previous personal and culturally shared experiences in our visual apprehension of things. We don't simply 'see' the glass of water or the car, rather we 'apperceive' it in relation to how we have seen glasses and cars before; what we see is made sense of through the relevance to our interests and motivations in the situation. Another concept, also derived from Husserl, that Schutz uses to explain how we understand mediated and symbolic phenomena is the related idea of 'appresentation' (1971: 294). This is the idea that what is present for someone else can be 'appresent' for us—that is not directly present to experience but through our empathizing with the other's experience becomes indirectly present. For Husserl, recognizing that others experience the world in a way that is similar to the way we do leads to the possibility of empathy and sharing of experience, particularly of the world of things, and the possibility of a *transcendental theory of the Objective world* (Husserl (1933/1950) 1999: 92—emphasis in the original). The Objective world includes not only the natural world of things but also the 'spiritual world' in so far as its objects refer us to the other's subjective experience of them. The shared world also includes 'all cultural Objects (books, tools, works of any kind and so forth) which moreover carry with them at the same time the experiential sense of thereness-for-everyone (that is, everyone belonging to the corresponding cultural community)'

(Husserl (1933/1950) 1999: 92). It is this sense of sharedness, of impressions based on very similar apperceptions, that creates a foundation for intersubjectivity. Each impression of something is apprehended within the person but the stock of impressions and ideas that it relates to is shared with the community of those with similar experiences. Other people may be separate consciousnesses but Husserl writes of a '*certain mediacy of intentionality*', a shared orientation of consciousness to the primordial world which enables 'a kind of *making "co-present"*, a kind of *"appresentation"*'' (Husserl (1933/1950) 1999: 109).[1]

This capacity of co-presence, of a presumed common ground of intentionality, means that I can imagine how someone else will apprehend an object they see in front of them. As I stand beside someone else looking at a car, I might reasonably imagine that she sees the car as just as ugly or shabby as I do. Side by side in the art-gallery, we both see a glass of water on a shelf and are curious about what it is doing there and what its claim to being an art object is—the one who has read the label sees the same thing but also sees it differently as well. Appresentation is a version of presentation that is derived from how I imagine the impression that other person is getting. It is based on my direct perception of the car or the glass and of the person, and on what I take to be a shared stock of knowledge, of apperceptions, about how cars, glasses and artworks are. Husserl is clear that appresentation is not a cognitive process that involves thinking or inference. It is something that happens in a glance in which the already-given, everyday world is the basis for understanding what someone else's sense is responding to. This does not need to be a precise or exact constitution of equivalent experience. It is because '(w)e have already seen like things before' that 'an *analogizing transfer* of an originally instituted objective sense to a new case with its anticipative apprehension of the object as having a similar sense' (Husserl (1933/1950) 1999: 111). The connection of my perception with the other's perception is based on similarity, a chain of what Husserl calls 'pairing' of things that are not the same but are alike.[2]

Pairing is the similarity of the thing I see in front of me to things that I have seen previously, or pictures of things that I have seen, that leads to apperception. And it is the pairing of myself with the Other, that makes appresentation possible. If it were a dog rather than a person looking at the car with me then any 'analogizing transfer' would be on a very different basis and would probably require a conscious act of imagination on my part. Even if the person was from a very different culture, for example one in which there were few cars, or few new and well-maintained cars, then her apperceptions would be different and her perceptions would be less appresent for me. Appresentation depends on sharing a very similar stock of knowledge and, the further away the other's experience, the less likely the person will see things in the same way. The sharing of a visible reaction stimulates a process of empathizing in appresentation; 'the outward conduct of someone who is angry or cheerful . . . I easily understand from my own conduct in similar circumstances' (Husserl (1933/1950) 1999: 120). This is a cumulative process in which my understanding of the other person's reaction to her life-world enhances the appresentation of her apperceptions for me. If she looks distastefully on the ugly old car, then I can see that her system of apperceptions is closer to mine than simply being

another human being. Husserl says 'every successful understanding of what occurs in others has the effect of opening up new associations and new possibilities of understanding' ((1933/1950) 1999:120). The process is of course reciprocal so that the structure of my apperceptions is progressively revealed to the other at the same time as mine is to him—this is the basis of intersubjectivity. The idea of empathy includes being able to imagine what it would be like to be perceiving the world from his perspective. Because he has a body like mine I can apprehend the things I see 'as if I were standing over there where the Other's body is' (Husserl (1933/1950) 1999: 123).

The possibility of community arises from this sharing of associations that Husserl calls 'co-perception'. As I and the other person stand looking at the car at least we both see a car and in this we are part of a *functional community of one perception* that arises from the fusion of our apperceptions and associations through the process of appresentation that shares a common temporality (Husserl (1933/1950) 1999: 122). The appresentation of apperceptions that enables me to see much the same in a glass of water or an old car as someone else depends on shared experiences; we must both live in cultures in which glasses are used to hold and carry water for drinking and cars are objects for carrying people that become less reliable as they age. For those Others who live in un-industrialized, isolated rural communities and for those who lived a few hundred years ago, such a shared set of typifications would not be available.

Schutz develops the concept of 'appresentational apprehension' to include cultural objects such as books, tools, houses, theatres, temples, machines (1971: 314). So, not only do I understand the Other in co-presence through appresentation, through engaging with his experience empathetically, I can also engage with the Other through mediations that communicate his experience: 'I may comprehend the Other by appresentation; by mutual understanding and consent a *communicative common environment is thus established*, within which the subjects reciprocally motivate one another in their mental activities' (Schutz 1971: 315). This communicative common environment includes language through which we may exchange values and ideas but it also includes the various types of images (sketches, diagrams, plans, photographs, moving images) by which we might share our visual impressions of things. Husserl's understanding of apperception and appresentation addresses the intersubjective world through which we share experiences, including impressions of things, which we take to be very similar. But Schutz takes this further to include in the realm of intersubjective understanding, the *mediated* world and the sociocultural world of things made by people that all become appresentational references in our stocks of knowledge (1971: 328). Schutz's concept of the 'symbol' is precisely about a pairing that has its reality in another province of meaning or subuniverse from that of paramount reality.

For Schutz a symbol has its pair in a province of meaning beyond that of everyday life—it may represent something in a dream world, the world of science, a religious or spiritual world or any other world that is not experienced as everyday reality. This is noticeably different from the common use of the term symbol as something that simply stands for something else. If appresentation through symbols links us to a universe of meaning beyond that of paramount reality, it is still connected and relevant to our

experiences in the everyday world. This is because people can share symbols that stand for entities outside paramount reality (e.g. 'social status', 'the environment', 'energy', 'fashion'), which are also part of the relevance structures that orient them to the things they see within paramount reality. These abstract entities are constructs of common-sense thinking that 'we can apprehend only symbolically; but the symbols appresenting them themselves pertain to the paramount reality and motivate our actions with it' (Schutz 1971: 353). The interaction between two friends sharing a meal is solidly within their shared paramount reality; one pouring a glass of water for the other is within the realm of everyday life. But the action of sharing a meal and of the gesture of one pouring water for the other may also be symbolic of the friendship, the particular form of 'we-relationship' that is shared along with the meal. The symbols will vary according to the type of relationship or the type of social institution that is involved ('Its appresenting member is always the common situation as defined by the participants, namely that which they use, experience, enjoy, or endure together. A joint interest makes them partners, and the idea of *partnership* is perhaps the most general term for the appresented We-relation. (*We* are buddies, lovers, fellow sufferers, etc.)' Schutz (1971): 354—emphasis in the original).

CONCLUSIONS

In the hands of contemporary phenomenologists such Don Ihde and Peter-Paul Verbeek, the approach of phenomenology to the material world has been given a new lease of life as 'postphenomenology'. For Ihde this means a phenomenology that is nonfoundational and nontranscendental but takes into account variations in perspective (1993:8). For Verbeek it means a different way of thinking about the relationship between people and things in which 'subject and object *constitute* each other. Not only are they intertwined, but they coshape one another' (2005: 112—emphasis in the original). Verbeek's argument downplays the privilege accorded to human beings in the existential phenomenology of Heidegger and Jaspers who both saw the technological world as alienating, and is a response to Bruno Latour's actor-network theory, which challenges traditional notions of agency. I hope to have arrived at a similar position by a slightly different route; out of Husserl via Merleau-Ponty and Schutz. Merleau-Ponty's account of how we see things shows that it is the materiality of the body situated within its material environment that produces perception; it is not a biomechanical process that can be specified in terms of organs and functions. He also indicates the importance of experience and memory in the process of perception—but gives us little detail on how mind contributes to the process of seeing things. Schutz's phenomenology may well be discounted by philosophers because of its description of the social world and its inadequacy for analysing the material world of technology—it is true that his primary interest is in social interaction and micro-sociological analyses. But Schutz's fascinating attempt to understand the mediated and symbolic subuniverses in their relationship with the paramount reality of everyday life is often overlooked. His conceptual framework of relevance, zones of reach and of typifications gives us a structure to the mind that complements Merleau-Ponty's

embodied analysis of perception. Schutz's use of Husserl's concepts of 'apperception' and 'appresentation' help to show how memory works with the motor and sensory apparatus to constitute an embodied and sociocultural being that sees and makes sense of things as it engages with the life-world.

There is of course a serious limitation to the common ground between members of the same society that the half a century of sociology subsequent to Schutz's work has emphasized with its analysis of the social divisions of class, sex, race, age and ability. These differences are ideologically and politically of great importance, especially when they point to inequalities, and the tendency of phenomenological analysis to smooth over those contradictions between apperceptions and experience is precisely why Schutz's methodology has fallen into disuse. However, social divisions are not rifts in the fundamental way that human beings experience the world and variation in apperceptions can be seen as relational to the sociocultural perspective of different groups. The sociology of modernity has taught us to be suspicious of the taken-for-granted common ground in everyday practice because it so often favours the powerful and dominant groups. But modernity has at the same time increased the capacity for appresentational and apperceptive engagement. Put crudely, once the distinctive experiences of women or people of another race have been articulated for me—sometimes interpersonally but often through mediated means—I am better able to incorporate them into my own understanding of the world around me.

What is gained from the phenomenological approach to seeing things is that the analysis problematizes the relationship between the viewer and the material world in which he or she lives. That world may be routinely taken for granted by the viewer, but a phenomenological approach tries to unpack the cultural resources that are drawn on in the everyday ways in which people look at things as they act in the world without remarking on their visual qualities. This embodied capacity depends on the biological resources available to the human animal—precisely that physical equipment given in the body that may be damaged by malformation, trauma or disease—but it also depends on the cultural resources that are embedded within the body through social learning. That social learning may, in part, be via the medium of language. Parents, teachers, peers and the media may use language to point out, emphasize and give value to what is seen. But language is only ever supplementary to other modes of communication that above all include the content of what is in front of our eyes. We learn to look at things through looking at things and simply pointing and smiling, or showing an image of something new in close proximity to something loved and familiar, can be good enough to communicate value. And the response to the things we see in our visual field is always too immediate for the encoding and decoding of language, which is always serial and cumulative.

What is sustained through the various phenomenological—and postphenomenological—accounts of how we encounter our world is the pragmatic logic of everyday life. As we see things—glasses of water, cars, whatever—we engage with them through our practical concerns, both present and past. We don't use a system like language with its lexical and syntactical subsystems to make sense of the things we see; if we did then

our responses to the visual presence of things would be more amenable to analysis and be both more predictable and more consistent. We see things much more immediately but make sense of them through our accumulated direct, vicarious and mediated experiences. Our stocks of knowledge are an accumulation of typifications that are both shared within those who share the various sociocultural locations we occupy, and particular to our culture. How we see something is shaped both by our biography and by how we have engaged with our society. Sometimes we do learn a code for distinguishing things—as the bird spotter who learns to distinguish species by particular markings rather than simply seeing another 'little brown bird'. But in the flow of ordinary life such codes are seldom of much use. The vast majority of things we encounter in everyday life are familiar and routine and we recognize them and respond to them because we've seen something very similar many times before.

FURTHER READING

Harper, Douglas. 1987. *Working Knowledge: Skill and Community in a Small Shop*. Berkeley: University of California Press.

Ingold, Tim. 2000. *The Perception of the Environment: Essays on livelihood, dwelling and skill*. London: Routledge.

Verbeek, Peter-Paul. 2005. *What Things Do*. Pennsylvania: Pennsylvania University Press.

NOTES

1. All emphases in quotations follow the original.
2. 'Pairing is a *primal form of that passive synthesis* which we designate as "*association*" ' (Husserl (1933/1950) 1999: 112).

REFERENCES

Appadurai, Arjun, ed. 1986. *The Social Life of Things*. Cambridge: Cambridge University Press.

Attfield, Judy. 2000. *Wild Things: The Material Culture of Everyday Life*. Oxford: Berg.

Barthes, Roland. (1957a) 1979. *The Eiffel Tower and Other Mythologies*. New York: Hill and Wang.

Barthes, Roland. (1957b) 1993. *Mythologies*. London: Vintage Books.

Barthes, Roland. (1961) 1977. 'The Photographic Message', in *Image, Music, Text*. London: Fontana, 15–31.

Barthes, Roland. (1964a) 1967. *Elements of Semiology*. London: Cape.

Barthes, Roland. (1964b) 1977. 'The Rhetoric of the Image', in *Image, Music, Text*. London: Fontana, 32–51.

Barthes, Roland. (1967) 1990. *The Fashion System*. Berkeley: University of California Press.

Barthes, Roland. (1970a) 1982. *Empire of Signs*. London: Cape.

Barthes, Roland. (1970b) 1975. *S/Z*. London: Cape.

Bignell, Jonathan. 1997. *Media Semiotics: An Introduction*. Manchester: Manchester University Press.

Bruce, Vicki, Patrick R. Green and Mark A. Georgeson, Mark A. 2003. *Visual Perception: Physiology, Psychology and Ecology*. Hove: Psychology Press.

Buchli, Victor, ed. 2002. *The Material Culture Reader*. Oxford: Berg.

Burgin, Victor. 1982. 'Photographic Practice and Art Theory', in V. Burgin (ed.), *Thinking Photography*. London: Macmillan, 39–83.

Dant, Tim. 2005. *Materiality and Society*. Maidenhead: McGraw-Hill.

Dant, Tim. 2010. 'The Work of Repair: Gesture, Emotion and Sensual Knowledge', *Sociological Research Online*, 15/3: 7. http://www.socresonline.org.uk/15/3/7.html.

Davis, Fred. 1992. *Fashion, Culture and Identity*. Chicago: University of Chicago Press.

Dittmar, Helga. 1992. *The Social Psychology of Material Possessions*. Hemel Hempstead: Harvester Wheatsheaf.

Edwards, Elizabeth and Janice Hart, eds. 2004. *Photographs, Objects, Histories*. London: Routledge.

Emmison, Michael and Philip Smith. 2000. *Researching the Visual*. London: Sage.

Findlay, John M. and Iain D. Gilchrist. 2003. *Active Vision: The Psychology of Looking and Seeing*. Oxford: Oxford University Press.

Gell, Alfred. 1998. *Art and Agency: An Anthropological Theory*. Oxford: Clarendon Press.

Gordon, Ian E. 2004. *Theories of Visual Perception*. Hove: Psychology Press.

Gottdiener, Mark. 1995. *Postmodern Semiotics: Material Culture and the Forms of Postmodern Life*. Oxford: Blackwell.

Gregory, Richard L. 1998. *Eye and Brain: The Psychology of Seeing*, 5th edn. Oxford: Oxford University Press.

Gregson, Nicky and Louise Crewe. 2003. *Second-Hand Cultures*. Oxford: Berg.

Hebdige, Dick. 1979. *Subculture and the Meaning of Style*. London: Methuen.

Hochberg, Julian. 1972. 'The Representation of Things and People', in E. H. Gombrich, J. Hochberg and M. Black (eds), *Art, Perception and Reality*. Baltimore, MD: Johns Hopkins University, 47–94.

Hodge, Robert and Gunther Kress. 1988. *Social Semiotics*. Cambridge: Polity Press.

Husserl, Edmund. (1933/1950) 1999. *Cartesian Meditations: An Introduction to Phenomenology*. Dordrecht: Kluwer Academic.

Ihde, Don. 1993. *Postphenomenology*. Evanston, IL: Northwestern University Press.

Ingold, Tim. 2000. *The Perception of the Environment: Essays on Livelihood, Dwelling and Skill*. London: Routledge.

James, William. (1890) 1950. *Principles of Psychology: Volume 2*. New York: Dover.

James, William. (1899) 1927. *Talks to Teachers*. London: Longmans, Green.

Köhler, Wolfgang. 1947. *Gestalt Psychology*. New York: Liveright.

Kress, Gunther and Theo van Leeuwen. 1996. *Reading Images: The Grammar of Visual Design*. London: Routledge.

Llamazares, Ana Maria. 1989. 'A Semiotic Approach in Rock-art Analysis', in I. Hodder (ed.), *The Meanings of Things: Material Culture and Symbolic Expression*. London: Unwin Hyman, 242–8.

Lurie, Alison. 1981. *The Language of Clothes*. London: Bloomsbury.

Mauss, Marcel. (1950) 1990. *The Gift: Form and Reason for Exchange in Archaic Societies*. London: Routledge.

Merleau-Ponty, Maurice. (1945) 1962. *The Phenomenology of Perception*. London: Routledge.

Miller, Daniel. 1987. *Material Culture and Mass Consumption*. Oxford: Blackwell.

Molotch, Harvey. 2003. *Where Stuff Comes From*. London: Routledge.

Pearce, Susan M. 1992. *Museums, Objects and Collections*. Washington, DC: Smithsonian Institution Press.

Pink, Sarah. 2001. *Doing Visual Ethnography: Images, Media and Representation in Research*. London: Sage.

Pinney, Christopher. 2002. 'Visual Culture: Introduction', in V. Buchi (ed.), *The Material Culture Reader*. Oxford: Berg, 87–103.

Polhemus, Ted. 1994. *Streetstyle: From Sidewalk to Catwalk*. New York: Thames and Hudson.

Riggins, Stephen. 1994. *The Socialness of Things: Essays on the Socio-Semiotics of Objects*. New York: Mouton de Gruyter.

Rose, Gillian. 2001. *Visual Methodologies: An Introduction to the Interpretation of Visual Materials*. London: Sage.

Sartre, Jean-Paul. 1991. *The Psychology of Imagination*. New York: Citadel Press.

Schiffer, Michael Brian. 1999. *The Material Life of Human Beings*. London: Routledge.

Schutz, Alfred. 1971. 'Symbol, Reality and Society', in *Collected Papers Volume 1: The Problem of Social Reality*. The Hague, Netherlands: Martinus Nijhoff, 207–350.

Schutz, Alfred and Thomas Luckmann. 1974. *Structures of the Life-World: Volume 1*. London: Heinemann Educational Books.

Thwaites, Tony, Lloyd Davis and Warwick Mules. 1994. *Tools for Cultural Studies*. London: Macmillan.

Tilley, Christopher. 1989. 'Interpreting Material Culture', in I. Hodder (ed.), *The Meanings of Things: Material Culture and Symbolic Expression*. London: Unwin Hyman, 185–94.

Tilley, C., K. Webb, S. Küchler, M. Rowlands and P. Spyer. 2006. *Handbook of Material Culture*. London: Sage.

Verbeek, Peter-Paul. 2005. *What Things Do*. Philadelphia: University of Pennsylvania Press.

Photography and Visual Culture

FIONA SUMMERS

A black-and-white photograph by the artist Willie Doherty, entitled *The Other Side* (1988), shows a panoramic view across the rooftops of the city of Derry in Northern Ireland (see Figure 18.1). Derry appears in a slice of closely packed streets and buildings—domestic, commercial and religious—situated between the hills which form the Foyle Valley. Whilst there is a visual contrast between the texture of buildings and the ploughed earth in the foreground this contrast between rural and urban is mitigated by the lack of colour in the photograph, which renders both spaces monochrome. The image evokes conventions of traditional landscape painting and photography as well as the 'gritty' black-and-white documentary reportage that characterized representations of Northern Ireland during the 'Troubles'.[1] However, whilst evoking these genres of visual representation, *The Other Side* disturbs and disrupts the conventions of both the picturesque idealism associated with landscape and the realism associated with social documentary photography, through the questions it poses in relation to what it is we are looking at and *how* we are looking. The viewer is positioned at a distance from the city upon which the person gazes and three lines of white text appear across the image; THE OTHER SIDE written in the immediate foreground and above this, in smaller font (the laws of pictorial perspective implying a further distance) WEST IS SOUTH to the left and EAST IS NORTH to the right. The presence of text on the image explicitly prompts awareness of an activity in which we are regularly engaged, that is the act of looking at and discerning meaning from photographic representations of the world, since we are immediately asked to position ourselves in relation to the 'other side' and to think about whether what we are doing is looking *at* it. The cues provided by the written text disrupt the work of narrativization that is a key convention of photographic practice; there are stories here but the image refuses a singular, simple act of *showing how it is* (or was). The 'other side' of the subject may refer to a place other than where 'we' (camera/viewer)

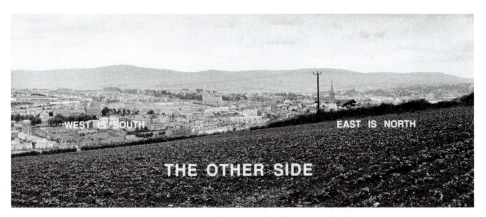

FIGURE 18.1 Willie Doherty, *The Other Side,* 1988, photograph. Courtesy of the artist, © Professor Willie Doherty.

stand or it may refer to the relationship of other *sides* between the west bank and east bank of the River Foyle, which are in the south and north of Derry respectively. However, viewers encountering this image will vary in their individual knowledge of the city represented; its name, geographical location in the world, politics and history as well as personal and emotional investments—or lack of—in what is shown. In this sense, the process of looking and discerning meaning from the photograph is a process of orientation, recognition and potential misrecognition—of geography, political differences, identifications—which highlights the ways in which photography is always a *point of view*, in both perceptual and ideological regards.

Photography holds a particularly persuasive power to communicate in ways that have often been seen as more truthful and reliable than other forms of media because it appears to show an act of visual perception (literally, a vision of the world), which in turn is made meaningful to the viewer through a further act of visual perception on the viewer's part (in the process of perceiving the world within the photographic image), and this obscures the extent to which the photograph constructs a view rather than simply records it.[2] Further, this point of view cannot be determined by either the photographer or the conventional rules of engagement of the camera within a scene (i.e. that of 'capturing'), which infer a mimetic relationship between the photograph and the world. Rather, the interrelationships between photographer, photograph and viewer involve a complex *negotiation* of making sense of the meaning of a photograph that has been extensively theorized by writers such as Susan Sontag (1979), Roland Barthes (1981), Victor Burgin (1982), John Tagg (1988) and Stuart Hall (1997) who focus particularly on the work of photographic representation in regard to ideology and power.[3] Whilst digital technologies have effected significant changes to all aspects of the taking, circulating and viewing of photographic images since much of this body of work was written, the arguments expounded by these writers continue to influence contemporary debate and critique on the social role of photography. Indeed, a significant proportion of writing on photography continues to be concerned with issues of interpretation and meaning in photographs and with the ways that photographs represent and structure identity and subjectivity.

THE QUESTION OF 'POST-PHOTOGRAPHY'

Despite an interest in focussing on the constitutive differences between analogue and digital photographic technologies in academic writing on photography since the 1990s (William J. Mitchell's 1992 book *The Reconfigured Eye: Visual Truth in the Post-photographic Era* is the mostly widely cited of this group), there has not been a widespread adoption of a purely technologically determinist perspective. Similarly, claims made during the 1990s that the digital revolution would ultimately lead to the demise of photography when subjected to scrutiny were found to be wide of the mark. Primarily, this is because photographs continue to carry many of the meanings and values they have held since before chemicals were replaced by algorithms. That is photographs still function as significant means of communication and expression: if differently than they did. In a further aspect, the *medium* of photography continues after its apparent demise as a chemical process, by way of the deep and invested familiarity we have with what are largely understood as indexical representations of the world. To put it another way, digital photographic technologies provide us with means to make alternate, vividly imaginary—or vividly *faithful*—views of the world, but the language and aesthetic of traditional, analogue photography endures, even if the technology itself will not. Lev Manovich (2003: 241) explains this in his argument that whilst the way photographs are constituted, displayed and encountered in modern visual culture is radically altered in the shift to digital technology, paradoxically the digital simultaneously 'glorifies' and 'immortalizes' the photographic, because in order for a 'synthetic' image generated on a computer to make sense *as a photograph* it must borrow the language and aesthetic of analogue. For instance, limits in the depth of field of the lens and slightly grainy surface texture of analogue photographs more closely resembles human vision, and therefore appears more 'real' than glossy *hyper*-real computer-generated or enhanced images so, as Manovich describes in relation to cinema, 'barely visible noise' is added to reduce the unconvincing perfection produced by the synthetic image (2003: 247). A digital aesthetic of perfection and simulcra has not, however, been without its use and meaning in cultural practice and there is a role for a number of different forms of photography, which might—rather uneasily—be divided along lines of those which appear to have an indexical relation to the world (a language and aesthetic associated with analogue) and those which offer visions of alternative worlds (the hyper-real image associated with the synthetic), however to some degree photography has always produced images that might fall either side of that, ultimately intangible, divide.

PHOTOGRAPHY AND EVERYDAY LIFE

The ubiquity of photographic images and technologies for producing and circulating photographs, which are increasingly digital and global in scope, has been widely discussed as a central aspect of contemporary, global media culture.[4] As a practice which produces many billions of objects, can be practiced by anyone with access to at least basic equipment and has been used so consistently since its invention in the first part

of the nineteenth century as a means for classification, for inciting desire, empathy and wonder, as well as signifying strength, bonds of love and national and familial pride, photography holds a totemic and highly privileged position across all areas of private and public life, almost without exception. Everyday encounters with photographic images are characterized by both proximity (advertising displays in shops and on billboards, newspaper front covers, photo-sharing Web sites, book and magazines) and intimacy (family portraits, passport photographs, as well as the still images produced by technologies such as ultrasound or surveillance equipment). The relationship between photography and everyday life is intimate in a further way; photographic images are inculcated in the constitution of subject and identity positions such that we cannot make sense of ourselves as subjects, or individuals, without an awareness (conscious or unconscious) of our own representability within the field of vision, and the form this representation might take. As Vivian Sobchack (2004: 136) argues, culturally pervasive perceptive (and expressive) technologies such as photography, cinema and computers have enormous impact on modalities of expression and signification, but there is also an effect of such technologies (or our encounter with these technologies) that moves beyond signification of bodily existence to constitution of it. Drawing on a phenomenological conceptualization of embodiment, Sobchack focuses on the carnality of visual perception and expression, to argue 'insofar as the photographic . . . [has] been *objectively constituted* as a new and discrete techno-logic, [it] has also been *subjectively incorporated*, enabling a new and discrete perceptual mode of existential and embodied presence' (2004: 139, emphasis in original).[5] Sobchack's point here is that the way in which we see and make sense of ourselves as subjects is fundamentally transformed by photographic visuality. Even if we individually desire not to record our lives with a camera, to look at old photographs of ourselves or to imagine how we might look in a photograph it is very likely that these things do occur, and on a daily basis. We may have three or four photographs of ourselves on the identification cards in our wallets, hundreds (or thousands) on social networking sites and stored on our computers and mobile phones. The significance of these photographs is far beyond merely identifying who we are in any straightforward sense—this face in the photograph matches this face in the flesh, as an identity card seeks to—but rather in identifying who we are as subjects; our class position, what kinds of friendships we have, how closely bonded we are with family, whether we are well or ill, successful, happy. In turn, personal photographs are coextensive with public and shared ones, for instance the billions of photographs made available to us through advertising, as well as in art, science, medicine, historical archives, journalism and law. Every photograph which represents a body or a way of life presents an opportunity, indeed an imperative, to refract one's own experience through what is shown, to consider our own relationality to what we see whether this is a relation of difference or affinity.

A significant proportion of discussion and debate on the social function of photographic images, found within work on cinema by theorists such as André Bazin, Jean-Louis Comolli (1980), Christian Metz (1982) and Laura Mulvey (1975), and developed in relation to still photographs by writers such as Roland Barthes (1981), John Berger (1991), Susan Sontag (1979, 2003) and Kaja Silverman (1996), has interrogated

relationships between subject formation, identity and the gaze, of which the camera (still or film) is arguably its key component.[6] The nature of this interrogation is largely oriented in terms of a Lacanian psychoanalytic conceptualization of subjectivity as being founded in a (mis)recognition of the self as a visual image. That is Lacan's argument that the child comes to understand itself as an individual for the first time through seeing him or herself in a mirror is extended to consider the ways in which we engage with photographs of ourselves in similar structures of recognition (this is me, I exist) and misrecognition (what I see apprehends and defines me but is not really 'me'). Silverman (1996: 197) argues that our activity of looking at things in the world is structured by the photographic gaze (the ways in which a camera frames and defines value and meaning), but also, crucially, we experience ourselves (our bodies and habits) as photographic spectacle.[7] Quoting Susan Sontag, Silverman writes: 'We learn to see ourselves photographically: to regard oneself as attractive is, precisely, to judge that one would look good in a photograph' (1996:197). For Silverman, as well as for Roland Barthes, what is distinctive about still photographic images in comparison to moving images is that whilst in both mediums the subject comes into being as an image (with all the potential for misrecognition and alienation this entails, because it is not who we *really are* or feel ourselves to be) the still image arrests movement, it freezes liveliness whilst simultaneously affirming that some *thing* existed by turning into an object.

For the human body this action of being turned into an object of vision (rather than, say, a sentient, mobile, and fleshy body) can be understood in relation to the pose, a concept which Barthes and Silverman both use to think through the ways in which we orientate our bodies in relation to the camera lens: 'Now, once I feel myself observed by the lens, everything changes: I constitute myself in the process of "posing", I instantaneously make another body for myself, I transform myself in advance into an image' (Barthes 1981: 10). Barthes argues that this is an active process, the body photographed is not passively caught in the lens but actively participates in becoming an object of vision. Yet, whilst one might desire that the resulting image 'should always coincide with my (profound) "self"' this is an impossibility, Barthes asserts, since 'it is the contrary that must be said: "myself" never coincides with my image; for it is the image which is heavy, motionless, stubborn (which is why society sustains it), and "myself" which is light, divided, dispersed' (1981: 12). In relation to formal portrait photography, Barthes continues:

> Four image-repertoires intersect here, oppose and distort each other. In front of the lens, I am at the same time: the one I think I am, the one I want others to think I am, the one the photographer thinks I am, and the one he makes use of to exhibit his art. . . . I do not stop imitating myself, and because of this, each time I am (. . .) photographed, I invariably suffer from a sensation of inauthenticity. (1981: 13)

The point that Barthes makes here—that there is never complete coincidence between who one imagines one is and how one appears—should not be interpreted to imply that there could be a 'real' image of oneself which a photograph (actual or in the

mind's eye) could present and re-present to others, because the self cannot be contained as a visible object (even if it is constituted as one). There is a fundamental disjuncture between pictures of ourselves and our 'selves' in which the latter must deal with the more rigid and coherent constructions of the former—that is photographs make sense of us as individuals in ways that we may experience as alien or inauthentic, even whilst we may enjoy this inauthenticity by *imagining it as authentic.*

Family photography and tourist photography are key examples of the ways in which the camera is utilized as a means to document imaginings of authentic relations between people, their feelings for one another and their locations in time and place, which is magnified by digital technology rather than discarded as a relic of the film camera era. Much of the work of representation that family photography does is in articulating visually the performative practices that families must engage with in order to be constituted *as* families. No family simply exists, fixed and unchanging, particularly in contemporary societies where kinship is not defined solely by blood and groupings of kin may be dispersed many thousands of miles apart; the relations between the people involved in families must be continuously and actively maintained and memorialized. As writers such as Annette Kuhn (1995), Marian Hirsch (1997), Patricia Holland (2001) and Jo Spence (1986) argue, photography plays a highly significant role in practices of performing familial relations of love and togetherness whilst simultaneously building intimate and apparently unequivocal memories through capturing the present for future viewing (the ideal family constituted in an anterior future). In front of the camera, families are able to enact versions of their relationships which are more ideal, harmonious and simplified than they may usually experience, most often selecting moments of success and joy through which to visualize each other as members of a shared unit rather than through distress and antagonism (which, although equally interrelational are not culturally desired). Similarly, family estrangements and nonconformity are not readily, or at least typically, part of families' presentations of self; indeed some 'members' of a family may be rendered invisible in the family albums through refusals to participate in the required performance. Through digital technology, family photographs continue to be highly regarded and valued cultural objects and it has become familiar practice for people to select images that show them with their children or other family members, smiling happily and positioned close to each other, for their profile pictures on social networking Web sites. Here, where we might expect photographs which only show the individual whose profile it is, what is established as the identity of the individual is their relationship with others. Indeed, the profile photograph might easily be used as a means through which to maintain a sense—and presentation—of the connections made offline; a rebuke to the popular perception that life online is singular and therefore isolated.

In his ethnographic work on families taking photographs at tourist sites in Denmark, Jonas Larsen suggests that 'the more family life becomes fluid and based on choices and emotions, the more tourist photography can be expected to produce accounts of a timeless and fixed love: The nuclear family is still a powerful choreographing myth' (2005: 424). Larsen's observation points to the ways in which the practice of taking photographs is not a straightforward one of capturing what is already happening (such as

children exploring part of an historic castle or a family group standing together beside an iconic building) but that people move their bodies and behave in ways that anticipate the action of the camera—and the image it will produce. The families Larsen observed and interviewed typically preferred not to take photographs of scenery, which they suggested would be too much like postcards (and as such would be boring for themselves and for their friends and extended family to whom they would be shown), but rather they wanted to picture their 'familyness' in the scene. Larsen notes that touch—of bodies to one another—was a prime aspect of the behaviour of families when their cameras were out, but which would not necessarily be maintained once photographing had ceased (and conflicts—especially between children—would resume). He argues that:

> proximity comes into existence because the camera event draws people together. In this sense, it is cameras, public places, and cultural scripts that make *proper* family life possible: relaxed and intimate . . . The desired family is the product of the photographic event that each family stages and performs actively and bodily. It is the enactment that produces 'familyness'. In other words, photographic performances produce rather than reflect family life. (2005: 430)

DIGITAL SHARING

Most domestic, personal photography is now produced and circulated digitally, the most immediate effect of which has been a much greater volume of photographs being both made and *shared*. José van Dijk (2008) argues that in the move from analogue to digital, photography is increasingly used as a means for mediating everyday experiences, so that the camera is no longer reserved for important and ceremonial moments but may also act as witness to the mundane. For van Dijk the increased volume and scope of everyday personal photography indicates a shift in emphasis in the role of photography from functioning as a memory tool to functioning as a means for social interaction and bonding, particularly amongst young people, by playing an important part in self-presentation (2008: 62). Whilst both analogue and digital photography are capable of serving as tools for memory and offering a means through which people might attempt to remodel versions of themselves, van Dijk suggests that in contemporary societies the communicative function of photographs in the here-and-now is more significant than making memories:

> Digital photography is part of . . . [a] larger transformation in which the self becomes the centre of a virtual universe made up of informational and spatial flows; individuals articulate their identity as social beings not only by taking and storing photographs to document their lives, but by participating in communal photographic exchanges that mark their identity as interactive producers and consumers of culture. (2008: 62–3)

Photography's traditional commemorative function is not abandoned in this shift, rather the practices of storing associated with analogue photography—at home in

albums, old envelopes and boxes—radically alter in new patterns of 'distributed sharing' whereby the exchanging of digital personal photographs becomes a form of *distributed memory* (van Dijk 2008: 68).

The photo-sharing Web site Flickr may be read as a key location through which distributed memory takes place, with many millions of users across the globe uploading photographs at a collective rate of approximately a billion per year.[8] Flickr is not simply a vast repository for photographs, but is a more dynamic form of archive made through communities for sharing, connecting and commenting. The site is structured as a relatively decentralized network and it is intended that members experience it as such, which can, for novice users, make navigation interesting and playful but also somewhat undirected and labyrinthine. In order to make sense of Flickr as a visitor or member, one is required to explore the vast network of connections between members' pages, individual photographs, groups and tags in a mode which is often most productive as a form of wandering, since the network as a whole is invisible, or at least is so intensely complex as to be unfathomable in its entirety. In most instances the photographs that are encountered on Flickr are those that one has come to see through a combination of semi-organized searching, happenstance and curiosity; discovering, for example that there is a group pool named 'Mountain Decay (and Flatland Rot)'.

Writing about Flickr, Susan Murray (2008: 151) suggests that digital photography 'signals a shift in the engagement with the everyday that has to do with a move towards transience and the development of a communal aesthetic that does not respect traditional amateur/professional hierarchies'. Although there are group pools that signify some expertise with camera technique and equipment (such as 'Leica M8 users' or 'Neutral density filters') there are countless group pools which contain photographs using a range of camera types, taken by photographers whose amateur or professional status is most often not identified (or significant to how the image is seen). Groups are most often based on themes; for example frogs, sunsets, cupcakes or benches, constituting an endless collection and sorting of virtual objects.[9] The metaphor of the 'pool' makes logical sense in the flow of images (members' photograph collections are described on Flickr as 'photostreams'), by positioning clusters of photographs in what can be relatively transient collections; group pools shift in popularity (how many members join and how many view the pool), the attention they receive from members (how often they upload to the pool, post comments and discussions) and new ones are constantly being created. Group pools are ways of creating communities on Flickr and offer some means for navigation, but there is limited research on how much (and in what ways) members invest time and interest in the group pools and whether, as a function of the site, group pools are more attractive to users than other means of navigation such as tagging.

Tagging on Flickr is entirely user-generated: members tag their own photographs and have complete freedom to choose words and phrases, from basic descriptions such as 'London' to more specific phrases 'Our family trip to London'. Tags are the principal term in the search mechanism for photos on Flickr and as such are an important means of categorizing individual images. However this categorization does not fix any photograph in a single place, since most users when they add tags, will add more than one, so

a photograph will fit in multiple places (and similarly may be entered in more than one pool). In sum, the taxonomy of Flickr might be best described as rhizomatic (like the Web) with complex networks of connection and nodes (group pools).[10] This is significant in terms both of how an archive of digital images comes to be actualized (it can accommodate vast networks of interconnection and contain more objects than can ever be viewed by a single person) and how viewer-members encounter *and build* the archive.

As Daniel Rubinstein and Katrina Sluis (2008) note, the mode of tagging used on Flickr has been described as 'folksonomy', a Web-centric portmanteau of 'folk' and 'taxonomy' which is used to denote the collaborative organization of content. The use of tagging here, along with commenting, titling and annotating also points to the role and importance of a range of textual practices in photo sharing and archiving; photo sharing Web sites are far from purely visual phenomena. The text-based tag attached to the photograph, Rubinstein and Sluis observe, is particularly significant because it is wholly active in creating connections to all the other photographs it might relate to. Since the tag is actually a hyperlink (possibly one of the most easily user-generated hyperlinks currently operating on the Web) it does the work of enabling users of the site to immediately situate their photographs within navigable reach of other users (2008: 19). In this sense, once tagged it is inevitable that the image will be viewed in relation to a series of others, that is in a flow, or *in motion*. This elicits a potential shift in the understanding of the relation between temporality and the photograph which informed much of the work of writers such as Barthes, Sontag and Silverman, for whom the photographic image's distinction from the moving image was its capacity to arrest movement (and time). Contemporary writing on photography by writers such as van Dijk, Murray and Rubinstein and Sluis suggests that we are no longer looking at 'frozen moments of time' when we look at photographs but rather have become engaged in viewing practices that are 'more akin to live transmission' (Rubinstein and Sluis 2008: 22). The ability to view a photograph on the camera screen at the point it is captured, and then to delete or edit, email and upload it online, unfixing or reframing its context, within moments of it having been taken imbues photography with a level of immediacy that has come to seem an obvious, if not yet mundane, feature of what photographic technologies can do.

For Murray this confluence of digital image technology and social network software has brought about a new aesthetic, in which photographs are no longer seen as being precious to the extent that analogue photographs were and the ability to store and erase on memory cards, as well as closure of the temporal gap between capturing and viewing, enabled by digital cameras, 'provides a sense of disposability and immediacy to the photographic image that was never there before' (2008: 156).[11] This perspective attaches a sense of loss to the predominance of digital technology (though not necessarily a regrettable one) which relates to wider debates about the perception of authenticity (and 'aura') as inherent to analogue technologies; in contrast to digital technologies where authenticity is not only absent but is regarded as an impossibility (where once the auratic quality of art was felt to be undermined by the advent of mechanical, analogue technologies, analogue's 'aura' is put under threat by digital modes of reproduction).[12] However, whilst there *is* evidently an increased transience to the photographic image

(easily deleted, or overwhelmed in the continuous flow), I would in turn argue that the repository of photographs archived online (within collaboratively built and shared, private, commercial and institutional archives) places a tangible value on individual photographs and photography as a practice which can still be understood in terms of values such as authenticity and permanence. That is despite the existence of an infinite volume of photographic images and the ease with which photographs can be taken ('crudely' snapped on mobile phones, auto-focus digital cameras and Webcams) attitudes towards the means of photographic production and its result, if not dutifully reverent, are not dismissive either; the communicative, expressive and rhetorical functions of photographs prevail as significant means through which people engage with and make sense of photographic images and through which claims continue to be made about the relative enduring value or meaning of one photograph or another.

THE PAIN OF OTHERS: THE PHOTOGRAPH
AS DOCUMENT AND WITNESS

The desire to memorialize through visual representation remains an important motivating factor in the production and circulation of photographs and despite extensive interrogation of the reliability of photography to provide accurate documentation of the actuality of a place, person or event photographs still *matter* very much as objects through which to witness and remember. Writing about the imperatives of mourning and memory in the ruin of the New York World Trade Centre in 2001 and since, Alison Young (2005) identifies two kinds of memorial images—firstly, those that became significant in searching for the missing, mostly personal photographs which were displayed around the city (and were in turn photographed in places where they were collected together) and secondly, photographs of the building's towers which were shown in newspapers, magazine articles and on television in coverage and discussion, and later on Web sites devoted to commemorating the Centre as it was. On remembrance walls at Ground Zero photographs of lost friends and relatives appeared alongside photographs of the former physical structure of the building, both types of image—human and nonhuman—vibrate with a sense of the past as painful, unrecoverable loss, whilst nevertheless acting as (ghostly) markers of proof that someone/something existed, the 'it has been' which cannot be grasped in the 'it is no longer' of the present. The personal photographs displayed around Ground Zero are like those displayed at numerous sites of public outrage and on gravestones throughout the world. The display of photographs in this way may be read as acts of both private and public mourning, in which the private photograph is brought into public space and is recognizable in that domain as private, intimate and personal, yet shared *through* that recognizability. Indeed, a viewer might flinch at the thought of one of their own vernacular photographs positioned in such circumstances and of their photographs which would become imbued with a melancholy opened up to the public.

The role of still photography around the site of the World Trade Centre is given additional meaning by the conditions of intense visual coverage and scrutiny that occurred during the events of 11 September and the weeks following. The technologies

that enabled many millions of people around the world to 'witness' events on television effected a cinematic quality to what is in many ways an unrepresentable situation. The compulsion to attempt to visualize and to watch as much as possible of the location and people involved is indicative of the cultural conflation of seeing and knowing—if we see we will understand (more)—in which photography has played a key role. However, the attempt to see and show can only mask the ultimate failure of complete comprehension and the moving photographic image has no more succeeded in transparently presenting the real than the still photograph has. David Campany (2003) argues that photographs of the collapsed remains and debris of buildings at Ground Zero by the photographer Joel Meyerowitz are imbued with added symbolic weight through his use of a technology which precedes the televisual. Meyerowitz's use of a 1942 plate camera, Campany asserts, confers nostalgia of a time before television and new media networks, which is rooted in an attachment to recovering the past and the idea that the return to a former technology 'will somehow rescue the processes of memory that have been made so complicated by the sheer amount of information we assimilate from diverse technologies' (2003: 126). The use of a plate camera may be read here as a means to re-pose problems associated with the (in)ability of a photograph to be faithful to its subject (here, in an act of mourning and memorialization) by employing a device which produces images slowly, and therefore, it would appear, honestly. A further interpretation of these photographs of the crumbled remains of concrete and glass structures is that each recalls other images of modern war and destruction, connecting the site of this singular event to others within a network of acts of devastation and injury.

NEGOTIATING THE PAST: THE ROLE OF PHOTOGRAPHY IN THE MEMORY MUSEUM

As much as photography has served as a means to document and provide witness to both significant moments and the everyday, it also has a prime function in how versions of the past are communicated to interested viewers in the spaces of museums and exhibitions. Writing on the photographs taken by American soldiers of prisoners at Abu Ghraib, Sontag (2004) notes that photographs have 'laid down the tracks of how important conflicts are judged and remembered', and adds that, 'the memory museum is now mostly a visual one (2004: 24).[13] These two things to which Sontag refers—that photographs immortalize *particular* specific moments and that museums use photography for acts of memory and remembering—are not coincidental, and this points to the way in which desires to commemorate versions of the past can be highly dependent on a kind of photographic 'fossil record' that remains (which may be already part of dominant discourse or requires seeking out). However, it would be erroneous to be overly deterministic about the trajectory of the visual record and we cannot predict or assume what meanings will be derived from the photographs that bear witness to events, for example to infer that the ones which are powerful now will continue to hold cultural value in the future, or at least the same kind of value. That is we cannot know by what means the future will recount (or judge) the past, however much we may attempt to determine or imagine the

visual record. Photographs do have considerable narrative power, but these narratives are not atemporal nor are they politically or culturally neutral.

Darren Newbury's work on anti-apartheid photography (2009) and in particular his discussion (2005) of the role of photography in two museums in South Africa—the Apartheid Museum in Johannesburg and the Hector Pieterson Museum in Soweto—offers careful examination of the ways in which, following changes in the political organization of South Africa in the 1990s, the photographs taken by oppositional organizations such as Afrapix and *Drum* magazine photographers took on the function of photographic archives, forming the basis of means of showing the past in what became 'post-apartheid' South Africa. Sontag's assertion that photographs leave an imprint in how conflicts are remembered resonates in the naming of Soweto's Hector Pieterson Museum, which is located in the area where thirteen-year-old Hector Pieterson was shot and killed at the start of the June 1976 Soweto student uprising. As Newbury describes, Pieterson was not the first or only child to be shot that day, but because Sam Nzima's photograph of Hector being carried by fellow student Mbuyisa Makhubo with his distraught sister, Antoinette, running by their side, became a national and international icon of the uprising, it is Pieterson in particular who is remembered. In Nzima's photograph, a reproduction of which is sited outside the museum close by the location where it was taken, it seems inconceivable for a viewer to avoid the anguish in the expression and posture of the children fleeing the police violence (unseen beyond the frame) and it is this potential of the medium to position the viewer as a witness and thereby move the viewer emotionally—which might mobilize the viewer politically—that made photography a powerful and important part of the anti-apartheid struggle. Shown in a museum over thirty years later at a time when the nation has undergone substantial political and social change, the anguish and pain of the photograph has not dissipated but is reframed to function as a remembrance of things past (and perhaps a call to prevent its reoccurrence) rather than a spur to immediate political awareness and action (for new generations of audience this may be their first encounter with the image and in this sense the photograph continues to illicit political awareness).

Alongside instances of struggle photography, Newbury explains, in the museum there are photographs taken in the townships of protests and violence, of the type which were used for national and international news stories, as well as images of nonviolent, domestic life. In the context of the museum, both types of photograph function as historical documents of life for black South Africans living under apartheid, the photographs of domestic life however, 'offer an alternative visual record to that with which people would be familiar from press and broadcast sources' (2005: 283). This connects to the problems associated with the over-determined visual record that photographic images can convey of a place, person or event. The repetition of specific photographic representations (of violence, or poverty, or crisis for example) can congeal in such a way that it becomes difficult to see around or beyond them. Because photographic representations are so prevalent and seductive (even when what is shown isn't conventionally picturesque) it is possible for the image to appear to stand in for and determine whatever subject is being 'captured'. However, this is not to suggest that photographs produce narrow or false

visions of the real truth, since photography has an important role to play in how truths are conceived and constructed. That is as a means of communication and sense-making, photographs enable ways of understanding, remembering and producing meaning, but they do so ideologically and in temporally and spatially specific contexts. Photographs taken of uprisings in Soweto and exhibited in the Hector Pieterson Museum show this meaning making at work; as Newbury (2005: 285) notes, photographs taken on behalf of insurance agencies tell a story of property damage, police photographs tell a story of criminality and the photographs that black photojournalists took tell a story of injustice and resistance to the predominantly white mainstream press, all of which are collected up in the service of an historical account of a nation's past and desire for reconciliation.

Photographs reframed in order to account for a nation or other collective past are often reframed for, *or by*, an international audience. In this context, Rachel Hughes (2003) asks questions about the politics and curatorship of the portrait photographs taken of incoming prisoners to Cambodia's S-21 prison during the genocide of the 1970s, which have been exhibited worldwide in museums and galleries since the mid 1990s. As Hughes points out, in their original context these photographs were 'for both prisoners and their masters, emblems of the regime's omnipotence and efficiency'; means to reinforce the institutional power of both the prison camp and Pol Pot's Democratic Kampuchea. Following the fall of the regime in 1979 the site of the prison became a commemorative exhibition space (Tuol Sleng Museum) and the photographs part of an archive stored there, where they were visited and studied by both Cambodian and non-Camodian researchers. Following this, in the early 1990s, the photographs were regarded as requiring rescue from 'a volatile political situation, years of neglect, a lack of resources and the absence of trained staff' by a North American–based Photo Archive Group set up by two photojournalists who had viewed the archive.[14] A central consequence of the Photo Archive Group's project to restore and index the photographs was their international circulation in both news and visual arts contexts, where they were reproduced in mainstream magazines, a dedicated case-bound publication and in an exhibition at the Museum of Modern Art in New York in 1997. Hughes, assertion that, 'the generation of sympathy for, and interest in, Cambodia's past and present has undoubtedly been fuelled by the global exposure of the photographs' points to the ways in which photography operates as a significant affective and motivating device, yet at the same time in this operation important questions of context, political power and ownership may be overlooked, as she argues, 'crucial questions regarding this exposure, however, remain under-explored' (2003: 30). For although such photographs might provide a way in which contemporary viewers may 'see' what is otherwise unseeable because it is in the past, the multiple reproduction of these images might, as Barbie Zelizer suggests, 'function most directly to achieve what [photography] ought to have stifled—atrocity's normalisation' (quoted in Hughes 2003: 40). In this mapping of the movement of the S-21 photographs, Hughes traces an important relation between the view that archive photographs 'hold the true memory of past events' and the way in which deterioration in the materiality of the photographs can 'be perceived, quite literally, as a lack of memory' (2003: 28). Yet, as Hughes points out, merely to preserve and exhibit photographs

of the past does not produce memory as a discrete, factual object; restoring the materiality of the image should not preclude vital questions about whose memory and what form of memory is made to seem materially present in the here-and-now.

CONCLUSION

In writing this survey of work on photography, structured through an intent to sketch out a view of the landscape of contemporary themes within photographic practice and writing on photography, it is apparent that whilst there may be significant signposts towards what photography is—and might yet be—the future of photography is likely to continue to be intriguingly complex in its application, meanings and effects. The ubiquity and pervasiveness of digital technologies in the daily lives of many (if not most) people around the globe, has evidently not reduced the importance of photography but rather has activated and built on photography's ability to mutate (as it did into cinema in the 1890s) in order to become crucial to the networked societies in which it is argued we (as global citizens) live, work and connect. There is now an unimaginable amount of photographs in virtual and/or material existence, and yet individual images from the present and past continue to have the capacity to elicit feelings of surprise, joy, anger, shame, grief and memory in ways that can be deeply felt and experienced, however much the individual photograph has come to occupy a position which is often seen as transient and impermanent. In my view there remains a strong case for arguing that 'a' photograph might be both impermanent *and* enduring and that this relation of transience/permanence typifies the ontology of photography both before and after the emergence of widespread digital technologies, since any photograph is both a brief fleeting moment in continuous time and a securing of that moment in frozen, suspended time. In this vein it is helpful to consider a much earlier discussion of the ontology of the photographic image; in his 1931 essay 'A Short History of Photography' Walter Benjamin advances a complex understanding of the relation between the photographic camera, human optical perception, the conscious and unconscious mind as well as the moments of future time that are held in the photographic image. Theorized through the concept of the 'optical unconscious', Benjamin argues that the camera's ability to capture moments in the flow of time enables us to see retrospectively elements within a scene which are lost to the conscious mind (or memory) as time, and that which occurs through it flows on, and away. For Benjamin the photograph provides evidence of an optical unconscious parallel to the 'instinctual unconscious' revealed through psychoanalysis ((1931) 1972: 7) because the camera records what the eye *might* have seen but that the conscious brain could not fully absorb or retain (and as such the eye could not consciously perceive). Consequently, the photographic camera and image produced by it is a technology of temporality as much as it is of optics since in viewing a photograph we seek out evidence not only of *what was* but also what was *yet to come;* as Benjamin notes,

> the spectator feels an irresistible compulsion to look for the tiny spark of chance, of
> the here and now, with which reality has, as it were, seared the character in the picture;

to find that imperceptible point at which, in the immediacy of that long-past moment, the future so persuasively inserts itself that, looking back, we may rediscover it. ((1936) 1972: 7)

In connecting Benjamin's view to the landscape of networked, distributed data and images in which we now find ourselves situated I want to suggest that the role of photography within digital culture alludes to a promise to offer us a means to negotiate and 'see' better what we cannot see amidst the unprecedented degree of irreconcilable information and data streams. The point that Benjamin describes above is the way in which the viewer may make an attempt to understand the present by looking back for clues (in the form of visual cues within the photograph; a strained smile, awkward embrace, a previously unnoticed exchange of glances) in order to contextualize the future-present in its past. Photography then might persist still in providing at least the hope of contextualizing who we are and what place we occupy, when so much of what might have seemed established has become un-tethered and when things we feel should be un-tethered remain stubbornly fixed. Through picture messaging, photo-blogging, photo sharing and uploading photographs to social network sites we are both grappling with information (and contributing to the data stream) whilst also making an attempt to share and communicate in a language which lends itself particularly ably to sharing across potential barriers of spoken language, literacy and varying degrees of computer expertise. Digital culture is defined, at least in part by information flows of a level of infinite complexity that is beyond the capacity of human comprehension, and so it is that photography—fully imbued with the consequences of this culture—has come to form a prime means for *making sense* in ways that we can experience as something which feels very much like familiar and direct human perception. Photography is an intricate yet shifting assemblage of technologies, bodies, politics and aesthetics; tangible *and* ephemeral, at this moment photography appears paradoxically to have become established and to be at the point of experiencing radical, dynamic change. Indeed, the role and meaning of photographic images is likely to persist as a key question within the study of visual culture; the ground is far from settled.

FURTHER READING

Evans, Jessica and Hunt, Barbara. 1997. *The Camerawork Essays*. London: Rivers Oram Press.

Rubinstein, Daniel and Sluis, Katrina. 2008. 'A Life More Photographic: Mapping the Networked Image', *Photographies*, 1/1: 9–28.

Sobchack, Vivian. 2004. *Carnal Thoughts: Embodiment and Moving Image Culture*. Berkeley: University of California Press.

NOTES

1. Doherty (1988) discusses his work in relation to photographic documentation of Derry in *Circa Art Magazine*.
2. Central to an understanding of the camera as a perceptual apparatus is the assertion that the camera lens functions as an extension of the eye. The argument can be traced back to

philosophical understandings of much earlier technologies such as the telescope and micro-scope, which as Martin Jay (1994) notes, were instrumental in producing modern perspec-tive. This was developed in early film theory—with deep scepticism towards the extension of a *single* sense—by Jean-Louis Baudry (1974), Christian Metz (1982) and others, later, more optimistically by Marshall McLuhan (1967) and recently by Vivian Sobchack (1992, 2004) who sees the relation between apparatus and eye as carnal and embodied. For additional de-bate on the relation between photographic representation and visual perception see Friday (2002), particularly Chapter 3, pp. 47–65.

3. Burgin, Tagg and Hall all contributed to the UK magazine *Camerawork*, published between 1976 and 1985. The essays published in *Camerawork* typically share a similar approach to the critique of photographic representation, namely in their interrogation of photography as a social practice. See Jessica Evans and Barbara Hunt (1997) *The Camerawork Essays*, which provides an anthology of key essays from the period.

4. For work on the role of images in contemporary media culture see Lull (2001), Lash and Lury (2004) and Feury (2008). Frosh (2001) and Machin (2004) provide discussion of global commercial image banks such as Getty Images, which although containing many thousands of images, tend to reproduce a limited and hierarchical flow of generic images emanating from a largely Euro-American consumerist perspective.

5. In this claim Sobchack is making about photography, she also includes the cinematic and 'the electronic'. Although she uses the word 'new' to discuss these technologies she isn't sug-gesting that our relationship to perceptive and expressive technologies, and the changes that emerge in these relationships, are only very recent. It might be most helpful to think of transformations as stretching back in time and ongoing.

6. For a detailed account of the arguments put forward by Roland Barthes, André Bazin and Christian Metz in this regard see Jay (1994).

7. Silverman's argument is broadly similar to Sobchack's (1992, 2004) conceptualization of the intimate relation between technological and human perception (discussed above); however Silverman, in taking a more psychoanalytic perspective, emphasizes the role of the gaze in producing the body as an object.

8. Flickr publicizes the numbers of photographs uploaded to the site by counting in billions and identifies, through the Flickr Blog, the first one billionth (no longer in existence on the site), the second (uploaded November 2007, photo description: Chinatown in Sydney), the third (uploaded November 2008, tagged 'New Orleans'), the fourth (uploaded October 2009, no tag or description, title: DSC09782), and counting continues. These photographs are, according to Flickr, identified entirely based on their place in the sequence of uploads rather than because they in some way represent the Flickr brand or mission. In many ways, simply having a place in the upload stream of images and having (or not having) tags, or a title assigned by the camera represents the Flickr identity appositely.

9. Group pools function on Flickr by members joining the group and then adding specific photographs from their own collection appropriate to the group description.

10. The term 'rhizomatic' is used in Gilles Deleuze and Felix Guattari's (1988) work to con-trast with dominant arboreal epistemologies and is understood as a network of multiplici-ties, which can be ruptured and remade so that flows (of information, say) can be rerouted around points of rupture. The terms 'rhizome' and 'arboreal' derive principally from botany where they classify differences in plants (grass is rhizomatic for example, whereas an oak tree is arboreal). The Web has widely been described as a rhizomatic system and Flickr may

function in similar—though not identical—ways (for instance if Flickr group pools may be seen as nodes, this is not to imply they are performing the same role as the nodes in computer network systems).

11. Murray notes that Polaroid technology provided immediate photographs before digital cameras were available, however there were financial costs involved for the user that are not there to the same degree as digital photography, which, she argues, gives no-cost disposability. Peter Buse (2008) provides further discussion of Polaroid technology and the immediate image. For an alternative perspective on the value of immediacy attached to digital photography see Kathleen Robbins's (2008) discussion of the benefits of using a film rather than digital camera *because of* the delay between exposure and viewing the transparency.

12. In 'The Work of Art in the Age of Mechanical Reproduction' Walter Benjamin (1936) argues that the traditional work of art is changed forever by mechanical reproduction and in particular its contemplative, revered quality—its *aura*—is lost. John Berger summarizes Benjamin's insight in the following passage, which might in a contemporary context be very aptly applied to digital photographic technologies: 'what the modern means of reproduction have done is to destroy the authority of art and to remove it . . . from any preserve. For the first time ever, images of art have become ephemeral, ubiquitous, insubstantial, available, valueless, free' ((1931) 1972: 32). Significantly, Benjamin is ambivalent about the value of an artwork's aura and furthermore, although in 'The Work of Art' essay he places photography and aura in opposition, in a later essay on a childhood photograph of Franz Kafka, Benjamin develops an alternative, less oppositional notion of photographic aura. For a detailed discussion of this see Carolin Duttlinger (2008).

13. Sontag argues that the defining association for people around the world of the 2003 Iraq invasion and subsequent conflict will be the photographs of the torture of Iraqi prisoners in Abu Ghraib. For further examination of the Abu Ghraib photographs and their implications see Butler (2005, 2009), Sjoberg (2007), Hagopian (2007) and van Dijk (2008). See also Edwards (2001) and Edwards and Hart (eds) (2004) for discussion of the relation between photographs (particularly ethnographic photographs), history and museums.

14. Douglas Niven and Christopher Riley, quoted in Hughes (2003: 29). The Archive Group sought to rescue the photographs whilst also training Cambodians in archive preservation. Hughes provides further discussion and analysis of this project, including how parts of the archive were removed for 'safe-keeping' and that Niven and Riley were framed as having *discovered* the photographs.

REFERENCES

Barthes, Roland. 1981. *Camera Lucida*. New York: Hill and Wang.

Baudry, Jean-Louis. 1974. 'Ideological Effects of the Basic Cinematographic Apparatus', trans. Alan Williams, *Film Quarterly*, 28: 39–47.

Benjamin, Walter. (1931) 1972. 'A Short History of Photography', *Screen*, 13/1: 5–26. Originally published in *The Literarische Welt*, 1931.

Benjamin, Walter. (1936) 1969. 'The Work of Art in the Age of Mechanical Reproduction', in *Illuminations*. New York: Schocken Books.

Berger, John. 1991. *About Looking*. New York: Pantheon.

Burgin, Victor, ed. 1982. *Thinking Photography*. London: Macmillan.

Buse, Peter. 2008. 'Surely Fades Away: Polaroid Photography and the Contradictions of Cultural Value', *Photographies*, 1/2: 221–38.

Butler, Judith. 2005. 'Photography, War, Outrage', *PMLA*, 120/3: 822–27.

Butler, Judith. 2009. *Frames of War: When Is Life Grievable?*. London: Verso.

Campany, D. 2003. 'Safety in Numbness: Some Remarks on the Problems of "Late Photography"', in D. Green (ed.), *Where Is the Photograph?* Maidstone and Brighton: photoworks/photoforum.

Comolli, Jean Louis. 1980. 'Machines of the Visible', in Teresa de Lauretis and Steven Heath (eds.), *The Cinematic Apparatus*. London: Macmillan, 121–42.

Deleuze, Gilles and Felix Guattari. 1988. *A Thousand Plateaus*, trans. B. Massumi. London: Athlone Press.

Doherty, Willie. 1988. 'Colouring the Black and White', *Circa Art Magazine*, 40: 26–31.

Duttlinger, Carolin. 2008. 'Imaginary Encounters: Walter Benjamin and the Aura of Photography', *Poetics Today*, 29/1: 79–101.

Edwards, Elizabeth. 2001. *Raw Histories: Photographs, Anthropology and Museums*. Oxford: Berg.

Edwards, Elizabeth and Janice Hart, eds. 2004. *Photographs Objects Histories: On the Materiality of Images*. London: Routledge.

Evans, Jessica, ed. 1997. *The Camerawork Essays: Context and Meaning in Photography*. London: Rivers Oram Press.

Feury, Kelli. 2008. *New Media: Culture and Image*. Basingstoke: Palgrave Macmillan.

Friday, Jonathan. 2002. *Aesthetics and Photography*. Burlington, VT: Ashgate.

Frosh, Paul. 2001. 'Inside the Image Factory: Stock Photography and Cultural Production', *Media, Culture & Society*, 23/5: 625–46.

Hagopian, Patrick. 2007. 'Abu Ghraib and the State of America: Defining Images', in Louise Purbrick, Jim Aulich and Graham Dawson (eds), *Contested Spaces: Cultural Representations and the Histories of Conflict*. Basingstoke: Palgrave Macmillan, xx.

Hall, Stuart, ed. 1997. *Representation: Cultural Representation and Signifying Practices*. London: Sage.

Hirsch, Marianne. 1997. *Family Frames: Photography, Narrative and Postmemory*. Cambridge, MA: Harvard University Press.

Holland, Patricia. 2001. 'Personal Photography and Popular Photography', in Liz Wells (ed.), *Photography: A Critical Introduction*. London: Routledge, 117–62.

Hughes, Rachel. 2003. 'The Abject Artefacts of Memory: Photographs from Cambodia's Genocide', *Media, Culture & Society*, 25/1: 23–44.

Jay, Martin. 1994. *Downcast Eyes: The Denigration of Vision in Twentieth-Century French Thought*. Berkeley: University of California Press.

Kuhn, Annette. 1995. *Family Secrets: Acts of Memory and Imagination*. London: Verso.

Larsen, Jonas. 2005. 'Families Seen Sightseeing: Performativity of Tourist Photography', *Space and Culture*, 8/4: 416–34.

Lash, Scott and Celia Lury. 2004. *Global Culture Industry: The Mediation of Things*. Cambridge, MA: Polity Press.

Lull, James. 2001. *Culture in the Communication Age*. London and New York: Routledge.

Machin, David. 2004. 'Building the World's Visual Language: The Increasing Global Importance of Media Banks in Corporate Media', *Visual Communication*, 3/3: 316–36.

Manovich, Lev. 2003. 'The Paradoxes of Digital Photography', in Liz Wells (ed.), *The Photography Reader*. Abingdon, Oxford and New York: Routledge, 240–49.

McLuhan, Marshall. 1967. *Understanding Media: The Extensions of Man*. London: Sphere Books.

Metz, Christian. 1982. *The Imaginary Signifier: Psychoanalysis and the Cinema*, trans. Celia Britton et al. Bloomington: Indiana University Press.

Mitchell, William J. 1992. *The Reconfigured Eye: Visual Truth in the Post-photographic Era*. Cambridge, MA: MIT Press.

Mulvey, Laura. 1975. 'Visual Pleasure and Narrative Cinema', *Screen,* 16/3: 6–18.

Murray, Susan. 2008. 'Digital Images, Photo-Sharing, and Our Shifting Notions of Everyday Aesthetics', *Journal of Visual Culture*, 7/2: 147–63.

Newbury, Darren. 2005. '"Lest We Forget": Photography and the Presentation of History at the Apartheid Museum, Gold Reef City, and the Hector Pieterson Museum, Soweto', *Visual Communication*, 4/3: 259–95.

Newbury, Darren. 2009. *Defiant Images: Photography and Apartheid South Africa*. Pretoria: University of South Africa (UNISA) Press.

Robbins, Kathleen. 2008. 'The Hostess Project', *Journal of Visual Culture*, 7/3: 335–48.

Rubinstein, Daniel and Katrina Sluis. 2008. 'A Life More Photographic: Mapping the Networked Image', *Photographies*, 1/1: 9–28.

Silverman, Kaja. 1996. *The Threshold of the Visible World*. New York and London: Routledge.

Sjoberg, Laura. 2007. 'Agency, Militarized Femininity and Enemy Others: Observations from the War in Iraq', *International Feminist Journal of Politics*, 9/1: 82–101.

Sobchack, Vivian. 1992. *The Address of the Eye: A Phenomenology of Film Experience*. Princeton, NJ: Princeton University Press.

Sobchack, Vivian. 2004. *Carnal Thoughts: Embodiment and Moving Image Culture*. Berkley: University of California Press.

Sontag, Susan. 1979. *On Photography*. Harmondsworth: Penguin.

Sontag, Susan. 2003. *Regarding the Pain of Others*. New York: Farrar, Straus & Giroux.

Sontag, Susan. 2004. 'Regarding the Torture of Others', *New York Times Magazine*, 23 May. http://www.nytimes.com/ref/membercenter/nytarchive.html.

Spence, Jo. 1986. *Putting Myself in the Picture: A Political, Personal and Photographic Autobiography,* edited by Frances Borzello. London: Camden Press.

Tagg, John. 1988. *The Burden of Representation: Essays on Photographies and Histories.* Basingstoke: Macmillan.

Van Dijk, José. 2008. 'Digital Photography: Communication, Identity, Memory', *Visual Communication*, 7/1: 57–76.

Young, Alison. 2005. *Judging the Image: Art, Value, Law*. London and New York: Routledge.

Television as a Global Visual Medium

KRISTYN GORTON

> Television is not just what appears on screen; it is a variety of invisible yet specific practices that occur in the air, in orbit and across lands.
>
> —*Lisa Parks (2005: 69)*

As Lisa Parks reminds us, television, as a global visual medium, is not 'just what appears on screen' but is also 'a variety of invisible yet specific practices that occur in the air, in orbit and across lands' (2005: 69). Television is able to traverse national boundaries, influence ideology and seep into the minds of its viewing public. Indeed, its ability to manipulate and reach across global parameters prompted fear and concern in early reception research. Now with the move towards digitalization some of these concerns are being repeated amidst new, emergent issues regarding convergence, content streaming, aesthetics, quality and branding. The following chapter explores television as a global medium while considering the role and function of television in contemporary society and culture by considering the emotional investment viewers make in what they watch.

We are in what has been referred to as 'TV 3', which covers the period post-1995. As Robin Nelson argues TV 3 'marks a new era hailing the triumph of digital-satellite capacity to distribute transnationally, bypassing national distribution and, in some instances, regulatory controls' (2007: 8; see also Creeber and Hills 2007). This leads to questions, rehearsed before, about how one culture is received and understood in another. It also raises concerns about how advanced capitalism affects viewing. As Nelson points out, '[i]n Western culture, the increasing affluence of consumer individualism has, for good or ill, promoted immediate over deferred gratifications and the pleasures of excess' (2007: 168–9). However, the move towards digitalization is not simply one to

do with content and consumer, it will also affect the institutional forces that dominate television. As John Caldwell argues: 'Televisual form in the age of digital simply cannot be accounted for without talking about the institutional forces that spur and manage those forms' (Caldwell 2004: 46).

Interpersonal forms of media, such as television, are integrated into people's daily lives. Many families in the Western world, for example have televisions in their kitchens and/or bedrooms, as well as in the main family room. This means that the television often becomes a backdrop, as well as a focal point, in people's everyday lives. As a social tool and as something with varied content, television is something people talk about, whether in groups, over the 'watercooler', or on online forums. Chat rooms dedicated to particular programmes now offer 'webisodes' or 'mobisodes' to further a viewer's interest in particular television programmes. The consequences of this are a further engagement with television and its various media outputs.

Although television is often part of people's everyday lives and rituals, this does not necessarily mean that viewers are consistently making meaning out of what they watch: there are times when viewers are passive, and times when they are active. In his conclusion to research carried out by the Glasgow Media Group, Greg Philo states that: 'it would be quite wrong to see audiences as simply absorbing all media messages, and certainly as being unable to distinguish between fact and fiction. But it is also wrong to see viewers and readers as effortlessly active, creating their own meanings in each encounter with the text' (1999: 287). For this reason, work on global television studies and ethnography continues to offer vital ways of studying audiences and the meanings they make.

Lisa Parks's work on satellites in *Cultures in Orbit: Satellites and the Televisual* (2005) for example illustrates not only the way exports are read in other cultures, but also how an American television programme such as *Dallas* is understood in the 'outback'. Focussing on the ways in which satellites are used and how this use tells us something about cultural practice allows Parks to comment both on the Indigenous culture she visits and the global presence it mediates. She argues that: 'Aboriginal Australians who own and operate Imparja TV use satellites not just to downlink, dub, and rerun American and British programs and flow structures; rather, they select shows and arrange them in ways that give shape and meaning to the Imparja footprint. [. . .] Imparja's flow can be conceived as hybrid in the sense that it represents a rewriting or reconfiguration of television programming made for audiences elsewhere' (2005: 63). Parks witnesses the way in which Indigenous Australians make meaning out of television exports instead of having meaning forced upon them. Her research leads her to suggest that we imagine 'flow' and 'footprint' 'not as fixed schedules and closed boundaries but as zones of situated knowledges and cultural incongruities that may compel struggles for cultural survival rather than simply suppress them' (2005: 62). In imagining more permeable and moveable boundaries, Parks's work supports the notion of an active audience and continues a line of research that interrogates the notion of cultural imperialism.

In thinking about the changes in the global television landscape, we must also consider how new technologies such as DVR recording devices (TiVo for instance) and an

increase in sales and availability of DVD box sets create new ways of viewing television. Handheld television devices also mean that television features more prominently in our lives than ever before. Indeed, we can argue that there are more irrational patterns in viewing where people watch television on their handheld recording devices than when they sit in front of the television in their homes (Morley: 2006). Increasing convergence within media texts—between Internet, television and film—has meant that we must think about how we watch differently. Virginia Nightingale (2007) argues that television is becoming more like the Internet and the Internet is becoming more like television. Nelson points out that some people are already reading their emails through their television and argues that 'increasingly the ubiquitous domestic small screens, through sharing digital technology, will become one' (2007: 12). The move towards digitalization in the UK, for instance will also greatly impact what we watch and how we watch it and will, as some argue, radically alter our relationship to television. But do these new viewing practices, which are more personalized and anchored around life-style, 'mean that television is *less* central or *more* central to our ways of life?' (Taylor and Wood 2008:146). Lisa Taylor and Helen Wood pose this interesting question in their work on television audiences and argue that we may never find the answers 'if prevailing discourses of new media force us to ask entirely different questions' (2008: 146). In other words, if we lose sight of the intimate relationship viewers have with television in favour of seeing television as simply part of media convergence, then we will also overlook important questions and research that aims to interrogate the specificities of television and its audience.

In *Ambient Television: Visual Culture and Public Space* (2001), for instance Anna McCarthy considers '[w]hat the TV set *does* outside the home—what social acts it performs, or is roped into, what struggles it embodies and intervenes in, what agencies speak through it, and which subjects it silences or alternatively give a voice' (2001: 1, author's italics). In so doing, she poses very provocative questions about the presence of television in the public domain. For instance, she asks: 'How much is the experience of waiting built into the format of TV programming and images in general—waiting for an upcoming program, a better music video, the resumption of a narrative interrupted by commercials? In other words, is waiting a "deep structure" of television spectatorship regardless of where we watch TV?' (2001: 218–9). McCarthy's questions are important insofar as they remind us how often television is used by its viewers to pass time. Whether we are waiting in a doctor's office or for dinner to be ready, television is often available to deal with feelings of boredom or restlessness. These engagements are very seldom emotional and very often forgettable. Indeed, a good deal of the time spent in front of the television can be understood as meaningless.

And yet, as McCarthy points out, televisions are often situated in eating places to make people feel better about eating alone or to relieve their anxieties of wasting time. She refers to a place in Manhattan called 'The Video Diner', which has individualized booths where you can watch TV and eat—and contrasts this with sports bars and news bars. She reminds us that we need to think about the 'material conventions of the screen as an object' (2001: 222); in other words, we need to think about how the physical

position of the screen affects the spectator's experience of watching TV. Perhaps we can take this a step further to suggest that it is necessary to think about the viewer's orientation to the screen in order to make sense of her engagement with what she watches. The viewer in the Video diner will have a very different commitment to a TV programme than the person in a sports bar, as will the person who sits down to watch a particular programme versus the one who tunes in while she waits. McCarthy's research is indicative of new, more self-conscious and self-reflexive research within television studies, which has generated significant questions about the television audience, the role of television in the global public sphere and the way people engage with what they watch.

The following section explores the place of television in the global sphere and discusses emergent theoretical ideas regarding the cultural influence television has on its audience. In so doing, it will raise issues regarding new models of television flow. I will also examine the emotional attachment viewers have with television: both in terms of the global brands that dominate our screens and the individual meanings we make.

THE 'AMERICANIZATION' OF GLOBAL TELEVISION

In their influential collection titled *Peripheral Vision: New Patterns of Global Television* (1996), editors John Sinclair, Elizabeth Jacka and Stuart Cunningham argued that a 'sea- change' in television systems started in the late 1970s (1996: 1). These changes were part of broader movements happening in the Western world including: 'globalisation, trade liberalization, increased national and international competition and a decrease in the centrality of the state as a provider of goods and services' (1996: 1). New changes in technology, specifically the satellite also meant more channels and choice in television programming. As Sinclair, Jacka and Cunningham suggest the 'satellite has acted as a kind of "Trojan-horse" of media liberalization' (1996: 2). Until the late 1970s, North America, Latin American and Australia were the only three regions to have a mixed system of broadcasting, which is a combination of public and private programming (Sinclair et al. 1996: 2). The change from public to private broadcasting systems meant that there was a heavy dependence on American imports (hence the popularity and worldwide distribution of *Dallas*). But it also led to more cross-cultural swaps—so the Latin American telenovellas (like soap operas) became popular in southern Europe (1996: 3). Sinclair, Jacka and Cunningham advance the idea of 'geolinguistic regions', which they describe as the 'broad proposition that export markets will develop amongst countries which share a similar language and culture' (1996: 26). Instead of thinking about the way television flows from one country to another, 'geolinguistic regions' encourages us to think about the way television is distributed to similar speaking cultures—such as the flow of the telenovella form from South America to Spain.

In general terms, media imperialism involves thinking that the major world source for media outputs can be found primarily in the USA and secondarily in Europe, specifically the UK, and that these centres act as hubs through which all cultural products must flow (Sinclair et al. 1996: 6). In his assessment of 'media imperialism' in the early 1980s, Fred Fejes argued that: 'A third concern that the media imperialism approach

must address if it is to progress is the issue of culture' (1981: 287). As Fejes pointed out, it is necessary for researchers of media imperialism to think about the ways it affects culture. The related term, 'cultural imperialism', therefore refers to the ways in which culture (language, modes of address, life-style, etc) is affected by media texts. In his influential *Mass Communications and American Empire* (1969), Herbert Schiller argued that 'The structure, character and direction of the domestic communications apparatus are no longer, if they ever were, entirely national concerns. This powerful mechanism now directly impinges on peoples' lives everywhere. It is essential therefore, that there should be at least some familiarity with what the American communications system is like, how it has evolved, what motivates it and where it is pointing' (1969: 17). Schiller's work was among the first to look directly at the domestic and international mass communications structure and policy in the USA and consider its global influence and the influence of his work continues to dominate. Sinclair, Jacka and Cunningham refer to Schiller's work as the 'locus classicus of the cultural imperialism thesis' (1996: 6) and Jonathan Bignell and Elke Weissmann suggest, 'most work takes Schiller as its starting point' (2008: 93). Indeed, recent work on global television suggests 'there are signs of a critical reassessment of "globalisation" in favour of a more "retro" theoretical position that uses the imperialist perspective with some new insights' (Corcoran 2007: 3).

As suggested earlier, the idea that American cultural products dominated other cultures started to prove one-sided. Theoretical perspectives such as postmodernism and postcolonialism and research into 'active' audiences led TV theorists to reconsider this 'one-way street' model. What they found was that although there were a lot of US imports there were also local programmes that commanded large audiences. The assumption that the Western model would be more powerful overlooked alternative models that were in many cases preferred. Indeed, media studies more generally now takes into account the way in which 'culture and symbolic representations now flow readily between countries via media, travellers and migrants, and is increasingly taken up into people's senses of self' (Washbourne 2010: 26).

In *The Making of Exile Cultures: Iranian Television in Los Angeles* (1993), for instance Hamid Naficy relates a moving anecdote about his daughter, Shayda, and his niece, Setareh, who met each other in Los Angeles and bonded over *The Little Mermaid*. Although Setareh spoke only German and Persian and Shayda could only speak English, they communicated through the songs of the popular Disney film. This experience leads him to argue that

> [t]he globalisation of American pop culture does not automatically translate into globalisation of American control. This globalised culture provides a shared discursive space where transnationals such as Setareh and Shayda can localise it, make their own uses of it, domesticate and indigenize it. They may think with American cultural products but they do not think American. (Naficy 1993: 2)

Naficy's point is important insofar as it challenges the suggestion that American products will turn their consumers into Americans. His work also continues the idea

that viewers and consumers communicate through products, they are not dominated by them. His experience provides us with an emotional account of how film and television provides a platform through which people can communicate. The songs allowed Seterah and Shayda to feel a sense of connection, despite the differences in their background and language.

NEW DIRECTIONS IN GLOBAL TELEVISION FLOW

Earlier conceptions of Americanization have greatly changed and as Arjun Appadurai argues, for 'the people of Irian Jaya, Indonesianization may be more worrisome than Americanization, as Japanization may be for Koreans' and so on, arguing that '[T]he new global cultural economy has to be seen as a complex, overlapping, disjunctive order that cannot any longer be understood in terms of existing center-periphery models' (2003: 40). Extending Benedict Anderson's notion of 'imagined communities', Appadurai advances terms such as 'ethnoscapes' and 'mediascapes' as a means of framing the conditions involved in the current global cultural economy. These terms are more helpful in thinking about television flow and the landscape it covers.

Several theorists on global television have returned to the concept of 'flow', first discussed by Raymond Williams, in order to understand how content and technology interact across global parameters. Williams's work on television is often remembered through the term 'flow', which he used to describe the television watching experience. However, as Lynn Spigel (2009) points out in her introduction to the 1992 publication of *Television: Technology and Cultural Form* (originally published 1974), Williams's analysis of 'flow' is just one chapter in a 'throughgoing critique of the relationships among television's technological invention, its innovation as a media institution and textual form, and its connection to social relationships and experience in modern Western culture' ((1974) 1992: x). Indeed, Williams's work on television, as Spigel suggests, which includes his selected writings on television (1989) and his columns in *The Listener*, comprise a significant contribution to the study of television and its audiences. In his chapter on 'Programming: Distribution and Flow', Williams describes the 'interruptions' inherent to the television-watching experience, but also notes the 'flow' that happens when programmes and advertisements begin to merge together on television. Williams saw this 'flow' as something distinct to American television and recounts the following experience of watching television in Miami, after arriving on an Atlantic liner: 'A crime in San Francisco (the subject of the original film) began to operate in an extraordinary counterpoint not only with the deodorant and cereal commercials but with a romance in Paris and the eruption of a prehistoric monster who laid waste New York' (Williams (1974) 1992: 85–6). Here Williams refers to the way in which television programmes and advertisements 'flow' together even though there are breaks in the programming schedule which, for Williams, results in 'a single irresponsible flow of images and feelings' ((1974) 1992: 86). In other words, because the programmes and advertisements share similar styles and content, the entire experience produces a 'flow' of feelings that are not always linked to any one programme or advertisement in particular.

Although television flow has changed since Williams wrote with the advent of DVRs and DVD box sets (see Kompare 2006), Albert Moran argues that the term itself continues to be a useful way to think about global television in that it joins 'the notion of transportation with that of communication' (2009: 13). In other words, it 'unites carriage and content' (2009: 12). The notion of flow reminds us that the two, 'carriage' and 'content', should be thought of together, rather than imagining global television as *either* about the physical way in which it flows *or* the message itself.

In his work on the 'global television marketplace', Timothy Havens points towards the 'disagreements about the forces that determine global television flows' (2006: 3). He suggests that the 'debate pits political economists, who argue that structural features of global television determine the kinds of programming that travel internationally and the places where they travel (i.e., Herman and McChesney 1997), against cultural scholars, who suggest that cultural homologies among exporting and importing nations determine such flows (i.e., Tracey and Redal 1995)' (Havens 2006: 3). Havens argues that 'local executives act as intermediaries between viewers and exporters, deciding which programmes to purchase and how to schedule them based upon their own understandings of the culture' (2006: 3). 'Thus, if a nation has the financial resources, it will produce its own programming; if not, it will seek imports from the most culturally similar nations it can find' (2006: 4). In their work on global television, Denise D. Bielby and C. Lee Harrington, like Havens, point towards the importance of television executives in terms of our understanding of cross-national television flow. They discuss the importance of NAPTE (National Association of Television Program Executives) in determining what is bought and sold in television (2008). Havens's and Bielby and Harrington's work illustrates the power television executives have in determining what we watch and what programmes are commissioned or cancelled.

Other theorists, such as Edward S. Herman and Robert McChesney, argue that 'Deregulation and new technologies not only stimulated global media expansion, they also provided the basis for a striking new wave of corporate consolidation in the media industry [. . .] Most important, the late 1980s gave birth to the development of a truly global media market, where the dominant firms were increasingly transnational firms' (2003: 36). Herman and McChesney's argument concerning the role TNCs (transnational corporations) play in the development of the current global cultural economy is crucial, especially in contemporary discussions of branding and streaming.

Unlike previous models of global television, which focus on the ways in which nations affect the cultural output on television through regulations and policy, Michael Curtin's work suggests that textual elements carry a significant weight when it comes to why people watch certain programmes. Instead of thinking about national borders in terms of the organization of meanings and identities, Curtin suggests rethinking the idea of nationality to consider instead the ways in which 'media capitals' affect flow. Curtin defines 'media capitals' as a 'nexus or switching point, rather than a container' they are 'particular cities that have become centres for the finance, production and distribution of television programs; cities like Bombay, Cairo and Hong Kong' (2003: 203). Instead of thinking about the ways in which nations effect content (through

regulatory constraints), Curtin's research suggests that particular cities across the globe are responsible for the production and distribution of television content. He argues that 'neo-network' television firms now focus their attention on marketing and promotion, which marks a change from the network era where the control of a handful of national channels was the 'key to profitability' (2003: 212). According to Curtin, this means that certain series, such as *Star Trek* or production companies, such as Disney animation be-come dominant global brands: '[g]iven a greater range of choices, audiences are drawn to products by textual elements—characters, storylines, special effects—rather than by the technological and regulatory constraints formerly imposed on the delivery system' (Curtin 2003: 212).

As Simone Murray points out in her work on 'brand loyalties', the 'commercial infra-structure for orchestrating content re-use emerges from the late 20th-century de-regulation of Western media markets, and the concentration of media properties of all kinds in the hands of a select group of multinational media conglomerates' (2005: 418). In other words, the opening up of the global marketplace in terms of television distribution has meant a consolidation in who controls content distribution. Murray argues that this has meant that media audiences are increasingly 'content-led' rather than 'technology-led', which has meant that the 'contemporary corporate ideal' is to move from a 'household brand' to a 'house *of* brands' (2005: 422, author's italics). As Murray explains:

> What exactly constitutes the brand in media enterprises is frequently moot. Increas-ingly, there is a move away from emphasising the globalised media conglomerate as the dominant brand (e.g. Time Warner) in favour of focusing on subsidiary enterprises as their own brands (e.g. Warner Bros, HBO, DC Comics), or even specific media prop-erties or characters as the brand kernel (e.g. *Time, Sex and the City* or *Harry Potter*). (2005: 422)

As Murray suggests, media enterprises are increasingly using their 'house of brands' to generate their consumer base rather than emphasize their corporate monopoly. Murray argues that '[i]n order for consumers to participate enthusiastically in the market for streamed content, producers must infuse goods with highly specific attitudinal and de-mographic characteristics sufficient to encourage in consumers an emotional investment in the corporate brand' (2003: 13–14). Murray's work points towards the importance of emotion in terms of understanding global audiences. The final section will address this 'emotional investment' and its connection to recent work on convergence.

EMOTIONAL ENGAGEMENTS

'We are in a crisis of belonging, a population crisis, of who, what, when, and where. More and more people feel as though they *do not* belong. More and more people are *seeking* to belong, and more and more people are not *counted* as belonging,' so begins Toby Miller's book titled *Cultural Citizenship: Cosmopolitanism, Consumerism and Tele-vision in a Neoliberal Age* (2007: 1, author's italics). Miller's pronouncement regarding

the state of the world and its citizens urges us to think more radically about the ways in which belonging becomes a very important issue in contemporary society. I would argue that part of this desire to belong can not only be found expressed through fictional and factual storylines on television but also in the way people get emotionally involved with what they watch.

In *Selling Television: British Television in the Global Marketplace*, for example Jeanette Steemers argues that 'the "public" is thus experienced in the private (or domestic) realm: it is "domesticated". But at the same time the "private" itself is thus transformed or "socialized". The space (and experience) created is neither "public" nor private in the traditional senses' (2004: 295–6).

In his work on 'convergence culture', Henry Jenkins defines convergence as 'the flow of content across multiple media platforms, the cooperation between multiple media industries, and the migratory behaviour of media audiences who will go almost anywhere in search of the kinds of entertainment experiences they want' (2006: 2). In other words, Jenkins is not just thinking about the technological development of media forms and the ways in which they affect each other—he is also thinking about the ways in which technological developments affect culture and affect people's use of media in their everyday lives. Convergence in Jenkins's work is not just about television being like the Internet and the Internet like television, but also the way in which people will seek information and new ways of connection through various media platforms (2006: 3).

Jenkins's interpretation of convergence leads him to come up with the term, 'affective economics'. He argues that 'according to the logic of "affective economics," the ideal consumer is active, emotionally engaged, and socially networked' (2006: 20). His conception of 'affective economics' effectively bridges concerns regarding 'carriage' and 'content'. One example of the kind of convergence and 'affective economics' that Jenkins refers to can be found on the Web sites of television programmes such as *Lost* and *24*. On these Web sites users can download 'mobisodes' at a cost to see some extra scenes not aired on television. Users can also play themed games and be sent on a 'Jack Bauer'–esque mission through their mobile phones. Here technologies converge: television, the Internet and mobiles work together to provide a service to their user. But, as Jenkins suggests, this is also about 'affective economics' as the Web sites rely on the fact that their viewers will be emotionally involved enough in the series to want to pay to find out more about the show or to experience simulated stories related to the programmes they enjoy.

Recent sociological literature on the concept of individualism, including primarily the work of Anthony Giddens (1990, 1991), Ulrich Beck and Elisabeth Beck-Gernsheim (2001) and Zygmunt Bauman (2001), illustrates the demand on the individual to be self-reflexive and to self-monitor and yet, to be aware of the risks posed by modern society. This culture of individualism has given way to what Elliott and Lemert refer to as "privatised worlds". In *The New Individualism: The Emotional Costs of Globalization* (2006) Elliott and Lemert chart a shift from a politicized culture to a privatized culture. Drawing on work by Beck, amongst others, they consider the impact of 'reflexive individualism' and the way in which it places emphasis on 'choosing, changing and

transforming' (Elliott and Lemert 2006: 97). The shift that Elliott and Lemert identify has also been the subject of work by Lauren Berlant, who argues that we increasingly live in 'an intimate public sphere'. According to Berlant the shift from a political public sphere to an intimate public sphere has led to a national politics that does not figure the nation in terms of the racial, economic and sexual inequalities that separate and divide the public; instead 'the dominant idea marketed by patriotic traditionalists is of a core nation whose survival depends on personal acts and identities performed in the intimate domains of the quotidian' (1997: 4). And what better place to perform these acts and identities than on television? Indeed, more recently, Berlant examines the way in which intimacy has increasingly been moved into the public domain and negotiated on our television screens. She argues, for instance that 'in the U.S. therapy saturates the scene of intimacy, from psychoanalysis and twelve-step groups to girl talk, talk shows, and other witnessing genres' (Berlant 2000: 1).

We can see the influence of the rise of individualization on television, particularly in the popularity of 'reality' and life-style television. Rachel Moseley has identified the 'makeover takeover' that has affected British television and argues that 'British makeover shows exploit television's potential for intimacy, familiarity, ordinariness and the radical destabilisation of the division between public and private' (2000: 313). In *Reality TV*, Anita Biressi and Heather Nunn refer to the 'revelation' side of reality programmes (2004)—which underlines the way in which programmes pivot around the final 'ta dah' moment, and as Biressi and Nunn argue, can be seen as part of the key to the success of the reality genre (2004: 3). Indeed, Charlotte Brunsdon charts a shift from a narrative of transformation around skill acquisition to one that emphasizes the 'reveal'. As she writes: 'While contemporary lifestyle programs retain a didactic element, it is narratively subordinated to an instantaneous display of transformation' (2004: 80). Beverley Skeggs (2004), Helen Wood (2004) and Charlotte Brunsdon (2004) have all discussed the way in which life-style and reality television 'life-style Britain'. As Wood and Skeggs argue: 'choice mediates taste, displaying the success and failure of the self to make itself' (2004: 206).

Reality programmes underline an individual's ability to self-regulate, make choices, compete, monitor his or her performance and transform: examples include *Big Brother*'s 'diary room' (Endemol 1999–); 'healthy competition' in *Survivor* (CBS, 2000–; ITV, 2001–), *Strictly Come Dancing* (BBC1, 2004–), *The Biggest Loser* (NBC, 2004–), and transformation in *10 Years Younger* (Channel 4, 2004–), *The Swan* (Fox, 2004–2005), *Extreme Makeover* (ABC, 2002–2007), *What Not to Wear* (BBC2, 2001–2004; BBC1 2004–). These programmes illustrate the emphasis placed on 'choosing, changing and transforming' that Elliott and Lemert identify as part of a self-reflexive individualist society. As they argue: 'The main legacy of this cultural trend is that individuals are increasingly expected to produce context for themselves. The designing of a life, of a self-project, is deeply rooted as both social norm and cultural obligation' (Elliott and Lemert 2006: 13). As Elliott and Lemert suggest, individual choice and self-transformation have become a cultural imperative and this demand is evident in the format and content of reality and life-style television.

The shift to a more individualized society and emphasis on 'choice' impacts not just *what* we watch but *how* we watch it. In terms of programming, the emphasis on consumerism is evident in the television 'tie-ins' and Web sites that cater to an individual interaction with the programme and its characters. Recording devices such as TiVo mean that viewers can choose what they watch and when they want to watch it. Interactive devices (such as the 'red button') put the viewer in control of what they watch. In *Remediation: Understanding New Media* (2001), Jay David Bolter and Richard Grusin argue that '[e]ven when television acknowledges itself as a medium, it is committed to the pursuit of the immediate to a degree that film and earlier technologies are not. Because of the structure of financing, television is even more immediately responsive than film to what advertisers and producers perceive as cultural demands. It is as if television programs need to win the moment-by-moment approval of their large, popular audiences, to evoke a set of rapid and predictable emotional responses: television must pursue immediacy as authentic emotion, as exemplified most plainly in the "heartwarming" drama' (2001: 187).

This sense of choice, control, interactivity and emotional engagement has led some scholars to think that fans/viewers have more power over what they watch than ever before. In his research on audiences and TV 3, for instance Derek Johnson cites examples in which fans or avid watchers of series are invited by the producers to write episodes, both in an effort to involve the audience but also within a strategy to acquire 'free labour' (2007: 6). However, Johnson is wary of the true welcome producers give these fan writers and argues that 'production institutions simultaneously work to manage fan proximities and bring them under industrial control' (2007: 9). In 'inviting' fans and avid watchers in, producers both benefit from the 'free labour' of their knowledge and maintain control over their participation. So while fans are more involved than before, they are also under more control.

Although most viewers have learned through their television-watching experience to be critical of what they watch, they may also find themselves emotionally involved with the characters or participants. This establishes an uneasy relationship for the viewers between their emotional reactions and their critical judgements. They might believe reality programmes to be rubbish but find themselves tuning in each night and getting emotionally involved.

Indeed, there are many viewers who take pleasure in reality and life-style programmes even when they are conscious of their constructed and ideologically questionable nature. My students, for instance often tell me that although they know many reality programmes, such as *Big Brother* or *American Idol* (Fremantle Media, 2002—), are heavily edited, they take pleasure in watching them and even find themselves crying during the back-stories. This is not to say that all viewers respond to this kind of double-thinking, but to underline that even those aware of the constructed nature of these programmes still enjoy their viewing experience: their critical knowledge does not always mediate against their viewing pleasures.

A paradox emerges here and runs throughout reality and life-style programming. One the one hand we, as viewers, are drawn into the emotional situations the characters find themselves in, and yet, on the other hand, we are also encouraged to speculate, judge and attend to the choices and decisions the families have made and continue to make. In her

work on *Wife Swap*, for instance Helen Piper suggests that 'there is clearly an affective invitation [in *Wife Swap*] to identify with the women's feelings and responses, but there is also an invitation to judge according to subjective concepts of "normal" (and by implication abnormal) domestic arrangements' (2004: 276). This dual-response of empathizing and judging confuses easy lines of identification with the participants. As Piper points out: 'you might share Ann's distaste of Diane's family's reliance on deep-fried food, for example, but does that oblige you to identify with her other lower-middle-class pretensions?' (2004: 279). However, instead of understanding the relationship between viewer and participant as Piper outlines, we can instead suggest that this confusion of empathy and judgement means that the viewer is selecting and choosing what aspects of both wives she or he feels are acceptable, and perhaps, that the viewer is actively participating in the act of 'choosing, changing and transforming'.

Berlant refers to the 'paradox of partial legibility' in her work on public intimacy and suggests that 'the experience of social hierarchy is intensely individuating, yet it also makes people public and generic: it turns them into *kinds* of people who are both attached to and under described by the identities that organise them' (1997: 1). *Wife Swap* is about differing wifely roles—what *kind* of wife a wife can be. The focus on the *kind* of wife rather than who the wife herself is means that we, as viewers, only partially attach ourselves to these people; the lack of description allows us to enter in our own judgements and choices.[1]

CONCLUSION

As this chapter has illustrated, research into television as a global visual medium yields debates around 'carriage' and 'content' and the interface between the two. As John T. Caldwell suggests: 'Studying television's "production of culture" is simply no longer entirely convincing if one does not also talk about television's "culture of production"' (2004: 45). It is crucial to consider both the way culture is constructed through the flow of television but we must also examine the culture around television production globally to truly understand why we watch what we do on television. Earlier models of global television produced a one-sided flow that did not take into account the popularity of local/national television programming. New areas for research within television studies regarding the transnational flow of programmes have greatly changed our conception of how television is made and received in one culture and understood in another. Indeed, a growing area of interest is around the adaptation and remakes of television series between countries such as the USA and the UK (see Steemers 2004; Rixon 2006).

Television as a global visual medium is not simply about who buys, sells or watches, but the flow between them. Increasingly, this flow is a highly privatized and consumer-based model based on content streaming and branding. Transnational corporations construct what Murray refers to as a 'house of brands' which capture audiences and keep them coming back for more. Global marketplaces such as Amazon capitalize on this relationship by sending emails to consumers suggesting further series viewers might like if they enjoyed 'x'. Emotion, as a concept, is becoming a key way to understand the global television marketplace because of the emphasis on viewers' attachments to

their favourite characters and series. This attachment has also led to changes in viewing practices: more and more people are 'bingeing' on television through DVD box sets or watching on DVRs to avoid commercial interruptions, which, as discussed, alters Williams's earlier conception of television flow.

These changes will affect not just what we watch but also how we study television as an academic discipline. James Bennett argues that the move towards digitalization will affect television studies and suggests that the field should pay close attention to 'both the interfaces and applications that structure our access to "television" content and manage user flows, as well as the discourses and aesthetics of such content/programming itself' (2008: 161). These two concerns, 'content streaming'[2] and aesthetics, are quickly becoming key issues within the field of television studies and illustrate new issues within the study of global television. Max Dawson, for instance argues that we must consider how television programmes adopt new aesthetics to fit the smaller screen (2007). As handheld devices become more accessible, new television programmes emerge that are more suited to the small screen. Likewise, it could also be argued that HD will affect television format and even narrative as aesthetics take precedence over story. Television as a global visual medium is changing rapidly as are the viewing practices of its audience. Indeed, it is difficult to say whether the medium will still exist as a box set in our living rooms. However, our emotional attachments to what we watch continue to engage us and keep us glued to the screen—and continue to allow TNC's to monopolize the global flow.

Television's future often comes under question with the advent of new media technologies. However, regardless of where it is watched (whether on the Internet, on the box set or on a handheld device), television remains an overwhelmingly accessible and powerful visual medium. The liveness and immediacy of the images it can transport into the intimacy of our domestic spaces means that it is still a visual medium that people tune into daily and rely on to keep them 'in touch' with the world. These images have a profound effect on our life-styles and choices; our decisions regarding the kind of person we imagine ourselves to be. Indeed, television not only provides information but also continues to be a visual medium that emotionally engages its viewers. The majority of people in the Western world experience global events through the television—it is a medium that unites us. And yet, it is continually degraded and viewed as inferior to other visual mediums. As a discipline, television studies has inherited this dismissal and is often considered less serious than film or theatre studies. Television's relationship to mass audiences means that it is rarely thought of as 'high art' or worthy of serious critical attention. And yet, this connection to the masses is one of the many reasons television demands our attention and understanding as a global visual medium.

FURTHER READING

Havens, Timothy. 2006. *Global Television Marketplace*. London: British Film Institute.
Jenkins, Henry. 2006. *Convergence Culture: Where Old and New Media Collide*. New York and London: New York University Press.
Moran, Albert. 2009. *New Flows in Global TV*. Bristol: Intellect.

Murray, Simone. 2005. 'Brand Loyalties: Rethinking Content in Global Corporate Media', *Media, Culture and Society*, 27/3: 415–35.

Parks, Lisa and Shanti Kumar, eds. 2003. *Planet TV: A Global Television Reader*. New York: New York University Press.

NOTES

This chapter includes condensed and revised material from my book *Media Audiences: Television, Meaning and Emotion* (Edinburgh: Edinburgh University Press, 2009).

1. For more on this see Gorton (2008).
2. Simone Murray notes that there is a lack of 'terminological consensus amongst media academics' (2005: 419) around streaming. She argues that the 'specific value of the term "content streaming" inheres in its ability to connote a broader, quintessentially 21st-century conceptualisation of content as innately liquid and multipurposable, one applicable across varied strategy, production and consumption contexts' (419).

REFERENCES

Appadurai, Arjun. 2003. 'Disjuncture and Difference in the Global Cultural Economy', in Lisa Parks and Shanit Kumar (eds), *Planet TV: A Global Television Reader*. New York: New York University Press, 40–52.

Bauman, Zygmunt. 2001. *The Individualized Society*. Cambridge: Polity Press.

Beck, Ulrich and Beck-Gernsheim, Elisabeth. 2001. *Individualization: Institutionalized Individualism and its Social and Political Consequences*. London: Sage.

Bennett, James. 2008. 'Television Studies Goes Digital', *Cinema Journal*, 47/3: 158–65.

Berlant, Lauren. 1997. *The Queen of America Goes to Washington City: Essays on Sex and Citizenship*. Durham, NC: Duke University Press.

Berlant, Lauren. 2000. *Intimacy*. Chicago: University of Chicago Press.

Bielby, Denise D. and C. Lee Harrington. 2008. *Global TV: Exporting Television and Culture in the World Market*. New York and London: New York University Press.

Bignell, Jonathan and Elke Weissmann. 2008. 'Cultural Difference? Not So Different after All', *Critical Studies in Television*, 3/1 (Spring): 93–8.

Biressi, Anita and H. Nunn. 2004. *Reality TV: Realism and Revelation*. London: Wallflower Press.

Bolter, Jay David and Richard Grusin. 2001. *Remediation: Understanding New Media*. Cambridge, MA: MIT Press.

Brunsdon, Charlotte. 2004. 'Lifestyling Britain: The 8–9 Slot on British Television', in Lynn Spigel and Jan Olsson (eds.), *Television after TV: Essays on a Medium in Transition*, Durham, NC: Duke University Press, 75–92. (This article originally appeared in (2003) *International Journal of Cultural Studies* 6/1: 5–23.)

Caldwell, John. 2004. 'Convergence Television: Aggregating Form and Repurposing Content in the Culture of Conglomeration', in Lynn Spigel and Jan Olsson (eds), *Television after TV: Essays on a Medium in Transition*. Durham, NC and London: Duke University Press, 41–74.

Corcoran, Farrel. 2007. 'Television Across the World: Interrogating the Globalisation Paradigm', *New Review of Film and Television Studies*, 5/1: 81–96.

Creeber, Glenn and Matt Hills. 2007. 'TVIII: Into, or Towards, a New Television Age?', *New Review of Film and Television Studies* 5(1): 1–4.

Curtin, Michael. 2003. 'Media Capital: Towards the Study of Spatial Flows', *International Journal of Cultural Studies*, 6/2: 202–28.

Dawson, Max. 2007. 'Little Players, Big Shows: Format, Narration and Style on Television's New Smaller Screens', *Convergence*, 13/3: 231–50.

Elliott, Anthony and C. Lemert. 2006. *The New Individualism: The Emotional Costs of Globalisation*. London: Routledge.

Fejes, Fred. 1981. 'Media Imperialism: An Assessment', *Media, Culture & Society*, 3: 281–9.

Giddens, Anthony. 1990. *The Consequences of Modernity*. Cambridge: Polity Press.

Giddens, Anthony. 1991. *Modernity and Self-Identity*. Cambridge: Polity Press.

Gorton, Kristyn. 2008. ' "There's No Place Like Home": Emotional Exposure, Excess and Empathy on TV', *Critical Studies in Television*, 3/1: 3–15.

Gorton, Kristyn. 2009. *Media Audiences: Television, Meaning and Emotion*. Edinburgh: Edinburgh University Press.

Havens, Timothy. 2006. *Global Television Marketplace*. London: BFI.

Herman, Edward S. and Robert W. McChesney. 1997. *The Global Media: The New Missionaries of Corporate Capitalism*. London: Cassell.

Herman, Edward S. and Robert McChesney. 2003. 'The Rise of the Global Media', in Lisa Parks and Shanti Kumar (eds), *Planet TV: A Global Television Reader*. New York: New York University Press, 21–39.

Jenkins, Henry. 2006. *Convergence Culture: Where Old and New Media Collide*. New York and London: New York University Press.

Johnson, Derek. 2007. 'Inviting Audiences In: The Spatial Reorganisation of Production and Consumption in TVIII', *New Review of Film and Television Studies*, 5/1: 61–80.

Kompare, Derek. 2006. 'Publishing Flow: DVD Box Sets and the Reconception of Television', *Television and New Media*, 7/4: 335–60.

McCarthy, Anna. 2001. *Ambient Television: Visual Culture and Public Space*. Durham, NC: Duke University Press.

Miller, Toby. 2007 *Cultural Citizenship: Cosmopolitanism, Consumerism and Television in a Neoliberal Age*. Philadelphia: Temple University Press.

Moran, Albert. 2009. *New Flows in Global TV*. Bristol: Intellect.

Morley, David. 2006. Personal conversation with the author.

Moseley, Rachel. 2000. 'Makeover Takeover on British Television', *Screen,* 41/3: 299–314.

Murray, Simone. 2003. 'Media Convergence's Third Wave: Content Streaming', *Convergence*, 9/8: 8–18.

Murray, Simone. 2005. 'Brand Loyalties: Rethinking Content within Global Corporate Media', *Media, Culture & Society*, 27/3: 415–35.

Naficy, Hamid. 1993. *The Making of Exile Cultures: Iranian Television in Los Angeles*. Minneapolis: University of Minnesota Press.

Nelson, Robin. 2007. *State of Play: Contemporary 'High End' TV Drama*. Manchester: University of Manchester Press.

Nightingale, Virginia. 2007. 'Lost in Space: Television's Missing Publics', SCMS Conference, Chicago.

Parks, Lisa. 2005. *Cultures in Orbit: Satellites and the Televisual*. Durham, NC: Duke University Press.

Philo, Gregg. 1999. *Message Received*. London: Longman.

Piper, Helen. 2004. 'Reality TV, Wife Swap and the Drama of Banality', *Screen*, 45/4: 273–86.

Rixon, Paul. 2006. *American Television on British Screens: A Story of Cultural Interaction*. Houndsmills: Palgrave Macmillan.

Schiller, Herbert. 1969. *Mass Communications and American Empire*. Boulder, CO: Westview Press.

Sinclair, J., E. Jacka and S. Cunningham. 1996. *Peripheral Vision: New Patterns in Global Television*. Oxford: Oxford University Press.

Skeggs, Beverley. 2004. *Class, Self, Culture*. London: Routledge.

Spigel, Lynn. 2009. *TV By Design: Modern Art and the Rise of Network TV*. Chicago: University of Chicago Press.

Steemers, Jeanette. 2004. *Selling Television: British Television in the Global Marketplace*. London: BFI.

Taylor, Lisa and Helen Wood. 2008. 'Feeling Sentimental about Television Audiences', *Cinema Journal*, 47/3: 144–51.

Tracey, M and W.W. Redal. 1995. 'The New Parochialism: the Triumph of the Populist in the Flow of International Television', *Canadian Journal of Communication*, 20(3), 343–65.

Washbourne, Neil. 2010. *Mediating Politics: Newspapers, Radio, Television and the Internet*. Maidenhead: Open University Press.

Williams, Raymond. (1974) 1992. *Television: Technology and Cultural Form*. London: Fontana.

Williams, Raymond. 1989. *Raymond Williams on Television: Selected Writings*, ed. Alan O'Connor. London and New York: Routledge.

Wood, Helen. 2004. 'What *Reading the Romance did for us*', *European Journal of Cultural Studies* 7(2), 147–54.

Wood, Helen and Beverley Skeggs. 2004. 'Notes on Ethical Scenarios of Self on British Reality TV', *Feminist Media Studies*, 4/2: 205–7.

Film and Visual Culture

ANDREW SPICER

THE CRISIS IN FILM STUDIES

The impact of digital technologies and the rise of New Media Studies has had a significant impact on Film Studies which, according to some commentators, is currently experiencing a crisis of legitimation in which its historical, theoretical, methodological and ontological foundations have been called into question. The material basis that film shared with photography—the effect of light striking and altering a strip of chemically treated paper which creates a physical, indexical connection to the world (the trace of the particular instant in time that has been captured)—has now been severed through digital transpositions into algorithmic numbers. The disappearance of the supposedly specific qualities of film as a medium, the realism of the image and the mechanical reproduction of the camera, has led to widespread pronouncements about the 'death of cinema' (see Geuens 2000; Tryon 2009: 73–6); if film was the dominant cultural form of the twentieth century, the twenty-first will belong to 'new media'.[1]

As a consequence, it is often argued, by both academics and practitioners, that we are living now in an era of 'post-cinema', or what Richard Grusin has more helpfully identified as a 'cinema of interactions', in which film has become a distributed form, circulating in various guises across a range of different media, and where the distinctive social and cultural ritual of watching a theatrically projected film is in the process of being replaced by a diffused continuum in which the viewer or user interacts with a digital artefact in various locations in a multiplicity of ways. As Grusin argues, in the 'current historical moment' film, like other media, is no longer singular and separate but only exists in relation to other media (2007: 215). Although Hollywood movies are still central to an understanding of what film is and continue to dominate the marketplace—what Thomas Elsaesser calls 'business as usual' (2000: 190–1)—it is no longer the Hollywood of old; film production, distribution and exhibition are changing significantly.

Many areas of film scholarship—what David Bordwell characterizes as 'middle-level research' (1996: 26–30)[2]—remain unaffected by these changes, but a significant number of studies argue that the impact of new audio-visual technologies is profound and necessitates that Film Studies be fundamentally rethought and redefined, attempting to understand film's new role within a radically transformed postmodern cultural landscape. The title of Christine Gledhill and Linda Williams's seminal collection, *Reinventing Film Studies* (2000), indicates its commitment to a major reconceptualization of the perennial issues that Film Studies has engaged with including medium-specificity, authorship, spectatorship, realism, aesthetics, the centrality of 'classical Hollywood cinema' and film history. As Janet Harbord comments in *The Evolution of Film: Rethinking Film Studies*, film's encounter with digital technologies has given these questions a new urgency (2007: 16). Chuck Tryon's *Reinventing Cinema: Movies in the Age of Media Convergence* (2009) sturdily charts the changes that are occurring, while Dudley Andrew's *What Cinema Is!* (2010) is imbued with a deep concern that something precious and unique about film might be being lost. Such concerns inform the most eloquent and wide-ranging account, David Rodowick's *The Virtual Life of Film*, which argues that because of the ontological changes occasioned by the shift from analogue to digital, film is no longer the preeminent modern medium that was constitutive of modernity itself, but has become 'completely historical' (2007: 93).

For Laura Mulvey, whose work has been central to Film Studies, the present moment is both challenging and, potentially, highly productive. She argues that film's 'disappearance' into digital multimedia offers a peculiarly valuable vantage point, a 'threshold moment', in which to look both forwards and backwards. It has allowed the affinities between new digital media and the optical media of the nineteenth century to be perceived, thereby releasing those earlier practices that prefigured film 'into their differentiated forms and histories' rather than being inertly homogenized as 'pre-cinema' (2007: xv–xvi). In the process film, as it has conventionally been understood, has begun to be recognized as a century-long phase within a 'larger continuous history . . . of "moving images" ' (Carroll 1996: xiii), where film becomes one component in 'an integrated history of audiovision' (Zielinski 1999: 22), understanding its role within a wider configuration of visual technologies (Lyons and Plunkett 2007: xvii–xxv) in order to produce an intermedial or 'convergence' history (Staiger and Hake 2009).

In what follows I will not attempt an inevitably superficial survey of recent literature on film—impossible in such a short space anyway—but focus on some of the more important accounts that have explicitly addressed this perceived 'crisis' in Film Studies caused by the impact of digital technologies. Particular attention will be given to those that engage with broad issues to do with the nature of film itself and thus which attempt to reinvent or reconceptualize the discipline in the wake of New Media.[3] In this way I hope to open out the issues adumbrated in this introduction and to explore film's relationships with wider practices of looking and, explicitly in the final section, explore the connections with Visual Culture. What will become clear is that in the process of reconceptualizing the nature of Film Studies, most film scholars now recognize that because image media mutate, recombine and migrate across disparate contexts, the discussion of

any medium is now a 'necessarily *inter*disciplinary question' (Beckman and Ma 2008: 4, original emphasis). However, we need to start with Film Studies' 'turn to history' (Spicer 2004) that this 'crisis' has occasioned, examining revisionist histories that have significantly broadened an understanding of how film emerged in high modernity and therefore what it might become.

THE TURN TO HISTORY: FILM AND MODERNITY

These revisionist histories contrast with the teleological narratives that characterized earlier film histories, which assumed the sovereignty of the ninety-minute feature film (Gunning 2000: 317). Informed by changes in the nature of history itself as a discipline, the objects of film history (including films themselves) are no longer understood as transparent data or facts, but as problematic forms of 'evidence' produced discursively (Sobchack 2000a: 301, 312; see also Sklar 1990; Chapman, Glancy and Harper 2007).[4] Specifically, the present 'threshold moment' has encouraged film historians to reexamine film's relationship to the technological, social and cultural transformations that constituted modernity, exploring film's role in the reconfiguration of motion, time and space, and also perception.[5]

Leo Charney and Vanessa Schwartz's *Cinema and the Invention of Modern Life* (1995) was central to this reexamination. The editors contend that film was not simply a new medium but central to how modernity was experienced and understood by a broad public. Film, they argue, 'arose from and existed in the intertwining of modernity's component parts: technology mediated by visual and cognitive stimulation; the re-presentation of reality enabled by technology; and an urban, commercial, mass-produced technique defined as the seizure of continuous movement' (10). Charney's *Empty Moments: Cinema, Modernity and Drift* (1998) explored the philosophical and ontological implications of this process, arguing that film enabled the dialectical relationship between modernity's shocks, surprises, distractions and overwhelming stimuli and its corollary, drift, the experience of vacancy, the sensation of empty moments, to be understood and negotiated. Mary Ann Doane's *The Emergence of Cinematic Time* (2002) also explored film's paradoxical function as the permanent record of fleeting moments, situating the emergence of cinema within the increasing regularization and standardization of time in late modernity, the development of 'industrialized time' that was essential to the penetration of capitalist work practices (8). She argues that early film 'actualities' made the contingent and the ephemeral legible, seizing and recording fragments of time and endowing them with a significance (10). In the process, film became the central form where temporality could be captured and made visible in space, an imprint of a pure moment in time that was both a record and, through movement and change, also a display 'that never ceases to strike the spectator as open, fluid, malleable—the site of newness and difference itself' (32).

Tom Gunning's work was seminal to a revised understanding of early film spectatorship. His influential notion of a 'cinema of attractions' argued that rather than naively mistaking the film image for reality, the film spectator was 'astonished by its

transformation. Far from credulity, it [was] the incredible nature of the illusion that render[ed] the viewer speechless' (1990: 118; see also Gunning 1995). As a complement to Gunning, Schwartz's *Spectacular Realities: Early Mass Culture in Fin-de-Siècle Paris* (1998) valuably demonstrates how the taste and the perceptive apparatus whereby the new phenomenon of film could be understood was itself created through the popularity of 'spectacular realities', phenomena such as shopping boulevards, the mass press and wax museums that developed during the second half of the nineteenth century and which, along with film, helped create modern mass society. Ben Singer's *Melodrama and Modernity: Early Sensational Cinema and Its Contexts* (2001) focuses on one form— sensational melodrama, notably serial-queen adventures such as *The Perils of Pauline* (1914)—but also situates this within the material context of sensationalism in other contemporaneous popular amusements: stage melodrama, dime novels, tabloid story papers and publicity, amusement parks and thrill rides and the discursive context of writings by contemporary observers, journalists, theorists and practitioners who made the connection between modern urban experience and film. Singer explores film's connection to the new intensified, sensory environment of the metropolis, its speed, discontinuities and 'audiovisual fragmentation', arguing that cinema became the most powerful form of this new 'aesthetics of astonishment', combining the capturing of powerful fleeting impressions, kinetic speed, novel sights, and visceral stimulation (2001: 130). His empirically grounded research shows how the forces shaping modernity—the shocks, fragmentation and superabundance of sensation famously identified by Walter Benjamin and Georg Simmel—actually operated in detail.

These studies, by implication, alert us to Mulvey's 'perceived affinities', providing an historical perspective on digital culture and how it might be understood, but others explicitly explored that connection. Miriam Hansen's influential 'The Mass Production of the Senses: Classical Cinema as Vernacular Modernism' (2000), valuably extended the discussion of film's relationship to modernity by arguing that 'classical Hollywood cinema'—the cornerstone of Film Studies and conventionally presented as a timeless, universal narrative idiom or 'what film is'—was actually a very specific form of film both historically and culturally. However, through its worldwide reach, classical Hollywood film became the first 'global sensory vernacular', a central element in the 'changing fabric of everyday life, sociability and leisure' that provided 'an aesthetic horizon for the experience of industrial mass society'. In the process, narrative film created new subjectivities by enabling 'viewers to confront the constitutive ambivalence of modernity' (333–44).[6] Two studies by Anne Friedberg extended this exploration of film's connection with modernity into the digital era. In *Window Shopping* (1993), Friedberg traces the cultural contexts of commodified forms of looking and the experiences of spatial and temporal mobility. Rather than understand film as an autonomous aesthetic product, she too argues that it must be read in the 'architectural context' of its reception as it emerged in the rich context of various forms of looking that were taking place: in the activities of shopping and tourism in a variety of locations, in dioramas, panoramas and phantasmagorias, in exhibition halls, winter-gardens, arcades, department stores, amusement parks and museums. Film was a key component in what she designates the 'mobilized virtual

gaze', contributing to a 'gradual and indistinct epistemological tear along the fabric of modernity' (2), eventually becoming central to the fabric of contemporary, postmodern life in malls, videos and DVDs, the Web, and virtual reality technologies. In *The Virtual Window* (2006), Friedberg examines the metaphorical and material importance of the window and its successor the screen as a framing device that has shaped perception and the understanding of images from Alberti's *De Pictura* (1435) through to contemporary 'postcinematic' visualities of camera phones, BlackBerries and other 'mobile' devices (6). Although film, unlike painting or architecture, was for a long period wedded to the single screen as its 'window on the world' with split screen technologies the province of avant-garde practices, Friedberg argues that this is now changing in the age of new media where the multiple screen format has now become the new vernacular. In the process, the specificity of film has become irreparably altered by digital technologies in which screens are converging, losing their apparatical distinctions, thereby promoting a different logic of visuality (217, 242).

THE RESHAPING OF FILM: PRODUCTION TECHNOLOGIES AND CONSUMPTION

The historical analyses already considered, in contradistinction to the unbridled techno-philic euphoria that characterized the mid 1990s[7], advance an understanding that digital forms are the product of changes that are evolutionary rather than revolutionary, trans-formations of existing practices rather than unprecedented (see Boddy 2008). Philip Rosen identifies a succession of hybridities rather than a great break (2001: 303), and Brian Massumi argues that the interaction of the digital and the analogue is occurring 'in self-varying continuity' (2002: 138). Henry Jenkins's highly influential *Convergence Culture* (2006) understands the present moment as transitional—'not fully integrated and ramshackle' (18)—where old and new forms 'collide' as they jostle for position and power. He argues that 'Old media are not being replaced. Rather, their functions and status are shifted by the introduction of new technologies' (14). As Jay Bolter and Rich-ard Grusin contend, new media work by refashioning older media (centrally film) in both form and content and are thus 'remediations' of existing forms (1998).

The Hollywood feature film is now a hybrid form, that, in the 'transitional post-major studio pre-Internet era' (Tryon 2009: 2–3), employs both analogue and digital technologies. However, feature films are increasingly being shot on digital video (DV) rather than celluloid, which may well soon cease to be manufactured (Enticknap 2005: 224–9). George Lucas has famously described film as an 'outdated Victorian technol-ogy' and announced, after *Star Wars Episode 2: Attack of the Clones* (2002), that he would 'never make another film—on film—again' (in Enticknap 2009: 416). More low-budget and experimental film-makers such as Mike Figgis are increasingly using digital formats because of their enhanced aesthetic possibilities and their increased speed and efficiency (Figgis 2007). There has been a huge expansion of ultra low-budget film production, partly inspired by *The Blair Witch Project* (1999), that uses inexpensive equipment, stan-dard editing software and that seeks an audience through the Internet, bypassing the

normal distribution and exhibition mechanisms (Tryon 2009: 93–4, 175). The energies of the film-making process are increasingly shifting from production (filming on location or in the studio) to post-production (Harbord 2007: 88). A range of new companies have sprung up, operating from cyberstudios, which exist to handle the intricacies of computer processing.

World cinema continues to be dominated by the digital, special effects–driven Hollywood blockbuster with media ownership still concentrated in a small number of multinational companies, what Robert Stam and Ella Shohat call the 'entrenched asymmetries of international power' (2000: 380). However, their account also indicates that this system is changing because global cultural and economic hegemonies have become more subtle and dispersed. Hollywood is no longer the orchestrator of a world system of images, but one mode in the complex transnational construction of 'imaginary landscapes' (2000: 383). In recognition of this shift, Film Studies has become increasingly interested in the concept of 'transnational cinemas', exploring the interactions of local and global cultures, and the development of low-budget forms of film-making (often using inexpensive digital technologies) in small, 'third world' or postcolonial cinemas that can provide them with a distinctive existence. These studies argue that a new kind of decentred multinational system has developed which has altered the earlier paradigm of separate national cinemas and the older opposition between Hollywood and European Art Cinema (Stam and Shohat 2000: 395; see also Naficy 1999, 2001; Ďurovičová and Newman 2010; Galt and Schoonover 2010; Iordanova, Martin-Jones and Vidal 2010).[8] Hamid Naficy contends that in a 'post-diasporic era' of increasing national fragmentation and the physical displacement of peoples across the globe, the contribution of 'accented cinema' created by displaced, exilic, 'asylee', diasporic, ethnic, transnational and cosmopolitan film-makers has become increasing important and influential (2009: 3–4, 11). Accented cinema, he argues, challenges classic cinema's coherence of time, space and causality through its use of interlocking narratives, fragmentation and the circularity of time and space in often lengthy episodic narratives with multiple points-of-view, multilingual dialogues, multicultural characters and numerous locations.

If modes and locations of production are shifting, so too are forms of film consumption. Cinemagoing continues to be an important social and cultural activity (Corbett 2001: 18; Acland 2003: 45–81, 212–28; Tryon 2009: 64, 77–8). Although some commentators, for instance John Belton, have cast doubt on the real impact of digital technologies calling it a 'false revolution' (2002: 98–114), the success of 3D projections of *Avatar* (that premiered in the UK in December 2009) suggest that audiences may continue to want the 'special thrill' of seeing a feature film in a large auditorium. However, this mode of exhibition has lost its centrality to the industry; only 15 per cent of a film's revenue typically comes from its theatrical release (Caldwell 2008: 9). It is been displaced by a range of different forms of film consumption on a diversity of screens, from IMAX to iPod (Wasson 2007), involving new modes of distribution including the Internet (Wasko 2002; Tryon 2009: 93–124). New forms of film have evolved including the director's cut, the animated prequel, the film's Web site with various 'extras' and the

DVD release that incorporates additional material including deleted scenes. A 'platform agnostic' generation of film viewers, relatively indifferent to the form in which they encounter a film, are also looking to the Internet as an unlimited warehouse for digital versions of films that can be downloaded 'on demand' onto home computers (Tryon 2009: 94–5). The 'long tail' of digital distribution makes available huge numbers of films that allows for niche marketing (Anderson 2009: 133–5).

Increasingly film consumption is centred in the home. 'Home film cultures' have grown rapidly since the 1980s, fuelled by the widespread release of titles on video and now DVD, leading to the growth of a new form of connoisseurship, the collector who amasses an extensive library of films (Klinger 2006). DVD 'special editions' with authoritative commentaries and extratextual material can add to a film's cultural capital and its sense of significance, promoting a form of knowledgeable cinephilia, though this often takes the form of the cult film rather than the historically significant one (Barlow 2005: 76–7, 110–11). And, as Aaron Barlow argues, DVDs must be understood as a new form of film, one that enables chapter viewing, freeze framing, forward and reverse slow motion and rapid scanning, even subtitling, all of which are controlled by viewers themselves. DVDs thus alter the way in which a film is experienced by the viewer, promoting modes of attention and engagement that differ significantly from seeing a film theatrically (Barlow 2005: 19; Isaacs 2008: 13–14).

These new forms of interaction are assiduously promoted by media corporations which, in an era of convergence, now work to a different logic that reshapes the relationship between audiences and producers (Jenkins 2006: 12). The new digital technologies have been designed to be more responsive to consumer feedback, and are more 'participatory', although, as Jenkins acknowledges, in most interactive environments what the user does is prestructured by the designer and shaped by existing social and cultural protocols. Jenkins claims that the increasing proliferation of fan and Internet communities that dissect and comment on the various versions of a film are gradually gaining more power and influence as companies begin to respond to their needs and desires (2006: 258; see also Keane 2007: 76–86).

Nor are these new forms of viewing confined to current films. As Victor Burgin argues in *The Remembered Film*, there are now far more possibilities for controlling and selecting the viewing experience of almost any film including 'classics' and thus 'for dismantling and reconfiguring the once inviolable objects offered by narrative cinema', formerly localized in time and space (2004: 8–9). Laura Mulvey's exploration of this changed relationship to earlier films in *Death 24x a Second* argues that freeze framing alters the connection between the still frame and the moving image, between continuous movement and stillness, and thus has the capacity to restore to film the weighty presence of passing time that earlier theorists, André Bazin and Roland Barthes, associated with the still photograph (2006: 66). Digital processes allow viewers to contemplate the sensuous beauty of specific images, breaking down the linearity of narrative continuity and splitting apart the different levels of time that are usually fused together. However, Mulvey argues, this new relationship to time is not a return to an earlier mode of attention. The older ontology of the singularity of the moment and the unrepeatable succession of

events has been replaced by a new ontology in which 'ambivalence, impurity and uncertainty displace traditional oppositions' (2006: 12).

THE EVOLUTION OF FILM: NEW FORMS
AND PRACTICES—DIGITAL FILM AESTHETICS

Digital technologies have led to the evolution of new forms of film and aesthetic practices. The most sustained and penetrating attempt to analyse 'digital cinema' is Lev Manovich's *The Language of New Media* that understands it as the product of the two interconnected histories of computing and media technologies (2001: 20). Manovich argues that in losing its indexical connection to the material world and becoming electronic art, film is now best understood as an expressive, graphic medium, as a subgenre of painting (295) or '*a particular case of animation that uses live-action footage as one of its many elements*' (302, original emphasis). The 'logic of replacement', characteristic of analogue film, has given way to the 'logic of addition and coexistence' (325), where data are endlessly mutable, selecting and recombining elements from existing menus, providing a navigable space for the user to surf (287). Analogue film's characteristic manipulation of space and time through montage and the cut has been replaced by the morph or digital composite (143), where elements are not juxtaposed but blended, and boundaries erased rather than foregrounded (155). For Manovich, this mutability of data offers extraordinary new possibilities for film-makers to generate, organize, manipulate and distribute images (314), including the reemergence of complex spatial narratives (324).

Few of these possibilities have so far been realized in mainstream cinema that has concentrated on using CGI to create visceral special effects within the existing aesthetic paradigms of classical cinema, albeit with the proliferation of mythic or fantasy worlds, often derived from comics or graphic novels. However, digital techniques have had an impact on film aesthetics in shot length, framing, camera movement, and the varied combinations of CGI and live action (Allen 2002). The existing principles of aesthetic distance and sequential unfolding are gradually giving way to ones based on 'envelopment and temporal simultaneity' (Morse 1999: 64). 'Impossible' events are shown as if actually happening and an ultra-detailed photo-realism renders the fantastic with the surface accuracy associated with photography. This has the function of insinuating that the real and the digital exist in the same time and space, and also presenting CGI imagery as a self-validating spectacle, thus demonstrating what Bolter and Grusin call the twin logics of 'immediacy' and 'hypermediacy' (1998: 6, 14, 21, 155). Increasingly, the 'real' is presented as a form of spectacle (Wollen and Hayward 1993: 2; King 2005: 13). This connects film, as Andrew Darley demonstrates in *Visual Digital Culture* (2000), to a range of practices (including music videos, computer games, theme park simulation rides and advertisements) whose mode is hyperreal spectacle, and which solicit audiences into seeking direct and immediate visual pleasures in a poetics of surface play and immersive spectacle rather than intelligibility (2000: 169–73,193 and passim).

As Manovich indicated, use of the morph is becoming more frequent. But, as Vivian Sobchack reminds us, although it represents, in its effortless shape-shifting that

confuses (often disturbingly) the animate and the inanimate, a fluidity and instability of body shape and identity that is characteristically postmodern, like all digital practices, morphing has a complex genealogy. It is thus an evolutionary practice with powerful historical precedents that link 'present day digital practice to a much broader history . . . of metamorphosis and its meanings', including early cinema's magic shows, attractions and trick films (2000b xiv–xv). A rather different digital effect was 'bullet-time' used in *The Matrix* (1999) in which, through a combination of conventional camerawork and computer animation, 'while an event plays out in slow motion, the camera appears to move the action at a higher speed and in a different direction' (Purse 2005: 152). The effect is both dynamic and immersive, drawing the spectator 'fully into the diegetic space, disrupting the conventional spatial relationship between the spectator, the screen, and the filmic world' (157–8). In the sequels, *Reloaded* and *Revolutions* (both 2003), this enveloping, immersive effect increased through the use of free-floating cameras within entirely virtual sets (Keane 2007: 125).

If mainstream feature films use digital aesthetics conservatively, much more radical uses occur in more avant-garde cultural practices.[9] A number of studies have documented these new forms.[10] A useful conspectus is provided in Holly Willis's *New Digital Cinema: Reinventing the Moving Image*, which argues that digital film-making is creating new forms of self-reflexive film that have fluid boundaries, breaking out of the confines of the rectangular cinema frame and standard genres. These new (or revived) forms are situated at the intersection of formerly separate realms of film-making: music video, animation, print design, street art, live club events, videoart, installations in galleries and museums, and now digital graffiti (2005: 4). These various locations are creating, along with the Internet, new environments in which viewers engage and interact with film. Like Manovich, Willis argues that digital films are characterized by a radical reorientation of spatial perception, the synthetic digital imagery creating a giddy sense of freedom that produces open and kaleidoscopic structures (2005: 67–8). These works help create a new film grammar and syntax built on hybridity and mixed forms, melding disparate film stocks, genres and formats that look back to modernist avant-garde experimentation but also create new 'digitextual' forms (Everett 2003), in their radical challenge to the paradigms of classical Hollywood cinema.

In the process of creating these new forms across multiple platforms, the role of the director is shifting significantly, morphing into the 'digitextualist' attuned to the flow and mix of codes on multiple screens in various locations. David Lynch, who always stretched the definition of what film could be—*Inland Empire* (2006) proceeds through the associative logic of hyperlinks—has devoted increasing energy and time to experiments with flash animation and low-definition digital video available to view on his Web site. In the process, Lynch has created a 'meta-auteur persona, consistently reflecting on the changing nature of authorship and spectatorship and adapting the presentation of his work accordingly' (Samardzija 2010: 4). Peter Greenaway, whose whole career has been devoted to subverting the 'four tyrannies' of traditional film-making, the script, actor, camera and frame, has comprehensively abandoned a single format in works that are multiple and densely layered, making him one of the great practitioners of the new

form of 'database cinema' (Manovich 2001: 237–39). This is best exemplified in *The Tulse Luper Suitcases* (2004), a 'media mosaic', consisting of four feature films, an interactive CD-ROM, 92 DVDs, an online game, a television series, numerous museum/gallery shows of the 92 suitcases, books and exhibitions, and the construction of several interactive Web sites that add new material, rework footage and encourage the user to connect with Greenaway's earlier work, and other aspects of Luper's 'life', as well as hosting a huge virtual archive that contains databases of images and information. Greenaway thus creates a complex, elusive, fragmentary 'historiographic metafiction' whose proliferating networks have generated their own fictional world (Peeters 2008: 323–38).

However, this 'metacinema' unfolding across multiple media platforms is not confined to avant-garde practice. Jenkins's central example of convergence culture and 'transmedia storytelling' that creates an encyclopaedic digital 'multimyth', is the Wachowski brothers' hugely successful 'The Matrix' franchise (2006: 95–134). This consisted of an initial feature film released in 1999, two sequels released in 2003, nine short animated films made by different film-makers (*The Animatrix*) and a videogame (*Enter the Matrix*) also released in 2003—which the distributors, Warner Bros., styled the 'Year of The Matrix'—several comic books and short stories released on the Web site and a 'special' ten-disc DVD, *The Ultimate Matrix Collection* (2004), containing six discs of additional material including detailed explanations of digital aesthetic innovations such as 'bullet time'. A clever mixture of popular fears concerning the impact and direction of technological change, cryptic allusions (including a reference to Baudrillard's *Simulacra and Simulations*), and an old-fashioned narrative of redemption and visceral action sequences, 'The Matrix' was less a cinematic text than an evolving popular culture entity, what Bruce Isaacs labels a third order metacinematic 'hypermyth' composed of simulacral tropes or cinematic quotations, that engages viewers in various forms in its evolving construction of a simulated, digitextual universe (2008: 118–30). Isaacs argues that it represents the characteristic work of a new generation of directors (his other example is Quentin Tarantino) for whom the cinematic imaginary is better than the real thing, who display a love of cinema not a love of art (181).

FILM AND VISUAL CULTURE

What the Wachowskis' 'The Matrix' or Greenaway's *The Tulse Luper Suitcases* demonstrate is that, if a particular form of cinema is over, film, in its varied 'virtual life', continues to be a crucial component of art and popular culture in the digital age. Film, in all its guises, remains central to a contemporary culture in which the conception of stable, enduring, finished works authenticated by an original version is disappearing, replaced by 'one that recognizes continual mutation and proliferation of variants' (Mitchell 1992: 52). Just as film was essential, as has been discussed, to the ways in which a broad public could come to terms with modernity, so it remains fundamental to postmodern digital culture. As Manovich argues, film has prepared audiences for new media because cinematic ways of seeing the world, of structuring time, of narrating a story, of linking one experience to the next, have become the basic means by which computer users access

and interact with all cultural data. We continue to see the world through rectangular frames, and cinema's aesthetic strategies have become the basic organizational principles of computer software and even virtual reality machines (2001: 50, 79, 81–6).

However, to understand that film retains an important place in the digital era and that the changes it has experienced are evolutionary rather than revolutionary, is not to underestimate the extent or profundity of those changes. The multiple and proliferating forms of film across a range of media and on a variety of screens has impelled, as noted in the introductionary section, a questioning of film's specificity and identity, prompting an uncertainty as to whether 'film is a central text with ancillary products in other media forms, or simply a media platform in a multimedia environment' (Harbord 2007: 43). David Rodowick argues that at an ontological level, a particular form of perception that gave attention to things in themselves and their duration, an appreciation of the sensuous depth of reproduced images and with them the 'complexity and density of phenomenological experience' and a 'deep connectedness with a way of being in the world', with memory and history, is now passing as we move into a digital culture (2007: 69–79).[11] He suggests that because digital images are less tied to the 'prior existence of things' as they neither occupy space nor change through time (137), they change our conception and our phenomenological relationship with images (86–7, 98). As Rodowick acknowledges, digital images often seem colder, less involving (107–8) and their proliferation may involve a retreat from the sensuous exploration of the physical world and the material structure of everyday life that were so central to the development of photography and film. Although Rodowick concludes that 'synthetic imagery is neither an inferior representation of physical reality nor a failed replacement for the photographic, but rather a fully coherent expression of a different reality, in fact, a new ontology' that provides the opportunity for the artist to probe imaginative life and a new kind of sociality (174–6), he also poses the question: 'When filmmaking and viewing become fully digital arts, will a certain experience of cinema be irretrievably lost?' (31). In the same vein, Leo Enticknap wonders how future film scholars will be able to understand the aesthetics and impact on audiences of 35 mm film if it only exists as a digital surrogate (2009: 420; see also Dixon 2000: 229).

These are genuine fears, but the specific crisis that Film Studies is experiencing through the impact of digital technologies and its loss of 'medium specificity' is mirrored in other disciplines (see, for instance, Krauss 1999) and is itself symptomatic of a deeper uncertainty about new ways of living and experiencing the world (Gunning 2000: 328). As Thomas Elsaesser remarks, the term 'digital' is 'less a technology than a cultural metaphor of crisis and transition' (1998: 202).[12] Thus the problems many film scholars are wrestling with should engage the attention of those who practice Visual Culture Studies. Mieke Bal characterizes Film Studies, along with Art History, as an object-defined discipline and thus to be distinguished from the interdisciplinary project of Visual Culture and its concern with practices of looking both historically and in the digital age (2003: 7, 9, 11, 13). There are eminent film scholars, such as Dudley Andrew, who wish to maintain Film Studies' disciplinary boundaries and who fear film's submergence into 'some larger notion of the history of audiovisions' or its disappearance into

'the foggy field of cultural studies' (2010: xvii).[13] Even Lisa Cartwright, whose work has been central to Visual Culture, argues in her essay on film and digital technologies that disciplinary convergence should not mean 'a flattening of difference and a de-skilling of [film's] labor force' (2002: 424).

However, what the studies discussed in this chapter demonstrate is that an engagement with broader concerns does not preclude retaining a particular focus on film, nor detailed empirical research into specific forms, practices and historical moments. Anne Friedberg—whose own work exemplifies this process—argues that increasingly film scholars are coming to recognize the importance of Visual Culture Studies which, she argues, has encouraged them 'to contextualize the study of film and other media in relation to a deeper history of visual representation and within a broader conception of the practices of vision and visuality' (2006: 253, n. 21). If, as I have suggested, Film Studies is becoming more interdisciplinary, with film scholars increasingly moving into the terrain occupied by cultural history and visual studies and discussing phenomena rather than objects, working with a wider conception of 'film' both historically and in the present, then its relationship with Visual Culture will become increasingly close and productive. Indeed, I want to argue that Film Studies' continuing historical and theoretical project (broadly conceived) is vital to a dynamic and expanding 'interdiscipline' of Visual Culture, one that can draw on the resources of a variety of disciplines to 'construct a new and distinctive object of research' (Mitchell (2002) 2005: 356). I see no reason why the particular knowledge and training of film scholars and the very real achievements of film scholarship need to be sacrificed in this process as they continue to engage with the broader issues of perception and visuality that Visual Culture has helped to identify.

CONCLUSION

The debates about film's medium specificity and ontology are, as Dudley Andrew's recent polemic (2010) indicates, far from settled. But, as this chapter has argued, the impact of digital technologies has impelled film scholars, from a range of perspectives, to try to redefine their discipline and broaden its research agenda. As noted, we appear to be living in a threshold moment when the relationship between the past, present and future of film can be rethought. This has involved both a turn to history—I did not have the space to consider many other provocative and stimulating accounts such as Giuliana Bruno's work on film and architecture (1993, 2002)—and the growth of a range of more explicitly philosophical studies, including, in addition to those I have mentioned, important monographs by Sean Cubitt (2004) and Garrett Stewart (2007), which try to tease out the ontological as well as the aesthetic implications of the shift from analogue to digital. As I have suggested, the major shift that has happened in the past decade or so has been the sustained effort by scholars, notably Manovich, to apprehend and also, importantly, to describe in detail, the *evolutionary* nature of new media, to understand new forms and practices as historical, hybrid and possibly transitional. This has replaced, to a large extent, the disabling future casting that characterized previous studies of new

media. Therefore we can look forward to studies of digital cinema that become ever more precise in their delineation of technological and aesthetic changes in the production, distribution, exhibition and consumption of film. But, even more important, ones, such as Nicholas Rombes's *Cinema in the Digital Age* (2009), that also engage with the possible cultural meanings of those changes.

As I have shown, in the process of considering the evolution of new forms of film, Film Studies has been forced to revise its central tenets including the centrality of Hollywood. This has necessitated a scrutiny of Hollywood itself—as in Jon Lewis's provocative collection *The End of Cinema as We Know It* (2001) and Geoff King's work on 'Indiewood' (2009)—but also an important new research agenda that considers the evolution of transnational cinema. In addition to the studies mentioned, important work is being undertaken on other forms of global cinema, for instance Derek Bose's study of Bollywood (2006). What I have characterized as Film Studies' postdigital revisionist project has included the rethinking of auteurism and the role of the director (with Greenaway and Lynch as exemplars of the shift away from the feature film into multisite modes), but has also involved new work on film genres (e.g. Langford 2005) and on gender, for instance Krin Gabbard and William Luhr's collection (2008) that includes attention to masculinities as well as femininities, queer and ethnic representations. Finally, Bruce Isaacs's work (2008), already referenced, on 'metacinematic hypermyths' suggests a highly productive area for further research and enquiry, one that moves beyond the confines of The Matrix mini-industry or Tarantino to consider how films themselves are part of wider cultural networks that accrete and proliferate endlessly in the highly populated cyberspace of digital culture.

FURTHER READING

Chapman, James, Mark Glancy and Sue Harper, eds. 2007. *The New Film History: Sources, Methods, Approaches*. Basingstoke: Palgrave Macmillan.

Gledhill, Christine and Linda Williams, eds. 2000. *Reinventing Film Studies*. London: Arnold.

Harbord, Janet. 2007. *The Evolution of Film: Rethinking Film Studies*. Cambridge: Polity Press.

Lyons, James and John Plunkett, eds. 2007. *Multimedia Histories: From the Magic Lantern to the Internet*. Exeter: University of Exeter Press.

Manovich, Len. 2001. *The Language of New Media*. Cambridge, MA and London: MIT Press.

Rodowick, D. N. 2007. *The Virtual Life of Film*. Cambridge, MA and London: Harvard University Press.

NOTES

1. Definitions of what constitutes 'new media' vary but typically include the Internet, Web sites, computer multimedia, computer games, CD-ROMS and DVDs. For a useful overview, see Lister et al. (2009: 9–51).

2. Bordwell contrasts current 'post-theory' scholarship with earlier studies that, he argues, aspired to the formulation of abstract 'grand theory', a problematic distinction. For a useful overview of the changes in film theory see Tredell (2002).

3. Space does not permit a consideration of Gilles Deleuze's two highly influential accounts of cinema—*Cinema 1: The Movement Image* (London: Athlone Press, 1992) and *Cinema 2: The Time Image* (London: Athlone Press, 1989)—that have generated a mini industry of critical exegesis and commentary. See, inter alia, Gregory Flaxman (ed.), *The Brain Is the Screen: Deleuze and the Philosophy of Cinema* (Minneapolis and London: University of Minnesota Press, 2000).

4. See *New Review of Film and Television Studies*, 8/3 (September 2010); Special Issue: Researching Cinema History.

5. These accounts are informed by the seminal studies of Crary (1992 and 2001), Schivelbusch (1986 and 1995) and Kern (2003).

6. Hansen has recently extended her argument: see Hansen (2010).

7. Nicholas Negroponte's *Being Digital* (London: Hodder and Stoughton, 1995) is a famous example.

8. The journal *Transnational Cinemas* started in February 2010.

9. Documentary film-making has also been evolving into a more open form through the use of digital technologies: see Cubitt (2002: 27); Gaines and Renov (1999).

10. These include Le Grice (2001), Reiser and Zapp (2002), Shaw and Weibel (2002), Hamlyn (2003) and Hanson (2004); see also Zielinski (1999: 279–303).

11. For further discussion of this point see Rodowick (2001: 203–34) and Rosen (2001: 301–49).

12. Vincent Mosco (2004) has explored the various myths that have been constructed around the new digital technologies.

13. See the contributions to the 'In Focus: What Is Cinema' section of *Cinema Journal*, 43/3 (Spring 2004).

REFERENCES

Acland, Charles. 2003. *Screen Traffic: Movies, Multiplexes and Global Culture*. Durham, NC and London: Duke University Press.

Allen, Michael. 2002. 'The Impact of Digital Technologies on Film Aesthetics', in Dan Harries (ed.), *The New Media Book*. London: BFI, 109–18.

Anderson, Chris. 2009. *The Longer Tail: How Endless Choice Is Creating Unlimited Demand*. London: Random House Business Books.

Andrew, Dudley. 2010. *What Cinema Is! Bazin's Quest and Its Charge*. Malden, MA and Oxford: Wiley-Blackwell.

Bal, Mieke. 2003. 'Visual Essentialism and the Object of Visual Culture', *Journal of Visual Culture*, 2/1: 5–32.

Barlow, Aaron. 2005. *The DVD Revolution: Movies, Culture, Technology*. Westport, CT: Praeger Press.

Beckman, Karen and Jean Ma. 2008. 'Introduction', in Karen Beckman and Jean Ma (eds.), *Still Moving: Between Cinema and Photography*. Durham, NC and London: Duke University Press, 1–19.

Belton, John. 2002. 'Digital Cinema: A False Revolution,' *October*, 100: 98–114.

Boddy, William. 2008. 'A Century of Electronic Cinema', *Screen*, 49/2: 142–56.

Bolter, Jay David and Richard Grusin. 1998. *Remediation: Understanding New Media*. Cambridge, MA and London: MIT Press.

Bordwell, David. 1996. 'Contemporary Film Studies and the Vicissitudes of Grand Theory,' in David Bordwell and Noël Carroll (eds.), *Post-Theory: Reconstructing Film Studies*. Madison: University of Wisconsin Press, 3–36.

Bose, Derek. 2006. *Brand Bollywood: A New Global Entertainment Order*. London: Sage.

Bruno, Giuliana. 1993. *Streetwalking on a Ruined Map: Cultural Theory and the City Films of Elvira Notari*. Princeton, NJ: Princeton University Press.

Bruno, Giuliana. 2002. *Atlas of Emotion: Journeys in Art, Architecture, and Film*. London: Verso.

Burgin, Victor. 2004. *The Remembered Film*. London: Reaktion Books.

Caldwell, John T. 2008. *Production Culture: Industrial Reflexivity and Critical Practice in Film and Television*. Durham, NC and London: Duke University Press.

Carroll, Noël. 1996. *Theorizing the Moving Image*. Cambridge: Cambridge University Press.

Cartwright, Lisa. 2002. 'Film and the Digital in Visual Studies: Film Studies in the Era of Convergence', *Journal of Visual Culture*, 1/1: 7–23. Reprinted in Nicholas Mirzoeff (ed.), *The Visual Culture Reader*, 2nd edn. 2002. London: Routledge, 417–32.

Chapman, James, Mark Glancy and Sue Harper. 2007. 'Introduction', in James Chapman, Mark Glancy and Sue Harper (eds.), *The New Film History: Sources, Methods, Approaches*. Basingstoke: Palgrave Macmillan, 1–10.

Charney, Leo. 1998. *Empty Moments: Cinema, Modernity, and Drift*. Durham, NC and London: Duke University Press.

Charney, Leo and Vanessa Schwartz. 1995. 'Introduction', in Leo Charney and Vanessa Schwartz (eds.), *Cinema and the Invention of Modern Life*. Berkeley, Los Angeles and London: University of California Press, 1–12.

Corbett, Kevin J. 2001. 'The Big Picture: Theatrical Moviegoing, Digital Television, and beyond the Substitution Effect', *Cinema Journal*, 40/2: 17–34.

Crary, Jonathan. 1992. *Techniques of the Observer: On Vision and Modernity in the Nineteenth Century*. Cambridge, MA and London: MIT Press.

Crary, Jonathan. 2001. *Suspensions of Perception: Attention, Spectacle, and Modern Culture*. Cambridge, MA and London: MIT Press.

Cubitt, Sean. 2002. 'Digital Filming and Special Effects', in Dan Harries (ed.), *The New Media Book*. London: BFI, 17–29.

Cubitt, Sean. 2004. *The Cinema Effect*. Cambridge, MA and London: MIT Press.

Darley, Andrew. 2000. *Visual Digital Culture: Surface Play and Spectacle in New Media Genres*. London: Routledge.

Dixon, Wheeler Winston. 2000. *The Second Century of Cinema: The Past and Future of the Moving Image*. New York: State University of New York Press.

Doane, Mary Ann. 2002. *The Emergence of Cinematic Time: Modernity, Contingency, the Archive*. Cambridge, MA and London: Harvard University Press.

Ďurovičová, Nataša and Kathleen Newman, eds. 2010. *World Cinemas, Transnational Perspectives*. New York and London: Routledge.

Elsaesser, Thomas. 1998. 'Digital Cinema: Delivery, Event, Time', in Thomas Elsaesser and Kay Hoffman (eds), *Cinema Futures: Cain, Abel or Cable? Screen Arts in the Digital Age*. Amsterdam: Amsterdam University Press, 201–22.

Elsaesser, Thomas. 2000. 'The New New Hollywood: Cinema beyond Distance and Proximity', in Ib Bondebjerg (ed.), *Moving Images, Culture and the Mind*. Luton: University of Luton Press, 187–203.

Enticknap, Leo. 2005. *Moving Image Technology: From Zoetrope to Digital*. London: Wallflower Press.

Enticknap, Leo. 2009. 'Electronic Enlightenment or the Digital Dark Age? Anticipating Film in the Age without Film', *Quarterly Review of Film and Video*, 26: 415–24.

Everett, Anna. 2003. 'Digitextuality and Click Theory: Theses on Convergence Media in the Digital Age', in Anna Everett and John T. Caldwell (eds), *New Media: Theories and Practices of Digitextuality*. London and New York: Routledge, 3–28.

Figgis, Mike. 2007. *Digital Film-Making*. London: Faber and Faber.

Friedberg, Anne. 1993. *Window Shopping: Cinema and the Postmodern*. Berkeley, Los Angeles and London: University of California Press.

Friedberg, Anne. 2006. *The Virtual Window: From Alberti to Microsoft*. Cambridge, MA and London: MIT Press.

Gabbard, Krin and William Luhr (eds). 2008. *Screening Genders*. New Brunswick, NJ and London: Rutgers University Press.

Gaines, Jane M. and Michael Renov, eds. 1999. *Collecting Visible Evidence*. Minneapolis and London: University of Minnesota Press.

Galt, Rosalind and Karl Schoonover, eds. 2010. *Global Art Cinema: New Theories and Histories*. New York and London: Oxford University Press.

Geuens, Jean-Pierre. 2000. 'The Digital World Picture', *Film Quarterly*, 55/4: 16–27.

Gledhill, Christine and Linda Williams, eds. 2000. *Reinventing Film Studies*. London: Arnold.

Grusin, Richard. 2007. 'DVDs, Video Games and the Cinema of Interactions', in James Lyons and John Plunkett (eds), *Multimedia Histories: From the Magic Lantern to the Internet*. Exeter: University of Exeter Press, 209–21.

Gunning, Tom. 1990. 'The Cinema of Attraction: Early Film, Its Spectator and the Avant-Garde', in Thomas Elsaesser and Adam Barker (eds), *Early Cinema: Space, Frame, Narrative*. London: BFI, 229–35.

Gunning, Tom. 1995. 'An Aesthetic of Astonishment: Early Film and the [In]Credulous Spectator', in Linda Williams (ed.), *Viewing Positions*. New Brunswick, NJ: Rutgers University Press, 114–33.

Gunning, Tom. 2000. ' "Animated Pictures": Tales of Cinema's Forgotten Future, after 100 years of Films', in Christine Gledhill and Linda Williams (eds), *Reinventing Film Studies*. London: Arnold, 316–31.

Hamlyn, Nicky. 2003. *Film Art Phenomena*. London: BFI.

Hansen, Miriam. 2000. 'The Mass Production of the Senses: Classical Cinema as Vernacular Modernism', in Christine Gledhill and Linda Williams (eds), *Reinventing Film Studies*. London: Arnold, 332–50.

Hansen, Miriam. 2010. 'Vernacular Modernism: Tracking Cinema on a Global Scale', in Nataša Ďurovičová and Kathleen Newman (eds), *World Cinemas, Transnational Perspectives*. New York and London: Routledge, 287–314.

Hanson, Matt. 2004. *The End of Celluloid: Film Futures in the Digital Age*. Mies, Switzerland: RotoVision.

Harbord, Janet. 2007. *The Evolution of Film: Rethinking Film Studies*. Cambridge: Polity Press.

Iordanova, Dina, David Martin-Jones and Belen Vidal, eds. 2010. *Cinema at the Periphery*. Detroit: Wayne State University Press.

Isaacs, Bruce. 2008. *Toward a New Film Aesthetic*. New York: Continuum.

Jenkins, Henry. 2006. *Convergence Culture: Where Old and New Media Collide*. New York and London: New York University Press.

Keane, Stephen. 2007. *CineTech: Film, Convergence and New Media*. Basingstoke: Palgrave Macmillan.

Kern, Stephen. 2003. *The Culture of Time and Space 1880–1918*. Cambridge, MA and London: Harvard University Press.

King, Geoff. 2005. 'Introduction: The Spectacle of the Real', in Geoff King (ed.), *The Spectacle of the Real: From Hollywood to Reality TV and Beyond*. Bristol: Intellect, 13–21.

King, Geoff. 2009. *Indiewood, USA: Where Hollywood Meets Independent Cinema*. London: I. B. Tauris.

Klinger, Barbara. 2006. *Beyond the Multiplex: Cinema, Technologies, and the Home*. Berkeley, Los Angeles and London: University of California Press.

Krauss, Rosalind. 1999. *A Voyage on the North Sea: Art in the Age of the Post-Medium Condition*. London: Thames & Hudson.

Langford, Barry. 2005. *Film Genre: Hollywood and Beyond*. Edinburgh: Edinburgh University Press.

Le Grice, Malcolm. 2001. 'Digital Cinema and Experimental Film—Continuities and Discontinuities', in Malcolm Le Grice (ed.), *Experimental Cinema in the Digital Age*. London: BFI, 310–20.

Lewis, Jon. 2001. *The End of Cinema as We Know It: American Film in the Nineties*. New York: New York University Press.

Lister, Martin, Jon Dovey, Seth Giddings, Iain Grant and Kieran Kelly. 2009. *New Media: A Critical Introduction*, 2nd edn. London: Routledge.

Lyons, James and John Plunkett. 2007. 'Introduction', in James Lyons and John Plunkett (eds.), *Multimedia Histories: From the Magic Lantern to the Internet*. Exeter: University of Exeter Press, xvii–xxv.

Manovich, Len. 2001. *The Language of New Media*. Cambridge, MA and London: MIT Press.

Massumi, Brian. 2002. *Parables for the Virtual: Movement, Affect, Sensation*. Durham, NC and London: Duke University Press.

Mitchell, William J. 1992. *The Reconfigured Eye: Visual Truth in the Post-Photographic Era*. Cambridge, MA and London: MIT Press.

Mitchell, W.J.T. 2002. 'Showing Seeing: A Critique of Visual Culture', *Journal of Visual Culture*, 1/2: 165–81. Reprinted in Nicholas Mirzoeff (ed.). 2002. *The Visual Culture Reader*, 2nd edn. London: Routledge, 86–101.

Morse, Margaret. 1999. 'Body and Screen', *Wide Angle*, 21/1: 63–75.

Mosco, Vincent. 2004. *The Digital Sublime: Myth, Power, and Cyberspace*. Cambridge, MA and London: MIT Press.

Mulvey, Laura. 2006. *Death 24x a Second: Stillness and the Moving Image*. London: Reaktion Books.

Mulvey, Laura. 2007. 'Foreword', in James Lyons and John Plunkett (eds), *Multimedia Histories: From the Magic Lantern to the Internet*. Exeter: University of Exeter Press, xv–xvi.

Naficy, Hamid. 2001. *An Accented Cinema: Exilic and Diasporic Filmmaking*. Princeton, NJ: Princeton University Press.

Naficy, Hamid. 2009. 'From Accented Cinema to Multiplex Cinema', in Janet Staiger and Sabine Hake (eds), *Convergence Media History*. New York and London: Routledge, 3–13.

Naficy, Hamid, ed. 1999. *Home, Exile, Homeland: Film, Media, and the Politics of Place*. London: Routledge.

Peeters, Heide. 2008. '*The Tulse Luper Suitcases*: Peter Greenaway's Left Luggage', in Paula Willoquet-Maricondi and Mary Alemany-Galway (eds), *Peter Greenaway's Postmodern/ Poststructuralist Cinema*. Lanham, MD: Scarecrow Press, 151–60.

Purse, Lisa. 2005. 'The New Spatial Dynamics of the Bullet-Time Effect', in Geoff King (ed.), *The Spectacle of the Real: From Hollywood to Reality TV and Beyond*. Bristol: Intellect.

Reiser, Martin and Andrea Zapp, eds. 2002. *New Screen Media: Cinema/Art/Narrative*. London: BFI.

Rodowick, D. N. 2001. *Reading the Figural, or, Philosophy after the New Media*. Durham, NC and London: Duke University Press.

Rodowick, D. N. 2007. *The Virtual Life of Film*. Cambridge, MA and London: Harvard University Press.

Rombes, Nicholas. 2009. *Cinema in the Digital Age*. London: Wallflower Press.

Rosen, Philip. 2001. *Change Mummified: Cinema, Historicity, Theory*. Minneapolis and London: University of Minnesota Press.

Samardzija, Zoran. 2010. 'DavidLynch.com: Auteurship in the Age of the Internet and Digital Cinema', *Scope*, 16. http://www.scope.nottingham.ac.uk/article.php?issue=16&id=1171, accessed 25 March 2010.

Schivelbusch, Wolfgang. 1986. *Railway Journey: The Industrialization and Perception of Time and Space*. Berkeley, Los Angeles: University of California Press.

Schivelbusch, Wolfgang. 1995. *Disenchanted Night: The Industrialization of Light in the Nineteenth Century* (trans. Angela Davies). Berkeley, Los Angeles: University of California Press.

Schwartz, Vanessa. 1998. *Spectacular Realities: Early Mass Culture in Fin-de-Siècle Paris*. Berkeley, Los Angeles: University of California Press.

Shaw, Jeffrey and Peter Weibel, eds. 2002. *Future Cinema: The Cinematic Imaginary after Film*. Cambridge, MA and London: MIT Press.

Singer, Ben. 2001. *Melodrama and Modernity: Early Sensational Cinema and Its Contexts*. New York: Columbia University Press.

Sklar, Robert. 1990. 'Oh! Althusser!: Historiography and the Rise of Cinema Studies', in Robert Sklar and Charles Musser (eds), *Resisting Images: Essays on Cinema and History*. Philadelphia: Temple University Press, 12–35.

Sobchack, Vivian. 2000a. 'What Is Film History?, or, the Riddle of the Sphinxes', in Christine Gledhill and Linda Williams (eds), *Reinventing Film Studies*. London: Arnold, 300–15.

Sobchack, Vivian, ed. 2000b. *Meta-Morphing: Visual Transformation and the Culture of Quick Change*. Minneapolis: University of Minnesota Press.

Spicer, Andrew. 2004. 'Film Studies and the Turn to History', *Journal of Contemporary History*, 39/1: 147–55.

Staiger, Janet and Sabine Hake, eds. 2009. *Convergence Media History*. New York and London: Routledge.

Stam, Robert and Ella Habiba Shohat. 2000. 'Film Theory and Spectatorship in the Age of the "Posts" ', in Christine Gledhill and Linda Williams (eds), *Reinventing Film Studies*. London: Arnold, 381–401.

Stewart, Garrett. 2007. *Framed Time: Toward a Postfilmic Cinema*. Chicago: University of Chicago Press.

Tredell, Nicolas. 2002. *Cinemas of the Mind: A Critical History of Film Theory*. Cambridge: Icon Books.

Tryon, Chuck. 2009. *Reinventing Cinema: Movies in the Age of Media Convergence*. New Brunswick, NJ and London: Rutgers University Press.

Wasko, Janet. 2002. 'The Future of Film Distribution and Exhibition', in Dan Harries (ed.), *The New Media Book*. London: BFI, 195–206.

Wasson, Heidee. 2007. 'The Networked Screen: Moving Images, Materiality, and the Aesthetics of Size', in Janine Marchessault and Susan Lord (eds), *Fluid Screens, Expanded Cinema*. Toronto and London: University of Toronto Press, 74–95.

Willis, Holly. 2005. *New Digital Cinema: Reinventing the Moving Image*. London: Wallflower Press.

Wollen, Tana and Philip Hayward. 1993. 'Introduction: Surpassing the Real', in Philip Hayward and Tana Wollen (eds), *Future Visions: New Technologies of the Screen*. London: BFI, 1–9.

Zielinski, Siegfried. 1999. *Audiovisions: Cinema and Television as Entr'actes in History*. Amsterdam: Amsterdam University Press.

Pragmatic Vision: Connecting Aesthetics, Materiality and Culture in Landscape Architectural Practice

KATHRYN MOORE

REDEFINING PERCEPTION

The main premise of this chapter is that a radical redefinition of the relationship between the senses and intelligence is way, way overdue. Written from the perspective of an experienced teacher and practitioner of landscape architecture, the chapter notes that the problems are not specific to this discipline alone, but are equally relevant to architecture, urban design and other art and design disciplines, as well as philosophy, aesthetics, visual culture and education more generally.

I will argue that making a fundamental shift in the way we think about how we perceive enables us to focus on what we see rather than what we imagine might lurk beneath the surface; it is the interpretation of what we see, the materiality of the world that should be the focus of visual culture studies and design theory if we are to teach design expertise and create the quality environments expected by society. Exposing the conceptual void and widespread cultural misconceptions created by current foundational theories of perception as well as elaborating the specific problems this causes within design pedagogy and the design process, the chapter outlines the consequences of adopting an alternative, pragmatic conception of consciousness for perception, visual skill, aesthetics, objectivity, language and meaning. It is set within the context of emerging radical design practices in landscape architecture.

EMERGING DESIGN PRACTICE

In the context of a growing response to the disastrous environments created in the last few decades, cities across the world have strategies for sustainability, long-term ecological balance, creativity and cultural identity. There is at last, a tangible recognition that the physical, cultural and social condition of our environment has a profound effect on the quality of life and is a key component of robust economic growth. We know that good-looking quality places lift the spirit and have a dramatic effect on people's morale, confidence and sense of self-worth. Dreary, unkempt, dysfunctional places make people feel unvalued and resentful. This is nothing but common sense really, a statement of the obvious. It's just a pity it's taken some of us so long to realize it. Now, it has become a political reality and we all have a responsibility.

With financial meltdown and climate change at the forefront of the new political agenda, an extraordinary but fragile renaissance is taking place as society, governments and investors are beginning to appreciate the true value and complexity of the landscape. This is reflected in the number and range of legislative initiatives emerging across the world, such as the European Landscape Convention, a UNESCO proposal for an International Landscape Convention and a number of national and regional landscape charters being developed in Central America, Asia Pacific, Australia, Costa Rica, Brazil, Mexico, Argentina and Colombia.

Running parallel with these legislative and policy initiatives there is evidence of a considerable shift in planning and development hierarchies, with landscape determined as the lead driver for change, an important economic and social concern that is now firmly on the mainstream political agenda. Examples include the speculative West 8 Blue Isles Plan to create artificial dune islands off the coast of Belgium and the Netherlands to neutralize the rising sea level for the coming century and provide a million small estates, and Palmboom and van der Bouts plan for 450 hectares of urban extension at Amsterdam. This consists of 18,000 dwellings on the IJmeer Lake, which has six islands of different sizes, where the city and the water work together as a whole, the buildings are treated as part of the landscape and the configuration of land and water, and the composition of shorelines preceded the land use planning decisions. Integrating nature and culture, dealing with issues of expertise and public aspirations, with conservation and design, protection and the creation of new landscapes is the landscape-planning project for the Black Country Consortium in the West Midlands. Based on the concept of broadening horizons, derived from an understanding of the region's topography, the history of mineral exploitation and landscape despoliation, Capita Lovejoy proposes to manipulate layers of urban topography, urban floor and urban architecture to radically change the visual and spatial identity of the region over a thirty-, sixty- and ninety-year period.

Illustrating the point that regarding landscape as a resource that is environmental, economic and social is valid, Juurlink and Geluck's Leek-Roden Inter-municipal landscape masterplan for 6,000 dwellings and 110 hectares of business activity on the Drents plateau proposes a new model of scattered development to create great diversity in living environments by spreading the dwellings along subtly different landscape types

and characters. An embryonic proposal in Costa Rica to plan the expansion of the city within the context of the surrounding mountains, taking into account the uniqueness of the urban form of central San Jose, considers the cultural iconography and narratives of its landscape, as well as its biological, horticultural and agricultural potential.

Cutting across the traditional artistic/ecological divide are projects such as Vall d'en Joan in Spain. Here, Batlle i Roig's extraordinary idea is to work with the engineers' technological requirements to reclaim the valley from being merely a dump for urban waste by creating dams and platforms, but to transform them into terraces and fields, using technical, agricultural solutions to re-create the romance of long-lost agricultural landscapes. Along a 75 km stretch of coast on the Dead Sea, Gross Max assesses abiotic, biotic and human factors along with the requirements of future users and the availability of flat land to inform the development process in areas where there is little rain and tourism is seen as the only way to sustain the economy (Topos 1998; Gross.Max. 2007).

Unafraid of engaging with aesthetics, the Norwegian Public Road Authority has created the necessary legislation to require multidisciplinary working across many departmental boundaries, to deliver a national and local strategy for the highway infrastructure. The ambition is to design all new roads without adversely affecting important landscape features and significantly, to add beauty to the surroundings. The Rainbow Route across the Netherlands, with 120 km of infrastructure, including the motorway, town centres, recreational areas, agriculture, forestry, housing and business activity, being developed as one project by the Dutch Ministry of Spatial Design, Water Management and Transport exemplifies an integrated approach to development, planned and co-ordinated from a landscape point of view.

Focussing on the relationship between people and their physical environment as well as demonstrating the connection between research and artistic practice, Mathur and Cunha redefine the edge between the sea, the monsoon and river in an exhibition challenging conceptions of Mumbai's relationship with water (Mathur and Cunha 2009), and in the Living Lottery project in Birmingham, Spaghetti Junction is taken as a point of arrival rather than as a means of escape, as something to look at and watch from nearby and far away requiring an investigation in terms of its topographical location, locally and regionally. The important ethical and democratic dimension of this renaissance is reflected in projects such as the Right To Landscape movement (a collaborative initiative between Lincoln University, New Zealand, the Cambridge Centre for Landscape and People (CCLP) UK and the American University of Beirut (AUB), Lebanon). This chapter explores theories relating to the value of landscape and ways in which it could become a positive tool to protect human rights, working towards justice and the well-being of indigenous populations and local communities.

Each of these demonstrates that it is no longer enough to simply consider the landscape or take it into account. It is not an afterthought, the bits left in between the buildings, developments, highways and town centres, or a vague blanket cover that will look after itself. Given its proper status, it is the context upon and within which these dynamic processes take place. With all of its cultural, social and physical potential, the landscape is seen as a base layer, against which decisions about all future development

need to be made. It is precisely these kinds of holistic strategies that are important in addressing the major challenges of industrialization, urbanization, energy, demographic shifts and changing patterns of work and habitation, as well as climate change, the depletion of natural resources, de/forestation, problems relating to food production, biodiversity, heritage, a host of issues relating to the quality of life and other aspects of land use change and development.

These projects are, however, exceptional. To have any real chance of providing a sustainable and lasting blueprint for the landscape, this way of working needs to become whole heartedly absorbed into all of the decision-making institutions and organizations responsible for policy, strategic or regional planning at a national and international level, as well as, of course, in education. To do so requires reevaluating many of the assumptions we have about the nature of the visual, aesthetics, the design process and landscape, so that these kinds of projects do not happen by chance, but by design. One way to do this is by developing a pragmatic, holistic approach to consciousness and perception.

This helps clarify and resolve the great design riddle: why it is still largely considered to be unteachable and how we can dismantle this old idea?

DESIGN DICHOTOMY

The role of design in all of this is far from clear, in fact it is rather tenuous, fragile and easily dismissed. It is of course, possible to teach many aspects of design—design theory, criticism, history, its technology and modes of communication. There are guides on collaboration, team building and how to carry out design reviews. But the real nitty-gritty of the discipline, the designing part of design, is clouded by subjectivity, and therefore somehow impossible to teach. Spectacularly ill defined, it is often seen as a highly personal, mysterious act, almost like alchemy. And then there is the dangerous idea that it is possible, indeed preferable, to hide behind the supposed objective neutrality implied by the more 'scientific', technology-based, problem-solving approaches. We even hesitate about defining what it is that designers do, considering talk about aesthetic and artistic sensibility, let alone design expertise to be a contradiction in terms.

CHALLENGING FOUNDATIONAL THEORIES OF PERCEPTION

The problem is philosophical. Endlessly nuanced and variable, the general picture we have of the perceptual process depends on a sensory interface or mode of thinking that somehow intervenes on our behalf to organize various inputs in order to serve intelligence—a 'disastrous idea that has haunted Western philosophy since the seventeenth century' (Putnam 1999: 43.) As a result, significant chunks of the design process are lost in an arcane, sensory miasma, the consequence of a damaging metaphysical duality that has slipped under the intellectual radar, disguised in visual and perceptual theories. The challenge is to develop a greater understanding as to what designing means, in both theory and practice, by disengaging it from such primitive bodily ways

of knowing, separating it from psychology and using a fresh, common sense approach
to bring materiality back into the picture.

The core argument has been developed by taking one of the main preoccupations of
contemporary cultural discourse, the argument for and against the existence of universal
truth, and carrying it into the perceptual realm by adopting a pragmatic line of inquiry
which questions the very nature of foundational belief. With this one pivotal adjust-
ment, the whole metaphysical edifice built on the flawed conception of a sensory mode
of thinking comes tumbling down. Constructed in its place is a means of dealing with
spatial, visual information that is artistically and conceptually rigorous, making it pos-
sible to move debate into the real world informed by knowledge and ideas.

The villain of the piece is an old philosophical tradition that actually prevents us
from having informed discussions about the significance of the way things look, the ma-
terial, physical qualities of what we see. Reinforced by a host of beliefs, myths and fables
it exiles materiality to a metaphysical wilderness where it languishes, separated from in-
telligence, safely hidden out of sight, out of mind. Manifested in the interface thought
to exist between us 'in here' and the real world 'out there', likened to a veil, this is what
is thought to help correlate, crystallize, process or structure our sensory impressions. It
is called many things—a sensory modality, visual thinking, the aural or tactile modal-
ity, the experiential, the haptic, even unfocussed peripheral vision. Whatever it is called,
however it is characterized, it is there to pick up the really important stuff. It sifts the
wheat from the chaff, sorts out the things worth noticing. Discriminating on our behalf,
it helps us understand the world. Dig deep enough, however, and all you find are value
judgements masquerading as universal truth, the 'real' truth that exists 'out' there if only
we look hard enough, or are lucky enough to be clever enough, or sensitive enough to
find it. The actual mechanics of it remain a mystery or as Jay puts it 'somewhat clouded'
(Jay 1994: 7). From a pragmatic point of view, this perceptual whodunit is insoluble
because the entire plot is based on a rationalist belief in different modes of thinking and
prelinguistic starting points of thought, a set of assumptions that have been with us so
long they have become a part of common sense. It is difficult to exaggerate how much
the general understanding of intelligence is dominated by this divide and, in turn, the
difficulties it creates.

FRAGMENTING CONSCIOUSNESS

The visual, sensory mode of thinking is perhaps the most celebrated expression of this
interface. There are contradictory views of the visual. The focus of considerable atten-
tion, on the one hand it is regarded as the holy grail of art education yet at the same
time is derided and despised by many philosophers and design theorists. The most com-
mon view characterizes the visual as an ancient, more primitive mode of thinking, less
sophisticated than verbal thinking, which is supposedly conceptual, intellectual and
on a higher level (see Koestler 1964; Goldschmidt 1994). Each is thought to involve
a different cognitive style. Visual thinking, it follows, having nothing to do with in-
telligence, is more likely to be subjective, intuitive and irrational, 'chaotic, instinctive

and unpredictable' (Raney 1999), whereas verbal thinking, more usually associated with the cool rationality of language, is apparently linear, analytical and logical. A raft of misconceptions directly related to this basic premise sets the scene for a diminution of the visual, not only as a cognitive style, but also in the act of looking, the skill of seeing and the physical appearance of things. The situation is made all the more complex by the presumption that the senses are discrete and function separately. This implies that not only do we use a sensory mode of thinking, but also experience the world selectively, one sense at a time, for example visually, orally or simply through touch. It informs the idea that things can be designed in a way that privileges one particular sense over another and even that landscapes or art can be appreciated from one sensory dimension, all of which is done viscerally, without thinking. But is it really possible to design for sound and touch, without considering the spatial or visual implications? Spatial dimensions, roughness, smoothness, materials, themselves have visual, aural and tactile qualities. It is impossible to separate them. Is it reasonable to suppose that we can suppress our sense of smell, taste and touch? True, you can stick your fingers in your ears, to block out the passing traffic, but it is impossible to decide not to hear it, even though you may not always notice it. It is impossible to be in a landscape and decide not to feel the wind and the rain, not to sniff the air or hear sounds of life. You can protect yourself against them, you may well take them for granted, become casual about what notice you take of them, but you can't just decide them away.

The notion that the sensory inputs are separate, engendered by the penchant for dividing up consciousness, comes about, Dewey explains, because we presume that since we see a painting through our eyes and hear music through our ears, it is only too easy to think that such visual or auditory qualities are 'central if not exclusive' to the expression of the ideas, to the immediate nature of the work and to the way we experience the work (Dewey (1934) 1980: 123). Nothing he adds, 'could be further from the truth'. Suggesting that a painting or the smell of bread, 'are stimuli to which we respond with emotional, imaginative and intellectual values drawn from ourselves ...', he argues these are not to be seen as separate responses to be synthesized (no matter how quickly), but one response only (Dewey (1934) 1980: 123).

An added complication and contradictory scenario engendered by the distinctions made between vision and the other senses is fed by what Jay calls an 'essentially ocular-phobic discourse' (Jay 1994: 15). With a vigorous denouncement of a so-called cultural over-emphasis on what is characterized as the dominant 'cool and distant realm of vision' (Pallasmaa 1994: 29), once again, the visual is singled out as a prime suspect, but this time from an entirely different perspective. Ingold summarizes the list of trumped-up charges brought against it,

> that sound penetrates, whereas vision isolates, that what we hear are sounds that fill the space around us whereas what we see are things abstracted or 'cut out' from the space before us, that the body responds to sound like a resonant cavity and to light like a reflecting screen, that the auditory world is dynamic and the visual world static, that to hear is to participate whereas to see is to observe from a distance, that hearing is social

whereas vision is asocial or individual, that hearing is morally virtuous whereas vision is intrinsically untrustworthy, and finally, that hearing is sympathetic whereas vision is indifferent or even treacherous. (Ingold 2000: 251–2).

It's an impressive list of crimes and misdemeanours, prosecuted in particular by phenomenological discourse, with the visual as chief perpetrator and villain of the piece. Now installed as the primary instrument of objective knowledge it is held responsible for architecture having apparently turned 'into the retinal art of the eye' (Pallasmaa 1994: 29), creating a lack of sensuality or experience of being in the world, which is what Heidegger refers to as a loss of nearness.

The separation of the senses, one from another, together with the fallacy which William James identifies of casually borrowing psychological principles and terms to explain concepts that have nothing to do with psychology (James 1884: 65) makes it almost inevitable that the perceived characteristics of a visual mode of thinking, either with all that irrational, subjective or cool and distant baggage attached, impacts on every aspect of the visual, physical world. Causing mischief and mayhem, it is, Ingold remarks, as if 'vision had been compelled to take on the mantle of a particular cognitive style and all the virtues and vices that go with it' (Ingold 2000: 286). The weight of prejudice against the visual distorts our conceptions of images and almost any other kind of so-called visual information and the visual dimension of materiality, if considered at all, is regarded with suspicion. Reflexively we associate graphics, for example with 'illiteracy, delusion, shape shifting and colouring emotion' (Stafford 1997: 11). Images are seen as deceptive, seductive and notoriously unreliable, and questions of form, subjective and certainly not worthy of much attention. We are urged to 'avoid the gravitational pull of the object' (Borden and Rendell 2000: 5) and warned that focussing on what something looks like is an unnecessary indulgence, a 'retreat into form' used to 'justify inattention to function, construction, environment, and so on' (Schuman 1991: 4–5).

CULTURAL MISCONCEPTIONS

Although rarely articulated, the concept of a sensory interface is hugely pervasive, affecting almost every facet of Western culture. Henry James described it as a theory that 'cheats us of seeing' (Henry James to Robert Louis Stephenson, on 12 January 1891 (Putnam 1999: 3)). What is also evident is that it robs us of artistic sensibility too. It lies at the heart of the common idea that art involves a different conceptual framework from science, a different mode of thinking, that art is a pleasurable pastime whereas science is a serious endeavour and that it is possible to forget all you know in order to fully appreciate a piece of music, a painting or the landscape, embracing the sensuality of the experience with a clean slate, uncontaminated by knowledge or rationality. Why, despite so much evidence to the contrary, do we still characterize scientists as cool, detached, unencumbered by emotion and artists as passionate, subjective and slightly deranged, why do we think decisions can be made on the one hand intuitively without knowledge and on the other objectively, without value judgements?

EPISTEMOLOGICAL CRISES

The prevalence of this dogma explains why a premium is put on reading or writing rather than drawing. We are not learning to be aware of our surroundings, to recognize our responses to place and space and are rarely shown why things look like they do given the time, place or context. More generally, it skews the way intelligence is defined or what counts as valid knowledge and gives a prejudicial and narrow view of the role of language. The same implacability militates against arguments for resources, space, time or money in competition with more so-called rational disciplines. Nullifying any educational rationale for substantial areas of decision making within the arts there is instead a misguided dependence on concepts such as creativity, the genius loci, ideation or the mind's eye, delving into the subconscious or sharpening intuitive responses. Whilst this makes what designers do seem rather mysterious and intriguing, it is in fact, deeply questionable. Responsible for the continuing distinction made between theory and practice, the separation of ideas from form, emotions from intelligence and a host of other misconceptions, the sensory interface fuels the myth that anything other than the purely practical or neutrally functional is a bit iffy, too subjective, a matter of taste really and best avoided. Giving the impression that concepts such as artistic rationality, aesthetic sensibility and design expertise are contradictions in terms rather than credible educational objectives, it baulks any attempt to provide a convincing rationale for art education, still generally regarded as 'nice but not necessary' as Eisner reluctantly admits (Eisner 2002: xi).

IMPLICATIONS FOR DESIGN PEDAGOGY

Educationally this is disastrous. At the centre of aesthetic experience, the sensory mode of thinking is what students are expected to reap the benefits of, if they are to be in any way successful. But the fundamental dichotomy between body and mind enshrined in theories of perception actually creates insoluble puzzles within aesthetics that inevitably spill into design discourse. Is the aesthetic frisson created by the recognition of a perfect, and unchanging truth out there in the world, or a resonance with innate archetypal structures in the mind? Or to put it another way, is beauty objective or subjective?

Aesthetics, almost more than any other discipline, is dependent on the idea of universal truth. It doesn't seem to matter whether it is approached from a position that is highly esoteric and obscure or the sensual, foggy perceptual world of feelings or from one that is transcendental or empirical in perspective. In aesthetic theory, what really counts are the universal superstructures that stand outside culture but act to underpin and unite our responses. In the attempt to identify these universals, in here, out there, somewhere, we are supposed to set aside all reason, opening ourselves without reservation to what is outside of us in order to sense something 'other'. From a pragmatic perspective, asking anyone to step outside of what they know to sense significance or beauty as it really is, without the encumbrances of knowledge and culture, is as pointless as it is ridiculous.

Then, most damaging of all, running through a whole range of design theory is the highly pejorative attitude towards the visual, underscoring the supercilious contention that whatever it is that determines our responses, it is certainly not 'merely' visual. It may well be acknowledged as a component, but is also thought to be a distraction. The physical, material qualities of place are thus edged out of the frame because an appreciation of such things is considered too subjective or ephemeral. Marginalizing the visual dimension is to sideline the physical form of the landscape, which is systematically overlooked in the search for invisible or hidden meaning to supply the aesthetic buzz. As a result, we have lost the art of critical looking. Through long-term neglect and discrimination, we no longer have the confidence, the appetite or even the language to talk about appearances. It is abundantly clear however, that we live and work in a visual, spatial medium. It is both pretentious and foolhardy to think we can manipulate it without knowing the implications of what we are dealing with. Undervaluing the cultural and social implications of appearances disables attempts to understand the impact the quality of the real, tangible environment has on the quality of life.

There is a more insidious side to this. Legitimizing a numbing passivity in the eye of the beholder, it is the senses and the like that call the tune. It makes no difference if the agency is a belief in unconscious or subconscious archetypal structures in our minds or unchanging significant truths in the world, the process depends on the senses having a perceptive resonance or moment of clarity in order to recognize and filter information for us. In other words, it lets us off the hook.

In thrall to the unconscious, deep-seated structures or archetypal resonances (things which by definition we can never, ever know), we use the site, intuition, God, ecology, universal morality, whatever takes our metaphysical fancy, to justify our beliefs and desires, rather than come clean and take responsibility for our own thoughts and actions in response to what we know. In doing so we are unwittingly building a safe house for all kinds of hidden agendas. Since the visual dimension in particular is increasingly swept under the philosophical carpet, other criteria are called upon to do the aesthetic legwork. In this way, the concept of the genius loci for example obscures a whole range of aspirations, including the call for a return to old ways of seeing, utilitarian pleas to design the practical way, the search for symmetry and balance, ecological diversity, public participation and classical architecture, process rather than product and, like John Major's cricket and warm beer, sentimentality, a longing for a time and place that exists only in the imagination. Such constraints become integral parts of what Johnson describes as a 'false consciousness' projected by architects 'about the correctness of what they design, mostly without external verification' (Johnson 1994: 394).

But perhaps most damaging of all is that an implicit and pervasive dependence on such concepts often serves to reinforce existing preconceptions and prejudices rather than encourage a more challenging or imaginative approach. It is an easy way to relinquish the responsibility we have as designers to investigate, analyse and interpret the significance of what we see in a critical, grounded, culturally astute way. It has a stultifying impact on design practice. It is an easy option and a bad habit, and currently it is fuelling a pervasive emphasis on 'process and programmatic context' rather than content.

THE PRAGMATIC APPROACH

The alternative is not about rethinking how to design. There are many brilliant design-ers around who know how to do this only too well. It is more about reassessing how we think we think we design. Using an entirely different basis from which to understand the way we think unlocks a major part of the debate. The philosophical argument is sur-prisingly simple. Rorty and other pragmatists insist that it is a mistake to assume there is a difference to be made in the first place, wrong to think consciousness is fragmented into different kinds of knowing or intelligence or different conceptual spheres of knowl-edge. In addition, the characteristics of the subjective/objective dichotomy that theo-rists and thinkers have been trying so hard to dispel over the last few decades matches precisely that of the visual/verbal duality. Both have the same foundational basis. If one dichotomy can be proved erroneous, then so can another. One simple move, take away the foundation stone, the very idea that there are different modes of thinking, and there is no need to worry about how the different realms can be reconciled. All those intrac-table problems melt away.

Disassemble the argument for different types of reasoning and the idea that there are different ways of thinking is similarly undone. From a pragmatic perspective, it follows that neither uses a special kind of reasoning. Essentially, this is to say that we think the same way no matter what we happen to be thinking about. In understanding emotions or equations, formulae or artistic responses we interpret, reinterpret, judge and try to make sense of our feelings because there is simply no other way to make sense of what we see, to make sense of the world. Just because we are looking at a painting does not mean we are thinking in pictures, or that when we are reading a book, we are thinking linguistically. Whatever grabs our attention or catches our eye, no matter what gets us thinking, we al-ways get to think about it by the same route, through language. There are no exceptions, no special cases, ifs or buts. Language binds us, separates us, it quite literally defines us.

REWORKING PERCEPTION

'Offering a middle way between reactionary metaphysics and irresponsible relativism' (Putnam 1999: 5), redefining the relationship between the senses and intelligence means that essentially there is no need to choose one or the other. This releases us from the end-less debate between positions that are natural or cultural, classical versus romantic, scien-tific or artistic, theoretical from practical, value-laden from quantitative, or approaches that are personal or community-based. This significant transformation comes about for the simple reason that we are no longer required to fathom out all those complicated in-teractions between 'sensations and the shaping or judging capacity of the mind' or quite how much 'participatory dimension' there is in the visual process between spectator and object (Jay 1994: 30). This new approach is not based on concepts of subjectivity or ob-jectivity. It is interpretative, but not hermeneutical. Following the interpretative line a step or two further, it argues that not only is reasoning interpretative, as Best (1992) and Snodgrass and Coyne (2006) have suggested, but that perception also is interpretative.

Rather than arguing as Arnheim and many others have done, that we should recognize the intelligence of perception, it is to argue that perception is intelligence.

Collapsing the visual, intelligence and language and many other elements of consciousness into a holistic concept of perception takes the supernatural element of design theory and education out of the equation and reveals that far from masking design ability or creativity, concepts and language actually allow us access to the arts, both in its making and criticism. This radical shift makes it possible to get what Bryson calls 'a firm grasp of the tangible world' (Bryson (1999) 2001: 31). A question of developing a common sense realism about conception and perception, rather than trusting the world to pass messages to us through sense data, perfect forms or amenable spirits, we can rely on our reactions and responses being entirely dependent on the sense we make of what we see. We respond to the world through intelligence and that response is informed by education. This has implications for notions of truth, visual skills, aesthetics and objectivity.

Truth

The challenge of negotiating the territory between the subjective and the objective is to avoid the assumption that real, unchanging truth is the ultimate end point of inquiry, whilst simultaneously avoiding being sucked into the argument that the only alternative is to believe everything is relative and dependent on a point of view. Put slightly differently, we should refuse the prop of believing there is such a thing as objective neutral truth, but also avoid dismissing things we don't like or understand or agree with as value judgement, subjective opinions or questions of taste. In any field of endeavour this takes some thinking about.

Ditching the idea of universal truth as a guide is not the same as saying that truth does not exist. It is absolutely true that this table does exist. I definitely did have bacon and eggs for breakfast but these absolute truths are of no particular significance. No matter how scientifically a site can be defined, all this will ever be is one kind of description—no closer to the essential truth about the site than any other, and as with any other kind of truth, it will also be open to question and subject to change. Truth is shifting, flexible, sometimes enduring but never immutable. Significantly, it is also not a matter of questioning the existence of objects in the world. If there were a tiger in this room, even the most militant existentialist would not sit there questioning the reality of it being there. Most people would run and not because of some deep-seated recognition of the intrinsic nature of 'tigerness' but because they *know* that tigers are dangerous. The tiger incontrovertibly does exist. The point is, what do you make of it?

Visual Skill

The benefits of this shift are considerable. From this new perspective visual skill, rather than being a particular mode of thinking, is an educated awareness of the traditions of the landscape as well as its physical materiality. It is about having a strong sense of our culture, neither generic nor archetypal, but a learned, cultivated skill, comprising

observation and discernment within the traditions, materiality and ideas of a particular medium. It is a truly critical component of artistic sensibility. To consider the visual in this light makes it possible to learn about why landscapes look the way they do, how and why we respond to places and then applying this knowledge to design. When you first see the Manhattan skyline or the Statue of Liberty, for example the impact is so intense because of the associations gleaned from numerous books, films and anecdotes. These influences flood in because we recognize directly the physical fabric of what we see, its spatial, visual qualities, its form and character, its myths and legends.

Aesthetics

As far as aesthetic-theory is concerned, effectively booting out the presumption that there is something psychologically elemental in our responses, aesthetic experience is real enough, but not in the way it has traditionally been conceived. What might cause an aesthetic experience, the object or the activity, is immaterial. It's the response that counts. If we are lucky, we will be rendered speechless by the power of a painting, the beauty of a landscape, or the balance of a mathematical equation. Pleasurable, emotional, moving and inspiring experiences can happen when reading a classic novel or merely wandering down the street—it is not the painting that counts, or the landscape or the music, but the quality of the experience. Since the quality of the experience we have is defined by what we know, this makes it entirely accessible. Knowledge we can teach, judgements and values can be learned.

Objectivity

Having startling consequences for the roles of language, the emotions, intelligence and subjectivity, it also changes our concepts of objectivity. The bottom line is that in any study, design or otherwise, we are constrained or liberated by the language and concepts we have at our disposal. There is no other way of knowing, no other kind of meaning to uncover, no genial spirits to give us a nudge in the right direction. Not the site or what lies beneath, within or without it, nor even the fears and desires of our prehistoric ancestors. The point is that in science just as much as in the arts, our interpretation of problems and their potential solutions changes as Bryson suggests, 'as the world changes' (Bryson 1983: xiv). There can be no final analysis based on absolute knowledge. We need a healthy measure of scepticism to deal with the hard facts enshrined in regional spatial plans, perennially used to justify the economic imperative for new roads, the distribution of new settlements, how big they should be or the cost the market will stand in terms of quality housing or town centre development. The evidence of such quantitative 'factual' decisions is only too clear. Just look around any town or city.

THE DESIGN PROCESS

Reevaluating these fundamental assumptions inevitably impacts on our thinking with regards to many aspects of the design process. Technology for example rather than the

mechanical or practical part of a project, we have to see as a means of understanding how far materials might be pushed or manipulated in order to express ideas with style and confidence. Drawing, rather than somehow accessing intuition, grazing the senses, making us more aware of our emotional responses or kicking part of the brain into touch, is simply a way of working things out, exploring ideas and speculating about possibilities. As an investigative tool it is hard to beat. It is also a matter of realizing that 'meaning is not simply something "expressed" or "reflected" in language: it is actually *produced* by it' (Eagleton 1983: 60). There is no other way for meaning to be manifest. This is the case in all experience. That is as far and as deep as it goes.

Implications for Theory

It sets a different kind of scenario for theory too. Theory is often characterized as something to be applied, or invoked as and when necessary, thought to be the language of critics, not designers. Redefining the relationship between artist and critic and therefore between theory and practice, Dewey argues that when creating art, 'the act itself is exactly *what* it is because of *how* it is done. In the act there is no distinction, but perfect integration of manner and content, form and substance' (Dewey (1934) 1980: 109). Explaining that it is only upon reflection that distinctions can be made between what is done and how it is done, this is the kind of theory that is needed, a body of work that will indicate, if it does its job properly, the relationship between materiality and ideas, form and content.

Esoteric or down to earth, jargon-laden or straightforward, these reflections are precisely what develops an understanding of the language of the medium. There is an urgent need to refocus and develop theory that is insightful enough to inform design. This new kind of theory would not be particularly concerned with whether an approach is semiotic, structuralist, or poststructuralist, phenomenological or even hermeneutic. There would be no need to fight one philosophical corner against another and unnecessary to depend on the language or jargon of that discourse in order to make a point. The main purpose is to delve into the particularities, appropriateness and expression of certain ideas in built form, given the place, time and context.

Generating Form

Recognizing that both perception and language are interpretative removes a blindfold. It is the final radical shift that enables us to understand one of the most obscure aspects of the whole design process, that of generating form demonstrating the indivisibility of ideas, theory, expression and technology in practice, realizing that it is as impossible to design without concepts as it is to talk without a tongue. Sensible discussions can emerge about the making of informed, imaginative and often-difficult design decisions, making it clear that there is nothing mysterious about all this. These decisions are the nuts and bolts of the process. An artistic rationale if you like.

Dispensing with the metaphysical dimension of perception introduces a much-needed critical element to all of design education, not just certain parts of its theory or technology. As an approach it certainly rattles some cages. But it helps to democratize

the design process. Not only does it rid us of many intractable problems associated with design theory and philosophy but also from a student's point of view, he or she can at last stand up and give a proper rationale for his or her work. The student can lead the critic and to a certain extent, take control. It shifts the balance of power a little. Adopted in the studio, what makes this approach more liberating is that students, instead of being left with the sinking feeling that they must be missing that indefinable something, are able to start working confidently with ideas, expressing and adapting them within the medium or brief. They can be assured that progressing their design skill is a question of learning not voodoo. No-one is suggesting that every student will become a brilliant designer, but at least everyone stands an even chance of learning *how* to design, which has to be better than being led to believe that it's an inherent ability, a gift you might never manage to open.

THE ARTISTIC, CRITICAL BASIS OF DESIGN DISCOURSE

The understanding that even the most intimate, seemingly mystical elements of the design process are based on knowledge and knowledge alone prepares the ground for a fresh artistic and conceptual approach to design, as well as establishing it as a holistic, critical endeavour. We need to recognize that there is no choice but to engage with ideas at every stage of the development process, whether this is in the initial research, finding a concept, inspiration for a design or surveying the scene. It is a question of realizing that preconceptions and habits of thought inform every aspect of our decision making, any judgements we make about the value of what we find. The recommendations we make for future proposals, how and why we draw up a scheme in a particular way or plan the long-term management and care of the land, all are shaped and framed by our language and ideas, by what we know.

The unequivocal focus this analysis of consciousness gives to knowledge enables us to define design more sensibly, taking it beyond the rather trite suggestion that 'design' is simply what designers do. Design is a question of research and decision making. Designing is about making propositions, presenting a vision for the future. Central to the discipline is the forward-thinking, the anticipatory and predictive nature of its practice. On this basis, those who have a responsibility for the landscape (in its broadest sense), whether they deal with words rather than drawings, a computer rather than a pencil, they are effecting, predicting or managing spatial change. It all has a visual dimension; it is all about designing one way or another. But the point is that it does take considerable expertise to do it well, to work with and express ideas through technology, in a spatial, visual medium, whatever the scale, from the most ecological to the most hi-tech, from the restrained to the exuberant.

SHAPING THE QUALITY OF EXPERIENCE

Moving the debate away from the arcane and unknowable into the real world informed by knowledge and ideas serves to remind us how much theory and philosophy can

learn from practice, rather than the reverse and drives home the point that theory and philosophy need not necessarily be metaphysical by nature. Using a new paradigm to work out old problems, the philosophical argument changes the nature of the discourse, not by discovering a new language as such, but by fusing, overlaying and cutting across concepts that have up till now been compartmentalized and segregated by a collection of psychological and philosophical beliefs packaged, promoted and sold so successfully over time that they have become part of our way of life. It has wider social and political implications and demands. From this perspective, landscape is not just about ecology, nature conservation or matters of heritage. It's not only the physical context, the constructed public realm, the national parks, coastlines, squares, promenades and streets, but it also reflects our memories and values, the sense of pride we share in the places where we work and live, the experiences we have of a place, as citizens, employers, visitors, students and tourists. It is the material, cultural, social context of our lives.

The landscape is about ideas, and the expression of these ideas shapes the quality of our experience. Rather than ideas versus nature, we have ideas of nature. Instead of seeing nature as something separate from culture, from ourselves, we must recognize that in the way we live our lives, with every intervention we make, we are expressing (consciously or not) an attitude towards the physical world. The choice is not whether we work with art or ecology, with nature or culture, but how considerately, imaginatively and responsibly we go about our business, because for every one of our actions, there is a reaction in the physical world. We impact on it every minute of every day of our lives. Where we decide to build new cities or expand old ones, place streets, squares, parks and gardens. How we do this, why we do this, reflects the value we place on the quality of our environment. Working with natural processes, given the global challenges we face, is an ecological imperative. We have no choice in the matter. But it is the whole thing, the ideas and values we hold and their expression in physical form, be it green, gray or blue, that defines us. This is what frames the experience we all have of the places we live in, and it is this experience that is a properly relevant definition of nature. After all, natural systems don't stop where the buildings start.

It is difficult to overestimate the role of language in all of this. At present, the constructed public realm is dismally misrepresented as public open space, recreational space or green space. The paucity of official planning jargon inevitably leads to an ignorance in policy and often in practice, of the rich complexity and subtlety of the physical context, thereby seriously underestimating the impact it has on the quality of life. To address the problem therefore, we must look to change the habitual descriptions and references. A more differentiated vocabulary, making explicit the quality and character of places, one that elucidates the multitude of uses and functions of space from the highly symbolic to the everyday, is needed to make the physical fabric of our lives more tangible. To effect real change, an evocative, expressive way of speaking that accurately reflects the way we live our lives has to permeate official documents and guidelines, become accepted and then expected in project and competition briefs and so on. If we really want to fully articulate the way we experience the world, there can be no room for the dry bureaucratic talk that squeezes the life out of any debate about place and space. It is not as though we are stuck for ideas. There is a

wealth of literature and research, evidence scientific, academic and anecdotal, imaginative narratives to inspire and show us things we hadn't noticed in the world.

Shifting paradigms from the metaphysical to the pragmatic enables us to understand more about the nature of visual skill and the role it plays in design. It does not mean that mystery and ambiguity no longer have a place, or even that designs cannot be inspired by metaphysical concepts. But it does mean that we can remove some of the mystery from the actual process of designing. Visual skill can be seen as something that we need to learn in order to become designers. With metaphysics out of the picture there are no universal qualities of beauty, no perfect forms to find. Some things are enduring in their appeal, like Trafalgar Square or the gardens at Stowe. Others are more ephemeral, their appeal short-lived, like almost any shopping centre created in the latter part of the twentieth century or BMX bikes or graffiti. The role of fashion and style, so pivotal when purchasing cars, shoes, T-shirts, changing as it does from week to week, year on year, is not merely inconsequential second-hand aesthetics; on the contrary, it is absolutely key to our sense of culture, identity and visual awareness. Dewey's suggestion that aesthetics is 'a manifestation, a record and celebration of the life of a civilisation, a means of promoting its development and is also the ultimate judgement upon the quality of a civilisation' (Dewey (1934) 1980: 326) hands us the responsibility to ensure the record is a good one.

Ditching the metaphysical baggage embedded in current theories of perception enables us to articulate the art of design, teach the generation of form, connect spatial strategies to real places and develop ways of working that not only encourage but also demand the expression of ideas, the ideas that are fundamental to the design process.

FURTHER READING

Bryson, N. 1990. *Looking at the Overlooked: Four Essays on Still Life Painting*. London: Reaktion Books.

Dewey, J. 1934. *Art as Experience*. New York: Berkley.

Eagleton, T. 2003. *After Theory*. London: Allen Lane/Penguin Books.

Putnam, H. 2002. *The Collapse of the Fact/Value Dichotomy and Other Essays*. Cambridge, MA and London: Harvard University Press.

Rorty, R. 1999. *Philosophy and Social Hope*. London: Penguin Group.

NOTE

1. Parts of this chapter have been developed from my book *Overlooking the Visual: Demystifying the Art of Design* (Moore 2010).

REFERENCES

Best, D. 1992. *The Rationality of Feeling*. London: Falmer Press.

Borden, I. and J. Rendell. 2000. *InterSections: Architectural Histories and Critical Theories*. London: Routledge.

Bryson, N. 1983. *Vision and Painting: The Logic of the Gaze*. Basingstoke: Palgrave.

Bryson, N. (1999) 2001. 'The Natural Attitude', in J. Evans and S. Hall (eds), *Visual Culture: The Reader*. London and Thousand Oaks, CA: Sage in association with The Open University, 23–32.

Dewey, J. (1934) 1980. *Art as Experience*. New York: Berkley.

Eagleton, T. 1983. *Literary Theory: An Introduction*. Minnesota: University of Minnesota Press.

Eisner, E. 2002. *The Arts and the Creation of Mind*. New Haven, CT: Yale University Press.

Goldschmidt, G. 1994. 'On Visual Design Thinking: The Vis Kids of Architecture', *Design Studies*, 15 (2 April): 158–74.

Gross.Max. 2007. *Gross.Max*. Seoul: C3 Publishing.

Ingold, T. 2000. *The Perception of the Environment*. London and New York: Routledge.

James, W. 1884. 'Psychological Foundations', in J. J. McDermott (ed.), *The Writings of William James, A Comprehensive Edition*. Chicago and London: University of Chicago Press.

Jay, M. 1994. *Downcast Eyes: The Denigration of Vision in Twentieth-Century French Thought*. Berkeley: University of California Press.

Johnson, P.-A. 1994. *The Theory of Architecture Concepts, Themes and Practices*. New York: Van Nostrand Reinhold.

Koestler, A. 1964. *The Act of Creation*. London: Hutchinson & Co.

Mathur, A. and D. D. Cunha. 2009. *Soak, Munbai in an Estuary*. Calcutta: Rupa and Co.

Pallasmaa, J. 1994, July. 'An Architecture of the Seven Senses: Questions of Perception', in S. Holl, J. Pallasmaa and A. Perez-Gomez (eds), *Architecture and Urbanism*, Special Issue.

Putnam, H. 1999. *The Threefold Cord: Mind, Body and World*. New York: Columbia University Press.

Raney, K. 1999. 'Visual Literacy and the Art Curriculum', NSEAD, *International Journal of Art and Design Education*, 18(1): 41–47.

Schuman, T. 1991. 'Forms of Resistance: Politics, Culture and Architecture', in T. Dutton (ed.), *Voices in Architectural Education, Cultural Politics and Pedagogy*. Westport, CT and London: Bergin & Garvey, 3–27.

Snodgrass, A. and R. Coyne. 2006. *Interpretation in Architecture: Design as a Way of Thinking*. Abingdon: Oxon and New York: Routledge.

Stafford, B. M. 1997. *Good Looking: Essays on the Virtue of Images*. Cambridge, MA and London: MIT Press.

Topos, Ed. 1998. *Free Spaces for the City Topos*. Munich: Callwey Munchen.

Images and Information in Cultures of Consumption

MARTIN HAND

In this chapter I will identify and discuss some of the central debates at the intersection of research in consumer culture and visual culture. In what follows I will argue that the role of consumer culture in modern societies is generally understood in terms of ubiquitous visuality. The notion that we live in an increasingly visual culture rests in part upon the idea that there has been a general commodification of images, that everyday life has been thoroughly aestheticized through design and branding, and that we consume more images than ever before via the mediations of advertising and marketing. Indeed, if we think of the proliferation of advertising industries, the degree of popular attention paid to the nature and so-called effects of advertising in shaping the terrain of production and consumption, the current visibility of the brand and its emotional frames, and the increasing visual design of commodities in the twenty-first century it seems that consumer culture is primarily a visual culture. This is partly an affect of the pervasive idea that contemporary industrialized societies are now 'consumerist' rather than 'productionist' in orientation; that there has been an intensive commercialization of sociocultural life in late capitalism. The majority of work in the field of visual culture that takes consumption as its focus—often called 'visual consumption'—has concentrated upon advertising and its audiences. Consumer culture is often understood as, or at least typified in terms of advertising. This connects with a central, if not *the* central issue in social scientific studies of consumer culture: the relative agency of consumers in relation to changing structures or modes of provision. In this sense, debates about the interpretive agency of the viewer in visual culture often mirror debates about the role of the consumer in consumer culture. The extent to which 'viewing' is thought to be 'consuming' has become a central point of argument, related to increasing visual commodification and of rising consumerism in late-modern culture. By engaging with some of these debates I will suggest that research in consumer culture and visual culture has a great deal to learn from

each other. But it is also the case that both are problematized, theoretically and method-ologically, by some of the substantive changes occurring through pervasive digitization, particularly around the issue of interpretive agency in relation to information.

CONSUMING IMAGES

It is now a commonplace to describe contemporary society as 'consumerist' or a 'con-sumer culture' (Dunn 2008; Lury 1996; Sassatelli 2007; Slater 1997). It is only relatively recently that 'consumption' has developed such a distinctive identity as a substantive or theoretical topic in the academy. The development of nineteenth-century capitalism and the implications for social relations have provided the broader concerns into which issues of consumption have been slotted (see Veblen (1899) 1953). While sociologists such as Baudrillard (1981), Bourdieu (1984) and Castells ((1972) 1977) worked, in very different ways, to reposition consumption as a more distinctive field, this field has been dominated by culturalist approaches. Moreover, when semiotic approaches to the image (Hall 1997) are privileged, it is often thought that current cultures of consumption are the logical consequence of the irrationality of image consumption, particularly through the construction of need and desire via ubiquitous advertising (Sturken and Cartwright 2001). Such advertising is a key aspect of how reflexive capitalism self-consciously seeks (not necessarily successfully) to organize the visual field. As Schroeder states '[T]he cur-rent market revolves around the image, consumers consume visions of a good life, fueled by consumer lifestyle images' (2002: 43). This is certainly the view of many in market-ing and design industries and the points of connection and convergence between visual culture, design and consumption make for rich territory here. We can think of visual consumption in terms of how advertising and marketing have become central sociocul-tural institutions in mediating almost all aspects of social life, and how individual and collective identities now appear inseparable from images.

In mapping the relationships between consumption and visual culture it is necessary to consider a number of theoretical and substantive shifts involved in the approaches taken to commodification and consumption. There are three shifts in particular that form the basis of discussion here. Firstly, there have been significant changes in how ob-jects or commodities are conceptualized in relation to consumption practices. This can be seen through substantive changes in the nature of advertising, in how and through what means objects are visually presented to consumers, and how consumption itself is visually portrayed. Secondly, the ways in which practices of the design industries and 'new marketing' have shifted the terrain of the visual in relation to commodities has, in a sense, deflated the role of the visual, or at least the modern idea of 'representation'. Thirdly, the advent of digitization is having a profound effect upon the scale and scope of consumer culture in general, the relationships between production and consumption, and has arguably brought about the death of advertising as it has been conventionally understood. Indeed, those studying 'new media' have pointed to the novel characteris-tics of networked mediation, suggesting that many-to-many communication establishes radically different modes of distribution and exchange (Poster 2006).

One of the key issues for studies of visual consumption is the extent to which we can rely upon research on advertising and related visual materials to tell us about consumption processes and consumers. In this regard, I think that there is value in questioning the occularcentric models of consumer culture that prevail in the interdisciplinary area of visual culture. From the perspective of current research in consumer culture, the acquisition and use of objects in everyday life has practical, experiential and symbolic dimensions (Sassatelli 2007; Shove et al. 2007). In analyses of 'visual consumption', the latter has taken on undue significance. The primacy of the visual in shaping, determining and mediating consumption is misleading, particularly when we bring current theories of materiality and practice to bear on images and information. The reliance on the notion that goods have a *primarily* 'symbolic character', or that consuming media is necessarily about seeing, has led us away from considering a more thoroughly contextualized account of visuality in relation to the embodied materialities and multiplicities of consumption practices. This is partly to do with a continued emphasis upon 'conspicuous consumption' (Veblen (1899) 1953), which, by definition, tends to privilege the visible, as opposed to 'inconspicuous consumption' (Grunow and Warde 2001), which focusses upon the routine and invisible. In this way, it is the case that the objects of consumer culture have largely been treated in semiotic terms: as primarily symbolic entities operating as 'intermediaries' for self-actualizing processes (whether conceived as 'resistance', 'subjectification', etc), linked to class, identity, gender, ethnicity and so on (McCracken 1988; Featherstone 2007). In other words, the visual extends here to that which is potentially 'decoded' in terms of social relations; the material culture of contemporary society has been subject to techniques of ethnographic and of literary and semiotic analysis in an effort to analyse the aesthetic, symbolic and experiential dimensions of consumer culture (see Lury 1996; Shove et al. 2007).

While it is arguably the case that studies of consumption have employed inadequately sophisticated models of visual media and mediation (see Jansson 2002), it is also the case that the broad field of 'visual culture' has often positioned consumption in terms of decontextualized commodity fetishism read from a semiotic analysis of advertising and marketing materials alongside somewhat popular representations of consumers and consumer culture. In reality, the relationships between specific conceptions and interpretations of the visual (in semiotics, as representation, etc) and theories of consumption, consumers and consuming are multifaceted. But in terms of the visual culture of reflexive capitalism, we can see how the significance of semiotic approaches to consumer goods has actually come to dominate commercial decisions about aesthetics and general visual appeal (Julier 2000; Shove et al. 2007).

THE VISUAL FACE OF CAPITALISM

The critique of modern consumer culture, including the apparent centrality of the commodified image and visual-orientated consumer behaviour, is often part of a broader critique of capitalist modernity. Sassatelli (2007) has observed that much work on social and cultural change is underpinned by an anticonsumerist rhetoric. Miller (2001) has

similarly observed how Western intellectuals have come to assume this default position, often conflating a critique of consumption with a critique of specific socioeconomic and cultural tendencies in US society (and perhaps an implicit denigration of 'popular culture'). The potentially diverse practices of use and interpretation in cultures of consumption are condensed into a monolithic 'consumer culture', the assumed effect of which is to systematically shift processes of identity formation away from stable structures and ideals and towards the fleeting and illusory notion of 'presenting' an 'image' of the self to others. In this view, all sociality is reduced to a commodity, and selves become isolated (see Lasch 1979; Putnam 2001). In other words, consumer culture *produces* alienated, isolated and unstable consumers. This is partly because of the sheer scale, scope and proliferation of representations in advertising, magazines and so on; ideological representations which position the consumer in terms of needing to constantly accumulate and discard objects in order to resolve contradictions between (meaningless) work and (pleasurable) consumption.

This discourse of manipulation and exploitation has its immediate roots in post-Marxist political economy and critical theory. The expansion and reorganization of capitalist forms of production during the twentieth century has led to what we might think of as the 'victory' of exchange-value over use-value. Indeed, one of the key claims of Marxist and post-Marxist critical theory has been that cultural industries, particularly advertising, have been able to systematically connect a seemingly infinite number of images (meanings) to commodities (Featherstone 2007). Both Baudrillard (1970) 1997, 1981) and Jameson (1991) saw this as key to the development of postmodern culture: a culture of depthlessness, where the 'commodity-sign' is an image that has become free of its material vehicle or object. In other words, the visual culture of post-modernity is immaterial as societies of production have given way to ones of reproduction, the social has been displaced by the cultural, and a total aestheticization of everyday life has taken place (see Lury 1996). A key research issue arises here regarding the polysemic nature of image production and consumption, often cast in terms of even greater domination through image saturation and a resultant banalization of cultural life (Taylor and Harris 2005). In this work, although both visuality and consumption are paramount, visual consumption is largely an effect of major changes in production, particularly flexible specialization. This problematic relationship between production and consumption has been subject to much criticism and raises important issues about how we address the more nuanced practices of use and interpretation in potentially diverse cultures of visual consumption. While well-known studies of audience and interpretive communities have been paramount in anthropology and cultural studies, they have not shaped the research field in visual consumption. The point here is that the concepts of commodity fetishism and the commodity sign are about the triumph of appearances in either an exploitative or simulational relation, and it is these ideas that have dominated research in the field of visual consumption. Ironically, the productivist tendency is reproduced by those pursuing a poststructuralist critical theory, where radical changes in distribution and exchange are assumed to arise through technological change (e.g. Poster 2006). The related trajectory moved away from the commodity

itself and towards a reading of the sites and objects of consumption as 'spectacles': 'In societies where modern conditions of production prevail, all of life presents itself as an immense accumulation of spectacles. Everything that was directly lived has moved away into a representation' (Debord 1983: n1).

In the terms of a critical theory of the commodified image the apparent ubiquity of digital image making, particularly the saturation of digital photography, has the effect of 'leveling' the specificity of the image, of rendering all images equivalent as exchangeable and somewhat autonomous commodities (Taylor and Harris 2005; Sontag 1977). In this view, while 'reality' is always mediated, this is now performed in such a way that social subjects experience a greater 'distance' between themselves and the world. Any sense of mutual interdependence between realities and subjects is undermined; the bewildering numbers of images become immaterial vehicles of spectacle, alienation and abstraction. In critical theory, the importance here is one of drawing a connection between the increased number of images in the world and the totalizing effects of exchange-value over use-value. In this way the notion of 'sensory overload' and the overproduction of commodified images associated with the Frankfurt School have become reinvigorated recently in light of digitization (see Taylor and Harris 2005). Where for Benjamin the reproducibility of the visual heralded aestheticized urban scenes, we are now in the realm of the infinitely malleable digital image, with considerable implications for how we theorize production, consumption and exchange. But despite their merits there are clear limits to these accounts, I think, when we consider how consumption practices are conceptualized. Firstly, in these 'production of consumption' frameworks, consumption is taken to be a necessarily capitalist process (which it is not), and 'superficial' or at least secondary in relation to production. Secondly, what we fail to observe are the ways in which images are interpreted or made by consumers, where it is assumed that either a standardization of the image has occurred through commodification or it is now impossible for consumers to be effective semioticians or bricoleurs.

The symbolic role of consumer goods can be thought of, then, in terms of the commodity-sign and its commercial manipulation by advertising and marketing industries. From very different sociological and anthropological standpoints which maintain a concrete material-symbolic relation, the overproduction of goods has led others to argue that the acquisition of 'positional goods' (Hirsch 1976) that act as symbolic markers of social status also becomes more complex. For example, the related emergence of so-called lifestyle consumption has involved the dissolving of previously clear taste markers between relatively stable social groups (see Chaney 1996; Featherstone 2007). Knowledge of how to acquire, manipulate and display consumption preferences then becomes ever more crucial in establishing social, economic and cultural capital (Bourdieu 1984). The visual components of consuming, the proliferation of life-style magazines and other cultural intermediaries such as brands, becomes an important arena for considering the impact of increasing numbers of symbolic goods and the ongoing organization and classification of everyday life. Perhaps most significantly here, the overproduction and diversification of goods questions the abilities of consumers to 'read' visual markers with enough competence, not to develop a consciousness of their own exploitation, but to establish

any structure or stability in symbolic capital for the conduct of everyday life. This may result in the positioning of some as the 'flawed consumers' of Bauman's (2000) liquid modernity. This kind of cultural speed and circulation is also related to the alleged collapse of 'high' and 'low' culture, and the aestheticization of city spaces in a simulational or 'themed' culture of consumption (Gottdiener 2001). The differences between everyday commodities and 'art' have been eroded, and the professionalization of design and advertising has transformed them into 'artistic' institutional practices (see Forty 1986). Issues of visual classification are highly significant when we consider the rise of mass media over the course of the twentieth century, and now the pervasiveness of digital mediation through the 'new visuality' of the Internet (Schroeder 2002) and the vast visual content industries (Frosh 2003). In sum, we should perhaps avoid the pitfalls of assuming that the ambivalence and contingency of the image and its consumption is simply a consequence of postmodernization. As discussed below, such ambivalence has many trajectories and components, recognition of which has led in part to the move towards 'co-creation' in advertising and marketing.

MEDIATION: PARADIGMS OF ADVERTISING

The dominant visual face of capitalist production has been advertising. Although some form of advertising arguably existed in ancient Greece, the more systematic visual promotion of goods via print technology takes root among newspapers from the late-seventeenth century in Europe. During the twentieth century the ways in which this particular form of visuality has been theorized covers a wide spectrum from notions of the 'colonization of consciousness' (see Ewan 1976) to the proliferation of possibilities for consumer bricolage and tactical self-transformation (Fiske 1987) to the currently popular ideas around co-creation and prosumption (Beer and Burrows 2007).

It has been argued that the world of goods has a 'photographic face' (Cadava 1999: 135) such that products are conceived *primarily* in terms of their visuality communicated through the global advertising industries and burgeoning 'image factories' (Frosh 2003). But the ways in which the relationship between such images and products is organized and theorized has shifted significantly over the nineteenth and twentieth centuries. Where it was once thought that images of products (in advertising) reflected the properties or potential effects of the product it is now apparent that images and ideas often *precede* products. While this may have always been the case to some extent it is now self-conscious and *explicit* (Schroeder 2002). This is part of a shift towards experience, attention or image economies (Lash and Urry 1994) in which images and signs are increasingly significant as products in their own right. Accordingly, efforts at market segmentation and product specialization are conducted via the segmentation and specialization of images. The shift from product-orientated advertising to brand-orientated marketing in some ways exemplifies these processes. As a result, the concerted management of brand identities has become central to contemporary or 'new' marketing, particularly where brand images are opened up to multidirectional flows of information, often with unpredictable or creative results (Klein 2000; Lash 2002; Lury 2004; Matrix 2006; Moor 2007).

As suggested so far, the dominant arena for an analysis of visual consumption has been advertising, and with good reason. Such analyses have taken many forms. Some have been predicated on the kind of commodity fetishism outlined above, where advertising *produces* a kind of 'commodity self' (Dunn 2008), while others have concentrated upon the more performative and ambivalent aspects of advertising in shaping or making the (post)modern consumer (Cronin 2004; Lury 1996), where others have critiqued the stereotypical production of the gendered consuming subject (Buckley 1986; Sparke 1986). Many have sought to critique advertising as having a considerable psychological impact upon consumers, of organizing them into homogenous 'mass' groups, and even of forcing consumers to act against their own will and judgement (see Slater 1997 for a history of these accounts). A great deal is assumed here in terms of the indexicality of images and their psychosocial effects and the *passivity* of consumers. In a more nuanced practice-orientated argument it has been observed that the proliferation of advertising images increases the range of options available to consumers, not only in terms of what can be acquired but also 'who they can be' (Warde 2005). The paradox is that this makes the problem of 'making the wrong choice' ever more acute (Slater 1997). As self-identity is now inextricably tied to consumption practices (Bauman 2007; Featherstone 2007; Giddens 1991; Lury 1996) the role of advertising in creating both markets *and* 'active consumers' is central.

Whatever the actual mechanisms and effects of encoding and decoding processes and practices, the majority of advertising has visually *positioned* the consumer as agential, as active in making choices about acquisition, and 'speaks' to consumers as individualized social actors. The images used in advertising invariably (and somewhat obviously) portray a potential process of positive self-actualization and becoming and are intended to be read relatively 'narrowly'. Historically, such positive affirmations have taken many forms, from offering fantasies of democratization (Loeb 1994) to self-control and civility (Lears 1994). The critique of visual advertising, then, proposes that consumers make choices but those choices are largely manufactured and determined by the advertising industries as they seek ways to segment and create new specialized and niche markets (making the consumer passive in effect). The extent to which this is the case provides much material for debate, particularly in the context of modern-postmodern-information societies.

In both theoretical and methodological terms we should be initially cautious about simply ascribing too much agency and causal power to the advertising industry. Advertising takes place within broader cultural contexts of consumption, and more specifically in professional cultures which shape the nature of the practice (see Cronin 2004; Nixon 2003). Indeed, as Cronin (2004) observes, we should pay a great deal of attention to how advertising agencies articulate some very specific concerns of their sociohistorical location. The promotion of particular forms of subjectivity through images (the 'ironic' consumer, the 'knowing' consumer) are not simply conspiratorial creations in the minds of advertising professionals, but are caught up in wider changes in the mobilization of consumer agency (e.g. the 'green consumer'). It is also very difficult, methodologically, to ascertain whether advertising actually persuades consumers to purchase products, a

point which I will come back to below in considering the role of social practices in shaping visual consumption. Nonetheless, it has been argued convincingly that advertising is significant in creating the visual terrain of consumption by *encouraging* consumers to identify with particular images of life-style, the logos of brand names, and to link consumers to other aspects of marketing (Matrix 2006; Schroeder 2002).

Following this line of thought, advertising images produce new possibilities of meaning for products. Chains of associations are linked to images, which have been generally conceived in terms of use and exchange values, and of 'commodity fetishism'. Advertising, from a Marxian perspective, is a machine for fetishizing commodities in that it strips commodities of information about the conditions of production and imbues them with a range of cultural meanings which mystify the object (see also Barthes 1972). Cultural meanings attached to products via advertising might be emotionally charged, anthropomorphic, and most important become embedded in the object (such that, say, perfume becomes 'romantic', 'feminine' and so on). Such qualities are highly differentiated across product genres though juxtaposition of diverse visual images, a process which becomes more complex as markets become highly segmented both in terms of products and life-style categories in reflexive capitalism. Rather than assume a reified relation, it is instructive here to briefly identify a series of shifts in the relation of image to product. Leiss et al. (2005) develop an analytic strategy of historically mapping advertising formats in order to explain key shifts in how representation has been organized, specifically in terms of how products and people are entangled in meaningful ways. Their model is a useful one here in identifying trends and trajectories of advertising research in relation to socioeconomic change.

Products

The historical literature on advertising has generally argued that early forms were necessarily local in orientation, focussed upon the assumed intrinsic qualities of the product, and the trustworthiness of the producer (see Leach 1993; McFall 2004). This has been called 'rational' or 'reason-why' advertising (McFall 2004) and usually featured images of the product alone with associated explanatory text concerned with explaining why this specific product should be acquired. Leiss et al. (2005) have argued that in the early part of the twentieth century such advertising operated along two cultural frames— 'idolatry' and 'iconography'. In the first, products are presented purely in terms of their use-value and are largely abstracted from the processes of production—in other words, as self-evidently valuable in its own right. In the second, products are embodiments of the attributes of modernization ('functionality', 'efficiency', 'labour-saving') and are configured by reference to how the product and its purchase will be understood socially. The product is the centre of visual attention, often in isolation, where text is used mainly to elaborate on the specific attributes of the object (Leiss et al. 2005: 175) This format has all but disappeared (except returning in ironic form) since the early part of the twentieth century (Hand and Shove 2004).

Life-styles

According to Leiss et al. (2005) and others we see a move towards the 'personalization' or customization of advertising operating along different cultural frames: 'narcissism' (products are personalized and the potential outcomes are emulative in nature) and 'totemism' (products are emblems of collectively orientated consumption practices). This move away from 'rational' advertising was the outcome of many developments from the 1920s onwards, including the increasing involvement of psychologists in providing models of the differentiated 'consumer mind', the rapid growth of urban centres and associated changes in labour and product markets, the new media technologies such as radio and eventually television, resulting in the mass-mediation of advertising along Fordist lines. As part of a broader aestheticization of, for example domestic space, the product becomes part of an ensemble of symbolic meanings which move outside of the supposed intrinsic qualities of the object. This symbolic association does not necessarily work on logical or immediately coherent connections but once established 'brings the product into a meaningful relationship with abstract values and ideas signified by a natural or social setting' (Leiss et al. 2005: 179). The increasing use of 'art' and photography in advertising resulted in these connections being easier to make where in the personalized format, 'people are explicitly and directly interpreted in their relationship to the world of the product. Social admiration, pride of ownership, anxiety about lack of use, or satisfaction in consumption become important humanizing dimensions of the interpretation of products' (Leiss et al. 2005: 184). In tandem with the increasing standardization of goods, and whole ensembles of goods (such as the 'fitted kitchen'), we see efforts to personalize the product image. The relationship between person and product is an interactive and reciprocal entanglement in which self-improvement in the broadest sense will result.

Branding and Design

By the late-twentieth century, brand images had supplanted products as the key focus of advertising. The cultural frame here is life-styles or 'life scripts'. This combines aspects of the product-image and personalized formats. Activities or practices that were once presented as necessary or as labour are now a matter of constructed self-identity or social identity (cooking might be a prime example here). These so-called life-style advertisements have became the most prominent at the present time and appear to be intertwined with the ascendance of new marketing practices and techniques that incorporate elements of the brand (see Lury 2004). This is also related to shifts in the relationships between materials and historicity, where for example previous styles can be retrofitted and become a matter of 'personal choice' rather than standardized design. It has been acknowledged by many that, regardless of the nuances of actual consumption practices, advertising now addresses or interpolates the 'post modern consumer' (see Featherstone 2007; Sassatelli 2007; Sturken and Cartwright 2001). Advertisements know that consumers *know*, so to speak. The simple positioning of products in relation

to generic meanings will no longer suffice in a media-saturated culture where the efficacy and symbolic meaning of products can circulate rapidly and be subject to endless debate and diversification. In this sense, for some, we live in an age of postadvertising. That is dynamic processes of branding which try to *manage* the intertextual mobilities of images, products and consumers, have rendered the 'static' reception-orientated understanding of advertising redundant. This is partly to do with digitization and the distribution of the image becoming free of traditional moorings (for example the predicted demise of billboard advertising via hand-held devices). It is also an outcome of shifts towards producer-consumer reciprocity or 'prosumption'. Lury (2004) has developed the most sophisticated account of the development of the brand *as a practice*, where 'the establishment and maintenance of lines between a product item, a product line and a product assortment comes to be increasingly organized in relation to brands through the implementation of brand-name decisions, multi-brand decisions and brand repositioning strategies' (25–6). In other words, brands are 'new media objects' which organize the field of production and consumption in terms of brand-identities rather than products and consumers.

The role of visual mediation becomes more ambivalent here. The conjoining of new media technologies, marketing strategies and the diverse activities of consumers have created new objects, sites, processes and practices of visual consumption which are different from radio or television cultures of advertising. While visual representation remains highly significant, it is arguably becoming more difficult to retain an ocularcentric view of how vision operates in relation to consumption (see Julier 2000). On the one hand, the intertwining of the visual, of information, and of production and consumption through branding is producing a radical intertextual 'immediacy' which renders the notion of a separate realm of representation (and of ideological manipulation) highly problematic (Lash 2002). On the other hand, the role of *materials* (plastics, steel, reflective materials, 'fleshy' rubber) in the design and consumption of visual information technologies is becoming more widely recognized. The 'materiality of practice', where product images and positive images of consumption are seen as but one element in consumption processes, is an important corrective to models of commodity acquisition as a result of advertising and marketing techniques (Shove et al. 2007).

DIGITAL MEDIATIONS

The relatively concise issue for this chapter has been how the relationships between commodification, consumption and visuality have been dominantly conceived over the twentieth century in the scholarly literature. In the remainder of the chapter I suggest a number of ways in which visual consumption has become inseparable from broader processes and debates about informationalization and digitization. There are many ways of thinking about this, from convergences of technology and content, the conglomeration of culture industries, to considerations of new screen-based sites of consumption and the radical shifts in the distributive possibilities of visual materials. I am limited here to making some brief and suggestive connections between research in these areas.

Informatic Materials

To begin, in a possibly essentialist framework some have argued that we now live in an 'image culture'—a culture in which the image is *the medium* of our times (Jansson 2002; but see Julier 2000). In this sense, it is argued, consumption is more than ever before inseparable from images. The image has simultaneously become the vehicle, context, content and commodity in consumer culture; we live in a fully mediatized culture (Lundby 2009) in which the economy is culturalized and cultural life is commercialized (see Lash and Urry 1994; Lash 2002; Lash and Lury 2007). Emerging work in this area—where studies of 'ubiquitous media' take the complexity of consumption seriously—are few and far between. The key arguments emerging in this field are that the social is increasingly displaced by the cultural in digital society (Lash and Lury 2007; Poster 2006), that cultural processes are increasingly computerized whether we know it or not (Manovich 2001), and that an increasingly commodified yet participatory culture is emerging through Youtube, Flickr and a variety of platforms for user-generated visual content (Matrix 2006; Poster 2006; Thrift 2005). The argument here also concerns how increasing numbers of material commodities are 'image loaded' (Jansson 2002) or 'mediated' (Lash and Lury 2007) such that the distinction between objects and (visual) media becomes largely obsolete (e.g. iPhone). The development of multidirectional and multifunctional media is clearly central here, distancing these trajectories from those of mass media through radio and television.

Of course, we might initially say that this is somewhat similar to the argument advanced by Baudrillard (1981) and Jameson (1991) where in a sense products only refer to other products in a generalized system of symbolic exchange. But, according to recent work on informationalization, such theoretical propositions have become *materially tangible* in everyday life, partly as an outcome of ongoing processes of flexible accumulation (Harvey 1990) and the emergence of new kinds of visually saturated informational commodities such as smart phones which simultaneously 'act' as things, spaces and networks (Thrift 2005). While some of the focus in this area has continued to stress 'dematerialization'—where consumers are thought to encounter only signs rather than 'concrete' commodities—for others it is precisely the emergence of 'lively' *materials* with high visual content that characterizes the present information culture. There are also a number of developments which render consumption processes and practices more complex, and at times, far less *visible*. Indeed, the routine invisibility of informational restructuring—in this case of marketing, consumer profiling and organizing of consumption spaces—is arguably one of the most significant developments of our time (Gane, Venn, and Hand 2007; Lyon 2003).

Co-creation, Reciprocity and Prosumption

In reflexive capitalism, the creation of value is becoming a matter of 'co-creation'. That is consumers are being 'put to work' so to speak in producing brand identities and

products through affective and immaterial labour (Arvidsson 2005; Holt 2004). This can also be seen as a matter of 'McDonaldization'; in this case, of the outsourcing of consumer activity in brand value creation. This has taken the form of consumers producing advertisements for producers, often as a response to online competitions. We might also include here the phenomenon of blogging, which offers the possibility to marketers to find and appropriate 'cool' via the cultural competence of consumer discourses.

In a different vein, we can see the voluntaristic production of visual culture by consumers occurring on a global scale if we think of the blogosphere again, the highly significant YouTube phenomenon (Burgess et al. 2009), the rise of online mapping technologies such as user-generated Google Maps, and the unfathomable amount of online photographic images uploaded in Flickr. Indeed, one of the major issues today arising from both the image-as-information and changes in the apparatus of image making is the redistribution of production and consumption in relation to digital images (Beer and Burrows 2007; Taylor and Harris 2005). This relates to changes in the hardware and software industries, the rise of branded environments, and the reciprocal activities of consumers (Ardvisson 2005). There are a number of important aspects to this. Firstly, the boundaries between amateur and professional image making appear increasingly porous, for example between photo-sharing Web sites and the official domains of stock photography (Frosh 2003). Secondly, the development of practice-orientated software applications such as Microsoft's Photosynth which purports to be shaped by the practices of consumers in creating new image-objects and environments. Thirdly, digitization allows for the individualization of the image-making process whereby consumers arguably become 'pro-sumers' or 'craft-consumers', which is having particularly significant implications in the domain of journalism and news reporting (Campbell 2005; Leadbeater and Miller 2004; Sennett 2008).

Of course, the dynamics of consumption or prosumption practices are likely to have different kinds of impacts upon historically constituted trajectories of production and consumption. Moreover, the possibilities of variability appear exaggerated in the present where digital cultural objects as mediators are not only highly distributed but more or less designed to facilitate multiple interpretations and uses. In other words, the emergence of digital technologies linked to the Web are 'inscribed' with open-ended ambivalence in symbolic, practical and material ways. Current digital information technologies are mobile, additive and adaptable, *designed to be active* (Kuchler 2008).

Mobilities, Screens and Applications

In terms of the digital image we now have a situation of infinite variation rather than infinite reproduction, with clear implications for the notion of 'aura', originality and authorship. Often it is unclear 'who' produces, consumes or owns an image or an identity. But the field of intellectual property and copyright has become the key site for maintaining older or establishing newer modes of authorship in digital capitalism. Secondly, the fixity of the photographic image has become the *mobility* of the digital image, where

images can circulate at greater speed and with broader reach (Jenkins 2006). Thirdly, while images have always been manipulated, the manipulation of digital images is implied as a defining characteristic of digital photography (Mitchell 1992). Moreover, the manufacture and proliferation of technologies associated with image production and consumption (cell phones, laptops, Web applications, CDs, USBs and so on) represent a dramatic extension in the parameters of visual content, storage, use and exchange. Each of these dimensions raises important issues for larger social, economic and political debates about visual communication, ownership and interpretation (Frosh 2003; Lury 2004).

The new screen-based 'social media' such as Facebook are generating their revenues not from advertising but from commercially developed *applications*. The conjunction of hand-held screen, visual applications, and flows of commercially significant consumer data represents a novel trajectory in the field of visual consumption. Some of these developments are likely to be approached under a broader rubric of the rethinking of the relations between technology and culture across the social sciences. For example recent work which aims to rethink what counts as political economy in light of digitization and new spatialities (Thrift 2005), plus influential accounts of digital brand environments (Lury 2004; Moor 2007) and current interdisciplinary approaches to media and technology found within science and technology studies and material culture (Latour 2005; Shove et al. 2007). The flows of digitally encoded visual information through suites of object-screens represent a proliferating materialization *and* informationalization of visual culture, working via the mobility of bodies. As Lash (2002) and others have argued, it is much more difficult to conceive visual culture to be a field of representation in light of these processes.

Many have argued that the characteristics of Web 2.0 applications are truly innovative and novel (O'Reilly 2005). It is clear that social networking sites, wikis and the like enable vast amounts of user-generated visual content to be uploaded, often in the form of private or personal images placed in the public domain. In contrast to the idea that such digital visual creativity is the outcome of technological innovation, this needs to be seen in terms of a quickened form of reciprocity—between consumers and media, between practices of participation and the adoption of media which enable such forms of participatory consumption to be distributed in new ways. In tandem with such active forms of consumption, the information produced and circulated now restructures actual geographic territories (city, neighbourhood) through automated classification systems such as neighbourhood profiling, Google maps, GPS systems, loyalty cards, Public Wi-Fi and so on (Burrows and Gane 2006). The flows of information produced through ordinary practice (made visible in online data as 'consumption patterns') are invisibly classified by software. Instead of searching for our preferences in the marketplace, we are presented with our preferences as the result of algorithmic assessment of previous interests or purchases. As individual consumers we are increasing 'socially sorted' (Lyon 2003) into differentiated life-style categories *and* at the same time encouraged to 'sort ourselves out' in terms of consumption orientations and preferences.

CONCLUSION

This has not been an exhaustive review and analysis of scholarship in visual consumption. The modest task here has been to simply point towards some of the dimensions and trajectories in the field with a view to providing concise summaries of significant debates. Given the dual argument that in the global north social actors are addressed as consumers in almost all walks of life, and that we live in image-saturated societies, the terrain of 'visual consumption' might literally encompass all activities that involve watching, looking and seeing, alongside processes of visual interpretation, handling, manipulation and so on. In terms of substantive topics for research, the possibilities are almost infinite. In a more considered vein, this chapter has highlighted the dominant ways in which research in visual culture which specifically addresses consumption has unfolded. The line of argument throughout has been that, in essence, the potential diversity and nuance of consumption practices have been neglected in visual culture research. The tendency has been to reproduce critical theories of commodity fetishism developed in response to the advent of nineteenth- and early-twentieth-century capitalist forms of production and mass-mediated promotional cultures. There is much merit to this of course, but it has resulted in a skewed agenda shaped by issues of commodification and its assumed effects rather than actual consumption processes. I am suggesting here that the terrain of visual consumption is moving towards a more nuanced consideration of the ways in which images are acquired, interpreted, used and increasingly co-created by situated consumers, in relation to historically and socioeconomically defined contexts. The second line of argument has privileged some of the new digital technologies of visual consumption that have been emerging over the last twenty years or so. The coming together of these technologies and new modes of production, consumption and distribution offers, in my view, some exciting new trajectories for interdisciplinary research in this field, especially in terms of exploring lived practices of visual consumption beyond the productivist/consumerist dichotomy and towards the consideration of new kinds of sociotechnical 'agents' shaping the visual field.

From this point of view, *visual culture*, increasingly circulates *as* information. The 'architectures of participation' underpinning co-creative and voluntaristic forms of visual production such as YouTube and Flickr does, at the very least, blur the boundaries between cultural production and consumption (Beer and Burrows 2007). It appears that trends in prosumption are being made explicit through new technologies, multiplying the possibilities for information-driven visual reflexivity. Visual culture can no longer be externalized as ideological, symbolic or representational. This arguably conjoins design, production, distribution and consumption in new ways with as yet unforeseen consequences. Important questions arise in terms of north-south power relations, of how global consumption patterns are both visually anchored around life-style-orientated imaginaries of the 'good life' and also made visible to others, and of how we need to think though questions of visual ontology in relation to the embedded machineries of lived consumption practices.

Finally, it is worth stressing the point that moving away from research focussed primarily upon issues of representation and commoditization is not only a matter of changing theoretical fashions. It is as much to do with the changing practices of consumers, perhaps most acutely so in the field of visual cultural prosumption, and how these changes are inextricably tied to the rematerialization of culture in digital terms.

FURTHER READING

Lash, S. and J. Urry. 1994. *Economies of Signs and Space*. London: Sage.

Lury, C. 2004. *Brands: The Logos of the Global Economy*. London: Routledge.

Schroeder, J. 2002. *Visual Consumption*. London: Routledge.

Shove, E., M. Watson, M. Hand and J. Ingram. 2007. *The Design of Everyday Life*. Oxford: Berg.

REFERENCES

Arvidsson, A. 2005. *Brands*. London: Routledge.

Barthes, R. 1972. *Mythologies*, trans. A. Lavers. New York: Hill and Wang.

Baudrillard, J. (1970) 1997. *The Consumer Society*. London: Sage.

Baudrillard, J. 1981. *For a Critique of the Political Economy of the Sign*. St. Louis: Telos Press.

Bauman, Z. 2000. *Liquid Modernity*. Cambridge: Polity Press.

Bauman, Z. 2007. *Consuming Life*. Cambridge: Polity Press.

Beer, D. and R. Burrows. 2007. 'Sociology and, of, and in Web 2.0', *Sociological Research Online*, 12/5: http://www.socresonline.org.uk/.

Bourdieu, P. 1984. *Distinction: A Social Critique of the Judgment of Taste*. Cambridge, MA: Harvard University Press.

Buckley, C. 1986. 'Made in Patriarchy: Towards a Feminist Analysis of Women and Design', *Design Issues*, 3/2: 3–14.

Burgess, Jean, Joshua Green, Henry Jenkins, John Hartley. 2009. *YouTube: Online Video and Participatory Culture*. Cambridge: Polity Press.

Burrows, R. and N. Gane. 2006. 'Geodemographics, Software and Class', *Sociology*, 40/5: 793–812.

Cadava, E. 1999. *Words of Light: Theses on the Photography of History*. Princeton, NJ: Princeton University Press.

Campbell, C. 2005. 'The Craft Consumer: Culture, Craft and Consumption in a Postmodern Society', *Journal of Consumer Culture*, 5/1: 23–41.

Castells, M. (1972) 1977. *The Urban Question: A Marxist Approach*. London: Edward Arnold.

Chaney, D. 1996. *Lifestyles*. London: Routledge.

Cronin, A. 2004. *Advertising Myths*. London: Routledge.

Debord, Guy. 1983. *The Society of the Spectacle*. London: Rebel Press.

Dunn, R. G. 2008. *Identifying Consumption*. Philadelphia: Temple University Press.

Ewan, Stuart. 1976. *Captains of Consciousness: Advertising and the Social Roots of the Consumer Culture*. New York: McGraw-Hill.

Featherstone, Mike. 2007. *Consumer Culture and Postmodernism*. London: Sage.

Fiske, J. 1987. *Television Culture*. London: Methuen.

Forty, A. 1986. *Objects of Desire*. London: Thames and Hudson.

Frosh, P. 2003. *The Image Factory*. Oxford: Berg.

Gane, N., C. Venn, and M. Hand. 2007. 'Ubiquitous Surveillance: An Interview with N. Katherine Hayles', *Theory, Culture and Society*, 24/7–8: 349–58.

Giddens, A. 1991. *Modernity and Self-Identity*. Cambridge: Polity Press.

Goffman, E. 1979. *Gender Advertisements: Studies in the Anthropology of Visual Communication*. New York: Harper & Row.

Goldman, R. and S. Papson. 1996. *Sign Wars: The Cluttered Landscape of Advertising*. New York: Guilford Press.

Gottdiener, M. 2001. *The Theming of America*. Boulder, CO: Westview Press.

Grunow, J. and A. Warde, eds. 2001. *Ordinary Consumption*. London: Routledge.

Hall, S., ed. 1997. *Representation: Cultural Representations and Signifying Practices*. London: Sage.

Hand, M. and E. Shove. 2004. 'Orchestrating Concepts: Kitchen Dynamics and Regime Change in *Good Housekeeping and Ideal Home*, 1922–2002', *Home Cultures*, Volume 1(3): 235–56.

Harvey, D. 1990. *The Condition of Postmodernity*. Oxford: Blackwell.

Hirsch, F. 1976. *Social Limits to Growth*. Cambridge, MA: Harvard University Press.

Holt, D. 2004. *How Brands Become Icons: The Principles of Cultural Branding*. Cambridge, MA: Harvard Business School Press.

Jameson, F. 1991. *Postmodernism, or, The Cultural Logic of Late Capitalism*. Durham, NC: Duke University Press.

Jansson, A. 2002. 'The Mediatization of Consumption', *Journal of Consumer Culture*, 2/1: 5–31.

Jenkins, H. 2006. *Convergence Culture*. New York: New York University Press.

Jhally, S. 1997. *Advertising and the End of the World*. Northampton: Media Education Foundation.

Julier, G. 2000. *The Culture of Design*. London: Sage.

Klein, N. 2000. *No Logo: Taking Aim at the Brand Bullies*. New York: Picador.

Kuchler, Suzann. 2008. 'Technological Materiality: Beyond the Dualist Paradigm', *Theory, Culture and Society*, 25/1: 101–20.

Lasch, C. 1979. *The Culture of Narcissism*. New York: W. W. Norton.

Lash, S. 2002. *Critique of Information*. London: Sage.

Lash, S. and C. Lury. 2007. *Global Culture Industry: The Mediation of Things*. Cambridge: Polity Press.

Lash, S. and J. Urry. 1994. *Economies of Signs and Space*. London: Sage.

Latour, B. 2005. *Reassembling the Social*. Oxford: Oxford University Press.

Leach, William. 1993. *Land of Desire: Merchants, Power and the Rise of a New American Culture*. London: Vintage Books.

Leadbeater, C. and P. Miller. 2004. *The Pro-Am Revolution*. London: Demos.

Lears, J. 1994. *Fables of Abundance: A Cultural History of Advertising in America*. New York: Basic Books.

Leiss, W., S. Kline, S. Jhally and J. Botterill. 2005. *Social Communication in Advertising: Consumption in the Mediated Marketplace*, 3rd ed. New York and London: Routledge.

Loeb, L. A. 1994. *Consuming Angels: Advertising and Victorian Women*. Oxford: Oxford University Press.

Lundby, Knut, ed. 2009. *Mediatization: Concept, Changes, Consequences*. New York: Peter Lang.

Lury, C. 1996. *Consumer Culture*. Cambridge: Polity Press.

Lury, C. 2004. *Brands: The Logos of the Global Economy*. London and New York: Routledge.

Lyon, D. 2003. *Surveillance as Social Sorting*. Cambridge: Polity Press.

Manovich, L. 2001. *The Language of New Media*. Cambridge, MA: MIT Press.

Matrix, S. E. 2006. *Cyberpop: Digital Lifestyles and Commodity Culture*. New York: Routledge.

McCracken, G. 1988. *Culture and Consumption*. Bloomington: Indiana University Press.

McFall, L. 2004. *Advertising: A Cultural Economy*. London: Sage.

Miller, D. 2001. 'The Poverty of Morality', *Journal of Consumer Culture*, 1/2: 225–43.

Mitchell, William J. 1992. *The Reconfigured Eye: Visual Truth in a Post-photographic Era*. Cambridge, MA: MIT Press.

Moor, L. 2007. *The Rise of Brands*. Oxford: Berg.

Nixon, Sean. 2003. *Advertising Cultures: Gender and Creativity at Work in Advertising*. London: Sage.

O'Reilly, T. 2005. 'What Is Web 2.0: Design Patterns and Business Models for the Next Generation of Software', http://oreilleynet.com/1pt/a/6228, accessed June 10, 2007.

Poster, M. 2006. *Information Please*. Durham, NC: Duke University Press.

Putnam, R. 2001. *Bowling Alone*. New York: Simon and Schuster.

Sassatelli, R. 2007. *Consumer Culture: History, Theory, Politics*. London: Sage.

Schroeder, J. E. 2002. *Visual Consumption*. London: Routledge.

Sennett, R. 2008. *The Craftsman*. New Haven, CT: Yale University Press.

Shove, E., M. Watson, M. Hand and J. Ingram. 2007. *The Design of Everyday Life*. Oxford: Berg.

Slater, D. 1997. *Consumer Culture and Modernity*. Cambridge: Polity Press.

Sontag, S. 1977. *On Photography*. Harmondsworth: Penguin.

Sparke, P. 1986. *An Introduction to Design and Culture in the Twentieth Century*. London: Allen and Unwin.

Sturken, M. and L. Cartwright. 2001. *Practices of Looking*. Oxford: Oxford University Press.

Taylor, P. and J. Harris. 2005. *Digital Matters*. London: Routledge.

Thrift, N. 2005. *Knowing Capitalism*. London: Sage.

Veblen, T. (1899) 1953. *Theory of the Leisure Class*. New York: Mentor.

Warde, A. 2005. 'Consumption and Theories of Practice', *Journal of Consumer Culture*, 5/2: 131–53.

Developments in the Field of Visual Culture

Editorial Introduction

All of the chapters in Part Five in different ways explore innovations and challenges inspired by recent developments in the field of visual culture. A common theme running through these chapters is the emergence of more performative, practice-based and reflexive methodologies in contemporary visual studies (what might also be called 'the new visual studies').

Gillian Rose introduces her chapter by using the work of the theorist Mieke Bal to pose basic questions about the status of method, critical practice and reflexivity in visual culture studies. The chapter is designed to remedy the lack of reflection on issues of method and methodological debate and to suggest methodological strategies that are powerful enough to approach visuality as an event and performance rather than a static structure (text) or background resource (culture). By criticizing well-established cultural studies perspectives and text-based models—and what she helpfully calls their 'implicit methodology'—she makes a strong case for other paradigms of meaning and interpretation based upon situated *practices*, active *audience reception* and *context-sensitive* hermeneutics.

Reframing visuality as 'located social, affective and economic events' leads to a much more dynamic (as well as pragmatic) approach to analysis. Rose urges her readers to abandon all forms of detached 'connoisseurship' in order to become much more reflexive about their own assumptions and active engagements in acts of reading and interpretive analysis. To this end the idea of situated 'practices of looking' is commended as a more useful approach to visuality as a field of *occasioned* practices. Rather than turn to traditional art-historical approaches or decontextual semiotics we might learn how to analyse visual practices from work carried out in sociology and discourse analysis (along the lines developed by Foucault and others).

The new methodological frontier would thus place the following concerns high on the agenda of future visual research: the *situated* or *occasionality* of things visual, the

performativity of visual practices, the social, ethical and political *consequences* of interpretive seeing, and the *embodied* and *reflexive* involvements of all agents within the field of the visual (producers, observers, users, analysts and so on). Here future interdisciplinary research will need to abandon the artificial distance assumed by 'connoisseurs' and turn towards action-based performative research methodologies. At this point there is a convergence between Rose's critique and the empirical schema of action research formulated in the chapter by David Gauntlett and Fatimah Awan as well as the ethnographic-based claims for a more multimodal approach to sensory experience in David Howes's chapter.

Rose has not only theorized such a 'performative' and 'reflexive' turn but has empirically explored the possibilities of using visual material (e.g. in work on family photographs in her *Doing Family Photography*) as occasions for analysis and self-reflection. When carried out with full awareness of its implications for both analyst and research subject such a practice-oriented methodology leads to a much more critical and self-critical standpoint. The aim of this renewed reflexivity is to recover the simple idea that 'looking is a social act among humans and between humans and other things'.

Charlie Gere traces the challenges of recent visual-culture research from the perspective of digital media and what has been called the digitalization of everyday life. His focus is upon the contemporary phenomenon of digital art as a challenge to traditional analytical frameworks. He is guided in his analysis by the work of Jean-Luc Nancy and Jacques Derrida's metacommentary on Nancy's work on the sense of touch. Where analogue culture emphasizes tactile values, the coming of digital culture leads to a world of flowing images and simulacra promising universal interactivity (the *World* Wide Web), *connectivity* (*Facebook*, *Web 2.0* networks, etc), and instantaneous simultaneity of encounter and affect. With digitalization we move from the Heideggerian 'world-view' to the total globalization of all relations. Digitalization and new media force their users to adopt the ambivalent status of cyborgs. We no longer watch television or films but are 'plugged into' visual media; we no longer 'apply' techniques and technologies but are absorbed into the new ecologies of cyberspace and its eco-technical apparatuses.

Where Gillian Rose urges visual-cultural researchers to employ more performative and practice-based technologies so Gere suggests that those who study contemporary visuality cannot avoid a critical encounter with new visual media. Here traditional methods based upon a disengaged (and 'analogue') approach to meaning and significance— a commitment to disinterested 'readings' of significant objects and artefacts—gives way to a much more 'connected' and reflexively 'wired' view of the world. The older metaphysical terms of 'representation' and mirroring language no longer operate in digitalized space.

This is emphatically exemplified by the production, dissemination and appropriation of new media art forms. Here cultural worlds based upon digital art become the basis for a new global mass culture (with digital gaming overtaking mass-production film and television programming in commercial terms).

One of Gere's tentative conclusions is to suggest that the exponential growth in digital art (and related digital media) will have an enormous impact upon traditional sensory experience and knowledge based upon analogue means. New ways of thinking,

new methods and new forms of reflexivity might be expected to arise from the way in which digitalization throws users back upon their taken-for-granted assumptions about the senses and sensory experience. Here what used to be called 'art' might function in returning audiences to a renewed encounter with the richness and diversity of the sensory world, of the life and life-worlds that endure beyond the apparatuses and technologies of representation.

Roger Burrows is also concerned with implications of digitalization, but approaches the revolution in new media and mediated culture from a sociological perspective. For him digitalization processes are both an 'object of inquiry' and a 'challenge to established methodological practices'.

His particular theme is the impact of visualization and the 'descriptive turn' in contemporary sociology. He sets the scene by criticizing what he calls 'epochalism', or that mode of thinking that represents history in terms of stages of 'epochal' social change. To move beyond this way of thinking and to respect the complexity of social worlds he explores the impact of digitalization upon *empirical* social research, especially in the development of new forms of visualization and visualization methodologies.

It is well known that traditional sociology has not made a great use of visual techniques and methods; this oversight or recalcitrance has become emphatic in the way in which empirically based research has, until quite recently, ignored the vast array of data and data-gathering machinery made available through digital means (census data, commercial data mining, consumer-based research, state auditing, citation information and so on). Digitalization and the information revolution have led to a radical revaluation of the place of the visual in social research. For example, artefacts in contemporary capitalism are now saturated with information, circulating as both the result and carriers of 'codes', 'logos', information-tracking devices and so on (the bar-codes at the supermarket being an early precursor). One recent way of exploiting such coded-objects is the ability of interested parties to 'harvest' and 'profile' information about their usage and their users. This provides exemplary 'pictures' or representations of categories of voters, consumers, house-owners and the like. Here digitalization places powerful empirical tools of visualization in the hands of corporate and state agencies. Burrows breaks new ground in exploring the networking logics of information-carrying objects ('spimes') as a vast 'internet of things'.

Anticipating the 'descriptive-visual' turn in contemporary sociological research, Burrows (following the recent work of Mike Savage) commends a sociological perspective that might recover the immanent, qualitative and 'surface patterns' of social life. We should forgo the speculative temptations of 'depth' analysis and explore the 'lyrical' configurations of everyday social life. This becomes particularly important in extending the cultural turn of recent social thought to televisual and media/ted culture. One exemplary form of this transdisciplinary approach is the creation of the television series *The Wire* as both entertainment and as powerful exercises of the sociological imagination. By exploiting the full range of visualization techniques made available by contemporary cyber-culture Burrows anticipates a fusion of empirical and imaginative media that will give rise to new 'visual inscription devices'.

He concludes his chapter by briefly analysing three such 'sociological inscription devices' that might energize the practices of contemporary sociology: recent innovations in mainstream social statistics software that will enhance visual research and presentation of data; the beginnings of a 'new cartography' and related developments in Web 2.0 social software; and innovative data profiling techniques in 'commercial sociology' (in particular what has been called *geodemographics*). All of these 'devices' are characterized by an explicit concern to document social reality through the visual characterizations of data. When these and other techniques are allied with theoretical analysis of social systems we can legitimately anticipate a paradigm shift in modes of descriptive analysis and societal visualization. Sociology—and perhaps other social sciences—will then be forced to follow visual studies research and enter the great debate about the emerging forms of visual analysis and visualization methodologies.

David Gauntlett and Fatimah Awan provide a graphic example of both the increasing reflexivity of descriptive research and the benefits to be gained by adopting new visualization technologies in the conduct of social research. Where Burrows focussed upon new kinds of 'inscription device', their central topic is the emergence of action-based creative methods in social research.

Where traditional uses of visual methodologies were predominantly 'object-directed' and analytically interested—in the sense that they were concerned with the description, analysis and, perhaps, explanation of visualizable phenomena, Gauntlett and Awan are concerned with methods and approaches that actively *create* new visual things *in the course of research*.

In their terms, the emergence of a new visual sociology is characterized by researchers who utilize visual media and materials (such as drawings, diagrams, photographs, videos and the like) that invite interpretations on the part of social agents, that actively intervene in social life, and invite participants to formulate their practices and reflect upon their social positions and life-worlds.

Action-based sociological research thus encourages the use of visual materials and visualization techniques on the part of research participants as ways of generating 'thick descriptions' and reflective accounts of members' worlds. They illustrate these innovations with research involved in the making of drawings and diagrams, the creative use of photography as ethnographic tools, the use of video diaries as instruments of self-representation and identity formation, personal narratives and reflective practices of editing.

Drawing upon Gauntlett's own work *Video Critical* (1997), they describe the ways in which research participants have created their own original visual 'texts' (videos, films, etc) in the study of children's interpretations of media events and environmental issues. Giving video cameras to children or allowing participants to record and analyse their own 'worlds' is thus not only a rich source of sociological data but also something like a 'life-transforming experience'.

They also describe recent research in the use of *visual metaphors* by participants and, more particularly, research on the ways in which children actively build metaphorical models of their 'sense of self' using Lego bricks. Gauntlett has argued that as these techniques enable researchers to visualize identity formation as a complex *process*, mediated

by actions and practices, it might be extended to more complex representations of 'invisible' and 'intangible' phenomena (such as emotions and relationships).

Their chapter concludes by stressing the myriad ways in which metaphor-mediated forms of seeing and action-based techniques of representation might be extended to ethnographic and qualitative research in other fields and disciplines.

John Onians and his colleagues and co-workers **Helen Anderson and Kajsa Berg** explore the relationships between trends in visual culture and visual studies and neuroscience. Their central claim is that contemporary neuroscience provides powerful tools in the understanding of the visual world as well as providing a 'new dimension to visual culture'.

Recent technological developments in brain-scanning (itself a particularly important visual technology) and recent theories of the modular and 'neural plasticity' have increased our knowledge of the importance of pattern recognition and 'aesthetic' experience in everyday brain functioning. Onians's own work is centrally concerned with creating a framework of concepts that he calls *neuroarthistory* designed to explore the dynamic interfaces between aesthetics and neuronal activity. The first part of their chapter explores the origins and diversification of this ground-breaking work in areas such as neuroaesthetics, neurosculpture, neuroarchitecture, neuromarketing and neuromuseology ('the use of neuroscience to understand the history and role of museums').

After detailing current thinking about the origins and functions of the brain in neuroscience, the authors apply these findings to visual culture, noting that much theorizing about the information society has itself drawn its concepts from 'parallels between the human nervous system, the social, economic and technical systems of the modern world and the system of the art scene and visual culture'. Today these analogies and parallels have themselves influenced both the content and form of popular visual culture.

In her contribution to this chapter, Helen Anderson explores the theme of neural plasticity, the view that the brain is a dynamic and modular system which changes and transforms itself in interactions with its relevant environments. Understanding how this plasticity—particularly the plasticity of the visual cortex—works might shed light on the changing forms of visual experience and perception. More particularly her contention is that this knowledge should prove central to a more scientifically informed approach to art production and reception. One example of the interaction between neural plasticity and environment is the use of different neuronal formations to explain contrasts between different styles of painting in the Renaissance. Perspective was a particular concern of Florentine painting (reflecting predominantly geometrical and planar structures associated with that city) while Venetian art was more focussed upon 'repeated experience of light reflected from water and of the similar effects produced by polished coloured marbles, gold glass mosaic and oriental silks' (Onians 1998: 15). Similar mechanisms might be applied to the emergence of later art forms and styles.

Kajsa Berg introduces the important concept of *neural mirroring*, the outcome of *mirror neurons,* neural systems linked to interpersonal and emotional responses (neurons that 'fire not just when someone makes a movement, but when that person sees someone else making the same movement'). These 'empathy' neurons suggest a link between

the activities of viewers and artistic objects. Berg documents a range of voices that have posited this empathetic relationship, culminating in important research into the neurological functions of mirror neurons in the 1990s. The intriguing thought is that the dynamics (or 'plasticity') of mirror-neuronal activity can illuminate the history of art appreciation and artistic production: in clarifying the roots of mimesis and representation, in suggesting explanations for how spectators 'identify' with figurative works, in introducing embodiment and movement as central problems of aesthetics, as well as in more active applications to performance art and installations (the use of neuroscience in the work of Amy Caron is cited in this context). Neuroaesthetics will play an important role in making *implicit* reliance upon neuronal structures and dynamics *explicit* research topics. The future for neural-based aesthetics is both exciting and daunting. One field that the authors single out is the renewed appreciation of 'synaesthesia' and a much more multisensorial approach to the interaction between human beings, their environments and artefacts. Neuroarthistory might thus complement and extend the work of phenomenology and poststructuralist approaches to embodied experience: 'As images of the brain become both more familiar and more accessible, the words of philosophers will lose their preeminence as the primate gateway to the mind, being joined, if not replaced, by visual culture'.

The task of moving beyond a narrow word-based and textual understanding of visual experience, of rethinking phenomena like synaesthesia and affective empathy, and developing an explicitly multisensorial philosophy of concrete experience also informs the chapter by **David Howes**. Howes is a cultural anthropologist who has written extensively about the relationships between ethnographic work, sensory experience and culture. He argues that while visual techniques and methods have been central to traditional anthropology (with its emphasis upon direct observation, field work, ethnographic representation through field notes and so on) this has led to a paradoxical situation in which the 'implicit' visual bias has gone unnoticed and unquestioned and the emphasis on visual devices has sidelined and occluded the role of the other senses and nonvisual experience in anthropological work.

Following the work of Anna Grimshaw (*The Ethnographer's Eye*), Sarah Pink (*The Future of Visual Anthropology*) and others, he proposes a multisensorial 'revisualization' of ethnographic research.

While the use of visual techniques plays a seminal role in nineteenth-century anthropology the visual turn in anthropology dates back to the 1990s as a reaction against the textual models of ethnographic representation in both classical and more reflexive frameworks. The recent revisualization of the discipline was stimulated by Anna Grimshaw's 2001 work *The Ethnographer's Eye*; among a series of other studies Grimshaw tried to recover the work of W.H.R. Rivers (1864–1922) and his use of photography in providing 'thick descriptions' of traumatized soldiers suffering from shell-shock. Howes describes Rivers' famous Torres Strait expedition which aimed to explore the sensory and perceptual life of native peoples. While their findings were mixed and problematic this study represented an early effort at 'sensualizing anthropology'. This would later be

taken further by the use of film and documentary techniques (described in Part II of *The Ethnographer's Eye*).

Building on these insights Howes argues for an explicit and reflexive multimodal approach to capture the complexity and contextual detail of sensory experience. Advances in this direction have been compiled in his edited collection, *Empire of the Senses: The Sensual Culture Reader* (2004) as well as his anthology *The Sixth Sense Reader* (2009). The future of such a multisensorial ethnography is one that will incorporate multiple technical observation instruments, different methodological directions and explicit forms of interdisciplinary cooperation (e.g. between artists, filmmakers, new environmental sciences and so on).

Against the background of radical conceptual changes in our sociological understanding of culture and in particular visual culture **Barry Sandywell** attempts to formulate the burgeoning field of *new visual studies* in seven basic arguments or 'theses'. He suggests that taken together these theses outline the emergence of something like a *reflexive ontology of image experience* and a *critical-reflexive paradigm* for visual culture research.

While being interdependent, each of these theses aims to condense empirical and theoretical developments into their generative or 'deep' structure and to provoke further elaboration and concrete application of the various 'turns' towards a more transdisciplinary approach to visual culture that will openly acknowledge its social, cultural and political assumptions and implications.

As the seven theses are also proposed as *provocations* as much as *epistemological* directives they can only be schematically outlined here: the *historicity* thesis (detailing the complex history or historicity of acts of seeing); the *artefactuality* thesis (underlining the fabricated, socially constructed and revisionary character of all visual objects and the importance of practice-oriented situational analysis in understanding processes of construction and reconstruction); the *language* thesis (emphasizing the radical interdependence between visibility and visualization and the wider realms of conceptuality, discourse and language); the *technopoiesis* thesis (that all visual phenomena are mediated, shaped and transformed by technological devices); the *sociocultural* thesis (drawing attention to the grammar of social relations and power implicated in the visual field); the *political* thesis (positing the dialectical relationship between regimes of visibility and ethical and political formations in society and history); and the *reflexive praxis* thesis (the claim that visual practices and institutions are agencies of self-reflection and transformative change in society).

Finally **Barry Sandywell** provides a comprehensive overview and mapping of the current literature in visual-cultural studies including disciplines and perspectives that have been highly influential in shaping the current field of visual inquiry. The chapter has been constructed to help readers find their way around this rapidly growing field, to construct their own reading and research programmes, and to encourage the formulation of more experimental, interdisciplinary and transdisciplinary teaching agendas in visual culture.

The Question of Method: Practice, Reflexivity and Critique in Visual Culture Studies

GILLIAN ROSE

Mieke Bal's essay 'Visual Essentialism and the Object of Visual Culture' is a rigorous commentary on what Bal calls 'the primary pain point' of visual culture studies (Bal 2003: 6). Bal argues that visual culture studies are founded on the specificity of their object of study, but at the same time are unclear about exactly what that object is. Hence their 'pain', inflicted on Bal at least by the range of 'unquestioned assumptions' and even 'blatant nonsense' that substitute in visual culture studies for careful consideration of that object (Bal 2003: 11, 12). Bal offers her own analgesic, suggesting that the proper object of study for visual culture studies should in fact be a nonobject: 'visuality' itself. For Bal, visuality becomes an object of study in moments of seeing, or 'visual event[s]' (9), when, in an encounter between a human subject and another entity, something emerges as 'a fleeting, fugitive subjective image accrued in the subject' (9). Her interest is therefore as much in 'performing acts of seeing' as in 'the materiality of the object seen' (11).

This chapter uses Bal's argument to consider what Bal calls 'the question of method' (Bal 2003: 23). In her essay, Bal claims that 'methodological reflection cannot be avoided at this time' (23), and, indeed, 'method' is central to all of her work (as the collection of her essays edited by Norman Bryson attests (Bal and Bryson 2001)). It is therefore entirely typical that she should introduce her concern with the 'visual event' and with 'performing acts of seeing' in the form of a question serving to generate particular sorts of evidence: with methodology, in other words. Her question is this: 'what happens when people look, and what emerges from that act?' (Bal 2003: 9). And her essay is structured such that its arguments culminate in a section entitled 'The Question of Method'; 'methodology' is also a key word of her essay.[1]

Yet, of the seven essays published in response to Bal, only three engage with the question of methodology, and that only very briefly: for example in Griselda Pollock's passing and approving reference to 'modes of analysis' that 'reframe Art History's precious authored objects as texts and theoretical practices' (Pollock 2003: 259). I want to make three points in relation to this apparent uninterest in questions of methodology by Bal and her respondents. Firstly, I think Bal is correct to place so much importance on methodology, and I hope it will be obvious by the end of the chapter why this is the case. Secondly, though, it seems to me that the uninterest in questions of method shown by the responses to Bal's paper is symptomatic of a much wider uninterest in questions of method across the field of visual culture studies more generally (which is hardly surprising, since all of her respondents have been extremely influential in visual culture studies). Thirdly, this lack of interest in discussing questions of methodology seems to be caused by the hegemony of an implicit methodology. So for all the talk of interdisciplinarity and what can be done differently by working across established research boundaries, visual culture studies, I suggest, has remarkably little interest in methodological discussion or experimentation. So, for example Pollock's refusal, quoted above, to consider art objects as objects denies the relevance to visual culture studies of a body of work which does indeed treat artworks (and other sorts of visualized materials) as objects, and also precisely as a means of avoiding questions of preciousness, authorship, aesthetics and connoisseurship. I am thinking here of work in anthropology, inspired in different ways by the work of Alfred Gell (1998) and Arjun Appadurai (1986), among others, in which art is seen as less a matter of textual meaning and much more as a matter of social doing. In this work, artworks, and other visual objects, are conceptualized as visual objects possessing agency which, when encountered, produce compressed performances with social effect (e.g. Myers 2001; Pinney 2003, 2005; Poole 1997; Thomas 1991).[2] Yet this anthropological work is rarely referred to in visual culture studies (one exception being Bal herself).[3] Nor does the well-established field of audience studies (see Gillespie 2005) make much of an appearance in discussions of visual culture.

This current lack of methodological debate has certain consequences for what visual culture studies can do. The first part of this chapter sketches the characteristics of the implicit methodology that dominates visual culture studies, as I see it, and examines what sort of criticism it produces, what sort of objects of study, and what kind of critic. I should say at once though that my aim is not to dismiss these critical positions and projects in any way. As Pollock says, 'there have to be sites of critical contestation of what is at stake in the ideological investments in high culture and the global capital investments in popular culture' (Pollock 2003: 259); and any site, using whatever methods, that achieves such contestation—as so much excellent work in visual culture studies has already done—is surely to be valued. However, particular methods achieve particular ends. And while the implicit methodology of so much visual culture studies to date has been very effective at certain forms of critique, it is perhaps time to ask whether that methodology alone remains fully adequate to addressing visual culture in all its richness and complexity. In particular, it seems to me that if visual culture needs

to explore the rather different territory of visual events and performances of seeing—as, following Bal and others, I think it must—then different methodologies may well be required.

So in the second section of the chapter, I build on aspects of Bal's own methodology. But this chapter is not absolutely faithful to Bal's position (if such a thing were possible). This is partly because her own methodology has already been elaborated by Norman Bryson (2001), and there seems little point in repeating his remarks. More significantly, though, as Bryson notes, Bal's methodology is based on examining the logic of 'discourse, enunciation and voice' as 'they are focalized or embedded in the actual discursive situation' (Bryson 2001: 19). If visual culture studies is fully to engage with the consequences of Bal's move towards performance and event, this chapter suggests that it also needs some methodological resources to enable it to say more than Bal can about the 'actual situation' emergent upon specific acts of seeing. These resources, I suggest, would focus less on the logic of 'discourse, enunciation and voice', and more on the logics of discourse, practice and place. In other words, I am suggesting that if visual culture studies is to look more closely at visuality as an event, it would benefit from being able to ask questions about the particularities of events as they take place in different locations with diverse human and artefactual actants.

THE IMPLICIT METHODOLOGY OF VISUAL CULTURE STUDIES: ANOTHER KIND OF CONNOISSEURSHIP?

To attempt to describe the taken-for-granted methodology of visual culture studies is clearly fraught with difficulties. Works that might count as visual culture studies are numerous, diverse and spread far and wide; and the field has not been, and is not, without any methodological discussion whatsoever. My strategy here is to take just a couple of examples of visual culture criticism, and to suggest what is typical about their critical methodologies. The examples come from an influential textbook and a body of criticism addressing one sort of visual object.

The first example is a highly respected textbook on visual culture: *Practices of Looking*, written by Marita Sturken and Lisa Cartwright (2001). As its title suggests, this book argues strongly that visual objects, in and of themselves, carry little inherent meaning; 'one of the central tenets of this book is that meaning does not reside within images, but is produced at the moment that they are consumed by and circulated among viewers' (Sturken and Cartwright 2001: 7). That is meaning is made through social practices. Hence the title of their second chapter, 'Viewers Make Meaning'. But here their argument slips. It moves away from the viewers and their making, and towards the interpretation of images' meanings as conducted by the critic. This happens because Sturken and Cartwright argue that there are in fact three sites at which the meaning of an image is reached—through its viewers' interpretations, but also through the meanings it carries itself, and the context in which an image is seen—and it is the critic's task to unpack 'the complex social relationship' between these three sites in relation to a variety of media and genres of visual images (45).

In making this claim, Sturken and Cartwright undoubtedly offer a nuanced and critical account of visual culture. Their account has three features, though, that deserve emphasis. Firstly, they focus heavily on the question of meaning. Producers' meanings, viewers' meanings, dominant-hegemonic, negotiated or oppositional meanings, ideological meanings . . . This search for the meaning of visual materials is indeed at the heart of most visual culture studies, and Sturken and Cartwright (2001: 45–71) helpfully point out where this methodology comes from: Stuart Hall's 1974 essay on the coding and decoding of meanings, in which semiology and Foucauldian discourse analysis sit rather uneasily side-by-side (Nightingale 1996). I agree that the theoretical roots of visual culture studies' implicit methodology do indeed lie in a usually unproblematized conflation of a watered-down semiology with a thinned-out version of discourse analysis. The second feature of Sturken and Cartwright's (2001: 45–71) account that is characteristic of visual culture studies more generally is their slip from viewers making meaning to the critic's interpretive role. For while viewers in their account make meaning in theory, actual viewers are given very little say in their book. The subtle audience ethnographies undertaken by scholars such as Valerie Walkerdine (1990) or Marie Gillespie (1995), for example are nowhere to be found in their account.[4] The third feature is also an absence: that of the visual culture studies critic. For surely there are actually four sites of meaning-making, the fourth being the critic who interprets the 'junctures and articulations of visual culture' (Bal 2003: 21).

These three aspects of visual culture studies' methodology—a focus on meaning and interpretation, the absence of actual audiences, and a certain invisibility on the part of the critic—are accompanied by a fourth, which again is a legacy from Hall's version of cultural studies: a search for critique. This is particularly evident in my next example, which is a body of work addressing public art.

I'll begin with a quotation from a book chapter written by Patricia Phillips, a distinguished writer on public art (Phillips 2003). She is discussing a mosaic in a subway station in New York called *Oculus*. Two artists photographed eyes of schoolchildren in the city, and made mosaics from the photos. Here is what Phillips says about the mosaic:

> Historically, eyes have been endowed with symbolic significance. They are windows to the soul, the centre of individual identity. The eyes—in fact, hundreds of pairs of individuals' eyes—offer compelling information about gender, race and ethnicity as physical attributes and social constructions. The eyes of the city's children are poignant representations of its vigorous diversity. Clearly, the gaze can be intrusive and aggressive, but *Oculus* sensitively demonstrates that it can also be compassionately connective. The project is a moving and generous image of the multiple dimensions of contemporary public life. (Phillips 2003: 125)

Innocuous enough. But this quote seems to me to share the methodological approach of Sturken and Cartwright (2001). Clearly, Phillips too is concerned about the meaning of this artwork. In explicating its meaning, she is typical in the way she discusses a number of different aspects of the work located at one or other of Sturken

and Cartwright's three sites: its formal qualities and historical references, its institutional context and its critical reception. In this particular example, I'd point to phrases like '*historically*, eyes have been endowed with *symbolic significance*', which demonstrates the critic's knowledge of historical scholarship and cultural context. The effects of these sites are integrated (implicitly) via the critic's theoretical apparatus, with the phrases 'gender, race and ethnicity as physical attributes and social constructions' and 'representations of its *vigorous* diversity' both implying the work of the critic in placing *Oculus* in relation to a specific kind of cultural theory and politics. As a consequence of this analysis of the work's meaning, the reader is then told what the effects of this work of art are. '*Oculus sensitively demonstrates* that the gaze can also be compassionately connective'; 'the project *is* a moving and generous image of the multiple dimensions of contemporary public life'. Once again, there is no discussion of what other viewers (subway users, for example) might be making of it, and no reflection on the critic's method of reaching her conclusions.

In this example, it is also particularly clear that public art is being judged on the grounds of its political effect. In this case, Phillips claims that the mosaic represents public life as vigorously and multiply gendered and racialized, and assumes that this is a good thing. As Grant Kester points out in his book *Conversation Pieces* (2004), one criteria that dominates most (modernist) art criticism methodology is precisely whether an artwork resists 'dominant meanings', howsoever defined. The most highly valued artworks produced by much art criticism are those which are seen to resist the production of hegemonic meaning, to refuse to reproduce discourse, to destabilize the power-knowledge nexus. Critics expect that 'the work of art should challenge or disrupt the viewer's expectations about a given image, object, or system of meaning' (Kester 2004: 17). This expectation is very much at work in discussions of what constitutes good public art, and, I would argue, in visual culture studies more generally. So, take just three examples, Phillips (1994: 61) says that public art 'can be a form of radical education that challenges the structures and conditions of cultural and political institutions', Suzanne Lacey (1995: 13) claims that it should imply or state ideas about social change, and Jane Rendell (1999: 4) says that public art should provide 'moments, places and tools for self-reflection, critical thinking and radical practice'. In similar fashion, visual culture studies' implicit methodology also praises critique in the objects it sees. The objects that it valorizes are those that pull their viewers out of their ordinary values and perceptions, and that is its fourth characteristic.[5]

Now, clearly such criticism is a valuable skill for building those 'sites of contestation' demanded by Pollock and many other visual culture critics. However, we should perhaps be more aware than we are of some of its implications. One implication in particular deserves more attention, I think, which is the way in which this methodology enables its particular sort of critic to ignore what Toby Miller (2001) calls the 'occasionality' of 'visual events', in all their extraordinary variety. By 'occasionality', Miller means 'the conditions under which a text is made, circulated, received, interpreted, and criticized, taking seriously the conditions of existence of cultural production' (306). I would emphasize the importance of where a particular visual event takes place in particular: the 'same' object may participate in quite different visual events when it is in a family album

and when it becomes part of mass media discourse of grief and blame (Rose forthcoming). Yet the semiological-discursive methodology of visual culture studies makes the occasionality of visual events difficult to explore. The focus on meaning and interpretation tends to lead to a methodological focus on the formal qualities and discursive context of visual objects; the uninterest in audiences leads to art objects in particular being read as if where they were (not) seen was irrelevant; and the uninterest in the specific conditions and processes in which the critic is working produces claims about the meaning inherent to visual objects which ignores the particular conditions under which that claim is made. As Miller (2001: 307) notes, film theorists, for example never discuss what difference it makes to their interpretation of 'the' meaning of a film that they watched it on a DVD player, repeatedly, on their own, in an office or study—rather than seeing it once, on a large screen, at a packed multiplex on a Saturday night. Finally, the urge to see things as critical means that vast swathes of visual events have simply never made it onto the visual studies agenda.

But if we think of an installation in an art gallery, or a family photograph album, or the latest blockbuster at a multiplex, and think of them, not solely in terms of their formal properties and philosophical implications, but also as located social, affective and economic events, then we will produce a rather different account of them: an account that can consider the importance of institutional context, of the people who funded, installed and looked at them, of the corporeal and discursive gestures and comportments by which they happen. We then start to have a rather different sense of such objects and how they are visible: not simply as objects to be interpreted, but as remarkably complex objects that came into being only through the participation of numerous actors, both human and nonhuman. We might then also be more inclined to consider the critic as one of those actors, and reflect more carefully on his role.

In contrast to this approach to visual culture—which I will develop in the next section—I'd like to name visual culture studies' implicit methodology as a newer kind of conoisseurship. 'Conoisseurship', in its traditional sense, involves detecting the influences of other artists on a particular artwork, through the deployment of what Irit Rogoff (1998) has called 'the good eye'. As Rogoff says, this eye does its work mysteriously, apparently intuitively evaluating the provenance and quality of an artwork. What I have been describing in this section might be described as the effect of 'the good theory', which is mobilized in an equally unreflexive manner to produce an equally perceptive critic who can reveal the meaning and critical effect of visual materials. The creation of this critical position is surely in part at least a consequence of visual culture critics' uninterest in methodology. Visual culture critics tend to write as if their judgement was self-evident, the only one possible, as if their account of a visual work is a process of description or revelation rather than construction. It isn't of course, as I'm sure if directly asked they would readily admit—it's a result of years of training in disciplinary conventions (particularly the 'textualist and historical side to the humanities' (Miller 2001: 305)), of archival research, of teaching and being taught, of conference going and so on. And there have been some worries recently that, if you like, too much work has to be brought to bear on a visual object to work out what it means. Sometimes this expresses

itself in a concern that images end up merely illustrating theoretical accounts (Pinney 2003; Bal 2003: 23); sometimes it takes the form of various worries that visual things are all too rarely allowed to exceed or escape interpretive frameworks (Holly in Cheetham, Holly and Moxey 2005; Farago and Zwijnenberg 2003; Mitchell 1996); sometimes a frustration at how the rich diversity of actual visualities keeps on being straightjacketed into a limited conceptual language (Maynard 2007). And with this suggestion that some methodological debate in visual culture studies has not been, and is not, nonexistent, the next section returns to Mieke Bal's work.

TOWARDS A METHODOLOGY FOR PERFORMING ACTS OF SEEING

So far, I've suggested that the implicit methodology of visual culture studies is producing a certain sort of approach to visual culture. It is an approach that values objects that critique the dominant power relations in that context and that privileges only the critic's interpretations of object and context. Productive as that methodology is, there are other ways of thinking about visual events and the objects entangled in them, that allow us to see other things and occupy other critical positions. This section develops this suggestion, returning to some of Bal's insights but taking them in a rather different direction.

Practice

As should be obvious by now, I find Bal's concern with visual events and 'the practices of looking invested in any object' (Bal 2003:11) very productive. In particular, her use of the term 'practice' can open up a rather different approach to visual culture studies, different both from its implicit methodology but also rather different from Bal's own approach. Here, I want to suggest that the social sciences might have something to offer visual culture methodologies. In particular, the current interest in 'practice' among a range of social theorists offers some ways of approaching the occasionality of visual events.

In the social sciences, the notion of 'practice' has a complex theoretical genealogy. Importantly, it is not opposed to discourse: indeed, Foucault's work might be read as an extended meditation on practices as power (Laurier and Philo 2004). However, the current interest in practice certainly draws on more than just Foucault for its theoretical underpinnings: Merleau-Ponty, Bourdieu, de Certeau, Appadurai, Ingold and a group of science studies writers including Latour and Serres all make their appearance in discussions of practice (for a review see Reckwitz 2002). A succinct definition of practice is offered by Theodore Schatzki (1996: 83), who describes a social practice as a cluster of 'doings and sayings'. Andreas Reckwitz (2002: 249) elaborates:

> A 'practice'... is a routinised type of behaviour which consists of several elements, interconnected to one another: forms of bodily activities, forms of mental activities, 'things' and their use, a background knowledge in the form of understanding, know-how, states of emotion and motivational knowledge.

A practice, then, is a fairly consistent way of doing something, deploying certain objects, knowledges, bodily gestures and emotions. It is through practices that social relations and institutions happen, and through practices that subject positions and identities are performed. From this, it becomes possible to see how Miller's 'occasionality' might be pushed from his cultural-materialist account of 'context' to a rather more radical account of how seeing happens. For now we can suggest that different ways of seeing are bound up into different, more-or-less conscious, more-or-less elaborate, more-or-less consistent practices. Visualities are one practice among many, and in their routinization and place-specificity they make certain sorts of things visible in particular ways.

There are two things to emphasize here. Firstly, practices are always embedded in specific places. The different visualities mobilized in a shopping centre (Becker 2002; Degen, DeSilvey and Rose 2008) are not the same as the visualities in an art gallery (Heath and vom Lehn 2004) or a train (Bissell 2009) or an expo (Jansson 2007a), because the practices in those sorts of place are not the same. There are two dynamics here (see also Jansson 2007b). Firstly, particular locations usually invite quite specific performances of seeing (which include specific modes of bodily and other sensorial comportments). Sitting in a cinema seat, the etiquette of where to put coats and bags, what to eat and drink there and how, when you can talk and when you shouldn't, the specific kinds of gazes given to films (as opposed to invited by them, about which we know a lot)—all these things are peculiar to cinemas, and vary between different cinemas. Anna McCarthy's book *Ambient Television* (2001) demonstrates the place-specificity of practices of looking in a different way, by unpacking the different modes of visuality structuring television programmes made for specific locations, such as airport lounges, hospital waiting rooms and checkout queues. Her study explores the co-constitution of nondomestic TV genres and the places in which they are shown very effectively (though, typically, she doesn't say much about how the people in these places practice the TV). Secondly, though, it is the practices undertaken in those places which reproduce them as those sorts of spaces (or not). If everyone started to wander in and out of all the cinemas in a multiplex just like they wander in and out of galleries in a museum, strolling down a side aisle, along the front and up the other side, inspecting the walls all the while, it would no longer be a cinema. Practices of looking, then, are also about the practising of places.

This emphasis on place is not simply a question of the spaces in which visual events take place, however. The sorts of geographies practically constituted through such events may well exceed the immediate location of their event. Divya Tolia-Kelly's (2004) work, for example on how diasporic identities are mobilized through various decorative objects in migrants' houses, tells of an intimate imbrication of certain domestic and global spatialities. Thus the space performed by practices, including visual practices, is not necessarily a simple question of location (an altarpiece in a church versus an image of that altarpiece on a tourist Web site). It might also entail all sorts of other geographies, of various geometries and modalities.

Secondly, the performativity of practice. That is (following Butler 1990), practices produce the entities that are claimed to preexist the practice. While both, say, a

Caravaggio painting and a gallery visitor (Bal 1996: 117–28), or an on-line game and a gamer, may seem to exist prior to their mutual encounters, they do not; they constitute each other as they interact (and such interactions are not only visual, of course). Hence practices are relational. 'Performing acts of seeing' produce both seer and seen (Bal 2003: 11, 14). And as performative, practices both discipline these positions but slippages in their reproduction also occur. Bal has in fact offered examples of both of these possibilities, in the organization of New York's museum district which inscribes a racialized distinction between Nature and Culture in the separate buildings of the American Museum of Natural History and the Metropolitan Museum of Art (Bal 1996:15–36), and the relation between two paintings and their apparatus of display in one corner of a gallery (Bal 1996: 117–28).

What this broad approach means for visual culture studies is significant, I would argue. Firstly, it changes the basic question from 'what does this visual thing mean?' to something much closer to Bal's formulation, 'what happens when people look, and what emerges from that act?' (Bal 2003: 9). Further, in suggesting that visualities themselves are practices, it immediately raises the question of the location of those practices. In an age when images are increasingly mobile across different media and sites of display, this becomes a pressing question to be able to ask. And, thirdly, a whole range of social actors make an appearance. This includes the visual culture critic, as the next subsection elaborates. But it also includes, I would argue, all those other folk who encounter all sorts of visual things, in all sorts of ways, in everyday ways, and it suggests that their ways of seeing are just as central to a visual event as those of the critic. In short, 'practice' can turn visual culture studies closer to the sites and inhabitants of the everyday (Highmore 2002).

Reflexivity

Bal's argument has a certain version of reflexivity at its heart, and, like her emphasis on practice, this also has significant implications for the work of critical interpretation typical of so much of visual culture studies. Simply, reflexivity is central to Bal's position because visual culture critics are also people doing specific kinds of looking in particular places. The critic is not exempt from, or outside of, Bal's understanding of visuality as practice. Hence the work of critics must also be considered as embodied, located, relational and performative. Critics cannot simply apply their critical-theoretical tools onto objects understood as existing prior to the moment of criticism. Instead, objects are brought into particular forms of being through the act of criticism.

> The so-called empirical object does not exist 'out there' but is brought into existence in the encounter between object and analyst, mediated by the theoretical baggage each brings to that encounter. This transforms the analysis from an instrumentalist 'application' into a performative interaction between the object (including those aspects of it that remained invisible before the encounter), theory and analyst. In this view, processes of interpretation are part of the object and are, in turn, questioned on the side of the analyst. (Bal 2003: 23–4)

The analyst brings certain questions and theories to bear on her object of study, and, Bal argues, the object often answers back, offering a particular and productive version of itself in this exchange from which the critic should learn (and hence Bal notes that 'some specificity for material objects must be retained' (Bal 2003: 15)). This understanding of the critic as essentially entangled in what she is studying is very different from the distanced analytical stand offered by connoisseurs of visual culture. It places the analyst much more in the midst of things, a participant in visualities rather than their detached observer.

Given this entanglement, Bal argues that an 'element of self-reflection is indispensable' to critical work (Bal 2003: 24). But Bal has quite a specific understanding of reflexivity. Reflexion, for Bal, means thinking of interpretive practices as both 'method and object of questioning' (24). This sort of self-reflection is central to several other accounts of performative research methodologies (see for example Gregson and Rose 2000; Pratt 2000; Latham 2003). Aspects of methodology are paused over, examined, rehearsed and revised, as the research process proceeds and things are learnt from the research objects. No longer simply passing a verdict in the mode of a 'colonising humanist' (Pratt 2000: 639), the critic is now required to work through the process of reaching that verdict, demonstrating that it was attained through a series of specific interactions rather than from a series of cumulative revelations.

In my own work on what a particular group of mothers did with their family photos, for example I interviewed women in their houses, looked at lots of their photos with them, and then worked with interview transcripts and notes. Eventually I made a number of claims about the effects of family photos for these mothers, one of which depended on just such a moment of self-reflection. It wasn't until I'd been working with the transcripts for a couple of months that I suddenly realized that, in all the hours of conversation poring over thousands of photos, one topic was hardly ever discussed: what the children pictured so often felt about being photographed. It wasn't, it seemed, a pressing issue for the mothers taking the photos—and nor, significantly, had it been for me, as their interviewer, as a researcher working with interview material and also a mother myself. Reflecting on my complicity with this absence, I concluded that our shared uninterest in how children felt suggested that the real subjects of the photos weren't in fact the children at all, but the mothers, and what taking and looking (and holding) photographs of their children meant to them. Questioning the range of my research questions allowed me to begin to explore why it is that, despite their predictable and banal content and its construction of traditional notions of 'the family', commented on by so many visual culture critics, family photos are intensely valued by so many mothers (Rose 2005).

Another implication that needs teasing out from Bal's methodological position is that understanding research in terms of performative practices also makes the conclusions of research rather more provisional. This is not because—as some versions of reflexivity abroad in the social sciences would claim—every person is differently positioned and therefore sees things differently (although in certain circumstances and in specific ways this may well be important). Rather, it is because performances may in principle

always be performed differently; there is always the possibility that looking again might change what is seen and unseen. Interpretation is of the moment in which it was undertaken (Latham 2003: 2005). Elsewhere, Bal (1999: 10) argues that this challenge to the epistemic authority of the critic should be central to visual culture studies, and that it can come both from the 'exposed object' and the reader/viewer.

Critique

So far, I have argued that understanding visual culture research as a practice demands a certain reflexivity from the researcher. It does so because it entangles the researcher as much as anyone else in practices and performances of looking. This is already a form of critique, I think; it offers a critique of those analytical positions that assume they are outside such social practices. It makes the 'third person' approach to visualized objects (Bryson 2001: 5) much harder, if not impossible, to sustain, and thus challenges those pronouncements, discussed earlier in this chapter, about what an image definitively means. But what of social critique? I suggested earlier that much visual culture studies are critical in the sense that they claim to discover the meaning of a visual entity, and then assess whether that meaning supports or criticizes hegemonic discourses. But what happens when critique focusses on event rather than meaning—on what happens rather than what is signified? And when the critic places herself in the midst of that happening rather than assuming a position exterior to it? What critical tools does 'practice' offer?

One tool has already been mentioned: performativity. To repeat the familiar argument once more, if something is performed it can always be performed differently. It is an argument that's difficult to disagree with. It's also an argument that makes the critic rather passive, though, simply waiting for practices to be done in a more just or liberatory way. As well as this, I wonder if the observational mode of visual culture studies explored here might be able to offer a rather more active, interventionist form of critique.

Many who have engaged in practice-focussed research do indeed describe their mode of critique as interventionist. Critique as intervention works, not with notions of context and depth, but rather with action and surface. It suggests the need to examine what's going on, what's happening, with great care, and then place what is there into different alignments and combinations, reflexively, with a certain critical aim in mind. Cathrine Egeland describes this approach thus:

> Critique as intervention can thus be conceived of as a strategy aimed at describing, redescribing, combining and recombining elements of knowledge that may have critical effects. (Egeland 2005: 269)

Eric Laurier and Chris Philo, for example note 'the surplus of detail provided by actual events at hand' (Laurier and Philo 2004: 431) and advocate pushing description to such an extent that surfaces become troubled by what is already there but often not noticed, 'things lying in plain view, open to everyone, yet all too often unexamined' (430). This

is a strategy of critique that's not about going behind or beyond what others ('people') might see, but about working with what is there and changing its emphasis, intensity, relationality. Similarly, although from a Deleuzian direction, Patricia Ticineto Clough (2000: 286) has talked about 'cutting out an apparatus of knowing and observation from a single plane or for differently composing elements of an apparatus with the aim of eliciting exposure or escaping it, intensifying engagement or lessening it'. That no-tion of 'cutting out' again suggests a strategy of placing things in different arrangements rather than revealing what they really mean. Such estrangements and realignments are what produce a critical effect.

John Allen and Michael Pryke (1993), for example in a study of the spatialities of the City of London, were particularly interested in the parallel existence of two social worlds in the offices of the financial corporations they were studying. On the one hand, the well-paid world of the bankers: on the other, a world of very low-paid caterers, security guards and cleaners. The bankers' way of seeing their everyday workplace was such that those low-paid workers were simply invisible. They were not seen, and thus the reliance of the bankers upon them was denied. Allen and Pryke intervened in this invisibiliza-tion by making a series of montages of the City space—its buildings and its information flows—into which they gradually inserted more and more evidence of the presence of the low-paid workers. This suggests that montage—whether written or using images—is one tactic of intervention; there are surely others (see for example Markussen 2005). Critique, then, need not only be a matter of finding a meaning and assessing its effect in relation to wider discursive formations. Critique can also take the form of finding what is already there and rearranging it 'to witness the world into being in quite different ... ways' (Dewsbury 2003: 1908).

CONCLUSION

One of the aims of this chapter has been to spell out rather more clearly than is usually the case what the implications are of the implicit methodology that dominates a great deal of visual culture studies. For implications it certainly has, both in the kind of critic it creates, and in the kinds of accounts of visual objects it produces. It focusses almost entirely on the meaning of visual things, it ignores the places in and the subjectivities through which visual events happen, it neglects the particular positioning of the critic, and is desperate to find critique. The work that it does is nonetheless valuable, I would insist. It is important to have engaged and sustained readings of cultural texts that push at superficial understandings and offer new ways of thinking and seeing. I do not want to advocate any one method as inherently 'better' than the other. I simply want to em-phasize that methodologies have effects, and that if visual culture studies is to come of age as a truly innovative interdisciplinary subject, it needs to pay much more attention to the consequences of its current implicit methodology, and to explore the interpretive possibilities offered by a range of other methodological strategies.

For there are indeed other ways to engage with those things which can help us by grounding them, not in semiotic or discursive systems of meaning, but in the

constellations of practice that bring certain ways of doing things together with certain objects to produce specific subjective and social effects. Images do not happen on their own, ever. Their production, circulation, display and disposal are always in conjunction with people, in places, in mutually constitutive relations. This theoretical understanding of visualities and visual objects underpins my advocacy here of another methodology for visual culture studies. My argument is that visual culture studies should be plunging much more often into those encounters between humans and what surrounds them, exploring what becomes visible, and in what ways. And from this perspective, the kind of critical work dominating visual culture studies becomes just one quite specific practice among many other kinds, one that produces a particular kind of critic and a particular version of the visual material being studied.

To focus on the practices through which visual events happen is to go detailed. It is to look carefully at bodies, comportments, gestures, looks; to look and touch objects, images, ways of seeing; to consider the routine, the everyday and the banal as well as the exceptional; to consider affect and emotion as well as cognition and representation. It is to pay attention to people's doings and sayings and to watch what eventuates in specific places. It is to allow different modes of reflection—by both the researcher and the researched—on those practices. It is to draw on ethnographic methods, often, and to reflect on the way in which the critic and his methods are also and always part of what happens. And in focussing on such details, as the thick descriptive methods of both some anthropology and science studies shows, is absolutely not to lose sight of questions of power. Indeed, looking carefully at how people look and what happens when they look is to address with some specificity the highly complex and mutable visual practices that are part of power relations, as Foucault surely taught us. If you want to know what family photograph albums mean, sure, collect a few and take them home, study them and work out that they present highly selective images of family life that are oppressive to women. If you want to know what they do, though, find out what gets done with them. How are they made (di Bello 2007), where are they stored, when are their contents altered (Tinkler 2008), how are they looked at, and above all, what happens when they are made, stored, revised and looked at (Rose forthcoming). How are those family snaps seen, how are they caressed, defaced, cropped and ignored, what subjectivities and relations are in the making as these things happen?

I cannot claim that this more ethnographic approach to visual events is superior to the new connoisseurship currently dominating visual culture studies. However, in its move away from an approach to visualities still based largely on parallels with language, and its insistence that looking is a social act among humans and between humans and other things, it can give us a different sense of visual culture which relies less on visual objects and more on the processes which animate them and make them matter. Clearly such a methodological focus on practice has its own challenges, which I have not discussed here: for example methods to access human encounters with visualized objects are difficult to formulate, and describing what practices are happening is far from being an innocent operation. Nonetheless, I would suggest that visual culture studies can only be enriched by experimenting with a practice-oriented methodology.

FURTHER READING

Bissell, P. 2009. Visualising Everyday Geographies: Practices of Vision through Travel-time. *Transactions of the Institute of British Geographers*, 34/1: 42–60.

Larsen, J. 2008. 'Practices and Flows of Digital Photography: An Ethnographic Framework', *Mobilities*, 3/1:141–60.

Rose, Gillian. 2010. *Doing Family Photography: The Domestic, the Public, and the Politics of Sentiment*. Aldershot: Ashgate.

NOTES

1. Bal's essay seems to use the terms 'method' and 'methodology' interchangeably. Since 'method' tends usually to refer to more technical questions of analytical procedure, my sense is that she actually centres methodology in her work. However, since part of my argument is to emphasize the more procedural aspects of method as a consequence of considering methodology, I too shift between using these two terms in this chapter.

2. The phrase 'compressed performance' comes from Christopher Pinney's paraphrase of Marilyn Strathern's work (Pinney 2004).

3. For example, in the opening pages of her 2003 essay she refers approvingly to the work of Arjun Appadurai (1986), who is also very influential on the work of those anthropologists I mention, particularly Thomas (1991). Similarly, in her edited collection *The Practice of Cultural Analysis* (Bal 1999), she works with an essay contributed by distinguished anthropologist Johannes Fabian.

4. Sturken and Cartwright seem to reference only two authors (both North American) that have contributed to audience studies: Janice Radway and Constance Penley. There is no sustained discussion of the British school of audience studies initiated by people such as David Morley, Charlotte Brunsden and Ann Gray.

5. Even in the case of 'new genre public art' (Lacey 1995), with its commitment to 'community involvement', there's still a tendency for artists to be the ones with the ideas while local people are simply asked to do the work. Indeed, this is the basis of Miwon Kwon's (2004) fairly devastating account of a major new genre public art project in Chicago a few years ago.

REFERENCES

Allen, John and Michael Pryke. 1993. 'The Production of Service Space', *Environment and Planning D: Society and Space*, 12/4: 453–75.

Appadurai, Arjun. 1986. 'Introduction: Commodities and the Politics of Value', in Arjun Appadurai (ed.), *The Social Life of Things: Commodities in Cultural Perspective*. Cambridge: Cambridge University Press, 33–63.

Bal, Mieke. 1996. *Double Exposures: The Subject of Cultural Analysis*. London: Routledge.

Bal, Mieke. 1999. 'Introduction', in Mieke Bal (ed.), *The Practice of Cultural Analysis: Exposing Interdisciplinary Interpretation*. Stanford, CA: Stanford University Press, 1–14.

Bal, Mieke. 2003. 'Visual Essentialism and the Object of Visual Culture', *Journal of Visual Culture*, 2/1: 5–32.

Bal, Mieke and Norman Bryson. 2001. *Looking In: The Art of Viewing*. London: Routledge.

Becker, Karen. 2002. 'Just Looking? Displays of Power in a Shopping Centre', in R. J. Granqvist (ed.), *Sensuality and Power in Visual Culture*. Umea: Umea Universitat, 165–200.

Bissell, P. 2009. 'Visualising Everyday Geographies: Practices of Vision through Travel-time. *Transactions of the Institute of British Geographers*, 34/1: 42–60.

Bryson, Norman. 2001. 'Introduction: Art and Intersubjectivity', in Mieke Bal and Norman Bryson (eds), *Looking In: The Art of Viewing*. London: Routledge, 1–33.

Butler, Judith. 1990. *Gender Trouble: Feminism and the Subversion of Identity*. London: Routledge.

Cheetham, M. A., M. A. Holly and K. Moxey. 2005. 'Visual Studies, Historiography and Aesthetics', *Journal of Visual Culture*, 4/1: 75–90.

Clough, Patricia Ticineto. 2000. 'Comments on Setting Criteria for Experimental Writing', *Qualitative Inquiry*, 6/2: 278–91.

Degen, Monica, Caitlin DeSilvey and Gillian Rose. 2008. 'Experiencing Visualities in Designed Urban Environments: Learning from Milton Keynes', *Environment and Planning A*, 40/8:1901–1920.

Dewsbury, J.-D. 2003. 'Witnessing Space: "Knowledge without Contemplation" ', *Environment and Planning A*, 35/11: 1907–1932.

di Bello, Patrizia. 2007. *Women's Albums and Photography in Victorian Britain: Ladies, Mothers and Flirts*. London: Ashgate Press.

Egeland, C. 2005. 'Sexing-up the Subject: An Elaboration of Feminist Critique as Intervention', *European Journal of Women's Studies*, 12/3: 267–80.

Farago, C. and R. Zwijnenberg. 2003. 'Art History after Aesthetics: A Provocative Introduction', in C. Farago and R. Zwijnenberg (eds), *Compelling Visuality: The Work of Art in and out of History*. Minneapolis: University of Minnesota Press, vii–xvi.

Gell, Alfred. 1998. *Art and Agency: An Anthropological Theory*. Oxford: Clarendon Press.

Gillespie, Marie. 1995. *Television, Ethnicity and Cultural Change*. London: Routledge.

Gillespie, Marie, ed. 2005. *Media Audiences*. Maidenhead: Open University Press.

Gregson, Nicky and Gillian Rose. 2000. 'Taking Butler Elsewhere: Performativities, Subjectivities, Spatialities', *Environment and Planning D: Society and Space*, 18/4: 433–54.

Heath, C. and D. vom Lehn. 2004. 'Configuring Reception: Looking at Exhibits in Museums and Galleries', *Theory Culture and Society*, 21/6: 43–65.

Highmore, Ben. 2002. *Everyday Life and Cultural Theory: An Introduction*. London: Routledge.

Jansson, André. 2007a. 'Encapsulations: The Production of a Future Gaze at Montreal's Expo '67', *Space and Culture*, 10/4: 418–36.

Jansson, André. 2007b. 'Texture: A Key Concept for Communication Geography', *European Journal of Cultural Studies*, 10/2: 185–202.

Kester, Grant. 2004. *Conversation Pieces: Community and Communication in Modern Art*. Berkeley: University of California Press.

Kwon, Miwon. 2004. *One Place After Another: Site Specific Art and Locational Identity*. Cambridge, MA: MIT Press.

Lacey, Suzanne. 1995. 'Preface', in Suzanne Lacey (ed.), *Mapping the Terrain: New Genre Public Art*. Seattle: Bay Press, i–ix.

Latham, Alan. 2003. 'Research, Performance and Doing Human Geography', *Environment and Planning A*, 35/11: 1993–2017.

Laurier, Eric and Chris Philo. 2004. 'Ethnoarcheology and Undefined Investigation', *Environment and Planning A*, 36/3: 421–36.

Markussen, T. 2005. 'Practising Performativity: Transformative Moments in Research', *European Journal of Women's Studies*, 12/3: 329–44.

Maynard, Patrick. 2007. 'We Can't, eh, Professors? Photo Aporia', in James Elkins (ed.), *Photography Theory*. New York: Routledge, 319–33.

McCarthy, Anne. 2001. *Ambient Television: Visual Culture and Public Space*. Durham, NC: Duke University Press.

Miller, Toby. 2001. 'Cinema Studies Doesn't Matter; or, I Know What You Did Last Semester', in M. Tinkcom and A. Villarejo (eds), *Keyframes: Popular Cinema and Cultural Studies*. New York: Routledge, 303–11.

Mitchell, W.J.T. 1996. 'What Do Pictures *Really* Want?', *October*, 77: 71–82.

Myers, F. R. 2001. 'Introduction: The Empire of Things', in F. R. Myers (ed.), *The Empire of Things: Regimes of Value and Material Culture*. Oxford: James Currey, 33–61.

Nightingale, V. 1996. *Studying Audiences: The Shock of the Real*. London: Routledge.

Phillips, Patricia. 1995. 'Public Constructions', in Suzanne Lacey (ed.), *Mapping the Terrain: New Genre Public Art*. Seattle: Bay Press, 60–71.

Phillips, Patricia. 2003. 'Public Art: A Renewable Resource', in Malcolm Miles and Tim Hall (eds), *Urban Futures*. London: Routledge, 122–33.

Pinney, Christopher. 2003. 'Introduction: "How the Other Half"…', in Christopher Pinney (ed.), *Photography's Other Histories*. Durham, NC: Duke University Press, 256–72.

Pinney, Christopher. 2004. *"Photos of the Gods": The Printed Image and Political Struggle in India*. London: Reaktion Books.

Pinney, Christopher. 2005. 'Things Happen: or, From Which Moment Does That Object Come', in Daniel Miller (ed.), *Materiality*. Durham, NC: Duke University Press, 256–71.

Pollock, Griselda. 2003. 'Visual Culture and Its Discontents: Joining in the Debate', *Journal of Visual Culture*, 2/2: 253–60.

Poole, Deborah. 1997. *Vision, Race and Modernity: A Visual Economy of the Andean Image World*. Princeton, NJ: Princeton University Press.

Pratt, Geraldine. 2000. 'Research Performances', *Environment and Planning D: Society and Space*, 18/5: 639–51.

Reckwitz, A. 2002. 'Toward a Theory of Social Practices: A Development in Culturalist Theorising', *European Journal of Social Theory*, 5/2: 243–63.

Rendell, Jane. 1999. 'A Place between, between Theory and Practice', *Public Art Journal*, 1/1: 1–5.

Rogoff, Irit. 1998. 'Studying Visual Culture', in Nicholas Mirzoeff (ed.), *The Visual Culture Reader*. London: Routledge, 24–36.

Rose, Gillian. 2005. ' "You Just Have to Make a Conscious Effort to Keep Snapping Away I Think": A Case Study of Family Photos, Mothering and Familial Space', in Sarah Hardy and Caroline Wiedmer (eds), *Motherhood and Space: Configurations of the Maternal through Politics, Home and the Body*. New York: Palgrave Macmillan, 221–40.

Rose, Gillian. forthcoming. *Doing Family Photography: The Domestic, the Public, and the Politics of Sentiment*. Aldershot: Ashgate.

Schatzki, Theodore. 1996. *Social Practices: A Wittgensteinian Approach to Human Activity and the Social*. Cambridge: Cambridge University Press.

Sturken, Maria and Lisa Cartwright. 2001. *Practices of Looking: An Introduction to Visual Culture*. Oxford: Oxford University Press.

Thomas, Nicholas. 1991. *Entangled Objects: Exchange, Material Culture and Colonialism in the Pacific*. Cambridge, MA and London: Harvard University Press.

Tinkler, Penny. 2008. 'A Fragmented Picture: Reflections on the Photographic Practices of Young People', *Visual Studies*, 23/2: 255–66.

Tolia-Kelly, Divya. 2004. 'Locating Processes of Identification: Studying the Precipitates of Re-memory through Artefacts in the British Asian Home', *Transactions of the Institute of British Geographers*, 29/3: 314–29.

Walkerdine, Valerie. 1990. *Schoolgirl Fictions*. London: Verso.

Digital Art and Visual Culture

CHARLIE GERE

The digital has come to define our culture in a number of different ways, including, though by no means limited to, the material means by which that culture stores and disseminates its productions. As such it might be compared to earlier instances of the impact of new technologies on culture, such as that of printing, but with far greater impact, spread and ubiquity, and above all far greater speed of transformation. In our 'visual culture', the overarching topic of this book, the digital is ubiquitous. Almost every magazine or advertising or printed image, increasingly large amounts of television and film, as well as of course images on the World Wide Web and in computer games will be digital (as will books, music and almost every conceivable media phenomenon). In this chapter I look at the question of the work of art in the digital age (to use a well-worn, Benjaminian formulation), though, rather than Walter Benjamin, I take the work of Jean-Luc Nancy as my guide, particularly in relation to the question of the hand. I am concerned with what digital art, as opposed to the more general realm of digital visual culture, can offer. In particular I am interested in how it is differentiated or distinguished from the wealth of rich visual experiences now available on the Web and through other digital visual media.

I start with what appears a rather obvious point, that the word 'digital' can mean different things, that might even seem to contradict each other. According to the *Oxford English Dictionary* the word 'digital' has a number of meanings, including '[O]f, pertaining to, using or being a digit', meaning one of the 'ten Arabic numerals from 0 to 9, especially when part of a number', and also 'designating a computer which operates on data in the form of digits or similar discrete data . . . Designating or pertaining to a recording in which the original signal is represented by the spacing between pulses rather than by a wave, to make it less susceptible to degradation' (the word for data in the form of a wave being 'analogue').

But the dictionary also defines 'digital' as '[O]f or pertaining to a finger or fingers' and [R]esembling a finger or the hollow impression made by one'. Obviously the other meaning of digital is directly related to fingers and therefore to our capacity to count, but flesh-and-blood fingers and hands nevertheless do seem curiously at odds with supposedly cold, inhuman digital technology. But of course it is with the hands, and particularly the fingers that we grasp and use tools and also with which we touch, and there are long, parallel traditions within Western thinking, one of which privileges the hand with its relation to tool use as a marker of humanity, and another which privileges touch as the primary and most important sense. The former is found in writings from St Gregory of Nyssa in the fourth century CE, through to the twentieth-century palaeo-anthropologist André Leroi-Gourhan while the latter can be traced from Aristotle who, in *De Anima* and elsewhere, describes touch as the primary sense, through to Aquinas and onto Heidegger in the twentieth century.

Touching is central to our very conception of our humanity. In *On Touching—Jean-Luc Nancy* Derrida analyses what he describes as a 'humanualism' (*humainisme*) that pervades much Western thinking. He takes as an example the essay 'Sur l'influence de l'habitude' by the late-eighteenth, early-nineteenth-century philosopher Maine de Biran, in which he finds the teleological hierarchy that privileges the human hand over the grasping organ of other animals. 'Humans are the only beings who have this hand at their disposal; they alone can touch, in the strongest and strictest sense. Human beings touch more and touch better' (Derrida 2005: 152). Even de Biran's comments about the grasping and manipulating capacity of the elephant's trunk, which seems to fulfil 'approximately' the same set of functions, are revealed as humanualist by his qualification by the word 'approximately' (153). But, writing about Jean-Luc Nancy's work, Derrida declares that the ' "question of the hand," which is also a history of the hand, as we know, remains—should remain—impossible to dissociate from the history of technics and its interpretation, as well as from all the problems that link a history of the hand with the hominizing process' (154). In a footnote linked to this sentence Derrida alludes to his own *Of Grammatology*, as well as to the work of Andre Leroi-Gourhan and Bernard Stiegler, in particular his *Technics and Time* (381).

Works of art are traditionally the products of handiwork, of grasp and touch, and they are also objects that can, in theory be touched. Yet, in the gallery, the traditional work of art is not to be touched. In the gallery or museum it is in a vitrine, behind glass or rope, bordered by dowling on the floor or protected by infra-red beams, alarms and guards. At the same time the work of art is highly tactile, haptic, tangible; the contours of sculpture or the surface of paintings seem to invite touch, while at the same time making it impossible (for eminently practical reasons to be sure, to do with security and conservation). In terms of affect we are also 'touched' or even 'moved' by a work of art. We can even say that works of art can be sticky, refusing to let us go from their presence, even as they refuse to be touched. One can of course see this perhaps as a reflection of their perceived fragility and their value, but it also can be seen as something more interesting and complex, a sense of their auratic untouchability, which in turn denotes something about their status as art.

By contrast, digital media attempt to present us with visual and other experiences that appear far from discrete. They are part of a fluid stream, a flow, a continuum of data, with which we interact and become part of, a milieu, that precisely does not allow for the separation of the work of art, its sequestering behind glass or rope. Digital media by contrast encourage apparently seamless connectivity; virtual reality and new forms of 3-D cinema aim to immerse the spectator, as do interactive games and environments, while social networks make communication and networking both immediate and de-materialized. The more distant and dematerialized our media is, the more it seems to engage in interactivity, and to encourage a sense of touching and grasping. Thus it can be suggested that the work of art in the digital age can be thought of in terms of a chias-mus in which the analogue work of art is distinguished by its digital discretion, whereas the digital work is characterized by its apparent analogue continuity.

This is where art may have some interesting things to say. Artists started to experi-ment with the artistic possibilities of new technologies such as computers as early as the 1960s, when artists such as Nicolas Schöffer in France and Roy Ascott in Britain began to be interested in techno-scientific ideas such as Cybernetics. In the mid 1960s the first computer art shows were mounted, in Germany and the United States. These were followed by exhibitions and events such as *9 Evenings* at the Armory in New York, staged by Billy Klüver and Robert Rauschenberg's group Experiments in Art and Tech-nology (EAT) in 1966. EAT was founded to foster collaborations between artists and engineers.

In the years that followed a number of major exhibitions involving new technologies were held, including *The Machine as Seen at the End of the Mechanical Age* at MOMA in 1968, which was accompanied by a show of work commissioned by EAT, *Some More Beginnings* at the Brooklyn Museum. In the same year the legendary exhibition *Cyber-netic Serendipity*, curated by Jasia Reichardt, was held at the ICA in London. A year later *Event One* took place in London (the latter organized by the Computer Arts Society). In 1970 critic and theorist Jack Burnham organized *Software: Information Technology, Its meaning for Art* at the Jewish Museum in New York. Like *Cybernetic Serendipity* this show mixed the work of scientists, computer theorists and artists with little regard for any disciplinary demarcations. Also in 1970 Kynaston McShine curated *Information* at MOMA, which dealt with the issues and possibilities of new technologies, but only featured the work of artists. In 1971 the results of Maurice Tuchman's five-year *Art and Technology* programme were shown at the Los Angeles County Museum.

Between the early 1970s and the early 1990s digital art was regarded as out of the mainstream of the art world, and even marginalized. A number of artists, including Jef-frey Shaw, Stelarc, Roy Ascott and others, continued to work with new technologies, but perhaps the most important event in terms of digital art practice in recent times was the development of the first user-friendly Web browser in 1994. The World Wide Web had been developed as a result of the pioneering ideas of Tim Berners-Lee, a British sci-entist at the European Nuclear Research Centre (CERN) in Switzerland. Berners-Lee was interested in using the Internet to allow access to digital documents. To this end he developed a version of the Standard Generalized Markup Language (SGML) used in

publishing, which he called Hypertext Markup Language or HTML. This would allow users to make texts and, later on, pictures, available to viewers with appropriate software, and to embed links from one document to another. The emergence of the Web coincided almost exactly with the collapse of the Soviet Union and it was the new-found sense of freedom and the possibilities of cross-border exchange, as well as funding from the European Union and nongovernmental organizations such as the Soros Foundation, that helped foster the beginnings of net art in Eastern Europe, where much of the early work was done. When 'user-friendly' browsers such as Mosaic and Netscape came out in the early to mid 1990s the possibilities of the Web as a medium were seized upon by a number of artists, who, in the mid 1990s, starting producing work under the banner of 'net.art'. This meant work that was at least partly made on and for the Web and could only be viewed on-line. The term 'net.art' was supposedly coined by Vuk Cosic in the early 1990s to refer to artistic practices involving the World Wide Web, after he had received an email composed of ASCII gibberish, in which the only readable element was the words 'net' and 'art' separated by a full stop.

In some senses the pioneering work of net.artists in exploring the possibilities of the World Wide Web as a medium has been overshadowed by more commercial visual experiences, many of which are highly sophisticated and extremely beguiling, without exactly being art. Given the extraordinary proliferation of such material on the Web, it is perhaps interesting to ask what artists may be able to offer. In 2005 Google released *Google Earth*, a program enabling the user to view satellite images of almost any part of the earth. It is an almost perfect expression of the panoptic or even pan-haptic ambitions of networked digital media. The impression is given of the possibility of total access to the entire world. The default view when the program is started shows an image of the earth suspended in space. In this it seems to be a direct descendent of the various representations of the Earth from space that abounded before and after the early Apollo missions, and which helped foster and support a vision of global community and connectivity. Google Earth indeed seems to encapsulate many of the capabilities of and desires for digital imagery in a networked culture. As the Web site puts it, 'Google Earth lets you fly anywhere on Earth to view satellite imagery, maps, terrain, 3D buildings, from galaxies in outer space to the canyons of the ocean. You can explore rich geographical content, save your toured places and share with others.' Google Earth is the realization of a fantasy of, as the narration to Thomson and Craighead's film *Flat Earth*, puts it, 'the age old dream; to look down from above', as well as 'the dream of flying; the dream of transcendent mastery'.

Jean-Luc Nancy could have had Google Earth in mind when he wrote, in his book *The Creation of the World, or, Globalization*, 'How are we to conceive of, precisely, a world where we find only a globe, an astral universe, or an earth without sky'. For Nancy the world has lost its capacity to 'form a world' and seems instead only capable of proliferating the 'un-world' (immonde), and destroying itself as if permeated with a death drive. He suggests that

> A world 'viewed', a represented world, is a world dependent on the gaze of a subject of
> the world . . . A subject of the world . . . cannot itself be in the world . . . Even without a

religious representation, such a subject, implicit, or explicit, perpetuates the position of the creating, organizing, and addressing God ... of the world. (2007: 40)

For Nancy a 'world is never in front of me, or else it is not my world ... As soon as a world appears to me as a world, I already share something of it: I share part of its inner resonance'. He continues that 'It follows from this that a world is a world only for those who inhabit it.' Thus 'the meaning of the world does not occur as a reference to something external to the world' and the experience of the world consists in traversing 'from one edge to the other and nothing else'.

In his essay 'Being Singular Plural' Nancy proposes the following. 'Let us say we for all being, that is, for every being, for all being, one by one, each time in the singular of their essential plurality' (2000: 3). For Nancy it is this that makes meaning. 'There is no meaning if meaning is not shared, and not because there would be an ultimate or first signification that all beings have in common, but because *meaning is itself the sharing of Being*. Meaning begins where presence is not pure presence but where presence comes apart ... in order to be itself *as* such. This "as" presupposes the distancing, spacing, and division of presence' (2). 'Everything, then, passes between us ... The "between" is the stretching out ... and distance opened by the singular as such, as its spacing of meaning. That which does not maintain its distance from the "between" is only immanence collapsed in on itself and deprived of meaning' (5).

> From one singular to another, there is contiguity but not continuity. There is proximity, but only to the extent that extreme closeness emphasizes the distancing it opens up. All of being is in touch with all of being, but the law of touching is separation; moreover, it is the heterogeneity of surfaces that touch each other. *Contact* is beyond fullness and emptiness, beyond connection and disconnection. If 'to come into contact' is to begin to make sense of one another, then this 'coming' penetrates nothing; there is no intermediate and mediating 'milieu'. (2000: 5)

Nancy writes of singular bodies, the 'deported, massacred, tortured bodies, exterminated by the millions, piled up in charnel houses ... the bodies of misery, the bodies of starvation, battered bodies, prostituted bodies, mangled bodies, infected bodies, as well as bloated bodies, bodies that are too well nourished, too "body-built", too erotic, too orgasmic'. There are already five billion bodies and soon there will be eight billion. 'Sixteen billion eyes, eighty billion fingers: to see what, to touch what?' (2008: 83).

> Our billions of images show billions of bodies—as bodies have never been shown before. Crowds, piles, melees, bundles, columns, troops, swarms, armies, bands, stampedes, panics, tiers, processions, collisions, massacres, mass graves, communions, dispersions, a sur-plus, always an overflowing of bodies, all at one and the same time compacted in masses and pulverizing dispersals, always collected (in streets, housing projects, megapolises, suburbs, points of passage, of surveillance, of commerce, care and oblivion), always abandoned to the stochastic confusion of

the same places, to the structuring agitation of their endless, generalized, departure. (Nancy 2008: 39)

Nancy warns us not to pretend that this discourse of bodies is archaic, because 'Capital means: a body marketed, transported, displaced, replaced, superseded, assigned to a post and a posture, to the point of ruin, unemployment, famine, a Bengali body bent over a car in Tokyo, a Turkish body in a Berlin trench, a black body loaded down with white packages in Suresnes or San Francisco' (2008: 109–10). In *Corpus* Nancy develops the logic of *partes extra partes*, a phrase used by Maurice Merleau-Ponty to describe the way in which, in Ian James's words, 'material bodies exist in a relation of exteriority to each other, and the way in which the components or constitutive parts of bodies likewise exist outside of each other, never occupying the same place, and are thus able to articulate themselves as bodies and come into relation or contact with other bodies' (James 2005: 143). 'Where are the bodies anyway?' asks Nancy, and replies that they are going to work, are hard at work. They are '*partes extra partes* combining with the entire system through figures and movements, pieces and levers, clutches, boxes, cutouts, encapsulations, milling, uncoupling, stamping, enslaved systems, systemic enslaving, stocking, handling, dumping, wrecks, controls, transports, tires, diodes, universal joints, forks, crankshafts, circuits, diskettes, telecopies, markers, high temperatures, pulverizings, perforations, cablings, wiring, bodies wired to nothing but their minted force, to the surplus value of capital collected and concentrated there' (Nancy 2008: 109).

Thus the sharing of embodied sense which gives us a world takes place in Nancy as an 'originary technicity' , comparable to Derrida's notion of archi-écriture, but also allowing a far greater engagement with the constitutive effects of embodiment, and the distance and contingency of biological and technical bodies. As Ian James explains it in his book on Nancy 'when I drive a car, speak into a mobile phone, or type into a laptop computer I am not just "using" technical apparatus; I am connected or "plugged into" them in a way which more fundamentally reveals a certain manner of being or existence and a certain experience or constitution of world-hood' (2005: 145). The word Nancy uses for this is 'ecotechnics', in which our world is 'the world of the "technical", the world whose cosmos, nature, gods, whose system, complete in its intimate jointure, are exposed as "technical" ' (2008: 89).

In an essay written in response to the first Gulf War Nancy employs 'ecotechnics' as the name of a single network of reciprocity of causes and effects referred to under the 'double sign' of respectively 'planetary technology' and 'world economy', which is 'without end' in terms of millions of dollars, yen, therms, kilowatts, optical fibres, megabytes. Inasmuch as it 'damages, weakens, and upsets the functioning of all sovereignties' (except those that coincide with its power) ecotechnics 'gives value to a primacy of the combinatory over the discriminatory, of the contractual over the hierarchical, of the network over the organism, and more generally, of the spatial over the historical [and] to a multiple and delocalized spatiality over a unitary and concentrated spatiality ... Either significations are spread out and diluted to the point of insignificance in the ideologies of consensus, dialogue, communication, or values (where sovereignty is thought to

be nothing but a useless memory), or a surgery without sutures holds open the gaping wound of meaning, in the style of a nihilism or aestheticizing minimalism (where the gaping wound itself emits a black glow of lost sovereignty)' (Nancy 2000: 135–6).

There can no longer be an observer of the world, a point Heidegger realized, in exposing the end of the age of the world picture (Nancy 2000: 135–6). 'A world outside of representation is above all a world without God capable of being the subject of its representation' (Nancy 2000: 135–6). Nancy suggests that the world is thus neither 'the representation of a universe (cosmos) nor that of a here below (a humiliated world, if not condemned by Christianity), but the excess … of a stance by which the world stands by itself, configures itself, and exposes itself in itself, relates to itself without referring to any given principle or to any determined end' (2000: 47). He compares this to 'the rose grows without reason' of the mystic Angelus Silesius. According to Nancy there is however a capitalist version of the 'without reason', which 'establishes the general equivalent of all forms of meaning in an infinite uniformity'. The 'without reason' is that which makes modernity an enigma in that it can take the form both of capital and of the mystic's rose (2000: 47).

Nancy distinguishes between 'globalization' and 'world-forming', both of which can be expressed by the word 'mondialization' in French. Following Marx he makes the claim that the processes of globalization, concerned as they are with the extortion of the value of work, can, in turn, lead to 'world-making' inasmuch as it reverses the global domination of such extortion. As he puts it 'commerce engenders communication, which requires community, communism' (2000: 37). Globalization is however 'the suppression of all world-forming of the world', inasmuch as it concerns the production of absolute values without remainder. But the market that produces such values also produces a wealth of knowledge and signification, a growing order of symbolic wealth. Nancy thus proposes a fragile hypothesis involving an inversion in which the 'production of value' becomes the 'creation of meaning' (2000: 49). Nancy is well aware that the term 'creation' is charged with theological meaning and implications, and must be grasped 'outside of its theological context'. It is the exact opposite of 'any form of production in the sense of a fabrication that supposes a given, a project, and a producer' (2000: 51). As 'mystics of three monotheisms but also the complex systems of all great metaphysics' have elaborated, creation is 'ex nihilo', meaning not that it is 'fabricated with nothing by a particularly ingenious producer' but that it is 'created from nothing', nothing grows to become something, the 'genuine formulation of a radical materialism, that is to say, precisely, without roots' (2000: 51). As Nancy hinted earlier this is not contrary to monotheism but in fact its outcome and the outcome in particular of the 'deconstruction of monotheism' (which produces not an atheism or a theism but an 'absentheism'). Indeed Nancy alludes to the Lurianic kabala in which 'God annihilates itself … as a "self" or as distinct being in order to "withdraw" in its act—which makes an opening of the world' (2000: 70). The nothing from which creation grows is the 'without reason' of the world.

This might be compared to the idea of *Chora*, which Derrida took from Plato's *Timaeus* to describe 'the spacing that is the condition for everything to take place, for everything

to be inscribed' (Derrida and Eisenman 1997: 3). Derrida suggests that Chora 'is a matrix, womb, or receptacle that is never offered up in the form of presence, or in the presence of form' (Derrida 1978: 160). The conjunction of 'matrix' and 'womb' is a reminder of the derivation of the former from 'mater', meaning 'mother'. In 'Faith and Knowledge' Derrida describes Chora as 'nothing (no being, nothing present)'. It is 'desert in the desert' (Derrida 2002: 59), 'there where one neither can nor should see coming what ought or could—perhaps—be yet to come. What is still left to come' (47). This desert is the 'most anarchic and anarchivable place possible' and 'makes possible, opens, hollows, infinitizes the other. Ecstacy or existence of the most extreme abstraction'. The 'abstraction' or 'desertification' of this 'desert without pathway and without interior' 'can … open the way to everything from which it withdraws' and 'render possible precisely what it appears to threaten' (47). Derrida connects the desert not just to *Chora*, but also to his conception of the 'messianic, or messianicity without messianism', meaning 'the opening to the future or to the coming of the other as the advent of justice, but without horizon of expectation and without prophetic prefiguration. The coming of the other can only emerge as a singular event when no anticipation sees it coming, when the other and death—and radical evil—can come as a surprise at any moment' (56). In that it both has no material existence and it is based on pure difference the 'digital' is something like Derrida's Chora. Graham Ward observes that 'Cyberspace is the realization of a metaphor used repeatedly by Derrida …—the Khora, the plenitudinous womb, dark, motile, and unformed from which all things issue' (Ward 1997: xvi).

In her essay 'Read_me, run_me, execute_me; Code as Executable Text: Software Art and Its Focus on Program Code as Performative Text' Inke Arns explicitly describes such work in terms derived from J. L. Austin's concept of the performative (Arns n.d.). Arns makes an important distinction between 'generative art' and 'software art', the latter allowing 'for a critical reflection of software (and its cultural impact)' and as involving projects that use 'program code as their main artistic material or that deal with the cultural understanding of software' and not as 'a pragmatic-functional tool that serves the "real" art work, but rather as a generative material consisting of machinic and social processes' (Arns n.d.). In describing the 'performativity of code' Arns claims that this is 'not to be understood as a purely technical performativity, i.e. it does not only happen in the context of a closed technical system, but affects the realm of the aesthetical, the political and the social'. In that it has 'immediate, also political consequences on the actual and virtual spaces (amongst others, the internet), in which we are increasingly moving and living: it means, ultimately, that this coded performativity mobilizes or immobilizes its users. Code thus becomes Law, or, as Lawrence Lessig has put it in 1999 "Code (already) is Law" ' (Arns n.d.).

Digital media, artefacts inscribed with material representations of digital data, may exist but the digital itself does not exist. 'There is no there there'. In whatever form or medium it may be materialized it is itself nothing but difference. It has, in William Gibson's words, 'infinite plasticity' (Gibson 1999: 71). In her book *The Future of Hegel: Plasticity, Temporality and Dialectic* Catherine Malabou derives the 'plastic' from the Greek *plassein*, to model or mould, thus meaning to be 'susceptible to the change of

form', 'malleable', but also 'having the power to bestow form'. (For Malabou plasticity is the best description for Hegel's theory of temporality and offers a way of understanding him as a far more dynamic and open-ended thinker than has traditionally been the case.) 'Plasticity' thus means being at once capable of both receiving and giving form. It is thus a term connected to art, and in particular, sculpture, the art of touch.

Inasmuch as software art involves both the plasticity of data and the touch of the hands on the keyboard it is a kind of sculpture, an art of touch as well. Of course bound up with creation is destruction. Malabou reminds us that 'Plastic' is also a term for an explosive material, with a nitroglycerine and nitrocellulose base, which can lead to the annihilation of form (Malabou 2005: 8). One of the most famous, or notorious examples of software art is the so-called forkbomb, in which a piece of code recursively clones itself until it saturates and eventually disables an operating system. Mclean won the software prize at the 2002 Transmediale Festival for his thirteen-line forkbomb, though Jaromil's 2002 forkbomb is regarded as the most elegant example: The entire code, which runs in Unix is as follows; :(){ : |:& };:. In their work 'www.jodi.org' Joan Heemskerk and Dirk Paesens, known collectively as Jodi, present what appears to be meaningless chaos on the screen. However the source HTML turns out to be in the form of a diagram of how to build a nuclear bomb. Thus, against the mainstream use of digital media, to present us with an apparently endless stream of visual and other experiences, concealing the social, political and cultural antagonisms underlying our globalized society, some digital art acts to explode this continuum in order to reveal the various codes underneath.

For Nancy the world has lost its capacity to 'form a world' and seems instead only capable of proliferating the 'un-world' (immonde). He declares that 'our task today is nothing less than the talk of creating or forming a symbolisation of the world'.

> *To create the world* means: immediately, without delay, reopening each possible struggle for a world, that is, for what must form the contrary of a global injustice against the background of general equivalence. But this means to conduct this struggle precisely in the name of the fact that this world is coming out of nothing, that there is nothing before it and that it is without models, without principle and without given end, and that it is *precisely* what forms the justice and the meaning of a world. (Nancy 2008: 54)

He continues that it is art 'that indicates the stakes by exceeding all submission to an end and exposing itself to remaining without end' (54).

In his essay 'Why Are There Several Arts and Not Just One' Nancy investigates the plurality of arts and the supposed singularity of 'art'. The 'singular plural' of art, of the arts and the tension between the singular art and the multiple arts is a 'tension between two concepts of art, one technical and the other sublime', or, in other words, an understanding of the arts from the perspective of different techniques on the one hand, and of art from the perspective of some essence that exceeds any plurality (Nancy 1993: 2–3). This is closely connected to the modern distinction between art and technics. 'A careful

examination would, no doubt, show that a formula of the type "art and/or technics" could in its own way condense the enigma of our times.' This is traced back to a division first mooted by Plato between the mode of production, *teckhnē*, and the product, *poiēsis* (1993: 5).

It is here perhaps that Nancy's ideas have the most direct relevance to the question of visual art in a digital age. Following what he describes as a 'scenario ... in three acts' involving Kant, Schelling and Hegel, Nancy shows that the difference between the arts has been understood in terms of the difference between the senses (1993: 8). Deconstructing the common-sense presumption that the division of the arts follows the division of the senses, Nancy proposes that in fact the latter is produced by the former. 'In a word, the distribution or distributions of the senses, rather than sensibility as such, would themselves be the products of "art" ' (1993: 10). Nevertheless Nancy also points out that the arts do not correspond to the traditional five senses, and in particular touch, 'established by a very long tradition as the paradigm or even as the essence of the senses in general', 'does not open onto any kind of art' (he excludes sculpture as 'an art of touch' in that it 'exceeds touch') (1993: 11). He points out that 'the heterogeneity of the senses is impossible to decide' and 'considerably exceeds the five senses' and also that any such abstraction partition must always accede to a sensuous unity, especially given the minute percentage of sensory information that is actually put to work by the brain. Nor is it any point appealing to a putative 'sixth sense' that would unite the other five at a higher level, as this is either supersensory metaphysics or it fails to overcome the physical nature of sense (1993: 13).

Claiming that 'neither the senses as such nor their integration are either conditions or models of the arts' Nancy finds a solution in the work of Freud, who writes that 'It seems probable that any part of the skin and any sense organ—probably, indeed any organ—can function as an erotogenic zone', a fact which is 'exposed by the primacy of touch' (1993: 16). 'Touch is nothing other than the touch and stroke of sense altogether and of all the senses ... Touch *is* the interval and the heterogeneity of touch. Touch is proximate distance. It makes one sense what makes one sense (what it is to sense): the proximity of the distant, the approximation of the intimate' (1993: 17).

Thus for Nancy 'art touches on the sense of touch itself: in other words, it touches at once on the "self touching" inherent in touch and on the "interruption" no less inherent in it ... it touches on the immanence and transcendence of touch ... on the transimmanence of being-in-the-world ... Art does not deal with the "world" understood as a simple exteriority or milieu, or nature. It deals with being-in-the-world in its very springing forth' (1993: 18). But it also touches in the sense of shaking up, disturbing, destabilizing or deconstructing a world that 'in the final analysis is less a sensuous world than an intelligible world of markers, functions, uses and transitivities' or in other words, a 'milieu'. 'Art isolates or forces there the moment of the world as such, the being-world of the world, not as does a milieu in which the subject moves, but as exteriority and exposition of a being-in-the-world, exteriority and exposition that are formally grasped, isolated and presented as such' (1993: 18). In this way the 'irreducible plurality of ... the world' is made to appear through the zoning of the differential distribution of the senses. There

would be no world without the discreteness of these zones, and it is only this discreteness that allows the thing to be what it is in itself.

Thus the plurality of the arts isolates a sense to break down the living unity of perception and action, and forces it 'to be only what it is outside of signifying and useful perception'. Art 'forces a sense to touch itself, to be this sense, that it is', and, in doing so, to become not visual or sonorous, but pictorial or musical (1993: 21). Art 'disengages the world from signification and that is what we call "the senses" ' (1993: 22–3). This idea of the sense of the world as a suspension of signification is 'touch itself'. Nancy produces a wonderful list, a corpus, of the proliferating differences produced by the 'dis-location' by art of the 'common sense' of ordinary 'synaesthesia', not just between the sensorial registers but across them as well, including colour, nuance, paste, brilliance, shadow, surface, mass, perspective, contour, gesture, movement, shock, grain, timbre, rhythm, flavour, odour, dispersion, resonance, trait, duction, diction, articulation, play, cut, length, depth, instant, duration, speed, hardness, thickness, vapour, vibration, cast, emanation, penetration, grazing touch, tension, theme and variation et cetera, that is, multiplied touches, ad infinitum (1993: 22).

Returning to the problematic question of art and technics with which he begins the essay, for Nancy 'the arts are first of all technical', not in the sense that they are first a technical procedure followed or capped by a final, artistic part. They are technical in that 'technique means knowing how to go about producing what does not produce itself by itself'. Technique is 'a—perhaps infinite—space and delay between the producer and the produced, and thus between the producer and him—or herself' (1993: 25). Nancy quotes Thierry de Duve, 'to make art is to judge art, to decide, to choose' who in turn quotes Duchamp's famous dictum that 'to make something is to choose a tube of blue, a tube of red, to put a little on one's palette, and always to choose the quality of the blue, the quality of the red, and always choose the place in which one is going to put it on the canvas, it is always to choose' (1993: 25).

In his essay 'Painting in the Grotto' Nancy describes the beginning of art in the hand prints made twenty-seven to twenty-nine thousand years ago in the Cosquer caves in France, the earliest known paintings. (On the French government Web site describing the caves as well as fifty-five of these hand prints these are called 'digital markings'.) For Nancy these markings are the point where 'Man' confronts the strangeness and estrangement of his own humanity, and presented and figured it to himself. He is *homo monstrans*, before he is *homo sapiens*. It is 'the spacing by which man is brought into the world, and by which the world itself is a world: the event of all presence in its absolute strangeness' (1993: 70). These hand prints, with their open gestures, like an impossible or abandoned grasp, are described as the first self-portraits. Moreover the 'image praises the thing as detached from the universe of things and shown to be detached as is the whole of the world. (The whole of the world is detached from self: it is detachment)' (1993: 73). Nancy asks us to imagine the first imager, his hand advancing into a void, hollowed out at that very instant, which separates him from himself, and in doing so makes him a self. He touches the wall not as a support or an obstacle, but as a place, in which is opened up a 'distance that suspends the continuity and the cohesion of the

universe, in order to open up a world' (1993: 75). Thus art is always-already digital, and the digital is art, in that art is the means by which the synaesthetic continuity of the milieu is interrupted, where its spacing, contiguity and contingency allows the world in its plurality to be revealed, and where things are shown to touch but never to penetrate.

This brings us back to Google Earth. In 2007 new media artists Thomson and Craighead released a seven-minute video entitled *Flat Earth* which they described as a desktop documentary, which takes the viewer on a seven-minute trip around the world so that we encounter a series of fragments taken from real peoples' blogs. These fragments are knitted together to form a kind of story or singular narrative. One of the consequences of war waged through such means is that the human suffering it entails is concealed from the public and thus from the volatility of public opinion. We are allowed to forget that there are humans below the bombs, with voices and stories to tell.

This is exactly what Thomson and Craighead's *Flat Earth* achieves as it elegantly alters Google Earth, by linking a bomb's-eye view of the lives of those in the places observed, as recorded in blogs. We get glimpses of the lives of US and Japanese teenagers, an African villager, a London policeman and, perhaps most poignantly, a woman in Tehran, anticipating future US bombing. Thomson and Craighead take some of these themes further in their next work, *Short Films about War*, a double-screen projection of a seven-minute film. On the left hand screen images and short animated sequences are shown, the former consisting of downloads from Flickr and the latter of zooms into Google-Earth–style representations of parts of the world. On the right hand screen a scrolling list indicates the source of the images and of the blogs from which the voice-over narrations are taken. In giving us these glimpses *Flat Earth* and *Short Films about War* act as vital correctives to the ocular imperialism of Google Earth and, by extension, of the Internet in general, which is concealed from us by its counter-cultural credentials.

This is perhaps what digital art (as opposed to the more general realm of digital representation) can offer; a reminder of the lives behind the endless images of bodies, lives that are disavowed or effaced in our digital, virtual culture. It allows us to touch and touch upon those discrete existences with which we share this planet. It does so by breaking up the illusion of seamless interactivity and communicativity by interrupting the synaesthetic continuity of the milieu, and revealing, through spacing, contiguity and contingency the world in its plurality.

FURTHER READING

Derrida, Jacques. 1987. 'Geschlecht II: Heidegger's Hand' in *Deconstruction and Philosophy: The Texts of Jacques Derrida*. Edited by John Sallis. Chicago, London: University of Chicago Press.

Derrida, Jacques. 2005. *On Touching - Jean-Luc Nancy*. Stanford: Stanford University Press.

Nancy, Jean-Luc, 1993. 'Why Are There Several Arts and Not Just One?' in *The Muses*. Stanford: Stanford University Press.

Nancy Jean-Luc. 2000. 'Being Singular Plural' in *Being Singular Plural*. Stanford: Stanford University Press.

Nancy, Jean-Luc. 2008, *Noli Me Tangere: On the Raising of the Body*. New York: Fordham University Press.

REFERENCES

Arns, Inke. n.d. 'Read_me, run_me, execute_me', in *Code as Executable Text: Software Art and Its Focus on Program Code as Performative Text*. www.medienkunstnetz.de, http://www.medien kunstnetz.de/themes/generative-tools/read_me/, accessed 1 May 2009.

Derrida, Jacques. 1978. *Dissemination*, trans. Barbara Johnson. London: Athlone.

Derrida, Jacques. 2002. *Acts of Religion*, ed. Gil Anidjar. London: Routledge.

Derrida, Jacques. 2005. *On Touching: Jean-Luc Nancy*, trans. Christine Irizarry. Stanford, CA: Stanford University Press.

Derrida, Jacques and Peter Eisenman. 1997. *Chora L Works,* eds. J. Kipnis and T. Leeser. London: Monacelli Press.

Gibson, William. 1999. *All Tomorrow's Parties*. New York: G. P. Putnam and Sons.

James, Ian. 2005. *The Fragmentary Demand: An Introduction to the Philosophy of Jean-Luc Nancy*. Stanford, CA: Stanford University Press.

Malabou, Catherine. 2005. *The Future of Hegel: Plasticity, Temporality and Dialectic*. New York and London: Routledge.

Nancy, Jean-Luc. 1993. *The Muses*. Stanford, CA: Stanford University Press.

Nancy, Jean-Luc. 2000. *Being Singular Plural*. Stanford, CA: Stanford University Press.

Nancy, Jean-Luc. 2007. *The Creation of the World, or, Globalization*. Albany, NY: State University of New York Press.

Nancy, Jean-Luc. 2008. *Corpus*. New York: Fordham University Press.

Ward, Graham, ed. 1997. *The Postmodern God*. London and Oxford: Wiley-Blackwell.

Digitalization, Visualization and the 'Descriptive Turn' in Contemporary Sociology

ROGER BURROWS

EPOCHALISM/DIGITALIZATION

Epochalism is rife within much contemporary social theory. As Savage (2009a: 218) views it, much sociological discourse attempts to construct 'a distinctive narrative conception of temporality which cleanly separates out a past and present'. It does this by suggesting that 'we used to live in industrial/capitalist/modern society', whilst 'now we live in post-industrial/disorganized/post-modern/post-Fordist/globalized/detraditionalized/individualized/risk/network etc. society'. 'Delete as appropriate' he adds in a lighthearted footnote. Certainly, such modes of theorizing are very readily apparent within many recent discussions of social change that foreground the active role of digital technologies in invoking transformations of one type or another. Dodge and Kitchin (2004: 209), for example characterize the emerging role of digital code in social life as 'the lifeblood of the network society, just as steam was at the start of the industrial age'. For them '[c]ode, like steam, has the power to shape the material world; it is able to produce space'. A slightly more subtle characterization of the social role of digital code is articulated by Thrift and French (2002: 309), but still with a strong inflection of epochalism, when they argue that the 'technical substrate of ... societies ... has changed decisively as software has come to intervene in all aspects of everyday life'. For them, the increasing ubiquity of code is altering social ontology creating a 'new and complex form of automated spatiality ... which has important consequences for what we regard as the world's phenomenality'. The cultural theorist Scott Lash (2006; 2007a) concurs, arguing that social associations and interactions are no longer just being *mediated* by software and code but are becoming increasingly *constituted* by it. In his terminology, '[w]hat was a medium ... has become a thing, a product' (Lash 2007a: 18). Information is no longer just epistemological, it is becoming increasingly ontological. Information is now not

only a means by which we come to understand the world; it is an active agent in constructing it (Lash 2006: 581).

Epochalism, as Savage (2009a: 220) argues, is generally an unproductive mode of sociological theorizing:

> 'Disorganized capitalism'... , 'post-Fordism'... , 'individualization'... , 'reflexive (or late) modernity'... , the 'risk society'... , globalization ... , neoliberalism ... , the 'network society'... , have all waxed and waned over little more than a decade. Yet the arrival of such 'new' conditions is no sooner announced then they are replaced by yet newer epochal claims ... Why should we become especially interested in scrutinizing the particular characteristics of one account of epochal change when we can be pretty confident ... that this will be replaced by a new schema for understanding another epochal change in a little while? ... What does it mean for the credibility of social scientific knowledge itself when it seems to so readily embrace a culture of inbuilt obsolescence, where announcements about the arrival of fundamentally new conditions are no sooner made than they are dissipated by the next version?

However, it must be recognized that it is often difficult to register the significance of altered circumstances without lapsing into the discursive construction of such epochalistic binaries. Such is the case with theorizing the social significance of the increasing ubiquity of digital code. In this chapter rather than exploring how best we might *theorize* social life under conditions of increasing digitalization our focus will be on the implications of such processes for the conduct of *empirical* social research. It is again in the recent work of Savage (2009b) that we find a useful framing of this issue. He argues that in order to circumnavigate modes of sociological discourse with a fetish for epochalism we need to reinvigorate our engagement with new and innovative forms of *methodology* better able to capture the complex patterns of continuity and change that characterize all societies. He argues that this will best be done by encouraging a nascent 'descriptive turn' in the discipline in response to the onslaught of ubiquitous digitalization processes. From the point of view of this volume, this is of interest because he further argues that this reorientation will likely involve a revitalization of visualization methods, moving them from the periphery of the discipline towards a position more centre-stage (Savage 2009b).

DIGITALIZATION AND THE COMING CRISIS OF EMPIRICAL SOCIOLOGY

There is also an overriding sense in the literature that empirical sociology is in some sort of crisis (Adkins and Lury 2009; Savage and Burrows 2007; 2009). The precise contours of this crisis need not detain us here, other than to note that they are not unconnected with (but neither are they entirely due to) the ubiquity of digitalization processes. Sociology has been sluggish to respond to the implications that digitalization has for—to

repeat the terminology of Thrift and French—'what we regard as the world's phenom-enality'. This sluggishness of response to changed circumstances is not an inherent characteristic of the discipline. Indeed, for much of the postwar period the discipline was as successful as it was because it possessed a remarkable capacity for methodological innovation that allowed it to glean privileged access to the study of the 'social'. As Savage (2010) has detailed in his recent history of social science research methods, *Identities and Social Change in Britain since 1940: The Politics of Method*, what we now take to be very mundane techniques of sociological inquiry—the in-depth interview, the sample survey and so on—were, at the time of their invention, remarkable innovations. Indeed, it can be argued, *pace* Abbott (1988), that it was precisely these kinds of innovations in methodology that provided sociologists with their claims to jurisdiction over the study of social relations that they required in order to construct themselves as a profession distinct from other social scientists. Between about 1950 and 1990 sociologists could confidently claim a series of distinctive methodological tools that allowed them to claim privileged points of access to social relations. However, in the twenty-first century digitalization processes have resulted in social data becoming so routinely gathered and disseminated, and in such myriad ways, that the role of academic sociologists in generating data is become increasingly unclear (Savage and Burrows 2007).

The enmeshing of digital code and software with social structures and practices is clearly significant; whether it means we now confront a radically altered social ontology, as some would suggest (Lash 2007b), is a moot point, but the implications for the social sciences are certainly profound. Many everyday practices now leave behind a digital trace: applying for a social security benefit; purchasing an item from a shop; downloading music; playing a computer game; watching digital TV; making a phone call; being screened for a medical condition; searching for an item on the Internet; or—as UK MPs recently discovered—making an expenses claim.[1] The possibilities afforded by such transactional digitalization have been leapt on by commercial interests, the state and hobbyest (Hardey and Burrows 2008) but less so by the academy. For Savage (2009b), thinking through how we might begin to better *describe* such data to analytic ends, by means of radical methodological innovations designed to re-enchant the sociological imagination, is of crucial importance if the academy is to regain its position as an obligatory point of passage (Latour 2005) for the hordes of actants who now claim legitimate interest in 'knowing' the 'social' (Thrift 2005).

DIGITAL DATA

We are all aware of the increasing capacity of commerce and the state to use various types of digital transactional data to produce new forms of knowledge of use to them—knowledge that is largely a by-product of a huge number of mundane commercial or administrative transactions that leave a digital trace. Consider, for example the dramatic possibility that the next UK Census in 2011 could be the last. Every ten years the British state undertakes a Census of the population where every household is expected to complete a census return, and whose results have been used to monitor population change.

Such data has not only been at the heart of the UK policy and planning system it has also been a fundamental part of demographic and social scientific research. For the next Census, in 2011, the process of running the data collection will be subcontracted to a private contractor.[2] However, alongside this 'privatization' of a previously unambiguous function of the state, a parliamentary committee (House of Commons 2008) has suggested that the Census should be replaced by data collected via linked administrative data records, which it thinks will provide more accurate accounts of the population (Savage and Burrows 2009: 762). So rather than having to collect data using a specific tool of data collection (the census return) data would be collected which is a digital by-product of the ongoing interaction the citizen has with the administrative apparatus of the state. The technical challenges to developing such a system are, of course, huge, but the aspiration of having a 'real-time' record of population change—the ability to 'track' and 'trace' individuals through time and space as a result of their episodic interactions with state agencies is one that will almost certainly come to fruition.

It is an aspiration that has already been operationalized in various ways, often to dramatic effect, in much of the commercial sector. Tesco, the supermarket chain, through its work with subsidiary company *dunnhumby*[3] (sic), for example is able to manipulate huge amounts of data collected through its Tesco Clubcard scheme in order to provide rapid and detailed analysis of consumer behaviour. Experian, the credit referencing and data brokerage company, has geo-coded every individual and household in the UK (and much of the rest of the world) into distinct types of consumer by means of its Mosiac geodemographic systems (about which more below) constructed from a huge range of commercial and official transactional data sources (Burrows and Gane 2006; Parker et al. 2007). Internet-based operations such as *Amazon* and *iTunes* use the purchasing patterns of all consumers to make 'recommendations' to individual consumers. In academia Google Scholar does much the same thing by using citation practices as a means of determining which academic articles are the most 'similar' in order to recommend 'related' articles based upon high degrees of concordance between the citations.

Hitherto these processes have largely been concentrated on the development of relational databases where data entry is by means of routine transactions between the state, the citizen, commerce and the consumer. However, with the advent of Web 2.0 (Beer and Burrows 2007) and the recent explosion in 'user-generated content', we have witnessed the emergence of a new hybrid actor—the *prosumer* (Ritzer and Jurgenson 2009); ontologically neither a 'pure' producer nor a 'pure' consumer, these are actors who freely labour (or perhaps *play*bour?) in order to provide 'free' content. Such sites as *Facebook*, *Wikipedia*, *Flikr* and the rest all provide data 'freely' given by users. However, we are also at the cusp of another means by which the ubiquity of the digital tracking and tracing of social data will enter a phase shift. As Katherine Hayles (Hayles in Gane et al. 2007: 349) expresses it, if relational databases (be they derived from by-product transactional data or that actively provided by Web 2.0 prosumers) are the 'brains' behind digitalization, then they are about to get 'legs' as a plethora of new objects begin to enter our social worlds able to gather data on all manner of activities on a scale hitherto unimagined (Hayles 2009).

A TYPOLOGY OF DIGITAL OBJECTS

These objects have been very usefully typologized by Dodge and Kitchen (2009: 1348). We have, over the years, become increasingly familiar with what they call *peripherally coded objects* in which 'the presence of code is merely adornment ... a gas cooker might have a digital clock embedded in it, but if this timer ceases to function the cooker will continue to cook food'. Such objects have software embedded within them, 'but such code is not essential to their use'. However, in recent years we have seen the emergence of what they term *codejects*—categories of objects '*dependent* upon code to function—the object and its code are thoroughly interdependent'. They further subdivide these objects into three main types differentiated 'on the basis of their programmability, interactivity, remembering capacity, their ability for anticipatory action in the future based on previous use, and relational capacities'. First, *hard codejects* 'rely on code to function, but are not programmable and therefore have low levels of interactivity'—a USB memory stick is an example. Second, *unitary codejects*, which 'are programmable, exhibit some level of interactivity ... [but] ... do not record their work in the world'. Examples of *closed codejects* would include some 'audiovisual equipment such as radios, and CD and DVD players'. In these examples code 'is vital to the functioning and performance ... but the object executes its task independently of the world around it'. *Sensory codejects*, on the other hand—objects such as digital central heating control units or programmable washing machines—'have some awareness of their environment and react automatically to some kind of external stimulus'. Third, and crucially, Dodge and Kitchen (2009: 1348) register the increasing presence of what they term *logjects*—the putative 'legs' of digitalization processes to which Hayles refers. Logjects are objects:

> which have an 'awareness' of themselves and of their relations with the world and which, by default, automatically record aspects of those relations in logs that are stored and reused in the future. Logjects often have high levels of inter-activity and multifunctionality.

Permeable logjects create a log of use but do not form a constant connection with networks, the information they hold can only be obtained when it is connected into such networks. It therefore holds this information unless the user makes the effort to connect the device with a wider network that *might* then extract the information. An MP3 player, for example will only give up logs when docked into a networked computer which may then communicate this information about its use to external bodies. Compare this, however, with *networked logjects* which like the permeable variety retains information about the use and history of the object, but which differ in one vital regard in that rather than being self-contained units that may intermittently connect into a network they are, instead, fully networked and thus able to communicate this recorded information when required. Examples include satellite television boxes, home security monitoring systems, and, critically, mobile telephones. These devices then are constantly communicating information or are open for information to be harvested when required. We can clearly place the now networked versions of mobile music devices in this second

category of logjects; these devices are now wireless enabled and can therefore operate as networked devices which log and communicate information about their usage. Thus we can begin to see such objects as harvesting ever more detailed transactional data about us. The volume of such data will increase as and when such devices come to be used more routinely for paying for goods and services.[4]

The result is that the ability of these logjects to store and communicate information about their use means that things like the music or radio we listen to, the videos and TV shows we watch, the locations we move through, the photos we take and so on, are now becoming increasingly trackable and traceable as logjects are activated in everyday practices. With ever more networked logjects coming on the market—the Apple iPhone 3G being perhaps paradigmatic—we can begin to glimpse the possibility of the arrival of another new object likely to be a central concern of much future social scientific analyses—*the spime* (Burrows and Beer 2010).

SPIMES

Spimes (a neologism of space and time) are the thought 'invention' of former cyberpunk author Bruce Sterling (2005). Although he uses a different terminology, Sterling is interested in what is likely to result as networked logjects become ubiquitous. He sees them as the central feature of a newly emergent technoculture. Sterling identifies a number of prior technocultures: a pre-1500 culture of *Artefacts*; a post-1500s technoculture of *Machines*; a post-1800s technoculture of *Products*; and a *Gizmo* technoculture which began around 1989 and which we still (just) inhabit. Although still mass produced, a Gizmo device in the hands of its user will not necessarily be the same item that left the factory. They are increasingly user-alterable, upgradeable and unstable and require extensive informational support systems to function (hence the ubiquitous 'software updates ready to install'). Sterling's vision for the next technoculture is the *spime*; a theoretical image of future production, consumption and cultural practices. Sterling foresees a future based around 'trackable' objects. Every object produced will be assigned a unique identity. Radio frequency identification devices (RFID), or 'arphids' as they are known in the literature, may perhaps be viewed as a prefigurative of this (Bleecker 2006; Crang and Graham 2007; Gane et al. 2007; Hayles 2009).

As with the networked logject, as the spime moves through space and time it generates a log of activity—when and where it was made, where it was sent to, who has owned it, when it is used, whether it is functioning correctly, whether it needs repair and a whole myriad of other information. In so doing, it also records data about the things it comes into contact with. Sterling suggests that spimes will still be manufactured objects, but objects whose informational support is so overwhelmingly extensive and rich that they are best regarded as material instantiations of an immaterial system. Spimes begin and end as data. They are designed on screens, fabricated by digital means and precisely tracked through space and time throughout their 'earthly sojourn' (Sterling 2005: 11). Such entities will, of course, be 'eminently data-minable' (Sterling 2005: 11) to the extent that their value will more often than not be in the extractable information they contain rather

than in the object itself. In Sterling-speak: 'in an age of spimes, the object is no longer an object, but an instantiation' (Sterling 2005: 79). This then is a brave attempt to grapple with the consequences of the eminent trackability and traceability of objects; of the sociological consequences of what is rapidly becoming an 'Internet of things'.

DEALING WITH DATA INUNDATION: TOWARDS A 'LYRICAL SOCIOLOGY' OR TOWARDS THE DEVELOPMENT OF MORE MUNDANE INSCRIPTION DEVICES?

So the challenge for sociology is how best to deal with this inundation of digital 'social' data from administrative and commercial transactions; from Web 2.0 and the Internet more generally; and from the new categories of objects and/or logjects able to track and trace human conduct through time and space. Savage (2009b) is quite clear that what is required is a radical reappraisal of the analytic role of description *contra* causal modes of sociological analysis. He points out that outside of the academy:

> Market researchers profile different types of consumer, thus allowing firms to position their products and brands in a competitive marketplace. The security services profile criminal types by a process of association, linking a series of 'suspect' characteristics together so that the search for the perpetrators can be narrowed down. Government departments construct, and are themselves judged by their ability to meet, welters of 'indicators' … The medical sciences proliferate scanning devices which allow doctors to describe what is inside people's bodies, so allowing diagnosis to be anchored to inspection. (Savage 2009b: 155–6)

Such processes may, of course, be thought of as fundamentally *a*sociological in the sense that they run counter to the well-established Weberian dictum that sociologists should be striving to provide 'explanations' of social phenomena that are adequate both at the level of cause and at the level of meaning. In none of the examples cited above by Savage (2009b: 156) 'is it deemed essential to understand why someone is doing something or why something is happening'. Rather the aim seems to be 'to associate actions with other actions, leading to a concertina-like process of ever more elaborate description' (Savage 2009b: 156). It is also *a*sociological in another perhaps even more profound sense. Hitherto the majority of sociologists have been

> wedded to a 'depth model', whereby they were able to order the social by separating the 'wheat'—in the form of deep, causal or structural processes, usually linked to the 'master' variables of class, gender, nation, etc.—from the chaff of superficial, contingent observations. (Savage 2009b: 157)

The 'descriptive turn' potentially undermines this possibility, implying instead a sociology that foregrounds a concern for the complex articulation of *surface patterns*. Savage (2009b) attempts a symptomatic reading of a diverse range of contemporary sociologists

in an attempt to reveal their nascent recognition of the necessity to re-enchant the discipline with a new concern with the 'descriptive'. In the work of the Chicago-based sociologist Andrew Abbott in particular he finds a range of innovative strategies designed to confront the issue. Although Abbott is sympathetic towards a range of quasi-mathematical and visualization tools for ordering and sequencing data of various types in the end he views the best option for sociology as being the development of what he terms a 'lyrical sociology' (Abbott 2007). This is an approach to sociology that is explicitly opposed to *narrative*—by which Abbott intends both standard quantitative variable-centred sociology *and* qualitative forms of sociology that take a narrative and explanatory approach to the study of the social. He defines 'lyrical sociology' as

> an engaged nonironic stance towards its object of analysis, by specific location of both its subject and its object in social space, and by a momentaneous conception of social time … [It] typically uses strong figuration and personification, and aims to communicate its author's emotional stance towards his or her object of study, rather than to 'explain' that object. (Abbott 2007: 67)

Now, it is difficult to identify forms of contemporary *academic sociology* that meet anything approaching this definition. However, there are other manifestations of the contemporary *sociological imagination* that clearly do. For, it is not just the methods of sociology that have seeped out of the academy to become a ubiquitous part of the infrastructure of 'knowing capitalism' (Thrift 2005); the cultivation of a distinctively sociological sensibility has also become a far more generic aspect of our (popular) culture than perhaps we have hitherto realized (Beer and Burrows 2010). And it is often this sensibility outside of the academy that possesses the more 'lyrical' quality that could perhaps feed a more descriptive form of sociology. As C. Wright Mills (1959: 19, note 2) observed over fifty years ago, when he spoke of the 'sociological imagination' he was not referring to 'merely the academic discipline of "sociology" '; indeed, he was highly disparaging of much of what passed for academic sociology at the time—the 'grand theory' of Parsons and his acolytes, and the 'abstracted empiricism' of Lazarsfeld and his (Mills 1959: chs. 2 and 3).[5] Rather Mills located such a sensibility as residing within different regions of cultural production.[6] Clearly, the regions of cultural production have become far more diverse and complex in the past fifty years and it is no longer just in text-based cultural practices—journalism, fiction and history—that we can now locate such a sensibility (Osbourne et al. 2008).[7] Indeed such a lyrical sociological sensibility is now perhaps most likely to be found within our visual culture—*tele*visual culture in particular.

A paradigmatic instance of this has been the much-discussed HBO TV series *The Wire* (Penfold-Mounce et al. 2011; Potter and Marshall 2009; Sharma 2009)—other examples might include *The Sopranos* or *Generation Kill*. All are strong on characterization, social space, social time, figuration, personification and affect but relatively weak on traditional narrative. *The Wire* premiered in the USA on 2 June 2002 and ended on 9 March 2008, with sixty episodes airing over the course of its five seasons. All sixty episodes were finally shown on BBC2 in the first half of 2009. Set in Baltimore, Maryland,

USA it has a huge cast of over three hundred characters. The 'star' of the show is, how-ever, the city—a simulated postindustrial every town—within which the interactions between the drugs economy, race, the criminal justice system, the polity, globalization processes, the changing class structure, the education system and the (new and old) media are examined in minute detail. It has been widely critically acclaimed not just as a complex piece of 'entertainment' but also as a profoundly 'sociological' piece of TV (Potter and Marshall 2009)—as a form *of social science fiction*?[8] The eminent Harvard sociologist William Julius Wilson, for example very publicly proclaimed the following at a seminar held at Harvard on 4 April 2008; he opened proceedings with the following statement, which is worth quoting at length:[9]

> *The Wire*'s exploration of sociological themes is truly exceptional. Indeed I do not hesi-tate to say that it has done more to enhance our understandings of the challenges of urban life and urban inequality than any other media event or scholarly publication, including studies by social scientists ... *The Wire* develops morally complex characters on each side of the law, and with its scrupulous exploration of the inner workings of various institutions, including drug-dealing gangs, the police, politicians, unions, public schools, and the print media, viewers become aware that individuals' decisions and behaviour are often shaped by—and indeed limited by—social, political, and eco-nomic forces beyond their control.

Such lyrical, visual forms of the sociological imagination are, however, likely to be few and far between and do not, at any rate, directly tackle the issue of data inunda-tion. They are, in fact, a way of the social sciences finding solace in the humanities; an attractive form of visual sociological dérive giving the illusion of an ability of being able to analyse totalities—cities in the instance of *The Wire*—by recourse to lyrical, artistic, cultural and political visual sensibilities. We should all celebrate the arts and the hu-manities; doubly so when they invoke such a strong sense of the sociological imagina-tion. However, such forms of descriptive sociology only provide a context to, rather than being at the heart of the 'descriptive turn'; for this we need to seek out *methodological innovations in techniques of visualization* rather than *visual prowess in the presentation of fictional sociological data*. Obviously both can invoke the sociological imagination but we need to be clear that visual and fictional creativity per se—however brilliant—is in the end no substitute for the establishment and perpetuation of more mundane sociological inscription devices able to take on the realities of digital data inundation. Where might we begin to look for such devices?

VISUAL INSCRIPTION DEVICES FOR THE DESCRIPTIVE TURN?

We end this chapter by pointing to a range of rather disparate methodological devel-opments which, taken together, might begin to prefigure the development of a set of new sociological inscription devices able to underpin the 'descriptive turn' in sociol-ogy. We point, first, to very recent changes in mainstream social statistics software

(Uprichard et al. 2008) that will potentially revitalize exploratory and visual techniques, the development of which had earlier (in the late 1970s and early 1980s) been stymied. Next we examine the emergence of the 'new cartography' (Hardey and Burrows 2008) and associated developments in Web 2.0-based social software (Beer and Burrows 2007). Finally, we briefly examine practices in 'commercial sociology' (Burrows and Gane 2006)—geodemographics in particular—that increasingly rely upon the representation of social complexity by way of strongly visual characterizations of data.

Back to the Future? From SPSS to PASW

For many years SPSS—the *Statistical Package for the Social Sciences*—has been a staple of the majority of sociological educational diets. However, a visit to www.spss.com soon makes it clear that this particular piece of iconic software has been profoundly changed by a number of the issues we have noted above. The corporate history section of the Web site makes it very clear that, although SPSS '*stood* for the Statistical Package for the Social Sciences' (emphasis added), it is now no longer an acronym but the name of the company. The site no longer functions in order to interpellate 'social scientists'; rather it now hails those seeking 'business solutions'. Even the software itself—SPSS version 18.0 and beyond—has been rebranded as PASW—*predictive analytics software*. These developments are a culmination of the development of the brand since about 1997 when it began to take over a number of different software companies. Instead of acquiring products similar to the ones that had long been at the core of SPSS as a piece of 'social science' software, the products that were sought were ones that offered 'data mining', 'business intelligence', 'Web analytics', 'online analytical processing' and 'text mining'. This strategic shift was, of course, a commercial response to the profound processes of social digitalization that we have already noted. SPSS quickly caught on to the implications that the increased digitalization of data implies—even if the academy did not—and it has successfully established a market segment in, what it terms (and as we have seen) 'predictive analytics' (Uprichard et al. 2008). Although the advent of 'predictive analytics' in SPSS might seem like an uneventful turn of events it is emblematic of a new methodological ethos in quantitative methods that is beginning to reflect aspects of the 'descriptive turn'. The data inundation that has resulted from the digitalization of routine transactional operations, the ubiquity of the Web, the emergence on networked logjects and so on, offers the empirical basis for changes in the fundamental 'nuts and bolts' of quantitative sociology (Uprichard et al. 2008). Newly emergent forms of quantitative sociology involve a move from an explanation of how variables work together towards an exploration and description of different kinds of cases, and ultimately tentative predictions based on the depictions of those cases. This requires a focus on exploring and describing empirical data—a radical return then to Tukey's (1977) extensive work on exploratory data analysis (EDA), as well as Tufte's (1983, 1991, 1997) various efforts towards the visualization of quantitative data.

The New Cartography and Web 2.0 Social Software

As important as changes in social statistics have been, the recent cross-disciplinary fore-grounding of cartography is probably of more importance for debates about sociological visualization. Why have 'maps' of various sorts suddenly come to such analytic and popular prominence? The answer, of course, is nowhere better articulated than in the writings of Marxist cultural critic Fredric Jameson over a quarter of a century ago. In what was to become a seminal statement Jameson (1984: 89) called for the development of 'an aesthetics of cognitive mapping' designed to deal with what he viewed at the time as 'the incapacity of our minds ... to map the great global multinational and decentred communicational network in which we find ourselves caught as individual subjects' (Jameson 1984: 84). Of course this radical call for a new cartographical imagination presaged the emergence of the technologies able to underpin it by about two decades. But as Holmes (2006: 20) has pointed out, Jameson possessed a profound sense of what was needed. He clearly saw the necessity for '[e]pistemological shifts, pushed forward by the use of sophisticated technical instruments ... paralleled by the deployment of radically new visual vocabularies'. The 'mapping impulse Jameson foretold' (Holmes 2006: 20) has now arrived. As Abrams and Hall (2006: 12) express it in their programmatic statement concerning the emergence of the new cartographies:

> Mapping has emerged in the information age as a means to make the complex accessible, the hidden visible, the unmappable mappable. As we struggle to steer through the torrent of data unleashed by the Internet, and to situate ourselves in a world in which commerce and community have been redefined in terms of networks, mapping has become a way of making sense of things.

This new cartography takes many forms, but the paradigmatic instance has been Google Earth (http://earth.google.com/), launched in 2005 and the associated Google Maps. They have a simple interface, provide easy access to terabytes of high-resolution geographic information and, crucially, have the capability for users to add 'layers' of additional data. The significance of the new digital mapping resources cannot be underestimated. The convergence of such cartographic technologies with networked logjects, such as the Apple iPhone 3G, has already begun to transform our visualization, and thus understanding of, urban space (Hardey 2007). At the heart of this new popular cartography is the possibility of allowing people to 'play' using open source applications. One form of play—that of producing mashups—is particularly interesting as a potentially prefigurative form of descriptive sociology (Hardey and Burrows 2008). This term—*mashup*—has been appropriated from pop music where a DJ takes, for example a vocal track from one song and combines it with the instrumental track of another in order to produce an emergent sound derived from both sources. Within the context of the new cartography a mashup can be thought of as the result of using an application that combines content from more than one data source into an integrated, usually visual, representation. Mashups utilizing maps are then essentially a form of a Web-based 'Do-It-Yourself' geographic information system (GIS).[10]

Mashups, however, are just one of a number of Web 2.0 applications (Beer and Burrows 2007) that provide forms of what we might begin to think of as *infotainment* that allow users to 'play' with data and visualizations of social phenomena. The wonderful Web site flowingdata.com/ is a particularly useful source for developments in this area. Interestingly the site is headed with a quote from the social statistician and advocate of EDA, John Tukey: 'The greatest value of a picture is when it forces us to notice what we never expected to see.' This surely is a simple statement of the necessity for the re-enchantment of sociology via a radical turn not just to description but to visualization as well; a re-enchantment that the rest of the *FlowingData* site amply illustrates via myriad graphics and stunning innovations in the presentation of the 'surface patterns' of social life. As the site expresses it: 'Data visualization lets non-experts make sense of it all.' This is an aspiration that the Obama administration in the USA appears to be taking very seriously. It has launched *Data.gov*, which although it has all the features and 'feel' of any other Web 2.0 application, is in fact giving analysts and members of the public unprecedented access to 'high value, machine readable datasets generated by the Executive Branch of the Federal Government'. It provides a host of relatively easy-to-use tools for data analysis and visualization. Such applications, alongside others such as the brilliant www.gapminder.org/—which produces stunning dynamic visualizations of patterns of social inequality—and www.worldometers.info/—which produces numerical visualizations of world social and cultural statistics updated in 'real-time'—demonstrate techniques by which even the most innumerate social scientist might be drawn into thinking about how we might better describe our data, and in ways that are engaging to a range of different publics.

Geodemographics

This concern to describe complex social data sets by way of innovative techniques of visualization has, of course, long been a concern of 'commercial sociologists' (Burrows and Gane 2006). Although many rely upon graphical visualizations of their data, others have developed ways of describing their data that rely upon emblematic montages of images able to capture symbolically the complexities of the social phenomena they are seeking to describe. A prime example of this can be found in the manner in which data are used to characterize neighbourhoods. From the mid 1970s onwards the availability of postcoded data of various sorts made possible a new way of describing differences between neighbourhoods—what came to be known as geodemographics (Burrows and Gane 2006). It came to recognized by some in the academy that the clustered nature of the social ontology of towns and cities could be increasingly well described by applying emerging techniques of statistical cluster analysis to the myriad forms of postcoded social data that were emerging. So, crudely, the clustered differentiated 'reality' of 'ground truth' could be modelled using algorithms which, it was hoped, could produce homologous statistical constructs (see Uprichard et al. 2009 for a fuller account). The skill of the commercial geodemographers was not only to apply these techniques to data in which case was the postcode, but also to possess the cultural insight, literary

flair and visual sensibility which enabled the production of rich qualitative narratives able to effortlessly translate dull statistical output to compelling ideal typical characterizations of neighbourhoods and the people that animated them (Phillips and Curry 2002) and then to produce convincing visualizations of them. With the advent of widespread processes of digitization and the routine production of huge amounts of postcoded transactional data the informational base for the production of ever more subtle forms of geodemographic neighbourhood differentiation has continued apace (Savage and Burrows 2007). The most widely used system is currently the Mosaic classification owned by the global data corporation Experian (Burrows and Gane 2006; Parker et al. 2007; Uprichard et al. 2009). The most recent Mosaic system—released in July 2009—classifies each of the UK's 47 million adults, 24 million households and 1.78 million postcodes into 141 different person-types, 67 different households types and 15 groups. The broad outline of the technical details of how Mosaic is built is simple enough; it is a form of weighted cluster analysis applied to 440 different data elements. Some 38 per cent of these items are sourced from Census current year estimates, but the majority, 62 per cent, derive from other sources such as the electoral roll, life-style survey data, consumer credit records, the shareholders register, house price and council tax data and so on (digital transactional data for the most part). Once the initial clusters have been derived from these variables their 'accuracy' is validated 'on the ground' by way of extensive qualitative fieldwork and observation. Each cluster is then subject to a detailed characterization. It is at this level of characterization that the role of visualization comes into play.

The claim is that these sixty-seven ideal typical clusters can mutually exclusively and exhaustively 'map' all of the residential postcodes in the country; that the neighbourhood differentiation we can all observe around us can, in fact, be reduced to sixty-seven different types of place. In a more sociological argot we might think of these sixty-seven clusters as being ideal typical attempts to socio-spatially codify differences in habitus (Burrows and Gane 2006; Parker et al. 2007)—the embodied often nondiscursive tastes, preferences and practices that form the social basis for many types of distinction in a culture (Bourdieu 1984). What is perhaps of most interest here is the manner in which the combination of variables that have been fused together to form each cluster is characterized via the production of a detailed description aimed at producing a sense of the 'sort of people' who reside within the postcodes so classified. This involves a process of what Curry (2002) terms 'discursive displacement', in which a discourse based on what he calls the 'topographic'—the statistical clusters—is translated to one about the 'chorographic'—an ideal typical descriptive map of a place—and then, in the end, to one about actual 'physical' places—a particular street for example. The mechanics by which this process occurs is clearly an iterative one. The clusters are mapped, a sample of 'real' places within the cluster are visited, images are taken, streets are trod, statistics are reexamined, people are spoken to, focus groups are organized, narratives and characterizations are recalibrated and then visualizations of the localities are constructed: pictures of houses (e.g. 'Victorian Terraces'); their occupants, wearing particular clothes, with particular styles of hair and particular types of names (e.g. mid-aged

couples called 'Tom' and 'Kate' wearing clothes from The Gap and Hobbs with state-educated school aged–children); the cars they drive (e.g. Volvo); the newspapers they read (e.g. *The Guardian*); the technologies they have a predilection towards (e.g. iPhones and Apple Mac computers); the shops they favour (e.g. John Lewis) and so on. The outcome of this process is a detailed qualitative, quantitative and visual codification of each particular habitus. In the case of the UK Mosaic Types this takes the form of numerous dense pages of text, photos, graphs and charts that summarize the 'ideal typical' character of each cluster. These are detailed rich descriptions—visualized at a level of detail unheard of within mainstream sociology. These are not designed to be used for 'causal modelling'—as within variable-centred approaches to research—but simply to provide an understanding of the particular patterns of associations that exist between persons, objects, symbols, technologies and so on; associations that are obviously not random, but which come together as specific spatial melanges of sociocultural accoutrements recognizable as a distinct habitus (e.g. middle-class, provincial, urban, university-based, white liberals).

CONCLUDING COMMENTS

Of course each of these developments in the descriptive visualization of social phenomena—predictive analytics and the move back to visualization in social statistics, the new cartography and associated Web 2.0 innovations, visual montages designed to represent amalgams of 'variables' in the geodemographics industry—are not yet well established as inscription devices in sociology. However, if the discipline is going to take seriously the implications of digitalization processes as both an object of inquiry and as a challenge to its established methodological practices, then the innovations in sociological description that this will inevitably necessitate will mean that we will have to take visualization methodologies far more seriously than we have done hitherto.

FURTHER READING

Abbott, A. 2007. 'Against Narrative: A Preface to Lyrical Sociology', *Sociological Theory*, 25/1: 67–99.

Abrams, H. and P. Hall, eds. 2006. *Else/Where: Mapping New Cartographies of Networks and Territories*. Minneapolis: University of Minnesota Press.

Burrows, R. and N. Gane. 2006. 'Geodemographics, Software and Class', *Sociology*, 40/5: 793–812.

Hardey, M. and R. Burrows. 2008. 'Cartographies of Knowing Capitalism and the Changing Jurisdiction of Empirical Sociology', in N. Fielding, R. M. Lee and G. Blank (eds), *Handbook of Internet and Online Research Methods*. London: Sage, 507–18.

Savage, M. 2010. *Identities and Social Change in Britain since 1940: The Politics of Method*. Oxford: Oxford University Press.

Tufte, R. 1997. *Visual Explanations: Images and Quantities, Evidence and Narrative*. Cheshire, CT: Graphics Press.

NOTES

1. See, for example http://mps-expenses.guardian.co.uk/.
2. One of the candidates being the arms contractor Lockheed Martin. For details see http://censusalert.org.uk/.
3. See http://www.dunnhumby.com/.
4. See http://www.1800mobiles.com/mobile-commerce.html.
5. One rather suspects that, were he alive today, Mills would be at least as disparaging of the contemporary instantiations of this academic binary: perhaps with Deleuzian-inflected vitalism standing in for Parsons and autistic forms of econometrics applied to social issues standing in for Lazarsfeld (though Mills, in actuality, misrepresented him somewhat)?
6. He wrote: 'In England ... sociology as an academic discipline is still somewhat marginal, yet in much English journalism, fiction, and above all history, the sociological imagination is very well developed indeed' (Mills 1959: 19, note 2); whilst in France he notes that: 'both the confusion and the audacity of French reflection since World War Two rests upon its feeling for the sociological features of man's fate in our time, yet these trends are carried by men of letters rather than by professional sociologists'.
7. As Osborne, Rose and Savage (again) have recently argued: 'Whilst some professional sociologists may claim a monopoly on the right to speak truthfully in the name of society, they are not the only people who investigate, analyse, theorise and give voice to worldly phenomena from a 'social' point of view. In fact, today more people speak this social language of society than we might imagine ... Not just statisticians, economists of certain persuasions, educationalists, communications analysts, cultural theorists and others working in the academy who tend to use broadly "sociological" methods but also journalists, TV documentary-makers, humanitarian activists, policy makers and others who have imbibed a social point of view. In many cases it may be that these agents of the social world actually produce better sociology than the sociologists themselves' (Osborne et al. 2008: 531–2).
8. It is also, contingently, the case that one of the substantive themes of *The Wire*, amongst many others, is the impact of digitalization and the use of metrics on social and organizational life: drugs gangs; the police; systems of surveillance and tracking; the logistics industries; the education system and so on. Thus sociological appeal of *The Wire* is both substantive and methodological.
9. A video of the event can be found at http://www.iop.harvard.edu/Multimedia-Center/All-Videos/The-HBO-Series-The-Wire-A-Compelling-Portrayal-of-an-American-City. A slightly different version of this quote and a more detailed justification for it can be found in Chadda et al. (2008: 83).
10. There are numerous illustrations available but the collection at http://googlemapsmania.blogspot.com/ is particularly good.

REFERENCES

Abbott, A. 1988. *The System of Professions: An Essay on the Division of Expert Labor*. Chicago: University of Chicago Press.

Abbott, A. 2007. 'Against Narrative: A Preface to Lyrical Sociology', *Sociological Theory*, 25/1: 67–99.

Abrams, H. and P. Hall. 2006. 'Whereabouts', in H. Abrams and P. Hall (eds), *Else/Where: Mapping New Cartographies of Networks and Territories*. Minneapolis: University of Minnesota Press, 12–17.

Adkins, L. and C. Lury. 2009. 'What Is the Empirical?', *European Journal of Social Theory*, 12/1: 5–20.

Beer, D. and R. Burrows. 2007. 'Sociology and, of and in Web 2.0: Some Initial Considerations', *Sociological Research Online*, 12/5, http://www.socresonline.org.uk/12/5/17.html.

Beer, D. and R. Burrows. 2010. 'The Sociological Imagination as Popular Culture', in J. Burnett, S. Jeffers and G. Thomas (eds), *New Social Connections: Sociology's Subjects and Objects*. Basingstoke: Palgrave, 233–51.

Bleecker, J. 2006. 'A Manifesto for Networked Objects—Cohabiting with Pigeons, Arphids and Aibos in the Internet of Things', http://www.nearfuturelaboratory.com/index.php?p=185.

Bourdieu, P. 1984. *Distinction*. London: Routledge.

Burrows, R. and D. Beer. Forthcoming. 'Rethinking Space: Urban Informatics and the Sociological Imagination', in N. Prior and K. Orton-Johnson (eds), *Rethinking Sociology in the Digital Age*. Basingstoke: Palgrave.

Burrows, R. and N. Gane. 2006. 'Geodemographics, Software and Class', *Sociology*, 40/5: 793–812.

Chadda, A., W. J. Wilson and S. Venkatesh. 2008. 'In Defense of *The Wire*', *Dissent*, 55: 83–6.

Crang, M. and S. Graham. 2007. 'Sentient Cities: Ambient Intelligence and the Politics of Urban Space', *Information, Communication and Society*, 10/6: 789–817.

Curry, M. 2002. 'Discursive Displacement and the Seminal Ambiguity of Space and Place', in L. Lievrouw and S. Livingston (eds), *Handbook on New Media*. London: Sage, 502–17.

Dodge, M. and R. Kitchin. 2004. 'Flying through Code/Space: The Real Virtuality of Air Travel', *Environment and Planning A*, 36/2: 195–211.

Dodge, M. and R. Kitchen. 2009. 'Software, Objects, and Home Space', *Environment and Planning A*, 41: 1344–65.

Gane, N., C. Venn and M. Hand. 2007. 'Ubiquitous Surveillance: Interview with Katherine Hayles', *Theory, Culture & Society*, 24/7–8: 349–58.

Hardey, M. 2007. 'The City in an Age of Web 2.0: A New Synergistic Relationship between Place and People', *Information, Communication and Society*, 10/6: 867–84.

Hardey, M. and R. Burrows. 2008. 'Cartographies of Knowing Capitalism and the Changing Jurisdiction of Empirical Sociology', in N. Fielding, R. M. Lee and G. Blank (eds), *Handbook of Internet and Online Research Methods*. London: Sage, 507–18.

Hayles, K. 2009. 'RFID: Human Agency and Meaning in Information-Intensive Environments', *Theory, Culture & Society*, 26/2–3: 47–72.

Holmes, B. 2006. 'Counter-cartographies', in H. Abrams and P. Hall (eds), *Else/Where: Mapping New Cartographies of Networks and Territories*. Minneapolis: University of Minnesota Press, 20–25.

House of Commons. 2008. *Counting the Population. Eleventh Report of Session 2007–08: Volume I: Report, together with formal minutes, oral and written evidence*, 14 May, HC 183–I. London: The Stationery Office.

Jameson, F. 1984. 'Postmodernism, or the Cultural Logic of Late Capitalism', *New Left Review*, 146: 53–92.

Lash, S. 2006. 'Dialectic of Information? A Response to Taylor', *Information, Communication & Society*, 9/5: 572–81.

Lash, S. 2007a. 'Capitalism and Metaphysics', *Theory, Culture & Society*, 24/5: 1–26.

Lash, S. 2007b. 'New "New Media" Ontology', a Presentation at Toward a Social Science of Web 2.0, ESRC e-Society Research Programme Event, National Science Learning Centre, York, UK, 5 September, http://redress.lancs.ac.uk/Workshops/Presentations.html#web2.0.

Latour, B. 2005. *Reassembling the Social*. Oxford: Clarendon Press.

Mills, C. W. 1959. *The Sociological Imagination*. Oxford: Oxford University Press.

Osborne, T., N. Rose and M. Savage. 2008. 'Inscribing the History of British Sociology', *Sociological Review*, 56/4: 519–34.

Parker, S., E. Uprichard and R. Burrows. 2007. 'Class Places and Place Classes: Geodemographics and the Spatialisation of Class', *Information, Communication and Society*, 10/6: 902–21.

Penfold-Mounce, R., D. Beer and R. Burrows. 2011. '*The Wire* as Social Science Fiction', *Sociology*, 45/1: 152–67.

Phillips, D. and M. Curry. 2002. 'Privacy and the Phenetic Urge: Geodemographics and the Changing Spatiality of Local Practice', in D. Lyon (ed.), *Surveillance as Social Sorting: Privacy, Risk and Digital Discrimination*. London: Routledge, 137–52.

Potter, T. and C. W. Marshall. 2009. *The Wire: Urban Decay and American Television*. London: Continuum.

Ritzer, G. and N. Jurgenson. 2009. 'Production, Consumption, Prosumption: The Nature of Capitalism in the Age of the Digital "Prosumer" ', *Journal of Consumer Culture*, 10/1: 13–36.

Savage, M. 2009a. 'Against Epochalism: An Analysis of Conceptions of Change in British Sociology', *Cultural Sociology*, 3/2: 217–38.

Savage, M. 2009b. 'Contemporary Sociology and the Challenge of the Descriptive Assemblage', *European Journal of Social Theory*, 12/1: 155–74.

Savage, M. 2010. *Identities and Social Change in Britain since 1940: The Politics of Method*. Oxford: Oxford University Press.

Savage, M. and R. Burrows. 2007. 'The Coming Crisis of Empirical Sociology', *Sociology*, 41/5: 885–99.

Savage, M. and R. Burrows. 2009. 'Some Further Reflections on the Coming Crisis of Empirical Sociology', *Sociology*, 43/4: 765–75.

Sharma, A. 2009. ' "All the Pieces Matter"—Introductory Notes on *The Wire*', *Dark Matter*, Special Issue: *The Wire* Files, No. 4, http://www.darkmatter101.org/site/category/journal/issues/4-the-wire/.

Sterling, B. 2005. *Shaping Things*. Cambridge, MA: MIT Press.

Thrift, N. 2005. *Knowing Capitalism*. London: Sage.

Thrift, N. and S. French. 2002. 'The Automatic Production of Space', *Transactions of the Institute of British Geographers*, 27/4: 309–35.

Tufte, E. 1983. *The Visual Display of Quantitative Information*. Cheshire, CT: Graphics Press.

Tufte, E. 1991. *Envisioning Information*. Cheshire, CT: Graphics Press.

Tufte, R. 1997. *Visual Explanations: Images and Quantities, Evidence and Narrative*. Cheshire, CT: Graphics Press.

Tukey, J. 1977. *Exploratory Data Analysis*. Menlo Park, CA: Addison-Wesley.

Uprichard, E., R. Burrows and D. Byrne. 2008. 'SPSS as an Inscription Device: From Causality to Description?', *Sociological Review*, 56/4: 606–22.

Uprichard, E., R. Burrows and S. Parker. 2009. 'Geodemographic Code and the Production of Space', *Environment and Planning A*, 41/12: 2823–35.

Action-based Visual and Creative Methods in Social Research

DAVID GAUNTLETT AND FATIMAH AWAN

Much of the work in Visual Culture or Visual Studies is—to state the obvious – to do with analysis of things that we can see, and that already exist. In this chapter, we will be discussing a relatively new branch of sociological methodology which is somewhat different in that it involves participants *creating* new visual things, as part of the research process. This work is not necessarily or intrinsically connected to the emergent field of Visual Culture; it has perhaps developed more from the frustrations of some visually oriented researchers wanting to explore the social world in a different way.

Traditionally, in the social sciences, qualitative research with humans has been conducted through language-based events: in particular, through focus groups and interviews where participants are expected to be able to generate more-or-less immediate verbal accounts of their feelings and experiences. But alongside this, in recent years, there has been a growing interest in creative and visual research methods, in which participants are asked to make things such as videos, collage, drawings or models, to express their feelings or impressions. These methodologies often, in fact, come back to language at some point, as it is usually considered necessary to access the participants' own commentary on the thing that they have produced. Nevertheless, it is argued that by asking research participants to go through a reflective process, taking time to consider an issue and to create a visual response, we receive more carefully thought-through responses which can offer rich insights into what a particular issue or representation really means to an individual.[1]

THE EMERGENCE OF VISUAL SOCIOLOGY

The rise of interest in visual research methods is reflected in a small but growing body of literature on visual research methods produced by sociologists and anthropologists (Prosser 1998; Emmison and Smith 2000; Banks 2001; Van Leeuwen and Jewitt 2001;

Pink 2001, 2003; Knowles and Sweetman 2004). Indeed, the cause of visual sociology has been promoted for more than a quarter of a century through the activities, conferences and publications of the International Visual Sociology Association (IVSA), established in 1981. The founders of the IVSA were primarily photographers, who took their own photographs to record aspects of social life that would otherwise go unremarked and unrecorded. In these early days of visual sociology, the idea of the researcher handing over the camera, or other tools, to research subjects or participants had not really dawned. More recently, however, a new generation of researchers has started to join the IVSA and fostered some diversity of methods.

Visual research, as the books listed above typically note, is not an independent, self-contained approach; rather it is methodologically and theoretically diverse, utilizing a variety of analytical perspectives (for example anthropology, sociology and psychology) to study a broad spectrum of issues. Thus, visual research methods are regarded as complementary to existing approaches and, as Christopher Pole (2004) has suggested, have 'the capacity to offer a different way of understanding the social world' (7). However, despite the potential value offered by visual research methods, the approach remains reasonably marginal within existing qualitative practice.

In his discussion of image-based research, Jon Prosser (1998) claimed that the limited status of images within social research at that time was attributable to the employment of 'scientific' paradigms, as well as established qualitative strategies which give primacy to the written word. His study of ethnographic and methodological texts found that visual methodologies were given minimal coverage; rather, he says, they tended to suggest that 'images were a pleasant distraction to the real (i.e., word-orientated) work that constituted "proper" research' (98). Furthermore, Prosser argues that in instances when images are included, the *manner* and *tone* of their use is revealing. In terms of *manner*, he claims that a limited range of images are presented within texts, taking the form of black-and-white photographs or line drawings, which predominantly serve as illustrations of researchers, participants or objects under investigation. With regard to *tone*, Prosser maintains such texts suggest that images are constructed subjectively, distorting what they aim to represent, and therefore render objective analysis problematic. Thus, he proposes that the role of visual imagery within research is considered credible only in its supportive function to written accounts, and 'are unacceptable as a way of "knowing" ' (99) due to the perceived partial nature of their production making them unsuitable for effective analysis. Prosser suggests that methodological discussions typically give little credence to strategies to resolve such difficulties, and fail to emphasize how similar criticisms can be levelled against word-orientated research.

In this chapter we will discuss a selection of key studies, looking at studies which have used drawings and diagrams, photographs and videos. We will then focus, to some extent, on work in our own area—media 'audience' studies—considering studies which have asked participants to write news stories, edit video, produce video or use a range of methods including diaries and scrapbooks. Then we will consider the use of visual metaphors in social research—a potentially fruitful new dimension. But first we will consider the philosophical and ethical rationale for using such methods.

WHY USE CREATIVE METHODS?

The use of any particular methodological approach follows, of course, from philosophical or ideological beliefs as well as more pragmatic insights. In the case of visual creative methods, this may be a confluence of various things: perhaps a commitment to a qualitative, reasonably ethnographic desire to understand the meanings of people's lives as they experience them for themselves; frustration with language-based approaches; an interest in the possibilities of visual communication; and an ethical interest in enabling participants to get their own feelings and interests onto the research agenda as much as possible.

As noted above, qualitative methods typically require participants to produce immediate descriptions of their views, opinions or responses, in language. This may seem entirely natural to the kind of highly educated and more-or-less articulate people who become academic researchers, but it may be unrealistic to expect that diverse citizens will find it simple or straightforward to generate instant, verbal accounts of their feelings and experiences. Creative visual methods give participants a process to go through, during which they may be able to contemplate and assemble certain insights, and formulate some of their ideas more coherently. (Critics might argue that such considered responses are less 'real' than the spontaneous utterances demanded by focus groups or interviews; but researchers using creative techniques would say that their experience does not support this view: statements which emerge from a process of reflection are, we would say, of more value than the immediate, less considered responses required by other methods.)

Such processes therefore offer a different way into a research question—not necessarily 'better' in all cases, but facilitating a different route into discussion of a topic, and stimulating different parts of the brain to foster outputs which are different from those produced when the mind is focussed on immediate language production (Gauntlett 2007). Operating initially on the visual plane may also be of value when considering places, media, emotions and other experiences which are not primarily language-based.

These approaches can also be seen to have been influenced by the feminist critique of traditional research methods, which rose to prominence in the 1980s and 1990s (see for example Roberts 1990; Reinharz 1992; Hesse-Biber and Yaiser 2003; Letherby 2003). This critique was not merely a preference for qualitative over quantitative methods. Rather, these critics criticized both qualitative and quantitative researchers for their tendency to use participants as mere suppliers of data. Traditionally, research has been (more or less) a one-way street where an investigator prepares his or her questions, and then encounters 'subjects' and takes 'data' away. Participants are usually not involved in the research development, are not consulted about the style or content of the process— apart from in the moment(s) in which they supply data—and do not usually get an opportunity to shape the agenda of the research. The process usually involves little real interaction, or dialogue.

Creative and visual methods do not inherently or necessarily avoid this, but they provide more opportunities for participants to shape the content of the enquiry, to bring

in issues and questions which the researcher may not have considered, and to express themselves outside of boundaries set by the researcher. Of course, researchers remain all-powerful as they subsequently preside over the interpretation and analysis of data. Nevertheless, these approaches hopefully foster an ethical stance where the participants' *own* interpretations are given, at least, significant weight.

MAKING DRAWINGS AND DIAGRAMS

Researchers have typically asked participants to create visual material in order to access thoughts or feelings which they would not be likely to express in language. An early instance of this was the 'draw and write' technique, first presented by Noreen Wetton in 1972, which was originally developed as part of a project to explore emotional literacy in seven- to eight-year-old children. This work established that although children could express particular emotions visually—using both drawing and writing—they lacked this ability when relying solely on written or spoken words:

> It became apparent that the children experienced and empathized with a wide range of emotions including anger, frustration, despair, remorse, guilt, embarrassment and relief as well as delight, enjoyment, excitement. The children differed only from adults in that they did not have the vocabulary to express themselves. (Wetton and McWhirter 1998: 273)

Wetton and her colleagues argue that this approach can reveal how children conceptualize particular issues, in areas such as health and safety, and that the combined process of drawing *and* writing enables researchers to access aspects of children's knowledge that eludes conventional techniques.

More recently, also within the field of health research, Marilys Guillemin (2004) employed a similar strategy with adults in order 'to explore the ways in which people understand illness conditions' (272)—specifically, women's experience of the menopause, and of heart disease. Participants were asked to 'draw how they visualised their condition' (276). They were often reluctant at first, but eventually drew an image, 'sometimes hesitatingly and at times with such intent and force that I and they were taken aback' (276). The researcher asked each participant to describe and explain her drawing. The study revealed the many and diverse ways in which the women experienced these conditions. For example menopause was represented as a life transition (such as one part of a staircase, or as 'a sun setting and the moon coming up'), or as a lived experience (often chaotic), or as loss and grief.

These studies have highlighted how the use of drawings can be used to elicit a broader and richer range of data than would have been possible through traditional word-orientated approaches. Other projects have also confirmed the value of asking participants to generate visual material. For instance, Lorraine Young and Hazel Barrett's study of Kampala street children (2001) adopted similar strategies in an attempt to understand the children's 'socio-spatial geographies in relation to their street environments

and survival mechanisms' (142). Young and Barrett recognized that existing methods are not devised to provide an accurate reflection of the child's perspective, and fail to allow the child any influence on the research design and process. Therefore, Young and Barrett specifically aimed to develop procedures which fostered a high degree of child-led participation in order to produce 'research "with children" rather than research "about children" ' (144). They therefore utilized a range of visual methods. One group of children was asked to draw their own mental maps of Kampala, showing places that were important to them, and the 'depots' where they slept. In another activity, children were asked to produce three drawings of their everyday experiences, and in another, a large group worked together to produce symbols of daily activities and to place them on a timeline showing a typical day. Another group of children were asked to produce a 'photo diary', taking pictures of activities and places they visited over a 24-hour period. (Photographic methods like this are discussed in the following section.) The discussions about the maps, the drawings, the photographs and the timeline—during and after their production—were a crucial part of the process, eliciting valuable information. The researchers note that their engaging, nonthreatening, and action-oriented methods resulted in a high level of participation by the children (151), and meant that the children were able to communicate what was important to them, putting at the heart of the study material 'that would have been overlooked by an adult' (151).

MAKING PHOTOGRAPHS AND VIDEOS

Enabling research participants to take photographs obviously provides an opportunity for physical environments and social events to be recorded, but perhaps more important offers a set of images which can be subsequently considered and discussed—by the people who created them, and others—and used as prompts for reflection on the emotional and meaningful nature of people and places. For instance, Michael Schratz and Ulrike Steiner-Löffler (1998; see also Raggl and Schratz 2004) used photographic images produced by children in an attempt to evaluate the 'inner world' of school life from the pupils' standpoint. Participants were invited to photograph what they 'liked or disliked' about the school environment (1998: 235), and these images were used as the basis for group discussions. Significantly, the pictures instigated a dialogue amongst pupils and teachers about issues which had not formerly been discussed, including personal reflections of schooling.

A study by Alan Radley, Darrin Hodgetts and Andrea Cullen (2005) asked homeless adults to photograph places and activities of personal significance, in order to 'collect a series of glimpses of the city as seen through their eyes' (276). The researchers then discussed the images produced with the participants, leading to insights into homeless life. The photographs did not constitute an object of study in themselves, but served to engender communication, which itself became intrinsic to the analysis:

> We used photography in this research so that homeless people could show us their world as well as interpret it. Rather than see the photographs as bounded objects for interpretation, they are better understood as standing in a dialectical relationship with

the persons who produced them. Their meaning does not lie in the pictures, except in so far as this is part of the way people talk about them. To talk about the photographs one has taken is to make claims for them—to explain, interpret and ultimately take responsibility for them. (278)

Hence, Radley, Hodgetts and Cullen claimed that this kind of interview can be conceptualized as a *dialogic* relationship between researcher and participant, through which meaning is produced in a dialectic process, and therefore not imposed by either party.

Still photography, then, has proved to be valuable as a research tool (and see also Harper 1998; Prosser and Schwartz 1998; Banks 2001; Collier 2001; Bolton, Pole and Mizen 2001; Wright 2004). In keeping with these principles, video production has also demonstrated the advantages of combining discussion and visual work (e.g. Dowmunt 1980, 2001; Pink 2001, 2004; Noyes 2004). For example in a study conducted between 1998 and 2000, Ruth Holliday's (2004) exploration of queer performances employed video diaries in order to evaluate their potential 'for capturing some of the complex nuances of the representation and display of identities' (1597). This was enabled by lending video cameras to participants and requesting them to detail how they represented themselves in differing everyday environments—'work, rest (home), and play (the scene)' (1598)—both verbally *and* visually. Holliday specifically achieved these aims by encouraging respondents to film themselves in the appropriate settings whilst wearing, discussing and commenting upon the suitability of their typical clothing for each occasion. In doing so, she maintained that this approach allowed her to 'chart the similarities and differences in identity performances' (1598). Significantly, Holliday established that the use of video diaries helped amass information on 'identity performances' in ways that are unique to this method. On the one hand she suggested that, as opposed to a tape-recorded interview which can only express what the participants *say*, the videos provided a *visual illustration* that allowed for a more 'complete' image of self-representation; on the other, the act of making a video not only generated a visual representation, but these were also supported by the individual's *own* narrative. Moreover, Holliday stated that the *process* of video-making permitted participants to choose, alter and refine their presentations of self, thus affording them a more reflexive role within the research process:

Against other methods that focus on 'accuracy' or 'realism', then, this approach affords diarists greater potential to *represent* themselves; making a video diary can be an active, even empowering, process because it offers the participant greater 'editorial control' over the material disclosed. (1603, original emphasis)

TELLING AND EDITING STORIES

In the area of media audience studies, creative methods have been used to explore memories and preferences, and even the power of the media itself. For instance, the Glasgow Media Group devised a research technique which it called 'the news game' in which 'research participants were actively engaged in trying to write and criticize a media report'

(Eldridge, Kitzinger and Williams 1997: 161; and see Kitzinger 1990, 1993; Philo 1990). Participants were provided with materials such as news photographs and headlines, and asked to write an accompanying text that could take the form of a newspaper report, news broadcast script or a headline. These studies claimed to find that although participants apparently presented their own perspectives on these issues, in practice they replicated the ideological discourses predominant in the initial news reports. (However, it seems possible that when participants reproduced dominant ideological discourses in their own media texts, they did so not because they agreed with these ways of thinking, but because they may have thought that this was what they were being asked to do.)

In Kitzinger's study 'Understanding AIDS' (1993) participants were given thirteen photographs around which they produced a news report on AIDS that then became the focus of a group discussion. In these reports it was found that the participants reproduced the terminology and attitudes circulated by the mainstream press, such as 'promiscuous, irresponsible drug users or gay people' and 'innocent victims' (277). Kitzinger's analysis also highlighted the forcefulness of visual representations in the participants' understandings of AIDS: 'television and newspaper representations are, for many people, the lens through which they view the reality of AIDS' (Eldridge, Kitzinger and Williams 1997: 163).

In a development of this idea that research participants should 'get to grips' with media materials, Brent MacGregor and David Morrison's study (1995) of audience responses to coverage of the 1990–91 Gulf War sought to bring 'respondents into closer contact with the text ... enabling them to articulate their response in an appropriate manner' (143). This was achieved by asking participants to edit existing audiovisual news footage to create 'a report that you would *ideally* like to see on TV, not what you think others would like to see, not what you think journalists would produce' (146, original emphasis).

MacGregor and Morrison noted that prior to editing the footage, participants all claimed that they aimed to produce 'an ideal, impartial, neutral account' (146) by selecting what they considered to be the more reliable material. Importantly, the researchers observed that although there was considerable similarity between participants' comments made before and after editing, crucial nuanced differences were noted as a result of the editing process itself: 'Positions articulated in discussion which would have been reported as definitive in focus groups were modified as a result of the active engagement with the text' (147). For example MacGregor and Morrison note that participants described one text as having 'an undesirable emotional tone' (147) but were unable to identify why this was the case. However, on engaging in the editing process, the participants were able to suggest how this feeling had been created by presentation techniques. Therefore, the employment of this method seems to have enabled MacGregor and Morrison to access more significant and meaningful results than would have been made available by traditional methods. The researchers state that this method is 'not a methodological solution looking for a research problem, but a real tool capable of producing significant results in any situation where tangible viewer contact with the text can unlock new insights into the dynamic of how audio-visual texts are read' (148).

VIDEO-MAKING AS AUDIENCE RESEARCH

In an attempt to move further beyond the reliance on interviews and focus groups in qualitative research, David Gauntlett's *Video Critical* (1997) aimed to evaluate audience responses to mass media material by engaging participants in the creation of their *own* original texts, rather than merely modifying or discussing existing sources. For this project, Gauntlett worked with groups of children aged seven to eleven, from seven primary schools, in which they used video equipment to make documentaries on the issue of 'the environment', over a period of several weeks each. In the first meeting, a focus group style discussion identified that for children at that time, television was the primary source of information and commentary on environmental matters (96–7). It also appeared to show that, in each group, children were overwhelmingly enthusiastic about 'green' issues—but significantly, the research process over subsequent weeks would reveal that this was only patchily the case.

The study recorded the children's conception of the impact of environmental issues on their lives, and facilitated an understanding of how these beliefs were informed by media messages on this topic. The method enabled the researcher to amass a substantial amount of ethnographic data through observation and discussions with the participants throughout the video production project, in addition to the completed videos themselves—which Gauntlett states should be read as 'constructed, mediated accounts of a selection of the perceptions of the social world held by the group members' (93).

In line with the principles proposed by MacGregor and Morrison, Gauntlett highlights that initial discussions with participants were not necessarily indicative of their more deeply felt attitudes or beliefs, but rather they 'represented a kind of "brain dump" of *potential* interests and concerns, which in subsequent weeks were sifted and filtered to reveal the more genuinely-felt opinions' (150, original emphasis). The researcher suggests that the video-making process constitutes a significant departure from more traditional techniques, which often confined the participants within a predetermined structure that only allowed for limited responses. Video-making enabled the participants to influence the research process itself: participants were able to construct a free and open response to the research brief which Gauntlett encourages as a productive strategy, stating that 'the video project researcher celebrates their own inability to predict what will happen—a "risk" worth taking' (93). He also notes Stuart Hall's observation about the value of enabling everyday people to produce mediated representations:

> [I]t is important to get people into producing their own images because ... they can then contrast the images they produce of themselves against the dominant images which they are offered, and so they know that social communication is a matter of conflict between alternative readings of society. (Hall 1991, quoted in Gauntlett 1997: 92)

In another video study, Gerry Bloustein (1998) explored how ten Australian girls constructed their gendered identities, by inviting the participants to record what they believed were salient elements of their lives in an attempt to investigate 'everyday lived experience ... *through their own eyes*' (117, original emphasis). During this work she

claimed that the film-making process facilitated an arena in which the girls were able to experiment with the way in which they represented their identities, whilst also paradoxically revealing the restrictions and difficulties encountered in their quest to articulate 'alternative selves' (118). According to Bloustein then, the film-making process *as well as* the actual completed videos reflected the social/cultural frameworks and limitations impacting upon the girls' perceptions of themselves. Indeed, she claimed that the use of the camera empowered the participants, the camera becoming 'a tool for interpreting and redefining their worlds' (117). (We should note, however, that claims that studies of this kind are 'empowering' for participants are usually over-egging their value: taking part may be interesting and enjoyable, and may offer some insights, but cannot reasonably be expected to be a life-transforming experience.)

Research by Horst Niesyto (2000; see also Niesyto, Buckingham and Fisherkeller 2003) has highlighted the ever-increasing proliferation of media materials in young people's lives and how these are integral to the construction of social worlds and self-perception. He further noted that although there are a vast number of films that focus on youth which have provided the basis for critical analysis, very few of these films are produced by the young people *themselves*. In consideration of these factors, Niesyto developed a method which has been utilized within a number of projects in Germany where 'young people had the chance to express *personal images of everyday experience* in self-produced films' (2000: 137, original emphasis). Within these studies, Niesyto observed how different modes of filming revealed different perspectives of representation. For example the 'collage-like video films' gave insight into emotional and ambivalent aspects of identity through association and metaphor (143) and this was a particularly rewarding mode of expression utilized by the participants he described as 'marginal', as in many cases their media literacy exceeded their competence in more conventional forms of expression, such as talking and writing (144). Niesyto makes his point with gusto:

> In view of media's increasing influence on everyday communication, I put forward the following thesis: If somebody—in nowadays media society—wants to learn something about youth's ideas, feelings, and their ways of experiencing the world, he or she should give them a chance to express themselves also by means of their own self-made media products! (137)

These principles are evident and further developed in the more recent international project 'Children in Communication about Migration' (CHICAM), which sought to explore the lives and experiences of migrant and refugee children in a number of European countries (see www.chicam.org). This collaborative project, co-ordinated by David Buckingham, established 'media clubs' in six European countries (England, Italy, Sweden, Germany, the Netherlands and Greece) in which a researcher and a media educator worked with recently arrived refugee and migrant young people to make visual representations of their lives and experiences (De Block, Buckingham and Banaji 2005). The material was shared and discussed between the groups, over the Internet. The children made videos, collage (with cut-up magazines), arrangements of photographs with music

and specific photo tasks (such as a photo essay on likes and dislikes, or on national symbols), all of which were shared and discussed internationally via an online platform.

This method provided the researchers with a wealth of valuable data—or 'thick description' (Geertz (1973) 1993)—generated not only from the products produced by the children, but also from observations, written reflections and discussions by both researchers and children throughout the entirety of the project. Hence, in this formulation verbal data are not abandoned in favour of the visual, but rather they are considered as complementary factors. As two of the project researchers, Peter Holzwarth and Björn Maurer, state:

> In an era when audio-visual media play an increasingly influential role in children's and adolescents' perceptions, it is important that researchers not only rely on verbal approaches alone, but also give young people the opportunity to express themselves in contemporary media forms. Audio-visual data should not be considered an alternative to verbal data but rather a source of data with a different quality. (Holzwarth and Maurer 2003: 127)

MIXING METHODS AND APPROACHES

David Buckingham and Sara Bragg's (2004) study of young people aged nine to seventeen aimed to explore their attitudes towards representations of sex and personal relationships in the media. To achieve this the researchers utilized a number of methods: the completion of a diary or scrapbook in which the children documented their personal responses to media representation; interviews where they expanded upon the statements made in their diaries; group discussions that centred around a selection of video clips; further interviews discussing extracts from tabloid newspapers and magazines; and finally surveys that extrapolated further information about their opinions and social lives (18–19). Importantly, Buckingham and Bragg state that 'Research is not a natural conduit that extracts the "truth" about a topic or about what participants "really" feel and think about it' (17). Rather they acknowledge that their findings would be determined by the methods employed, the environment in which the study was conducted, relationships between the participants predating and developed during the research as well as their own chosen system of analysis. Ostensibly, although this position may appear to limit the potential scope of the research, it may in fact broaden the range of possibilities available to the researcher. As Buckingham and Bragg highlight, tasks were specifically arranged so they would prompt either 'personal' or 'public' responses from the participants dependent upon the nature of the individual task, such as writing or speaking in a group (22). Thus, by locating participants in varying discursive fields, they were more able to elicit 'different voices' which facilitated a more complex and arguably more comprehensive understanding of the students involved.

Indeed, use of these methods meant that the researchers were able to offer a range of findings including that young people utilize the media—particularly teenage magazines and soap operas—as a resource for learning about love, sex and relationships and use

the media to facilitate discussion on potentially embarrassing and sensitive issues with parents and peers; that although young people are aware of media regulation, such as the film classification system, and use it to inform their own media consumption, they believe they are capable of self-regulation and making autonomous judgements regarding their own viewing; and that young people consider sex within the context of their own morality and highlight the importance of trust, loyalty and respect in discussions about sex and relationships in the media, rather than demonstrating that the media has 'morally corrupted' them (236–41).

In their analysis, Buckingham and Bragg 'aimed at what Laurel Richardson (1998) has described as a "crystal" structure or a range of viewpoints, none of which is necessarily more transparent or true than any others, but where we can learn from the contradictions and differences between them to develop more complex ways of seeing issues' (2004: 22). Furthermore, as Buckingham has noted elsewhere (1993: 92), talk functions as a *social act*, that is to say talk is not merely a statement of held beliefs and attitudes, rather it is a behaviour or process which draws upon available cultural concepts to fulfil specific functions: 'people achieve identities, realities, social order and social relationships through talk' (Baker 1997, quoted in Buckingham and Bragg 2004: 23).

In consideration of this, Buckingham and Bragg emphasize the significant role of reflexivity in their approach—'that is the role of researchers in interpreting, representing and producing knowledge from the voices of research subjects' (2004: 38)—to promote an informed understanding of how their standpoints may influence and impact upon the research process. Noting then how their methods have moulded their work, they assert that *all* research is limited by the methods applied. However, they maintain that their methods will enable researchers to gain a greater insight into children's understandings and uses of the media that are not provided by other techniques. This, Buckingham and Bragg state, is due to the systematic, multifaceted and holistic approach of their own work:

> [R]eaders should be wary of the extent to which *all* methods necessarily constrain what research is able to show or prove ... We would strongly contest the idea that qualitative research is automatically more 'subjective' than quantitative research, or more subject to interpretation. The methods we have used enable us to be systematic and rigorous, both in ensuring the representativeness of the data we present and analyse, and in comparing material gathered through different methods and in different contexts. (41, original emphasis)

USING METAPHOR IN SOCIAL RESEARCH

The increased focus on reflexivity within qualitative enquiry (see Denzin and Lincoln 2005) has been central to developments in visual research methodologies and, it is argued, helps advance a fuller understanding of participants' experiences of their social worlds. More recently the use of metaphor has emerged within social research as an effective means of exploring individuals' experiences and identities. These ideas are highlighted

in Russell Belk, Ger Güliz and Søren Askegaard's (2003) analysis of consumer desire which engaged participants from Denmark, Turkey and the United States in a series of tasks to investigate 'the thoughts, feelings, emotions, and activities evoked by consumers in various cultural settings when asked to reflect on and picture desire, both as their particular idea of a general phenomena and as lived experiences' (332). Within these exercises, a proportion of the participants were instructed to complete a journal detailing their own accounts of fulfilled/unfulfilled desires and interviewed on the issues raised; remaining participants undertook tasks specifically designed to provoke metaphorical representations of desire including collage-making; drawing; and writing stories (332). Although Belk, Güliz and Askegaard acknowledged the journals and interviews provided valuable *descriptive* information, they maintained that the projective tasks revealed a greater depth of data. This is best exemplified in the collage-making activities, where participants not only represented what they desired, but also created metaphors for desire's dualistic nature by juxtaposing abstract images (333–40). Therefore, they claimed the combination of metaphoric expressions *as well as* participants' explanations enabled them to construct a thematic portrait of desire that exceeded constraints of language, and would not have been possible through any one method alone:

> We found the projective and metaphoric data to be very rich in capturing fantasies, dreams, and visions of desire. The journal and depth interview material was especially useful for obtaining descriptions of what and how desire was experienced. Although this is useful data, especially concerning the things people desire, it also showed some evidence of repackaging in more rational-sounding terms. Some informants found it difficult to elaborate on their private desires or did not want to reveal those desires. Hence, the projective measures sought to evoke fantasies, dreams, and visual imagination in order to bypass the reluctance, defence mechanisms, rationalizations, and social desirability that seemed to block the direct verbal accounts of some of those studied. (332)

Research by Brandon Williams (2002) on interprofessional communication in healthcare has also highlighted the usefulness of metaphors within collage-making, as a means for developing a more complex and comprehensive understanding of individuals.

The use of visual metaphors was further developed in Gauntlett's more recent work (2007, see also 2006) that engaged participants in *building* metaphorical models of their identities using Lego bricks. This method was a development of Lego Serious Play, a metaphorical consultancy process developed by Lego (see www.seriousplay.com), the Danish toy company that Gauntlett collaborated with. The approach draws some of its inspiration from Seymour Papert's theory of constructionism (see Papert and Harel 1991), which maintains 'that people learn effectively through *making* things' (Gauntlett 2006: 7, original emphasis), and argues against mind-body distinctions, claiming that our perceptions and experiences of the world are mediated bodily *as well as* mentally (see Merleau-Ponty (1945) 2002). Therefore physical engagement with our environment activates somewhat different cognitive procedures to those triggered by purely

cerebral activity. Thus, Gauntlett claims, by building metaphors of their identities prior to discussion, participants are not only granted *time* to *reflect* on what they create, but this process engages a *different type* of thinking about the issue itself. He suggests that this approach can therefore avoid some of the problems inherent in approaches which aim to elicit an immediate reaction, by allowing a considered and reflective response to the research task.

Of course, Gauntlett readily admits, asking a participant at the start of a research workshop to 'build a metaphorical model of your identity in Lego' would seem rather baffling. Rather, participants go through a series of exercises which get them acquainted with Lego building, and then with building in metaphors, before this ultimate task is reached in the second half of a workshop session which is at least four hours long.

Importantly, Gauntlett says, the method allows for a more complex representation of identity that does not presume an individual's self is a fixed, discernable artefact which can be described in a linear manner, but acknowledges its multifarious, amorphous and changeable nature more suited to symbolic expression. Furthermore, he states that the *process* of building a Lego model is particularly appropriate in this instance as it entails improvisation and experimentation, hence providing diverse forms of conceptualization. As Gauntlett explains, the process offers 'an alternative way of gathering sociological data, where the expressions are *worked through* (through the process of building in Lego, and then talking about it) rather than just being spontaneously generated (as in interviews or focus groups)' (2006: 5, original emphasis). Consequently, the researcher concludes that the method affords individuals time and opportunity to build a *whole* presentation of their identity that can be presented 'all in one go' (2007: 183)—rather than the linear, one-thing-then-another-thing pattern necessary in speech—and so enables participants to present a rounded and satisfyingly 'balanced' view of their identity. Of course, it must be remembered that this is only a selected view of what a participant thinks of as his or her 'identity'—but this thoughtfully selected representation is the very focus of the study. It is a mere snapshot, not only of a point in time, but of a point in time where the person was in an unusual research situation, making something out of Lego to explain to other participants and a university researcher. In spite of all these necessary caveats, however, Gauntlett maintains that the participants were presenting something which felt 'true' to them, and which they uniformly asserted was a reasonable presentation of their sense of 'who they were'.

The findings of the study (Gauntlett 2007: 182–96) suggest that the use of metaphors in social research techniques can be powerful, as they enable participants to make thoughtful representations of intangible concepts (such as emotions, identities and relationships), including the fruitful additional meanings which metaphors naturally suggest. In relation to how people think about their identities, the study found that there was in all cases a degree of tension between the desire to be a distinctive individual (not wanting to be the same as everybody else) and the desire to be a member of the community (wanting to fit in). People negotiated this in a range of different ways. In terms of media influences, the study found that the most significant role of the media was in circulating *stories*—in every form from 'real life' and celebrity magazine stories to news

and advertising as well as movies and TV dramas: narratives which people used as framing devices to understand aspects of their lives and their overall 'journey' (which was a common metaphor).

On a similar theme, Fatimah Awan's PhD study, *Young People, Identity and the Media* (2008), sought to exploit and develop the value of metaphors in social research by directing participants to create metaphorical collages on how they perceived their identities in order to examine how the media is used to shape their conceptions of self. For this project the researcher invited 111 young people aged thirteen to fourteen—of contrasting class and ethnic backgrounds—drawn from seven schools across Dorset, Hampshire and London to produce identity collages using media materials which expressed 'how I see myself' and 'how I think other people see me', and to provide their own interpretations of this work within unstructured interviews. From this process Awan was able to identify a number of findings about the young people's identities and their relationship with the media. In terms of how the young people conceptualized their identities the study revealed that whilst the participants appeared to construct their sense of self in accordance with traditional notions of masculinity and femininity, on closer reading their comments demonstrated that they did not wholly conform to these gendered positionings; rather, both boys and girls made forceful assertions of 'individualism' which seemed to transgress any gender differences and instead aimed to articulate a unique identity. In relation to the media, the study found that the participants' perceptions of ethnic minority representations were determined, to some degree, by their social worlds: with diversity intrinsic to multicultural milieus facilitating participants' negotiations of media representations alongside their *actual* understandings of ethnic minority individuals and cultural products encountered daily in these environments; and a lack of diversity within the predominantly white areas producing and perpetuating stereotyped notions of ethnicity. In addition the media's influence was most apparent in participants' accounts of media celebrities and pop stars as role models. For the young people role models did not exclusively perform a positive or negative function, or operate as figures whom individuals sought to imitate directly; rather role models acted as a 'tool kit' which enabled participants to utilize specific facets of these figures within the formations of their self-identities, and were adapted and/or negotiated in accordance with their aspirations, values and social context.

Importantly, Awan notes that within the collages constituent elements of these works functioned as metaphors to represent aspects of participants' identities, but the completed pictures operated as a metaphor on another plane through revealing contradictions, relationships and patterns within the *whole* image. This was possible as the task itself required participants to produce an entire visual representation of their identity, 'all in one go', as Gauntlett has put it (2007: 183), with individuals' reflections on their collages exploring each image independently whilst moving towards an explanation of what was shown by the overall piece. Consequently, viewing the collages enabled participants to consider their whole presentation of identity in relation to their responses to the constituent parts; the metaphors providing participants with an opportunity to express and share creative interpretations of their personal and social worlds.

CONCLUSIONS

Creative and visual research methods offer unique methodological advantages for exploring sociological questions. For instance, asking Ugandan street children to create maps, drawings and photographs, showing how they lived their lives, gave Young and Barrett (2001) an unusual opportunity to begin to see these lives from the children's' own perspective. Holliday's video diary study (2004) enabled participants to express 'queer' identities on their own terms—an opportunity to tell their own stories, in their own way, which they valued. Similarly, by asking young children to create their own videos about environmental issues, Gauntlett (1997) revealed that children were influenced by existing media coverage, but could create their own stories with their own emphases. In particular, it was the very *process* of the children's active engagement in producing the videos that granted the researcher access to more comprehensive and worthwhile data. Buckingham and Bragg's (2004) work on young peoples' attitudes towards sex and relationships in the media specifically sought to draw out participants' responses through the adoption of a variety of methods including diaries, interviews and group discussions. In doing so, the study facilitated a more complex and reflexive understanding of the students' thoughts and beliefs.

Belk, Güliz and Askegaard's (2003) work revealed that metaphors could overcome the limitations of language to convey ambivalent emotional and intuitive responses. In addition, Gauntlett's (2007) more recent study, in which metaphors of personal identity were constructed using Lego, established that this process exercises different modes of thinking which can produce more nuanced representations of the self, and therefore give researchers access to different kinds of data. Indeed, within social research concepts such as identity, audiences and representation frequently form the focus of study, but as these phenomena are *abstract* concepts, researchers become confronted with the difficulty of determining how to acquire information on these matters, often resorting to methods that depend upon individuals formulating and articulating their ideas in words. Metaphors can therefore provide a powerful alternative to the strictures imposed by formal language; as Brandon Williams (2002) has suggested, metaphors offer participants a strategy through which thoughts and feelings can be communicated that they may struggle to put into words, and facilitate freer and associative forms of 'open expression' (Williams 2002: 55).

In summary, then, these studies have started to trace a trajectory of research that employs creative and visual methods in the process of their investigations. The researchers discussed have argued that these methodological approaches offer crucial and distinct benefits over more traditional techniques, providing rich and varied data for analysis. To date, these methods have been applied in a relatively small number of quite specific research projects, and we can anticipate that visual and creative research techniques may be put to a wider set of interesting uses in the future.

FURTHER READING

Buckingham, D. and S. Bragg. 2004. *Young People, Sex and the Media: The Facts of Life?*. Basingstoke: Palgrave Macmillan.

Gauntlett, D. 2007. *Creative Explorations: New Approaches to Identities and Audiences*. London: Routledge.

Holliday, R. 2004. 'Reflecting the Self', in C. Knowles and P. Sweetman (eds), *Picturing the Social Landscape: Visual Methods and the Sociological Imagination*. London: Routledge, 1597–1616.

Prosser, J., ed. 1998. *Image-based Research: A Sourcebook for Qualitative Researchers*. London: Falmer Press.

NOTE

1. This review of the literature draws, rather unavoidably, on ones we have previously written in Gauntlett's book *Creative Explorations* (2007), Awan's PhD thesis (2008), and in a different Handbook, the Blackwell *Handbook of Media Audiences* (Awan and Gauntlett 2010).

REFERENCES

Awan, F. 2008. *Young People, Identity and the Media: A Study of Conceptions of Self-Identity Among Youth in Southern England*. PhD thesis, Bournemouth University. http://www.artlab.org.uk/fatimah-awan-phd.htm.

Awan, F. and D. Gauntlett. 2010. 'Creative and Visual Methods in Audience Research', in V. Nightingale (ed.), *Handbook of Media Audiences*. Oxford: Blackwell, 360–79.

Banks, M. 2001. *Visual Methods in Social Research*. London: Sage.

Belk, R. W., Güliz, G. and S. Askegaard. 2003. 'The Fire of Desire: A Multisited Inquiry into Consumer Passion', *Journal of Consumer Research*, 30/3: 326–51.

Bloustein, G. 1998. ' "It's Different to a Mirror 'Cos It Talks to You": Teenage Girls, Video Cameras and Identity', in S. Howard (ed.), *Wired Up: Young People and the Electronic Media*. London: University College London Press, 114–33.

Bolton, A., C. Pole and M. Mizen. 2001. 'Picture This: Researching Child Workers', *Sociology*, 35/2: 501–18.

Buckingham, D. 1993. 'Boy's Talk: Television and the Policing of Masculinity', in D. Buckingham (ed.), *Reading Audiences: Young People and the Media*. Manchester: Manchester University Press, 89–115.

Buckingham, D. and S. Bragg. 2004. *Young People, Sex and the Media: The Facts of Life?*. Basingstoke: Palgrave Macmillan.

Collier, M. 2001. 'Approaches to Analysis in Visual Anthropology', in T. Van Leeuwen and C. Jewitt (eds), *Handbook of Visual Analysis*. London: Sage, 35–60.

De Block, L., D. Buckingham and S. Banaji. 2005. *Children in Communication about Migration (CHICAM)—Final Report*. http://www.chicam.org/reports/download/chicam_final_report.pdf.

Denzin, N. K. and Y. S. Lincoln, eds. 2005. *The Sage Handbook of Qualitative Research*, 3rd edn. Thousand Oaks, CA: Sage.

Dowmunt, T. 1980. *Video with Young People*. London: Inter-Action Inprint.

Dowmunt, T. 2001. 'Dear Camera: Video Diaries, Subjectivity and Media Power', Paper Presented to ICA Preconference: Our Media Not Theirs, American University, Washington, DC, 24 May. http://ourmedianetwork.org/files/papers/2001/Dowmunt.om2001.pdf.

Eldridge, J., J. Kitzinger and K. Williams. 1997. *The Mass Media and Power in Modern Britain*. Oxford: Oxford University Press.

Emmison, M. and P. Smith. 2000. *Researching the Visual: Images, Objects, Contexts and Interactions in Social and Cultural Inquiry*. London: Sage.

Gauntlett, D. 1997. *Video Critical: Children, the Environment and Media Power*. Luton: John Libbey.

Gauntlett, D. 2006. 'Creative and Visual Methods for Exploring Identities: A Conversation between David Gauntlett and Peter Holzwarth', *Visual Studies*, 21/1: 82–91. http://www.art lab.org.uk/VS-interview-2ps.pdf.

Gauntlett, D. 2007. *Creative Explorations: New Approaches to Identities and Audiences*. London: Routledge.

Geertz, C. (1973) 1993. *The Interpretation of Cultures*. London: Fontana.

Guillemin, M. 2004. 'Understanding Illness: Using Drawings as a Research Method', *Qualitative Health Research*, 14/2: 272–89.

Harper, D. 1998. 'An Argument for Visual Sociology', in J. Prosser (ed.), *Image-based Research: A Sourcebook for Qualitative Researchers*. London: Falmer Press, 24–41.

Hesse-Biber, S. N. and M. Yaiser, eds. 2003. *Feminist Perspectives on Social Research*. New York: Oxford University Press.

Holliday, R. 2004. 'Filming "The Closet": The Role of Video Diaries in Researching Sexualities', *American Behaviour Scientist*, 47/12: 1597–1616.

Holzwarth, P. and B. Maurer. 2003. 'CHICAM (Children in Communication about Migration): An International Research Project Exploring the Possibilities of Intercultural Communication through Children's Media Productions', in M. Kiegelmann and L. Gürtler (eds), *Research Questions and Matching Methods of Analysis*. Tübingen: Ingeborg Huber Verlag, 126–39.

Kitzinger, J. 1990. 'Audience Understandings of AIDS Media Messages: A Discussion of Methods', *Sociology of Health and Illness*, 12/3: 319–35.

Kitzinger, J. 1993. 'Understanding AIDS: Researching Audience Perceptions of Acquired Immune Deficiency Syndrome', in J. Eldridge (ed.), *Getting the Message: News, Truth and Power*. London: Routledge, 246–77.

Knowles, C. and P. Sweetman, eds. 2004. *Picturing the Social Landscape: Visual Methods and the Sociological Imagination*. London: Routledge.

Letherby, G. 2003. *Feminist Theory in Research and Practice*. Maidenhead, Berkshire: Open University Press.

MacGregor, B. and D. Morrison. 1995. 'From Focus Groups to Editing Groups: A New Method of Reception Analysis', *Media, Culture and Society*, 17/1: 141–50.

Merleau-Ponty, M. (1945) 2002. *Phenomenology of Perception*. London: Routledge.

Niesyto, H. 2000. 'Youth Research on Video Self-Productions: Reflections on a Social-Aesthetic Approach', *Visual Sociology*, 15: 135–53.

Niesyto, H., D. Buckingham and J. Fisherkeller. 2003. 'VideoCulture: Crossing Borders with Young People's Video Productions', *Television and New Media*, 4/4: 461–82.

Noyes, A. 2004. 'Video Diary: A Method for Exploring Learning Dispositions', *Cambridge Journal of Education*, 34/2: 193–201.

Papert, S. and I. Harel. 1991. *Constructionism*. Norwood, NJ: Ablex.

Philo, G. 1990. *Seeing and Believing: The Influence of Television*. London: Routledge.

Pink, S. 2001. *Doing Visual Ethnography*. London: Sage.

Pink, S. 2003. 'Interdisciplinary Agendas in Visual Research: Re-situating Visual Anthropology', *Visual Studies*, 18/2: 179–92.

Pink, S. 2004. 'Performance, Self-representation and Narrative: Interviewing with Video', in C. Pole (ed.), *Seeing Is Believing? Approaches to Visual Research*. Oxford: Elsevier JAI, 61–78.

Pole, C., ed. 2004. *Seeing Is Believing? Approaches to Visual Research*. Oxford: Elsevier JAI.

Prosser, J., ed. 1998. *Image-based Research: A Sourcebook for Qualitative Researchers*. London: Falmer Press.

Prosser, J. and D. Schwartz. 1998. 'Photographs within the Sociological Research Process', in J. Prosser (ed.), *Image-based Research: A Sourcebook for Qualitative Researchers*. London: Falmer Press, 115–30.

Radley, A., D. Hodgetts and A. Cullen. 2005. 'Visualizing Homelessness: A Study in Photography and Estrangement', *Journal of Community and Applied Social Psychology*, 15/4: 273–95.

Raggl, A. and M. Schratz. 2004. 'Using Visuals to Release Pupils' Voices: Emotional Pathways into Enhancing Thinking and Reflecting on Learning', in C. Pole (ed.), *Seeing Is Believing? Approaches to Visual Research*. Oxford: Elsevier JAI, 147–62.

Reinharz, S. 1992. *Feminist Methods in Social Research*. New York: Oxford University Press.

Richardson, L. 1998. 'Writing: A Method of Inquiry', in N. K. Denzin and Y. S. Lincoln (eds), *Collecting and Interpreting Qualitative Materials*, vol. 3. London: Sage, 473–500.

Roberts, H., ed. 1990. *Doing Feminist Research*. London: Routledge.

Schratz, M. and U. Steiner-Löffler. 1998. 'Pupils Using Photographs in School Self-evaluation', in J. Prosser (ed.), *Image-based Research: A Sourcebook for Qualitative Researchers*. London: Falmer Press, 235–51.

Van Leeuwen, T. and C. Jewitt. 2001. *Handbook of Visual Analysis*. London: Sage.

Wetton, N. M. and J. McWhirter. 1998. 'Images and Curriculum Development in Health Education', in J. Prosser (ed.), *Image-based Research: A Sourcebook for Qualitative Researchers*. London: Falmer Press, 236–83.

Williams, B. 2002. 'Using Collage Art Work as a Common Medium for Communication in Interprofessional Care', *Journal of Interprofessional Care*, 16/1: 53–8.

Wright, T. 2004. *The Photographic Handbook*, 2nd edn. London: Routledge.

Young, L. and H. Barrett. 2001. 'Adapting Visual Methods: Action Research with Kampala Street Children', *Area*, 33/2: 141–52.

Neuroscience and the Nature of Visual Culture

JOHN ONIANS, WITH HELEN ANDERSON
AND KAJSA BERG

NEUROSCIENCE AND VISUAL CULTURE

JOHN ONIANS

The concept of visual culture has added important new dimensions to the study of human behaviour. It has accelerated the trend within fields such as art history, archaeology, anthropology and within studies of culture more generally towards treating all material expressions equally seriously and recognizing the extent to which they are always embedded in patterns of daily life. It has also drawn particular attention to the specifically visual properties of those expressions, that is to the importance for their production and consumption of the mediating role of the sense of sight. Both dimensions have increased the urgency of involving neuroscience in that study. Not only can a knowledge of neuroscience help directly with the understanding of all the inputs from the eye to the brain and the material outputs that result from them, but such knowledge also indirectly encourages the development of a framework that assumes the equal importance of all forms of material expression, whether traditionally 'high' or 'low' in whatever medium. Neuroscience shows both how the eye is an open door through which information relating to all these forms must travel, and how the brain, with its myriad connections and deep memory resources, links that information to the complete spectrum of human interests and needs from the most philosophical to the most visceral. This is why neuroscience is now in a position to add, in its turn, a new dimension to visual culture.

Historiography

The idea of using some knowledge of the brain to understand the making and consumption of art is not in itself new. Many thinkers, including Aristotle, Leonardo and Winckelmann, speculated on the inborn roots of artistic activity and when, in the late-nineteenth century, individual nerve cells, or neurons, became visible through the lenses of improved microscopes, writers started to describe the processes involved in the making of and response to art more precisely in neural terms (Onians 2007a). Robert Vischer and Heinrich Wölfflin among others gave particular prominence to the idea of *Einfüh-lung*, the unconscious empathy of the viewer with the object viewed, and argued that such empathy meant that visual experience of anything, whether natural or man-made, might affect artistic behaviour. But it was only with the emergence of a new knowledge of the brain in the last decades that neuroscience has been put to more systematic use. E. H. Gombrich was already using knowledge of the animal brain to make suggestions about human artistic behaviour and argued that the reason that ornament was so prominent worldwide was because of traits inbuilt into human biology (Gombrich 1984: xii). His pupil, Michael Baxandall, went further, founding the theory of the 'period eye' presented in his book on *Painting and Experience in Fifteenth Century Italy*, subtitled as a *Primer in the Social History of Pictorial Style* on the assumption that: 'everyone ... processes the data from the eye with different equipment' (Baxandall 1972: 29). Soon his argument that the preferences of the producers and consumers of art were shaped predictably by their experiences in other fields, such as dancing, banking or barrel-gauging became one of the founding tenets of the new fields of visual and cultural studies.

It was only in the next generation, however, that Baxandall's hunch could be backed up by detailed neuroscientific knowledge derived from new technologies. Functional Magnetic Resonance Imaging (fMRI) has made it possible, since the 1990s, to monitor blood movement in the human brain and so establish the neural areas involved in particular mental activities in real time and other techniques such as Transcranial Magnetic Stimularion (TMS) are yielding ever more refined results. The implanting of electrodes in monkey brains has made it possible to identify a new type of nerve cell, the 'mirror' neuron and now the latest electron microscopes can capture the process by which dendrites are formed on a particular neuron as a result of it being involved in a particular task, so illustrating one of neurons' most important attributes, their tendency to be shaped by experience, their so-called plasticity. The potential of these discoveries for illuminating artistic activity was first explored by neuroscientists themselves. Pierre Changeux's article, 'Art and Neuroscience' (Changeux 1994), presciently outlined a number of ways in which the new knowledge could help in the understanding of art and Semir Zeki's *Inner Vision: An Exploration of Art and the Brain* (Zeki 1999) argued that more recent painters had often unwittingly exploited the separate parts of the visual cortex (V) which he and others were then for the first time mapping, especially the areas dealing with colour and motion, V4 and V5. The year 1999 also saw two other significant developments. One was a paper by V. S. Ramachandran with William Hirstein in which they presented their eight laws of artistic experience, including the 'peak shift' principle, that

is the tendency for a particular visual trait to become stronger over time, which they see as underlying many stylistic changes (Ramachandran and Hirstein 1999). The other was the launch of the online *Journal of Neuro-aesthetic Theory* on the Web site artbrain.org, both founded by Warren Neidich, an ophthalmologist-turned-artist, who was the first person to use a detailed knowledge of neuroscience to specifically address issues central to the developing field of visual culture, such as the relation between contemporary art and politics. A collection of his essays subsequently appeared as *Blow-up: Photography, Cinema and the Brain* (Neidich 2003), an ambitious attempt to show the relevance of phenomena such as the interconnectedness of all areas of the brain and neural plasticity for an understanding of the way modern media were changing people's experiences. Scholars of visual culture themselves were not at first enthusiastic, being held back by a political bias against biological explanations and a commitment to 'social constructionist' explanations, but slowly some of their leaders abandoned these positions. Norman Bryson came to see Freud, Wittgenstein and the poststructuralists as dangerously 'clerical' because of their shared focus on the 'word', and in the preface to Neidich's *Blow-up* he celebrated neuroscience as an entirely fresh 'paradigm for thinking through cultural history and the philosophy of the human subject' (Neidich 2003: 11). W.J.T. Mitchell, too, in a similar tone of recantation, when listing some of the ideas that have 'hamstrung the embryonic discipline of visual culture', notes that it can no longer 'rest content with a definition of its object as "the social construction of the visual field", but must insist on exploring … *the visual construction of the social field*' (his italics) (Mitchell 2002: 238). Neither, though, went on to develop these ideas and instead it was scholars originally trained as art historians who found themselves turning to neuroscience because it enabled them to answer questions that had long concerned them. John Onians was looking for a framework for dealing with all visually interesting man-made objects worldwide, following the establishment of the first School of World Art Studies at the University of East Anglia, and this led him to explore both the properties shared by all human brains that made art a universal activity (Onians 1994, 1996) and the neurological principles that cause that activity to be highly varied at local and individual levels (Onians 2002, 2007a). He has used his understanding of the latter phenomenon to develop a discipline of neuroarthistory (Onians 2007a). David Freedberg's interest in iconoclasm had led him to want to understand the similarities in the use of images worldwide (Freedberg 1989) and in neuroscience he found explanations for them, explanations which he has elaborated through collaborations with the neuroscientist, Vittorio Gallese (Freedberg and Gallese 2007). Barbara Stafford had long been interested in the way different areas of culture, and especially science and art, had influenced each other, and in neuroscience she found a model of the mind which sheds new light on the many processes this involved as elaborated in her rich *Echo Objects* (Stafford 2007). Interestingly, all these are older scholars. One of the few mid-generation art historians to enthusiastically enter the new field is Oliver Elbs, who set up a Web site, mapology. org, and whose doctoral dissertation, exploiting in an original way the concepts of neural 'maps' and 'shifts', has been published as *Neuro-esthetics: Mapological Foundations and Applications (Map 2003)* in 2005. The relevance of his project for the study of visual

culture is evident from the breadth of the book's goal, which he defined as developing a nonreductionist approach 'to the contemplation of paintings (Newman, Rothko, …), the listening to music (counterpoint, Wagner, …), and the watching of films in general' (Elbs 2005: 194).

One point that emerges from this survey is that although the concept of Neuro(-)(a)esthetics has been launched independently, in different spellings and with different definitions, by a number of individuals, there is general agreement about its central concerns, which have their origins in the tradition of philosophical aesthetics, such as what is it that goes on in our minds when we contemplate or make art and how does this relate to other mental activity. Neuroarthistory can be seen as a subfield of Neuroaesthetics, one that uses the same knowledge to deal with particular problems in the tradition of art history—and visual culture/visual studies—such as why did this individual or group make, choose or use this particular visual expression at this particular time and this particular place?

Both Neidich's and Elbs's publications and Web sites feature highly expressive illustrations of the brain and its workings, and Neidich is himself one of a growing number of artists, architects, designers and creators in other media who are involved in the production of so-called Neuro-art, much of it growing directly out of medical imagery and, in the case of the subfield, Neurosculpture, medical modelling. Much of this work breaks new ground conceptually in its acknowledgement of the importance of the somatic, and especially the sensory, the emotional and visceral. Also concerned with the body is Neuroarchitecture, an approach that reflects the growing interest in the impact of buildings on their users. So obvious was the relevance of neuroscience to this issue that the field was recognized already in 2003, when the San Diego Chapter of the Architectural Institute of America founded the Academy of Neuroscience for Architecture. The field is also acquiring a historical dimension, as in Harry Mallgrave's *The Architect's Brain* (Mallgrave 2010), which reviews earlier neurologically founded attitudes to architecture and explores current developments.

A neuro-field which might not seem central to the study of visual culture is Neuromarketing, but its relevance emerges clearly from the Wikipedia definition of it as:

> a new field of marketing that studies consumers' sensorimotor, cognitive, and affective response to marketing stimuli. Researchers use technologies such as functional magnetic resonance imaging (fMRI) to measure changes in activity in parts of the brain, electroencephalography (EEG) to measure activity in specific regional spectra of the brain response, and/or sensors to measure changes in one's physiological state (heart rate, respiratory rate, galvanic skin response) to learn why consumers make the decisions they do, and what part of the brain is telling them to do it. (http://en.wikipedia.org/wiki/Neuromarketing#cite_note-0)

Although these enquiries are driven by the financial concerns of businesses, the information they yield on the response to design, packaging, advertisements etc has relevance

to an understanding of the neural correlates of visual culture in many other contexts, religion and politics, pleasure and propaganda, the public and private, the home and the museum. Indeed, this last factor makes it an essential tool in the equipment of Neuro-museology, the use of neuroscience to understand the history and role of museums, as launched by John Onians at the conference 'Art Museums Here and Now' in Abu Dhabi in April 2010.

Neuroscience, an Outline

The interests of Neuromarketing are important because they remind us of why we have brains in the first place. It is easy to forget this noble organ's humble evolutionary origins. These are well illustrated by a comparison between plants and animals. The only difference between an animal and a plant is that an animal needs to move to feed and reproduce and that is why it has brains, ultimately to meet the needs of its viscera, including the genitalia. Each creature has a sensory apparatus that takes in information relevant to these needs from the surrounding world and a motor apparatus to enable it to make the appropriate movements in relation to it. We are no different. Although we are used to thinking of the brain as an organ for higher activities, it only exists in order to help us to survive. This point is particularly vital for our understanding of the functions of the eye and the hand, the elements of the sensory and motor systems that are most important for the production and consumption of visual culture. Our eyes are principally there to gather information about potential foods/poisons in the vegetable world, prey and predators in the animal world, potential tools in the natural and man-made environment, and, in the social environment, information about parents and children, and about potential friends/enemies, mates/rivals. It is to gain that information that we attend to the visual environment, and it is to act on that information that we have limbs, of which the most vital are our hands.

We couldn't do either if we did not have a nervous system, centering on a brain, where information from the senses is processed and movement is initiated. In order for these activities to be carried out effectively the brain is composed of many physiologically discrete parts, each with a separate function. This is most clear in what is in evolutionary terms the most recent part, the Cortex. Much of this is taken up by one group of areas that take in and integrate information from the different senses (the Sensory Cortex) and another group of areas controlling the different limbs (the Motor Cortex). The relations between them are designed for maximum efficiency. Thus at the back of the brain we have a region that takes in information from the eyes, which is subdivided functionally into subareas, with V3 being most helpful for seeing shapes, V4 for seeing colours and V5 for seeing movement. To help us to organize this information and to act on it quickly these areas are linked to the rest of the brain by a lower 'ventral' and an upper 'dorsal' pathway. The ventral pathway links the Visual Cortex to the Temporal lobe and the Fusiform Gyrus, where separate areas are equipped from birth to sort forms into such vital categories as plants, animals, the human body, human faces and

places, and where visual information is linked to more information about the same objects coming from other senses, such as hearing and touch. The dorsal pathway on the other hand is linked to the areas of the Motor Cortex controlling the movements of the body needed to engage with these objects. We have some conscious control over these movements through the brain's 'frontal' lobes, where planning and decision making takes place, but their selection is largely governed by two lower areas at the centre of the brain, an upper 'Limbic System' containing such organs as the Amygdala, critical for emotional activation, and the Hippocampus, critical for long-term memory and spatial navigation, and the lower 'Basal Ganglia' containing areas such as the Superior Colliculus, critical for eye movements and the VTA critical for reward-learning, that is learning what is good for one. In these areas neurochemicals play an essential role, with dopamine, for example being essential both for the pleasure of reward-learning, and for aversion/punishment, while elsewhere in the body adrenaline plays an equally important role in preparing the heart, the lungs and other muscles for the life-saving fight-or-flight response. Chemicals also play an important role in the more small-scale fabric of the nervous system in the communication between one nerve cell, or neuron, and another. This fabric has a bewildering complexity. The brain contains about 100 billion neurons, each of which can have up to 100,000 connections to other neurons, and these neurons communicate with each other when an electrical impulse associated with a discharge of chemicals crosses the tiny gap, or synapse, between them. Many neurons have a single large axon at one end and many small dendrites at the other, and the discharge goes from axon to dendrite. The structure of these neural networks used to be thought to be fairly fixed, but it has become increasingly clear in recent years that in many areas of the brain it is susceptible to constant change, giving rise to the phenomenon of 'plasticity'. This is because the brain is very expensive. Half of all our nutrition goes to feed it; so evolution has ensured that its networks grow and shrink in response to our needs. The more a connection is used the more its conductivity improves and the more other connections form alongside it. Similarly, the less it is used the more its connections will die back and conductivity decline. Since all our activities, not just the sensory and motor engagements, but feeling and thinking depend on such networks, they are highly responsive to any increase or decline in any of these activities. We experience the benefits of this system when we start practicing a language or a musical instrument and its costs when we stop. One of the most powerful illustrations of the long-term consequences of the process is the massive growth of the area of the Motor Cortex controlling the little finger of the left hand on a concert violinist. An illustration of the process's rapidity is the study showing the growth of connections after just one day in the brain of a mouse reaching for a seed (Xu et al. 2009). Our actions and inactions shape our brain on both a large and small scale.

Applications

There are many ways in which this knowledge contributes to an understanding of visual culture. The first is that it makes us aware that it is only because seeing is so important

for our survival that we look with such intensity at any visual artefact, whether it is a 2,000,000-year-old stone tool or the latest digital video on MTV. The second, a corollary of the first, is the awareness that, without us being conscious of it, that looking involves not just other areas of the brain but the whole body. This means, for example that because our memory of stones is cued by both visual and tactile attributes we cannot look at the stone tool without appreciating its weight, coldness and so on, and because stones are also linked to the motor actions with which they might be associated we cannot look at it without our brain suggesting the possibilities of picking it up, using it to strike something else, and even throwing it, as well as the possible consequences of doing so. A more complex artefact, such as Michelangelo's Sistine Ceiling, carries many more such associations. The MTV video carries many others, not just those associated with the imagery, and we should remember that different areas of the cortex are going not only to react to its content of faces, bodies, places and so on, but also to make us aware of the background to its production, the marketing aspect, the technical aspect and so on. We cannot watch the video without our brain sensing, even at a minimal level, both why it was made and how. All these things might have been claimed before the recent neuroscience cast new light on the brain, but as claims they would have evoked much less interest than they do today, when many people have some level of knowledge of the brain's previously invisible properties.

The latest neuroscience sheds light on the whole history of visual culture, but arguably it sheds most on the visual culture of today, and that is for a very simple reason, visual culture of today is already directly and indirectly influenced by the new knowledge. There are many aspects to this. Most obvious is the range of parallels between the human nervous system, the social, economic and technical system of the modern world and the system of the art scene and of visual culture. One element central to this is the emergence of information theory/cybernetics and artificial intelligence. Since the 1960s and 1970s people working with machines have sought to make them more human and people working with the brain have sought to understand it as a machine, and, in that exchange, concepts such as computation, cognition, networking, sequential- and parallel-processing, hard-wiring, hard- and software, implants, cloning, avatars and so on have been so often shared across the two domains as to almost unite them. As a result people have tried to endow machines, especially computers and robots, with human properties, such as emotion, and have treated human beings like machines, for example adding to them new spare parts in the form of prostheses and implants. The consequent impact on visual culture has been enormous, with films such as *Avatar*, and the abused figures of the Chapman brothers being joined by a growing variety of Neuroart and Neuroarchitecture. Neuroscience illuminates the whole history of visual culture, but none more than that of today.

To apply neuroscience to the study of visual culture of any place or time means being alert to each new discovery in the field, but it also means exploiting fully those areas of knowledge that have already emerged as helpful in this enterprise. Two of these are 'neural plasticity' and 'neural mirroring', already mentioned above.

NEURAL PLASTICITY

HELEN ANDERSON

The primary importance of neural plasticity is that knowledge of the principles by which it is governed provides access to an important way of reconstructing the formation of individual brains at any time in history. This is because the brain is a dynamic organ, changing its structure throughout our lifetime, adapting to changes in our environment and to the motor and sensory experiences through which we relate to them. As the brain creates and strengthens, or discards and abandons synapses and neuronal pathways, our neurons constantly take on new roles and functions. Thus, for the individual, learning a new skill, such as playing a musical instrument (Johannson 2006), reading Braille (Hannan 2006) or driving a London taxi (Maguire et al. 2000) requires extensive practice, and this practice is instrumental in changing the neuronal connections in relevant brain regions. A recent experiment undertaken by Mithen and Parsons (2008) demonstrated not only how the activity in neural circuitry had been modified after singing lessons of a year's duration, but that the acquisition of this cultural skill affected other areas of the brain. Scans indicated increased activity in Brodmann's areas 22, 38 and 45 (Mithen 2009: 5), areas that are involved not only with melody, pitch and sound intensity, which one might expect, but also with language processing, speech production and emotional responses.

In the same way, at the community level, neural plasticity means that people from different cultures, because their different environments will be associated with different motor and sensory experiences, will acquire differences in brain organization that will necessarily affect their behaviour. Knowledge of the process by which this happens is an important resource for anyone studying visual culture, since, if we know to what sorts of environments people have been exposed, we have some basis for understanding what factors may have influenced their activities and perceptions.

Visual Plasticity

The most revealing aspect of neural plasticity in the context of visual culture studies is the plasticity of the visual cortex (Black et al. 1991; Dragoi and Sur 2004; Kourtzi and DiCarlo 2006). One-third of the visual cortex is used in object recognition, but such object recognition is not hard-wired. As we navigate our environment, the brain's visual centres continually reorganize themselves, classifying novel features, and learning to pick out important objects, effectively creating a changing catalogue of shapes (Låg et al. 2006). Such learning gives rise to the attribute of 'perceptual fluency'; and research has shown that such fluency influences a wide variety of judgements and cognitive operations (Reber et al. 1998; Reber and Schwarz, 1999; Reber et al. 2004).

Essentially, visual identification terminates in the Temporal Lobes, where neurons respond to complex visual stimuli such as faces and objects. Object recognition requires a system that is able to cope with changes in scale, viewing angle, luminance, contrast, motion and other such variables, until our knowledge of the object stabilizes (Li and

DiCarlo 2008). This process relies on successive experiences of a visual object gradually contributing to the building up of neuronal connections until the response to it can be described as 'view invariant'. Critical to the process is the intensity of our attention. Research has shown that the more attention we give to something, the more rapidly our sensory systems will become fluent in its perception (Yotsumoto and Watanabe 2008).

The Lateral Occipital Cortex is central to this process. Neurons in this region cluster together in columns, and analysis of their spatial distribution demonstrates that cells located close together in the cortex have similar stimulus selectivities (Tanaka 2003). For example, cells in a column may respond to star-like shapes, or shapes with multiple protrusions. Each cell in the column is similar in that it responds to star-like shapes, but each cell may differ in the preferred number of protrusions or the amplitude of the protrusions (Tanaka 2003: 94). Furthermore, neighbouring neurons are more likely to respond to similar features (Reddy and Kanwisher 2006: 411). What this means is that neurons that respond to a particular visual stimulus that shares properties with another will be grouped together; particular shapes or forms can trigger the response of similar neurons. Fundamentally, we make visual associations with objects that share similar properties.

A crucial component of perceptual fluency arises from connections the brain makes with stored information. The brain has mechanisms that reward us for learning about our environment; such mechanisms would have an obvious evolutionary advantage. Food, sex and other naturally rewarding experiences release dopamine into the brain, a neurotransmitter produced naturally in the body and central to the reward system and the formation of emotional responses. Dopamine is not, however simply the 'reward chemical' in the brain, dopamine neurons also respond to aversive events (Matsumoto and Hikosaka 2009). A subset of neurons in the Basal Ganglia (an area directly connected to the visual areas in the brain, learning and memory) actually becomes more active with the depleted dopamine transmission produced by aversion (O'Reilly and Frank 2006). Humans seem to learn from both reward and punishment.

In the context of visual culture studies, knowledge of the ways in which the human visual system operates is a constructive resource, for both artist and viewer. Understanding how the visual cortex is influenced by environment and experience, how we make associations between objects that share similar properties and how the brain incentivizes behaviour allows for a more analytical approach to art production and reception.

Historiography

The first person to use the term *neural plasticity* appears to have been the Polish neuroscientist Jerzy Konorski (1948), who proposed similar ideas to Donald Hebb, one of the strongest proponents of an environmentalist view of brain development (1949). More recently, a theory of how environmental input affects the organization of neural systems was developed by Changeux (1983, 1996 et al., Changeux and Connes 1989). Changeux strongly supports the view that the nervous system is active rather than reactive and that interaction with the environment results in the selection of certain networks and

reinforces the connections between them. The study of functional plasticity in the cortex has been advanced significantly by the development of *in vivo* imaging techniques, making it possible to separate genetic from environmental effects on development.

Neural plasticity has been studied more in the Visual Cortex than any other cortical region. The intensity of research concerning the anatomy, physiology and function of the Visual Cortex has made it possible to study the environmental effects on development at various levels. What has become a classic set of experiments undertaken by David Hubel and Torsten Wiesel (Hubel and Wiesel 1959, 1962, 1970; Wiesel and Hubel 1965) significantly expanded the scientific knowledge of sensory processing during the 1960s and 1970s, exploring how neurons in the brain could be organized to produce visual perception. Their seminal discoveries proposed that the visual system responds differentially to lines of different orientation and that these mechanisms are genetically established in the nervous system at birth. Only later are these resources modified by experience.

Following the discoveries of Hubel and Wiesel, research undertaken by Semir Zeki and others (Zeki 1993; Wong-Riley et al. 1993) in the study of vision and the brain led to the conclusion that the visual cortex possesses six different visual regions that are functionally specialized to deal with properties of objects such as colour, form and motion. Tanaka (1993, 1996; Tamura and Tanaka 2001, Tanaka et al. 2005; Lehky and Tanaka 2007; Yamashita, Wang and Tanaka 2010) further showed that neurons located in the Temporal Lobe respond to complex visual stimuli and neurons with similar, although slightly different responsiveness to particular features tended to cluster together in columns. The stimulus specificity of these neurons is altered by experience, and fMRI studies have shown that specificity can increase with stimulus familiarity (Reddy and Kanwisher 2006: 411).

Applications

We take for granted that art is a global phenomenon, but its beginnings were local, and the place and pace of its emergence are central concerns for archaeologists. So too is its relation to human cognitive abilities, an issue on which neuroscience is well adapted to inform our thinking (Anderson forthcoming).

The collection of shells as forms of personal ornamentation is one of the earliest forms of art-related activity engaged in by modern-type humans, dating back some 100,000 years. Even this early in the archaeological record, it is most often considered in relation to ideas of social or ethno-linguistic diversity; as evidence for trade, exchange or cultural transmission. But our knowledge of neural plasticity can play an important new role in our approach by helping us to think about the importance of shells in more basic material terms. The period when shells are first visible in the archaeological record, between c. 110,000–75,000 years ago, coincides with the movement of modern humans into coastal environments. The skilful and successful exploitation of marine resources was evidently becoming more widespread. Adaptation to such environments involved mechanisms of learning and memory, and the sight of shells, which were essential for survival, would have been associated with positive connotations.

The very act of collecting shells requires a certain visual attention or perceptual fluency, and perceptual fluency can lead to perceptual preference. In communities where the sight of shells had become a source of pleasure individuals started to collect and show them to each other, eventually using them in personal adornment. Feasibly, this began with the use of shells which, because they exhibited natural perforations, could easily be strung together as ready-made beads. The act of intentional perforation occurred as humans replicated the natural process, intensifying the pleasure their display produced in the wearer and proving equally appealing to the viewer.

But shells are also inextricably tied to particular locations. Their cultural value based not only in visual display but associated with a meaningful and rewarding environment. The collection of shells had the potential to attach people to a particular place, becoming a stimulus for memory. Even today we collect shells from the beach as a memento of our visit. As we strive to understand our cognitive past, by invoking principles established by neuroscience, we can advance our thinking concerning the importance of environment and experience in art production and reception right up to the present.

This is exemplified in a reappraisal of Renaissance aesthetics. It is well understood that during the fourteenth and fifteenth centuries the artists of Florence and Venice produced two very different styles of paintings. While Florentine artists were concerned with linearity and perspective, Venetian artists were keenly interested in the relationship between light and colour. While such distinctions have been related to cultural influences, the underlying reasons for their importance have recently been explained in neuropsychological terms (Onians 1998). The introduction of linear perspective that emerged in Florence has been argued to have been inspired by visual experience of the city's particular built environment at the time. Florence incorporated a straight river, a quadrilateral Roman centre and a Medieval system of straight roads lined with rectangular buildings exposing repeated horizontal lines of masonry. Only in Florence did such geometrical and linear perspectives ensure that the neural networks of individuals experiencing such an environment 'were biologically better prepared to apply existing theory on the geometry of optics to the representation of pictorial space' (Onians 1998: 15). In Venice, by contrast, neural networks were more finely tuned to the 'repeated experience of light reflected from water and of the similar effects produced by polished coloured marbles, gold glass mosaic and oriental silks' (Onians 1998: 15). There patrons would have acquired a visual predilection for reflected light and colour, favouring oil paint because of its capacity for 'capturing brilliance and refulgence' (Onians 1998: 15). The observed differences between these two schools of paintings in Renaissance Italy are well established and can be explained in common-sense terms. What neuroscience does is to reveal the neurological basis for the common-sense view.

The same is true again and again in the history of visual culture, as in the case of Matisse, the instigator of the Fauvist movement. He has always been renowned for his use of colour and his passion for decorative pattern and motifs, and although it has been said that we know, 'next to nothing of the visual influences that fed and shaped his imagination in its formative stages' (Spurling 1993: 463), the basis for a neurological explanation has already been laid. Matisse, who was descended from a family of weavers, grew

up in Bohain-en-Vermandois, a small town near the Belgian border, whose principal product was textiles. Indeed Bohain was, 'famous for the glowing colours and prodigal variety of its luxury fabrics' (Spurling 1993: 463). Articulated as a biographical *aperçu*, understanding that Matisse grew up in a setting where colour, texture and pattern were part of his environmental visual repertoire is enormously significant. Indeed, Spurling goes on to suggest that, 'A child growing up there would have been familiar from infancy with the sound of clacking shuttles and the sight of weavers loading and plying coloured bobbins, hunched over their work like a painter at his easel' (Spurling 1993: 463). Our knowledge of neural and visual plasticity makes tangible Matisse's preoccupation with colour and elaborate pattern in his painting, and indeed corroborates the author's speculations. Recognizing the extent to which neural networks respond to and are configured by environment and experience can help us both to support current explanations and to develop new ones.

NEURAL MIRRORING

KAJSA BERG

The principles of neural mirroring can illuminate the behaviours and responses of both the artist/maker and the viewer/consumer. Mirroring is essential in order to understand both the actions of others and their emotions. Mirror neurons are a class of premotor neurons in the brain that fire not just when someone makes a movement, but when that person sees someone else making the same movement. As a result, when a person observes an action by another, his or her brain responds as if he or she were in fact moving. Similar types of neurons react in the same way to emotional expressions, pain and touch. This provides a link between individuals. It also provides a link between the viewer and artefacts. The consequence of this embodied response is that humans are able to understand the actions of others, and as an extension, empathize with them. It is thus not strange that the notion that we feel empathy and emotional engagement as a result of seeing someone else's movements and expressions is a recurring theme in sources ranging from classical Greek philosophy to modern art history (Onians 1999: 690–715; Onians 2007b: 307–20; Freedberg and Gallese 2007: 197–203 and Stafford 2007: 75–104).

Historiography

According to Xenophon, Socrates believed that the correct depiction of movement in art is central to aesthetic experience (Xenophon 1926: 235). Horace advises the poet that 'if you would have me weep, you must first feel grief yourself: then ... will your misfortunes hurt me' (Horace 1926: 459). His words were paraphrased by both Alberti and Leonardo (Alberti 1972: 81, Da Vinci 1989: 130–5), who state that a good painter should represent emotion and movement correctly in order to move the viewer. Charles Le Brun similarly suggested that 'JOY is an agreeable emotion of the soul which consists in the enjoyment of a good which the impressions of the brain represent as its own' (Le

Brun 1994: 126). In 1866 Friedrich Theodor Vischer discussed how humans intuitively project their emotions on the rest of the world: 'Thus we say, for example, that this place, these skies and the colour of the whole, *is* cheerful, *is* melancholy, and so forth' (Vischer 1998: 687–8). His son, Robert Vischer, suggested that humans empathetically transpose themselves onto the objects they look at, be it a 'proud' fir tree, an 'angry' cloud or a 'prickly stubborn' cactus (Vischer 1998: 690–3). These ideas influenced Heinrich Wölfflin in his doctoral thesis 'Prologomena to a Psychology of Architecture' (1886). Vischer implies that the aesthetic experience engages the eyes and then takes place in the human imagination. Wölfflin proposes instead that empathy involves the whole body so that when looking at columns it is 'as if we ourselves were the supporting columns' (Wölfflin 1998: 714). His mirror neurons then sustained his art historical contribution as he recognized the different impact of specific architectural styles on the viewer's body. The brain, however, remained on the fringes of studies of empathy throughout the twentieth century until the discovery of human mirror neurons in the 1990s.

Individual mirror neurons were discovered in macaque brains in 1988 (Rizzolatti et al. 1988: 491) and then Jean Pierre Changeux tentatively suggested that they could be integral in gesture recognition in art (Changeux 1994: 195–6). Clusters of similar neurons were identified in human brains in 1996 (Rizzolatti et al. 1996: 131). V. S. Ramachandran predicted that this discovery would have a massive impact on neuroscience and psychology (Ramachandran, Altschuler, and Hillyer 1997: 22). The art historian David Freedberg, who argues that emotion has been ignored in favour of purely historical, cultural and social factors, also realized the potential of mirror neurons. Together with the scientist Vittorio Gallese, he suggested that mirroring could help explain embodied aesthetic responses and: 'challenge the primacy of cognition in responses to art' (Freedberg and Gallese 2007: 197). Most recently, in 2010, individual mirror neurons were recorded in several areas of the human brain (Mukamel et al. 2010: 750).

Mirror Neurons

The first scientific evidence of mirror neurons was found in the macaque's premotor cortex. These neurons are activated not just when a macaque monkey performs a particular movement, but when he only sees it. They respond strongly to hand and mouth movements and are particularly active in the performance of goal-oriented movements, such as grasping, tearing and holding. Further research suggests that mirror neurons are present in the human brain and integral to a variety of responses and behaviours, including empathy. Mirroring also occurs in the case of facial expressions. For example, the same area of the Insular Cortex responds when the person feels disgust, makes an expression of disgust or just sees someone else's expression of disgust. The actual experience of the emotion (such as happiness) is then closely linked to both seeing and making the expression (smiling) (Wicker et al. 2003: 655). The results are also similar in the case of pain-processing and touch. In an experiment that consisted of test-subjects viewing still imagery of hands and feet being cut, the Anterior Insula was particularly active and it showed very similar activity when subjects were in actual pain (Jackson, Meltzoff, and Decety 2005: 771).

Mirror neurons are not static in their operation, as their responsiveness can be enhanced as a consequence of neural plasticity. This can be illustrated by an experiment in which ballet dancers, capoeira dancers and nonexperts watched ballet (Calvion-Merino et al. 2005: 1243–9). The results showed that ballet dancers' brains, particularly their Premotor Cortex, responded more than those of the others. Because their neural resources for making the movements had been strengthened through constant training, their brains could more easily respond to the sight of them. The capoeira dancers and nonexperts, by contrast, lacking the neural resources needed for these particular movements in their own motor repertoire, did not respond as strongly.

Variations in response occur in the emotional as well as the motor field. Scientists focussing on autism hypothesize that thinning of grey matter (a sign of the lack of neural connections) in areas where mirror neurons are generally located leads to decreased empathetic ability. Generally, mirroring neurons are crucial for emotional and empathetic responses. That they are susceptible to plasticity means that they are malleable and their structures are shaped not just by genetic, but also by environmental and other contextual factors.

Application

Onians has suggested that the principles of mirroring are central to the understanding of Greek culture in general and the emergence of life-sized and life-like sculpture in particular. Evidence that empathetic responses, and that imitation and emulation in general were important aspects of Greek culture, can be found in mythology (later collected in Ovid's (1916) *Metamorphoses*), theatre (as seen in Aristotle's (1997) *Poetics*) and sculpture. In Xenophon's *Memorabilia* Socrates asks the sculptor Cleiton a number of questions and establishes that the illusion of life in art is a result of 'accurately representing the different parts of the body as they are affected by the pose—the flesh wrinkled or tense, the limbs compressed or outstretched, the muscles taut or loose'. This 'exact imitation of the feelings that affect bodies in action also produce[s] a sense of satisfaction in the spectator' (Xenophon 1926: 235).

Freedberg uses several examples to show how mirror neurons are crucial in understanding artworks (Freedberg and Gallese 2007: 197–203). Thus, as Michelangelo's *Slave Called Atlas* struggles out of the material, his strain is understood and felt by the viewer's brain and body. Similarly, looking at the mutilated and damaged bodies in Goya's *Disasters of War* leads to an internal simulation of pain. The responses are presented as universal and the examples could be supplemented by references to a weightlifter struggling with his load or the sufferings of a victim in a gory horror film. Freedberg also presents Caravaggio's *Doubting Thomas* as a timeless example. As Thomas pushes a finger into Christ's wound, the pain of being prodded and the sensation of touching flesh can be transmitted through sight of the image. However, this response is likely also to be the product of mirroring enhanced by plasticity, since, around 1600 in Rome there was a new active engagement with movement and emotional expression. This was especially clear in the case of religious life and religious imagery. Not only did the practice of

Spiritual Exercises encourage the subject to mentally and practically imitate saints, the Virgin and Christ, but images were used as an aid to meditation, with, for example the gruesome martyrdom scenes in the paintings in S. Stefano Rotondo being used to train Jesuit novices. As with the motor resources of modern ballet dancers, Catholics in Early Modern Rome would have had their neural resources for both imitation and empathy greatly reinforced. Caravaggio's emphasis on movement would have played on these new empathetic sensibilities, as when his Chiesa Nuova *Entombment* responds to St Filippo Neri's wishes that all of the paintings be used in meditation. The congregation would have performed the Spiritual Exercises daily. The paintings functioned as visual aids, helping the viewer to understand the biblical narratives by experiencing the depicted movements and emotions through their own brains and bodies. The imagery would have encouraged emotional involvement as a means of making the viewer more pious.

Examples of such reinforcement can be found in many periods, including today, as in the case of Amy Caron, a contemporary American artist who uses neuroscience in her installation work. She cooperates with several neuroscientists including V. S. Ramachandran and Vittorio Gallese in the process. The performance installation, *The Waves of Mu*, explores mirror neurons as a way of engaging the audience. Mu waves are the electromagnetic oscillations that reflect the mirror neuron activity in the brain. The audience begins by walking through an installation representing a brain, where the artist provides a multisensory experience, combining various arts, music and food. The second part includes the artist playing the part of a scientist, explaining the mirror neuron function to the audience through evoking emotional responses. The artist's work allows the audience to experience mirroring both consciously and unconsciously (Phillips 2010: 10) and uses mirror neurons to engage and educate her spectators.

Many other modern artists have also made use of mirror neurons to catch their viewers' attention, even without explicit knowledge of the brain. In 1997 the Royal Academy showed works by Young British Artists then in the Saatchi Collection in the exhibition *Sensation*, a title that referred not just to the exhibition's shocking novelty, but also to the physical and mental feelings the works evoked in the viewer. Designed to involve the spectator emotionally and viscerally the Chapman Brothers' *Zygotic acceleration, biogenetic, de-sublimated libidinal model* and their *Tragic Anatomies* displayed grotesque fibreglass child mannequins moulded together, several with nose and mouth replaced by penis and anus. Also, by reproducing Goya's etchings of the disasters of war in a life-sized realistic sculpture *Great Deeds against the Dead*, the same artists amplified the mirroring of pain. Marcus Harvey, Sarah Lucas, Mark Quinn, Jenny Saville are only a few of the artists in Saatchi's collection that use the human body as a means to catch people's attention and thus rely on the mirroring of their spectators to create visceral responses that engage viewers' attention and interest.

Nor is it surprising that visual culture elsewhere in the world at different periods exploits mirror neurons particularly intensively. The anthropologist Nicholas Argenti has suggested that, even though the complex and violent history of slave trade is barely spoken of in the Cameroon Grassfields, it is still experienced through masked dance performances in which feelings about contemporary oppression are embodied in movements

that refer to similar problems in the past (Argenti 2007: 142). While masks and dances are spoken of in mythical terms the movements of the dancers and their relationships tell another story. Argenti links the slow shuffling movements of the mask wearers with the exhaustion of slaves, the uncomfortable closeness of the masks and their restricted movements with the lines of slaves bound together and the stooped dancer with a large ungainly headdress with the porter collapsing under the weight of his head-load. It seems then that the implicit performance and experience of these movements offers an outlet for historical atrocities that are not expressed in words. The past is reenacted and remembered through the people's bodily engagement and mirror neuron responses.

THE FUTURE

JOHN ONIANS

More than all other current approaches to visual culture, the neuroscientific is certain to become ever more important. This is partly because understanding of the brain is set to increase rapidly, as ever more urgent medical and social needs generate ever improving technologies of investigation. As scanners become less cumbersome and the computer programs needed to process the data they yield become more sophisticated, images of the brain will become ever more detailed. Similarly, as ways of monitoring individual neurons become more refined and methods for tracking neurochemicals become more effective, an increase in the comprehension of the complexity and specificity of neural processes will lead to a new appreciation of the correlations between sensory inputs and behavioral outputs. Also illuminated will be the correlations between different sensory modalities that give rise to synaesthesia. This field will only gain in importance as visual culture is joined by such parallel enterprises as aural, tactile olfactory and gustatory culture, and all are integrated in a better understanding of culture as a whole.

Another reason why a neuroscientific approach can be predicted to become more important is the widening of its application as more and more people find that neuroscience can sustain and enhance the approaches they are already using. Phenomenology was based on the idea that we need to understand how things are experienced, especially through the body, and now neuroscience can tell us more and more about that experience. Again, Poststructuralism argued that we should be wary of notions of objectivity, and that more attention needed to be paid to subjectivity, and now neuroscience can confirm that need by throwing new light on personal mental formation. Neuroscience can also illuminate the process of 'social construction' by clarifying its neural basis. Even traditional positivists will be increasingly drawn to neuroscience, as they discover that the previously obscure phenomenon of unconscious 'artistic influence' can be explained through an understanding of the neural changes caused by mere exposure to an artwork.

Finally, nothing will cement the relationship between neuroscience and visual culture more than those developments within neuroscience which render the mind itself more and more visible. At present scholars in the humanities often cling to a view of the brain as a god-like black box, its mysteries impenetrable. But this view is daily

undermined, as the black box becomes ever more transparent and people realize that the brain provides not just a more complex model of the mind, but one which is clearer, because it is more accessible to sight. As visualizations of the brain become both more familiar and more accessible, the words of philosophers will lose their pre-eminence as the prime framework for conceptualizing the mind, being rivalled, if not replaced, by a rich repertoire of imagery, both still and moving, generated by groups as diverse as scientists and artists.

Out of this imagery will emerge new paradigms for the study of visual culture. These will be founded in a broad agreement on:

1. the brain's susceptibility to constant physical change, especially under the influence of experience;
2. the more or less complete integration in the brain of all of the body's faculties and activities, the sensory and the motor, the intellectual, the emotional and the visceral, and recognition that each can influence the others;
3. the preeminence of the sense of sight as a source of information and the consequent recognition of the importance of visual experience for the organization of knowledge at both individual and community level;
4. the desirability of acknowledging, alongside the distinctiveness of all fields of visual experience, the mutual influences between them.

FURTHER READING

Freedberg, D. and V. Gallese. 2007. 'Motion, Emotion and Empathy in Artistic Experience', *Trends in Cognitive Neurosciences*, 197–203.

Neidich, W. 2003. *Blow-up: Photography, Cinema and the Brain*. New York: Distributed Art Publishers.

Onians, J. 2007. *Neuroarthistory: From Aristotle and Pliny to Baxandall and Zeki*. London and New Haven, CT: Yale University Press.

Stafford, B. M. 2007. *Echo Objects: The Cognitive Work of Images*. Chicago: University of Chicago Press.

Zeki, S. 1999. *Inner Vision: An Exploration of Art and the Brain*. Oxford: Oxford University Press.

REFERENCES

Alberti, Leon Battista. 1972. *On Painting* and *On Sculpture*, ed. and trans. Cecil Grayson. London: Phaidon, 81.

Anderson, Helen. Forthcoming. 'Beginnings of Art, 100,000–28,000 BP: A Neural Approach', *British Archaeological Journal*, .

Argenti, Nicholas. 2007. *The Intestines of the State*. Chicago: University of Chicago Press.

Aristotle. 1997. *Poetics*, trans. Malcolm Heath. London: Penguin.

Baxandall, M. 1972. *Painting and Experience in Fifteenth Century Italy: A Primer in the Social History of Pictorial Style*. Oxford: Oxford University Press.

Black, J. E., A. M. Zelazny and W. T. Greenough. 1991. 'Capillary and Mitochondrial Support of Neural Plasticity in Adult Rat Visual Cortex', *Experimental Neurology*, 111: 204–9.

Calvion-Merino, Beatriz, D. E. Glaser, S. T. Grezes, R. E. Passingham, and P. Haggard 2005. 'Action Observation and Acquired Motor Skills: An fMRI Study with Expert Dancers', *Cerebral Cortex*, 15, 1243–9.

Changeux, Jean-Pierre. 1983. *L'homme neuronal* (1985 *Neuronal Man: The Biology of Mind*). Paris: Fayard.

Changeux, Jean-Pierre. 1994. 'Art and Neuroscience', *Leonardo*, 27/3: 189–201.

Changeux, Jean-Pierre and Alain Connes. 1989. *Matière à pensée* (1995 *Conversations on Mind, Matter and Mathematics*). Paris: Odile Jacob.

Changeux, J. P., A. Bessis, J. P. Bourgeois, P. J. Corringer, A. Devillers-Thiery, J. L. Eiselé, M. Kerszberg, C. Léna, N. Le Novère, M. Picciotto and M. Zoli. 1996. 'Nicotinic Receptors and Brain Plasticity', *Cold Spring Harbor Symposia on Quantitative Biology*, 61: 343–62.

Da Vinci, Leonardo. 1989. *On Painting: An Anthology of Writing*, ed. Martin Kemp and trans. Margaret Walker. New Haven. CT: Yale University Press.

Dragoi, V. and M. Sur. 2004. 'Plasticity of Orientation Processing in Adult Visual Cortex', in Leo Chalupa and John Werner (eds), *The Visual Neurosciences*. Cambridge, MA and London: MIT Press, 1654–65.

Elbs, O. 2005. *Neuro-esthetics: Mapological Foundations and Applications (Map 2003)*. Munich: M Press.

Freedberg, D. 1989. *The Power of Images: Studies in the History and Theory of Response*. Chicago: University of Chicago Press.

Freedberg, D. and V. Gallese. 2007. 'Motion, Emotion and Empathy in Artistic Experience', *Trends in Cognitive Neurosciences*, 197–203.

Gombrich, E. H. 1984. *The Sense of Order: A Study in the Psychology of Decorative Art*, 2nd edn. London: Phaidon.

Hannan, C. K. 2006. 'Review of Research: Neuroscience and the Impact of Brain Plasticity on Braille Reading', *Journal of Visual Impairment & Blindness*, 100/7: 397–413.

Hebb, D. O. 1949. *The Organization of Behavior: A Neuropsychological Theory*. New York: Wiley.

Horace. 1926. *Ars Poetica*, trans. Henry Rushton Fairclough. London: William Heinemann.

Hubel, D. H. and T. N. Wiesel. 1959. 'Receptive Fields of Single Neurones in the Cat's Striate Cortex', *Journal of Physiology*, 148/3: 574–91.

Hubel, D. H. and N. Wiesel. 1962. 'Receptive Fields, Binocular Interaction and Functional Architecture in the Cat's Visual Cortex', *Journal of Physiology*, 160: 106–54.

Hubel, D. N. and T. N. Wiesel. 1970. 'The Period of Susceptibility to the Physiological Effects of Unilateral Eye Closure in Kittens', *Journal of Physiology*, 206: 419–36.

Jackson, Phillip, A. N. Meltzoff, and J. Decety. 2005. 'How Do We Perceive the Pain of Others? A Window into the Neural Processes Involved in Empathy', *Neuroimage*, 24/3, 771–9.

Johansson, Barbro B. 2006. 'Music and Brain Plasticity', *European Review*, 14/1: 49–64.

Konorski, J. 1948. *Conditioned Reflexes and Neuron Organization*. Tr. from the Polish ms. under the author's supervision. Cambridge: Cambridge University Press, 89.

Kourtzi, Z. and J. J. DiCarlo. 2006. 'Learning and Neural Plasticity in Visual Object Recognition', *Current Opinion in Neurobiology*, 16: 152–58.

Låg, T., K. Hveem, K.P.E. Ruud and B. Laeng. 2006. 'The Visual Basis of Category Effects in Object Identification: Evidence from the Visual Hemifield Paradigm', *Brain and Cognition*, 60/1: 1–10.

Le Brun, Charles. 1994. 'Lecture on Expression' (Paris: 1688), in Jennifer Montague, *The Expression of the Passions, the Origin and Influence of Charles Le Brun's Conférence sur l'Expression Générale et Particulière*. New Haven, CT: Yale University Press, 126–40.

Lehky, Sidney R. and Keiji Tanaka. 2007. 'Enhancement of Object Representations in Primate Perirhinal', *Journal of Neurophysiology*, 97: 1298–1310.

Li, N and J. J. DiCarlo. 2008. 'Unsupervised Natural Experience Rapidly Alters Invariant Object Representation in Visual Cortex', *Science*, 321: 1502–7.

Maguire, E. A., D. G. Gadian, I. S. Johnsrude, C. D. Good, J. Ashburner, R. S. Frackowiak and C. D. Frith. 2000. 'Navigation-related Structural Change in the Hippocampi of Taxi Drivers', *PNAS*, 97/8: 4398–403.

Mallgrave, H. 2010. *The Architect's Brain: Neuroscience, Creativity and Architecture*. Chichester: Wiley/Blackwell.

Matsumoto, Masayuki and Okihide Hikosaka. 2009. 'Two Types of Dopamine Neuron Distinctly Convey Positive and Negative Motivational Signals', *Nature*, 459: 837–41.

Mitchell, W.J.T. 2002. 'Showing Seeing: A Critique of Visual Culture', in M. A. Holly and K. Moxey (eds), *Art History, Aesthetics, Visual Studies*. Williamstown: Clark Studies in the History of Art, 231–50.

Mithen, S. 2009. 'The Music Instinct: The Evolutionary Basis of Musicality', The Neurosciences and Music III—Disorders and Plasticity: *Annals of the New York Academy of Sciences*, 1169: 3–12.

Mithen, S. and L. Parsons. 2008. 'The Brain as a Cultural Artefact', *Cambridge Archaeological Journal*, 18/3: 415–22.

Mukamel, Roy, Arne D. Ekstrom, Jonas Kaplan, Marco Iacoboni, and Itzhak Fried. 2010. 'Single-neuron Responses in Humans during Execution and Observation of Actions', *Current Biology*, 20, 750–6.

Neidich, W. 2003. *Blow-up: Photography, Cinema and the Brain*. New York: Distributed Art Publishers.

Onians, J. 1994. ' "I Wonder …": A Short History of Amazement', *Sight and Insight: Essays on Art and Culture in Honour of E. H.Gombrich at 85*. London: Phaidon, 11–33.

Onians, J. 1996. 'World Art Studies and the Need for a New Natural History of Art', *Art Bulletin* (June): 206–9.

Onians, J. 1998. 'The Biological Basis of Renaissance Aesthetics', in F. Ames-Lewis and M. Rogers (eds), *Concepts of Beauty in Renaissance Art*. Aldershot: Ashgate, 2–27.

Onians, J. 1999. 'The Nature of Art in Lin Fengmian's China', in *The Approach of LIN Fengmian: The Centenary of LIN Fengmian*. Hangzhou: China Academy of Art Press, 690–715.

Onians, J. 2002. 'The Greek Temple and the Greek Brain', in G. Dodds and R. Tavernor (eds), *Body and Building: Essays on the Changing Relations of Body and Architecture*. Cambridge, MA: MIT Press.

Onians, J. 2007a. *Neuroarthistory. From Aristotle and Pliny to Baxandall and Zeki*. London and New Haven, CT: Yale University Press.

Onians, J. 2007b.'Neuroarchaeology and the Origins of Representation in the Grotte de Chauvet', in Colin Renfrew and Iain Morley (eds), *Image and Imagination; A Global History of Figurative Representation*. Cambridge: Cambridge University Press, 307–20.

O'Reilly, R. C. and M. J. Frank. 2006. 'Making Working Memory Work: A Computational Model of Learning in the Frontal Cortex and Basal Ganglia', *Neural Computation*, 18: 283–328.

Ovid. 1916. *Metamorphoses*, trans. Frank Justice Miller. London: Heinemann.

Phillips, Lisa. 2010. 'Inspiring People: Brainy Artist Amy Caron', *Neurology Now*, 6/4: 10.

Ramachandran, V. S. and W. Hirstein. 1999. 'The Science of Art: A Neurological Theory of Aesthetic Experience', *Journal of Consciousness Studies*, 6/6–7: 15–51.

Ramachandran, V. S., E. L. Altschuler, and S. Hillyer. 1997. 'Mirror Agnosia', *Proceedings of the Royal Society of London*, 264: 645–7.

Reber, R. and N. Schwarz. 1999. 'Effects of Perceptual Fluency on Judgments of Truth', *Consciousness and Cognition*, 8: 338–42.

Reber, R., N. Schwarz and P. Winkielman. 2004. 'Processing Fluency and Aesthetic Pleasure: Is Beauty in the Perceiver's Processing Experience?', *Personality and Social Psychology Review*, 8/4: 364–82.

Reber, R., P. Winkielman and N. Schwarz. 1998. 'Effects of Perceptual Fluency on Affective Judgments', *Psychological Science*, 9: 45–8.

Reddy, L., and N. Kanwisher. 2006. 'Coding of Visual Objects in the Ventral Stream', *Current Opinion in Neurobiology*, 16: 408–14.

Rizzolatti, G. 1996. 'Premotor Cortex and the Recognition of Motor Actions', *Cognitive Brain Research*, 3: 131–41.

Rizzolatti, G., R. Camarda, L. Fogassi, M. Gentilucci, G. Luppino, and M. Matelli. 1988. 'Functional Organization of Inferiour Area 6 in the Macaque Monkey: II Area F5 and the Control of Distal Movements', *Experimental Brain Research*, 71/3, 491–507.

Sensation (exhibition catalogue). 1997. London: Royal Academy of Art.

Spurling, Hilary. 1993. 'How Matisse Became a Painter', *The Burlington Magazine*, 135/1084: 463–70.

Stafford, B. M. 2007. *Echo Objects: The Cognitive Work of Images*. Chicago: University of Chicago Press.

Tamura, H. and K. Tanaka. 2001. 'Visual Response Properties of Cells in the Ventral and Dorsal Parts of the Macaque Inferotemporal Cortex', *Cerebral Cortex*, 11: 384–99.

Tanaka, K. 1993. 'Neuronal Mechanisms of Object Recognition', *Science*, 262: 685–8.

Tanaka, K. 1996. 'Inferotemporal Cortex and Object Vision', *Annual Review of Neuroscience*, 19: 109–39.

Tanaka, K. 2003. 'Columns for Complex Visual Object Features in the Inferotemporal Cortex: Clustering of Cells with Similar but Slightly Different Stimulus Selectivities', *Cerebral Cortex*, 131: 90–9.

Tanaka, K., G. Wang, S. Obama, W. Yamashita and T. Sugihara. 2005. 'Prior Experience of Rotation Is Not Required for Recognizing Objects Seen from Different Angles', *Nature Neuroscience*, 8: 1768–75.

Vischer, Friedrich Theodor. 1998. 'Critique of My Aesthetics' (1866), in Charles Harrison, Paul Wood and Jason Gaiger (eds), *Art in Theory: 1815–1900*. Oxford: Blackwell, 687–8.

Vischer, Robert. 1998. 'The Aesthetic Act and Pure Form' (1873), in Charles Harrison, Paul Wood and Jason Gaiger (eds), *Art in Theory: 1815–1900*. Oxford: Blackwell, 690–3.

Wicker, Bruno, Christian Keysers, Jane Plailly, Jean-Pierre Royet, Vittorio Gallese, and Giacomo Rizzolatt. 2003. 'Both of Us Disgusted in *My* Insula, the Common Neural Basis of Seeing and Feeling Disgust', *Neuron*, 40/3, 655–64.

Wiesel, T. N. and D. N. Hubel. 1965. 'Extent of Recovery from the Effects of Visual Deprivation in Kittens', *Journal of Neurophysiology*, 28: 1060–72.

Wölfflin, Heinrich. 1998. 'Prologomena to a Psychology of Architecture' (1886), in Charles Harrison, Paul Wood and Jason Gaiger (eds), *Art in Theory: 1815–1900*. Oxford: Blackwell, 711–17.

Wong-Riley, M., R. F. Hevner, R. Cutlan, M. Earnest, R. Egan, J. Frost and T. Nguyen. 1993. 'Cytochrome Oxidase in the Human Visual Cortex: Distribution in the Developing and the Adult Brain', *Visual Neuroscience*, 10: 41–58.

Xenophon. 1926. *Memorabilia*, book 3, trans. Edgar Cardew Marchant. London: William Heinemann, x, 6–9, 235.

Xu, Tonghui, Xinzhu Yu, Andrew J. Perlik, Willie F. Tobin, Jonathan A. Zweig, Kelly Tennant, Theresa Jones, and Yi Zuo. 2009. 'Rapid Formation and Selective Stabilization of Synapses for Enduring Motor Memories', *Nature*, 462/17: 915–19.

Yamashita, Wakayo, Gang Wang and Keiji Tanaka. 2010. 'View-invariant Object Recognition Ability Develops after Discrimination, Not Mere Exposure, at Several Viewing Angles', *European Journal of Neuroscience*, 31: 327–335.

Yotsumoto, Yuko and Takeo Watanabe. 2008. 'Defining a Link between Perceptual Learning and Attention', *PLoS Biology*, 6/8: 1623–6.

Zeki, S. 1993. *A Vision of the Brain*. Oxford: Blackwell.

Zeki, S. 1999. *Inner Vision: An Exploration of Art and the Brain*. Oxford: Oxford University Press.

Re-visualizing Anthropology through the Lens of *The Ethnographer's Eye*

DAVID HOWES

The practice of fieldwork is integral to modern anthropology. The origins of this practice date back to the Cambridge Anthropological Expedition to Torres Strait of 1898, led by the biologist A. C. Haddon. One of the men Haddon recruited for this mission was the physician-psychologist W.H.R. Rivers (1864–1922). Rivers was transformed by the experience into an ethnologist (though this remained but one facet of his multifaceted career), and he for his part sought to turn anthropology into a science. In addition to his initial work on visual perception and subsequent work on social organization and cultural diffusion in Melanesia, Rivers made important contributions to the codification of fieldwork methods. Best known for *The Todas* (Rivers 1906)—a truly classic ethnographic monograph (indeed, the first of its kind)—and winner of the Gold Medal of the Royal Society, Rivers stood both as the most eminent social anthropologist in England and for a seat in Parliament (as the Labour candidate for the University of London constituency) on the eve of his untimely death in 1922 (see Slobodin 1978; Langham 1981; Kuklick 1998).

To return to the Torres Strait expedition, this endeavour broke with the tradition of 'armchair anthropology' typified by Sir J. G. Frazer and E. B. Tylor of Oxford. Frazer and Tylor based their anthropological reflections on the writings of missionaries, colonial officials and travellers.[1] In place of relying on such amateur reports or 'hearsay', *scientific* anthropology would henceforth be founded on *observation*, or 'going to see for yourself' (Grimshaw 2001: 7 and 2007: 299.) Significantly, Haddon arranged for a photographer to accompany the expedition; he also acquired a cinematographer to assist the team in recording the social life and culture of the natives of the Torres Strait.

Only about four minutes of the film Haddon shot have survived. This footage shows people engaged in both practical and ceremonial activities—all very

evidently staged for the camera (Grimshaw 2007: 298). As for the photographs, they consist mainly of close-ups of individuals (in both frontal and profile poses), scenes from everyday life, and scenes from the psychological experiments which the team performed (e.g. a photo of the set-up for testing the visual acuity of the Torres Strait Islanders using Haken's E). The photographs lend an aura of objectivity to the extensive descriptions of native life contained in the six-volume *Reports* of the expedition (Haddon 1901). But they remain illustrative, subordinate to the text of the *Reports*. This subordinate status is indicative of the extent to which anthropology is first and foremost a text-based discipline, typified by the ethnographic monograph. 'What does the ethnographer do?—he writes' (Geertz quoted in Howes 2003: 26).

TEXTUALIZING ANTHROPOLOGY

It took anthropologists the better part of a century to start to reflect critically on the textual basis and biases of their discipline. This awakening plunged the field into a 'crisis of representation'. The latter crisis was signalled by a variety of texts which began appearing in the 1980s with titles like 'Ethnographies as Texts' (Marcus and Cushman 1982), 'On Ethnographic Authority' (Clifford 1983) and *Works and Lives: The Anthropologist as Author* (Geertz 1988). While most anthropologists continued reading the old monographs for what they said (e.g. W.H.R. Rivers as an authority *on* the Toda, Bronislaw Malinowski as an authority *on* the Trobriand Islanders), the authors of these new works started analysing the older works (particularly Malinowski's) for the 'rhetorical strategies' or 'modes of authority' they deployed. In the result, many ethnographers gave up the study of other cultures for that of other texts. As Marcus and Cushman put it in the manifesto that heralded this textual revolution in anthropological understanding: 'In this emergent situation, ethnographers read widely among new works for models, being interested as much, if not more, in *styles of text construction* as in their cultural analysis, both of which are difficult to separate in any case' (Marcus and Cushman 1982: 26, emphasis added).

The styles of the new works which blossomed in the 1980s and 1990s have the appearance of being quite heterogeneous: some were written dialogically, others polyphonically; memoirs and confessions also became increasingly common, while 'monograph' became a term of opprobrium. Yet what above all distinguished the new works and gave them a certain unity relative to the realist writings of the past was that: 'In these experiments, reporting fieldwork experience is just one aspect of wide-ranging personal reflections' (Marcus and Cushman 1982: 26). The pretence of 'objectivity' was abandoned in the name of 'reflexivity', and the idea of 'observation' was supplanted by that of 'negotiation' as in 'ethnography [is located] in a process of dialogue where interlocutors actively negotiate a shared vision of reality' (Clifford 1983: 43). Above all, the 'I' of the ethnographer was given a new licence to express itself within the text, instead of standing behind it.

The overthrow of traditional canons of authority was summed up as follows by James Clifford in 'Partial Truths' (the introduction to a highly influential book from the mid 1980s entitled *Writing Culture*):

> Many voices clamor for expression. Polyvocality was restrained and orchestrated in traditional ethnographies by giving to one voice a pervasive authorial function and to others the role of sources, 'informants,' to be quoted or paraphrased. [But once] dialogism and polyphony are recognized as modes of textual production, monophonic authority is questioned, revealed to be characteristic of a science that has claimed to *represent* cultures. (Clifford 1986: 15)

The trouble with the claim to 'represent cultures' had to do with the unexamined ideology it imported: 'an ideology claiming transparency of representation and immediacy of experience' (Clifford 1986: 14)—both highly dubious propositions from the postmodernist vantage point of the mid 1980s, apparently. The new standard that emerged from this rupture with the monophonic-realist conventions of the past was that 'the proper referent of any account is not a represented "world"; now it is specific instances of discourse' (Clifford 1986: 14).

The limiting of ethnography to reporting on 'specific instances of discourse' involved a reduction in the scope of what once passed under this name. For example if one goes back to Rivers's *The Todas* (1906), in the introduction to that monograph, one finds a discussion of how Rivers would elicit 'independent accounts' of a given practice from different 'witnesses' (i.e. informants), then compare them and 'cross-examine into any discrepancies' (Rivers 1906: 7–17). Only then would he describe (or 'write-up') the practice or custom for posterity. To Rivers, ethnography was a process of 'corroboration', not negotiation, and the accounts given by informants were always supplemented by observation: 'I did not content myself with . . . [the] independent accounts till I had satisfied myself of the trustworthiness of the witness, and had learnt enough of the customs in question to be in a position to weigh the evidence' (Rivers 1906: 10, 465–7). Proceeding in this fashion, Rivers became a superior authority on Toda culture to his Toda informants (at least in his own estimation). He wrote in a singular voice, relying on the rigors of his method of data collection to eliminate misrepresentations.

In the wake of the textual revolution of the 1980s, by contrast, ethnographer and informant had to be *equally present* in the text if a monograph was to conform to 'the principle of dialogical textual production' (Clifford 1986: 14) or be consistent with the new emphasis on 'the emergent and cooperative nature of textualization' (Tyler 1986: 127). One of the casualties of this new emphasis on textualization was sense perception, or what an earlier generation had called 'observation'. Thus, one postmodern anthropologist went so far as to proclaim: 'Perception has nothing to do with it'—the 'it' being ethnography. Specifically:

> An ethnography is no account of a rationalized movement from percept to concept. It begins and ends in concepts. There is no origin in perception, no priority of vision, and no data of observation

Or, again:

> [An ethnography] is not a record of experience at all; it is the means of experience. That experience became experience only in the writing of the ethnography. Before that it was only a disconnected array of chance happenings. (Tyler 1986: 138)

Case closed.

VISUALIZING ANTHROPOLOGY

It was against this backdrop of hypertexuality in mainstream anthropology that the sub-discipline of visual anthropology underwent its reflexive moment in the 1990s. Visual anthropologists stopped simply making films or taking pictures and started reflecting on anthropology itself as a 'way of seeing' (just as the textual anthropologists had come to view anthropology as 'a kind of writing' before them). What Clifford says of writing in the following quotation could equally well be said of seeing: 'No longer a marginal, or occulted dimension, writing has emerged as central to what anthropologists do both in the field and thereafter' (Clifford 1986: 2).

The visual revolution in anthropological understanding unfolded in a series of steps. The first step involved the interrogation of the alleged objectivity of the photograph and other visual media by exposing how these technologies had been used to promote essentialist ideologies of race and gender. The second step involved the expansion of the boundaries of visual anthropology to include not just photography and film but visible culture (e.g. art) and visual systems (Banks and Morphy 1997). The third step involved contesting the marginal status of the visual in the 'discipline of words' that anthropology had become, and, at the same time bringing to light the centrality of vision to the writing process itself. Consider Anna Grimshaw's argument in *The Ethnographer's Eye: Ways of Seeing in Modern Anthropology* (2001). 'Over the last decade', she writes in her introduction

> anthropology has been much discussed as a particular kind of literary endeavour. What happens if we imagine it differently—as a form of art or cinema? Such a proposal may seem fanciful, perverse even, though it is not without its precedents. By suggesting that we 'see' anthropology as a project of the visual imagination, rather than 'read' it as a particular kind of literature, I believe that we can discover contrasting ways of seeing and knowing within the early modern project. The 'visualization' of anthropology I propose is built around a particular example. [In Part I of *The Ethnographer's Eye,*] I take three key figures from the classic British school (1898–1939) and place their work alongside that of their artistic and cinematic counterparts, I consider the work of W.H.R. Rivers alongside that of Cézanne and the Cubist artists (as the precursors of cinematic montage—Griffith, Eisenstein and Vertov); I place Bronislaw Malinowski in the context of Robert Flaherty's development of a Romantic cinema; and, finally, I seek to explore Radcliffe-Brownian anthropology by means of its juxtaposition with

the interwar school of British documentary associated with John Grierson. (Grimshaw 2001: 9)

The 'perversity' of Grimshaw's proposal consists in the way she chose to examine vision as a way of knowing at a time when the 'denigration of vision' was the norm, due to the influence of certain contemporary French philosophers (Jay 1993) and Johannes Fabian's blistering critique of 'visualism' in anthropology for its alleged objectifying and dehumanizing effects (Fabian 1983). The 'fancifulness' of her pro-posal consisted in the way her analysis is based on 'imaginative connections' between modern art and modern anthropology which were 'unashamedly speculative', as she herself admitted (Grimshaw 2001: 11). The interest of her proposal lies in the way she recuperated the legacy of W.H.R. Rivers, and has gone on in her own work to rehabilitate observation, and to experiment with other media besides writing for the communication of anthropological findings. We shall explore Grimshaw's own con-tribution to the visualization of anthropology presently, but first let us examine how she visualizes Rivers's life and work.

RIVERS'S UNOPTICAL UNCONSCIOUS

Grimshaw discovered Rivers not through her anthropological training but rather through literature—specifically, through chancing upon the novels of the contemporary British writer Pat Barker (see Grimshaw 2001: 3, 33). Rivers figures as one of the main characters in Barker's 'War Trilogy' (Barker 1997): *Regeneration* (1991), *The Eye in the Door* (1993), and *The Ghost Road* (1995). These novels centre on the relationships Rivers formed with a series of army officers suffering from war neuroses (or 'shell shock') who came under his care first at Craiglockhart Hospital in Scotland where he was stationed during the early part of the First World War and later in London, after he transferred to the Central Hospital at Hampstead.

'Barker works in interesting ways with vision and visualization', and these lie 'at the heart of her interpretation of Rivers', Grimshaw (2001: 33) writes. For example one of the subthemes of the novels is how Rivers lost the power to visualize scenes in his mind's eye due to a traumatic childhood incident (which is a source of recurrent, albeit incho-ate, flashbacks).[2] The implication is that this loss drove him to dedicate his medical/psychological career to plumbing the mysteries of visual perception (first as a student of the physiology of vision in Jena and later as a field researcher in Melanesia and India) and visual hallucinations and nightmares (during his period as a military psychiatrist at Craiglockhart and thereafter). The memory of this incident is so shrouded in repression that Rivers never manages to reconstruct it definitively and thereby confront, much less resolve, the psychic issues at the root of his visual troubles. However, in classic (almost archetypal) wounded-healer fashion, he goes on to author *Instinct and the Unconscious* (1920) and the posthumous *Conflict and Dream* (1923), and in the result became one of the foremost interpreters of psychoanalytic theory to the British public. It could be

said that Rivers gained his deep insights into the unconscious (which were substantially less sexualized though no less profound than Freud's) through reflecting on his own inability to visualize, and the troubled visions of his patients in the aftermath of their war experience (for details see Slobodin 1978).

In addition to pointing to a certain ambivalent relationship to vision as the spring of Rivers's complex personality, Grimshaw notes that

> eyes are scattered everywhere across the novels. Barker often refers to Rivers' habit of drawing his hand across his eyes; but eyes are also found on the battlefield; they are picked up and held in the hand; they watch, secretly but tangibly present, within different scenes. (2001: 34)

And, there is the powerfully suggestive title of the second novel in the trilogy. 'What did the image of the eye in the door suggest about vision and anthropology?' (Grimshaw 2001: 34).

In pursuing this question, Grimshaw gives short shrift to Rivers's actual experiments on visual perception and concentrates on his invention of 'the genealogical method'. Finding out how the members of a community stand to each other through collecting oral genealogies and modelling these relationships in the form of a kinship diagram was a crucial innovation in anthropological field research methodology introduced by Rivers (see Langham 1981). He developed it at about the same time Picasso and Braque made their breakthrough into Cubism, leading Grimshaw (2001: 36–7) to remark: 'that Rivers, like the Cubist painters, reduced the visible world to a simple abstract form (the kinship diagram) in order to construct a more complex [multiperspectival, relational] view of reality than had previously been attempted'. As an expression of the structural order behind the sensible flux, this modernist way of seeing proved extremely productive in art as in anthropology, but it was soon dashed by the experience of the Great War. The battlefield of the First World War was 'the graveyard of the eye'. Grimshaw quotes Martin Jay:

> The Western front's interminable trench warfare . . . created a bewildering landscape of indistinguishable, shadowy shapes, illuminated by lightning flashes of blinding intensity, and then obscured by phantasmagoric, often gas-induced haze . . . When all the soldier could see was the sky above and the mud below, the traditional reliance on visual evidence for survival could no longer be easily maintained. (Quoted in Grimshaw 2001: 41)

The conventional association between vision, reason and order was sundered, temporarily replaced by vision, nightmare-phantasy and turmoil. This was both the cause and the context of Rivers's work with the army officers suffering from war neuroses which preoccupied him during the latter part of his career, and which supplied much of the raw material for *Conflict and Dream* (1923). Grimshaw sees the latter work as analogous

to the cinematic works of Rivers's contemporary, D. W. Griffith, who used the then novel technique of montage to plunge the viewer into a world characterized by 'movement, complexity, interconnection, violence and conflict' (Grimshaw 2001: 26) as well as Dziga Vertov in *A Man with a Movie Camera* (1929), who also captured the dynamism and disorder of his times using novel film techniques.

In her visualization of the history of anthropology, Grimshaw goes on to describe how the 'anxious, fragmented, multiperspectival vision' of Rivers[3] was supplanted by the 'innocent', 'visionary eye' of Malinowski (who endeavoured to write 'from the native's point of view'),[4] and transformed again into 'the gaze', or 'disembodied eye of observation' of Radcliffe-Brown. As noted previously, she also posits a cinematic double for each of these figures, Flaherty in the case of Malinowski, and Grierson in the case of Radcliffe-Brown.

I find Grimshaw's analysis highly suggestive, and important for the way it highlights the multiple ways of seeing and knowing that took shape within early modern anthropology (i.e. there was not just the one mode—the Radcliffe-Brownian mode, which is an easy target for criticism (e.g. Fabian 1983)). However, there was more to the anthropology of this period than meets the eye. The nonvisual senses have a history too, and it is important that this not be occluded by filtering the history of the discipline exclusively through the model of the camera lens or gaze.[5] Otherwise visual anthropology risks falling into the same trap as textual anthropology, for which there had ceased to exist any *hors texte* by the mid 1980s.[6]

THE MEASUREMENT OF THE SENSES

To return to the Torres Strait expedition, the men Haddon recruited—Rivers and his two protégés (fellow physician-psychologists) Charles Myers and William McDougall—went to Melanesia not just to 'see for themselves' (Grimshaw 2001: 7) but *to measure*. Specifically, they went to gauge the sensory acuity of the natives. Rivers took on the study of visual perception (colour vision, spatial vision, susceptibility to illusion) but also oversaw and collaborated on the tests administered by the other two; Myers, who was something of a musician, was assigned hearing, taste and smell as well as the study of reaction-times; and McDougall was responsible for 'cutaneous sensations' (pain, temperature, localization) and the 'muscular sense' (weight). The team brought along a formidable battery of tests to determine the natives' thresholds of perception, including Haken's E, Lovibund's tintometer, the Müller-Lyer and other such illusions, Politzer's Hörmesser (for measuring auditory sensitivity), Galton's whistle (for pitch discrimination), diverse musical instruments, Zwaardemaker's olfactometer, various taste solutions, a hand-grasp dynamometer, an algometer (for studying pain thresholds), and marbles, to mention only about a third of the items in their 'psychological kit'.

Why this fascination with testing the senses of 'savages'? First, because it was doable: perception had come to be (re)defined as a psychophysical process by various German researchers of the highest authority, and a whole barrage of apparatuses (like those

mentioned above) had been invented to study it as such. Second, because it was the thing to do, in keeping with the Spencerian hypothesis, which was key to the general intellectual climate of the period (late Victorian).

The Spencerian hypothesis (or rather conceit) was grounded in a series of cultural assumptions concerning the relationship between the intellect on the one hand and the body and senses on the other, and between the senses themselves in terms of higher vs. lower, and civilized vs. primitive. Various treatises dating from the eighteenth century already played up the supposedly superior sensory abilities and proclivities of 'primitive' peoples, particularly in so far as the 'lower', 'primitive' senses were concerned (smell and touch). These representations became commonplace in the nineteenth century, supported by the anecdotal observations of travellers and missionaries. All this fed into the Spencerian hypothesis, which held that '"primitives" surpassed "civilised" people in psychophysical performance because more energy remained devoted to this level in the former instead of being diverted to "higher functions"' (Richards 1998: 137). Here is how Rivers gave expression to this conceit

> We know that the growth of intellect depends on material which is furnished by the senses, and it therefore at first sight may appear strange that elaboration of the sensory side of mental life should be a hindrance to intellectual development ... [However, if] too much energy is expended on the sensory foundations, it is natural that the intellectual superstructures should suffer.

And, that such is the case was attested by the fact that:

> the savage is an extremely close observer of nature ... [T]he attention is predominantly devoted to objects of sense, and ... such exclusive attention is a distinct hindrance to higher mental development. (Rivers 1901: 44)

In keeping with this notion, Rivers and company introduced their experiments to the Torres Strait Islanders as follows:

> The natives were told that some people had said that the black man could see and hear, etc., better than the white man and that we had come to find out how clever they were, and that their performances would all be described in a big book so that everyone would read about them. This appealed to the vanity of the people and put them on their mettle. (Rivers 1901: 3).

It will be appreciated that, given the supposed connection between sensory superiority and mental inferiority, to win at this contest was also to lose.

Rivers and Myers carried out very thorough eye and ear exams of the natives, noting the prevalence of colour-blindness, deafness, etc (so that the issues of pathology and acuity could be kept separate). They also gathered extensive data on sensory vocabularies (not just colour terms, but taste and smell and hearing terms too), prompted

by the supposition that there might be some association between extensiveness of no-menclature (e.g. the presence/absence of a word for blue) and degree of sensitiveness (to said colour). They carried out their studies of psychophysical performance with re-markable resolve considering the deficiencies or outright failure of much of their test equipment, illness (which impaired their own sensory abilities), and native resistance (e.g. to having tubes stuck up their noses—understandably). For example the hearing threshold tests were compromised by the pounding of the surf and rustle of the breeze in the palm trees—not your ordinary laboratory conditions. Getting a result was diffi-cult (Richards 1998). They also had to control for the problem of subjects responding to the tests based on inferences (which obviously involved some degree of intellection) as opposed to reporting 'immediate sense impressions' (which is what they were after).[7] Their difficulties in this connection ought to have prompted more reflection on the impossibilities of ever completely stripping the perceptual process of its cultural and personal lining, but they did not.

What did the team find? The results were mixed, as were their interpretations and McDougall appears to have differed from Rivers and Myers in the conclusions he drew. Thus, McDougall studied the Islanders' tactile sensitivity using a compass to measure the threshold for the discrimination of two points on the skin and found this to be comparatively low: 'about one half that of Englishmen' (McDougall 1901: 192). He used an algometer, which presses a point against the skin with varying levels of pressure to determine sensibility to pain and found this to be comparatively high: 'nearly double that of Englishmen' (McDougall 1901: 195). He concluded that the na-tives' 'delicacy of tactile discrimination constitutes a racial characteristic' and that the 'oft-repeated statement that savages in general are less susceptible to pain than white men' was exact (McDougall 1901: 193–4). McDougall did not perceive any contra-diction to the quite opposite results of these two tests, nor did he demonstrate the same methodological acumen (or experimental reflexivity) as his fellow team members (Richards 1998).

While McDougall found confirmation for the prevailing stereotypes of 'primitive' man, Rivers and Myers found no definite racial differences in the acuity of the senses they studied (see further Rivers 1905). For example Myers found the average olfactory acuity to be slightly higher in Torres Strait than in Aberdeenshire and general auditory acuity to be inferior, but emphasized the limits of the test equipment he utilized (and incomparability of the data) more than anything, while Rivers concluded that 'the gen-eral average' in Torres Strait 'do not exhibit that degree of superiority over the European in visual acuity proper which the accounts of travelers might have led one to expect' (Rivers 1901: 42). Rivers otherwise found that some visual illusions were experienced more strongly by native subjects than by British subjects, and others less strongly, but there was no 'marked degree' of difference here either. This strike in favour of the psy-chophysical unity of humankind and incipient critique of the racist reasoning of the day was, however, tempered by Rivers and Myers resorting in the next sentences of their respective reports to relating anecdotes of native sensory virtuosity or extraordi-nary 'powers of observation'. They simply could not get the Spencerian hypothesis out

of their heads. The one difference from MacDougall (1901) is that they related these manifestations of extrasensitivity to 'habits of life' or custom rather than inheritance—but, then, because customs could be graded in terms of degree of civilization, this alternate explanation did nothing to unseat the Spencerian hypothesis. Thus, Rivers and Myers were both very modern in their use of statistics and the (experimental) evidence of the senses to challenge racist doctrines, and very Victorian in the way they persisted in employing evolutionary-style reasoning to interpret the scarcest indication of difference in the statistical tables their research generated.

SENSUALIZING ANTHROPOLOGY

Part II of *The Ethnographer's Eye* is entitled 'Anthropological Visions'. It starts with a chapter on cinema and anthropology in the postwar period and then presents a series of case studies of prominent ethnographic film-makers, including Jean Rouch, followed by David and Judith MacDougal, and finally Melissa Llewlyn-Davies. The first chapter is interesting for what could be called its 'intervisuality' as Grimshaw traces the influence of different postwar cinematic genres—Italian neorealism, *cinéma vérité*, direct cinema—on the nascent tradition of ethnographic film. Always one for uncovering differences, Grimshaw goes on to point out the singularities and contrasts between the cinema 'as initiation' style of Rouch, the 'observational cinema' of the MacDougals and the 'made for television' style of Llewlyn-Davies. Here we will focus on Grimshaw's analysis of the MacDougals' oeuvre.

The 'observation' involved in observational cinema has to do with intimacy rather than distance and intensity rather than objectivity. Above all, it entails a particular social relationship with a film's subjects—namely, a relationship based in humility and respect, not surveillance. This unique use of the term was coined by Colin Young, the mentor of the small group of film-makers (including the MacDougals) working at UCLA in the late 1960s. Their modus operandi was summed up as follows by one of their company:

> We shoot in long takes dealing with specific individuals rather than cultural patterns or analysis. We try to complete an action within a single shot, rather than fragmenting it. Our work is based on an open interaction between us as people (not just film-makers) and the people being filmed. (Hancock quoted in Grimshaw 2001: 13)

Grimshaw elaborates on these remarks by suggesting that observational cinema is fundamentally about integrity—the integrity of events, the integrity of the encounter, and the integrity of the film-maker. The former is established through the extended shot, that of the encounter through making the relationship between film-maker and subject central to the film, and that of the film-makers themselves through attention to detail, and through editing (see further Grimshaw 2009).

As regards the importance of detail, Grimshaw lays much stress on 'the focus and intensity of the camera eye' in the case of David MacDougal's work. (It should be

noted that Judith MacDougal was the one responsible for the sound in the films the MacDougals shot together.) She writes:

> [The camera eye] serves as a filter, one which seems anxious not to intrude, but to simply to [sic] be there, quietly watching, an expression of the film-maker's sensitivity and deference towards his subjects. And yet the occasional movements of the camera and its changing positions are necessary, in fact, to remind us of MacDougall's presence, to reassure us of the *integrity* of the vision he is presenting, one intimately tied to his having *genuinely* been there. (Grimshaw 2001: 131, emphasis added)

As an example of the way the MacDougals practised observational cinema, consider *To Live with Herds: A Dry Season among the Jie* (1971). This film explores the pastoral life of a herding people in Uganda within the context of wider political and economic changes. It has a five-part structure. The film opens in a Jie compound, with a series of shots that extoll the quiet dignity of the organic, cyclical way of life of the Jie and their cattle. Then, in a single extended shot, a man by the name of Logoth points out the extent of Jie terrain in response to a request to do so from the film-makers. The ensuing parts disclose the prejudice and casual brutality of the Ugandan state apparatus towards pastoralists, as well as the incursion of market relations. There is a dust storm, which seems an apt symbol for the increasing turbulence of life (even as the film has no symbolic pretensions), and the film draws to a close on the edge of the cattle camps (once again), with an extended shot of Logoth and others exchanging greetings. The *cyclical* structure of the film is no accident: it reinforces the MacDougals' powerful indictment of market-driven and state-sponsored *linear* notions of progress and development. The message is in the juxtaposition, the montage.

To Live with Herds is heavily and artfully edited, despite the appearance of being direct. Grimshaw raises the question of whether the formal perfection of its structure does not betray the principles of observational cinema (for it can hardly be considered a 'found' film). She then moves on to discuss how the MacDougals themselves moved on to develop 'participatory' or what could be called 'conversational cinema'. The latter approach is said by Grimshaw to have involved 'a shift away from vision and towards voice', and from structure to process, since the notion of '[c]onversation signalled informality, spontanaeity and open-ended interaction' (Grimshaw 2001: 138). There was a change in David MacDougal's camera technique as well, from the 'privileged camera style' of the Jie films (where the camera can be anywhere within a scene—aperspectival, omniscient) to what he called an 'unprivileged camera style'. The latter, which emphasizes the situatedness of the film-maker's perspective,

> essentially involved 'humanising' the camera. There was an acknowledgment of film's subjective qualities, and the text itself was to reveal that 'film-makers are human, fallible, rooted in physical space and society, governed by chance, limited in perception'. (Grimshaw 2001: 138)

The first traces of this shift towards a more situated and voiceful or collaborative film process can be seen in the *Turkana Conversations* trilogy, which the MacDougals worked on in the early 1970s. The films in this trilogy do not assume a unified culture (as with the Jie films), but rather deal with points of crisis within Turkana society as well as between it and the dominant society. They are structured around conversations with different individuals rather than a single representative individual (such as Logoth).

In the late 1970s, the MacDougals shifted terrain from East Africa to Australia, and lived as resident film-makers in aboriginal communities in the Arukun area of northern Queensland. During this period their films stopped being about the struggle between indigenous communities and the state, and become part of that struggle, that process. 'The MacDougals sought to give voice to people', Grimshaw (2001: 142) writes, 'allowing people to tell their own stories, to name experience, such that the members of the Aboriginal community could assert, challenge or redefine relationships with the world on their own terms.' This process of redefinition plays out within the time of filming, so that the film becomes a record of an open-ended, tumultuous conversation between different members of the communities concerned, state officials and the film-makers themselves.

The MacDougals shifted terrain again, from Australia to India in the 1980s, while remaining based at the Australian National University, Canberra. Grimshaw's analysisof their contribution to the evolution of visual anthropology ends with a discussion of *Photo Wallahs* (1991).[8] *Photo Wallahs* centres on the practice of photography in Mussoorie, a former hill station which is now a popular Indian vacation and honeymoon destination. Making a film about the history of photography in this Himalayan resort may be seen to represent a 'return to a preoccupation with vision rather than voice' (Grimshaw 2001: 145), but in point of fact, this documentary, with its emphasis on indigenous aesthetics, is best seen as transitional to what could be called the 'sensational cinema' of the latest phase of David MacDougal's film career. This sensorial turn found its fullest expression in *Doon School Chronicle* (2000), and its most complete theorization in *The Corporeal Image: Film, Ethnography and the Senses* (MacDougal 2005). Neither of these works would have been accessible to Grimshaw at the time she was writing *The Ethnographer's Eye*, although they definitely resonate with how her own work has evolved since the publication of that book, as we shall see presently.

MacDougal chose to make a video study of what he calls the 'social aesthetics' of Doon School, the famed residential boys' secondary school situated near Mussoorie in the foothills of the Himalayas, as a companion study to Sanjay Srivastava's (2007) ethnography of the school's role in reproducing and shaping concepts of the modern Indian citizen and nation. While Srivastava's work focusses on the socialization of the boys, MacDougal's video concentrates on the aesthetics or 'culturally patterned sensory experience' of school life, including 'the design of buildings and grounds, the use of clothing and colors, the rules of dormitory life, the organization of students' time, particular styles of speech and gesture, and the many rituals of everyday life that accompany such

activities as eating, school gatherings, and sport' (MacDougal 2005: 98). All of these 'aesthetic features' are held by MacDougal to be influential in their own right, and not simply 'the symbolic expression of more profound forces (such as history and ideology)'. 'What is interesting sociologically', he writes

> is the extent to which these aesthetic patterns may influence events and decisions in a community, along with the other more commonly recognized social forces of history, economics, politics, and ideology. All these forces are, of course, interconnected, but it often seems that the aesthetic features of a society are too easily assimilated into other categories, to such a extent that they become invisible or ignored. (MacDougal 2005: 98)

MacDougal would likely agree with Italo Calvino: 'It is only after you have come to know the surface of things . . . that you can venture to seek what is underneath. But the surface of things is inexhaustible' (cited in Howes 2004: 245).

Looking back, it could be said that while MacDougal's films have long been lauded for their audio and visual detail, now the message is in those very details; while his films have come to be known for foregrounding individuals, now the accent is on how individuals are formed, or, put another way, how 'the school impressed its own distinctive stamp on them' (MacDougal 2005: 96); and, where the image of a cycle or the idea of conversation formerly provided the organizing framework for his films, now the focus is on 'aesthetic features' or *the presence and interrelations of the senses*, as when he writes: 'Doon School's social aesthetic is made up of many elements and consists not so much in a list of ingredients as a complex, whose interrelations as a totality (as in gastronomy) are as important as their individual effects' (MacDougal 2005: 98). Summing up, Mac-Dougal's abiding concern with sensitizing audiences to issues has transformed into a concern with sensitization itself.[9]

MacDougal's *The Corporeal Image*, in addition to setting out the socioaes-thetic theory that informs *Doon School Chronicles*, makes many robust claims and arguments for the sensual in anthropology, with film being the primary medium for conveying sense experience. For example Chapter 2 is entitled 'Voice and Vision', and consists of a sustained reflection on the contrasts between text and image, narrative and film, with respect to conveying and fostering the analysis of complex social events. MacDougal comes down squarely in favour of film on account of its intrinsic multi-modality, which is hardly surprising in view of his métier, but he remains conscious of the experiential limits of film even as he extols its sensory extensivity relative to the printed page.

> one of the distinctive things about film is its routine mixing of different modes of thought and perception. There is a continuous interplay among its varied forms of address—the aural with the visual, the sensory with the verbal, the narrative with the pictorial. There is a semblance of this interplay in literature, as well, but it is actually a construction of the writer's and reader's imaginations, since the actual form of address,

words on a page, remains constant. Although films still have a comparatively limited experiential range (one does not smell the flowers in a film, or speak with others, or touch, or feel touched), they do offer the spectator some insight into the integrated and often confusing social reality faced by the protagonists. Writing can provide the jolt of a physical encounter, but films provide a flow of sensory (and other) experiences that requires considerable application to derive from writing. (MacDougal 2006: 52)

MacDougal does not always in his writings underscore the limited experiential range of film to the extent he does in this passage,[10] and there could be more debate regarding the respective merits of text and film with respect to dissecting and communicating sense experience,[11] but the most important point to retain from this discussion is its cross-modal reflexivity. Instead of simply being reflexive about textuality, or simply being reflexive about visuality, MacDougal situates both within the larger context of a growing concern with the possibilities of intersensoriality or 'sensuous scholarship' (Stoller 1997).[12] Sarah Pink makes a similar case in *The Future of Visual Anthropology: Engaging the Senses* (Pink 2006).

This brings us back to Grimshaw, who was the first to theorize in a comprehensive way the epistemological possibilities of visualization as opposed to textualization, and for whom visualization has increasingly come to mean the sensualization of knowing and of how anthropologists ought to communicate what they know. Thus, one finds repeatedly in her writings since the publication of *The Ethnographer's Eye* references to the project of 'visualizing anthropology' as 'going beyond the narrow concerns of ocularity to investigate ways of knowing located in the body and in the senses' (Grimshaw and Ravetz 2005: 2).[13] For her, 'questions of the visual' are to be 'interpreted broadly as about embodied and sensory-based ways of knowing' (Grimshaw 2005: 25). Using a camera (i.e. practising observational cinema) is important to her because of the way it 'positions oneself differently in the world', and enables a shift from the conventional 'word-sentence to an image-sequence approach' to knowledge production (Grimshaw 2007: 199). But her practice has also evolved beyond reflecting on what is distinctive about the insights observational cinema can yield to involve collaborative projects with diverse visual artists and experimentation with alternative sites for the dissemination of knowledge. As she notes,

anthropologists have not gone very far in pushing beyond existing conventions. Even in the area of visual anthropology, filmmakers tend to make pieces for conventional screening or they work with museums to present knowledge through particular arrangements of textually situated objects. (Grimshaw 2007: 203)

Grimshaw urges them to try 'putting anthropology in different spaces', such as an art gallery, and to start thinking of fieldwork as 'about techniques of material practice' or 'making objects'. What she has in mind when she refers to these techniques is 'seeking ways to realign the researcher's [and the audience's] body within the process of inquiry

such that understanding might encompass the full range of the senses and emerge from embodied intersubjective encounter' (Grimshaw 2007: 204). Anthropology is no longer about writing and publishing texts or shooting and screening films but about making and experiencing objects or environments.

Since 2009 I have been collaborating with my colleague in the Design Art Department at Concordia, the artist and performance theorist Chris Salter, to produce 'total sensory environments' as an alternative and complement to the ethnographic monograph and ethnographic film. The Mediations of Sensation project has involved contemplating diverse case studies in sensory anthropology (e.g. Classen 1993) and imagining how to model them using coloured light, sound, vibration, motion, heat and haze, among other sensory cues. The 'atmospheres' Chris Salter has created using new (and traditional) media have proved to be deeply engaging, as visitors (or better, 'experiencers' since it is impossible to remain a viewer) find their senses elicited and then conjoined in all sorts of unexpected ways which open cracks in the conventional Western sensory paradigm and plunge them into parallel sensory worlds. For visitors to make sense of these 'performative environments' involves practicing just the sorts of 'realignments' Grimshaw describes.[14]

CONCLUSION

The exercise in 're-visualizing anthropology' broached here has involved investigating two moments in the history of the discipline—namely, the turn of the twentieth century and the turn of the twenty-first century—when vision appeared to play the dominant role in the production of knowledge, if one follows Anna Grimshaw's argument in *The Ethnographer's Eye*. However, in both instances the focus on vision turned out to occlude the equally constitutive role of diverse nonvisual senses in the constitution and advancement of anthropological knowledge. In this chapter, I have tried to make a case for attending to the interplay of the senses, rather than focus on any one sense in isolation, because of the additional insights into cultural processes which such an intersensory approach can generate.

FURTHER READING

Bull, Michael and Les Back, eds. 2003. *The Auditory Culture Reader*. Oxford: Berg.

Classen, Constance, ed. 2005. *The Book of Touch*. Oxford: Berg.

Drobnick, Jim, ed. 2006. *The Smell Culture Reader*. Oxford: Berg.

Edwards, Elizabeth and Kaushik Bhaumik, eds. 2008. *Visual Sense: A Cultural Reader*. Oxford: Berg.

Howes, David, ed. 2004. *Empire of the Senses: The Sensual Culture Reader*. Oxford: Berg.

Howes, David, ed. 2009. *The Sixth Sense Reader*. Oxford: Berg.

Korsmeyer, Carolyn, ed. 2005. *The Taste Culture Reader: Experiencing Food and Drink*. Oxford: Berg.

NOTES

1. The charge of being an armchair anthropologist is not entirely fair when directed at E. B. Tylor. As Gosden, Larsden and Petch have brought out in *Knowing Things*, Tylor trained his attention on objects rather than people: his fieldsite was the museum, and he paid as close attention to material culture as the succeeding generation of anthropologists would pay to social organization. The Pitt Rivers Museum, which was Tylor's bailiwick, is famous for its arrangements of objects in static displays to demonstrate evolutionary sequences. But these schemes were arrived at through an intimate first-hand knowledge of the things themselves—that is through manipulation. For example Tylor gave demonstrations of fire-making with rubbing sticks, and also practised boomerang throwing in the University Parks. In this way he picked up the habitus of the object. Consider further Tylor's vision for the museum:

 When will hearing be like seeing? says the Persian proverb. Words of description will never give the grasp that the mind takes through the handling and sight of objects. And this is why in fixing and forming ideas of civilization a museum is so necessary. (Quoted in Gosden, Larson, and Petch 2007)

 Note that while the museum remained a place to handle as well as see objects for scientists like Tylor, by this period the general public was forced to form its ideas of civilization by sight alone (see Classen 2005 and 2007).

2. Barker may have derived part of her inspiration for the development of this subtheme from the passage in Ian Langham's psychological portrait of Rivers in *The Building of British Social Anthropology*, where he writes

 As Rivers himself states on a number of occasions, his conscious cerebrations were almost wholly devoid of visual imagery, although he remembered being capable of visualization as a child and still experienced it while dreaming. According to Rivers, the loss of his childhood capacity to picture could be understood as part of the process by which he had become especially interested in abstract matters, and had, therefore, devoted less attention and interest to the concrete world. One of the major motivations of much of Rivers' scientific work seems to have been to understand mental processes based on visualization, a type of thought which he himself was apparently no longer able to consciously perform. (Langham 1981: 54)

 It will be appreciated that, in his diminished ability to visualize, Rivers was a living example of the Spencerian hypothesis. It was no conceit for him.

3. Rivers had a thing about vision, to be sure. However, he was also a stammerer, a fact ignored by Grimshaw, but one which certainly had an impact on his life (see Slobodin 1978: 8). His sexual orientation was also indeterminate, or to put this another way, as repressed as his visual imagination. It would further appear that Rivers had a thing about skin: over the course of 167 sessions in his rooms at Cambridge between April 1903 and October 1907, Rivers was involved in an experiment concerning the recovery of tactile sensitivity through nerve regeneration. His research partner for this experiment, Henry Head, had the nerves in his left forearm severed so that he could track and describe the process of

regeneration first-hand; Rivers administered pricks, made measurements and took notes. This experiment with and on his close friend Head absorbed Rivers deeply. Out of it there emerged a theory of the protopathic versus epicritic mechanisms of the skin (known as the Head-Rivers Hypothesis), which Rivers continued reflecting on and embellishing into a general theory of sensibility and of the differences between the mentality of 'primitive' and 'civilized' peoples (Slobodin 1978: 31–3; Langham 1981: 57–78). All this to say that filtering the interpretation of Rivers's life and work through the lens of his (alleged) fixation on the visual risks obscuring the no less important role of certain nonvisual senses (namely the cutaneous senses and speech) both with respect to the shaping of his character and to his scientific interests and output. Incidentally, it would be fascinating to compare the Rivers-Head friendship with the Freud-Fliess friendship since these intellectual (and erotic) partnerships served as the crucible for the generation of theories that would have a profound impact on Western psychology (see Howes 2003: ch. 7).

4. Of course, Malinowski's gaze was not so innocent, as we learned from his posthumously published diary. Furthermore, there was actually a problem with his 'visionary eye': for example he espied what he took to be the 'big picture' of the kula ring when he should have been listening, as discussed at length elsewhere (Howes 2003). There is, moreover, some question regarding the extent to which Malinowski's sensibility actually differed from that of Rivers's

Consider Malinowski's psychophysical understanding of himself during his initial fieldwork, described in his diary. He consistently represented his feelings in Riversian—[or what we have been calling Spencerian] . . . terms. Journeying by ship, he reported: 'Lay in euthanasian [sic] concentration . . . living only by the five senses and the body (through impressions) causes direct merging with surroundings.' And he identified his frequent lapses from his ideal moral standard as descents into sensuality . . . [for example,] when he had no 'energy to get to work', his 'moral tonus [wa]s also considerably lower,' he succumbed to 'lecherous thoughts,' and his 'metaphysical conception of the world [was] completely dimmed'. (Kuklick 1998: 179)

Thus, underlying the ostensibly opposed 'visions' of Rivers and Malinowski there persisted a common (very Victorian) sensibility. All this to say that Grimshaw's overwhelming focus on the visual sometimes occludes as much as it reveals. Incidentally, Malinowski's life and work would be a fascinating subject for a sensory biography, such as has been attempted elsewhere for Freud and also for Marx (see Howes 2003: ch. 7 and 8).

5. See notes 3 and 4 for some indication of the occlusions which result from too strong a fixation on vision.

6. 'Il n'y a pas de hors texte' was a favourite slogan of poststructuralists at the time.

7. This was supposed to be more of a problem when testing European populations, because of the presumed inverse relation between the development of higher and lower functions, but it would still interfere with the drawing of comparisons, and so had to be 'controlled'.

8. Judith and David MacDougall parted ways after filming *Photo Wallahs* (see Grimshaw 2001: 145).

9. One can track this transition by following the changing meanings attached to camera angles and movements. In MacDougall's observational cinema stage, these signify his having 'genuinely been there' (according to Grimshaw), in his conversational cinema stage they indicate

'perspective', and in his sensational cinema stage they index 'the presence of the filmmaker's body' (see MacDougall 2006: 26–8, 54).

10. See 'Screening the Senses' (Howes 2008) for a discussion of how some senses get screened out in the process of transposing the lived into the filmed.

11. For a discussion of how writing may do a better job at conserving 'the parity of the senses' (MacDougall 2006: 60) than film see Howes 2003: 57–8.

12. Thus, MacDougall makes many keen observations concerning the interrelations of the senses in *The Corporeal Image* (see e.g. MacDougall 2006: 29, 42), albeit mainly limited to what could be called 'the film senses' of vision, audition and kinesthesia.

13. This opening in the direction of the 'other' senses from within visual anthropology dovetails with the rise of sensory anthropology (see Howes 1991; Classen 1993, 1997; Geurts 2002; Robben and Sluka 2007), which also has its roots in a critique of the hypertextuality of mainstream anthropology in the 1980s (Howes 2003), but is also somewhat more wary of relying on visual technologies like the camera to free the ethnographic imagination.

14. Those interested in following the results of the Mediations of Sensation project are invited to do so by periodically visiting the 'Senses' Web site at http://www.david-howes.com/senses/MediationsofSensation.htm and the labxmodal Web site at http://xmodal.hexagram.ca/.

REFERENCES

Banks, Marcus and Morphy, Howard, eds. 1997. *Rethinking Visual Anthropology*. New Haven, CT: Yale University Press.

Barker, Pat. 1997. *Regeneration / The Eye in the Door / The Ghost Road*. New York: Quality Paperback Book Club.

Classen, Constance. 1993. *Worlds of Sense: Exploring the Senses in History and across Cultures*. London and New York: Routledge.

Classen, Constance. 1997. 'Foundations for an Anthropology of the Senses', *International Social Science Journal*, 153: 401–12.

Classen, Constance. 2005. 'Touch in the Early Museum', in Constance Classen (ed.), *The Book of Touch*. Oxford: Berg, 275–86.

Classen, Constance. 2007. 'Museum Manners: The Sensory Life of the Early Museum', *The Journal of Social History* 40(4): 795–814.

Clifford, James. 1983. 'On Ethnographic Authority', *Representations*, 2: 118–46.

Clifford, James. 1986. 'Introduction', in James Clifford and George Marcus (eds), *Writing Culture: The Poetics and Politics of Ethnography*. Berkeley: University of California Press, 1–26.

Clifford, James and George Marcus, eds. 1986. *Writing Culture: The Poetics and Politics of Ethnography*. Berkeley: University of California Press.

Fabian, Johannes. 1983. *Time and the Other: How Anthropology Makes Its Object*. New York: Columbia University Press.

Geertz, Clifford. 1988. *Works and Lives: The Anthropologist as Author*. Stanford, CA: Stanford University Press.

Geurts, Kathryn Linn. 2002. *Culture and the Senses: Bodily Ways of Knowing in an African Community*. Berkeley: University of California Press.

Gosden, Chris, Frances Larson, and Alison Petch. 2007. *Knowing Things: Exploring the Collections of the Pit Rivers Museum, 1884–1945*. London: Oxford University Press.

Grimshaw, Anna. 2001. *The Ethnographer's Eye: Ways of Seeing in Modern Anthropology*. Cambridge: Cambridge University Press.

Grimshaw, Anna. 2005. 'Eyeing the Field: New Horizons for Visual Anthropology', in Anna Grimshaw and Amanda Ravetz (eds), *Visualizing Anthropology*. Bristol: Intellect, 17–30.

Grimshaw, Anna. 2007. 'Reconfiguring the Ground: Art and the Visualization of Anthropology', in Mariet Westermann (ed.), *Anthropologies of Art*. Williamstown, MA: Sterling and Francine Clark Art Institute, 195–220.

Grimshaw, Anna. 2009. 'Rethinking Observational Cinema', *Journal of the Royal Anthropological Institute* (n.s.), 15: 539–56.

Grimshaw, Anna and Amanda Ravetz. 2005. 'Introduction', in Anna Grimshaw and Amanda Ravetz (eds), *Visualizing Anthropology*. Bristol: Intellect, 1–16.

Haddon, A. C., ed. 1901. *Reports of the Cambridge Anthropological Expedition to Torres Straits*. Cambridge: Cambridge University Press.

Howes, David, ed. 1991. *The Varieties of Sensory Experience: A Sourcebook in the Anthropology of the Senses*. Toronto: University of Toronto Press.

Howes, David. 2003. *Sensual Relations: Engaging the Senses in Culture and Social Theory*. Ann Arbor: University of Michigan Press.

Howes, David. 2008. 'Screening the Senses', in Rob van Ginkel and Alex Strating (eds), *Wildness and Sensation: Anthropology of Sinister and Sensuous Realms*. Apeldoorn, Netherlands: Het Spinhuis, 295–315.

Jay, Martin. 1993. *Downcast Eyes: The Denigration of Vision in Contemporary French Thought*. Berkeley: University of California Press.

Kuklick, Henrika. 1998. 'Fieldworkers and Physiologists', in Anita Herl and Sandra Rouse (eds), *Cambridge and the Torres Straits: Centenary Essays on the 1898 Anthropological Expedition*. Cambridge: Cambridge University Press, 158–80.

Langham, Ian. 1981. *The Building of British Social Anthropology: W.H.R. Rivers and His Cambridge Disciples in the Development of Kinship Studies, 1898–1931*. Dordrecht: Reidel.

MacDougal, David. 2005. *Film, Ethnography, and the Senses*. Princeton, NJ: Princeton University Press.

Marcus, George and Dick Cushman. 1982. 'Ethnographies as Texts', *Annual Review of Anthropology*, 11: 25–69.

McDougall, William. 1901. 'Cutaneous Sensations', in A. C. Haddon (ed.), *Reports of the Cambridge Anthropological Expedition to Torres Straits*, vol. II. Cambridge: Cambridge University Press, 186–204.

MacDougall, David. 2006. *The Corporeal Image: Film, Ethnography and the Senses*. Princeton: Princeton University Press.

Pink, Sarah. 2006. *The Future of Visual Anthropology: Engaging the Senses*. London: Routledge.

Richards, Graham. 1998. 'Getting a Result: The Expedition's Psychological Research 1898–1913', in Anita Herl and Sandra Rouse (eds), *Cambridge and the Torres Straits: Centenary Essays on the 1898 Anthropological Expedition*. Cambridge: Cambridge University Press, 136–57.

Rivers, W.H.R. 1901. 'Introduction and Vision', in A. C. Haddon (ed.), *Reports of the Cambridge Anthropological Expedition to Torres Straits*, vol. II. Cambridge: Cambridge University Press, 1–78.

Rivers, W.H.R. 1905. 'Observations on the Sense of the Todas', *British Journal of Psychology*, 1: 321–95.

Rivers, W.H.R. 1906. *The Todas*. London: Macmillan.

Rivers, W.H.R. 1920. *Instinct and the Unconscious*. Cambridge: Cambridge University Press.

Rivers, W.H.R. 1923. *Conflict and Dream*. London: Kegan Paul.

Robben, Antonius and Jeffrey Sluka, eds. 2007. *Ethnographic Fieldwork: An Anthropological Reader*. Oxford: Blackwell.

Slobodin, Richard. 1978. *W.H.R. Rivers*. New York: Columbia University Press.

Srivastava, Sanjay. 2007. *Passionate Modernity: Sexuality, Class, and Consumption in India*. London: Routledge.

Stoller, Paul. 1997. *Sensuous Scholarship*. Philadelphia: University of Pennsylvania Press.

Tyler, Stephen. 1986. 'Post-modern Ethnography', in James Clifford and George Marcus (eds), *Writing Culture: The Poetics and Politics of Ethnography*. Berkeley: University of California Press, 122–40.

Seven Theses on Visual Culture: Towards a Critical-Reflexive Paradigm for the New Visual Studies

BARRY SANDYWELL

Many recent theoretical perspectives and critical-analytical approaches to visual perception and visual culture have implicitly or explicitly defined some of the conceptual contours for a more radical transdisciplinary approach to visual studies. The following presentation attempts to articulate some of the operative presuppositions for a critical and reflexive paradigm of research in the emerging field of the New Visual Studies. The themes are formulated in seven generic theses that are partially elaborated in corollary theorems, arguments and speculations. These all revolve around the interplay between our consciousness of images and materializations of image consciousness operating prior to all theorizing and disciplinary projects. Needless to say this schematic presentation should be viewed as an invitation for further thought and, in the light of this, more concrete specification and development.

THE HISTORICITY THESIS

The historicity thesis holds that history (or 'historicity') enters into the fabric of visual phenomena to shape diverse frameworks of visual experience and, correlatively, that models of visuality generate different configurations of virtual existence and cultural experience.

1. What is called 'seeing' or 'vision' has a history. This elementary thesis claims that what is deemed to be 'phenomenal', 'natural', and 'universal' is in reality shaped by historical conditions and local social arrangements. Like social practices in general, seeing is located in and dependent upon pre-given systems of meaning and institutional contexts. The universe of the perceptible—and,

thereby, of the conceivable, believable and knowable—is already articulated in particular language-games, discourses and other technical apparatuses (these might be called 'practices of seeing').

2. As these material contexts implicate complex social and semantic histories they invite *genealogical* questions concerning the diverse functions of images, image techniques and image consciousness as these inform the changing texture of human experience. Given the *temporality* of perception it follows that every domain of the visible (and in principle every form of research into the visible) is *finite* and *time-dependent*. As the contingent structures of phenomenenality display an irreducible temporal dimension even the most vivid act of seeing—whether in real-time perception of objects, in inner cognition, or in acts of reading and cultural criticism—'takes time' and this ineluctable 'interval' discloses constellations of signifying effects that shape the constructive possibilities of physical, personal and social experience.

3. As an *appropriation* of the world, every perception contains memories of earlier perceptions. Seeing—visual consciousness—is contextual, modal and plural. Each act of perception depends on prior contexts of meaning, forms and rituals that are destined to be overtaken by future, hitherto unanticipated, acts of meaning. If seeing is both a *belated* praxis and a *projective* site of intentional activity then there are innumerable ways of viewing, an indefinite number of 'eyes' and *incommensurable* perspectives correlated to different interpretive communities (consider, for example the *similarities* and *differences* between utopian visions, theological contemplation, the philosopher's gaze, scientific observation, the clinical inspection, ethnographic seeing, the lover's look, the optic of childhood, technologically expanded perception, etc, etc). Under analysis each of these 'perspectives' turns out to be a particular historical and cultural experiment in imaging that invites historical and sociological investigations of the changing dynamics of image practices. Images not only reflect social life but also in complex ways mediate and change social relationships. What are commonly called 'images' are in reality *symbolic processes* embedded in particular life-worlds (what we call 'world' is more accurately defined as 'imagined worlds').

4. As a *spatiotemporal signifying event* seeing can function as a reminder of the impossibility of pure knowledge. Given its obsession with *objects* as visual *things* rather than with *processes of envisioning*, the history of Western philosophy could be productively rewritten in terms of the framing of sense-perception and, in particular, the sense perception of everyday things as a model for experience in general (Sandywell 2011). Such a history would necessarily take the form of a reconstruction of noncommensurate theories of ordinary perceptual experiences of things. The still-point in this diachronic multiplicity is the *functionality of the image* or the universe of *real virtuality* invoked by different theories of perception and knowledge. Such a reconstruction would also reveal how every discipline that has tried to conceptually delimit vision—philosophy, aesthetics,

psychology, sociology, poetics, phenomenology and so on—implicitly draws upon particular images of *imaging* (and thereby, *imagination*) in its analytical strategies and programmatic perspectives. Hidden behind all the academic paraphernalia, the basic gesture of disciplinarity is one that elides the myriad possibilities of image processing to promote a single conceptually privileged *way of seeing*—what might be called the *rule of a conceptual optic*. 'Disciplinarity' *means* normatively *envisioning* phenomena as 'phenomena worth studying' by real and projected communities through particular *conceptual instruments*. And the paradigmatic instruments of *envisioning* are historically situated *metaphors* and *concepts* drawn from particular images of visual life (images that exploit the *reflexive citability* of a 'seeing of seeing', an 'imaging of images', 'instancing of a generality', 'exemplifying a genre', etc). In this way all disciplines impose a *conceptual* diagram upon both their investigative objects *and* their prospective audiences ('seeability', 'observability', 'analysablity', 'reportability', 'readability', 'interpretability', 'criticizability', etc all being diagrammatic visual capacities). A discipline's research horizon is constituted by a promissory rule of verbal *and* visual translation: 'Speak like this and you will see *these* phenomena'. But being primarily object-focussed, disciplines rarely disclose and reflect upon the temporal-historical structure of their own conceptual operations (they are, in effect, silent about their translation and interpretive procedures). By *reverse engineering* this process of envisioning we can restore the *act-character* of vision as a *seeing-through imagery* and take the first step towards a *reflexive cultural paradigm* premised upon the *plurality* and typical *incommensurability* of visual translations of reality.

5. If there can be no *pure seeing*, if we *see* through *historical* eyes, being attentive to historicity transforms every substantive topic and theoretical perspective in visual research into an index of a *genesis of meaning* and, more specifically, a *genesis of memory, subjectivity* and *sociality understood as social processes*. As 'reality' is always something *appropriated, interpreted* and *envisioned*, all 'thinking' about the visual is already indebted to the visuality of thinking: no discipline ever simply *gazes* at objects as though through a transparent medium; objects are always *mediated*, always *half-known things*, entities that never shake off their aura of unknowability. Individuals have to *learn* to see, just as they have to be *trained* to *attend* to what is revealed in perception. When approached as a *process* every act of perception—like every act of reading and writing—bears the traces of violence and decision (more particularly in the 'cuts' that separates *this* act of seeing from alternatives and from the horizontal possibilities of things yet to be seen and things unseen). By means of cultural reverse engineering *subjectivity*—or, if you will, *materialized consciousness*—is restored to every process of objectification. If cultures change as old ways of seeing, reading and remembering are replaced by new forms of visual knowledge so 'cultures of inquiry' display an analogous hermeneutic pattern of displacement. For example what is now called 'science'—including social science—developed as a

long historical struggle to re-see and re-interpret the world through analytical, objectivist, causal lenses (modes of perception whose existence was purely hypothetical and 'unthinkable' prior to their concrete actualization). And to see 'objects' scientifically—to observe, classify and analyse phenomena—also meant to desist from seeing objects in mythical, theological and everyday cultural frames antedating the birth of science.

6. If we see *in* and *through* such normative practices and imaginative forms (where *praxis*, *poiesis* and *episteme* belong to the same dialectical constellation) it follows that any critical programme of visual studies must investigate the situated eventfulness, plurality and heterogeneity of *practices of seeing*. 'Practices of seeing' are thus not primarily passages or relays conveying significance from object to subject. Rather, as multidimensional networks, practices *constitute* the material space for such abstract entities like subjects and objects ('readers', 'writers', 'interpreters' and so on are both the outcomes and agencies of such networks). Once we accept the idea that perception is more than a natural *faculty* we also see that there can be no immediate *seeing* or direct *visual meaning* that could bring the world to presence untouched by sociocultural instruments. When extended to the realm of culture as a whole this thesis entails that there can be no uniquely privileged image, presentation or re-presentation without *mediation* (of concepts, technical devices, discursive and nondiscursive practices, interpretive communities, ideological formations, cultural frameworks, brain circuitry and so forth) and therefore without *repetition*: every 'inspection' is also a 'retrospection', every image a re-imagining, every perception a memory. From this reflexive perspective 'culture' is a misnomer for 'mediated cultures' (just as 'visuality' is better understood as shorthand for 're-mediated visualities'). This interpretive principle makes every critical investigation of the complex grammars governing the semantic field of vision (or visualities) in both everyday life and vision-oriented discourses a primary research priority.

7. Vision is not what you think it is. This is the lesson common to a range of disciplines from cultural studies to neuroscience. Vision is more like a synaptic *link* in a complex network than a self-standing presence. We have to radically re-imagine the functions of visual consciousness more dynamically as simultaneously sensory modality, metaphor and conceptual diagram. The semantic relations and multiplicities 'vision' enfolds suspend the consoling idea that there might be *one* answer to the question, What is it *to see*? Here we can extend what Guglielmo Cavallo and Roger Chartier claim about *reading*, that seeing 'is not a solely abstract intellectual operation; it involves the body, is inscribed within a space, and implies a relationship to oneself or to others' (1999: 4).

8. Thinking concretely we could say that where individuals *see* with their senses, cultures 'envision' through their collective memories, metaphors and technical diagrams. Rather than naturalizing 'seeing' we should think in terms of

changing 'scopic regimes', historically variant modes of organizing observation and perception of the world. Transform a society's *practices of seeing*—its *ways of meaning*, symbolic frameworks and institutionalized traditions—and you change the meaning of historical situations and the terms of sociocultural experience. To first *see* we already have to have *imagined*. Seeing is a thoughtful repetition, or rather, an iterable possibility of materialized imagination (where, for example we might view social institutions as imaginary diagrams). This accords the work of imaginative metaphor a fundamental *cognitive* role across *every* sphere of meaning (revealing the forms and contents of culture as heterogeneous topographies of creative symbolic praxis). When understood literally the historicity thesis—and more specifically the thesis of the historicity of cultures of inquiry—facilitates the construction of new objects of thought, conceptual frameworks and research methodologies untrammelled by current disciplinary boundaries. One of these problematics is the cluster of reflexive questions developed by the emerging paradigm we call New Visual Studies.

9. A central contention of the new visual studies movement is that it is the work of *situated imagination*—what Greek culture calls *poiesis* and what German philosophy calls *Dichtung*—that has created the visible and not the visible that controls the imaginable. From this perspective the discourses of theory—like the language-games of everyday life—are themselves crafted from ancient forms of *poiesis* and figuration that are already at work in the material processes of human embodiment. Like language itself, visual consciousness and theories of the visible are the outcome of congealed poetry. The world is not passively waiting to be seen (appropriately denigrated as 'the myth of the given' or the ideology of immaculate perception); rather what we call 'world' has always-already *been seen*; what we see and what we call 'world' is pre-given within the terms of some interpretive framework. We might more usefully think of seeing as a type of cultural *mapping* or *diagramming* responsive to wider changes in values, discourses and cultural experience. And, in principle, there is no *original* map or diagram (just as in technical spheres there is no original blueprint). What passes for 'perceived reality' is itself a legacy of earlier imaging techniques *embedded in the human sensorium*. We could say that what is visible, observable and reportable is indebted to a densely interwoven matrix of neurons, memories and other imaging techniques (indexed in theoretical terms by the problematics of neurophysiology, phenomenology and technology).

10. The map analogy explains why seeing the world differently requires *work* and *self*-transformation. Seeing is like map-*making* (and like mapping it is motivated by cultural relevances, prior definitions of value and powerful interests in objectifying reality). If seeing is a mode of being-in-the-world the anticipation of seeing differently becomes foundational for the work of cultural criticism. As with other social practices we need to think of seeing simultaneously as contestation *and* tradition. Accepting the logic of reflexivity encourages a

generic social constructivist and hermeneutic orientation towards visual formations (indeed the term 'historicity' can be replaced in many contexts by the word 'constructive' and its derivatives). But we do not 'construct' from nothing (this would be one consequence of the myth of visual immediacy). Rather, we see *in medias res*. We *construct* meanings from within the dense materiality of things, events and relationships as these have been imagined and institutionally embodied. The latter formations—in their 'obviousness'—have been typically neglected by the dominant paradigms of visual research—especially the material conditions of visuality, everyday visual technologies, gender differences in seeing, the functionality of grammar, cognitive scripts and narrative logics and so forth. Here the historicity thesis operates as an *ethical* incentive to interrupt the scientistic and technocratic stories informing previous forms of inquiry within the human sciences and to imagine more creative models and metaphors that are capable of recovering visual worlds lost to social theory and philosophy. In place of third-person ontologies the New Visual Studies commend pragmatic, transactional and reflexive narratives of the complex *cultural* life of seeing.

11. In the light of this turn towards the *materiality of visual experience* it is not surprising that many of the new cultural methodologies—semiotics, psychoanalysis, deconstruction, genealogy, cultural studies, feminist research, ethnography, multiculturalism, cognitive science and so forth—have framed their analytical tasks as *acts of material anamnesis*. Memory, recollection and the recovery of lost objects and worlds then assume a more fundamental role in critical self-reflection. With the insight that an archaic past still haunts the scenarios of the present these forms of analysis commit themselves to the work of *recovering* and *translating* worlds of experience that have been occluded by traditional approaches or repressed by ideologies and dominant power structures. A shared interest in *anamnesis*—in deconstructing, reconstructing and translating past worlds—has opened dialogues between new visual research, poetry and poetics, literature, neurophysiology and some of the more innovative explorations of postcontinental reflexive philosophy. The New Visual Studies promises to become an exemplary site of the radical social and hermeneutic 'turn' of contemporary postanalytical thought.

12. If the existential significance of every form of visibility is contingent upon neurophysiological networks, social contexts, historical meanings and political appropriations then different cultural self-definitions of visibilization—different *ways of seeing*—enter into the self-understanding of human action, individuation and community. Here the active role of visualization techniques in different societies (or earlier phases of the same culture) prove to be central to the project of human self-understanding (e.g. the critical confluence of a range of visualization technologies that contributed to the constitution of the nation-state and national identities with the coming of modernity). How different historical societies have *seen* their worlds, *articulated* images of life, and

projected *possible futures* in concrete activities becomes a central research topic in the study of *sociocultural change*.

13. An important consequence of these recursive complexities is a renewed appreciation of the *constitutive* function of *images* and *imagination* in the self-constitution of bodies, selves and social worlds. The *self*—a person's style, comportment and mode of embodiment—is revealed in a way of seeing. What was once merely a romantic ideology—the celebration of the creative ego and the struggle for identity—can now be translated into a systemic programme of critical research. The paradoxical thought also follows that the world is always something *yet to be seen*.

14. The constructivist-hermeneutic orientation applies in principle to its own organizing metaphors, procedures and textual practices. We find the Möbian loop that the topic and the analytical resources of visual analysis are both woven from practices of seeing. The general thesis stipulates that the 'historicity of the visual' should be reflexively turned back upon the situated processes of research into visual phenomena. Visual structures only become accessible through visual means (just as we can only *read* maps if we understand the idea and uses of mapping). Thus how different theories and conceptual frameworks have 'seen' the world can also be treated as question-worthy—and questionable—phenomena in their own right. This reflexive imperative becomes especially crucial where the disciplines of art, art history, art criticism and academic visual research have actively contributed to the great transformations that inaugurated modernity and the cultural changes that implemented reflexive practices and energies within increasingly globalized forms of life. In the light of these transformations traditional conceptions of what it is to be human have to be rethought and this process of reconfiguration needs to be viewed as a consequential *reflexive* variable in the contradictory dynamics of modern life. In ethical terms, we have to accept *responsibility* for *how* and *what* we see.

This ethical dimension further underlines the *radical* involvement of the *self* and *self-cognition* in the constitution of visible worlds and thus the vital importance of exploring 'techniques of subjectivation' (or subject formation) as specific historical-technological-political processes. In this context almost every form of postcritical inquiry has come to the conclusion that images and image technologies (icons, image flesh, image systems, imaginary formations, multimedia, ideological figurations and so on) have a powerful *ontological* role to play in the formation and (de)formation of selfhood, social relationships and life-worlds. The restricted and one-sided approaches to seeing and vision that have operated in the philosophical tradition are turned into *questions* rather than 'applied' as neutral instruments of thought. What began life as an imaginatively projected 'virtual reality'—for example the projective ideas human agents have of their own activities and selves—ends up institutionalized as 'real virtuality'. By reversing this process we may experience the 'shock

of the old' as an incentive to re-envision the new by recovering the normative concerns and discourse formations of the old.

15. Visual worlds understood in their complex heterogeneity, discontinuous singularity and multidimensional concreteness are invariably contested sites of *values* mediated and mandated by power relationships. This applies to the world of the painting or poem as it does to the social relations of everyday life, subcultures and the larger structures of society. To become real 'selfhood' has to be envisioned. Hence the almost inevitable hypostatization wherever the 'self' is in question. Dominant forms of subjectivation operate by bringing perceived excess, extremes and threatening alterities to some norm of delimited order. *What* can be seen, *how* it is seen and *by whom* are subject to social control imperatives. Like the universe of affective life, the life of seeing also has to be carefully monitored and organized by institutional imperatives (here the rule of social control is, 'Not everything should be seen (spoken, thought, etc.)'). This is why the possible modalities of seeing are invariably differentially valued, distributed and normatively patrolled by political regimes (consider, for example the long history of patronage as a political economy that licensed and controlled 'legitimate' aesthetic representation or the equally contorted history of visual censorship and proscription). We thus anticipate the emergence of a transdisciplinary 'political economy' of image delimitation (or what some have called *political aesthetics*) as a central focus of visual inquiry.

 The investigation of historically specific visual worlds and correlated modes of subjectivation is itself a contested cultural terrain of practices (a situation characterized by alternative approaches to cultural life-worlds, different methodological translations, analytical perspectives and definitions of relevance). The effects of these contestations and interruptions—their active role in the genealogy of discourses, critical engagements, disciplinary traditions and so on—endure as traces in the orthodox problematics and writing styles of art history, aesthetic criticism and aesthetic philosophy as these have been institutionalized in academic debates about the arts, art education and the function of aesthetic objects in society. Even the traditional idea of a 'field' of specialized disciplines devoted to the objective investigation of visual objects is a particular historical ordering that both discloses and forecloses interpretive differences and possibilities. The writing practices and texts that these specialized disciplines have generated as normative orderings of visual phenomena become researchable topics for reflexive inquiry (e.g. as the study of how social ordering *glosses* discontinuity, interruption and alterity in everyday life to produce 'life as usual'). The systemic deconstruction of such institutional formations as 'canonicity', 'genre', 'disciplinarity', 'normal inquiry', 'methodic perspectives' and the like now takes centre-stage as part of a radically reflexive hermeneutics of cultural orderings.

16. In the light of this self-reflexive paradigm every traditional conception of aesthetics, art and art education needs to be transformed through a re-specification

of aesthetic knowledge and its social and ideological functions. We then ask not '*what* is art?' but '*when* is art?' and 'for *whom* are these objects, artefacts and performances art?' This becomes the working principle for a genealogy of the 'aesthetic self'. By bracketing the ideological signifier 'art' we begin the process of aesthetic deconstruction and re-specification of everyday aesthetics as one of the many dimensions of human action and cultural self-definition. The first phase of this re-visioning must be one that celebrates the historicity of art worlds (and today, art markets) and the mutable forms of aesthetic self-consciousness they both foster and inhibit. This critical reappraisal of 'aesthetic sensibility' necessarily moves beyond a traditional hermeneutics of art objects towards critical socio-historical genealogies focusing upon the dialectical relationships between image-making, sociality and human praxis as these are interwoven into the horizons of different interpretive communities. As the ancient roots of the term 'aesthetics' attest (as the 'science of the sensuous'), a new aesthetics will need to recover the affective and cultural embodiments of aesthetic experience as these are shaped by the multisensory formations of human activity. The reconstituted domain of such an embodied aesthetics must be capable of providing further instruments of contestation, self-reflection and criticism of social and ethico-political arrangements (in this sense even the classical 'discourse of beauty' with its emphasis on spectatorship and visual pleasure may yet retain its force as a resource for future projects of art practice and aesthetic experiment). A radical constructivist conception of visibilization thus promises to open creative dialogues between the politics of knowledge and the ethics of visualization as these operate in different societies and civilizations.

THE ARTEFACTUALITY THESIS

The artefactuality thesis holds that all visual objects, practices and institutions are socially constructed artefacts subject to situational analysis, deconstruction and revisionary transformation.

1. The conditions of visibility are not themselves visible. If we see through social eyes then historical forms of perception are specific to local cultures (and subcultures) and their *available technologies*. The topography of the visible is further mediated by ethical and political relations and representations (as powerful interests struggle to control and channel visual energies by regulating the visible and the invisible *in particular situations and for particular purposes*). We have suggested that one of the least noticed aspects of visual praxis is its remarkable ability to conjure order out of chaos (or rather, to *order* chaos for normative ends). Inversely, what has been *made* socially and *historically* can be 'unmade' through critique and social transformation. This process reveals the realm of subjectivity and the multiple *selves* that are correlated to different

practices of seeing and their material correlates (a visual space that is 'occupied' by no subject being a contradiction in terms).

2. We first encounter the visual order *in* and *as* the world of everyday *artefacts* and *structures* that provide the background contexts of human activities (social spaces, physical objects, visual representations, texts and so on). In this sense the larger part of material culture is organized around the *invisible orderings* of visible things. A material phenomenology of 'things visual' reveals the social applications, uses and appropriations of objects in the context of a diverse range of social transactions.

3. If different *orderings* of visual experience function as blueprints for broader *cultural formations* it follows that 'cultures of visibility' are necessarily contingent formations indebted to social imaginaries and circumstances that vary considerably in space and time (and one exemplary axis in such a history is the social regulation of what passes for 'aesthetic experience' in different societies). Just as individuals see the world differently (and to some extent inhabit different 'worlds') so whole societies and cultures carve out different sensory worlds and identities from the tactile, auditory, olfactory and visual possibilities of experience. Just as the living body feels itself into place prior to projecting itself in space so cultures first *imagine* a space of possibilities prior to colonizing these virtualities.

4. In understanding the dynamics of such affective life-worlds everything depends upon the *meaning* that individuals give to artefacts within the terms and practical orders set by a dominant political aesthetic as these are institutionalized in the transactions of everyday life. What is called 'ordinary life' turns out to be a heterogeneous intersection of cultural imaginaries, unrecognized desires and mundane pleasures (in this sense the term 'material culture' obscures the *embodied* and *affective* dimensions of artefacts and visual experiences that organize the routines and rhythms of everyday life). From this perspective 'ordinary life' assumes the appearance of the 'extraordinary'. What is deemed 'normal' and 'familiar' is, in effect, the charnel house of the imaginary.

5. Each social imaginary is also, from another perspective, an *economy of pleasure*. Affectivity—the economy of emotional life—is also subject to cultural-historical ordering. Bringing individuals into the space of familial, pedagogic and public life is first and foremost a work of *ethical-aesthetic* praxis at the level of primordial *affectivity*. Every acquired 'posture' and 'habitus' promises another map of the real, another way of seeing. New members of a community are just as subject to figural shaping and stylization as any material artefact. How a community imagines and represents its 'other', how a society normatively distributes its zones of pleasure, how it constitutes *practical* ontologies of alterity are highlighted as fundamental topics for a reflexive programme of visual research. Here the issue is not how we see, but how we *come to see* and *not to see* the mundane realities of ordinary life.

6. Once this bracketing of taken-for-granted visual knowledge has been effected we may approach the architecture of the visible as grounded in particular image constellations. The genealogical project of an 'archaeology of the visible'—itself part of an archaeology of pleasure and historical subjectivation—is one such reflexive domain within a wider theoretical investigation of world-making signifying praxis.

7. The investigation of the *concrete cultural* functions of visual artefacts and media in constituting human selves and life-worlds (what might be called the constitutive function of *symbolpoiesis* in subjectivation practices) becomes a priority for future historical, sociological and cultural analyses. What conventional social theory simply accepts as 'subjects' and 'objects' are now seen as the phenomenal outcomes of imaginary processes of subjectivation and objectivation (e.g. in the widely differing forms of human embodiment, in the transition from fixed status selfhood into the mobile selves of urban and metropolitan cultures or the symbolic constitution of 'nationhood'). How a culture imagines 'nature' and 'human nature'—indeed how it projects 'being' and 'being-in-the-world'—becomes a *problem* and researchable *question*. How is 'nature' envisioned? How are the differences between natural orders and artificial orders themselves visualized? How are visual representations of nature (and human nature) articulated by the arts and sciences?

8. How individuals and collective actors 'view' others and themselves, how identities and 'otherness' are translated and codified in social roles and practices, how whole societies come to normatively objectify the 'alterity' of others all belong within the general problematic of social legibility. Here the ethics of visuality, the phenomenology of social recognition, and the sociology of urban space converge in a reflexive ontology of social reality. Prior to all formalized 'visual practices' a child already lives in affective, sensory and imaginary worlds that have been stylized and configured through visual schemata. Learning to live and interact in a particular life-world is a process of acquiring the competences governing orientations towards artefacts, objects and persons. A large part of everyday enculturation—what sociologists call *socialization*—coincides with the translation of *past* practices of visibilization into contemporary social forms. Once established these acquisitions function as a corpus of 'normal' or 'everyday' knowledge, a situated pragmatic repertoire that also involves an 'un-learning' of earlier affective intentionalities and world orientations. The very ubiquity of such *normalized* visual practices in everyday life suggests that regimes of visibility have a powerful—if subterranean—role in shaping selves, social relations and institutions (this ranges from the banal observation that every form of social action and interaction presupposes the visibility of objects and bodies as normatively prescribed fields to the more disturbing idea that visual worlds are already shaped by ideological forms and power relations). Something like vision machinery is already at work in the organization of both personal life and public space (machinery that is most visible in the imaginary formations of sacred practices and religious institutions).

9. As visual media and practices are themselves cultural artefacts saturated with the effects of technological apparatuses they defy analysis in terms of the standard divisions of 'verbal' and 'visual', 'discursive' and 'figural', 'word' and 'image'. Most so-called *visual* practices are in reality dense configurations of images, sounds and text linked to the major pleasure zones of a society. Thus whole realms of 'art' turn out to be instances of densely *implicated practices* (involving configurations of media, performances, material objects, relations of patronage, commercial instruments and the like). By unconsciously operating within an ocularcentric worldview we tend to spontaneously oppose the image to graphic phenomena (photograph *and* text, image *and* word and so on) forgetting that at root both presuppose a common image ontology. We should recall that reading and writing are themselves visual (and, indeed, manual) competences. The 'world of literacy' as this has been organized by powerful institutional apparatuses is at base a continuous circulation of word-images and related behavioural and cultural diagrams. Such 'audio-visual' image flows are inherently dynamic, mediated political formations (we might compare the premodern medieval world of theocentric image economies with the expanded circuitry of transnational capitalism as a social constellation where, verbal signs operate in symbiosis with complex iconic displays such as billboards, advertising brands, designer artefacts, newsprint, Web pages and global logos). The ever-expanding circuitry of image flows becomes inseparable from the wider economic, political and cultural 'logics' at work in the worldwide organization and regulation of visual space. We anticipate that future theorizations of these dynamic topographies will only be possible along the lines of an expanded sociocultural theory of image-production, reproduction and appropriation (that does not coincide with semiotics, sociology or social theory as these are currently understood). As a uniquely *social* constellation we can project an expanded and historically sensitive *visual rhetoric* as one of the key transdisciplinary domains within the new visual studies.

10. Social space is necessarily visible space. In fact every social space is an empirical force field of discontinuous zones of transcendence. This does not simply mean that visual objects are a subset of sociocultural objects. Rather, visualization practices range across every form of social objectivity, including the most abstract and virtual relations and systems. Whatever their provenance, social institutions and social worlds necessarily project themselves *as* visual worlds (as institutionalized ways of seeing and being seen). And the instruments involved in this projection are quite mundane devices—material objects, conversational practices, vectors of pleasure and pain, everyday rhetorics and the like. As the outcome of specific signifying practices social worlds are already saturated with reflexively accessible local knowledge and interpretive repertoires. Thus members of particular visual worlds do not have to be instructed about appropriate visual codes, practical activities and translation activities. They are, as sociologists say, always-already reflexive actors spontaneously drawing upon practical competences and interpretive skills in making sense

of their activities. It follows that the sociocultural diagrams that order social life are invariably dialectical logics of visualization bound up with the construction of identity and differential presence understood as negotiated and contested symbolic processes. Here the symbolic construction of shared spectacles, image screens, and visible spaces plays a fundamental role in the constitution of social life as well as in every attempt to gain systematic knowledge of social reality. But this work of mundane construction can never be considered complete or free from conflicts and contradictions. For example how a community distributes its population into social categories and ranks invariably assumes the form of visible classifications and symbolic representations. Demographic sets and relationships are by definition socially constructed 'objectivities' imposed upon subjects who spontaneously resist classification in and through their concrete mapping practices.

11. The process of symbolic categorization and ordering makes social space both real and virtual, both material and ideal (to such an extent that individuals come to accept that they live in a particular locality, eat and dress in particular ways, are members of a family, participate in ritualized practices and so on). At root all of these quasi-spatial orderings are social *fictions* that organize bodies and social relationships into intelligible structures (e.g. the symbolic and iconic fashioning of the idea of a 'people' or 'society'). The repertoires of self-understanding available to a society are further mediated and fictionalized through the constructive operation of image apparatuses (what can be envisioned by a given historical society or civilization depends on the cultural cartography of visualizable zones). In an increasingly digitalized world such topographies increasingly assume the form of virtual geodemographic systems wired up to governmental, corporate advertising and commercial marketing interests. Everyday forms of 'social literacy' then take the form of an ability to navigate these emergent societal networks (suggesting perhaps that historically there has always been a complex dialectic between practices of social and visual legibility). As with early forms of sociocultural change it is only from the vantage point of the emerging world of hypervisuality that we gain perspective upon earlier attempts to create national and transnational regimes of the visible.

12. The artefactuality thesis provides an analytical context for the plausible idea that of all visual technologies photographic inscription has defined the modern age in all its violence, horror and wonder. The etymology of 'photography'—*light writing*—is itself a clue to an unanticipated future of image techniques concerned with fixing the flux of events into precise, if unfathomable, images. Hence if the iconic events of the twentieth century are invariably dramatized as photographed occasions, the iconic events of the twenty-first century will be celebrated as mobile digital images. Given photography's democratic promiscuity and media ubiquity these speculations also suggest why modern culture displays its surfaces in sprawling, undisciplined, heterogeneous series of

personal and collective memories. It has become impossible to imagine the effects of 'thinking away' the mediations of photographic and cinematic images from recent history. Here we simply note the important research topic of the ubiquitous role of digitally mediated identities and memory cultures in contemporary society. The digital mobilization of photography in the form of the iPhone and related mobile communication machines promises to radically transform the practice of photographic activity and social organizations linked to photographic representation (visual design, reportage, photo and video journalism, civic journalism, publishing, social research, biographical archiving, Internet social Web sites, blogging and so on). In this context the problematics of individual, familial and collective memory become unavoidable topics for a reflexive investigation of how new media technologies have reorganized what we know as everyday life.

THE LANGUAGE THESIS

The language thesis holds that visibility is correlated to the field of language and is as discontinuous and heterogeneous as the spectrum of available language-games in a given society.

1. Language (whether as dialogue, communication or discourse) is fundamental to research in visual fields. The idea of historicity thus extends to the languages of seeing and the grammars of visual experience (see Sandywell 2011). Visibility is typically constructed in and displayed by a diverse series of image practices governed by specific, and often divergent, 'codes'. Image artefacts (graffiti, writing, symbolism, photography, material design, architectural styles, dress codes and fashion, the moving image, aesthetic ideologies, computer-generated images, etc) enter into the circuitry of language that diagrams the virtual life of a culture. If the meaning of 'language' can be extended in this way then what is called 'seeing' is already saturated with the work of signs, emblems, insignia, masks and other diagrammatic symbols. From this perspective verbal and nonverbal media appear as signifying workshops—virtual laboratories—where new forms of visibility and visual pleasures are forged (where, for example, the discourses of poetry and literature generate visual experience and produce visual formations for particular audiences). While visual codes tend to be transinstitutional in their functions, subuniverses of a culture typically display their own distinctive styles of visualization and iconic discourse (hence the 'graphic' dimensions of visual media expressed in words such as photo*graphy* and cinemato*graphy*).

2. The grammar of images needs to be analytically distinguished from the linguisticality of verbal communication. Visuality is not merely another department subsumed under the logic of signs. As a working hypothesis we might propose that each subuniverse of meaning is governed by its own particular

structure of visual schematization through which it objectifies and actualizes lines of possible action and symbolic performances (which then function as idealized spaces of normative activity for wider social constituencies). Parallels, homologies and transpositions across such sense-making universes will inevitably be strained (consider for example the classical problems generated by attempts to reduce the 'languages' of photography and cinematography to classical questions of mimesis and realistic representation or, inversely, attempts to think of 'literature' as purely pictorial in its operations). The precise structure of the grammars governing such universes—neural cognition, everyday perception, art, architecture, photography, scientific modelling, technical design, themed worlds and so on—will need to be delimited *prior* to empirical research within and upon these worlds.

3. Whatever the final resolution of these semantic and philosophical relationships may be we can say that research into the logics of cultural diagrams will play a central role in new visual studies theory. We might even suggest that in genealogical and developmental terms the *regime of the image*—the diagramming of social imaginaries in and through iconic symbolisms—*antedates* all verbally based semiotic and cultural formations. This revaluation of the mimetic faculty might occasion a comprehensive rethinking of the denigration of symbols and symbolic consciousness in social thought. What are the evolutionary links between visual 'signing' and linguistic signs? How do visual signs acquire symbolic functions? What are the social functions of images? Why are words lacking for phenomena that are half-word and half-image? The fact that such hybrid visual diagrams are pervasive and 'normal' in the ordering work of modern societies (in advertising logos, objects covered with text, signs on building facades, architectural monuments, instruction manuals, etc) perhaps explains why visual phenomena have rarely been studied as topics in their own right. What such hybridized phenomena have in common is a shared indebtedness to material diagrams and diagrammatic translation operations (alphabetic literacy being the most pervasive instance of these translation processes).

4. Images (e.g. systems of visual representation, but also nonverbal mimesis), although superficially similar to linguistic signs and symbols, need to be approached and understood in terms of their own *specific* semantic constraints. Here a comprehensive *phenomenology of symbolic diagrams* is still lacking. For example, we might compare the linear sonorous ontology of verbal communication with the multisensorial singularities of visual symbols and artworks (exemplified today in the multisensory events associated with performance art). We could contrast the discrete semiotic units and double articulation of spoken language with the continuous, analogical and synaesthetic grammars of visual imagery. We might also contrast the binary principles of verbal encoding with the multidimensional principles of iconic coding and the mimetic behaviour it facilitates. Where the former leads speech and communication to its

referents, the latter transports the viewer to intangible and invisible worlds of transcendent meaning. Here the tradition of religious icons provides one such model of iconic semiosis. Another example is the verbal icons that organize poetic signification. A third is the diagrammatic iconologies that operate in written language and graphic texts (including texts such as architecture and the built environment). A fourth is the mimetic organization of childhood speech and play. Where one encoding privileges the referential and the objective, the other prioritizes the symbolic, subjectivity and spiritual transformation. Icons are thus not 'about' anything outside of the universe of significance they precipitate.

In the light of these reflections we would need to reconsider the so-called victory of geometrical perspective over the pre-perspective regimes of religious art and iconic depiction. The idea of visual *progress* implicit in the heroic story of Renaissance art is itself indicative of a misunderstanding of the cultural grammars of visibilization at work in premodern aesthetic and religious practices. All of these issues require a more radical analysis of the role of symbolism in the mimetic life-worlds of human beings.

Such underlying differences have evolved into the grammars that govern visual systems (and here 'grammar' is clearly a metaphorical diagram that will need to be re-specified and reformulated after the detailed empirical examination of the social life of visual images, symbols and image-based sign systems). We can certainly imagine a genealogy of the grammar of image formations complementing a genealogy of discursive formations. We can also imagine a future field of inquiry devoted to explorations of the *interactions* and *transactions* between different image formations, symbolism and discursive formations. Future research will need to revisit earlier traditions of iconography and iconology as path-breaking investigations of iconic symbolism (this also points towards a more historically oriented sociology of symbols and symbolic consciousness as a *desideratum* of the new paradigm).

5. It has become a media cliché to speak of photography, cinema and related image-based technologies as 'languages' although we hear much less of the negative analogies and distortions that such a comparison involves. What kind of language, for example is the symbolic language of pictorial art? What kind of 'communication' is in play in photography or cinematic media? Who speaks in the 'language' of poetry? What would the syntax, semantics and pragmatics of visual imagery look like? What is the equivalent of conversation in our dialogical encounter with visual artworks? For each of these analogies we need to exercise extreme vigilance by asking: *Who* speaks *this* language? What are the parallels to verbal self-reference in image-based worlds? Given the prior operations of nonverbal signs and mimetic symbols what are the limits of 'speech' as a general model of human symbolic behaviour and semiopraxis? Can we not imagine versions of 'art' where art holds out the only available resource communication where other forms of communication have broken down or fallen

into silence (a theme of extremes and limits that links the craft of poetry and visual art to the question of the 'un-representable' and the 'inexpressible' in human experience)? It is conceivable that we have still not fully explored the distinctive grammars of vision because of a restrictive and unduly rational understanding of the meaning of 'language'. As we are too 'close' to speech and speaking we tend to misrepresent nonverbal symbolic practices by translating them into quasi-communicative forms. Perhaps the image-flesh of poetry and art is closer to the nonverbal grammars of music and dance and to possible *grammars of transfiguration and transcendence* that still have no name or conceptual articulation?

6. New media have made the experience of reflexivity, interactivity and creativity in visual practices both commonplace and problematic. Paradoxically, the extreme digitalization of media has led to a radical re-appraisal of earlier iconic and mimetic forms. With the invention of mobile computer-based communications and digital photography the traditional image of the photographic 'author' (as well as the photographic 'viewer') has been transformed by the possibilities of interactivity and collaborative image production. The 'author' and 'viewer' roles have been disassembled and reconfigured in novel ways. As a consequence the virtual symbolic worlds disclosed by digitalization have precipitated a renewed interest in the constitutive work of symbolic consciousness. With the technical possibilities of accessible software photographers can now creatively edit and 'publish' their work outside the normal channels of the organized media. This not only democratizes image-making (*iconpoiesis*) but leads to new forms of symbolic action (*symbolpoiesis*) such as personal archiving, image morphing, genealogical research, biographical writing and reconstruction, critical intervention in political narratives and so forth). All of these phenomena index important programmes of future empirical research.

7. In keeping with the increasing reflexivity of modern media, we can also suggest that *writing about* visual culture (in visual studies, art criticism, research, education, curriculum development and so on) has itself become a visual phenomenon of some consequence. Writing and criticism—especially the diverse activities involved in art education, art history and aesthetic popularization—become integral moments of the 'art system' as more individuals have access to vision-based archives of artworks, texts and performances (no other society has been able to routinely access the complete *oeuvre* of a writer or composer). Whole new programmes of research and research methodologies become possible as the interactivity and reflexivity of new media impact upon existing intellectual divisions of labour and disciplinary paradigms. The use of digital media to access analogue artefacts and artworks might be illustrated by the example of the 'tour' through virtual architectural spaces, museums and art galleries. Where the latter traditionally functioned as *places* to go and see, they now become *instruments of seeing* and *research* in their own right. All of these emergent practices open up symbolic worlds that were earlier unthinkable in

their impact upon aesthetic experience, education and general public awareness of visual culture. Somewhat paradoxically these 'virtual pathways' have led to an increasingly 'visceral' awareness of the material characteristics of public architecture, artworks and aesthetic creativity. Such striking developments lead to a fourth thesis.

THE TECHNOPOIESIS THESIS

The technopoiesis thesis holds that visual phenomena are creatively mediated, shaped and transformed by available technologies.

1. The 'modes of production' of visibility (and correlated visual practices and fields) are contingent upon technologies and their creative applications within particular social practices. The root of the word '*techne*' emphasizes the productive, labour-intensive, craft-like dimensions of visual worlds (as artifices that are contingent upon particular production conditions, divisions of labour, forms of appropriation and so on). '*Poiesis*' indexes the creative and transformative dimensions of media and technology (hence the familiar modernist definition of poetry as the creative re-crafting of word materials to create the poetic 'object' and poetic 'thought'). It follows that our understanding of social worlds—art worlds, science worlds, political worlds, poetic worlds and so forth—is inevitably indebted to the operative workings of unacknowledged technical, ideological and material conditions (for example as expressed in the banal truth that most of these 'worlds' are the products of human praxis and, more particularly, of *man*-made *designs*). The phallocentric logic at work in many mainstream institutional systems points to more deep-rooted structures of meaning and ideological determinations.
2. The force fields of the visual are decisively shaped by the range of ocular machines available to a community (again consider such inventions as the museum, library, national archive and research centre as information machines). Here we need to expand the narrow sense of 'technology' to include all creative apparatuses and their correlative discourses (hence *techno-logy*). Ocular machines (for example optical machines such as the *camera obscura,* Claude glass, telescope, microscope, electromagnetic scanners, cellular telephones) create different objects (and thereby, different object relations and object phenomenologies). Such object fields define constellations of the visible as the primary theme for a reflexive philosophy of visuality (here the parallels between research upon the visual machinery of advanced biomedicine and surgery—for example the neuro-imaging techniques made available through MRI (magnetic resonance imaging) scanners—and the massive developments of radio telescope and electron microscope technology). In all these cases the technology in question is embedded in a dense social fabric of material structures, technical know-how, social organizations and communication systems. A radical social theory

of visual technology promises to integrate some of the major advances in the contemporary knowledge economy with paradigm changes in the arts, communication studies and philosophy. And inevitably all of these domains are engaged in new forms of multi- and transdisciplinary dialogue about their respective perspectives and object fields.

3. The complex interplay of physical, social, political and cultural conditions of visualization technologies excludes every form of technological determinism in the study of visual fields and scopic regimes. The invention and use of a particular visual technology does not wholly determine or dictate its possible uses (as we see from the exponential differential applications of the Internet and the unanticipated impact of the new media upon everyday life). Here it is the specific *applications* and creative *appropriations* of technical instruments and machines in human activities that shape visual culture (e.g. the singular configuration of photography, digital mathematics, satellite communications and global networks involved in the production of Internet visibility and more generally the mathematical conditions behind the global digitization of visual culture). We should also note that such technologies also re-programme the uses of previous and now 'residual' technologies into new configurations (the Internet remains indebted to forms of screen machinery with very ancient roots). The invention of a new visual machine does not automatically eliminate older technologies. Rather, older social, aesthetic and technical forms are often given a new lease on life through the extensions and unpredictable applications of a new technology.

4. Technological reductionism is also discredited by the fact that no medium (or technology) can be a mirror, copy or recording of the world: every medium involves a *transformation* of experience. Here the dialectical language of reciprocal interaction and discontinuous mutations is more useful than the historicist scheme of linear progress or the one-sided dominion of technical framing (the Heideggerian *Ge-stell*). The unanticipated effects of new practices and cultural forms is more typical of rapid periods of technological change. While machines frequently usurp human powers, in general creative application and practical appropriation have characterized the history of cultural apparatuses.

5. It follows that radical changes in visual media, information and communication technologies do not merely extend the human sensorium, but transform the possibilities of human experience and self-understanding in unpredictable and emergent ways. Changing media impose different interpretive diagrams upon the flux of events. Here 'interpretation' has to be viewed as a primary form of transformative *action* (we might index this with the generic title of *diagrammatization*). In the light of this concern for the constitutive work diagrammatic consciousness we need to rewrite the history of photography and the moving image (seeing the invention of cinema and all the cinematographic apparatuses associated with cinema is the first phase of a radical transformation of visuality and visual relationships in the (post)modern world).

A future 'politics of the image' was implicit in the first act of making photographs or constructing fictions of reality from reels of discrete images. While photography and moving imagery are certainly sign systems, in reality they operate completely differently as interpretive deformations and imaginative re-creations of the world. At this juncture the politics of the image interfaces with the politics of the imaginable and both recoil to the transformative work of diagrammatization.

THE SOCIOCULTURAL THESIS

The sociocultural thesis contends that regimes of the visual are constituted by and constitutive of existing social relations and, more particularly, existing relations of authority and power as these are diagrammatically inscribed in social institutions.

1. A critical phenomenology of culture—an analytic of its specific dynamics, organized sites, modes of appearance, contradictory forms and appropriations— presupposes a social hermeneutics of technology and power relations. Such a phenomenology necessarily assumes the form of a 'critique' of existing material, social and cultural relations. With its concern for modes of subjectivation or subject-constitution as *sociocultural* activities this critical perspective foregrounds the ethical and political interfaces of the New Visual Studies. We have already seen from the historicity thesis that cultures of visuality are always cultures of subjectivity (and most typically cultures of political subjectivity). The sociocultural argument gives flesh to this formal argument by exploring the production and manipulation of spaces and temporal events by powerful groups and societies.

2. If we still retain the concept, for analytical purposes 'culture' can be differentiated into possible worlds of embodied meaning correlated to sense-producing apparatuses (this claim presupposes a more general theory of the auto-production of social life as organized semiopraxis). This theme of societal autopoiesis foregrounds the play of reflexivity as the investigation of cultural artefacts implicates the study of apparatuses that are themselves deployed to produce artefacts and relations (consider the higher technological economies where laser-based technologies are used to produce high-resolution lenses, reflecting mirrors and further laser-based instruments). Furthermore, the outcome of such analyses suggests further levels of artefactuality that become available as possible topics of meta-inquiry. For example what has been called 'art' (or 'art worlds') now appears as a heterogeneous series of image machines operating at the heart of a wide range of different signifying practices. Film—cinema—can then be approached materialistically as technologically conditioned ribbons of narrative-bearing images ('moving pictures'). But cinema should also be seen in phenomenological terms as the sites and spaces of viewing experience (from the pleasure-palaces of early cinema to the industrialized complexes of digital cinema). The coming of

digital media has the effect of radically restructuring the industrial systems and distribution networks associated with classical Hollywood cinema.

3. What appears as 'the social' or 'the political' in a given culture depends on the available regimes of visibilization (or, as we might now say, diagrammatic regimes). These are equally regimes of subjectivation as the normalization of visual space bears directly upon the organization of the self, self-other relations and subjective experience. By virtue of their complex origins and dynamics such regimes are essentially contested formations. However, no culture or civilization is ever wholly dominated by a single regime of visualization (hence the so-called hegemony of vision or scopic regimes in the development of modern European cultures needs to be reconsidered in more concrete, differentiated and historically specific terms). We might conjecture that at the core of every powerful social imaginary lies a visual imaginary.

4. New visual media and communicative forms facilitate novel art forms (creating hybrid media of self-expression and self-articulation). Consider, for example the direct linkages between so-called postmodern art forms and the wider dynamics of consumerism and mass popular culture that have reshaped the whole terrain of popular culture over the last fifty years. In analysing the changing functions of art (and visual media more generally) it is crucial to distinguish between conformist and contestatory art/cultural practices and places. Experimental art, constructivist practice, multimedia installations, ready-mades, earth-art and performance arts also in their different ways draw attention to the material singularities of aesthetic praxis. The emphasis upon the dense materiality of art practices also problematizes the function of artworks in relation to social space and the affective dimensions of viewing and spectatorship (the transformation of the religious icon, the use of art in political discourse, the democratic expansion of artworks through the practice of collecting, museums and galleries, the interrelationships between art and the designed character of the public sphere and so forth). Once more it is the critical self-deconstruction of art in a tradition that stretches from Dada and Epic Theatre to the Situationist International that has problematized the dialectical interfaces between art and nonart.

5. The revival of a critical-historical aesthetics must be initiated by way of a critique of current aesthetic discourse and mediated through the experimental practices of this critical problematic. A future aesthetic philosophy will necessarily be radically cultural and historical in its basic design and operative procedures. To recover the concreteness of *art practices* a material aesthetics must first deconstruct academic aesthetics as a primary antagonist. As socio-historical conditions mutate so too do forms of aesthetic contestation (rendering the thesis that whatever resists and derails commonsense assumptions acquires the functions of aesthetic praxis). Here again the emphasis upon the 'conditions of production' of artworks must be complemented by an analysis of the social relations of situated appropriation and affective 'consumption' (the analysis of art and desire and art-as-pleasure being important foci for such sociological

studies). In many respects this condenses to the formula that 'art is what art does'. But this formula can be misinterpreted as 'anything goes' nihilism that ignores the fact that there are establishment, conformist and insular art practices just as there are anti-establishment, revolutionary and expansionary art practices. These connections become critically important in the current expansion of art markets and the growth of a global public sphere in which art and aesthetic discourses play a central role. It goes without saying that a one-sided analysis of 'aesthetic commodification' is not the last word on the meaning and changing significance of artworks. We stand by the idea that the truth content of different art forms can only be located in their singularities—and ultimately in the defamiliarization effects of multisensorial performances in relation to everyday *doxa* and mundane forms of life.

THE POLITICAL THESIS

The political thesis holds that logics of visibility provide apparatuses of political self-definition, self-understanding and self-exploration for a given community or society.

1. Traditional definitions of the visual elide the complex political functions of visuality by imposing simplistic grids upon a complex dialectical field. For example most 'disciplinary' approaches to visual phenomena fail to address the multisensorial dimensions and transdisciplinary dynamics of visibility. Such perspectives ignore both the situated and the dialectical character of the image by trading upon the one-dimensional logic of the visual in formulations like 'visual studies', 'visual rhetoric', 'visual arts' and 'visual philosophy'. The tacit assumption is that what these concepts designate are settled and stable 'domains' available for academic colonization. Visuality is too readily identified with a one-sided idea of the visual sense or with 'perception' as this has been conceptualized by orthodox science, aesthetics and philosophy. It then follows that how different ways of seeing actually function within the operative ontologies of film studies, television studies, Internet studies and so on necessarily remains an unresolved question. The resulting paradigms are thus abstract and apolitical. We spontaneously think of 'vision' as the sensory input from the 'outside world' that impinges upon the receptive eye (or, in modern parlance, the brain). 'Art' is treated independently from questions of the politics of truth and knowledge, liberated into the bad infinity of 'whatever is recognized as art is art', if what passes for art gives pleasure then this is enough and so on.

2. What some have called the 'ocular bias' of European culture has excluded the practical realm of embodied images and replaced this with a disembodied idea of the visual (what might be called the visual or videological bias of Western thought). On one side the sensory density of seeing and contextual envisioning is reduced to a mechanistic and biologized idea of the optical, while on the other 'the visual' has been elevated as a high-order faculty that transcends

political life and exemplified by the more 'contemplative' and 'theoretical' interests of human praxis. Either type of deflationary reduction or idealist inflation has the effect of disembodying visual experience from its material and political contexts and replacing situated image production with an abstract *idea* of the visual. Either art is a branch of sensory pleasure or it is the portal to philosophical truth. In principle it has absolutely nothing to do with the political arrangements of a society.

3. A major task of future transdisciplinary visual studies is to restore the ethico-political dimensions of sensory experience and, more particularly, the politics of visual regimes that cross disciplinary boundaries. In historical terms, we require a richer philosophical anthropology of the political life of visual media. Here the emphasis needs to be placed on both 'life' and the media's links to social machines (e.g. the critical role of visual experience in contemporary science, medical technologies and bio-politics). More broadly this requires an equally radical critique of the disembodied concept of 'culture' as this has hitherto operated in the traditional arts and human sciences.

4. In the wake of this sensory auto-critique the arts and aesthetics of the future will necessarily adopt transdisciplinary (and initially perhaps 'in-disciplinary') stances towards what passes for aesthetic and cultural discourse. Given that many of the major forces impacting upon contemporary art practice are derived from outside the universe of art—in the development of 'new media', digital software, commercial markets, free-media movements, corporate sponsorship, state cultural policy and so on—a critical theory of art can no longer focus exclusively upon the 'artwork' or artefact as a realm 'in itself'. The traditional ontology of the 'in-itself' has come to an end. Aesthetic transcendence is one of the first victims of this 'auto-deconstruction of realms'. To incorporate the most creative forms of theorizing in these new formations any transdisciplinary aesthetics will need to open dialogues with a diverse range of new visual media and information systems.

5. As a space of aesthetic contestation the ethico-political dimensions of this emerging framework will necessarily lead to the transformation of traditional cultural studies and media studies as these have been encased in the semiotic-oriented categories of powerful theoretical frameworks. The radicalization and reshaping of existing programmes in explicitly political and ethical directions will inevitably involve the self-critique and transcendence of current semiotic, critical-theoretic, feminist, media-based approaches to visual studies.

THE REFLEXIVE PRAXIS THESIS

The reflexive praxis thesis proposes that visual practices and visual fields are active agencies in transforming social relations and prefiguring possible futures.

1. We have suggested that visual fields are reflexive arrangements that facilitate (or obstruct) specific modes of social praxis (thus the process of globalization

is historically inseparable from the emergence of reflexive practices that have transformed the visible world through digital media and related information technologies). As it is the conceptual recalcitrance of alterities that disturbs existing social arrangements the traditional realm of art can be re-seen as an earlier source of a-categorial singularities (here 'singularity' may be defined as anything that resists subsumption under the rule of a general concept or category). We then recover the domain of *art* as the province of outlaw and renegade praxes. If the vocation of art is to contest and defamiliarize the sclerotic relations and structures of everyday life then wherever 'art' settles into an expression or reflection of a genre it loses its questioning functions (which is not to say that it loses its visual qualities or applications to other noncontestatory domains). The recovery of the singularity of art practices is one field where the politics of past, present and future aesthetics might be renewed. If philosophy is the construction of concepts, art is the creation of iconic utopias, of imaginary nonplaces and forbidden pleasures. The 'value' of an art form would then be measured by the energies and rhythms of freedom it releases. In the chiastic formula: the freedom of art is the art of freedom (like poetry art is an apparatus that visibilizes the world). Art is to be appraised by the *praxis* it engenders.

2. In contemporary society the 'objects' of visual culture are increasingly defined in globalized cybernetic terms (a process that is itself dependent upon material systems, software applications and global social arrangements that are pervasively visual). With increasing societal complexity there is a general movement from local to global visibilities and the convergence of local and global (the glocalization of the visible facilitated by mobile digital machines and new convergent technologies has become a media symbol of these mutations).

3. The transformation of the world into a 'picture', 'view' or 'spectacle' is contingent upon powerful icon-based information technologies (alphabetic communication, print, telegraph, televisual, digital, convergent and so on). From this we derive the popular idea of the 'society of the spectacle' and the aestheticization of social and political arrangements as both products and agencies of modern mass media and related technological formations. However, the 'society of the spectacle' has itself been assimilated to commercial interests and is actively and un-ironically promoted as an idealized state of social being. Idealized images of consumer bliss neutered by pleasure have become the preferred rhetoric of global consumerism and socially engineered perception. Yet one unintended consequence of global consumption is the proliferation of iconic imagery and the reaffirmation of the immense power of visual media. Contemporary capitalism, it would seem, can only expand and multiply its operations through a vast range of interlocking imagineering industries. To borrow a Marxist idiom, until the advent of globalization we had not realized the tremendous powers lying dormant within the machinery of symbolic praxis.

4. One aspect of the global culture industries is the revolutionary shift towards generalized iconicity as mass media become digitalized and globalized. Global culture industries symbolized by corporate names like Google, Microsoft, News

Corp, Time Warner and Sony are now imagineering enterprises that harness the resources of graphic animation, computer simulation and commercial rhetoric not only to sell their products but to transform everyday life through new types of communication and social relations. Indeed, with the coming of cyberculture the commodification of visual space is now in the driving seat of hyper-capitalist development. Here we witness the dialectic of unanticipated consequences: the very 'socializing' effect of 'new media' creates practices and operations which transform users into active manipulators of symbols. Modern digital technologies are themselves increasingly reconfigured around keyboards, click-and-drop computing, visual iconography and mobile forms of representation (computer graphics, iPods, iPhones, portable video, e-Books/Tablets, etc). By exploiting the new imagineering logics, hyper-capitalism displaces word-based paradigms by icon-based ontologies (and their associated habitus). Before this is a theoretical shift, it is a real-world transformation that both empowers and disempowers groups and classes throughout the global economy. We are at the beginning of a digital imaging age where the corporate shift from televisuality to cybervisuality marks the dawn of an intensively global culture produced by new image cultures (film, television, photographic Web sites, digital cinema, multimedia advertising, scientific and technical representations, model-building and so on). Intensively visual corporations such as Microsoft, Google and Yahoo are the latest examples of this transition to visual cyberspace. The impact of the mobile visual dynamics of Web 2.0 social media (Facebook, Flickr, YouTube, MySpace, Bebo and so on) is already a phenomenon with fundamental implications for the reorganization of social and political life. With respect to the actuality of 24/7 digital image flows we move from the realm of virtual reality to an age of real virtuality.

5. In the light of these emergent phenomena we urgently require more reflexive transdisciplinary concepts capable of articulating the intended and unintended consequences of global electronic mediators. Above all we need a radical social theory of the dialectical structure of global visual cultures. Future visual studies research must begin with the global digitalization of contemporary society and culture as a strategy of understanding the revolutionary innovations and technologies of earlier forms of visualization. It must also revisit the question of the truth-value of artworks and the functions of aesthetic praxis within the wider horizon of human self-understanding. At the point where there is no more space for art, everything becomes art. But even at this null-point the disappearance of art and the nihilist regime of nonart themselves become media events with all the characteristics earlier ascribed to artworks.

6. The coming of cyberculture illuminates the social significance of earlier analogue technologies (which now fall into the category of 'residual media'). The emergence of 'information arts' and digital imagineering sheds light upon earlier aesthetic innovations and practices. The 'trans-' element in 'transdisciplinary' underlines the generic application of these themes across traditionally

defined borders (e.g. the concern for image logics and representational iconicity now traverses almost every form of global multimedia and so-called creative industries).

7. By responding positively to these emergent processes the New Visual Studies paradigm provides a powerful example of the processes of transdisciplinarity that are currently reconfiguring the organization of higher education and research on a global scale. Future visual studies will necessarily be collaborative enterprises drawing upon such emergent fields as media studies, art-design complexes, Internet studies, informatics/geodemographics, multidisciplinary investigations of information technology systems, artificial intelligence, investigations of complex discourse formations, the study of hypermodern social formations—network societies, information societies, reflexive capitalism, reflexive modernization theory and new globalisms.

8. The great danger for post- and in-disciplinary collaboration is for New Visual Studies paradigms to over-identify with their phenomenal objects to produce a transdisciplinary form of technocratic-administrative scientism. To avoid this development the methodologies of the new visual studies must be resolutely vigilant about their presuppositions and consistently reflexive towards the phenomenal domains they take as their research focus. Mapped onto a broader theoretical canvas we need to locate the New Visual Studies within a radically reflexive material theory of everyday life practices. Only by resisting the technocratic logics of contemporary society will visual studies be able to fully contribute to the understanding of the ubiquitous functions of the visible in society and participate in the transformation of everyday life.

FURTHER READING

Cavallo, G. and R. Chartier, eds. 1999. *A History of Reading in the West*, trans. L. G. Cochrane. Cambridge: Polity Press.

Halsall, F., J. Jansen and T. O'Connor, eds. 2009. *Rediscovering Aesthetics: Transdisciplinary Voices from Art History, Philosophy, and Art Practice*. Stanford, CA: Stanford University Press.

Jay, M. 1998. *Cultural Semantics: Keywords of Our Time*. London: Athlone Press.

Sandywell, B. 2011. *Dictionary of Visual Discourse: A Dialectical Lexicon of Terms*. Farnham, Surrey: Ashgate.

Weber, S. 2008. *Benjamin's –abilities*. Cambridge, MA: Harvard University Press.

REFERENCES

Cavallo, G. and R. Chartier, eds. 1999. *A History of Reading in the West*, trans. L. G. Cochrane. Cambridge: Polity Press.

Sandywell, B. 2011. *Dictionary of Visual Discourse: A Dialectical Lexicon of Terms*. Farnham, Surrey: Ashgate.

Mapping the Visual Field: A Bibliographical Guide

BARRY SANDYWELL

The following bibliographical chapter delineates some of the landmark contributions to research on visual theory, visual culture and visual studies over the past two to three decades. Because of the extent and range of publications in this field and the exponential growth of interest in visual culture more generally there is no attempt to provide anything like a complete or comprehensive bibliography. Rather, I have taken a more selective approach and singled out texts that are both accessible and intellectually stimulating in a range of interrelated thematic areas. The main aim of this chapter is to provide readers with an introductory map of the complex landscape of visual research as this has been shaped by different theoretical and cultural traditions. Given the multidisciplinary and transdisciplinary character of the new visual studies emphasis has been placed on texts that invite their readers to question existing research agendas and encourage them to cross disciplinary boundaries and imagine new knowledge formations.

ORGANIZATION

The bibliography has been divided into the following sections:

1. Resources in Visual Culture
2. Visual Theory: Major Theoretical Frameworks in Visual Culture
3. History of Visual Culture
4. Art History, Art Theory and Aesthetics
5. Cultural Studies Perspectives
6. The Sociology and Anthropology of Visual Art, Techniques, Media and Communications (including the use of visual technologies such as photography and film in anthropological research)

7. Visual Rhetoric
8. Architecture and Design
9. Visual Cultural Institutions
10. Visual Experiences of the Social World
11. Technoculture and Visual Technology: The Global Digital Revolution
12. The Politics of Vision
13. The Politics of Seeing and Being Seen: New Social Movements
14. Visual Pedagogy
15. (Re)envisioning the Public Sphere

RESOURCES IN VISUAL CULTURE

Today there is a wealth of background reading and resources for students and researchers interested in pursuing inquiries in the field of visual culture. This section identifies some of the most critical documents from the past two decades.

Readers in Visual Culture

S. Brent Plate, ed., *Religion, Art and Visual Culture: A Cross-Cultural Reader* (2002)
Jessica Evans and Stuart Hall, eds., *Visual Culture: The Reader* (1999)
Amelia Jones, ed., *The Feminism and Visual Culture Reader* (2003)
David Michael Levin, ed., *Modernity and the Hegemony of Vision* (1993)
Nicholas Mirzoeff, ed., *The Visual Culture Reader* (1998)
George Robertson, Melinda Mash and Lisa Tickner, eds., *The Block Reader in Visual Culture* (1996)

Useful Collections of Writings on Visual Culture

Lisa Bloom, ed., *With Other Eyes: Looking at Race and Gender in Visual Culture* (1999)
Teresa Brennan and Martin Jay, eds., *Vision in Context* (1996)
Norman Bryson, Michael Ann Holly and Keith Moxey, eds., *Visual Culture: Images and Interpretations* (1994)
Ian Heywood and Barry Sandywell, eds., *Interpreting Visual Culture: Explorations in the Hermeneutics of the Visual* (1999)
Christopher Jenks, ed., *Visual Culture* (1995)
Stephen Melville and Bill Readings, eds., *Vision and Textuality* (1995)
Joanna Morra and Marquard Smith, eds., *Visual Culture: Critical Concepts in Media and Cultural Studies* (2006)

General Introductions to Visual Studies

Malcolm Barnard, *Approaches to Understanding Visual Culture* (2001)
Terry Barrett, *Interpreting Art: Responding to Visual Culture* (2002)
Norman Bryson et al. *Visual Theory: Painting and Interpretation* (1991)
Victor Burgin, *In/different Spaces: Place and Memory in Visual Culture* (1996)

Margaret Dikovitskaya, *Visual Culture: The Study of the Visual after the Cultural Turn* (2005)
James Elkins, *Visual Studies: A Skeptical Introduction* (2003)
John R. Hall, Blake Stimson and Lisa Tamiris Becker, eds., *Visual Worlds* (2005)
Richard Howells, *Visual Culture: An Introduction* (2003)
Christopher Jenks, ed., *Visual Culture* (1995)
Nicholas Mirzoeff, *An Introduction to Visual Culture* (1999)
W.J.T. Mitchell, *Picture Theory* (1994)
Gillian Rose, *Visual Methodologies* (2001)
Barry Sandywell, *Dictionary of Visual Discourse: A Dialectical Lexicon of Terms* (2011)
Tony Shirato and Jen Webb, *Understanding the Visual* (2009)
Marquard Smith, ed., *Visual Culture Studies: Interviews with Key Thinkers* (2008)
Marita Sturken and Lisa Cartwright, *Practices of Looking: An Introduction to Visual Culture* (2001)
John A. Walker and Sarah Chaplin, *Visual Culture: An Introduction* (1997)

Journals in Visual Culture

Art Journal (College Art Association of America)
Block
British Journal of Aesthetics
Cahiers du Cinéma
Cahiers pour l'Analyse
camera obscura
Cinéthique
Cine-tracts
Cinema Journal
Critical Studies in Mass Communication
Cultural Critique
Cultural Hermeneutics
Cultural Studies
Cultural Studies: Critical Methodologies
Early Popular Visual Culture
European Journal of Cultural Studies
Film Quarterly
Gender, Place and Culture
Information, Communication and Society
International Journal of Cultural Studies
Invisible Culture
Journal of Aesthetics and Art Criticism
Journal of Intercultural Studies
Journal of Jewish Art and Visual Culture
Journal of Visual Culture
Leisure Studies
Media, Culture and Society
New Formations: A Journal of Culture/Theory/Politics
New Media and Society

October
Oxford Art Journal
Parallax
Revue d'Esthétique
Screen
Screen Education
Sémiotext(e)
Semiotica
Signs: Journal of Women in Culture and Society
Social Semiotics
Textual Practice
Theory and Society
Theory, Culture and Society
Visual Arts and Culture
Visual Sociology
Visual Studies
Word and Image

Internet Resources

Each of the key theorists in the field of studies now has multiple Web sites that provide background information (some of these more useful than others). For guidance to some of the key names see Marquard Smith, ed., *Visual Culture Studies: Interviews with Key Thinkers* (2008) and past volumes of the *Journal of Visual Culture* (see Sage Journals Online at http://vcu.sagepub.com). See also the responses of a range of researchers in 'Questionnaire on Visual Culture', *October*, 77, Summer 1996, pp. 25–70.

A sample of related Web sites might include:

http://www.corbis.com
http://www.culturemachine.net/index.php/cm
http://mitpress.mit.edu/Leonardo
http://www.rhizome.org/
http://www.org.uk
http://www.ubu.com/film
http://www.icosilune.com/2008/08
http://www.film-philosophy.com
http://www.scope.nottingham.ac.uk
http://www.sensesofcinema.com
http://www.metacritic.com
http://www.visual-studies.com
http://www.imagehistory.org/theory/institutes.htm
http://www.aber.ac.uk/media
http://www.surrealismcentre.ac.uk

VISUAL THEORY: MAJOR THEORETICAL FRAMEWORKS IN VISUAL CULTURE

Among the most prominent theoretical approaches to visual culture are those drawn from the philosophical traditions of Phenomenology and Hermeneutics, Psychoanalysis, Semiotics, Structuralism, Wittgenstein and Wittgensteinian Philosophy, Poststructuralism, Postmodernism, Marxism and Critical Theory, Feminism, Gay and Lesbian Studies, Queer Theory and Postcolonialism. All of these movements are attempts to describe and evaluate the multidimensional phenomenal structures of 'being-in-the-world' and all, necessarily, adopt particular theoretical practices and perspectives for this purpose. For general background to these traditions see William McNeill and Karen S. Feldman, eds., *Continental Philosophy: An Anthology* (1998), Constantin V. Boundas, ed., *The Edinburgh Companion to Twentieth-Century Philosophies* (2007), and Dermot Moran, ed., *The Routledge Companion to Twentieth Century Philosophy* (2008).

Phenomenology and Hermeneutic Philosophy

> Seeing is not a certain mode of thought or presence to self; it is the means given me for being absent from myself, for being present from within at the fission of Being only at the end of which do I close up into myself. (Merleau-Ponty, 'Eye and Mind', in 1993: 146)

Phenomenology

Phenomenological philosophy has had a longstanding interest in things visual. Indeed, the central models of phenomenological analysis in the work of the founding theorist, Edmund Husserl, are primarily taken from *visual* perception. This perceptual orientation was questioned by Husserl's students, most particularly by Martin Heidegger and Maurice Merleau-Ponty. Where Heidegger's criticism of Husserl's Cartesian ocularcentrism led to the development of philosophical hermeneutics, the French philosopher Maurice Merleau-Ponty deepened Husserl's perceptual emphasis by historicizing and ontologizing the structures of perception and existence (Merleau-Ponty 1962, 1993). It is probably Merleau-Ponty's version of phenomenological analysis with its acute sense of the involvement of the body and intercorporeality in all forms of awareness that provides the natural home for a critically oriented theory of visual culture understood as a historically embodied phenomenal field.

Merleau-Ponty is also unique in the early phenomenological tradition in engaging in an extensive dialogue between philosophy and painting as two complementary ways of rethinking seeing and perception. The movement from 'pure' or transcendental phenomenology to existential phenomenology prefigures the field of incarnate phenomenology—the investigation of the embodiments of lived experience and the heterotopical sites of perceptual/aesthetic experience. In 1948 Merleau-Ponty concluded a series of radio broadcasts with a comprehensive vision of the role of phenomenological

thought as a general framework for integration in the arts, humanities and sciences. He writes: 'The world of perception consists not just of all natural objects but also of paintings, pieces of music, books and all that the Germans call the 'world of culture'. Far from having narrowed our horizons by immersing ourselves in the world of perception, far from being limited to water and stone, we have rediscovered a way of looking at works of art, language and culture, which respects their autonomy and their original richness' (2008: 76). The current name for this rediscovered terrain is, of course, *visual culture*.

For Merleau-Ponty's major work, the *Phenomenology of Perception*, see the references below. One of the most useful collections of Merleau-Ponty's essays on painting (including commentaries on the contemporary relevance of these essays) is G. A. Johnson and M. B. Smith, eds., *The Merleau-Ponty Aesthetics Reader: Philosophy and Painting* (1993). A useful guide to Merleau-Ponty's phenomenological thought can be found in Rosalyn Diprose and Jack Reynolds, eds., *Merleau-Ponty: Key Concepts* (2008), G. A. Johnson and M. B. Smith, eds., *Ontology and Alterity in Merleau-Ponty* (1990) and T. Carman and M.B.N. Hanson, eds., *The Cambridge Companion to Merleau-Ponty* (2004). Also see the essays by Michael Gardiner and Martin Jay in this volume.

Emund Husserl, *Ideas Towards a Pure Phenomenology and Phenomenological Philosophy* (1931)
Edmund Husserl, *The Crisis of European Sciences and Transcendental Phenomenology* (1970)
Edmund Husserl, *Ideas Pertaining to a Pure Phenomenology and to a Phenomenological Philosophy. Third Book: Phenomenology and the Foundations of the Sciences (Ideen III)* (1980)
Maurice Merleau-Ponty, *The Phenomenology of Perception* (1962)
Maurice Merleau-Ponty, *Sense and Non-Sense* (1964a)
Maurice Merleau-Ponty, *Signs* (1964b)
Maurice Merleau-Ponty, *The Primacy of Perception and Other Essays* (1964c)
Maurice Merleau-Ponty, 'The Intertwining—The Chiasm', in *The Visible and the Invisible* (1968), pp. 130–55
Maurice Merleau-Ponty, *The World of Perception* (2008)

Other phenomenological thinkers developed Husserl's transcendental phenomenology in more social and cultural directions. Among these the following texts should be noted:

Renaud Barbaras, *Vie et intentionalité* (2003)
Mikel Dufrenne, *The Phenomenology of Aesthetic Experience* (1966)
Aron Gurwitsch, *Human Encounters in the Social World* (1979)
Michel Henry, *The Essence of Manifestation* (1973)
Michel Henry, *Philosophy and Phenomenology of the Body* (1975)
Emmanuel Levinas, *Totality and Infinity* (1969)
Emmanuel Levinas, *The Theory of Intuition in Husserl's Phenomenology* (1973)
Emmanuel Levinas, *Ethics and Infinity* (1985)
Jean-Paul Sartre, *Being and Nothingness: An Essay on Phenomenological Ontology* (1958)
Jean-Paul Sartre, *The Imaginary: A Phenomenological Psychology of the Imagination* (2004)
Alfred Schutz, *Phenomenology of the Social World* (1967)

For the continuing relevance of phenomenological problematics for visual studies see:

T. W. Basch and S. Gallagher, eds., *Merleau-Ponty, Hermeneutics and Postmodernism* (1992)

Peter Burke and J van der Veken, *Merleau-Ponty in Contemporary Perspective* (1993)

Martin Dillon, ed., *Merleau-Ponty Vivant* (1991)

R. Diprose and J. Reynolds, eds., *Merleau-Ponty: Key Concepts* (2008)

Don Ihde, *Postphenomenology: Essays in the Postmodern Context* (1993)

Martin Jay, 'Sartre, Merleau-Ponty, and the Search for a New Ontology of Sight', in David Michael Levin, ed., *Modernity and the Hegemony of Vision* (1993), pp. 143–85

G. A. Johnson and M. B. Smith, eds., *Ontology and Alterity in Merleau-Ponty* (1990)

David Michael Levin, *The Philosopher's Gaze* (1999)

William McNeill, *The Glance of the Eye: Heidegger, Aristotle, and the Ends of Theory* (1999)

Dermot Moran, *Introduction to Phenomenology* (2000)

D. E. Olkowski, 'Feminism and Phenomenology', in Simon Glendinning, ed., *The Edinburgh Encyclopedia of Continental Philosophy* (1999), pp. 323–32

D. E. Olkowski and J. Morley, eds., *Merleau-Ponty, Interiority and Exteriority* (1999)

Aurora Plomer, *Phenomenology, Geometry and Vision: Merleau-Ponty's Critique of Classical Theories of Vision* (1991)

Charles Tilley, *The Phenomenology of Landscape* (1994)

Charles Tilley, *The Materiality of Stone* (2004)

Cathryn Vasseleu, *Textures of Light: Vision and Touch in Iragaray, Levinas, and Merleau-Ponty* (1998)

Hermeneutics

Modern hermeneutics has also been shaped by its phenomenological predecessors, most especially by the writings of Wilhelm Dilthey, Edmund Husserl and Martin Heidegger. However, it is the development of a fully fledged 'philosophical hermeneutics' in the work of Hans-Georg Gadamer and Paul Ricoeur that has provided occasions and encounters with other approaches to the visual world; these include dialogues with critical theory (Jürgen Habermas), deconstruction (Jacques Derrida), ordinary language philosophy (Wittgenstein), social theory (Jürgen Habermas, Richard Bernstein), genealogy (Michel Foucault), American pragmatist traditions (Richard Rorty, Charles Taylor, Hubert Dreyfus, Joseph Margolis), cognitive science (Dan Zahavi), feminism and critical thought. More recent researchers are also rediscovering a hermeneutic dimension in earlier thinkers as apparently diverse as Marx, Nietzsche, Dewey, Benjamin, Adorno and Merleau-Ponty.

Richard J. Bernstein, *Beyond Objectivism and Relativism: Science, Hermeneutics and Praxis* (1983)

Clive Cazeaux, ed., *The Continental Aesthetics Reader* (2000), Part 2, 'Phenomenology and Hermeneutics'

Wilhelm Dilthey, *Selected Writings* (1976)

Hubert Dreyfus, *Being-in-the-World* (1991)

Hans-Georg Gadamer, 'Aesthetics and Hermeneutics', in *Philosophical Hermeneutics* (1977), pp. 95–104

Hans-Georg Gadamer, 'The Idea of Practical Philosophy', in *Praise of Theory: Speeches and Essays* (1998), pp. 50–61

Hans-Georg Gadamer, *Truth and Method* (2004)

Martin Heidegger, *Being and Time* (1927/1962)

Martin Heidegger, 'The Origin of the Work of Art', in *Poetry, Language and Thought* (1971), pp. 15–87.

Martin Heidegger, 'The Age of the World-Picture', in *The Question Concerning Technology and Other Essays* (1977), pp. 115–54

Martin Heidegger, 'The Origin of the Work of Art', in *Martin Heidegger. Basic Writings* (1978), pp. 143–87

Ian Heywood and Barry Sandywell, eds. *Interpreting Visual Culture: Explorations in the Hermeneutics of the Visual* (1999)

Richard Hollinger, ed., *Hermeneutics and Praxis* (1985)

John Llewelyn, *Beyond Metaphysics: The Hermeneutical Circle in Contemporary Continental Philosophy* (1985)

Gary Madison, *The Hermeneutics of Postmodernity: Figures and Themes* (1988)

William McNeill, *The Glance of the Eye: Heidegger, Aristotle, and the Ends of Theory* (1999)

D. Michelfelder and R. Palmer, eds., *Dialogue and Deconstruction: The Gadamer-Derrida Encounter* (1989)

Richard Rorty, *Philosophy and the Mirror of Nature* (1979)

J.-M. Schaeffer, *Art of the Modern Age: Philosophy of Art from Kant to Heidegger* (2000)

Richard Shusterman, *Pragmatist Aesthetics* (1992)

High J. Silverman, ed., *Questioning Foundations: Truth/Subjectivity/Culture* (1993)

G. Warnke, 'Ocularcentrism and Social Criticism', in D. M. Levin, ed., *Modernity and the Hegemony of Vision* (1993), pp. 287–308

Ludwig Wittgenstein, *Philosophical Investigations* (1958)

Psychoanalysis

Visual phenomena and visual metaphors play a profound role in classical psychoanalysis and in the revisionary variants of psychoanalysis associated with the traditions of structuralism, semiotics and feminist theorizing. The literature relating to this domain is already vast and expanding. The following texts provide useful starting points:

Georges Bataille, *Story of the Eye* (2001)

Hélëne Cixous, *The Hélène Cixous Reader* (1994)

Luce Iragaray, *Speculum de l'autre femme* (1974), *Speculum of the Other Woman*, (1985)

Luce Iragaray, *Ce sexe qui n'en est pas un* (1977), *This Sex Which Is Not One* (1985)

Luce Iragaray, *Ethique de la différance sexuelle* (1984), *An Ethics of Sexual Difference* (1993)

Luce Iragaray, *The Iragaray Reader* (1992)

Sarah Kofman, *L'Enigme de la femme: La femme dans les texts de Freud* (1980), *The Enigma of Woman: Woman in Freud's Writings* (1985)

Sarah Kofman, *The Childhood of Art: An Interpretation of Freud's Aesthetics* (1988)

Sarah Kofman, *Freud and Fiction* (1991)

Sarah Kofman, *Nietzsche and Metaphor* (1993)

Sarah Kofman, *Selected Writings* (2007), Part 1 'Reading (with) Freud' and Part 4 'The Truth in Painting'

Julia Kristeva, *Desire in Language: A Semiotic Approach to Literature and Art* (1977/1980)

Julia Kristeva, 'Word, Dialogue and Novel', in *Desire in Language: A Semiotic Approach to Literature and Art* (1977/1980)

Julia Kristeva, *Pouvoirs de l'horreur: Essai sur l'abjection* (1980), *Powers of Horror: An Essay on Abjection* (1982)

Julia Kristeva, *A Kristeva Reader*, (1982)

Jacques Lacan, *Ecrits* (1977)

Jacques Lacan, *Four Fundamental Concepts of Psychoanalysis* (1977)

Jacques Lacan, *The Seminar of Jacques Lacan, Book 1: Freud's Papers on Technique, 1953–1954* (1988)

Jacques Lacan, *The Seminar of Jacques Lacan, Book 2: The Ego in Freud's Theory and in the Technique of Psychoanalysis, 1954–1955* (1988)

Michelle Le Doeuff, *Recherches sur l'imaginaire philosophique* (1980), *The Philosophical Imaginary* (1986)

Michelle Le Doeuff, *L'Etude et le rouet, des femmes, de la philosophie, etc.* (1989), *Hipparchia's Choice: An Essay Concerning Women Philosophy, etc.* (1991)

Toril Moi, *Sexual/Textual Politics* (1985)

Toril Moi, ed., *A Kristeva Reader* (1986)

Chris Weedon, *Feminist Practice and Poststructuralist Theory* (1987)

Margaret Whitford, ed., *The Iragaray Reader* (1991)

Monique Wittig, *The Straight Mind and Other Essays* (1992)

For the broader social background and cultural applications see:

Barbara Creed, *The Monstrous-Feminine: Film, Feminism, Psychoanalysis* (2001)

Elizabeth Grosz, *Jacques Lacan: A Feminist Introduction* (1990)

E. Ann Kaplan, ed., *Psychoanalysis and Cinema* (1990)

Ernst Kris, *Psychoanalytic Explorations in Art* (2000)

Jean Laplanche and Jean Bertrand Pontalis, *The Language of Psychoanalysis* (1973)

George Makari, *The Revolution in Mind: The Creation of Psychoanalysis* (2008)

Herbert Marcuse, *Eros and Civilization* (1956)

Herbert Marcuse, *One-Dimensional Man* (1964)

Christian Metz, *The Imaginary Signifier* (1982)

Christian Metz, *Psychoanalysis and the Cinema: The Imaginary Signifier* (1983)

Laura Mulvey, *Visual and Other Pleasures* (1989)

Jacqueline Rose, *Sexuality in the Field of Vision* (1986)

Kaja Silverman, *The Subject of Semiotics* (1983)

Kaja Silverman, *The Acoustic Mirror: The Female Voice in Psychoanalysis and Cinema* (1988)

Kaja Silverman, *Male Subjectivity at the Margins* (1992)

Kaja Silverman, *Threshold of the Visible World* (1996)

Structuralism and Semiotics

Structuralism

Structural ways of thinking trace their origins to the linguistics of Ferdinand de Saussure (1857–1913). Saussure commended the idea of a general theory of signs or semiology

as an integrative framework for the human studies (1969). This idea became influential in French intellectual life with the writings of Lévi-Strauss, Barthes, Althusser, Lacan and others. A comprehensive history of structuralism can be found in François Dosse, *History of Structuralism*, Vol. 1, *The Rising Sign, 1945–1966* and Vol. 2, *The Sign Sets, 1967-Present* (1997). A general introduction to semiotic approaches to cultural analysis is provided by Andy Tudor, *Decoding Culture: Theory and Method in Cultural Studies* (1999), John Hartley, *A Short History of Cultural Studies* (2003) and Lawrence Grossberg, Cary Nelson and Paula Treichler, eds., *Cultural Studies* (1992).

Semiotics

For the language of images (visual iconicity, visual rhetorics, communications, technology of image culture; the relationship between discursive and pictorial representation and so forth) see:

Hans Belting, *Likeness and Presence* (1994)
Hans Belting, *Art History after Modernism* (2003)
John Dewey, *Art as Experience* (1934)
Nelson Goodman, *Languages of Art* (1968)
Stephen Melville and Bill Readings, eds., *Vision and Textuality* (1995)
W.J.T. Mitchell, ed., *The Language of Images* (1980)
W.J.T. Mitchell, *Iconology: Image, Text, Ideology* (1987)
W.J.T. Mitchell, ed., *Landscape and Power* (1994)
W.J.T. Mitchell, *Picture Theory: Essays on Verbal and Visual Representation* (1994)
W.J.T. Mitchell, 'Showing Seeing: A Critique of Visual Culture', *Journal of Visual Culture*, Vol. 1(2), 2002, pp. 165–81
W.J.T. Mitchell, *What Do Pictures Want? Essays on the Lives and Loves of Images* (2006)

For approaches to visual imagery and representations that draw explicitly upon linguistic and semiotic models see:

Roland Barthes, *Mythologies* (1972)
Roland Barthes, *Image-Music-Text* (1977)
Roland Barthes, *Camera Lucida: Reflections on Photography* (2000)
John Berger, *Ways of Seeing* (1972)
John Berger, *About Looking* (2002)
Gregory Currie, 'The Long Goodbye: The Imaginary Language of Film' (1993)
Umberto Eco, *A Theory of Semiotics* (1976)
Umberto Eco, *The Role of the Reader* (1979)
Umberto Eco, *Travels in Hyperreality* (1987)
Garry L. Hagberg, *Art as Language* (1995)
Gunter Kress and Theo van Leeuwen, *Reading Images: The Grammar of Visual Design* (1996/2006)
Claude Lévi-Strauss, *The Savage Mind* (1966)
Louis Marin, *To Destroy Painting* (1995)
Louis Marin, 'Topics and Figures of Enunciation: It Is Myself That I Paint', in Stephen Melville and Bill Readings, eds., *Vision and Textuality* (1995), pp. 195–214

F. Saint-Martin, *Semiotics of Visual Language* (1990)
Kaja Silverman, *The Subject of Semiotics* (1983)

From Semiotic Codes to Cultural Intertextuality

For texts that emphasize the complex dialectic of image-text-culture relationships:

Roland Barthes, *The Pleasure of the Text* (1975)
Roland Barthes, *S/Z* (1990)
Lynne Cooke and Peter Wollen, eds. *Visual Display: Culture beyond Appearances* (1995)
Jacques Derrida, *Jean-Luc Nancy: On Touching* (2005)
Umberto Eco, *The Open Work* (1989)
Jean-Luc Nancy, *The Ground of the Image* (2005)
Jean-Luc Nancy, *Noli Me Tangere: On the Raising of the Body* (2008)

From Structuralism to Poststructuralism and Deconstruction

While it is difficult to cleanly separate 'structuralist' and 'poststructuralist' perspectives we can note the movement away from 'scientific' and 'formalist' semiotic analysis derived in European social theory from the linguistic writings of Ferdinand de Saussure, the social anthropology of Claude Lévi-Strauss, and the early semiology of Roland Barthes to the psychoanalytic 'post-structuralism' of Jacques Lacan, the genealogical studies of Michel Foucault, deconstructionist criticism in Jacques Derrida, and the fully fledged anti-structuralism of Gilles Deleuze, Felix Guattari, Jean-Francois Lyotard, Paul Virilio and others. The 'deconstructive turn' places all structural and systems metaphors in brackets in order to explore what such images presuppose and how they might be 'dissolved' to give ground to other ways of thinking about and analysing of social and cultural phenomena.

For general background see Barker, ed. (2000); Baynes (1987); Dreyfus and Rabinow (1982); Easthope and McGowan (1997); Lane (1970); McGowan (2007); Silverman (1996).

Basic reading here includes:

Maurice Blanchot, 'Everyday Speech', trans. Susan Hanson, *Yale French Studies*, 1987, pp. 12–20
Maurice Blanchot, *The Infinite Conversation* (1992)
Gilles Deleuze, *Francis Bacon: The Logic of Sensation* (2003)
Jacques Derrida, *Speech and Phenomena* (1973)
Jacques Derrida, *Writing and Difference* (1978b)
Jacques Derrida, *Margins of Philosophy* (1982)
Michel Foucault, *The Order of Things: An Archaeology of the Human Sciences* (1971)
Michel Foucault, *The Archaeology of Knowledge* (1972)
Michel Foucault, *The Birth of the Clinic* (1973)
Michel Foucault, *Discipline and Punish* (1977)
Michel Foucault *The History of Sexuality*, vol. 1 (1978)
Michel Foucault, *The Hermeneutics of the Subject* (2005)
Jacques Lacan, *Écrits* (1977)
Claude Lévi-Strauss, *The Savage Mind* (1966)

Claude Lévi-Strauss, *Structural Anthropology* (1968 and 1977)
Jean-François Lyotard, *The Postmodern Condition* (1984)
Jean-François Lyotard, *The Differend: Phrases in Dispute* (1988)
Gianni Vattimo, *The End of Modernity* (1988)
Gianni Vattimo, *The Transparent Society* (1992)
Gianni Vattimo, *The Adventures of Difference* (1993)
Paul Virilio, *The Aesthetics of Disappearance* (1991a)

Deconstruction in Visual Theory

The trajectory of poststructural thought might be reduced to the diagram of the movement from 'work' to 'text' to 'image'. Work in visual studies influenced by the movement towards poststructuralist perspectives would include:

Peter Brunette and David Wills, eds., *Deconstruction and the Visual Arts: Art, Media, Architecture* (1994)
Peter Crowther, *The Kantian Sublime: From Morality to Art* (1989)
Peter Crowther, *Critical Aesthetics and Postmodernism* (1993)
Peter Crowther, *Philosophy after Postmodernism* (2003)
Jacques Derrida, *The Truth in Painting* (1987)
Luc Ferry, *Homo Aestheticus* (1993)
Philippe Lacoue-Labarthe, *Typography: Mimesis, Philosophy, Politics* (1989)
John McCumber, 'Derrida and the Closure of Vision', in David Michael Levin, ed., *Modernity and the Hegemony of Vision* (1993), pp. 234–51
Stephen Melville and Jeremy Gilbert-Rolfe, *Seams: Art as a Philosophical Context: Critical Voices in Art, Theory and Culture* (1996)
Jean-Luc Nancy, *The Ground of the Image* (2005)
Madan Sarup, *An Introductory Guide to Post-Structuralism and Postmodernism,* (1993)
Richard Shusterman, *Pragmatist Aesthetics, Living Beauty, Rethinking Art* (1992)
Richard Shusterman, *Surface and Depth: Dialectics of Criticism and Culture* (2002)
Barbara Maria Stafford, *Good Looking: Essays on the Virtue of Images* (1996)
Jean Starobinski, *1789: The Emblems of Reason* (1982)
David Wood, ed., *Derrida: A Critical Reader* (1992)

Marxism and Critical Theory

For general background see Eagleton (2000, 2003); Eagleton and Milne (1996); Easthope and McGowan (1997/2004); Hemingway (2006); McGowan (2007); Nelson and Grossberg, eds (1988). For recent essays on the significance of Marxism for contemporary art and aesthetics see Matthew Beaumont et al., eds., *As Radical as Reality Itself: Essays on Marxism and Art for the 21st Century* (2007).

While so-called Western Marxist traditions have emphasized art and visual culture as part of their attempt to address the economic determinism of classical base-superstructure models of the social formation the particular dynamics of visual phenomena are relatively unrepresented if not invisible in the canonical Marxist texts. To this day there remains no Marxist equivalent to Hegel's *Aesthetics: Lectures on Fine Art* (1975). The great exceptions to this generalization lies in the writings of figures associated with

the first-generation Frankfurt School of Critical Theory—Walter Benjamin, Theodor Adorno, Siegfried Kracauer, Herbert Marcuse and Ernst Bloch, the Hungarian Marxist Georg Lukács, and with figures from the heterodox tradition of French Marxism—Jean-Paul Sartre, Maurice Merleau-Ponty and Henri Lefebvre. The work of these subtraditions of Western Marxism have, however, been very influential in contemporary cultural studies, critical media and communications theory. Important contemporary figures in this Left-Hegelian tradition are Ben Agger, Terry Eagleton, Alex Honneth, Martin Jay, Fredric Jameson, Douglas Kellner, Mark Poster and Albrecht Wellmer, among others.

Theodor W. Adorno and Culture Industry Perspectives

Second (and now third) generations of Critical Theorists have continued to build on these beginnings, recently reanimated by the recovery of Adorno's work on the 'culture industry' and his critical appraisal of art and aesthetics in the framework of a more politically oriented 'negative dialectics' (Adorno, *Negative Dialectics*, 1973). Today this Adornoesque reading of the crisis of art and society is continued by such figures as Jay M. Bernstein, Simon Critchley, Fredric Jameson, Susan Buck-Morss, Douglas Kellner and Samuel Weber. The general trend of these later interpreters, however, is one that makes an explicit effort to avoid the binarism and elitism of Adorno's critique of popular culture for more situated and interpretative approaches to the operations, functions and practices of everyday culture and cultural criticism.

Theodor W. Adorno, *The Culture Industry* (2001)
Theodor W. Adorno, and M. Horkheimer, *Dialectic of Enlightenment* (1972)
Andrew Arato and Eike Gebhardt, eds., *The Essential Frankfurt School Reader* (1982)
Walter Benjamin, *The Work of Art in the Age of Its Technological Reproducibility and Other Writings on Media* (2008)
Jay M. Bernstein, *The Fate of Art: Aesthetic Alienation from Kant to Derrida and Adorno* (1992)
Ernst Bloch, *The Principle of Hope* (1986)
Susan Buck-Morss, *The Origin of Negative Dialectics* (1977)
Susan Buck-Morss, *The Dialectics of Seeing: Walter Benjamin and the Arcades Project* (1989)
Susan Buck-Morss, 'Globalization, Cosmopolitanism, Politics, and the Citizen' (2002), *Journal of Visual Culture*, 1/3 (2002): 325–40
Noël Carroll, *A Philosophy of Mass Art* (1998)
Howard Caygill, *Walter Benjamin: The Colour of Experience* (1998)
Denis Cosgrove, *Social Formation and Symbolic Landscape* (1984)
Terry Eagleton, *The Ideology of the Aesthetic* (1990)
David Frisby, *Fragments of Modernity: Theories of Modernity in the Work of Simmel, Kracauer and Benjamin* (1986)
Andrew Hemingway and William Vaughan, *Art in Bourgeois Society 1790–1850* (1998)
Ben Highmore, ed., *The Everyday Life Reader* (2002)
Fredric Jameson, *Marxism and Form* (1971)
Fredric Jameson, *The Political Unconscious* (1981)
Fredric Jameson, *Postmodernism* (1991)
Martin Jay, *Downcast Eyes* (1993a) (also Jay 1986, 1988, 1993b)
Douglas Kellner, *Media Spectacle* (2003)

Henri Lefebvre, *Everyday Life in the Modern World* (1984)
Henri Lefebvre, *The Production of Space* (1991)
Henri Lefebvre, *The Critique of Everyday Life*, Vol. 1 (1992)
Herbert Marcuse, *The Aesthetic Dimension* (1978)
Don Paterson, *The Book of Shadows* (2004)
Gerhardt Richter, *Thought-Images: Frankfurt School Writers' Reflections from Damaged Life* (2007)
G. Rose, *The Melancholy Science* (1978)
Michael Ryan, *Marxism and Deconstruction: A Critical Articulation* (1982)
Samuel Weber, *Benjamin's –abilities* (2008)
Sigrid Weigel, *Body- and Image-Space: Re-reading Walter Benjamin* (1996)
Raymond Williams, *Marxism and Literature* (1977)

Postcolonial Theory

In general terms Postcolonial theory challenges the received assumptions about Western socioeconomic and cultural dominance. In particular it is concerned with the critical deconstruction of the colonial gaze and exploitative relations based upon racial differences, with images of oppression, images of empire, Orientalism, the dialectics of colonialism and postcolonialism; postcolonial critiques of dominant image regimes and so forth. As with intellectual movements like Deconstruction and Genealogy, it should be approached in an open and plural way concerned with the many systems of 'colonialisms' that organize the 'hybridized' geopolitical spaces of the world today.

Peter Burke, *Cultural Hybridity* (2009)
P. Gilroy, *The Black Atlantic: Modernity and Double Consciousness* (1993a)
P. Gilroy, *Small Acts* (1993b)
P. Gilroy, 'British Cultural Studies and the Pitfalls of Identity', in J. Curran et al., eds., *Cultural Studies and Communication* (1996), pp. 35–49
Paul Gilroy, 'Art of Darkness: Black Art and the Problem of Belonging to England', in Nicholas Mirzoeff, ed., *The Visual Culture Reader* (1998), pp. 331–37
Marie-Louise Pratt, *Imperial Eyes: Travel Writing and Transculturation* (1992)
E. Said, *Orientalism* (1978)
E. Said, *Culture and Imperialism* (1993)
Gayatri C. Spivak, *In Other Worlds: Essays in Cultural Politics* (1987)
Gayatri C. Spivak, 'Can the Subaltern Speak?', in C. Nelson and L. Grossberg, eds., *Marxism and the Interpretation of Culture* (1988), pp. 271–313
Gayatri C. Spivak, *The Post-Colonial Critic: Interviews, Strategies, Dialogues* (1990)
Shirley Anne Tate, *Black Skins, Black Masks* (2005)
Robert Young, *Colonial Desire* (1995)

Postmodern Theory and Postmodern Visual Culture *(rereading, evaluating and moving beyond the theories of Baudrillard, Deleuze, Derrida, Guattari, Jameson, Iragaray, Lyotard, Žižek and others)*

While the 'post-' in 'Post-modernism' and Poststructuralism remains a source of debate and controversy we can say broadly that postmodern discourses adopt a more radical

scepticism towards many of the leading narratives of modernity in social and political thought and modernism in the arts. In place of 'the Same', 'Identity' and 'Order' it sets into play the forces of difference, nonidentity and transformation. For early statements regarding the postmodernization of modern culture see the collection of essays edited by Hal Foster, *Postmodern Culture* (1983).

Jean Baudrillard, *Simulations* (1983)
Jean Baudrillard, *Selected Writings* (1988)
Jean Baudrillard, *The System of Objects* (1996)
Ulrich Beck, *Risk Society: Towards a New Modernity* (1992)
Roy Boyne, *Foucault and Derrida: The Other Side of Reason* (1990)
R. Braidotti, *Patterns of Dissonance. A Study of Women in Contemporary Philosophy* (1991)
Manuel Castells, *The Rise of the Network Society* (1996)
Guy Debord, *The Society of the Spectacle* (1977, 1994)
Gilles Deleuze and Felix Guattari, *Anti-Oedipus: Capitalism and Schizophrenia* (1977)
Gilles Deleuze and C. Parnet, *Dialogues* (1987)
Fredric Jameson, *Postmodernism* (1991)
Douglas Kellner, *Jean Baudrillard: From Marxism to Postmodernism and Beyond* (1989)
Scott Lash, *Another Modernity, a Different Rationality* (1999)
Bruno Latour, *We Have Never Been Modern* (2006)
Jean-Francois Lyotard, *Discourse, Figure* (1971)
Jean-Francois Lyotard, *The Postmodern Condition* (1984)
Jean-Francois Lyotard, *Lessons on the Analytic of the Sublime* (1994)
Sadie Plant, *Zeroes and Ones: Digital Women and the New Technoculture* (1997)
H. J. Silverman, ed., *Questioning Foundations: Truth/Subjectivity/Culture* (1993)
S. Žižek, *The Sublime Object of Ideology* (1989)
S. Žižek, *Looking Awry: An Introduction to Jacques Lacan through Popular Culture* (1991)
S. Žižek, *Tarrying with the Negative: Kant, Hegel, and the Critique of Ideology* (1993)
S. Žižek, *Welcome to the Desert of the Real* (2002)

HISTORY OF VISUAL CULTURE

The task of analysing and understanding visual phenomena has been central to the arts and humanities for centuries. The exploration of visual experience has very ancient origins in the writings of Plato and Aristotle and their Arab interpreters like the ninth-century theorist Ibn al-Haytham (or Alhazen, b. 965). The modern reappearance of optical philosophy is usually ascribed to the writings of Renaissance scientists, philosophers and artists (Roger Bacon, Alberti, Vasari, Brunelleschi, Leonardo, Cellini and so on) and, in the seventeenth century, to the natural philosophy of Isaac Newton and the rationalist philosopher René Descartes, particularly the latter's work on the physics of perception and optical experience:

L. B. Alberti, *On Painting and Sculpture* (1972)
B. Cellini, *Autobiography* (1998)
René Descartes, 'Optics', in *Selected Philosophical Writings* (1988), reprinted in Nicholas Mirzo-
 eff, ed., *The Visual Culture Reader* (1998), pp. 60–5

Isaac Newton, *Opticks, or a Treatise of the Reflections, Refractions, Inflections and Colours of Light* (1952)

Giorgio Vasari, *Lives of the Artists* (1987)

For the complex history of the eye and ocularcentrism in European culture see

Hans Blumenberg, 'Light as a Metaphor for Truth: At the Preliminary Stage of Philosophical Concepty Formation', in David Michael Levin, ed., *Modernity and the Hegemony of Vision* (1993), pp. 30–62

Simon Clark, *Vanities of the Eye: Vision in Early Modern European Culture* (2007)

John Hendrix and Charles H. Carman, eds., *Renaissance Theories of Vision* (2010)

Simon Ings, *The Eye: A Natural History* (2008)

Martin Jay, 'Scopic Regimes of Modernity', in H. Foster, ed., *Modernity and Identity* (1992)

Martin Jay, *Downcast Eyes: The Denigration of Vision in Twentieth-Century French Thought* (1993a)

Dalia Judovitz, *Subjectivity and Representation in Descartes* (1988)

Dalia Judovitz, 'Vision, Representation, and Technology in Descartes', in David Michael Levin, ed., *Modernity and the Hegemony of Vision* (1993), pp. 63–86

Andrea Wilson Nightingale, *Spectacles of Truth in Classical Greek Philosophy* (2005)

Barry Sandywell, 'Specular Grammar: The Visual Rhetoric of Modernity', in Ian Heywood and Barry Sandywell, eds., *Interpreting Visual Culture: Explorations in the Hermeneutics of the Visual* (1999), pp. 30–56

Michael Wintle, *The Image of Europe* (2009).

The Prehistory of Visual Studies

For overlaps and interfaces with art history and the historiography of art history see Grant Pooke and Diane Newall, *Art History: The Basics* (2008). For the social construction of the *beaux artes* ('Fine art'), connoisseurs and connoisseurship, authentication and validation, cabinets of curiosities to national museum displays and aesthetic archives and the birth of aesthetics in the eighteenth century or what might be called the modern aesthetic regime see Jacques Rancière, *The Politics of Aesthetics* (2006) and *The Future of the Image* (2007). While aesthetic reflection in its modern sense can be traced to Leon Battista Alberti (1404–1472) the classic roots of modern aesthetics as a theory of the fine arts remains Johann Joachim Winckelmann's *History of Ancient Art* (1764), Kant's *Critique of Judgement* (1790), Schiller's *Letters on the Aesthetic Education of Man* (1967), and Hegel's *Aesthetics: Lectures on Fine Art* (1975). German aesthetics was profoundly influenced by the idea of recovering the aesthetic form of life attributed to the ancient Greeks (an attribution that was inseparable from the ideal of an aesthetically founded German education system within an autonomous German nation state). The most accessible collection of aesthetic texts from Lessing, Hamann, Moritz, Novalis, Hölderlin, Schiller and Schlegel is Jay M. Bernstein, ed., *Classic and Romantic German Aesthetics* (2003). For a critical analysis of the 'Hellenic' ideology underlying the eighteenth-century origins of aesthetics see Martin Bernal, *The Fabrication of Ancient Greece 1785–1985* (1987).

Philosophy of Perception

The philosophy and psychology of perception is a vast area embracing speculation and research on visual perception that dates back to the earliest Greek writers. Its modern representatives are thinkers like John Locke, David Hume, George Berkeley, Maine de Biran, Wilhelm Wundt, Hermann von Helmholz, Robert Vischer, Edmund Husserl, Gestalt psychologists such as Karl Koffka, Wolfgang Köhler and Kurt Goldstein, Ernst Gombrich, Maurice Merleau-Ponty, James J. Gibson, among many others. The collection of essays edited by Alva Noë and Evan Thompson, *Vision and Mind: Selected Readings in the Philosophy of Perception* (2002) is to date the standard reader in the philosophy of perception. A useful introductory text on the psychology of vision is Richard L. Gregory's *Eye and Brain: The Psychology of Seeing* (1998). Also see Michele Emmer, ed., *The Visual Mind* (2005), Robert L. Solso, ed., *Cognition and the Visual Arts* (1996), Roy Sorensen, *Seeing Dark Things: The Philosophy of Shadows* (2008), Evan Thompson's *Colour Vision* (1995), and Semir Zeki's *Inner Vision: An Exploration of Art and the Brain* (1999).

For the philosophy and sociology of vision in the context of multisensorial experience see the essays in David Howes, ed. *Empire of the Senses* (2006). Also useful as background: Constance Classen, *Worlds of Sense: Exploring the Senses in History and across Cultures* (1993), Constance Classen, *The Book of Touch* (2005), Mark Johnson, *Philosophy in the Flesh: the Embodied Mind and Its Challenge to Western Philosophy* (1999), David Howes, *Sensual Relations* (2003), Barbara Maria Stafford, *Echo Objects: The Cognitive Work of Images* (2007), Michael Taussig, *Mimesis and Alterity: A Particular History of the Senses* (1993) and Gail Weiss, *Body Images: Embodiment as Intercorporeality* (1999). Berg has also published a number of works on the senses in its *Sensory Formations* and *Senses and Sensibilities* series (see the bibliographical essay 'Forming Perceptions' in David Howes, ed., *Empire of the Senses* (2006), pp. 399–403). Deconstructionist approaches have also questioned the dominance of sensory phenomenology. See Jacques Derrida's *Jean-Luc Nancy: On Touching* (2005). Michel Serres's *Les cinq sens (philosophie des corps mêlées, volume I)* has been recently translated into English, *The Five Senses: A Philosophy of Mingled Bodies*, vol. 1 (2008). All of these diverse writings concur in pointing towards a more concrete and relational theory of the visual and, in particular, a relational concept of aesthetic illumination and knowledge.

Vision in the History of Science

The development of concepts of rigorous observation, empirical seeing and factual evidence has been inseparable from the idea and conduct of modern science. Among the vast body of relevant literature see:

Kathleen Adler and Marcia Pointon, eds., *The Body Imaged: The Human Form and Visual Culture since the Renaissance* (1993)

Sian Ede, *Strange and Charmed: Science and the Contemporary Visual Arts* (2000)

Peter Galison and Caroline Jones, eds., *Picturing Science, Producing Art* (1998)

Martin Kemp, *The Science of Art: Optical Themes in Western Art from Brunelleschi to Seurat* (1990)

Martin Kemp, *Visualizations: The Nature Book of Art and Science* (2000)

Martin Kemp, *Seen/Unseen: Art, Science and Intuition from Leonardo to the Hubble Telescope* (2006)

Thomas Kuhn, *The Structure of Scientific Revolutions* (1962)

David Lindbergh, *Theories of Vision from Al-kindi to Kepler* (1996)

Barbara Maria Stafford, *Body Criticism: Imaging the Unseen in Enlightenment Art and Medicine* (1991)

Philosophy of Visuality

Vision and issues relating to visual perception can be found across the traditions of contemporary phenomenology, hermeneutics and deconstruction. Here the work of such thinkers as Husserl, Merleau-Ponty (1962, 1964a,b,c), Jean-Paul Sartre, Emmanuel Levinas, Max Scheler and Martin Heidegger should be singled out as classical precursors of the visual turn in modern thought. An accessible introduction to phenomenology can be found in Gallagher and Zahavi, *The Phenomenological Mind: An Introduction to Philosophy of Mind and Cognitive Science* (2008). Zahavi is worth reading with respect to the linkages between the phenomenology of perception and first-person subjectivity (see Zahavi, *Subjectivity and Selfhood: Investigating the First-Person Perspective* (2005)). For the phenomenological and hermeneutic background to visual analysis see the literature mentioned under these headings above. For a useful collection of essays on the embodied subject, drawing inspiration from the 'philosophy of the body' in the thought of Maurice Merleau-Ponty see Dorothea Olkowski and Gail Weiss, eds., *Feminist Interpretations of Maurice Merleau-Ponty* (2006). The older study by M. H. Segal, D. T. Campbell and M. J. Herskovits, *The Influence of Culture on Visual Perception* (1966), is still an important resource.

Social History of Visual Regimes

This thematic category would include the social history of seeing, scopic regimes, visual discourse formations, ideals and ideologies of viewing and seeing. Seminal contributions to this growing tradition can be dated to the work of theorists such as Walter Benjamin, Ernst Bloch, Lewis Mumford, Marshall McLuhan (McLuhan's 'the medium is the message' became one of the cultural catchphrases of the 1960s), and the much underrated writings of Raymond Williams on media technology (his *Television: Technology and Cultural Form* (1974) and futuristic *Towards 2000* (1983) in particular).

Mainstream philosophy has also come to be interested in the role of visual media and visual metaphors in the constitution of models of mind, understanding and reality. The work of the US pragmatist philosopher Richard Rorty is well known for popularizing and disseminating the idea of the 'linguistic turn' in modern philosophy. He has also written a very influential book on the idea of representation and 'mirroring' within modern epistemology. See Richard Rorty, *Philosophy and the Mirror of Nature* (1979). Developing an idea used by the French film semiologist Christian Metz, Martin Jay has written extensively on 'scopic regimes' and their links to contested modernities. His

original essay on the topic appeared in 1988. Martin Jay's *Downcast Eyes: The Denigration of Vision in Twentieth-Century French Thought* (1993a) remains a classical statement of the 'textual' bias in modern French philosophy. Parallel themes can be found in the writings of Michael Baxandall (the concept of 'the period eye' for example in his *Painting and Experience in Fifteenth-Century Italy* (1972)) and David Michael Levin (*The Opening of Vision* (1988), *Modernity and the Hegemony of Vision* (1993), *The Philosopher's Gaze* (1999) and *Sites of Vision: The Discursive Construction of Sight in the History of Philosophy* (1997)).

Visuality, Power Formations and Modernity

Many of the key works of Michel Foucault are relevant to the study of the linkages between modern society and regimes of visibilization. Foucault has been most influential in putting the power/knowledge/culture nexus upon the intellectual map. Among the central texts are *The Order of Things* (1971), *The Archaeology of Knowledge* (1972), *The Birth of the Clinic* (1973), *Discipline and Punish* (1977) and *History of Sexuality*, Vol. 1 (1978). See also G. Gutting, *Michel Foucault's Archaeology of Scientific Reason* (1989).

Genealogies of Western Thought and Its Cultural Contexts

> the fact that the world becomes picture at all is what distinguishes the essence of the modern age. (Heidegger, 'The Age of the World Picture', in Heidegger 1977)

Michel Foucault, *The Archaeology of Knowledge* (1972)
Michel Foucault, *The Birth of the Clinic: An Archaeology of Medical Perception* (1973)
Michel Foucault, *The Hermeneutics of the Subject* (2005)
David Michael Levin, ed. *Modernity and the Hegemony of Vision* (1993)
Barry Sandywell, *Logological Investigations*, 3 vols. (1996)
Barry Sandywell, *Dictionary of Visual Discourse: A Dialectical Lexicon of Terms* (2011)
Gary Shapiro, *Archaeologies of Vision: Foucault and Nietzsche on Seeing and Saying* (2003)

Visual Culture in the Context of Wider Cultural Formations

For an incisive history of Western visual culture see Martin Kemp, *The Science of Art: Optical Themes in Western Art from Brunelleschi to Seurat* (1990) and *The Oxford History of Western Art* (2002). For the scopic regimes of modernity see Martin Jay (1988, 1993a). For premodern scopic regimes see Marie-Jose Mondzain, *Image, Icon, Economy: The Byzantine Origins of the Contemporary Imaginary* (2004), Valentin Groebner, *Defaced: The Visual Culture of Violence in the Late Middle Ages* (2008). On medieval visual culture see Erwin Panofsky, *Gothic Architecture and Scholasticism* (1951) and Otto Georg von Simson, *The Gothic Cathedral: Origins of Gothic Architecture and the Medieval Concept of Order* (1988).

On Renaissance 'visualities' (especially the invention of three-dimensional perspective space and its vital importance in the definition of Renaissance humanism) see Hubert Damisch, *The Origin of Perspective* (1994), Sarah Kofman, *Camera Obscura* (1999),

and Jonathan Crary, *Techniques of the Observer* (1990). Martin Jay summarizes the assumptions of Renaissance visual space as geometrically isotropic, rectilinear, abstract and uniform ('Scopic Regimes of Modernity', 1988). For the development of the idea of the individualized and 'alienated' Renaissance artist see Margot and Rudolf Wittkower, *Born under Saturn* (1963). For the wider historical and cultural background see John Hale, *The Civilization of Europe in the Renaissance* (1993) and Simon Clark, *Vanities of the Eye: Vision in Early Modern European Culture* (2007). A Heideggerian perspective is developed in Ernesto Grassi's *Heidegger and the Question of Renaissance Humanism* (1983). For the optical metaphysics that Heidegger opposed see William McNeill, *The Glance of the Eye: Heidegger, Aristotle, and the Ends of Theory* (1999). A fascinating analysis of the early use of the camera obscura is given in David Hockney's *Secret Knowledge: Rediscovering the Lost Techniques of the Old Masters* (2001). Also see Maillet (2004) on the role of the 'Claude Glass' in Western art practices.

For an important socio-historical survey of transformations of visual space in the transition to modernity see Stephen Kern's *The Culture of Time and Space 1880–1918* (1993). For further background on the dialectical relationships between industrialization, modernization and the transformation of visual space see Louis Dupré, *Passage to Modernity* (1993), Norbert Elias, *The Civilizing Process* (1982), Donald M. Lowe, *History of Bourgeois Perception* (1982), Charles Taylor, *Sources of the Self* (1989), Charles Taylor, *A Secular Age* (2007), Stephen Toulmin, *Cosmopolis: The Hidden Agenda of Modernity* (1990) and Alan Trachtenberg, *The Incorporation of America: Culture and Society in the Gilded Age* (1982). For general historical background see Barry Sandywell, *Logological Investigations*, volume 1, *Reflexivity and the Crisis of Western Reason* (1996).

Impact of Visual Technologies upon Scopic Regimes and Imaginary Cultures

There are many recent works devoted to the investigation of the social and cultural impact of visual technologies such as writing, the camera, moving pictures, video and digital communications. Among the most influential are:

Jonathan Crary, *Techniques of the Observer: On Vision and Modernity in the Nineteenth Century* (1990)
Jonathan Crary, *Suspensions of Perception: Attention, Spectacle and Modern Culture* (1999)
Don Ihde, *Postphenomenology* (1993)
John Tagg, *The Burden of Representation: Essays on Photographies and Histories* (1988)
John Tagg, *Grounds of Dispute: Art History, Cultural Politics and the Discursive Field* (1992)

For technology and the transformation of visual imagination see Rosalind Williams, *Notes on the Underground* (1990). For directions that are more rooted in phenomenological traditions see Don Ihde's *Technology and the Lifeworld: From Garden to Earth* (1990) and *Postphenomenology* (1993). William McNeill has an interesting analysis of the transformation of visual experience through modern science and technology (Part II, 'The Transformation of Theoria', in *The Glance of the Eye* (1999), pp. 161–218). Barry Sandywell treats the coming of cyberspace and 'technovision' extensively in his *Dictionary of Visual Discourse* (2011).

ART HISTORY, ART THEORY AND AESTHETICS

Basic Art History

Art history is the traditional forbear of visual studies. In its dominant perspective it has focused upon the work of individual artists, artistic images (in two-dimensional and three-dimensonal forms), artistic practices, genres (styles), art movements and art institutions. In the terminology of German epistemology traditional art history thought of itself as an *ideographic* rather than a *nomothetic* discipline. Over its long history the discipline has typically located itself as part of the 'humanities' concerned with the origins and consequences of cultural life rather than the sciences with their concern for abstract generalities and laws. An introductory overview of art history can be found in John Harris, *Art History: The Key Concepts* (2006). There have been several attempts to reinvigorate these descriptive and idiographic concerns. For the 'new art history' see John Harris, *The New Art History: A Critical Introduction* (2001). For a popular account of myth and symbology in the 'reading' of paintings see Patrick de Rynck, *Understanding Paintings: Bible Stories and Classical Myths in Art* (2009).

Despite their analytical limitations many traditional accounts of art history from some of the founders of the discipline are still valuable. These might include writings in the German tradition of *Kunstwissenschaft* of Alois Riegl, Heinrich Wölfflin, Erwin Panofsky, E. H. Gombrich, Rudolf Arnheim, Wilhelm Pinder, Hans Sedlmayr, Aby Warburg, Edgar Wind, Arnold Hauser and others. For examples of traditional approaches to art history see R. Arnheim, *Art and Visual Perception: A Psychology of the Creative Eye* (1969), E. H. Gombrich, *The Story of Art* (1950/1995), *Art and Illusion* (1960), and *The Image and the Eye* (1962), Erwin Panofsky, *Meaning and the Visual Arts* (1955), Alois Riegl, *Late Roman Art Industry* (1985), and Hans Sedlmayr, *Art in Crisis* (2006). More critical accounts can be found in Svetlana Alpers, *The Art of Describing: Dutch Art in the Seventeenth Century* (1989), Svetlana Alpers, *Rembrandt's Enterprise: The Studio and Market* (1988) and Michael Baxandall, *Painting and Experience in Fifteenth Century Italy* (1972) and *Patterns of Intention: On the Historical Explanation of Pictures* (1985). For the Viennese school and its influence see Frederic J. Schwartz, *Blind Spots: Critical Theory and the History of Art in Twentieth Century Germany* (2005) and Chrisopher S. Wood, ed., *Vienna School Reader: Politics and Art Historical Method in the 1930s* (2000).

A representative sample of texts on art history can be found in Donald Preziosi's edited collection, *The Art of Art History: A Critical Anthology* (1998). See also Steve Edwards, ed., *Art and Its Histories: A Reader* (1996), Steve Edwards and Paul Wood, eds., *Art of the Avant-Gardes* (2004) and John Onians, ed., *Sight and Insight: Essays on Art and Culture in Honour of E. H. Gombrich* (1994). For a recent review of concepts and terminology see Robert S. Nelson and Richard Shiff, eds., *Critical Terms for Art History* (2003) and P. Smith and C. Wilde, eds., *A Companion to Art Theory* (2002).

For influential voices in the description and criticism of modern art see Jason Gaiger and Paul Wood, eds., *Art of the Twentieth Century: A Reader* (2003). For a richly illustrated history of the avant-gardes see Christopher Green's *The European Avant-gardes* (1995). It would be no exaggeration to claim that the language of modern art and

art criticism has been shaped by modernist movements. These include Impressionism, Expressionism, Cubism, Fauvism, Primitivism, Constructivism, Dadaism, Surrealism, Photomontage, Abstract Formalism, Abstract Expressionism, Minimalism, Conceptual Art, Pop Art and Neo-Realism. Accessible accounts of aesthetic modernism can be found in:

Clive Bell, *Art* (1987)
Peter Bürger, *Theory of the Avant-Garde* (1984)
T. J. Clark, *The Painting of Modern Life: Paris in the Art of Manet and His Followers* (1984)
Clement Greenberg, 'Modernist Painting', in *The Collected Essays and Criticism*, Vol. 4 (1993)
Robert Hughes, *The Shock of the New: Art and the Century of Change* (1991)
Karen Jacobs, *The Eye's Mind: Literary Modernism and Visual Culture* (2001)
Amelia Jones, ed., *A Companion to Contemporary Art since 1945* (2006)
Elaine de Kooning, *The Spirit of Abstract Expressionism* (1994)
Eugene Lunn, *Marxism and Modernism* (1982)
B. K. Scott, ed., *The Gender of Modernism: A Critical Anthology* (1990)
David Summers, *Real Spaces: World Art History and the Rise of Western Modernism* (2003)
Brian Wallis, ed., *Art after Modernism: Rethinking Representation* (1984)

Art Theory

Dana Arnold, ed. *Art Theory* (2003)
Yve-Alain Bois, *Art since 1900* (2005)
Herschel B. Chipp, *Theories of Modern Art: A Source Book by Artists and Critics* (1984)
Cynthia Freeland, *Art Theory: A Very Short Introduction* (2003)
Jason Gaiger and Paul Wood, eds. *Art of the Twentieth Century: A Reader* (2003)
Charles Harrison and Paul Wood, eds. *Art in Theory: 1900–2000* (2002)
Zoya Kocur and Simon Leung, eds. *Theory in Contemporary Art since 1985* (2004)

Aesthetics

For a general overview see B. Gaut and D. M. Lopes, eds., *The Routledge Companion to Aesthetics* (2001) and M. Kelly, ed., *Encyclopaedia of Aesthetics* (1998). For mainly European aesthetic debate see Clive Cazeaux, ed., *The Continental Aesthetics Reader* (2000). For studies of different perspectives and problems in contemporary aesthetics:

Monroe C. Beardsley, *Aesthetics from Classical Greece to the Present* (1966)
Jay M. Bernstein, ed., *Classic and Romantic German Aesthetics* (2003)
Andrew Bowie, *Aesthetics and Subjectivity* (2003)
Clive Cazeaux, ed., *The Continental Aesthetics Reader* (2000)
R. G. Collingwood, *The Principles of Art* (1938)
John Dewey, *Art as Experience* (1934, 2005)
Terry Eagleton, *The Ideology of the Aesthetic* (1990)
David Goldblatt and Lee B. Brown, eds., *Aesthetics: A Reader in Philosophy of the Arts* (2005)
Catherine Van Eck and Edward Winters, eds., *Dealing with the Visual: Art History, Aesthetics and Visual Culture* (2005)

Visual Theory and New Art History

Mieke Bal, *Reading 'Rembrandt': Beyond the Word-Image Opposition* (1991)

Mieke Bal, *Double Exposures: The Subject of Cultural Analysis* (1996)

N. Bryson et al., eds. *Visual Theory* (1991)

Mark A. Cheetham, *Kant, Art and Art History: Moments of Discipline* (2001)

Mark A. Cheetham, 'Visual Studies, Historiography and Aesthetics', *Journal of Visual Culture*, Vol. 4(1), 2005, pp. 75–90

Mark A. Cheetham, *Abstract Art against Autonomy: Infection, Resistance, and Cure since the 60s* (2006)

Mark A. Cheetham with E. Legge and C. Soussloff, eds., *Editing the Image: Strategies in the Production and Reception of the Visual* (2008)

Mark A. Cheetham et al., eds., *The Subjects of Art History: Historical Objects in Contemporary Perspective* (1998)

James Elkins, *Visual Studies: A Skeptical Introduction* (2003)

James Elkins, ed. *Art History versus Aesthetics* (2006)

Jocelyn Hackforth-Jones and Mary Roberts, *Edges of Empire: Orientalism and Visual Culture* (2005)

Michael Ann Holly and Marquard Smith, eds., *What Is Research in the Visual Arts: Obsession, Archive, Encounter* (2008)

Peter Kivy, *Philosophies of Arts: An Essay in Differences* (1997)

Stephen Melville and Bill Readings, eds., *Vision and Textuality* (1995)

Catherine Soussloff, *The Absolute Artist* (1997)

Anti-aesthetics

Theodor Adorno, *Aesthetic Theory* (1990, 1997)

Andrew Benjamin, ed., *Walter Benjamin and Art* (2004)

Clive Cazeaux, ed., *The Continental Aesthetics Reader*, Part 5, 'Poststructralism and Postmodernism' (2000)

Guy Debord, *The Society of the Spectacle* (1977, 1994)

Hal Foster, ed., *The Anti-Aesthetic: Essays on Postmodern Culture* (2002)

Yuriko Saito, *Everyday Aesthetics* (2007)

Wolfgang Welsch, *Undoing Aesthetics* (1997)

The global generalization of aesthetic forms and media now includes work on the expanded functions of narrative and mimesis through digitalization, analyses of techno-digital art (televisual aesthetics); the complex relationships between 'everyday' art, representation and social relations; art and its media; technological infrastructures of art practices, design, graphic media; information and image construction/processing; digitalization of art practices; the fate of the European avant-gardes and so on.

Victor Burgin, *In/different Spaces* (1996)

Stephen Connor, *The Book of Skin* (2003)

Terry Eagleton, *The Ideology of the Aesthetic* (1990)

Steve Edwards, ed., *Art and Its Histories: A Reader* (1996)

Steve Edwards and Paul Wood, eds., *Art of the Avant-Gardes* (2004)

Rosalind Krauss, *The Optical Unconscious* (1993)

Peter Osborne, *Philosophy in Cultural Theory* (2000)

Peter Osborne, ed., *Walter Benjamin: Critical Evaluations in Cultural Theory* (2004)

Yuriko Saito, *Everyday Aesthetics* (2007)

Peter Wollen, *Readings and Writings* (1982)

Peter Wollen, *Raiding the Icebox: Reflections on Twentieth-Century Culture* (1993)

Radical Art Theory and Art Practice

Philip Alperson, ed., *The Philosophy of the Visual Arts* (1992)

Norman Bryson, *Vision and Painting: The Logic of the Gaze* (1983)

Norman Bryson, *Tradition and Desire: From David to Delacroix* (1984)

Norman Bryson, *Looking at the Overlooked: Four Essays on Still Life Painting* (2004)

Victor Burgin, *The End of Art Theory* (1986)

T. J. Clark, *The Painting of Modern Life* (1984)

Keith Moxley, *The Practice of Theory: Poststructuralism, Cultural Politics, and Art History* (1994)

Griselda Pollock, *Vision and Difference: Feminism, Femininity and the Histories of Art* (1988)

Griselda Pollock, *Avante-Garde Gambits 1888–1893: Gender and the Colour of Art Theory* (1993)

Griselda Pollock, *Differencing the Canon: Feminist Desire and the Writing of Art's Histories* (1999)

Griselda Pollock, ed., *Generations and Geographies in the Visual Arts: Feminist Readings* (1996)

Typography/Art/Writing

Norman Bryson, ed., *Calligram: Essays in the New Art History from France* (1988)

Richard H. Davis, *Lives of Indian Images* (1999)

Johanna Drucker, *The Visible Word: Experimental Typography and Modern Art, 1909–1923* (1994)

Joanna Drucker, *The Alphabetic Labyrinth: The Letters in History and Imagination* (1995)

E. E. Eisenstein, 'Some Conjectures about the Impact of Printing on Western Society and Thought', *Journal of Modern History*, 40, 1968, pp. 1–56

E. E. Eisenstein, 'The Advent of Printing and the Problem of the Renaissance', *Past and Present*, 45, 1969, pp. 19–89

E. E. Eisenstein, *The Printing Press as an Agent of Change: Communications and Cultural Transformations in Early-Modern Europe* (1979)

E. E. Eisenstein, 'Some Conjectures about the Impact of Printing on Western Society and Thought: A Preliminary Report', in H. J. Graff, ed., *Literacy and Social Development in the West* (1981), pp. 53–68

E. E. Eisenstein, *The Printing Revolution in Early Modern Europe* (1983)

Lucien Febvre and Henri-Jean Martin, *The Coming of the Book: The Impact of Printing, 1400–1800* (1997)

J. Goody, *The Domestication of the Savage Mind* (1977)

J. Goody, ed., *Literacy in Traditional Societies* (1968)

J. Goody and I. Watt, 'The Consequences of Literacy', *Comparative Studies in Society and History*, 5, April 1963, pp. 304–45

Eric Havelock, *Preface to Plato* (1963)

P. Lacoue-Labarthe, *Typography: Mimesis, Philosophy, Politics* (1989)

Walter J. Ong, *The Presence of the Word: Some Prolegomena for Cultural and Religious History* (1967)

Walter J. Ong, *Rhetoric, Romance, and Technology: Studies on the Interaction of Expression and Culture* (1971)

Walter J. Ong, *Interfaces of the Word* (1977)

Aesthetics and Critical Social Theory

For key texts see Clive Cazeaux, ed., *The Continental Aesthetics Reader* (2000), Part 3, 'Marxism and Critical Theory'.

T. Adorno, *Aesthetic Theory* (1990, 1997)

Norman Bryson, *Vision and Painting: The Logic of the Gaze* (1983)

Norman Bryson et al., eds., *Visual Theory* (1991)

Peter Bürger, *Theory of the Avant-Garde* (1984)

Paul Crowther, *The Transhistorical Image: Philosophizing Art and Its History* (2002)

Ian Heywood, *Social Theories of Art* (1997)

Margaret Iversen, *Alois Riegl: Art History and Theory* (1993)

Scott Lash, 'Reflexivity and Its Doubles: Structure, Aesthetics, Community', in U. Beck, A. Giddens and S. Lash, eds., *Reflexive Modernization* (1994), pp. 110–73

L. Nochlin, *The Politics of Vision: Essays on Nineteenth-Century Art and Society* (1991)

Catherine Soussloff, *The Subject in Art: Portraiture and the Birth of the Modern* (2006)

Richard Wollheim, *Art and Its Object* (1980)

Richard Wollheim, *Painting as an Art* (1987)

Aesthetic Philosophy

It is important to distinguish the more traditional 'philosophy of art' with its central concern with the nature of beauty, normative values and aesthetic appreciation from 'aesthetic philosophy' in its more recent 'continental-philosophical' meaning. The former has been typically concerned with applying the techniques of Anglo-American conceptual analysis to aesthetic questions and problems (see Dickie 1974 and 1997). While the latter approaches 'artworks' and 'the aesthetic' as the starting point for the development of distinctive postempiricist philosophical positions and perspectives. The 'continental' current of aesthetic philosophy traces its roots to Kant's *Critique of Judgement* (1790) and to debates about the social origins and functions of art in the Hegelian, Marxist and Critical Theory traditions. Adorno's *Aesthetic Theory* (1997) comes closest to the development of a distinctively postmodern aesthetic philosophy. Recent writings in this vein have reassessed the place of art and aesthetic objects as fundamental to any comprehensive understanding of the human condition (for example Joseph Margolis 2009). Today there are many signs of dialogue and rapprochement between these strands of thought; for example the emphasis is now placed upon the plural multiplicities that intersect across the fields of philosophical reflection and visual art (for example

Peter Kivy's *Philosophies of Arts: An Essay in Differences* (1997) or the collection of essays edited by David Goldblatt and Lee B. Brown, *Aesthetics: A Reader in Philosophy of the Arts* (2005)). For an overview of aesthetic theorizing in the twentieth century see Paul Guyer, 'Twentieth-Century Aesthetics' (2008).

Theodor Adorno, *Aesthetic Theory* (1990, 1997)
Andrew Benjamin, *Object, Painting* (1994)
Yve-Alain Bois, *Painting as Model* (1993)
Andrew Bowie, *From Romanticism to Critical Theory* (1997)
Andrew Bowie, *Aesthetics and Subjectivity* (2003)
Paul Crowther, *The Transhistorical Image: Philosophizing Art and Its History* (2002)
Arthur C. Danto, *The Transfiguration of the Commonplace* (1981)
Arthur C. Danto, *The Philosophical Disenfranchisement of Art* (1986)
Arthur C. Danto, *After the End of Art: Contemporary Art and the Pale of History* (1997)
Arthur C. Danto, *The Abuse of Beauty* (2003)
George Dickie, *Art and the Aesthetic* (1974)
George Dickie, *Introduction to Aesthetics* (1997)
Roger Scruton, *Art and Imagination: A Study in the Philosophy of Mind* (1974)
Frank Sibley, *Approaches to Aesthetics* (2001)

For the philosophical implications of art for 'philosophical anthropology' see Joseph Margolis, *The Arts and the Definition of the Human: Toward a Philosophical Anthropology* (2009). Also in this context, Stephen Melville and Jeremy Gilbert-Rolfe, *Seams: Art as a Philosophical Context: Critical Voices in Art, Theory and Culture* (1996) and Peter Crowther, *Art and Embodiment* (1993).

The Return of Beauty

A clear case of 'the return of the repressed' in recent visual culture is the revival of interest in questions of beauty and pleasure (questions that were central to mainstream art history—of the kind exemplified by Bernard Berenson and Kenneth Clarke—but were effectively sidelined by the dominant modernist versions of cultural theory). For attempts to recover the problematics of beauty see:

Dave Beech, *Beauty: Documents of Contemporary Art* (2009)
Bonnie Berry, *The Power of Looks: Social Stratification of Physical Appearance* (2008)
Umberto Eco, *Art and Beauty in the Middle Ages* (1988)
Umberto Eco, ed., *On Ugliness* (2008)
Paul A. Fishwick, ed., *Aesthetic Computing* (2006)
Dave Hickey, *The Invisible Dragon: Essays on Beauty* (2009)
Mark Johnson, *The Meaning of the Body: Aesthetics of Human Understanding* (2008)
Stephen Johnstone, ed., *The Everyday (Documents of Contemporary Art)* (2008)
Elizabeth Prettejohn, *Beauty and Art: 1750–2000* (2005)
Elaine Scarry, *On Beauty and Being Just* (2006)
Wendy Steiner, *The Scandal of Pleasure: Art in the Age of Fundamentalism* (1997)
Wendy Steiner, *Beauty in Exile: The Rejection of Beauty in Twentieth-Century Art* (2002)

Janet Wolff, 'Groundless Beauty: Feminism and the Aesthetics of Uncertainty', *Feminist Theory*, Vol. 7(2), 2006 (Special Issue on Beauty)

Janet Wolff, *The Aesthetics of Uncertainty* (2008)

Anthony Zee, *Fearful Symmetry: The Search for Beauty in Modern Physics* (1999)

Ethics of Seeing

Important explorations of the ethical grounds and dimensions of visual experience include:

Walter Benjamin, *Illuminations: Essays and Reflections* (1969/1992)

Walter Benjamin, 'Theses on the Philosophy of History', in *Illuminations* (1969/1992), pp. 245–55

Walter Benjamin, 'The Work of Art in the Age of Its Technological Reproducibility', in Walter Benjamin, *The Work of Art in the Age of Its Technological Reproducibility and Other Writings on Media* (2008), pp. 19–55

L. A. Blum, *Moral Particularity and Perception* (1994)

Judith Butler, *Precarious Life: The Powers of Mourning and Violence* (2004)

Kenneth Clark, *The Nude* (1970)

Claire Colebrook, *Ethics and Representation: From Kant to Post-Structuralism* (2000)

Simon Critchley, *The Ethics of Deconstruction: Derrida and Levinas* (1992)

Anne Eaton, 'Painting and Ethics', in D. Goldblatt and L. B. Brown, eds., *Aesthetics: A Reader in Philosophy of the Arts* (1997), pp. 63–8

Claire Farago, ed., *Leonardo da Vinci and the Ethics of Style* (2008)

Mark Johnson, *Moral Imagination: Implications of Cognitive Science for Ethics* (1994)

Charles E. Larmore, *Patterns of Moral Complexity* (1987)

Jerrold Levinson, *The Pleasures of Aesthetics* (1996)

Jerrold Levinson, ed., *Aesthetics and Ethics: Essays at the Intersection* (1998)

Martha Nussbaum, *The Fragility of Goodness* (1986)

Martha Nussbaum, *Love's Knowledge: Essays on Philosophy and Literature* (1990)

Elaine Scarry, *The Body in Pain* (1985)

Elaine Scarry, *On Beauty and Being Just* (2006)

Susan Sontag, *Regarding the Pain of Others* (2004)

Janet Wolff, *The Aesthetics of Uncertainty* (2008)

CULTURAL STUDIES PERSPECTIVES

For general outlines and further bibliographical references to the cultural studies paradigm see:

Jeffrey C. Alexander and Steven Seidman, eds., *Culture and Society: Contemporary Debates* (1990)

M. Barrett et al., eds., *Ideology and Cultural Production* (1979)

Tony Bennett and John Frow, eds., *The Sage Handbook of Cultural Analysis* (2008)

Simon During, *Cultural Studies* (2005)

Simon During, ed., *The Cultural Studies Reader* (1993)

Lawrence Grossberg et al., *Cultural Studies* (1992)

Gary Hill and Clare Birchall, eds., *New Cultural Studies* (2006)
Brian Longhurst et al., *Introducing Cultural Studies* (2008)
Jim McGuigan, *Cultural Analysis* (2009)
Jessica Munns and Gita Rajan, eds., *A Cultural Studies Reader: History, Theory, Practice* (1995)
Cary Nelson and Lawrence Grossberg, eds., *Marxism and the Interpretation of Culture* (1988)
John Storey, *Cultural Theory and Popular Culture: An Introduction* (2008)
John Storey, ed., *Cultural Theory and Popular Culture: A Reader* (2008)
Andy Tudor, *Decoding Culture: Theory and Method in Cultural Studies* (1999)
Graeme Turner, *British Cultural Studies: An Introduction* (1996)

Media Studies of Visuality

For recent statements from key figures in the field of visual studies see Marquard Smith, ed., *Visual Culture Studies: Interviews with Key Thinkers* (2008).

General Introductions

Tony Bennett et al., eds., *Culture, Society and the Media* (1982)
Adam Briggs and Paul Cobley, *The Media* (2002)
Peter Burke and Asa Briggs, *A Social History of the Media* (2005)
Stuart Hall, ed. *Representation: Cultural Representations and Signifying Practices* (1997)
Douglas Kellner, *Media Culture* (1994)
Jim McGuigan, *Cultural Analysis* (2009)
Nicholas Mirzoeff, *An Introduction to Visual Culture* (1999)
John B. Thompson, *Media and Modernity* (1995)

Mass Communication

Tony Bennett and John Frow, eds., *The Sage Handbook of Cultural Analysis* (2008)
Paddy Scannell et al., eds., *Culture and Power: A Media, Culture and Society Reader* (1992)
Philip Schlesinger, *Media, State and Nation: Political Violence and Collective Identities* (1991)
Nick Stevenson, *Understanding Media Cultures: Social Theory and Mass Communication* (1995)

Philosophy of Film and the Moving Image

Stanley Cavell, *The World Viewed: Reflections on the Ontology of Film* (1971)
Stanley Cavell, *Pursuits of Happiness: The Hollywood Comedy of Remarriage* (1981)
Stanley Cavell, *Contesting Tears: The Hollywood Melodrama of the Unknown Woman* (1996)
Stanley Cavell, *Cities of Words: Pedagogical Letters on a Register of the Moral Life* (2004)
Lucien Taylor, ed., *Visualizing Theory* (1994)

Film Studies (history, film theory, film genres, reception theory, semiotics, etc)

Useful anthologies on film and cinema are Richard Allen and Murray Smith, eds., *Film Theory and Philosophy* (1997), Noël Carroll and Jinhee Choi, eds., *Philosophy of Film*

and Motion Pictures: An Anthology (2006) and Keith Barry Grant, ed. *Film Genre Reader* (1986). Also:

Rick Altman, *Film/Genre* (1999)

David Bordwell, *Making Meaning: Inference and Rhetoric in the Interpretation of Cinema* (1989)

David Bordwell and Noël Carroll, eds., *Post-Theory: Reconstructing Film Studies* (1996)

Noël Carroll, *Theorizing the Moving Image* (1996)

Shohini Chaudhuri, *Feminist Film Theorists: Laura Mulvey, Kaja Silverman, Teresa de Lauretis, Barbara Creed* (2006)

Gregory Currie, *Image and Mind: Film, Philosophy and Cognitive Science* (1995)

Andrew Dudley, *The Major Film Theories* (1976)

Richard Dyer, *Stars* (1982)

Richard Dyer, *Now You See It: Studies on Lesbian and Gay Film* (1990b)

Anne Friedberg, *Window Shopping: Cinema and the Postmodern* (1993)

Anne Friedberg et al. eds., *Close Up 1927–1933: Cinema and Modernism* (1998)

Annette Kuhn, ed. *Alien Zone: Cultural Theory and Contemporary Science Fiction* (1990)

Christian Metz, *Film Language: A Semiotics of the Cinema* (1974)

Christian Metz, *The Imaginary Signifier* (1982)

Christian Metz, *Psychoanalysis and the Cinema: the Imaginary Signifier* (1983)

Laura Mulvey, 'Visual Pleasure and Narrative Cinema', in G. Mast and M. Cohen, eds., *Film Theory and Criticism* (1975), pp. 803–16

Laura Mulvey, *Visual and Other Pleasures* (1989)

Eric Santner, *Stranded Objects: Mourning, Memory, and Film in Postwar Germany* (1990)

Robert Stam, *Subversive Pleasures* (1989)

Robert Stam, *Tropical Multiculturalism: A Comparative History of Race in Brazilian Cinema and Culture* (1997)

Robert Stam, ed., *New Vocabularies in Film Semiotics* (1992)

Visual Institutions

Scientific, Medical and Technological Institutions Premised upon Visual Apparatuses and Technologies

Nik Brown and Andrew Webster, *New Medical Technologies and Society: Reordering Life* (2004)

Lisa Cartwright, 'Gender Artifacts: Technologies of Bodily Display in Medical Culture', in Lynne Cooke and Peter Wollen, eds., *Visual Display* (1995), pp. 218–36

Lisa Cartwright, *Screening the Body: Tracing Medicine's Visual Culture* (1995)

Michel Foucault, *The Birth of the Clinic: An Archaeology of Medical Perception* (1973)

Ludmilla Jordanova, *Sexual Visions: Images of Gender in Science and Medicine between the Eighteenth and Twentieth Centuries* (1989)

Ludmilla Jordanova, 1999. *Nature Displayed: Gender, Science and Medicine 1760–1820* (1999)

Bruno Latour, *Politics of Nature: How to Bring the Sciences into Democracy* (2004)

Bruno Latour and Peter Weibel, eds., *Making Things Public* (2005)

John Law and John Hassard, eds., *Actor Network Theory and After* (1999)

Niklas Rose, *The Politics of Life Itself* (2006)

Barbara Maria Stafford, *Body Criticism: Imagining the Unseen in Enlightenment Art and Medicine* (1991)

Barbara Maria Stafford, *Echo Objects: The Cognitive Work of Images* (2007)

Andrew Webster, *Health, Technology and Society: A Sociological Critique* (2007)

Keith Wilder, *Photography and Science* (2009)

Visuality in Popular Culture

Visual Identities/Representations

Homi K. Bhabha, *The Location of Culture* (1994)

Homi K. Bhabha, ed., *Nation and Narration* (1990)

John Fiske, *Media Matters* (1996)

John Frow, *Cultural Studies and Cultural Value* (1995)

John Frow, *Time and Commodity Culture: Essays in Cultural Theory and Postmodernity* (1997)

John Frow, *Genre* (2005)

Paul Gilroy, *The Black Atlantic* (1993a)

Paul Gilroy, ' "Jewels Brought from Bondage": Black Music and the Politics of Authenticity', in Erin Striff, ed., *Performance Studies* (2003), pp. 137–51

Stuart Hall, 'What Is This "Black" in Black Popular Culture', in Gina Dent, ed., *Black Popular Culture* (1992), pp. 21–33

Mark Poster, *The Mode of Information* (1990)

Mark Poster, *The Second Media Age* (1995)

Celebrity Culture: Life in the Lens

Richard Dyer, *Heavenly Bodies: Film Stars and Society* (2003)

P. David Marshall, ed., *Celebrity Culture Reader* (2006)

Sean Redmond and Su Holmes, eds., *Stardom and Celebrity: A Reader* (2007)

Chris Rojek, *Celebrity* (2004)

Jackie Stacey, *Star Gazing: Hollywood Cinema and Female Spectatorship* (1993)

Graeme Turner, *Understanding Celebrity* (2004)

Postocular Theory

Susan Buck-Morss, *The Dialectics of Seeing: Walter Benjamin and the Arcades Project* (1989)

Susan Buck-Morss, 'Dream World of Mass Culture: Walter Benjamin's Theory of Modernity and the Dialectics of Seeing', in D. M. Levin, ed., *Modernity and the Hegemony of Vision* (1993), pp. 309–38

Lisa Cartwright, 'Science and the Cinema', in *Screening the Body: Tracing Medicine's Visual Culture* (1995), pp. 1–16

Jonathan Crary, *Techniques of the Observer: On Vision and Modernity in the Nineteenth Century* (1990)

Martin Heidegger, *The Question Concerning Technology and Other Essays* (1977)

Martin Jay, *Downcast Eyes: The Denigration of Vision in Twentieth-Century French Thought* (1993a)

Martin Jay, *Force Fields: Between Intellectual History and Cultural Critique* (1993b)

Martin Jay, 'Sartre, Merleau-Ponty, and the Search for a New Ontology of Sight', in David Michael Levin, ed., *Modernity and the Hegemony of Vision* (1993), pp. 143–85

Scott Lash and Jonathan Friedman, eds., *Modernity and Identity* (1992)

David Michael Levin, 'Visions of Narcissism: Intersubjectivity and the Reversals of Reflection', in Martin Dillon, ed., *Merleau-Ponty Vivant* (1991), pp. 47–90

David Michael Levin, ed. *Modernity and the Hegemony of Vision* (1993)

Donald M. Lowe, *History of Bourgeois Perception* (1982)

W.J.T. Mitchell, *The Reconfigured Eye: Visual Truth in the Post-Photographic Era* (1992)

B. Sandywell, *Dictionary of Visual Discourse* (2011)

Wolfgang Schivelbusch, *The Railway Journey: The Industrialization of Time and Space in the Nineteenth Century* (1986)

Charles Taylor, *Sources of the Self: The Making of the Modern Identity* (1989)

THE SOCIOLOGY AND ANTHROPOLOGY OF VISUAL ART, TECHNIQUES, MEDIA AND COMMUNICATIONS (INCLUDING THE USE OF VISUAL TECHNOLOGIES SUCH AS PHOTOGRAPHY AND FILM IN ANTHROPOLOGICAL RESEARCH)

The Social History of Visual Life

Mieke Bal, 'His Master's Eye', in David Michael Levin, ed., *Modernity and the Hegemony of Vision* (1993), pp. 379–404

Mieke Bal, *Double Exposures: The Subject of Cultural Analysis* (1996)

Mieke Bal, ed., *The Practice of Cultural Analysis: Exposing Interdisciplinary Interpretation* (1999)

Mieke Bal, *Quoting Caravaggio: Contemporary Art, Preposterous History* (2001)

Mieke Bal, 'Visual Essentialism and the Object of Visual Culture', *Journal of Visual Culture*, Vol. 2(1), 2003, pp. 5–32

Mieke Bal and Norman Bryson, *Looking In: The Art of Viewing* (2001)

Mieke Bal, Jonathan Crew and Leo Spitzer, eds., *Acts of Memory: Cultural Recall in the Present* (1997)

John A. Walker and Sarah Chaplin, *Visual Culture: An Introduction* (1997)

Visuality in Reflexive Anthropology

The concern for describing and representing the lived experience of other cultures has been central to anthropology from its inception. However only recently have the actual techniques and methodologies of anthropological representation become topics of research in their own right. Anthropology today, however, has taken the 'visual turn' and programmes of research across the world now include visual themes and methodologies. It might be argued that the theme of reflexivity was first made central in critical anthropology (e.g. by Clifford and Marcus, *Writing Culture*) that dates back to 1986. The Society for Visual Anthropology was also founded around the same time (1984).

Richard L. Anderson, *Calliope's Sisters: A Comparative Study of Philosophies of Art* (2004)

Constance Classen, *Worlds of Sense: Exploring the Senses in History and across Cultures* (1993)

Constance Classen, *The Book of Touch* (2005)

James Clifford and George E. Marcus, eds., *Writing Culture: The Poetics and Politics of Ethnography* (1986)

Richard H. Davis, *Lives of Indian Images* (1999)

Johannes Fabian, *Time and the Other: How Anthropology Makes Its Object* (1983)

Johannes Fabian, 'Presence and Representation: The Other and Anthropological Writing', *Critical Inquiry*, 16, 1990, pp. 753–73

Clifford Geertz, *The Intepretation of Cultures* (1973)

Clifford Geertz, *Local Knowledge* (1983)

Alison Griffiths, *Wondrous Difference: Cinema, Anthropology and Turn-of-the Century Visual Culture* (2001)

David Howes, *Sensual Relations: Engaging the Senses in Culture and Social Theory* (2003)

David Howes, ed. *The Varieties of Sensory Experience: A Sourebook in the Anthropology of the Senses* (1991)

Jay Ruby, 'Visual Anthropology', in D. Levinson and M. Ember, eds., *Encyclopedia of Cultural Anthropology* (1996)

Jay Ruby, *Picturing Culture: Explorations in Film and Anthroplogy* (2000)

Jay Ruby, 'The Last 20 Years of Visual Anthropology: A Citical Review', *Visual Studies*, 2005, 20, pp. 159–70.

Lucient Taylor, ed., *Visualizing Theory* (1994)

Stephen Tyler, 'Postmodern Ethnography', in J. Clifford and G. E. Marcus, eds., *Writing Culture* (1986)

Doing Visual Sociology: Visual Methods and Methodologies in Sociology

The sociology of visual culture has a chequered history in the discipline of sociology at large. While the 'philosophy of art' has Hegelian roots, Marxist sociology is represented by the writings of Arnold Hauser. In classical social theory art and visual culture can be found in the 'sociological aesthetics' of Georg Simmel. Key figures in Critical Theory would be Theodor Adorno, Walter Benjamin, Siegfried Kracauer and Ernst Bloch. We might also include the writings of Friedrich Nietzsche (for example his *Birth of Tragedy*, 1872) and Jacob Burckhardt (1818–1897) in cultural history (Burckhardt's *Die Kultur der Renaissance in Italien* (1860), *The Civilization of the Renaissance in Italy* (1860) and *The Greeks and Greek Civilization*, 1872, in particular), Alois Riegl (1858–1905) (*Late Roman Art Industry*, 1901), Wilhelm Worringer (*Abstraction and Empathy*, 1908), and Heinrich Wölfflin (1864–1945) in art history (his *Principles of Art History: The Problem of the Development of Style in Later Art*, 1915). Benjamin's materialist hermeneutic of art and reproductive techniques is clearly influenced by the path-breaking work of Alois Riegl. Consider one of the principles that Benjamin formulates in his 'Art in the Age of Mechanical Reproduction': 'During long periods of history, the mode of human sense perception changes with humanity's entire mode of existence. The manner in which human sense perception is organized, the medium in which it is accomplished, is determined not only by nature but by historical circumstances as well. The fifth century, with its great shifts of population, saw the birth of the late Roman art industry and the Vienna Genesis, and there developed not only an art different from that of antiquity but also a new kind of perception. The scholars of the Viennese school, Riegl and Wickhoff, who resisted the weight of classical tradition under which these later art forms had been

buried, were the first to draw conclucions from them concerning the organization of perception at the time' (Benjamin, 'The Work of Art in the Age of Mechanical Repro-duction', in *Illuminations*, 1992, p. 216; see also Benjamin, *The Work of Art in the Age of Its Technological Reproducibility*, 2008, pp. 19–55).

Later contributors to this genre of *Kulturgeschichte* and *Kunstwissenschaft* include Wilhelm Dilthey, Heinrich Wölfflin, Max Dessoir, Benedetto Croce, Aby Warburg, Erwin Panofsky, Ernst Cassirer, Ernst H. Gombrich, Ernst Robert Curtius, Paul O. Kristeller, Arnaldo Momigliano, Georg Misch, Ernesto Grassi, Meyer Schapiro, Benjamin Nelson, Lewis Coser, Robert K. Merton, Hayden White, Peter Gay, Florian Znaniecki, among others.

Creative Visual Methodologies

The journal *Visual Studies*, a platform organized by the International Visual Sociology Association, is probably the most immediate source for visual sociology. Its revised remit of basic aims (from 2009) is:

- Provide an international forum for the development of visual research
- Promote an acceptance and understanding of a wide range of methods, ap-proaches and paradigms that constitute image-based research
- Reduce the disparity of emphasis between visual and written studies in the so-cial sciences
- Promote an interest in developing visual research methodology in all its vari-ous forms
- Encourage research that employs a mixture of visual methods and analytical ap-proaches within one study
- Critically reflect and contribute to the dialogue surrounding 'the visual' across the social sciences and humanities
- Provide an arena for in-depth explorations of various approaches, particular methods, themes and visual phenomena.

One of the earliest conferences focussing explicitly upon visual culture was organized by the Edinburgh Institute for Advanced Studies in the Humanities (Visual Knowledges Conference, University of Edinburgh, 17–20 September 2003). For documentation see John Frow, ed., *Visual Knowledges* (2003).

The First International Visual Methods Conference was held at the University of Leeds (15–17 September 2009). The preconference literature contains the following paragraph: 'A striking phenomenon of visual research two decades ago was its invisibility. There is now a general awakening to the ubiquity of imagery and visual culture in contemporary lives, which necessitates the development of visually orientated theoretical frameworks coupled with the application of rigorous and complementary visual research methods'.

The Leeds Visual Methods Conference provided an inventory of themes ad-dressed under 'method' as: researcher created visual data, participatory visual methods,

arts-based methods, creative visual methods, visual representation, visual ethics and the analysis of visual data. A related conference also took place in London from 15–17 July 2009, with a wider brief: 'Visuality/Materiality: Reviewing Theory, Method, and Practice'. The stated aim of the conference was 'to consider whether representation and the need for a new interpretive paradigm coalesce/intersect'. The title of the conference foregrounds the interaction of the material and the visual to provide a 'dialogic space' where 'the nature and role of a visual theory can be evaluated in the light of materiality, practice, affect, performativity; and where the methodological encounter [sic] informs our intellectual critique' (from the Internet statement of purpose, http://www.geography.dur.ac.uk/conf/visualitymateriality).

Further references and resources can be found in publications of Gillian Rose and David Gauntlett (both also contributors to the present Handbook). For background see:

Mieke Bal, 'Visual Essentialism and the Object of Visual Culture', *Journal of Visual Culture*, Vol. 2(1), 2003, pp. 5–32
M. S. Ball and G. Smith, *Analysing Visual Data* (1992)
Marcus Banks, *Visual Methods in Social Research* (2001)
Marcus Banks, *Using Visual Data in Qualitative Research* (2008)
Howard Becker, *Exploring Society Photographically* (1981)
Howard Becker, *Doing Things Together* (1986)
Elizabeth Chaplin, *Sociology and Visual Representation* (1994)
Michael Emmison and Philip Smith, *Researching the Visual* (2000)
John Grady, 'Scope of Visual Sociology', *Visual Sociology*, Vol. 11(2), 1996, pp. 10–24
Caroline Knowles and Paul Sweetman, eds., *Picturing the Social Landscape: Visual Methods and the Sociological Imagination* (2004)
Keith Moxey, 'Visual Studies and the Iconic Turn', *Journal of Visual Culture*, Vol. 7(2), 2008, pp. 131–46
Sarah Pink, *Doing Visual Ethnography* (2001)
John Prosser, ed. *Image-based Research* (1998)
Gillian Rose, *Visual Methodologies* (2001)
Theo van Leeuwen and Carey Jewitt, eds., *The Handbook of Visual Analysis* (2001).

We should also not ignore the visual dimensions of sociologists like Erving Goffman, for example in his *The Presentation of Self in Everyday Life* (1969) and *Frame Analysis: An Essay on the Organization of Experience* (1974).

Visual Archives/Archiving/Curatorship

Peter Burke, *Eyewitnessing: The Uses of Images as Historical Evidence* (2007)

Sociology of Visual Representation

Howard Becker, *Art Worlds* (1982)
Elizabeth Chaplin, *Sociology and Visual Representation* (1994)
Caroline Knowles and Paul Sweetman, eds., *Picturing the Social Landscape* (2004)
Bruno Latour, *Science in Action* (1987)

Bruno Latour, *Politics of Nature* (2004)

John Law and G. Fyfe, eds. *Picturing Power: Visual Depiction and Social Relations* (1988)

Niklas Luhmann, *Art as a Social System* (2000)

Jonathan Potter, *Representing Reality: Discourse, Rhetoric and Social Construction* (1996)

Anthony Woodiwiss, *The Visual in Social Theory* (2001)

Recent Research in Institutional Visualization (statistics, medicine, social embodiments, scientific visualization, bio-medical technologies, etc)

Lorrain Daston, ed., *Things That Talk: Object Lessons from Art and Science* (2004)

Edward R. Tufte, *Envisioning Information* (1990)

Edward R. Tufte, *Visual and Statistical Thinking: Displays of Evidence for Making Decisions* (1997)

Edward R. Tufte, *Visual Explanations: Images and Quantities, Evidence and Narrative* (1997)

Edward R. Tufte, *The Visual Display of Quantitative Information* (2001)

Ethnographic Perspectives

Elizabeth Edwards, *Raw Histories: Photographs, Anthropology and Museums* (2001)

Douglas Harper, 'Visualizing Structure: Reading Surfaces of Social Life', *Qualitative Sociology*, Vol. 20(1), 1997, pp. 57–77

Douglas Harper, *Working Knowledge: Skill and Community in a Small Shop* (1987)

Douglas Harper, *Changing Worpp: Visions of a Lost Agriculture* (2001)

Douglas Harper, *Good Company: A Tramp Life* (2006)

Paul Hockings, ed., *Principles of Visual Anthropology* (2003)

Sarah Pink, *Doing Visual Ethnography: Images, Media and Representations in Research* (2001)

Sarah Pink, *Working Images: Visual Research and Representation in Ethnography* (2004)

Sarah Pink, *The Future of Visual Anthropology: Engaging the Senses* (2006)

Gregory C. Stanczack, *Visual Research Methods: Image, Society and Representation* (2007)

VISUAL RHETORIC

The classic account of 'the rhetoric of the image' is Roland Barthes's essay 'Rhetorique de l'image' (*Communications* 1, 1964), translated by Stephen Heath in Barthes's *Image-Music-Text* (1977).

 Also see:

Gunther Kress and Theo van Leeuwen, *Reading Images: The Grammar of Visual Design* (1996/2006)

Carolyn Handa, ed., *Visual Rhetoric in a Digital World: A Critical Sourcebook* (2004)

Jen Webb, *Understanding Representation* (2009)

Perspectives in Visual Communication

Roland Barthes, *Empire of Signs* (1983)

Roland Barthes, *Camera Lucida: Reflections on Photography* (2000)

Victor Burgin, ed., *Thinking Photography* (1982)

Steve Edwards, *Photography: A Very Short Introduction* (2006)

Susan Sontag, *On Photography* (1977/2002)

Graphs, Diagrammatics and Visual Communication

James Elkins, *What Painting Is* (1998)

James Elkins, *The Domain of Images* (1999)

James Elkins, *Visual Studies: A Skeptical Introduction* (2003)

Edward R. Tufte, *Visual Explanations: Images and Quantities, Evidence and Narrative* (1997)

Edward R. Tufte, *The Visual Display of Quantitative Information* (2001)

Politics of Visual Persuasion: Communication in Televisual Culture

Robert Allen, *Channels of Discourse Reassembled: Television and Contemporary Criticism* (1992)

Pierre Bourdieu, *Distinction* (1984)

Pierre Bourdieu, *On Television and Journalism* (1998)

Barbara Creed, *Media Matrix: Sexing the New Reality* (2003)

John Fiske, *Television Culture* (1987)

John Fiske and John Hartley, *Reading Television* (2003)

John Hartley, *Tele-ology: Studies in Television* (1992)

Philip Schlesinger et al., eds., *The Sage Handbook of Media Studies* (2004)

Roger Silverstone, *Television and Everyday Life* (1994)

ARCHITECTURE AND DESIGN

Architectural Theory

Peter Brunette and David Wills, eds., *Deconstruction and the Visual Arts* (1994)

Elizabeth Grosz, *Architecture from the Outside* (2001)

Juhani Pallasmaa, *The Eyes of the Skin: Architecture and the Senses* (2005)

Neil Spiller, *Visionary Architecture: Blueprints of the Modern Imagination* (2007)

Mark Wigley, *The Architecture of Deconstruction: Derrida's Haunt* (1993)

Mark Wigley, 'The Domestication of the House: Deconstruction after Architecture', in Peter Brunette and David Wills, eds., *Deconstruction and the Visual Arts* (1994), pp. 203–27

Peter Zumthor, *Thinking Architecture* (1996)

Peter Zumthor, *Atmospheres: Architectural Environments-Surrounding Objects* (2006)

Design and Visual Culture

Malcolm Barnard, *Art, Design and Visual Culture* (1998)

Vilém Flusser, *Shape of Things: A Philosophy of Design* (1999)

John Hartley, ed., *Creative Industries* (2004)

Guy Julier, *Thames and Hudson Dictionary of Design since 1900* (1998)

Guy Julier, *The Culture of Design* (2007)

Donald A. Norman, *The Design of Everyday Things* (2002)

John A. Walker and Sarah Chaplin, *Visual Culture: An Introduction* (1997)

Fashion

Malcolm Barnard, *Fashion and Communication* (1996)

Christopher Breward, *Fashion* (2003)

Dick Hebdige, *Subculture: The Meaning of Style* (1979)

Dick Hebdige, *Hiding in the Light* (1988)

Naomi Klein, *No Logo: Taking Aim at the Brand Bullies* (2001)

Andrew Wernick, *Promotional Culture: Advertising, Ideology and Symbolic Expression* (1991)

VISUAL CULTURAL INSTITUTIONS

Media, Communication and Culture: Practices and Technologies of Looking

David Barlow and Brett Mills, *Reading Media Theory: Thinkers, Approaches, Contexts* (2008)

James W. Carey, *Communication as Culture* (1989)

Murray Edelman, *Constructing the Political Spectacle* (1988)

John Fiske, *Media Matters* (1996)

Niklas Luhmann, *The Reality of the Mass Media* (2000)

Dan Schiller, *Digital Capitalism: Networking the Global Market System* (1999)

Philip Schlesinger et al., eds., *The Sage Handbook of Media Studies* (2004)

Marita Sturken and Lisa Cartwright, *Practices of Looking* (2001)

Liesbet van Zoonen, *Feminist Media Studies* (1994)

Museums, Archiving, Curatorship and Cultural Memory

Tony Bennett, *The Birth of the Museum: History, Theory, Politics* (1995)

Lynne Cooke and Peter Wollen, eds., *Visual Display* (1995)

Elizabeth Edwards, *Raw Histories: Photographs, Anthropology and Museums* (2001)

Cynthia Freeland, 'Money, Markets, Museums', ch. 4 in *Art Theory* (2003), pp. 60–82

Eilean Hooper-Greenhill, *Museums and the Interpretation of Visual Culture* (2000)

Alberto Manguel, *The Library at Night* (2008)

Donald Preziosi, 'The Other: Art History and/as Museology', ch. 9 in Donald Preziosi, ed., *The Art of Art History: A Critical Anthology* (1998), pp. 451–525

Donald Preziosi and Claire Farago, eds. *Grasping the World: the Idea of the Museum* (2003)

Daniel J. Sherman and Irit Rogoff, eds., *Museum Culture: Histories, Discourses, Spectacles* (1994)

Public Art, Spectacles, Spaces/Places

Marc Augé, *Non-Places: Introduction to an Anthropology of Supermodernity* (1995)

Edward S. Casey, *Getting Back into Place: Toward a Renewed Understanding of the Place-World* (1993)

Michel Foucault, 'Of Other Spaces', *Diacritics*, Vol. 16(1), 1986, pp. 22–7

Doreen Massey, *Space, Place and Gender* (1994)

Craig Owens, *Beyond Recognition: Representation, Power and Culture* (1992)

Maurice Roche, *Mega-events and Modernity* (2000)

Mark C. Taylor and Esa Saarinen, *Imagologies: Media Philosophy* (1994)

Photography

Readers interested in contemporary photography might begin with Susan Sontag's *On Photography* (1977/2002) and Roland Barthes's *Camera Lucida*. An important collection of essays on the photographic image can be found in Alan Trachtenberg, ed., *Classic Essays on Photography* (1980).

Roland Barthes, *Empire of Signs* (1983)

Roland Barthes, *Camera Lucida: Reflections on Photography* (2000)

Pierre Bourdieu, *Photography: A Middle-Brow Art* (1996)

Victor Burgin, ed., *Thinking Photographly* (1982)

Victor Burgin, *In/different Spaces: Place and Memory in Visual Culture* (1996)

Steve Edwards, *Photography: A Very Short Introduction* (2006)

Vilém Flusser, *Towards a Philosophy of Photography* (2000)

Vilém Flusser, *Writings* (2004)

Helmut Gernsheim, *The History of Photography* (1955)

Helmut Gernsheim, *The Origin of Photography* (1982)

Helmut Gernsheim, *A Concise History of Photogaphy* (1986)

Rosalind E. Krauss and Jane Livingstone, *L'Amour Fou: Photography and Surrealism* (1985)

Martin Lister, ed. *The Photographic Image in Digital Culture* (1995)

Patrick Maynard, *The Engine of Visualization: Thinking through Photography* (1997)

W.J.T. Mitchell, *The Reconfigured Eye: Visual Truth in the Post-Photographic Era* (1992)

Warren Neidich, *Blow-up: Photography, Cinema and the Brain* (2003)

John Roberts, *The Art of Interruption: Realism, Photography, and the Everyday* (1998)

Don Slater, 'Domestic Photography and Digial Culture', in M. Lister, ed., *The Photographic Image in Digital Culture* (1995), pp. 129–46

Susan Sontag, *On Photography* (1977/2002)

John Tagg, *The Burden of Representation: Essays on Photographies and Histories* (1988)

John Tagg, 'Globalization, Totalization and the Discursive Field', in Anthony D. King, ed., *Culture, Globalization and the World-System* (1991), pp. 155–60

John Tagg, *Grounds of Dispute* (1992)

Alan Trachtenberg, ed., *Classic Essays on Photography* (1980)

Liz Wells, *Photography: A Critical Introduction* (2004)

Liz Wells, ed. *The Photography Reader* (2003)

Photojournalism: From the Analogue Camera to Film and Digital Multimedia

Howard Becker, *Exploring Society Photographically* (1981)

Howard Becker, *Doing Things Together* (1986)

Pierre Bourdieu, *On Television and Journalism* (1998)

Jonathan Crary, 'Modernizing Vision', in Hal Foster, ed., *Vision and Visuality* (1988), pp. 29–44

Jonathan Crary, *Techniques of the Observer* (1990)

Scott McQuiare, *Visions of Modernity: Representation, Memory, Time and Space in the Age of the Camera* (1998)

Bill Nichols, *Blurred Boundaries: Questions of Meaning in Contemporary Culture* (1995)

Advertising Discourse and Graphic Design

While advertising, perhaps, still remains 'the official art of modern capitalist society' (Raymond Williams); advertising discourse—the proliferating global institution of the advertising industry—has come to include a range of interrelated thematics, including questions of image-creation (visual and verbal imagineering), persuasive communication, the manipulation of consumer identities, consumerism and the exponential growth of global consumption, the spread of advertising techniques to organizational dynamics, politics and the wider society, and the impact of hyper-consumerist attitudes and ideological formations upon wider ecological, political and cultural systems.

Marc Augé, *Non-Places: Introduction to an Anthropology of Supermodernity* (1995)
Guy Cook, *The Discourse of Advertising* (2001)
Stuart Ewen, *Captains of Consciousness: Advertising and the Social Roots of Consumer Culture* (1976)
Anne Friedberg, *Window Shopping: Cinema and the Postmodern* (1993)
Erving Goffman, *Gender Advertisements* (1976)
Scott Lash, Celia Lury and Deirdre Boden, *Global Culture Industries: The Mediation of Things* (2007)
Gilles Lipovetsky, *Hypermodern Times* (2005)
Celia Lury, *Brands: The Logos of the Global Economy* (2004)
Anne McClintock, *Imperial Leather* (1995)
Vance Packard, *The Hidden Persuaders* (1957/2007)
Patricia Pisters, *The Matrix of Visual Culture: Working with Deleuze in Film Theory* (2003)
Jonathan Schroeder, *Visual Consumption* (2002)
Robert A. Sobieszek, *The Art of Persuasion: A History of Advertising Photography* (1988)
Theo van Leeuwen and Carey Jewitt, eds., *Handbook of Visual Analysis* (2001)
Judith Williamson, *Decoding Advertisements* (1978)

Global Consumerism

Arjun Appadurai, *Modernity at Large: Cultural Dimensions of Globalization* (1996)
Arjun Appadurai, ed., *The Social Life of Things: Commodities in Cultural Perspective* (1986)
Zygmunt Bauman, *Consumerism and the New Poor* (1998)
Robert Bocock, 'Consumption and Lifestyles', in R. Bocock and K. Thompson, eds., *Social and Cultural Forms of Modernity* (1992), pp. 119–69
Robert Bocock, *Consumption* (1993)
Philip Corrigan, *The Sociology of Consumption* (1997)
Tim Dant, *Material Culture in the Social World* (1999)
Stuart Ewen, *Captains of Consciousness: Advertising and the Social Roots of Consumer Culture* (1976)
Stuart Ewen, *All Consuming Images: The Politics of Style in Contemporary Culture* (1988)
Stuart Ewen and Elizabeth Ewen, *Channels of Desire: Mass Images and the Shaping of American Culture* (1992)
Mike Featherstone, *Consumer Culture and Postmodernism* (1991)
Jukka Gronow, *The Sociology of Taste* (1997)

David Harvey, *Spaces of Global Capitalism* (2006)
Sott Lash and John Urry, *Economies of Signs and Space* (1994)

Leisure

David Chaney, *Lifestyles* (1996)
Scott Lash and John Urry, *Economies of Signs and Space* (1994)
Celia Lury, *Brands: The Logos of the Global Economy* (2004)
Hugh Mackay, ed., *Consumption and Everyday Life* (1997)
Daniel Miller, *Material Culture and Mass Consumption* (1987)
Chris Rojek, *Decentring Leisure: Rethinking Leisure Theory* (1995)
Chris Rojek, *The Labour of Leisure: The Culture of Free Time* (2009)
Rob Shields, ed. *Lifestyle Shopping: The Subject of Consumption* (1992)

VISUAL EXPERIENCES OF THE SOCIAL WORLD (IMAGINARY FORMATIONS AS MATERIAL OBJECTS, CITYSCAPES, DOMESTIC TECHNOLOGIES, ETC)

Visual Construction of the Social

Marc Augé, *Non-Places: Introduction to an Anthropology of Supermodernity* (1995)
Fiona Candlin and Raiford Guins, eds., *The Object Reader* (2009)
Cornelius Castoriadis, *The Imaginary Institution of Society* (1997)
David B. Clarke, *The Consumer Soicety and the Postmodern City* (2003)
Tim Dant, *Material Culture in the Social World* (1999)
E. Edwards and J. Hart, eds., *Photographs, Objects, Histories* (2004)
Vilém Flusser, *Writings* (2004)
Martin Hand, *Making Digital Cultures: Access, Interactivity, and Authenticity* (2008)
Caroline Knowles and Paul Sweetman, eds., *Picturing the Social Landscape* (2004)
Graham MacPhee, *The Architecture of the Visible* (2002)
Elizabeth Shove, Matthew Watson, Martin Hand and Jack Ingram, *The Design of Eveyday Life* (2007)
Jo Spence and Patricia Hollands, eds. *Family Snaps: the Meaning of Domestic Photography* (1991)
Charles Taylor, *Modern Social Imaginaries* (2004)
Nigel Thrift, *Knowing Capitalism* (2005)
Nigel Thrift, *Non-Representational Theory* (2007)

Cityscapes in Theory

Howard Caygill, *Walter Benjamin: The Colour of Experience* (1998)
Graham Gilloch, *Walter Benjamin: Critical Constellations* (2002)
David Harvey, *Consciousness and Urban Experience* (1985)
David Harvey, *Spaces of Global Capitalism* (2006)
Richard Sennett, *The Conscience of the Eye: The Design and Social Life of Cities* (1991)
Edward J. Soja, *Postmodern Geographies: The Reassertion of Space in Critical Social Theory* (1989)
Edward J. Soja, *Thirdspace: Journeys to Los Angeles and Other Real-and-Imagined Places* (1996)

Nigel Thrift, *Non-Representational Theory* (2007)

Sophie Watson and Katherine Gibson, eds., *Postmodern Cities and Spaces* (1995)

Elizabeth Wilson, 'The Invisible Flaneur', in Sophie Watson and Katherine Gibson, eds., *Postmodern Cities and Spaces* (1995), pp. 59–79

Nature Envisioned

Peter Coates, ed., *Nature: Western Attitudes since Ancient Times* (1998)

Peter de Bolla, 'The Visibility of Visuality: Vauxhall Gardens and the Siting of the Viewer', in Stephen Melville and Bill Readings, eds., *Vision and Textuality* (1995), pp. 282–95

Neil Evernden, *Social Creation of Nature* (1992)

Ludmilla Jordanova, *Nature Displayed: Gender, Science and Medicine 1760–1820* (1999)

Bruno Latour, *Politics of Nature* (2004)

New Formations: A Journal of Culture/Theory/Politics, no. 64, 'Earthographies: Ecocriticism and Culture', guest editors Wendy Wheeler and Hugh Dunkerley

Peter Osborne, *Travelling Light: Photography, Travel, and Visual Culture* (2000b)

Marie-Louise Pratt, *Imperial Eyes: Travel Writing and Transculturation* (1992)

Paul Rodaway, *Sensuous Geographies: Body, Sense and Place* (1994)

Simon Schama, *The Embarrassment of Riches* (1988)

Simon Schama, *Landscape and Memory* (1995)

Barbara Maria Stafford, *Voyage into Substance: Art, Science, Nature and the Illustrated Travel Account* (1984)

Steven Vogel, *Against Nature: The Concept of Nature in Critical Theory* (1996)

Keith Wilder, *Photography and Science* (2009)

The Tourist Gaze

Yiorgos Apostolopoulos et al., eds., *The Sociology of Tourism* (2001)

Dean MacCannell, *Empty Meeting Grounds: The Tourist Papers*, vol. 1 (1992)

Dean MacCannell, *The Tourist: A New Theory of the Leisure Class* (1999)

Tom Selwyn, ed., *The Tourist Image* (1996)

John Urry, 'Cultural Change and Contemporary Holiday-making', *Theory, Culture and Society*, Vol. 5, 1988, pp. 35–55

John Urry, 'The "Consumption" of Tourism', *Sociology*, Vol. 24(1), 1990, pp. 23–35

John Urry, *The Tourist Gaze* (1990)

John Urry, *Consuming Places* (1995)

John Urry, *Mobilties* (2007)

John Urry and Chris Rokek, eds., *Touring Cultures* (1997)

Images in/as Memory

Mieke Bal, Jonathan Crew and Leo Spitzer, eds., *Acts of Memory: Cultural Recall in the Present* (1997)

Victor Burgin, *In/different Spaces: Place and Memory in Visual Culture* (1996)

Paul Connerton, *How Societies Remember* (1989)

Norbert Elias, *On Time* (1991)

Elizabeth A. Grosz, ed., *Becomings, Explorations in Time, Memory and Futures* (1999)

Maurice Halbwachs, *On Collective Memory* (1992)

Roger S. Schank, *Dynamic Memory* (1982)

Roger S. Schank and Robert P. Abelson, *Scripts, Plans, Goals and Understanding: An Inquiry into Human Knowledge Structures* (1977)

Representations of the Past

Eric Hobsbawm and Terence Ranger, eds., *The Invention of Tradition* (1983)

David Lowenthal, *The Past Is a Foreign Country* (1985)

David Middleton and Derek Edwards, eds., *Collective Remembering* (1990)

Kevin Walsh, *Representations of the Past: Museums and Heritage in the Postmodern World* (2007)

Harriet Harvey Wood and A. S. Byatt, eds., *Memory: An Anthology* (2008)

Global Urban Cityscapes (visualizing urban landscape and social change)

Mike Davis, *City of Quartz* (1990)

Mike Featherstone, ed., *Global Culture* (1990)

David Harvey, *The Condition of Postmodernity* (1989)

Stephen Kern, *The Culture of Time and Space 1880–1918* (1993)

Edward Soja, *Postmodern Geographies* (1989)

Keith Tester, ed., *The Flâneur* (1994)

Marvin Trachtenberg, *Dominion of the Eye: Urbanism, Art and Power in Early Modern France* (1997)

Sharon Zukin, *Loft Living: Culture and Capital in Urban Change* (1989)

Sharon Zukin, *Cultures of Cities* (1995)

TECHNOCULTURE AND VISUAL TECHNOLOGY: THE GLOBAL DIGITAL REVOLUTION

Globalization of Media and Culture

John Beynon and David Dunkerley, eds., *Globalization: The Reader* (2001)

Manuel Castells, *The Rise of the Network Society* (1996)

Mike Featherstone, ed., *Global Culture: Nationalism, Globalization and Modernity* (1990)

Anthony Giddens, *Runaway World* (2002)

Fredric Jameson, *The Geopolitical Aesthetic: Cinema and Space in the World System* (1992)

Laura Marks, *The Skin of the Film: Intercultural Cinema, Embodiment and the Senses* (2000)

Nicholas Mirzoeff, *Watching Babylon: The War in Iraq and Global Visual Culture* (2005)

Digitalization, New Media and Cyberculture and Their Impact upon Visual Studies

Roland Barthes, *Camera Lucida* (2000)

J. Buick and Z. Jevtic, *Cyberspace for Beginners* (1995)

Lisa Cartwright, 'Film and the Digial in Visual Studies: Film Studies in the Era of Convergence', *Journal of Visual Culture*, Vol. 1(1), 2002, pp. 7–23

Jonathan Crary, *Techniques of the Observer: On Vision and Modernity in the Nineteenth Century* (1990)

Gregory Currie, *Image and Mind: Film, Philosophy and Cognitive Science* (1995)

Mike Davis, *Beyond Blade Runner: Urban Control, the Ecology of Fear* (1992)

Teresa de Lauretis and Stephen Heath, eds., *The Cinematic Apparatus* (1985)

Don Ihde, *Technology and the Lifeworld: From Garden to Earth* (1990)

Don Ihde, *Postphenomenology: Essays in the Postmodern Context* (1993)

Steve Jones, ed., *Cybersociety* (1994)

Lev Manovich, *Tekstura: Russian Essays on Visual Culture* (1993)

Lev Manovich, *The Language of New Media* (2001)

Laura Marks, *The Skin of the Film: Intercultural Cinema, Embodiment and the Senses* (2000)

W.J.T. Mitchell, *The Reconfigured Eye* (1992)

Stephen Neale, *Cinema and Technology: Image, Sound, Colour* (1985)

Howard Rheingold, *Virtual Reality* (London: Mandarin, 1993)

David Tomas, *Beyond the Image Machine: A History of Visual Technologies* (2004)

The Fate of Literacy in the Digital Age of Global Optics

Espen J. Aarseth, *Cybertext: Perspectives on Ergodic Literature* (1997)

Charlie Gere, *Digital Culture* (2002)

George P. Landow, *Hypertext 2.0: The Convergence of Contemporary Critical Theory and Technology* (1997)

Lawrence Lessig, *The Future of Ideas: The Fate of the Commons in a Connected World* (2002)

Mitchell Stephens, *The Rise of the Image, the Fall of the Word* (1998)

John B. Thompson, *Books in the Digital Age* (2005)

Cyberspace as Cybervisuality: Digitalization, Virtualization and Cyberculture

Michael Benedikt, *Cyberspace: First Steps* (1991)

Jay D. Bolter and Richard Grusin eds., *Remediation: Understanding New Media* (2002)

Manuel Castells, *End of Millennium*, Vol. 3 of *The Information Age* (1998)

H. U. Gumbrecht and M. Marrinan, *Mapping Benjamin: The Work of Art in the Digital Age* (2003)

Steven A. Johnson, *Interface Culture* (1999)

Mark Poster, *What's Wrong with the Internet?* (2001)

Mark Poster, *Information please: Culture and Politics in the Age of Digital Machines* (2006)

Dan Schiller, *Digital Capitalism: Networking the Global Market System* (1999)

Digital Telepresence/Virtualization/Cybercommunities

Roger Burrows and Mike Featherstone, eds., *Cyberspace/Cyberbodies/Cyberpunk: Cultures of Technological Embodiment* (1995)

Steven A. Johnson, *Interface Culture* (1999)

Barry Sandywell, 'Monsters in Cyberspace' (2006)

Elia Zureik and Mark B. Salter, eds., *Global Surveillance and Policing: Borders, Security and Identity* (2005)

Digital Image Culture(s) of Wired Capitalism

Andrew Darley, *Visual Digital Culture: Surface Play and Spectacle in New Media Genres* (2000)
Martin Lister, ed., *The Photographic Image in Digital Culture* (1995)
Sadie Plant, *Zeroes and Ones: Digital Women and the New Technoculture* (1997)
Kevin Robins, *Into the Image: Culture and Politics in the Field of Vision* (1996)
Dan Schiller, *Digital Capitalism: Networking the Global Market System* (1999)
David Tomas, *Beyond the Image Machine: A History of Visual Technologies* (2004)

Ubiquitous Everyday Visual Technologies (from the Walkman to mobile multimedia technology)

Charlie Gere, *Digital Culture* (2002)
S. Johnstone, ed., *The Everyday (Documents of Contemporary Art)* (2008)
Mike Michael, *Reconnecting Culture, Technology and Nature: From Society to Heterogeneity* (2000)
Michael Sheringham, *Everyday Life: Theories and Practices from Surrealism to the Present* (2006)
Roger Silverstone and Eric Hirsch, eds., *Consuming Technologies: Media and Information in Domestic Spaces* (1984)

Seeing and Being Seen in the Electronic Age/Surveillance Society

Christopher Dandeker, *Surveillance, Power and Modernity* (1990)
Michel Foucault, *Discipline and Punish* (1977)
David Lyon, *The Electronic Eye: The Rise of Surveillance Society* (1994)
David Lyon, *Surveillance Society: Monitoring Everyday Life* (2001)
David Lyon, *Surveillance as Social Sorting* (2003)
David Lyon, ed., *Theorizing Surveillance: The Panopticon and Beyond* (2006)
Joseph Meyrowitz, *No Sense of Place: The Impact of Electronic Media on Social Behaviour* (1985)
Nigel Thrift, *Non-Representational Theory* (2007)

Screen Culture/s

Victor Burgin, ed., *Thinking Photography* (1982)
Lisa Gitelman, *Always Already New: Media, History and the Data of Culture* (2006)
Martin Jay, 'Photo-unrealism: The Contribution of the Camera to the Crisis of Ocularcentrism', in Stephen Melville and Bill Readings, eds., *Vision and Textuality* (1995), pp. 344–60
Jacques Lacan, *Television* (1990)
Jonathan Schroeder, *Visual Consumption* (2002)
Sherry Turkle, *Life on Screen: Identity in the Age of the Internet* (1995)
Siegfried Zieliknski, *Deep Time of the Media: Towards an Archaeology of Hearing and Seeing by Technical Means* (2008)

Telepistemology/Telerobotics

Bruce Damar, *Avatars! Exploring and Building Virtual Worlds on the Internet* (1997)
Stan Franklin, *Artificial Minds* (1995)

Ken Goldberg, ed., *The Robot in the Garden: Telerobotics and Telepistemology in the Age of the Internet* (2000)

Sidney Eve Matrix, *Cyberpop: Digital Lifestyles and Commodity Culture* (2006)

THE POLITICS OF VISION

Many of the most recent works in visual studies can be viewed as transdisciplinary investigations of 'political aesthetics'. In Jacques Rancière's version this focusses upon the social imaginary organization of 'the visible'. Politics in Rancière's work is constitutively linked to the social organization of sensory, aesthetic life:

'Politics revolves around what is seen and what can be said about it, around who has the ability to see and the talent to speak, around the properties of spaces and the possibilities of time' (2006: 13).

This expanded conception of 'politics' relates visual studies to a critical theory of everday life. His historicizing concept of the 'distribution of the sensible' becomes one type of structuring regime of intelligibility determining the possible relationships between the visible, the sayable and the thinkable (2006: 60–1). From this more critical perspective we can look back at some of the classics in the field and recover them as prefiguring the new transdisciplinary problematics (e.g. John Berger's path-breaking *Ways of Seeing* (1972)).

Visual Regimes

Zygmunt Bauman, *Liquid Modernity* (2000)

Zygmunt Bauman, *Consuming Life* (2007)

Pierre Bourdieu, *The Field of Cultural Production: Essays on Art and Literature* (1993)

Pierre Bourdieu, *The Rules of Art: Genesis and Structure of the Literary Field* (1995)

Jan Bremmer and Herman Roodenburg, eds., *A Cultural History of Gesture: From Antiquity to the Present Day* (1993)

Roger Chartier, *Cultural History: Between Practices and Representations* (1993)

Roger Chartier, ed., *A History of Private Life*, Vol. 3 (1989)

Michel de Certeau, *The Practice of Everyday Life* (1984)

Samuel Y. Edgerton Jr., *The Renaissance Rediscovery of Linear Perspective* (New York: Basic Books, 1975)

Norbert Elias, *The Civilising Process*, 2 vols. (1982 and 1987)

Michel Foucault, *The Order of Things: An Archaeology of the Human Sciences* (1971)

Michel Foucault, *The Birth of the Clinic: An Archaeology of Medical Perception* (1973)

Michel Foucault, *Discipline and Punish* (1977)

Peter Gay, *The Bourgeois Experience: Victoria to Freud* (1984)

Scott Lash and John Urry, *Economies of Signs and Space* (1994)

David Morgan, *The Sacred Gaze: Religious Visual Culture in Theory and Practice* (2005)

David Morgan and Sally M. Promey, *The Visual Culture of American Religions* (2001)

Linda Nochlin, *The Politics of Vision: Essays on Nineteenth-Century Art and Society* (1991)

Marcia Pointon, *Strategies for Showing: Women, Possession and Representationin English Visual Culture 1650–1800* (1997)

The Digital Revolution and Its Impact upon the Visual Field

Timothy Druckery, ed., *Electronic Culture: Technology and Visual Representation* (1996)

Timothy Druckery and Peter Weibel, eds. *Electronic Culture: History, Theory and Practice* (2001)

Charlie Gere, *Digital Culture* (2002)

Charlie Gere, *Art, Time and Technology* (2006)

Charlie Gere and Hazel Gardiner, eds., *Art Practice in a Digital Culture* (2009)

Martin Hand, *Making Digital Cultures: Access, Interactivity, and Authenticity* (2008)

Friedrich Kittler, *Discourse Networks 1800/1900* (1990)

Friedrich Kittler, *Literature, Media, Information Systems* (1997)

Friedrich Kittler, *Gramophone, Film, Typewriter* (1999)

Friedrich Kittler, *Optical Media* (2009)

Barry Sandywell, 'On the Globalization of Crime: The Internet and the New Criminality', in Yvonne Jewkes and Majid Yar, eds., *Handbook of Internet Crime* (2009), pp. 38–66

Janet Wasko, *Hollywood in the Information Age* (1994)

War and Militarization of Visuality

Manuel de Landa, *War in the Age of Intelligent Machines* (1992)

Manuel de Landa, *A Thousand Years of Nonlinear History* (1997)

Friedrich Kittler, *Literature, Media, Information Systems* (1997)

Wolfgang Schivelbusch, *The Railway Journey: The Industrialization of Time and Space in the Nineteenth Century* (1986)

Paul Virilio, *Pure War* (1983)

Paul Virilio, *Speed and Politics* (1986)

Paul Virilio, *War and Cinema: The Logistics of Perception* (1989)

Paul Virilio, *The Aesthetics of Disappearance* (1991a)

Paul Virilio, *The Vision Machine* (1994)

Lebbeus Woods, *War and Architecture* (1993)

THE POLITICS OF SEEING AND BEING SEEN: NEW SOCIAL MOVEMENTS

The Cultural Politics of Class, Feminism, Race and Ethnicity

On the postmodern politics of identity and difference see:

Craig Calhoun, ed., *Social Theory and the Politics of Identity* (1994)

Lorraine Code, *What Can She Know? Feminist Epistemology and the Construction of Knowledge* (1991)

Mike Featherstone, *Consumer Culture and Postmodernism* (1991)

Diana Fuss, *Essentially Speaking: Feminism, Nature and Difference* (1989)

Michael Keith and Steven Pile, eds., *Place and the Politics of Identity* (1993)

Scott Lash and Jonathan Friedman, eds., *Modernity and Identity* (1992)

Scott Lash and John Urry, *Economies of Signs and Space* (1994)

Richard Rorty, *Philosophy and the Mirror of Nature* (1979)

Richard Rorty, *Objectivism, Relativism, and Truth* (1991)

Rosemary Putnam Tong, *Feminist Thought: A More Comprehensive Introduction* (2008)

Iris Marion Young, *Justice and the Politics of Difference* (1990)

Iris Marion Young, 'The Ideal of Community and the Politics of Difference', in Linda J. Nicholson, ed., *Feminism/Postmodernism* (1990), pp. 300–26

Slavoj Žižek, *Everything You Always Wanted to Know about Lacan but Were Afraid to Ask Hitchcock* (1992)

Class, Race, Ethnicity and Gender in the Visual Field

Rosi Braidotti, *Nomadic Subjects: Embodiment and Sexual Difference in Contemporary Feminist Theory* (1994)

Mary Kelly, *Post-Partum Document 1973–1979* (1999)

Mary Kelly, *Interim* (1990)

Mary Kelly, *Gloria Patri* (1992)

Linda Nochlin, 'Why Are There No Great Women Artists', in V. Gornick and B. K. Moran, eds., *Women in Sexist Society* (1971), pp. 480–510

Jacqueline Rose, *Sexuality in the Field of Vision* (1986)

Jacqueline Rose, 'Sexuality and Vision: Some Questions', in H. Foster, ed., *Vision and Visuality* (1988), pp. 115–23

Racialized Seeing and Racialized Cultures: 'Racial' Difference, Subjectivities and Identity Politics in a Multicultural Age

Martin A. Berger, *Sight Unseen: Whiteness and American Visual Culture* (2005)

Homi K. Bhabha, *The Location of Culture* (1994)

Homi K. Bhabha, ed., *Nation and Narration* (1990)

Lisa Bloom, ed., *With Other Eyes: Looking at Race and Gender in Visual Culture* (1999)

Fiona Carson and Claire Pajaczkowska, *Feminist Visual Culture* (2002)

Gen Doy, *Black Visual Culture: Modernity and Postmodernity* (2000)

Emory Elliott et al., eds., *Aesthetics in a Multicultural Age* (2002)

Johannes Fabian, *Time and the Other* (1983)

John Fiske, *Media Matters: Race and Gender in US Politics* (1996)

Paul Gilroy, *The Black Atlantic* (1993a)

Stuart Hall, 'The Meaning of New Times', in S. Hall and M. Jacques, eds., *New Times: The Changing Face of Politics in the 1990s* (1989), pp. 116–33

Stuart Hall, 'Cultural Identity and Diaspora', in J. Rutherford, ed., *Identity* (1990), pp. 222–37

Stuart Hall, 'New Ethnicities', in J. Donald and A. Ratansi, eds., *'Race', Culture and Difference* (1992a), pp. 252–59

Stuart Hall, 'The Formation of a Diasporic Intellectual: An Interview with Stuart Hall by Kuan-Hsing Chen', in D. Morley and K.-H. Chen, eds., *Stuart Hall: Critical Dialogues in Cultural Studies* (1996a), pp. 484–503

Stuart Hall, 'Introduction: Who Needs 'Identity'?', in S. Hall and P. du Gay, eds., *Questions of Cultural Identity* (1996b), pp. 3–17

Stuart Hall and P. du Gay, eds., *Questions of Cultural Identity* (1996)

Stuart Hall, 'Culture and Power: Stuart Hall Interviewed by Peter Osborne and Lynne Segal', *Radical Philosophy*, 86 (Nov/Dec 1997), pp. 24–42

bell hooks, *Black Looks: Race and Representation* (1992)

Erin Manning, *Relationscapes: Movement, Art, Philosophy* (2009)

W.J.T. Mitchell, ed., *Landscape and Power* (1994)

Angela McRobbie, *Feminism and Youth Culture: From Jackie to Just Seventeen* (1991)

Angela McRobbie, *Postmodernism and Popular Culture* (1994)

Kobena Mercer, *Welcome to the Jungle: New Positions in Black Cultural Studies* (1994)

Edward Said, *Orientalism* (1978)

Edward Said, *Culture and Imperialism* (1993)

Shawn Michelle Smith, *American Archives: Gender, Race, and Class in Visual Culture* (1999)

Gendered Visual Experience

Christine Battersby, *Gender and Genius: Towards a Feminist Aesthetics* (1989, 1994)

Susan Bordo, *The Flight to Objectivity: Essays on Cartesianism and Culture* (1987)

Susan Bordo, 'Feminism, Postmodernism and Gender-scepticism', in L. Nicholson, ed., *Feminism/Postmodernism* (1990), pp. 133–56

Clive Cazeaux, ed., *The Continental Aesthetics Reader* (2000), Part 6, 'Psychoanalysis and Feminism'

Shohini Chaudhuri, *Feminist Film Theorists: Laura Mulvey, Kaja Silverman, Teresa de Lauretis, Barbara Creed* (2006)

Teresa de Lauretis, *Technologies of Gender: Essays on Theory, Film, and Fiction* (1987)

Joanna Frueh et al. eds., *New Feminist Criticism* (1993)

R. Krauss, *The Optical Unconscious* (1993)

Marcia Pointon, *Naked Authority: The Body in Western Painting, 1830–1908* (1990)

Kaja Silverman, *Male Subjectivity at the Margins* (1992)

Lisa Tickner, *Spectacle of Women: Imagery of the Suffragette Campaign 1907–14* (1988)

Linda Williams, *Viewing Positions: Ways of Seeing Film* (1989)

Linda Williams, *Hard Core: Power, Pleasure, and the 'Frenzy of the Visible'* (1999)

Gay Culture/Queer Visualities

For a useful collection on feminism and film see Ann E. Kaplan, ed., *Feminism and Film* (2000). For a reader in 'queer visuality' see Michele Aaron, ed., *New Queer Cinema: A Critical Reader* (2004). Other texts include:

Teresa Brennan and M. Jay, eds., *Vision in Context* (1996)

Judith Butler, *Subjects of Desire: Hegelian Reflections in Twentieth Century France* (1987)

Judith Butler, *Gender Trouble: Feminism and the Subversion of Identity* (1990)

Judith Butler, *Bodies That Matter: On the Discursive Limits of 'Sex'* (1993)

Judith Butler, *Excitable Speech: A Politics of the Performative* (1997)

Judith Butler and J. Scott, eds., *Feminists Theorize the Political* (1992)

Craig Calhoun, ed., *Social Theory and the Politics of Identity* (1994)

N. Katherine Hayles, *How We Became Posthuman: Virtual Bodies in Cybernetics, Literature, and Informatics* (1999)

N. Katherine Hayles, *Writing Machines* (2002)

N. Katherina Hayles, 'Computing the Human', *Theory, Culture and Society*, Vol. 22(1), 2005, pp. 131–51

Luce Iragaray, *Speculum of the Other Woman* (1985)

Amelia Jones, ed., *The Feminism and Visual Culture Reader* (2003)

Annette Kuhn, *Women's Pictures: Feminism and Cinema* (1994)

Myra Macdonald, *Exploring Media Discourse* (2003)

Griselda Pollock, *Vision and Difference: Femininity, Feminism and the Histories of Art* (1988)

Griselda Pollock, *Avante-Garde Gambits 1888–1893: Gender and the Colour of Art Theory* (1993)

Griselda Pollock, *Differencing the Canon: Feminist Desire and the Writing of Art's Histories* (1999)

Jacqueline Rose, *Sexuality in the Field of Vision* (1986)

Steven Seidman, 'Posrtmodern Social Theory as Narrative with a Moral Intent', in S. Seidman and D. G. Wagner, eds., *Postmodernism and Social Theory: The Debate over General Theory* (1998), pp. 47–81

Steven Seidman, ed., *Queer Theory/Sociology* (1996)

(Re)envisioning the Body: Embodiment, the Gaze, Visual Pleasure and Identity

Kathleen Adler and Marcia Pointon, eds., *The Body Imaged: The Human Form and Visual Culture since the Renaissance* (1993)

Susan Bordo, *Unbearable Weight: Feminism, Western Culture and the Body* (1993)

Steven Connor, *The Book of Skin* (2003)

Antonio Damasio, *The Feeling of What Happens: Body and Emotion in the Making of Consciousness* (1999)

Elizabeth A. Grosz, *Sexual Subversion: Three French Feminists* (1989)

Elizabeth.A. Grosz, *Volatile Bodies: Toward a Corporeal Feminism* (1994)

Elizabeth A. Grosz, *Space, Time, and Perversion: Essays on the Politics of Bodies* (1995a)

Elizabeth A. Grosz, 'Women, *Chora*, Dwelling', in Sophie Watson and Katherine Gibson, eds., *Postmodern Cities and Spaces* (1995b), pp. 47–58

Elizabeth A. Grosz and Elspeth Probyn, eds., *Sexy Bodies: The Strange Carnalities of Feminism* (1995)

bell hooks, *Black Looks: Race and Representation* (1992)

bell hooks, *Art on My Mind: Visual Politics* (1995)

bell hooks, *Reel to Real: Race, Sex and Class at the Movies* (1996)

Amelia Jones, *Postmodernism and the En-gendering of Marcel Duchamp* (1995)

Drew Leder, *The Absent Body* (1990)

Susie Orbach, *Bodies* (2009)

Ted Polemus, *Social Aspects of the Human Body* (1978)

Elaine Scarry, *The Body in Pain: The Making and the Unmaking of the World* (1985)

Dorothy Smith, *The Everyday World as Problematic: A Feminist Sociology* (1987)

Barbara Maria Stafford, *Good Looking: Essays on the Virtue of Images* (1996a)

Barbara Maria Stafford, *Echo Objects: The Cognitive Work of Images* (2007)

Francisco Varela et al. *The Embodied Mind* (1991)

Pornography

Drucilla Cornell, ed. *Feminism and Pornography* (2000)

Andrea Dworkin, *Pornography: Men Possessing Women* (1981)

Lynn Hunt, ed., *The Invention of Pornography: Obscenity and the Margins of Modernity* (1993)

Walter Kendrick, *The Secret Museum: Pornography in Modern Culture* (1987)
Nicholas Mirzoeff, ed. *The Visual Culture Reader* (1998), Part 6, 'Pornography'
Linda Williams, *Hard Core: Power, Pleasure and the 'Frenzy of the Visible'* (1999)
Linda Williams, *Screening Sex* (2008)

Prosthetic Identities

Jean Baudrillard, *Selected Writings* (1988)
Scott Bukatman, *Terminal Identity: The Virtual Subject in Postmodern Science Fiction* (1993)
Lisa Cartwright, 'Gender Artifacts: Technologies of Bodily Display in Medical Culture', in Lynne
 Cooke and Peter Wollen, eds., *Visual Display* (1995), pp. 218–36
Jonathan Crary and Sanford Kwinter, eds., *Incorporations v. 6 (Zone 6)* (1994)
Amelia Jones, *Body Art/Performing the Subject* (1998)
Celia Lury, *Prosthetic Culture: Photography, Memory and Identity* (1998)
Nicholas Mirzoeff, *Bodyscape: Art, Modernity, and the Ideal Figure* (1995)
Barbara Maria Stafford, *Echo Objects: The Cognitive Work of Images* (2007)
Stephen Wilson, *Information Arts* (2002), section 2.5, 'Body and Medicine', pp. 148–200

Images of Class and Class Difference in the Organization of Visual Experience

Pierre Bourdieu, *Distinction: A Cultural Critique of the Judgement of Taste* (1984)
Mike Davis, *City of Quartz: Excavating the Future in Los Angeles* (1990)
David Harvey, *Consciousness and Urban Experience* (1985)
David Harvey, *The Condition of Postmodernity* (1989)
David Harvey, *Spaces of Global Capitalism: A Theory of Uneven Geographical Development* (2006)
Shawn Michelle Smith, *American Archives: Gender, Race, and Class in Visual Culture* (1999)
Edward Soja, *Postmodern Geographies: The Reassertion of Space in Critical Social Theory* (1989)

Cyborg Culture and Biopolitics

Anne Balsamo, *Technologies of the Gendered Body: Reading Cyborg Women* (1996)
Timothy Druckery and Peter Weibel, eds. *Electronic Culture: History, Theory and Practice* (2001)
Donna Haraway, 'A Cyborg Manifesto: Science, Technology and Socialist-Feminism in the Late
 Twentieth Century', in *Simians, Cyborgs and Women: The Reinvention of Nature* (1991a),
 pp. 149–81
Donna Haraway, 'Situated Knowledges: The Science Question in Feminism and the Privilege
 of Partial Perspective', in *Simians, Cyborgs and Women: The Reinvention of Nature* (1991b),
 pp. 183–201
Katherine Hayles, *How We Became Posthuman* (1999)
Katherine Hayles, *Writing Machines* (2002)
Katherine Hayles, *My Mother Was a Computer* (2005)
Constance Penley and Andrew Ross, ed. *Technoculture* (1991)
Sadie Plant, *Zeroes and Ones: Digital Women and the New Technoculture* (1997)
Niklas Rose, *The Politics of Life Itself* (2006)
Vivian Sobchack, *Carnal Thoughts: Embodiment and Moving Image Culture* (2004)
Stephen Wilson, *Information Arts* (2002)

VISUAL PEDAGOGY

Visual literacy—education in the competences involved in understanding visual culture—is essential to training courses concerned with the role of images and visual experience in contemporary culture. The bibliography in this area is now quite extensive. Among the most accessible texts are:

Mieke Bal and Norman Bryson, *Looking In: The Art of Viewing* (2001)
Anna Bentkowska-Kafel, Trisha Cashen and Hazel Gardiner, eds., *Digital Art History* (2005)
Anna Bentkowska-Kafel, Trisha Cashen and Hazel Gardiner, eds., *Digital Visual Culture: Theory and Practice* (2009)
Peter Burke, *Cultural Hybridity* (2009)
Fiona Candlin and Raiford Guins, eds., *The Object Reader* (2009)
James Elkins, *How To Use Your Eyes* (2000)
Gunther Kress and Theo van Leeuwen, *Reading Images* (2006)
Gillian Rose, *Visual Methodologies: An Introduction to the Interpretation of Visual Materials* (2001)
Barbara Maria Stafford, *Good Looking: Essays on the Virtue of Images* (1996a)
Barbara Maria Stafford, *Visual Analogy: Consciousness as the Art of Connecting* (1996b)
Graeme Sullivan, *Art Practice as Research: Inquiry in the Visual Arts* (2005).

Also:

Mieke Bal and Inge Boer, *Point of Theory: Practices of Cultural Analysis* (1994)
Stanley Cavell, *Cities of Words* (2004)
Francis Halsall, Julia Jansen and Tony O'Connor, eds., *Rediscovering Aesthetics* (2009), Part III, 'Aesthetics in Artistic and Curatorial Practice'
W.J.T. Mitchell, 'Showing Seeing: A Critique of Visual Culture', *Journal of Visual Culture*, Vol. 1(2), 2002, pp. 165–81
W.J.T. Mitchell, *What Do Pictures Want? Essays on the Lives and Loves of Images* (2006)
Barbara Maria Stafford, *Artful Science, Enlightenment, Entertainment and the Eclipse of Visual Education* (1994)
Stephen Wilson, *Information Arts* (2002)
Richard Wollheim, *The Thread of Life* (1984)

(RE)ENVISIONING THE PUBLIC SPHERE

For orientation and general background see back-issues of *Culture Machine: Generating Research in Culture and Theory* (http://www.culturemachine.net/index.php/cm).

Seyla Benhabib, ed., *Democracy and Difference Contesting the Boundaries of the Political* (1996)
Richard Butsch, ed., *Media and Public Spheres* (2007)
Craig Calhoun, *Habermas and the Public Sphere* (1993)
Nick Crossley and John Michael Roberts, eds., *After Habermas: New Perspectives on the Public Sphere* (2004)
Jürgen Habermas, *The Structural Transformation of the Public Sphere: An Inquiry into a Category of Bourgeois Society* (1992)
Jim McGuigan, 'The Cultural Public Sphere', ch. 1, *Cultural Analysis* (2009)

Martha Nussbaum, *The Fragility of Goodness* (1986)

Barbara Maria Stafford, *Artful Science, Enlightenment, Entertainment and the Eclipse of Visual Education* (1994)

BIBLIOGRAPHY

Aaron, M., ed. 2004. *New Queer Cinema: A Critical Reader*. Edinburgh: Edinburgh University Press.

Aarseth, E. J. 1997. *Cybertext: Perspectives on Ergodic Literature*. Baltimore and London: Johns Hopins University Press.

Adler, K. and M. Pointon, eds. 1993. *The Body Imaged: The Human Form and Visual Culture since the Renaissance*. Cambridge: Cambridge University Press.

Adorno, T. W. 1973. *Negative Dialectics*, trans. E. B. Ashton. London: Routledge and Kegan Paul.

Adorno, T. W. 1990. *Aesthetic Theory*. London: Routledge.

Adorno, T. W. 1997. *Aesthetic Theory*. trans. Robert Hullot-Kentor. Minneapolis: University of Minnesota Press; London: Athlone Press (*Aesthetischen Theorie*. Frankfurt am Main: Suhrkamp, 1970).

Adorno, T. W. 2001. *The Culture Industry: Selected Essays on Mass Culture*, ed. J. M. Bernstein. Harmondsworth: Penguin (Penguin Classics).

Adorno, T. W. and M. Horkheimer. 1972. *Dialectic of Enlightenment*. New York: Herder and Herder.

Alberti, L. B. 1972. *On Painting and Sculpture*, ed. and trans. Cecil Grayson. London: Phaidon.

Alexander, J. C. and S. Seidman, eds. 1990. *Culture and Society: Contemporary Debates*. Cambridge: Cambridge University Press.

Allen, R. 1992. *Channels of Discourse Reassembled: Television and Contemporary Criticism*, 2nd edn. London: Routledge.

Allen, R. and M. Smith, eds. 1997. *Film Theory and Philosophy*. Oxford: Oxford University Press.

Alpers, S. 1988. *Rembrandt's Enterprise: The Studio and Market*. Chicago: University of Chicago Press.

Alpers, S. 1989. *The Art of Describing: Dutch Art in the Seventeenth Century*. Harmondsworth: Penguin.

Alperson, P. ed. 1992. *The Philosophy of the Visual Arts*. Oxford: Oxford University Press.

Althusser, L. 1971. 'Ideology and Ideological State Apparatuses', in L. Althusser (ed.), *Lenin and Philosophy and Other Essays*, trans. B. Brewster. London: New Left Books, 127–88.

Altman, R. 1999. *Film/Genre*. London: British Film Institute.

Anderson, R. L. 2004. *Calliope's Sisters: A Comparative Study of Philosophies of Art*, 2nd edn. Englewood-Cliffs, NJ: Prentice-Hall.

Apostolopoulos, Y., S. Leivadi, and A. Yiannakis, eds. 2001. *The Sociology of Tourism: Theoretical and Empirical Investigations*. London and New York: Routledge.

Appadurai, A. 1996. *Modernity at Large: Cultural Dimensions of Globalization*. Minneapolis: University of Minnesota Press.

Appadurai, A. ed. 1986. *The Social Life of Things: Commodities in Cultural Perspective*. Cambridge: Cambridge University Press.

Arato, A. and Eike Gebhardt, eds. 1982. *The Essential Frankfurt School Reader*. New York: Urizen Books.

Arnheim, R. 1958. *Film as Art*. London: Faber and Faber.

Arnheim, R. 1972. *Towards a Psychology of Art. Collected Essays*. Berkeley: California University Press.

Arnheim, R. 1969. *Art and Visual Perception: A Psychology of the Creative Eye*. London: Faber and Faber; Berkeley: California University Press, 2004.

Arnold, D. 2003. *Art Theory*. Oxford: Blackwell.

Augé, M. 1995. *Non-Places: Introduction to an Anthropology of Supermodernity*. London: Verso.

Austin, J. L. 1962. *Sense and Sensibilia*. Oxford: Oxford University Press.

Bal, M. 1991. *Reading 'Rembrandt': Beyond the Word-Image Opposition*. New York: Cambridge University Press.

Bal, M. 1993. 'His Master's Eye', in David Michael Levin (ed.), *Modernity and the Hegemony of Vision*, 379–404.

Bal, M. 1996. *Double Exposures: The Subject of Cultural Analysis*. London: Routledge.

Bal, M., ed. 1999. *The Practice of Cultural Analysis: Exposing Interdisciplinary Interpretation*. Stanford, CA: Stanford University Press.

Bal, M. 2001. *Quoting Caravaggio: Contemporary Art, Preposterous History*. Chicago: University of Chicago Press.

Bal, M. 2003. 'Visual Essentialism and the Object of Visual Culture', *Journal of Visual Culture*, 2/1: 5–32.

Bal, M. and Inge E. Boer. 1994. *Point of Theory: Practices of Cultural Analysis*. New York: Continuum.

Bal, M. and Norman Bryson. 2001. *Looking In: The Art of Viewing*. London: Routledge.

Bal, M., Jonathan Crew and Leo Spitzer, eds. 1997. *Acts of Memory: Cultural Recall in the Present*. Lebanon, NH: Dartmouth College Press/University Press of New England.

Ball, M. S. and G. Smith. 1992. *Analysing Visual Data*. London: Sage.

Balsamo, A. 1996. *Technologies of the Gendered Body: Reading Cyborg Women*. Durham, NC: Duke University Press.

Banks, M. 2001. *Visual Methods in Social Research*. London: Sage.

Banks, M. 2008. *Using Visual Data in Qualitative Research*. London: Sage.

Barbaras, R. 2003. *Vie et intentionalité: Researches phénoménologiques*. Paris: Vrin.

Barker, C. 2000. *Cultural Studies: Theory and Practice*. London and Thousand Oaks, CA: Sage.

Barlow, D. and B. Mills. 2008. *Reading Media Theory: Thinkers, Approaches, Contexts*. Harlow: Pearson Education.

Barnard, M. 1996. *Fashion and Communication*. London: Routledge.

Barnard, M. 1998. *Art, Design and Visual Culture*. Basingstoke: Macmillan.

Barnard, M. 2001. *Approaches to Understanding Visual Culture*. Basingstoke: Palgrave.

Barrett, M., P. Corrigan, A. Kuhn, and J. Wolff, eds. 1979. *Ideology and Cultural Production*. London: Croom Helm.

Barrett, T. 2002. *Interpreting Art: Responding to Visual Culture*. London: Mayfield.

Barthes, R. 1970. *S/Z*. Paris: Editions du Seuil; Oxford: Blackwell, 1990.

Barthes, R. 1972. *Mythologies*, trans. A. Lavers. London: Jonathan Cape.

Barthes, R. 1975. *The Pleasure of the Text*, trans. R. Miller. New York: Hill and Wang; London: Jonathan Cape.

Barthes, R. 1977. *Image-Music-Text*, trans. S. Heath. London: Fontana.

Barthes, R. 1983. *Empire of Signs*. New York: Hill and Wang.

Barthes, R. 2000. *Camera Lucida: Reflections on Photography*, trans. R. Howard. London: Vintage.

Basch, T. W. and Gallagher, S. eds. 1992. *Merleau-Ponty, Hermeneutics and Postmodernism.* Albany: State University of New York.

Bataille, G, 1986. 'The Use Value of D.A.F. de Sade', in *Visions of Excess.* Minneapolis: Minnesota University Press, 94–102.

Bataille, G. 1988. *The Accursed Share: An Essay on General Economy: Volume 1, CoNsumption.* New York: Zone Books.

Bataille, G. 1993. *The Accursed Share: An Essay on General Economy: Volume 11, The History of Eroticism: Volume III, Sovereignty*, trans. R. Hurley. New York: Zone Books.

Bataille, G. 1997. *The Bataille Reader*, ed. F. Botting and S. Wilson. Oxford: Basil Blackwell.

Bataille, G. 2001. *Story of the Eye.* Harmondsworth: Penguin.

Bataille, G. 2009. *The Cradle of Humanity,* trans. M. and S. Kendall. New York: Zone Books.

Battersby, C. 1989 and 1994. *Gender and Genius: Towards a Feminist Aesthetics.* London: The Women's Press.

Baudelaire, C. 1995. *The Painter of Modern Life and Other Essays*, trans. J. Mayne. London: Phaidon.

Baudrillard, J. 1983. *Simulations*, trans. P. Foss, P. Patton and P. Beitchman. New York: Semiotext(e).

Baudrillard, J. 1988. *Selected Writings.* Cambridge: Polity Press.

Baudrillard, J. 1993. *The Transparency of Evil: Essays on Extreme Phenomena.* London and New York: Verso.

Baudrillard, J. 1996. *The System of Objects*, trans. J. Benedict. London: Verso.

Bauman, Z. 1998. *Consumerism and the New Poor.* Milton Keynes: Open University Press.

Bauman, Z. 2000. *Liquid Modernity.* Cambridge: Polity Press.

Bauman, Z. 2007. *Consuming Life.* Cambridge: Polity Press.

Baxandall, M. 1972. *Painting and Experience in Fifteenth Century Italy: A Primer in the Social History of Pictorial Art.* Oxford: Oxford University Press; 2nd edn. 1988.

Baxandall, M. 1985. *Patterns of Intention: On the Historical Explanation of Pictures.* New Haven, CT: Yale University Press.

Baxandall, M. 1995. *Shadows and Enlightenment.* New Haven, CT and London: Yale University Press.

Baynes, K., J. Bohman, and T. McCarthy, eds. 1987. *After Philosophy: End or Transformation.* Cambridge, MA: MIT Press.

Beardsley, M. C. 1966. *Aesthetics from Classical Greece to the Present: A Short History.* University: University of Alabama Press.

Beaumont, M., A. Hemingway, E. Leslie, and J. Roberts, eds. 2007. *As Radical as Reality Itself: Essays on Marxism and Art for the 21st Century.* Oxford: Peter Lang.

Beck, U. 1992. *Risk Society: Towards a New Modernity*, trans. Mark Ritter. London: Sage.

Becker, H. 1981. *Exploring Society Photographically.* Chicago: University of Chicago Press.

Becker, H. 1982. *Art Worlds.* Berkeley: University of California Press.

Becker, H. 1986. *Doing Things Together: Selected Papers, Part 4: Photography.* Evanston, IL: Northwestern University Press.

Beech, D. 2009. *Beauty: Documents of Contemporary Art.* Cambridge, MA: MIT Press.

Bell, C. 1987. *Art*, ed. J. B. Bullen. Oxford: Oxford University Press.

Belting, H. 1994. *Likeness and Presence: A History of the Image before the Era of Art*, trans. Edmund Jephcott. Chicago: University of Chicago Press.

Belting, H. 2001. *The Invisible Masterpiece*, trans. Helen Atkins. Chicago: University of Chicago Press.

Belting, H. 2003. *Art History after Modernism*, trans. Caroline Saltzwedel, Mitch Cohen and Kenneth J. Northcott. Chicago: University of Chicago Press.

Benedikt, M. 1991. *Cyberspace: First Steps*. Cambridge, MA: MIT Press.

Benhabib, S. ed. 1996. *Democracy and Difference Contesting the Boundaries of the Political*. Princeton, NJ: Princeton University Press.

Benjamin, A. 1988. *The Problem of Modernity: Adorno and Benjamin*. London: Routledge.

Benjamin, A. 1994. *Object, Painting*. London: Academy Editions.

Benjamin, A. ed. 2004. *Walter Benjamin and Art*. London and New York: Continuum.

Benjamin, W. 1969. 'The Work of Art in the Age of Mechanical Reproduction', in W. Benjamin, *Illuminations: Essays and Reflections*. New York: Schocken Books; London: Jonathan Cape, 1970; repr. London: Fontana, 1992.

Benjamin, W. 1992. 'Theses on the Philosophy of History', in *Illuminations*. London: Fontana, 245–55.

Benjamin, W. 1977. *The Origin of German Tragic Drama*. London: New Left Books.

Benjamin, W. 1985. 'A Small History of Photography' (1931), in Benjamin, *One-Way Street and Other Writings*. London: Verso.

Benjamin, W. 1985. 'On the Mimetic Faculty' (1933), in Benjamin, *One-Way Street and Other Writings*. London: Verso.

Benjamin, W. 1989. *Charles Baudelaire: A Lyric Poet in the Era of High Capitalism*. London: Verso.

Benjamin, W. 1996. *Selected Writings, Volume 1, 1913–1926*, ed. M. Bullock and M. W. Jennings. Cambridge, MA: Belknap Press of Harvard University Press.

Benjamin, W. 1999. *The Arcades Project*, trans. H. Eiland and K. McLaughlin. Cambridge, MA and London: Belknap Press of Harvard University Press.

Benjamin, W. 2008a. *The Work of Art in the Age of Its Technological Reproducibility and Other Writings on Media*. Cambridge, MA: Harvard University Press.

Benjamin, W. 2008b. 'The Work of Art in the Age of Its Technological Reproducibility', in Walter Benjamin, *The Work of Art in the Age of Its Technological Reproducibility and Other Writings on Media*. Cambridge, MA: Harvard University Press, 19–55.

Bennett, T. 1995. *The Birth of the Museum: History, Theory, Politics*. London and New York: Routledge.

Bennett, T., J. Curran, M. Gurevitch, and J. Wollacott, eds. 1982. *Culture, Society and the Media*. London; Methuen.

Bennett, T. and John Frow, eds. 2008. *The Sage Handbook of Cultural Analysis*. London: Sage.

Bentkowska-Kafel, A., Trisha Cashen and Hazel Gardiner, eds. 2005. *Digital Art History*. Chicago: University of Chicago Press.

Bentkowska-Kafel, A., Trisha Cashen and Hazel Gardiner, eds. 2009. *Digital Visual Culture: Theory and Practice*. Chicago: University of Chicago Press.

Berger, J. 1972. *Ways of Seeing*. London: BBC Publications/Penguin.

Berger, J. 2002. *About Looking*. New York: Vintage Books.

Berger, M. A. 2005. *Sight Unseen: Whiteness and American Visual Culture*. Berkeley: University of California Press.

Bernal, M. 1987. *The Fabrication of Ancient Greece 1785–1985*, vol. 1 of *Black Athena: The Afroasiatic Roots of Classical Civilization*. London: Vintage Books.

Bernstein, J. M. 1992. *The Fate of Art: Aesthetic Alienation from Kant to Derrida and Adorno*. Cambridge: Polity Press.

Bernstein, J. M. 2001. *Adorno: Disenchantment and Ethics*. Cambridge: Cambridge University Press.

Bernstein, J. M., ed. 2003. *Classic and Romantic German Aesthetics*. Cambridge: Cambridge University Press.

Bernstein, R. J. 1983. *Beyond Objectivism and Relativism: Science, Hermeneutics and Praxis*. Philadelphia: University of Pennsylvania Press.

Berry, B. 2008. *The Power of Looks: Social Stratification of Physical Appearance*. Farnham, Surrey: Ashgate.

Beynon, J. and D. Dunkerley, eds. 2001. *Globalization: The Reader*. London: Routledge.

Bhabha, H. K. 1994. *The Location of Culture*. London: Routledge.

Bhabha, H. K., ed. 1990. *Nation and Narration*. London: Routledge.

Blanchot, M. 1992. *The Infinite Conversation*, trans. Susan Hanson. Minneapolis: University of Minnesota Press.

Bloch, E. 1986. *The Principle of Hope*, vol. 1, trans. N. Plaice, S. Plaice, and P. Knight. Oxford: Blackwell.

Bloom, L., ed. 1999. *With Other Eyes: Looking at Race and Gender in Visual Culture*. Minneapolis: University of Minnesota Press.

Blum, L. A. 1994. *Moral Particularity and Perception*. Cambdridge: Cambridge University Press.

Bocock, R. 1992. 'Consumption and Lifestyles', in R. Bocock and K. Thompson (eds.), *Social and Cultural Forms of Modernity*. Cambridge: Polity Press, 119–69.

Bocock, R. 1993. *Consumption*. London: Routledge.

Bois, Y.-A. 1993. *Painting as Model*. Cambridge, MA: MIT Press.

Bois, Y.-A. 2005. *Art since 1900: Modernism, Antimodernism, Postmodernism, vol. 1: 1900–1944*. London: Thames and Hudson.

Bolter, J. D. and R. Grusin, eds. 2002. *Remediation: Understanding New Media*. London and Camdbridge, MA: MIT Press.

Bordo, S. 1987. *The Flight to Objectivity: Essays on Cartesianism and Culture*. Albany: State University of New York Press.

Bordo, Susan. 1993. *Unbearable Weight: Feminism, Western Culture and the Body*. Berkeley: University of California Press.

Bordwell, D, 1989. *Making Meaning: Inference and Rhetoric in the Interpretation of Cinema*. Cambridge, MA: Harvard University Press.

Bordwell, D. and N. Carroll, eds. 1996. *Post-Theory: Reconstructing Film Studies*. Madison: University of Wisconsin Press.

Boundas, C. V., ed. 2007. *The Edinburgh Companion to Twentieth-Century Philosophies*. Edinburgh: Edinburgh University Press.

Bourdieu, P. 1977. *Outline of a Theory of Practice*. Cambridge: Cambridge University Press.

Bourdieu, P. 1984. *Distinction: A Social Critique of the Judgement of Taste*. London: Routledge and Kegan Paul.

Bourdieu, P. 1991. *Language and Symbolic Power*, trans. G. Raymond and M. Adamson. Cambridge, MA: Harvard University Press.

Bourdieu, P. 1993. *The Field of Cultural Production: Essays on Art and Literature*. Cambridge: Polity Press.

Bourdieu, P. 1995. *The Rules of Art: Genesis and Structure of the Literary Field*. Cambridge: Polity Press.

Bourdieu, P. 1996. *Photography: A Middle-Brow Art*. Palo Alto, CA: Stanford University Press.

Bourdieu, P. 1998. *On Television and Journalism*. London: Pluto.

Bourdieu, P. and A. Darbel. 1991. *The Love of Art: European Art Museums and Their Public*, trans. C. Beattie and N. Merriman. Cambridge: Polity Press.

Bowie, A. 1997. *From Romanticism to Critical Theory: The Philosophy of German Literary Theory*. London: Routledge.

Bowie, A. 2003. *Aesthetics and Subjectivity: From Kant to Nietzsche*, 2nd edn. Manchester and New York: Manchester University Press.

Boyne, R. 1990. *Foucault and Derrida: The Other Side of Reason*. London: Unwin Hyman.

Braidotti, R. 1991. *Patterns of Dissonance: A Study of Women in Contemporary Philosophy*. Cambridge: Polity Press.

Braidotti, R. 1994. *Nomadic Subjects: Embodiment and Sexual Difference in Contemporary Feminist Theory*. New York: Columbia University Press.

Bremmer, J. and Herman Roodenburg, eds. 1993. *A Cultural History of Gesture: From Antiquity to the Present Day*. Cambridge: Polity Press.

Brennan, T. and M. Jay, eds. 1996. *Vision in Context: Historical and Contemporary Perspectives on Sight*. London: Routledge.

Brent Plate, S. ed. 2002. *Religion, Art and Visual Culture: A Cross-Cultural Reader*. London: Palgrave Macmillan.

Breward, C. 2003. *Fashion*. Oxford: Oxford University Press.

Briggs, A. and Paul Cobley. 2002. *The Media*, 2nd edn. Harlow: Pearson Education.

Brown, N. and A. Webster. 2004. *New Medical Technologies and Society: Reordering Life*. Cambridge: Polity Press.

Brunette, P. and D. Wills, eds. 1994. *Deconstruction and the Visual Arts: Art, Media, Architecture*. Cambridge: Cambridge University Press.

Bryson, N. 1983. *Vision and Painting: The Logic of the Gaze*. New Haven, CT: Yale University Press.

Bryson, N. 1984. *Tradition and Desire: From David to Delacroix*. Cambridge: Cambridge University Press.

Bryson, N. 2004. *Looking at the Overlooked: Four Essays on Still Life Painting*. London: Reaktion Books.

Bryson, N., ed. 1988. *Calligram: Essays in the New Art History from France*. Cambridge: Cambridge University Press.

Bryson, N., K. Moxey, and M. A. Holly, eds. 1991. *Visual Theory: Painting and Interpretation*. New York: HarperCollins.

Bryson, N., M. A. Holly and K. Moxey, eds. 1994. *Visual Culture: Images and Interpretations*. Hanover, NH: Wesleyan University Press.

Buckland, W. 1995. *The Film Spectator: From Sign to Mind*. Amsterdam: Amsterdam University Press.

Buck-Morss, S. 1977. *The Origin of Negative Dialectics: Theodor W. Adorno, Walter Benjamin and the Frankfurt Institute*. New York: Macmillan Free Press.

Buck-Morss, S. 1989. *The Dialectics of Seeing: Walter Benjamin and the Arcades Project*. Cambridge, MA: MIT Press.

Buck-Morss, S. 2002. 'Globalization, Cosmopolitanism, Politics, and the Citizen', *Journal of Visual Culture*, 1/3: 352–40.

Buick, J. and Z. Jevtic. 1995. *Cyberspace for Beginners*. Cambridge: Icon Books.

Bukatman, S. 1993. *Terminal Identity: The Virtual Subject in Postmodern Science Fiction*. Durham, NC: Duke University Press.

Burckhardt, J. 1945. *The Civilization of the Renaissance in Italy*. Oxford and London: Phaidon Press.

Burckhardt, J. 1998. *The Greeks and Greek Civilization*, trans. S. Stern and ed. O. Murray. London: Fontana/HarperCollins.

Bürger, P. 1984. *Theory of the Avant-Garde*, trans. M. Shaw. Minneapolis: University of Minnesota Press.

Burgin, V. 1986. *The End of Art Theory: Criticism and Postmodernity*. Atlantic Highlands, NJ: Humanities Press International.

Burgin, V. 1996. *In/different Spaces: Place and Memory in Visual Culture*. Berkeley: University of California Press.

Burgin, V. ed. 1982. *Thinking Photography*. London: Macmillan.

Burke, P. 2007. *Eyewitnessing: The Uses of Images as Historical Evidence*. London: Reaktion Books.

Burke, P. 2009. *Cultural Hybridity*. Oxford: Polity Press.

Burke, P. and A. Briggs. 2005. *A Social History of the Media: From Gutenberg to the Internet*. Cambridge: Polity Press.

Burke, P. and J. van der Veken. 1993. *Merleau-Ponty in Contemporary Perspective*. Boston: Kluwer Academic Books.

Burrows, R. and M. Featherstone, eds. 1995. *Cyberspace/Cyberbodies/Cyberpunk: Cultures of Technological Embodiment*. London: Sage.

Butler, J. 1987. *Subjects of Desire: Hegelian Reflections in Twentieth Century France*. New York: Columbia University Press.

Butler, J. 1990. *Gender Trouble: Feminism and the Subversion of Identity*. New York and London: Routledge.

Butler, J. 1993. *Bodies That Matter: On the Discursive Limits of 'Sex'*. New York and London: Routledge.

Butler, J. 1997. *Excitable Speech: A Politics of the Performative*. London and New York: Routledge.

Butler, J. 2004. *Precarious Life: The Powers of Mourning and Violence*. London: Verso.

Butler, J. and J. Scott, eds. 1992. *Feminists Theorize the Political*. London: Routledge.

Butsch, R., ed. 2007. *Media and Public Spheres*. London: Palgrave Macmillan.

Calhoun, C. 1993. *Habermas and the Public Sphere*. Cambridge, MA: MIT Press.

Calhoun, C., ed. 1994. *Social Theory and the Politics of Identity*. Oxford: Basil Blackwell.

Candlin, F. and Raiford Guins, eds. 2009. *The Object Reader*. London and New York: Routledge.

Carey, J. W. 1989. *Communication as Culture: Essays on Media and Society*. Boston: Unwin Hyman.

Carman, T. and M.B.N. Hanson, eds. 2004. *The Cambridge Companion to Merleau-Ponty*. Cambridge: Cambridge University Press.

Carroll, N. 1996. *Theorizing the Moving Image*. New York: Cambridge University Press.

Carroll, N. 1998. *A Philosophy of Mass Art*. Oxford: Clarendon Press.

Carroll, N. and J. Choi, eds. 2006. *Philosophy of Film and Motion Pictures: An Anthology*. Oxford: Blackwell.

Carson, F. and Claire Pajaczkowska. 2002. *Feminist Visual Culture*. London and New York: Routledge.

Cartwright, L. 1995. 'Gender Artifacts: Technologies of Bodily Display in Medical Culture', in Lynne Cooke and Peter Wollen (eds.), *Visual Display*. Seattle: Bay Press, 218–36.

Cartwright, L. 1995. *Screening the Body: Tracing Medicine's Visual Culture*. Minneapolis: University of Minnesota Press.

Casey, E. S. 1993. *Getting Back into Place: Toward a Renewed Understanding of the Place-World*. Bloomington: Indiana University Press.

Castells, M. 1996. *The Rise of the Network Society*. Oxford: Blackwell.

Castells, M. 1997. *The Power of Identity*. Malden, MA: Blackwell.

Castells, M. 1998. *End of Millennium*, Vol. 3 of *The Information Age*. Oxford: Blackwell.

Castoriadis, C. 1997. *The Imaginary Institution of Society*. Cambridge: Polity Press.

Cavell, S, 1971. *The World Viewed: Reflections on the Ontology of Film*. New York: Viking Press; enlarged edn. Cambridge, MA: Harvard University Press, 1979.

Cavell, S. 1979. *The Claim of Reason: Wittgenstein, Skepticism, Morality, and Tragedy*. New York: Oxford University Press.

Cavell, S. 1981. *Pursuits of Happiness: The Hollywood Comedy of Remarriage*. Cambridge, MA: Harvard University Press.

Cavell, S. 1996. *Contesting Tears: The Hollywood Melodrama of the Unknown Woman*. Chicago: University of Chicago Press.

Cavell, S. 2004. *Cities of Words: Pedagogical Letters on a Register of the Moral Life*. Cambridge, MA: Belknap Press.

Caygill, H. 1998. *Walter Benjamin: The Colour of Experience*. London and New York: Routledge.

Cazeaux, C., ed. 2000. *The Continental Aesthetics Reader*. London and New York: Routledge.

Cellini, B. 1998. *The Autobiography of Benvenuto Cellini*. Harmondsworth: Penguin/Penguin Classics.

Chaney, D. 1996. *Lifestyles*. London and New York: Routledge.

Chaplin, E. 1994. *Sociology and Visual Representation*. London: Routledge.

Chartier, R. 1993. *Cultural History: Between Practices and Representations*. Oxford: Polity Press.

Chartier, R., ed. 1989. *A History of Private Life*, Vol. 3, *Passions of the Renaissance*. Cambridge, MA: Belknap Press.

Chaudhuri, S. 2006. *Feminist Film Theorists: Laura Mulvey, Kaja Silverman, Teresa de Lauretis, Barbara Creed*. London and New York: Routledge.

Cheetham, M. A. 2001. *Kant, Art and Art History: Moments of Discipline*. Cambridge: Cambridge University Press.

Cheetham, M. A. 2005. 'Visual Studies, Historiography and Aesthetics', *Journal of Visual Culture*, 4/1: 75–90.

Cheetham, M. A. 2006. *Abstract Art against Autonomy: Infection, Resistance, and Cure since the 60s*. Cambridge: Cambridge University Press.

Cheetham, M. A., Michael Ann Holly and Keith Moxey, eds. 1998. *The Subjects of Art History: Historical Objects in Contemporary Perspective*. Cambridge: Cambridge University Press.

Cheetham, M. A., E. Legge and C. Soussloff, eds. 2008. *Editing the Image: Strategies in the Production and Reception of the Visual*. Toronto: University of Toronto Press.

Chipp, H. B. 1984. *Theories of Modern Art: A Source Book by Arists and Critics*. Berkeley: University of California Press.

Cixous, H. 1994. *The Hélène Cixous Reader*, ed. Susan Sellers. London and New York: Routledge.

Clark, K. 1970. *The Nude*. Harmondsworth: Penguin.

Clark, S. 2007. *Vanities of the Eye: Vision in Early Modern European Culture*. Oxford: Oxford University Press.

Clark, T. J. 1984. *The Painting of Modern Life: Paris in the Art of Manet and His Followers*. London: Thames and Hudson; New York: Knopf.

Clarke, D. B. 2003. *The Consumer Society and the Postmodern City*. London: Routledge.

Clary, J. 1990. *Techniques of the Observer: On Vision and Modernity in the Nineteenth Century*. Cambridge, MA: MIT Press.

Classen, C. 1993. *Worlds of Sense: Exploring the Senses in History and across Cultures*. London and New York: Routledge.

Classen, C. 2005. *The Book of Touch*. Oxford: Berg.

Clifford, J. and G. E. Marcus, eds. 1986. *Writing Culture: The Poetics and the Politics of Ethnography*. Berkeley: University of California Press.

Coates, P., ed. 1998. *Nature: Western Attitudes since Ancient Times*. Berkeley: University of California Press.

Code, L. 1991. *What Can She Know? Feminist Epistemology and the Construction of Knowledge*. Ithaca, NY and London: Cornell University Press.

Colebrook, C. 2000. *Ethics and Representation: From Kant to Post-Structuralism*. New York: Columbia University Press.

Collingwood, R. G. 1938. *The Principles of Art*. Oxford: Oxford University Press.

Connerton, P. 1989. *How Societies Remember*. Cambridge: Cambridge University Press.

Connor, S. 2003. *The Book of Skin*. Ithaca, NY: Cornell University Press.

Cook, G. 2001. *The Discourse of Advertising*. London and New York.

Cooke, L. and P. Wollen, eds. 1995. *Visual Display: Culture beyond Appearances*. Seattle: Bay Press.

Cornell, D., ed. 2000. *Feminism and Pornography*. Oxford: Oxford University Press.

Corrigan, P. 1997. *The Sociology of Consumption: An Introduction*. London: Sage.

Cosgrove, D. 1984. *Social Formation and Symbolic Landscape*. London: Croom Helm.

Crary, J. 1990. *Techniques of the Observer: On Vision and Modernity in the Nineteenth Century*. Cambridge, MA: MIT Press.

Crary, J. 1999. *Suspensions of Perception: Attention, Spectacle and Modern Culture*.

Crary J. and S. Kwinter, eds. 1994. *Incorporations v. 6 (Zone 6)*. New York: Zone Books.

Creed, B. 2001. *The Monstrous-Feminine: Film, Feminism, Psychoanalysis*. London and New York: Routledge.

Creed, B. 2003. *Media Matrix: Sexing the New Reality*. Sydney: Allen and Unwin.

Critchley, S. 1992. *The Ethics of Deconstruction: Derrida and Levinas*. Oxford: Basil Blackwell.

Crossley, N. and John Michael Roberts, eds. 2004. *After Habermas: New Perspectives on the Public Sphere*. Oxford: Blackwell.

Crowther, P. 1989. *The Kantian Sublime: From Morality to Art*. Oxford: Clarendon Press.

Crowther, P. 1993. *Art and Embodiment: From Aesthetics to Self-Consciousness*. Oxford: Clarendon Press.

Crowther, P. 1993. *Critical Aesthetics and Postmodernism*. Oxford: Clarendon Press.

Crowther, P. 2002. *The Transhistorical Image: Philosophizing Art and Its History*. Cambridge: Cambridge University Press.

Crowther, P. 2003. *Philosophy after Postmodernism: Civilized Values and the Scope of Knowledge*. London: Routledge.

Currie, G. 1993. 'The Long Goodbye: The Imaginary Language of Film', *British Journal of Aesthetics*, 33/3 (July): 207–19. Reprinted in N. Carroll and J. Choi (eds), *Philosophy of Film and Motion Pictures: An Anthology*. Oxford: Blackwell, 2006, 91–9.

Currie, G. 1995. *Image and Mind: Film, Philosophy and Cognitive Science*. Cambridge: Cambridge University Press.

Cytowic, R. E. 2003. *The Man Who Tasted Shapes*. Cambridge, MA: MIT Press.

Damar, B. 1997. *Avatars! Exploring and Building Virtual Worlds on the Internet*. Berkeley, CA: Peachpit Press.

Damasio, A. 1994. *Descartes' Error: Emotion, Reason, and the Human Brain*. New York: Avon Books.

Damasio, A. 1999. *The Feeling of What Happens: Body and Emotion in the Making of Consciousness*. New York: Harcourt Brace.

Damisch, H. 1994. *The Origin of Perspective*, trans. John Goodman. Cambridge, MA: MIT Press.

Dandeker, C. 1990. *Surveillance, Power and Modernity*. Cambridge: Polity Press.

Dant, T. 1999. *Material Culture in the Social World*. Buckingham and Philadelphia: Open University Press.

Danto, A. C. 1981. *The Transfiguration of the Commonplace: A Philosophy of Art*. Cambridge, MA: Harvard University Press.

Danto, A. C. 1986. *The Philosophical Disenfranchisement of Art*. New York: Columbia University Press.

Danto, A. C. 1992. *Beyond the Brillo Box: The Visual Arts in Post-Historical Perspective*. New York: Farrar, Straus, Giroux.

Danto, A. C. 1997. *After the End of Art: Contemporary Art and the Pale of History*. Princeton, NJ: Princeton University Press.

Danto, A. C. 2003. *The Abuse of Beauty: Aesthetics and the Concept of Art (the Paul Carus Lectures)*. Chicago and LaSalle, IL: Open Court Publishing.

Darley, A. 2000. *Visual Digital Culture: Surface Play and Spectacle in New Media Genres*. London: Routledge.

Daston, L., ed. 2004. *Things That Talk: Object Lessons from Art and Science*. New York: Zone Books.

Davis, M. 1990. *City of Quartz: Excavating the Future in Los Angeles*. London: Verso.

Davis, M. 1992. *Beyond Blade Runner: Urban Control, the Ecology of Fear*. Westfield, NJ: Open Magazine Pamphlets.

Davis, R. H. 1999. *Lives of Indian Images*. Princeton, NJ: Princeton University Press.

de Certeau, M. 1984. *The Practice of Everyday Life*, trans. Stephen F. Rendall. Berkeley: University of California Press.

de Certeau, M. 1986. *Heterologies: Discourse on the Other*, trans. B. Massumi. Manchester: Manchester University Press.

de Kooning, E. 1994. *The Spirit of Abstract Expressionism: Selected Writings*. New York: George Braziller.

de Landa, M. 1992. *War in the Age of Intelligent Machines*. New York: Zone Books.

de Landa, M. 1997. *A Thousand Years of Nonlinear History*. New York: Zone Books/Swerve Editions.

de Landa, M. 2002. *Intensive Science and Virtual Philosophy*. London and New York: Continuum.

de Lauretis, 1987. *Technologies of Gender: Essays on Theory, Film, and Fiction*. Bloomington: Indiana University Press.

de Lauretis, T. and S. Heath, eds. 1985. *The Cinematic Apparatus*. London: Macmillan.

de Rynck, P. 2009. *Understanding Paintings: Bible Stories and Classical Myths in Art*. London: Thames and Hudson.

Debord, G. 1977. *The Society of the Spectacle*. Detroit: Black and Red Press.

Debord, G. 1994. *The Society of the Spectacle*, trans. D. Nicholson-Smith. New York: Zone Books.

Deleuze, G. 1983. *Nietzsche and Philosophy*, trans. H. Tomlinson. New York: Columbia University Press.

Deleuze, G. 1984. *Kant's Critical Philosophy: The Doctrine of the Faculties*, trans. H. Tomlinson and B. Habberjam. Minneapolis: University of Minnesota Press.

Deleuze, G. 1986a. *Cinema 1: The Movement-Image*, trans. H. Tomlinson and B. Habberjam. London: Athlone Press.

Deleuze, G. 1986b. *Foucault*. Paris: Editions de Minuit.

Deleuze, G. 1988a. *Bergsonism*, trans. H. Tomlinson and B. Habberjam. New York: Zone Books.

Deleuze, G. 1988b. *Foucault*, trans. S. Hand. Minneapolis: University of Minnesota Press.

Deleuze, G. 1989. *Cinema 2: The Time-Image*, trans. H. Tomlinson and R. Galeta. London: Athlone Press.

Deleuze, G. 1990. *The Logic of Sense*, trans. M. Lester and C. Stivale. New York: Columbia University Press.

Deleuze, G. 1994. *Difference and Repetition*, trans. P. Patton. New York: Columbia University Press.

Deleuze, G. 1995. *Negotiations 1972–1990*, trans. Martin Joughin. New York: Columbia University Press.

Deleuze, G. 2003. *Francis Bacon: The Logic of Sensation*, trans. Daniel W. Smith. London and New York: Continuum.

Deleuze, G. and F. Guattari. 1977. *Anti-Oedipus: Capitalism and Schizophrenia*, trans. R. Hurley, M. Seem and H. Lane. London: Athlone Press.

Deleuze, G. and F. Guattari. 1986. *Nomadology: The War Machine*, trans. B. Massumi. New York: Semiotext(e).

Deleuze, G. and F. Guattari. 1987. *A Thousand Plateaus: Capitalism and Schizophrenia*, trans. B. Massumi. Minneapolis: Minnesota University Press.

Deleuze, G. and F. Guattari. 1994. *What Is Philosophy?*, trans. G. Burchell and H. Tomlinson. New York: Columbia University Press.

Deleuze, G. and C. Parnet. 1987. *Dialogues*. London: Athlone Press.

Derrida, J. 1973. *Speech and Phenomena and Other Essays on Husserl's Theory of Signs*. Evanston, IL: Northwestern University Press.

Derrida, J. 1976. *Of Grammatology*, trans. G. C. Spivak. Baltimore: Johns Hopkins University Press.

Derrida, J. 1978a. 'Cogito and the History of Madness', in *Writing and Difference*, trans. A. Bass. London: Routledge and Kegan Paul,, 31–63.

Derrida, J. 1978b. *Writing and Difference*, trans. A. Bass. London: Routledge and Kegan Paul.

Derrida, J. 1981. *Positions*. London: Athlone Press.

Derrida, J. 1982a. *Dissemination*, trans. B. Johnson. Chicago: University of Chicago Press.

Derrida, J. 1982b. *Margins of Philosophy*, trans. A. Bass. Brighton: Harvester Press.

Derrida, J. 1987a. *The Postcard: From Socrates to Freud and Beyond*, trans. A. Bass. Chicago: University of Chicago Press.

Derrida, J. 1987b. *The Truth in Painting*, trans. Geoff Bennington and Ian McLeod. Chicago: University of Chicago Press.

Derrida, J. 2005. *Jean-Luc Nancy: On Touching*. Stanford, CA: Stanford University Press.

Descartes, R. 1988. *Selected Philosophical Writings*, trans. John Cottingham, R. Stoothoff, and D. Murdoch. Cambridge: Cambridge University Press.

Descombes, V. 1980. *Modern French Philosophy*, trans. L. Scott-Fox and J. M. Harding. Cambridge: Cambridge University Press.

Dewey, J. 1934. *Art as Experience*. London: George Allen and Unwin.

Dewey, J. 2005. *Art as Experience*. London: Perigee Books.

Dickie, G. 1974. *Art and the Aesthetic: An Institutional Analysis*. Ithaca, NY and London: Cornell University Press.

Dickie, G. 1997. *Introduction to Aesthetics: An Analytic Approach*. Oxford and New York: Oxford University Press.

Dikovitskaya, Margaret. 2005. *Visual Culture: The Study of the Visual after the Cultural Turn*. Cambridge, MA: MIT Press.

Dillon, M., ed. 1991. *Merleau-Ponty Vivant*. Albany: State Universiy of New York Press.

Dilthey, W. 1976. *Selected Writings*, ed. H. P. Rickman. Cambridge: Cambridge University Press.

Diprose, R. and J. Reynolds, eds. 2008. *Merleau-Ponty: Key Concepts*. Stocksfeld: Acumen.

Dosse, F. 1997. *History of Structuralism*: vol. 1, *The Rising Sign, 1945–1966* and vol. 2, *The Sign Sets, 1967-Present*. Minneapolis and London: University of Minnesota Press.

Doy, G. 2000. *Black Visual Culture: Modernity and Postmodernity*. London and New York: I. B. Tauris.

Dreyfus, H. 1991. *Being-in-the-World*. Cambridge, MA: MIT Press.

Dreyfus, H. and P. Rabinow. 1982. *Michel Foucault: Beyond Structuralism and Hermeneutics*. Chicago: University of Chicago Press.

Drucker, J. 1994. *The Visible Word: Experimental Typography and Modern Art, 1909–1923*. Chicago: University of Chicago Press.

Drucker, J. 1995. *The Alphabetic Labyrinth: The Letters in History and Imagination*. London: Thames and Hudson.

Druckery, T., ed. 1996. *Electronic Culture: Technology and Visual Representation*. New York: Aperture Foundation.

Druckery, T. and Peter Weibel, eds. 2001. *Electronic Culture: History, Theory and Practice*. Cambridge, MA: MIT Press.

Dudley, A. 1976. *The Major Film Theories*. New York: Oxford University Press.

Dufrenne, M. 1966. *The Phenomenology of Aesthetic Experience*, trans. E. S. Casey. Evanston, IL: Northwestern University Press.

Dupré, L. 1993. *Passage to Modernity*. New Haven, CT: Yale University Press.

During, S. 1992. *Foucault and Literature: Towards a Genealogy of Writing*. London and New York: Routledge.

During, S. 2005. *Cultural Studies: A Critical Introduction*. London: Routledge.

During, S., ed. 1993. *The Cultural Studies Reader*. London: Routledge.

Dworkin, A. 1981. *Pornography: Men Possessing Women*. New York: Putnam.

Dyer, R. 1982. *Stars*. London: British Film Institute.

Dyer, R., ed. 1990a. *Gays and Film*. London: BFI.

Dyer, R. 1990b. *Now You See It: Studies on Lesbian and Gay Film*. London: Routledge.

Dyer, R. 2003. *Heavenly Bodies: Film Stars and Society.* London: Routledge.

Eagleton, T. 1990. *Ideology of the Aesthetic.* Oxford: Blackwell.

Eagleton, T. 2000. *The Idea of Culture.* Oxford: Blackwell.

Eagleton, T. 2003. *After Theory.* London: Allen Lane.

Eagleton, T. and D. Milne. 1996. *Marxist Literary Theory: A Reader.* Oxford: Blackwell.

Easthope, A. and K. McGowan. 1997. *A Critical and Cultural Theory Reader.* Buckingham: Open University Press; 2nd edn. 2004.

Eaton, A. 2005. 'Painting and Ethics', in D. Goldblatt and L.B. Brown (eds.), *Aesthetics: A Reader in Philosophy of the Arts.* Upper Saddle River, NJ: Prentice Hall/Pearson Education, 63–8.

Eco, U. 1976. *A Theory of Semiotics.* Bloomington: University of Indiana Press.

Eco, U. 1979. *The Role of the Reader: Explorations in the Semiotics of Texts.* Bloomington: Indiana University Press.

Eco. U. 1987. *Travels in Hyperreality.* London: Picador.

Eco, U. 1988. *Art and Beauty in the Middle Ages*, trans. Hugh Bredin. New Haven, CT and London: Yale University Press.

Eco, U. 1989. *The Open Work.* Cambridge, MA: Harvard University Press.

Eco, U., ed. 2008. *On Ugliness*, trans. Alastair McEwen. New York: Rizzoli.

Ede, S. 2000. *Strange and Charmed: Science and the Contemporary Visual Arts.* London: Calouste Gulbenkian Foundation.

Edelman, M. 1988. *Constructing the Political Spectacle.* Chicago: Chicago University Press.

Edgerton, S. Y., Jr. 1975. *The Renaissance Rediscovery of Linear Perspective.* New York: Basic Books.

Edwards, E. 2001. *Raw Histories: Photographs, Anthropology and Museums.* London: Palgrave Macmillan.

Edwards, E. and J. Hart, eds. 2004. *Photographs, Objects, Histories.* London: Routledge.

Edwards, S. 2006. *Photography: A Very Short Introduction.* Oxford: Oxford University Press.

Edwards, S., ed. 1996. *Art and Its Histories: A Reader.* New Haven, CT: Yale University Press.

Edwards, S. and Paul Wood, eds. 2004. *Art of the Avant-Gardes.* New Haven, CT: Yale University Press.

Eisenstein, E .E. 1968. 'Some Conjectures about the Impact of Printing on Western Society and Thought', *Journal of Modern History*, 40: 1–56.

Eisenstein, E. E. 1969. 'The Advent of Printing and the Problem of the Renaissance', *Past and Present*, 45: 19–89.

Eisenstein, E. E. 1979. *The Printing Press as an Agent of Change: Communications and Cultural Transformations in Early-Modern Europe*, 2 vols. New York: Cambridge University Press.

Eisenstein, E. E. 1981. 'Some Conjectures about the Impact of Printing on Western Society and Thought: A Preliminary Report', in H. J. Graff (ed.), *Literacy and Social Development in the West.* Cambridge: Cambridge University Press, 53–68.

Eisenstein, E. E. 1983. *The Printing Revolution in Early Modern Europe.* Cambridge: Cambridge University Press.

Eisenstein, S. 1988. *Writings, Volume 1: 1922–1934*, ed. and trans. Richard Taylor. London: British Film Institute.

Elias, N. 1982/1987. *The Civilizing Process*, 2 vols. Oxford: Blackwell.

Elias, N. 1991. *On Time.* Oxford: Blackwell.

Elkins, J. 1998. *What Painting Is.* London and New York: Routledge.

Elkins, J. 1999. *The Domain of Images.* Ithaca, NY: Cornell University Press.

Elkins, J. 2000. *How to Use Your Eyes.* London and New York: Routledge.

Elkins, J. 2003. *Visual Studies: A Skeptical Introduction.* London and New York: Routledge.

Elkins, J., ed. 2006. *Art History versus Aesthetics.* London and New York: Routledge.

Elliott, E., L. Freitas Caton and J. Rhyne, eds. 2002. *Aesthetics in a Multicultural Age.* Oxford: Oxford University Press.

Emmer, M., ed. 2005. *The Visual Mind.* Cambridge, MA: MIT Press.

Emmison, M. and P. Smith. 2000. *Researching the Visual: Images, Objects, Contexts and Interactions in Social and Cultural Inquiry.* London: Sage.

Evans, J. and Stuart Hall, eds. 1999. *Visual Culture: The Reader.* Thousand Oaks, CA and London: Sage.

Evernden, N. 1992. *Social Creation of Nature.* Baltimore: Johns Hopkins University Press.

Ewen, S. 1976. *Captains of Consciousness: Advertising and the Social Roots of Consumer Culture.* New York: McGraw-Hill.

Ewen, S. 1988. *All Consuming Images: The Politics of Style in Contemporary Culture.* New York: Basic Books.

Ewen, S. and E. Ewen. 1992. *Channels of Desire: Mass Images and the Shaping of American Culture.* Minneapolis: University of Minnesota Press.

Fabian, J. 1983. *Time and the Other: How Anthropology Makes Its Object.* New York: Columbia University Press.

Fabian, J. 1990. 'Presence and Representation: The Other and Anthropological Writing', *Critical Inquiry*, 16, 753–73.

Farago, C. 1995. *Reframing the Renaissance: Visual Culture in Europe and Latin America 1450–1650.* New Haven, CT: Yale University Press.

Farago, C., ed. 2008. *Leonardo da Vinci and the Ethics of Style.* Manchester: Manchester University Press.

Featherstone, M. 1991. *Consumer Culture and Postmodernism.* London: Sage.

Featherstone, M., ed. 1990. *Global Culture: Nationalism, Globalization and Modernity.* London: Sage.

Febvre, L. and Henri-Jean Martin, 1997. *The Coming of the Book: The Impact of Printing, 1400–1800.* London: Verso.

Ferry, L. 1993. *Homo Aestheticus: The Invention of Taste in the Democratic Age.* Chicago: University of Chicago Press.

Fishwick, P. A., ed. 2006. *Aesthetic Computing.* Cambridge, MA: MIT Press.

Fiske, J. 1987. *Television Culture.* London: Routledge.

Fiske, J. 1996. *Media Matters: Race and Gender in US Politics.* Minneapolis: University of Minnesota Press.

Fiske, J. and J. Hartley. 2003. *Reading Television*, 2nd rev. edn. London and New York: Routledge.

Flusser, V. 1999. *Shape of Things: A Philosophy of Design.* London: Reaktion Books.

Flusser, V. 2000. *Towards a Philosophy of Photography.* London: Reaktion Books.

Flusser, V. 2004. *Writings*, trans. Erik Eisel. Minneapolis: University of Minnesota Press.

Foster, H., ed. 1983. *Postmodern Culture.* London and Sydney: Pluto Press.

Foster, H. 1985. *Recodings: Art, Spectacle, Cultural Politics.* Port Townsend, WA: Bay Press.

Foster, H., ed. 1988. *Vision and Visuality.* Seattle: Bay Press.

Foster, H., ed. 2002. *The Anti-Aesthetic: Essays on Postmodern Culture.* New York: New Press.

Foucault, M. 1971. *The Order of Things: An Archaeology of the Human Sciences.* New York: Vintage Press.

Foucault, M. 1972. *The Archaeology of Knowledge and the Discourse on Language*, trans. A. M. Sheridan Smith. London: Tavistock.

Foucault, M. 1973. *The Birth of the Clinic: An Archaeology of Medical Perception*, trans. Alan Sheridan-Smith. London: Pantheon.

Foucault, M. 1977. *Discipline and Punish: The Birth of the Prison*. Harmondsworth: Penguin.

Foucault, M. 1978. *The History of Sexuality, Volume 1: An Introduction*, trans. R. Hurley. Harmondsworth: Penguin.

Foucault, M. 1986. 'Of Other Spaces', *Diacritics*, 16/1: 22–7.

Foucault, M. 2005. *The Hermeneutics of the Subject. Lectures at the Collège de France, 1981–82*, ed. Frédéric Gros and trans. Graham Burchell. New York: Picador.

Franklin, S. 1995. *Artificial Minds*. Cambridge, MA: MIT Press.

Freeland, C. 2003. *Art Theory: A Very Short Introduction*. Oxford: Oxford University Press.

Friedberg, A. 1993. *Window Shopping: Cinema and the Postmodern*. Berkeley: University of California Press.

Friedberg, A., J. Donald, and L. Marcus, eds. 1998. *Close Up 1927–1933: Cinema and Modernism*. Princeton, NJ: Princeton University Press.

Frisby, D. 1986. *Fragments of Modernity: Theories of Modernity in the Work of Simmel, Kracauer and Benjamin*. Cambridge, MA: MIT Press.

Frow, J. 1995. *Cultural Studies and Cultural Value*. Oxford: Clarendon Press.

Frow, J. 1997. *Time and Commodity Culture: Essays in Cultural Theory and Postmodernity*. Oxford: Clarendon Press.

Frow, J. 2005. *Genre*. London and New York: Routledge.

Frow, J., ed. 2003. *Visual Knowledges*. Edinburgh: Institute for Advanced Studies in the Humanities.

Frueh, J., C. L. Langer and A. Raven, eds. 1993. *New Feminist Criticism: Art, Identity, Action*. New York: Icon Editions.

Fuss, D. 1989. *Essentially Speaking: Feminism, Nature and Difference*. London: Routledge.

Gadamer, H.-G. 1977. *Philosophical Hermeneutics*, trans. and ed. David E. Linge. Berkeley: University of California Press.

Gadamer, H.-G. 1998. 'The Idea of Practical Philosophy', in *Praise of Theory: Speeches and Essays*, trans. C. Dawson. New Haven, CT and London: Yale University Press, 50–61.

Gadamer, H.-G. 2004. *Truth and Method*. London: Continuum.

Gaiger, J. and P. Wood, eds. 2003. *Art of the Twentieth Century: A Reader*. New Haven, CT and London: Yale University Press (in association with The Open University).

Galison, P. and Caroline A. Jones, eds. 1998. *Picturing Science, Producing Art*. London and New York: Routledge.

Gallagher, S. and D. Zahavi. 2008. *The Phenomenological Mind: An Introduction to Philosophy of Mind and Cognitive Science*. London and New York: Routledge.

Gaut, B. and D. M. Lopes, eds. 2001. *The Routledge Companion to Aesthetics*. London: Routledge.

Gay, P. 1984. *The Bourgeois Experience: Victoria to Freud*. Oxford: Oxford University Press.

Geertz, C. 1973. *The Interpretation of Cultures*. New York: Basic Books.

Geertz, C. 1983. *Local Knowledge*. New York: Basic Books.

Gere, C. 2002. *Digital Culture*. London: Reaktion Books; 2nd rev. edn. 2008.

Gere, C. 2006. *Art, Time and Technology*. Oxford: Berg.

Gere, C. and Hazel Gardiner, eds. 2009. *Art Practice in a Digital Culture*. Farnham, Surrey: Ashgate.

Gernsheim, H. 1955. *The History of Photography: From the Earliest Uses of the Camera Obscura in the Eleventh Century up to 1914*. London and New York: Oxford University Press.

Gernsheim, H. 1982. *The Origins of Photography*. London: Thames and Hudson.

Gernsheim, H. 1986. *A Concise History of Photography*. New York: Dover Books.

Gibson, J. J. 1950. *The Perception of the Visual World*. Boston: Houghton Mifflin.

Gibson, J. J. 1966. *The Senses Considered as Perceptual Systems*. Boston: Houghton Mifflin.

Giddens, A. 2002. *Runaway World: How Globalisation Is Reshaping Our Lives*. London: Profile.

Gilloch, G. 2002. *Walter Benjamin: Critical Constellations*. Cambridge: Polity Press.

Gilroy, P. 1987. *There Ain't No Black in the Union Jack: The Cultural Politics of Race and Nation*. London: Hutchinson.

Gilroy, P. 1993a. *The Black Atlantic: Modernity and Double Consciousness*. London: Verso.

Gilroy, P. 1993b. *Small Acts: Thoughts on the Politics of Black Cultures*. London: Serpent's Tail.

Gilroy, P. 1996. 'British Cultural Studies and the Pitfalls of Identity', in J. Curran, D. Morley, and V. Walkerdine (eds.), *Cultural Studies and Communication*. London: Arnold, 35–49.

Gilroy, P. 2003. ' "Jewels Brought from Bondage": Black Music and the Politics of Authenticity', in Erin Striff (ed.), *Performance Studies*. Basingstoke: Palgrave Macmillan, 137–51.

Gitelman, L. 2006. *Always Already New: Media, History and the Data of Culture*. Cambridge, MA: MIT Press.

Glendinning, S., ed. 1999. *The Edinburgh Encyclopedia of Continental Philosophy*. Edinburgh: Edinburgh University Press.

Goffman, E. 1969. *The Presentation of Self in Everyday Life*. Harmondsworth: Penguin.

Goffman, E. 1974. *Frame Analysis: An Essay on the Organization of Experience*. Boston: North-eastern University Press.

Goffman, E. 1976. *Gender Advertisements*. New York: Harper.

Goldberg, T., ed. 2000. *The Robot in the Garden: Telerobotics and Telepistemology in the Age of the Internet*. Cambridge, MA: MIT Press.

Goldblatt, D. and L. B. Brown, eds. 2005. *Aesthetics: A Reader in Philosophy of the Arts*, 2nd edn. Upper Saddle River, NJ: Prentice Hall/Pearson Education.

Gombrich, E. H. (1950) 1995. *The Story of Art*. London: Phaidon Press.

Gombrich, E. H. 1960. *Art and Illusion: A Study in the Psychology of Pictorial Representation*. London: Phaidon.

Gombrich, E. H. 1970. *Aby Warburg: An Intellectual Biography*. London: Warburg Institute, University of London.

Gombrich, E. H. 1979. *The Sense of Order: A Study in the Psychology of Decorative Art*. Oxford: Phaidon Press.

Gombrich, E. H. 1962. *The Image and the Eye: Further Studies in the Psychology of Visual Representation*. Oxford: Phaidon Press; repr. New York: Phaidon, 1997.

Goodman, N. 1968. *Languages of Art: An Approach to a Theory of Symbols*. Indianapolis, IN: Bobbs-Merrill.

Goodman, N. 1984. *Of Mind and Other Matters*. Cambridge, MA: Harvard University Press.

Goody, J. 1977. *The Domestication of the Savage Mind*. Cambridge: Cambridge University Press.

Goody, J. ed. 1968. *Literacy in Traditional Societies*. Cambridge: Cambridge University Press.

Goody, J. and I. Watt, 1963. 'The Consequences of Literacy', *Comparative Studies in Society and History*, 5 (April): 304–45.

Graff, H. J., ed. 1981. *Literacy and Social Development in the West*. Cambridge: Cambridge University Press.

Grant, K. B. ed. 1986. *Film Genre Reader*. Austin, Texas: University of Texas Press.

Grassi, E. 1983. *Heidegger and the Question of Renaissance Humanism: Four Studies*. New York, Binghampton: Center for Medieval and Early Renaissance Studies.

Gray, A. and J. McGuigan, eds. 1993. *Studying Culture: An Introductory Reader*. London: Edward Arnold.

Green, C. 1995. *The European Avant-gardes: Art in France and Western Europe 1904-c1945*. London: Zwemmer.

Greenberg, C. 1984. *Art and Culture*. Boston: Beacon Press.

Greenberg, C. 1993. *The Collected Essays and Criticism, Vol. 4. Modernism with a Vengeance: 1957–1969*, ed. John O'Brian. Chicago: University of Chicago Press.

Greenberg, C. 1999. *Homemade Aesthetics: Observations on Art and Taste*. Oxford and New York: Oxford University Press.

Gregory, R. L. 1998. *Eye and Brain: The Psychology of Seeing*, 5th ed. Oxford and Tokyo: Oxford University Press.

Griffiths, A. 2001. *Wondrous Difference: Cinema, Anthropology and Turn-of-the Century Visual Culture*. New York: Columbia University Press.

Groebner, V. 2008. *Defaced: The Visual Culture of Violence in the Late Middle Ages*, trans. P. Selwyn. New York: Zone Books.

Gronow, J. 1997. *The Sociology of Taste*. London: Routledge.

Grossberg, L., C. Nelson and P. Treichler, eds. 1992. *Cultural Studies*. London and New York: Routledge.

Grosz, E. A. 1989. *Sexual Subversion: Three French Feminists*. Sydney: George Allen and Unwin.

Grosz, E. A. 1990. *Jacques Lacan: A Feminist Introduction*. London: Routledge.

Grosz, E. A. 1994. *Volatile Bodies: Toward a Corporeal Feminism*. Bloomington: Indiana University Press.

Grosz, E. A. 1995a. *Space, Time, and Perversion: Essays on the Politics of Bodies*. London: Routledge.

Grosz, E. A. 1995b. 'Women, *Chora*, Dwelling', in S. Watson and K. Gibson (eds.), *Postmodern Cities and Spaces*. Oxford: Basil Blackwell, 47–58.

Grosz, E. A. 2001. *Architecture from the Outside: Essays on Virtual and Real Space*. Cambridge, MA: MIT Press.

Grosz, E. A., ed. 1999. *Becomings, Explorations in Time, Memory and Futures*. Ithaca, NY: Cornell University Press.

Grosz, E. A. and E. Probyn, eds. 1995. *Sexy Bodies: The Strange Carnalities of Feminism*. London: Routledge.

Gumbrecht, H. U. and M. Marrinan. 2003. *Mapping Benjamin: The Work of Art in the Digital Age*. Stanford, CA: Stanford University Press.

Gurwitsch, A. 1979. *Human Encounters in the Social World*, trans. F. Kersten. Pittsburgh: Duquesne University Press.

Gutting, G. 1989. *Michel Foucault's Archaeology of Scientific Reason*. Cambridge: Cambridge University Press.

Guyer, P. 2008. 'Twentieth-Century Aesthetics', in D. Moran (ed.), *The Routledge Companion to Twentieth Century Philosophy*. London and New York, 913–65.

Habermas, J. 1992. *The Structural Transformation of the Public Sphere: An Inquiry into a Category of Bourgeois Society*. Cambridge: Polity Press.

Hackforth-Jones, J. and Mary Roberts. 2005. *Edges of Empire: Orientalism and Visual Culture*. Malden, MA: Blackwell.

Hagberg, G. L. 1995. *Art as Language*. Ithaca, NY: Cornell University Press.

Halbwachs, M. 1992. *On Collective Memory*, trans L. A. Coser. Chicago: University of Chicago Press.

Hale, J. 1993. *The Civilization of Europe in the Renaissance*. New York: Atheneum.

Hall, G. and C. Birchall, eds. 2006. *New Cultural Studies: Adventures in Theory*. Athens: University of Georgia Press; Edinburgh: University of Edinburgh Press.

Hall, J. R., Blake Stimson, and Lisa Tamiris Becker, eds. 2005. *Visual Worlds*. London: Routledge.

Hall, S. 1989. 'The Meaning of New Times', in S. Hall and M. Jacques (eds.), *New Times: The Changing Face of Politics in the 1990s*. London: Lawrence and Wishart, 116–33.

Hall, S. 1990. 'Cultural Identity and Diaspora', in J. Rutherford (ed.), *Identity*. London: Lawrence and Wishart, 222–37.

Hall, S. 1992a. 'New Ethnicities', in J. Donald and A. Ratansi (eds.), *'Race', Culture and Difference*. London: Sage, 252–59.

Hall, S. 1992b. 'What Is This "Black" in Black Popular Culture', in Gina Dent (ed.), *Black Popular Culture*. Seattle: Bay Press, 21–33.

Hall, S. 1996a. 'The Formation of a Diasporic Intellectual: An Interview with Stuart Hall by Kuan-Hsing Cen', in D. Morley and K.-H. Chen (eds.), *Stuart Hall: Critical Dialogues in Cultural Studies*. London: Routledge, 484–503.

Hall, S. 1996b. 'Introduction: Who Needs Identity', in S. Hall and P. du Gay (eds.), *Questions of Cultural Identity*. London: Sage, 3–17.

Hall, S. 1997. 'Culture and Power: Stuart Hall Interviewed by Peter Osborne and Lynne Segal', *Radical Philosophy*, 86 (Nov/Dec): 24–42.

Hall, S., ed. 1997. *Representation: Cultural Representations and Signifying Practices*. London: Sage.

Hall, S. and P. du Gay, eds. 1996. *Questions of Cultural Identity*. London: Sage.

Halsall, F., J. Jansen and T. O'Connor, eds. 2009. *Rediscovering Aesthetics: Transdisciplinary Voices from Art History, Philosophy, and Art Practice*. Stanford, CA: Stanford University Press.

Hand, M. 2008. *Making Digital Cultures: Access, Interactivity, and Authenticity*. Aldershot: Ashgate.

Handa, C., ed. 2004. *Visual Rhetoric in a Digital World: A Critical Sourcebook*. New York: Bedford/St. Martin's Press.

Haraway, D. 1991a. 'A Cyborg Manifesto: Science, Technology and Socialist-Feminism in the Late Twentieth Century', in *Simians, Cyborgs and Women: The Reinvention of Nature*. London: Free Association Books, 149–81.

Haraway, D. 1991b. 'Situated Knowledges: The Science Question in Feminism and the Privilege of Partial Perspective', in *Simians, Cyborgs and Women: The Reinvention of Nature*. London: Free Association Books, 183–201.

Haraway, D. 1991c. *Simians, Cyborgs and Women: The Reinvention of Nature*. London: Free Association Books.

Hardt, M. and A. Negri. 2000. *Empire*. Cambridge, MA: Harvard University Press.

Harper, D. 1987. *Working Knowledge: Skill and Community in a Small Shop*. Chicago: University of Chicago Press.

Harper, D. 2001. *Changing Worpp: Visions of a Lost Agriculture*. Chicago: University of Chicago Press.

Harper, D. 2006. *Good Company: A Tramp Life*, rev. edn. New York: Paradigm.

Harris, J. 2001. *The New Art History: A Critical Introduction*. London and New York: Routledge.

Harris, J. 2006. *Art History: The Key Concepts*. London and New York: Routledge.

Harrison, C. and P. Wood, eds. 2002. *Art in Theory. 1900–2000: An Anthology of Changing Ideas*. New York: Wiley-Blackwell.

Hartley, J. 1992. *Tele-ology: Studies in Television*. London: Routledge.

Hartley, J. 2003. *A Short History of Cultural Studies*. London: Sage.

Hartley, J., ed. 2004. *Creative Industries*. Oxford: Blackwell.

Hartwig, M., ed. 2007. *Dictionary of Critical Realism*. London and New York: Routledge.

Harvey, D. 1982. *The Limits to Capital*. Oxford: Blackwell.

Harvey, D. 1985. *Consciousness and Urban Experience*. Oxford: Blackwell.

Harvey, D. 1989. *The Condition of Postmodernity: An Enquiry into the Origins of Cultural Change*. Oxford: Blackwell.

Harvey, D. 2006. *Spaces of Global Capitalism: A Theory of Uneven Geographical Development*. London: Verso.

Havelock, E. 1963. *Preface to Plato*. Cambridge, MA: Harvard University Press.

Hayles, N. K. 1999. *How We Became Posthuman: Virtual Bodies in Cybernetics, Literature, and Informatics*. Chicago: University of Chicago Press.

Hayles, N. K. 2002. *Writing Machines*. Cambridge, MA: MIT Press.

Hayles, N. K. 2005. *My Mother Was a Computer*. Chicago: University of Chicago Press.

Hebdige, D. 1979. *Subculture: The Meaning of Style*. London: Methuen.

Hebdige, D. 1988. *Hiding in the Light*. London: Routledge.

Hegel, G.W.F. 1975. *Aesthetics: Lectures on Fine Art*, trans. T. M. Knox. Oxford: Oxford University Press.

Heidegger, M. 1927. *Sein und Zeit*. Tübingen: Max Niemeyer.

Heidegger, M. 1962. *Being and Time*, trans. John Macquarrie and Edward Robinson. New York: Harper and Row.

Heidegger, M. 1971. 'The Origin of the Work of Art', in *Poetry, Language, Thought*, trans. A. Hofstadter. New York: HarperCollins, 15–87.

Heidegger, M. 1977a. 'The Age of the World-Picture', in *The Question Concerning Technology and Other Essays*, trans. William Lovitt. New York: Harper and Row, 115–54.

Heidegger, M. 1977b. *The Question Concerning Technology and Other Essays*. New York: Harper and Row.

Heidegger, M. 1978. 'The Origin of the Work of Art', in D. Krell (ed.), *Martin Heidegger: Basic Writings*. London: Routledge and Kegan Paul, 143–87.

Heller, A. 1984. *Everyday Life*. London: Routledge and Kegan Paul.

Hemingway, A., ed. 2006. *Marxism and the History of Art: From William Morris to the New Left*. London: Pluto Press.

Hemingway, A. and W. Vaughan. 1998. *Art in Bourgeois Society 1790–1850*. Cambridge: Cambridge University Press.

Hendrix, J. and C. H. Carman, eds. 2010. *Renaissance Theories of Vision*. Abingdon, Oxon: Ashgate.

Henry, M. 1973. *The Essence of Manifestation*, trans. G. Etzkorn. The Hague: Martinus Nijhoff.

Henry, M. 1975. *Philosophy and Phenomenology of the Body*, trans. G. Etzkorn. The Hague: Martinus Nijhoff.

Heywood, I. 1997. *Social Theories of Art*. London: Macmillan.

Heywood, I. and B. Sandywell, eds. 1999. *Interpreting Visual Culture: Explorations in the Hermeneutics of the Visual*. London: Routledge.

Hickey, D. 2009. *The Invisible Dragon: Essays on Beauty*, rev. and expanded. Chicago: University of Chicago Press.

Highmore, B. 2001. *Everyday Life and Cultural Theory: An Introduction*. London: Routledge.

Highmore, B., ed., 2002. *The Everyday Life Reader*. London and New York: Routledge.

Hobsbawm E. and T. Ranger, eds. 1983. *The Invention of Tradition*. Cambridge: Cambridge University Press.

Hockings, P., ed. 2003. *Principles of Visual Anthropology*, 3rd edn. New York: Walter de Gruyter.

Hockney, D. 2001. *Secret Knowledge: Rediscovering the Lost Techniques of the Old Masters*. London: Thames and Hudson.

Hollinger, R., ed. 1985. *Hermeneutics and Praxis*. Notre Dame, IN: University of Notre Dame Press.

Holly, M. A. and Marquard Smith, eds. 2008. *What Is Research in the Visual Arts: Obsession, Archive, Encounter*. New Haven, CT: Yale University Press.

hooks, b. 1990. *Yearning: Race, Gender and Cultural Politics*. Boston: South End Press.

hooks, b. 1992. *Black Looks: Race and Representation*. London: Turnaround.

hooks, b. 1995. *Art on My Mind: Visual Politics*. New York: The New Press.

hooks, b. 1996. *Reel to Real: Race, Sex and Class at the Movies*. London: Routledge.

Hooper-Greenhill, E. 2000. *Museums and the Interpretation of Visual Culture*. London and New York: Routledge.

Howells, R. 2003. *Visual Culture: An Introduction*. Oxford: Polity Press.

Howes, D. 2003. *Sensual Relations: Engaging the Senses in Culture and Social Theory*. Ann Arbor: University of Michigan Press.

Howes, D., ed. 1991. *The Varieties of Sensory Experience: A Sourebook in the Anthropology of the Senses*. Toronto: University of Toronto Press.

Howes, D., ed. 2006. *Empire of the Senses. The Sensual Culture Reader*. Oxford and New York: Berg.

Hughes, R. 1991. *The Shock of the New: Art and the Century of Change*, rev. edn. London: Thames and Hudson.

Hunt, L., ed. 1993. *The Invention of Pornography: Obscenity and the Margins of Modernity*. New York: Zone.

Husserl, E. 1931. *Ideas Towards a Pure Phenomenology and Phenomenological Philosophy*. New York: Macmillan.

Husserl, E. 1970. *The Crisis of European Sciences and Transcendental Phenomenology*. Evanston, IL: Northwestern University Press.

Husserl, E. 1980. *Ideas Pertaining to a Pure Phenomenology and to a Phenomenological Philosophy. Third Book: Phenomenology and the Foundations of the Sciences (Ideen III)*. The Hague: Martinus Nijhoff.

Husserl, E. 1997. *Thing and Space: Lectures of 1907*, trans. R. Rojcewicz. Dordrecht: Kluwer Academic.

Ihde, D. 1990. *Technology and the Lifeworld: From Garden to Earth*. Bloomington: Indiana University Press.

Ihde, D. 1993. *Postphenomenology: Essays in the Postmodern Context*. Evanston, IL: Northwestern University Press.

Inglis, D. and M. Herrero, eds. 2008. *Art and Aesthetics. Critical Concepts in the Social Sciences*, 4 vols. London: Routledge.

Ings, S. 2008. *The Eye: A Natural History*. London: Bloomsbury.

Iragaray, L. 1974. *Speculum de l'autre femme*. Paris: Minuit; *Speculum of the Other Woman*, trans. G. C. Gill. Ithaca, NY: Cornell University Press, 1985.

Iragaray, L. 1977. *Ce sexe qui n'en est pas un*. Paris: Minuit; *This Sex Which Is Not One*, trans. C. Porter and C. Burke. Ithaca, NY: Cornell University Press, 1985; also extracted in E. Marks and I. de Courtrivon, eds., *New French Feminisms*. Brighton, Sussex: Harvester Press, 1981.

Iragaray, L. 1984. *Ethique de la différance sexuelle*. Paris: Minuit; *An Ethics of Sexual Difference*, trans. C. Burke and G. C. Gill. Ithaca, NY: Cornell University Press and London: Athlone Press, 1993.

Iragaray, L. 1992. *The Iragaray Reader*, ed. Margaret Whitford. Oxford: Blackwell.

Iragaray, L. 2008. *Sharing the World*. London and New York: Continuum.

Iversen, M. 1993. *Alois Riegl: Art History and Theory*. Cambridge, MA: MIT Press.

Jacobs, K. 2001. *The Eye's Mind: Literary Modernism and Visual Culture*. Ithaca, NY: Cornell University Press.

Jacobsen, M. H., ed. 2009. *Encountering the Everyday: An Introducion to the Sociologies of the Unnoticed*. London: Palgrave Macmillan.

Jameson, F. 1971. *Marxism and Form: Twentieth-Century Dialectical Theories of Literature*. Princeton, NJ: Princeton University Press.

Jameson, F. 1981. *The Political Unconscious*. Ithaca, NY: Cornell University Press.

Jameson, F. 1988. 'Postmodernism and Consumer Society', in Ann Kaplan (ed.), *Postmodernism and Its Discontents*. London: Verso, 13–29.

Jameson, F. 1991. *Postmodernism or, the Cultural Logic of Late Capitalism*. Durham, NC: Duke University Press.

Jameson, J. 1992. *The Geopolitical Aesthetic: Cinema and Space in the World System*. Bloomington and London: Indiana University Press and British Film Institute.

Jay, M. 1986. 'In the Empire of the Gaze: Foucault and the Denigration of Vision in Twentieth-Century French Thought', in David Couzens Hoy (ed.), *Foucault: A Critical Reader*. Oxford: Blackwell, 175–204.

Jay, M. 1992. 'Scopic Regimes of Modernity', in Scott Lash and Jonathan Friedman (eds.), *Modernity and Identity*. Oxford: Basil Blackwell; also in Hal Foster (ed.), *Vision and Visuality*. Seattle: Bay Press, 1988, 178–95.

Jay, M. 1993a. *Downcast Eyes: The Denigration of Vision in Twentieth-Century French Thought*. Cambridge, MA.: Harvard University Press.

Jay, M. 1993b. *Force Fields: Between Intellectual History and Cultural Critique*. New York and London: Routledge.

Jay, M. 2002a. 'Visual Culture and Its Vicissitudes', *October*, 77/1: 42–44.

Jay, M. 2002b. 'The Visual Turn: The Advent of Visual Culture', *Journal of Visual Culture*, 1/1: 267–78.

Jenks, C., ed. 1995. *Visual Culture*. London and New York: Routledge.

Johnson, G. A. and M. B. Smith, eds. 1990. *Ontology and Alterity in Merleau-Ponty*. Evanston, IL: Northwestern University Press.

Johnson, G. A. and M. B. Smith, eds. 1993. *The Merleau-Ponty Aesthetics Reader: Philosophy and Painting*. Evanston, IL: Northwestern University Press.

Johnson, M. 1994. *Moral Imagination: Implications of Cognitive Science for Ethics*. Chicago: University of Chicago Press.

Johnson, M. 1999. *Philosophy in the Flesh: The Embodied Mind and Its Challenge to Western Philosophy*. New York: Basic Books.

Johnson, M. 2008. *The Meaning of the Body: Aesthetics of Human Understanding*, repr. edn. Chicago: University of Chicago Press.

Johnson, S. A. 1999. *Interface Culture: How New Technology Transforms the Way We Create and Communicate*. New York: Basic Books.

Johnstone, S., ed. 2008. *The Everyday (Documents of Contemporary Art)*. Cambridge, MA: MIT Press.

Jones, A. 1995. *Postmodernism and the En-gendering of Marcel Duchamp*. Cambridge: Cambridge University Press.

Jones, A. 1998. *Body Art/Performing the Subject*. Minneapolis: University of Minnesota Press.

Jones, A., ed. 2003. *The Feminism and Visual Culture Reader*. London and New York: Routledge.

Jones, A., ed. 2006. *A Companion to Contemporary Art since 1945*. Oxford: Blackwell.

Jones, S., ed. 1994. *Cybersociety*. London: Sage.

Jordan, G. and C. Weedon, eds. 1995. *Cultural Politics: Class, Gender, Race and the Postmodern World*. Oxford: Blackwell.

Jordanova, L. 1989. *Sexual Visions: Images of Gender in Science and Medicine between the Eighteenth and Twentieth Centuries*. Madison: University of Wisconsin Press.

Jordanova, L. 1999. *Nature Displayed: Gender, Science and Medicine 1760–1820*. London and New York: Longman.

Judovitz, D. 1988. *Subjectivity and Representation in Descartes: The Origins of Modernity*. Cambridge: Cambridge University Press.

Judovitz, D. 1993. 'Vision, Representation, and Technology in Descartes', in David Michael Levin (ed.), *Modernity and the Hegemony of Vision*. Berkeley: University of California Press, 63–86.

Julier, G. 1998. *Thames and Hudson Dictionary of Design since 1900*, rev. 3rd edn. London: Thames and Hudson.

Julier, G. 2007. *The Culture of Design*, 2nd edn. London: Sage.

Kant, I. 1978. *The Critique of Judgement*, trans. James Creed Meredith. Oxford: Clarendon Press.

Kaplan, E. A., ed. 1990. *Psychoanalysis and Cinema*. New York and London: Routledge.

Kaplan, E. A., ed. 2000. *Feminism and Film*. Oxford: Oxford University Press.

Kearney, R. 2004. *Paul Ricoeur: The Owl of Minerva*. London: Ashgate.

Keith, M. and Steven Pile, eds. 1993. *Place and the Politics of Identity*. London: Routledge.

Kellner, D. 1989a. *Critical Theory, Marxism and Modernity*. Cambridge: Polity Press.

Kellner, D. 1989b. *Jean Baudrillard: From Marxism to Postmodernism and Beyond*. Stanford, CA: Stanford University Press.

Kellner, D. 1994. *Media Culture: Cultural Studies, Identity and Politics between the Modern and the Postmodern*. London and New York: Routledge.

Kellner, D. 2003. *Media Spectacle*. London and New York: Routledge.

Kelly, M. 1990. *Interim*. New York: Museum of Contemporary Art.

Kelly, M. 1992. *Gloria Patri*. Art installation.

Kelly, M., ed. 1998. *Encyclopaedia of Aesthetics*, 4 vols. New York: Oxford University Press.

Kelly, M. 1999. *Post-Partum Document 1973–1979*. Berkeley, CA: University of California Press.

Kemp, M. 1990. *The Science of Art: Optical Themes in Western Art from Brunelleschi to Seurat*. New Haven, CT: Yale University Press.

Kemp, M. 2000. *Visualizations: The Nature Book of Art and Science*. Oxford: Oxford University Press.

Kemp, M. 2002. *The Oxford History of Western Art*. Oxford: Oxford University Press.

Kemp, M. 2006. *Seen/Unseen: Art, Science and Intuition from Leonardo to the Hubble Telescope*. Oxford: Oxford University Press.

Kendrick, W. 1987. *The Secret Museum: Pornography in Modern Culture*. New York: Viking; Berkeley: CA: University of California Press, 1996.

Kern, S. 1993. *The Culture of Time and Space 1880–1918*. Cambridge, MA: Harvard University Press.

Kittler, F. A. 1990. *Discourse Networks 1800/1900*, trans. Michael Metteer and Chris Cullens. Stanford, CA: Stanford University Press.

Kittler, F. A. 1997. *Literature, Media, Information Systems*. London and New York: Routledge.

Kittler, F. A. 1999. *Gramophone, Film, Typewriter*, trans. Geoffrey Winthrop-Young and Michael Wutz. Stanford, CA: Stanford University Press.

Kittler, F. A. 2009. *Optical Media: Berlin Lectures 1999*, trans. Anthony Enns. Cambridge: Polity Press.

Kivy, P. 1997. *Philosophies of Arts: An Essay in Differences*. Cambridge: Cambridge University Press.

Klein, N. 2001. *No Logo: Taking Aim at the Brand Bullies*. New York: Flamingo.

Knowles, C. and P. Sweetman, eds. 2004. *Picturing the Social Landscape: Visual Methods and the Sociological Imagination*. London: Routledge.

Kocur, Z. and S. Leung, eds. 2004. *Theory in Contemporary Art since 1985*. New York: Wiley-Blackwell.

Kofman, S. 1980. *L'Enigme de la femme: La femme dans les texts de Freud*; *The Enigma of Woman: Woman in Freud's Writings*, trans. Catherine Porter. Ithaca, NY: Cornell University Press, 1985.

Kofman, S. 1988. *The Childhood of Art: An Interpretation of Freud's Aesthetics*, trans. W. Woodhull. New York: Columbia University Press.

Kofman, S. 1991. *Freud and Fiction*, trans. S. Wykes. Boston: Northeastern University Press.

Kofman, S. 1993. *Nietzsche and Metaphor*, trans. D. Large. Stanford, CA: Stanford University Press.

Kofman, S. 1999. *Camera Obscura: Of Ideology*. Ithaca, NY: Cornell University Press.

Kofman, S. 2007. *Selected Writings*, ed. Thomas Albrecht, Georgia Albert and Elizabeth G. Rottenberg, introduction by Jacques Derrida. Stanford, CA: Stanford University Press.

Krauss, R. 1993. *The Optical Unconscious*. Cambridge, MA: MIT Press.

Krauss, R. E. and J. Livingstone, 1985. *L'Amour Fou: Photography and Surrealism*. New York: Abbeville Press.

Kress, G. and Theo van Leeuwen. 1996. *Reading Images: The Grammar of Visual Design*. London and New York: Routledge; 2nd edn. 2006.

Kris, E. 2000. *Psychoanalytic Explorations in Art*. New York: International Universities Press.

Kristeva, J. 1977a. *Desire in Language: A Semiotic Approach to Literature and Art*, trans. T. Gora, A. Jardine and L. S. Roudiez and ed. L. S. Roudiez. New York: Columbia University Press, 1980.

Kristeva, J. 1977b. 'Word, Dialogue and Novel', in *Desire in Language: A Semiotic Approach to Literature and Art*. trans. T. Gora, A. Jardine and L. S. Roudiez. New York: Columbia University Press, 1980, 64–91.

Kristeva, J. 1980. *Pouvoirs de l'horreur: Essai sur l'abjection.* Paris: Seuil; *Powers of Horror: An Essay on Abjection.* New York: Columbia University Press.

Kristeva, J. 1982. *A Kristeva Reader*, ed. T. Moi. New York: Columbia University Press.

Kuhn, A, 1994. *Women's Pictiures: Feminism and Cinema.* London: Verso.

Kuhn, A., ed. 1990. *Alien Zone: Cultural Theory and Contemporary Science Fiction.* London: Verso.

Kuhn, T. S. 1962. *The Structure of Scientific Revolutions.* Chicago: University of Chicago Press.

Lacan, J. 1977a. *Écrits: A Selection*, trans. A. Sheridan. London: Tavistock.

Lacan, J. 1977b. *Four Fundamental Concepts of Psychoanalysis*, trans. A. Sheridan. Harmondsworth: Penguin.

Lacan, J. 1988a. *The Seminar of Jacques Lacan, Book 1: Freud's Papers on Technique, 1953–1954*, trans. J. Forrester. Cambridge: Cambridge University Press.

Lacan, J. 1988b. *The Seminar of Jacques Lacan, Book 2: The Ego in Freud's Theory and in the Technique of Psychoanalysis, 1954–1955*, trans. S. Tomaselli. Cambridge: Cambridge University Press.

Lacan, J. 1990. *Television.* New York: W. W. Norton.

Lacoue-Labarthe, P. 1989. *Typography: Mimesis, Philosophy, Politics.* Cambridge, MA: Harvard University Press.

Landow, G. P. 1997. *Hypertext 2.0: The Convergence of Contemporary Critical Theory and Technology.* Baltimore: Johns Hopkins University Press.

Lane, M. 1970. *Structuralism: A Reader.* London: Jonathan Cape.

Laplanche, J. and J.-B. Pontalis. 1973. *The Language of Psychoanalysis*, trans. D. Nicholson-Smith. London: Hogarth Press.

Larmore, C. E. 1987. *Patterns of Moral Complexity.* Cambridge: Cambridge University Press.

Lash, S. 1994. 'Reflexivity and Its Doubles: Structure, Aesthetics, Community', in U. Beck, A. Giddens and S. Lash (eds.), *Reflexive Modernization.* Cambridge: Polity Press, 110–73.

Lash, S. 1999. *Another Modernity, a Different Rationality.* Oxford: Blackwell.

Lash, S. and Jonathan Friedman, eds. 1992. *Modernity and Identity.* Oxford: Basil Blackwell.

Lash, S. and John Urry. 1994. *Economies of Signs and Space.* London: Sage.

Lash, S., Celia Lury and Deirdre Boden. 2007. *Global Culture Industries: The Mediation of Things.* Oxford: Polity Press.

Latour, B. 1987. *Science in Action: How to Follow Scientists and Engineers through Society.* Cambridge, MA: Harvard University Press.

Latour, B. 2004. *Politics of Nature: How to Bring the Sciences into Democracy.* Cambridge, MA: Harvard University Press.

Latour, B. 2006. *We Have Never Been Modern.* Cambridge, MA: Harvard University Press.

Latour, B. and P. Weibel, eds. 2005. *Making Things Puiblic: Atmosferes of Democracy.* Cambridge, MA: MIT Press.

Law, J. and G. Fyfe, eds. 1988. *Picturing Power: Visual Depiction and Social Relations, Sociological Review Monograph, 35.* London: Routledge.

Law, J. and J. Hassard, eds. 1999. *Actor Network Theory and After.* Oxford: Blackwell.

Leder, D. 1990. *The Absent Body.* Chicago: University of Chicago Press.

Le Doeuff, M. 1980. *Recherches sur l'imaginaire philosophique.* Paris: Payot; *The Philosophical Imaginary*, trans. C. Gordon. London: Athlone Press, 1986.

Le Doeuff, M. 1989. *L'Etude et le rouet, des femmes, de la philosophie, etc.* Paris: Seuil; *Hipparchia's Choice: An Essay Concerning Women Philosophy, etc.*, trans. T. Selous. Oxford: Basil Blackwell, 1991.

Lefebvre, H. 1984. *Everyday Life in the Modern World*. London: Allen Lane; New Brunswick, NJ: Transaction.

Lefebvre, H. 1991. *The Production of Space*, trans. D. Nicholson-Smith. Oxford: Blackwell.

Lefebvre, H. 1992. *The Critique of Everyday Life*, vol. 1. London: Verso.

Lessig, L. 2002. *The Future of Ideas: The Fate of the Commons in a Connected World*. New York: Vintage.

Levin, D. M. 1988. *The Opening of Vision: Nihilism and the Postmodern Situation*. London and New York: Routledge.

Levin, D. M. 1991. 'Visions of Narcissism: Intersubjectivity and the Reversals of Reflection', in Martin Dillon (ed.), *Merleau-Ponty Vivant*. Albany: State University of New York Press, 47–90.

Levin, D. M. 1999. *The Philosopher's Gaze: Modernity in the Shadows of Enlightenment*. Berkeley: University of California Press,

Levin, D. M., ed. 1993. *Modernity and the Hegemony of Vision*. Berkeley: University of California Press.

Levin, D. M., ed. 1997. *Sites of Vision: The Discursive Construction of Sight in the History of Philosophy*. Cambridge, MA.: MIT Press.

Levinas, E. 1969. *Totality and Infinity: An Essay on Exteriority*, trans. Alphonso Lingis. Pittsburgh: Duquesne University Press.

Levinas, E. 1973. *The Theory of Intuition in Husserl's Phenomenology*, trans. André Orianne. Evanston, IL: Northwestern University Press.

Levinas, E. 1985. *Ethics and Infinity*. Pittsburgh: Duquesne University Press.

Levinson, J. 1996. *The Pleasures of Aesthetics*. Ithaca, NY: Cornell University Press.

Levinson, J. ed. 1998. *Aesthetics and Ethics: Essays at the Intersection*. Cambridge: Cambridge University Press.

Levinson, J., ed. 2003. *The Oxford Handbook of Aesthetics*. Oxford: Oxford University Press.

Lévi-Strauss, C. 1966. *The Savage Mind*. London: Weidenfeld and Nicolson; Chicago: University of Chicago Press.

Lévi-Strauss, C. 1968 and 1977. *Structural Anthropology*, 2 vols. New York: Doubleday, 1963; London: Allen Lane, 1968 and 1977.

Lindbergh, D. 1996. *Theories of Vision from Al-kindi to Kepler*, 2nd edn. Chicago: University of Chicago Press.

Lipovetsky, G. 2005. *Hypermodern Times*. Cambridge: Polity Press.

Lister, M., ed. 1995. *The Photographic Image in Digital Culture*. London and New York: Routledge.

Llewelyn, J. 1985. *Beyond Metaphysics: The Hermeneutical Circle in Contemporary Continental Philosophy*. London: Humanities/Macmillan Press.

Lloyd, D. and P. Thomas. 1998. *Culture and the State*. London and New York: Routledge.

Longhurst, B., E. Baldwin, S. McCracken, M. Ogborn, G. Bagnall, G. Crawford, and G. Smith. 2008. *Introducing Cultural Studies*, 2nd edn. Harlow: Pearson Education.

Lowe, D. M. 1982. *History of Bourgeois Perception*. Chicago: University of Chicago Press; Brighton: Harvester Press.

Lowenthal, D. 1985. *The Past Is a Foreign Country*. Cambridge: Cambridge University Press.

Luhmann, N. 2000a. *Art as a Social System*. Stanford, CA: Stanford University Press.

Luhmann, N. 2000b. *The Reality of the Mass Media*. Stanford, CA: Stanford University Press.

Lunn, E. 1982. *Marxism and Modernism*. Berkeley: University of California Press.

Lury, C. 1998. *Prosthetic Culture: Photography, Memory and Identity.* London and New York: Routledge.

Lury, C. 2004. *Brands: The Logos of the Global Economy.* London and New York: Routledge.

Lyon, D. 1994. *The Electronic Eye: The Rise of Surveillance Society.* Cambridge: Polity Press; Minneapolis: University of Minnesota Press.

Lyon, D. 2001. *Surveillance Society: Monitoring Everyday Life.* Buckingham: Open University Press.

Lyon, D. 2003. *Surveillance as Social Sorting.* Cambridge: Polity Press.

Lyon, D., ed. 2006. *Theorizing Surveillance: The Panopticon and Beyond.* Uffculme, Devon: Willan.

Lyotard, J.-F. 1971. *Discourse, Figure.* Paris: Klinckseick.

Lyotard, J.-F. 1974. *Economie libidinale.* Paris: Seuil.

Lyotard, J.-F. 1984a. *Driftworks,* trans. R. McKeon, S. Hanson, A. Knab, R. Lockwood, and J. Maier. New York: Semiotext(e).

Lyotard, J.-F. 1984b. *The Postmodern Condition: A Report on Knowledge,* trans. G. Bennington and B. Massumi. Manchester: Manchester University Press.

Lyotard, J.-F. 1988. *The Differend: Phrases in Dispute,* trans. George Van den Abbeele. Minneapolis: University of Minnesota Press; Manchester: Manchester University Press.

Lyotard, J.-F. 1991. *The Inhuman: Reflections on Time,* trans. G. Bennington and R. Bowlby. Oxford: Basil Blackwell.

Lyotard, J.-F. 1994. *Lessons on the Analytic of the Sublime,* trans. E. Rottenberg. Stanford, CA.: Stanford University Press.

Lyotard, J.-F. 1997. *Postmodern Fables,* trans. G. Van Den Abbeele. Minneapolis and Longon: University of Minnesota Press.

MacCannell, D. 1992. *Empty Meeting Grounds: The Tourist Papers,* vol. 1. London and New York: Routledge.

MacCannell, D. 1999. *The Tourist: A New Theory of the Leisure Class,* 3rd edn. Berkeley: University of California Press.

Macdonald, M. 2003. *Exploring Media Discourse.* London: Arnold.

Mackay, H., ed. 1997. *Consumption and Everyday Life.* London: Sage.

MacPhee, G. 2002. *The Architecture of the Visible.* London and New York: Continuum.

Madison, G. B. 1988. *The Hermeneutics of Postmodernity: Figures and Themes.* Bloomington: Indiana University Press.

Maharaj, S. 1994. *Global Visions: Towards a New Internationalism in the Visual Arts.* London: Kala Press.

Maillet, A. 2004. *The Claude Glass: Use and Meaning of the Black Mirror in Western Art,* trans. J. Fort. New York: Zone Books.

Makari, G. 2008. *The Revolution in Mind: The Creation of Psychoanalysis.* London: Duckworth.

Manguel, A. 2008. *The Library at Night.* New Haven, CT and London: Yale University Press.

Manning, E. 2009. *Relationscapes: Movement, Art, Philosophy.* Cambridge, MA: MIT Press.

Manovich, L. 1993. *Tekstura: Russian Essays on Visual Culture.* Chicago: University of Chicago Press.

Manovich, L. 2001. *The Language of New Media.* Cambridge, MA: MIT Press.

Manovich, L. 2003. 'New Media from Borges to HTML', in N. Wardrip-Fruin and N. Montfort (eds.), *The New Media Reader.* Cambridge, MA: MIT Press, 13–25.

Marcuse, H. 1956. *Eros and Civilization: A Philosophical Inquiry into Freud.* London: Routledge and Kegan Paul.

Marcuse, H. 1964. *One-Dimensional Man*. Boston: Beacon Press.

Marcuse, H. 1978. *The Aesthetic Dimension: Toward a Critique of Marxist Aesthetics*. Boston: Beacon Press.

Margolis, M. 2009. *The Arts and the Definition of the Human: Toward a Philosophical Anthropology*. Stanford, CA: Stanford University Press.

Marin, L. 1995a. *To Destroy Painting*. Chicago: University of Chicago Press.

Marin, L. 1995b. 'Topics and Figures of Enunciation: It Is Myself That I Paint', in Stephen Melville and Bill Readings (eds.), *Vision and Textuality*. London: Macmillan, 195–214.

Marks, L. 2000. *The Skin of the Film: Intercultural Cinema, Embodiment and the Senses*. Durham, NC: Duke University Press.

Marshall, P. D., ed. 2006. *Celebrity Culture Reader*. London and New York: Routledge.

Massey, D. 1995. *Space, Place and Gender*. Cambridge: Polity Press.

Matrix, S. E. 2006. *Cyberpop: Digital Lifestyles and Commodity Culture*. London and New York: Routledge.

Maynard, P. 1997. *The Engine of Visualization: Thinking through Photography*. Ithaca, NY: Cornell University Press.

McClintock, A. 1995. *Imperial Leather: Race, Gender and Sexuality in the Colonial Contest*. London and New York: Routledge.

McCulloch, W. S. 1989. *Embodiments of Mind*. Cambridge, MA: MIT Press.

McGowan, K. 2007. *Key Issues in Critical and Cultural Theory*. Maidenhead, Berkshire: Open University Press/McGraw-Hill Education.

McGuigan, J. 2009. *Cultural Analysis*. London: Sage.

McLuhan, M. 1962. *The Gutenberg Galaxy*. Toronto: University of Toronto Press.

McLuhan, M. 1967. *The Media Is the Message*. Harmondsworth: Penguin.

McLuhan, M. 1970. *Culture Is Our Business*. New York: McGraw-Hill.

McLuhan, M. 1989. *The Global Village: Transformations in World and Media in the 21st Century*. New York: Oxford University Press.

McLuhan, M. 1994. *Understanding Media: The Extensions of Man*. Cambridge, MA: MIT Press.

McNeill, W. 1999. *The Glance of the Eye: Heidegger, Aristotle, and the Ends of Theory*. Albany: State University of New York Press.

McNeill, W. and K. S. Feldman, eds. 1998. *Continental Philosophy: An Anthology*. Oxford: Blackwell.

McQuaire, S. 1998. *Visions of Modernity: Representation, Memory, Time and Space in the Age of the Camera*. London: Sage.

McRobbie, A. 1991. *Feminism and Youth Culture: From Jackie to Just Seventeen*. London: Macmillan.

McRobbie, A. 1994. *Postmodernism and Popular Culture*. London: Routledge.

McRobbie, A. 2005. *The Uses of Cultural Studies*. London: Sage.

Melville, S. and B. Readings, eds. 1995. *Vision and Textuality*. London: Macmillan.

Melville, S. and J. Gilbert-Rolfe. 1996. *Seams: Art as a Philosophical Context: Critical Voices in Art, Theory and Culture*. London: Routledge.

Mercer, K. 1994. *Welcome to the Jungle: New Positions in Black Cultural Studies*. London: Routledge.

Merleau-Ponty, M. 1945. *Phénoménologie de la perception*. Paris: Gallimard.

Merleau-Ponty, M. 1948. *Sens et non-sens*. Paris: Nagel.

Merleau-Ponty, M. 1960. *Signes*. Paris: Gallimard.

Merleau-Ponty, M. 1962. *The Phenomenology of Perception*, trans. Colin Smith. London: Routledge and Kegan Paul.

Merleau-Ponty, M. 1964a. *Sense and Non-Sense*, trans. Hubert Dreyfus and P. Dreyfus. Evanston, IL: Northwestern University Press.

Merleau-Ponty, M. 1964b. *Signs*, trans. R. McCleay. Evanston, IL: Northwestern University Press.

Merleau-Ponty, M. 1964c. *The Primacy of Perception and Other Essays.* Evanston, IL: Northwestern University Press.

Merleau-Ponty, M. 1964d. *Le Visible et l'invisible.* Paris: Gallimard.

Merleau-Ponty, M. 1968. *The Visible and the Invisible*, trans. Alphonso Lingis. Evanston, IL: Northwestern University Press.

Merleau-Ponty, M. 1993. *The Merleau-Ponty Aesthetics Reader: Philosophy and Painting,* ed. G. A. Johnson and M. B. Smith. Evanston, IL: Northwestern Unievrsity Press.

Merleau-Ponty, M. 2008. *The World of Perception*, trans. Oliver Davis. London and New York: Routledge.

Metz, C. 1974. *Film Language: A Semiotics of the Cinema.* New York: Oxford University Press.

Metz, C. 1982. *The Imaginary Signifier: Psychoanalysis and the Cinema*, trans. Celia Britton, A. Williams, B. Brewster, and A. Guzzetti. Bloomington: Indiana University Press.

Metz, C. 1983. *Psychoanalysis and the Cinema: The Imaginary Signifier.* London: Macmillan.

Meyrowitz, J. 1985. *No Sense of Place: The Impact of Electronic Media on Social Behaviour.* New York: Oxford University Press.

Michael, M. 2000. *Reconnecting Culture, Technology and Nature: From Society to Heterogeneity.* London and New York: Routledge.

Michelfelder, D. and R. Palmer, eds. 1989. *Dialogue and Deconstruction: The Gadamer-Derrida Encounter.* Albany: State University of New York Press.

Middleton, D. and D. Edwards, eds. 1990. *Collective Remembering.* London: Sage.

Miller, D. 1987. *Material Culture and Mass Consumption.* Oxford: Blackwell.

Mirzoeff, N. 1995. *Bodyscape: Art, Modernity, and the Ideal Figure.* London: Routledge.

Mirzoeff, N. 1999. *An Introduction to Visual Culture.* London and New York: Routledge.

Mirzoeff, N. 2005. *Watching Babylon: The War in Iraq and Global Visual Culture.* London: Routledge.

Mirzoeff, N., ed. 1998. *The Visual Culture Reader.* London and New York: Routledge.

Mitchell, W.J.T. 1987. *Iconology: Image, Text, Ideology.* Chicago: University of Chicago Press.

Mitchell, W.J.T. 1992. *The Reconfigured Eye: Visual Truth in the Post-Photographic Era.* Cambridge, MA: MIT Press.

Mitchell, W.J.T. 1994. *Picture Theory: Essays on Verbal and Visual Representation.* Chicago: University of Chicago Press.

Mitchell, W.J.T. 2006. *What Do Pictures Want? Essays on the Lives and Loves of Images.* Chicago: University of Chicago Press.

Mitchell, W.J.T., ed. 1980. *The Language of Images.* Chicago: University of Chicago Press.

Mitchell, W.J.T., ed. 1994. *Landscape and Power.* Chicago: University of Chicago Press; 2nd edn. 2001.

Moi, T. 1985. *Sexual/Textual Politics.* London: Methuen.

Mondzain, M.-J. 2004. *Image, Icon, Economy: The Byzantine Origins of the Contemporary Imaginary.* Stanford, CA: Stanford University Press.

Moran, D. 2000. *Introduction to Phenomenology.* London and New York: Routledge.

Moran, D., ed. 2008. *The Routledge Companion to Twentieth Century Philosophy*. London and New York: Routledge.

Morgan, D. 2005. *The Sacred Gaze: Religious Visual Culture in Theory and Practice*. Berkeley: University of California Press.

Morgan, D. and Sally M. Promey. 2001. *The Visual Culture of American Religions*. Berkeley: University of California Press.

Morra, J. and Marquard Smith, eds. 2006. *Visual Culture: Critical Concepts in Media and Cultural Studies*. London and New York: Routledge.

Moxey, K. 1994. *The Practice of Theory: Poststructuralism, Cultural Politics, and Art History*. Ithaca, NY: Cornell University Press.

Mulvey, L. 1975. 'Visual Pleasure and Narrative Cinema', *Screen*, 16/3: 6–18.

Mulvey, L. 1981. 'Afterthoughts on Visual Pleasure and Narrative Cinema', *Framework*, 6/15–17: 12–15.

Mulvey, L. 1985. 'Visual Pleasure and Narrative Cinema', in G. Mast and M. Cohen (eds.), *Film Theory and Criticism*, 3rd ed. Oxford: Oxford University Press, 803–16.

Mulvey, L. 1989. *Visual and Other Pleasures*. London: Macmillan; Bloomington: Indiana University Press.

Mulvey, L. 1996. *Fetishism and Curiosity*. London: BFI.

Munns, J. and G. Rajan, eds. 1995. *A Cultural Studies Reader: History, Theory, Practice*. London and New York: Longman.

Nancy, J.-L. 2005. *The Ground of the Image*. New York: Fordham University Press.

Nancy, J.-L. 2008. *Noli Me Tangere: On the Raising of the Body*. New York: Fordham University Press.

Neale, S. 1985. *Cinema and Technology: Image, Sound, Colour*. London: Macmillan.

Neidich, W. 2003. *Blow-up: Photography, Cinema and the Brain*. New York: D.A.P./UCR/California Museum of Photography.

Nelson, C. and L. Grossberg, eds. 1988. *Marxism and the Interpretation of Culture*. London: Macmillan.

Nelson, R. S. and Richard Shiff, eds. 2003. *Critical Terms for Art History*. Chicago: University of Chicago Press.

Newton, I. 1952. *Opticks, or a Treatise of the Reflections, Refractions, Inflections and Colours of Light*. London and New York: Dover.

Nichols, B. 1989. *Representing Reality: Issues and Concepts in Documentary*. Bloomington: Indiana University Press.

Nichols, B. 1995. *Blurred Boundaries: Questions of Meaning in Contemporary Culture*. Bloomington: Indiana University Press.

Nicholson, L. J., ed. 1990. *Feminism/Postmodernism*. London and New York: Routledge.

Nightingale, A. W. 2005. *Spectacles of Truth in Classical Greek Philosophy: Theoria in Its Cultural Context*. Cambridge: Cambridge University Press.

Nochlin, L. 1971. 'Why Are There No Great Women Artists', in V. Gornick and B. K. Moran (eds.), *Women in Sexist Society*. New York: Basic Books, 480–510.

Nochlin, L. 1988. *Women, Art, and Power and Other Essays*. New York: Harper and Row.

Nochlin, L. 1991. *The Politics of Vision: Essays on Nineteenth-Century Art and Society*. London: Thames and Hudson.

Noë, A. 2004. *Action in Perception*. Cambridge, MA: MIT Press.

Noë, A. and E. Thompson, eds. 2002. *Vision and Mind: Selected Readings in the Philosophy of Perception*. Cambridge, MA: MIT Press.

Norman, D. A. 2002. *The Design of Everyday Things*. New York: Basic Books.

Nussbaum, M. 1986. *The Fragility of Goodness*. Cambridge: Cambridge University Press.

Nussbaum, N. 1990. *Love's Knowledge: Essays on Philosophy and Literature*. Oxford: Oxford University Press.

Olkowski, D. E. 1999. 'Feminism and Phenomenology', in Simon Glendinning (ed.), *The Edinburgh Encyclopedia of Continental Philosophy*. Edinburgh: Edinburgh University Press, 323–33.

Olkowski, D. E. and J. Morley, eds. 1999. *Merleau-Ponty, Interiority and Exteriority*. Albany: State University of New York Press.

Olkowski, D. and G. Weiss, eds. 2006. *Feminist Interpretations of Maurice Merleau-Ponty*. University Park: Pennsylvania State University Press.

Ong, W. G. 1967. *The Presence of the Word: Some Prolegomena for Cultural and Religious History*. New Haven, CT: Yale University Press.

Ong, W. G. 1971. *Rhetoric, Romance, and Technology: Studies on the Interaction of Expression and Culture*. Ithaca, NY: Cornell University Press.

Ong, W. G. 1977. *Interfaces of the Word*. Ithaca, NY: Cornell University Press.

Onians, J. 2007. *Neuroarthistory: From Aristotle and Pliny to Baxandall and Zeki*. New Haven, CT and London: Yale University Press.

Onians, J., ed. 1994. *Sight and Insight: Essays on Art and Culture in Honour of E. H. Gombrich*. London: Phaidon Press.

Orbach, S. 2009. *Bodies*. London: Profile Books.

Osborne, P. 2000a. *Philosophy in Cultural Theory*. London and New York: Routledge.

Osborne, P. 2000b. *Travelling Light: Photography, Travel, and Visual Culture*. Manchester: Manchester University Press.

Osborne, P., ed. 2004. *Walter Benjamin: Critical Evaluations in Cultural Theory*, 3 vols. London: Routledge.

Owens, C. 1992. *Beyond Recognition: Representation, Power and Culture*. Berkeley: University of California Press.

Packard, V. 1957. *The Hidden Persuaders*. New York: Random House. Republished (2007) by Ig Publishing.

Pallasmaa, J. 2005. *The Eyes of the Skin: Architecture and the Senses*. New York: John Wiley and Sons.

Panofsky, E. 1951. *Gothic Architecture and Scholasticism*. New York and Cleveland: Meridian.

Panofsky, E. 1955. *Meaning in the Visual Arts*. Garden City, NY: Doubleday.

Paterson, D. 2004. *The Book of Shadows*. London: Picador.

Penley, C. and Andrew Ross, eds. 1991. *Technoculture*. Minneapolis: University of Minnesota Press.

Pink, S. 2001. *Doing Visual Ethnography: Images, Media and Representations in Research*; 2nd edn. 2007. London: Sage.

Pink, S. 2004. *Working Images: Visual Research and Representation in Ethnography*. London: Routledge.

Pink, S. 2006. *The Future of Visual Anthropology: Engaging the Senses*. London: Routledge.

Pisters, P. 2003. *The Matrix of Visual Culture: Working with Deleuze in Film Theory*. Stanford, CA: Stanford University Press.

Plant, S. 1997. *Zeroes and Ones: Digital Women and the New Technoculture*. New York: Doubleday.

Plomer, A. 1991. *Phenomenology, Geometry and Vision: Merleau-Ponty's Critique of Classical Theories of Vision*. Aldershot: Avebury.

Pointon, M. 1990. *Naked Authority: The Body in Western Painting, 1830–1908*. Cambridge: Cambridge University Press.

Pointon, M. 1997. *Strategies for Showing: Women, Possession and Representation in English Visual Culture 1650–1800*. Oxford: Oxford University Press.

Polemus, T. 1978. *Social Aspects of the Human Body*. Harmondsworth: Penguin.

Pollock, G. 1988. *Vision and Difference: Femininity, Feminism, and the Histories of Art*. London and New York: Routledge.

Pollock, G. 1993. *Avante-Garde Gambits 1888–1893: Gender and the Colour of Art Theory*. London: Thames and Hudson.

Pollock, G. 1999. *Differencing the Canon: Feminist Desire and the Writing of Art's Histories*. London and New York: Routledge.

Pollock, G., ed. 1996. *Generations and Geographies in the Visual Arts: Feminist Readings*. London and New York: Routledge.

Pooke G. and D. Newall. 2008. *Art History: The Basics*. London and New York: Routledge.

Poster, M., ed. 1988. *Jean Baudrillard: Selected Writings*. Oxford: Polity Press.

Poster, M. 1990. *The Mode of Information: Postmodenism and Social Contexts*. Cambridge: Polity Press.

Poster, M. 1995. *The Second Media Age*. Cambridge: Polity Press.

Poster, M. 2001. *What's Wrong with the Internet?*, Minneapolis: University of Minnesota Press.

Poster, M. 2002. 'Visual Studies as Media Studies', *Journal of Visual Culture*, 1/1: 67–70.

Poster, M. 2006. *Information Please: Culture and Politics in the Age of Digital Machines*. Durham, NC: Duke University Press.

Potter, J. 1996. *Representing Reality: Discourse, Rhetoric and Social Construction*. London: Sage.

Pratt, M.-L. 1992. *Imperial Eyes: Travel Writing and Transculturation*. London and New York: Routledge.

Prettejohn, E. 2005. *Beauty and Art: 1750–2000*.Oxford: Oxford University Press.

Preziosi, D., ed. 1998. *The Art of Art History: A Critical Anthology*. Oxford and New York: Oxford University Press.

Preziosi, D. and C. Farago, eds. 2003. *Grasping the World: The Idea of the Museum*. Aldershot: Ashgate.

Prosser, J. 1998. *Image-based Research: A Sourcebook for Qualitative Researchers*. London and Bristol: Falmer Press.

'Questionnaire on Visual Culture'. 1996. *October*, 77 (Summer): 25–70.

Rancière, J. 2006. *The Politics of Aesthetics: The Distribution of the Sensible*, trans. G. Rockhill. London: Continuum.

Rancière, J. 2007. *The Future of the Image*. London: Verso.

Redmond, S. and Su Holmes, eds. 2007. *Stardom and Celebrity: A Reader*. London: Sage.

Rheingold, H. 1993. *Virtual Reality*. London: Mandarin.

Richter, G. 2007. *Thought-Images: Frankfurt School Writers' Reflections from Damaged Life*. Stanford, CA: Stanford University Press.

Riegl, A. 1985. *Late Roman Art Industry*, trans. R. Winkes. Rome: G. Bretschneider.

Roberts, J. 1998. *The Art of Interruption: Realism, Photography, and the Everyday*. Manchester: Manchester University Press.

Robertson, G., M. Mash and L. Tickner, eds. 1996. *The Block Reader in Visual Culture*. London and New York: Routledge.

Robins, K. 1996. *Into the Image: Culture and Politics in the Field of Vision*. London: Routledge.

Roche, M. 2000. *Mega-events and Modernity*. London: Routledge.

Rodaway, P. 1994. *Sensuous Geographies: Body, Sense and Place*. London: Routledge.

Rogoff, I. 1998. 'Studying Visual Culture' in Nicholas Mirzoeff (ed.), *The Visual Culture Reader*. London and New York: Routledge, 14–26.

Rogoff, I. 2000. *Terra Infirma: Geography's Visual Culture*. London and New York: Routledge.

Rojek, C. 1995. *Decentring Leisure: Rethinking Leisure Theory*. London: Sage.

Rojek, C. 2004. *Celebrity*. London: Reaktion Books.

Rojek, C. 2009. *The Labour of Leisure: The Culture of Free Time*. London: Sage.

Rorty, R. 1979. *Philosophy and the Mirror of Nature*. Princeton, NJ: Princeton University Press.

Rorty, R. 1989. *Contingeny, Irony, and Solidarity*. Cambridge: Cambridge University Press.

Rorty, R. 1991. *Objectivism, Relativism, and Truth*. Cambridge: Cambridge University Press.

Rose, G. 1978. *The Melancholy Science: An Introduction to the Thought of Theodor W. Adorno*. London: Macmillan.

Rose, G. 1993. *Feminism and Geography: The Limits of Geographical Knowledge*. Cambridge: Polity Press.

Rose, G. 2001. *Visual Methodologies: An Introduction to the Interpretation of Visual Materials*. London: Sage; 2nd edn. 2007.

Rose, J. 1986. *Sexuality in the Field of Vision*. London: Verso.

Rose, J. 1988. 'Sexuality and Vision: Some Questions', in H. Foster (ed.), *Vision and Visuality*. Seattle: Bay View Press, 115–23.

Rose, N. 2006. *The Politics of Life Itself: Biomedicine, Power, and Subjectivity in the Twenty-First Century*. Princeton, NJ: Princeton University Press.

Ruby, J. 1996. 'Visual Anthropology', in D. Levinson and M. Ember (eds.), *Encyclopedia of Cultural Anthropology*. New York: Holt and Company, vol. 4: 1345–51.

Ruby, J. 2000. *Picturing Culture: Explorations in Film and Anthropology*. Chicago: University of Chicago Press.

Ruby, J. 2005. 'The Last 20 Years of Visual Anthropology: A Citical Review', *Visual Studies*, 20: 159–70.

Ryan, M. 1982. *Marxism and Deconstruction: A Critical Articulation*. Baltimore: Johns Hopkins University Press.

Said, E. 1978. *Orientalism*. Harmondsworth: Penguin.

Said, S. 1993. *Culture and Imperialism*. London: Chatto and Windus.

Saint-Martin, F. 1990. *Semiotics of Visual Language*. Bloomington: Indiana University Press.

Saito, Y. 2007. *Everyday Aesthetics*. Oxford: Oxford University Press.

Sandywell, B. 1996a. *Logological Investigations*, 3 vols. London: Routledge.

Sandywell, B. 1996b. *Logological Investigations, Volume 1, Reflexivity and the Crisis of Western Reason*. London: Routledge.

Sandywell, B. 1999. 'Specular Grammar: The Visual Rhetoric of Modernity', in I. Heywood and B. Sandywell (eds.), *Interpreting Visual Culture: Explorations in the Hermeneutics of the Visual*. London: Routledge, 30–56.

Sandywell, B. 2006. 'Monsters in Cyberspace: Cyberphobia and Cultural Panic in the Information Age', *Information, Communication & Society*, 9/1 (February): 39–61.

Sandywell, B. 2009. 'On the Globalization of Crime: The Internet and the New Criminality', in Yvonne Jewkes and Majid Yar (eds.), *Handbook of Internet Crime*. Uffculme, Devon: Willan, 38–66.

Sandywell, B. 2011. *Dictionary of Visual Discourse: A Dialectical Lexicon of Terms*. Aldershot: Ashgate.

Santner, E. 1990. *Stranded Objects: Mourning, Memory, and Film in Postwar Germany*. Ithaca, NY: Cornell University Press.

Sartre, J.-P. 1943. *L'Etre et le néant*. Paris: Gallimard.

Sartre, J.-P. 1958. *Being and Nothingness: An Essay on Phenomenological Ontology*, trans. Hazel E. Barnes. London: Methuen.

Sartre, J.-P. 2004. *The Imaginary: A Phenomenological Psychology of the Imagination*. London: Routledge.

Sarup, M. 1993. *An Introductory Guide to Post-Structuralism and Postmodernism*, 2nd edn. Hemel Hempstead: Harvester Wheatsheaf.

Saussure, F. de. 1969. *Course in General Linguistics*, trans. W. Baskin. New York: McGraw-Hill.

Scannell, P., P. Schlesinger, and C. Sparks, eds. 1992. *Culture and Power: A Media, Culture and Society Reader*. London: Sage.

Scarry, E. 1985. *The Body in Pain: The Making and the Unmaking of the World*. Oxford and New York: Oxford University Press.

Scarry, E. 2006. *On Beauty and Being Just*. London: Duckworth.

Schaeffer, J.-M. 2000. *Art of the Modern Age: Philosophy of Art from Kant to Heidegger*. Princeton, NJ: Princeton University Press.

Schama, S. 1988. *The Embarrassment of Riches: An Interpretation of Dutch Culture in the Golden Age*, 2nd edn. London: Fontana.

Schama, S. 1995. *Landscape and Memory*. London: HarperCollins.

Schank, R. S. 1982. *Dynamic Memory*. Cambridge: Cambridge University Press.

Schank, R. S. and R. P. Abelson. 1977. *Scripts, Plans, Goals and Understanding: An Inquiry into Human Knowledge Structures*. Hillsdale, NJ: Erlbaum.

Schiller, D. 1999. *Digital Capitalism: Networking the Global Market System*. Cambridge, MA: MIT Press.

Schiller, F. 1967. *Letters on the Aesthetic Education of Man*, trans. E. M. Wilkinson and L. A. Willoughby. Oxford: Clarendon Press.

Schivelbusch, W. 1986. *The Railway Journey. The Industrialization of Time and Space in the Nineteenth Century*. Berkeley: University of California Press.

Schlesinger, P. 1991. *Media, State and Nation: Political Violence and Collective Identities*. London: Sage.

Schlesinger, P., J.D.H. Downing, D. McQuail, and E. Wartella, eds. 2004. *The Sage Handbook of Media Studies*. London: Sage.

Schroeder, J. E. 2002. *Visual Consumption*. London and New York: Routledge.

Schutz, A. 1967. *The Phenomenology of the Social World*. Evanston, IL: Northwestern University Press.

Schutz, A. 1971. *Collected Papers*, vol. I, ed. M. Natanson. The Hague: Martinus Nijhoff.

Schutz, A. and A. Gurwitsch. 1989. *Philosophers in Exile: The Correspondence of Alfred Schutz and Aron Gurwitsch, 1939–1959*. Bloomington and Indianapolis: Indiana University Press.

Schutz, A. and T. Luckmann. 1973. *Structures of the Lifeworld*. London: Heinemann.

Schwartz, F. J. 2005. *Blind Spots: Critical Theory and the History of Art in Twentieth Century Germany*. New Haven, CT and London: Yale University Press.

Scott, B. K., ed. 1990. *The Gender of Modernism: A Critical Anthology*. Bloomington: Bloomington University Press.

Scruton, R. 1974. *Art and Imagination: A Study in the Philosophy of Mind*. London: Methuen.

Sedlmayr, H. 2006. *Art in Crisis: The Lost Center*. New Brunswick, NJ: Transaction Publishers.

Segal, M. H., D. T. Campbell and M. J. Herskovits. 1966. *The Influence of Culture on Visual Perception*. Indianapolis, NY: Bobbs Merrill.

Seidman, S. 1998. 'Postmodern Social Theory as Narrative with a Moral Intent', in S. Seidman and D. G. Wagner (eds.), *Postmodernism and Social Theory: The Debate over General Theory*. Oxford: Basil Blackwell, 47–81.

Seidman, S., ed. 1996. *Queer Theory/Sociology*. Cambridge, MA: Basil Blackwell.

Selwyn, T., ed. 1996. *The Tourist Image*: *Myths and Myth-making in Tourism*. Chichester: John Wiley.

Sennett, R. 1991. *The Conscience of the Eye: The Design and Social Life of Cities*. London: Faber.

Serres, M. 2008. *The Five Senses: A Philosophy of Mingled Bodies*, vol. I, trans. Margaret Sankey and Peter Cowley. London and New York: Continuum.

Shapiro, G. 2003. *Archaeologies of Vision: Foucault and Nietzsche on Seeing and Saying*. London and Chicago: University of Chicago Press.

Sheringham, M. 2006. *Everyday Life: Theories and Practices from Surrealism to the Present*. Oxford: Oxford University Press.

Sherman, D. J. and Irit Rogoff, eds. 1994. *Museum Culture: Histories, Discourses, Spectacles*. Minneapolis: University of Minnesota Press.

Shields, R., ed. 1995. *Lifestyle Shopping: the Subject of Consumption*. London and New York: Routledge.

Shirato, T. and Jen Webb. 2009. *Understanding the Visual*. London: Sage.

Shove, E., M. Watson, M. Hand and J. Ingram. 2007. *The Design of Everyday Life*. Oxford and New York: Berg.

Shusterman, R. 1992. *Pragmatist Aesthetics, Living Beauty, Rethinking Art*. Oxford: Blackwell.

Shusterman, R. 2002. *Surface and Depth: Dialectics of Criticism and Culture*. Ithaca, NY: Cornell University Press.

Sibley, F. 1959. 'Aesthetic Concepts', *Philosophical Review*, 68: 421–68.

Sibley, F. 2001. *Approaches to Aesthetics: Collected Papers on Philosophical Aesthetics*. Oxford: Oxford University Press.

Silverman, H. J. 1999. *Textualities: Between Hermeneutics and Deconstruction*. London and New York: Routledge.

Silverman, H. J., ed. 1993. *Questioning Foundations: Truth/Subjectivity/Culture*. London: Routledge.

Silverman, K. 1983. *The Subject of Semiotics*. Oxford: Oxford University Press.

Silverman, K. 1988. *The Acoustic Mirror: The Female Voice in Psychoanalysis and Cinema*. Bloomington: Indiana University Press.

Silverman, K. 1992. *Male Subjectivity at the Margins*. London and New York: Routledge.

Silverman, K. 1996. *Threshold of the Visible World*. London and New York: Routledge.

Silverstone, R. 1994. *Television and Everyday Life*. London: Routledge.

Silverstone, R. and Eric Hirsch, eds. 1984. *Consuming Technologies: Media and Information in Domestic Spaces*. London: Routledge.

Smith, D. 1987. *The Everyday World as Problematic: A Feminist Sociology*. Milton Keynes: Open University Press.

Smith, M., ed. 2008. *Visual Culture Studies: Interviews with Key Thinkers*. London: Sage.

Smith, P. and C. Wilde, eds. 2002. *A Companion to Art Theory*. Oxford: Blackwell.

Smith, S. M. 1999. *American Archives: Gender, Race, and Class in Visual Culture*. Princeton, NJ: Princeton University Press.

Sobchack, V. 2004. *Carnal Thoughts: Embodiment and Moving Image Culture*. Berkeley: University of California Press.

Sobieszek, R. A. 1988. *The Art of Persuasion: A History of Advertising Photography*. New York: Abrams.

Soja, E. J. 1989. *Postmodern Geographies: The Reassertion of Space in Critical Social Theory*. London: Verso.

Soja, E. J. 1996. *Thirdspace: Journeys to Los Angeles and Other Real-and-Imagined Places*. Oxford: Blackwell.

Solso, R. L., ed. 1996. *Cognition and the Visual Arts*. Cambridge, MA: MIT Press.

Sontag, S. 1977. *On Photography*. New York: Picador; Penguin Classics edn. Harmondsworth: Penguin, 2002.

Sontag, S. 1994. *Against Intepretation* (1961). London: Vintage.

Sontag, S. 2004. *Regarding the Pain of Others*. New York: Picador.

Sorensen, R. 2008. *Seeing Dark Things: The Philosophy of Shadows*. New York: Oxford University Press.

Soussloff, C. 1997. *The Absolute Artist: The Historiography of a Concept*. Minneapolis: University of Minnesota Press.

Soussloff, C. 2006. *The Subject in Art: Portraiture and the Birth of the Modern*. Durham, NC: Duke University Press.

Spence, J. and P. Hollands, eds. 1991. *Family Snaps: The Meaning of Domestic Photography*. London: Virago.

Spiller, N. 2007. *Visionary Architecture: Blueprints of the Modern Imagination*. London: Thames and Hudson.

Spivak, G. C. 1987. *In Other Worlds: Essays in Cultural Politics*. New York: Methuen.

Spivak, G. C. 1988. 'Can the Subaltern Speak?', in C. Nelson and L. Grossberg (eds.), *Marxism and the Interpretation of Culture*. London: Macmillan, 271–313.

Spivak, G. C. 1990. *The Post-Colonial Critic: Interviews, Strategies, Dialogues*. London: Routledge.

Stacey, J. 1993. *Star Gazing: Hollywood Cinema and Female Spectatorship*. London and New York: Routledge.

Stafford, B. M. 1984. *Voyage into Substance: Art, Science, Nature and the Illustrated Travel Account, 1760–1840*. Cambridge, MA: MIT Press.

Stafford, B. M. 1991. *Body Criticism: Imaging the Unseen in Enlightenment Art and Medicine*. Cambridge, MA: MIT Press.

Stafford, B. M. 1994. *Artful Science, Enlightenment, Entertainment and the Eclipse of Visual Education*. Cambridge, MA: MIT Press.

Stafford, B. M. 1996a. *Good Looking: Essays on the Virtue of Images*. Cambridge, MA: MIT Press.

Stafford, B. M. 1996b. *Visual Analogy: Consciousness as the Art of Connecting*. Cambridge, MA: MIT Press.

Stafford, B. M. 2007. *Echo Objects: The Cognitive Work of Images*. Chicago: University of Chicago Press.

Stallabrass, J. 2006. *Contemporary Art: A Very Short Introduction*. Oxford: Oxford University Press.

Stam, R. 1989. *Subversive Pleasures: Bakhtin, Cultural Criticism, and Film*. Baltimore: Johns Hopkins University Press.

Stam, R. 1997. *Tropical Multiculturalism: A Comparative History of Race in Brazilian Cinema and Culture*. Durham, NC: Duke University Press.

Stam, R., ed. 1992. *New Vocabularies in Film Semiotics: Structuralism, Poststructuralism and Beyond*. London and New York: Routledge.

Stanczack, G. C. 2007. *Visual Research Methods: Image, Society and Representation*. London: Sage.

Starobinski, J. 1982. *1789: The Emblems of Reason*, trans. Barbara Bray. Charlottesville: University of Virginia Press.

Steiner, W. 1997. *The Scandal of Pleasure: Art in the Age of Fundamentalism*. Chicago: University of Chicago Press.

Steiner, W. 2002. *Beauty in Exile: The Rejection of Beauty in Twentieth-Century Art*. Chicago: University of Chicago Press.

Stephens, M. 1998. *The Rise of the Image, the Fall of the Word*. Oxford: Oxford University Press.

Stevenson, N. 1995. *Understanding Media Cultures: Social Theory and Mass Communication*. London:Sage.

Storey, J. 2008. *Cultural Theory and Popular Culture: An Introduction*, 5th edn. Harlow: Pearson Education.

Storey, J., ed. 2008. *Cultural Theory and Popular Culture: A Reader*, 4th edn. Harlow: Pearson Education.

Sturken, M. and L. Cartwright. 2001. *Practices of Looking: An Introduction to Visual Culture*. Oxford: Oxford University Press.

Sullivan, G. 2005. *Art Practice as Research: Inquiry in the Visual Arts*. London: Sage.

Summers, D. 2003. *Real Spaces: World Art History and the Rise of Western Modernism*. London: Phaidon.

Tagg, J. 1988. *The Burden of Representation: Essays on Photographies and Histories*. London: Palgrave Macmillan.

Tagg, J. 1991. 'Globalization, Totalization and the Discursive Field', in Anthony D. King (ed.), *Culture, Globalization and the World-System*. London: Macmillan, 155–60.

Tagg, J. 1992. *Grounds of Dispute: Art History, Cultural Politics and the Discursive Field*. Minneapolis: University of Minnesota Press.

Tate, S. A. 2005. *Black Skins, Black Masks: Hybridity-Dialogism-Performativity*. Aldreshot: Ashgate.

Taussig, M. 1993. *Mimesis and Alterity: A Particular History of the Senses*. London and New York: Routledge, 1993.

Taylor, C. 1989. *Sources of the Self: The Making of the Modern Identity*. Cambridge, MA: Harvard University Press.

Taylor, C. 2004. *Modern Social Imaginaries*. Durham, NC: Duke University Press.

Taylor, C. 2007. *A Secular Age*. Cambridge, MA: Harvard University Press.

Taylor, L., ed. 1994. *Visualizing Theory: Selected Essays from V.A.R. [Visual Anthropology Review] 1990–1994*. London and New York: Routledge.

Taylor, M. C. and Esa Saarinen. 1994. *Imagologies: Media Philosophy*. London: Routledge.

Taylor, P. A. and Jan Li Harris, eds. 2008. *Critical Theories of Mass Media: Then and Now*. Maidenhead, Berkshire: Open University Press/McGraw-Hill.

Terranova, T. 2004. *Network Culture: Politics for the Information Age*. London: Pluto Press.

Tester, K., ed. 1994. *The Flâneur*. London and New York: Routledge.

Thompson, E. 1995. *Colour Vision: A Study in Cognitive Science and the Philosophy of Perception*. London: Routledge.

Thompson, J. B. 1995. *Media and Modernity: A Social Theory of the Media*. Cambridge: Polity Press.

Thompson, J. B. 2005. *Books in the Digital Age*. Cambridge: Cambridge University Press.

Thrift, N. 2005. *Knowing Capitalism*. London: Sage.

Thrift, N. 2007. *Non-Representational Theory: Space/Politics/Affect*. London and New York: Routledge.

Tickner, L. 1988. *Spectacle of Women: Imagery of the Suffragette Campaign 1907–14*. Chicago: Chicago University Press.

Tilley, C. 1994. *The Phenomenology of Landscape: Places, Paths and Monuments*. Oxford: Berg.

Tilley, C. 2004. *The Materiality of Stone: Explorations in Landscape Phenomenology*. Oxford: Berg.

Tomas, D. 2004. *Beyond the Image Machine. A History of Visual Technologies*. London and New York: Continuum.

Tong, R. P. 2008. *Feminist Thought: A More Comprehensive Introduction*, 3rd edn. Boulder, CO: Westview Press.

Toulmin, S. 1990 *Cosmopolis: The Hidden Agenda of Modernity*. Chicago: University of Chicago Press.

Trachtenberg, A. 1982. *The Incorporation of America: Culture and Society in the Gilded Age*. New York: Hill and Wang.

Trachtenberg, A., ed. 1980. *Classic Essays on Photography*. New Haven, CT: Leet's Islands Books.

Trachtenberg, M. 1997. *Dominion of the Eye: Urbanism, Art and Power in Early Modern France*. Cambridge: Cambridge University Press.

Trotsky, L. 1924. *Literature and Revolution*, trans. R. Strunsky. London: RedWords, 1991.

Tudor, A. 1974. *Theories of Film*. New York: Viking.

Tudor, A. 1999. *Decoding Culture: Theory and Method in Cultural Studies*. London: Sage.

Tufte, E. R. 1990. *Envisioning Information*. New York: Graphics Press.

Tufte, E. R. 1997a. *Visual and Statistical Thinking: Displays of Evidence for Making Decisions*. New York: Graphics Press.

Tufte, E. R. 1997b. *Visual Explanations: Images and Quantities, Evidence and Narrative*. New York: Graphics Press.

Tufte, E. R. 2001. *The Visual Display of Quantitative Information*, 2nd edn. New York: Graphics Press.

Turkle, S. 1984. *The Second Self: Computers and the Human Spirit*. New York: Simon & Schuster.

Turkle, S. 1995. *Life on the Screen: Identity in the Age of the Internet*. New York: Simon & Schuster.

Turner, G. 1996. *British Cultural Studies: An Introduction*, 2nd edn. London: Routledge.

Turner, G. 2004. *Understanding Celebrity*. London: Sage.

Tyler, S. A. 1986. 'Postmodern Ethnography: From Document of the Occult to Occult Document', in J. Clifford and G. E. Marcus (eds.), *Writing Culture*. Berkeley: California University Press, 122–40.

Ulmer, G. 1989. *Teletheory. Grammatology in the Age of Video*. New York: Rouledge.

Urry, J. 1990. *The Tourist Gaze: Leisure and Travel in Contemporary Societies*. London: Sage.

Urry, J. 1995. *Consuming Places*. London: Routledge.

Urry, J. 2007. *Mobilities*. Cambridge: Polity Press.

Urry, J. and Chris Rokek, eds. 1997. *Touring Cultures: Transformations of Travel and Theory*. London: Sage.

Van Eck, C. and E. Winters. eds. 2005. *Dealing with the Visual: Art History, Aesthetics and Visual Culture*. Farnham: Ashgate.

Van Leeuwen, T. and C. Jewitt, eds. 2001. *The Handbook of Visual Analysis*. London: Sage.

Van Zoonen, L. 1994. *Feminist Media Studies*. London: Sage.

Varela, F., E. Thompson and E. Rosch. 1991. *The Embodied Mind: Cognitive Science and Human Experience*. Cambridge, MA: MIT Press.

Vasari, G. 1987. *Lives of the Artists*, trans. George Bull. Harmondsworth: Penguin.

Vasseleu, C. 1998. *Textures of Light: Vision and Touch in Iragaray, Levinas, and Merleau-Ponty*. London and New York: Routledge.

Vattimo, G. 1988. *The End of Modernity*. Baltimore: Johns Hopkins University Press.

Vattimo, G. 1992. *The Transparent Society*. Oxford: Blackwell.

Vattimo, G. 1993. *The Adventures of Difference*. Baltimore: Johns Hopkins University Press.

Virilio, P. 1983. *Pure War*. New York: Semiotext(e).

Virilio, P. 1986. *Speed and Politics*, trans. M. Polizzotti. New York: Semiotext(e).

Virilio, P. 1989. *War and Cinema: The Logistics of Perception*, trans. P. Camillier. London: Verso.

Virilio, P. 1991a. *The Aesthetics of Disappearance*, trans. P. Beitchman. New York: Semiotext(e).

Virilio, P. 1991b. *Lost Dimension*, trans. D. Moshenberg. New York: Semiotext(e).

Virilio, P. 1993. *L'art du moteur*. Paris: Galilée.

Virilio, P. 1994. *The Vision Machine*. Bloomington: Indiana University Press/British Film Institute.

Virilio, P. 1997. *Open Sky*, trans. J. Rose. London: Verso.

Virilio, P. 2003. *Art and Fear*, trans. J. Rose. London: Continuum.

Vogel, S. 1996. *Against Nature: The Concept of Nature in Critical Theory*. Albany: State University of New York Press.

Von Simson, O. G. 1988. *The Gothic Cathedral: Origins of Gothic Architecture and the Medieval Concept of Order*, 3rd edn. Princeton, NJ: Princeton University Press.

Walker, J. A. and S. Chaplin. 1997. *Visual Culture: An Introduction*. Manchester and New York: Manchester University Press.

Wallis, B., ed. 1984. *Art after Modernism: Rethinking Representation*. New York: New Museum of Contemporary Art/David Godine.

Walsh, K. 2007. *Representations of the Past: Museums and Heritage in the Postmodern World*. London: Taylor and Francis.

Warnke, G. 1993. 'Ocularcentrism and Social Criticism', in D. M. Levin (ed.), *Modernity and the Hegemony of Vision*. Berkeley: University of California Press, 287–308.

Wasko, J. 1994. *Hollywood in the Information Age: Beyond the Silver Screen*. Oxford: Polity.

Watson, S. and Katherine Gibson, eds. 1995. *Postmodern Cities and Spaces*. Oxford: Basil Blackwell.

Webb, J. 2009. *Understanding Representation*. London: Sage.

Weber, S. 2008. *Benjamin's –abilities*. Cambridge, MA and London, England: Harvard University Press.

Webster, A. 2007. *Health, Technology and Society: A Sociological Critique*. Basingstoke: Palgrave Macmillan.

Weedon, C. 1987. *Feminist Practice and Poststructuralist Theory*. Oxford: Basil Blackwell.

Weigel, S. 1996. *Body-and Image-Space: Re-reading Walter Benjamin*. London: Routledge.

Weiss, Gail 1999. *Body Images: Embodiment as Intercorporeality*. New York and London: Routledge.

Wells, L. 2004. *Photography: A Critical Introduction*. London and New York: Routledge.

Wells, L., ed. 2003. *The Photography Reader*. London: Routledge.

Welsch, W. 1997. *Undoing Aesthetics*. London: Sage.

Wernick, A. 1991. *Promotional Culture: Advertising, Ideology and Symbolic Expression*. London: Sage.

Whitford, M., ed. 1991. *The Iragaray Reader*. Oxford: Basil Blackwell.

Wigley, M. 1993. *The Architecture of Deconstruction: Derrida's Haunt*. Cambridge, MA: MIT Press.

Wilder, K. 2009. *Photography and Science*. London: Reaktion Books.

Williams, L. 1989. *Viewing Positions: Ways of Seeing Film*. New Brunswick, NJ: Rutgers University Press.

Williams, L. 1999. *Hard Core: Power, Pleasure, and the 'Frenzy of the Visible'*. Berkeley: University of California Press.

Williams, L. 2008. *Screening Sex*. Durham, NC and London: Duke University Press.

Williams, R. 1974. *Television: Technology and Cultural Form*. London: Fontana.

Williams, R. 1977. *Marxism and Literature*. Oxford: Oxford University Press.

Williams, R. 1983. *Towards 2000*. London: Chatto and Windus.

Williams, R. 1990. *Notes on the Underground: An Essay on Technology, Society, and the Imagination*. Cambridge, MA: MIT Press.

Williamson, J. 1978. *Decoding Advertisements: Ideology and Meaning in Advertising*. London: Marion Boyars.

Wilson, S. 2002. *Information Arts: Intersections of Art, Science, and Technology*. Cambridge, MA: MIT Press.

Wintle, M. 2009. *The Image of Europe: Visualizing Europe in Cartography and Iconography throughout the Ages*. Cambridge: Cambridge University Press.

Wittgenstein, L. 1958. *Philosophical Investigations*. Oxford: Blackwell.

Wittig, M. 1992. *The Straight Mind and Other Essays*. Boston: Beacon Press.

Wittkower, M. and R. 1963. *Born under Saturn; the Character and Conduct of Artists: A Documented History from Antiquity to the French Revolution*. London: Weidenfeld and Nicolson.

Wolff, J. 2006. 'Groundless Beauty: Feminism and the Aesthetics of Uncertainty', *Feminist Theory*, 27/2 (Special Issue on Beauty).

Wolff, J. 2008. *The Aesthetics of Uncertainty*. New York: Columbia University Press.

Wollen, P. 1982. *Readings and Writings: Semiotic Counter Strategies*. London: Verso.

Wollen, P. 1993. *Raiding the Icebox: Reflections on Twentieth-Century Culture*. Bloomington: Indiana University Press.

Wollheim, R. 1973. *On Art and the Mind*. Cambridge, MA: Harvard University Press.

Wollheim, R. 1980. *Art and its Object*. Cambridge: Cambridge University Press.

Wollheim, R. 1984. *The Thread of Life*. Cambridge: Cambridge University Press.

Wollheim, R. 1987. *Painting as an Art*. London: Thames and Hudson.

Wood, C. S. ed. 2000. *Vienna School Reader: Politics and Art Historical Method in the 1930s*. New York: Zone.

Wood, D., ed. 1992. *Derrida: A Critical Reader*. Oxford: Basil Blackwell.

Wood, H. H. and A. S. Byatt, eds. 2008. *Memory: An Anthology*. London: Chatto and Windus.

Woodiwiss, A. 2001. *The Visual in Social Theory*. London and New York: Athlone Press.

Woods, L. 1993. *War and Architecture*. Princeton, NJ: Princeton Architectural Press.

Young, I. M. 1990. *Justice and the Politics of Difference*. Princeton, NJ: Princeton University Press.

Young, R.J.C. 1995. *Colonial Desire: Hybridity in Theory, Culture and Race*. London and New York: Routledge.

Zahavi, D. 2005. *Subjectivity and Selfhood: Investigating the First-Person Perspective*. Cambridge, MA: MIT Press.

Zee, A. 1999. *Fearful Symmetry: The Search for Beauty in Modern Physics*. Princeton, NJ: Princeton University Press.

Zeki, S. 1999. *Inner Vision: An Exploration of Art and the Brain*. Oxford: Oxford University Press.

Zieliknski, S. 2008. *Deep Time of the Media: Towards an Archaeology of Hearing and Seeing by Technical Means*. Cambridge, MA: MIT Press.

Žižek, S. 1989. *The Sublime Object of Ideology*. London: Verso.

Žižek, S. 1991. *Looking Awry: An Introduction to Jacques Lacan through Popular Culture*. Cambridge, MA: MIT Press.

Žižek, S. 1992. *Everything You Always Wanted to Know about Lacan but Were Afraid to Ask Hitchcock*. London: Verso.

Žižek, S, 1993. *Tarrying with the Negative: Kant, Hegel, and the Critique of Ideology*. Durham, NC: Duke University Press.

Žižek, S. 2000. *The Ticklish Subject: The Absent Centre of Political Ontology*. London: Verso.

Žižek, S. 2002. *Welcome to the Desert of the Real*. London: Verso.

Žižek, S. 2006. *Interrogating the Real*. London: Continuum.

Zukin, S. 1989. *Loft Living: Culture and Capital in Urban Change*. New York: Rutgers University Press.

Zukin, S. 1995. *Cultures of Cities*. Oxford: Blackwell.

Zumthor, P. 1996. *Thinking Architecture*. Berlin, Basel and Boston: Birkhäuser Verlag, 2nd expanded edn.

Zumthor, P. 2006. *Atmospheres: Architectural Environments-Surrounding Objects*. Berlin, Basel and Boston: Birkhäuser Verlag.

Zureik, E. and Mark B. Salter, eds. 2005. *Global Surveillance and Policing: Borders, Security and Identity*. Uffculme, Devon: Willan.

NAME INDEX

Aaron, Michael, 721

Adler, Kathleen, 722

Adorno, Theodor W., 23, 24, 155, 159, 167, 202, 306, 680, 686, 696, 698, 699, 705

Agamben, Giorgio, 43, 295

Agger, Ben, 686

Alberti, Leon Battista, 348, 484, 618, 688

Alexander, Jeffrey C., 700

Alhazen (Ibn al-Haitham), 688

Alpers, Svetlana, 10, 63, 105, 694

Alperson, Philip, 697

Althusser, Louis, 70, 167, 314, 683

Anderson, Benedict, 469

Anderson, Helen, xv, 539, 607, 614

Andrew, Dudley, 490

Appadurai, Arjun, 420, 429, 543, 548, 712

Argenti, Nicholas, 621, 622

Aristotle, 24, 560, 608, 620, 688

Arnheim, Rudolph, 694

Arnold, Matthew, 167

Atherton, Margaret, 106

Augé, Marx, 710, 712, 713

Austin, J.L., 566

Awan, Fatimah, xv, 536, 538, 589, 602

Babbage, Charles, 17, 82

Bacon, Roger, 688

Badiou, Alain, 43, 216n13

Bainbridge, Simon, xv, 160–1

Bakhtin, Mikhail, 14, 28, 352, 355

Bal, Mieke, 79, 284, 317, 490, 535, 542–4, 547–8, 550–1, 696, 704, 707, 714, 724

Balsamo, Anne, 723

Banks, Marcus, 707

Banksy, 235, 239, 251

Barnard, Malcolm, xv–xvi, 35, 40–1, 42, 76, 389, 709, 710

Barrett, Michele, 700

Barthes, Roland, 10, 23, 28, 35, 37, 41, 156, 170, 173, 176, 312, 326, 392, 393, 394, 399, 416, 428, 446, 448, 449, 486, 523, 683, 684, 708, 711, 715

Bataille, Georges, 351, 681

Battersby, Christine, 298, 721

Baudelaire, Charles, 17, 407

Baudrillard, Jean, 60, 116, 250–1, 295, 406, 417, 517, 519, 526, 687, 688, 723

Bauman, Zygmunt, 4, 377, 402, 472, 522, 712, 718

Baxandall, Michael, 10, 22, 608, 692, 694

Bazin, André, 399, 448, 486

Beardsley, Monroe, 695

Beck, Ulrich, 377, 397, 472, 688

Beck-Gernsheim, Elisabeth, 397, 472

Becker, Howard, 549, 707, 711

Beer, David, 575, 577

Beiser, Frederick, 29
Bell, Quentin, 409
Bellour, Raymond, 313
Belting, Hans, 683
Benedikt, Michael, 716
Benhabib, Seyla, 724
Benjamin, Andrew, 696, 698
Benjamin, Walter, 14, 18–19, 23, 24, 28, 31,
 39, 44–5n9, 61, 109, 176–7, 185–6, 281,
 290, 292, 296, 395, 458, 520, 559, 680,
 686, 691, 700, 705
Bennett, Tony, 700, 701, 710
Bentkowska-Kafel, Anna, 724
Berenson, Bernard, 699
Berg, Kajsa, xvi, 539–40, 607, 618
Berger, John, 8, 10, 19, 448, 683, 718
Berger, Martin, A., 720
Bergson, Henri, 107
Berkeley, George, 106, 690
Berman, Marshall, 377
Bernal, Martin, 689
Berners-Lee, Tim, 561
Bernstein, Jay M., 686, 689, 695
Bernstein, Richard J., 680
Bhabha, Homi K., 184, 703, 720
Blanchot, Maurice, 342, 684
Bloch, Ernst, 24, 686, 691, 705
Bloom, Lisa, 720
Blum, Alan, 14
Blum, L. A., 700
Böcklin, Arnold, 298
Bocock, Robert, 712
Boehm, Gottfried, 44n8, 216n13
Bois, Yve-Alain, 202, 217n23, 695, 699, 729
Bolla, Peter de, 64, 116, 714
Bolter, Jay David, 474, 716
Bordo, Susan, 721, 722
Bordwell, David, 481, 702
Borges, Jorge Luis, 108
Bourdieu, Pierre, 164, 174, 203, 284, 365,
 372, 517, 520, 548, 584, 709, 711, 718,
 723
Bourriaud, Nicholas, 156, 179–80
Bowie, Andrew, 699
Boyne, Roy, xvi, 281–3, 290, 688
Braider, Christopher, 106–7

Braidotti, Rosi, 43, 720
Braque, Georges, 158–9, 166, 209–11, 288,
 367, 373, 378–9, 633
Braudel, Fernand, 390, 406, 409, 411
Brennan, Teresa, 721
Breton, André, 344
Brunelleschi, Filippo, 348, 688
Bryson, Norman, 10, 14, 72, 78, 284, 317,
 509, 510, 542, 544, 552, 609, 696, 697,
 698, 724
Buber, Martin, 285
Buci-Glucksmann, Christine, 63, 105–6
Buck-Morss, Susan, 23, 44n9, 686, 703
Bukatman, Scott, 723
Bürger, Peter, 695, 698
Burgin, Victor, 168, 179, 393, 446, 486,
 696, 697, 709, 711, 714, 717
Burke, Edmund, 222, 282, 297
Burke, Peter, 687, 701, 707, 724
Burkhardt, Jacob, 705
Burrows, Roger, xvi, 528, 537, 572, 573,
 575, 577, 583–5, 716
Butler, Judith, 43, 549, 700, 721
Butsch, Richard, 724

Cadava, Eduardo, 521
Calhoun, Craig, 719, 721, 724
Campbell, Colin, 416
Candlin, Fiona, 724
Caravaggio, 620–1
Carlyle, Thomas, 407
Caron, Amy, 540, 621
Cartwright, Lisa, xvi–xvii, 10, 15, 16, 80,
 323, 361, 524, 544, 702, 703, 710, 715,
 723
Casey, Edward, S., 710
Cassat, Mary, 314, 316
Cassirer, Ernst, 706
Castells, Manuel, 43n1, 517, 688, 715, 716
Castoriadis, Cornelius, 43, 713
Cavallo, Guglielmo, 651
Cavell, Stanley, 34, 701, 724
Caygill, Howard, 713
Cazeaux, Clive, 695, 696, 698, 721
Certeau, Michel de, 23, 163, 236, 238, 240,
 243, 248–9, 315, 548

Cézanne, Paul, 23, 65, 201, 382n16
Chaney, David, 520, 713
Changeux, Jean-Pierre, 619
Chaplin, Elizabeth, 9, 707
Charney, Leo, 482
Chartier, Roger, 651, 718
Cheetham, Mark, 696
Chekhov, Anton, 139
Clark, Kenneth, 80, 699, 700
Clark, Simon, 689
Clark, T. J., 159, 206, 211–12, 288,
370–1, 697
Classen, Constance, 11, 690, 704
Clifford, James, 629–30, 631, 704
Cocteau, Jean, 136–7
Coleridge, Samuel Taylor, 299
Collingwood, R. G., 141, 695, 733
Comolli, Jean-Luis, 448
Connerton, Paul, 714
Connor, Stephen, 696, 722
Cooke, Lynne, 23
Cornell, Drucilla, 722
Corrigan, Philip, 712
Coser, Lewis, 706
Craig-Martin, Michael, 431–3
Crane, Diana, 413
Crary, Jonathan, 15, 106, 693, 703, 711,
716, 723
Crimp, Douglas, 77
Critchley, Simon, 686
Croce, Benedetto, 215n4, 706
Crossley, Nick, 724
Crowther, Paul, 685, 698, 699
Cubit, Sean, 491
Currie, Gregory, 716
Curtius, Ernst Robert, 706
Cytowic, Richard, 26

Dali, Salvador, 344
Damar, Bruce, 717
Damasio, Antonio, 722
Damisch, Hubert, 692
Dandeker, Christopher, 717
Dant, Tim, xvii, 391, 712, 713
Danto, Arthur, 14, 43n1, 45n10, 202, 699
Darley, Andrew, 717

Darwin, Charles, 17–18
Daston, Lorrain, 708
Davey, Nicholas, xvii, 66–7
da Vinci, Leonardo, 608, 618, 688
Davis, Mike, 715, 716, 723
Davis, Whitney, 96–7
Deacon, Richard, 156, 170
Debord, Guy, 31, 60, 115, 240–1, 281, 292,
293, 301, 342, 347, 520, 688, 696
Deleuze, Gilles, 17, 43n1, 79–80, 106, 302,
352, 684, 687, 688
Derrida, Jacques, 77, 170, 173, 186, 192,
536, 560, 565–6, 680, 684, 687, 690
Descartes, René, 23, 24, 63, 105–6, 347,
352, 688
Dessoir, Max, 706
Dewey, John, 401, 504, 511, 514, 680,
683, 695
Dickie, George, 2, 45n10, 698, 699, 736
Dijk, José van, 451–2
Dikovitskaya, Margaret, xvii, 59–60, 72,
75–6, 92, 134–5, 315, 323
Dilthey, Wilhelm, 103, 112n2, 680, 706,
736
Dix, Otto, 138
Dosse, François, 683
Douglas, Mary, 367, 385
Dreyfus, Hubert, 680, 684, 736
Drucker, Joanna, 697
Druckery, Timothy, 719, 723
Dryden, John, 297
Duchamp, Marcel, 239, 295
Dudley, Andrew, 702
Dufrenne, Mikel, 679
Dumas, Alexander, 371
Dupré, Louis, 693
During, Simon, 700
Duro, Paul, 72
Duttlinger, Carolin, 23
Dworkin, Andrea, 722
Dyer, Richard, 702, 703

Eagleton, Terry, 511, 685, 686, 695
Eco, Umberto, 683, 684, 699
Edgerton, Samuel, Y., 718
Edwards, Steve, 694, 696, 709, 711

Eisenstein, Elizabeth E., 697
Elbs, Oliver, 609, 610
Elgar, Edward, 25
Elias, Norbert, 693, 714, 718
Elkins, James, 696, 709, 724
Emin, Tracy, 41
Emmison, Michael, 707
Ewan, Stuart, 712

Fabian, Johannes, 632, 705, 720
Farago, Claire, 700, 710
Featherstone, Mike, 4, 518, 519, 520, 522,
 524, 712, 715, 716, 719
Feuerbach, Ludwig Andreas, 293
Fiske, John, 703, 709, 710, 720
Flusser, Vilém, 7, 281, 284–6, 326–40, 709,
 711, 713
Foster, Hal, 14, 92, 102, 688, 696
Foucault, Michel, 16, 17–18, 40, 42, 79,
 108, 111, 290, 326, 353, 418, 548, 554,
 680, 684, 692, 702, 710, 717, 718
Frank, Robert, 156, 172
Franklin, Stan, 717
Frazer, J. G., 628
Freedberg, David, 609, 619, 620
Freud, Sigmund, 568, 609, 633
Friedberg, Anne, 284, 321, 398, 483, 702, 712
Frow, John, 703
Fuss, Diana, 719

Gadamer, Hans-Georg, 29, 45n11, 67, 132,
 139–40, 143–4, 145, 146, 680–1
Gardiner, Michael E., xvii, 64–5
Garfinkel, Harold, 14, 384n32
Gattegno, Caleb, 69
Gauntlett, David, xvii–xviii, 536, 538, 589,
 596, 603, 707
Gay, Peter, 706, 718
Geertz, Clifford, 46n13, 598, 629, 705
Gell, Alfred, 543
Gere, Charlie, xviii, 536, 559, 716, 717, 719
Gernsheim, Helmut, 711
Gibson, James J., 690
Gibson, William, 566
Giddens, Anthony, 4, 377–8, 397, 419, 472,
 522, 715

Gilloch, Graham, 713
Gilpin, William, 222–5
Gilroy, Paul, 687, 703, 720
Gitelman, Lisa, 7, 717
Goethe, Johann Wolfgang, 139, 351, 353,
 355–6
Goffman, Erving, 35, 712
Goldberg, Ken, 718
Goldstein, Kurt, 690
Gombrich, Ernst H., 24, 608, 690, 694, 706
Goodman, Nelson, 683
Goody, Jack, 697
Gormley, Antony, 304
Gorton, Kristyn, xviii, 395, 464
Goya, Francisco, 621
Grassi, Ernesto, 693, 706
Green, Christopher, 694
Greenaway, Peter, 108, 399, 488, 489
Greenberg, Clement, 167, 177, 178–80
Gregory, David, 19
Gregory, Richard L., 43n1, 690
Griffith, D. W., 634
Griffiths, Alison, 705
Grimshaw, Anna, 540, 629, 631–2, 632–42
Grossberg, Lawrence, 683, 685, 700
Grosz, Elizabeth, A., 709, 715, 722
Grusin, Richard, 474, 480, 716
Guattari, Felix, 684, 687, 688
Guins, Raiford, 724
Gutting, Gary, 42, 692

Habermas, Jürgen, 98n7, 142, 680, 724
Haddon, A. C., 628, 629
Halbwachs, Maurice, 715
Hale, John, 693
Hall, Stuart, 10, 33, 42, 174, 393, 446, 517,
 545, 596, 701, 720
Hand, Martin, xviii, 401, 516, 523, 713,
 719
Hansen, Miriam, 296–7, 483
Haraway, Donna, 19, 76, 284, 322, 723
Harper, Douglas, 594, 708
Harrington, Austin, 148
Harris, John, 694
Hartley, John, 683, 709
Harvey, David, 526, 713, 715, 723

Hauser, Arnold, 694, 705
Havelock, Eric, 698
Hayles, Katherine, N., 575, 721, 723
Hebdige, Dick, 174, 390–1, 427, 710
Hegel, Georg Wilhelm Friedrich, 24, 29, 190, 202, 293, 350, 364, 568, 685, 705
Heidegger, Martin, 14, 23–4, 29, 103–8, 137–8, 143–4, 145, 146, 202, 286, 343, 349, 440, 505, 560, 678–9, 680–1, 691, 693, 703
Heller, Agnes, 128
Helmholz, Hermann von, 14, 690
Henry, Michel, 679
Heywood, Ian, xviii, 7, 23, 35, 43n1, 134–5, 158–60, 287–9, 698
Hirsch, Fred, 520
Hirsch, Marian, 450
Hirst, Damien, 41
Hirstein, William, 608–9
Hjelmslev, Louis, 428
Hobsbawm, Eric, 715
Hockney, David, 693
Hodge, Robert, 428
Hoffmansthall, Hugo von, 367
Hoggart, Richard, 364
Holland, Patricia, 450
Hollander, Anne, 390, 411–12
Holly, Michael Ann, 71–2, 317
Honneth, Alex, 686
Hooke, Robert, 14
hooks, bell, 720, 722
Horace (Quintus Horatius Flaccus), 27, 618
Horkheimer, Max, 159, 167
Howes, David, xviii–xix, 6, 11, 26, 536, 540, 628, 690, 705
Hubel, David, 616
Hume, David, 690
Hunt, Lynn, 722
Husserl, Edmund, 14, 23–4, 29, 285, 286, 331, 391, 393, 427, 437–8, 678–9, 680, 690, 691
Huyssen, Andreas, 93

Ihde, Don, 391, 393, 427, 440, 693, 716
Ingold, Tim, 429, 442, 504–5
Iragaray, Luce, 687, 721

Irvine, Martin, xix, 161–3, 235
Isaacs, Bruce, 489, 492
Iversen, Margaret, 698

James, Henry, 505
James, William, 391, 392, 427, 435–6, 505
Jameson, Fredric, 61, 93–4, 96–7, 115, 165, 171, 342, 519, 526, 582, 686, 688, 715
Jaspers, Karl, 103, 440
Jay, Martin, xix, 8, 9, 19, 62–4, 80–1, 83, 102–14, 116, 127, 343, 344, 503, 504, 508, 633, 686, 689, 691–2, 693, 703, 717
Jencks, Chris, 9, 43n1
Jenkins, Henry, 484, 486
Jewitt, Carey, 707
Jhally, Sut, 403
Johnson, Mark, 690, 699, 700
Johnson, Steven, A., 716
John the Baptist, 66–7, 136–40
Jones, Amelia, 35, 310, 722, 723
Jones, Steve, 716
Jordanova, Ludmilla, 714
Joyce, James, 111, 295
Judd, Don, 168–9

Kahlo, Frieda, 320
Kant, Immanuel, 24, 95, 142, 143–4, 149–50, 282, 297, 347, 568, 689, 698
Kaplan, E. Anne, 313, 721
Keats, John, 161, 232–3, 299
Kellner, Douglas, 302, 686
Kelly, Mary, 283, 314, 321, 720
Kelly, Michael, 695
Kemp, Martin, 690–1, 692
Kendrick, Walter, 723
Kermode, Frank, 202
Kern, Stephen, 22, 693, 715
Kiefer, Anselm, 305
Kittler, Friedrich A., 7, 10, 14, 719
Kivy, Peter, 699
Klages, Ludwig, 297
Klein, Naomi, 710
Klein, Stephen, 403
Koenig, René, 408
Koffka, Karl, 690

Kofman, Sarah, 681, 692
Köhler, Wolfgang, 430–1, 690
Kollwitz, Kathy, 320
Konorsky, Jerzy, 615–16
Koons, Jeff, 156, 170, 175–6
Kostler, Arthur, 503
Kracauer, Siegfried, 686, 705
Krauss, Rosalind, 109, 490, 697, 711, 721
Kress, Gunther, 683, 708, 724
Kristeller, Paul O., 706
Kristeva, Julia, 43, 417, 682, 747
Kruger, Barbara, 168, 179, 244, 245,
 246, 284
Kuhn, Annette, 450, 702, 722
Kuhn, Thomas S., 69, 691

Lacan, Jacques, 28, 192, 315, 449, 683, 684,
 717
Landa, Manuel de, 43n1, 719
Landow, George P., 716
Lash, Scott, 521, 525, 526, 572, 573, 688,
 698, 704, 712, 713, 718, 719
Latour, Bruno, 64, 116–17, 440, 574, 688,
 702, 707, 708
Lauretis, Teresa de, 721
Leavis, F. R., 33
Leder, Drew, 722
Le Doeuff, Michéle, 43, 682
Leeuwen, Theo van, 707, 708, 712, 724
Lefebvre, Henri, 19, 236, 241, 249, 281,
 286, 295, 342, 343–58, 686
Leiss, William, 403, 524
Leroi-Gourhan, André, 560
Lessig, Lawrence, 716
Lévi-Strauss, Claude, 354, 683, 684
Levin, David Michael, 9, 342, 350, 692, 704
Levinas, Emmanuel, 679, 691
Levinson, Jerrold, 700
Lindbergh, David, 691
Lister, Martin, 711, 717
Locke, John, 690
Longhurst, Brian, 701
Longo, Robert, 156, 170, 171
Loos, Adolph, 413
Lorraine, Claude, 160
Lowe, Donald M., 9, 693, 704

Lowenthal, David, 715
Lucas, George, 484
Luhmann, Niklas, 708
Lukács, Georg, 686
Lurie, Alison, 415–16
Lury, Celia, 403, 517, 519, 521, 524–5, 526,
 528, 712, 713, 723
Lynch, David, 399, 488
Lyon, David, 717
Lyotard, Jean-François, 43n1, 61, 94–5, 684,
 687, 688

MacCannell, Dean, 714
McCarthy, Anna, 466, 549
MacDougall, David, 637–8
MacDougall, Judith, 637–8
MacDougall, William, 634–7
McGuigan, Jim, 701, 724
Machery, Pierre, 176–7
MacIntyre, Alasdair, 139
McLuhan, Marshall, 7, 40, 44n3, 284, 326,
 330, 331, 337, 691
McNeill, William, 24, 693
MacPhee, Graham, 713
McRobbie, Angela, 721
Magritte, René, 344
Mahler, Gustav, 25
Maine de Biran, Marie-Francois-Pierre, 560,
 690
Malinowski, Bronislaw, 407, 629, 644n4
Mallarmé, Stéphane, 372
Malpas, Jeff, 22
Mandelstam, Osip, 16
Manet, Edouard, 166
Manguel, Alberto, 18, 43n1, 710
Manning, Erin, 720
Manovich, Lev, 7, 44n1, 399, 447, 487–8,
 489–90, 491, 526, 716
Marcus, George E., 704
Marcuse, Herbert, 129, 167, 686
Margolis, Joseph, 680, 698, 699
Marinetti, Filippo Tomasso, 281, 291
Marks, Laura, 715, 716
Marriner, Robin, xix, 155
Martin, Louis, 683
Marx, Karl, 167–8, 293, 350, 359, 377, 680

Massey, Doreen, 710

Massumi, Brian, 484

Matisse, Henri, 375

Maynard, Margaret, 391, 419, 421

Maynard, Patrick, 711

Melville, Stephen, 9, 71–2, 696, 699

Merleau-Ponty, Maurice, 15, 23, 24, 25–6, 64–5, 90–1, 96–7, 115–29, 202, 286, 356–7, 391, 392, 427, 434–5, 435–6, 440–1, 548, 564, 678–80, 686, 690, 691

Merton, Robert K., 706

Metz, Christian, 102–3, 110–11, 173, 313, 448, 691, 702

Meyrowitz, Joseph, 717

Michael, Mike, 717

Michelangelo Buonarotti, 613

Miller, Daniel, 713

Miller, Toby, 397, 546

Mills, Charles Wright, 579

Milton, John, 297

Mirzoeff, Nicholas, 10, 34–5, 41–2, 46–7n14, 60, 76, 78–9, 92, 132, 135, 146–7, 323, 701, 715, 723

Misch, Georg, 706

Mitchell, W.J.T., 6, 10, 15–16, 25, 37, 60, 69, 74–5, 92, 447, 609, 683, 704, 711, 716, 720, 724

Momigliano, Arnaldo, 706

Mondzain, Marie-Jose, 692

Monroe, Marilyn, 172

Moore, Kathryn, xix, 400, 499, 514

Morgan, David, 718

Morisot, Berthe, 314, 316

Morris, William, 33

Moxey, Keith, 72, 158, 205–6, 214, 284, 707

Mozart, Wolfgang Amadeus, 139

Mulvey, Laura, 35, 312–13, 318, 399, 448, 471, 481–2, 486, 702

Mumford, Lewis, 691

Myers, Charles, 634

Nakahara, Lisa, 320

Nancy, Jean-Luc, 4, 190, 536, 559, 562–4, 565–70, 684

Neale, Stephen, 716

Neidich, Warren, 609, 610, 711

Nelson, Benjamin, 706

Newton, Isaac, 338, 688, 689

Nietzsche, Friedrich, 23, 122–3, 134, 137, 342, 343, 349–50, 351, 369, 680, 705

Nochlin, Linda, 283, 315–16, 318, 698, 718, 720

Noë, Alva, 690

Nussbaum, Martha, 700, 725

Nye, David, 282, 299–300

Ong, Walter J., 698

Onians, John, xix–xx, 15, 17, 34, 73–4, 539, 607, 609, 617, 694

Opie, Catherine, 284

Orbach, Susie, 722

Osborne, Peter, 697, 714

Ovid (Publius Ovidius Naso), 620

Pallasmaa, Juhani, 355, 504–5, 709

Panofsky, Erwin, 24, 347, 692, 694, 706

Parks, Lisa, 464–5

Penley, Constance, 723

Phillips, Patricia, 545

Philo, Greg, 465

Picasso, Pablo, 41, 136–7, 158–9, 166, 177, 189, 190, 209–11, 243, 246, 288, 367, 368–70, 378–81, 633

Pinder, Wilhelm, 694

Pink, Sarah, 540, 590, 707, 708

Pippin, Richard, 4, 202

Plant, Sadie, 688, 717, 723

Plato, 17, 23, 24, 27, 28, 62, 104, 188, 190, 327, 565, 688

Poggi, Christine, 159, 206, 208, 209, 210, 214, 288, 292, 368–9, 371–3

Pointon, Marcia, 718, 721

Polhemus, Ted, 391, 408, 421, 427, 722

Polke, Sigmar, 155

Pollock, Griselda, 19, 284, 316, 543, 546, 697, 722

Pollock, Jackson, 246

Poster, Mark, 519, 526, 686, 703, 716

Potter, Jonathan, 708

Potter, Sally, 108, 418

Pound, Ezra, 337

Preziosi, Donald, xx, 97, 156–7, 694, 710
Prosser, Jon, 590
Proust, Marcel, 354
Putnam, Hilary, 502, 508

Radcliffe-Brown, A. R., 634
Ramachandran, V. S., 608–9, 621
Rancière, Jacques, 4, 61–2, 95–6, 236, 689, 718
Rauschenberg, Robert, 170, 172, 244, 246
Readings, Bill, 9, 34, 287, 364–5, 696
Reckwitz, Andreas, 548
Relph, Edward, 22
Rheingold, Howard, 716
Richter, Gerhard, 156, 158, 203–6
Ricoeur, Paul, 67, 680
Riegl, Alois, 694, 705
Rivers, W.H.R., 540, 628, 629, 630–1, 632–4
Robbins, Kevin, 717
Roberts, John, 711
Roche, Maurice, 710
Rodowick, David N., 79, 83, 398–9, 481, 490
Rogoff, Irit, 19, 33, 41, 77–8, 547
Rojek, Chris, 703, 713
Rombes, Nicholas, 492
Rorty, Richard, 24, 105, 401, 508, 680, 691, 719
Rosa, Salvator, 160
Rose, Gillian, xx, 23, 535, 536, 542, 551, 707, 724
Rose, Jacqueline, 105–6, 108, 283, 314–15, 682, 720, 722
Rose, Niklas, 723
Ross, Andrew, 723
Roth, Nancy, xx, 284–6
Rothko, Mark, 610
Ruby, Jay, 705
Ruskin, John, 33, 167
Rynck, Patrick de, 694

Said, Edward, 721
Saito, Yuriko, 32, 696, 697
Salle, David, 155
Sandywell, Barry, xx–xxi, 3, 4, 7, 9, 11, 14, 23, 24, 31, 35, 40, 45–6n11, 46n13,

134–5, 541, 648, 649, 661, 673, 674, 689, 693, 704, 716, 719
Sartre, Jean-Paul, 119, 286, 430, 679, 686, 691
Saussure, Ferdinand de, 169, 428, 682–3, 684
Savage, Mike, 537, 572, 573, 578–80
Scarry, Elaine, 699, 700, 722
Schama, Simon, 714
Schank, Roger S., 715
Schapiro, Meyer, 706
Scheler, Max, 691
Schelling, F.W.J., 568
Schiller, Dan, 710, 716, 717
Schiller, Friedrich, 282, 298, 689
Schiller, Herbert, 396, 468
Schivelbusch, Wolfgang, 22, 353, 704
Schlesinger, Philip, 701, 709, 710
Schostakovich, Dmitri, 25
Schroeder, Jonathan, 712, 717
Schutz, Alfred, 391, 392, 427, 436–7, 438, 679
Schwartz, Frederic J., 694
Schwartz, Vanessa, 482–3
Scruton, Roger, 699
Sebald, W. G., 23, 43n1
Sedgwick, Eve Kosofsky, 322
Sedlmayr, Hans, 694
Seidman, Steven, 722
Sennett, Richard, 713
Serra, Richard, 303
Serres, Michel, 548, 690, 758
Seurat, Georges, 166
Shakespeare, William, 139, 412
Shapiro, Gary, 42, 692
Sheringham, Michael, 717
Sherman, Cindy, 284
Shields, Rob, 713
Shohat, Ella, 25, 30
Shove, Elizabeth, 713
Shusterman, Richard, 685
Sibley, Frank, 699
Silverman, Kaja, 448–9, 682, 684, 721
Silverstone, Roger, 717
Simmel, Georg, 379, 389, 390, 409, 705
Simonides, 27

Simson, Otto Georg von, 692
Slater, Don, 517, 522
Smith, Adam, 405–6
Smith, Dorothy, 722
Smith, Marquand, 701
Smith, Shawn Michelle, 723
Sobchack, Vivian, 321–2, 394, 448, 723
Socrates, 327, 620
Soja, Edward J., 12, 19, 713, 715, 723
Solso, Robert L., 690
Sontag, Susan, 8, 10, 18, 23, 28, 98n3, 393, 395, 448, 455, 520, 700, 709, 711
Sorensen, Roy, 690
Soussloff, Catherine M., xxi, 60–2, 696
Spence, Jo, 450, 713
Spencer, Herbert, 635–7
Spicer, Andrew, xxi, 398, 480, 482
Spiller, Neil, 709
Spivak, Gayatri C., 77, 316, 687
Stacey, Jackie, 703
Stafford, Barbara Maria, 10, 24, 31, 43n1, 214, 505, 609, 690, 702, 703, 714, 722, 723, 724, 725
Stallybrass, Peter, 390, 412
Stam, Robert, 25, 30, 702
Steiner, Wendy, 699
Stephens, Mitchell, 716
Stephenson, Robert Louis, 505
Stevenson, Nick, 701
Stewart, Garrett, 491
Stiegler, Bernard, 560
Storey, John, 702
Strauss, Leo, 109
Sturken, Marita, 16, 323, 361, 524, 544, 710
Sudjik, Deyan, 140–1
Sue, Eugène, 371
Sullivan, Graeme, 724
Summers, Fiona, xxi, 393, 445
Sweetman, Paul, 418, 590

Tagg, John, 393, 446, 693, 711
Tarantino, Quentin, 492
Taylor, Charles, 44n1, 680, 693, 704
Terranova, Tiziana, 7
Tester, Keith, 715

Thompson, E. P., 364
Thompson, Evan, 690
Tilley, Charles, 22
Tomas, David, 716, 717
Toulmin, Stephen, 693
Trachtenberg, Alan, 693, 711, 715
Tudor, Andy, 683, 701
Tufte, Edward R., 708
Turkle, Sherry, 717
Turner, Graeme, 701, 703
Turner, J.M.W., 145
Twombly, Cy, 244, 246
Tylor, E. B., 628

Uprichard, Emma, 583–4
Urry, John, 160, 521, 526, 713, 714, 718

Varela, Francisco J., 44n1, 722
Vasari, Giorgio, 688, 689
Vattimo, Gianni, 44n1, 685
Veblen, Thorstein, 389, 390, 408–9, 517, 518
Verbeek, Peter-Paul, 391, 393, 427, 440
Vertov, Dziga, 634
Virilio, Paul, 9, 17, 44n1, 282, 684, 685, 719
Vischer, Friedrich Theodor, 619
Vischer, Robert, 608, 619, 690
Vogel, Steven, 714

Walsh, Kevin, 715
Warburg, Aby, 694, 706
Warhol, Andy, 156, 171–2
Wasko, Janet, 719
Weber, Max, 377, 389, 578
Weber, Samuel, 191, 686
Webster, Andrew, 702, 703
Weiss, Gail, 690
Wellmer, Albrecht, 686
Wells, H. G., 407
Wells, Liz, 711
Welsch, Wolfgang, 696
White, Hayden, 706
Wiesel, Torsten, 616
Wigley, Mark, 709
Wilder, Keith, 714
Williams, Brandon, 600, 603

Williams, Linda, 721, 723
Williams, Raymond, 68, 76, 364, 396,
 469–70, 691
Williams, Rosalind, 693
Williamson, Judith, 35, 712
Willis, Holly, 488
Wilson, Stephen, 47n17, 723, 724
Winckelmann, Johann Joachim, 608, 689
Wind, Edgar, 694
Wittgenstein, Ludwig, 23–4, 106, 609, 680
Wolff, Janet, 77, 284, 317, 700
Wölfflin, Heinrich, 24, 608, 619, 694, 706
Wollen, Peter, 23, 313, 314, 697
Wollheim, Richard, 25, 698, 724
Wood, Christopher S., 694
Woodiwiss, Anthony, 708
Woods, Lebbeus, 719

Woods, Paul, 694
Wordsworth, William, 160, 220, 299
Worringer, Wilhelm, 705
Wundt, Wilhelm, 690

Xenophon, 618, 620

Yoshida, Komiko, 284, 321

Zahavi, Dan, 680, 691
Zee, Anthony, 700
Zeki, Semir, 608, 616, 690
Zielinski, Siegfried, 7, 481, 717
Žižek, Slavoj, 10, 687, 688, 720
Znaniecki, Florian, 706
Zukin, Sharon, 715
Zumthor, Peter, 709

Subject Index

Bold page references indicate chapter-length treatment of the topic.

absence, 73, 76, 83, 370, 545
 dialectic of, 296, 354
 material objects, 103, 111, 238, 430
 signifiers of, 246
 of women, 283–4, 314
absolute, 74, 127
 artist, 96
 idea of art, 97
 knowledge, 510
 relativism, 116
 space, 286, 344–5, 346
 spectator, 119
 values, 565
abstract, 25, 115ff., 520
 reason, 343
 space, 286, 693
Abstract Expressionism, 245, 695
Abstract Formalism, 695
abstraction, abstract/concrete, 25–6
 of modern life, 370–1
 see also concrete, the
act, 20–1, 544, 554, 650
action, 7, 12–13, 16, 19, 20
 seeing as, 650–1
action-based sociological research,
 589–606

advertising, 37–8, 251–2, 403–4, 517–18,
 712
 see also consumerism/consumer culture
aesthesis/aisthesis, 32, 343, 349
aestheticization, 9, 403
 of everyday life, 1, 403–4
 of politics, 403
aesthetic(s), 695–700
 classical, 42, 44n6
 commodification, 669
 contestation, 670
 demystification, 203
 distanciation, 14–15, 670
 eighteenth-century, 689
 of everyday life, 13, 389–90, 550
 experience, 510
 Greek, 618, 689
 hermeneutical, 21, 66–7, **131–51**
 hybrid, 42
 machines, 17–18
 see also visibility machines
 material/materialist, 201–2
 object-centred, 201–14, 490
 philosophical, **131–51**, 610, **674–764**,
 698–700
 political, 718–19

aesthetic(s), (*continued*)
 sociological, 705–6
 subject-centred, 148–50
 turn, 95–7
Aesthetics (G.W.F. Hegel), 29, 202, 685, 689
Aesthetic Theory (Theodor W. Adorno), 696,
 698, 699
affective intentionalities, 658
affectivity, 471–5, 657
 and art, 540
 and emotional life, 472–3, 619–20
 and empathy, 474–5, 539–40, 618, 619
 see also neural, mirroring
 and interpersonal relations, 620
agency, 516, 522–3, 526–7, 541, 573, 670–3
alienation, 125–7, 147, 281–2, 293, 520
 as *Bodenlos*, 328–30
 Cartesian, 147–8
 cultural, 149, 294–5, 378–90
 effect, 13
 as loss of being in the world, 505
 social, 293, 348–9, 449
 technological, 440–1
alterity, 123–7, 671, 690
 as difference, 671, 658
 ontologies of, 123ff., 358, 655–7,
 679, 680
Althusserian Marxism, 314, 322
Analytical Philosophy, 29, 678, 698
 of art, 698
Angel of the North, 305
anthropology, **628–47**
 cultural, 73–4, 429, 540
 and film-making, **628–47**
 reflexive, 704–5
 re-visualizing, **628–47**
 sensualizing, 637–42
 textualizing, 629–31
 and visual art, 704–8
 visualizing, 631–2
 see also ethnography
anti-aesthetics, 696–7
appearance, 14, 16, 210, 315, 507
 of being, 62
 modes of, 667
 production of, 136–7

sensory, 32, 214
 triumph of, 519
 visible, 66, 403
apperception, **426–44**
 defined, 435–7
 in phenomenology, 392–3, 427, 435–7,
 436–40
apprehending, 426–7
 as understanding, 427
 see also appresentation
appresentation, **426–44**
 in everyday life, 426–7
 and pre-theoretical knowledge, 437–40
 in Schutz's phenomenology, 392–3, 437–8
 and typifications, 437
architecture, **499–515**
 and art, 281
 and design, **499–515**
 landscape, **499–515**
 theory, 400, 709–10
art
 as dialogical field, 253–6
 and ideology, 656
 and interpretation, 656
 and its other, 171–5
 and judgement, 13, 15, 66, 95, 132, 138,
 297, 367, 512
 as knowledge, 671
 as love, 222, 304, 343, 357, 441, 489,
 649
 as reflection, 21
 and science, 43n1
 and sense-making, 20–1
 as social engagement, 21
 and technics, 560, 567–8, 569
 and value(s), 362–6, 671
 and visuality, 1–2
art, philosophy of, 357–8
art criticism, 694–5
artefact(s), 13–14, 16–17, 20–1, 656–7,
 667–8
 cultural, 82–3, 93, 109, 174, 658–9
 digital, 566, 664
 domestic, 13, 657–8
 everyday, 33, 207–8, 371, 657
 as extensions of the self, 40–1

visual, 28, 33, 36–7, 39, 73, 91, 214, 380, 393, 658
artefactuality thesis, the, 541, 656–61
art history, 540, 618, 694–700
 and British universities, 78
 and connoisseurship, 544–8
 and cultural studies, 3, 10, 80–2, 490
 new, 694, 696
 traditional, 20–1, 71–3
 and visual culture, 10–11, 696
art object(s), 2, 66–7, 131ff., 666–8, 689, 698–9
art and politics, 667, 667–8, 669–70, 718
art practice, 3, 289
 and feminism, 319–20
art theory, 695
 radical, 697
 see also art worlds
artwork, 22–3, 134–50, 545–6, 560, 668–9
art worlds, 164, 667–8
 see also historicity; historicity thesis, the
attention, 435, 617
 field of, 434–5
audience/audience research, **589–606**
 active, 535–6, 543
 videos in, 596–8
aura, 295–300, 453–4
 in art/aesthetic objects, 281
 death of, 282
 and technical reproducibility, 296–7, 461n12, 520–1, 527–8, 705–6
autonomy, 26, 208, 370
 aesthetic, 62, 70, 155, 167–8
 challenged, 70, 168–71, 175, 483–4
autopoiesis, 667–8
avant-garde(s), 21, 156, 159, 162, 172, 177, 200–1, 237, 244, 292, 313, 337, 343, 366, 372–3, 374, 375–9, 399, 484, 488–9, 694–5, 695

baroque reason, 63, 106–8
beauty
 and aesthetics, 656, 699–700
 see also aesthetic(s)
 discourse of, 656
 female, 298–9

natural, 401–2
 see also landscape
objective or subjective, 506
return of, 401, 699–700
and the sublime, 283, 298–9
theories of, 699–700
being, 20, 27, 38, 62, 64, 65, 103, 143–5, 563
 Martin Heidegger on, 62–3, 103–4
 modes of, 79, 104, 105, 161
 primordial, 123–7
being-in-the-world, 65, 104–8, 120, 121–2, 212, 321, 352, 368, 490, 505, 568, 652, 658, 671, 678, 680
bibliography of visual studies, **674–764**
Birmingham Centre for Cultural Studies, 33, 42, 317
body, corporeality, 19–20, 286–7
 body-subject, 286, 322
 body-without-organs, 352
 fashioned, 417–18
 in fashion studies, 404–22
 the grotesque, 352
 image, 20
 images of, 722–3
 multisensory, 157, 322, 351–7, 536, 642
 as object of vision, 449–50
 re-envisioning, 722
 scanners, 17, 622–3
 see also gender; sexuality
brain
 complexity of, 607, 612–13, 622–3
 dynamics, 614
 functioning, 612
 mapping, 622–3
 networks, 623
 organization, 614–15
 plasticity, 623
 scanning/scanners, 539
 structure, 623
 visualizations of, 623
 see also neural, mirroring; neural, plasticity; neuroscience
branding, 401–3, 471, 524–5
 see also consumerism/consumer culture
British cultural theory, 317, 364–5

camera, 445–63, 464–79
 as extension of the eye, 459–60n2
 lens, 634, 638
Camera Lucida, 46n13
camera obscura, 17–18, 106, 349, 665
Camera Obscura (journal), 284, 313, 317,
 318
camouflage, 136–40
 and painted surfaces, 138–42
capitalism
 and commodification, 346–7, 401–2,
 516–17
 culture of, 93–4
 as mass visual culture, 201, 202, 402
 and modernity, 159, 362–4, 518–19
 multinational, 94, 215n6, 475–6
 and nihilism, 377–81, 669, 672
 reflexive, 518, 526–9, 671
 as wired capitalism, 536, 671–2, 717
Cartesian, 30, 67, 148, 352
 dualism, 27, 104, 118, 502–3
 perspectivalism, 62, 105–6
 thought, 104–8
Cartesianism, 27–8, 116ff., 352–7
celebrity culture, 703
certainty of perception, 435
Chora (in Plato), 565–6
cinema
 digitalization of, 399
 end of, 491–2
 and metacinema, 489–90
 as spectacle, 281–2
 technologies, 15, 398–9
 see also film; film theory, film studies
cities
 and aesthetic culture, 235–78
 global, 162, 235, 241–2, 253–4
 phenomenology of, 253–4
 re-writing, 240–3, 248–9
 and urban street art, 161–3, 235–38,
 235–78
cityscapes, 713
 and social theory, 713–14
 and visual media, 713–15
collage, **361–86**
 and images of modernity, 254–6

and politics, **235–78**, **361–86**, 373–6
 see also Cubism
colour
 in everyday life, 430–5
 in Matisse, 617–18
 as non-sensory presence, 434–5
 in painting, 617–18
 phenomenology of, 434–5
 variation/variability, 242
commodity/commodification,
 see consumerism/consumer culture
commodity fetishism, **516–32**, 522–3
communications studies, 33, 285–6
communication systems, 665–6
conceptual art, 695
concrete, the, 8, 11, 14, 20–1, 25, 64–5, 67,
 95, 118, 122, 125, 203, 288, 346,
 353–7, 392, 520, 526, 540, 648,
 651, 654, 655, 660, 668, 690
connoisseurship, 535, 544–8
consciousness
 fragmenting, 503–5
 historical, 326
 of images, 648ff.
 materialized, 650
 visual consciousness, **326–41**
constitution, 572–3, 654
consumerism/consumer culture, 401–2,
 516–32
 active, 521–2
 and advertising, 401, 521–5, 712
 and capitalism, 517–18
 and commodification, 517–21
 and commodities, 518–20
 consuming images, 60, 517–18, 712
 and design, 401
 global, 16, 712–13
consumption, 404–24, 417, 516–21
 conspicuous, 409, 518
 visual, 516–17
 see also consumerism/consumer culture
context(s), 535–6
 architectural, 499–515
 biographical, 442
 cultural, 281, 483–4, 541, 649
 geographical, 549

ideological, 311
material, 311, 368–70, 400, 426–7
media, 337–40
physical/environmental, 239–41, 400
place, 546–8, 549
political, 281–2, 311, 541
social, 281, 311–12, 377–9
see also practice(s)
craft, 560–1, 665
as handiwork, 560
see also techně; touching (tactility)
crisis of art/aesthetics, 202–3, 686
critical-reflexive paradigm, 541, **648–73**
critical theory, 20, 24, 33, 670, 678, 680,
685–7
and aesthetics, 698–9, 705–6
criticism, 8, 546–8
critique, 29, 552–3
as defamiliarization, 41, 282, 287, 393,
441, 552–3
as distance, 553
as engagement, 553–4
of everyday life, 282, 392–3, 441, 550
as intervention, 552–3
in visual studies, 542, **542–58**
Cubism, **200–19**, **361–86**
collage (synthetic Cubism), 158–9, 200–1,
201–15, **361–86**, 364ff.
and modernism, 23, 366–7, 695
and modernity, 158–60, 362–3, 633
cultural
analysis, 68–89
anthropology, 3
constellations, 35–6, 553–4
geography, 6, 29
praxis, 651
theory, 674–764
turn, 70–1, 315–17
see also bibliography of visual studies
culturalism/cultural relativism, 116, 117,
130, 508
Cultural Studies, 3, 4–5, 33, 35, 46n12,
674–764, 700–4
culture
defined, 667
as disembodied, 670

as embodied meaning, 667
everyday, 666–7
low and high, **164–83**
as memory, 651–2, 714–15
phenomenology of, 667–8
in ruins, 363–6
as way of life, 68, 364
culture industry/cultural industries, 4, 6,
84n2
global, 670–3
cultures of visibility, 22–3
see also visibilization; visual culture
cybercommunity, 716–17
cyberculture, 672–3
studies, 6, 715–18
see also digital; digitalization; new media;
technoculture
cybernetics, 561–2, 671
cyberspace, 5, 9, 10–11, 693, 716
cybervisuality, 716
cyborg, 536
and biopolitics, 723
culture, 536, 723
see also cyberculture

Dada, 239, 246, 668
and street art, 238–41
Dasein, 104–5
death
of art, 215n4
of the author, 156, 170, 176
of cinema, 480
Deconstruction, 11, 29, 33, 684–5
in visual theory, 685
defamiliarization, 13–15, 16, 41
in art/aesthetics, 41–2
of everyday life, 15–16
denigration of vision, 9, 51, 88, 111, 129,
343, 519, 632, 692, 703
description/the descriptive turn, 537, 573,
572–88
design/graphic design, **405–25**, **499–515**
and advertising, 712
and art, 709–10
the art of, 131–51
critical, 513–14

design/graphic design, (*continued*)
 discourse, 512–14
 pedagogy, 502, 506–7
 philosophical basis of, 400–1
 practice, 500–2, 512–13
 pragmatic approach to, 140–50, 401, 506,
 508
 the process, 502, 510–12
 see also fashion, fashion theory, fashion studies
designed environments, **499–515**
desire, 668–9
diagram/diagrammatics, 651–2, 709
 diagrammatization, 666–7
 diagrams in visual research, 592–3
 and drawings, 592–3
dialectics, 26–7
 the dialectical turn, 97
 in the work of Flusser, 285–6
dialogical, dialogism, 28, 33, 131–2, 163
 and street art, 240–1
 see also hybridity/hybridities
dialogics of seeing, 28, 64, 115–30
dialogue, 285–6, 337–40, 629–30
Dichtung, 652
Dictionary of Visual Discourse
 (Barry Sandywell), 693
differance, 77, 363
difference, 30–1
digital
 the age, 559ff., 561
 and analogue, 16–17, 393, 447, 536,
 559–60
 art, **164–83**, 536–7, **559–71**
 cinema, 480–98, 487–9
 culture, 458–9, 559–60
 data, 6–7, 559–60, 574–5
 empires, 468–9
 film aesthetics, 487–9
 imaging, 403–4, 717
 imperialism, 467–9
 media, **445–63**, **559–71**
 mediations, 525–9
 objects, 334–7, 459, 576–7
 revolution, 1, 9–10, 11, 18, 161–2, 403,
 719
 sharing, 451–4

studies, 701–4
 see also new media
digitalization, 47n16, **559–71**
 and consumer culture, 525–9, 715–16
 and everyday life, 536, 537
 and feminist cultural studies, 321
 global, 403–4, 572–3, 715–18
 and photography, 452–4
 process, 585, 559–71, 572–88
 and television, 464–5ff.
disciplinarity, 3, 86n10, 92, 133, 195–6
 as conceptual construction, 650
 see also interdisciplinarity
discourse, 19–20, 24–5, 535
 analysis, 29–30, 285–6, 535–6, 553–4
 networks, 30, 285
 see also text
disembedding, 377–9, 383–4n30
 radical, 378–9
Downcast Eyes (Martin Jay), 9, 80, 105–7,
 111, 129, 343, 691–2
dualism, *see* Cartesian
duality, 503

ecophilosophy, 6
eidos, 104
ekphrasis, 26
electronic age, 36, 717–18
 see also surveillance/surveillance society
embodiment, 18, 20, 321–2, 448, 564–5
 and fashion, 405–6
 and the gaze, 119, 448–9
 and identity, 20, 448–9
 and photography, 448–9
 and pleasure, 471–5, 668–9
 and research, 536
empirical sociology/social research, 537,
 573
 crisis of, 573–4
empiricism, 312, 579
Enlightenment, 4, 21, 24, 41, 73, 116, 187,
 192, 299, 347, 349–50, 686, 691
epic theatre, 668
epochalism, 537, 572–3
epoché, 285, 658
essence, 692

ethics, 5, 35, 96, 97, 192, 195, 331, 590, 653, 656, 658
ethics of seeing, 591–2, 658, 681, 700, 707
ethnographic methodologies, 391, 407–8
ethnography, 23, 391, 554
 of everyday life, 391, 550–2
 reflexive, 540–1, 552–4
 of seeing, **589–606**, **628–47**
ethnomethodology, 14
Euclidean geometry, 347, 693
Eurocentrism, 8–9, 34, 42, 193–4, 196n2
everyday artefacts, 40
 see also artefact(s)
everyday life, 669–73
 as 'home', 329, 346, 486
 theories of, 673
 as topic and resource, 15–16, 673
 transformation of, 673
everydayness, 13, 33
 as invisible, 13
 as topic, 15
evidence, 18, 74, 105, 138, 458, 482, 514, 619, 637, 690, 707, 708
experience
 and brain plasticity, 613
 as culture, 391, 393, 427, 648, 652
 phenomenological, 19, 20, 26, 119, 121, 174, 238, 344, 351, 400, 437, 490, 592, 596–7, 600, 678–9, 704
 of the visual, 77, 471–5
eye, 426–7, 458–9, 607–8

fashion, fashion theory, fashion studies, **405–25**
 and class differences, 390, 405–6
 and dress, 405–25
 and globalization, 419–22
 history of, 389–90, 407–9, 410–12
 and identity, 389, 390–1, 404–7, 412–15
 neglect of the visual in, 416–17
 and social status, 405–6
 theoretical perspectives, 389, 409–18, 710
fashion business/industry, **405–25**
Fauvism, 695
feminism, **310–25**
feminism and visual culture, **310–25**

feminist
 aesthetics, 310–25
 art criticism, 321
 art history, 315–17
 art practice, 319–20
 art theory, 8, 310–25
 critique, 591–2, 670
 visual culture theory, 8, 20, 35, 283, 310–23
fetishism, 522–3
figure, *see* body
film, **480–98**
 and modernity, 482–4
 and visual culture, 489–90
film theory, film studies, **480–98**
 crisis in, 480–2
 feminist, 312–14
 multi-national, 398–9
 turn to history, 482–4
 and visual culture, 4, 10, 34
form
 generating, 511–12
 as Gestalt, 430–5
 politics of, 371–3
 significant, 29
 as structure, 1, 5, 13, 29, 85–6
formalism, 166, 695
frame(s), framing, 104–5, 368–70
 reframing, 184–6, 368, 666–7
functional magnetic resonance imaging (FMRI), 17, 608, 665
functions, 38
fusion of horizons, 45–6n11, 66–7
Futurism, 281, 290, 291–2

gay and lesbian studies, 678, 721
gay culture/queer visualities, 721–3
gaze
 in art history, 318–19
 female, 318, 722
 in film studies, 318–19
 male, 102, 119, 283, 318
 photographic, 394, 448–9
 theory of the, 314–15, 318–19, 722–3
 see also look(ing); seeing

gender, **290–309**
 politics, 283, **290–309**
 studies, 21, 29, 310–11, 721–2
 in the visual field, 310–23, 721–3
 see also feminism
gendered visual experience, 21, 311–12, 721–3
genealogy, 649, 680, 692
geodemographics, **572–88**, 581–5, 583–4
geodemographics industry, 581–2
geography, 3, 5, 6, 29, 243, 282, 311, 329,
 446, 707
Gestalt, 119, 126–7, 427, 430–1, 434
Gestalt theorists, 427, 430–1, 434, 690
Gestell (frame), 104, 349, 666
gestures, 330–3
 grafitti as critical, 235–78
globalization, 1, 4, 9, 10, 16, 40, 78–9, 97,
 311, 475–6, 536, 562–3, 671–2
Google, 671, 672
Google Earth, 562, 570
graffiti
 New York, 238–41, 241–2
 and street art, **235–78**
 see also street art
grammar, 661
 cultural, 661
 of images, 661–2
Guernica (Pablo Picasso), 189
Guerrila Girls, 320, 324

hegemony of vision, 9, 347, 668, 675, 680,
 689, 692
hermeneutical aesthetics, **131–51**
hermeneutic interpretation, 21
hermeneutics, 21–2, 66–7, **131–51**, 678,
 680–1, 691
 context-sensitive, 535–6, 540–1
 Gadamerian, 29
 Heideggerian, 25, 29
 Materialist, 705
 ontological/philosophical, 66–7
hermeneutic theory, **131–51**
heteroglossia, 8, 28
historicity, 9, 29–30, 44n10
historicity (of seeing and visual knowledge),
 648–73

historicity thesis, the, 9, 541, 648–56
history, 8, 10, 63, 82, 90–1, 192–3, 326ff.,
 648–56
 of aesthetic objects, 10
 of art, 82–3
 representations of, 715
 of scopic regimes, 63–4, 102–14
Hollywood, 398, 480–1, 668
 industrial system, 398–9, 400, 485–6
hybridity/hybridities, 161–3, 491–2
 cultural, 235–8, 491
 and globalization, 235, 687
 and street art, 161, **235–78**, 235–8, 240
 see also street art
hyperreality, 60, 447

icon, 21, 24, 26, 109, 140, 434, 654, 660–1,
 662–3, 664, 668, 671–2, 673,
 683
iconic turn, **200–19**
 see also Cubism
iconography, 27
identity, 18–20, 722–3
 visual, 703
ideographic/nomothetic, 694
ideology, 5, 24–5, 70, 135, 184, 283, 525,
 655–6, 691
image(s)
 Bild, 103, 104, 139, 286, 338, 355
 configurations, 27, 36–7, 658–9
 consciousness, 648ff.
 consuming, 517–18
 Cubist, 200–19, 361–86
 digital, 717
 haecceity of, 6, 23, 384n32, 544
 history of, 71–3
 image-based research, 24ff.
 in/as memory, 451–2, 714–15
 materiality of, 429, 542, 653, 665–6,
 668
 ontology of, 37, 66–7, 91–2, 529–30
 phenomenology of, 662
 politics of the, 667, 717–23
 production, 37, 91
 regimes, 24–5
 technologies, 91

imaginary, 39, 91, 103, 161, 207, 251, 318, 485, 489, 652, 654, 657–8, 668, 671, 679, 692, 693, 713, 718
imagination, 430, 651–2
 visual, 693
imagined communities, 469
imagineering, 31, 712
 industries, 671–2, 712–13
 virtual, 32, 671
 visual, 42–3, 670–3
Impressionism, 695
in-disciplinarity, 672–3
informatics, 526–9
information
 arts, 47n17
 ontological, 572–3
 systems, 40
 visual culture as, 529–30
institutional turn, the, 1–3
institution(s)
 aesthetic, 2–3
 social, 18–19
 systems, 464–5
 visual, 702–3, 710–13
intentionality, 22, 24
intercorporeality, 342–60, 678–9
interdisciplinarity, 3–4, 10–11, 34–5, 83–4, 93–4, 164, 541, 674
 see also transdisciplinarity
International Visual Sociology Association, 706
Internet resources, 677
Internet studies, 6, 669, 673
Interpreting Visual Culture (Ian Heywood and Barry Sandywell), 7, 9, 35, 42, 43n1, 134–5
intersubjectivity
 in everyday life, 437–9
 neural basis of, see neural, mirroring
 in philosophy, 115ff., 126–7
 see also alterity
intertextuality
 and authorship, 176–7
 see also text

journals in visual culture, 676–7

knowledge, 20–1, 24–5, 42–3, 74, 77, 642, 706–7
 figures of, 74–5
 models of, 502–3
Kunstwissenschaft, 694

Lake District (the English Lake District), 220–34
landscape, 220–34, 499–515
 architecture, 499–515
 and art, 160–1
 and the picturesque, 222–5
 representations of, 22
 and Romanticism, 160, 220–2
 and the sublime, 222–5
language, 401–2
 of art, 662–3, 694–5
 of design, 513–14
 everyday, 401
 field of, 661
 metaphor of, 427–9
 of photography, 663
language thesis, the, 541, 661–5
Lego, 538–9, 600–2
leisure, 713
 industries, 713
life-style, 389, 403, 420–22, 471–5, 520–21, 524
 see also consumerism/consumer culture; design/graphic design; fashion, fashion theory, fashion studies
life-style television, 473–5
life-world (Lebenswelt), 193, 285
 life-worlds, 19–20, 35, 40, 537, 649
 structures, 436–7
linguistic perspectives, 3, 6–7, 24, 74–5, 391, 401, 427–9
linguistic turn, the, 24, 205–6, 400–1
literacy, literate culture, 326–41
 visual, 714
 in visual culture, 716
literary theory, 3
logocentrism, 2
 see also text
Logological Investigations (Barry Sandywell), 45n10, 46n13, 692, 693

look(ing)
 everyday, 552
 as social act, 536, 553–4
 at things, 542

map, map-making, mapping
 cognitive, 30
 informational, 582–3
 neural, 539
 and power, 18
 visual research/theory, 674–764
 see bibliography of visual studies
mapology, 609–10
Marxism, 29–30, 33, 35, 283, 312, 671,
 678, 685–7, 698, 705
 Althusserian, 20, 70, 314–15,
 322
 British, 33, 317, 364
 critical, 23–4
 Gramscian, 33, 42
 post-, 519–21
 Structural, 20
mass communication(s), 665–6
material, materiality, 22
 of art, 22–3
 of culture, 499–514
 of everyday life, 402–3
 things, 426–44
 of visual experience, 440–2, 653
media
 globalized, 9, 670–3, 715–18
 history of, 327–8
 as instruments of self-understanding,
 39–40, 40–1
 mixed, 25, 671–3
 transformations, 665–7, 670–1,
 673
 ubiquitous, 526–9, 673, 717
mediascapes
 and global flow, 396–7, 469–71
 see also cityscapes
media theory/studies, 10–11, 33
mediation, 34, 381, 438–9, 442, 517–18,
 596, 642, 650
 digital, 525–9
memory, 74, 451–2, 651

metaphor
 of language, 427–9
 of mind, 691–2
 in social research, 539, 599–602
metaphors of seeing, 538–9
metaphysics of presence, 350
methodology
 creative visual, 538–9, 589, 591–2, 706–8
 hegemonic, 543
 immanent, 22–3
 implicit, 525, 543–4, 544–8
 practice-based, 535
 reflexive, 26–30, 535, 538, 589
 strategic, 1, 5, 7, 25–6, 30, 36, 38, 39, 97,
 133, 244
 as topic, 535, 542–4, 555n1
methodology, interactive/creative, 538,
 589–606, 706–8
 see also reflexivity
Microsoft, 671, 672
militarization of visuality, 719
mimesis, 24, 286, 540
mind-body dualism, *see* Cartesian
Minimalism, 695
mirror, mirroring, 29
 in art, 29, 411
 in Greek culture, 618, 620–1
 in human behaviour, 618
 as metaphor, 19, 29, 105, 126, 411, 536,
 666, 691
 of nature, 105, 691–2
 neurons, 25, 539, 540, 608, 613, 618,
 619–20, 621
 see also neural, mirroring
modernism, 4, 5, 21, 165ff., 177–80, 295–6,
 373–5, 377–9
modernist art, **164–83**
 and visual culture, 164–83
modernity, 102–14, 377–9, 383n28
 as the age of the world-picture, 103–8, 350
 and culture, 42, 362–3, 377–9
 images of, 376–9
 and visual culture, 186–90, 287–8, 693
morph/morphing, 487–8
mountaineering, **220–34**
 and the picturesque, 222–5

and spectacle, 160, 229–32
and the sublime, 222–5
and visual experience, 160–1, 225–7
multidisciplinary visual studies,
 see interdisciplinarity
museological space, 184–99
see also museology
museology, **184–99**
 crisis in, 184–99
 and cultural studies, 21, 14–15
museum(s), **184–99**
 and archiving, 178, 179, 710
 and collecting, 313, 320, 390, 710
 as cultural memory, 184–99
 and curatorship, 178, 204, 235, 239, 247,
 336, 410, 457, 707, 710
 and modernity, 186–7
 as a social institution, 18–19
 as topic of cultural analysis, 184–99

nature
 as object, 714
 as spectacle, 715, 220–34
nature envisioned, 658, 714
Neo-Kantianism, 67, 132–3
neural, 539
 mirroring, 539–40, 613, 618–22
 plasticity, 539, 613, 614–18
neuroaesthetics, 539, **607–27**, 610
neuroarthistory, 43n1, 539, 540, 609
 see also neuroaesthetics
neurophysiology, 653–4
neuroscience, 539, 607, 622–3, 653
 applications, 612–13
 history, 608–11
 photography 43n1
 research, 611–12
neuroscience and visual culture, **607–27**
new media, 2–3, 321, 395–6, 398–9, 475–6,
 481–2, 536, 664–5, 670, 715–18
newspapers, 371–3
New Visual Studies, 3–7, 35–41, **90–101**,
 648–73, 648, 652, 673
 dimensions of, 35–41, 648–73, 672–3
 see also reflexive visual studies/self-reflexive
 visual studies; reflexivity

object
 constitution, 572, 654
 fields, 666–7
 theoretical, 665
objectify, objectification, *see* alienation
objective world
 phenomenology of, 436–7, 438
objectivity, 437–8, 509–10, 629–30
observation, 629
 disembodied, 637
 ethnographic, 628–9
 objective, 509–10, 629
 see also seeing
ocularcentric, ocularcentrism, 24–5, 119–20,
 286, 669–70
 consumer, 518
 see also scopic regimes
ocularphobia, 401, 504
Ordinary language philosophy, 678, 680
Orientalism, 687
Other, the, *see* alterity
others
 pain of, 454–5

painting, 17, 201–14, 357–8, 378–81
pantograph, 157, 188–90
paradigm(s), 7, 8, 10, 15, 18, 21, 24, 26,
 32–3, 34, 40–1, 70, 93, 116, 119,
 126, 147, 160, 168, 175, 205, 235,
 312–14, 322, 485, 513–14, 521, 541,
 590, 609, 623, 648–73, 700, 706–7
perception
 as apperception, 427–9, 430–5
 see also apperception
 as embodied process, 427ff., 434–5
 as field of presence, 434
 as intelligent practice, 499, 509–10
 as interpretation, 499–500, 508–9
 multisensory, 286, 322, 351–7, 642
 as privileged sense, 24–5, 343
 reworking, 508–10
 as seeing, 24, 426–7, 630–1
 as temporal, 649–50
 theories of, 502–3
 as world appropriation, 344, 649
 see also sense-perception

perception, phenomenology of, **115–30,
 426–44**
 philosophy of, 115–29, 440–1, 502–5,
 690
performance, performativity, 11–12, 91–2,
 535–6, 548–53, 549–60, 642
period eye(s), 22, 608, 692
perspectivalism, 62–3, 105, 106, 119–23,
 128
perspective(s), 649–50
 metaphysical, 186, 502–3, 508, 513–14
 pragmatic, 441, 502ff., 506–7, 514
 Renaissance, 348–9, 539
 theoretical, 68–89, 674–764
phallocentrism, 665
phallus, 665
 and power, 665–6
pharmakon, 196n2
phenomenological reduction (*epoché*), 285,
 331–2
phenomenology, 14–15, 22–3, 391–2, 540,
 622, 678–80, 691
 classical (Husserlian), 14, 24, 29, 392–3,
 678
 embodied, 20
 of everyday life, 391
 existential, 440–1
 Flusser's, 331–3
 material, 657
 Merleau-Ponty's, 64–5, 115–30
 post-, 693
 Schutz's, 426–44
 social, 20, 392
Phenomenology of Perception (Maurice
 Merleau-Ponty), 115–30
philosophy, 10, 347–8
 ancient, 327, 343, 688
 of art, 33, 193, 698–9, 705
 modern, 674–764
 multisensory, 540, 642
 of perception, 64–5
 of reflection, 64–5
 and visual culture, 10–11
 Western, 23–4, 502–3, 560, 649, 692
photographic image, 18, 285–6, 660–1
photography, **445–63**, 711

digital, 37, 393, 447
 as document and witness, 446, 454–5
 everyday, 18, 447–51
 and everyday life, 37–8, 447–51
 family, 450–1, 536, 551–2
 and fashion, 405–25
 history of, 15–16, 327–8
 and ideology, 446–7
 as memory/memorializing, 450–4,
 455–8
 and power, 446
 semiotic analysis of, 446–7
 social functions of, 448–51
 tourist, 451, 714
 in visual research, 445–63
photojournalism, 711
pictorial
 arts, 32–3
 signs, 74–5
 turn, 9, 23–31, 44n8, 69–70, 158–9,
 205–6, 216n13
 also see visual turn, the
pictures, 60, 69, 74, 78, 165, 288, 300, 335,
 364, 371, 376, 426, 438, 537, 562,
 593, 631ff., 693
place(s), 22, 547–8, 549
 see also context(s)
pleasure, 397, 668–9
 economy of, 657
 viewing, 397–8, 722
poiesis, 651–2, 665–6
point of view, 122, 126, 213, 316, 363, 393,
 434–5, 446
political thesis, the, 541, 669–70
politics, 4, 24, 373–6, 546, 666–7, 669–70,
 717–18
 cultural, 42–3, 86n11, 669
 defined, 718
 new social movements, 718, 719–23
 politics of vision, 11, 24–5, 32–5,
 546–7, 667, 669–70, 718–19,
 719, 720–23
pornography, 318–19, 348, 722–3
postcolonialism, postcolonial theory, 678,
 687
postdisciplinary, 3–4, 6–7

postmodernism, postmodernization, 4, 5, 8–9, 15, 94–5, 156, 38n2, 572–3, 668–9, 678, 687–8
 see also epochalism
postmodernity
 and visual culture, 8, 34, 78–80, 86n9, 93–4, 196n1, 361–2, 519–21, 668, 687–8
postocular theory, 703–4
post-phenomenology, 441
post-photography, 447
 see also photography
post-postmodern aesthetics/visual culture, 34–5, 254–6
poststructuralism, 29, 42, 540, 678, 684–5
power, 548, 692
 and knowledge, 548–9, 692
 relations, 554
practice-oriented methodology, 525–6, 548–53, 552–4
practice(s), 2–3, 36–7, 548–53
 constellations of, 553–4
 defined, 548–9
 of everyday life, 6–7, 35–6, 235–78
 methodological, 525, 548–9
 as multidimensional networks, 651
 situated, 525, 548
practices of seeing, 14–15, 16–18, 19–20, 139–40, 310–11, 430–5, 441–2, 544, 548–9, 648–56
Pragmatism, 680
praxis, 441, 651, 665–7, 670–1
 see also practice(s)
presence, present, 37, 434, 441–2
 as co-presence (appresentation), 437–9
 embodied, 540
 as visibility, 37–8
 see also embodiment; perception; visibility
prosthetic identities, 723
Prosthetics, 18–19
psychoanalysis, 33, 283, 312, 348, 681–2
 Lacanian, 33–4, 342, 449
psychoanalytic theory, 33, 312–13, 678
public art, **235–78, 290–309**
 and architecture, 281, 303–6, 555n5
 and space, 710
 see also street art

public sphere(s), 669
 interactive, 342–60
 intimate, 354, 397–8, 454, 473
 re-envisioning, 724–5
 and street art, **235–78**
 see also street art

Queer Theory, 678, 721–3
Questionnaire on Visual Culture (*October* 77), 42, 84–5n3, 167, 180, 196n1

'race'
 and ethnicity, 719–20
 in the visual field, 720–1
racialized seeing, 720
reading, 37–8, 427ff.
 as critique, 248–9
 as interpretation, 37
 and seeing, 37, 427–8
realism, 509
 common sense, 509–10
reality, 24
reality television, 397, 473
real virtuality, 32
reflection, radical, *see* social theory
reflection, reflective
 analytical, 356–8
 hermeneutical, 21
 hypochondriacal, 202–6
 phenomenological, 115–30
 philosophy of, 115–30
reflective distance, *see* defamiliarization
reflexive praxis thesis, the, 541, 670–73
reflexive sociology (Bourdieu), 288
reflexive visual studies/self-reflexive visual studies, 2–3, 5, 8–9, 11–12, 23–4, 72–3
reflexivity, 5, 23, 535–6, 550–2
 critical, 541
 logological, 45n10
 methodological, 535–6
 systematic, 38–9
remediation, 474–5
Renaissance, 390, 539, 688
 aesthetics, 21, 348–9, 617, 663
 Florence, 539, 617
 humanism, 692

Renaissance, (*continued*)
 Venice, 539, 617
 visual space, 693
representation, 24, 29, 211–14, 286,
 517–18, 691
 critique of, 525–8, 529–30
 modes of, 20–1, 715
 origins of, 540
 and politics, 525–530
representationalism, 21, 27, 29
reversibility, 119–23, 125–6, 127
rhetoric(s), 29–30
 visual, 29, 708–9
rhetorics of the visible, 30
Roman art industry, 705
Romanticism, 21, 116, 351
Romantic poets, 33, 160

science
 as seeing differently, 650–1
 vision in, 80, 322
 vision in the history of, 690–1
scopic regimes, 19, 47n16, 62–4, **102–14**
 competing, 111
 history of, 691–3
 multiple, 108–11
 pre-modern, 692–3
scopic regimes revisited, **102–14**
Screen (and *Screen Education*), 317
screen/screen culture, 395–60, 717
seeing, 12–15, 426–7
 biomechanical accounts of, 426–7
 as dynamic, 650–1
 as learned behaviour, 510
 as map-making, 652
 as meaning-making, 648
 as performative act, 650
 as signifying event, 649–50
 ways of, 391–2, 716–18
self, 11, 40, 654
 aesthetic of, 95
 analysis, 11–12
 haptic continuum of the, 355
 implied self, 18–19
 see also subject, subjectivity
self-cognition, 654–5

selfhood, 19–20, 157, 394, 655
self-reflection, 11, 541, 550–2
self-relation, 652
 see also reflexivity; selfhood
self-transformation, 652
semiology, 35, 410, 427, 682–3
 analysis of meaning, 415–16, 427–8,
 553–4
 and visual meaning, 416, 428–9, 544–5
semiotic(s), 3, 20, 33, 35, 155, 312, 317,
 392, 517–18, 670, 678, 682–5
 see also semiology
sensation(s), 436, 504–5, 642
 distribution of, 718
sense-perception, 342–60
senses, 11, 84n1, 286, 353–7
 and intelligence, 499–500, 503–5
 interrelated, 640–2, 652
 measuring the, 634–7
 multiple, 642
sensory
 environments, 503
 interface, 504, 505
 revolution, 11
 totality, 84n1
 turn, 20, 639–40
sexuality, 348–9
 see also gender
shock, 41, 291–2, 654–5
 see also defamiliarization
sight
 as privileged sense, 115, 650
 see also hegemony of vision; senses
sign
 pictorial and linguistic, 74–5
signifiers, 169–70, 427–9, 682–3
simulacrum/simulacra, 116
singularity, 23, 98n4
 of art, 22–3
 as event, 544
 as exception, 669, 671
 as unique individual(s), 669
situated
 acts of seeing, 544
 imagination, 652
 practices, 535–6

situation, 544
Situationism, 98n1, 162–3, 239, 281, 290
 and revolution, 240–1
 and street politics, 162, 239
 see also Dada; *Society of the Spectacle*;
 street art
skills, 509–12, 514
 see also craft
social class, 719–20
 images of class/class difference, 719, 720,
 723
social construction/constructionism, 609,
 652–3
 of art and artefacts, 40
social media, *see* new media
social relations, 658–9
 see also practice(s)
social theory
 radical, 665–7, 672–3
society, 76–7
 visual constitution of, 76, 572, 654,
 665–7
Society of the Spectacle (Guy Debord), 31, 61,
 79–80, 115–16, 281, 282, 292–5,
 520, 671–2
 and alienation, 293
 see alienation; Situationism
sociocultural thesis, the, 541, 667–9
sociological imagination, 579–80
sociology, 33, 537
 commercial, 538, 578–80, 581–3
 doing visual, 705–6, 706–8
 reflexive, 541
 sociology of art/aesthetics, 78–9
 sociology of visual culture, 704–8
sociology of the spectacle, **290–309**
space/spatiality, **342–60**
 absolute, 345–6
 and *Chora*, 565–6
 concrete and abstract, 343
 disembodied/homogeneous, 693
 and embodiment, 287, 343–5
 geometric, 287, 347–50, 663, 693
 and heterotopias, 346ff.
 isotropic, 693
 and landscape, 500–2

lived, 19, 22, 344ff.
mountain, 220–34
 see also mountaineering
optical, 347
phallic, 287, 348
the production of, 19, 249–53, 342–58,
 342–60
social, 286
uniform, 693
urban, **235–78**, 240–3, 376–81
spectacle, **290–309**
 cinematic, 300–2
 consumer, 519–20
 interactive, 303–5
spectator, spectatorship, 10, 19, 20, 80,
 290–309
 in film, 480–98
 in mountaineering, 220–34
 in television, 464–79
 in visual studies, 10, 80
specular, 24, 65, 78, 119, 127–8,
 689
specularization, 9, 78
specular society, 5, 32
spimes, 537, 577–8
street art, **235–78**
 and art sub-cultures, 236–8
 genealogy of, 238–41
 politics of, 254–6
 as surface aesthetic, 240–3, 244–5,
 248
 as urban culture, 250–4
 and visual culture, 238–41, 249–53
 see also graffiti
Structuralism, 3, 20, 29, 33, 427–9,
 682–5
Structural Marxism, 20
structures of phenomenality, 649–50
subject, subjectivity, 19–20, 39–40, 449,
 553–4
 and misrecognition, 449
 and object, 125–6, 353–7, 508
 and reflection, 449, 550–2
subjectivation/objectivation, 18–19, 20, 39,
 354
subject-object dualism, 115–30

sublime, the, 282, 295–300
 technological, 299–301
 see also beauty
substance, 38, 123, 213, 511
Surrealism, 286, 343–4
surveillance/surveillance society, 10–11,
 80–1, 717
symbolic/symbolism
 goods, 520–1
 Schutz's theory of, 393, 439–40
symbolpoiesis, 658, 664
synaesthesia/synesthesia, 18, 25

Tate Modern, 178, 179, 254, 283
technê, 665–6
 see also technopoiesis; technopoiesis
 thesis, the
technoculture
 global, 9
 see also digital; digitalization
technology, 9, 11, 14, 322, 484–7, 665–7
technopoiesis, 665
technopoiesis thesis, the, 541, 665–9
telepistemology/telerobotics, 717–18
television, televisual media, **464–79**
 Americanization of, 467–9
 in everyday life, 464–79
 as global visual medium, 395, 464–7
 as mass communication, 469–71
temporality, 649
 see also time, temporality
text, 445, 629
textual bias (of cultural studies), 6, 24–5,
 86n6, 391, 540, 629, 692
textualism, 6–7, 85–6n5, 391, 540, 547–8,
 629, 629–31, 692
textuality
 and vision, 39–40
theatre, film and television studies, 3
theoretical frameworks, 30, **68–89**, 678–88
theoria, 24, 333
'Theory', 3–4, 42–3, 59–60, 155, 169–70,
 196n1
theory wars, 3, 34
Timaeus (Plato), 565–6
time, temporality, 19–20, 430–5, 649–50

touching (tactility), 536, 619, 636
 as primary sense, 560
tourism, 160, 161, 221, 483, 501, 714
tourist gaze, 160, 714, 222–3, 714
traditions, theoretical, 68–89, 674–764
transdisciplinarity, 541, 666, 718
transdisciplinary
 approaches, 4–5, 6–7, 541
 concepts, 4, 541, 666, 672–3
 future of, 670, 672–3
 research, 41–3, 673, 718–23
 visual analysis, 1, 41–2, 673
transformations, 5–6, 541, 666–7, 670–1
transverse problematics, 11–12
truth
 content, 669
 photographic, 336
 subjective and objective, 503
 universal, 506, 509–10
 visual, 509
Truth and Method (Hans-Georg Gadamer),
 147
truths, *see* perspective(s)
typifications
 as appresentation, 436–7
 in everyday knowledge, 437
 see also apperception
typography, 697–8

unconscious, the, 18
 cultural, 507
 optical, 109, 458
 unoptical, 632–3
university, 11, 34
 critiques of, 94–5, 135–6, 287, 364–5
University of London, 628
University of Rochester (USA), 313, 321
University of York (UK), 47n17
ut pictura poiesis, 27

value(s)
 in aesthetics, 94–5
 in art, 362ff., 671
 cultural, 5, 362–4
 judgements, 505
 in social life, 362, 420–2

videological bias, 669

viewing, *see* look(ing); spectator; specular

violence, 67, 143, 246, 319, 348, 371, 456, 634, 650, 660, 692, 700, 701

virtual existence, 37

virtualization, 32–3, 37, 716–18
 see also digital; digitalization

visibility, 249–53
 conditions of, 16, 33, 76, 80, 231, 237, 653, 656–7, 666, 668
 contest of, 249–53
 as field, 1–56
 as topic of visual studies, 1–56

visibility machines, 15–19

visibilization, 15–18

Visible and the Invisible, The (Maurice Merleau-Ponty), 23, 90–1, 117ff., 120, 126, 128, 129, 679

visual art, 7–8

visual construction of the social field, 16, 76, 609

visual consumption, 402, **516–32**, 517–18
 see also consumerism/consumer culture

visual cortex, 539–40, 611, 615–16

visual culture, 2–3, 22–3, 31–5
 defined, 34–5, 75–6, 80–2, 91, 135–6, 311, 491
 field of, 1ff., 10, 12–15, 91–2
 history of, 668–94
 redemptive value, 90–101
 resources in, **674–764**, 675–7
 Western, 692–3

visual engagement, 19–21, 22

visual inscription devices, 537–8, 580–5

visual intelligence, 499–515
 in everyday life, 12–13, 310
 as practical skills, 13, 509–10
 in practice, 430–5

visuality, 2–5, 7, 12–13, 115–29
 hegemonic, **342–60**, 355–8, 503–4, 669–70
 in Merleau-Ponty, **115–30**
 ubiquitous, 516–17, 717–18
 see also visualization; visual theory; visual turn, the

visualization
 of the brain, 607–27
 in culture, 541, 655–8
 internal, 75
 logic of, 347–50
 methods, 573, 580
 regimes, 668
 techniques, 580, 665–7

visual life
 as embodied, 19–20
 see also embodiment
 and learned behaviour, 13
 neural basis of, 607–27
 plasticity of, 607–27

visual media
 as languages, 427–9

visual metaphor(s), 538

visual methodology, **542–58**, **589–606**
 creative, 538–9, 591–3, 706–8
 film/video making, 593–4, 596–8
 mixing methods, 598–9
 photographs in, 593–4
 sociological, 537–8, 589–90, 707–8
 telling stories in, 594–5

visual pedagogy, 724

visual performance, 21–2
 see also performance, performativity

visual production and consumption, 417, **516–32**, 518–21

visual quality/qualities, *see* phenomenology

visual regimes, 718–19
 social history of, 691–3
 see also scopic regimes

visual sociology
 emergence of, 589–90

visual studies, 1–10, 31–5, 310–11
 bibliography, 541, **674–764**
 interdisciplinary, 34
 object oriented, 538–9

visual technologies, 14, 15–18, 665
 as apparatus, 16, 334–7, 665–7
 everyday, 35–6
 history of, 14, 656–7
 and scopic regimes, 693
 specialized, 665–6, 693
 see also visibility machines

visual theory, **1–56**, **68–89**, **674–764**
 mapping, **674–764**
 traditions of, **674–764**, 678–87
visual turn, the, **68–89**, **90–101**, **102–14**
 and interdisciplinarity, 3–6, 34–5
 and postmodernity, 5, 18–19
 and visual research, 23–31, 69–70

wallpaper, 371–3
walls
 cultural walls, cultural wall system, 241,
 243, 247–8, 252, 254–5
 as sites of art, 237, 238–41, 243–4, 245
 see also street art
war, 719
 see also militarization of visuality
Ways of Seeing (John Berger), 8, 718
Web/Web culture, 32–3, 162–3, 561–2
Web 2.0, 452–3, 528–9, 536, 538, 575, 585,
 661, 672–3
Welt, 103ff.
Weltanschauung, 103
Weltbild (world-picture), 104–8, 350, 536
We-relation, 439–40
Western Marxism, *see* critical theory,
 post-Marxism
wilderness, 160–1
Wire, The, 537, 579–80
word-oriented thinking, *see* textualism
work, *see* praxis; skills; *technê*

work of art, *see* art
world
 being in the, 121–2
 and body/embodiment, 118–19, 120,
 115–30
 making, 67, 142–3
 material, 426–44
 sensory, 121ff.
 visual, 13
World Art Studies, 73–4
world cinema, 484–7
World Trade Center, 282, 454–5
world-view/world-picture, 62–3, 104–8,
 671–2, 692
World Wide Web (the Internet), 78–9, 90–1,
 162, 399, 536, 559, 661
 as rhizomatic system, 460–1n10
writing, 75, 697–8
 about visual culture, 664
 demise of, 326–7
 dominance of, 428–9, 506
 invention of, 284, 327
 and linear consciousness, 284–6

zones
 of actual reach, 437
 of encounter, 21–2
 of engagement, 22
 of theory, 11